Textiles of Southeast Asia

Tradition, Trade and Transformation

Revised Edition

by Robyn Maxwell

Foreword by Mattiebelle Gittinger

PERIPLUS

For the other members of the Asian Textiles Advisory Committe of the Australian National Gallery—Anthony Forge, Jim Fox, John Maxwell and Jamesm Mollison—since it was their good counsel and great enthusiasm for the textiles of Southeast Asia that inspired this book.

Published by Periplus Editions (HK) Ltd

Originally published by the Australian National Gallery
and Oxford University Press Australia, 1990
First Periplus edition, 2003

First edition © Australian National Gallery and Robyn Maxwell, 1990
Second edition © Australian National Gallery and Robyn Maxwell, 1994
This edition © Periplus Editions (HK) Ltd, 2003 design
This edition © National Gallery of Australia and Robyn Maxwell, 2003 text

ISBN 0-7946-0104-9

Printed in Singapore

Distributed by:

North America, Latin America and Europe
Tuttle Publishing
Distribution Center,
Airport Industrial Park, 364 Innovation Drive,
North Clarendon, VT 05759-9436
Tel (802) 773 8930; Fax (802) 773 6993
Email: info@tuttlepublishing.com

Asia Pacific
Berkeley Books Pte Ltd
130 Joo Seng Road, #06-01/03, Singapore 368357
Tel (65) 6280 1330; Fax (65) 6280 6290
Email: inquiries@periplus.com.sg

Japan
Tuttle Publishing
Yaekari Building, 3F,
5-4-12 Osaki, Shinagawa-ku, Tokyo 141-0032
Tel 81 (03) 5437 0171; Fax 81 (03) 5437 0755
Email: tuttle-sales@gol.com

Indonesia
PT Java Books Indonesia
Jl. Kelapa Gading Kirana, Blok A-14/17, Jakarta 14240
Tel 62 (21) 451 5351; Fax 62 (21) 453 4987
Email: cs@javabooks.co.id

PHOTOGRAPH CREDITS

The photographs not listed below were made available by the Australian National Gallery, Canberra (photographer Gordon Reid). All other photographs were provided by the following institutions and individuals: American Museum of Natural History, New York 69, 86, 128 (J. Kirschner), 205, 429, 432, 520, 521; Art Gallery of South Australia, Adelaide 26, 165, 261, 282, 394, 449; Australian Museum, Sydney 166, 247, 295; Patricia Cheesman-Naenna 414; Field Museum of Natural History, Chicago 33, 55, 141, 196; J. A. W. Forge 103, 210; James J. Fox 130; Koninklijk Instituut voor de Tropen, Amsterdam 32, 126, 127, 129, 211, 249, 250, 302, 341, 357 (van Eerde), 362, 375, 384 (Roepke), 397, 404, 426, 428, 453, 502, 508, 509, 518; John R. Maxwell 1, 2, 4, 30, 34, 35, 36, 39, 46, 56, 58, 62, 63, 67, 70, 72, 74, 78, 80, 97, 104, 114, 123, 146, 155, 157, 159, 171, 180, 197, 200, 201, 202, 215, 218, 221, 226, 227, 228, 229, 231, 232, 240, 254, 256, 265, 303, 305, 306, 320, 340, 355, 356, 358, 361, 367, 371, 385, 409, 420, 422, 423, 431, 445, 446, 454, 455, 458, 462, 465, 469, 473, 476, 478, 480, 481, 485, 497, 503, 512, 516, 526, 531, 538, 544, 549, 552, 553, 557, 561, 562, 567, 568, 569, 570, 572, 573, 574, 578, 579; Robyn J. Maxwell 208, 216, 225, 229, 347, 461, 482, 483; Musée de L'Homme, Paris 47 (Matras), 61 (Hoffet), 120, 167, 206, 212, 213, 217, 219, 230, 233, 237, 252, 253, 259, 284, 286, 288, 307, 332, 349, 352, 362, 364, 366, 388, 393, 398, 402, 427, 444, 464; Museum of Cultural History, University of California, Los Angeles 31, 42, 89, 90, 154, 523, 529, 530, 532; Museum für Volkerkunde, Basel 343; National Anthropological Archives, Smithsonian Institution, Washington 152, 353; The Newark Museum, Newark 108; Royal Anthropological Institute, London 83; Royal Commonwealth Society, London 438.

FOREWORD

Southeast Asia presents one of the richest and most varied textile regions in the world. This is true both in the realms of textile patterning techniques and in the complexity with which textiles operate in autonomous belief systems. Textiles link today's inhabitants with their ancestors and promise a continuity with future generations. They confirm pledges of alliance and, in their exchange, acknowledge kin and social obligation. Because textile making throughout the region is predominantly woman's work, textiles are considered 'female' currency in the exchange of complementary male and female goods that occurs at virtually all life crisis ceremonies. They are also a prime means of woman's creative expression. Locally crafted cloth may also suggest historical influences and ancient customs and practices that hint of continuities that once bound the entire Southeast Asian area before the advent of nation states.

Robyn Maxwell's book orders this kaleidoscope of technique, custom and history by distilling the elements that unite this diversity. She first summarizes previous work and in subsequent chapters examines in detail the fundamental historical influences that have contributed to the textiles we know today and places these in a social context. She illustrates her analysis with textiles of beauty and sometimes ones of great rarity. In addition, readers will delight in the many archival and field photographs that lend exotic and meaningful context to the cloths.

Her work draws on extensive field work in the region, acquaintance with European, American and Asian collections and the superlative Southeast Asian holding of the National Gallery of Australia. It also utilizes the scholarship of others and includes an extensive bibliography.

This is not a lightly read — or held — volume. It is, however, the most comprehensive single book to address the textiles of this region. That was true when the work first appeared in 1990 and remains so today.

Mattiebelle Gittinger
Research Associate
The Textile Museum
Washington, DC

CONTENTS

ACKNOWLEDGEMENTS

A book of this scope could not have been written without incurring debts of gratitude to a great many people and a large number of institutions. While I cannot thank each one personally, I would like to acknowledge the great support which was generously given, and without which my research could not have been carried out.

I would particularly like to thank my good friend, Professor J. A. C. Mackie, formerly Research Director of the Centre of Southeast Asian Studies at Monash University and Professor of the Department of Political and Social Change at the Australian National University. Jamie was the first to encourage me to make a serious and extensive study of Indonesian textiles and he has continued to be supportive in many large and small ways during the course of my work.

My initial period of research in Indonesia from 1976 to 1978 was made possible by an award from the Myer Foundation of Australia under its Asia and Pacific Grant-in-Aid programme, efficiently administered at that time by Ms Meriel Wilmot. The research in Indonesia was carried out under the auspices of the Indonesian Institute of Sciences and the sponsorship of the Institute of Textile Technology, Bandung. I am grateful to the Research Director of the Bandung institute, Mr Wibowo Moerdoko, for his interest in the project and his understanding, and to Sofian for his company and assistance during one of our visits to Sumatra.

Research throughout Indonesia was only made possible by the courteous assistance of a large number of government officials from the Departments of the Interior, Industry, Culture and Education. Invariably, at all levels of government our papers and permits were efficiently processed and useful practical information and advice was often forthcoming in discussions with interested and knowledgeable administrators. On many occasions, officials took time from their own busy routines to accompany us to specific places of interest.

The vital part of my two years' work in Indonesia was carried out in villages throughout the archipelago where weaving and traditional textiles are still a central part of life and culture. I wish to thank the many kind people who shared their homes and their food with us during my fieldwork in their region. Above all, I wish to acknowledge the women who patiently demonstrated the intricate processes, techniques and procedures of their textile art. I am also indebted to the men and women who spent many hours explaining the meaning of their cloth to me, and in particular, those who honoured me by displaying their own treasured possessions, family heirlooms and items of sacred ritual, and by allowing photographs to be taken. There are too many people to name and it would be unfair to single out individuals. My debt to these people is impossible to repay, but any merit in this work is in large part a reflection of the long, tiring but exhilarating days spent in the company of so many.

During my work in Indonesia, I received courteous assistance from the staff of the National Museum and the Textile Museum in Jakarta and provincial museums in Banda Aceh, Palembang, Bukit Tinggi, Den Pasar and Ujung Pandang, and I wish in particular to thank Dra Suwati Kartiwa and D. Sufwandi Mangkudilaga. I am also pleased to acknowledge the advice and assistance I received in Indonesia from a large number of knowledgeable but necessarily anonymous informants, private collectors and admirers of fine textiles.

I also owe a great deal to many friends for their personal support during the period of my research in Indonesia. I particularly wish to thank my Bandung friends Danny and Helen Lok and the Hardjono family for their numerous acts of kindness and a close friendship maintained over many years. Elsewhere in

Indonesia I must acknowledge the assistance of Erawati and Verra Darwiko, Mr and Mrs Bonaparte Hutagalung, Abdurahim and his family, Chris and Bronwyn Rose, and Helen and Philip Jessup.

In 1978–79 I was pleased to receive a vacation scholarship from the Australian National University in the Department of Anthropology in the Research School of Pacific Studies which enabled me to pursue library research. In 1983 a Netherlands Government Scholarship provided me with the opportunity to examine in detail the historic European collections of Southeast Asian textiles established during the colonial period.

I received invaluable assistance from the staff of a number of institutions and museums during my research there throughout 1983 and during two subsequent research visits to Europe in 1985. In the Netherlands I wish to thank the following people in particular for the access they provided to the collections under their care: Jan Avé and Maria Lahmann at the Rijksmuseum voor Volkenkunde, Leiden; Rita Bolland, Koos van Brakel and the staff of the registration and photography sections of the Koninklijk Instituut voor de Tropen; Alit Veldhuisen-Djajasoebrata and the staff of the Museum voor Land-en Volkenkunde, Rotterdam; Rita Wassing-Visser and Suwandi at the Volkenkundig Museum Nusantara, Delft. I also wish to acknowledge the assistance of the staff at the Volkenkundig Museum and the Nederlands Textielmuseum in Tilburg; the Volkenkundig Museum Justinus van Nassau, Breda; the Museum voor het Onderwijs, The Hague; the Princessehof Museum, Leeuwarden; and the Koninklijk Instituut voor Taal-, Land-, en Volkenkunde, Leiden.

In other parts of Europe I received generous assistance from Carl-Wolfgang Schümann and Brigitta Schmedding at the Deutsches Textilmuseum, Krefeld; Brigitte Khan Majlis, Karin von Welck and Gisela Völger of the Rautenstrauch-Joest-Museum in Cologne; Johanna Agthe of the Museum für Völkerkunde, Frankfurt; Natasha Nabholz and Urs Ramseyer of the Museum für Völkerkunde, Basel; and Mmes Bataille and Cousin, M. Dupaigne and the staff of the Photothèque at the Musée de L'Homme, Paris. During my several visits to Europe I have accumulated personal debts to many friends for their support, encouragement and companionship and I would particularly like to thank Rens Heringa, Professor and Mrs P. E. de Josselin de Jong, Henk Maier, and Stuart and Rosemary Robson.

For assistance during a number of brief visits to the United Kingdom, I would like to express thanks to the staff of the following institutions: the Victoria and Albert Museum; the Museum of Mankind; the Royal Anthropological Society; the Anthropology Museum, Cambridge; the Pitt-Rivers Museum, Oxford; and in particular to Ruth Barnes, Brian Durrans, Henry Ginsburg and Jonathan Hope. I am especially grateful for my long and close friendship with John Guy, Assistant Keeper of the Indian Department at the Victoria and Albert Museum, and for his professional assistance on many occasions.

In the United States of America and Canada, the staff of the following museums were also extremely helpful: the Field Museum of Natural History, Chicago; the Textile Museum, Washington; the Museum of Natural History, New York; the Museum of Cultural History and the Anthropological Archives of the Smithsonian Institution, Washington; the Metropolitan Museum of Art, New York; the Los Angeles County Museum of Art; and the Museum of Cultural History at the University of California, Los Angeles. In Canada I was welcomed by the staff of the Royal Ontario Museum, Toronto. I would particularly like to thank Monnie Adams, Charlotte Coffman, Dale Gluckman, Mary Kahlenberg, Richard Mellot, Jeff Holmgren and Anita Spertus for their personal interest and professional support. My special thanks, of course, go to Mattiebelle Gittinger who has always encouraged my own textile research and that of others in the Southeast Asian region and whose own work provides a model for the standard of scholarship I would like to achieve.

Elsewhere in Asia, especially during short periods of research in 1983, 1985 and 1988, I have received generous assistance from the staff of various national museums. In particular, I would like to thank Ms Zubaidah at the Museum Negara, Kuala Lumpur; Constance Sheares and Lee Chor Lin of the National Museum, Singapore; Dr Jose Peralta and the photography department of the National Museum, Manila; and the late Ms Chira Chongkol at the National Museum, Thailand. I would also like to thank Piriya Krairiksh for his special assistance during my time in Bangkok. I am especially grateful to Patricia Cheesman, Chiang Mai, for her practical and professional assistance. In India the staff of the Calico Textile Museum in Ahmedabad extended every assistance during a difficult period of reorganization.

At the Australian National Gallery, I thank the Director and the staff of Conservation, Exhibitions, International Art, Photographic Services, Publications and Registry for their assistance on this project. I wish to acknowledge the important contribution of Ruth McNicoll who in 1979 as the then Curator of Primitive Art was responsible for beginning the collection of Southeast Asian textiles at the Australian National Gallery, and who coordinated the early work of the Asian Textiles Advisory Committee. Other Australian museums and art galleries with interests in Asian art have been most supportive, and I wish particularly to

thank Dick Richards of the Art Gallery of South Australia, Zoë Wakelin-King of the Australian Museum, and Fiona Leibrick of the Northern Territory Museum of Arts and Sciences.

I am indebted to the editorial and production staff at Oxford University Press and to Peter Shaw for their hard work and professionalism during the many months it has taken to convert a cumbersome manuscript into a handsome book. I am especially grateful to Louise Sweetland, Oxford's Academic Publisher, who has generously given of her time and energy and has been personally supportive in overcoming innumerable difficulties.

I am very grateful for the professional and personal assistance, often inseparable, of many friends and colleagues in Australia during the course of this project. These include Marybeth Clark, Darryl Collins, Christine Dixon, Penny Graham, Mike and Margarete Heppell, Ruurdje Laarhoven, Barbara Leigh, Cecilia Ng, Hugh O'Neill, David Stuart-Fox and S. Supomo. For personal support both in Australia and during periods of research overseas I wish to thank Rob Metherall, Helen Trudgian, and other members of my close family, especially Alison Runnalls and Simeran Maxwell.

Gratitude of a special kind must be directed to the members of the Asian Textiles Advisory Committee of the Australian National Gallery. Without Anthony Forge, Jim Fox, John Maxwell and James Mollison this project could never have succeeded. It was during the lively, lengthy and enlightening meetings of the Committee and the long discussions which developed along with our friendships that many of the ideas arose which form the basis of this book. Each has been very generous with his advice, ideas, encouragement and criticism. I am very thankful for all of these contributions. They cannot be underestimated. Of course John Maxwell has provided the strongest and closest support, from the great discoveries to the final full-stops. Thank you.

Robyn Maxwell
Department of Asian Art
Australian National Gallery

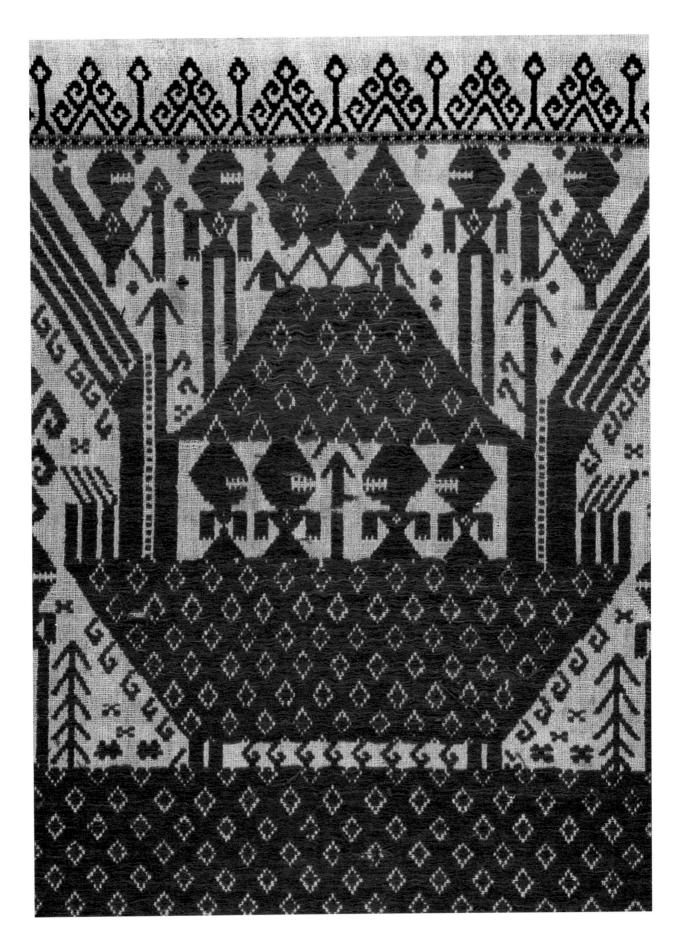

Chapter 1

AN INTRODUCTION TO SOUTHEAST ASIAN TEXTILE HISTORY

Throughout Asia textiles are one of the most powerful and exciting art forms, and in Southeast Asia in particular, the spiritual and ritual importance that textiles play in ceremonies of state and religion is reflected in their great mystery and splendour. Southeast Asian textiles are outstanding works of art, formed by a rich variety of techniques. The finest examples, often of elaborate and complex design, display superb levels of technical skill in weaving, dyeing, embroidery and appliqué. A diversity of materials includes bark, plant fibres, cotton, silk, beads, shells, gold and silver, and among a profusion of patterns and motifs we find human figures, abstract geometric shapes, ships, arabesques, calligraphy, flowers, recognizable animals and imaginary monsters.

The most common function for textiles is their use as articles of clothing. However, apart from their importance as everyday and ceremonial dress, textiles in Southeast Asia have numerous other functions including their use as religious hangings, royal insignia, theatrical backdrops, sacred talismans or secular currency, for they are intimately connected to systems of religion, political organization, marriage, social status and exchange. These functions in turn affect the size, shape, structure and decoration of the cloths.

Since decorative textiles are of great importance as elaborate festive garments, as symbols of prestige, and as items of wealth and [1,2] religious significance, the making of such cloth often requires physical and spiritual precautions to protect the quality of dyeing and weaving, and the well-being of the artisan. Consequently, legends and rituals surround both the origins and the making of important fabrics.

The texture of the materials, the skill of the craftswoman, the richness of the colours, and the clarity and intricacy of the patterning and design are the usual criteria for assessing the beauty and merit of these textiles. However, as we shall see, some unpretentious striped or plain-dyed cloths have great ritual potency. Moreover, many designs and motifs convey important messages significant only to those familiar with the particular social and religious principles of the people who have produced them. It is only by seeing cloths in their cultural context that we can begin to understand their true value and meaning.

Opposite Detail of Plate 245

1
A Dou Donggo woman from mountain Sumbawa, Indonesia, immersing handspun cotton thread in a pot of locally grown indigo dye. The use of local vegetable dyes is still widespread in eastern Indonesia where many women weave cloth for family and ceremonial needs. Despite the apparent simplicity of the apparatus, textiles of great beauty and complexity are produced.

2
Still a typical scene in many parts of Southeast Asia, a woman on the verandah of the ancestral house weaves a handspun fabric on a simple backstrap tension loom. Drying in the sun on bamboo poles across the front of the house are freshly dyed cotton threads. This village is in the mountainous Ngada district of central Flores, Indonesia.

3
'Voorvechter van het eiland Sawoe (Champion from the island of Savu)' coloured lithograph by P. van Oort, published in a volume by C.J. Temminck, *Verhandelingen over de Natuurlijke Geschiedenis der Nederlandsche Overzeesche Bezittingen*, Leiden, J.G. La Lau, 1839-47, Plate 44

4
'Borneosche Krijgsman (Borneo Warrior)' coloured lithograph by C.W. Mieling after drawings by A. van Pers, published in his *Nederlandsch Oost-Indische Typen*, The Hague, Koninklijke Steendrukkerij, 1855

5 (detail)
higi huri worapi
man's wrap
Savunese people, Savu, Indonesia
handspun cotton, natural dyes
warp ikat
226.0 × 111.0 cm
Rijksmuseum voor Volkenkunde, Leiden, 1-141

The value of old records of textiles varies considerably. An early written description is often totally inadequate to determine the visual appearance of a cloth or costume, and old drawings, lithographs and photographs add an important pictorial dimension. However, as these two nineteenth-century lithographs show, the information they convey can also become distorted. Van Oort captures accurately the fabric worn by the Savunese 'champion', easily recognizable as a *higi huri worapi* (a

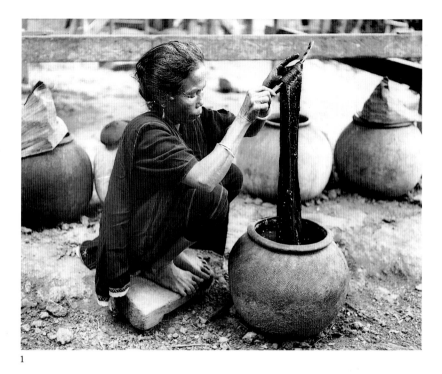

1

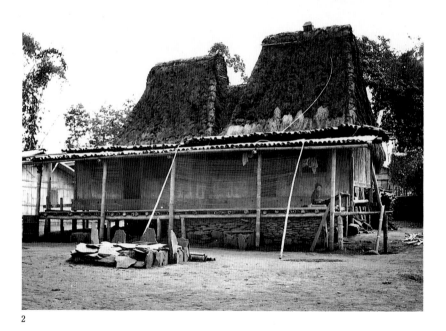

2

APPROACHES TO THE STUDY OF SOUTHEAST ASIAN TEXTILES

This book aims to bring some order and meaning to the rich but apparently confusing field of Southeast Asian textiles. This problem has bedevilled researchers since the European colonial era. During the last quarter of the nineteenth century, as part of the study of 'native' arts and crafts, a number of ethnologists began to record the textile arts of various parts of Southeast Asia. An extensive and valuable literature on Indonesian textiles, in particular, dates from this

3,4,5

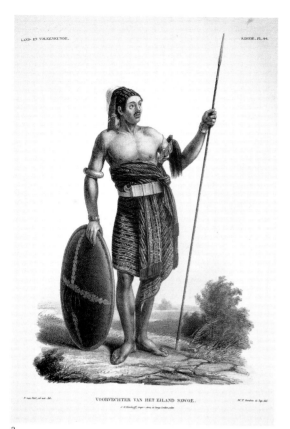

VOORVECHTER VAN HET EILAND SAWOE.

3

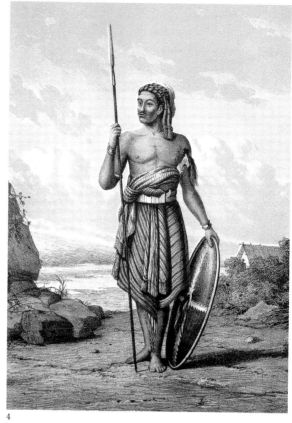

4

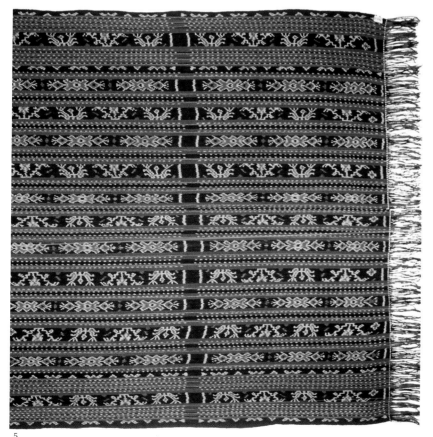

5

man's wrap for members of the *Hubi Ae*, the Greater Blossom moiety) similar to a very early nineteenth-century museum example from the original F. von Siebold collection of the Rijksmuseum voor Volkenkunde, Leiden. This is one of the earliest Indonesian textiles in any European public collection.

However, the later adaptation of van Oort's work by van Pers, published in 1855, completely distorts the information by adding slight but significant variations to the colour and detail of the costume, and by attributing the ethnic origins of the person to Borneo. This lithograph is in sharp contrast to the wonderful impressions of nineteenth-century life in Java by van Pers which appear in the same volume.

6
kamben cerek
breastcloth
Balinese people, east Bali, Indonesia
handspun cotton, natural dyes
tapestry weave
220.0 × 53.0 cm
Australian National Gallery 1984.3173

7
kandit
waist-sash; ceremonial hanging
Tausug people, Sulu archipelago,
Philippines
silk, dyes
tapestry weave
357.0 × 36.5 cm
Australian National Gallery 1984.1223

Two similar designs appear on early twentieth-century tapestry weave textiles from Hindu Bali in Indonesia and the Islamic Tausug people of the southern Philippines. Both are worked in a geometric tapestry weave, known by the Tausug as *siyabit*. The open windows of the Balinese tapestry weave appear to have been achieved by a combination of carefully arranged groups of warp threads and the insertion, at intervals in the weft, of palm-leaf slivers that were removed on completion of the textile. Despite the contrast between the sombre green, red, yellow and natural brown handspun Balinese cotton and the luminous pink, blue, orange and purple of the Tausug silk, both fabrics contain comparable interpretations of popular Southeast Asian diamond grid and zigzag patterns.

period, and includes many important works of Dutch scholarship written earlier this century. J.A. Loebèr (1903; 1913; 1914; 1916; 1926) produced a number of studies on various aspects of Indonesian decorative arts, including several on or related to textiles. Between 1912 and 1927 J.E. Jasper and M. Pirngadie produced a series of volumes which set out to describe in great detail the native crafts of the Dutch East Indies, including two volumes documenting textile types and techniques (1912b; 1916). At around the same time, G.P. Rouffaer and H.H. Juynboll completed an important and detailed study of Indonesian batik (1914). During the 1930s and 1940s, a trickle of articles on the subject appeared in both ethnological and popular journals. This study was considerably enriched by the work of the Swiss textile scholar Alfred Bühler who continued to make important contributions to the wider field of ethnographic textiles until his death in 1981.[1]

Since the Second World War, the study of Indonesian textiles has expanded on various fronts. Apart from an important interpretative work drawing upon museum textile collections in the Netherlands (Jager Gerlings, 1952), there has been a number of comprehensive studies of the textiles of specific ethnic groups. Among the first of these, most of which have been based in anthropology or art history, were M.J. Adams's monograph (1969) and numerous articles on Sumbanese textiles, and M.S. Gittinger's analysis of south Sumatran ship cloths (1972). An impressive number of exhibition catalogues have also appeared, the most notable being M.S. Gittinger's *Splendid Symbols* (1979c), which combines a valuable synthesis of the scholarship on the subject with many photographs of outstanding examples.

Despite the recent increase in important studies and journal articles, the textiles of many ethnic groups in Indonesia still remain substantially unrecorded, and the published material on the textile arts from elsewhere in Southeast Asia remains remarkably thin.[2] Moreover, Indonesian textiles have been studied largely in isolation from the material cultures of neighbouring countries,[3] despite the fact that many historians, linguists and other social scientists have long since recognized the benefits of regarding the whole of Southeast Asia as a coherent and integrated field of study.[4] This study, however, addresses the wider region of Southeast Asia. The boundaries of Southeast Asian countries have been largely determined by political forces operating over relatively recent times. Such political units conform only roughly to ethnic boundaries;[5] the wider cultural parameters of the region or its shared historical experiences of the past several thousand years are therefore obscured.

A wider perspective has distinct advantages. It enables us to deal with the problems of textile-producing cultures now divided by national borders. Common historical experiences that have influenced textile arts across the entire region can be examined, and many useful comparisons can be made within and between ethnic groups that otherwise would be impossible. While this book is generously illustrated with material from Indonesia, indicating the extraordinary richness of its textile traditions, fine examples of fabrics from Malaysia, the Philippines, Thailand, Laos and other parts of mainland Southeast Asia have been included.

Many studies of Southeast Asian textiles have focused on the geographic or ethnic divisions within the region,[6] while others have concentrated upon a descriptive account ordered according to deco-

10,11

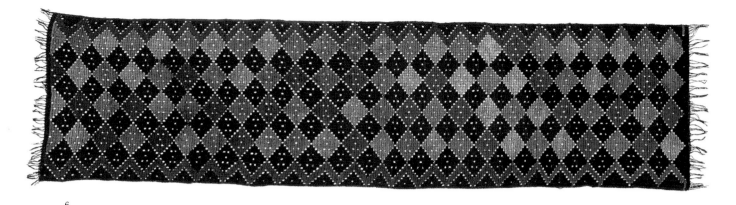

6

7

rative techniques.[7] Both of these aspects form an important part of the material of this study. However, instead of concentrating on the differences implicit within Southeast Asian textiles — from either a technical or an ethnic perspective — I have searched for the connections and the meanings that lie within this diversity.[8] Southeast Asia's quest for design and its receptiveness to certain splendid, decorative ideas from outside the region are seen in the creative transformations in local and foreign designs, material and decorative techniques. The book, therefore, is not arranged geographically or by ethno-linguistic group. However, a checklist of the textiles in the book according to ethnic and geographic origin appears in the index. The juxtaposition of cloths of different sources, techniques and functions is intended to illuminate certain shared features as well as the uniqueness of particular responses to common influences.

6,7
8,9

Outside pressures and indigenous responses are familiar foci for historians of Southeast Asia. The region is strategically situated at an important international crossroad between major global centres of population. Over many centuries it has been a destination for a constant stream of visitors from both neighbouring and distant foreign lands. These have included explorers and adventurers, foreign envoys, and the soldiers and sailors who accompanied them. Some

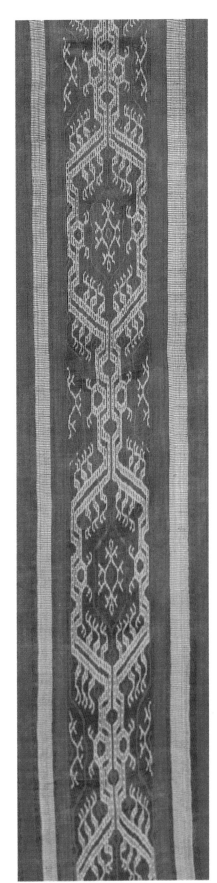

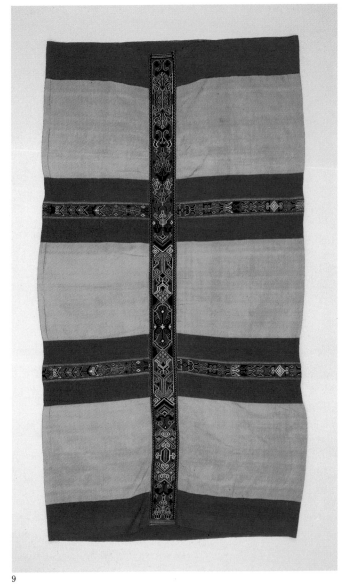

9

8 (detail)
kumo
hanging; ceremonial gift
T'boli people, Mindanao, Philippines
abaca fibre, natural dyes
warp ikat
40.0 x 864.0 cm
Australian National Gallery 1989.397

9
malong landap
woman's skirt
Maranao people, Mindanao, Philippines
silk, dyes
tapestry weave
94.0 × 165.0 cm
Australian National Gallery 1984.1250

While similar textiles can be found in
cultures from geographically distant
parts of Southeast Asia, the fabrics of
neighbouring cultures may have
evolved along very different paths. On
Mindanao, for example, two ethnic
groups produce fabrics and garments
which use different materials,
decorative techniques and
iconography. The Maranao weave in
imported silk in bands of clear bright
colours. On an early twentieth-century
example purple and green bands are
joined into a cylinder with intricate
multicoloured tapestry-woven bands
(*langkit*). The T'boli still create
ancient warp ikat (*t'nolak*) resist
patterns of spirals, rhombs and keys in
red and black vegetable dyes against
the natural shades of the locally grown
wild banana fibre. This panel of *t'nolak*
dates from the nineteenth century.

8

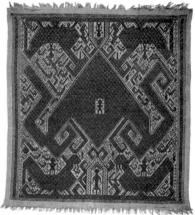

11

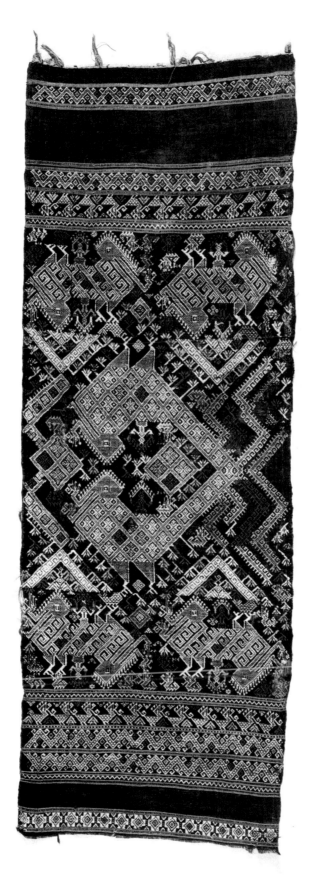

10

10
pha biang
ceremonial shawl
Tai Nuea people, Sam Nuea region,
Laos
handspun cotton, silk, natural dyes
supplementary weft weave
119.0 × 43.0 cm
Australian National Gallery 1986.1927

11
tampan
ceremonial cloth
Paminggir people, Lampung, Sumatra,
Indonesia
handspun cotton, natural dyes
supplementary weft weave
74.0 × 80.0 cm
Australian National Gallery 1984.1193

Similar techniques and patterns can be
found on textiles in particular parts of
Southeast Asia that are remote from
each other. The supplementary weft
weavings of the Tai Nuea of northern
Laos bear a striking similarity to the
ship-cloth weavings of southern
Sumatra. Weavers in both regions
have developed intricate asymmetrical
designs filled with mythical creatures
carrying anthropomorphic riders. The
central figure is represented on this
brown and natural Sumatran *tampan*
with a lozenge-shaped body while on
the Tai cloth a similar motif
sometimes appears as a separate
diamond mandala. Birds, smaller
dragon shapes, and shrine structures
appear in varying degrees of realism
on each of these nineteenth-century
textiles, and both contain fine detail
worked in key and spiral
configurations. On other examples
woven by these peoples, the prominent
banded borders are surprisingly
similar.

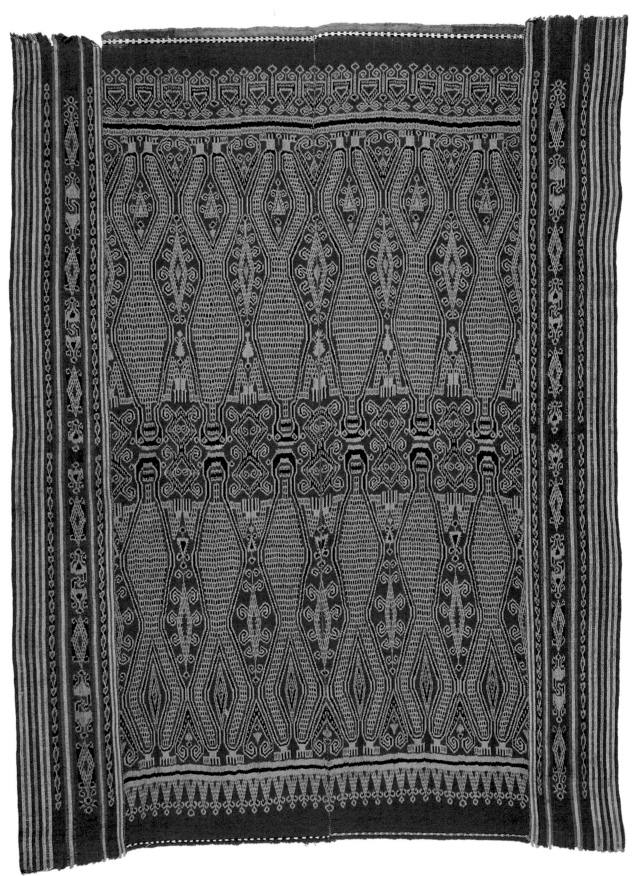

12

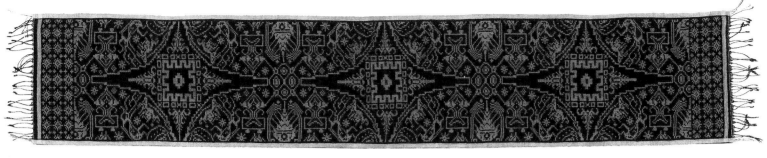

13

12
pua kumbu
ceremonial cloth
Iban people, Sarawak, Malaysia
handspun cotton, natural dyes
warp ikat
185.0 × 247.0 cm
Australian National Gallery 1983.27

Anthropomorphic figures are among
the oldest symbols found on textiles.
On this nineteenth-century *pua*, male
figures appear in one half and female
figures in the other. Such human
forms often represent significant
ancestors or deities. Two central
panels and additional borders
composed of stripes and smaller
creatures on each side, are worked in
red and dark brown vegetable dyes
against natural cream handspun
cotton.

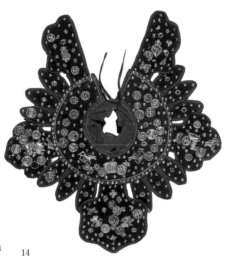

14

13
kamben geringsing patelikur isi
cloth for ritual wear and use
Balinese people, Tenganan, Bali,
Indonesia
handspun cotton, natural dyes
double ikat
214.0 × 39.0 cm
Australian National Gallery 1980.726

The three stark mandala that separate
sets of smaller shrine and stupa
shapes, still recognized by the Hindu
weavers of Tenganan as small house
temples (*sanggar*) and sources of holy
water (*cupu*), are strong reminders of
the Indian influence on Southeast
Asian art. One of the stylized forms
flanking the shrines is said to be the
dog (*asu*) motif. The floral star shapes
are the scented ivory offering flower
(*si gading*). This is an early
twentieth-century example of the
intricate double ikat technique, in

which the brown and black resist-dyed
warp and weft threads have been
loosely woven on a simple backstrap
loom into a fabric on which both warp
and weft patterns are visible. Like
many *geringsing* textiles, this cloth's
name (*patelikur*) indicates the width or
number of bundles of warp thread that
are required for its making.

14
lengkung léhér
ceremonial collar
Malay and Abung people, south
Sumatra, Indonesia
commercial wool and cotton cloths,
gold alloy ornaments
appliqué
48.0 x 54.0 cm
Australian National Gallery 1985.615

This gold-studded necklet worn by
Malay brides is modelled on the cloud
collar of Chinese ceremonial costume.
Many of the propitious symbols it
displays were worked in low grade
gold alloy by Straits Chinese smiths
during the nineteenth and early
twentieth centuries. The green base-
cloth and red trim are of imported
factory-manufactured cloth.
The selection of images appears to
be random. Animals from the Chinese
zodiac appear in realistic shapes —
the horse, the goat or buffalo, the
rooster and the dog-lion. Within
decorative roundels are other animals
and floral images — bats, butterflies,
phoenix, fish and lotus — while the
Chinese lotus image (*ho hua*) is also
depicted in vases (*ping*). The thistle,
and in particular, the solid central
crown are European decorative
devices.

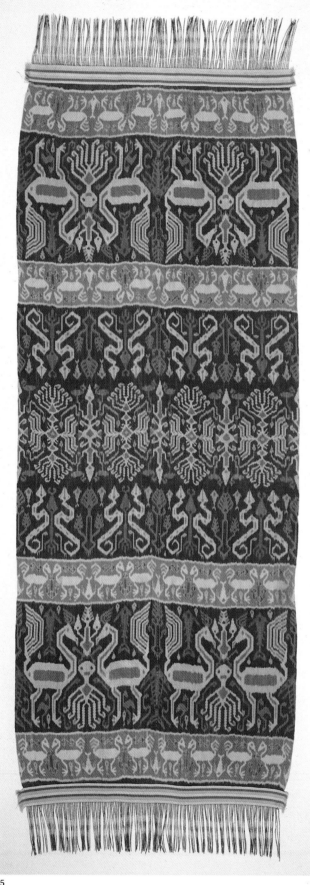

15

15
hinggi kombu
man's cloth
Sumbanese people, east Sumba,
Indonesia
cotton, natural dyes
warp ikat, band weaving, staining
69.0 × 311.0 cm
Australian National Gallery 1984.580

The sacrificial chicken or cock is often
represented on ceremonial textiles.
Although many flying creatures, both
real and mythical, can be found in
Southeast Asian fabric design, the cock
has been a feature of village life and
art since prehistoric times. Between
each pair of confronting cocks are fish
and squid motifs. Other bands include
smaller chickens and snakes. In the
central section the dyer has created a
schematic design from bird and squid
forms, in keeping with the custom of
filling this part of the cloth with motifs
adapted from imported textiles. Rich
saturated natural dyes are used on this
cloth which reflects a style popular at
the turn of this century. At each end
of a fine Sumba *hinggi* the weaver
incorporates the unwoven sections of
the warp fringe as wefts into a new
warp that lies across the end of the
woven fabric. The effect is a strong
bright striped band (*kabakil*).

16
dodot
royal ceremonial skirtcloth
Indramayu district, Java, Indonesia
cotton, natural dyes
batik
207.0 × 357.5 cm
Australian National Gallery 1984.3163

Dodot, voluminous ceremonial batik
wraps, are more than twice as large as
kain panjang skirtcloths. They are
decorated in patterns appropriate to
their use by the Javanese nobility as
ceremonial and dance costume. This is
a version of the scenes of cosmic
mountain and forest landscape known
as *semèn* in which the chevron peaks
of mountain ranges and vague
representations of buildings, possibly
shrines, can be discerned. The huge,
stylized, double-wing motif, the
mirong, appears in each corner of the
dodot. It is often identified as the
garuda bird of Hindu mythology,
which, over time, has become a
symbol of many Southeast Asian
courts. Other smaller *mirong* and *lar*
(the single-wing motif) are scattered
throughout the freely drawn design.
This early twentieth-century batik is
dyed in the unusual olive tones of the
Indramayu district, west of Cirebon on
Java's north coast, where Javanese and
Sundanese cultures blend.

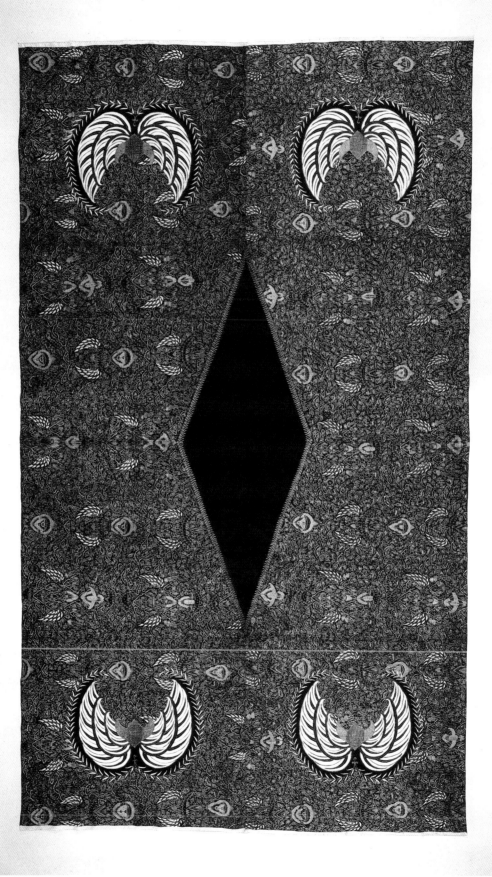

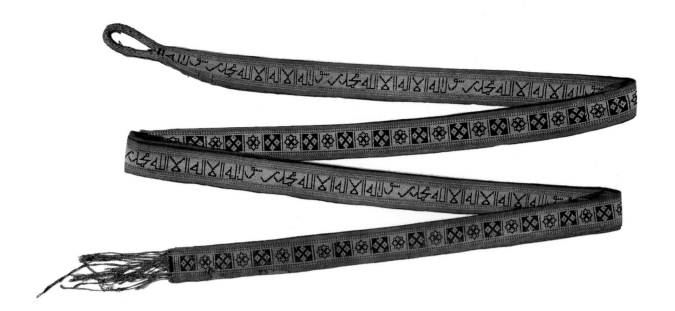

17
tali banang
man's ceremonial sword-belt
Buginese people, Sulawesi, Indonesia
cotton, natural dyes
tablet weaving
12.0 × 380.0 cm
Australian National Gallery 1984.1989

The Islamic inscription in Kufic
calligraphy reads 'There is no God but
Allah and Muhammad is His prophet'.
While this is written in Arabic,
inscriptions on other textiles from the
Southeast Asian region also appear in
local Malay languages. Tablet-woven
bands were used as belts, straps,
bindings and even stitched into special
betel-nut bags by the women of
central and south-west Sulawesi. This
nineteenth-century sword-belt is
formed from one long strip using a
rare tablet weaving method which
includes even the tubular loop. The
colours, indigo-blue and white with red
borders, may have evoked the same
talismanic protection for the warrior
as strands of twined threads in these
tricolours often do elsewhere in
Southeast Asia.

merely passed through Southeast Asia while others came to control
new territories for their rulers. Petty traders and the agents of large
and powerful enterprises were lured to Southeast Asia by the possi-
bilities of new markets and the quest for commodities. Among the
newcomers were many who professed religious beliefs foreign to
Southeast Asians — and were keen to proselytise. There were also
those who, driven from their homeland by poverty or persecution,
sought a land of hope and opportunity. Some were only transient
visitors while others stayed longer. Many newcomers, however,
never returned to their original homeland, settling permanently in
Southeast Asia. Most have left some imprint on the cultures of the
region.

The textile arts of Southeast Asia reflect these diverse
influences: the ancestor figures of earliest legend, the sacred mandala *12*
of the Hindu-Buddhist world, the zodiac menagery of Chinese icon- *13,14*
ography, the flowing calligraphy of Islam and the lace of the West. *17,18*
This book explores some of these foreign influences and the imagin-
ative and exciting local responses to the new ideas and materials.

The study begins by examining the earliest forms of textiles and
the decorative techniques associated with them. Some of the essential
raw materials have an ancient history in Southeast Asia and prehis-
torians and archaeologists provide clues to a number of the earliest
textile techniques, designs and patterns. Certain motifs and symbols, *15*
still evident today, seem to have had a very long history throughout
the region. Since textiles are an integral part of Southeast Asian life,
an exploration of the most ancient cultural practices and social organ-
ization contributes to an understanding of the functions of cloth.

It is with this ancient but well-established artistic base that the
two earliest and strongest cultural forces in the region — India and *16,19*
China — interacted. Geographic proximity has contributed to this
process since certain parts of Southeast Asia have had a more inten-
sive and continuous contact. This is particularly evident where the
ethnic, linguistic and cultural influence of southern China is to be
found among many of the peoples of northern Thailand, Burma, Laos

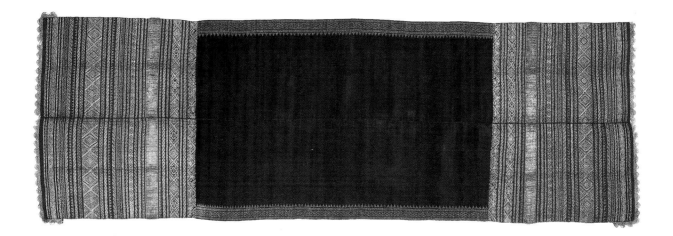

and Vietnam. A number of ethnic groups are also spread across southern China into neighbouring states. In a similar fashion, the Naga people straddle the border between India and Burma.

Chinese and Indians sailed the waters of Southeast Asia in the same centuries, although the intensity and directness of their respective influence varied over time and place throughout the region. Indian influence, especially in the form of Indian textiles, continued after the arrival of the Europeans, while the impact of Chinese culture became more direct with large-scale migrations from southern China to the European colonies during the nineteenth and early twentieth centuries.

Throughout Asia, the history of textiles largely follows the history of trade, and the strategic position of the Southeast Asian region and its bountiful natural resources attracted trade from early times. Islam has been a religious element in Southeast Asia since the twelfth century. Traders from India and Persia, and even China, along with travellers from the Middle East, spread Islam into Southeast Asia where it became a dominant political and cultural force during the fifteenth and sixteenth centuries.[9] I have tried to establish the distinctive contributions of Islam to Southeast Asian textile art.

European political and economic supremacy after the eighteenth century affected the development of Southeast Asian textile traditions, even though the objects they traded and the symbols of power they manipulated were not always produced by Europeans themselves. Indian textiles, acquired and distributed through European trading monopolies, took on meanings and functions unique to the cultures of Southeast Asia. At the same time, certain local textile designs and techniques were influenced by European textile art. The West is still a powerful force in Southeast Asia and continues to influence textiles into the twentieth century.

TEXTILES, HISTORY, SOCIAL AND CULTURAL CHANGE

Textiles provide insights into the history of Southeast Asian societies and much of the textile history is closely tied to the conventional accounts of Southeast Asia's past. Sumptuous gold brocades and silk garments were the finest products of those Southeast Asian court

18
tengkuluak; kain sandang
woman's headcloth; shouldercloth
Minangkabau people, west Sumatra, Indonesia
silk, cotton, gold thread, natural dyes
supplementary weft weave, bobbin lace
246.0 × 83.5 cm
Australian National Gallery 1984.576

This sumptuous ceremonial textile has wide, gold and silk, striped end sections which glow against a rich purple centre. The major motifs are variations on stars (*bintang*). While cloths of this supplementary weft style have been made for centuries, the influence of European fashion and textile techniques has led to the addition of lace edges and fringes on this nineteenth-century example.

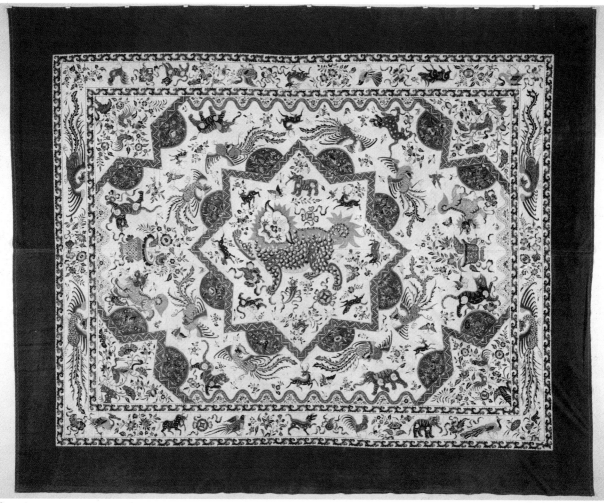

19

19
lelangit (?)
canopy
Peranakan Chinese people, north-coast Java, Indonesia
cotton, natural dyes
batik
270.0 × 255.0 cm
Australian National Gallery 1984.3091

Huge batik canopies were a significant feature of ceremonies within the immigrant Chinese communities along the north coast of Java in the nineteenth and early twentieth centuries. This example is in the rich red dyes for which the Lasem district is famous. The animal motifs, that include the central motif of the dog-lion (*qilin, kilin*), male and female phoenix, geese, oxen, deer, elephants and butterflies, symbolize the hopes for longevity, marital felicity, fertility and other blessings. Strewn through the field and borders are minor motifs, beribboned auspicious symbols, cloud shapes and Chinese flowers such as the lotus. Such symbols suggest the

use of these large textiles at marriage festivities. While the batik's motifs closely follow Chinese models, its general design structure, with wide equal borders and floral sinuous flowering trees in each corner, also appears to have been influenced by a type of painted Indian cotton chintz, which was imported into Southeast Asia for centuries (Maxwell, 1990). The unique Javanese waxing pen (*canting*) was used to execute the hand-drawn batik.

20
bi
ceremonial hanging
Acehnese people, Sumatra, Indonesia
cotton, wool, silk, gold thread, sequins, glass beads
appliqué, couching, embroidery, lace
64.0 × 208.0 cm
Australian National Gallery 1984.1986

This long red embroidered panel (*bi*) was hung around the bed or throne (*pelaminan*) at celebrations of weddings or circumcisions in the Acehnese and Malay communities of coastal Sumatra. Among the floral and foliated couched gold thread patterns, other realistic motifs appear. The mythical *bouraq* (*burak*), Muhammad's mount for his visit to Heaven, is shown with a female head and the winged body of a horse. Under one *burak*, a swastika of Buddhist origins can be seen. The embroidered Malay inscription in Kufic script on the creature's flanks, though missing some sequins, seems to wish those who marry happiness (*menikah*) and good

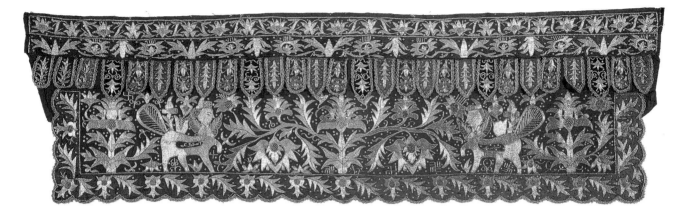

20

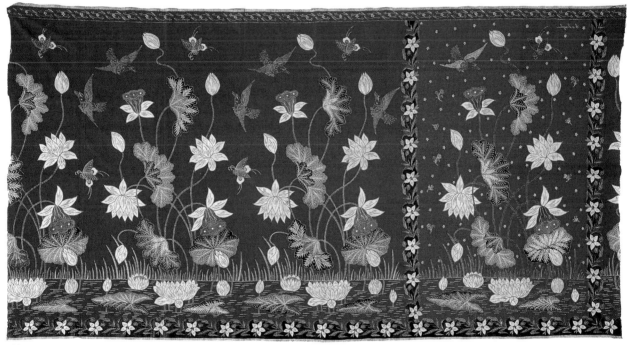

21

fortune (*selamat*). The motifs are presented in the formal symmetrical style popular on Islamic textiles such as Mughal hangings and Central Asian carpets, although the structure of these panels is also similar to certain Chinese ceremonial hangings found throughout Southeast Asia. Early twentieth century

21
kain sarong
woman's skirt
Eliza van Zuylen (1863-1947),
Pekalongan, Java, Indonesia
cotton, natural dyes
batik
106.0 × 200.0 cm
Australian National Gallery 1984.3170

During the nineteenth and early twentieth centuries, the immigrant and mestizo European and Chinese women living in Indonesia began to wear cylindrical batik cotton skirts. They added their own preferred motifs to the multitude of existing batik designs. Bird motifs such as the swallow and swan appeared amid bouquets of

European flowers, particularly on the contrasting head-panels. Even the lotus is depicted in European naturalistic style typical of these designs. This batik with the studio mark of the famous atelier, E. van Zuylen, a workshop that operated from 1890 to 1946 (de Raadt-Apell, 1980: 13), still uses the traditional north-coast Javanese red and blue dyes against a white ground.

centres that were the wielders of power and the patrons of the arts. Legends and court chronicles in Southeast Asia record the meetings, migrations and marriages between local rulers and the courts of India, China and the Middle East, and textiles illustrate the cultural diversity that has developed from such exchanges.

The form and the intensity of each foreign cultural influence changed with time. The art of India under Mughal rule was not the same art that inspired the great Hindu-Buddhist temples of Southeast Asia; Chinese culture in the eighth century was very different from the late nineteenth century; the Spanish in the fifteenth century presented a different image of European culture from the Dutch in the early twentieth century; Islam in India is not the same as in the Arab world. Moreover, the Great Traditions of Asia and Europe were transformed into Lesser Traditions with trade and distance. The Chinese peasant fleeing his homeland, the Gujarati merchant-pedlar, the Dutch colonial soldier and the Islamic teacher-traveller did not represent the great artistic centres or courts of their cultures. The objects and impressions that reached Southeast Asia were unlikely to have been the finest that the East and West could produce. In fact, historians cannot agree about what Southeast Asians really saw of the arts of the Great Traditions of India and China and there is much debate about the actual means by which new philosophies, religions and arts were transmitted to the distant lands of Southeast Asia.

Since traditional textile production in Southeast Asia was exclusively the task of women, textiles are able to show history from a different perspective by reflecting a female view of the contact between different cultures and are an alternative to the princely epics of war, succession and dominance. Textiles also remind us that many cultures and traditions existed outside the powerful court centres and kingdoms that dominate most accounts of Southeast Asian history. Many of the fabrics illustrated here — particularly the warp-decorated vegetable fibre textiles — provide valuable information about life in some of the more isolated and remote locations in Southeast Asia not directly in contact with the centres of international power and trade.

Perhaps the most difficult influences to assess are those of any one Southeast Asian culture upon its neighbours. Interregional influences have existed since prehistoric times, and while changes in textile design have often resulted from the political hegemony of a particular group during certain periods, most have been subtly absorbed and have passed undocumented. However, the important role of decorative textiles in establishing group identities has contributed to great diversity of colour, pattern and style.

Transformations have not only occurred in textile technique and design. The function and meaning of Southeast Asian textiles changed over time to accommodate new circumstances, new political structures and new belief systems. As religious ceremonies have changed, so too has the role of textiles. Changing notions of modesty, for example, have contributed to the development of new garments in the region and new applications for existing fabrics. Various foreign influences have gradually encouraged changes away from rectangular and cylindrical cloths towards more structured clothing.

Sometimes old cloths take on new meanings with new ideas from the modern world, and when ancient heirloom textiles are too fragile to be used as in the past, locally made substitutes have often assumed

22,23

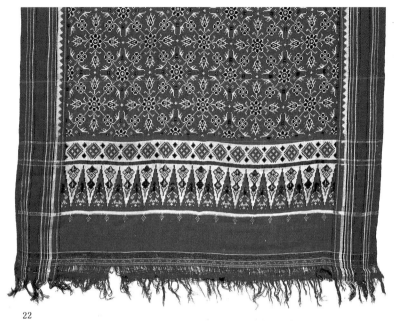

22

23

22 (detail)
patolu (Gujarat, India); *sindé* (Lio, Flores, Indonesia)
treasured heirloom and ritual object
Gujarat region, India; Indonesia
silk, gold thread, natural dyes
double ikat
462.0 × 104.0 cm
Australian National Gallery 1981.1140

23 (detail)
luka semba
male ritual leader's shawl
Lio people, Flores, Indonesia
cotton, natural dyes
warp ikat
209.0 × 72.0 cm
Australian National Gallery 1981.1142

The sources of the motifs on Southeast Asian cloth were sometimes imported luxury fabrics such as the silk *patola* from north-west India. One of the most popular of all Indian textiles imported into Southeast Asia was the star-patterned *patolu*, known today in Patan (the only centre in Gujarat still to weave the double ikat silks) as the basket design, *chhabadi bhat* (Bühler and Fischer, 1979, vol.1: 77). The pattern appears on different coloured grounds, the most common versions having red or yellow backgrounds. The popularity of this textile inspired weavers from many Southeast Asian cultures to produce their own versions of its motifs and even design structure, which appear in cotton and silk, in batik and ikat, throughout the Philippines, Indonesia and Malaysia.

On some Southeast Asian fabrics the original Indian design was faithfully copied while on other textiles it was absorbed and incorporated into existing patterns. There is a striking congruity between certain ancient Indian textiles and even twentieth-century Lio cloths. However, while the brightly coloured Indian double ikats were obviously the original source of the dark brown and cream Lio designs, these trade cloths are now rare in this part of Indonesia, and Lio weavers nowadays associate the star-shaped motifs with certain types of local sea crabs.

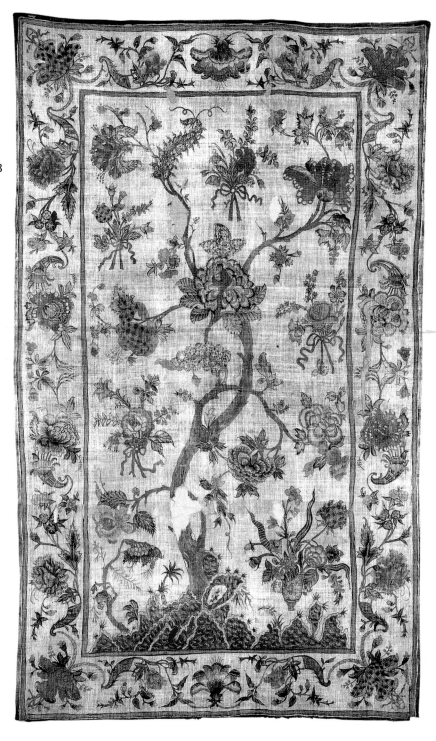

24
kalamkari (south India); *ma'a* or
mawa (Toraja, Sulawesi, Indonesia)
treasured heirloom and ritual object
Petaboli district, Coromandel coast,
India; Toraja region, central Sulawesi,
Indonesia
handspun cotton, natural dyes and
mordants
mordant painting, batik
225.0 × 134.0 cm
Australian National Gallery 1984.1093

Indian trade cloths have been valued
heirlooms in the Toraja region of
central Sulawesi for centuries. These
figurative red and blue cloths (*ma'a,
mawa*, also known as *mbesa* in the
northern Toraja districts) appear to
have generated a new genre of
hand-drawn and block printing
techniques among the Toraja people
themselves. This particular example
dates from the 1720s.
This genre of Indian mordant-painted
cotton cloth (*palampore*) with its
ornate flowering tree and border of
garlands and bouquets, was created
specifically for the European market.
Many, however, reached Southeast
Asia where their exotic foliage also
had wide appeal and provided a rich
source of design.

some of the status of the heirloom models, even those originally
obtained from foreign sources. The original meanings of patterns
have also changed and nowadays weavers often look to their immedi-
ate world to explain the meaning of motifs and are no longer aware of
what they may have meant to their ancestors. Old motifs have some-
times been retained or reworked, often appearing with new symbols
on the same textile. Recent social, religious and cultural change
merely continues a process which has been occurring throughout his-
tory though at a dramatically faster rate.

25 (detail)
kain panjang
skirtcloth
Cirebon, Java, Indonesia
cotton, natural dyes
batik
106.0 × 258.3 cm
Australian National Gallery 1984.3103

The motif of this particular hand-drawn batik from the north coast of Java is clearly derived from the designs on Indian *palampore*, the mordant-painted and dyed cotton bedspreads and hangings containing the 'tree of life' motif which were traded for many centuries into Southeast Asia. Indian *palampore* are now extremely rare heirlooms in Java. However, this batik, although made around 1970, shows minimal local interpretation. The pattern, in brown and blue against a white ground, is known in Cirebon as the coconut (*krambil*). The culture of the people of this coastal region of west Java displays both Javanese and Sundanese elements.

Design elements are formed from a variety of apparently conflicting symbols derived from different philosophies. The paths by which both objects and ideas arrived were often more circuitous than the trade routes. For example, the so-called 'tree of life' was a popular design on both Western and Oriental textiles traded into the region, but the history and development of this motif followed a complex path across several continents on its way to Southeast Asia (Maxwell, 1990). It is often impossible to distinguish clearly between symbolic representation and decorative devices, and to decide at which stage certain designs moved from one sphere to the other. In some cultures the break has been so dramatic that it is no longer possible to attach significant meaning to symbolism on textiles, although their aesthetic qualities may be greatly admired.

Textiles do not represent discrete instances of historical or cultural change; numerous decorative techniques, and several sources of patterning may have contributed to a single cloth. Many textiles can only be understood by reference to the history of other cloths, other objects and other cultures. A ceremony performed in an isolated village may require many textiles of different age, technique, and origin — local cloths and neighbouring Southeast Asian or imported Indian and European fabrics. In Borneo, an Iban Dayak festival may draw a display of Chinese porcelain, Javanese gongs, ancient or European beads, Malay gold brocade and batik from Java, as well as large numbers of textiles woven by the Iban themselves. Certain lost Southeast Asian textile traditions still survive among the fine heirlooms of a neighbouring culture and some types of Indian cloths, no longer found in India, are still valued as sacred treasures in many parts of Southeast Asia.

Throughout the book I have often used the convention of the ethnographic present, although in many recent cases, and in some instances for the last century, circumstances have so changed South-

26

26
bowl
Vietnam
stoneware body, cobalt blue
underglaze
Art Gallery of South Australia 834C6

27
kain panjang
woman's skirtcloth
Peranakan Chinese people, Lasem,
Java, Indonesia
cotton, natural dyes, gold leaf
batik, gold leaf gluework
272.5 × 104.5 cm
Australian National Gallery 1983.3683

Foreign textiles were not the only
sources of inspiration for local
weavers; other exotic and expensive
items of trade contained motifs that
influenced their work. Ceramics
similar to this fifteenth-century bowl
from Vietnam with the popular fish
motif, have been traded throughout
the region from China and mainland
Southeast Asia since the Han dynasty
of 206 BC to AD 220. These objects
are often used together with textiles
in important ceremonies such as
mortuary rites. Many motifs of
apparent Chinese origin on Southeast
Asian textiles, especially animals, fish
and birds, appear to have been adapted
from designs on porcelain. Such
Chinese influences on motif and style
are apparent on this late nineteenth-
or early twentieth-century hand-drawn
batik from Lasem on the north coast
of Java. The main design consists of
red and blue-black carp, lotus flowers
and crustaceans, with obscure phoenix
shapes inside the rectangular panel
(*papan*). This skirtcloth would have
been wrapped around the torso so that
the decorated end-panel of triangular
tumpal designs remained outermost.
The addition of fine gold leaf indicates
that the cloth was intended for festive
occasions, such as weddings.

27

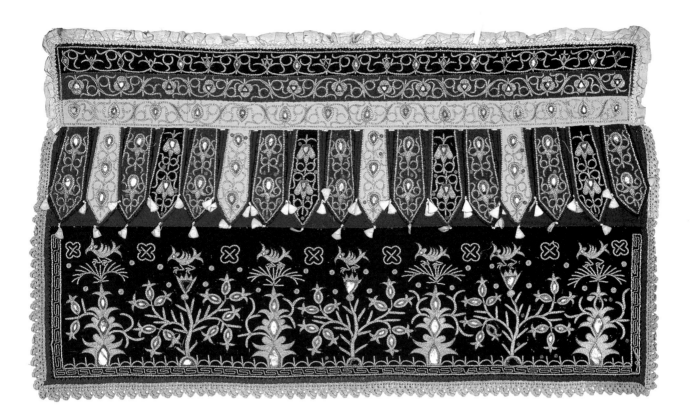

east Asian cultures that textiles are no longer made or used as they once were. In certain parts of Southeast Asia, while cloths are still woven, they are a poor substitute for the beautiful objects of previous centuries, and their role in ritual is often severely diminished. The post-war period of nationalism which brought about the end of European colonial domination has had a vital impact upon artistic traditions. The conclusion of the book explores the problems facing traditional arts in the twentieth century where rapid social and cultural change and the impact of cheap, imported or manufactured substitutes threaten remaining textile traditions. The cultural milieu and social systems that once required beautiful traditional fabrics, but absorbed exciting foreign ideas and decorative influences, may soon disappear.

A NOTE ON DATING AND TERMINOLOGY

It is exceptionally difficult to date precisely Southeast Asian traditional textiles. Changes in technique, materials or designs were often sporadic and subtle and passed largely unrecorded. Innovations in one area sometimes took decades to reach another. For example, while inhabitants of some islands in eastern Indonesia enthusiastically accepted the introduction of commercial cotton thread in the late nineteenth century, women on neighbouring islands continued to spin cotton with a drop-weight spindle into the 1980s. Nevertheless, there are factors we can use to provide tentative dates for many textiles. Sometimes accurate information about origins is available when textiles enter public collections and occasionally the cloths themselves contain evidence. The later batik cloth from Java, for example, sometimes features the date or the name of the artisan or workshop, and in

28
tirai
ceremonial hanging
Malay people, east Sumatra, Indonesia
cotton, wool, batik cloth, gold thread,
lead-backed mirrors, beads
couching, embroidery, appliqué
60.5 × 88.5 cm
Australian National Gallery 1984.2001

This nineteenth-century Malay hanging is used to decorate the bridal or circumcision chamber and throne (*pelaminan*). Used for ceremonies which combine Islamic and Hindu rituals with ancient Southeast Asian customs, its lining consists of pieces of century-old, hand-drawn batik and handspun cotton plaid fabric from other parts of Indonesia which have been joined with pieces of European chintz and flannel. The form of the sparkling black, red and yellow textile may be compared with certain Chinese hangings while the pendant 'tongues' suggest Central Asian influence. The design incorporates Chinese-Persian motifs of trees and birds that have cosmic appeal in many Southeast Asian cultures. The three-branched trees, also a popular motif in Mughal art, are framed by border patterns formed from Islamic arabesques and Chinese cloud designs. The factory-manufactured lace surround suggests the influence of European textiles.

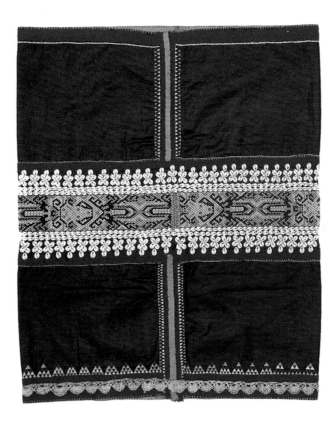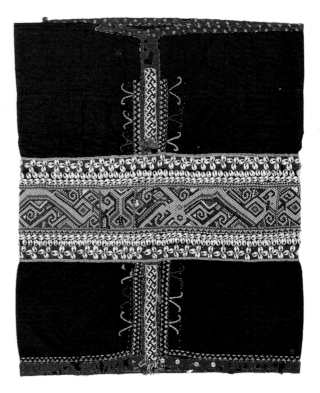

29
kain lekok
women's ceremonial skirts
Maloh people, west Kalimantan,
Indonesia
cotton, flannel, beads, shells, sequins
beading, appliqué, lace
52.0 × 45.0 cm; 51.0 × 42.0 cm
Australian National Gallery
1982.1300; 1982.1301

Bead and shell appliqué are one of the
most ancient means of ornamenting
the human body in Southeast Asia and
are fixed to matting, bark-cloth and
woven fibres. On these twentieth-
century examples, a myriad of tiny,
gaily coloured seed-beads has been
threaded into bands of serpents (*naga*)
and human figures (*kakalétau*) which
have then been stitched to a black
cotton base fabric and decorated
further with an appliqué of split shells,
lace and brightly coloured imported
cloth. The linings are made from old
fragments of Malay plaid and Javanese
batik fabric.

some cases textiles can be identified with a popular artistic phase. In
some parts of Southeast Asia, as a result of cultural stagnation or
social change, the craft of making traditional textiles had deteriorated
or even totally disappeared by a certain date.

It is also possible to use the comparative material in a number of
large ethnographic collections in Europe, the United States and in
Southeast Asia itself. The collecting of ethnographic objects began
during the nineteenth century as part of the attempt to document the
evolutionary ideas of social theorists such as Spencer. However,
although many museums contain large and valuable collections of
Southeast Asian textiles, including some of the earliest cloths from
the region, their usefulness as a point of reference is often limited by
the extent and accuracy of the institutions' records. The same applies
to the extensive and important photographic archives in a number of
museums.

Many textiles illustrated in this book date from the nineteenth
century, a period of rococo elaboration in the decorative arts of many
Southeast Asian cultures, as it was during the same period in Europe.
Many of the grand symbols of sovereignty associated with Southeast
Asian royalty were consolidated during this period and have remained
caught as the 'traditional' form of dress in the modern era. Coinciding
with the colonial domination of nearly the entire region, cultural dis-
tinctions between groups became more rigid. Probably more than
ever before, clothing became the visible sign of the relationship
between an individual and his or her social milieu and a focus for dif-
ferentiation between individuals and between groups.

Wherever possible, accurate local language names are provided
for the textiles illustrated. These terms often provide important
information about the history of the textiles and the people who have

made and used them and have been gleaned from a variety of sources including published literature and data collected during fieldwork in Southeast Asia. Where there is some doubt about the accuracy of the local language terms provided, this has been indicated by a question mark in parenthesis. In a few cases, the local language names of certain textiles have not yet been recorded. This has been indicated in the captions by a series of period marks. An English language descriptive term for each item has also been attempted. However, the use of anglicized expressions derived from Southeast Asian languages, such as the term 'sarong', are misleading and imprecise. For the same reasons certain national language terms and their English translations now in common usage have also been avoided. For example, the term 'selimut', the Indonesian word for blanket often applied to large rectangular cloths, is quite inaccurate since most of these textiles are in fact men's wraps or ceremonial hangings.

For those readers who are not textile specialists, there are many technical terms that refer specifically to weaving and textile techniques and which may need further elaboration. A full explanation of many of these terms would have required a lengthy appendix so only a basic glossary of the most important has been included. However, interested readers are referred to some of the many works listed in the bibliography dealing with the techniques and processes of Southeast Asian textiles. An exhaustive general treatment of this subject can be found in Emery's comprehensive study, *The Primary Structure of Fabrics* (1980).

The metric measurements given for each textile in accompanying captions include any fringes where these are a part of the fabric structure. Most of the photographs of textiles are from the collection of the Australian National Gallery and although ethnographic completeness has neither been possible nor been attempted, these examples have been supplemented with material drawn from the collections of other institutions and from photographs taken throughout Southeast Asia. The name of the relevant institution and the record or accession number is provided for each museum textile illustrated.

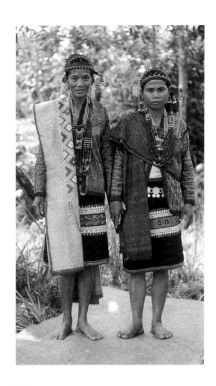

30
In west Kalimantan, Indonesia, two Maloh women in festive dress combine their own locally made beaded skirts (*kain lekok*) with warp ikat and tapestry weave jackets made by their Iban neighbours and gold thread brocade shouldercloths from one of the Malay groups of coastal Borneo, probably Sambas.

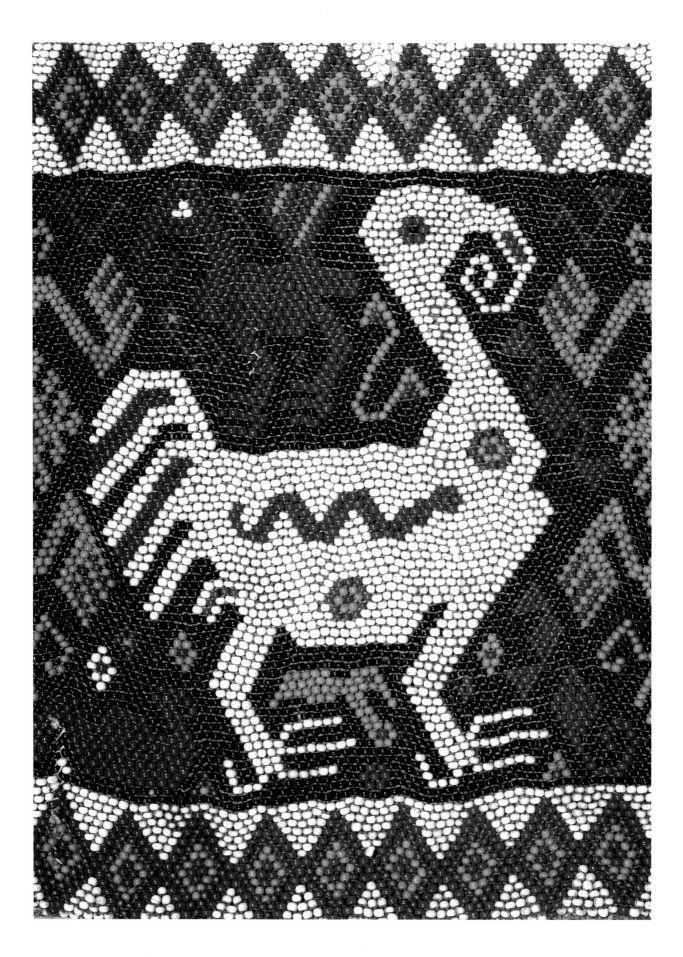

Chapter 2

THE FOUNDATIONS

The ancestors of today's Southeast Asian textile artisans have lived in the region for thousands of years. Gradual prehistoric migrations brought peoples from Taiwan and southern China into the region (and, in the case of the Austronesian speakers, out into the Pacific) where they merged with or subsumed earlier populations. The estimated time span of these eras, based on archaeological evidence, varies considerably across the Southeast Asian region. The prehistorian Bellwood points out that 'the Neolithic period begins at different times in different areas of Southeast Asia, but it is generally superseded by bronze-using cultures soon after 1000 BC, and perhaps by as early as 3500 BC in Thailand' (1979: 153).[1] The early settlers' languages — Proto-Austronesian, Austro-Asiatic and Thai-Kadai — formed the basis of those of present-day Southeast Asia. From the period of these migrations the cultural foundations were established for many Southeast Asian customs and techniques that are still evident today.

Original cultural traits included a belief in ancestors and spirits, shamanism, omens and magic, extended burial rites, head-hunting and tattooing, the domestication of certain animals, early forms of agriculture and boat-building. No centralized class system seems to have existed: status and authority were based largely on family descent groups in localized districts (Bellwood, 1979; 1985). Aspects of early Southeast Asian life are still reflected in the fabrics of the region, in their motifs and the ways in which they are used.[2]

Throughout the Late Neolithic and Metal Ages, objects of utility and ritual in the region were decorated in increasingly elaborate styles. Prehistoric burial sites across the region provide sufficient evidence of artifacts, tools, techniques and designs to allow speculation on the earliest forms of fabric and decoration (Bellwood, 1979: Chapters 7 and 8). The crafts of bark-cloth making and weaving were probably well developed before the ancestral migrations occurred.[3] Significantly, many of the patterns and motifs that form the striking ornamentation found on prehistoric pottery and metal work are also found in the textile art of the region. For example, the spirals of the 3000-year-old Ban Chiang pots are still recognizable on the regional weavings of Thailand.[4] While archaeologists generally end this prehistoric period at the time of Christ when the region became subject

Opposite Detail of Plate 132

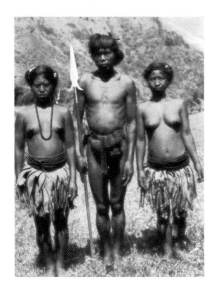

31
This turn-of-the-century photograph shows women from mountainous Luzon in the Philippines wearing leaf skirts. Their male companion wears a woven cotton loincloth.

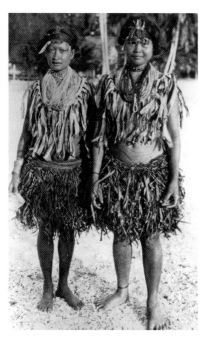

32
A 1929 photograph of two women from the island of Mentawai, off the west coast of Sumatra, wearing costume constructed of various leaves

to the growing influences of India and China, some of the textile materials and techniques used during the prehistoric period have survived in the region into recent times.

LEAVES, BARK AND FIBRES: THE FOUNDATIONS OF THE EARLIEST FABRICS

Unprocessed leaves and plant fibres have long been used to make clothing, and simple garments from these materials have been worn by isolated Southeast Asian groups into the twentieth century. The similarity of many leaf and fibre skirts across the region indicates that the materials have largely determined the shape and structure of these clothes. Their use in remote areas, from Burma to New Guinea, but especially on the islands of Enggano and Mentawai off the west coast of Sumatra, on Luzon, Palawan and Mindanao in the Philippines, and among the Sakai of peninsular Malaysia, suggests that this type of clothing was worn in Neolithic times. It was probably the apparel of the early inhabitants of the region who were displaced and absorbed by more technologically advanced prehistoric immigrants.

31,32

In this century, in many cultures where other clothing materials are now available, leaves and fibres are still used as ritual garb. Examples of such use include the personification of the evil spirit encased in fibre on the island of Buru in Indonesia (Gittinger, 1979c: 50, Fig.20), the masked shamans of Borneo (Khan Majlis, 1984: Col. Plates opp. 48), the fibre-enveloped dancers of certain 'Bali Aga' villages and the delicately folded formal palm-leaf headbands of mountain Sumbawa, Bali and Lombok. In Bengkulu, however, the veil of leaves that forms the bride's head-dress is now fashioned from silver (Jasper and Pirngadie, 1927: 153), while in Bali and many other parts of Indonesia, the flowers and leaves previously used to create decorative head-dresses have been transformed into crowns of gold which still retain the essential floral form.

Bark-cloth beaters, very similar to those still used today, have been found in a number of Neolithic archaeological sites (Bellwood, 1979: 173–4).[5] These stone mallets were obviously used to beat bark to form felted fabric. The texture of bark fabric and its potential as a raw material to fashion garments varies considerably. At one end of the spectrum, crude untreated pieces of bark were stitched together with fibre, a technique used to form effective protective coats for some Dayak warriors in Borneo. Softer, smoother, felted surfaces were achieved by soaking and pounding the bark fibres with mallets, and paper-fine quality was produced from the careful processing of the bark of certain trees.

33,34

35

36

One of the plants used to make fine bark-cloth, the paper mulberry (Broussonetia papyrifera), is one of the oldest cultivated plants in Southeast Asia (Bellwood, 1979: 139). The extent of its cultivation is uncertain although it was still being planted in Java in the nineteenth century (Kooijman, 1963: 58–62).[6] The finest bark-cloth offered great freedom for design, and could be readily painted or printed with pigments, as in many traditional Balinese paintings. Some such paintings were executed on good quality white bark-cloth imported from Sulawesi well into this century (Forge, 1978: 9, Fig.48; Solyom and Solyom, 1985: 3). In Bali it is possibly significant that the calendars for the Balinese 210-day year (*wuku*) used for

prediction were often on bark-cloth. According to some Balinese informants, bark-cloth was also the preferred fabric for death-cloths.[7] With the spread of written scripts throughout the region, bark became the raw material used for sacred manuscripts, talismanic hieroglyphs and even magical cures for illness.[8]

Painted decoration on bark-cloth throughout insular Southeast Asia ranges from broad, strong strokes to fine, detailed, linear patterns similar to those found on wood and bamboo carving. Paintings with soot and ochres have been found in Stone Age caves in the region,[9] and painted bark-cloth made in the central Philippines, Seram, central Sulawesi and by the various Dayak groups of Borneo, appears to draw upon similar ancient designs and techniques. The framing border commonly found on Lake Sentani painted bark-cloth fabrics is an unusual decorative device. The manner in which figures often protrude from the linear frame or even stand outside looking in indicates the strikingly free design format permitted by painting on bark-cloth. While these cloths are worn by women on festive occasions, they are also hung over a young woman's grave (Kooijman, 1959: 20). Further east in Polynesia, the similar design structure of some painted bark-cloths to that of many Indonesian woven cloths led the textile historian, Alfred Bühler, to suggest the possibility of a lost weaving art in that Pacific region (1969: 228). It seems more likely that the ancient design elements of both the Pacific and Southeast Asia, particularly of the Austronesian peoples within the region, have been continually developed and transformed, using various materials and decorative techniques. Consequently, similar patterns have often emerged in both regions.

Bark-cloth beaters are easily transportable and many of the groups who used bark-cloth were shifting cultivators and hunters. However, many are now settled agriculturalists and alternatives to bark-cloth, such as various types of thread and cloth, are widely available. As a result, the use of bark-cloth has almost disappeared except for isolated pockets of insular Southeast Asia.[10] However, in some

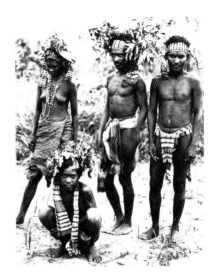

33
A photograph by Fay Cooper-Cole, taken in 1907–08, of a group of Batak people dressed for a ceremony on Palawan, in the Philippines. All participants are wearing bark-cloth wraps, loincloths and head-dresses, many of which exhibit hand-painted designs.

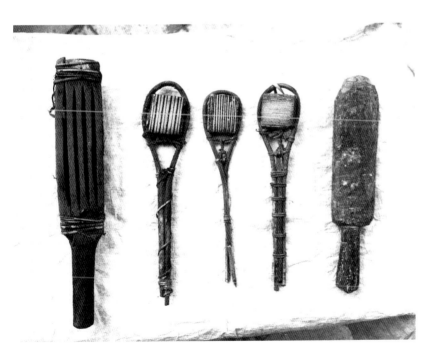

34
Bark-cloth continues to be made to the present day in the northern regions of central Sulawesi and is used for delicate ceremonial garments and sturdy everyday apparel including sleeping covers, rectangular headcloths for men, tunics and huge cylindrical skirts for women. A range of bark-beating implements is shown against a cloth of fine white bark (*fuya* or *nunu*) produced by an ancient felting technique. The surfaces of the stone head of the *pébamba* or *iké* are of different grades for the early and middle stages of the bark-pounding process. The wooden mallet that is applied to finish the finest cloth is also known as an *iké*.

35
baju sungkit
man's jacket
Tebidah Dayak people, Sintang
district, west Kalimantan, Indonesia
bark-cloth, cotton, natural dyes
embroidery
34.5 x 45.0 cm
Rijksmuseum voor Volkenkunde,
Leiden 781-59

This nineteenth-century bark-cloth
jacket displays decoration in the form
of stitched reinforcement, one of the
earliest forms of embroidery in the
Southeast Asian region. The hooked
rhomb designs, in white thread,
contrast with the brown bark-cloth
base. The garment has woven insets
at each side and red and blue cotton
binding. In other parts of Kalimantan,
thick, soft bark-cloth jackets are
patterned with painted or stencilled
designs (Wassing-Visser, 1983: 12, 84;
Gittinger, 1979c: 224).

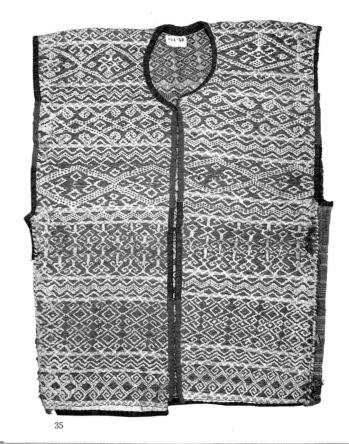

35

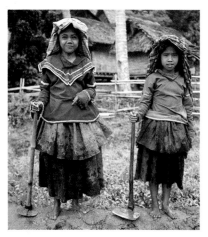

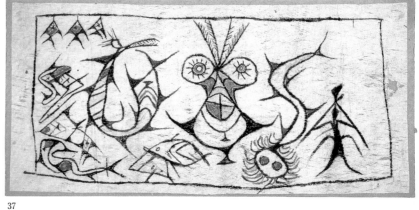

37

36
Two young women wearing layered
bark-cloth skirts (*nunu*) till the rice
fields near Kulawi, central Sulawesi.

37
saboiboi (?)
woman's skirtcloth
Lake Sentani region, Irian Jaya,
Indonesia
bark-cloth, ochres
painting
127.0 x 57.0 cm
Australian National Gallery 1985.1870

The framed asymmetry of this Lake
Sentani painted bark-cloth contrasts
with the bold repeated designs on
other Melanesian bark-cloth. Cloths of
these dimensions are worn by women
as festive skirts, and on the death of a
young woman, bark-cloths are also
hung by the grave. This particular
cloth, with ochre-brown and black
designs on a natural ground, was part
of a collection of ethnographic art
belonging to and inspiring the
European artist Max Ernst. It was
probably brought to Paris in the early
1930s.

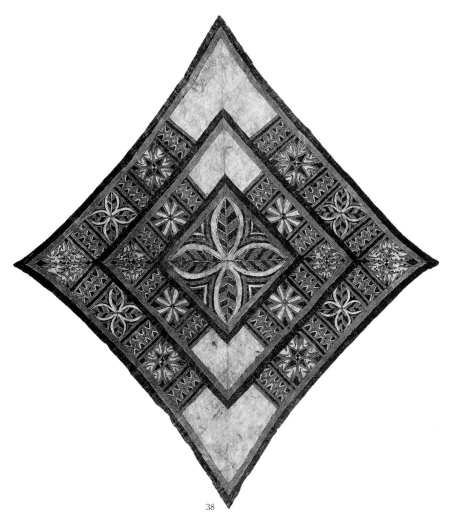

38

siga

man's headcloth

To Bada people, Bada district, central Sulawesi, Indonesia

bark-cloth, pigments

painting

92.0 x 91.0 cm

Australian National Gallery 1982.2296

Studies of Toraja bark-cloth iconography (Kaudern, 1944; Kooijman, 1963; Adriani and Kruyt, 1912; Greub, 1988) suggest that the central motif on this black, white and luminous-pink headcloth of paper-thin, felted bark-cloth represents either the sirih leaves used in the ancient custom of betel-nut chewing or the ears of the water buffalo. However, buffalo-head patterns (*petonu* or *petondu*) can be clearly identified in each corner of the cloth. Other motifs on this early twentieth-century bark-cloth may represent the sun or valuable beads.

38

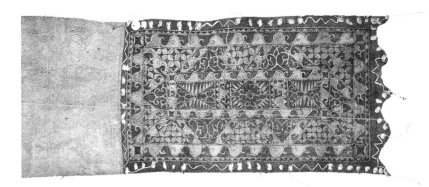

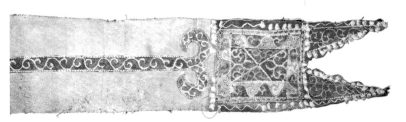

39

39 (detail)

baro (?)

loincloth

Halmahera, Indonesia

bark-cloth, pigments, shells

painting, drawing, appliqué

Museum voor Land- en Volkenkunde, Rotterdam 6814

Meticulous black and white pigment-painted line drawings decorate the belts, loincloths and head-dresses of Seram and the Halmaheras. In this late nineteenth-century example of two ends of a loincloth from Halmahera, the basic fabric is fine, cream-coloured bark-cloth, stained with yellow and brown. The remnants of a shell appliqué trim are still evident.

40

40
poté
widow's hood
Sa'dan Toraja people, central Sulawesi,
Indonesia
cotton, natural dyes
tablet weaving, macramé, tapestry
weave
110.0 x 92.0 cm
Australian National Gallery 1983.3685

This is an unusual tablet- and
tapestry-woven fabric, folded and
joined along one side to form a hood.
It seems to date from around 1900.
Like most Sa'dan Toraja funeral
garments, after weaving it has been
dyed black, apparently with crushed
Homolanthus populneas leaves and
mud. Articles of clothing of the
deceased are ceremonially blackened
with leaves and mud, and it seems that
the hoods worn by Sa'dan Toraja
widows were also coloured in this way
(Solyom and Solyom, 1985: 47;
Nooy-Palm, 1975: 66). Toraja men
also wear *poté* mourning cloths but of
a different type. Elsewhere in
Southeast Asia, bark-cloth appears to
have been retained as widows' garb,
and mourning hoods made from
bark-cloth are recorded among certain
Dayak peoples of Borneo.

The Dusun and Tempasuk of Sabah
wear cowl-like hoods for both work
and ceremonial occasions, sometimes
with bead or shell bands along the
edges. Although comparatively rare,
these various examples of shaped
hoods may have developed from the
widespread Southeast Asian practice of
covering the head with an open or
folded textile during funerary and
other life-cycle rites.

41

41
pio uki'
ceremonial loincloth; banner
Kalumpang or Sa'dan Toraja people,
central Sulawesi, Indonesia
handspun cotton, natural dyes
supplementary weft weave
517.0 x 51.0 cm
Australian National Gallery 1981.1127

This early twentieth-century
ceremonial hanging follows the older
format for men's loincloths (*pio* or
piu), with an undecorated white centre
for wrapping around the body and
intricately worked woven panels which
fall in front and behind the wearer. In
the twentieth century, the *pio* have
also functioned as ceremonial banners,
known as *tombi*, which are apparently
viewed as talismans (Koubi, 1982: 219
fn.6). The term *uki'* (*ukir*, to carve)
suggests that the patterns on these
loincloths, like the patterning (*okir*) on
cloths woven by the Maranao women
of Mindanao, are closely related to the
carving done by men.
The realistic scenes of village life
including buffalo-drawn ploughs, dogs,
chickens in cages and traditional
houses found on this cloth are rare on
Southeast Asian textiles. The scene
evokes images of fertility and
prosperity, and the large number of
figures suggests the importance of this
cloth. The figure in the lower left
corner is probably female, while a man
sits in the shelter accompanied by his
prize fighting-cock. The curved roof of
the structure, a rice granary rather
than a large dwelling, is identical to
those still found in Sa'dan Toraja
villages today and this is reinforced by
the effect of the floating weft threads
which suggests thatching. The empty
shape in the upper right-hand corner
probably depicts a fish-pond in the rice
fields.
In contrast to the human figures,
which appear in red, the buffaloes are
worked in blue thread, with the heads
turned to show their wide horn span.
One appears to have a highly valued
light blaze on its forehead. The
schematic designs in the other
supplementary weft bands in red, blue
and green, include the star-shaped
motif known as *doti langi'* (spots of
heaven), like the buffalo a symbol of
wealth and abundance.

42
A platoon of local Filipino soldiers
from a regiment raised in Luzon early
this century. Despite their recruitment
into the American colonial army, the
men still wear their traditional
loincloths and brass leggings.

42

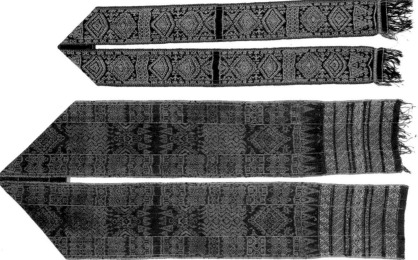

43

44

44

tanda sirat; klapong sirat
end-panels of a man's loincloth
Iban people, Sarawak, Malaysia
handspun cotton, natural dyes, brass bells
supplementary weft weave, supplementary weft wrapping
42.0 x 28.6 cm; 47.0 x 31.0 cm
Australian National Gallery 1981.1149

The decorative ends of the long wrap-around loincloth (*sirat*) of the Iban (and those of other closely related Dayak groups in Indonesian Kalimantan such as the Desa and the Kantuk) are usually worked in supplementary thread patterns, usually red and indigo-blue on a white foundation weave. Both panels are sometimes woven in one length of fabric to be cut and sewn to a separate length of plain cloth, in this instance apparently a length of red Indian imported cotton fabric. However, the designs on each *sirat* end are usually characteristically different. On this late nineteenth-century example, the patterns on the rear panel are contained in narrow bands of supplementary weft weaving (*pilih*) while the front panel consists of a square of supplementary weft-wrapped design (*sungkit*) filled with stylized figures. The anthropomorphic figures are reduced to crosses on the front, and pairs of similar stylized figures also appear on the back.

43

hita; hitilirrati
man's loincloth or girdle
Oirata district (?), Kisar, South Maluku, Indonesia
handspun cotton, natural dyes
warp ikat, supplementary weft weave, twining
10.6 x 301.2 cm; 13.0 x 250.0 cm
Australian National Gallery 1985.383; 1985.384

These nineteenth-century men's cotton loincloths demonstrate the contrast between the warp patterns in subdued red or brown, blue and neutral warp ikat and the bright yellow supplementary weft ends which hang when worn in front and behind. Loincloths with these elaborate, asymmetrical, supplementary patterns were reserved for ceremonial wear. The same ancient warp ikat motifs are also found in horizontal bands on woman's cylindrical skirts. While zigzag patterns appear to depict snakes, and other Kisar loincloths also contain bird motifs, the meaning of the hooks and spirals is unknown. Small human figures appear along the borders of the shorter cloth. Loincloths on Kisar, as elsewhere in Southeast Asia, are no longer worn as originally intended and are now used as girdles and shawls.

cultures where bark-cloth has long been replaced by woven fabrics for everyday and festive wear, bark-cloth garments, as well as leaf cloaks and skirts, still hold ritual significance and appear to offer the necessary symbolic protection at funerals and other such times of spiritual disorientation. For example, in southern Borneo bark-cloth is donned in rites associated with death, including the simulated death that takes place during ritual tattooing and the ritual rebirth of circumcision ceremonies. In the same region, a widow or widower wears clothing made of bark-cloth until the mortuary feast to ensure her or his own continued 'existence' after the funeral (Scharer, 1963: 89–90). A bark-cloth fabric is included amongst the full set of four death cloths required for an Ifugao of importance, though these are not often worn in Luzon today (Roces, 1985: fn.6).

Despite the replacement of bark-cloth, certain ancient forms of clothing originally made from the fabric are still being used. One example is the decorated loincloth which is still the main male garment of many largely isolated mountain cultures throughout both mainland and insular Southeast Asia. Most loincloths are made of plain, woven fabric with elaborately patterned ends that hang down front and back. The patterns on the end sections of loincloths produced during the last century often resemble those on some of the earliest stone statues found in the region.[11]

41,42
43,44

Over time the functions of certain textile types may change. Nowadays, for example, heirloom Toraja loincloths (*pio*) are used mainly as ceremonial banners. Sacred woven cloths taking the name of loincloths (*cawet*) are also worn around the necks of male participants in certain sacred rites in Bali.[12] The cotton tunics worn by Toraja women were also originally made from bark-cloth, and sometimes bark-cloth has been retained as a lining for cotton garments. In fact, the use of bark-cloth has survived in Borneo and south Sumatra mainly as a foundation or lining for other materials.[13]

45

Elaborate matting skills probably existed in prehistoric times. Interlacing (or plaiting) usually requires only a simple instrument to strip the fibre and, as with textiles and the wooden apparatus used to make them, no ancient mats have survived thousands of years of hot, wet, tropical conditions. We are left with imprints on prehistoric pot-

46,47

45
halili petondu
woman's tunic
To Kaili people, central Sulawesi,
Indonesia
bark-cloth, cotton, mica
appliqué, embroidery
79.0 x 58.0 cm
Australian National Gallery 1984.590

The major motif on this early twentieth-century tunic from the north-west region of central Sulawesi is the *petondu*, the buffalo motif depicted as a schematic star with eight curling embroidered points. Although the graceful curve of the buffalo horn is an ancient symbol in this area often appearing on painted bark-cloth and woodcarving, in this instance the appliqué is applied to commercial cotton cloth. Bark-cloth (*nunu*) is used, however, as a lining. The visual impact of the garment is increased by the addition of mica discs among the red and orange fabric diamonds.

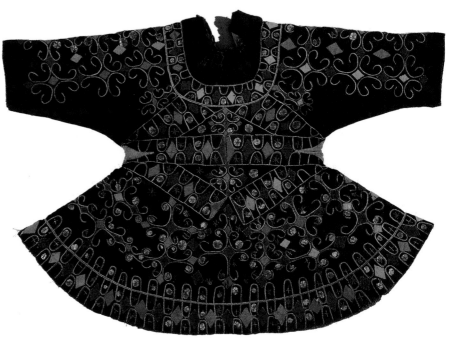

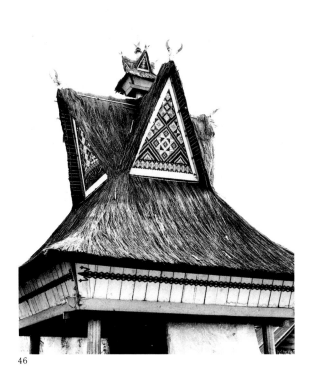

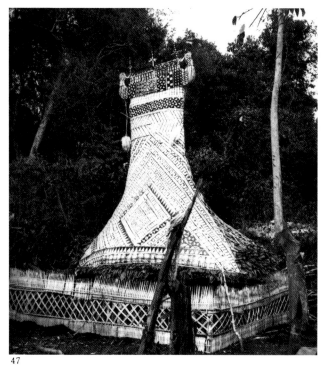

46

47

tery which was beaten with basketry or corded paddles.[14] Matting and forms of twining, however, may have been the forerunners of more recent textile traditions, and like bark-cloth fabric, are still the basis for textile seats, mats, bags and some types of tunics decorated with shells and beads.

The earliest types of clothing may have included plaited hats, baskets and carry-bags. Similar patterns can be achieved through interlacing and weaving and this suggests that the same visual aesthetics were retained with the change from one technology to the other. On the other hand, the designs on woven textiles, whatever the basic fibre, contrast markedly with those on painted bark-cloth, and applique textiles that follow bark-cloth styles. These techniques allow both angular and curving shapes and a greater freedom than can easily be achieved by weaving.[15]

The motifs on basketry and mats are often similar to those on woven textiles. Across the island of Borneo, for example, decorative designs on both mats and textiles have been identified on Metal Age objects found there. Burial sites dating between 1600 and 400 BC in the Niah Caves of Sarawak have yielded shell discs,[16] beads, bone needles, wooden coffins and pottery ornamented with bold, rectangular meanders and spirals in red, black and cream.[17] The designs on mats and other plaited objects made by the Kenyah-Kayan and Ot Danum-Ngaju people exploit hooks and spirals using black and undyed fibres, while patterns in the same style can be found in the supplementary *pilih* designs on Iban women's skirts and jackets. While most body tension loom weaving uses a simple 'one-under-one-over' tabby weave, twill weaves which have created textures on cloth quite akin to plaiting or matting have also been produced in many parts of Southeast Asia, and discoveries of fragments of twill weave vegetable-fibre fabric in the Niah Caves in Sarawak are the oldest known woven fabric

48,49
50,51

52,53
54

55,56

46
This rice barn in the Karo Batak region of north Sumatra is decorated with motifs similar to those found on textiles. The plaited bamboo under the roof forms geometric patterns while a long lizard shape is depicted along each side of the lower wall.

47
Hooked rhomb designs are evident in the painting on this grave structure of a rich Katieng woman from Ratanakiri province, Cambodia, and the finial displays a serpent-headed ship, an ancient transition symbol throughout Southeast Asia. Graves of similar appearance decorated with woven cloth over a bamboo frame are erected by the Jarai of southern Vietnam (Leuzinger, 1978: 235, Pl. 298).

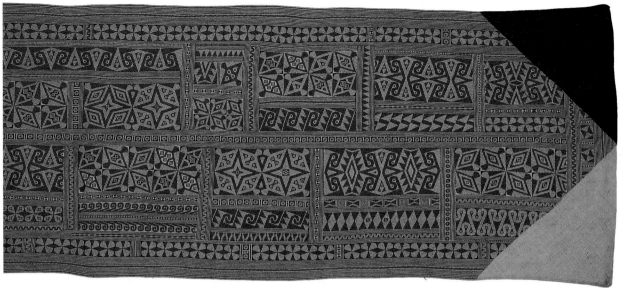

48

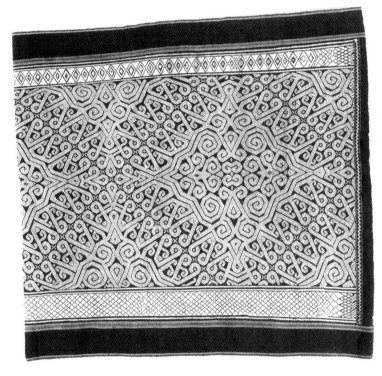

49

48 (detail)
uhu wai kalung (?)
communal mat
Punan Aput people, Long Sulé,
central Kalimantan, Indonesia
rattan fibre, natural black dyes
interlacing
570.0 x 154.0 cm
Australian National Gallery 1986.1247

49
kain pilih
woman's skirt
Iban people, Layar River, Sarawak,
Malaysia
cotton, dyes
supplementary weft weave
47.0 x 52.0 cm
Australian National Gallery 1985.1746

This black, red and white woman's
skirt in the distinctive supplementary,
floating weft weave known to the Iban
as *pilih*, has the same dramatic visual
impact as the two-coloured plaited
mats of the non-textile weaving Punan
of central Kalimantan. The reverse
sides of both mat and textile reveal
the same pattern in negative. While
the meaning of the formal patterning
on the cylindrical skirt is uncertain,
the mat motifs include representations
of the mighty hornbill in various
schematic arrangements, depictions of
the North Star and the eye of the
blowpipe, and several vegetative
patterns. Many of these designs
closely follow Kenyah-Kayan motifs
from the same region of Borneo. Like
Iban textiles, such huge mats are
stored as heirlooms and displayed by
families on ritual occasions. Both black
and white items demonstrate the
continuation of ancient skills and
patterns into the twentieth century.

50
pha biang
ceremonial shawl
Tai Phuan people, Xieng Khouang,
Laos
silk, cotton, natural dyes
supplementary weft weave
236.0 x 42.0 cm
Australian National Gallery 1986.1922

The asymmetrical design structure of
Lao shawls, with an undecorated
centre and unequal ends of different
patterning that are sometimes stitched
to the central section, is similar to that
of men's loincloths elsewhere in the
Southeast Asian region. So too are the
intricate hooked lozenge patterns that
form the basis of this design. On this
early twentieth-century Tai Phuan
cloth, rows of birds, paired dragons
and long-nosed lions have been placed
between the formal decorative bands.
This cloth uses bright yellow, blue,
white and green supplementary silk
wefts against a deep lac-red foundation
weave of mixed silk and cotton.

51
kelambi pilih
jacket
Iban people, Sarawak, Malaysia
cotton, natural dyes
supplementary weft weave
114.0 x 46.0 cm
Australian National Gallery 1981.1148

The natural world is a popular source
of designs for the weavers of
Southeast Asia. The bands of floating
red and blue *pilih* motifs on this early
twentieth-century jacket could only be
exactly explained by the weaver who
made the jacket. However, the various
hooks and spirals have been identified
by one experienced Iban weaver to
include gourd seeds (*igi genok*), horse
mango (*buah bunut*), forked roots
(*akar besimpang*), the long rice vessel
(*tungkus asi panjai*) and diamond
patterns (*buah lunchong*). Similar
patterns are repeated on the front. A
jacket of this length is worn by a ritual
orator (*lemambang*) while officiating at
Iban festivals (*gawai*).

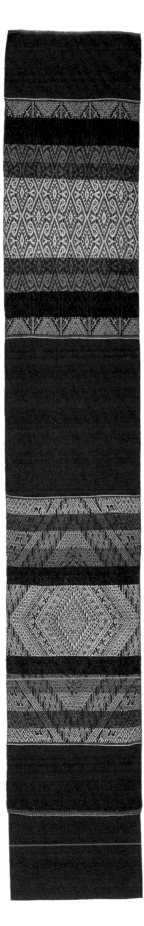

50

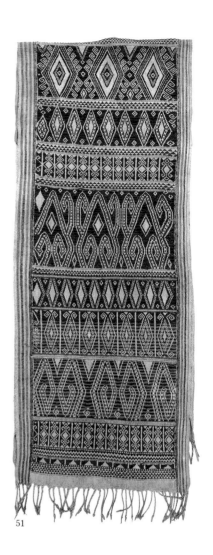

51

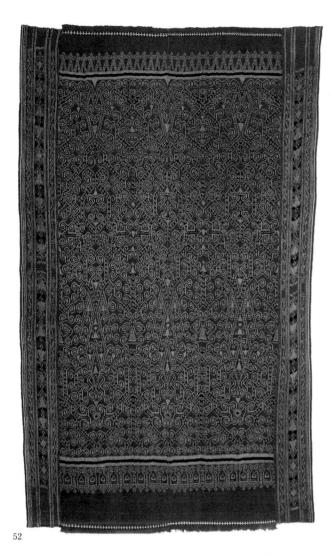

52

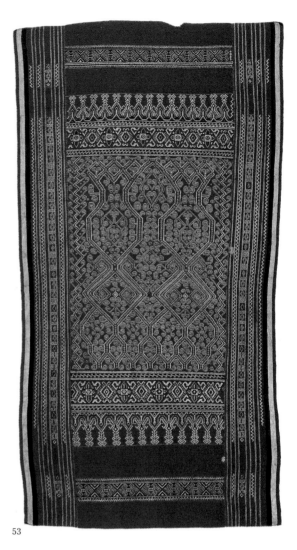

53

52
pua kumbu
ceremonial cloth
Iban people, Sarawak, Malaysia
handspun cotton, natural dyes
warp ikat
279.0 x 167.5 cm
Australian National Gallery 1981.1097

53
pua sungkit
ceremonial cloth
Iban people, Sarawak, Malaysia
handspun cotton, natural dyes
supplementary weft wrapping
112.0 x 213.0 cm
Australian National Gallery 1982.1296

54
pua kumbu
ceremonial cloth
Iban people, Layar River, Sarawak,
Malaysia
handspun cotton, natural dyes
warp ikat
126.3 x 222.0 cm
Australian National Gallery 1984.611

Iban textiles are decorated in the same tricolour as their ancestors' pottery. These three huge, nineteenth-century woven cloths (*pua*) were used by the Iban in ceremonies invoking the presence of benevolent ancestors and spirits. Such is the power of *pua* woven by ritually experienced women, that malevolent beings can be kept at bay on such occasions by a display of these fine textiles. The patterns are highly schematic depictions of ideas drawn from the natural world and the shared repertoire of Iban mythical and legendary designs. It is possible that the borders of the ceremonial cloth in Plate 52, which are worked in a different style, were made by a second and younger weaver, a customary way for less mature women to gain textile experience. Clearly from a different district, the motifs in Plate 54 are filled with striking, checkered ikat patterns in black and white forming a strong contrast against the dark maroon ground. While exhibiting similar designs, the *pua* in Plate 53 is

worked in the weft-wrapping technique (*sungkit*), in which the pattern is established during the weaving process.

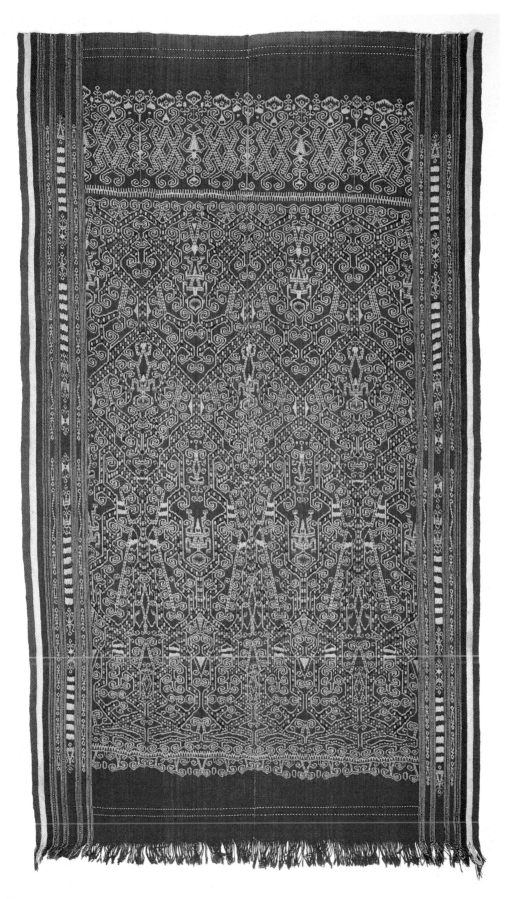

54

55
gamong
ceremonial cloth
Ifugao people, Luzon, Philippines
bark fibre, natural dyes
twill weave
Field Museum of Natural History,
Chicago 113768-2

56 (detail)
ulos gobar; uis gobar
ceremonial cloth
Toba Batak people, Silalahi district,
north Sumatra, Indonesia
cotton, dyes
twill weave, supplementary weft,
supplementary warp
183.0 x 121.0 cm
Rijksmuseum voor Volkenkunde,
Leiden 869-20

These red, blue and white cloths
display a similar design structure, as
broad warp-orientated bands and a
twill-weave pattern of concentric
diamonds are the major decorative
features of each. Both textiles have an
important role in burial rituals. The
gamong are specifically made as outer
shrouds. For the funeral, one panel of
the cloth may be only loosely attached
to facilitate the custom of tearing
away part of a burial cloth so that
other spirits will not disturb the
deceased or his living kin out of their
jealousy of such a fine fabric. The
gobar design is the most prestigious
cloth in the north-western district of
Lake Toba, and is used in life and in
death by the most senior members of
a lineage. A carefully structured
system of rank applies to all Toba
Batak *ulos* textiles (sometimes also
known here by the Karo term *uis*).
They are exchanged on all ceremonial
occasions when the alliances forged
through marriage between the clans or
lineages (*marga*) are reiterated. Both
textiles date from the late nineteenth
century.

55

yet to be discovered in insular Southeast Asia. Twill fabrics in Borneo
(Jager Gerlings, 1952: Figs 18–21) have been made with leaf fibres
such as *lemba* or *doyo* (Curculigo latifolia), although it seems that the
Ifugao textiles of this genre were woven from twisted bark
fibres.[18]

Most mat designs show surface patterns achieved by interlacing
different coloured fibres; other types of mats are decorated with
those ancient ornaments, shells and beads. With such objects, there is
no clear division between mats and textiles. The decorative
techniques merge, similar designs appear in both media and the
objects themselves often serve the same functions. The existence of
objects made from both woven cloth and plaited matting further
obscures the distinction. The largest examples, the huge beaded mats
from south Sumatra, are supported by plaited matting that is covered
with handspun cotton cloth and decorated with strands of ancient
beads.[19] Although little is known about these remarkable objects, the
iconography of the beaded designs is closely related to motifs that
appear on woven and embroidered cloth from the same region. The
use of decorated, sometimes beaded matting for ceremonial para-
phernalia is widespread. In particular, the containers for betel-nut
ingredients are decorated with beads, and in many places other types
of decorative plaited mats, like textiles with similar iconography, are
used as hangings, room-dividers, shrouds, and ceremonial seats.
Another term for the *palepai*, the large supplementary weft hangings
of Lampung in southern Sumatra, is 'the big wall', *sesai balak*
(Gittinger, 1972: 5). It is probable that, while textiles were eventually
used for such purposes, mats had often been used instead in earlier
times.

The related technique of twining or interlacing with rattan or
other vegetable fibres also provides a sturdy garment and a base
material for painting or adding shells, beads and other appliqué.

57

56

58 Jackets thus made are found throughout insular Southeast Asia. In
particular, twined flaps and jackets, sporting split or carved shell discs
and other decorative materials as protective scales or armour, were
59,60 used into the twentieth century by the Toraja of Sulawesi, the Ifugao
of Luzon and many peoples of Irian Jaya and Borneo. Often these, like
many of the bark and beaded coats, were worn during expeditions and
ceremonial activities connected with head-hunting. An affinity also
exists between plaiting and the twining technique used in textile
decoration in many parts of Indonesia and Sarawak where two wefts
are alternatively wrapped over and under the warp threads (Gittin-
ger, 1979: 226). The absence of shed-openers or heddles that serve
to open the appropriate warp threads to allow the weft to be inter-
laced suggests that both these techniques may have been the fore-
runners of weaving.

It is fairly certain that loom-woven fibre fabrics have had a very
long history in the Southeast Asian region,[20] although concrete evi-
dence of particular types of looms and cloth is scarce. Fibres and
wooden tools in Metal Age tombs have not survived and instances of
61 the use of the foot-braced loom, depicted on some Bronze Age metal
sculptures found in certain locations, are rare.[21] Nevertheless, other
very simple tension looms are found throughout Southeast Asia and
into the Pacific region, and the oldest and most widespread of these
62,63 weaving devices for utilizing local vegetable fibres is the simple back-
strap tension loom which uses a continuous circulating warp. The
type of looms used in Southeast Asia were also found in neighbouring
Micronesia into the twentieth century (Ling Roth, 1918: 64–112),

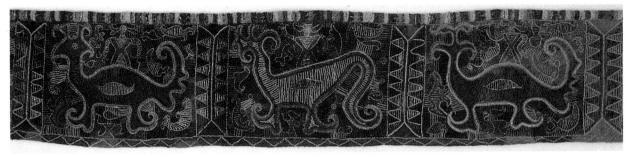

57

57 (detail)
selesil; palepai maju (?)
ceremonial hanging
Paminggir people, Lampung, Sumatra,
Indonesia
vegetable fibre, handspun cotton,
beads, natural dyes
interlacing, appliqué, beading
360.0 x 50.0 cm
Australian National Gallery 1984.618

Although some seventy per cent of
this object is in its original state,
severely damaged sections of the cloth
were rearranged in the process of
repair before it came into the
Australian National Gallery collection.
As a result, some of the mythical
creatures appear in a slightly different
sequence to the original design. A
figure originally on the far left of the
cloth has been moved to the opposite
end where it is now the final motif.
Anthropomorphic figures are mounted
on the animals, which bear a striking
resemblance to those creatures found
on other textiles of different
decorative techniques also made in this
region of Sumatra. Unfortunately, little
reliable ethnographic information is
available for these objects, although
they clearly date from the nineteenth
century or earlier. Mattiebelle
Gittinger (personal communication,
1984) has suggested that the term
selesil was used for certain beaded
cloths in Lampung although we are
uncertain whether this term was ever
applied to these particular large
beaded hangings.

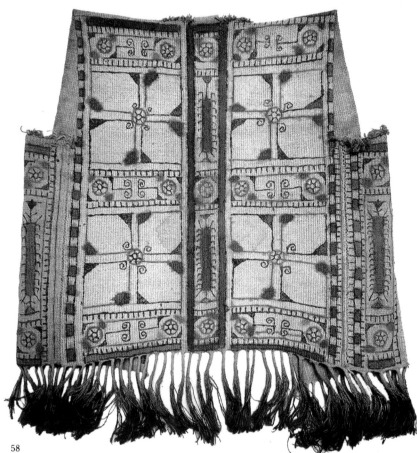

58

58
désé
hunting jacket
Nagé Kéo people, Ndora, Flores,
Indonesia
vegetable fibre, pigments
twining, painting
Tropenmuseum, Amsterdam 2104–3

According to Nagé Kéo informants,
twined and painted fibre hunting
jackets (*désé*) from central Flores,
were only made in the Ndora and
Rawa districts, though in the past
these skills may have also been
evident in other parts of the domain
(van Suchtelen, 1921: Fig.116). The
patterns on this early twentieth-
century example are painted in dark
and ochre-browns and black.

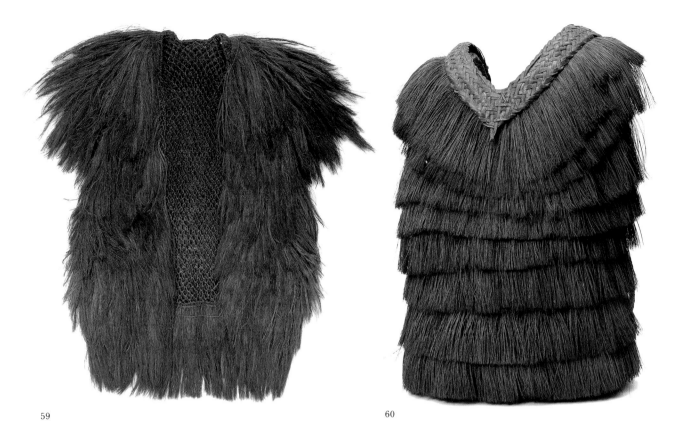

59

60

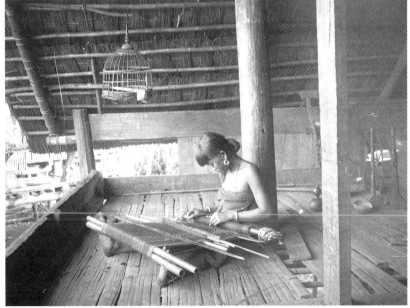

61

This *bango* back-pack, a basket with shoulder straps, is constructed of interlaced split rattan attached to a wooden base. It has the same tufted black hairy surface as the jacket in Plate 59, an item of apparel that provided protection from the torrential tropical rains. The base fabric of the jacket, however, is not plaited matting but a strong, pliable, twined and knotted fibre mesh. Among the Ifugao the *bango* is still associated with hunting and ceremonial activities believed to expiate disasters such as bad deaths or illness. Both objects probably date from the early twentieth century.

61
A photograph taken in the mid-1930s in Laos of a woman, possibly from the Kassang community, who is using a foot-braced loom similar to those depicted on Bronze Age metal sculptures found in Southeast Asia. Such looms have also been used by certain minority peoples in Cambodia and Vietnam (Boulbet, 1964).

59
............
warrior's jacket
Ifugao people, Luzon, Philippines
bangi (Caryota cuminggi) and other
fibre
twining, knotting
85.0 x 72.0 cm
Australian National Gallery 1984.1234

60
bango
back-pack
Ifugao people, Luzon, Philippines
bangi (Caryota cuminggi), rattan,
wood
interlacing, knotting
Australian National Gallery 1988.522
Gift of Jonathan Thwaites, 1988

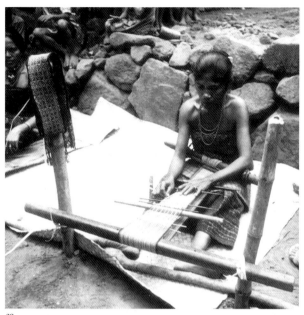

62

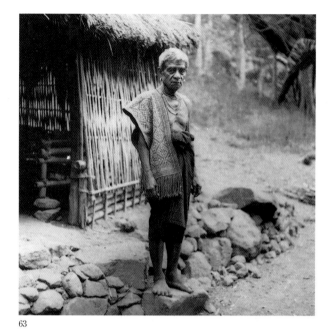

63

64

62
A Lamaholot woman weaving a *met*, a supplementary warp weave belt, on a backstrap tension loom in the Ili Mandiri region of east Flores. A recently recorded bronze maternity figure located in a nearby district of east Flores (Adams, 1977) displays a foot-braced loom being used to weave a band with a pattern similar to those found on these *met* belts.

63
A Lamaholot elder wearing a wide ceremonial sash (*met*) in east Flores, Indonesia. The textile, in handspun cotton and natural dyes, is woven in a supplementary warp weave, reserved for belts and sashes in the Lamaholot region, but used as a major decorative device in other parts of the region, including east Alor and some Atoni domains in Timor.

and many of the designs and some of the raw materials that are also used in Southeast Asia enjoy a much wider use in the Pacific arc suggesting ancient Austronesian origins.

It is difficult to know what raw materials were used in the earliest weaving processes. Clay whorls for drop-weighted spindles have been found in many mainland archaeological sites and this suggests that cotton was already in use in prehistoric times (Bellwood, 1980: 63). The absence of similar finds of prehistoric spindle whorls in insular Southeast Asia has been used to support the argument that weaving arrived late to the island world of the region.[22] However, this may also be explained by the use of wooden spindle-weights which are still widely used throughout eastern Indonesia today and by the fact that spindles are not required at all in the preparation of most bast and leaf fibres suitable for weaving.

Many varieties of wild fibres suitable for weaving thread can be found throughout the region. Their use, without spindles, but knotted or rolled on the leg, still continues today, although this has been greatly diminished by the availability and attractiveness of cotton. Hemp, taken from under the bark of certain cannabis plants, is preferred by the Hmong of northern Thailand for making their pleated batik skirts, although cotton thread is also used.[23] Another popular bast fibre is abaca. Best known in its commercial form as Manila hemp and exported from Luzon in colonial times,[24] it is taken from the inner section of the wild banana plant (Musa textilis), dried and separated into strands and then joined into the long threads needed for weaving. On Mindanao, this fibre is used as both thread and binding material for ikat, the decorative technique whereby threads are resist-tied and dyed into patterns before weaving.

Throughout the island of Borneo, the leaf of a wild swamp grass (Curculigo latifolia) widely known as *lemba*, and to the Benuaq people as *daun doyo*, is woven into fabric with warp ikat patterns to make women's skirtcloths and, in the past, ceremonial hangings.[25] On Tanimbar it is the threads of the lontar palm (Borassus flabelliformis)

65,68,69

66,67
71,72

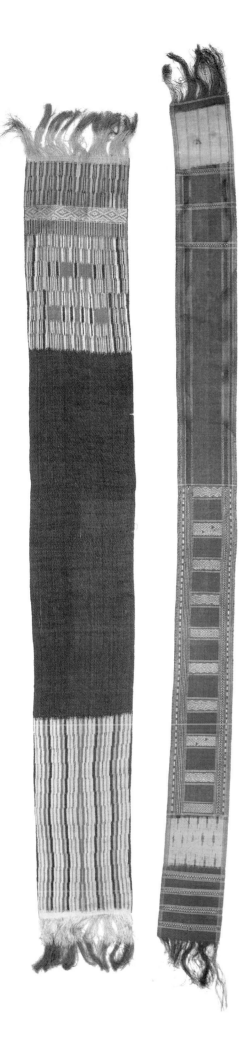

64
tol
belts
Kusae, Micronesia
vegetable fibre, natural dyes
linked warp weave, supplementary
weft weave
18.4 x 149.0 cm; 11.0 x 168.0 cm
Australian National Gallery 1984.772;
1984.771

The linked warp fibres of these
nineteenth-century Micronesian girdles
are an unusual decorative feature,
difficult to execute on the standard
Southeast Asian body-tension loom
with a continuous circulating warp.
Patterns of similar visual effect are
worked in warp ikat in most parts of
Southeast Asia. However, the floating
supplementary weft bands and their
geometric designs are a familiar
feature on the cloths of many islands
of eastern Indonesia. The finely woven
Kusae ceremonial girdles were highly
prized possessions throughout the
former Caroline Islands where they
were acquired through trade. The
longer *tol* is red-brown with white
supplementary wefts, and the shorter,
wider belt has a plain black centre,
with yellow, red and white
end-patterns.

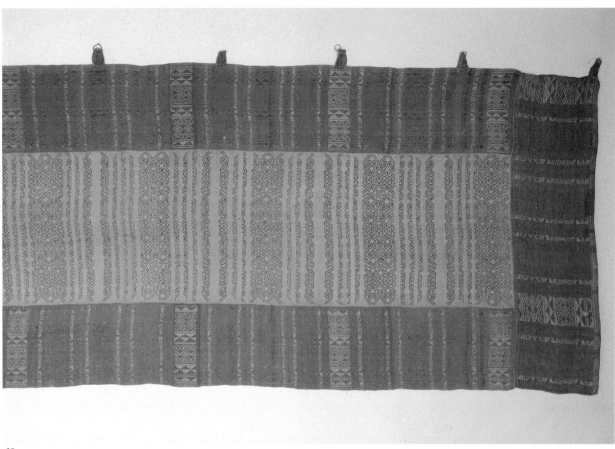

65

65 (detail)
hoté; tepiké
room-divider; hanging
Sangihe-Talaud Islands, Indonesia
abaca fibre, natural dyes, brass rings
supplementary weft weave
775.0 x 160.0 cm
Australian National Gallery 1986.1239

Until the twentieth century the
textiles of the Sangihe-Talaud Islands
continued to be woven of Musa textilis
fibre, locally known as *hoté*. This huge
nineteenth-century cloth is composed
of five joined panels, patterned in
banded, supplementary weft weave
and containing the ancient spirals and
hooked lozenges that occur on many of
the oldest textiles in the Southeast
Asian region. Textiles of these
dimensions were used as hangings and
room-dividers and this particular
example still has brass rings attached
to its upper side. Finer threads of *hoté*,
sometimes mixed with wild pineapple
fibres, were also woven into fabric
that was used to make long gowns for
men and tunics for women. Because
narrow loom widths of fabric were
joined in many parts of Southeast Asia
to make larger objects, design
similarities can often be distinguished
in the textiles of neighbouring regions.
This hanging is thus similar in
structure and motif to the large batik
hangings made by the Toraja living
further to the south in Sulawesi.

66
tawit'ng doyo
ceremonial textile
Benuaq people, east Kalimantan,
Indonesia
doyo fibre (Curculigo latifolia), natural
dyes
warp ikat
207.0 x 98.0 cm
Australian National Gallery 1985.386

This nineteenth-century example of a
Benuaq ceremonial cloth is formed
from two large panels. While the
structure of this cloth is similar to the
well-known Iban *pua kumbu*, the
central section and the motifs
displayed there are stylistically related
to both Iban and T'boli warp ikat
designs. The natural colours are soft,
yet sharply defined, indicative of
precise tying of the warp threads of
the *doyo* fibre before dyeing occurs.
Little is known of the function of these
cloths although their structure and
size suggest that they were used as
ceremonial hangings.

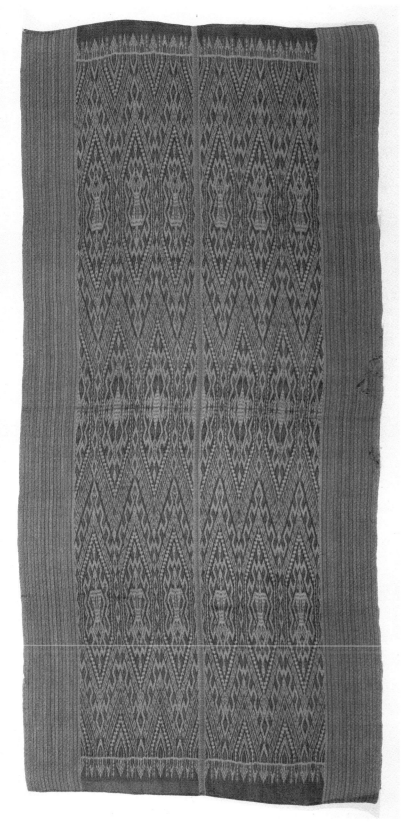

66

67

67
A Benuaq woman in east Kalimantan
knotting dried *lemba* or *daun doyo*
fibres (Curculigo latifolia) into long
strands to make thread for warp ikat
skirtcloths (*ulap doyo*). The woman
wears a long wrap-around skirt of
more modern decorative technique,
embroidery and appliqué on
commercial cotton fabric, although the
structure of the garment is similar to
the ancient fibre ikats.

68
kumo
a pair of ceremonial cloths
T'boli people, Mindanao, Philippines
abaca fibre, natural dyes
warp ikat
65.0 x 220.0 cm; 62.0 x 220.0 cm
Australian National Gallery 1984.1228

These two identical textiles in red,
black and natural colours would
probably be stitched together to form
a ceremonial hanging (*kumo*).
Separately, they may have functioned
as women's skirts. The main diagonal
grid motif is the snake or python
pattern (*sawo*), a popular and powerful
design throughout Southeast Asia,
where a variety of ikat motifs are so
named. The intervening zigzag lines
are known as *sigul*. During the *t'muke
kumo* ceremony, a protective warp
ikat (*t'nolak*) cloth is placed over the
bride, to be removed later by one of
the groom's family (Casal, 1978). The
same symbolism is evident after the
settlement of bride-wealth
agreements, when children who are
betrothed are blanketed with these
abaca ikat. Early twentieth century

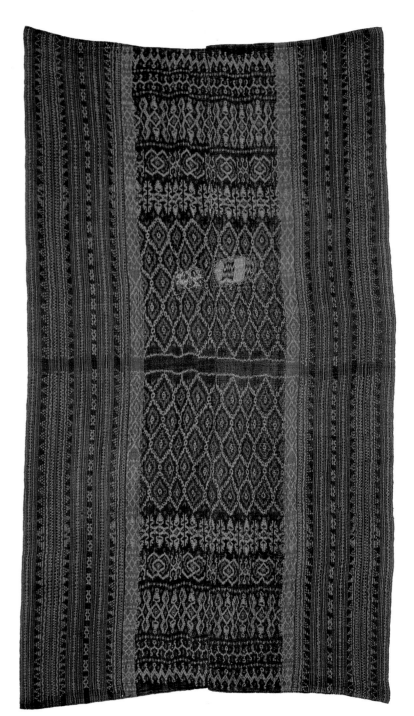

68

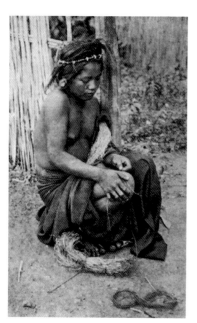

69

69
A Filipino woman preparing abaca
fibres before they are woven into
fabric in 1920. The fibre is rolled into
yarn on her thigh.

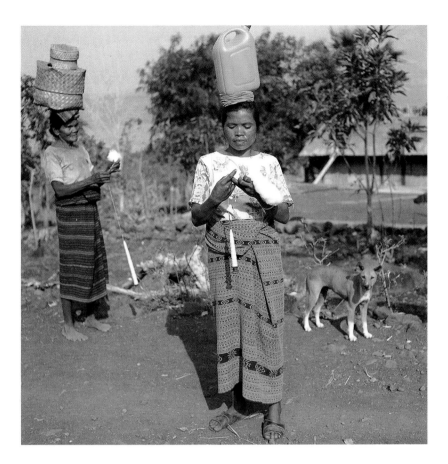

70
Women on the island of Solor in eastern Indonesia spin locally grown cotton using a wooden drop-weight spindle as they stroll to the fields to carry out routine agricultural tasks.

that are tied and dyed into warp ikat patterns before weaving. Other threads for weaving are obtained in eastern Indonesia from the pineapple, from varieties of palmyra plants including the pandanas and sago palms, and from a number of lesser known plants native to the region. Throughout Southeast Asia, the processing of thread, like the weaving of traditional cloth, is the work of women.

70,73

The fibre used in many parts of eastern Indonesia as the resist-binding for ikat is obtained from the Corypha palm. While today it is rarely the basic fibre for woven fabric,[26] it continues to be used to produce the material for sails in some of the oldest sea-going cultures of insular Southeast Asia.[27] The Southeast Asian textile traditions were probably spread to Madagascar from Indonesia early in the first millenium AD by seafaring travellers using the Corypha sails (Bellwood, 1979: 124; Mack, 1987).

74

One of the most important stages in the preparation of textiles is the dyeing of the woven fabric or, in the case of many ancient forms of decorative textiles, the dyeing of the threads before weaving. Many strong natural dyes and mordants are available to the peoples of Southeast Asia. Of the range of naturally-obtained materials found in the region, dyestuffs used to make blue-black and pink-red-brown colours predominate.[28] These include mud[29] and varieties of indigo for blue-black colours,[30] and barks or roots such as Morinda citrifolia, Caesalpina sappan, and Pelthophorum ferrugineum (*soga*) for red-brown. Stick lac, the residue obtained from insect deposits in tree bark (Coccus lacca), is the most widely used red dyestuff in mainland Southeast Asia (Prangwatthanakun and Cheesman, 1987: 45). Some

1

71
............
ceremonial hanging, skirt (?)
Toraja people, central Sulawesi,
Indonesia
handspun cotton, natural dyes
supplementary warp weave
151.0 x 139.0 cm
Australian National Gallery 1983.3692

72 (detail)
............
woman's skirtcloth (?)
Benuaq people, east Kalimantan,
Indonesia
doyo fibre (Curculigo latifolia), natural
dyes
supplementary warp weave, staining
173.0 x 73.0 cm
Rijksmuseum voor Volkenkunde,
Leiden 427–26

There is remarkable similarity in the
technique and design of these two
nineteenth-century fabrics although
they were woven on different islands
and with different thread. Little is
known about the function of either
textile since a knowledge of the
supplementary warp technique appears
to have died out in these areas during
the last century and very few extant
examples of these textiles remain.
However, this technique is still
practised in isolated regions of eastern
Indonesia. The red, white and
blue-black colour combinations are also
similar for both textiles, although the
black patterns have been painted on to
the white supplementary warp bands
of the Benuaq textile, said to be a
skirtcloth (Jager Gerlings, 1952: Fig.
17).

73 (detail)
homnon
woman's skirt
Kisar, south Maluku, Indonesia
handspun cotton, natural dyes
warp ikat
125.0 x 130.0 cm
Australian National Gallery 1985.382

This woman's cylindrical skirt is
woven from fine blue, red and natural
handspun cotton thread. The many key
designs are carefully arranged in
narrow bands. The textiles of the
islands in south Maluku (south
Moluccas) are often woven from other
materials, including the fibres of lontar
palm-leaves (a substance also widely
used as a binding thread for warp ikat
throughout Southeast Asia). This
example probably dates from the early
twentieth century.

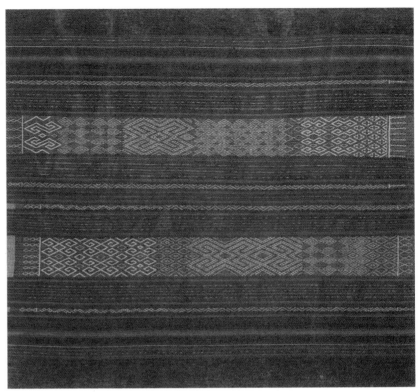
71

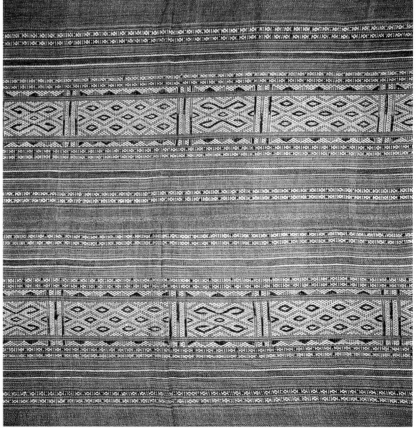
72

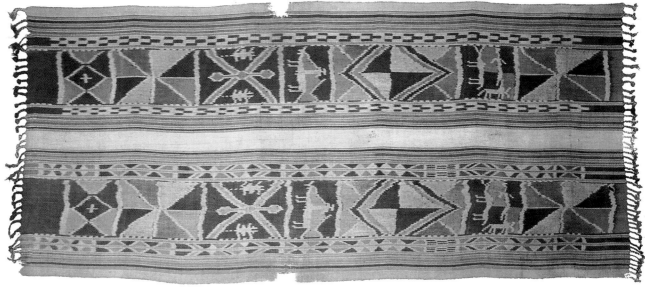

74

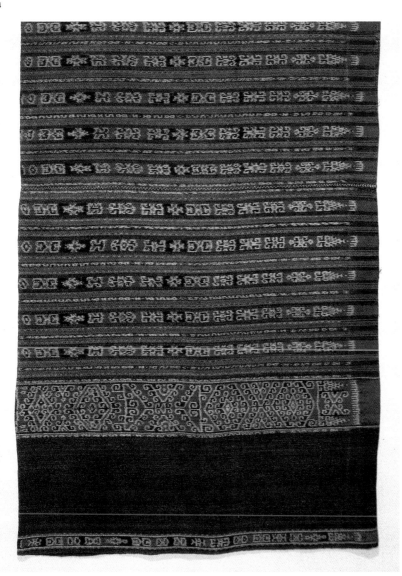

73

74
lamba mena (?)
shroud; canopy; room-divider
Sakalava people, west Madagascar
raffia fibre, natural dyes
warp ikat
Rijksmuseum voor Volkenkunde,
Leiden 4927–5

Early in the first millenium AD, sailors
from the Indonesian archipelago had
already begun to roam the Asian world
in pursuit of trade and adventure. The
contacts and settlements that resulted
also left their mark on the culture of
the island of Madagascar. The
language is Austronesian, and the
textile arts reflect those of Borneo
from where prehistorians suggest the
voyages originated. This provides
additional evidence for the antiquity of
complex warp ikat in the Southeast
Asian region. Some Madagascar
banded warp ikat patterns include
stylized human figures, although the
dyes available there produce different
shades of brown from those found in
Southeast Asia, and yellow is a
prominent colour. The fibre used in
this nineteenth-century example is
obtained from the leaves of the Raphia
palm. The main function of these large
cloths as shrouds (*lamba mena*; red or
colourful cloths) may also reflect their
Southeast Asian ancestry (Mack, 1987:
76–80).

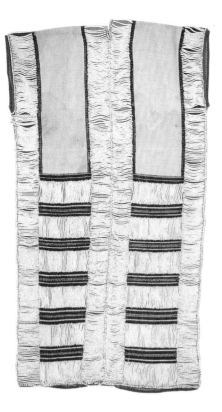

75
............
ceremonial man's jacket
Ayatal people, Taiwan
vegetable fibre, shells
supplementary warp weave, twill
weave, twining
48.0 x 88.0 cm
Australian National Gallery 1988.639

The Austronesian-speaking peoples
include the indigenous inhabitants of
the island of Taiwan and prehistorians
have concluded that the ancestors of
many of today's Southeast Asians
migrated from that region thousands
of years ago. Many similarities remain
between the arts of the various
indigenous peoples of Taiwan and their
Southeast Asian neighbours (Feldman,
1985). This long nineteenth-century
jacket is constructed from hemp fabric
woven on a body-tension loom. The
bands of simple supplementary warp
patterning are in red and brown, while
the foundation weave is in finer white
thread with a strong twined trim. The
garment is a high status object,
decorated with many strands of
slit-shell discs that were used in
ceremonial exchange (Barbier and
Newton, 1988: 344–5).

art historians believe that indigo has a far longer history in Southeast
Asia than red dyes (Bühler, 1941), although indigo has generally been
replaced by the red dyes of Morinda citrifolia and stick lac as the
preferred dye for ceremonial textiles. Brown *soga* dyes, like those
associated with fine hand-drawn wax-resist batik from central Java,
seem to be a later development. The tricolour of red, black and white
has symbolic significance for many Southeast Asian peoples, and
these are the colours found on very old types of textiles such as the
abaca warp ikats of Mindanao, the banded cloths of eastern Indonesia
and the bark tunics of the Toraja.

HARD FABRICS: THE AMBIGUITY OF BEADS AND SHELLS

Garments often became objects of significance when highly valued
items were attached to twining, bark-cloth, woven fibres, and plain or
decorated cotton cloth. Miniature bells, shells and beads have been
used since prehistoric times to enliven the appearance of fabrics and
increase their value. Beads, in particular, have been an important
form of jewellery in almost every culture in Southeast Asia. As well as
necklaces, bracelets and anklets, they have been threaded into head-
bands, belts and other articles of display. In fact, many beaded gar-
ments are an extension or an elaboration of jewellery, and in rare
cases a decorative fabric for festive wear is composed entirely of
beads.

Shells have been a primary form of decoration since Neolithic
times throughout Southeast Asia, and the earliest recorded beads 75
were made from shells, stone and clay, though probably other natural
objects such as seeds were also used. Job's tears, seeds from a type of
tropical grass, ornament the tunics and shirts of the Karen and Akha
women of northern Thailand and seeds are also used to decorate fab- 76
ric in New Guinea and Mindanao.[31] Small nassa shells, widely used as
decoration by both mountain and coastal dwellers, are slit so they can 77,78
be stitched easily on to fabric with twine or cotton. In the western
regions, the Naga people decorate men's shawls and loincloths with
stark, white, shell figures and circles on dark, warp-striped, cotton
fabric. By the Metal Age decoration included glass, gold and stones
such as carnelian, which may have been among the oldest objects to
arrive in the region from India.[32] Shells and ancient beads are still
valued as heirlooms and trade items in many cultures, and as objects
to be fixed to garments for ceremonial occasions, although the natural
fibres used to thread them have gradually been replaced by cotton and
nylon. So highly valued are beads and shells that they have become
the subject of legends, a major form of currency and a source of
wealth.

Metaphorically, beads and shells are 'hard' objects, sometimes
classified like ivory, metal jewellery and weaponry as 'male'. Opposed
to this category are those complementary objects regarded as
'female' and 'soft'. These include textiles as the most significant item
made by women, although when beads are worn as garments and
attached to textiles, they may also be classified as female. As bead and
shell appliqué requires the work of both sexes the creation of these
objects symbolically links both the male and female realms. The role
of men in making or acquiring shell discs and beads is complementary
to the exclusively female activities of thread preparation and weaving.

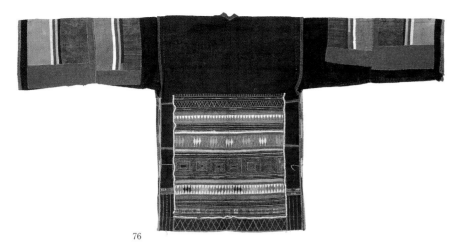

76

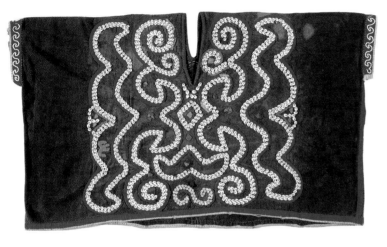

77

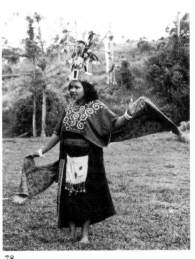

78

76

............

woman's jacket
Akha people, north Thailand
handspun cotton, natural dyes, Job's
tears seeds
appliqué, patchwork
133.0 x 66.0 cm
Australian National Gallery 1986.1246

The indigo blue cotton jackets of the
Yer Tung Akha display multicolured
patchwork and stitching in linear rows
of triangles, diamonds and rectangles.
The angularity of the patterns is
similar to those found on Hmong batik.
Some jackets are decorated with rows
of seeds, shells, beads, bells and coins.
Job's tears seeds were once reserved
for the jackets of older women, and
these were donned by new brides only
after modest public displays of
'reluctance'. Similarly, a young woman
may wear a white skirt at her
marriage celebrations, although this is
regarded as a sign of great authority
normally reserved for knowledgeable
and mature Akha women (Nabholz-
Kartaschoff, 1985: 162). This example
dates from the mid-twentieth century.

77

kaya bé; *baju bé*
woman's tunic
Toraja people, Kalumpang region,
central Sulawesi, Indonesia
cotton, shells, beads, felt pieces
appliqué
73.0 x 43.0 cm
Australian National Gallery 1984.3174

The white shells, red cloth appliqué
and bindings, and the black cotton
ground on the Kalumpang woman's
ceremonial tunic reflect the
fundamental tricolours of the Toraja
world. Despite the remoteness of
inland mountain valleys, split shells
and beads were traded into the
hinterlands of Southeast Asia where
they were used to decorate ceremonial
garments worn by the local nobility.
For most of this century at least,
imported milled black cotton fabric
appears to have been used as the base
cloth for many appliqué decorated
garments.

78

A Toraja schoolteacher dancing at a
family wedding in the Kalumpang
district of central Sulawesi wears a
kaya bé decorated with shell appliqué,
with a nine-metre-long skirtcloth
edged with braid (*kundai pamiring*), a
beaded shoulder-sash (*kamandang* or
sekè), and a Javanese batik sash for
dancing (*kembé*). Informants pointed
out that this cloth should have been a
sarita or a *mawa*, both prestige
heirloom imported textiles in this
region. She also wears an elaborate
horn-shaped head-dress of bamboo,
brass and feathers known as *tanduk
rembé*.

79
kandauré
beaded neck-piece; ceremonial object
Sa'dan Toraja people, central Sulawesi,
Indonesia
beads, cotton
beading, tablet weaving, plaiting
40.0 x 121.0 cm
Australian National Gallery 1983.3688

This early twentieth-century example
is threaded with yellow, black, red,
white, blue and turquoise beads. The
key-shaped motif known as *pa' sekong*
(spiral motif), which is widely used in
Toraja art, appears below a row of
small white human figures. This large
spiral shape is also known as *pa'
kandauré* after its prominent use on
these beaded objects. The red and
blue diamond-patterned cotton band at
the top of the object is produced by a
tablet weaving technique and a plaited
braid completes the lower edge.
Kandauré appear to symbolize
abundance and splendour and are worn
at many ceremonies by dancers with
the long strands of beads tied in front
across the breasts and the cylinders
hanging down the women's backs.
They are also hung from tall poles at
funerals and from clan houses at the
merok ceremonies that maintain a
family's well-being. On these occasions
the *kandauré* are hung so that the
small beaded human figures appear
upright at the neck, perhaps indicating
a more ancient function for these
beaded objects.

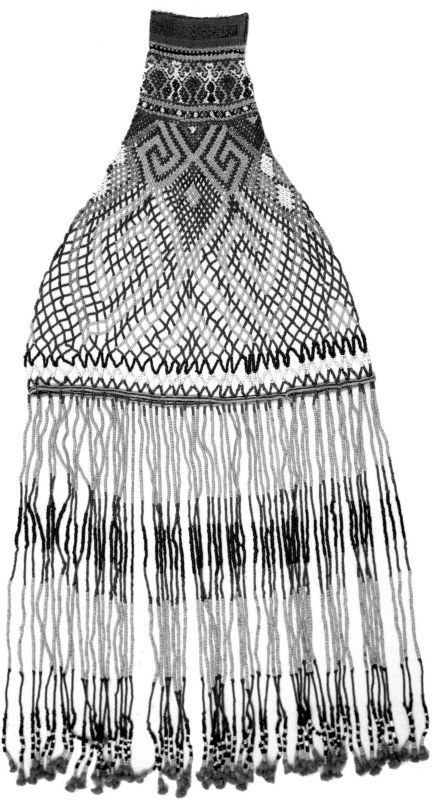

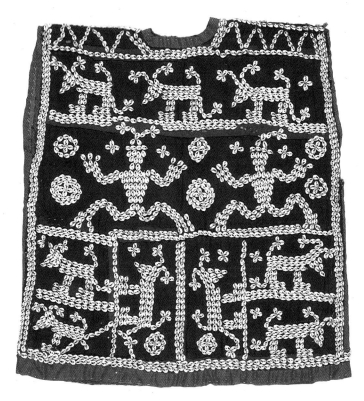

81

80

80
A young Maloh woman in west
Kalimantan beading a band for a
woman's skirt (*kain lekok*)

81
sapé buri
ceremonial jacket
Maloh people, west Kalimantan,
Indonesia
cotton, split shells
appliqué
46.0 x 51.0 cm
Australian National Gallery 1982.1298

82
kain manik
woman's ceremonial skirt
Maloh people, west Kalimantan,
Indonesia
cotton, beads
warp ikat, appliqué, beading
46.0 x 55.0 cm
Australian National Gallery 1982.1303

Maloh women make jackets and skirts
in a number of styles using bead
(*manik*) and shell (*buri* or *parus*)
appliqué. This fully beaded skirt has
yellow human figures (*kakalétau*)
between black water serpents (*naga*),
appearing in stylized form in the upper
and lower bands. Within Maloh
iconography, the *kakalétau* represent
guardian and ancestor spirits. On
occasions, the slaves who were owned
by the Maloh ruling class (*samagat*)
were sacrificial victims and,
significantly, the figures on this skirt
are placed near the mouth of the
water serpent. The motifs on the shell
appliqué jacket are also arranged in
bands with the *kakalétau* motif flanked
by creatures that seem to be a playful
rendition of the dog motif (*asu*). The
base fabric for both the skirt and the
jacket is black with a red trim,
although the fabric used as a lining for
the skirt is a faded Iban warp ikat
skirt (*kain kebat*). Both objects date
from the twentieth century.

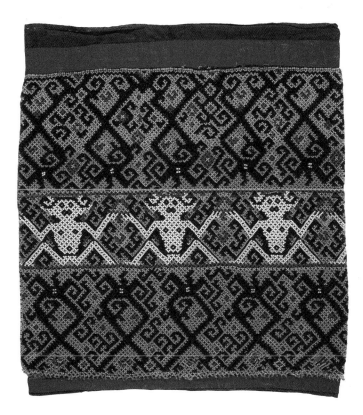

82

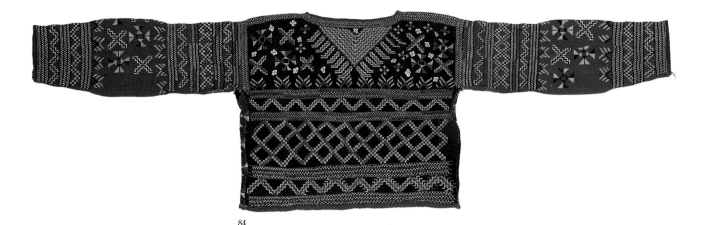

84

83

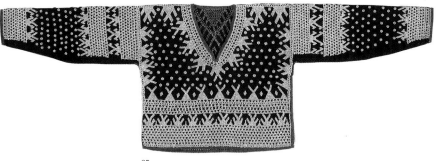

85

83
In Mindanao, a Bilaan man drills holes in small shell discs which are to be sewn in decorative patterns on clothing: an early twentieth-century photograph.

84
umpak (?)
woman's shirt
Bilaan people, Mindanao, Philippines
cotton, dyes, shell pieces
embroidery, appliqué
112.0 x 33.0 cm
Australian National Gallery 1986.2119

Drilled shell discs (*kalati*) are a subsidiary decorative device on this heavily embroidered blouse. On other Bilaan garments, they are the sole decorative material. Commercial cotton fabric, black for the body and red for the sleeves, has been used as the basis for the elaborate yellow, red, black and white cross-stitch work and has replaced the earlier gauze-like abaca fibre cloth called *sinamay*. Early twentieth century

85
dàgom
shirt
Kulaman people, Mindanao, Philippines
cotton, beads
appliqué
121.0 x 40.0 cm
Australian National Gallery 1984.1226

The white seed-bead decoration on this mid-twentieth-century blue cotton blouse with red trim follows older patterns that were executed with small, split-shell discs. Other examples of this type of garment may have a base-cloth of imported handspun cotton or of dark locally woven abaca.

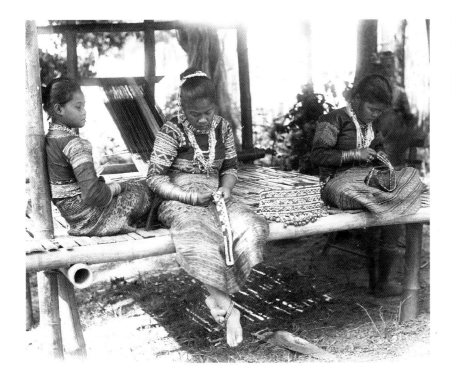

86
Bagobo women decorating bags and bands with fine beads, and wearing warp ikat, abaca-fibre skirts. The photograph was taken at a turn-of-the-century trade exposition at St Louis, USA.

Among the Dayak peoples shell and bead appliqué is sometimes co-ordinated with men drawing the designs and women threading the beads. On Mindanao pearly shell discs made from larger shells require holes to be drilled by men before they can be attached to clothing by women. In the case of the Naga it is the woman who weaves, while the man who wears the shell-decorated wrap signifying his martial successes, sews the white shell discs to the prepared fabric (Femenias, 1984: 50–1). In rare situations, as among the Toraja where beading is also performed by men,[33] the objects might be viewed as jewellery rather than clothing. Men are the workers of jewellery, especially metal objects, throughout the whole of the Southeast Asian region (Rodgers, 1985).

Beads embellish and enrich many objects: jackets and skirts, mats and hangings, and accessories such as belts, bags, boxes and bands. On Borneo ingenious beaded items abound amongst the various Dayak peoples and beads decorate Dayak head-pieces, seat-mats and baby-carriers. Ornamental appliqué of various other materials including animal teeth, coins and bronze bells are also added to these objects. While the baby-carriers are among the most complex beaded items of the Kayan (Sheppard, 1978: 91), probably the most spectacular Borneo beadwork of all is made by the Maloh women of the upper Kapuas River in west Kalimantan where it covers the surface of the base garment or is applied in narrow decorative bands (J.R. Maxwell, 1980).

Maloh skirts and sleeveless jackets are decorated with realistic and formalized images, and contain important messages about Maloh social structure, legends and trade. These appliqué garments combine many precious foreign and heirloom items, including beads, shells, Dutch coins and brass bells (made either by Chinese or Maloh craftsmen). The base fabric of these garments often consists of warp ikat cloth made by the neighbouring Iban and obtained through trade

............

women's dance aprons
Doreri district, Kepala Burung (Bird's
Head) and Cenderawasih Bay region,
Irian Jaya, Indonesia
beads, fibre thread, commercial cotton
cloth
beading
52.0 x 52.0 cm; 71.5 x 57.5 cm
Australian National Gallery
1986.1251; 1986.2456

Although little is known about these
beaded objects from Irian Jaya, they
are used worn tied around a dancer's
waist by women of the Bird's Head
and Cenderawasih (formerly Geelvink)
Bay areas (D. Fassey, personal
communication, 1985). The use of
green beads is a striking feature of the
design of one of these aprons which is
divided into a grid of asymmetrically
matched triangles and squares,
suggestive of the patterns used for
body painting and carving across a
wider area of New Guinea, and in
many Austronesian cultures.
A stylized anthropomorphic or reptile
figure in bold black and white
dominates the design of another apron.
The figure itself is filled with intricate
lozenge shapes, repeated in larger
versions on either side of the central
motif in blue, green, yellow, and
orange beads. These diamonds are
worked in key and S spiral details. A
fine fringe with tassels made from
strips of imported cloth falls from the
lower edge.

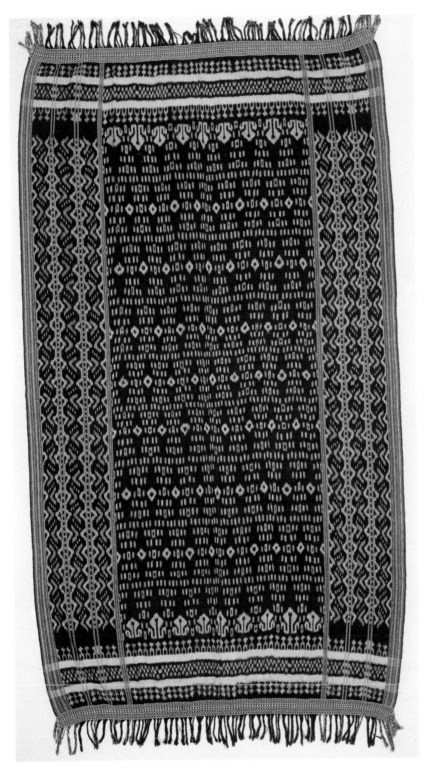

88
hanggi ngoko; hanggi wolo remba
nobleman's cloth; shroud
Kodi district, west Sumba, Indonesia
handspun cotton, natural dyes
warp ikat, weft twining
149.0 x 274.0 cm
Australian National Gallery 1987.1817

The men's cloths (*hanggi*) of west Sumba show a small range of largely schematic designs (*wolo, wola,* to ikat; *remba*, net, net-like, plaited) and on this example only the gold ceremonial ear pendant (*mamuli*) is realistically depicted. In the Kodi district, textiles contain icons representing the male gifts exchanged for cloth at marriage. In particular, the men's cloth displays the *mamuli*, the omega-shaped emblem of female sexuality, while women's skirts depict the diamond-shaped buffalo eye or horse tail (Hoskins, 1988).
Though the design structure is that of a man's cloth, these are rarely worn and then only by the rich and noble. It is largely intended as a shroud for mature men of high rank, and as such it is appropriate that it exhibits the dappled pattern of the python skin (*ngoko*). Snakes and other reptiles are associated in Kodi legend with ancestral deities and the afterlife, and the python's ability to change its skin is a powerful analogy for rebirth. The *hanggi* shrouds serve the deceased in his travels to the next realm like the thick skin of the great python. In contrast to other Southeast Asian textile traditions, which have increasingly striven for intricate, finely worked patterns, the thickness of handspun thread and the finished fabric is a desirable feature of these protective Kodi cloths (Geirnaert-Martin,1990).

by the non-weaving Maloh. The beaded motifs encompass dangerous designs from Maloh cosmology, including the mythical serpent and the ancestor or guardian spirits. Other motifs symbolize the solid prosperity of Maloh society: the hearthstone and certain animals that are an important source of food. The success and status of a family and its social position is indicated by the wearing of such finery on ritual occasions.

The beadwork still practised in many isolated parts of insular Southeast Asia relies on beads from a variety of foreign sources. The Maloh have adopted an extensive range of colours using beads now widely available from Europe and Japan. So, too, have the women of Irian Jaya whose dance aprons retain ancient key and spiral designs and sometimes anthropomorphic motifs in rhombic and triangular grids.[34] Elsewhere in insular Southeast Asia the characteristic red, black and white colour combination has prevailed, even though other colours are often available. The beadwork of Mindanao is spectacular yet often conservative in colour, with the Bagobo, for example, adding fine red, black and white seed-beads to a variety of objects made from woven abaca fabric, including pants and shirts, bags and bands.

87

86

Jewellery, including ornamental earrings, are among the objects that have been recovered from prehistoric sites in Southeast Asia. Like beads, items of jewellery are symbols of wealth and prosperity and since textile decoration is not an isolated art form, the metal earrings and head-pieces that are used by a number of Southeast Asian people on ceremonial occasions also appear as symbols of wealth on traditional fabrics. Golden head-dresses repeat the upturned buffalo horn or boat shape and are decorated with similar images to the textiles. On the island of Sumba, gold jewellery, like textiles, plays an important role in marriage settlements, and displays images such as the fighting warrior, the cosmic tree, the domestic fowl and the horned buffalo. Jewellery motifs, in particular head-dresses and earrings, occasionally appear as separate designs on cloth or are sometimes evident on the anthropomorphic figures displayed on certain textiles.

88

TEXTILE STRUCTURES: TRANSFORMATIONS WITHIN TECHNICAL CONSTRAINTS

Many similarities in woven textile designs across the region can be partly attributed to the immediate possibilities of the simplest back-tension loom with its continuous circulating warp, the commonest and most ancient weaving apparatus in the region. It is probable that the earliest woven ornamentation was narrow, plain, or simply patterned warp stripes. One of the oldest design structures on loom-woven cloth is the organization of patterning in warp bands, as certain other decorative techniques, such as complementary and supplementary warp weaving and warp ikat, are simplest to achieve when they are worked in narrow widths. As more elaborate techniques developed, larger and more complex designs became possible.

89,90,91
92,93

The warp stripes found on many Southeast Asian textiles are not randomly assembled.[35] For example, every band of a traditional Flores skirtcloth, whether decorated with ikat or plain-dyed threads, is deliberately proportioned and appropriately named, and these design formulae have been passed down from generation to genera-

95

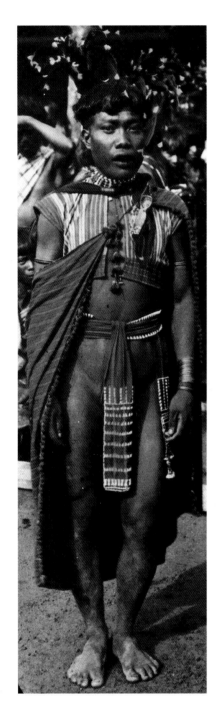

89
An early twentieth-century photograph of a Gaddang man in ceremonial costume

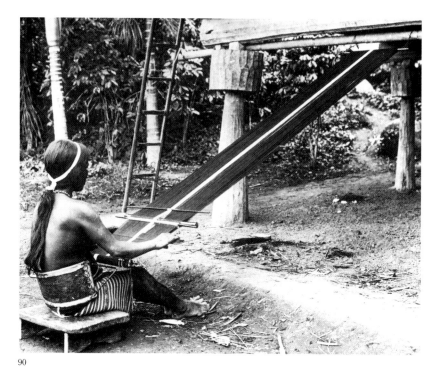

90
An early twentieth-century photograph of a Gaddang woman using a backstrap tension loom and weaving with a long, continuous, striped warp strung underneath a traditional house. The resulting fabric was cut into lengths to form the basic Gaddang garments for men and women — wrap-around skirts and loincloths, jackets, belts and cloaks.

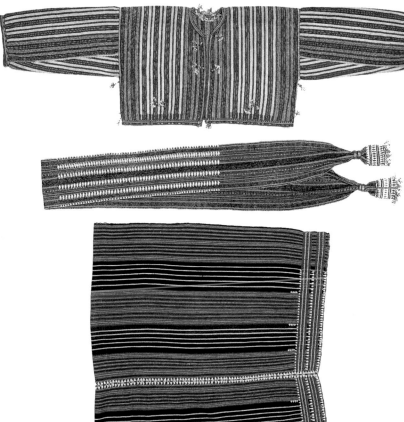

91

91
woman's skirt (*lufid*); belt (*wakes* or *inawin*); jacket (...)
Gaddang people, Luzon, Philippines
cotton, dyes, beads
tabby weave, supplementary weft weave, appliqué, embroidery
77.0 x 104.0 cm; 12.0 x 185.0 cm;
107.0 x 30.0 cm
Australian National Gallery
1984.1212; 1985.1693; 1984.1211

The textiles woven by many of the peoples of the mountainous interior of Luzon are composed of basic warp stripes or bands, evident on the articles of female apparel worn by the Gaddang. The combinations of colours and stripes indicate the particular ethno-linguistic origins of the wearer: these examples are red, white and blue. Archaeological finds in Luzon dating from the fifteenth century confirm the early use of beads to form decorative patterns on skirts and other garments, and the Gaddang are noted for their striking beadwork. Probably mid-twentieth century

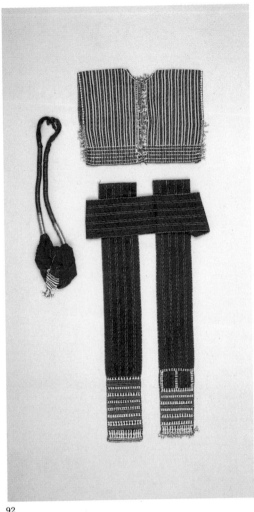

92

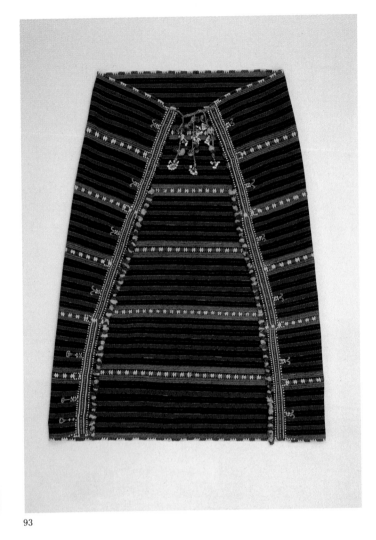

93

92
man's loincloth (*baag* or *wanes*); jacket
(...); betel-nut or tobacco bag (...)
Gaddang people, Luzon, Philippines
cotton, dyes, beads, silver, brass
tabby weave, beading, embroidery,
appliqué, twining
267.0 x 12.5 cm; 45.0 x 31.0 cm; 15.0
x 65.0 cm
Australian National Gallery
1984.1208; 1984.1207; 1984.1210

93
............
cape
Gaddang people, Luzon, Philippines
cotton, dyes, beads
tabby weave, beading, embroidery
53.0 x 93.0 cm
Australian National Gallery 1984.1209

Like some inhabitants of the more
isolated parts of Southeast Asia, the
men of central Luzon continued to
wear an ancient garment, the
loincloth, into the twentieth century.
However, the Gaddang man's cape,
joined at two adjacent corners, is an
unusual item of clothing for Southeast
Asia, where most men's shawls consist
of rectangular fringed cloths. A cloak
permits far more freedom of
movement than a shawl, and a similar
garment is worn by Paiwan men in
Taiwan. The Gaddang male garments,
like those worn by women, are made
from locally woven red, white and blue
striped fabric trimmed with

embroidery and beads. The blue in the
cape, however, is much brighter than
the other textiles and is embroidered
in bright yellow thread. The betel-nut
or tobacco bag, however, is prepared
from a square of imported cotton cloth
pulled through silver and brass rings.
The age of these garments varies from
early to mid-twentieth century.

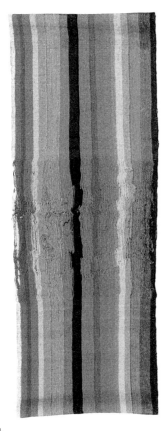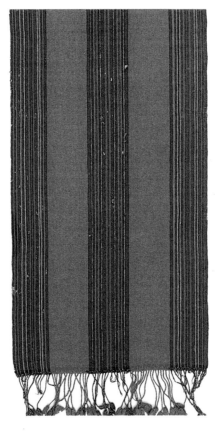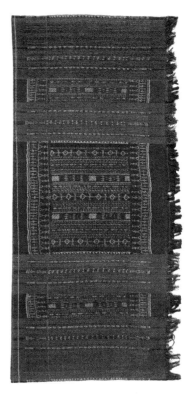

94

95

94 (detail)
kekombong; lempot umbaq
ritual cloths
Sasak people, Lombok, Indonesia
handspun cotton, natural dyes
warp-faced tabby weave
49.0 x 150.0 cm; 97.0 x 35.0 cm
Australian National Gallery
1984.3181; 1987.1094
Gift of Michael and Mary Abbott,
1987

The Sasak use a variety of names for
this type of cloth throughout Lombok.
Lempot umbaq means literally a
shouldercloth (*lempot*) to carry the
baby. Elsewhere the term used is
umbaq kombong or *kekombong*.
Although only decorated with simple
warp stripes, these are considered to
be important cloths. They are woven
by old women in many different but
established combinations of natural
colours, and often in a rather rough,
open weave, suggestive of the urgency
with which they are required. These
textiles are worn at the various
ceremonies heralding changes in a
person's social status. Their talismanic
or curative functions are called upon
during rites associated with both
individual and communal well-being,
and special copies of heirloom
kekombong are sometimes prescribed

to cure physical or social diseases,
such as deafness or kleptomania.
The combination of rich colours of the
nineteenth-century red and
brown-black cloth suggests that it may
be a *kekombong ragi majapahit*, a
pattern believed by the Sasak to have
originated during the golden age of the
fourteenth- and fifteenth-century
east-Javanese empire of Majapahit,
which claimed suzerainty over large
tracts of the archipelago including the
island of Lombok. The rainbow stripes
on the uncut mid-twentieth-century
cloth demonstrate the wide range of
tones achieved from the natural dyes
of the bark of Morinda citrifolia roots,
Indigofera tinctoria leaves and crushed
turmeric, Curcuma domestica.

95
hoba
woman's skirt; ceremonial gift
Nagé Kéo people, Flores, Indonesia
handspun cotton, natural dyes
warp ikat, supplementary weft weave
200.0 x 170.0 cm
Australian National Gallery 1984.577

Of the traditional garments of the
Nagé Kéo, only the woman's skirt
(*hoba*) is still woven in the Boawai
district of central Flores. (Men's
shawls (*sada*) and a rectangular cloth
bound with blanket-stitch, probably a
saddlecloth for the horses of
prominent leaders, are no longer made
or used.) The *hoba* are composed of
two predominantly maroon banded
panels flanking an indigo central panel.
All three panels of this
mid-twentieth-century textile are
decorated with bands of small white
ikat motifs. A few bright yellow and
pink supplementary threads, which are
evident only on one side of the fabric,
are an essential feature. As important
ceremonial gifts, the *hoba* are usually
sewn together with the continuous
warp threads still intact. Unlike these
ceremonial cloths, cylindrical skirts
intended for everyday wear (*niko
nako*) are composed of randomly
arranged stripes.

96
ulos rujat
ceremonial cloth
Toba Batak people, north Sumatra,
Indonesia
handspun cotton, natural dyes
warp ikat, supplementary weft weave,
twining
93.5 x 219.4 cm
Australian National Gallery 1983.3696

Throughout Southeast Asia the
simplest warp ikat patterns consist of
narrow warp bands of S spirals, V and
rhomb motifs. On this wide, single
panel cloth associated with the Porsea
district of the Toba Batak region of
north Sumatra, the central patterning
is flanked by red-brown borders woven
in threads dyed with Morinda citrifolia
roots, known to the Toba Batak as
bangkudu. (Another popular cloth
made elsewhere in the Toba region,
the *ulos sibolang*, has a similar
structure and design although it is
woven entirely in shades of indigo
from Marsdenia tinctoria, known
locally as *salaon*.) A little
supplementary weaving appears across
each end and the design of the cloth
suggests that in the past it may also
have been made in three sections in
the manner of some other Toba Batak
textiles. The fringe and the twined
borders, traditionally the work of men,
show precise and detailed patterns
that contrast with the soft blurring of
the central ikat, and are suggestive of
the carving on architectural structures
and other objects also executed by
men and painted in the same red,
black and white colours. Early
twentieth century

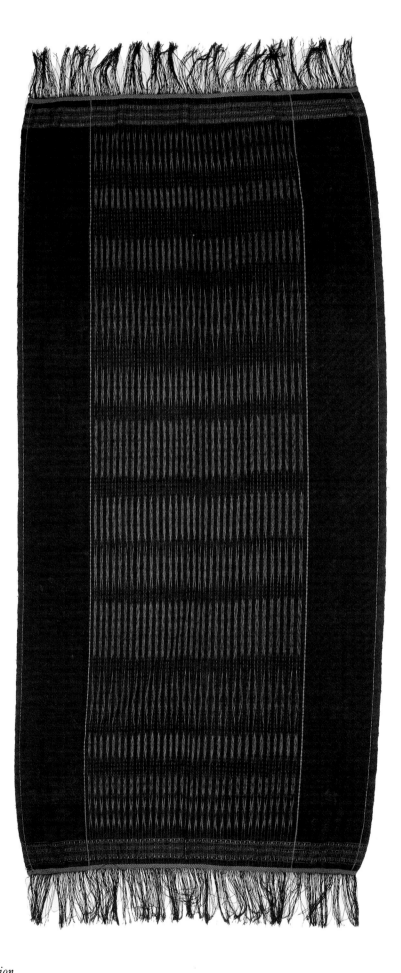

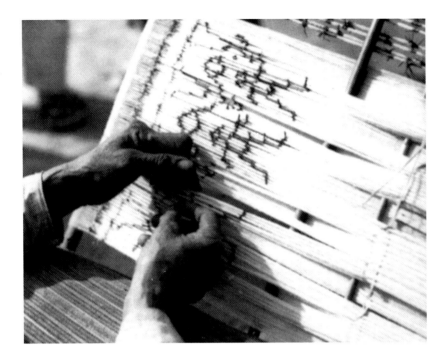

A woman on the island of Lembata ties
an ikat pattern (*mowak*) of interlocking
human figures (*ata diken*) with strips
of *gebang* palm fibre on to bundles of
warp threads set out on a tying-frame.

tion. On the islands of Lombok and Bali, specific combinations of
colours and stripes are required on cloths that serve different healing
or talismanic functions, while the border stripes on the large woven
fabrics of Borneo and Sulawesi are an integral part of cloth compo-
sition. On Iban textiles the border stripes are believed necessary to
keep the central pattern confined, which is vital if the main body of the
cloth depicts a dangerous tiger or crocodile.

94,99

The subtle use of stripes for textile decoration is not confined, of
course, to warp-decorated traditions. On Bali and Lombok subtle
shades of natural colours are graded in weft stripes to produce beauti-
ful textiles. The optical tricks created by the use of stripes, which
have been exploited by many twentieth-century Western artists, have
been applied dramatically to a number of traditional Southeast Asian
textiles composed of stripes or the intersection of stripes in
grids.[36]

The strength of narrow banded patterns is evident in the simple
lines of two-colour warp ikat woven by many ethnic groups, such as
the Batak peoples of north Sumatra, who have remained compara-
tively isolated from external influence and trade until recent times.
However, banded patterns have been retained even in Southeast
Asian cultures long exposed to foreign ideas, materials and designs.
The Malays of Terengganu, for example, have created silk textiles
with weft ikat bands, and both Batak and Malay artisans work with
combinations of ancient chevron and rhomb shapes to achieve com-
parable patterns.

96,98

100

Designs created from small blocks of ikat-protected threads
stretched into pointed V patterns between narrow warp stripes, are
also found on Bontoc cotton cloth on Luzon, and in slightly more elab-
orate patterned bands on a great many warp ikat textiles from eastern
Indonesia. The simple V and lozenge also decorate other Luzon cloths
woven with a supplementary warp technique, in which an extra set of
warp threads in contrasting colour, is interwoven with the normal

98 (detail)
ija plang rusa; ija plang rutha
man's waistcloth; wrap
Aceh, Sumatra, Indonesia; used in
Kelantan, Malaysia
silk, natural dyes
warp ikat
96.4 x 190.8 cm
Australian National Gallery 1985.381

This nineteenth-century man's wrap is
an item of ceremonial dress in
Kelantan, Malaysia, where men's
trousers were also made of the same
fabric. However, other Kelantan ikat
silk fabrics are decorated with weft
patterns and there is no clear evidence
that the arrowhead warp ikats
sometimes attributed to Kelantan were
actually woven there. This particular
textile was almost certainly woven in
Aceh, north Sumatra. Despite its
proximity to India and its position on
the old trade routes, Aceh was one of
the very few areas in Southeast Asia
to continue to use the warp ikat
technique after silk thread was
introduced. Weft ikat was never
practised in Aceh, although according
to early travellers' records, silk thread
was widely used there and was
eventually produced locally. This cloth
is deep red with narrow stripes of
black and white ikat. Cotton textiles of
almost identical size, colour and design
are woven in the nearby Toba Batak
region of north Sumatra where they
are used as ceremonial baby-carriers
(*ulos mangiring*).

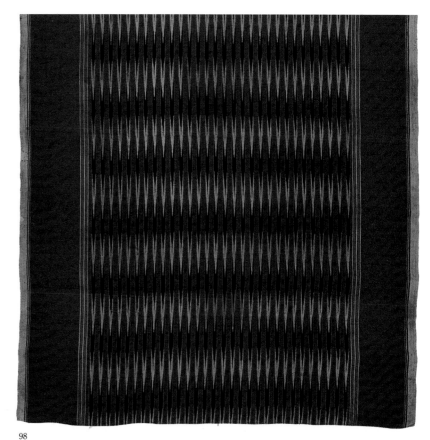

98

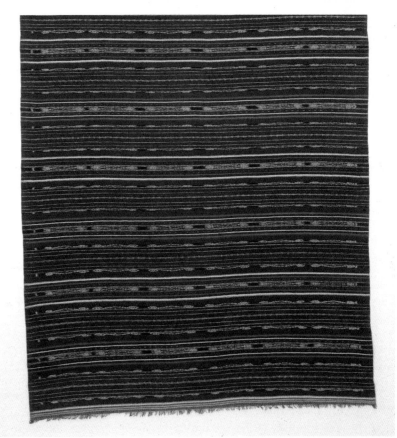

99

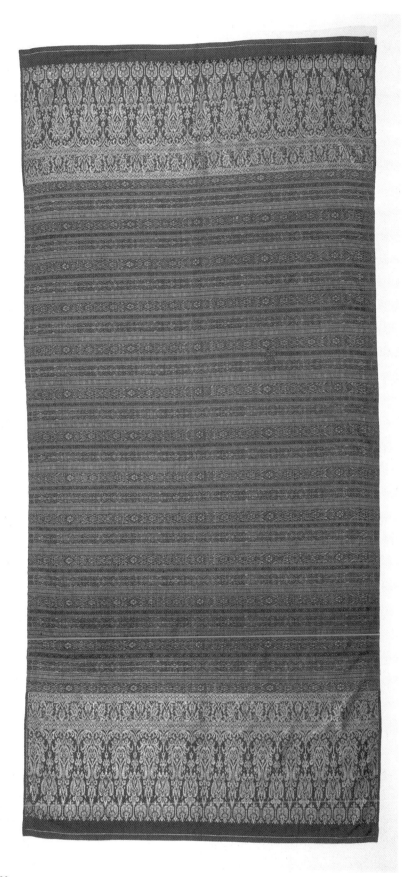

99 (detail)
ana' nene'
sacred textile
Sasak people, Sembalun, Lombok,
Indonesia
handspun cotton, natural dyes
weft ikat, tapestry weave
193.5 x 94.2 cm
Australian National Gallery 1985.1743

This Sasak weft ikat cloth, possibly
belonging to a class of textile known
as *sokong* after the village of that
name, contains graded bands of
superbly moderated colours. According
to Dutch sources, these textiles were
known as *ana' nene'* (child of the
ancestors) in the Masbagik area of
Lombok, and were used during
ceremonies to collect water from a
holy spring (Haar, 1925: 74; Goris,
1936: 227, 230). The weft ikat
designs repeat the spirals and rhombs
found in ancient warp ikat patterns
and a narrow tapestry band finishes
each end of the fabric. The colours are
white and shades of blue to black. No
examples of these weft ikat cloths
were collected during the colonial
period and, unlike the warp-striped
lempot or *kekombong*, there are only
occasional references to these textiles
in any accounts of Sasak weaving.
Nineteenth century

100
kain lemar
ceremonial wrap; shawl
Malay people, Terengganu, Malaysia
silk, gold thread, natural dyes
weft ikat, supplementary weft weave
103.0 x 206.0 cm
Australian National Gallery 1984.1248

While the field of this nineteenth-
century textile displays motifs based
on simple V and rhomb shapes known
as the *cuai* pattern, the refined
development of the weft ikat technique
has permitted the dyer to use seven
different colours in narrow patterned
bands. The dominant colour of the
cloth is red, and the narrow green
stripes are unusual. In contrast to this
exquisite but subdued field, the ends of
the cloth glow with opulent gold
thread.

100

101 (detail)
kain sandang (?)
shouldercloth; waistcloth
Bengkulu-Pasemah region, Sumatra,
Indonesia
cotton, natural dyes, metallic thread,
lead
supplementary weft weave
64.0 x 163.0 cm
Australian National Gallery 1984.571

102
pha sin
woman's ceremonial skirt
Tai Phuan people, Laplae, Uttaradit
province, Thailand
cotton, silk, natural dyes
supplementary weft weave,
supplementary warp weave
142.0 x 92.0 cm
Australian National Gallery 1986.1242

Textiles often combine design
elements and decorative techniques
derived from different stages of their
culture's history. In both of these
early twentieth-century cloths, the
central field is filled with simple spots
of supplementary thread, although the
supplementary warp patterns (*muk*) of
the Tai cloth are woven with a
complex set of heddles
(Prangwatthanakun and Cheesman,
1987: 38–9). The borders of each
cloth, however, are spectacular
examples of the supplementary weft
tradition using silk and gold threads,
although in the working out of the
patterns ancient elements have been
retained — zigzags, spirals, stars and
hooks. The weavers have exploited
this contrast between elaborate
borders and simple centres to achieve
dramatic cloths. On the Tai cloth, the
lower decorative edge of the skirt (*tin
chok*) is woven separately and then
sewn to the main section of the cloth
(*dta muk*). The fine discontinuous
supplementary work (*chok*) in yellow
and green silk contains tiny birds and
stylized ship images, which are also
links with the earlier cultures of this
part of Southeast Asia. The Sumatran
cloth is deep indigo with red ends, and
at each end a section of unwoven (or
pulled) warp threads has been wrapped
in lead to provide additional
decoration.

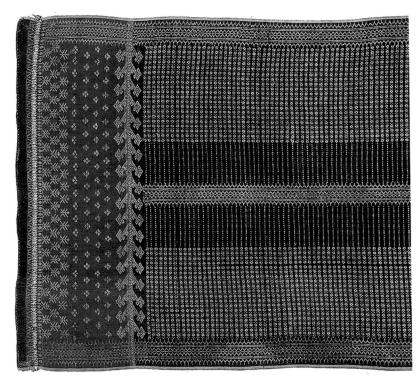

101

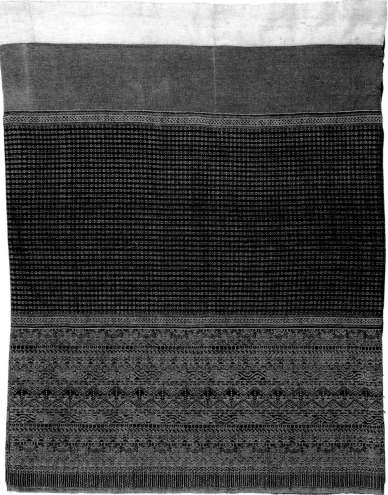

102

warp to produce the pattern (which appears in mirror image on the reverse side of the fabric). Like many ancient designs, the arrowhead or chevron also appears on other types of textiles woven on different kinds of looms. This usually led to its transformation from warp to weft decoration and hence the arrowhead banded design is found on many weft-decorated silk textiles throughout Southeast Asia.

97 Although it is uncertain when the development of the warp ikat resist technique (the resist tying and dyeing into patterns of the loom threads, the warp, before inserting the weft) began in Southeast Asia, *103* it is clearly of great antiquity. In parts of New Guinea, a proto-ikat technique is still used to pattern the free-floating bast fibres that make up skirts, although these differ from the warp ikat garments of Southeast Asia in that they are not woven.[37] The harsh tropical climate of the region has prevented the discovery of archaeological textiles comparable to the important finds in the Middle East, China and South America. Consequently the earliest decorated textiles so far found in insular Southeast Asia apparently date from only the fourteenth or fifteenth century. While these warp ikat textile fragments found in caves on Banton Island near Mindoro are not of the same period as the earliest archaeological finds in Southeast Asia, they provide the earliest known examples of narrow warp fibre bands with simple S spiral, square, rhomb and triangle shapes, patterns that are comparable to those of textiles still made in many parts of the region.[38]

Although many of the oldest textile designs use warp decoration, *101,102* the patterns of some supplementary weft textiles suggest that this technique also has a long history in Southeast Asia. These patterns are formed on the surface of the fabric from supplementary floating weft threads introduced between the foundation weave. In other instances, such as certain Shan,[39] Iban and Timorese textiles, the extra weft threads are wrapped around the warp threads between the throws of the basic weft, resulting in a decorative effect very similar to embroidery. However, by choosing from a repertoire of designs

103
A proto-ikat technique, in which fibres are tied and dyed, although not woven into fabric, is still practised in areas bordering on Southeast Asia (Larsen et al., 1976: 18–22). This Mundugumar woman in New Guinea wears a loose fibre skirt, resist-dyed with bright chemical dyes.

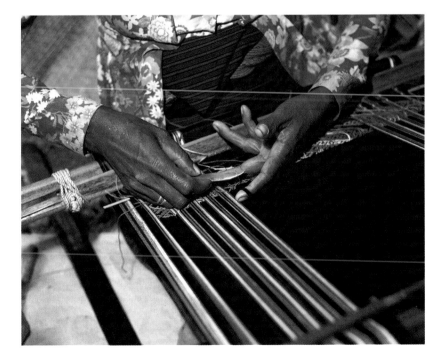

104
A woman in the Oelolok district of central Timor weaving a textile with supplementary weft wrapping known as *buna*. A number of weft-wrapping techniques are practised throughout Timor, each of them known by a particular term. The decorative effect of this technique, which is used in various parts of Southeast Asia, is often confused with embroidery.

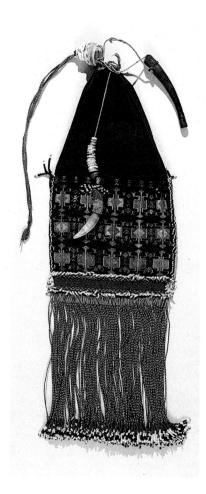

105
funé mama (?)
man's bag for betel-nut
Tetum people, Besikama district,
south Belu region, Timor, Indonesia
handspun cotton, natural dyes, ivory,
bone, beads, shells
supplementary weft wrapping
63.0 x 22.0 cm
Australian National Gallery 1986.1249

This mid-twentieth-century betel-nut
bag is finely worked in supplementary
weft weave (*buna*). The brightly
coloured motifs against an indigo
ground are apparently the crocodile
(*be'i* or *hau sufa*) and the human
figure (*atoni*), although these shapes
are occasionally interpreted as the
frog (*beso*). The use of such powerful
images and the supplementary weft
wrapping technique was once
restricted in Timor to rulers and war
leaders, and the women who weave
such motifs are aware of their
potency. A long, bright, rolled fringe is
an additional decorative feature of this
drawstring bag.

and motifs also found on other types of weaving, such as warp ikat and
supplementary warp patterning, the weaver, by using the weft-
wrapping method, produces cloths that look very similar to the other
textiles of that culture. In Timor, for example, reptilian motifs are
produced by many decorative textile techniques including supplemen-
tary warp weaving and supplementary weft wrapping. In Sarawak,
the Iban weave *pua sungkit*, a textile made with supplementary wefts
wrapped around the undecorated warp. Many display similar designs
and structural arrangement to the warp ikat *pua kumbu* and fulfil
similar important ritual purposes.

Similarities evident in the layout and structure of cloths from
many different parts of Southeast Asia woven from quite different
fibres (such as *lemba*, abaca and cotton) suggest the sustained use of
these structures over a long period. While the simple, continuous
warp, body-tension loom is capable of producing most elaborately
decorated textiles, the width of the fabric that can be consistently
produced on this equipment is limited, whatever the fibre. As a result,
garments and ritual objects made from these fabrics are constructed
of parallel panels. The minimum of cutting and the maximum use of
selvage produces durable garments composed of joined panels —
rectangular cloths for men and cylindrical skirts for women.

This technical limitation of the narrow loom has given rise to
striking design structures. By combining odd numbers of fabric
panels, decorative and highly formalized arrangements of warp bands
became possible. For example, two identical panels are often separ-
ated by a different central panel. Symmetry is thus maintained while
extra width is achieved. This central section sometimes continues a
banded pattern found in the side sections, but in other examples a
stark contrast is provided by either an elaborately decorated or quite
plain panel. On certain cloths, such as the Kisar men's wrap, the use of
different coloured grounds in the side bands and in the central section
is an integral feature of the design. Even the stitches used to join
panels may create additional ornamentation. These design features,
and the colours in which they are worked, are one way of indicating a
person's place of origin.

Throughout insular Southeast Asia this tripartite design feature
has gradually become a major decorative device on warp-decorated
textiles and may also have influenced the format of weft-patterned
designs.[40] Where the central panel contains the most important
design elements it is sometimes described as the 'mother'. The
Bagobo of Mindanao refer to this panel as the mother (*ine*) and the
flanking side panels as the child (*bata*). The metaphor linking cloth
structure with the human body is repeated in different ways in other
cultures. The Ifugao, for example, identify the correct side of the
textile as its back (*odo'gna*) while the reverse side is known as the
cloth's stomach (*putu'na*).[41]

While the technical constraints of these decorative textile
techniques affect the ways in which motifs and patterns are executed
and explain some of the familiar and recurring variations, the under-
lying similarities of deep-rooted custom and belief in many Southeast
Asian cultures help to explain the similarities evident in designs on
cloth from quite different parts of the region. In these textile designs
we frequently find ideas and symbols repeated again and again. The
double or S spiral motif, sensuously curved or strongly cornered, is

104,105

53

106

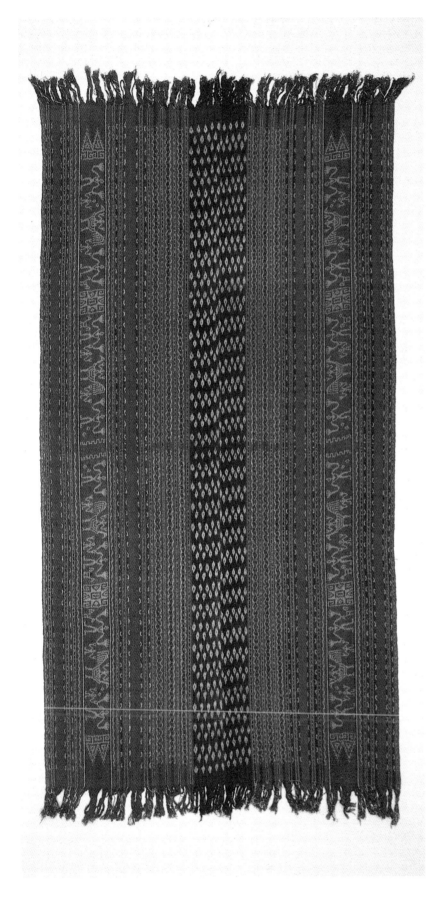

106

............

man's cloth
Kisar or Luang, south Maluku,
Indonesia
handspun cotton, natural dyes
warp ikat
220.0 x 105.0 cm
Australian National Gallery 1984.605

Most items of apparel composed of
two, three or more panels exploit the
necessary constraints of narrow,
backstrap loom fabrics by retaining the
symmetrical design structure with a
contrasting central section. This
unusual nineteenth-century cloth from
the islands of Kisar or Luang is made
in two identical panels but follows the
tripartite design format of the eastern
Indonesian man's wrap. Although
textiles of this exact structure are not
recorded for this region of the south
Moluccas, the bands of figurative warp
ikat indicate the textile's origins. The
patterned bands of human figures,
fowls and schematic shapes are all
ancient motifs. The human forms,
wonderfully proportioned with wide
shoulders and a powerful stance, may
have ancestral connotations. The
figurative and plain striped red bands
form a strong contrast with the
striking blue and white spotted central
section.

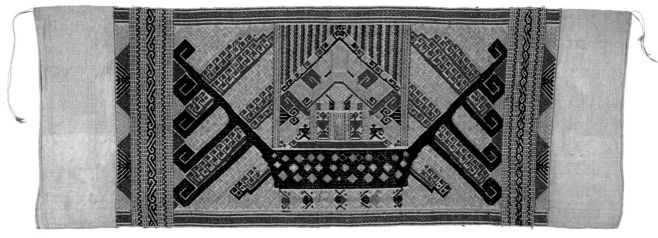

107

107
tatibin
ceremonial cloth
Paminggir people, Lampung, Sumatra,
Indonesia
handspun cotton, natural dyes, metallic
thread, silk
supplementary weft weave
44.5 x 122.0 cm
Australian National Gallery 1984.573

The curving prows at each end of the
great ships that are the central motif
on the supplementary weft cotton
cloths of the south Lampung region of
Sumatra are one of the most striking
examples of the use of an ancient
decorative motif, the hook. The
smaller and rarer *tatibin* exhibit the
same iconography and style as the
huge *palepai* textiles. This late
nineteenth-century cloth resembles the
single blue ship designs found on the
palepei of the Kota Agung district on
the south coast of Lampung. Turmeric
dyes have been generously used, and
spots of pink silk and silver thread
appear amid the yellow-orange, red
and blue supplementary threads.

108
.............
shroud
Isnai people, Luzon, Philippines
cotton, natural dyes
warp ikat
142.0 x 213.0 cm
Newark Museum 30.601
Gift of Mrs Sadie De Roy Koch, 1930

This striking indigo and white textile,
with strong red warp stripes, is
described in the museum notes as a
death blanket. It is one of the few
examples of large warp ikat designs
remaining from the island of Luzon.
Nothing is known of the design's exact
original meaning, although the large
hooked motifs are similar to those
identified by the art historian Schuster

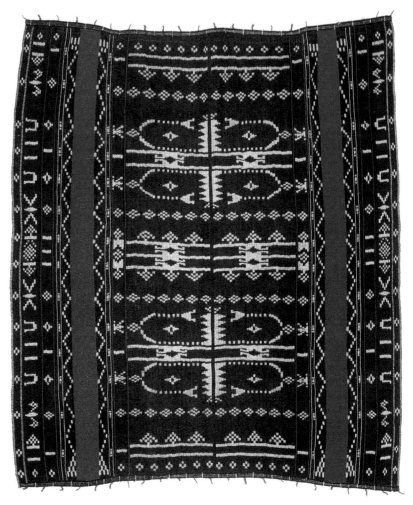

108

(1965: 342) as 'genealogical patterns',
a succession of deceased ancestors.
Late nineteenth or early twentieth
century

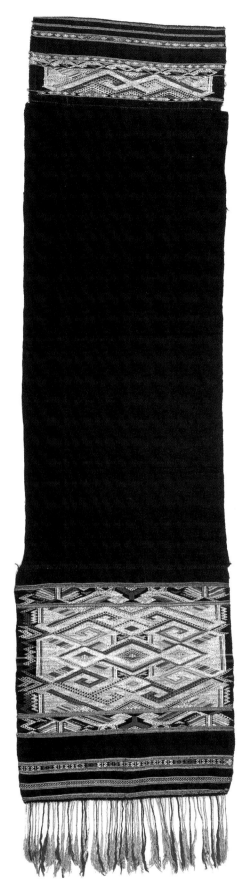

109
pha biang
ceremonial shawl
Tai Daeng people, Laos
silk, cotton, dyes
supplementary weft weave
200.0 x 47.0 cm
Australian National Gallery 1984.3193

The rhomb and hook pattern appears
in a quite different guise on this
twentieth-century Lao shawl. The
green, white, orange and purple silk
threads are a brilliant contrast against
the sombre indigo cotton ground.
Apart from small creatures in the
borders of the main decorative section,
the design is non-figurative, although
its arrangement hints at the dragon
design (*naga*), which is a popular
image on the textiles of northern
mainland Southeast Asia. Similar
supplementary weft diamond-key
patterns are found on textiles from
Vietnam through to the Himalayas.

110
kemben; kain kembangan
offering cloth; breastcloth
Javanese people, central Java,
Indonesia
cotton, dyes
stitch-resist dyeing
492.0 x 52.2 cm
Australian National Gallery 1984.3183

A large rhomb section occupies the
centre of a number of central Javanese
cloths, including certain huge
ceremonial textiles (*dodot*) and men's
headcloths. It is also the main
decorative device found on a number
of breast-wrappers. These long, cotton
textiles with a stark, tie-dyed or
stitch-resist (*tritik*) central lozenge are
a type of *kain kembangan* (flowered
cloth). Such textiles are part of the
traditional offerings made to deities,
and are of greater ritual importance
than Javanese batik. They are worn at
the most sacred ceremonies at all
levels of Javanese society — in court
and village alike. This early
twentieth-century dark indigo textile
with its green centre (*jumputan?*)
may have been associated with annual
homage and offerings orientated to the
south, the location of the home of
Kanjeng Ratu Kidul, the goddess of
the south seas and legendary ancestor
of the Surakarta ruler.

109

110

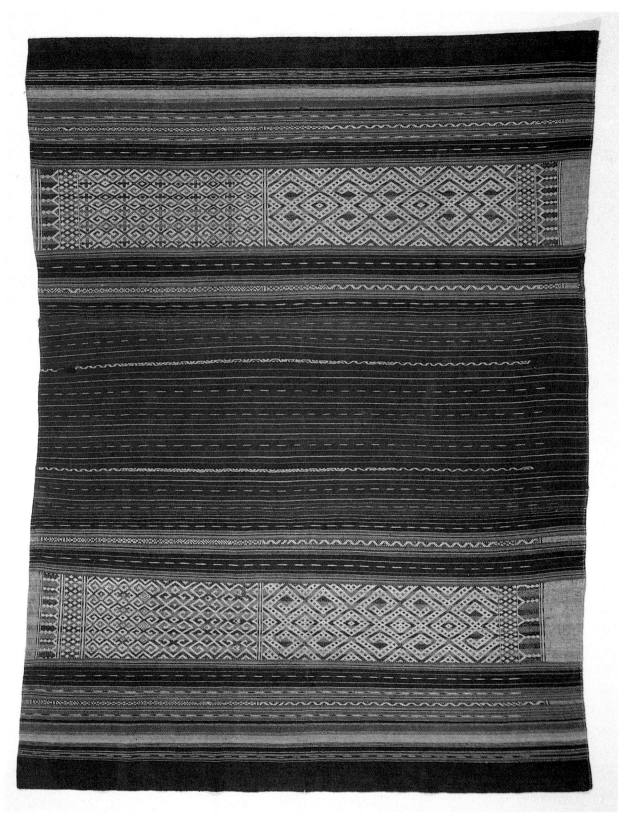

111

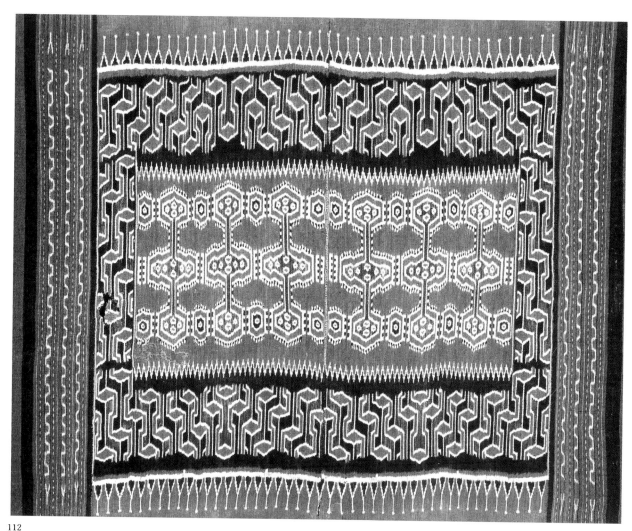

112

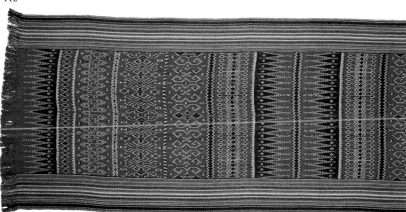

113

113 (detail)
pori lonjong
ceremonial hanging; shroud
Toraja people, Rongkong district,
central Sulawesi, Indonesia
cotton, natural dyes
warp ikat
132.5 x 434.0 cm
Australian National Gallery 1985.616

The intricacies that can be achieved
with rhomb, key and spiral
configurations can be judged from
these Toraja examples. The
twentieth-century *pori lonjong* (*pori*,
ikat; *lonjong*, long) has crisp bold ikat
in two panels. The much older textile,
possibly a woman's skirt, contains
subtle variations of interlocking spiral
patterns in unusual supplementary
warp bands. The huge, early
twentieth-century *pori situtu'*
(probably from the term *tutup*, to
close or cover) also includes the
characteristic side stripes but the
textile is composed of four panels. The
striking, but enigmatic, spotted central

111
............
skirt; ceremonial hanging
Toraja people, Rongkong district (?),
central Sulawesi, Indonesia
handspun cotton, natural dyes
supplementary warp weave, warp ikat
185.0 x 145.0 cm
Australian National Gallery 1984.612

112 (detail)
pori situtu'
ceremonial hanging; shroud
Toraja people, Rongkong district,
central Sulawesi, Indonesia
handspun cotton, natural dyes
warp ikat
375.0 x 158.0 cm
Australian National Gallery 1982.2295

pattern is surrounded by continuous, flowing spirals outlined in white.
The colours on each cloth are white, a powerful red, and a dramatic blue, which are all characteristic of Rongkong textiles. To achieve such clarity in the warp ikat, Toraja weavers increase the impact of the pattern by using a double thickness of warp threads. These Rongkong textiles are used throughout the Toraja region in a variety of ceremonies, and the warp ikat cloths are associated particularly with mortuary rites. In the northern region around Kulawi, however, they are also worn as layered skirts by women of high status.

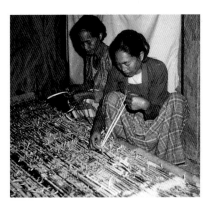

114
Unlike the usual practice in Southeast Asia, where each woman ties the ikat threads for her own cloths, the tying of the warp ikat for the huge ceremonial hangings of the Toraja is a communal activity involving a number of women working together. This group of women live in the Rongkong district.

evident throughout Southeast Asia and out into the Pacific. Sometimes it provides the dominant patterning, while on other textiles it is confined to border meanders or filling. A diagonal orientation of these patterns is a feature of ancient Southeast Asian art that is still prevalent. The hook or key is also found everywhere, as a major pattern or as ornamental detail. Schematic patterns are formed of repeated keys *108* while the same motif embellishes readily recognizable shapes drawn from everyday life. On the *palepai* and *tatibin* textiles of south *107* Sumatra, the prow and stern of the ships are formed with bold curling hooks, and on even the most stylized of the *tampan* a vague impression of the ship is maintained within the overall key patterns. In central Sulawesi, the textiles of the Toraja provide some of Southeast *111,112* Asia's most striking examples of the use of hook and spiral motifs. *113,114*

The lozenge or rhomb is a common pattern used as a separate isolated motif, as part of a continuous repeated design, or inter- *109,110* meshed and embellished with other decorative devices. The intersection of popular diagonal patterns may produce a lattice grid. As the *117,118* diminishing diamond-within-a-diamond pattern, it provides an overall twill effect on certain textiles such as the blouses of the Karen women of northern Thailand, the belts of the Toba Batak of Sumatra and the coverings of the Kalinga of Luzon. The diamond sometimes appears on its own but is also used in conjunction with hooks or V shapes. The hooked lozenge, sometimes combined with a smaller lozenge, is one of the most basic forms used to represent living creatures, both human and animal.

Many of these designs have a far wider distribution than the Southeast Asian region. One author, noting the universality of the hooked lozenge as a decorative device, has suggested that it may have originally been the woman's symbol, signifying birth (Allen, 1981), though this explanation is rarely offered by Southeast Asian textile *115* artisans. It is common for similar patterns and motifs to be interpreted differently by weavers across the region, and there are even conflicting accounts within a single ethnic group about the actual meaning of certain schematic designs.[42]

Many minimal designs are composed of the most simple arrangements of dots and dashes. Such basic patterns are painted on to bark, formed by beads and shells, and worked in simple forms of ikat and wax-resist batik. The rough handspun village batiks of Tuban on the *116* north coast of Java contain all-over patterns of dots that make a sharp contrast to the more complex and elaborate batik patterns executed on fine commercial fabric elsewhere in Java. Combinations of dashes form chevron patterns and some of the most elaborate ikat designs of the region are actually composed of dots or are filled with intricate *119* stippling.

Triangular shapes are an ancient motif in Southeast Asian art, and the narrow bands on one of the earliest dateable textiles found in insular Southeast Asia — a fourteenth- or fifteenth-century warp ikat abaca cloth from a burial site — includes double rows of small triangles (Solheim, 1981: 79; Roces, 1985: 9). The adoption of triangles into border patterns allows unlimited scope for decorative filling and elaboration. These motifs are often identified by very specific terms. To the Ifugao of central Luzon, the triangles denote rice sheaves, or when they are displayed in pairs, a dragonfly (Ellis, 1981: 224), while the people of Tanimbar identify these motifs as flags (McKinnon, 1989). Triangles are also associated with sharp and dangerous

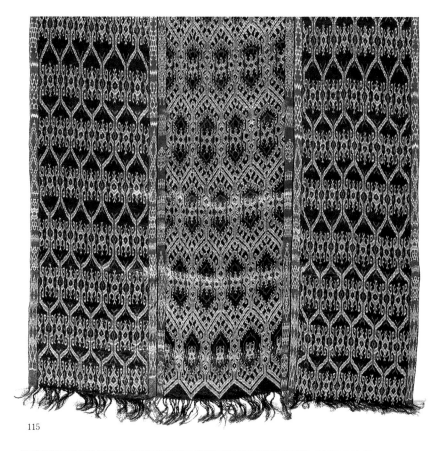

115

115 (detail)
kumo
ceremonial cloth; hanging
T'boli people, Mindanao, Philippines
abaca fibre, dyes
warp ikat
163.0 x 370.0 cm
Australian National Gallery 1984.1216

This huge abaca red, black and white hanging is composed of three recently woven panels. These textiles are especially prominent at betrothal and marriage ceremonies. The central ikat panel displays the *bangala* pattern depicting a person within the security of a house. The hooked decorations on the sides of the hexagons are likened to the roof ornaments on old traditional houses, and the figures that are enclosed within this grid represent humans (Casal, 1978). The hooked rhomb image has sometimes been interpreted as a female symbol and some of the more realistic human figures do appear to be giving birth to smaller images of the same shape. The *bangala* is also a popular T'boli tattoo pattern.

116 (detail)
kain sruwal
material for trousers
Javanese people, Nggaji, Tuban district, Java, Indonesia
handspun cotton, natural dyes
batik
150.6 x 58.0 cm
Australian National Gallery 1984.490

In the past throughout rural Java, men wore knee-length pants made of this type of cloth — locally woven, plain, checked or striped fabric known as *lurik*, which is sometimes decorated with batik patterns. An arrowhead pattern of small white batik dots, known as 'soft rain' (*udan liris*), stands out against the blue-black ground which is referred to as 'blackened' (*irengan*). The dyes are obtained from natural indigo (known in this district as *tom*) and a special type of wood (*kayu tingi*). In the Tuban district, trousers made from this type of fabric are worn by the groom as a change of dress (*salin manten*) during a wedding (R. Heringa, personal communication, 1984). Twentieth century

116

The Foundations 83

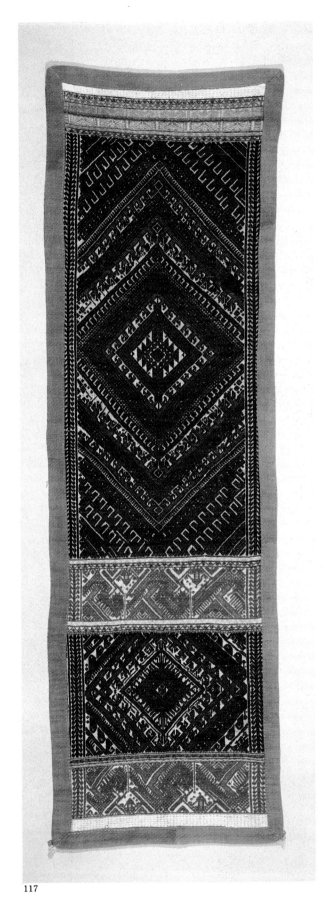

117

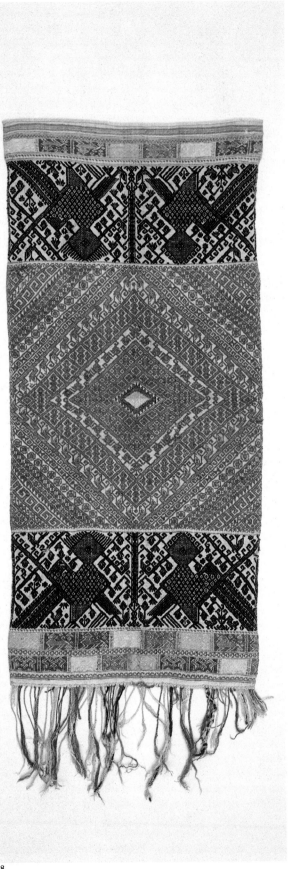

118

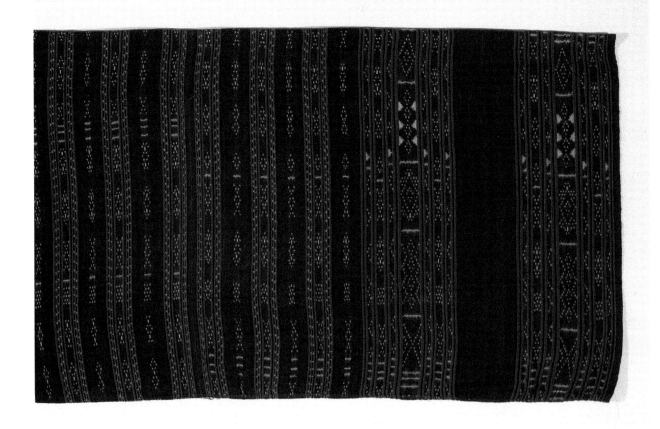

119

117
pha lo hua chang; *pha lop*
elephant's headcloth; sleeping sheet
Tai Lue people, Laos; Thailand
handspun cotton, silk, natural and
synthetic dyes
supplementary weft weave
146.0 x 45.0 cm
Australian National Gallery 1984.3191

118
pha biang
ceremonial shawl
Tai Nuea people, Laos
silk, cotton, natural dyes
supplementary weft weave
107.5 x 41.0 cm
Australian National Gallery 1987.1819

The major diamond pattern on each of
these Tai cloths is built up of
increasingly wider and more complex
patterns and reveals the endless
variations that can be developed from
a limited number of simple ornamental
designs. The mid-twentieth-century
Tai Lue textile is based on the
structure of an elephant headcloth
(*pha lo hua chang*), although recently
such cloths have been used as sleeping
sheets (*pha lop*) presented at marriage

by young women to their mother-in-
laws (P. Cheesman, personal
communication, 1989). Bound by red
fabric, it presents a bold diamond
configuration in red, blue-black and
white cotton. On this cloth the usual
plain central section is no longer
evident. Schematic animal figures and
geometric designs have been subtly
incorporated within the large hooked
diamond motifs and into the
surrounding bands of both cloths,
although the silk thread of the
nineteenth-century Tai Nuea shawl has
permitted clearer images to be woven.
Mythical creatures appear in the
borders of both textiles, in particular
the twin *naga* serpents and bird-like
creatures within the cream, green,
gold and light-blue bordering bands of
the Tai Nuea cloth.

119 (detail)
tama
woman's ceremonial skirt; ceremonial
gift
Palué people, Palué, Indonesia
handspun cotton, natural dyes
warp ikat
170.0 x 72.0 cm
Australian National Gallery 1986.1921

The warp ikat cloths from the tiny
volcanic island of Palué, off the north
coast of central Flores, exhibit bright
red and black colours which are quite
distinctive and may be influenced by
the limited sources of water on this
barren island. The combination of tiny
ikat dots, used to build schematic
patterns in bands, is a feature of these
cloths. Fine old *tama* are now rare on
Palué, and certain cloths still in the
possession of elderly women are
believed to have special healing
qualities, and are used to treat the
skin diseases that are a recurring
problem on the island. The motifs on
this twentieth-century example are
said to represent natural objects such
as corn, tubers, chickens' feet,
pig-pens and serrated knives.

objects, such as daggers and teeth, which will protect either the person wearing the cloth or the central motif it contains. This interpretation is offered by Iban weavers nowadays for the elaborate end pattern of triangular points used to enclose the field patterns on *pua sungkit* textiles. 53

These are a few of many schematic motifs and patterns that can be traced back to very early Southeast Asian art. The patterning found on prehistoric pottery and metal-work includes rhombs, keys, spirals and double spirals, circles and crosses, meanders, T shapes and triangles. These designs became part of the art heritage of the entire region and despite the passing of more than two thousand years, they are still important elements in present-day textile ornamentation. While continuity with the past is maintained, novel combinations of these ancient motifs are now evident and new motifs are often developed to incorporate them.

CLOTHING AND IDENTITY

While textiles are woven for other purposes the making of clothing is most significant. In the past the main types of Southeast Asian garments were simple and depended on each culture's definition of modesty. Certain basic social divisions — sex, age, marital status and family affiliation — are often reflected in the structure and design of clothing. There is usually a clear division between male and female, no matter how simple the structure of the textile or its decoration,[43] and these distinctions are indicated by the shape, size and structure of the garments for each sex. Formerly, men usually wore the loincloth and women wore skirts, either short or to the ankle. Clothing for the upper body was rare, although men often used shawls and wraps, and sometimes elaborate jackets for festive occasions. Babies were carried in slings and shawls, and in basketry packs. Children often went naked until they approached the age of puberty when they adopted clothing appropriate to their age and unmarried or uninitiated status. Elaborately decorated fabrics were usually intended for important occasions: as ritual objects, as clothing for significant ceremonies, or as ritual gifts. 120,121

In some places decorative technique seems to have been gender specific. The supplementary weft weaving and tapestry weave of the Toraja appears only on men's loincloths while shell and patchwork appliqué are found only on women's tunics. The use of motifs to delineate gender is less common and cloths used by men and women for everyday occasions are often similar in materials and decorative technique. In some instances certain motifs are restricted to particular textiles. For example, the warp ikat skirts of Iban women do not display powerful deities, as these are considered more appropriate motifs for their sacred ceremonial hangings. For the neighbouring Maloh, however, this is clearly not the case since the dangerous and unpredictable water serpent frequently appears on women's beaded skirts and jackets. 41,45,77

29

In many cultures, while certain motifs and colours are appropriate for different ages, these distinctions also depend upon the social and ritual maturity of the wearer. As many new patterns have begun to appear in recent decades, it is often only elderly women who continue to wear the older and thus more traditional styles of cloth while young women are allowed to experiment with motifs and

120
In the early twentieth century some more remote peoples of Laos and Cambodia were still wearing the same type of clothing as their ancestors — the loincloth for men and the cylindrical or wrapped skirt for women. This photograph taken in Laos shows a Kha man and woman wearing these garments.

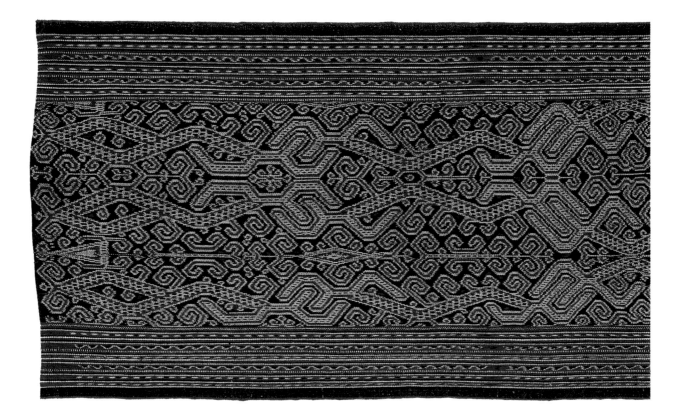

122 designs. In the Sikka region of Flores in eastern Indonesia, all women's skirts were once very long and composed of four panels. These are now rarely worn, and only by elderly women from remote
123 mountain villages. Two-panel skirts, waist to ankle in length, are now worn by everyone throughout the Sikka domain, although the long multi-panel skirts are still widely valued as an important form of bride-
124 wealth in Sikka and neighbouring Lembata.

The manner of wearing traditional clothing and the choice of textiles to be worn, varies according to age and experience, and these are important factors for determining status in many societies. In eastern Flores and the Solor archipelago, young unmarried women wear their skirts tied by a string around the neck or pinned at the shoulders, young married women wear their skirts up around the breasts and mature women fold them around the waist (Maxwell, 1981: 62). Similar rules often apply to particular garments. Among the Kankanay of Luzon, while jackets are appropriate for young women, new mothers do not wear them because this would indicate that they do not care for their offspring or their new status (Ellis, 1981: 237). Similar ways of differentiating between garments according to age and status are also found in mainland Southeast Asia.

Ritual experience and wisdom, to a large part a function of age, is sometimes indicated by distinctive textile decoration. The colour, the structure of the designs and the use of ritually important motifs are often related to a strict hierarchy in the making of cloths. Only those women of social and ritual maturity may attempt to create certain motifs, perform certain types of weaving, or process particular dye-stuffs (Vogelsanger, 1980; Maxwell, 1981: 53; Maxwell, 1985: 145–53). Such restrictions are especially important in the case of ritually significant textiles.

121 (detail)
kain kebat
woman's skirt
Iban people, Sarawak, Malaysia
handspun cotton, natural dyes
warp ikat
51.5 x 117.0 cm
Australian National Gallery 1982.2305

Within the warp ikat traditions of Southeast Asia, the length of women's cylindrical skirts varies considerably. Some garments are worn folded, while others allow maximum movement and reach only to the wearers' knees. The Iban skirt falls into this latter category and is held in place with hoops of rattan, and on festive occasions with silver belts and coin chains. On this early twentieth-century example the clarity of the red, brown and natural warp ikat indicates the work of an already accomplished weaver, although the weaving of a *kain kebat* usually occurs at an early stage in a woman's career before she undertakes the more prestigious and ceremonially important *pua*. The motifs on these skirts are selected from nature and usually include various small creatures and plants. Although this skirt consists of only a single woven panel, it still displays a common Southeast Asian design feature — a central section enclosed by narrow striped bands.

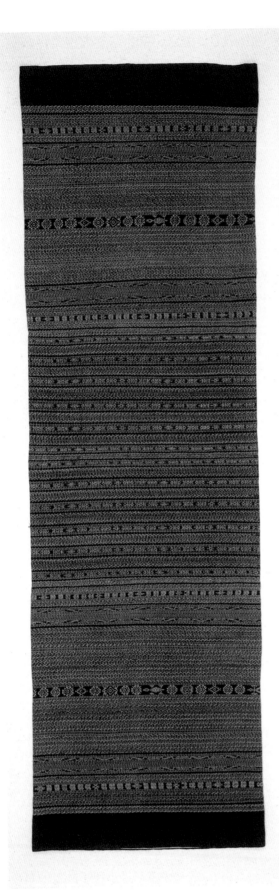

122

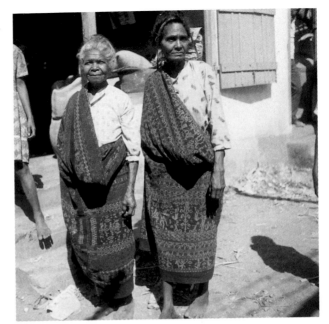

123

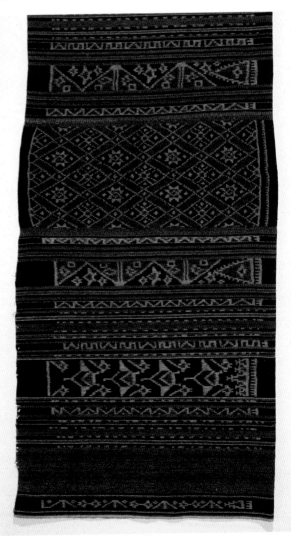

124

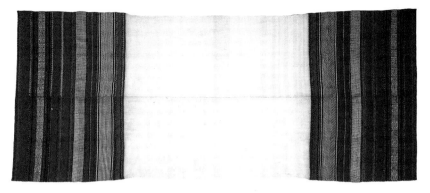

125

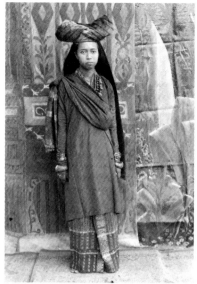

126

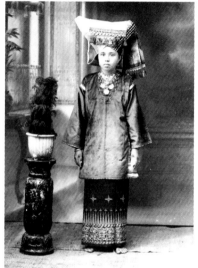

127

122
utang lian lipa
woman's skirt; ceremonial gift
Sikka people, Iwangeté district, Flores,
Indonesia
cotton, natural dyes
warp ikat
219.0 x 135.5 cm
Australian National Gallery 1981.1144

Four-panel, bride-wealth cloths are a
category of Sikka textiles generally
known as *utang wiwir wanan* or *utang
wata hutung* ('four joined together')
and are still made in some parts of the
Sikka domain. This example, from the
mountainous Iwangeté area, has
narrow, banded, warp ikat designs
which are in marked contrast to the
larger, wider, ikat patterns on
two-panel skirts. The widest of the
bands (*ina geté*) contains several
different motifs including the lizard
(*teké*), the circle under a plate (*pigang
uben*), the pineapple flower (*petan
puhun*) and the spinning-wheel (*jata
selér*). Another motif appears to be a
human figure with a child. The
patterning of this skirt (*utang*) is
apparently associated with the spirit of
the snake, suggested by its special
name *lian lipa* ('the snake-like
pattern'). Twentieth century

123
The two-panel Sikka skirt is generally
known as an *utang hawatan* (a single
skirt, as distinct from the double
length of the older style *utang wata
hutung*). The shorter skirt is now
widely worn with a blouse. The skirt
has a number of design structures
each with its own name.

124 (detail)
petak haren; kewatek nai telo
woman's skirt; bride-wealth gift
Lamaholot people, south Lembata,
Indonesia
handspun cotton, natural dyes
warp ikat
153.0 x 115.0 cm
Australian National Gallery 1984.1239

These long skirts of southern Lembata
are no longer prominent as women's
ceremonial costume. Nevertheless, the
red-brown textiles are still highly
valued items in the circulation of
bride-wealth that accompanies
marriage and other rites of passage,
particularly funerals. At such
ceremonial gatherings the participants
restate their kinship alliances through
appropriate male and female gifts.
Skirts intended for marriage gifts must
be worked only in handspun cotton and
natural dyes. Since these valued
textiles are stored between use, rarely
worn, and never washed, bright but
fugitive colours — such as the
turmeric yellows and greens, and pale
unsaturated pinks and blues — are
frequently included. The patterning of
the central field is a sign of the
weaver's clan membership and the
motifs are drawn from family
heirlooms. The banded borders include
the giant ray (*mokum*) and the boat
with paddles (*téna*). These are
important symbols in the coastal
whaling community of Lamalera, and
indicate that this cloth was probably
woven there. Mid-twentieth century

125
tengkuluak
woman's headcloth
Minangkabau people, west Sumatra,
Indonesia
silk, cotton, natural dyes, gold thread
supplementary weft weave
246.0 x 103.0 cm
Australian National Gallery 1984.3187

This nineteenth-century
supplementary weft headcloth still
retains the strong banded elements of
early Southeast Asian design using
red, white and gold threads. Like
many Minangkabau headcloths, cotton
is used for the warp threads and also
for the weft threads in those sections
of the textile hidden from view when it
is worn folded.

126 and 127
These early twentieth-century
photographs illustrate the
characteristic buffalo-horn shape of the
head-dress worn as ceremonial
costume by Minangkabau women.
Each subdistrict of the west Sumatran
highlands has its own method of tying
the *tengkuluak*. The woman in Plate
126 is from the Payakumbuh district,
while the woman in Plate 127 wears
her *tengkuluak* in Padang Panjang
style. In addition to these regional
differences, at marriage ceremonies,
the selection and arrangement of the
headcloth and shouldercloth also
indicate the marital status of the
wearer and her relationship to the
bride or groom (Ng, 1987).

The most ancient social systems are those based on descent — family, lineage, clan or moiety. These vary from place to place and may emphasize affiliations with either paternal or maternal relatives, or in some cases follow both descent lines. In those societies where great stress is placed on family alliances, particularly during participation in ceremonies, the signs of a person's family membership are frequently indicated by his or her apparel, especially that reserved for ritual occasions. At such ceremonies, the linch-pin of appropriate behaviour is the relationship by birth or marriage between those present and it is important to establish lineage membership.

On some textiles certain patterns or the structure of the designs indicate the ancestry of the wearer, and motifs belonging to a particular family or group are confined to its members. Threats of dire consequences are often made if these restrictions are transgressed. In the Lamaholot areas of east Flores and the islands of Solor, Lembata and Adonara, the family affiliations of the maker or wearer are identified by certain motifs in the widest band or central panel of warp ikat (R.J. Maxwell, 1980). On Savu, where the population is split into two along maternal lines, the two moieties wear skirts with slightly different design structures, and the finer subdivisions of the moiety are revealed in the main warp ikat decorative band (Fox, 1977a: 98–9; Maxwell, 1985: 145–7). The women of Savu also make men's cloths that show quite different banded designs for each moiety.

Even in societies with bilateral family arrangements, textiles also play a significant role at times of marriage and death. Here the

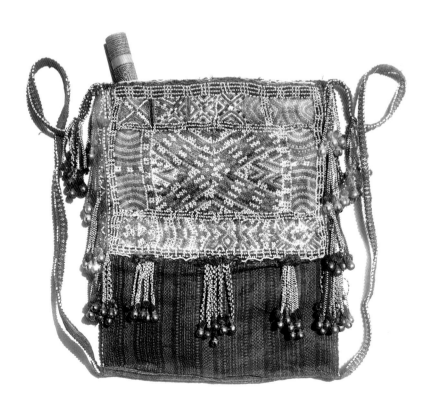

128
cabir (?)
bag for betel-nut and tobacco
Bagobo people, Mindanao, Philippines
abaca fibre, beads, brass bells
supplementary warp weave, appliqué

This early twentieth-century Bagobo betel-nut bag displays an elaborate geometric beaded design. It was photographed in Mindanao.

129
The ceremonial exchange of betel-nut is an important part of the protocol that is observed at the meeting of traditional rulers throughout Southeast Asia. This mid-twentieth-century photograph from Timor shows two Atoni or Dawan rulers in full costume and regalia.

128

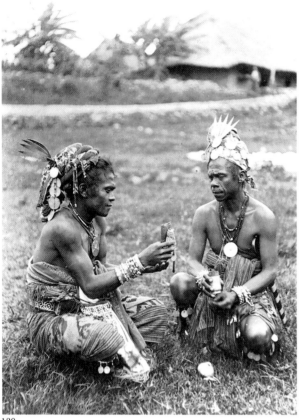

129

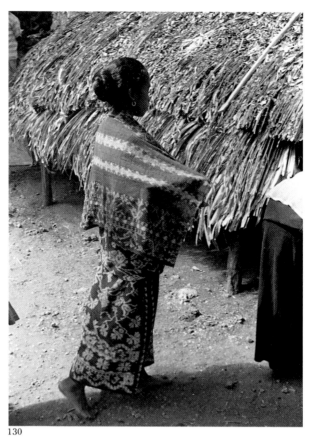

130

focus is on the display of wealth through the magnificent hangings that the extended family can muster for these occasions. Among the Minangkabau of Sumatra the relationships of the female guests to the bridal couple are indicated by the choice of specific garments and the way clothing is arranged, especially the shawl and headcloth (Ng, 1984: 22–38; Ng, 1987: 185–203).

Since the chewing of betel-nut as a stimulant began in prehistoric Southeast Asia, the paraphernalia associated with the custom also has a very long history.[44] Elaborate boxes, bags and wraps were devised to carry, store and offer the raw materials of nuts, sirih leaves and lime which are combined to create a mildly euphoric effect. The accoutrements of betel-nut chewing also developed ceremonial significance, and betel-nut is essential in most offerings to gods, ancestors and spirits. Weavers and dyers in Savu, for instance, place offerings that include betel-nut in the roof of the house — the dwelling place of benevolent deities — and at the corners of the loom or ikat tying-frame to distract or repel any mischievous spirits who might meddle with the threads (Maxwell, 1985). In Borneo, the Iban shamans use the flower of the sacred areca palm for augury and the betel-nut is a part of the offering covered with a magical *pua* textile. Beautiful betel-nut bags are part of the grave goods of a great ruler in Timor and Sumba.

In many Malay and Indonesian languages, the term *pinang*, meaning 'to offer betel-nut', is synonymous with courting and the formal request for a woman in marriage when, often in ceremonial

130

A young Rotinese woman visiting the house of her male relative's fiancée, as part of the betrothal ceremonies. Both the woman and the box of betel-nut ingredients that she carries are wrapped in the *sidi ana soka* (or in some parts of Roti, *sidi aba dok*), a short cylindrical textile now solely reserved for this occasion.

The *sidi ana soka* cloth is an unusual but important Rotinese traditional textile woven for this one specific purpose. Formed from two narrow panels into a short but uncommonly wide cylinder, it is designed to cover the head and shoulders of the bearer of symbolic betel-nut during the betrothal ceremony. *Soka* and *dok* are Rotinese terms for *gebang* (J.J. Fox, personal communication, 1986), and this suggests that this ritual fabric was originally made from the fibre of the *Corypha gebanga* palm. This material is used today in Roti to tie ikat patterns on to cotton warp threads.

131
............
lidded box for betel-nut ingredients
Lampung, Sumatra, Indonesia
matting, beads, fibre
interlacing, bead appliqué
14.0 x 22.0 x 18.0 cm
Australian National Gallery 1984.587

132
............
ceremonial betel-nut bag
Sumbanese people, east Sumba,
Indonesia
cotton, beads
beading
35.0 x 56.0 cm
Australian National Gallery 1986.1248

133
alu inu
betel-nut bag with lime container
Atoni or Dawan people, Timor,
Indonesia
cotton, bamboo, beads, horsehair,
coins, brass bells
beading, appliqué
15.0 x 22.0 cm; 12.0 x 14.0 cm
Australian National Gallery 1984.583

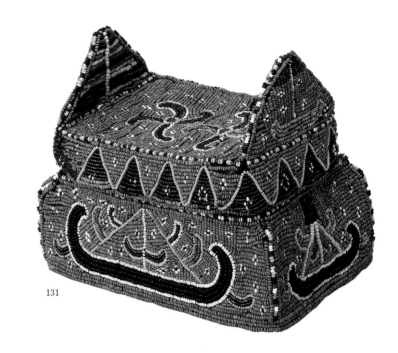

131

The shape of the beaded betel-nut box
from Lampung suggests both the
curved roof form of many Sumatran
houses, and the ship-of-transition, a
motif that also appears in coloured
beads on each side against the orange
ground of highly valued *muti salah*
beads. Boxes of this shape were also
made from brass and precious metals
and these containers are placed on or
covered by a special textile such as a
tampan. This example, like the other
Indonesian betel-nut containers, seems
to date from the late nineteenth
century.
Elaborately decorated textiles and
beadwork are included among the
possessions of the noble families of
Sumba and Timor, and ancient
symbols such as chickens and reptiles
are frequently depicted on these
treasures. Red, black and white beads
are common in several parts of
Southeast Asia but the Atoni betel-nut
bag and lime container with its
horsehair fringe is also decorated with
coins issued by the Dutch trading
company (Vereenigde Oostindische
Companie, VOC) period in the
seventeenth century.

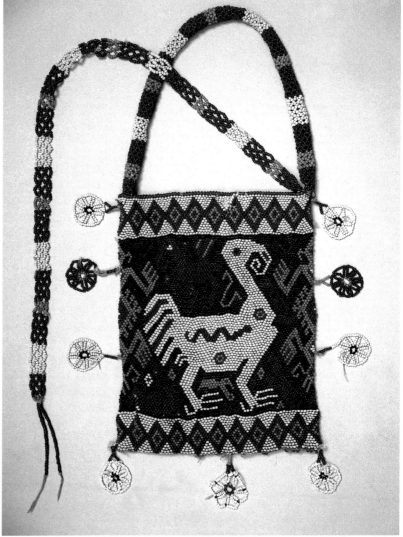

132

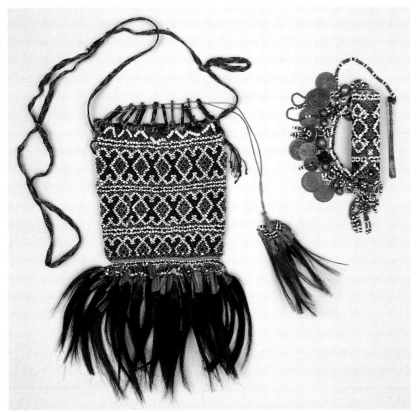

133

procession, the groom's extended family visit the home of the bride or her superior male relative.[45] Special textiles are sometimes used to envelop the betel-nut or the bearer. Beaded boxes were often reserved for serving betel-nut at home, while more portable textile pouches with drawstring straps carried betel-nut ingredients, or in more recent times tobacco, when travelling. In the northern mainland regions of Southeast Asia shoulder-bags are an important item of clothing. Special boxes and bags, including many made from fabric, are a common part of a family's heirloom treasures all over Southeast Asia.[46]

TEXTILES AND THE DUAL ASPECTS OF THE COSMOS

There are certain fundamental aspects of the social order that continue to affect the use of textiles throughout much of the region. Some prehistorians suggest that the concept of cosmic dualism, the division of the universe into two orders, was already formed by the Metal Age (Bellwood, 1985: 156). In societies where this form of dual organization developed, daily routines and ritual activities are ordered into two complementary yet opposing parts basically defined as male and female.

Early political systems were small scale with rank dependent on descent from the founding ancestors and from personal achievements in socially significant activities such as head-hunting, textile-making and agriculture. Status, particularly in groups that focus on unilateral descent, is still established largely according to relative superiority or dependence in marriage relationships, with the wife-giving group, the

family of the bride, in a ritually and socially stronger position than the wife-takers, the groom's kin. The wealth exchanged at the establishing of marriage alliances in many Southeast Asian societies is consistent with this dual cosmic ordering and is made up of distinct but complementary male and female valuables.

Since textiles are the products of women, they are understood as tangible representations of the female elements of the bipartite universe. On Sumba this male-female complementarity is encapsulated in the notion of the Highest Being who is the Father Sun–Mother Moon and the Creator of Human Life–Weaver of Human Life (Adams, 1969: 29). Although different cloths are appropriate apparel for men or women, textiles are seen collectively as a female component, along with the Lower World, darkness, inside, left, moon, and death. Cloth is a symbol of the woman's family, the wife-givers, who are ritually superior on ceremonial occasions.[47] Female aspects of the cosmos oppose yet complement the male characteristics of the Upper World, light, outside, right, sun, and life. In ritual exchanges textiles are a prominent part of the reciprocal gift for male objects such as metal, ivory, and buffalo from the man's family, whose burden in gift-giving is heavier because of the inferior status of the wife-takers.

In social settings where marriage alliances between families are reiterated, especially at mortuary ceremonies, gifts between marriage partners are very common, and textiles and metal goods or cattle are again exchanged. For example, at a funeral amongst the Lamaholot of east Flores and the Solor archipelago, the family of a deceased male leader will bring ivory to pillow the head of the dead, while the family of his wife will bring grave-gifts of valuable textiles to cover the body. The division of material objects into male and female types at marriages and funerals applies also in non-weaving regions, with textiles as appropriate female presentations from the wife-givers and goods associated with maleness such as metal, sailing equipment, or tusks from the wife-takers.[48] Within these two broad, dual categories for objects, further subdivisions into complementary male and female objects may be integrated, with gifts formed, for example, from pairs of male and female buffaloes, or paired men's cloths and women's skirts.

This pattern of exchange and reciprocity is found throughout much of Indonesia and also in parts of the Philippines. Among the T'boli of Mindanao during the *mo'ninum*, the final feast to celebrate a marriage, the groom's family builds an umbrella-like structure known as the *tabulé*, using spears and bamboo decorated with valued heirlooms which are part of the bride-price payments: mats, horse-bridles, gongs, and ancient Chinese plates. Meanwhile, the bride's family hangs the *kumo magal* from a long bamboo line. This consists of masses of special, three-panel warp ikat cloth (*kumo*) which will be [8,68] the reciprocal gift. The culmination of the ceremony involves the groom's family wielding the *tabulé* to symbolically penetrate the *kumo* wall, after which the remainder of the ceremony and exchange of gifts takes place within the bride's home (Casal, 1978: 82–4). Another Mindanao society, the Maranao, have continued this custom with the bridegroom 'entering' a large canopy to claim his bride (Roces, 1985: 3).

In ceremonial gift exchanges there is often a hierarchy in which some types of textiles of more complicated design and larger size are rated as having more value. The choice of cloth to be presented at

Toba Batak weddings, however, is determined by a potential wearer's age and status in the wider family group, the seniority of the giver and by the closeness of the family ties between giver and receiver. The parents of the bride wrap the seated couple in a highly valued cloth such as an *ulos ragidup*, while distant uncles and aunts of the bride cover them in textiles of lesser ceremonial value (Gittinger, 1975: 22–6; Niessen, 1985a: Chapter 2). Upon the arrival of a grandchild, it is the maternal grandparents who envelop the child in a ritual carrying cloth, the *ulos mangiring*. As we shall explore below, the use of textiles in these rites evokes their protective qualities, a common and ancient property. None of these cloths is specifically associated with a lineage, a family or even a village of origin and they are all widely used throughout the Toba Batak area.[49] For these people, *ulos* gifts, predominantly textiles, are always associated with the wife-giving group and *pisau* (knife) gifts, which now include rice and land, come from the wife-receiver's family and each is a sign of the support and protection that the marriage alliance affords each party.

This same male-female dichotomy is symbolically reflected in fine detail by the different directions in which men and women in certain cultures wind their hair, and wrap their headcloths and skirts.[50] The diagonal spiral patterns of central Javanese batik, known as *parang*, are arranged to slope in one direction for men, and in the opposite for unmarried women (Geirnaert-Martin, 1983). In east Sumba the fundamental understanding of these opposing characteristics — male-female, right-left, life-death — results in the inversion of everyday principles for the cloths associated with the dead.[51]

While these opposing categories are seen most vividly in societies that trace their descent unilineally, the metal-textile dichotomy has wider application in Southeast Asia. Symbolic structures incorporating both male and female elements, such as cosmic trees constructed from metal spears and complementary textiles and mats, are found throughout the region. They are evident, for example, amongst the cognatic peoples of Borneo and the patrilineal Sumbanese. Heavenly staircases of swords and cloth are part of the ritual of both the peoples of south Sumatra who have bilateral family patterns and the patrilineal Mien (or Yao) of northern Thailand.[52]

Perceptions of cosmic dualism that include the division of the universe into Upper and Lower Worlds inform the ancient depictions of animal life in Southeast Asian art. Birds and flying creatures of the Upper World are juxtaposed with aquatic creatures of the Lower World such as fish, lizards and crocodiles, snakes and sea-serpents. Depictions of animal life have similar connotations elsewhere in Southeast Asia, for this is the form that the founding ancestors often assume in legend and in art.[53] Representations of animals and reptiles on ceremonial cloths clearly symbolize important identities from their spirit world.

The Sumbanese of eastern Indonesia believe a person is able to acquire the special powers and qualities of certain creatures when textiles displaying such motifs are worn. Particular animal patterns are equated with the characteristics of royalty and are depicted on those Sumba textiles and jewellery to be used by members of the Sumbanese ruling class, the *maramba* (Adams, 1969: 129–43). The identifiable creatures that appear on royal Sumba textiles include chickens or cocks (animals of ritual sacrifice), the deer with large spreading antlers (a symbol of royalty who also wear an upright,

15

134
lau hada
woman's ceremonial skirt
Sumbanese people, east Sumba,
Indonesia
cotton, mud dye, shells, beads
tabby weave, needle-worked fringe,
beading
158.0 x 62.0 cm
Australian National Gallery 1984.1246

Both real and imaginary reptiles are
favourite images on the most ancient
of textile techniques in Southeast Asia
and the beadwork of Sumba provides
many striking examples. This creature
(or creatures?) has multiple legs and
appears to have two heads. According
to the documentation attached to a
similar beaded skirt collected in 1883
after the Colonial Exhibition in
Amsterdam (Rijksmuseum voor
Volkenkunde, Leiden 370–3767), the
creature is tentatively identified as a
scorpion. Its bold white shape is
outlined in bright red, blue, orange
and green beads.
Black mud-dyeing is probably one of
the oldest techniques in Southeast
Asia and can still be found in a few
places, including Lombok, central
Sulawesi and Sumba. In each case it
appears to be the woven cloth rather
than the threads that are treated. A
hot mud process is used in Sumba to
dye certain types of women's skirts
(*lau*), including those to which bands
of heirloom beads (*hada*) are later
added. The fringe of a cloth can be
made during the weaving process or it
can be added later with a needle.
Although fringes usually appear at
either end like the cut warp,
needle-inserted fringes decorate the
surface of the fabric on this type of
lau hada. Thus two forms of designs
are formed on the same mud-dyed
ground — one in the brightest beads
and shells and another in a dark
embroidered fringe. Late nineteenth or
early twentieth century

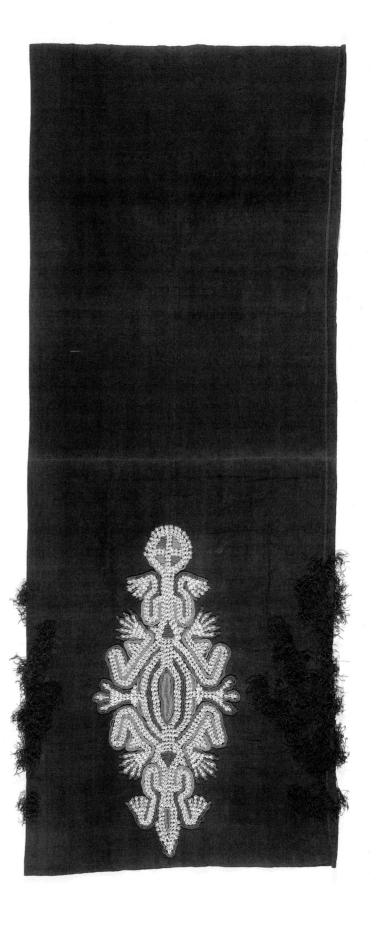

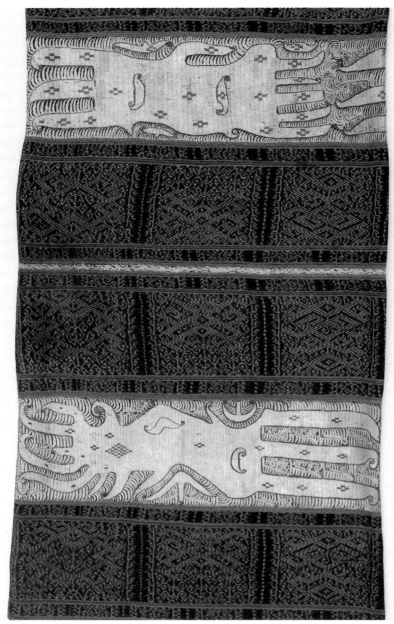

135

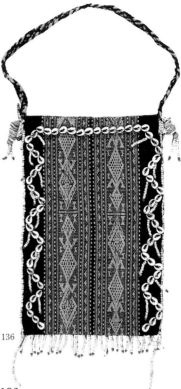

136

135 (detail)
tapis
woman's ceremonial skirt
Paminggir people, Lampung, Sumatra,
Indonesia
silk, handspun cotton, natural dyes
warp ikat, embroidery
65.5 x 127.0 cm
Australian National Gallery 1980.1633

The mature and careful weaver can
harness the very qualities and power
that make certain spirits, animals and
insects so dangerous to humans.
However, the original meaning of the
ambiguous motif appearing in the
embroidered bands on this Lampung
textile is now unknown. The presence
of small creatures within the larger
squid-like form suggest that it may
have been one of the imaginative
Paminggir monsters also found on the
tampan cloths. In other renditions of
this type of embroidered skirt these
motifs appear to be stylized human
forms. The base fabric of this
nineteenth-century textile is decorated
with bands of warp ikat.

136
alu mama
betel-nut bag
Atoni or Dawan people, Timor,
Indonesia
cotton, shells, beads, natural dyes
supplementary warp weave, appliqué
53.0 x 21.0 cm
Australian National Gallery 1986.1250

In Timor, the great crocodile motif
(*besi mnasi*) is based upon a creature
of central importance in ancestral
legends. Offerings are made to
appease the crocodile spirit, and this
always includes the ingredients for
betel-nut chewing. This twentieth-
century woven betel-nut bag also
displays rhomb, spiral and key motifs
in indigo and white, with subtle stripes
of other natural colours, and illustrates
how shells and beads are used as a
subsidiary element to provide finishing
decoration to textiles.

branching, golden head-dress), and the shrimps who shed their shells in a process of renewal (symbolic of a ruler's powers).

Crocodiles, pythons, and predatory beasts are linked in east Sumba with the ruler whose power over life and death is unquestioned. However, the relationship of mortals with such potentially dangerous creatures is often ambiguous, so the crocodile and snake are both symbols of danger and symbols of protection throughout many parts of Southeast Asia. When these creatures appear on cloths used as funeral shrouds they are invoked as figures of the Underworld to secure safe passage for the dead to the next life.

Birds, also significant in legend and ritual, are widely depicted in textile iconography as the domestic fowl, various exotic species of bird from the natural world, and mythical winged creatures representing the gods, spirits and ancestors who inhabit the Upper World and frequently assume these guises. At their most important rituals, especially those connected with male prestige and head-hunting, the Iban prepare a carved and painted effigy of the mighty hornbill. This is known as a *kenyalang*, and is associated with the legendary god of war and supreme augury bird-deity, *Lang Singalang Burong*. On occasions when the *kenyalang* is displayed in his honour, textiles are always present. A bird identified as the hornbill also often appears on various art forms, including mats, textiles and carving, in other parts of Borneo and in the Lampung region of Sumatra. Another ancient textile motif is the domestic fowl, a part of Southeast Asian village life in prehistoric times which remains a minor but essential sacrificial animal in many family and community ceremonies.

Colours are also a part of the ancient Austronesian dualism that has ordered conceptions of the universe. Black is often associated with the left and with femaleness, while red is associated with the right and maleness. Hence red is the suitable colour for a warrior's outfit. While the application of these colours reflects the availability of dyestuffs during early history, the significance of these colour categories can still be detected in Southeast Asian costume. For example, in the Thai court of the late Ayutthaya period, the right-hand guards wore red and the left-hand contingent wore black (Terwiel, 1983: 11); and at the court of Bima in Sumbawa, the Sultan's troops wore red as a sign of bravery, while his civil retainers wore blue-black (Hitchcock, 1985: 19). Throughout Southeast Asia, it is common to find that red is the favoured colour for ceremonial costume while black is used for everyday apparel.[54]

Red, black and white threads twined together into yarn form a symbol of the unity of the cosmos and the divergent or conflicting forces it encompasses. Bundles of these threads are used as magic talismans by the Balinese and the Bataks of north Sumatra, and a jacket of red in northern Thailand is adorned with a black and white cross which is believed to lengthen the wearer's life (Campbell et al, 1978: 37). Certain Balinese offerings are only considered complete when they incorporate both black and red sacred *geringsing* double ikat textiles.[55] The Karo Batak of north Sumatra, on the other hand, believe that the tricolour threads represent the three elements that form the foundations of their social structure. The intertwining of threads of the three colours (*benang tiga rupa*) symbolizes the ideal unity and co-operation which should exist between a family and its bride-givers and bride-takers, since no ceremony can be properly and effectively performed without the presence of these three essential elements of the Karo kinship system.[56]

134

135,136

137

138

15,139

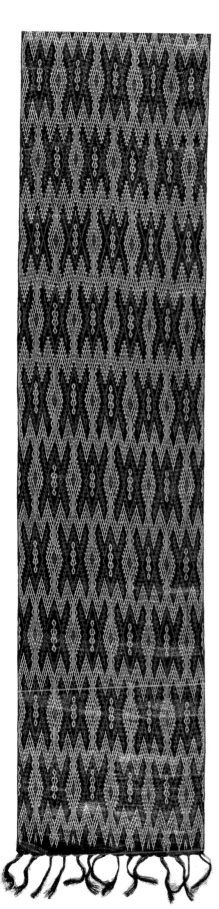

137

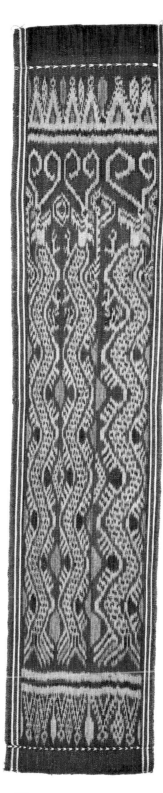

138

137 (detail)
kumo
ceremonial cloth; hanging
T'Boli people, Mindanao, Philippines
abaca fibre, natural dyes
warp ikat
766.0 x 57.0 cm
Australian National Gallery 1984.1217

The birds depicted on Southeast Asian textiles are often legendary creatures. The stylized motif on this mid-twentieth-century ceremonial hanging is said to be a large bird with great flapping wings (*g'mayaw*) that possesses the power to make the observer dizzy. This is not a bird familiar to village Mindanao but is known only to the ancestors and today 'is seen only from afar' (Casal, 1978). This long single panel with a plaited fringe is a recent fine example of abaca ikat.

138
tambai gawai
ceremonial banner
Iban people, Sarawak, Malaysia
cotton, natural dyes
warp ikat, twining
122.4 x 26.4 cm
Australian National Gallery 1981.1111

Long banners (*tambai*) are hung from a *kenyalang*, the carved wooden representation of the mighty hornbill at important Iban festivals (*gawai*) connected with male prestige and head-hunting. This is one of three banners, collected in the Baleh region of Sarawak in 1950 by Emeritus Professor Derek Freeman and Monica Freeman. It shows three mythical water serpents (*nabau*).

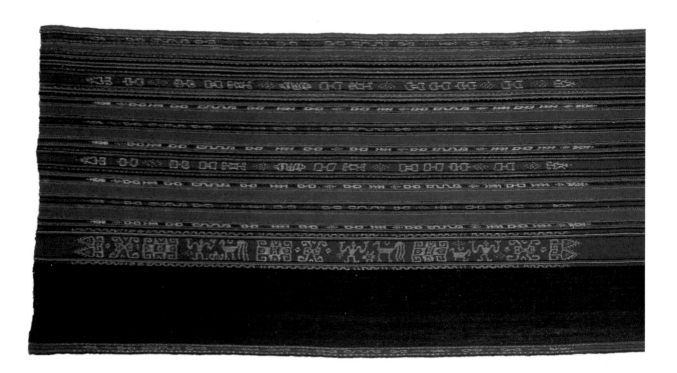

139 (detail)
homnon
cloth for a woman's skirt
Kisar or Luang, South Maluku,
Indonesia
handspun cotton, natural dyes
warp ikat
69.4 x 260.5 cm
Australian National Gallery 1984.606

The major bands of warp ikat on this length of cloth contain motifs representing the domestic fowl, as well as human figures and schematic star motifs. These motifs are known generally as *rimanu* in this region (Jasper and Pirngadie, 1912b: Plates 26–7). Although the exact meaning of the term is unknown, in many Austronesian languages *manu* is a word used for the domestic chicken. Such designs were only worn by local leaders and their families. This early twentieth-century textile was taken as a souvenir to the Netherlands and so was never cut and formed into a woman's cylindrical skirt as the weaver had intended. In south Maluku, women of the small island of Luang specialized in weaving and their cloths were traded to the more arable neighbouring islands. It is possible that this early twentieth-century cloth was made there where it would be known by the ancient Austronesian term *lawar* or *lavre*, a name for skirts which has wide currency elsewhere in eastern Indonesia, and is related to the Hawaian term for skirt, *lau*.

WARFARE AND WEAVING, TALKING AND TEXTILE-MAKING: COMPLEMENTARY RITES OF MEN AND WOMEN

Head-hunting was an important ritual central to life in many societies and was believed to be a way of generating fertility and prosperity.[57] The taking of heads to re-establish equilibrium and well-being after death or disaster still features prominently in the legends of many ethnic groups. Head-hunting and the rituals of warfare provide important symbols that establish cosmic order and represent the social well-being of society. Such symbols are evident on many objects including textiles. In east Sumba, the most striking example is the skull tree (*andung*) that stands in large villages. The *andung* pole, hung with skulls and firmly embedded in a stone platform, stood as a central altar for head-hunting rites associated with agricultural increase and inter-village warfare, and it is often re-created in detail on the warp ikat and supplementary warp textiles of the area (Adams, 1969: 130–1; Adams, 1971a: 32). *140*

Iban textiles associated with head-hunting rituals contain many powerful motifs. Nineteenth-century examples of *pua sungkit* show *142* the severed trophy skulls (*antu pala*) hanging from branches. These designs are a vivid depiction of the fruitfulness of past expeditions, and were an ideal symbol on textiles used by ritually important women to receive and cradle newly acquired heads when Iban warriors returned from successful raids. Heads were not only trophies demonstrating success in warfare; they became fertility metaphors — both agricultural and human. In an Iban legend the mighty *Lang Singalang Burong* splits an enemy skull and from it pours seeds which when planted yield a human crop (Freeman, 1979: 233–46).

Other Southeast Asian peoples, such as the Ifugao of Luzon and the various Dayak groups of Sarawak and Kalimantan, stored captured heads, and these were displayed during preparations for war

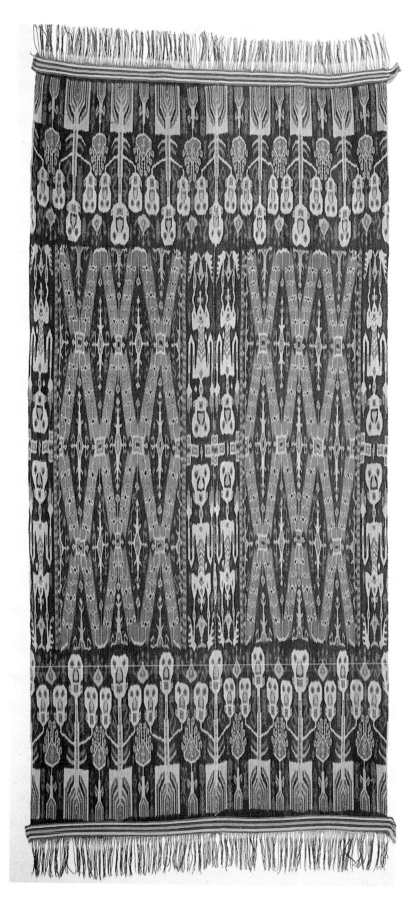

140
hinggi kombu
man's cloth
Sumbanese people, east Sumba,
Indonesia
cotton, natural dyes
warp ikat, weft twining, staining
304.0 x 127.0 cm
Australian National Gallery 1984.1240

The bold use of a large, diagonal,
central pattern flanked by elongated
male figures contributes to the
striking vertical effect of this *hinggi*
design. The major motif at each end is
the *andung*, a tree-like structure on
which the skulls of vanquished enemies
are hung. This twentieth-century cloth
is worked in natural red and blue
vegetable dyes with some additional
yellow staining.

141

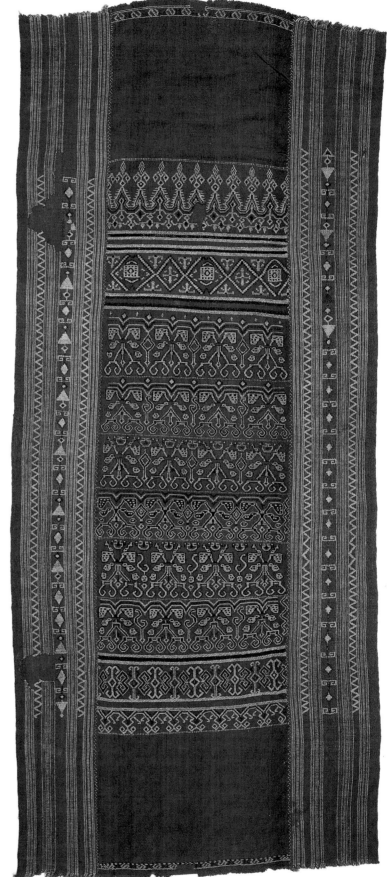

141
sawal and *k'gal saro*
trousers and jacket for a warrior
Kulaman people, Mindanao, Philippines
abaca fibre, natural dyes
stitch-resist dyeing
Field Museum of Natural History,
Chicago 129644; 129645

In this unusual resist technique, the
motifs are stitched on to the abaca
fabric before the cloth is dyed. Items
of costume in these rich red-brown
dyes and with intricate designs were
reserved for successful head-hunters,
and among the lozenge and spiral
motifs, human figures appear to
symbolize past or future victims.

142
pua sungkit
ceremonial cloth
Iban people, Sarawak, Malaysia
handspun cotton, natural dyes
supplementary weft wrapping
88.0 x 210.0 cm
Australian National Gallery 1980.1659

A powerful nineteenth-century *pua
sungkit* depicts the severed
trophy-head design (*antu pala*),
associated with head-hunting
expeditions, longhouse prosperity and
Iban notions of fertility. The motifs
have sometimes been identified by
Western observers as depicting the
great Iban patron god of war, *Lang
Singalang Burong*, hung with skulls.
However, even the most ritually
experienced weaver would not dare to
depict that legendary warrior-ancestor
on a *pua sungkit*, the Iban textile type
synonymous with power (M. Heppell,
personal communication, 1987). The
six rows of *antu pala* motifs have been
worked in supplementary weft
wrapping technique against the rich
maroon ground, and those sets of

142

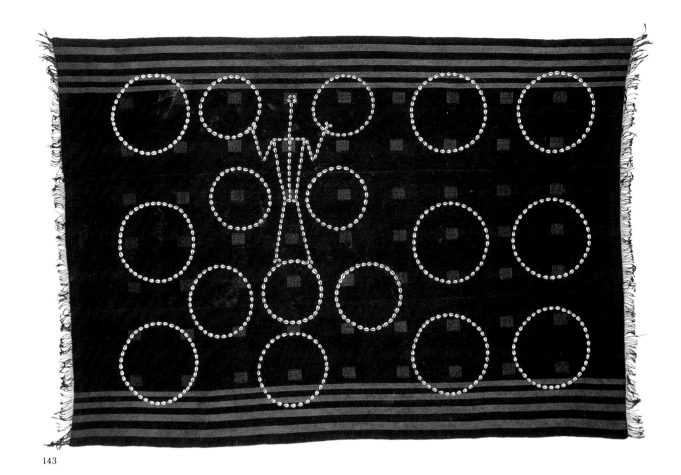

143

and at fertility rites during the agricultural cycle. The Naga of western Burma also believed that success in head-hunting would harness the essence of enemies' souls and ensure agricultural abundance (Hutton, 1928). For men in such societies, status was originally achieved through prowess in warfare and this was recognized and displayed by the wearing of special costume (Femenias, 1984: 50–1). The Bagobo and Kulaman of Mindanao also had certain items of apparel — stitch-resist jackets and pants, and tie-dyed headcloths in rich red-brown blood colours — that were only worn by warriors who had taken an enemy head.

Warfare required fine regalia and special protective clothing. Twining was frequently the medium for hunters' and warriors' jackets and these are still found in a few isolated places. The tightly twined jackets of Flores, Sulawesi and Borneo were all intended to deflect enemies' blows. In Borneo, institutionalized inter-tribal fighting and head-hunting led to an amazing range of war jackets made of woven fibre and thick cotton, quilting, embroidered bark, skin, rattan, beads, shell discs of various shapes and sizes, and even anteater scales (Avé and King, 1986: opp.16; Khan Majlis, 1984: 326–32, 342–3). On the most elaborate Iban warp ikat cotton jackets and coats, twining and tapestry weave are employed for the bright medallions and border trim, and in Timor the intricate twined and tapestry-woven accessories of the *méo* warriors are some of the finest textile work from that island. The Ifugao of Luzon make twined jackets with a technique similar to macramé.[58] These jackets, and the hairy backpack (*bango*), seem to be associated with hunting and with ceremonies

Margin references: 143, 141, 58, 144,145 146, 59,60

trophy heads worked predominantly in dark indigo are more prominent than those worked in buff undyed thread. The triangular end patterns depict the coiled python (*leko sawa*).

143
............
man's shawl
Naga people, north-east India
handspun cotton, natural dyes, shells
supplementary weft weave, appliqué
168.0 x 110.0 cm
Australian National Gallery 1986.1923

The sombre black and brown warp stripes on this nineteenth-century Naga warrior's shawl provide an appropriate contrast for the white shell appliqué. The circular motifs are believed to represent the moon, a propitious symbol for head-hunting raids, while the human figures are intended to indicate the tally of his victims and act as omens for the future. Small checkered badges of red supplementary thread are scattered across the surface. These shawls are used by local chieftains and their families, and the precise arrangement of the stripes indicates the rank of the wearer.

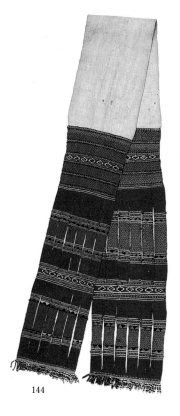
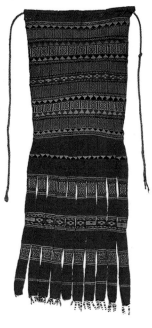

144

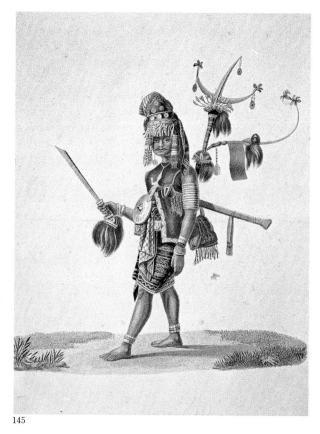

145

144
pilu saluf; ilaf
belt or sword decoration; head
decoration for the *méo* (ritual war
leader)
Atoni or Dawan people, Timor,
Indonesia
cotton, natural dyes, beads
tapestry weave, twining,
supplementary weft wrapping
130.0 x 11.5 cm; 61.0 x 21.2 cm
Australian National Gallery
1980.1661; 1980.1662

145
Coloured lithograph first published in
1864 by J.Th. Bik in his book
*Aantekeningen nopens eene reis naar
Bima, Timor, de Moluksche eilanden,
Menado en Oost Java*

The elaborate ceremonial regalia of
the Timorese ritual warrior-leaders
(*méo*) are recorded in this lithograph
based on the voyage of the two Bik
brothers to the Indies around 1822. It
clearly shows the finely worked,
tapestry weave sword and head
ornaments, the ceremonial betel-nut
bag, a beaded lizard neck-piece, and a
plaid sash and headcloth (possibly
plangi tie-dye) imported from a
neighbouring region. The warrior's
wrap is a locally woven, cotton,
supplementary warp and is typical of
the textiles of the Molo district in
central-west Timor, from which the
narrow belt and head-piece in Plate
144 may have come. Many of these
Timorese tapestry weave items, such
as those illustrated here, are
predominantly red, the colour
associated with bravery and warriors
in many parts of Southeast Asia. Other
colours are typically white, orange,
yellow and black. Early twentieth
century

146

146
A woman in the Amanuban domain of
central-west Timor plaiting a
decorative tie for an Atoni ceremonial
bag or piece of regalia. She uses
smooth stones as weights to provide
simple even tension.

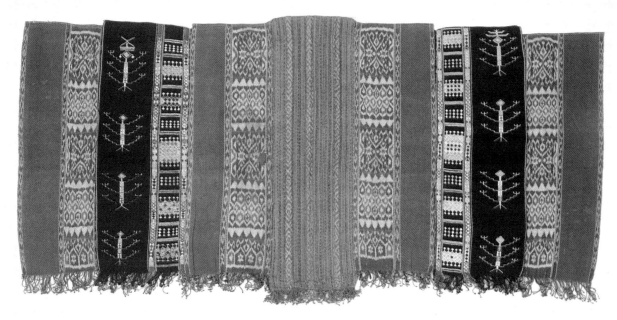

147

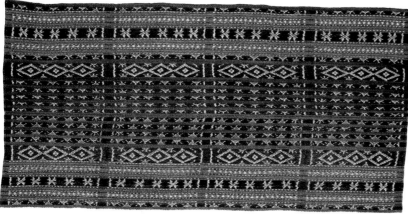

148

Horses have been an important animal in eastern Indonesia for centuries, and the small ponies of Sumba, Bima, Flores and Timor have gained a considerable reputation for their sturdiness and suitability in Southeast Asian conditions. They are ridden almost exclusively by men throughout the Lesser Sunda Islands and play a prominent role in ritual related to hunting and warfare. Fine saddle-cloths have been created for these important occasions.

The Rotinese horse blanket, a medium-sized rectangular cloth, displays red, blue and white banded warp ikat designs. These textiles generally can be distinguished from Rotinese men's wraps by their lack of a fringe. The spectacular nineteenth-century Tetum horse blanket, used by a ruler of a domain in the south Belu region, is a remarkably elaborate textile. It is constructed of layers of finely decorated fabric, and the central sitting section is padded with kapok. The effect is of alternating bands of red and brown warp ikat and gleaming brightly coloured silk supplementary weft wrapping on a dark indigo foundation weave.

147
............
royal horse blanket
Tetum people, south Belu region, Timor, Indonesia
handspun cotton, silk, natural dyes, kapok
supplementary weft wrapping, warp ikat, quilting
104.0 x 215.0 cm
Australian National Gallery 1989.846

148
lafa ina
horse blanket
Rotinese people, Roti, Indonesia
handspun cotton, natural dyes
warp ikat
179.0 x 89.0 cm
Australian National Gallery 1984.1103

149
tais
woman's skirt
Tetum people, south Belu region,
Timor, Indonesia
cotton, dyes
supplementary weft wrapping,
supplementary warp weave
114.4 x 59.4 cm
Australian National Gallery 1988.640

Although the horse is a prominent
feature of Timorese life, it is not
alluded to in the earliest ancestral
legends and it is still recognized as a
foreign image (*kasi*) in Timorese art.
Nevertheless, for at least the last
century the horse has been an
important part of textile iconography
in the south Belu region.
Asymmetrical design, with each motif
created separately by the weft
wrapping technique, is a characteristic
feature of Tetum textiles. Figures,
standing and on horseback, are
arranged vertically on this brilliant red
cloth, according to the way it would be
worn, with the warp bands apparently
unable to constrain the weaver's
enthusiasm. This mid-twentieth-
century example has been produced
using brightly coloured commercial
dyes.

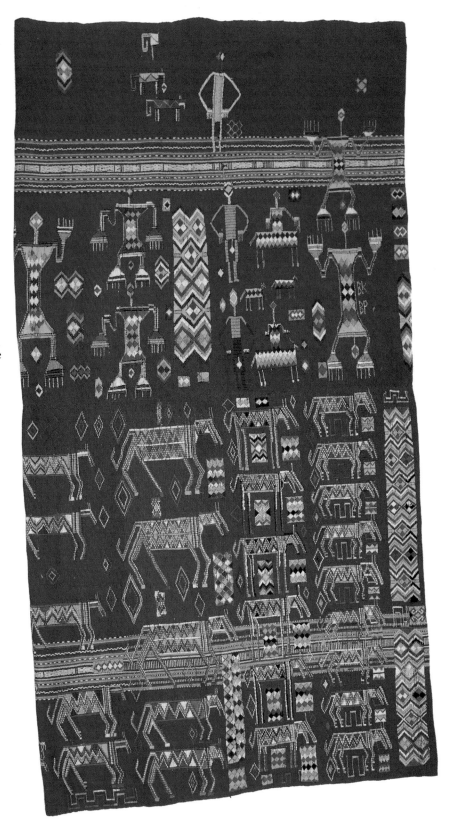

150
seda
man's shawl
Ngada people, Flores, Indonesia
cotton, natural dyes
warp ikat, braiding
291.0 x 116.0 cm
Australian National Gallery 1984.3188

Spindly animal figures often appear
indistinctly on the dark indigo textiles
of the Ngada of central Flores. On this
early twentieth-century man's shawl
the images are remarkably clear. The
cloth reads in one direction
asymmetrically, indicating that the two
bands were woven separately, and
were not cut and joined as is
customary for symmetrical design
structures. A hooked square motif
enclosing a diagonal grid alternates
with the horse. The ninth strand of
the long fringe is knotted in diagonally
opposite corners but the significance
of this, if any, is unknown.

such as exorcism and those following violent deaths, when sacrifices
are necessary.[59]

The complementarity of gender specific skills is such that among
the Iban, weaving was known and valued as 'women's war'. Young
Iban women are chided — in life and in legend — if they have not yet
made a complex patterned *pua*, and without passing this test in the
past they could not receive a captured head. Just as men are encour-
aged to travel far in their quest for experience and adventure, the
further a *pua* travels, the more prestigious the reputation of the
woman who wove it.[60] Old heirloom *pua*, especially those that were
carried by the longhouse communities in their mid-nineteenth-
century migrations, are particularly revered.

In Bima on the island of Sumbawa, this complementarity of
warfare and weaving is also expressed in a rhyme sung by young
women to their warrior sweethearts:

'Arrows in your shield can be used as heddles,
So go forward in battle, I'll hear no excuses.'
(Hitchcock, 1985: 48)

On the island of Savu in eastern Indonesia, a woman spins yarn
throughout a ceremonial cockfight held by men at the Great Altar in
Mahara (Mesara), marking the opening of the Praise of the Earth, an
annual period of festive dancing and gong-playing (Kana, 1983: 87).
The competitive sport of cockfighting is closely associated with male
blood-letting and in many parts of Southeast Asia it has replaced
various forms of traditional warfare that are now prohibited.

While it is not known when or how the first horses arrived in
Southeast Asia, this animal has become closely identified with ritual
warfare, hunting and associated ceremonial activities in many parts of
147,148 the region. Special horse blankets have been created for use by men of
high status, and throughout insular Southeast Asia the horse is a
familiar and recurring textile motif. Where it is closely associated
153 with male prestige and wealth, it has become an established transition
symbol and appears, like the buffalo, on textiles with and without
riders. In particular, it is a popular image on men's shawls and wraps.
149,150 Its depiction varies from the realistic horses of east Sumba and Tetum
textiles to the simple schematic patterns of Endeh and Ngada. In
mountain Luzon, the horse has also become a popular motif on the
151,152 supplementary weft ceremonial textiles of the Tinguian.

While the complementarity of weaving and warfare is symboli-
cally represented throughout Southeast Asia through the pairing of
spear and cloth, it is not only the male activities surrounding warfare

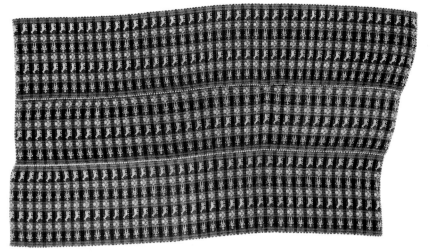

151

151
owes
ceremonial shawl; hanging;
shouldercloth
Tinguian people, Luzon, Philippines
cotton, dyes
supplementary weft weave,
embroidery
116.0 x 192.0 cm
Australian National Gallery 1984.1252

The supplementary weft textiles of
central Luzon also contain
anthropomorphic and animal motifs,
and this mid-twentieth-century
example alternates human figures and
horses. This type of cloth consists of
three red, white and blue panels that
are usually joined by bright
embroidery stitches. Carried as
shouldercloths by men, these
figurative textiles are most prominent
in the mortuary rituals of the Tinguian
and the Kalinga, when they are part of
the textile wealth displayed around the
body of the deceased.

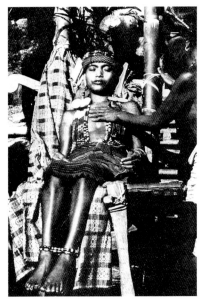

152

152
The Tinguian of Luzon surround the
body of the deceased with textiles
while it sits in state before burial.
Early twentieth-century photograph

that are symbolically linked with the tasks of women. Important
rituals performed by men find parallel meanings in the textile-making
of women. In ancient Austronesian cultures, male oratory can be
viewed as a weaving of legends, genealogies and history, and men's
oral symbols can be linked with the visual symbols women provide
through matting and textiles. The great oral and written chronicles of
Southeast Asia not only extol the feats of gods, ancestors and great
leaders but detail their fine apparel and rich regalia. In Iban gen-
ealogies, for example, men are identified by their names while women
are known by the *pua* patterns that they have invented.

Boat-building and house construction are two specific male ac-
tivities that are central to the well-being of the community,[61] and both
are often linked in legend and ceremony to textiles and weaving. On
the small island of Palué, off the coast of central Flores, textiles are
hung as symbolic sails at the launching of traditional fishing boats.[62]
Throughout the Indonesian archipelago, cloth is hung from the roof
and rafters of newly constructed traditional houses, temples, rice-
barns and community treasure-houses and is also placed along the
ridge pole of houses under construction as a symbol of protection.
This is also suggestive of masts and sails since houses and ships are
often symbolically linked. On the island of Roti, the combination of
structures built by men and covering textiles created by women is
understood as an essential part of the establishment and maintenance
of harmony and order. The T'boli of Mindanao believe that if certain
food prohibitions are not observed by young children, boys will grow
up incapable of building a house and girls will be unable to weave
(Casal, 1978: 96–7). Similarly, the Iban believe that, while in the
womb, the unborn child is offered a spear or a weaving-sword, and the
choice determines its sex.

Status in these societies is dependent upon age, experience and
wisdom, in particular the acquisition of ritual knowledge, and the
attainment of great proficiency in those skills necessary to apply it.
For women too, special ritual expertise and knowledge establishes
status and this often includes prowess at weaving important cloths.
The traditional division of labour in all Southeast Asian societies
leaves textiles as women's work and art. With rare exceptions, the
entire process of making and decorating textiles in Southeast Asia has
been the craft of women and their major outlet for creativity and

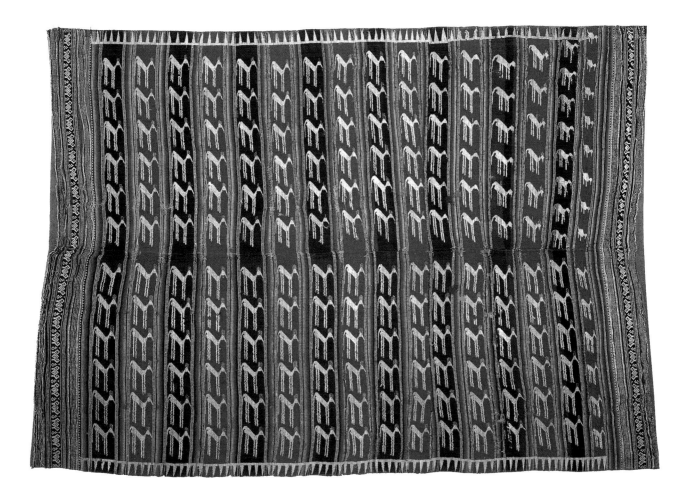

artistic endeavour.[63] Where exceptions exist, the patterns or techniques with which men work are usually closely related to traditional male activities and iconography like carving, pigment-painting and in some societies writing. For example, the braid that is added by Toba Batak men to complete an *ulos* cloth is called *sirat*, a term also meaning letters or writing. While their activities are viewed as distinct and separate, at times both male and female crafts are required for the ultimate success of a textile. The apparatus for thread preparation and wooden looms are usually made by men, sometimes lovingly carved to impress a sweetheart or provide a wife with the best possible equipment to ply her highly valued skills.[64]

The wearing of tattoos is an ancient sign of ritual maturity for both men and women. In the twentieth century tattooing has remained an important form of body decoration throughout eastern Indonesia, north Sumatra, Borneo, Luzon, Mindanao and the upland areas of Thailand and Burma. It has been traditional in many of these places to apply tattoos as symbols of merit after the performance of a particular feat, such as the successful taking of a head, bravery in warfare, the completion of an arduous journey (Chin, 1980: 60) or the weaving of a ritual cloth (Volgelsanger, 1980). Elsewhere in Southeast Asia, tattoos are also part of the process of initiation into adulthood and full participation in the social life of the group.

As in other crucial transition stages, during the rites of tattooing an individual is often protected by a powerful textile. Since clothing and tattooing serve as body decoration and indicate ritual prestige

153
............
ceremonial hanging; heirloom cloth
Abung people (?) south Sumatra, Indonesia
silk, gold thread, cotton
supplementary weft weave, embroidery
221.3 x 152.7 cm
Australian National Gallery 1984.1221

Little is known about this rare and important nineteenth-century cloth, although the Abung aristocracy are known to have displayed such textiles as hangings on ceremonial occasions. The iconography and technique suggest that it falls between two different traditions: the ancient supplementary cotton weavings that are filled with symbolic ships and strange mythical animals, and the silk and gold thread textiles of the Indianized courts of south Sumatra. Mysterious creatures are evident here within the clearly defined weft bands, although they also bear some resemblance to the familiar horse motif. On other cloths of this type anthropomorphic figures and spiral motifs have been noted. The images

are formed from floating wefts of gold-wrapped thread (which are now rather worn). The horse motifs, each slightly different, were woven without the aid of heddle sticks, and a number of missing motifs appear to have been filled in with couched embroidery, a technique that has been widely used on Abung ceremonial skirts. The magnificent rich colours of the weft stripes are also evident on many early Abung *tapis*, although on those textiles these colours are displayed in warp bands.

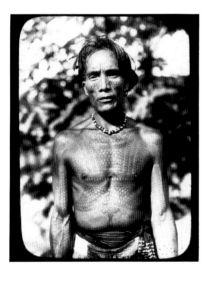

154
An early twentieth-century photograph of a man from Luzon in the Philippines wearing a loincloth that repeats the patterns tattooed on his chest, arms and face. A close similarity between textile patterns and body decorations is a common feature of many island and mainland Southeast Asian cultures.

and experience, similar patterns and motifs are often found in both media, and the meaning of certain textile motifs and designs may be explained by a comparison with tattoos, as well as other art forms such as carving and bamboo work. Tattooing is widely practised by the T'boli of Mindanao and many of the motifs are similar to those on their warp ikat and embroidered cloths. Certain stylized motifs, and the tattoos themselves, are believed to have important protective powers. Animal motifs (*bakong*) and anthropomorphic figures (*hakang*) are said to glow after a person's death to assist the departed to a safe destination in the afterlife (Casal, 1978: 34, 36). The same parallels between textile and tattoo motifs are evident among the Tetum people of Timor where it is believed that no matter where a person dies, their tattoos (*makerek*) will also ensure a safe journey to the next world. These protective qualities are also claimed for many textiles throughout Southeast Asia.

154

SYMBOLS OF DEATH AND LIFE

Archaeologists confirm that elaborate burial procedures were already practised in prehistoric Southeast Asia. It is clear from several significant burial sites that these rites involved items of wealth — pottery, beads and metal objects (Bellwood, 1979: passim). Funeral ceremonies still dominate the ritual calendar in many parts of the region and elaborate burial rites remain a feature of many Southeast Asian cultures. These are occasions when textiles are especially prominent as ceremonial gifts, as elaborate textile displays, as ritual apparel for both the dead and the living, and as objects of magic and spiritual power.

When primary or secondary burials are performed, textiles have a prominent role in the ritual. Bodies are clothed, wrapped or draped in decorative shrouds before and during burial. Textile canopies are raised above the deceased, and displays of the finest textiles that a family can muster line the rooms and hang from houses, compounds and graves. Offerings to ancestors and spirits include sacred textiles, which are sometimes perceived as clothing for the gods. Textile causeways are erected along which the dead proceed on their road to the afterworld, and carved effigies of the dead dressed in magical finery are paraded to burial caves — often with the purpose of deceiving malevolent spirits. During secondary burials the bones of the dead are exhumed, washed and carefully wrapped in highly valued textiles.

152,155 156,157 158,166

In some cultures it is customary to prepare special burial clothing. Hmong women, for example, create costumes from woven hemp for both themselves and their husbands. These textiles display additional layers of richly embroidered outer garments and are the finest examples of Hmong ceremonial clothing (Lewis and Lewis, 1984: 128–9). Textiles that are woven specifically as shrouds may require particular precautions, and a Kalinga woman in Luzon will only undertake the task of weaving such a cloth — a dangerous activity best performed by a shaman or seer — if she is barren or past child-bearing (Roces, 1985: 3).

Textiles are used on these occasions in particular and regulated ways, which may vary slightly from one village to another even within the same culture. Among the Ifugao, only the first-born son is buried with a full set of four ritual cloths and certain cloths are designated for

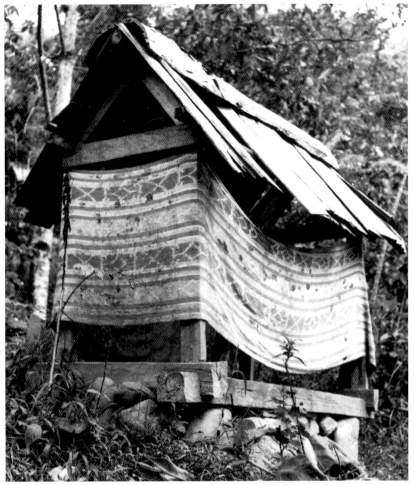

155

157

157
A wooden chest containing the bones of the ancestors is stored under the eaves of a traditional Lio house. A fringed textile, which has faded over the years, is draped over the chest.

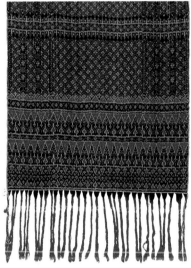

158

155
A long warp ikat textile encloses a grave outside a village between the Kalumpang and Rongkong regions of Sulawesi. Textiles from neighbouring regions are used for rituals in this part of central Sulawesi as the women in this area do not themselves weave. This particular type of warp banded cloth from Kalumpang is called *rundun lolo*.

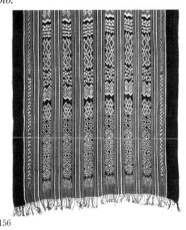

156

156 (detail)
pori lonjong
ceremonial hanging; shroud
Toraja people, Rongkong district, central Sulawesi, Indonesia
cotton, natural dyes
warp ikat
485.0 x 165.0 cm
Australian National Gallery 1988.521

The huge *pori lonjong* textiles, in bold, bright red, blue and white warp ikat, provide dramatic backdrops for the Toraja rituals of death. They are used throughout the Toraja region as hangings, temporary walls and shrouds, and also as women's ceremonial skirtcloths in the north of central Sulawesi. Each *pori lonjong* has a wide, patterned centre, usually composed of repeating sets of ancient schematic patterns — rhombs, spirals, crosses, zigzags and circles. These designs are bordered on each side by stark red, black (or blue) and white stripes. Most cloths are formed from two extremely long parallel panels.
Twentieth century

158 (detail)
luka semba
ceremonial shawl
Lio people, Flores, Indonesia
cotton, natural dyes
warp ikat
70.0 x 220.2 cm
Australian National Gallery 1984.1094

Fringed warp ikat textiles in deep red hues are worn by Lio men on ceremonial occasions, and are also draped over the deceased during funerary rites. This design combines simple spots divided into warp bands with elaborate triangular end patterns.
Twentieth century

159

159 (detail)
At Toba Batak funerals, textiles seal
the bonds established in life between
individuals and their kin (*dongan
sabutuha*), wife-givers (*hula-hula*) and
wife-takers (*boru*). In this photograph
the body of an elderly woman lies
covered with an appropriate cloth (an
ulos sibolang) while her kinsfolk
surround the coffin wearing other *ulos*
shawls. From a family album,
mid-twentieth century

160
tapis
woman's ceremonial skirt
Paminggir people, Lampung, Sumatra,
Indonesia
cotton, silk, natural dyes
warp ikat, embroidery
143.0 x 136.0 cm
Australian National Gallery 1981.1124

161
tapis
woman's ceremonial skirt
Paminggir people, Lampung, Sumatra,
Indonesia
cotton, silk, natural dyes
warp ikat, embroidery
130.4 x 118.5 cm
Australian National Gallery 1981.1125

Ship images appear on the skirts worn
in Lampung by women at ceremonies
to celebrate a change of status for
members of the community. The
motifs contained in the warp ikat
bands on most *tapis* are not often
identifiable. However, the ikat
patterns on these nineteenth-century
examples are suggestive of the
serpents, ships and mythical beasts
also found on other textiles produced
in this region. The figures on board
the ships displayed in the bands of
predominantly white embroidery are
depicted in a variety of ways, and both
sunburst and horn-shaped head-dresses
are evident. The bright detailed
embroidery work and its precise filling
of stripes, chevrons and checks is in

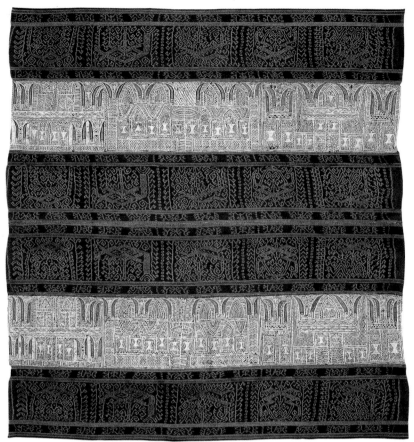

160

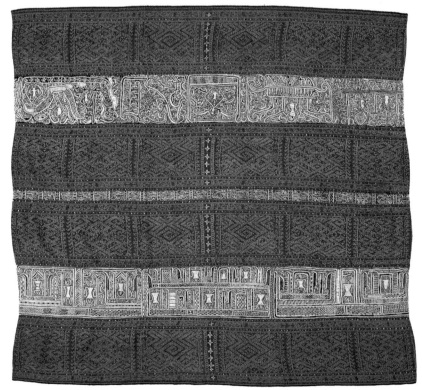

161

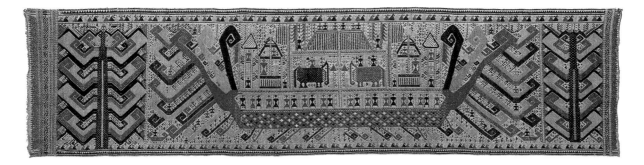

162

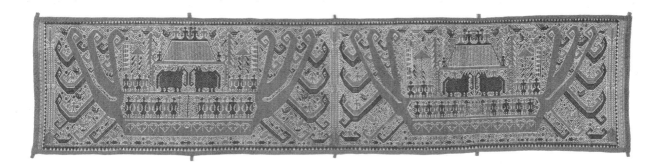

163

sharp contrast to the sombre brown
ikat, although both sections of each
textile are dyed in natural colours.

162
palepai
ceremonial hanging
Paminggir people, Kalianda district,
Lampung, Sumatra, Indonesia
handspun cotton, natural dyes, gold
ribbon
supplementary weft weave, appliqué
68.0 x 280.3 cm
Australian National Gallery 1985.610
Purchased with the assistance of
James Mollison, 1985

163
palepai
ceremonial hanging
Paminggir people, Kalianda district,
Lampung, Sumatra, Indonesia
handspun cotton, natural dyes
supplementary weft weave
64.0 x 286.0 cm
Australian National Gallery 1985.611
Purchased with the assistance of
James Mollison, 1985

The ship motif is most highly
developed and spectacularly displayed
on the *palepai* and *tampan* of
Lampung, textiles which are used at
many ceremonies of the life-cycle
including initiation into adulthood,
marriage and death. For the Paminggir
nobility who controlled the large
palepai ship cloths, the presence of
these prestigious textiles was also
essential at ceremonies pronouncing
the rank of the local ruler. The
transition symbolism of these textiles
is further developed by the inclusion of
riders on mythical creatures, which
are usually depicted aboard the ships.
The degree of realism with which the
ships and their passengers are
presented varies greatly according to
the particular time and place at which
these textiles were woven. Different
regional styles developed in Lampung,
although key and spiral ornamentation
was widely deployed in the background
and filling detail of all these textiles.
Some of these variations can be
observed on surviving
nineteenth-century examples of
supplementary weft *tampan, tatibin*
and *palepai* cloths, and also on the
embroidered bands of women's skirts
from the same region.
On the large *palepai* the main ship
motif appears either in red or blue,
with the red ships usually showing far
more elaborate detail than the more
solid blue variety. The ceremonial
hanging in Plate 162 is a fine example
of the rare single red ship *palepai*,
with wonderfully curved bows and
deck structures filled with fanciful
passengers and crew and pairs of
noble elephants. Turmeric dyes have
been generously used to produce a
rich orange effect. Where two red ship
images are displayed, as in the
ceremonial hanging Plate 163, there
always appears to be subtle variations
in their depiction, since different sets
of shed-sticks were apparently used to
weave each image. On this textile the
indigo blue is also a dominant colour.

specific categories of deceased persons. An Ifugao man is buried wearing an ikat loincloth, and a widow in a special type of wrap. Using a shroud fringed at only one border, the Karen place this fringed end of the cloth over the body to indicate to the deceased and any observers that he or she is dead (Lewis and Lewis, 1984: 80).

Clothing is thus important as a symbol of status for the dead as well as the living, and as a system of signals intended for supernatural beings. For example, the bodies of unmarried Karen girls are dressed in the costume of married women, so that their souls can proceed unhindered to the realm of the dead, for such clothing is a signal to any evil spirits who might prevent the journey that a husband is following behind (Lewis and Lewis, 1984: 96).[65] However, not all Southeast Asian peoples bury their dead in their finest fabrics. The Ifugao, for example, cover their corpses in used clothing, or if fine new cloths are used, these are torn slightly so that the waiting spirits, who also desire fine textiles, will not become jealous and steal the shrouds from those making their final journey (Lambrecht, 1958: 10). Textiles play a prominent role at many mortuary ceremonies at which the interplay between the realms of the spirits and ancestors, and the earthly domain of the living is clearly articulated.

Beads also play an important part in transition ceremonies, including those associated with death, and many beads have been found in a number of ancient burial sites. The Toraja drape the beaded *kandauré* over the body of prominent people at funerals, some Dayak 79 groups place beads under the eyelids of the corpse for the use of the soul in its passage to the next world (Dunsmore, 1978: 3), and the beaded 'singing' shawls used by young Karen women who chant at funerals are intended to aid the journey of transition (Campbell et al, 1978: 158). We know little about the functions of the huge beaded mats and hangings of Lampung, but it seems probable that, like the woven *tampan* and *palepai* textiles, the presence of these spectacular 57 beaded objects at important transition rituals evoked protection and aid in dealing with the ancestor and spirit world.

Many funeral arrangements emphasize the social order for the 159 living, as well as the dead. Where alliances forged by marriage are the basis for social relationships, protocol at funerals must be carefully followed. In eastern Indonesia, for example, gifts are given to indicate the prestige and wealth of the deceased and the powerful connections of the extended family. In such cases, textiles are usually presented by one set of relatives and different types of 'male' grave goods, such as livestock, by the other. Fine textiles are given as shrouds to honour prominent relations. In some places this custom has escalated into a potlatch competition of conspicuous consumption, when dozens of richly decorated textiles are buried and large numbers of buffaloes, cattle and pigs are slaughtered.[66]

Designs representing architectural structures and manned boats have been found on ancient Southeast Asian pottery and metal objects dating from the Neolithic and Metal Ages and in early Austronesian rock art. Archaeologists have argued that the appearance of such designs upon objects found in burial sites suggests that they were intended to represent 'the ship of the dead'. Although ship-like structures have been prominent in funeral rites throughout Southeast Asia, it is misleading to assume that such depictions in the region's art always symbolized 'the ship of the dead'. The notion of a symbolic soul 160,161 ship gives a fuller meaning to the motifs that appear on many tra-

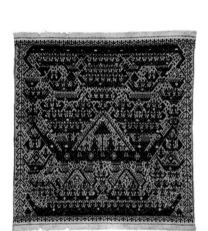

164
tampan
ceremonial cloth
Paminggir people, Lampung, Sumatra, Indonesia
handspun cotton, natural dyes
supplementary weft weave
67.0 x 63.0 cm
Australian National Gallery 1981.1103

The rich red ship images on the smaller *tampan* are often more schematic, and huge animals on board simple canoe-like vessels dominate the designs. There is usually a boat structure at both top and bottom of the *tampan*, and in some instances the design has been planned to read both ways. The size and dress of the human figures under large umbrella structures in Plate 164 indicate their superior status.

ditional textiles, since the same cloths may be used at various stages in the life-cycle when an individual moves from one social or spiritual state to another. The huge *palepai* supplementary weft hangings of south Lampung in Sumatra, which are the possessions of the Paminggir clan leaders, are the finest examples of ship symbolism to be displayed at ceremonies of the life-cycle. Smaller *tampan* textiles, also containing these powerful transition symbols, are more widely used throughout the southern region of Sumatra for marriage ceremonies and initiations into adulthood, such as tooth-filing and circumcision.

The association of the ship motif with rituals of human transition suggests that motifs representing the human form may also be situationally defined. Mythical animals with human riders are familiar images in ancient Southeast Asian design, particularly on objects required at rites of passage. It has been suggested that because the place of textiles is paramount at the funerals of significant members of

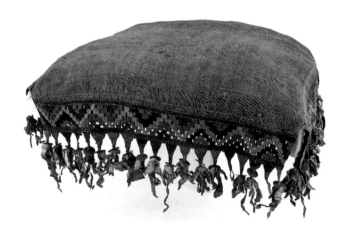

166

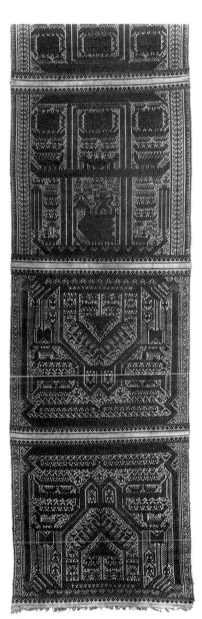

165

165 (detail)
tampan; titi jembatan agung
ceremonial textile
Paminggir people, Lampung, Sumatra, Indonesia
handspun cotton, natural dyes
supplementary weft weave
284.0 x 74.0 cm
Art Gallery of South Australia
747A150

A series of *tampan*, removed from the loom without being divided, was not only used for the same ritual functions as the single square *tampan* but it was also given a unique place in certain Lampung ceremonies. This long brown and white fabric served as a floor runner along which a bridal couple walked towards a ceremonial bedroom. As 'king and queen' of the day, their textile pathway was known as the royal bridge, the *titi jembatan agung* (Gittinger, 1972). Late nineteenth century

166 (detail)
lelangit
sacred canopy
Sasak people, Lombok, Indonesia
handspun cotton, natural dyes
slit-tapestry weave, tie-dyeing (?)
90.0 x 90.0 x 18.0 cm
Australian Museum E.78856

This nineteenth-century canopy was woven with a rare and sacred type of brown cotton. The four sides of the box are worked in slit-tapestry weave in rich natural colours and it is possible that the plain centre has been lightly tie-dyed. A canopy in the collection of the Rijksmuseum voor Volkenkunde, Leiden (2407–259), recorded as having come from Sewela in east Lombok, has tie-dyed circles in pale pastel shades scattered over a warm brown ground. The textile is hung as a heaven cloth or canopy (*lelangit*) above the deceased at traditional Sasak funerals.

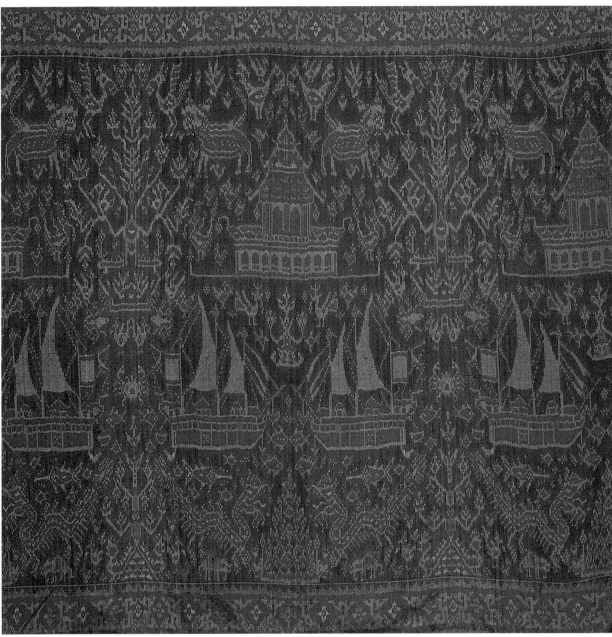

167

167 (detail)
pidan (?)
ceremonial hanging
Khmer people, Chvear Dam, Kandal
province, Cambodia
silk, natural dyes
weft ikat
Musée de L'Homme, Paris 70.61.33

A figurative design in weft ikat (*hol*)
contains trees, temples, birds, dragons
and other creatures from each of the
realms — sea, land and air. Elaborate
sailing vessels are a prominent motif
on these cloths which were used to
decorate the bride's home during the
marriage ceremony. Early twentieth
century

168 (detail)
kré alang
skirtcloth
Semawa people, west Sumbawa,
Indonesia
cotton, dyes, metallic thread
supplementary weft weave
181.0 x 124.0 cm
Australian National Gallery 1983.3687

The head-panel of this ceremonial
skirtcloth from the court of Sumbawa
displays ships with masts and rigging.
The structure at the feet of the
oversize crew suggests an outrigger, a
familiar and ancient feature of
Southeast Asian sailing craft, although
it may also be an attempt to depict the

poop deck of a local *prau*, repeated in
mirror image during the
supplementary weft weaving process.
Like other Southeast Asian textiles
that display these motifs, the ship on
Sumbawa cloth is often linked with the
ancient symbols of trees and birds.
The human figures are presented in a
flat frontal style with arms akimbo,
and the field displays a characteristic
diagonal grid pattern. The division of
this early twentieth-century cloth's
design into separate grey-green field
and red head-panel is typical of later
developments in the cloth structures
of coastal principalities.

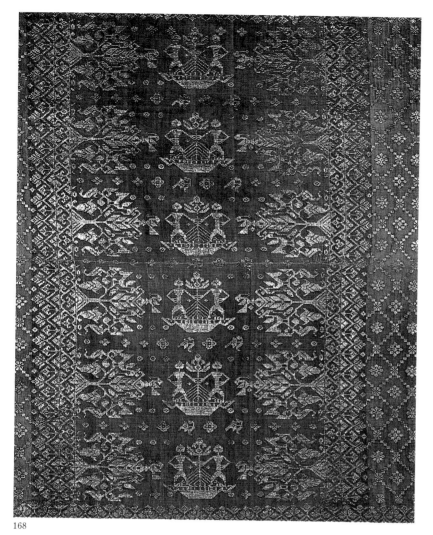

168

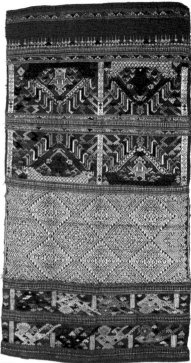

169

169
pha biang (?)
ceremonial cloth
Phutai people, Laos
silk, cotton, dyes
supplementary weft weave
40.0 x 75.0 cm
Australian National Gallery 1987.1824

In the mountainous northern areas of mainland Southeast Asia, the ship is usually a minor textile motif combined with other cosmic symbols, and small boats can be found on many Tai shawls in the bands that flank the central design. However, on this early twentieth-century Phutai example, a human figure stands on a platform, possibly a schematic version of a mythical creature, and the clearly depicted dragon-scaled boat is bordered by tree motifs. The foundation weave is lac-red with numerous bright supplementary coloured silks.

east Sumbanese nobility, the horses and riders found on certain wraps (*hinggi kombu*) may serve as psychopomp for the final journey to the next world (Adams, 1969: 167). As such, these anthropomorphic riders and their steeds may, like the ship motifs, represent the transition from one life state to another for those present at these ceremonies.

168 The people of the island of Sumbawa, who have been closely connected with seafaring and trade for over a millenium, weave supplementary weft skirts containing figures in poses with arms akimbo and on boats which vary from simple canoes to fully-rigged barques. On the textiles of south Lembata, boat motifs allude to the important place of ships and voyages in the economic life and legendary history of this coastal community. Significantly, ship motifs are also a part of

167,169 the textile iconography of the hill-dwellers in Cambodia, Laos and northern Thailand. On their garments, for instance, the small figures — sailors and riders of mythical beasts — are depicted in a symmetrical frontal perspective.

 The upward curving bows of the more schematic versions of the ship motif can be linked with other transition symbols in Southeast Asian art. On certain textiles used in south Sumatran rites of passage, an ambiguous, bifurcated and hooked shape appears to be a compound

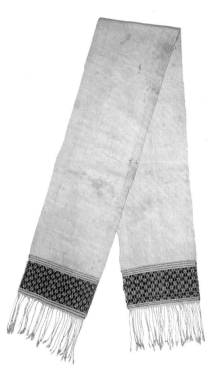

170
ayaboñ ña sinapowan
woman shaman's headcloth
Tinguian people, Luzon, Philippines
handspun cotton, natural dyes
supplementary weft weave
152.0 x 19.0 cm
Australian National Gallery 1984.3190

This white head cloth, with an ancient
Southeast Asian interlocking oval
design in floating indigo wefts, was
worn by female shaman during the
dawak ceremony. Early twentieth
century

symbol of ship, bird, tree and shrine, an important and highly appropriate image on such occasions (Gittinger, 1974). On other Southeast Asian textiles, and on jewellery and sculpture, the curved ship form blurs with the buffalo horn and the crescent moon shapes or with the traditional house and its characteristic upward curving roof.

COMMUNICATING WITH SPIRITS AND ANCESTORS

Supernatural beings are believed to have the power to intrude upon the lives of humans and affect the course of an already uncertain natural world. In legend, they are often credited with the creation or the discovery of the most fundamental objects upon which a culture is founded — staple foodstuffs such as rice, domestic animals such as the buffalo, and the basic raw materials from which clothing is fashioned such as cotton. Legends often refer to the role of great ancestors or gods in the discovery of important skills such as the art of spinning and weaving and the invention of many sacred designs.[67] Great care is taken to appease the wrath of ancestors and spirits and to ensure their pleasure, and their protection is invoked at times of crisis. Textiles are often a central part of the many mediating rituals that are performed to achieve and maintain this cosmic harmony and personal health.

Related to these notions about the role of ancestors and spirits are beliefs in omens and magic. Throughout Southeast Asia certain textiles are incorporated into magical practices and are believed to have sacred qualities. These qualities are invoked at life and death ceremonies when the ancestors and spirits are attracted or appeased by prominent displays and offerings of sacred fabrics, while dangerous or malevolent beings are kept at bay and their evil work thwarted.

Among the Iban of Sarawak there is evidently a close relationship between textiles and a belief in omens and dreams (Vogelsanger, 1980). Dreams seem to provide inspiration, in particular, for the arrangement of Iban motifs, and for the special name and the meaning that a cloth assumes. Iban women, however, clearly re-create the fabrics of their dreams from the artistic symbols available within their culture, and certain powerful and visually appealing patterns have been repeated from generation to generation, with minor design changes resulting from aesthetic or personal reinterpretations. Consequently when dreams are translated on to cloth it is sometimes possible to recognize familiar elements or even complete designs, although one Iban design may have a specific contextual meaning and it may be interpreted differently in another longhouse or district. *172,173*

Communication with spirits for the benefit of individuals or the social group is often performed by a shaman, a specialized religious practitioner who possesses the personal qualities and sense of calling essential for this dangerous task. Since natural disasters and personal misfortunes are widely believed to be the work of malevolent supernatural beings, a shaman is required to call back the wandering soul of a sick person, ensure the safe arrival of a new baby, or clean and cool the village after a visitation of pestilence. Throughout Southeast Asia a shaman may either be male or female. In fact, the restoration of the *170* cosmic order is often best performed by religious practitioners who incorporate both male and female qualities. Bisexuality is displayed in

transvestite apparel, and in certain societies a male shaman, after initiation, wears women's clothing and performs women's tasks, including weaving.[68] Some Southeast Asian textiles, like the shaman, harness these complementary yet opposing forces, and display symbolism containing male, female, or even bisexual elements.

171,174
175
Among the various Batak peoples of north Sumatra, there are a number of important ceremonial textiles that have male and female ends where each set of gender-related elements is concentrated. These include Toba Batak cloths (such as the *ulos ragidup* and the *ulos pinunsaan*), the Simalungun Batak headcloth, and some nineteenth-century Mandailing and Angkola Batak textiles. The most

178
northerly weaving districts of the neighbouring Minangkabau people also appear to have integrated comparable pairs of schematic shapes into a striking band at each end of certain cloths. Further south in the

176,177
Bengkulu and Pasemah region of Sumatra, the arrangement of different designs and the structure of the pattern at each end of the shouldercloth suggest an interesting comparison with the overt and intentional sexual imagery of Batak textiles.

While Batak elders readily identify the male and female ends and the sexual images on their textiles, such explicit identification of sexual symbolism is no longer apparent in neighbouring Sumatran areas. Minangkabau weavers understand the lozenge motifs on their supplementary silk textiles to be ceremonial cakes or heaps of sirih (an ingredient for betel-nut chewing), and triangular shapes are believed to represent bamboo shoots or 'the tree of life' (Sanday and Kartiwa, 1984: 18–25). While these motifs are now reduced to geometric patterning, and are identified with familiar everyday objects from the world around them, the weavers' ancestors may have intended motifs such as these to represent human figures.

Certain textiles are specifically designed to communicate with spirits. When physical danger threatens, such as an unexplained illness or pregnancy, a shaman or seer may prescribe the weaving of a special cloth to protect the owner and dispel the evil. A Batak village priest might suggest the weaving of an *ulos ragidup* as a cure for personal difficulties. This striking cloth, woven by a complex series of procedures, was also used in the past as an aid to divination. Textiles are also used by shamans among the peoples of northern Luzon, where they appear in a variety of ceremonies designed to placate the spirits. But instead of being read to predict the future, in this part of Southeast Asia they appear to hold the key to past events, such as the performance of great ceremonies (Ellis, 1981: 224–30).

At Iban ceremonies performed to re-establish order after a tragic and unexpected occurrence, such as the death of a child, the

179
shaman hangs an appropriately decorated *pua* at the entrance of the longhouse in his attempts to destroy the incubus believed to have caused the disaster. During the initiation of a *manang bali* (the transformed shaman with particular abilities to communicate with terrestrial shaman and draw upon their assistance to return a wandering or stolen soul and vanquish evil spirits[69]), a *pua* completely covers the initiate, as he attempts to climb over a symbolic wall of fire (*pagar api*) constructed of timber and decorative textiles.

In such rites the *pua* themselves are believed to be transformed into objects of supernatural power. This notion is implicit in an alternative Iban term for these textiles, *bali*, meaning 'to change in form'.[70] These textiles become avenues of communication and even

171
Two Toba Batak elders discuss the meaning of the motifs on the man's *ulos ni tondi* (soul-cloth), a finely worked *ulos ragidup* ('design of life') from the Taratung district south of Lake Toba. The *ulos ragidup* and *ulos pinunsaan* can be read by experts as an oracle to predict the future and particular cloths or designs might be prescribed by a Batak shaman as a cure for misfortune (Gittinger, 1975: 13–15).

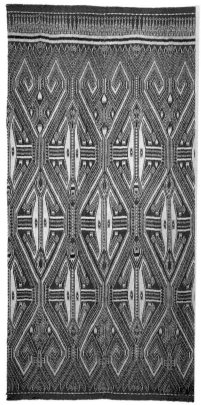

172

172
pua kumbu
ceremonial cloth
Kajut anak Ubu, Tiau River, Kapit
district, Sarawak, Malaysia
cotton, natural dyes
warp ikat
240.0 x 117.0 cm
Australian National Gallery 1981.1116

173
pua kumbu
ceremonial cloth
Iban people, Sarawak, Malaysia
handspun cotton, natural dyes
warp ikat, embroidered braid
232.0 x 136.0 cm
Australian National Gallery 1980.1658

These two textiles provide an
excellent example of the role of
dreams and the transmission of
cultural symbols in Iban weaving. The
pua in Plate 172 was collected and
carefully documented in the late 1940s
by Emeritus Professor Derek Freeman
and Monica Freeman. It was woven by
Kajut anak Ubu, who deliberately
followed a pattern said to have been
created in the 1930s in the remote
Ngemah River of the Kapit district by
another weaver, Jiram anak Balit, after
a dream revelation. (Monica Freeman
saw and recorded Jiram's original
design.) The design with Kajut anak
Ubu's own embellishments is described

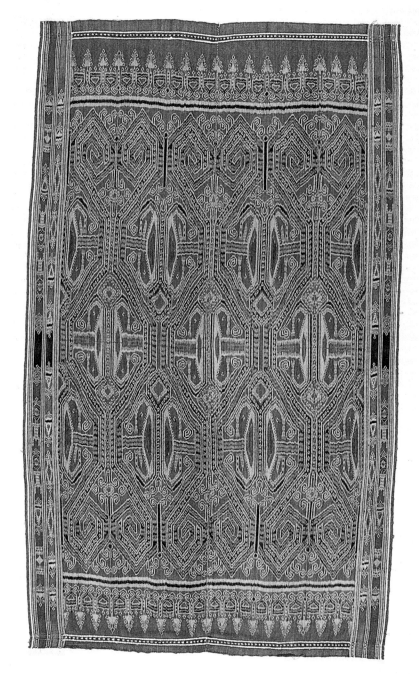

173

as the *teladan* pattern with the
flying-tiger or sea-tiger (*remaung
tasik*) design. The Iban in the Balai
River system at this stage were still
working in natural dyes, although with
diminished use of the many hooks
(*gelong*) that are a feature of the finest
Iban *pua kumbu*.
Of this design, the Freemans note:
'The *remaung* tiger spirit is one of the
most powerful entities in Iban
mythology being especially associated
with warfare and head-hunting. The

remaung is invoked on the occasion of
head-hunting rituals, when offerings
are put out for it on the top of the
roof of the longhouse. The tiger spirit,
it is believed, is able to fly and it is
said to streak through the air, making
a strange roaring noise, to carry off
these offerings. Looked on as
immensely powerful, and therefore
potentially dangerous, the *remaung* is
not invited actually to enter the
longhouse' (Freeman and Freeman,
1980).

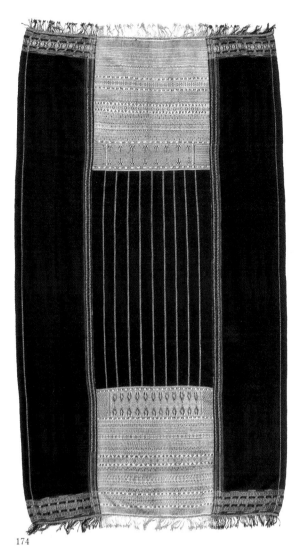

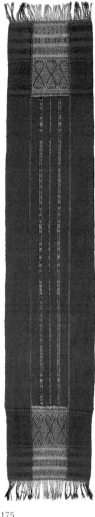

174

175

175
bulang
woman's headcloth
Simalungun Batak people, north
Sumatra, Indonesia
handspun cotton, natural dyes
supplementary weft weave,
supplementary warp weave
187.0 x 35.0 cm
Australian National Gallery 1984.1247

On certain Toba Batak ritual textiles
(*ulos*), such as the *ulos ragidup* and
the seemingly identical *ulos
pinunsaan*, (also known as *pinussaan*
and *nipussaan* after the term
sometimes used for the white inset
panels, *pussa*), the widest band of
supplementary weft patterns (*pina
halak*) at each end are distinctly
though schematically male and female.
The male *pina halak* band is
composed of elongated triangular
shapes (*baoa*) while the dominant
female motif in the other *pina halak*
band is the rhomb (*boru-boru*). (The
terms *tulang baoa* and *boru* are also
used to refer to key elements in the
Toba Batak kinship system.) When
using the cloths to cover the dead or
to envelop the living, Toba Bataks are
careful to extend the end appropriate
to the gender of the recipient.
A complicated and ordered sequence
of weaving the intricate,
supplementary weft ends containing
these male and female motifs, in the
sacred tricolour of black, white and
red, is strictly observed — even by
younger weavers who are uncertain or
ignorant of the sexual references of
these ancient motifs. In the Porsea
district on the eastern shores of Lake
Toba, the three central sections of the
ulos pinunsaan are woven separately,
cut and then sewn together with the
side panels to form a completed cloth.
The *ulos ragidup* that are woven by
the Toba Batak peoples south of the
lake and the brick-red woman's
headcloth (*bulang*) from the
Simalungun Batak (sometimes also
referred to as the Eastern Batak or
Batak Timur) have an elaborately
woven central section. The two end-
panels are not woven separately but
are worked on a second, white warp
which is inserted during the weaving
process (Gittinger, 1975: 13–15). This
difficult and lengthy procedure can
only be understood through an
awareness of the supernatural powers
that these traditional cloths are
thought to possess and the notion of
an unbroken, circulating warp as a
metaphor linking male and female
realms. Both cloths probably date from
the early twentieth century.

The same basic design, however, can
also be found on much older Iban
textiles. The *remaung tasik* pattern is
also clearly recognizable in Plate 173
combining elements of stripes and
wings with carefully articulated feet
and hands. As well as the rich red and
black over-dyed tones, this cloth
displays brilliant highlights of bright
indigo blue in both the central field
and the side stripes. This textile
appears to date from at least the early
twentieth century, although it may
well be even older. This suggests that
patterns such as this were clearly part
of the known repertoire of Iban
weavers, and it is evident that many
Iban women dream about and create
new patterns that integrate many old
established designs. In fact, in this way
talented Iban woman are able to
express their own creativity with some
modesty since the dream pattern is
considered to be a revelation received
from an ancestor-deity.

174
ulos pinunsaan
ritual cloth for clothing, wrapping and
shroud
Toba Batak people, Porsea district,
north Sumatra, Indonesia
cotton, natural dyes
supplementary warp weave,
supplementary weft weave, warp ikat,
twining
125.0 x 225.0 cm
Australian National Gallery 1984.256

176
kain bidak (?)
shouldercloth; skirtcloth
Pasemah region, Sumatra, Indonesia
silk, natural dyes, gold thread
supplementary weft weave, weft ikat
250.0 x 112.0 cm
Australian National Gallery 1980.728

The ornate, metallic thread foliated
elements on Pasemah ceremonial gold
and silk textiles contrast strangely
with the simple, narrow, weft ikat
stripes and the rows of riders on
animals at each end. The foundation
weave is predominantly red-brown.
These archaic symbols of transition
proliferate on the textiles of the
Lampung region to the south. The sex
of the riders is clearly represented and
the cloth is a rare example of a
Pasemah textile of this type with
explicit male and female ends.
Nineteenth century

177
tengkuluk; *pelung*
shouldercloths, waist-sashes
Pasemah-Bengkulu region, Sumatra,
Indonesia
cotton, metallic thread, natural dyes,
silk
supplementary weft weave
38.0 x 220.1 cm; 34.4 x 230.0 cm
Australian National Gallery
1981.1133; 1984.572

While little remains of identifiably
male and female character in the end
sections of these cloths, the subtle but
deliberate differences suggest a
comparison with the explicit sexual
symbolism found on many textiles
woven by Sumatran peoples further to
the north. On these cloths the
schematic patterns appear in
elaborate, continuous supplementary
weft brocade on either red or indigo
grounds. Fringes formed from silk
floss have been added after weaving.
Early twentieth century

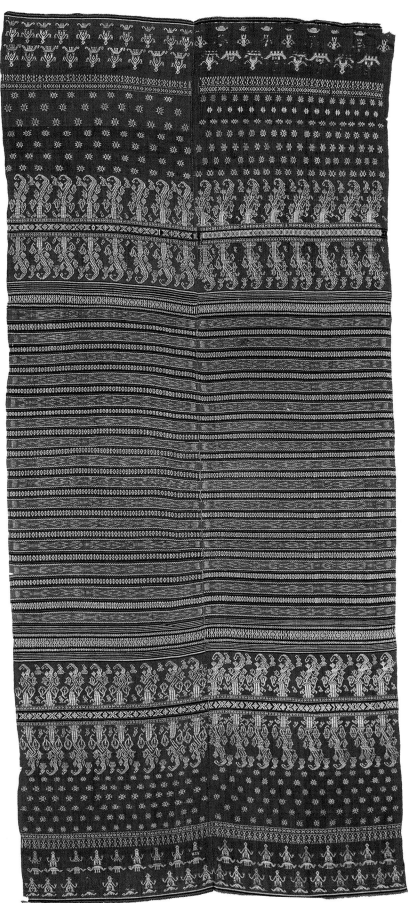

176

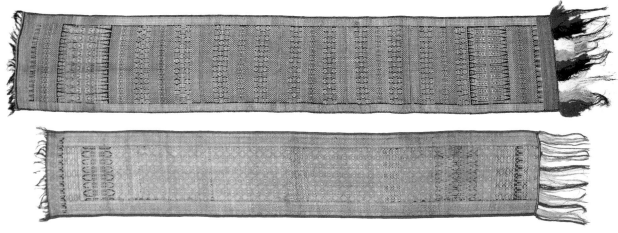

177

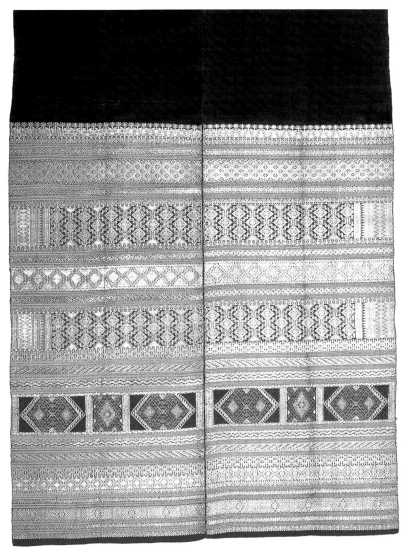

178

178 (detail)
tengkuluak; kain sandang
woman's headcloth; shouldercloth
Minangkabau people, Batu Sangkar
district, west Sumatra, Indonesia
cotton, silk, gold thread, natural dyes
supplementary weft weave
271.0 x 74.0 cm
Australian National Gallery 1984.574

The characteristic bright red and
orange silk bands which are woven
into the sumptuous gold brocade cloths
from the Batu Sangkar district of the
Minangkabau highlands also appear to
include both male and female
elements. The end-panels stand out
against the deep purple centre. Cotton
textiles with similar bright
multicoloured bands are also woven by
the Angkola Batak people to the north.
Nineteenth century

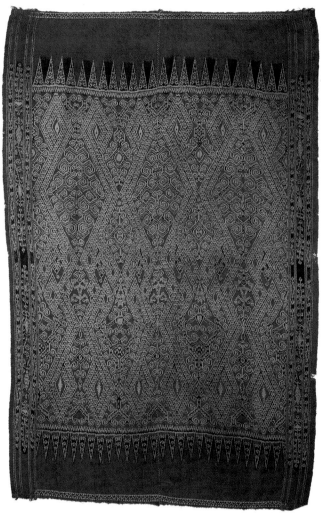

179

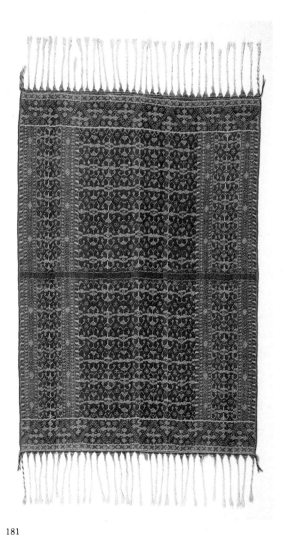

181

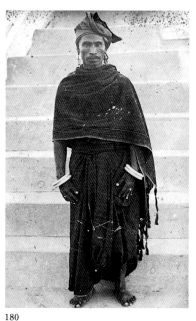

180

179
pua kumbu
ceremonial cloth
Iban people, Sarawak, Malaysia
handspun cotton, natural dyes
warp ikat
203.0 x 136.8 cm
Australian National Gallery 1981.1096

This huge *pua* was made to be hung at
various longhouse ceremonies. The
exact meaning of its formal design is
not known although the large, stippled,
spiral motifs depict highly stylized
river serpents (*nabau*). Food, in the
form of small creatures, is depicted
upside-down swimming towards the
serpent. Early twentieth century

180
This image of the Raja of the Lio
domain of central Flores was taken
from an early twentieth-century
photograph. The wide ikat shawl,
maroon headcloth, huge ivory
bracelets and heavy gold earrings are
still used as ceremonial dress for
traditional leaders in that domain.

181
semba mosalaki
man's ceremonial shawl
Lio people, Flores, Indonesia
cotton, natural dyes
warp ikat
113.5 x 209.0 cm
Australian National Gallery 1980.1656

A wide, two-panel, rich red-brown
shawl worn by the Lords of the Earth
(*mosalaki*) of central Flores. The
sections of the warp intended to be
the fringe have been carefully
protected from contact with the dyes,
and remain white. While the designs of
many of these shawls were inspired by
Indian trade textiles, this particular
pattern seems to represent the linked
genealogical figures found on many
Southeast Asian warp ikat fabrics.
Early twentieth century

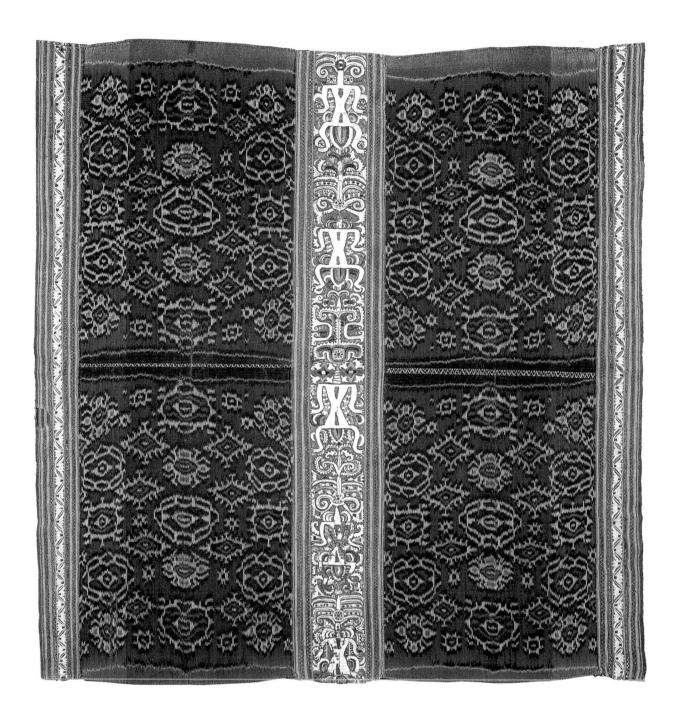

182
tapis inu
woman's ceremonial skirt
Paminggir people, Lampung, Sumatra,
Indonesia
handspun cotton, silk, natural dyes
warp ikat, embroidery
121.8 x 126.5 cm
Australian National Gallery 1989.1490

This type of Paminggir woman's skirt
is highly unusual because the design in
the central embroidery band can only
be read clearly when the textile is
turned on its side (that is, not as it is
intended to be worn). A row of finely
worked and highly stylized human
figures appear, each crowned with an
elaborate curling head-dress. While
these are ancient motifs, the rich red
warp ikat field that flanks the silk
embroidery has been strongly
influenced by imported Indian trade
textiles. Nineteenth century

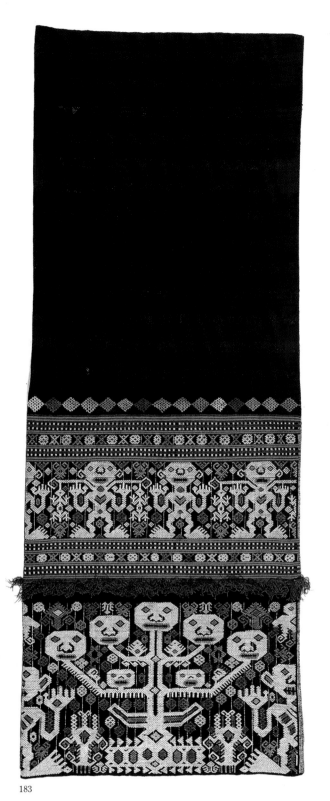

183

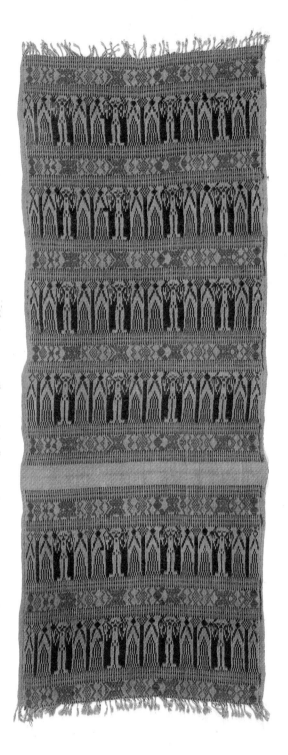

184

the temporary dwelling place of supernatural beings. Particularly during the era when head-hunting activities held a central place in the life of the Iban, the longhouse communities constructed temporary shrines (*ranyai*), in which the gods who were called to attend at ceremonies might dwell. These structures were walled with large and valuable *pua* depicting beings from Iban mythology. *Pua* were also

used as hangings to decorate the longhouse at every major celebration or ceremony invoking the gods' blessings. Amongst the Mien of mainland Southeast Asia, an initiate shaman is assisted by the head shaman, to climb a ladder of swords covered with a white cloth that is believed to represent a pathway to heaven (Campbell et al., 1978: 46). These rites make implicit demands on the qualities of sacred textiles, as protectors and as communication links with the benevolent beings of the Upper World.

It is often a shaman who uses the sacred quality of beads to full advantage. A curious beaded jacket (*thap suang*) is worn by the performers during the *manora* dance drama in southern Thailand.[71] This drama, while loosely based on Jataka Buddhist tales from India, also appears to re-enact an ancient ritual where the *manora* master is the pre-eminent shaman whose magical powers were called upon for exorcisms, ordinations of priests, topknot-cutting ceremonies, funerals, weddings and temple fairs. It seems that the function of this dance is to make an offering (*kae bon*) to placate a particular spirit who has granted a request (Ginsburg, 1975: 69–73). The *tua nora* can also use his powers to curse others, particularly rival *nora*, and to this end every *tua nora* wears protective charms and amulets, including these mysterious beaded vests with ancient, diamond grid patterns.

Where relationships are defined by family membership, the ritual leaders who intercede with the spirits and deities are often prominent clan elders and the donning of particular garments, such as *180,181* the large shawls of the Lio of central Flores, transforms the situation into one of portent. The Lords of the Earth are responsible for important decisions affecting the life of the community, such as pronouncements about the opening of the agricultural season. In these cases, leaders make magical use of heirloom textiles and other paraphernalia such as special betel-nut pouches.

Offerings to spirits and deities are an important facet of ritual and textiles are often included in these rites. Balinese offerings, which are set out as clothing for the gods (*rantasan*), contain textiles chosen for their sacred qualities and their suitability of colour. In Java the *110* tie-dyed *kain kembangan* are offered to the gods as ritual gifts. Iban offerings are covered with the finest *pua kumbu* textiles and the Toraja make offerings of sacred *ma'a* to the spirits that are responsible for securing fertility and safety for their villages and fields (Crystal, 1979: 58). In the Ngada region of Flores, it is customary at the completion of a successful harvest to cover a portion of it with fine cloths during the subsequent celebrations.

Given the antiquity and centrality of beliefs in ancestors and spirits and their apparent depiction in prehistoric art, it is not surprising that supernatural beings have secured an important place in textile iconography. Throughout Southeast Asia, gods, spirits and ancestors are widely depicted in anthropomorphic form. Sometimes, however, the style of these motifs is so schematic that their real meaning is not immediately apparent, and may not even be understood by present-day weavers. This problem is evident on many Iban textiles, particularly on older style *pua* where the anthropomorphic *52,53* forms are concealed within the rhomb and hook patterns. Exact *54* identification is only possible by experienced older weavers, and only by those women who still use these designs on their own textiles.

While some Iban weavers are still able to identify particular gods and spirits among the twists and curves of the patterns produced by

183
lau pahudu
woman's skirt
Sumbanese people, east Sumba, Indonesia
handspun cotton, natural dyes
supplementary warp weave, staining, embroidery
155.0 x 58.5 cm
Australian National Gallery 1984.617

This finely worked skirt was made by a member of a royal family in east Sumba. The foundation weave has a subtle black-on-black supplementary warp pattern in the top section and is joined to the lower panel with red-orange embroidery. The same colours appear in an added fringe. Though made in the twentieth century, the cloth contains motifs that have been used for many generations, including skull trees and human figures carrying lizards on shoulder poles. On most eastern-Indonesian cloths human figures are depicted in a two-dimensional form, although on rare Sumba examples like this one, a three-dimensional effect is achieved by the addition of ribs and shading through staining sections of the thick white supplementary warps after weaving.

184
subahnalé
sacred cloth
Sasak people, Lombok, Indonesia
handspun cotton, natural dyes
supplementary weft weave
111.0 x 42.0 cm
Australian National Gallery 1986.2113

Until recently figurative Sasak textiles did not exist in museum collections. In present-day central Lombok, Sasak weavers make supplementary weft textiles containing figures in the style of Balinese shadow-puppets, sometimes using metallic thread. However, the Sasak still distinguish between the routine weaving of these modern cloths and the careful rituals that were required in the past to create a textile they refer to by the term *subahnalé*. For those cloths, a small ceremony was performed and the weaving occurred in a special place where a woman remained undisturbed. On this example, simple figures with arms outstretched are separated by triangular structures. Like all sacred Sasak cloths, the cotton thread and dyes are entirely locally produced. The dominant colours are black and brown against a cream ground, with narrow green stripes as highlights between each band of figures. Early twentieth century

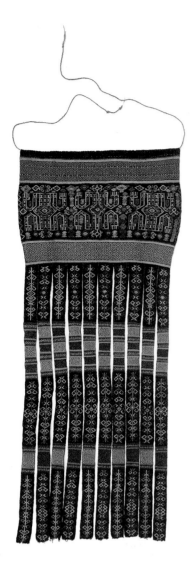

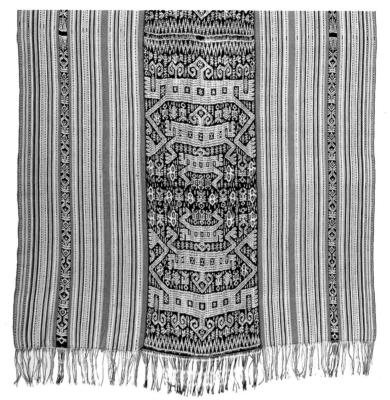

186

185
ilaf, vilu bokof (?)
ceremonial regalia of a ritual warrior
Tetum people (?), south Belu region,
Timor, Indonesia
handspun cotton, natural dyes
tapestry weave, twining,
supplementary weft wrapping
29.2 x 69.4 cm
Australian National Gallery 1982.2294

Figurative motifs are sometimes found
on the small headbands, belts and
decorative regalia of the *méo* warriors.
Details such as five-fingered hands and
body decoration suggest that these are
stylized depictions of human figures.
The mirror image of the design may
be merely decorative or it may have
been intended to symbolize copulation.
Since traditional warfare was
associated with fertility and potency,
this would be an appropriate motif on
the costume of ritual war leaders. Red
and orange weft threads appear
against a dark blue ground. Late
nineteenth or early twentieth century

ikat and weft-wrapping techniques, the meaning of both realistic and
stylized representations of the anthropomorphic form are more prob-
lematic in other Southeast Asian cultures. It is possible that both the
human figures and other more schematic shapes found on many tex- *182*
tiles represent supernatural beings. The oldest realistic represen-
tation of the human body on textiles presents a full frontal view, *183,184*
standing or squatting. Strength is conveyed in the stance, usually with
feet apart and arms raised, although the bold 'hands-on-hips' pose is
also an ancient representation. Compelling anthropomorphs, either in
isolation or as figures within larger figures, appear on various types of *185,186*
Timorese textiles. On the *méo* ritual warrior's head-dress, such fig-
ures may have been intended to invoke the protection of particular
spirits. In south Sumatra, extremely stylized linked figures appear as
a dominant motif on one specific banded type of *palepai*, while other *187*
styles of *palepai* and *tampan* are filled with more realistic, solid,
frontal images.

 While linked or enmeshed patterns of realistically depicted
human figures decorate many woven textiles, it has been suggested
that certain schematic designs such as the *sekong* rhomb and key
motif of the Toraja, may also be viewed as genealogical figures *188,189,190*
(Schuster, 1965: 341-6). In many cultures where these decorative
designs appear, revered and deified ancestors and clan founders are
believed to play an active part in the everyday affairs of their de-
scendants. Elsewhere in the region, anthropomorphic designs may
have a quite different and specific meaning. On the beaded skirts and
jackets of the Maloh of west Kalimantan, the *kakalétau* motif depicts *29,81,82*
both guardian spirits and also slaves whose fate was controlled by the
class of nobles with the right to make and wear the finest beaded
textiles (King, 1985; J.R. Maxwell, 1980). In some examples of Maloh

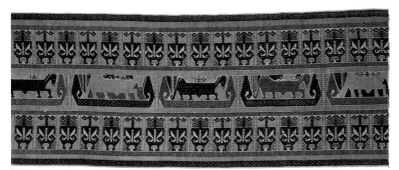

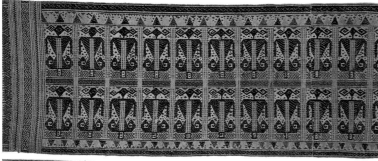

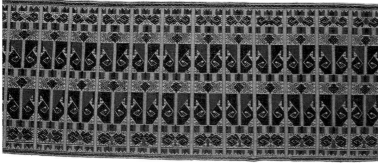

187

art, this motif is truncated to form a mask or face (*udo'*). Similar images are found on funerary structures in Kalimantan where they serve to frighten away marauding spirits.

Not all spirits and ancestors are depicted in the form of anthropomorphs. On the warp ikat abaca textiles of mountain Mindanao, the popularity among the Mandaya of creatures with features resembling both humans and crocodiles has been explained in terms of the crocodile's sacred character (Cole, 1913: 194–7). Similar ambiguous figures appear on many eastern Indonesian textiles, and in this region reptiles such as crocodiles and founding ancestors are intertwined in local legends. The crocodile spirit (*antu baya*) is also a prominent figure in Iban mythology although it is depicted with great caution when it is used as a motif on their textiles. When displaying such dangerous creatures, Iban weavers often include motifs representing food offerings. The presence of small animals or humans placed near or within the bodies of other large ferocious creatures of terrifying appearance, such as those sometimes found on Lampung *tampan* may be explained in the same way.[72]

186 (detail)
beti fut atoni; mau fut atoni
man's cloth
Atoni or Dawan people, Timor,
Indonesia
cotton, dyes
warp ikat
175.0 x 104.0 cm
Australian National Gallery 1980.1655

Patterns built up of interlocking figures are found in many parts of Southeast Asia. On this Dawan cloth, the largest blue and white warp ikat motifs are clearly depicted with five fingers and toes suggesting their anthropomorphic form. Whether these *fut atoni* (human ikat motifs) were once intended to depict specific ancestral figures is now unclear. However, the cycle of generations is wonderfully portrayed by the interlocking and repeating arrangement of these motifs of abundance. The background of the central panel is filled with tiny birds and other small creatures.
Mid-twentieth century

187 (details)
palepai
ceremonial hangings
Paminggir people, north Semangka
Bay region, Lampung, Sumatra,
Indonesia
handspun cotton, natural dyes
supplementary weft weave
304.0 x 63.8 cm; 277.0 x 62.5 cm;
302.0 x 65.0 cm
Australian National Gallery 1985.504
(Gift of Mrs Bamberger, 1985);
1982.140 (Gift of Russell Zeeng,
1982); 1984.1192

A type of *palepai*, in which the motifs are worked in horizontal bands, shows seated (or male?) figures with curling limbs wearing head-dresses or horns. In the past, *palepai* (the largest of the supplementary cotton weavings of the Paminggir people) passed to the eldest son of the local clan or district leader as a symbol of hereditary leadership. In certain cases, the *palepai* textiles have been found cut into two, perhaps as a result of disputes over inheritance. These cloths are predominantly red, blue and orange and date from the nineteenth century.

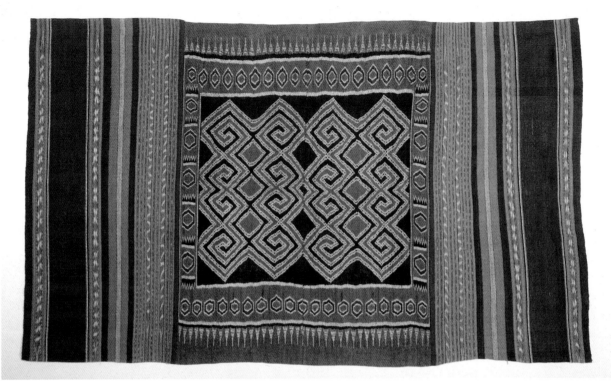

188

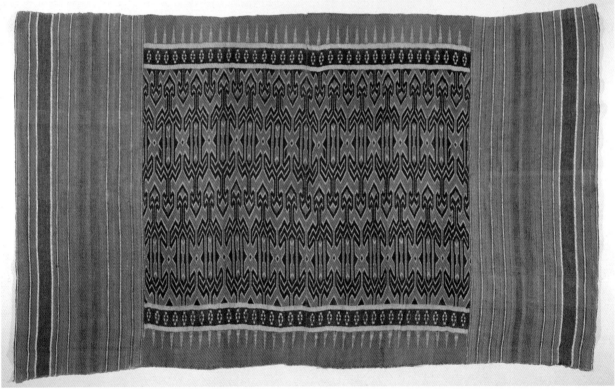

189

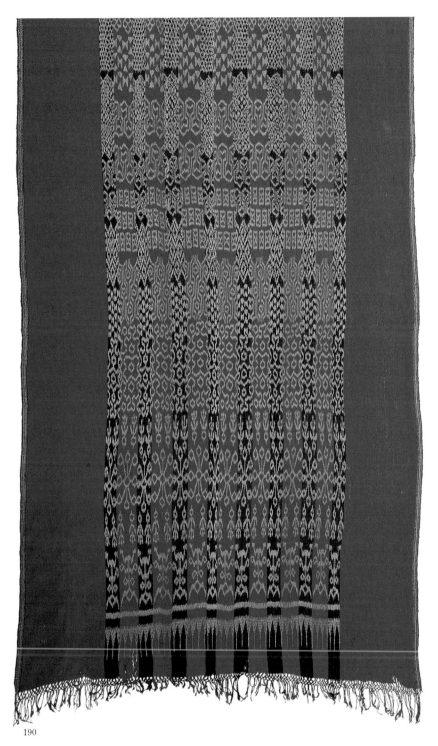

190

188
pori situtu'
ceremonial hanging; shroud
Toraja people, Rongkong district,
central Sulawesi, Indonesia
handspun cotton, natural dyes
warp ikat
265.0 x 157.0 cm
Australian National Gallery 1981.1126

189
sekomandi
ceremonial hanging; shroud
Toraja people, Kalumpang district,
central Sulawesi, Indonesia
handspun cotton, natural dyes
warp ikat
261.0 x 152.0 cm
Australian National Gallery 1981.1129

190 (detail)
pori lonjong
ceremonial hanging; shroud
Toraja people, Rongkong district (?),
central Sulawesi, Indonesia
handspun cotton, natural dyes
warp ikat
955.0 x 175.0 cm
Australian National Gallery 1984.600

Human forms are evident in many
schematic and interlocking spiral
patterns throughout Southeast Asia.
Such designs appear on each of these
three late nineteenth- or early
twentieth-century Toraja warp ikat
textiles. The *seko* or *sekong* pattern is
still a popular Toraja design, though
the term itself now has no known
meaning other than the name of this
pattern and some of the textiles on
which it appears. Anthropomorphic
forms are also discernible in the
patterns on the enormous *pori lonjong*
(long ikat cloth), which is nearly ten
metres in length. Side bands appear on
all Toraja ikat textiles, as they do on
most Iban *pua*, and are evidently an
archaic design feature. Slightly
different red and blue-black dyes were
a feature of the Rongkong and
Kalumpang-Makki valleys, and the
cloth in Plate 190 features the blue
found on many Rongkong cloths rather
than the characteristic over-dyed black
of the Kalumpang area.

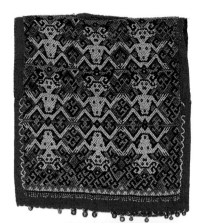

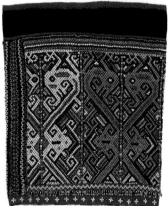

191

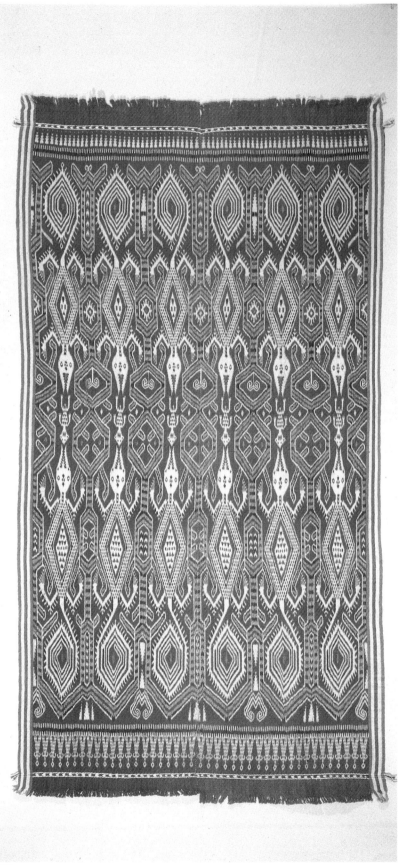

192

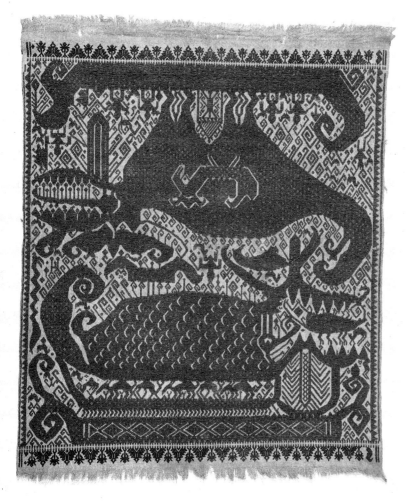

193

'The crocodile is believed to stand in a kind of totemic relationship to the Iban, and to keep a special surveillance over their lives. It is thus customary for an Iban who does not want the food that he or she has been offered, to touch this food while uttering the words: *Udah, aki.* These words which mean: "It is done, grandfather," are addressed to the crocodile.'

To satisfy the powerful spirit that she has daringly recreated and which might, upon the completion of the textile, come to life and attack her, the weaver has placed small human figures as food between the jaws of the confronting crocodiles. These figures may also represent 'an individual who has committed the "sin" of refusing food, and is about to be taken by a crocodile' (Freeman and Freeman, 1980).

193
tampan
ceremonial cloth
Paminggir people, Lampung, Sumatra, Indonesia
handspun cotton, natural dyes
supplementary weft weave
67.0 x 81.5 cm
Australian National Gallery 1984.579

While boat structures are evident at both top and bottom of this *tampan*, the scene is dominated by two huge terrifying creatures with bared fangs intent on devouring other animals. One has already been consumed. Although the horns suggest a water buffalo and the scaled body of one creature suggests a crocodile or dragon, these brown monsters seem to have arisen entirely from the vivid imagination of the weaver. *Tampan* depicting large ferocious animals were one of a number of style categories produced during the nineteenth century. Overwhelmed by the larger figures, the human forms depicted here are simple standing figures with pronounced genitalia. The background is filled with small hooks which repeat the bold strokes in the creatures' tails and the prows of the ships. Nineteenth century

191
kain manik; *sapé manik*
woman's ceremonial skirt; ceremonial jacket
Maloh people, west Kalimantan, Indonesia
cotton, dyes, beads, brass bells
beading, appliqué
42.0 x 50.0 cm; 51.0 x 45.0 cm
Australian National Gallery
1982.1297; 1982.1302

Throughout Southeast Asia initiation into adulthood often involves tooth-filing, which emphasizes clearly the distinction between humans and animals. Monsters with pointed fangs are carved into the ends of wooden funerary structures in certain parts of Kalimantan as an appropriate image to frighten spirits who might disturb the dead. The mask-like face may also serve to frighten marauding spirits when it appears on textiles. On this Maloh skirt, the face or mask image (*udo*) is depicted interlocked with the water serpent (*naga*). An old Malay handspun cotton plaid, worked in natural dyes, has been used as the skirt's lining. The beaded jacket with the human (*kakalétau*) design is lined with striped cotton and is fringed with brass bells. On both garments bright yellow, orange and white motifs stand out from the black, blue and green beads. Early twentieth century

192
pua kumbu
ceremonial cloth
Iban people, Sut River, Kapit district, Sarawak, Malaysia
cotton, natural dyes
warp ikat
234.0 x 124.2 cm
Australian National Gallery 1981.1117

Collected by the anthropologist Derek Freeman and Monica Freeman in 1950 at Rumah Nyala on the Sut River, this red, black and white pua depicts the crocodile spirit (*antu baya*). Of this design, the Freemans (1980) comment:

194
*dodot bangun tulak alas-alasan
pinarada mas*
royal ceremonial skirtcloth
Javanese people, Surakarta, Java,
Indonesia
cotton, natural dyes, gold leaf
stitch-resist dyeing, gluework
357.5 x 207.0 cm
Australian National Gallery 1984.3167

This late nineteenth-century cloth
belongs to a category of Javanese
cloths known as *kain kembangan*
(flowered cloth). These stitch-resist
dyed cloths have an ancient history of
sacred and ceremonial use in Java, and
combine a number of auspicious
elements. The black and white colours
are considered especially propitious.
It is decorated with scenes of animals
and foliage known as *alas-alasan*
(forest-like pattern), which are
whimsically worked in fine gold leaf
gluework (*pinarada mas*). While many
of the small animals and insects
depicted on the cloth are dangerous to
humans and threatening to life-giving
crops, their presence may serve as a
form of symbolic protection since the
particular name of the cloth (*bangun
tulak*) suggests the notion of repelling
evil (Solyom and Solyom, 1980a: 260;
Veldhuisen-Djajasoebrata, 1985).
These huge skirtcloths (*dodot*) are
worn in the courts of central Java, and

COOLING CLOTHS: TEXTILES AS PROTECTION

Throughout Southeast Asia cloths are used in many sacred activities
that are intended to ensure the safety of the individual, the prosperity
of the group and the equilibrium of the universe. Textiles appear both
in times of unpredictable disaster and during the regular cyclical
rituals associated with agriculture, fertility and prosperity. Different
cloths or sets of cloths are appropriate to each level of ritual. While
those used in bride-wealth exchanges or in cases of individual illness
or misfortune are the property of families, the cloths used at agri-
cultural fertility rites often belong collectively to the clan or village
and are stored in a central shrine or ritual house. There they are
secured away with other sacred objects in the high peaked roofs of
traditional buildings — the dwelling places of benevolent ancestors
and spirits, and where offerings are placed to ensure their guardian-
ship.[73]

Textiles are believed to have the power to ward off evil spirits
who attempt to steal an individual's soul, and thus inflict illness and
ultimately death. *Geringsing* are renowned as a type of double ikat [13]
cloth in Bali and also as the name of a particular batik pattern in Java,
and both have special protective qualities. The chronicles tell of the
use of *geringsing* by Javanese warriors in battle, while in Bali and even
in the Sasak districts of Lombok, the double ikat *geringsing* cloths
appear in cyclical ceremonies and rites of passage, and at times of
unusual and unexpected crisis.

The concept of using a textile as a protective barrier against
malevolent forces is implicit in the name of the *bangun tulak* cloths of [194]
central Java, a term meaning 'to turn back evil'. These blue-black and
white tie-dyed cloths are an important part of the paraphernalia of the

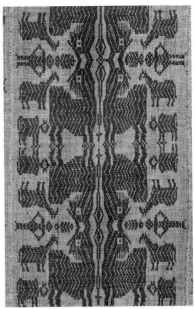

196

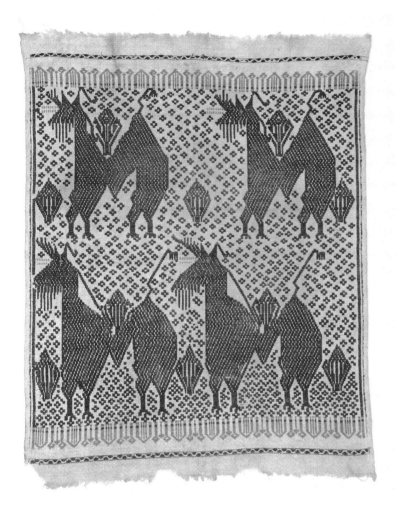

195

195,196 *garebag*, an ancient annual feast of renewal when the links between the heavenly and earthly realms are stressed and which, since the arrival of Islam in Java, is celebrated on Muhammad's birthday (Veldhuisen-Djajasoebrata, 1985: 132). These cloths are also worn as huge ceremonial wraps (*dodot*) by court dancers and by royal bridal couples at the marriage rituals that ensure the prosperity and fertility of the court of Surakarta in central Java. Combinations of blue-black and white on textiles are considered propitious in Java and Bali, and are appropriate colours for protective textiles (Solyom and Solyom, 1980b: 278). Banners in these colours were hung at times of community crisis, and in certain villages in one part of Java today, black and white cloths referred to by the term for banner (*panji*) are used in exorcism rituals (Heringa, 1985: 120). In Javanese and Balinese legend, black and white checked cloth (*kain poleng*) is worn by particular gods and heroes, and the stone temple guards of Bali are swathed in *poleng* checks during temple festivals.

The depiction on textiles of motifs associated with danger and aggression, including grotesque and mysterious creatures, seems to be a deliberate attempt to harness these qualities to repel life-threatening forces.[74] We find, for example, rows of teeth (*ipon-ipon*) and centipedes (*ansisibang*) placed on the intricate white supplementary

this indigo and white example also has gold leaf gluework on those reverse sections of the cloth that are revealed when it is draped around the loins. Royal bridal couples appear in these textiles during the *manten temon* part of the marriage ceremonies.

195
usap
sacred textile
Sasak people, Lombok, Indonesia
handspun cotton, natural dyes
supplementary weft weave
45.5 x 58.2 cm
Australian National Gallery 1986.2454

196 (detail)
owes (?)
ceremonial shawl; hanging
Tinguian people, Luzon, Philippines
handspun cotton, natural dyes
supplementary weft weave
Field Museum of Natural History,
Chicago 108887

In many parts of Southeast Asia, strange and enigmatic monsters appear on supplementary weave textiles. Today, the meaning of such images is often unclear to the weavers who merely follow patterns established in ancestral times. In the case of the rare figurative Lombok *usap*, the blue bearded creatures and the diamond-shaped remnants of rider or howdah are no longer a part of twentieth-century Sasak textile iconography. On the indigo and natural Tinguian cloth, the main figure is also bearded. Nineteenth-century textiles

197 (detail)
kain panjang
skirtcloth
Javanese people, Yogyakarta, Java,
Indonesia
cotton, natural dyes
batik
Rijksmuseum voor Volkenkunde,
Leiden B110.19

The broken sword pattern (*parang rusak*) is considered to be one of the most powerful batik designs in central Java. It was originally one of the restricted patterns permitted to be used only by the Javanese nobility of the Mataram court (Veldhuisen-Djajasoebrata, 1988: 60). The higher a noble's rank, the larger the *parang rusak* pattern that could be worn. This example was collected in the early twentieth century by the famous Dutch Javanologist, R.A. Kern, who recorded it as the *barong* (giant *parang*) pattern.

weft panels of certain Toba Batak textiles,[75] and these same creatures are also displayed on the *bangun tulak alas-alasan* of central Java. Bands of poisonous scorpions (*maeng ngord* and *maeng ngao*) and pythons (*ngu hluam*) on Esarn fabrics in northern Thailand are believed auspicious (Peetathawatchai, 1973: 49–51), while saw teeth, tiger claws, thorns, and forks appear on Mien embroideries that are used during important life-cycle ceremonies associated with the notion of repelling danger. The tiger, once a constant threat to villagers in northern Thailand, must be placated with annual rituals. However, it is also believed that its powers can be assumed through the wearing of a textile displaying its symbols. For the Mien, only their priests have sufficient power to control such forces, and the use of the strong tiger design is restricted to the robes of these religious leaders.[76]

The deployment of dangerous sharp symbols — swords, knives and teeth — for protection is also widespread throughout Southeast Asia. One of the most famous symbols of this kind is the *parang rusak* 197 (broken sword) pattern used on wax-resist batiks in central Java. There are several interpretations of this pattern, all of them variations on the ancient interlocking double spiral. Significantly, terms remarkably similar to *parang rusak* are also used to describe certain warp ikat textiles found throughout the Malay world bearing the equally ancient arrowhead pattern. This arrowhead pattern is known as *plang rutha* in Aceh and *plang rosa* in Malaysia. It also appears on 98 Toba Batak ceremonial baby-carriers (*ulos mangiring*), where it is known as the *padang rusa* design. On another Toba Batak cloth, the *ulos rujat*, it has contributed to the textile's name. Many of these 96 cloths are used in situations where notions of protection are implicit. In Java, however, the *parang rusak* was a batik pattern traditionally restricted to the palace circles, which meant that the protective qualities of the symbol were exclusive to the rulers of central Java.

While ritual cloths are often rich in decorative symbolism, the importance of simple and unpretentious cloths in certain cultures may easily be overlooked. Typically, these cloths are either monochrome[77] or woven with a plain, striped warp or weft. Despite their apparent simplicity, these cloths may still be ritually important and many are also regarded as talismans when woven by knowledgeable women or according to particular magical formulae. Some of the simple Sasak textiles woven in Lombok (in particular, the *kekombong* or *umbaq*) are an excellent illustration of these themes. Specific combinations of coloured warp stripes are used to create the soul cloth in which a new-born baby is wrapped. The same cloth is present at the child's first hair-cutting, and at rites associated with the attainment of adulthood, such as circumcision. It is then stored away carefully by the individual to whom it belongs so that it can be produced as a protective talisman at any time in the future when danger or disaster threatens. The Sasaks also use simple striped cloths as waist-ties, often loosely and hurriedly woven, to prevent all manner of illness or anti-social behaviour, especially in the case of children. The names given to these simple cloths vary according to the particular ailment for which they are prescribed.[78]

In other parts of Southeast Asia the most elaborate and prestigious cloths must be used on occasions associated with changes of status — birth, marriage, initiation into adulthood, pregnancy, and death. The ritual function of many magnificent cloths explains why so much energy and enormous care is expended. This contrast between the most simple textiles and the most elaborate is strikingly evident in the case of Bali. In addition to the complex double ikat textiles of Tenganan Pegeringsingan that display extraordinarily elaborate patterns, the Balinese also weave many quite simple cotton textiles composed of narrow warp stripes known as *wangsul*. Both of these types of cloth are believed to have magical endowments. Furthermore, when the need for protection arises, such as in cases of illness, both may be required.

It is interesting to note that many textiles featuring elaborate designs and complex weaving techniques also retain the stripes and bands found on the most simple cloths. As well as the technical and aesthetic advantages of including these elements as part of the design, stripes are often considered to contain protective qualities, both for the central motifs of the cloth itself and also for those who use it.

The addition of beadwork not only contributes to the value of a textile but it also enhances its ritual significance, in particular, its protective qualities, for the toughness and durability of beads are considered to be a source of strength to those who wear them. Beads and shells, like other rare and foreign objects traded into inland regions, assume special supernatural qualities and the use of beads as magical talismans and charms is particularly evident throughout Borneo.[79] The history of particular beads and the heroic feats of the ancestors who set out in quests to obtain them have been recorded in the legends of the Maloh people of west Kalimantan (J.R. Maxwell, 1980: 136). Strands of beads play a role similar to that of sacred textiles, being used in Maloh marriage rites and placed in the holes prepared for the main poles of a Maloh longhouse (King, 1975: 114–15).

198
pua kumbu
ceremonial cloth
Iban people, Sarawak, Malaysia
handspun cotton, natural dyes
warp ikat
252.0 x 120.0 cm
Australian National Gallery 1981.1098

199 (detail)
pua kumbu
ceremonial cloth
Iban people, Sarawak, Malaysia
handspun cotton, natural dyes
warp ikat, twining
239.0 x 130.0 cm
Australian National Gallery 1980.1657

Paired male and female figures
present powerful images on cloths
intended for fertility rites such as the
collecting of heads. The cloth in Plate
198 is especially powerful as it depicts
ancestral figures or spirits (*antu*) who
prey on animals and human beings
represented by the small figures
lodged between the larger spirits. It
presents a frightening pattern to an
Iban weaver, and would only be
undertaken at some risk. The *pua* in
Plate 199 displays small paired figures
wearing earrings and head-dresses. An
Iban informant interpreted the large
abstracted figures below them as
water spirits (*antu ai*) spurting from
whirlpools, and she identified the
lower border pattern as cats sleeping
in the recess of the hearth. A creeper
pattern binds the various elements
into a coherent and satisfying design.
The colour of the natural dyes on both
these early twentieth-century textiles
has been excellently preserved.

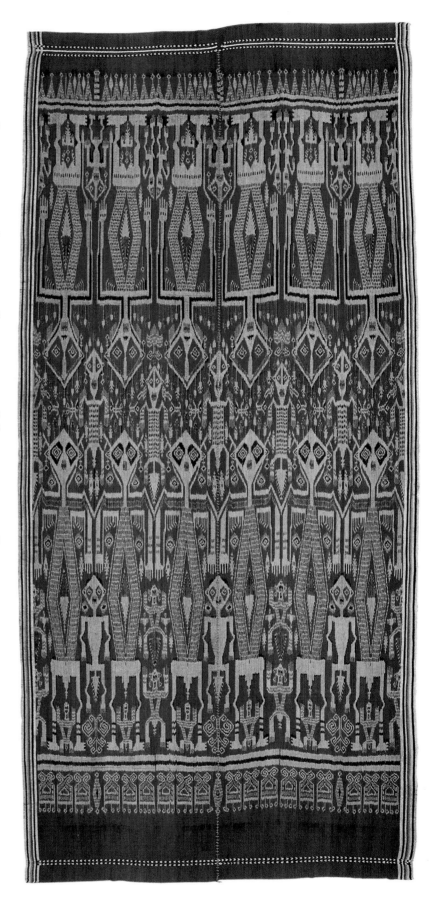

FERTILITY AND INCREASE

The motifs and designs on textiles required particularly in marriage and agricultural rites frequently contain messages that relate to the notion of fertility. Male and female figures, or symbols representing male and female qualities, are one prominent design category found on many Southeast Asian textiles.

Like the carved ancestor figures and guardian spirits that are strategically located to protect houses, rice-barns, clan and spirit houses or family shrines and to ensure fertility and agricultural success, male and female figures are often depicted on textiles in pairs, seated or standing, realistic or highly stylized. On certain examples, the sex of the human figures is clearly distinguished by obvious and explicit genitalia. Occasionally, specific items of clothing or jewellery, such as earrings and head-dress, may identify a figure's sex or status. Like carved sculptures, the association of paired figures with notions of fertility is most evident on some textiles where figures are presented in the act of copulation. Paired male and female figures are prominent on Iban textiles, and frequently a band of each appears at opposite ends of a *pua kumbu* used at rites which promote fertility and agricultural increase.

With simplification and stylization, the male and female elements of the design are sometimes reduced to phallic and vulval symbols. This has occurred in the case of certain Batak textiles, where these motifs appear as ancient rhomb and triangular schematic shapes in the decorative panels at each end of the cloth. Similar motifs are found on many other textiles throughout the region. Although the hooked rhomb design has few conscious associations with fertility and female symbolism among present-day weavers, many textiles containing this design are used in rites by peasant farmers and villagers seeking to secure a successful harvest. In these cases this motif appears to be symbolic of the fruitful mother. Its appearance on many Toraja and Iban ikat cloths used at funerary and head-hunting ceremonies is also appropriate, for although these rites are connected with death they are also intended to promote the abundance of life.

As well as the rhomb and triangle, the human form is represented by a number of other geometric symbols, in particular a simple cross. Sometimes, however, the association of these motifs with the human form is not readily apparent. In the case of the Bagobo of Mindanao, the development of anthropomorphic motifs has passed through several stages and different types of abstracted human figures sometimes appear together on the same garment. On the ends of traditional Iban loincloths (*sirat*) clearly defined human motifs are only immediately evident on certain old examples. However, when these realistic designs are compared with other more abstract examples, the weavers' intentions can be discovered and human figures emerge from the simple cross form. It is reasonable to assume that many other symbols, now merely seen as geometric decoration, were also intended to represent humans, animals and other important creatures and objects.[80]

The use of textiles as hangings and banners at ceremonies that focus on fertility and renewal is especially evident among the Torajanese. Fine textiles form a symbolic link between the participants in Toraja feasts of renewal and their families' ancestors. Huge

198,199

44

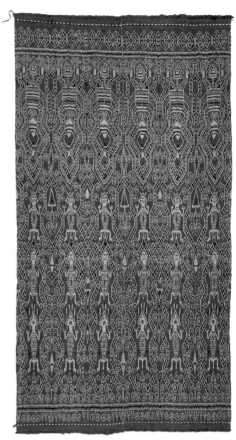

199

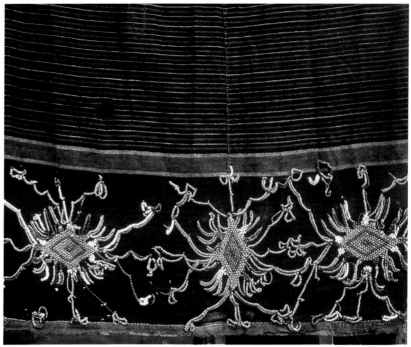

201

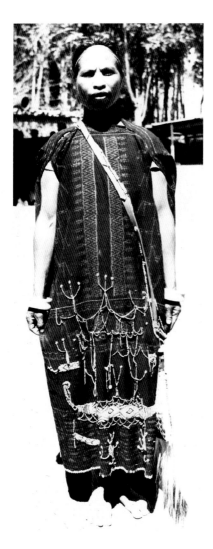

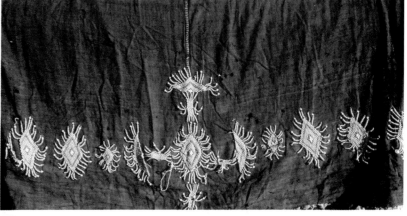

202

200
A Ngada woman prepares for dancing
at a ceremony wearing a fine example
of a *lawo butu* with a large beaded
ship motif.

201 (detail)
lawo butu
ceremonial skirt for young women
Lio people, Flores, Indonesia
handspun cotton, natural dyes, beads
beadwork appliqué

202 (detail)
utang beké
heirloom skirt
Sikka people, Flores, Indonesia
handspun cotton, natural dyes, beads
beadwork appliqué

203
lawo butu
woman's ceremonial skirt
Ngada people, Flores, Indonesia
handspun cotton, natural dyes, beads,
shells
warp ikat, beadwork appliqué
179.0 x 74.0 cm
Australian National Gallery 1981.1141

The beaded motifs on these three
nineteenth-century textiles from
different parts of Flores are formed
from bright, hand-made beads in the
traditional colours — red, black, white
and yellow. The beads on each of
these cloths are very old and though
their exact origin is unknown, they
were probably obtained through trade.
If the base fabric becomes worn or
damaged, the beadwork is removed to

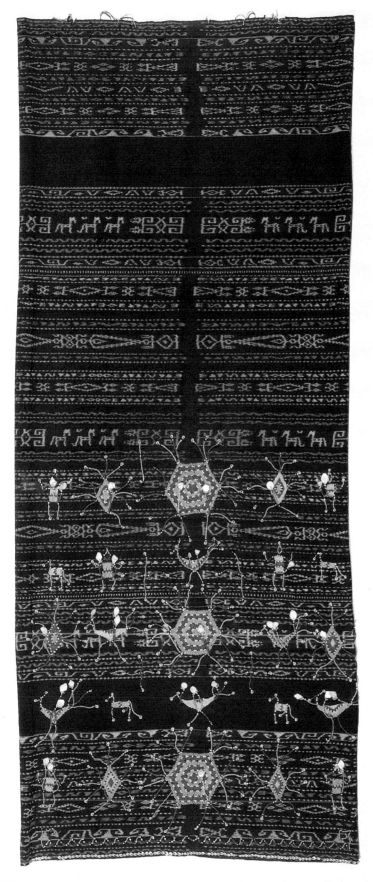

203

a new cloth. The beaded designs are predominantly large, striking rhombs and hexagons with trailing strands of beads and shells. The exact meaning of these mysterious shapes is now lost. On the Ngada cloth, the beadwork also includes humans, horses and chickens, and elderly Lio and Sikka informants recall similar motifs on their own beaded skirts. The rhomb and hexagonal beaded motifs on the heirloom skirts of central Flores may be symbols of female fertility.

All the beaded cloths of central Flores have great ceremonial significance. The long Ngada cloth is worn tied at the shoulder by mature women of the highest rank on ceremonial occasions. The Lio skirt is worn only by young unmarried women when ritual sacrifices and dancing are required. It is used at times of crisis, in particular when rains needed for the success of the crops have not arrived. The exact function of the Sikka *utang beké* is now uncertain. Its name derives from the term *beké* or *breké* (long hunger), the period of famine often experienced before the arrival of the next harvest. This suggests that in the past this cloth may have fulfilled a role similar to the Lio beaded skirts. The heirloom skirt in this photograph was believed by its guardian to be magical (*pirè*), and by changing its condition it was able to indicate the fortunes of the coming year. If it was observed to be torn and in holes, a famine was imminent, but when it appeared in good condition, the harvest would be bountiful. This textile is considered to belong to the realm of the old and wise, for if young people look upon it they risk becoming barren and unfruitful.

Like most textiles important in ritual, the base cloth of each of these beaded textiles is of handspun cotton and natural dyes. Only the Ngada example contains warp ikat designs. The clear, banded warp ikat motifs include rhomb and key combinations and simple horses (*jara*). Some of the ikat motifs in the minor bands have been worked in red dyes (Morinda citrifolia). In the Ngada region of Flores this is quite rare and indigo is usually the only dyestuff applied to thread.

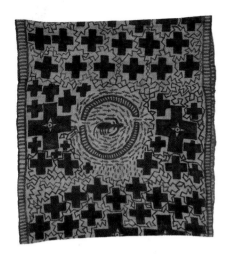

204
ma'a; *mawa*
sacred textile
Sa'dan (?) Toraja people, central
Sulawesi, Indonesia
handspun cotton, natural dyes and
mordants (?)
painting, block printing
47.4 x 78.8 cm
Australian National Gallery 1981.1146

The sacred textiles of the Toraja
(*ma'a*) consist of both locally made
cloth and fabrics originally acquired
through trade. Many *ma'a*, however,
are believed by the Toraja to have
been woven by the gods. This
seamless circular textile was
completed by the continued insertions
of weft threads, probably with a
needle, until no unwoven warp
remained. It was probably not intended
to be worn, although its original
prototype may have been a skirt and
its cylindrical structure is similar to
the enormous bark-cloth skirts made
in one felted piece by the northern
Toraja peoples.
The medium of painting and printing
with carved wooden stamps allows
greater freedom of arrangement than
woven decoration permits. The
imagery on this textile is of wealth
and abundance. The buffaloes inside the
corral include one fine beast shown in
the characteristic Toraja style
combining profile and aerial
perspective. Other buffaloes are
depicted as elongated crosses and the
small dashes to one side probably
represent dogs or domestic fowl,
which are found in all Toraja villages.
The largest black motifs, the heavy
black crosses, represent heavenly
stars or spots (*doti langi'*). *Ma'a*
cloths with the *doti langi'* motif are
displayed particularly at the Toraja
rituals celebrating the agricultural
cycle and feasts of merit. Probably
nineteenth century

cloths are hung from the walls of temporary shelters erected to accommodate guests, and billow like sails from the peaks of the curved roofs of traditional houses. Many symbols of fertility are evident on these Toraja textiles and on the decorative costume worn on these ceremonial occasions. One of the most prominent of these symbols is the *doti langi'* motif, believed to represent the stars of heaven. This motif is frequently displayed on certain sacred textiles known as *ma'a*, and according to Toraja mythology it is an indication of the wealth and prosperity of the lineages that own these sacred textiles. Unlike their huge warp ikat shrouds, which according to the Toraja conception of a dualistic cosmos are associated with death and the west, the *ma'a* sacred textiles are closely identified with the east and the Toraja rites of life (Crystal, 1979: 58). The *ma'a* textiles are rarely part of the paraphernalia of funerals, although on occasions they are used to wrap the head of a prominent and wealthy local leader. Like many other Southeast Asian sacred cloths associated with life-generating rituals, it is believed that the opening of an heirloom *ma'a* will immediately bring rains, essential at the beginning of the agricultural season.

204

Beads have become special symbols associated with communal prosperity, fertility and abundance. At harvest ceremonies, the Maloh believe that the more beads displayed on fine textiles the more rice grains will be harvested from their fields in the following year (J.R. Maxwell, 1980: 135). Throughout such feasts participants are careful to ward off evil spirits and appease omen birds of good fortune. Elsewhere in Borneo, the Kelabit place special magical beads at the end of stakes in the ricefield to ensure a bountiful crop (Harrison, 1950). Although beaded neck-pieces and aprons are part of Sa'dan Toraja dance costume, the *kandauré* is not only used as ceremonial costume; it is also an object of great ritual significance and it hangs from poles during the great feasts of the agricultural cycle and village renewal when the protection of the ancestors is once again called upon. As a symbol of prosperity, the numbers and brilliance of its beads are likened to the descendants of a house or lineage (Nooy-Palm, 1969: 189).

191

79

In the Ngada, Lio and Sikka districts of Flores, spectacular beadwork also appears on certain rare cotton textiles. These cloths are thought to possess special spiritual qualities and are associated with fertility and events that affect the general prosperity of the community. In the Ngada region, ritually mature women control the use of beaded skirts as ceremonial costume at fertility rites, and fine cloths are placed over offerings after a bountiful harvest (Maxwell, 1983). In the Lio domain, beaded skirts are used in ceremonies performed to secure the well-being of the village, fertility and, in particular, a successful harvest. In the past, similar beaded skirts also appear to have been used for such purposes in the neighbouring domain of Sikka.

201,202, 203

200

Scenes on certain textiles present a characteristic vision of human activity. Some of the most interesting examples of this genre are in central Sulawesi, where cameo scenes of secure village life on cloth are reminiscent of images found on early Southeast Asian bronze drums, although they can still be identified as representing rural life today. Elsewhere, particular decorative techniques have imposed constraints limiting the textile artisans' capacity to apply the free lines necessary to create the non-repetitive imagery of such vil-

41

lage scenes. For example, although T'boli warp ikat patterns are said
to represent human figures in the security of traditional housing
structures (Casal, 1978: 153–4), these designs have none of the re-
alism of Toraja supplementary weft textiles. As we shall see, embroid-
ery, painting and especially batik were more suitable media for
freely-designed motifs.

115

The earliest domesticated animals in Southeast Asia seem to
have been pigs, fowls and, somewhat later, dogs and certain types of
cattle (Bellwood, 1985: 156, 205, 232; Bellwood, 1979: 149–51).
These domestic animals have become an established and valuable
commodity in village Southeast Asia and a dependence upon their
continuing fertility and increase is an important aspect of everyday
life and ritual sacrifice. Consequently animal motifs are an obvious
element in the art of the region, including its traditional textiles.[81]
However, the relationship between textiles and domestic animals is
further strengthened by their use as cloaks to cover those animals
selected to play a significant role in ceremony and ritual.

205,206

The domestication of the water buffalo was an important stage in
the development of wet rice agriculture and it remains one of the
most valuable domestic animals in the region. Beyond agricultural
utility, the domestic buffalo is especially important as a sacrificial
animal in ritual, and as a prominent symbol of fertility, wealth and
economic prosperity. These massive creatures figure highly in myth
and ritual, and their huge horns decorate houses and shrines. The
number of horns and the size of their span is widely regarded as an
indicator of prosperity, and so, in addition to the depiction of the
entire animal, the graceful curve of the buffalo horn has become an
appropriate motif for the decoration of fine textiles and appears in a
variety of decorative techniques. In the Toraja region, which is
renowned for the slaughter of buffalo in large numbers at great cer-
emonies and particularly at funerals, stylized horns in crosses, hooks
and spirals decorate many garments and hangings used on these
occasions. The buffalo motif also appears on Paminggir textiles from
southern Sumatra, and on wooden and metal objects that are used for
such ancient initiation ceremonies as tooth-filing. During these rites
textiles are hung above or placed beneath the young adults. On tex-
tiles from Sumba the gold head-ornament (*lamba*) that imitates
upwardly curving buffalo horns, is a popular pattern.

38,45

The crescent-shaped motif has many possible symbolic allusions,
not only to buffalo horns, but also to ships, forms of traditional
jewellery, the crescent moon, and the characteristic roof-line of tra-
ditional houses. Of all the ancient schematic designs that appear on
Southeast Asian textiles, the meaning of the circle provokes the most
speculation. It is frequently identified as a sun image while the half-
circle or crescent is believed to represent the moon, and both are
important symbols in agricultural fertility rites throughout the
region.[82]

SECRETS TO SUCCESS: RITUAL AND
THE CREATION OF TEXTILES

Although the dyeing and weaving of cloth is a common everyday pur-
suit throughout the region, the making of textiles intended for ritual
and ceremony is often a matter of great concern. This work often
involves women in procedures fraught with uncertainty, calls upon

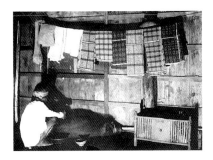

205
A huge sacrificial pig under a display
of valuable *owes* textiles. The
photograph was taken in a Tinguian
village in Luzon before 1910.
Textiles are often used to cloak
animals intended for ritual sacrifices.
Sacred cloths are placed over the
buffaloes to be slaughtered at Toraja
funerals while the Iban weave small
warp ikat textiles to cover pigs and
other small animals used in ritual
sacrifices.

206
This early twentieth-century
photograph shows two oxen covered in
woven cloth during an agricultural
festival to celebrate the turning of the
first furrow in rural Cambodia.

special rituals and magical practices, and involves a degree of secrecy at particular stages.

Secrecy often surrounds the use of traditional materials and techniques, especially dyestuffs and their application. The discovery and use of dyes by the founding ancestors is related in the origin myths of many Southeast Asian peoples, and on the island of Savu, one particular legend is suggestive of the secrecy that still surrounds the use of indigo there. Two sisters, believed to be the ancestors of the Savunese matrilineal moieties (*Hubi Ae* and *Hubi Iki*) into which the society of that island is divided, were about to receive their mother's secret recipes for achieving beautiful indigo blue. The daughters knew nothing about the indigo process in which the active precipitate sinks to the bottom of the pot during the fermentation and liming of the mire of rotting leaves. One sister, hoping to cheat her sibling of the valuable secrets, crept out at night to steal the indigo. Unwittingly, she poured off the fluid in the pot and ran away with it, not realizing that she had stolen only the thin liquid wastes which settle at the top. Her descendants are supposed never to have been able to match the supremacy of her sibling's heirs at indigo-dyeing (Maxwell, 1985: 146–7). While such secrecy surrounds the use of indigo in a number of cultures, elsewhere it is the knowledge of red dyestuffs such as Morinda citrifolia which is a closely guarded secret (Maxwell, 1981).

There are, however, practical reasons for maintaining secrecy. The wealth and prestige of a family, in part, often depends upon the quality of particular textiles which women prepare. It is general practice for young girls to learn from senior female relatives the many skills of preparing and dyeing thread and weaving cloth. The secrecy surrounding the making of traditional textiles is designed to protect the family's skills, and their knowledge of special procedures and particular designs, against emulation by other family groups. These precautions are of great significance in cultures where textiles are an essential item of marriage settlement and ceremonial exchange. For example, the Karen women, particularly the mountain-dwelling Pwo and Sgaw, protect their own special warp ikat patterns by working the designs in the forest far away from others.[83] In some cultures of Southeast Asia, anyone copying a family's designs does so at risk of punishment: cloth or threads may be slashed, and the person who has stolen the patterns may be put under a curse. In other cultures the attitudes are more pragmatic and weavers are permitted to borrow other women's designs for a fee.

Anxiety and special care accompany many of the stages of dyeing and weaving cloth because of perceived physical and spiritual dangers. For example, there is widespread belief that if the natural order of things is overturned, if inappropriate behaviour takes place, if a death occurs, if males are involved at auspicious times, if pregnant women approach, or if the family secrets are divulged to others, the dyes will fail to produce the desired effect on the thread. Moreover, this failure may even be accompanied by illness, miscarriage or madness. In the Esarn region of Thailand, the black-dyeing with *krajai* berries takes place in a special location outside the village, safe from Buddhist monks (*sangha*) and pregnant or menstruating women, for it is believed that contact with such people will immediately cause the colour of the dyed thread to fade (Peetathawatchai, 1973: 48). Legend also forbids the use of certain dyes by some groups. For

example, the women of Tenganan in Bali are not permitted to grow or dye with indigo, and this important stage in the creation of their textiles is provided by dyers from surrounding villages.[84]

Since the making of certain traditional textiles is vital to the whole group, prohibitions can modify the behaviour of both sexes during crucial stages of production. For example, among the Nagé Kéo of central Flores, the Dusun of Sabah and the Naga of western Burma, women may not weave while men are hunting or engaged in warfare.[85] In the village of Tenganan, work on the *geringsing* double ikat cloths and other sacred textiles halts during the course of major village ceremonies, including men's rituals such as the fighting with thorn branches (*perang duri*). In a number of cultures, during other important male activities such as house construction and boat-building similar prohibitions are maintained. On the other hand, there are many regions where ritual prohibitions also apply to men during cloth-making procedures. They are forbidden to approach dye-pots, step under or over drying threads, or touch the ikat tying-frame or the loom (Maxwell, 1981). It is widely believed that the breaking of these prohibitions results in the failure of that stage of the cloth-making process and brings personal misfortune upon the transgressor.[86]

The relationship between humans and the supernatural is at best ambiguous, so special steps are often taken to protect a textile from the damage that may be inflicted by malevolent spirits. Sometimes certain spirits are represented as motifs on textiles to frighten other evil spirits away. However, the accurate execution of these motifs is dangerous work. Consequently, offerings are made, auspicious days are chosen, shamans are consulted and personal behaviour and potential interruptions are closely monitored during the cloth-making processes.[87] In certain cases, legends warn against the simultaneous use of red-brown dyes and blue-black dyes. Such beliefs may arise out of the conflicting qualities associated with red and black in Southeast Asian cosmology.[88]

Certain designs or particular textiles are often considered to be more powerful than others and only knowledgeable and experienced older women attempt them. Hence only a technically and ritually mature Iban woman will attempt to weave a *pua* depicting the water serpent (*nabau*) or a crocodile spirit (*antu baya*). Moreover, she will approach the tying and weaving of these symbols of the supernatural with great propriety, and she will attempt to ensure the benevolence of the spirit figure that she is recreating by tying into the design, motifs depicting gifts of food. Certain sections of the work, such as the eye of a particularly powerful or dangerous spirit, are worked in utter silence. On strong patterns that produce potent textiles permitting close proximity to the gods on ritual occasions, such as the jaw of the honey bear (*rang jugah*), clear prescriptions for behaviour apply. The ikat-tying has to continue without a break until a less dangerous section of the motif is reached. To fail in the correct performance of these textile procedures could mean *empa*, to be eaten by the pattern. Similar precautions are observed in such situations elsewhere in Southeast Asia. The weaving of the sacred *kekombong* in Lombok and the death cloths of the Ifugao are other dangerous textile activities undertaken only by older women who have ceased menstruating.

In the many parts of the Southeast Asian region where malevolent spirits are thought to threaten the weaving of the textiles so important to the well-being of the community, offerings are made and

179,192

small rituals enacted. The spirits of the dead are kept from the indigo-pots of the Toba Batak with oaths and protective screens (Niessen, 1985), while the Rotinese shield the indigo from harm by a thatch of chicken feathers or a plaited Christian cross (Bühler, 1941). On Lombok, Sasak weavers follow similar precautions with offerings of rice, betel-nut and thread to appease spirits who steal yarn, although these offerings are only necessary when sacred Sasak textiles requiring handspun cotton, are being woven. The clappers and bells attached to weaving apparatus in many parts of the region not only sound the industriousness of the weaver but are often intended to frighten away malevolent spirits (Casino, 1981: 130–1).

The warping of a textile is considered a particularly dangerous stage of the weaving process. On Savu, women who share in the task of winding the warp threads on to the frame before the ikat-tying of the pattern, eat a special ritual meal together on the night before they begin. If the warping is not completed in one day, Savunese weavers believe that the thread may be stolen by a mischievous spirit leaving insufficient material to complete the cloth. Although there are practical reasons for the accurate measuring out of the thread to proceed without interruption when using a continuous warp weaving technique, explanations based upon the role of demons and spirits often take precedence. Warping also becomes symbolic of time, and the unsevered warp threads represent the cycle of time and the continuity of the life forces. These notions are particularly evident in the Toba Batak region where the weaving of an *ulos ragidup* specifically draws upon this symbolism.

The section of unwoven warp thread is widely considered a magical element of a ritual textile. Consequently, severing the unwoven and uncut warp — the fringe-to-be — is a sacred act, and ceremonies mark this stage of the making of traditional textiles in many cultures.[89] Such a ceremony is performed with the sacrifice of a chicken by the Iban, who believe that until this occurs, a cloth will not be at peace and will disturb its weaver's dreams. In some parts of Indonesia the unwoven warp remains unsevered as long as the textile is required for ritual use, and cutting the warp threads alters the status of the cloth from sacred and ceremonial to secular and everyday. The cloths that form a central part of bride-wealth in Lembata and parts of Flores have ceremonial exchange value only while their warp remains intact. Weavers attribute this custom to the continuous lifeline qualities of the warp thread, and in south Lembata the warp is perceived as hair (Barnes, 1989b). The sacred *geringsing* in Bali and certain *kekombong* in Lombok also retain their most magical and curative powers while the fringe threads remain unsevered. For the Toba Batak, the *ulos lobu-lobu*, a circular black textile with an uncut warp, is said to symbolize the repetition of generations; and hence as an omen cloth it is an appropriate remedy prescribed for a mother whose infants are sickly or dying (Niessen, 1985a: 154). The bark-cloth skirts of the northern Toraja are made without seams through the bark-cloth felting process. However, the ultimate form of the circular continuous woven textile is represented by one particular type of sacred *ma'a* made in such an exacting fashion that the entire warp is filled with wefts to form a completely tubular fabric without any seam.

95,124

204

The economic base and social structure of many Southeast Asian societies have changed dramatically over the last two thousand years, and hardly any communities have remained isolated from the influence of the outside world. Only a few of these societies still make textiles that clearly indicate what the earliest cloth designs and structures may have been, and the teasing out of ancient designs and their meanings is necessarily speculative in a tropical region where climate and pests work against the preservation of burial gifts or even family heirlooms. Furthermore, the oldest Southeast Asian textiles in museum collections for which we have firm and incontrovertible dates originate from only the late eighteenth century, and most of these collections were acquired in the late nineteenth and twentieth centuries.[90]

Although the earliest, most 'traditional' elements of Southeast Asian textiles are not easy to establish, many cloths made during the last century contain patterns and motifs that give at least some idea of the most ancient and deeply rooted design elements of the region. Some of these have been retained for use in rituals while other ancient garments and fabrics have long ago been replaced by more recent products.

The receptiveness of Southeast Asians to new ideas and influences from outside the region did not result in ancient patterns and design formats disappearing without trace. On the contrary, elements reappear even in the textiles made in those parts of Southeast Asia most influenced by the outside world. What is remarkable is the continuity of ancient materials, techniques and motifs in the face of seemingly overwhelming alternatives. Despite these new pressures and totally different sources of design, many new motifs were reworked within the structures of older designs using some of the symbolic and decorative features of the most ancient patterns. Conversely, new design structures were adopted and filled with patterns possessing an ancient history.

Despite the emphasis often given in many accounts of Asian and Southeast Asian art history to the importance of the geometric spirals and rhombs associated with Dong-Son culture, it is evident that from prehistoric times the symbols used in Southeast Asian art have not been restricted to schematic forms. Images of anthropomorphs, mystical creatures, and birds and animals from the natural world have been depicted realistically and imaginatively in the textile art of the region.

Given the flimsy archaeological evidence directly related to textiles, it is impossible to delineate systematically specific Neolithic or Metal Age elements. Nevertheless, it is evident that before the period of contact with other great and powerful civilizations to the west and north, the textile arts of Southeast Asia had an abundance of striking symbols and rich materials. When inspirations from outside Southeast Asia began to provide new stimuli, these ancient elements were transformed with imagination into other beautiful fabrics.

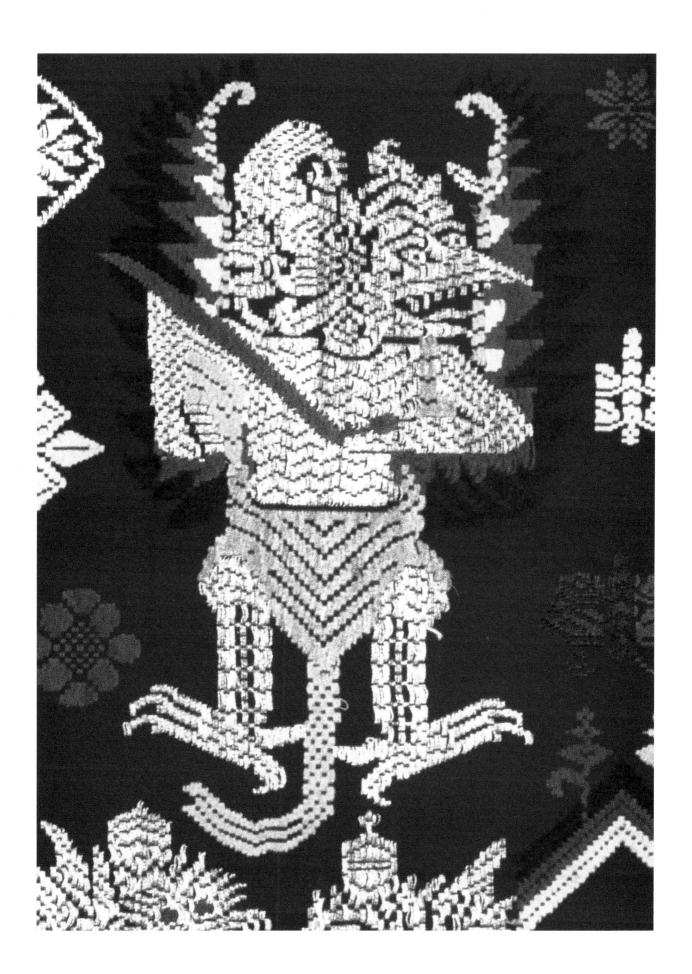

Chapter 3

INDIAN IMPRESSIONS

The splendid architectural monuments and classical sculpture of the Indianized world of Southeast Asia have been well documented and extensively described in the literature on Southeast Asian history. Unlike those stone and metal remains, textiles from this period have survived only as enigmatic patterns on the garments of sculpted figures. Nevertheless, the impact of Indian ideas and techniques was as important in the field of textiles as it was in the field of sculpture and architecture, and many of the characteristics we now admire in Southeast Asian fabric design represent local responses to Indian ideas and Indian objects that filtered into the region over many centuries.

207

While contacts between the Indian subcontinent and the world of Southeast Asia began two thousand years ago,[1] their intensity and cultural impact varied greatly over time and place. The great period for the spread of Indian philosophical, religious and political influence and the trade that accompanied it, began during the first millennium AD, and Indian traders and scholars were present in significant numbers along the Southeast Asian sector of the trade route which stretched from China to the Mediterranean. One historian, writing about Indonesia, describes a situation that had arisen throughout much of Southeast Asia by this period: 'By the seventh century AD the main outlines of the characteristic political situation of the islands may be discerned — a situation in which a varying number of kingdoms rival one another, conquer and absorb one another, and contri-

Opposite Detail of Plate 268

207
geringsing wayang kebo
shouldercloth, breastcloth or waistcloth; sacred textile
Balinese people, Tenganan, Bali, Indonesia
handspun cotton, gold thread, natural dyes
double ikat, embroidery
213.0 x 55.4 cm
Australian National Gallery 1982.2308

The squatting figures displayed in an attitude of prayer or homage on this magnificent *geringsing* are suggestive of scenes found on the bas relief sculpture of the Hindu-Buddhist temples and shrines of Java and Bali. Rich gold thread embroidery embellishes the stupa-like motifs and the end-panels, and provides a contrast to the subtle brown, black and natural tones of the double ikat patterns. Heirloom *geringsing* cloths of this design are sacred objects important in Balinese ritual and ceremony. When worn as apparel they are also symbols of high status, and if the warp threads

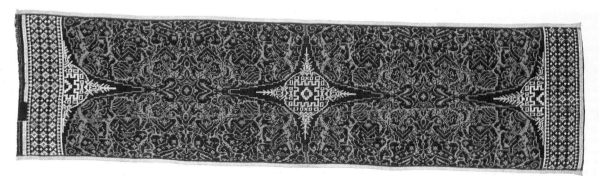

207

remain uncut, *geringsing* patterned with *wayang* (shadow-puppet) motifs are a most fitting gift to the gods, who may wear them as garments (*rantasan*). On this cloth, the warp threads have been severed and a small section of the fabric has been removed from one end, suggesting that it has been used outside Tenganan for an important ceremony such as a curative rite. Since a cloth of this richness is exceptionally valuable, this ritual was almost certainly performed for or by persons of very high status.

208
Many Indic features of art and architecture are repeated on the textiles of Southeast Asia. The *naga* serpent finials, the golden parasol, the *deva* figures and the rich ornamentation of this pavilion in a Buddhist temple complex in northern Thailand are also familiar designs in the region's court centres. A small stupa in the front of the pavilion is wrapped in cloth.

bute to new groupings as dynasties rise or fall or merge' (Legge, 1980: 30). The result was a continued merging and overlayering of many of those cultural characteristics that had been developing since prehistoric times. While the prehistoric migrations that had shaped the formation of culture throughout insular Southeast Asia had halted before the period of strong Indian and Chinese influence began, the geographic relocation of populations has continued to occur, particularly in mainland Southeast Asia, until the present day.

One key characteristic of Indian acculturation was the spread of writing, and epigraphical records have contributed to our limited knowledge of the Indianization process. The earliest inscriptions in central Burma date from around AD 500.[2] Statues, architecture and inscriptions provide considerable evidence of Hindu influence in Southeast Asia from the fifth century onwards,[3] although the earliest Indian contacts with Sumatra are attributed to the first and second centuries AD (Wolters, 1967). The foundations of the Indianized Khmer empires in mainland Southeast Asia were probably in place by the sixth century (Hall, 1985: 76–7), and Hindu-Buddhist kingdoms were discernible throughout Southeast Asia by the seventh century.

Some of these early Indianized courts, such as Angkor in Cambodia and the first kingdom of Mataram in central Java, were based on a feudal, wet rice agricultural system, while others including Champa in Vietnam, Sriwijaya in south Sumatra, and Kedah on the narrow isthmus of the Malay peninsula, depended upon maritime and trading activities. In time, these coastal states, and others along the eastern seaboard of Sumatra and around the perimeter of coastal Borneo, were especially vulnerable to other foreign intrusions — in particular the incursions of the Chinese, the Arabs, and eventually the Portuguese and the Spanish. However, the early Indian period of Southeast Asian history heralded far-reaching economic and social change which had a considerable impact on the history of the region. The basis of this transformation was trade, and as a result, social and economic stratification in Southeast Asia became more pronounced and entrenched.[4]

One of the most important issues raised by the spread of Indian culture to Southeast Asia concerns the process by which it was transmitted.[5] While the established routes of trade and travel between the Indian subcontinent and Southeast Asia brought certain sections of society into contact with Indian merchants and seamen, and took many Southeast Asian sailors and travellers into the ports of South Asia, it is questionable whether it was these well-established trading links that led to the spread of Hindu-Buddhist principles to Southeast Asia. Ideas based on these principles first took root in the courts of the region before gradually spreading into the surrounding countryside, and although the growth of migrant merchant settlements brought some Southeast Asians into contact with Indian culture, there was little direct social or economic exchange between the foreign quarters of the ports and the indigenous population of the hinterland. It seems likely that the harbingers of the more sophisticated aspects of Indian religion, ritual and statecraft were Indian rulers and Brahmanic scholars, invited to Southeast Asia by regional dynasties to enhance their claims to authority (van Leur, 1955). Unlike the political intervention of the Chinese, there is no epigraphical evidence or contemporary historical account of major Indian conquests. However, local territorial and dynastic disputes, and intermarriage between

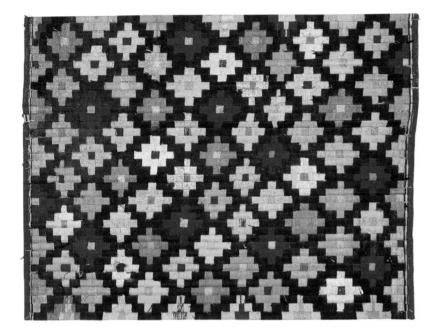

The checkered patterning on this early twentieth-century wrapper for a Buddhist palm-leaf manuscript is achieved by weaving or twining thick warp (?) slivers of bamboo with wefts of brightly coloured and naturally dyed handspun cotton. The effect is a slit-tapestry weave fabric, in stepped rhombs of orange-yellows, maroon, greens, purples, pinks and natural against a dominant black ground. Few of these wrappers have survived the regular ritual cleansing of the monasteries in northern Thailand where the sacred books are stored, and few palm-leaf manuscripts of this type are now made. Prayer flags woven in the same region have wefts of palm fibre or bamboo slivers inserted into the cotton fabric as reinforcement during the weaving process.

powerful families, did lead to the spread of Indian models of state and religion, and courtly life.

Over the centuries, aspects of Hindu-Buddhism were steadily absorbed into Southeast Asian cultures. Some Indian-derived philosophical and religious conceptions of the universe seem to have fitted existing traditions so appropriately that it is sometimes difficult to distinguish them from indigenous elements, especially when interpreting the products of artistic endeavour. Consequently, Southeast Asian textiles reveal both the adaptation of ancient ideas to Indian style, and the transformation of Indian designs, motifs and themes according to local aesthetic principles.

Buddhism has provided the most enduring Indian influence and Theravada Buddhism remains the major religion of Burma, Thailand, Laos and Cambodia. While Indian religions were also evident at one time or another in the Malay states and Indonesia, they were ultimately replaced by Islam. In present-day insular Southeast Asia, Hinduism is now found only in Bali although vestiges of Hindu-Buddhism remain evident in the syncretic belief systems of many other peoples, notably the Javanese. There was far less direct Indian influence and less social and cultural change in the east of the region, and few metal or stone objects attributable to the Indian or Indianized cultures of the first millennium AD have been located in eastern Indonesia and the Philippines.

In those parts of the region where Buddhism and Hinduism remain dominant, the artistic creativity that is a part of religious expression owes much to Indian-derived ideas and philosophies. In those places where subsequent layers of influence have eroded Indic contributions to tradition, evidence of India's impact has endured in the temple architecture and sculpture of Thailand, Cambodia, the Malay peninsula, Java and Sumatra.[6]

The process of adapting and shaping foreign ideas, techniques and customs to fit a Southeast Asian mode and context was already occurring in the early kingdoms that were responsible for these great monuments. Southeast Asians were not merely passive recipients of

externally imposed initiatives and the art of these early Indianized courts quickly became distinguishable from its Indian sources. Groslier, discussing Hindu sculpture from the Malay peninsula, points out that 'by the end of the seventh century local schools had grown up and were already seeking to reach out beyond the traditional Indian techniques and create their own style of plastic art' (1966: 49). Similar processes were operating across the whole artistic spectrum. Even in those parts of Southeast Asia where an Indian religious framework is still very strong and where Buddhism has been a continuous source of cultural inspiration since the first millennium AD — particularly in Thailand, Laos, Cambodia and Burma — the fundamental Indian sources have become less distinct as local artists have increasingly exerted a more regional style on Indian-derived Buddhist elements, a regional style that shares much with other non-Buddhist cultures of Southeast Asia.

TEXTILES AND COSTUME IN INDIANIZED SOUTHEAST ASIA

The freestanding sculptures and the figures in the stone friezes on many of the ancient temples provide useful evidence of the possible effects of Indian culture on local textiles and costume.[7] Different notions of modesty developed in certain parts of Southeast Asia as particular features of Indian costume were gradually adopted by the indigenous aristocracy. Simple loincloths gave way to more voluminous forms of clothing for the lower body, and the legs of women, especially those of the aristocracy, were covered. According to one legend, the Brahmin founder of Funan, Kaundinya, coming from a foreign country to defeat and marry the local queen, and finding her naked, introduced clothing for women in the form of a folded cloth with a hole in the centre to be passed over the woman's head.[8]

According to sculptural evidence, Indian styles of dress adopted by the rulers of the earliest kingdoms of Southeast Asia included long skirts draped or folded in front, and held with clasps, belts and decorative sashes. Although the upper torso and head were usually left uncovered, large quantities of ornamental jewellery indicated the richness of the kingdom: bejewelled collars, head and ear ornaments,

210
This pair of wooden shadow-puppets (*wayang klitik*) is part of a collection that was brought to England around 1816 by the Lieutenant-Governor of Java, Sir Thomas Stamford Raffles. The aristocratic characters illustrate the ceremonial costume of the Indic courts of Southeast Asia and both Indian and Javanese textiles are represented on the carved figures in the collection (Forge, 1989). The voluminous *dodot* wrap on one figure seems to be an imported mordant-painted Indian cotton while the other displays a *parang rusak* batik design embellished with gold leaf. The leggings on one puppet suggest Indian silk *patola* fabric. The Raffles collection of puppets is at the Museum of Mankind, London.

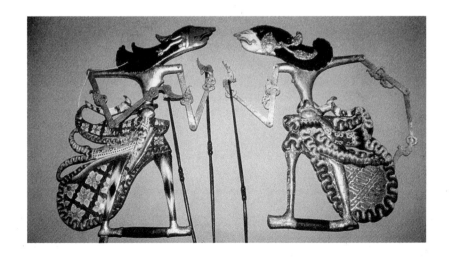

necklaces and ropes of gold slung across the breast, arm bracelets and bangles, including large peaked bands for the upper arm.

The basic items of apparel for the nobility and deities in many parts of the region did not change dramatically over the next thousand years. Perhaps because of the tropical climate, garments seem to have retained their simple elegance longer than in other civilizations, and many present-day forms of costume still resemble those evident on the sculptures of the early Hindu-Buddhist kingdoms.[9] During the Lopburi period in Thailand, for example, ankle-length wraps for women (*pha na nang*) and the *dhoti* style for men, now known after the Khmer as *chong kaben*, were evident. The same style is also clearly illustrated in the male costume depicted on Khmer sculpture of the Angkor period. The Khmer style was again popular in the Ayutthaya period[10] and since that time the *chong kaben* wrap (*pha nung* in Thai or *pha toi* in the north-east) has become firmly established in the central Thai kingdoms as the pre-eminent costume style for both men and women (Chira Chongkol, 1982: 128).

Throughout Indic Southeast Asia textiles remained simple, rectangular, and largely untailored. The only sculpted figures to appear in flowing robes are those of the Lord Buddha and male religious dignitaries. Judging from statuary, and from later eighteenth-century lacquer panels, paintings and even early photographs, garments or sashes for the upper body were still largely optional and essentially decorative for aristocratic women under Indian influence. The courts of central Thailand and Bali are two prominent examples where this has been clearly the case until recent times. The shoulder-sash, the *selendang* of the Malay world and the *sabai* of the Thai, may have been derived from a garment like the sari, the end of which is worn over the shoulder. However, functional textiles such as baby-carriers may also have influenced the development of the decorative woman's shouldercloth. It seems to have remained a floating diaphanous length of fabric, probably only required for attendance at temples and formal court ceremonies.

Visual reminders of the Indianized past are still evident in the ceremony and ritual associated with rulers and their courts throughout Southeast Asia. These ceremonies and the artifacts of royal ritual and regalia that are used on such occasions are often a blend of ancient and Indian elements. Textiles were always an important part of these events. The umbrellas, standards and canopies of state of the Indian world took on many of those sacred characteristics of cloth outlined in the previous chapter. While ancient types of textiles continued to be valued in the Indianized courts, certain imported Indian textiles began to assume a sacred status in the ancient religions of the region.

In many Southeast Asian cultures during the period of Indian influence, even more important innovations began to take place concerning the materials being worn and the designs that textiles displayed. Although it is difficult to distinguish foreign or local origins in sculptured patterns, eighteenth- and nineteenth-century Thai scenes in paintings and lacquer work clearly indicate that Indian trade cloths had assumed a prominent place in the furnishings and clothing of the central Thai courts.[11] We have little pictorial evidence from other parts of Southeast Asia and yet it appears that while the common people wore simple locally woven cloth, the nobility often favoured imported textiles or special local cloth with patterns emulating their designs.

210
211

212

213

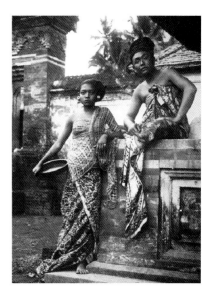

211
An early twentieth-century photograph of an aristocratic couple wearing long batik skirtcloths during a Hindu temple festival in Bali. When participating in temple festivals and making offerings, another cloth is wrapped around the upper body. The young woman wears a light open lace-like fabric, combining tapestry weave weft techniques with deliberately arranged gaps in the warp threads. These textiles are worn as breast-wrappings by Balinese women of superior rank.

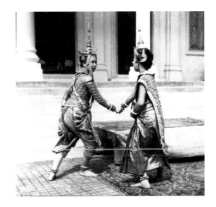

212
A mid-twentieth-century photograph of two royal dancers in Phnom Penh displays the ceremonial costume that has been widely favoured in the courts of mainland Southeast Asia. The female character wears a front-pleated brocade skirtcloth, while the male character wears a silk skirtcloth in the classical Khmer style in which the end of a length of fabric is drawn between the legs and fastened at the waist. Both dancers display richly embroidered upper garments and gold jewellery.

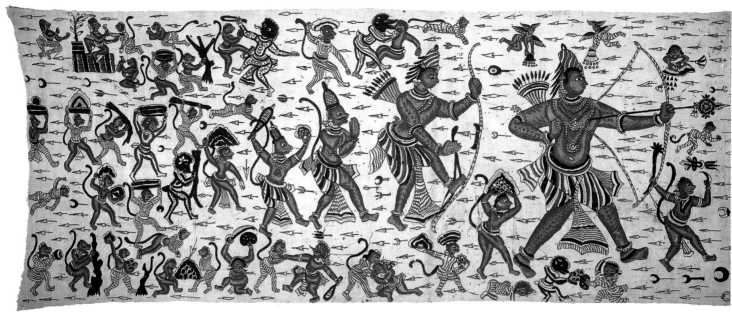

214

213

213
The Cambodian monarch, S.M. Monivong, is carried to his coronation in 1928 on a palanquin. A number of attendants hold aloft the royal umbrella, the symbol of state in the Indianized world.

The introduction through trade of large numbers of Indian textiles into Southeast Asia was certainly a significant factor in the development of the region's traditional textiles.[12] For many of the region's rulers, merchants and landowners who controlled trade in cargoes as diverse as spices, gold, bêche-de-mer, slaves and sandalwood, the most valued item of exchange was Indian cloth. The sources of this cloth were the major textile centres of India: Gujarat in the north-west, Bengal in the north-east, and the south-eastern Coromandel coast including those ports stretching along the coast of present-day Tamil Nadu (Madras), Andhra Pradesh and into Orissa. By the arrival of the first European travellers to the region, the trade in Indian textiles was already firmly established and Indian cloth was passing into Southeast Asia in considerable quantities through the region's major entrepôt centres.

214

After the thirteenth and fourteenth centuries the influences of India and Indian trade objects, particularly textiles, became inseparably intertwined with those of Islam. In fact, the trade in Indian textiles continued to burgeon long after Hindu traders had relinquished their supremacy to Arabs, Islamic Indians and Europeans. Significant sections of the population of Gujarat were among the first Indians converted to Islam by the end of the first millenium AD. Converts included local rulers and large sections of the merchant and textile-making communities. From the sixteenth to the nineteenth century, the Islamic Mughal courts significantly influenced the development of the decorative arts of India, including its textiles and costume.[13] The patterns that appeared on the exported textiles were not always those found in the courts of India, and seem to have combined regional Indian styles with patterns specifically designed for and appreciated by foreign markets, especially those in Southeast Asia itself. However, the influence of Indian textiles and their designs eventually spread by means of trade, far beyond the centres of Southeast Asian courts and the direct impact of Hindu-Buddhist culture, out into the hinterlands and remote corners of the region.

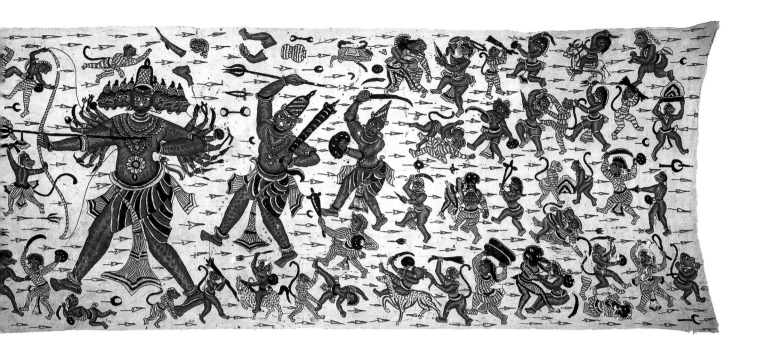

EARLY INDIAN INFLUENCES ON TECHNIQUES AND MATERIALS

Certain objects, materials and techniques filtered into Southeast Asia from India in such a distant and legendary past that their exact path is difficult to trace.[14] The earliest recorded evidence of several important elements of textile culture has been found in India, including the use of cotton thread and the adoption of a number of important dyestuffs, particularly mordanted red dyes. Probably these materials or a knowledge of their use came from that direction, and gradually passed on through mainland Southeast Asia by diffusion to the island archipelagos, although we have no way of determining exactly when or how this occurred. However, we do know that cotton, indigo and probably red dyes, also have a long history of use in the region, where they are commonly believed by Southeast Asian peoples to have been created or invented by their founding ancestors.

On linguistic grounds, the evidence of the Indian origin of indigo is inconclusive. In Indianized Southeast Asia where a great many Sanskrit words have been absorbed into local languages, Sanskrit-derived terms for this dyestuff are common. However, Austronesian words for indigo are also evident and in some Southeast Asian languages, more than one term is used. For instance, in Java we find the ancient word *taom* as well as the Sanskrit-derived *nila*. Certainly, a number of varieties of indigo plants used to produce dark blue-black dyes were known in India from early times but it is also probable that the earliest indigos were native to Southeast Asia and East Asia or were taken there in prehistoric times. Among Southeast Asian indigo plants are Marsdenia tinctoria, Strobilanthes flaccidifolia and a number of varieties of Indigofera, especially Indigofera tinctoria, and there are tropical and subtropical varieties that suit the region's range of climates.[15] The many references to indigo in Southeast Asian mythology suggest that it has been an essential feature of indigenous textile art for several thousand years.

214
............
sacred heirloom
south-east India; Bali, Indonesia
handspun cotton, natural dyes and mordants
mordant painting
520.0 x 120.0 cm
Australian National Gallery 1984.586

Among the many thousands of bales of fabric imported into Southeast Asia from India each year at the height of the textile trade in the seventeenth and eighteenth centuries were many brilliantly coloured silks and cottons. This trade cloth from the Coromandel coast of southern India depicts scenes from the Hindu Ramayana legend describing the battle between the forces of Rama and the monkey-king, and the ten-headed demon-king Ravana. Cloths of this particular design in red, black and blue on a white background were especially popular in Sulawesi and Bali, from where all recorded museum examples have been collected. Although Indian religion did not spread as far as central Sulawesi, many Indian cotton mordant-painted, block-printed and batik cotton textiles joined locally woven Toraja cloths as items of great ritual significance.

215

216

215,216

215
The use of Morinda citrifolia is widespread throughout insular Southeast Asia. A woman in the Lio domain of central Flores is pounding the dyestuff in a mortar. It will then be kneaded into cotton threads, which have already been prepared with a mordant of oil obtained from ground candlenuts (*kemiri*). The process may be repeated many times over a period of years to achieve the rich saturated red-brown colours so highly valued on the prestige textiles of this area.

216
In northern Thailand, a group of Karen villagers strip stick lac, the secretions of the Coccus lacca insect, from the branches of local trees. Theirs is a cotton weaving tradition, but silk-producing regions of mainland Southeast Asia also utilize the dyes of the secreted resin to produce rich red colours.

The introduction of red dyes is an even more complex matter, and a number of sources of red-brown dyes exist in the region. The most popular red dyestuff in insular Southeast Asia is obtained from the roots of the Morinda citrifolia tree, while in mainland Southeast Asia, the predominant source is stick lac, a resin secreted under bark by insects (known in Tai as *krang*). At least two other dyestuffs, turmeric (Curcuma domestica) and sappanwood (Caesalpinia sappan), were already well-established agricultural exports before the arrival of the Europeans and are still widely used throughout the region.

The textile historian, Alfred Bühler, has attributed the origins of mordanted red dyes in Southeast Asia, in particular Morinda citrifolia, to the spread of Indian culture (Bühler, 1941: 1423–6). His hypothesis is based upon the prevalence of red dyes on certain textiles with a complex central field design influenced by Indian trade textiles. However, red dyes from Morinda citrifolia — widely known throughout the Indonesian archipelago as *mengkudu, kombu*, or by variants of these terms — are also commonly found on textiles with patterning arranged in warp bands, one of the region's most ancient decorative design structures. Furthermore, Indian decorative techniques and raw materials used for mordanted red dyes are generally quite different from those found in Southeast Asia. The botanical evidence suggests that Morinda citrifolia was available in the region well before Indian trade cloths began to influence indigenous textile design there and long enough for its use to have passed into mythology and elaborate ritual. It is possible, however, that the skill of using mordants — essential for making red dyes colourfast — may have been brought to Southeast Asia from India and this may have enhanced the attractiveness of dyestuffs such as Morinda citrifolia throughout the region.

The use of red dyestuffs is well established for ritual textiles throughout the Southeast Asian region and mystery and secrecy now surround that dyeing process in areas where red textiles are the prime items of exchange (Maxwell, 1981). The colour is identified

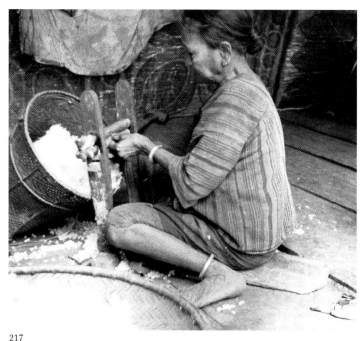

217

218

141

with strength and bravery in some parts of Southeast Asia, and the Kulaman of Mindanao used a rare form of embroidered resist-stitching, always in striking red colours, to effect ikat-like designs on the suits made for warriors (*malobot*) who have killed more than five enemy.[16]

217,218

The earliest cotton yarn yet found in the world is the mordant-dyed sample discovered in the Mohenjo Daro Indus valley site, which has been dated to at least the second millenium BC, and has been apparently identified as an ancient perennial form of cotton, Gossypium arboreum (Gittinger, 1982: 16). While archaeologists and historians suggest that the cultivation of cotton spread from India to Southeast Asia, evidently its use as a weaving material was also an early attribute of many Southeast Asian cultures. Many local (and early Chinese) terms for cotton seem to be variations on the Sanskrit term, *kapas* or *karpasa*. For example, in the northern Philippines the Ifugao of Luzon use the term *ka'po* (Lambrecht, 1958: 1); in eastern Indonesia throughout Flores it is known as *kapek*, while the Rotinese use *abas* and the Balinese refer to it as *kapas*.[17] In mainland Southeast Asia Khmer cotton cloth takes the term *ambas* (Stoeckel, 1923: 399). These terms suggest the Indian origins of this weaving yarn, although cotton itself and the terms by which it became known no doubt spread within the region among neighbouring cultures, and it was probably one of the early cultivated plants in Southeast Asia.

There are conflicting estimates of when either Gossypium arboreum or other later annual strains of cotton, such as Gossypium herbaceum and Gossypium hirsutum[18] arrived in insular Southeast Asia. However, cotton thread appears to have been in use by the time of Christ. It is well suited to the drier parts of insular Southeast Asia and the northern highlands of the mainland, but it does not flourish in the tropical coastal swamps and in areas with higher rainfall. In those areas, cotton and silk acquired through internal trade appear to have eventually displaced other locally made textile fibres. Historical records from the Tang period reveal that cotton was one of the

217 and 218
The preparation for the spinning of raw cotton into thread, whether by spindle or spinning-wheel, requires a number of simple processes. After the cotton-bolls are dried in the sun, they are deseeded using a mangle. A Kha Alak women in Saravané, Laos, is using a mangle typical of the type found throughout Southeast Asia. The cotton is then carded with a beater or a bow and finally the carded cotton is rolled into neat 'tails' preparatory to spinning. A young Toraja women is engaged on this final stage of the work in central Sulawesi.

219
A young girl in the Ratanakiri province of Cambodia uses a spinning-wheel to prepare locally grown cotton thread for weaving.

earliest tribute items sent from Southeast Asia to the Chinese imperial court.[19]

A number of ritual cotton cloths in certain parts of Southeast Asia are an unusual tawny-brown colour. While this occasionally results from dipping the thread or the woven cloth in sacred turmeric dyes,[20] sometimes the colour derives from a form of natural brown cotton; whether this is a tropical degeneration of white cotton or a separate genus is unclear. In parts of Indianized Southeast Asia and in India itself, natural brown cotton (Gossypium hirsutum, also known as Gossypium religiosum or Gossypium Nankeen) has sacred associations. This phenomenon has been noted for one type of striped cloth (*lurik*) woven in the Tuban district of Java, and known as *kain usik* (Heringa, 1990). The natural brown cotton used to weave this cloth is referred to in Tuban as *kapas lawa*, 'bat' cotton thread, although the precise connotations of this term are not recorded. Other examples of natural brown cotton can be found on the neighbouring islands of Lombok and Bali. *166,184*

The spinning-wheel was not used in the preparation of palm, leaf *219* and bast fibres for weaving, and was almost certainly a later introduction from the Indian subcontinent. Even in cotton-weaving cultures, it did not entirely replace the earlier drop-spindles which are *70* known by a range of local terms: for example *keturé* in east Flores, *ina* in Roti, and *toba'yan* by the Ifugao. The spinning-wheel is usually known by terms related to the Indian *charkhi*,[21] for example *jantre* in Bali, *cerka* among the Gayo people of Sumatra, and *jintera* in parts of Borneo.[22] Although the distribution of the simple drop-spindle and the more technologically advanced spinning-wheel seems to be random, ethnic groups closer to the well-known trade routes have tended to adopt the spinning-wheel while their more isolated neighbours have continued to use the spindle. On the island of Flores, the Sikka and Endeh people, who, through trade with the outside world, have a long history of contact use the spinning-wheel, while most Lamaholot and Nagé Kéo people continue to use spindles. The same pattern is evident in mainland Southeast Asia, and in northern Thailand the Karen use the wheel while the more isolated Akha retain spindles.

While these elements — cotton, indigo and mordanted red dyes — are difficult to disentangle from the earliest textile traditions of the region, a number of other elements clearly associated with Indian textiles gradually became part of Southeast Asian textile art as they were reworked in the light of existing styles and functions.

THE TRANSITION FROM WARP TO WEFT

Evidence pieced together from certain important textiles displaying ancient iconography and significant in ritual, suggests that supplementary weft patterning techniques (such as the wrapping of weft threads around a passive warp) existed before the period of Indian influence in Southeast Asia. Nevertheless, there is no doubt that the earliest weaving decoration in the region was predominantly warp-oriented — warp stripes and warp-banded designs, warp ikat, and supplementary and complementary warp weaving. However, a fundamental and widespread shift from warp to weft decoration seems to *220,221* have occurred throughout many parts of Southeast Asia during the period of Indian influence. As weft weaving techniques such as supplementary weft weaving and weft ikat increased in importance, new

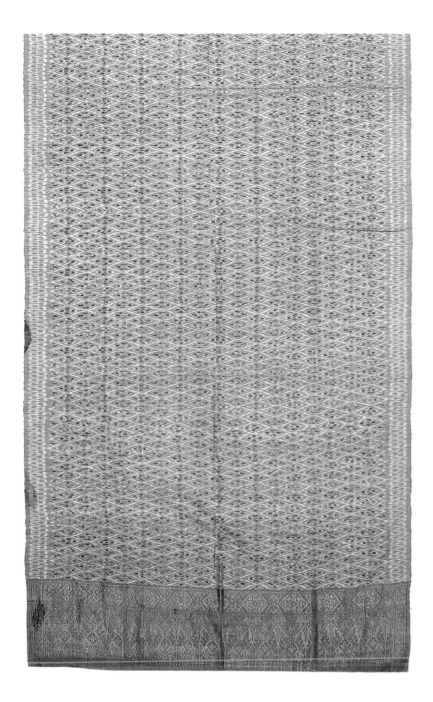

220 (detail)
kain limar
luxury textile; sash
Javanese people, Gresik (?), east Java,
Indonesia
silk, gold thread, dyes
weft ikat, supplementary weft weave
100.2 x 293.4 cm
Australian National Gallery 1988.1546

While warp ikat on cotton was clearly
an ancient textile type, weft ikat and
gold thread supplementary weft
textiles were also made in Java. These
weft orientated decorative techniques
were obviously a later development,
and served as prestige fabric, although
the techniques had largely disappeared
by the early twentieth century. This
fine green and purple example from
east Java probably dates from the late
nineteenth century. It appears that
these textiles were never a central
element for Javanese courtly use, and
their role was adequately filled by
other cloths such as Indian imported
silks and hand-drawn batik. A further
confirmation that these textiles had
little sacred or ritual significance —
although they appear to have enjoyed
some regional popularity — is that at
least by the early twentieth century
the thread patterns for the Javanese
weft ikat textiles known as *limar*
appear to have been tied by men, an
unusual occurrence for traditional
textiles in Southeast Asia.

and different design possibilities emerged. Warp ikat and supplementary warp weaving, bead and shell appliqué, and bark-cloth decoration were still practised, especially in the more isolated parts of the region and for certain important fabrics, but most of the Southeast Asian 94,99,222 peoples affected by the international trade routes adopted decorative weft techniques.

The development of weft ornamentation is evident in the woven patterns and ikat resist-dyed fabrics found throughout Indianized areas. In Cambodia during the Angkor period and in Thailand from the eleventh to the fourteenth century, carved statues and sculptures record figures wearing textiles with stripes running down the torso, indicating weft decoration (National Museum, 1968: 33–48). This 223,224 weft band arrangement is still prominent on Lao and northern Tai

221 (detail)
kain gubah; kain kasang
hanging; partition
Javanese people, Bantar Kawung
district, Brebes, west-central Java,
Indonesia
handspun cotton, natural dyes
warp ikat
760.0 x 164.0 cm
Museum voor Land- en Volkenkunde,
Rotterdam 24736

The little that is known of the *kain
gubah* or *kain kasang* suggests that
these huge warp ikat textiles of rough
handspun cotton fulfilled important
functions of a ritual nature. Their
design, colours and ceremonial use are
similar to the huge cotton warp ikats
of central Sulawesi. While the term
gobar is applied by many groups across
Asia to various types of cloth,
including a type of Indian import
(Diebels et al, 1987: 108), the
Javanese used the name *kain gubah*
for these large cotton fabrics which
were used as a movable wall or screen
for creating private areas or
ceremonial enclosures. The term
tenunan kasang was also applied to a
wall-hanging (Wilkinson, 1957). This
nineteenth-century example
incorporates bands of obscure animal
and human ikat motifs.

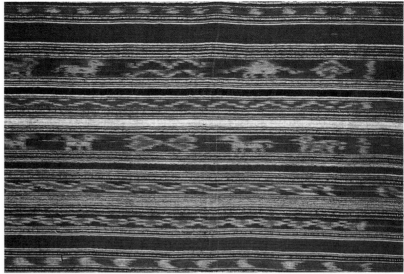

221

222 (detail)
ana' nene'
sacred textile
Sasak people, Lombok, Indonesia
handspun cotton, natural dyes
weft ikat, tapestry weave
241.0 x 89.5 cm
Australian National Gallery 1985.1744

While the weavers of eastern
Indonesia continued to decorate cotton
textiles with warp ikat patterns, in
many parts of central and western
Indonesia other types of materials and
decorative techniques are evident. The
most fundamental shift was to weft
ornamentation. This example displays
narrow weft stripes with subtle
gradations of natural red-brown and
blue colours. Rows of weft ikat
designs, developed from simple ancient
patterns, are interspersed between
graded stripes in such a manner that
they create the visual illusion of having
been worked in varying shades of
colour. This textile is woven from fine
handspun cotton, some of it apparently
natural brown cotton, and is finished
with a fine tapestry weave braid.

222

skirts, and has continued to be an important type of design structure
in other silk-weaving areas. In fact, on those Lao and Tai skirts where
aesthetic taste has demanded horizontal stripes, the skirts are usually
fashioned from weft-striped handloom fabric with seams sewn up each
side of the cylinder.

One of the most important factors contributing to the shift from
warp to weft decoration was the introduction of silk thread and the
technological changes associated with it. As a textile fabric, silk offers
attractive tactile and aesthetic qualities and it is well suited to a tro-
pical climate. By the time foreign travellers penned the first accounts
of life in Southeast Asia, the garments that attracted their attention
were the luxurious silk and gold thread textiles worn by the indige-
nous elites and nobility. Among the earliest accounts are the first
Chinese descriptions dating from the sixth century AD of a kingdom,

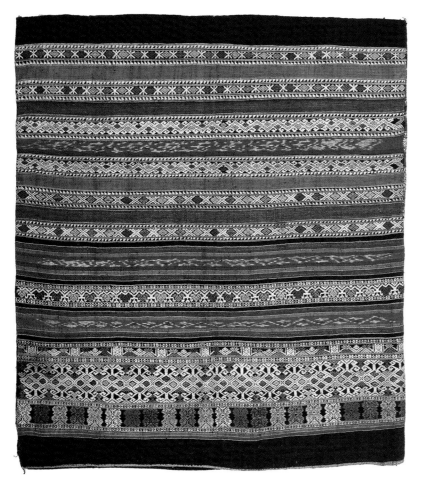

223

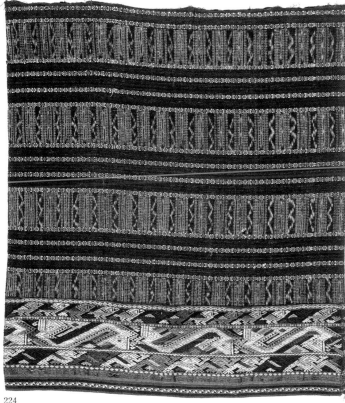

224

223
pha sin
woman's skirt
Tai Mui, Muong Muoy, Thailand
cotton, silk, natural dyes
supplementary weft weave, weft ikat
65.6 x 76.6 cm
Australian National Gallery 1987.1827

Because the decorative schematic patterning of this early twentieth-century Tai skirt is based on red and white weft ikat in weft stripes, the desired banded structure around the body of the wearer has been achieved by joining two lengths of fabric along each side. This structure is also widely used among the Tai Lue of the Lan Na region of northern Thailand. The schematic supplementary weft patterns are in a range of soft natural colours on an indigo blue ground.

224
pha sin
woman's ceremonial skirt
Tai Nuea people, Laos
cotton, silk, natural dyes
weft ikat, supplementary warp weave, supplementary weft weave
76.0 x 68.0 cm
Australian National Gallery 1984.3199

This skirt, probably made around 1930, is a visual reminder of the transition which Southeast Asian textile art has experienced. Waves of simple weft ikat on indigo-dyed cotton are separated by narrow stripes of white silk supplementary warps in the main body of the cloth. As is customary in the formation of Tai Nuea festive women's skirts, a wide band (*tin chok*) has been added to the bottom with mythical serpents and birds woven in bright supplementary silk wefts.

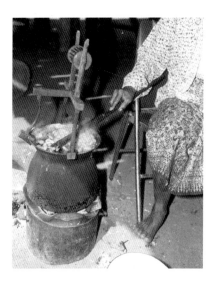

225
A Tai Lao woman in north-east Thailand is winding off the raw, golden-coloured silk thread from silkworm cocoons boiling in a cauldron. The silkworms are raised in flat woven baskets under the tall village houses.

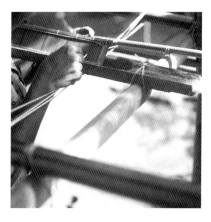

226
To prevent the fine silk threads from becoming tangled during the weaving process, a comb or reed was introduced as an integral part of the structure of the body-tension loom. Here a Mandar weaver in west Sulawesi inserts the silk warp threads through the comb.

possibly in east Java. These remark on the king's flowered silk robes (Wolters, 1967: 201). Reports from the fourteenth, fifteenth and sixteenth centuries come from court chroniclers, foreign travellers, and early Portuguese and Spanish adventurers. Silkworms have been cultivated in many parts of Southeast Asia, although silk has been almost entirely restricted throughout the Indonesian archipelago to coastal areas with ready access to trade. In those locations silk became associated with the established ruling elite whose Indianized ancestors were clearly attracted to luxury cloth. 225

While silk was originally imported from China, Indian silks have also been a luxury commodity in Southeast Asia for centuries. Through international sea trade and the overland Silk Road linking China across Central Asia with the Mediterranean, silk was known and admired in India and silk weft ikat textiles were found throughout the Indianized world during the European Middle Ages. The Sanskrit word for silk (*sutra*) is used throughout Southeast Asia, an indication of the role of Indian influence in the spread of silk textile technology.[23]

Despite the impact of India, the spread of silk-weaving throughout Southeast Asia also reveals the way indigenous cultures were probably influenced by ideas and materials obtained from their immediate neighbours. This is suggested by the way many peoples in different parts of the region share identical names for the same objects. For example, the term *sabai* is used to describe various items of silk apparel in many parts of coastal Southeast Asia, including Thailand, east Sumatra, and south Sulawesi.[24]

Why did the introduction of silk thread contribute to the shift from warp to weft decoration in those areas where it became prominent? There are a number of fundamental technical considerations here that merit our attention. Silk thread is finer and more difficult to handle than cotton and other vegetable fibres, and so it is necessary to find a way of preventing the loom threads from becoming tangled during the weaving process. In Southeast Asia, as elsewhere, this is achieved by including a comb or reed as a part of the weaving apparatus through which the fine warp threads are passed when the loom is assembled. However, with the addition of a reed as an integral part of the loom, certain decorative warp techniques such as warp ikat become more difficult to achieve. 226

Warp ikat techniques require the warp threads to be carefully measured out and wound on to a tying-frame, thereby establishing the length of the loom threads. These threads are then tied into the required ikat patterns. After this is completed the warp threads can be removed from the frame in carefully secured bundles and subjected to the dyebath procedures. (This can occur over a number of stages in multicoloured ikat.) When the dyeing is complete, the thread is set up on the loom by inserting the warp-beam and breast-beam through the circulating threads. No rewinding occurs, although additional plain warp stripes may be wound in between the ikat-patterned threads. To achieve warp ikat using fine silk thread and a comb, the continuous circulating warp threads, previously measured, tied and dyed, would then have to be inserted through the comb. While it is not impossible to do this, it would require these ikatted threads to be completely rewound and then painstakingly inserted backwards and forwards through the comb. Such a procedure would make the alignment of complex patterns extremely hard to achieve. Southeast Asian silk weavers seem to have moved away from these difficulties towards a 97 227

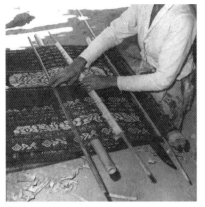

227

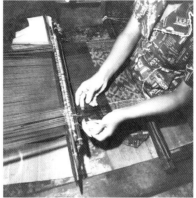

228

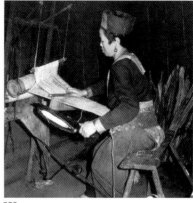

229

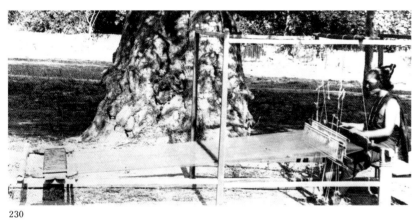

230

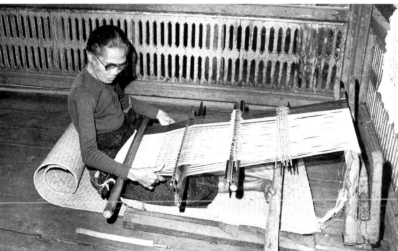

231

weft-ikatted threads previously wound on to shuttles, so that the weft ikat design appears clearly aligned. Gold thread weft patterning is simultaneously added to enrich the fabric; the weft ikat forms the foundation weave and the metallic supplementary threads are discontinuous. The woman uses small flat bobbins of gold thread to work back and forth across sections of the warp threads.

As the weaver completes lengths of the cloth, the woven sections are wound on to the breast-beam in front of her, and more warp thread is unrolled off the back-beam. When the fabric has been completed the rectangular, flat textile is unrolled from the breast-beam and the remaining warp threads disconnected from the warp-beam.

229 and 230
These photographs show a White Hmong or Hmong Deaw woman in northern Thailand (Plate 229) and a Khmer weaver in Cambodia (Plate 230) using looms with long discontinuous warps and foot-operated heddles. The Hmong woman uses backstrap tension to weave a narrow length of hemp fabric. This will be formed into a plain white pleated skirt, the ceremonial costume used to identify this particular group. (The woman's everyday dress includes a bright embroidered collar, cap and sash.) By contrast, the loom operated by the Khmer weaver is set within a solid frame and is not worked by body tension.

231
While the women's skirts of Lampung, Sumatra, are famous for their elaborate embroidered ornamentation, the basic silk and cotton fabric is woven on a backstrap tension loom. The loom includes a comb through which the warp is threaded. The resulting fabric is not continuous but rectangular.

227
A Savunese woman is weaving a cloth with a warp ikat pattern on a simple backstrap tension loom. The warp-beam and breast-beam are clearly evident. While the weaver is at work inserting a plain-dyed weft through the warp threads, the final pattern is clearly before her on the warp. The weft threads merely bind the existing designs firmly together. The circulating warp moves slowly

around the loom until the weaver returns to her starting point. The resulting warp-faced fabric is cylindrical when removed from the loom.

228
During the weft ikat weaving process, the warp is plain or striped. In this photograph of a Palembang weaver, the design grows as the weaver carefully inserts and adjusts the

232

232
The traditional Minangkabau loom
features a remarkably long
discontinuous warp with shed openings
that are operated by treadles. Its form
is very similar to the looms still used
by some Tai and Hmong groups in
mainland Southeast Asia, and differs
markedly from the backstrap tension
looms with hand-operated heddles used
by many silk-weavers elsewhere in
insular Southeast Asia. Minangkabau
weavers set the loom up beneath their
huge traditional houses, and as these
structures began to disappear it
became difficult to find an alternative
place to accommodate this very long
warp. This type of loom, photographed
in Silungkang in 1976, has not been
widely used for many years.

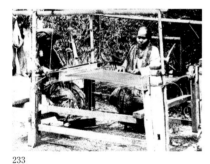

233

233
By the late nineteenth century, most
Minangkabau weaving was performed
on more modern frame looms.
Sometimes one woman carried out the
actual weaving while another assisted
with the selection of the appropriate
pattern sticks.

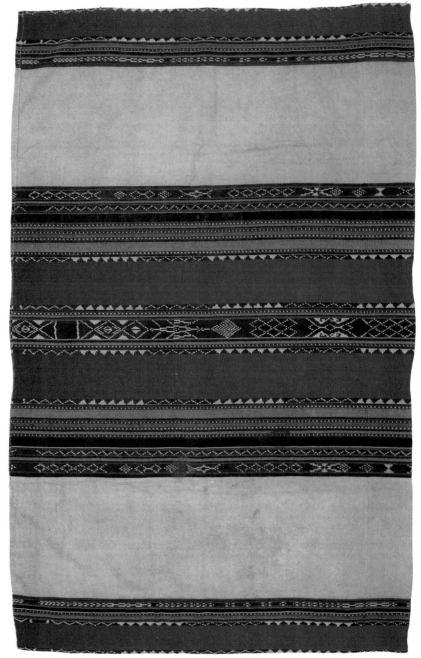

234

completely different solution — the use of plain warp threads and
weft patterning. Consequently, the use of silk and its related tech-
nology has contributed to the development of decorative weaving
techniques where the weaver's attention is directed to the possi-
bilities inherent in the weft threads.

One of the most significant decorative weft techniques to be
applied to silk thread in Southeast Asia is weft ikat, the resist-tying of
the patterns on to the weft threads before dyeing. Unlike the
technique of warp ikat where the ikat-resist patterns are applied to
the loom threads which are firmly secured and more easily controlled
during weaving, the process of weft ikat requires the winding of the 228

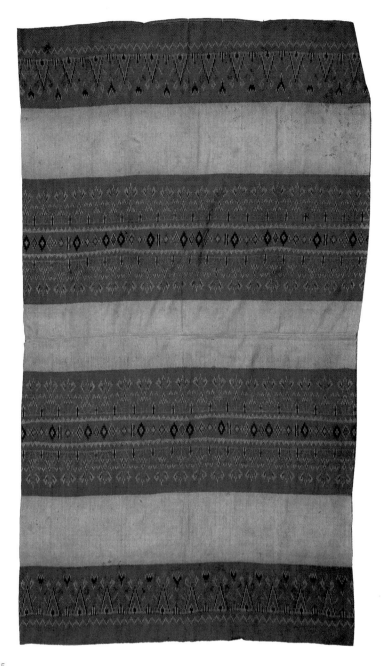

235

234
malong babalodan
woman's skirt
Magindanao people, Mindanao,
Philippines
silk, cotton, natural dyes
warp ikat
134.2 x 85.0 cm
Australian National Gallery 1986.2116

235
malong andon
woman's skirt
Maranao people, Mindanao, Philippines
silk, natural dyes
weft ikat
152.5 x 87.8 cm
Australian National Gallery 1985.1235

Two Islamic communities in western
Mindanao, both established sultanates
before the arrival of the Spanish and
closely related to each other
linguistically and culturally, weave
brightly coloured silk skirts for
ceremonial dress using quite different
methods. Although the Magindanao
were already more active than their
neighbours in trade with the outside
world before European intervention in
the region, their women's skirts have
retained an ancient design structure
with narrow cotton warp ikat bands
displaying simple triangular and
lozenge patterns. The skirt is
composed of five panels stitched
together, a wide central panel and four
narrow border panels containing the
stark black and white warp ikat
decoration. By contrast, the Maranao
apply the ikat resist technique to the
weft silk threads. The motifs on their
skirts, like many other Southeast
Asian silk textiles, have obviously been
influenced by Indian textiles obtained
through trade. In the past in this area
of the Philippines gold and purple were
reserved exclusively for royal use, and
these colours are a dominant feature
of both skirts.

already patterned weft threads on to bobbins before weaving can
begin. This procedure makes the actual insertion of the weft during
weaving a painstaking process as the weaver must carefully align each
new weft to ensure a clear revelation of the design. More of the warp
threads, which have been wrapped away around the warp-beam, are
released as the cloth is gradually woven and the patterning steadily
appears. This woven section is rolled around the breast-beam as the
work proceeds. The way in which the silk threads are inserted
backwards and forwards through the comb makes it difficult to pro-
duce a continuous circular warp.[25] Thus when the cloth is finally
completed it is removed from the loom as a flat rectangular length of
fabric unlike the cylindrical nature of the cotton warp ikat textiles
produced on the simple combless backstrap loom.

236
pha sin
woman's ceremonial skirt
Tai Nuea people, Laos
silk, cotton, natural dyes
weft ikat, supplementary weft weave
65.5 x 72.5 cm
Australian National Gallery 1987.1826

The finest skirts worn by Tai Nuea
women display elaborate bands of
alternating lac red silk and indigo blue
cotton weft ikat. Each band is
separated from the next by striking
supplementary weft designs. At the
lower edge another supplementary
band will be added. On many examples
the *naga* or *nak* motif is dominant.
This nineteenth-century textile reveals
an ikat pattern of intertwined serpents
alternating with a wide schematic band
of black and white ikat.

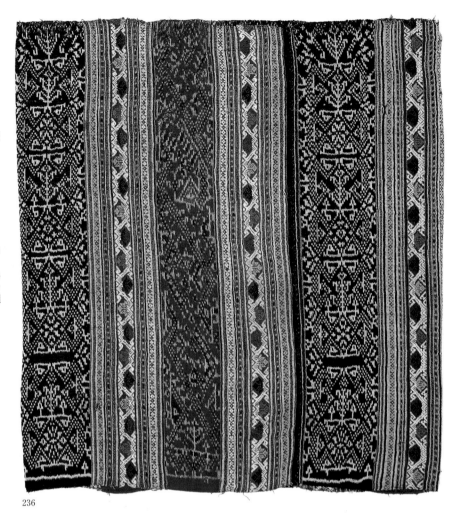

236

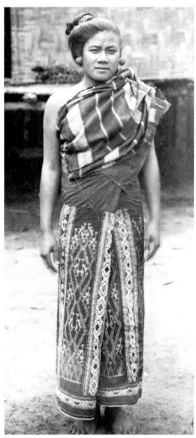

237

237
In this early twentieth-century
photograph a Tai Nuea woman in
Luang Prabang wears a fine skirt
decorated with bands of schematic
supplementary weft and weft ikat
patterns, and a weft-striped
breast-wrapper.

In addition to the inclusion of the comb to assist in controlling the
warp threads, the silk and metallic brocade weaving looms of the
region are basically of two types. The manual body-tension loom with
hand-lifted heddles is used in many parts of insular Southeast Asia
including coastal Sumatra, Java, Bali, Sumbawa, and south Sulawesi.
The foot-operated heddle loom is prominent in many parts of the
northern mainland of Southeast Asia, and also throughout the Malay
world including west Sumatra. Over the past century at least, the
latter type of loom has functioned within a rigid frame, which has
freed the weaver from the constraint of needing to apply constant and
even backstrap tension.

With gradual technological innovations different types of looms
can sometimes be found within the same area. In the Minangkabau
region of west Sumatra, an old style loom with a long discontinuous
warp persisted into the early part of this century, although it has been
steadily replaced by a rigid frame loom that has given weavers more
control over the meticulous arrangement of complex and detailed
supplementary weft designs. Variations on both these types of looms
can be found among many ethnic groups of mainland Southeast
Asia.[26]

Beautiful silk textiles using weft ikat are made in many cultures
across Southeast Asia. Silk weft ikat is found throughout mainland
Southeast Asia where the technique is practised in Laos and the Esarn
region of northern Thailand by many Tai groups, in Cambodia and in

231

229,230

232

233

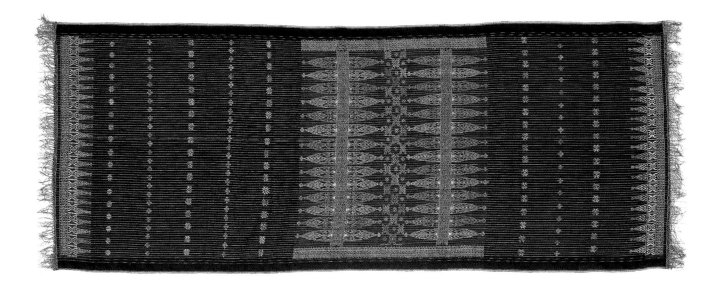

the Khmer-speaking districts of north-east Thailand such as Surin, and in northern Burma. It is also a prominent textile technique down the east coast of the Malay peninsula, along coastal Sumatra, in Bali and up into the southern Philippine island of Mindanao.

The combination of silk and weft ikat is nearly complete in Southeast Asia, and only isolated examples remain of the ancient warp ikat technique applied to silk fabrics. In Aceh very simple arrowhead patterning has been retained on silk warp ikat, often combined with supplementary weft metallic thread patterns. Possibly both warp and weft ikat continued to co-exist within the same textile-producing culture on the east coast of the Malay peninsula in Kelantan, where warp ikat on silk appears on a simple warp-banded style of fabric used for men's waistcloths and trousers.[27] Malay weavers in both Kelantan and Terengganu have also made rich weft ikat fabrics in both weft-banded patterns and large all-over designs.[28] Both warp and weft ikat are to be found on the silk cloth woven by the Buginese community in Donggala in coastal central Sulawesi (Kartiwa, 1983). However, these techniques appear to be relatively recent innovations, in the same way that weft ikat has developed in the Buginese homelands of southern Sulawesi.[29] On Mindanao in the southern Philippines the silk skirtcloths of the Maranao display weft ikat designs while the neighbouring Magindanao, though also working with silk, have retained simple and ancient motifs in narrow warp ikat bands.

Although silk is the thread most closely associated with weft ikat, this technique is still applied to cotton by a few ethnic groups. Handspun cotton weft ikats were woven both in Bali and in Lombok, although silk weft ikat cloths are now favoured in both islands.[30] In a few places the silk (and more commonly today, mercerized cotton) weft ikatted threads are woven with cotton warps for strength and economy. This practice is also followed by many Tai weavers, and some Tai Nuea woman's ceremonial skirts contain alternating bands of cotton and silk weft ikat, selected respectively for their capacity to absorb the indigo black dyes and lac red dyes. In some parts of mainland Southeast Asia where Buddhism is the dominant religion, such as Burma, there appears at first to have been some resistance to the

234,235

99,222

236,237

238
............
man's skirtcloth
Pasemah or Bengkulu region, Sumatra, Indonesia
cotton, metallic thread, natural dyes
supplementary weft weave, warp ikat, bobbin lace
169.5 x 64.5 cm
Australian National Gallery 1981.1158

This cloth successfully combines ancient and Indic influences. Gold and silver floating supplementary wefts have been placed against the dark blue and black warp stripes, which include tiny dashes of warp ikat in the borders. While a scattered field and a richly worked head-panel are common features of the ceremonial brocades of south Sumatra, the triangular motifs of the central section of this cloth are stylistically similar to the *pinar halak* bands of a Toba Batak *ulos ragidup*. This cloth also has unusual rows of small pointed patterns at each end.

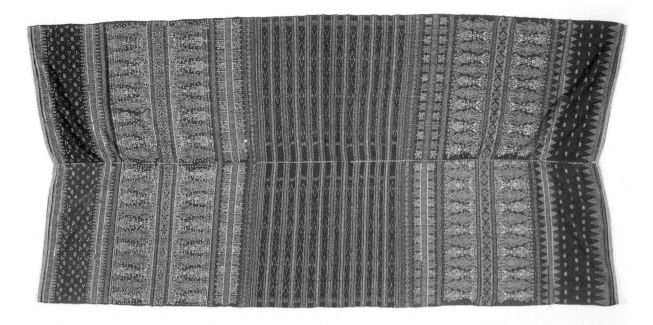

239

239
kain bidak (?)
shouldercloth; skirtcloth
Pasemah region, Sumatra, Indonesia
cotton, silk, gold and silver thread,
natural dyes, sequins
weft ikat, supplementary weft weave,
appliqué
208.5 x 108.7 cm
Australian National Gallery 1981.1159

Simple yet elegant weft ikat textiles
have been created in the Pasemah
region from sombre brown, blue and
white patterns composed of spirals,
rhombs and V shapes. Gold and silver
supplementary weft weaving has also
been practised there, though in
comparison with the famed Palembang
songket the results are more modest,
and the metallic supplementary
threads often appear on a base weave
of cotton rather than silk. In this
example the lustre of the gold thread
has been supplemented by glittering
sequins added to sections that show
when the textile is worn.

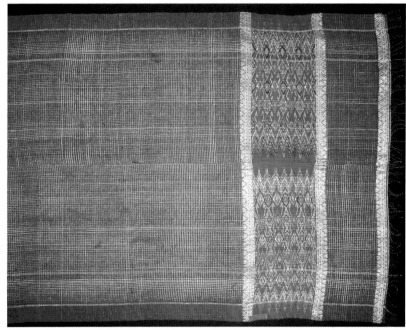

240

240 (detail)
selampang; samping
waistcloth
Minangkabau people, Silungkang, west
Sumatra, Indonesia
silk, gold thread, natural dyes
weft ikat, supplementary weft weave

Although weft ikat (*cuai*) may have
once been a speciality of the
Silungkang district of west Sumatra, it
had largely disappeared as a
decorative technique on Minangkabau
textiles by the end of the nineteenth

century. Its demise seems to have
coincided with the widespread
introduction of the frame loom in this
area at the expense of the older style
treadle loom.

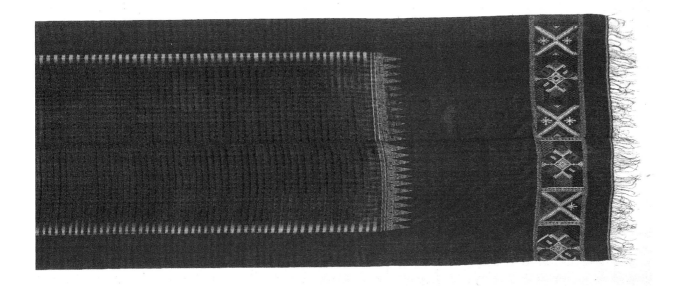

making of silk textiles on the grounds that living creatures are destroyed during the process (Schafer, 1962: 206), and the making of cotton cloth persisted until its position was challenged by imported silk fabric.[31]

Even in those parts of Southeast Asia where they took root, these new developments in technique and materials did not necessarily overwhelm existing indigenous textile traditions. Many of the oldest elements of Southeast Asian textiles were adapted and lingered on into the twentieth century. One striking example is to be found in the Sangihe-Talaud Islands north of Sulawesi where huge abaca textiles and room-dividers are woven using the supplementary weft technique. Many display a tripartite structure, banded designs, and rhomb and key ornamentation which are also prominent features of many of the oldest styles of Southeast Asian textiles, such as some of the Toba Batak cotton cloths of north Sumatra. However, in contrast to the simple backstrap looms of the Toba Batak, the Sangihe textiles are woven on body-tension looms with a comb and a continuous warp (Jasper and Pirngadie, 1912b: 59, 146), a transition loom between the simple body-tension looms of insular Southeast Asia and the looms used to weave Malay gold brocade in coastal Sumatra. Furthermore, some Sangihe textiles also display patterns indicating that, while continuing to use local wild banana fibre thread, the textile tradition absorbed many imported cloth patterns.[32]

One of the most interesting examples of the uneven penetration of foreign ideas is to be found in the Pasemah region of Sumatra where there is remarkable evidence of the meeting of the warp and the weft traditions. In the nineteenth century, simple warp ikat and supplementary warp cotton cloths were still being made in Pasemah with designs consisting of simple dots and dashes in a single colour. At the same time weavers were also producing intricate supplementary weft textiles using silk thread, and with bands of multicoloured weft ikat displaying elaborate arabesques and foliated trees woven in gold thread. As well as these textiles, there was also a range of simple weft

241
samping; tengkuluak; sandang; selendang
man's waistcloth; woman's headcloth or shouldercloth
Minangkabau people, Batu Sangkah (?), west Sumatra, Indonesia
silk, metallic thread, natural dyes
warp and weft compound ikat, supplementary weft weave, bobbin lace
100.0 x 249.0 cm
Australian National Gallery 1984.591

It is probable that this cloth was woven in Batu Sangkah in west Sumatra, an old cultural centre renowned for its weaving until the end of the nineteenth century. A simple combination of warp and weft ikat technique was used to create the checkered patterning in the central field, which is surrounded by clear, rich red borders. Fine bands of discontinuous weft silk motifs appear across each end, and the cloth is completed with metallic bobbin lace, a European technique which the Minangkabau adopted with considerable enthusiasm. The particular Minangkabau term used to describe such a cloth depends upon whether it is used as a waistcloth, a headcloth or a particular form of shouldercloth.

242
tampan
ceremonial cloth
Paminggir people, Lampung, Sumatra,
Indonesia
handspun cotton, natural dyes
supplementary weft weave
70.2 x 65.0 cm
Australian National Gallery 1981.1105

243
lampit
ceremonial mat
Paminggir people, Lampung, Sumatra,
Indonesia
split-rattan, cotton
twining, burnt pokerwork
74.0 x 64.6 cm
Australian National Gallery 1987.346

The form and function of the
split-rattan mats (*lampit*) found in
Lampung can be traced back to west
Java (M. Gittinger, personal
communication, 1984). Some of the
heirloom specimens in Sumatra may
actually have come from Java since it
appears that the *lampit* were a sign of
favour or patronage granted by the
rulers of Banten, who exercised
suzerainty over the Lampung region
for several centuries. It is not known
whether the rulers of the Palembang
court made these same symbolic gifts
to the people of the hinterland
although split-rattan mats have also
been located there and the people of
Pasemah regard that riverine centre
as the source of many of their sacred
heirlooms.
Like other sacred heirlooms in
Lampung, *lampit* and *tampan* were
stored in the umbrella-shaped
ancestral temple (*rumah poyang*).
Lampit (made by men) and *tampan*
(woven by women) were paired as
ritual objects symbolizing the male and
female elements of the universe,
although *lampit* were regarded as
more prestigious than the smaller
woven *tampan* and can only be found
among the heirlooms (*pusaka*) of noble
families in Lampung. Together they
were considered an appropriate seat
for the most powerful noble at
gatherings of local rulers or for an
aristocratic bride during a wedding
ceremony. On these occasions the
complete regalia included a betel-nut
container. In Pasemah split-rattan
mats, known there as *lampik*, were
associated with the worship of the
ancestors and were also used as the
seat of the ritual leader (*juai tua*).
The ceremonial pairing of *lampit* and
tampan is reflected in the similarity of
designs used on both types of object.
A *tampan* with a design very close to
that of the *lampit* in Plate 243 is

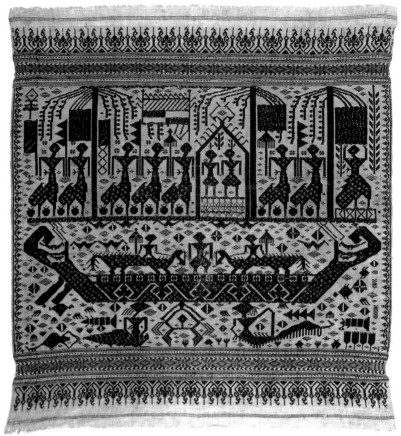

242

ikat cotton cloths and all-over silver and gold thread brocades. *177,239*
Although the reasons for such a wide range of textiles within a single
cultural complex are not entirely clear, for centuries there had been
contact between the mountain people of the Pasemah highlands and
the coastal entrepôt centre at Palembang. According to one ethnogra-
pher, 'every highland tale and legend is replete with images drawn
from Buddhist, Hindu and Islamic influences originating downstream'
(Collins, 1979: 54). Early photographs of the ceremonial dress of the
region (Jasper and Pirngadie, 1927) indicate that the people of
Pasemah, as well as wearing locally woven textiles, permitted and
even delighted in the use of a rich variety of cloths obtained from
elsewhere — in Sumatra, and from Java, India and Europe. Many of
these textiles were probably acquired through trade in primary pro-
duce with the port of Palembang.[33]

To the north of the Pasemah region in Sumatra, among the
neighbouring Minangkabau, although ikat is not a prominent decor-
ative technique, occasional examples of weft ikat on silk are still to be *240*
found. Rare examples also exist of Minangkabau textiles that combine
warp and weft ikat processes on a single cloth, and although the *241*
designs created by this process are only simple checks, the use of this
compound ikat technique is another unusual example of the meeting
of the warp and weft traditions.

In those places where ancient supplementary weft techniques
such as weft wrapping are still applied to cotton textiles, they are *104*
usually carried out on the older-style backstrap tension loom with a
continuous circulating warp and without a reed. Such textiles have

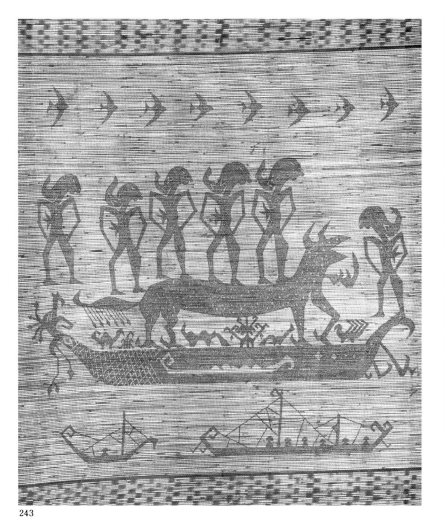

243

illustrated in Robbins (1985: 2). On this particular *tampan*, the ship is a large, elaborate sailing vessel, with clearly articulated rigging, sails and flags. The passengers and members of crew, one seen adjusting the sails, hold banners and umbrellas of rank and are depicted dressed in courtly costume resembling the *dodot*-style wraps worn throughout Java. The central figures on the raised dais may have been intended to represent a bridal couple. Although the image of the cosmic tree has been reduced to a decorative strip in one corner, the scene has far greater realism than other styles of *tampan*, and the animals on the lower deck are clearly intended to be horses. The mermaids depicted on this *tampan* are also found on batik cloths from the Cirebon court of west Java. The imagery of the *tampan* is matched by that of the *lampit*. The large vessel appears to have an outrigger and lacks sails, although perhaps because of the size and number of figures on board, the rigging has been omitted. The human figures display the elongated noses and arms, and upward curling head-dress associated with shadow-puppet profiles, and a ceremonial dagger (*kris*) is found at each waist.

remained important in ceremonial exchange and as objects of magic and ritual, essential for the reaffirmation of beliefs that stretch back to the time of the ancestors. As we have seen in the previous chapter, a continuous circulating warp produces an uncut cylinder, a factor of great significance in the making of these sacred cotton fabrics, and special ceremonies are required when the warp threads are severed. The spread of Indian religious ideas in no way diminished Southeast Asian beliefs in supernatural forces, or the mediating role played by sacred objects in important rites. The world of spirits and ancestors was expanded to include the sacred beings of Hinduism and Buddhism, and offerings to these deities continued to include the ancient elements of cloth and betel-nut.

Although worn as elaborate ceremonial costume, silk and gold and silver brocades contain none of the magical associations of these cotton cloths. The secular nature of beautiful silk and gold thread textiles is inherent in the weaving process used to create them. Unlike the potent metaphor provided by the circulating warp and the uncut cylinder, silk and gold thread textiles are removed from the loom as a single length of discontinuous fabric. In Bali and Lombok the distinction between these two types of textiles, the sacred and the secular, has resulted in two different types of looms remaining in use until today. A loom with a comb is used to produce a discontinuous

244
lampit
ceremonial mat
Paminggir people, Lampung, Sumatra,
Indonesia
split-rattan, cotton
twining, burnt pokerwork
84.0 x 94.0 cm
Australian National Gallery 1984.602

245
tampan
ceremonial cloth
Paminggir people, Lampung, Sumatra,
Indonesia
handspun cotton, natural dyes
supplementary weft weave
76.6 x 84.0 cm
Australian National Gallery 1986.1238

Burning motifs on to ritual objects is
an ancient decorative technique
applied to wood and bamboo, and the
symbols found on this *lampit* — the
sun (?), boats, birds and buffalo — are
important and recurring images also
found on many south Sumatran
tampan. This particular *tampan*
displays an unusual design structure
for these textiles. The major motif, the
ancient ship and serpent fused into the
dragon-boat shape, is repeated in
mirror image. The open jaws of the
serpent also appear on the *lampit* as
the bows of the ships.

246
tampan
ceremonial cloth
Paminggir people, Lampung, Sumatra,
Indonesia
handspun cotton, natural dyes
supplementary weft weave
68.0 x 78.0 cm
Australian National Gallery 1985.1742

usap
sacred textile
Sasak people, Lombok, Indonesia
handspun cotton, natural dyes
supplementary weft weave
54.2 x 57.0 cm
Australian National Gallery 1984.615

Both the *tampan* of Lampung and the
usap of Lombok are small
supplementary weave cloths which are
rarely worn, but are used for similar
functions during the transition rites of
the life-cycle — tooth-filing,
circumcision, first hair-cutting,
marriage arrangements and funerals.
Changes in religious beliefs have
affected both textiles. While the
tampan are no longer woven at all,
usap continue to be made by only a
few isolated Sasak communities, whose
ancient religious beliefs have
tenaciously endured despite the

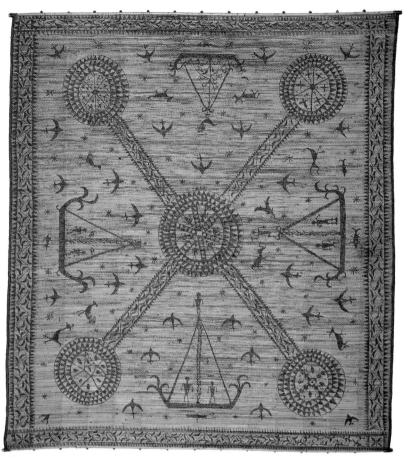

244

warp fabric for secular festive clothing, especially where silk and gold
thread are used. At the same time, a continuous warp body-tension
loom is used to weave sacred cotton cloths such as the Balinese
geringsing and the many varieties of simple striped cloth known as
wangsul (Bolland, 1971; Bolland and Polak, 1971).

A recent comparative study of the supplementary weft textiles of
the Paminggir of south Sumatra and the Tai of mainland Southeast
Asia reveals some surprising similarities of design and function (Git-
tinger, 1989a). This study emphasizes the similarities evident in the
border patterns, and as we have seen, these also extend to many
motifs in the central sections of these two groups of textiles. The Lao
cotton supplementary weft cloths are used as pillows and as gifts to
guests and monasteries to gain merit, while the south Sumatran *tam-
pan* function as gifts, wrappers and cushions for rituals associated
with tooth-blackening, weddings, and children's first hair-cutting.[34]
The female *tampan* textile has been linked with the male *lampit*, an
heirloom split-rattan mat, to become the *tikar-bantal*, a symbolic mat
and pillow gift (*tikar*, mat; *bantal*, pillow or cushion), and this
symbolic pairing can also be found in many other parts of Southeast
Asia, including the mainland.

While certain supplementary weft techniques on cotton are an
ancient and possibly prehistoric means of decorating Southeast Asian
textiles, and although it is unclear whether the *tikar-bantal* was a
result of Buddhist influence or represented an older Southeast Asian
tradition, the functions of the Paminggir and the Tai Nuea textiles are

10,11

242,243
244,245

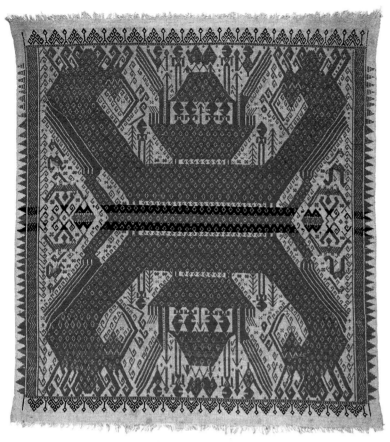

245

encroachment of reformist Islam. As with the final phase of *tampan* in Sumatra, the patterns on the Sasak cloth have become far simpler and figurative scenes have given way to geometric and schematic patterns. These late nineteenth-century examples also reveal the decorative style that developed on both *tampan* and *usap* under the impact of trade textiles which are still treasured as heirlooms in both regions.

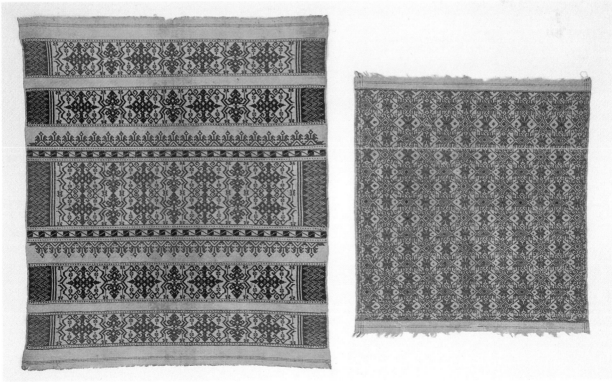

246

those of the Buddhist world, part of the cultural heritage shared by the people of Laos and Sumatra for more than a millenium (Gittinger, 1989a). The symbolic place of such textiles in acts of merit among the Tai Nuea, and in rites of passage such as marriages and funerals and at meetings of local rulers in south Sumatra, suggests a common ancient history.

In the past the cultural influences that gave rise to these textiles in Laos and south Sumatra may have spread over a much larger area within Southeast Asia and at least as far east as the island of Lombok. This is certainly suggested by the remarkable visual and functional similarities between certain Sasak supplementary woven cloths (the *usap, subahnalé* and *pesujutan*), and those of both the Tai Nuea and the Paminggir. In each case, the design similarities include both the border patterns and the central motifs, and on all these textiles we can find human figures, umbrellas, shrines and mythical creatures. 246

The small size of the Sasak supplementary weft cotton weavings generally precludes their use as clothing or as hangings, and unlike other sacred Lombok textiles (such as the *umbaq* or *kekombong*) these cloths are rarely worn and appear, like the *tampan*, to be token textiles — truncated versions of some earlier functional form.[35] There are also interesting similarities between the format and some of the designs on the rare *tampan* runners (known as *titi jembatan agung* — the great bridge), the Buddhist prayer flags of mainland Southeast Asia and those examples of *usap* cloths that remain in an undivided series.[36] 165

Only a small number of Lombok cotton supplementary weft textiles with figurative designs have been located, but there is sufficient evidence to make an interesting comparison with the neighbouring island of Sumbawa. Despite the fact that Sumbawa came under the influence of the Islamic Sultanate of Goa in south Sulawesi during the early seventeenth century, many figurative designs — including ships, trees, birds and human figures — continued to appear on west Sumbawan cotton textiles using supplementary metallic thread. The impact of divergent historical experiences over recent centuries has emphasized the separate cultural identity of the peoples of Bali, Lombok and west Sumbawa, despite the linguistic evidence that points to a shared past.[37] However, the iconographic similarities evident on their textiles suggest that these islands were influenced by common cultural forces during an earlier historical epoch. 168,247

While many supplementary weft cotton textiles are the products of Southeast Asian societies that have been influenced to some degree in the past by Indian-derived Hinduism and Buddhism, they undoubtedly contain many elements of the most ancient textile traditions of the region. Disentangling the strands of historic cultural influence on cloths made over the last two hundred years can only lead to tentative conclusions. However, it is clear that in comparison with these cotton cloths the weft-decorated silk and gold thread textiles of the Indianized world of Southeast Asia were admired as expensive objects of great beauty but were never imbued with sacred values. There is little evidence of ceremonial activity surrounding the making of these textiles, and magic and ritual played almost no part in the preparation of their dyestuffs or weaving. While bestowed upon loyal courtiers and foreign dignitaries, the silk and gold textiles were not a feature of ancient bride-wealth exchanges.[38] These lavish and expensive fabrics became symbols of elegant courtly life and evidence of heavenly blessings rather than supernatural handiwork.

GOLD AND SILK: NEW SYMBOLS OF STATUS

Forms of hierarchy existed within Southeast Asian societies before the impact of Indian influences, and the descendants of village founders often dominated ritual and controlled agriculture. The huge potlatch destruction of livestock during prestige feasting and the lavish burial practices that consume masses of textiles, porcelain and other items of wealth in Sumba, Toraja and Timor are expressions of power and the means to consolidate and boost the prestige of groups and individuals in those societies.

However, these hierarchical relationships were often fluid and changeable. In particular, they depended on ties forged through marriage such as those existing between bride-givers and bride-takers in many Indonesian societies, and on knowledge of and prowess in economically and ritually significant activities such as head-hunting and warfare. While some groups had always had greater access to and control over land, heirlooms and sacred paraphernalia than their fellow Southeast Asians, a more rigid distinction between rulers and ruled developed under Indian influence in those parts of the region where this was most strongly experienced. This fundamental change involved the move away from kin-based social structures towards the consolidation of ranked groups holding hereditary power and wealth.

The transformation from a system in which ritual leaders acquire their authority through experience, expertise and control of the ritual cycles affecting village agriculture, to a system in which a ruler's prestige is based on birth and on the control of wealth, including trade and land, is evident in the case of the Abung and Paminggir of south Sumatra. In those societies conspicuous consumption and the ability to hold lavish feasts marked the promotion of prominent leaders to higher levels of nobility. In Buddhist societies of mainland Southeast Asia, acts of merit, such as the presentation to temples of large and expensive gifts, also permitted wealthy individuals who were not necessarily members of the nobility to secure grace in the hereafter. Since the first millenium AD, these gifts, which were usually recorded or inscribed, have included fine textiles and clothing.[39] Throughout the region, various taxes, tributes, and gifts — for temples, harbours and principalities — were extracted in precious goods, and textiles and raw materials such as cotton and silk have always figured prominently in these affairs.

The powerful position of many leading clans developed into a system of local rulers and this generated deeper social stratification. In the early coastal trading kingdoms and entrepôt cities and in the great inland land-based empires, prestige and power became vested in certain noble dynasties, and Indian religion and culture provided a means of justifying and consolidating their rule. It also supplied the visual symbols of kingship — the sacred canopy, the royal umbrella, the wheel of law, holy texts, weapons, and mighty creatures such as the elephant, and introduced the ceremonies at which these could be displayed. While these influences did not solidify into the caste system of India — even in Bali where Hinduism has remained a powerful force — a more rigid stratification produced an aristocracy, and classes of free persons and slaves. These positions were inherited and to a large extent determined the pattern of life in these societies, where the access of outsiders and the common people to land, wealth, power, and the perquisites of office was very restricted.

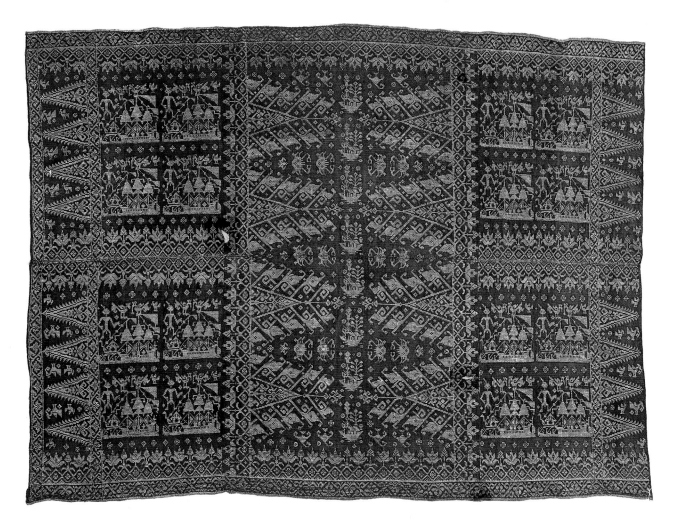

247
kré alang
skirtcloth
Semawa people, west Sumbawa,
Indonesia
cotton, metallic thread
supplementary weft weave
117.0 x 164.0 cm
Australian Museum, Sydney E66721

The weaving of rich brocade was a skill closely associated with all the royal houses of Sumbawa. While strong cultural links were forged through marriage and tribute between this island and the southern Sulawesi kingdoms, the supplementary weft technique, the cotton base cloth, and especially the ancient cosmic iconography that is a striking feature of Sumbawan skirts, suggest that their textile traditions have greater affinity with other peoples of Southeast Asia. Many figurative motifs can be distinguished on this beautiful west Sumbawa silver brocade — humans, ships, birds, crabs and triangular trees. The male figures are depicted in a simple frontal stance with explicit genitalia and wearing a curious head

In those areas most deeply affected by these social transformations, the role and function of textiles began to change. Increasingly, textiles were used as symbols of rank or markers of status. In these stratified societies, it was no longer important for the symbols on textiles to distinguish between different descent groups or to indicate individual prowess at those pursuits that were highly valued within village-based communities. Textiles were judged more on sumptuousness and expense rather than on any significant meaning they may have held in ritual. Cloths were especially created to be worn at times of ceremony and festivity, and the materials prominent 248,249 in the courts of Southeast Asia on these occasions were sumptuous silks and glittering gold thread.

As textiles became a sign of class differences within hierarchical societies, a range of highly specific and subtle signals of rank were also adopted. The foreign or local origins of cloth, the textures, the designs and the manner in which it was worn, were all ways of dis- 250 tinguishing the rulers from the ruled. Certain motifs and colours became the symbols of noble birth, and many cloths could, in fact, be worn by both men and women. Throughout the Malay world, for example, yellow clothing became associated with aristocratic costume and was reserved exclusively for royalty. The use of umbrellas and other items of court regalia were also linked with high office. No 251 ceremony was complete without parasols of silk or velvet, plain-coloured or embossed with gold, embroidery and sequins. In many 213,252

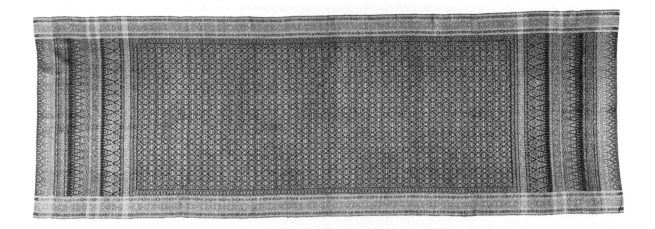

248

cultures the number of tiers of the parasol indicated the precise rank of the official. As Indian and ancient meanings became blurred in these situations, there was a natural interplay between the old and the new functions that textiles possessed. Canopies and hangings provided splendid surroundings for ceremonies of state but they also clearly drew upon the protective and magical elements associated with certain sacred fabrics of ancient origin.

The possession of royal regalia and sacred heirlooms became both a means of obtaining rulership and a proof of an individual's claim to that position.[40] Heirlooms that were accorded such status included sacred texts, weapons, objects made of gold and precious stones, and valuable textiles. This royal regalia usually included objects of foreign as well as ancient indigenous origin. For example, in the Thai court of the Ayutthaya period, the state umbrellas were accompanied by special betel-nut apparatus, and the king's bodyguard were marked by special tattoos like warriors of old (Terwiel, 1983: 2, 6). Objects made of gold have always been prized throughout Southeast Asia and gold was one of the most important commodities sought by early Indian traders. Even in communities little affected by the spread of Indian statecraft, gold became a symbol of wealth, and the paramount metal offered by the male party in ritual exchanges. However, although people in these societies made beautiful gold jewellery, they rarely used gold to decorate their textiles.

As competition to produce more and more elaborately decorated textiles developed among the indigenous aristocracy and wealthy rulers, one of the most striking means at their disposal was the application of gold to the surface of cloth.[41] In Indianized Southeast Asia, gold became both a form of wealth and a symbol of majesty and the Upperworld, and cloths so decorated became suitable apparel for royal and ceremonial use. One striking decorative device of these Hindu-Buddhist courts was the embellishment of the rich but soft hues of the naturally-dyed weft ikat fabrics with expensive supplementary gold thread weaving. Silver- and gold-wrapped thread was sometimes made by local smiths, and the equipment for making silver thread still exists in the court of Bima although it has not been used for many decades.[42] However, for at least the last century, weavers throughout Southeast Asia have usually depended upon imported metallic thread from India and particularly China.

ornament resembling the simple leaf head-dress still worn today in some parts of Sumbawa. Great care has been taken with the ship motif to depict such features as the masts, sails and rigging, the flags and the poop deck. The light-maroon and mauve colours are unusual even in coastal communities of the region but bright colours are a feature of the cotton textiles from western Sumbawa. The continued popularity of cotton, even for fine ceremonial textiles, may have been a result of its easy cultivation in the dryer climate of eastern Indonesia.

248
pha yok Muang Nakhon
ceremonial skirtcloth
Thai (or Malay?) people, Nakhon Si Thammarat, Thailand
silk, gold thread, dyes
supplementary weft weave
94.0 x 278.0 cm
Australian National Gallery 1982.10
Gift of Winifred Thorvaldson, 1982

This brocade cloth was probably woven in Thailand, although many such skirtcloths were also made in India and in Cambodia for export to the Thai court. The finely worked gold supplementary thread (*yok thong*) and the green, pink and purple silk (possibly obtained from chemical dyes) suggest early twentieth-century Thai origins, and the cloth was probably woven in southern Thailand in the Nakhon Si Thammarat region (Peetathawatchai, 1976). By the late nineteenth century, few Thai or Malay weavers were still making these beautiful textiles in the Nakhon Si Thammarat and Surat Thani regions and surviving examples are rare.

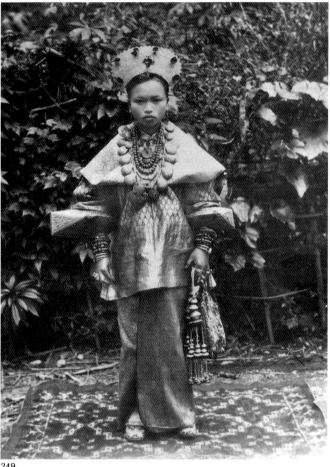

249

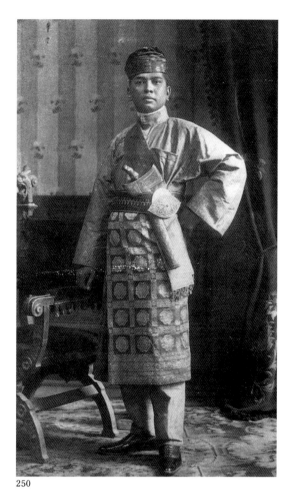

250

249
The wearing of cloth of gold became a dazzling sign of physical and spiritual blessing throughout much of Southeast Asia. In this early twentieth-century photograph, a young woman from Sungai Puar in the Minangkabau highlands appears in ceremonial costume made from handwoven gold and silver supplementary weft textiles, worn with a lavish display of the family's heirloom jewellery.

250
A turn-of-the-century photograph of the Crown Prince of the Malay court of Deli in north Sumatra. While the various Malay sultanates of coastal Borneo, eastern Sumatra, the Riau archipelago and the Malay peninsula have shared the same basic elements of courtly dress, there are slight variations in the textiles of each of these locations. Some of the Malay courts have produced their own fine cloths while others imported their royal cloths from neighbouring or foreign, particularly Indian, weaving communities. These sumptuous textiles are clearly Southeast Asian, though whether such fine textiles were ever made in north Sumatra is unknown. They may have been woven in Palembang.

251
payung (?)
ceremonial umbrella for royalty
north-west India; Java, Indonesia
silk velvet, gold thread, sequins, tinsel, semi-precious stones
couched embroidery, appliqué
85.0 cm radius
Australian National Gallery 1987.1545

This sumptuous umbrella, believed to have been used in aristocratic circles in Java, has been worked in a fashion popular in India from Mughal times, where the embroidery technique was known as *zargozi*. This is a strikingly opulent example of gold embroidered burgundy velvet. The motifs include sprays of flowers, birds and the swastika emblem. The gold metallic fringe is a later addition. Following Hindu-Buddhist Indian customs, umbrellas became an important symbol of the ruler throughout Southeast Asia, and were held above royalty by their retainers during processions or while seated in state.

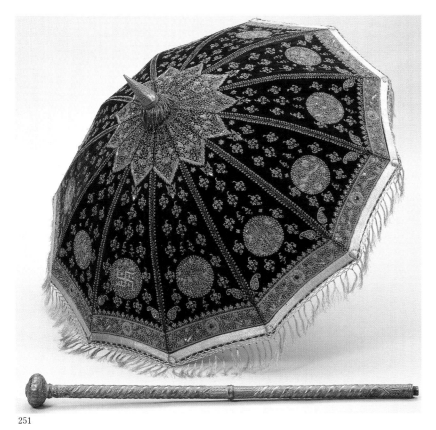

251

253

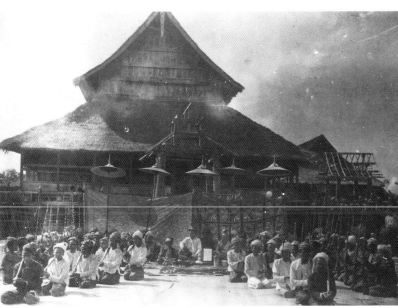

252

252
A Shan (?) ruler and his court in Muang Sing in northern Laos near the Chinese border, at the turn of the century. The umbrellas of rank and fine textiles provide an appropriate backdrop for the royal appearance in many parts of Southeast Asia.

253
Only a little gold thread appears on the supplementary weft weave textiles of the various Tai communities, although the skirts and shouldercloths worn in the Tai Lao courts, particularly at Luang Prabang, in the nineteenth and twentieth century used some gold brocade. In this late nineteenth-century photograph, the daughter of the ruler of Xieng Noi wears a banded skirt with an ornately patterned lower border of metallic-thread supplementary weft brocade.

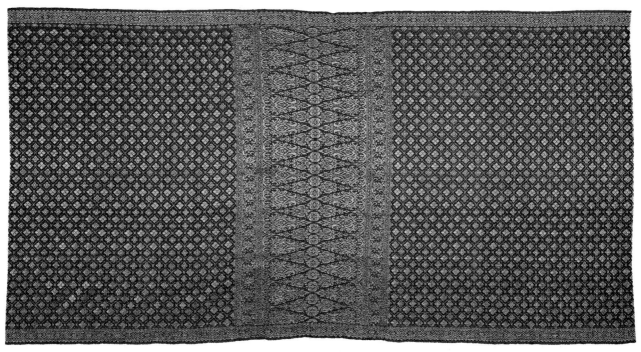

255

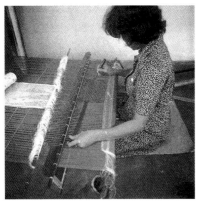

254

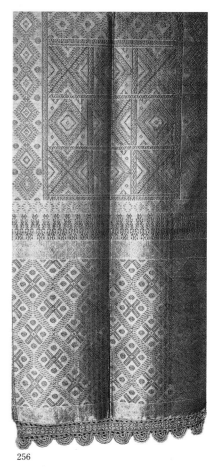

256

254
This woman is setting up a loom to weave *kain songket* in the Palembang district of Sumatra. The plain silk warp has been passed through the reed or comb and the main heddle threads. The pattern to be worked in supplementary gold thread is being marked out with thick white threads preliminary to inserting shed sticks which will be selected in a particular sequence during the weaving process. This procedure results in the precise, symmetrical patterning that characterizes the gold brocades of Southeast Asia.

255
kain lemar songket bertabur
skirtcloth
Malay people, Terengganu, Malaysia
silk, gold thread, natural dyes
weft ikat, supplementary weft weave
212.8 x 103.2 cm
Australian National Gallery 1984.1097

Valuable silk and gold fabrics became a sign of the prosperity and power of the royal houses of Southeast Asia. On some textiles the patterns of the pink and red silk weft ikat (*lemar*) and the gold thread brocade (*songket*) are intricately interwoven. The gold motifs are scattered across the field (*bertabur*) instead of forming a continuous pattern. This ornate cloth combines bold brocade floral motifs set within a subtle grid of weft ikat in shades of deep red, pink and cream. A single panel of densely woven supplementary metallic thread became a striking feature of these skirtcloths, while textiles intended as sashes and shouldercloths have similar patterns worked across each end.
While these cloths are now associated with the Sultanate of Terengganu on the east coast of the Malay peninsula, in the past they were also part of royal ceremonial costume in the Riau and Lingga archipelagos which lie between the Malay peninsula and southern Sumatra. These silk weft ikat textiles are known on the east coast of Malaysia as *kain lemar* or *kain limau*, and when referring specifically to these Malay examples the term *lemar*

will be used. In Sumatra and Java they are known by the term *kain limar*.

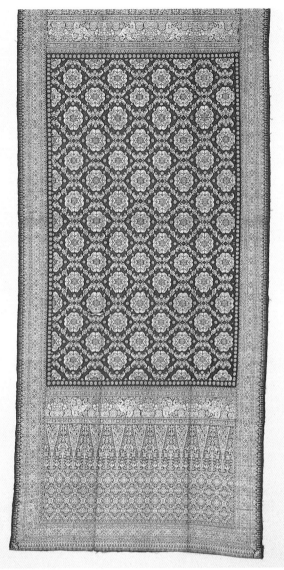

257

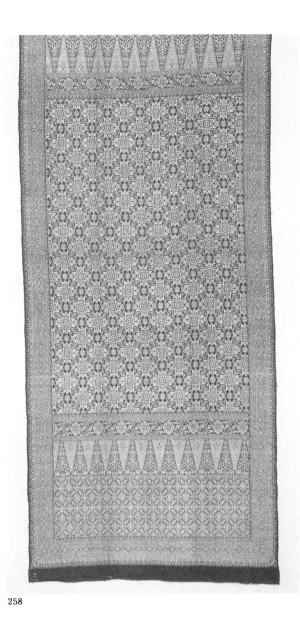

258

256 (detail)
kain sandang; selendang
shouldercloth
Minangkabau people, Pandai Sikat,
west Sumatra, Indonesia
silk, cotton, gold and silver thread,
natural dyes
supplementary weft weave, bobbin lace
210.0 x 56.0 cm
Rijksmuseum voor Volkenkunde,
Leiden 2299–152

Some of the most magnificent gold and
silver brocade has been woven in the
Minangkabau region of west Sumatra.
On this nineteenth-century example
various schematic patterns alternate in
gold and silver supplementary weft
thread against a barely visible maroon
and black ground. Each end is further
ornamented with a wide band of
metallic-thread bobbin lace.

257 (detail)
kain songket
shouldercloth; waistcloth
Malay people, Palembang, south
Sumatra, Indonesia
silk, gold thread, natural dyes
supplementary weft weave
210.0 x 81.0 cm
Australian National Gallery 1988.1553
Gift of Michael and Mary Abbott,
1988

258 (detail)
kain songket
shouldercloth; waistcloth
Malay people, Palembang, south
Sumatra, Indonesia
silk, gold thread, natural dyes
supplementary weft weave
84.5 x 260.0 cm
Australian National Gallery 1989.497

These 'cloth of gold' (*kain songket
lepus*) from Palembang are densely
decorated in a grid of continuous
floating supplementary wefts of
gold-wrapped thread, with highlights in
multicoloured silk. Eight-petalled
rosettes and eight-pointed stars are
familiar motifs. The central field
design is protected at each end by a
row of jagged triangular teeth, known
in the Palembang area as the *pucuk
rebung* (bamboo shoot) motif. The high
quality of the gold ensures a
surprisingly supple fabric.

The complex patterns on gold thread supplementary weaves are usually achieved with the aid of additional shed-sticks, although one or two major heddles facilitate the shed openings for the basic tabby weave. In the court settings of the region, the looms used to weave these rich brocades were solid and elaborate pieces of apparatus, with carved, lacquered and gilt breast-beams and back-plates, and stands supporting the warp-beam around which the unwoven warp threads were rolled. *254*

The most exceptional of these textiles is the legendary 'cloth of gold', on which the entire surface of a rectangular silk cloth is filled with floating gold thread woven in intricate designs. For practical and economic reasons, however, shouldercloths and waistcloths usually have bands of gold brocade only across each end. On cylindrical skirts the head-panel and borders often display glittering gold thread with patterns composed of rows of foliated triangles, separated from the main pattern of the central field by an arabesque band. Rich supplementary weft brocade fabrics are still used today in many coastal regions and include the *malong andon* of the Maranao of Mindanao, the *ija* of Aceh in north Sumatra, the *kain songket* of Terengganu and Palembang, and the *pha yok thong* of Nakhon Si Thammarat. The most richly decorated textiles were often given appropriate names. In Lampung, the Abung refer to one of their most densely couched and embroidered skirts as *jung sarat*, the laden ship.[43] The richer and more sumptuous the display of gold on any particular textile or combination of textiles that make up a complete costume, the greater the wealth and prestige of the wearer's family. *256,257,258* *255* *248*

The courts of Thailand, Cambodia, the Malay peninsula and coastal Indonesia were all renowned for their sumptuous gold brocades. The richest supplementary weft cloths use gold-wrapped thread as a surface decoration floating across the basic silk foundation weave. In most instances the gold thread floats across the outer surface of the garment but a stronger and more supple fabric results when the supplementary weft is regularly interwoven into the warp rather than stretched in long sections across the fabric. Couched gold thread embroidery, in which the metallic thread is laid on the surface of woven cloth and anchored into place with embroidery stitches, permits the maximum display of any gold thread used. As we shall see, it was probably a later introduction into Southeast Asian textile art, but by the nineteenth century it was a well-established technique on court costume. *260*

Apart from embroidery and the weaving of brocade, gold is also added to woven and dyed fabrics by an entirely different method — it is glued on to the surface of the cloth. Gold leaf or gold dust is applied after free brushwork, stencils or stamps have been used to apply a bole or glue solution. The gold leaf (known as *prada* or *telepok* throughout many parts of Indonesia and Malaysia) is applied only to one side of a length of fabric and sometimes only to the section that will be revealed when the cloth is worn. Hence, as a decorative technique, it produces a spectacular effect in a most economical way.[44] *259*

A few examples have been found in central Sulawesi where the Toraja have used ground mica to create a glittering effect (Solyom and Solyom, 1985: 4). Whether this is a local innovation based upon the mica disc appliqué often used on Toraja women's tunics or an emulation of gold leaf gluework observed on imported cloths, remains

unclear. Elsewhere in Southeast Asia, this technique has become an important method of creating glowing decorative patterned fabric, especially where court centres developed and an indigenous aristocracy required elaborate costume. In Bali gold leaf gluework is used on spectacular theatrical costumes and though the work is often crude, this is not obvious in dance performances. In Thailand, Sumatra, Java and Bali, gold leaf is also used to highlight certain patterns already dyed on to the cloth. These are usually wax-resist batik and mordant-printed cottons, although in south Sumatra gold leaf is also found on simple *tritik* stitch-resist fabrics. In the Thai courts of Ayutthaya and Bangkok, gold leaf was applied to some of the finest examples of imported Indian mordant-painted cottons (*pha lai yang khien thong*). The designs achieved in Palembang are similar to those used on woven gold brocade and it appears that gold leaf has been used in the past as a quick and labour-saving substitute for the weaving of supplementary gold-wrapped thread. It was also used in areas where gold brocade weaving (widely known as *songket* in insular Southeast Asia) was apparently unknown. In the nineteenth and twentieth centuries, the rulers of certain Malay principalities wore complete outfits — trousers, shirts and wraps — decorated entirely with gold leaf, and the patterns on these textiles are similar to those which appear on gold brocade woven in the south Sumatran-Malay region. For example, it seems to have been adopted as royal dress fabric in the Malay court of Selangor. In contrast to those gold leaf designs that simulate woven patterns, the Javanese have used this technique to create a spectacular textile, the *dodot bangun tulak pinarada mas*, which depicts a world of foliage and animal life based upon ancient Javanese legendary sources. In fact gold leaf gluework may well have preceded batik as a technique for decorating textiles in Java (Forge, 1989).

On certain textiles the application of gold leaf dramatically alters the original design of the base cloth. In the Palembang region, *prada* designs based upon popular local gold brocade patterns are also applied to Indian trade cloths, but in a manner that highlights particular elements of the block-printed design. Some Javanese batik patterns lend themselves to the addition of *prada*, and gold leaf gluework is often used merely to embellish designs, in particular those derived from Indian trade cloth such as the *jilamprang* star.[45] The Balinese, however, also apply *prada* to batik cloth obtained from Java, but in such a way that the dominant pattern is often completely changed. Lotus and bird patterns are especially prominent on these luxury fabrics.

In comparison with sturdy warp ikat cotton textiles, gold brocades are both fragile and expensive, and gold leaf decoration on cloth is even less durable. Heavily ornamented gold thread costumes, flimsy silks, and beaded and sequinned embroidery have accentuated the distinction between everyday clothing and festive dress, as well as that between the wealthy nobility and the common people. The association of these rich and ornate silk and gold decorated textiles with the nobility is evident in their present-day use by other sections of society. On certain important ceremonial occasions, elaborate gold thread textiles, sometimes borrowed or hired, are used in ways to emulate royalty. For example, at wedding ceremonies and the initiation of young people into adulthood through circumcision or tonsure rituals, the major actors wear gold and silk costume, are carried

261

262

194

263

264

265

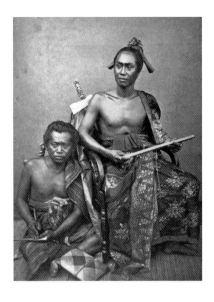

259
An 1865 photograph of Gusti Ketut Jelantik, Raja of Bulèlèng in north Bali and his scribe inspecting lontar palm texts. The ruler's skirtcloth is decorated in gold leaf with what appear to be flaming monster heads (*kala*) and foliate motifs. While elaborate triangular borders finish two edges of the garment the upper and lower selvages are completed with a golden woven braid. The same structure is still used for Balinese gold leaf gluework wraps which are worn nowadays mostly by dancers as dramatic theatrical costume. The photograph from the van Kinsberger collection was published in Colijn (1912).

260 (detail)
tapis tua
woman's ceremonial skirt
Abung people, south Sumatra,
Indonesia
cotton, natural dyes, gold thread,
metallic tinsel, sequins
couched embroidery, appliqué
103.0 x 59.0 cm
Australian National Gallery 1980.729

The weaving of gold thread is not the
only method used to create golden
garments. Many rich hangings and ac-
cessories display gold thread stitched
to the surface. The most spectacular
use of gold thread couching as a
decorative technique for ceremonial
wear is found among the Abung. On
ceremonial occasions, noblewomen
appear in cylindrical skirts of sombre
warp stripes which provide a foil for
the sumptuous gold thread, mirror and
sequin designs. On the most densely
couched *tapis* the striped base-cloth is
entirely covered by the gold thread
and the patterning is achieved through
rhythmic couching stitches, creating a
quilted effect on the layer of gold. The
title of this textile (*tapis tua*) literally
means 'the ancient skirt'.

261 (detail)
geringsing sanen empeg
ceremonial cloth
Balinese people, Tenganan, Bali,
Indonesia
handspun cotton, natural dyes, gold
leaf
double ikat, gluework
229.0 x 24.0 cm
Art Gallery of South Australia 738A85

Sacred *geringsing* are woven only in
Tenganan, although they are highly
revered throughout Bali. On this
unusual example, the subdued tones of
the double ikat have been embellished
with gold leaf, a fine illustration of the
way a sacred and magical cloth may be
enhanced by subsidiary decoration for
ceremonial display. This ikat pattern is
known as *dindingai* (plaited bamboo
wall).

At certain ceremonies almost
invariably connected with martial or
exorcistic activities, Tenganan men
wear, around their necks, *geringsing
sanen empeg* with uncut warp threads
in a style referred to as a *cawet
geringsing* (Ramseyer, 1977: 223–4).
The term *cawet* suggests that such
narrow cloths may originally have
functioned as a man's loincloth. With
the unwoven warp threads still intact
the potency of these textiles is
enhanced, both as a ritual object
essential during occasions such as
princely tooth-filing, and as a worthy if
unpretentious gift of clothing to the

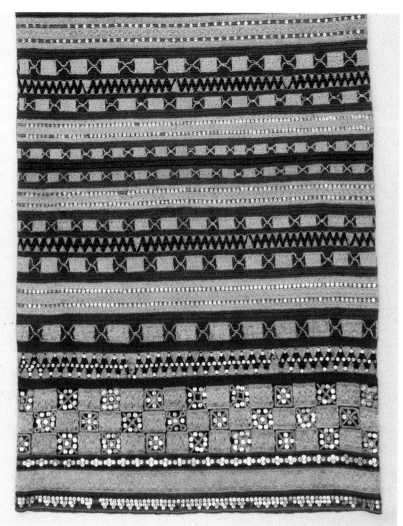

260

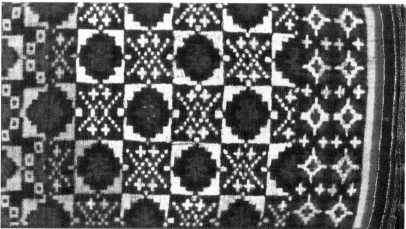

261

gods. After the warp threads have
been severed, the *geringsing* are
restricted to human use and are used
in those rites that mark the passing of
various stages of human existence.
While other woven cloths are present

at birth, a small *geringsing* is placed
over the genitals of the deceased
during ritual washing of the corpse.

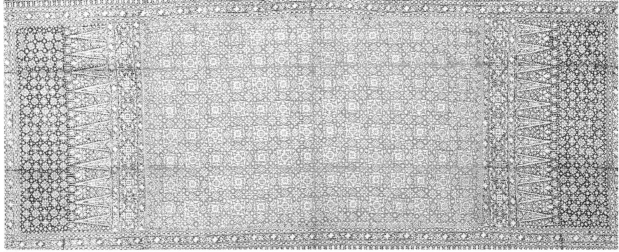

262

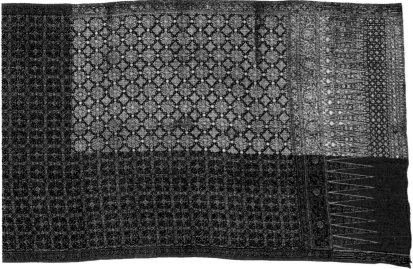

263

1–5). The resulting gold pattern is different from the design of the base-cloth, and closely resembles the gold brocade weaving of this region. *Sembagi* are now worn as shouldercloths and waist-sashes by both men and women throughout south Sumatra, Pasemah and Lampung. Without the gold leaf these are appropriate textiles to use as shrouds in the Palembang region.

262
kain telepok; *kain prada*
ceremonial shouldercloth
Malay people, Palembang, south
Sumatra, Indonesia
silk, natural dyes, gold leaf
stitch-resist dyeing, gluework
210.0 x 85.0 cm
Australian National Gallery 1989.1871

This nineteenth-century gold leaf cloth closely follows the structure and visual appearance of Palembang *kain songket*, which are woven with supplementary weft gold thread. However, the gold patterns on this textile are formed by the gluework application of gold leaf, while the red and green stitch-resist sections simulate different coloured warp and weft bands.

263 (detail)
kain sembagi (in Palembang)
ceremonial skirtcloth; shouldercloth;
waist-sash
Coromandel coast, India; Palembang
region, south Sumatra, Indonesia
handspun cotton, natural dyes and
mordants, gold leaf
mordant block printing, batik, painting,
gluework
261.0 x 113.2 cm
Australian National Gallery 1981.1165

Large numbers of painted and printed cottons, originally from the south-east of India, are still stored as family heirlooms in the Palembang and Lampung regions of south Sumatra. This example in red, blue, over-dyed purple and yellow natural dyes was made in India, but the opulent gold leaf was added in Sumatra to the section of the cloth that is revealed when it is worn (Loebèr, 1914: Figs

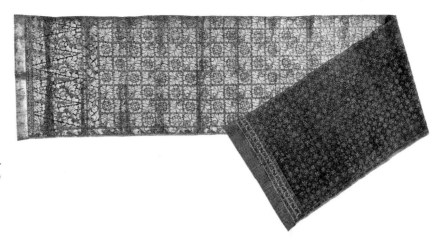

264
kain prada
breastcloth
Java; Bali, Indonesia
cotton, natural dyes, gold leaf
batik, gluework
270.0 x 56.0 cm
Australian National Gallery 1987.1081
Gift of Michael and Mary Abbott,
1987

The base-cloth for this late nineteenth-
or early twentieth-century breast-wrap
for ceremonial occasions is a blue and
white hand-drawn batik of the style
often associated with Jambi in east
Sumatra. Indigo and white batiks were
particularly popular in Bali where they
were often decorated with gold leaf
gluework. While some Balinese gold
patterning follows the batik design,
this cloth is an example of the way a
very different pattern was sometimes
laid on the surface of the batik without
regard for the existing motifs. The
floral and leafy geometric field is
enclosed with triangular end borders
that were not a feature of the batik's
original design. The *prada* patterns on
this cloth seem to have been created
by the application of stamps.

in royal procession under ceremonial umbrellas and sit on specially
erected thrones as 'king or queen for the day'. In mainland Southeast
Asia, Buddhist monks are ordained in lavish courtly style, and are
likened to the Lord Buddha as the Prince Gautama (Van Esterik,
1980). Unlike the cotton warp ikat textile tradition where the finest
cloths are worn at festive occasions and, when old or damaged, are
then used as ordinary everyday clothing, the gold thread and *prada*
textiles are always stored for the next ceremony and are only brought
out for deliberate display. These textiles were never intended for
everyday apparel, and the finest and most elaborate examples have
never been within the reach of the ordinary people of Southeast
Asia.[46]

INDIAN COSMOLOGY AND TEXTILE SYMBOLISM

Textiles, like other Southeast Asian art forms, draw upon the sacred
legends of India for themes and motifs. From the panoply of gods and
heroes in Hindu legends, the Ramayana and Mahabharata characters
hold a special place in the region's symbolism and iconography. The
Jataka legends that describe the lives of the Lord Buddha also provide
vivid scenes for decorative textiles intended for both the monasteries
and courts of mainland Southeast Asia. Throughout the region, in-
digenous historical epics and folk-tales are often treated in the same
style as these Indian stories and legends when they are used in drama,
graphic art and on textiles.[47]

266,267,268,
269

271

Under the influence of these sources, the depiction of the human
form underwent considerable changes. The curves of the body gen-
erally became more sinuous and a sense of movement was developed.
On textiles, this was more easily achieved by using non-weaving
techniques such as embroidery, batik and painting, although stylistic
changes are also evident in those parts of Southeast Asia where dec-
orative weaving skills were central elements of textile tradition.

In the case of supplementary weft and weft ikat textiles, this 276
display of movement may be more suggestive than realistic, although
figures found fighting, praying, kneeling and dancing sometimes
replaced the solid and passive frontal pose associated with the oldest
elements of textile iconography. These changes are evident on some
rare Sasak supplementary weft textiles from Lombok that depict
human figures. Certain examples display figures in the frontal pose

typical in ancient Southeast Asian art, while others feature figures in stylized profile flanking a shrine-like structure. A similar stylistic dichotomy can be found on certain Lampung *tampan* and *palepai*, where figures sometimes appear in profile, sitting, lying, dancing and in other active positions that are quite unlike those on what have been identified as the oldest styles of *tampan* and *palepai*.[48]

272

Despite the impact of Indian influence, there are other striking examples of the retention of an ancient style of displaying the human figure. The Balinese deity, *Acintya* (*Sangyang Tunggal*), appears in a very fluid frontal form on magical painted cloths that are used as drawings (*tumbal rajah*) to deflect evil and to counter magical charms.[49] Classical Hindu elements such as the crowned serpent are also evident on these cloths.

273

There is still debate about whether the shadow-puppet play originated in Asia or the Middle East. However, it unquestionably reached its apogee in Southeast Asia, where ritual performances were based upon local reinterpretations of Indian legends. Figures with the characteristic elongated profiles and limbs of the shadow puppet are evident on certain early architectural friezes in east Java (Worsley, 1986), and are especially prominent on Javanese batik in the nineteenth and early twentieth centuries, and on Balinese cloth-paintings and weft ikat textiles.

270,274,275

Unlike the style of those human motifs associated with ancient Southeast Asian art where gender is indicated by explicit genitalia, the gender of these figures is depicted through clothing, hair and weapons, while identity or status are suggested by the patterns on a figure's clothing and regalia. Figures can be found on some *tampan* wearing textiles like the high status cloth, the huge *dodot*, and on some Javanese and Balinese textiles certain deities and warriors are depicted wearing black and white checks (*poleng*). The symbol of high office in the Indianized world, the unfurled and multi-tiered umbrella, appears on textiles above royal or noble figures. The patterns on the costume of other figures are often clear enough to identify the type of textile portrayed. The zigzag patterned costume worn by figures on Burmese *kalaga* clearly resembles Burmese silk tapestry weave wraps. The *apsara* celestial nymphs,[50] the embodiments of beauty, depicted on both Indian painted cloths designed for Thai use and on Khmer weft ikat textiles, often appear to be wearing the same types of textile as the ones on which they themselves are represented.

277

The mounted rider as a symbol of transition already existed in many parts of Southeast Asia before the impact of Indian culture. However, under its influence a number of different animals began to appear as variations on this motif, including elephants, lions, serpents, and mythical birds. In coastal societies where power and influence were based on trade, noble animals such as the elephant rather than the buffalo of inland agricultural societies often appear on textiles as a symbol of might. Complex and obscure creatures — the *karang asti*, *barong* and *kala* of Bali, the *raja singa* of Laos, the *ganggamina* and *peksinagaliman* of Java, and the *nagapaksin*, *trinnasingha*, and *khot khasi* of Thailand — combine the characteristics of noble beasts such as the lion, the elephant, the phoenix, the fish and the serpent.

In Burma, rich and ornate appliqué materials have been used by the Burmese elite to create elaborate hangings (*kalaga*) portraying both secular romantic encounters and especially stories from well-known legends such as the Jataka lives of the Buddha. Scenes of

271

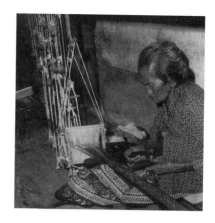

265
An elderly woman weaving on a special braid loom at one of the royal palaces in Karangasem, Bali. The borders (*lambé*) of many Balinese outer wraps (*kampuh* or *saput*) are trimmed with braid woven from bright metallic thread. This type of loom-woven braid was widespread throughout coastal Southeast Asia until earlier this century.

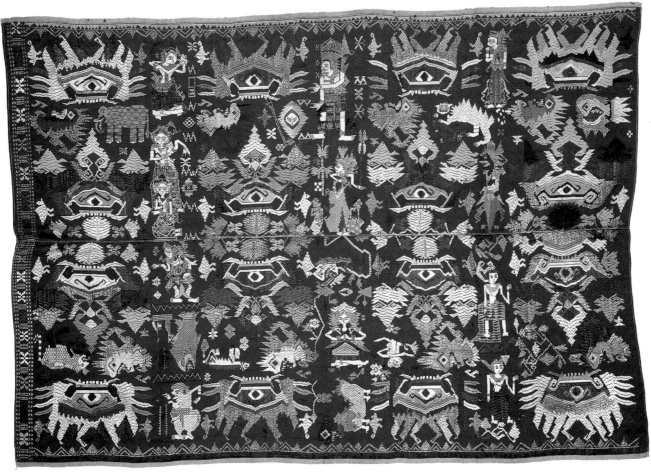

266

266
saput songket; kampuh songket
skirtcloth; hanging (?)
Balinese people, Bali, Indonesia
silk, gold thread, dyes
supplementary weft weave
109.8 x 157.0 cm
Australian National Gallery 1989.407

267
saput songket; kampuh songket
skirtcloth; hanging (?)
Balinese people, Bali, Indonesia
silk, gold and silver thread, natural
dyes
supplementary weft weave
107.5 x 123.0 cm
Australian National Gallery 1988.1578
Gift of Michael and Mary Abbott,
1988

268
saput songket; kampuh songket
skirtcloth; hanging (?)
Balinese people, Bali, Indonesia
silk, gold and silver thread, natural
dyes
supplementary weft weave
158.0 x 114.0 cm
Australian National Gallery 1989.401

Balinese weft ikat and silk and metallic
thread brocade textiles sometimes
depict figures from the Hindu epics in
wayang kulit shadow-puppet style.
When these textiles featuring the
garuda and other deities are made in
the conventional skirtcloth format,
they are possibly not intended to be
worn, but are used as hangings on
ceremonial occasions. The richness of
the gold thread and the intricacy of
the silk weaving suggest that each of
these cloths was woven in one of Bali's
palaces (*puri*).
The fields, and sometimes the border
triangles of textiles of this genre, are
filled with a rich panoply of mythical
creatures. Plates 267 and 268 display
wayang-style figures, including the
garuda, arranged in frieze-like rows
and engaged in various activities —
dancing, hunting wild boar and trapped
by a serpent. Plate 266, however,
contains, in addition to the *wayang*
figures, an amazing variety of images
including fish, elephants, monkeys,
tigers and snakes. The design is
dominated by monster heads with long
tongues (*kala*) or protruding teeth
(*boma*).

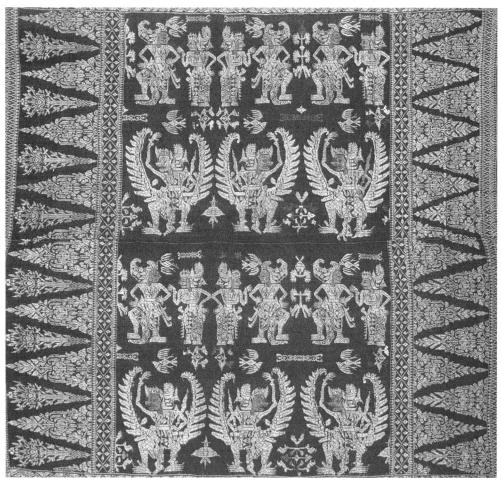

267

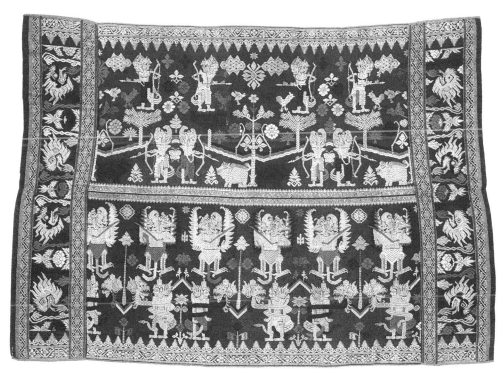

268

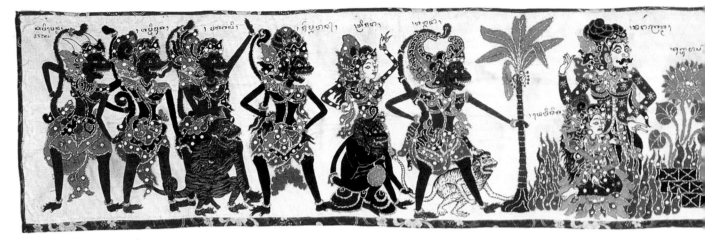

269

269
ider-ider
valance for a temple or pavilion
Balinese people, north Bali, Indonesia
cotton, silk, dyes, sequins, tinsel
embroidery, appliqué
43.0 x 228.0 cm
Australian National Gallery 1987.1084
Gift of Michael and Mary Abbott,
1987

Although most of the pictorial valances
that are hung below the eaves of
Balinese temples on ceremonial
occasions are painted, for a short
period in the late nineteenth century a
number of bold embroidered hangings
were made in the north of Bali. This
scene is worked in brilliant coloured
silk on a white cotton ground, and the
hanging is lined with nineteenth-
century European printed cotton. The
accuracy of the embroidery style and
the Balinese script indicate that this
was the work of a literate noblewoman
who was well versed in Balinese
artistic conventions and who was
extremely skilled in the art of silk
embroidery, a technique rarely used to
decorate textiles on that island. The
use of Sanskrit-derived texts and
script on textiles is also rare and it
appears to be applied only to Balinese
textiles required for religious rituals.
This textile depicts an episode from
the Ramayana epic known as Sita's
Ordeal, in which Sita undergoes trial
by fire to prove her faithfulness to her
husband Rama during her captivity by
the multi-headed demon-king, Ravana.
She is portrayed seated on a flaming
pyre which has been transformed by
her virtue into a lotus. Ranged on
either side are the *peluarga*, Rama's
animal-headed supporters, with their
names embroidered above them in

Balinese script. Their faces indicate
their particular animal origins, and
such stylized figures are still found
today on Balinese pigment-painted
cloths.

270
selendang, kain tanah liat (in
Minangkabau region)
shouldercloth
north-coast Java; Minangkabau people,
west Sumatra, Indonesia
silk, natural dyes
batik
129.0 x 48.0 cm
Australian National Gallery 1984.585

In addition to the foreign textiles
imported into Southeast Asia, a local
cloth trade has operated throughout
the region over many centuries. The
styles of these local trade textiles
seem to have been designed to suit
the tastes of particular markets, and
batik textiles from the north coast of
Java were in great demand in many
parts of Southeast Asia, including
Sumatra. Fringed silk shouldercloths
(*selendang*) have become a part of
Minangkabau ceremonial costume and
are known throughout west Sumatra
as *kain tanah liat*, after their
clay-brown colouring. Although many
of the export silk batiks destined for
Sumatra contain floral and geometric
patterns, this example shows a series
of *wayang* shadow-puppet characters
amid fish and twisting branches. The
rendition of the figures is rather
crude. Some appear strangely
disembodied, and one character in the
top right-hand corner has a peculiar
elongated profile.

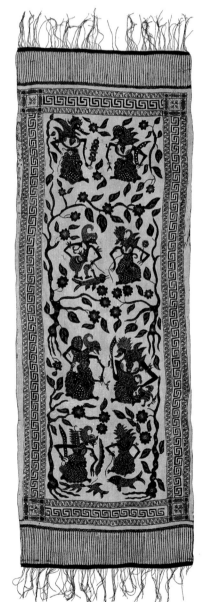

270

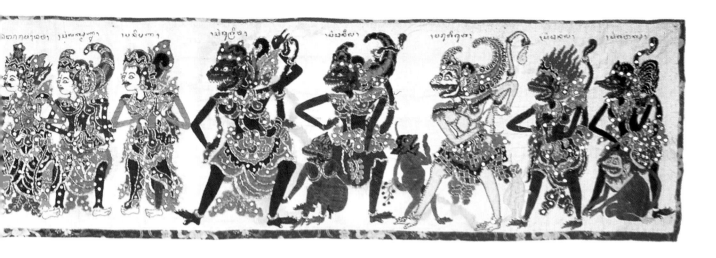

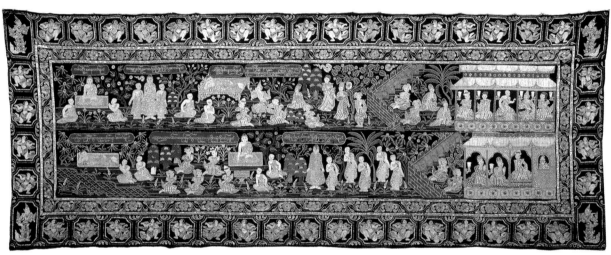

271

271
kalaga
hanging
Burmese people, Taunggyi, Amarapura
region, Burma
silk, velvet, paper, sequins
embroidery, appliqué
165.0 x 442.0 cm
Australian National Gallery 1977.112

This *kalaga* temple-hanging depicts an episode from the Jataka legends which describe the lives of the Lord Buddha. The embroidered inscription indicates that the cloth was a donation from Ko Sein of Taunggyi, south-east of Amarapura, to a Buddhist monastery in the Burmese year 1273 (1911). The figures wear various forms of Burmese costume, which are carefully detailed: monks' robes, the up-turned garments of royalty, the turban-like head-dress and long robes made from cloth woven by the characteristic zigzag tapestry weave technique (*lùn-taya*). The faces on the figures are painted on to pieces of paper which are then stitched into place. An elegantly attired courtier stands in each corner of the huge hanging and the surrounding border is filled with winged *apsara*, the celestial nymphs of the Indianized world which also appear on many Indian cotton prints popular throughout Southeast Asia. They are depicted on this black velvet cloth as chubby, pink seraphim. The formal scene is presented with great realism and an unusual sense of perspective is achieved by the three-dimensional wall and bed and the overlapping positions of some of the figures. Both these features are rare on Southeast Asian textiles, suggesting that this was a style of *kalaga* that developed during the colonial period. Burmese sculptural styles had become more naturalistic by the late eighteenth century, and paintings of that period depict similar religious stories in an unbroken panorama.

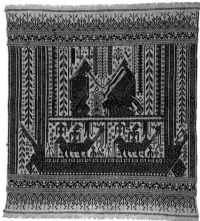

272

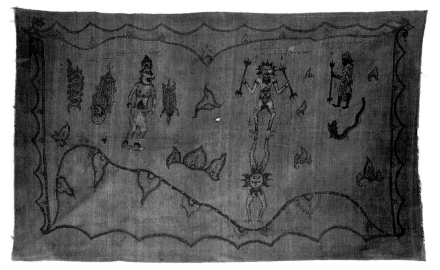

273

272 (detail)
tampan
ceremonial cloth
Paminggir people, Lampung, Sumatra,
Indonesia
handspun cotton, natural dyes
supplementary weft weave
69.0 x 73.0 cm
Australian National Gallery 1984.601

This red-brown *tampan* displays a
strong ship carrying two mythical
beasts with riders in classical
Indianized profile and flanked by
formal renderings of the cosmic tree.
The dominant design element is the
pair of unusual central figures.
Grotesque and mythical elements are
evident in the long, weird, touching
noses, and the twisted, elongated arm
and lumpy body of the figure on the
right. While details such as the hair on
one figure and an apparent dagger at
the waist of the other suggest that
they represent a male and female pair,
an image of Ganesha the elephant god
taken from an Indian printed cotton
may have been the original source of
this design. Similar motifs arranged in
rows are found on other *tampan* and
also appear on one type of Balinese
geringsing wayang cloth. Indian trade
cloths with the Ganesha design have
also been used as ceremonial
wall-hangings in south Sumatra, and
the Abung people refer to these cloths
as *lindung tuho* (*lindung*, shelter;
tuho, ancient), a term that suggests
their protective properties.

273
tumbal rajah
ritual hanging
Balinese people, Bali, Indonesia
cotton, pigments
painting
148.0 x 88.0 cm
Australian National Gallery 1980.1635

Indic symbols and Sanskrit-derived
Balinese script have been combined
with other archaic motifs on this
textile which appears to have been
woven from natural brown cotton, a
fibre considered sacred in some parts
of the Indianized world of Southeast
Asia. In the past, the Balinese are also
known to have drawn cabbalistic
diagrams and formulae (*rerajahan* or
tatumbalan) on bark-cloth, lontar
palm-leaf (Ramseyer, 1977: 100), and
more recently on paper. These designs
are painted in red, black and pale blue
pigments.
Although the exact purpose of this
magic cloth is unknown, the presence
of *Acintya* (also known as *Sanghyang
Tunggal*, the Unimaginable) wielding a
trident in each hand, suggests that it
was probably used in rites to secure
either personal or communal well-
being. The presence of this mystical
figure is essential at the shadow-
puppet performances that accompany
the ritual cleansing of a village after a
disaster and when holy water is
required by Balinese priests during the
exorcism of sinister and evil beings.
Sanghyang dances are performed in
villages throughout Bali to protect the
community against black magic
(Loveric, 1987; Ramseyer, 1977). The
cloth may have been hung above the
gateway into a temple compound.

274
Mahabharata Balé Sigala-gala
hanging; banner
Cirebon region, Java, Indonesia
cotton, natural dyes
batik
260.0 x 106.5 cm
Australian National Gallery 1984.3101
Purchased from Gallery Shop Funds

This nineteenth-century batik depicts,
in the profile style characteristic of
Javanese shadow-puppets, the *balé
sigala-gala* episodes from the
Mahabharata epic in which the
Pandawa were threatened to be
burned alive. A number of key scenes
from the legend are arranged in a
narrative frieze format, reminiscent of
those found on some of the oldest
Sivaite and Buddhist temples in Java,
and also on traditional Balinese
paintings. The reason for the division
of the scenes into two horizontal
panels is unknown, but the
iconography and design structure of
the cloth suggest that it was not
intended to be worn as a skirtcloth.
The linear design standing out against
a light ground, the floating lightning
forking from spiral cloud formations,
and the inclusion of building or shrine
structures and tree motifs are all
features found on many of the batiks
associated with the courts of Cirebon.
The garments of the various
characters depicted on this batik are
an indication of the type of costume
worn in the Javanese courts of the
past. These include jackets and coats
of different cut and sleeve length, long
and short pants for male figures, and
skirtcloths of various fabrics and
patterns draped in different ways. The

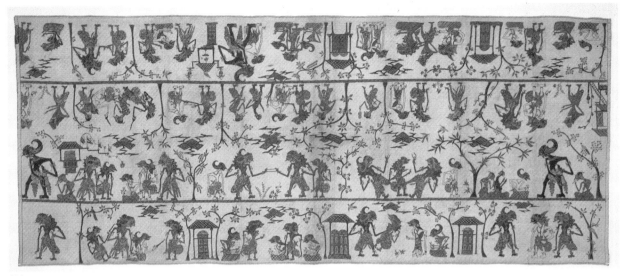

274

275

priests wear long coats, and Bima —
the large, dark figure in the lower
frieze — wears the ancient and sacred
black and white checkered *kain
poleng.* Most of the characters have
the facial features, head-dress and
costume of the aristocracy, with the
obvious exception of the court jesters
in the lower centre.

The batik is signed in Romanized
script along one edge with the name
of the designer or owner
Hortanoeningrat (?), a name
suggesting aristocratic family
connections. This batik, like many
from Cirebon, may have been waxed
by a man. The unusual role played by
men in the production of batik in this
part of north-coast Java and the
characteristic patterns and motifs in
dark tones against a pale ground
suggest that this batik style may have
originated in painting traditions which,
in Southeast Asia, are the domain of
men.

275
Srikandi Gerwani (Berdikari)
kain panjang
skirtcloth
Mohamad Hadi (1916–83), Solo, Java,
Indonesia
cotton, natural dyes
batik
251.5 x 106.0 cm
Australian National Gallery 1984.3065
Purchased from Gallery Shop Funds

This batik was created in 1964 by the
late Mohamad Hadi, a prominent
member of left-wing artistic circles in
central Java, who established a batik
workshop in Surakarta during the
early 1960s. The batik has been
created using natural dyes of *soga*
brown and indigo and it is structured
in the *pagi soré* (night and day) format
with a different pattern on opposite
sides and ends of the design, marked
by a subtle but distinct change in the
ground-filling pattern. The design

cleverly combines features of
traditional Javanese batik with an
overtly political message,
comprehensible to those steeped in the
Hindu legends of the shadow-puppet
theatre. The groups of three stylized
human figures, in classical *wayang
kulit* profile with elongated arms and
sharp aristocratic faces, all depict
manifestations of Srikandi, one of the
noble wives of the Mahabharata hero,
Arjuna. She appears in different
costume, appropriate to the three
distinct cultural streams identifiable in
Javanese society — an aristocrat in
courtly costume, a devout Muslim with
headcloth and long-sleeved jacket, and
a peasant with a locally woven striped
tunic, sun-hat and bare feet. Srikandi
is not carrying her famed bow and
arrow but bears instead a book, the
gift of literacy to women in rural
areas. Hadi has used the figure of
Srikandi — familiar to Javanese as an
outgoing, active and independent
goddess-like heroine — as a social
reformer committed to the cause of
improving the position of women in
village Java.

The other section of the design
depicts the cosmic tree-mountain
image (*gunungan* or *kekayon*), an
important symbol in the shadow play
performance where it is used to
indicate a change of scene, the end of
a performance, a tumultuous event or
the passage of time. Its appearance on
this batik suggests the social and
political transformation Hadi believed
was already under way in rural Java
(Maxwell and Maxwell, 1989).

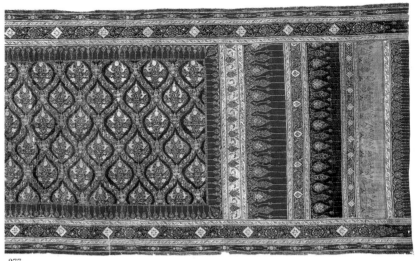

277

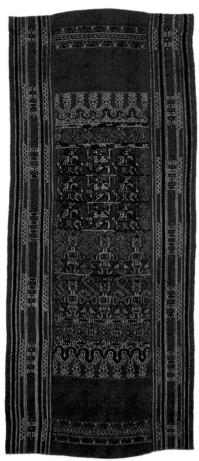

276

276
pua sungkit
ceremonial cloth
Iban people, Sarawak, Malaysia
handspun cotton, natural dyes
supplementary weft wrapping
215.0 x 95.0 cm
Australian National Gallery 1984.3185

In the more remote areas of insular
Southeast Asia, despite the fact that
the social structures and religious
beliefs of the inhabitants appear to
have remained largely unaffected by
the Indianized courts in neighbouring
coastal principalities, Indian motifs and
designs sometimes appear in their
arts. On this textile the Indian
influences are evident in the dancing
figures depicted in profile in three
rows in the central field. The Iban,
however, identify this figure as *Dara
Meni*, the goddess of the waters who
taught them the skills of using
dyestuffs (M. Heppell, personal
communication, 1987). On this cloth
she is combined above two rows of the
Bong Midang spirit depicted with a
leering grin in a rigid frontal pose.
(This figure has also been identified as
an *antu gerasi*, a dangerous
transvestite spirit known to transform
itself on occasions into a female.)
The adaptation of Indian trade cloth
border patterns is suggested by the
upper and lower decorative bands
enclosing the central field of figurative
motifs. The Iban identify the triangular
patterns as the coiled python (*leko
sawa*) guarding the main pattern,
while the lower floral pattern is the
star (*buah tiga*).

277 (detail)
pha lai yang
ceremonial furnishing cloth
Coromandel coast, India; Bangkok
region, Thailand
handspun cotton, natural dyes and
mordants
mordant painting and printing, batik
289.0 x 91.7 cm
Australian National Gallery 1981.1160

The cloths made in India in the
seventeenth or eighteenth centuries
for the Thai court of Ayutthaya
contain the aesthetic elements
favoured by that court: detailed
drafting, many beautiful natural
colours, fine quality fabric and
appropriate patterns. The central field
of this painted cloth displays a
magnificent grid of tendrils with
figures (possibly depicting the *garuda*)
standing guard at each intersection.
Within each flame-shaped lozenge are
three deities. The central *deva* figure
is in an attitude of prayer (*tepanom*)
and is flanked on either side by
nymphs in dancing positions. The
borders and end-panels demonstrate
the superb skills of mordant painting
and dyeing which are a feature of the
Indian textiles destined for the Thai
courts from at least the seventeenth
and eighteenth centuries. The colours
are predominantly red, pink, black and
white. Wall paintings dating from this
period reveal the use of these textiles
as coverings, hangings, curtains and
clothing, although it is unlikely that a
cloth displaying deities would have
been worn as a skirtcloth. Many of the
patterns on these Indian cloths are
also evident in other decorative arts of
the Ayutthaya and the earlier Sukhothai
period, including woodcarving.

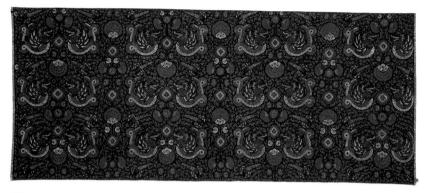

278

278
kain panjang
skirtcloth
Nyai Bei Mardusari, Solo, Java,
Indonesia
cotton, natural dyes
batik
252.0 x 104.0 cm
Australian National Gallery 1984.3072
Purchased from Gallery Shop Funds

Under Indian religious influence the
reptiles of ancient mythical prowess
were transformed into the mighty
naga serpent. Crowned and winged
naga are the dominant symbols on this
Javanese batik. The spiralling body
with scales in alternating patterns is
capped with another crown, while the
wing pattern appears as the claws of
the lobster and in minor bird motifs.
Another stately motif is the large
central circle, a highly stylized
depiction of the peacock. The
creatures float against a sea of foliage
and lotuses. This dark brown and black
batik was designed for the Javanese
aristocracy by a well-known Solo
batik-maker and dates from the 1970s.

279
dodot pinarada mas
ceremonial skirtcloth
Javanese people, Yogyakarta, Java,
Indonesia
silk, cotton, natural dyes, gold leaf
batik, gluework
210.5 x 379.0 cm
Australian National Gallery 1984.3165

The design of this opulent skirtcloth is
a variation on the cosmic forest and
mountain scenes known as *semèn*. It
contains bird and snake images, and a
powerful version of the *sawat*, the
stylized double-wing and fanned tail of
the mythical *garuda*, a motif that was
used as an heraldic symbol by the
great central Javanese empire of
Mataram. The chevron patterns of the
mountain ranges are the dominant
factor holding the whole design
together. These cosmic royal patterns
are enhanced by gold leaf (*pinarada
mas*) and a luminous, light blue piece
of fine silk which has been carefully
stitched into place to cover the
indigo-blue central lozenge (*modang*).

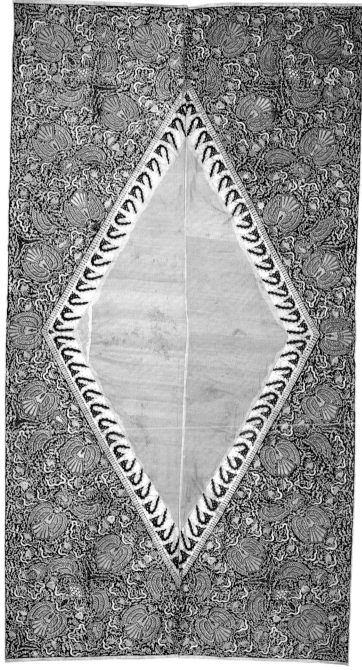

279

280
pha sin
woman's ceremonial skirt
Tai Nuea people, Laos
silk, cotton, natural dyes
weft ikat, supplementary weft weave
67.0 x 94.2 cm
Australian National Gallery 1988.1650

This nineteenth-century cylindrical
skirt displays bands of temple-stupa
motifs (*prasat*) in black and white weft
ikat. The alternating red bands contain
nak serpent motifs, so stylized as to
appear to be lozenge and star patterns.
A length of rich brown silk has been
attached to the top of the cloth, and a
band of cotton braid at the lower edge.

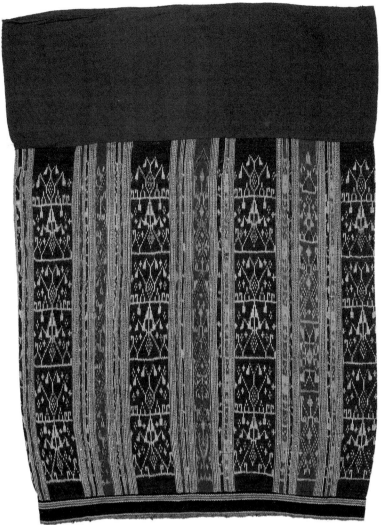

280

281
tampan
ceremonial cloth
Paminggir people, Lampung, Sumatra,
Indonesia
handspun cotton, natural dyes
supplementary weft weave
73.0 x 74.0 cm
Australian National Gallery 1981.1104

This distinctive form of *tampan*,
probably woven in the peninsula
between the Semangka and Lampung
Bays, presents courtly scenes in three
frieze-like bands, resembling the
narrative friezes on Hindu-Buddhist
architecture. In the centre of each
row, a pavilion or temple contains a
small human figure, presented in
profile. Flanked in mirror image on
each side of these structures are
fanciful, mythical creatures, bearing
riders holding regalia associated with
noble status. The ship, the dominant
symbol on many *tampan* and *palepai*,
has been reduced here to a platform.

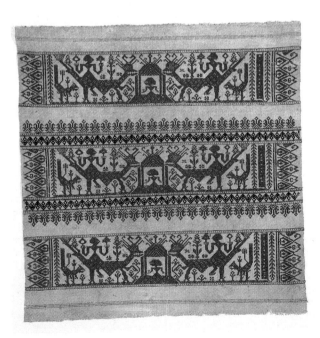

281

282
geringsing peparé
skirtcloth
Balinese people, Tenganan, Bali,
Indonesia
handspun cotton, natural dyes
double ikat
165.0 x 171.0 cm
Art Gallery of South Australia 747A70

This is a rare example of three
geringsing textiles sewn together to
form a single over-garment (*saput* or
kampuh). Joined red *geringsing* cloths
are worn as a *saput* by both men and
women at important rituals within the
village of Tenganan. Particularly for
women, the way such cloths are worn
is an indication of marital status,
although the exact manner of folding
and draping ceremonial textiles is also
determined by the precise
requirements of the many elaborate
rituals and ceremonies of Tenganan's
religious calendrical cycle.
The striking red, black and white
patterns appear to be schematic
representations of Indic architectural
motifs, particularly the stupa and the
base plan of the temple, and these
ancient motifs of intersecting circles
are emphasized by the red outlines of
the designs. However, the star-shapes
which have also been worked into the
pattern suggest the possibility that an
Indian *patola* cloth motif may also
have contributed to the total design.

283
saput endek
skirtcloth
Balinese people, Bali, Indonesia
silk, dyes
weft ikat
115.0 x 137.0 cm
Australian National Gallery 1984.1539

Many Balinese silk weft ikats contain
bold depictions of mythical characters
or legendary animals that dominate
the design. This skirtcloth (*saput*) is
composed of two identical joined
panels and displays archers wearing
carefully articulated clothing. Although
they resemble the style of Balinese
shadow-puppets, the mirror image and
angularity imposed by the weft ikat
process (*endek*) has resulted in rather
stiff figures that are in sharp contrast
to the dynamism of Balinese traditional
painting. Architectural features, such
as shrines, are used as scene-dividers
in the arrangement of the motifs, and
the jagged lozenge that frames the
central figures suggests brickwork.
These features and the overall design
arrangement of this cloth suggest the
influence of certain Balinese double
ikat textiles.

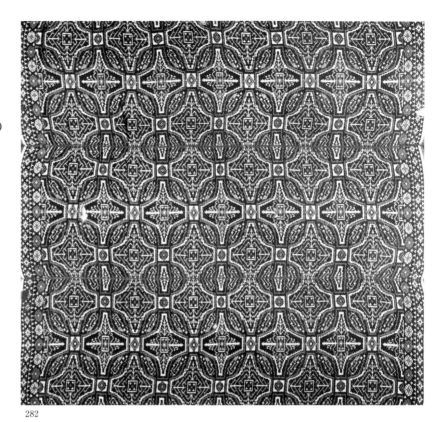
282

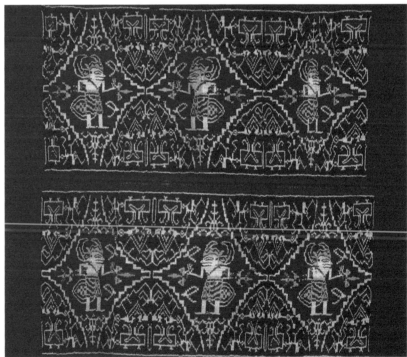
283

people, pageants and places are depicted with considerable realism.[51] By the late nineteenth century, especially around Rangoon, the simple religious function of the *kalaga* had been overwhelmed by the richness of their decoration. Gold thread, silver sequins, semi-precious stones, gilt paper, and even European rickrack tape were applied to velvet or imported chintz grounds, contributing to the three-dimensional effect of the ornate and sometimes padded stump-work surface of these hangings. *Kalaga* not only appeared in court settings as hangings and screens, but were widely used on various ceremonial occasions by wealthy Burmese. Many of these textiles have been donated to Buddhist temples and monasteries to gain merit.

Most textiles that realistically depict legendary scenes are intended as hangings for temples, monasteries or palaces. They consistently draw upon Indian mythology and are usually a relatively recent development in the region. Compared with ancient weaving and ikat techniques, those of painting, batik and embroidery that are often used to depict freely-drawn figures and non-repetitive detail on these textiles appear to be later methods of decorating fabric in Southeast Asia.

Elements of Indian cosmology became significant in the belief systems of many Southeast Asian people and ancient notions of cosmic dualism were often elaborated upon according to these influences. Textile iconography provides many examples of this process, in particular the impact of Indian ideas upon the notions of the Upper and Lower Worlds. The serpent or snake (*naga*), the ruler of the water kingdom below the earth and a symbol of the Lower World in Indian iconography, found ready acceptance in Southeast Asia where crocodiles, snakes and other reptiles were already important ancient images in ancestral legend and art.[52] In the art of Indianized Southeast Asia, the mythical *naga* is sometimes shown in the act of creation, churning the seas into milk teeming with life. The *naga* appears on textiles in various guises. It is powerfully depicted as a pair of crowned and often interlaced snake-kings (*nagaraja*). The *garuda* — mythical bird of Hindu legends, mount of Wishnu and central figure in the Ramayana epic — is also prominent in the art and mythology of the region.

Upper World symbols of birds and Lower World symbols of reptiles are frequently paired in Southeast Asian mythology and Indian influences have strengthened this juxtaposition. The *garuda* and the *naga* are both prominent as symbols associated with court regalia throughout the region and appear together, for example, on the royal seal and the state barge at the Bangkok palace.[53] These motifs are both included among those restricted patterns traditionally reserved for the batik cloths of the central Javanese aristocracy, and are also a familiar image on the silk weft ikat cloths of the Khmer. The winged *naga*, a synthesis of the symbols of heaven and earth, is also depicted on cloth, although in Java truncated versions of this creature are usually identified as the *garuda*.

Under the influence of Indian cosmology, the Upper World abode of ancestral deities was transformed into Mount Meru, the realm of the Hindu gods located at the centre of the universe. The notion of the mountain as an artistic symbol in Southeast Asia was most powerfully expressed in architecture, and splendid temples and immense stupa were erected to emulate the sacred mountain. The symbolic moun-

167

278

16
267,268

tain is also depicted on textiles, sometimes overtly in cosmic scenes, and also schematically as stupa or temple images and in diagrammatic yantra. The sacred mountain often appears as an important though highly stylized motif on Javanese textiles in the forested scenes known as the *semèn* or *alas-alasan* patterns, where the mountain is part of a landscape filled with shrines, ponds, trees, birds and animals.[54] These symbols of the cosmic landscape were harnessed for the exclusive use of the Javanese aristocracy. Such designs only appear on Javanese cloth decorated with wax-resist batik or gold leaf, and are not to be found on the ancient woven textiles of Java which included thick warp ikat cottons and rice-paste-resist batiks.

Shrine or temple structures, further symbols of Mount Meru, are also evident on some *semèn* patterns and on batik cloths from the courts of north-coast Cirebon, although the architectural representations on these textiles are rather different to those of central Java. The split and winged gateways and hill-top shrines that appear on Cirebon batiks with the *taman arum* (scented garden) design, while symbolic of Mount Meru, are closer in appearance to present-day Balinese temple structures.

The architectural imagery on silk weft ikat textiles is depicted with far greater realism and these textiles are usually intended for use as ceremonial hangings rather than as clothing.[55] The pagoda or temple with a curving roof is a popular image that appears on many of the silk hangings (*pidan*) of Cambodia, and since these textiles are often given to monasteries to gain merit such religious allusions are not surprising.[56] On other Southeast Asian textiles, even in Malay regions where Islam has long been the dominant religious influence, stylized images of temples (*prasat*) often appear as border triangles.

Architectural images are also found on certain supplementary weft *tampan* and *palepai* textiles from south Sumatra. The central shrines or pavilions usually contain seated human figures, and flanking this major focus are other standing figures, often wearing clothing suggesting ceremonial garments. In raised hands, the figures hold a triangular stemmed object, possibly a flywhisk, a flaming lamp, a trident (*trisula*), or a stylized lotus. These are all symbols of royalty in the Indianized world.[57] The roof of the shrine on these textiles is often decorated with flames or lotus finials, although these designs are usually rendered with ancient hooked ornamentation. Roofs and portals also appear on certain Balinese textiles where they dissolve into a nimbus of flames around deities depicted in a profile, shadow-puppet style.

Balinese cloths sometimes combine obscure though realistic human figures and highly schematic motifs based upon temple architecture. This is especially evident on certain *geringsing* double ikat cloths from Tenganan that display scenes reminiscent of bas relief sculpture found on temples (Bühler et al, 1975–6). On those patterns known as *geringsing wayang*, kneeling figures of priests and royalty, and shrine and tree images are divided by large and dramatic mandala shapes that suggest the floor plans of temples. Since temples in the Indic tradition are the abode of the gods, these architectural yantra and altar motifs are most appropriate for sacred textiles essential to religious ritual. Similar though more stylized versions of these temple motifs also appear on Balinese silk weft ikat, while on neighbouring Lombok elements of architectural motifs are also evident on some

Margin reference numbers: 279, 16,194, 280, 167, 281, 13,207,282, 283

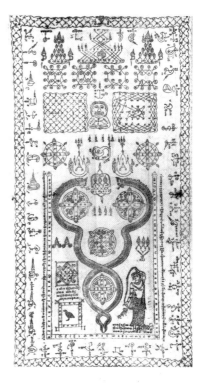

284
...........
sacred headscarf
Khmer people, Cambodia
cotton (?), pigments
stencil printing
Musée de L'Homme, Paris 70.120.143

This twentieth-century (?) Khmer textile was printed by stencil with sacred Buddhist formulae whose magical symbols, according to the museum records, were believed able to protect soldiers from bullets. Throughout the Indianized world of Southeast Asia there are frequent references in chronicles and legends to the ancient notion that warriors could be made invulnerable to harm by the wearing of sacred clothing containing magical patterns. In Thailand handspun cotton jerkins and caps, also intended to protect the warrior, display similar formulae drawn upon them in ink.

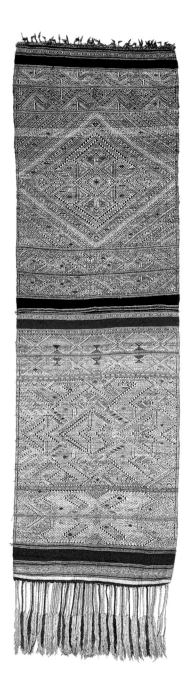

285
pha biang
ceremonial shawl
Tai Nuea people, Laos
silk, dyes
supplementary weft weave
130.0 x 43.0 cm
Australian National Gallery 1984.3197

The details of the rhombs making up the complex mystical lozenge known as *douang tda* (star eye or third eye) are composed of ancient forms of decoration including hooks, spirals and stylized creatures. On one half of the indigo-based Tai Nuea *pha biang* are barely discernible mythical beasts on the dense white silk brocade, though the creatures' eyes have been woven in bright discontinuous silk thread.

figurative supplementary weft cloths. Although the technique and appearance of these Sasak cloths is closer to the ship cloths of south Sumatra, the designs on these textiles, like the *geringsing wayang* of Bali, suggest the temple frieze imagery associated with the Majapahit monuments of Java. The presence of these motifs on ancient sacred cotton textiles is an indication that Indian influences were absorbed into Sasak textile design long before Lombok's colonization by Bali during the eighteenth and nineteenth centuries. In fact, Sasak legends tell of religious links with Majapahit in Java and with the Indianized principalities of Sumatra. *184*

HARNESSING THE COSMOS FOR THE KING

Yantra graphics, magical geometrical diagrams that draw upon Buddhist, Hindu and sometimes more ancient formulae, have had wide appeal throughout Southeast Asia. Many of these designs, such as those in the mandala form, are conspicuous in the art of the region, including its textiles. Among those Karen who still follow the ancestral religion, such diagrams are also found in the symbolism of their tattoos,[58] and tattooing ceremonies are used to propitiate the ancestral spirits of the lineage, and prevent or dispel evil and sickness. Elsewhere these magical diagrams take the form of line-drawings on woven cloth.[59] In Cirebon on the north coast of Java, mandala designs are evident on certain splendid batik banners displaying elaborate Islamic calligraphy (Wastraprema, 1976: Plate 14), and these are believed to have been associated in the past with the notion of protection (Abdurachman, 1982: 154). While the appearance of magical yantra designs on such cloths suggests the impact of Indic cosmology, it also indicates that many ancient ideas about the supernatural power of textiles and other objects remained a potent force. *284*

Throughout Asia many yantra and Buddhist mandala diagrams serve primarily as a vehicle for meditation, detachment and spiritual discipline (Madhu Khanna, 1979: 207–31). A number of intricate lozenge patterns known as *douang tda* (star eye or third eye) provide such a focus on the supplementary weft weavings of the Tai Nuea and Tai Lue of Laos and northern Thailand. In the Tai designs the complexity of the central diamond as a meditative yantra is enhanced with anthropomorphic and animal figures and ancient cross-hatching and key ornamentation. At one ancient Tai Nuea ceremony held annually to appease the spirits, a long textile (*pha biang*) displaying this yantra is wrapped around the head so that the centre of the diamond section (or third eye) falls mid-forehead (Cheesman, 1984: 88, 91; 1982: 123). *285,286,287, 288*

Other Southeast Asian textiles also have an important association with the head. The Javanese square batik headcloth features a diamond-shaped central lozenge (*modang*). The same motif also appears on many large *dodot* and on the *kain kembangan*, a textile used as a sacred offering and ritual garment, examples of which have also been worn as a headcloth by Javanese rulers at certain ceremonies.[60] The forehead, regarded as one of the energy centres of the body, is a special focus for Tantric meditation. Its mantra or sacred sound is the primordial incantation, *om* (Madhu Khanna, 1979: 120–1). It has been suggested that the *modang* as a mirror symbol has Tantric ritual significance and reflects the diamond being in Indian *292* *110* *289*

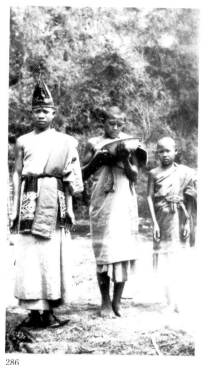

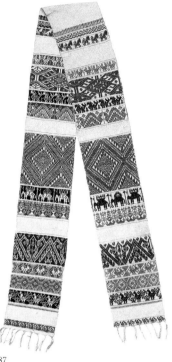

286 287

286
Textiles of the *pha biang* structure
were once worn by men and women. A
young Tai Nuea Buddhist monk at Hoa
Muong, in the province of Hua Phan in
northern Laos, appears to wear a red
supplementary weft textile of the *pha
biang* type around his waist as a sash.

287
tung; pha chet luang
ceremonial banner; man's
shouldercloth
Tai Lue people, Thailand; south China
handspun cotton, dyes
supplementary weft weave
311.0 x 24.0 cm
Australian National Gallery 1987.1582

This ceremonial flag (*tung*) was
probably made in Sip Song Pan Na in
southern China, although it has been
used more recently by the Tai Lue
people of Mae Sai, in northern
Thailand (P. Cheesman, personal
communication, 1987). Narrow cotton
prayer flags, some with small bamboo
rods inserted intermittently into the
weft as stiffening, hang from tall poles
at Buddhist rituals such as the annual
Bun Phravet ceremony. They combine
schematic patterns with shrines and
architectural elements (*prasat*), and
noble creatures including elephants,
birds, horses and serpents. Many of
these images are familiar in other
forms of Theravada Buddhist art,
especially in Sri Lanka. Although most
of the bright supplementary weft
motifs in brown, red, blue and black
appear against a natural cotton
ground, the use of white motifs on
white is unusual. These narrow cloths
are also worn by men at ceremonies
as shouldercloths (*pha chet*).

288
This procession in Vientiane during
the annual Buddhist festival of Bun
Phravet was photographed in the
mid-twentieth century. While the
actual decorative technique used on
these ceremonial banners and prayer
flags (*tung*) is not discernible, they
exhibit the same diamond-shaped
mandala as the supplementary weft
pha biang. It is doubtful, however,
that women's ritual shawls and
headcloths, even when new, would be
displayed as banners at Theravada
Buddhist ceremonies (P. Van Esterik,
personal communication, 1987).
Prayer flags are constructed by groups
of women in many techniques, and
often include palm-leaves, paper, and
metallic fragments.

288

289
sabuk and *ebek*
a set of two ceremonial belts
Javanese people, Surakarta, Java,
Indonesia
cotton, human hair
weaving, plaiting (?)
15.4 x 82.4 cm; 5.4 x 99.5 cm
Australian National Gallery 1987.1062

In many Southeast Asian cultures the
head is considered to be the most
sacred part of the human body.
Perhaps for this reason, hand-plaited
belts of women's hair provide
talismanic protection and, unlike other
parts of the body such as nail
clippings, are not considered
dangerous if they fall into the wrong
hands (Solyom and Solyom, 1979).
The designs on these early twentieth-
century Javanese examples are only
indistinctly defined by the pattern of
the weave. These black belts were
used as waist-bands with men's formal
costume, the narrower *ebek* worn over
the top of the wider *sabuk*.

290
tampan maju; selesil (?)
ceremonial mat
Paminggir people, Lampung, Sumatra,
Indonesia
cotton, rattan matting, beads, shells
interlacing, appliqué
57.0 x 118.0 cm
Australian National Gallery 1983.3689

291
............
ceremonial cloth
Abung people (?), Kota Bumi district,
south Sumatra, Indonesia
bark-cloth, cotton, silk, dyes, gold
metallic thread, mirror pieces
embroidery
65.0 x 65.0 cm
Australian National Gallery 1980.1629

Despite differences in size and
technique, these two objects display
some interesting similarities. Both are
backed by a supporting material that
gives them a rigidity unusual for
textiles in Southeast Asia. Both are
comparatively rare objects, and
although both are from Lampung, they
stand apart from the many other kinds
of textiles made in that region. Only a
small number of other examples of
these objects have been noted, and
almost no information about their
exact origins or social functions has
been recorded. The small embroidered
square has been worked on handspun
indigo-dyed cotton and its dimensions
are similar to the *tampan* of the
Paminggir, and to the ceremonial food
and gift covers of the Malay peoples of

289

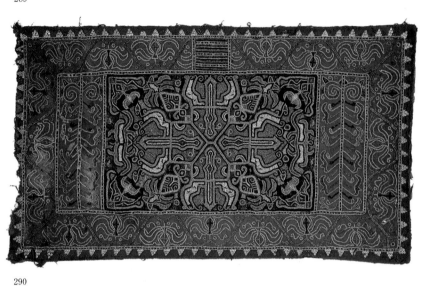

290

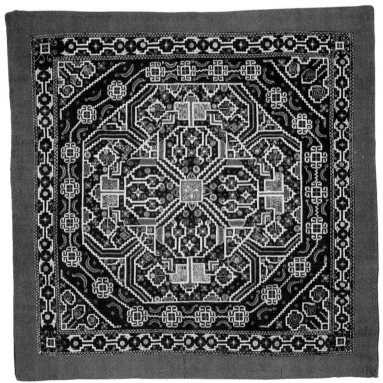

291

philosophy who may be the Buddha or a relevant Hindu deity (Wessing, n.d.). The batik process itself is perceived by the Javanese as an analogy for the mystical experience which is said to batik a design on the heart (Geertz, 1960: 287; Hardjonagoro, 1980: 229).

The mandala form appears in various re-creations on other textiles. It is evident on a style of south Sumatran embroidered textile that is backed with beaten bark-cloth, and comparable symbolism also appears on a large beaded hanging from the same region. Among the many batik designs produced in Java and Jambi are a range of geometric patterns believed to have their origins both in the Hindu *manca pat* cosmic five-point colour and compass configuration and in philosophical conceptions of the cosmos that probably predated Hindu-Buddhism.[61] Indian notions added another dimension to the ancient division of the cosmos into an Upper and a Lower World, and the associated dualistic ordering of their elements. The Hindu association of the points of the compass with five specific deities (*panca dewata*) and particular colours, and the Trimurti Hindu trinity of Brahma, Wishnu and Siwa which are associated respectively with earth, water and air, gradually merged with ancient notions about the organization of the universe and its opposing colours of red and black.

In Bali elements of both cosmological views survive, and twined red, black and white threads still provide protection at auspicious times.[62] At Hindu temple ceremonies brightly coloured offerings, cloths and banners are temporarily ordered to suit the cosmic image: white in the east representing Iswara, red in the south for Brahma, yellow in the west for Mahadewa, black in the north for Wishnu, and

290,291

east Sumatra and Malaysia. While the dimensions of some beaded hangings are similar to those of the woven *palepai*, the size and structure of this object suggest that it may have served as a sitting mat, forming part of the ostentatious pile of mats and textiles displayed at ceremonial occasions such as noble weddings.

Both objects retain certain ancient elements — matting, bark-cloth, shells, beads and spiral motifs. The ancient iconography of ships and mythical creatures found on the woven textiles of southern Sumatra is also evident on some of the other large beaded hangings from this region that have been recorded. However, on both these textiles the stark central motif with stupa-like projections and angular lines is closer to the architectural mandala of the Indianized Southeast Asian world. Insects, butterflies and stylized birds are evident as minor motifs on both textiles.

292
pis siyabit
man's headcloth
Tausug people, Sulu archipelago,
Philippines
silk, dyes
tapestry weave
86.0 x 90.0 cm
Australian National Gallery 1984.1215

A tapestry-woven headcloth (*pis*) and a waist-sash of the same technique used to hold a dagger are essential elements of the ceremonial costume of a Tausug man. Many Tausug headcloths display a similar mandala-style central configuration, and the geometric design (*siyabit*) is intended as eye-catching ornamentation.

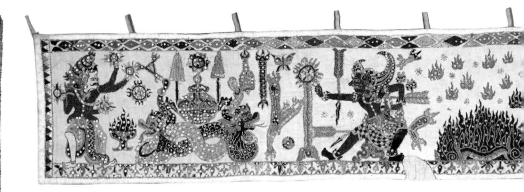

293

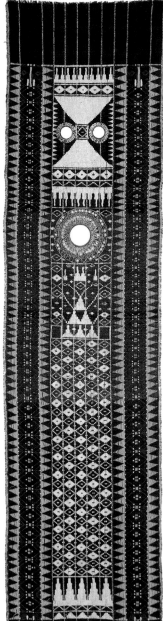

294

293
ider-ider
valance for a temple or pavilion
Balinese people, north Bali, Indonesia
silk, cotton, dyes, sequins, tinsel
embroidery, appliqué
263.0 x 43.0 cm
Australian National Gallery 1985.1740

On this nineteenth-century *ider-ider*
the manner of the ornamentation and
the style of the free-standing figures in
the frieze suggest the influence of
foreign models. Both Chinese and
European embroideries contain
realistic figurative scenes, but the
particular imagery of this valance is
clearly Hindu. The main focus of the
scene is the *nawasanga*, the
identification of the eight compass
points and their centre with the Hindu
deities, the winds, colours, and magic
and symbolic weapons (Ramseyer,
1977: 108–9). The universe is
envisaged as a cosmic compass with
the god of each cardinal point depicted
carrying his symbolic weapon. They
can be identified from left to right on
the *ider-ider* as follows: in the north
Wishnu with the *cakra*, in the
north-east Sambhu, in the east Iswara
with the thunderbolt (*bajra*), in the
south-east Maheswara, in the south
Brahma with his club (*danda*), in the
south-west Rudra, in the west
Mahadewa with his lasso (*pasa*), and in
the north-west Sangkara. Many of
these deities are incarnations of the
great Siwa who resides at the centre
on a lotus. The entire scene is
suggestive of the symbolism of the
lotus, with eight petals and its centre.
Interspersed among these figures is a
rich panoply of other religious images,
including the sceptre and the
ceremonial umbrella above entwined
serpents.

294
lamak
shrine hanging
Balinese people, Kesiman (?), Badung
district, Bali, Indonesia
handspun cotton, natural dyes, mirror
pieces in brass mounts, sequins, gold
ribbon
supplementary warp weave, appliqué,
embroidery
163.0 x 42.0 cm
Australian National Gallery 1989.496

295
lamak
shrine hanging
Balinese people, Bali, Indonesia
silk, cotton, sequins, gold thread,
mirror pieces
appliqué, embroidery
25.0 x 220.0 cm
Australian Museum E74106

The *lamak* are an essential feature of
Balinese temple ceremonies, when
they are used as shrine and temple-
door decorations and hung as banners
from tall poles. Most designs combine
the ancient circle motif with a stylized
hour-glass triangle representing the
rice goddess figure (*cili* or *Dewi Sri*).
Lamak are usually fashioned from
palm-leaf by a pinned appliqué
technique. However, a small number
of woven examples using an ancient
supplementary warp technique (Plate
294) have also been recorded. Some of
these *lamak* are believed to have been
woven around the turn of the century
in the village of Kesiman by a woman
known as Men Nis who claimed to
have learnt the skill of weaving *lamak*
through divine inspiration (Pelras,
1967). A rare appliqué *lamak* of bright
cotton cloth (Plate 295) emulates in a
more permanent form, the texture and
patterning of the palm-leaf variety. Both
lamak incorporate brass-mounted mir-
ror discs, thought in Bali to deflect evil.

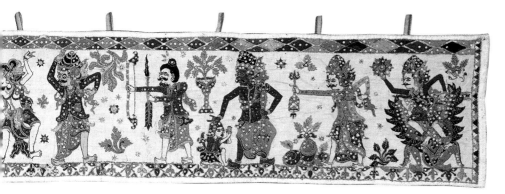

multicoloured at the centre for Siwa (Stuart-Fox, 1982). In Java, the association of textiles with these Hindu conceptions has been identified in the central Javanese principalities and in certain north-coast traditions, where particular batik colours are associated with the compass directions, age and life stages (Heringa, 1985: 120).

In other cultures, it is the eight major compass directions and the central axis that are the basis of another set of sacred patterns. In particular, the lotus with its eight petals and centre is the perfect representation of this concept in Southeast Asian art. In Bali, where this cosmic division of compass points, the *nawasanga*, also incorporates Hindu deities, their respective colours and the attributes of their weapons, the use of the lotus symbol is said to indicate that the cosmic laws are being obeyed (Ramseyer, 1977: 109). The same principle of eight points with a centre is also prominent in temple-plan and mandala designs.

293

The ancient Southeast Asian circular sun motif was transformed under Indic influence into eight-pointed rosettes or lotuses, although the actual iconography of the lotus in Southeast Asia also draws upon Chinese influences. It is widely reproduced in the art of the Palembang region of Sumatra, the centre of the Buddhist state of Sriwijaya from around the eighth century AD. Nowadays, Palembang weavers interpret the rosette as the *kembang manggis* motif, because of its visual similarity to the nodules on the base of the exotic mangosteen fruit. Throughout Indianized Southeast Asia the circle, the star and the lozenge have also become identified with and are stylistically closer to the lotus, the *cakra* (the weapon of Wishnu), the Buddhist wheel of law and the mandala motif. While it is possible in Southeast Asia to find old Indian trade textiles patterned with mandala-style motifs, the popularity of these imported cloths and the attractiveness of their designs may have been due to their compatibility with these existing Southeast Asian cosmological principles.[63] The circle, star and lozenge shapes have also continued to retain their celestial meaning. The circle motif still appears on the Hindu Balinese shrine hangings (*lamak*), while the ancient *cili* fertility figure, often stylized into two isosceles triangles point-to-point, has become closely identified with an Indianized goddess of wet rice agriculture, Dewi Sri. Although various decorative techniques have been used to create these *lamak* hangings, plaited and appliqué palm-leaves remain the most common method, probably because they are temporary altar decorations.

257,258

294,295

295

296 (detail)
kain sembagi
ceremonial shouldercloth; sash
Coromandel coast, India; south
Sumatra, Indonesia
cotton, natural dyes and mordants
batik, mordant block printing
260.0 x 110.0 cm
Australian National Gallery 1984.1996

This nineteenth-century Indian trade cloth is typical of those used throughout south Sumatra as a waist-sash or breastcloth on ceremonial occasions. It displays a design also found on many batik cloths in both Java and Sumatra. Although such motifs and design structures were already an established part of locally made Southeast Asian textiles by the nineteenth century, the earliest Indian prototypes had probably played a crucial role in spreading them throughout the region. Crude, brightly coloured prints with similar patterns were also made in European factories in imitation of these cloths, and similar designs appear in south Sumatra on silk and gold thread textiles.

The philosophical basis for the depiction and reinterpretation of motifs from a wide range of Indian artistic symbols was firmly established during the first millenium AD, and many of these underlying Indic philosophical principles are still profoundly important for artists in much of present-day Southeast Asia. While ancient materials and textiles have prevailed in many parts of the region, in the areas where Indian influence was deepest, new materials and techniques were steadily adopted. These innovations led to the creation of unique types of textiles and the development of different ways of presenting old images as compatible symbols of the cosmos.

INDIAN TRADE TEXTILES: SACRED HEIRLOOMS AND SYMBOLS OF RANK

Indian goods were obviously popular in those parts of Southeast Asia where Indian ideas and concepts were influential, and the combination of ideas and objects played a large part in the development of new aesthetics in Southeast Asian textile art, particularly in court circles. The region was a source of many commodities attracting traders, eventually to such distant destinations as the Moluccas, Timor, and even New Guinea. Consequently, the influence of Indian objects acquired through trade was by no means limited to the Indianized world but spread through local trading networks into many of the most remote and seemingly inaccessible areas. One of the most important commodities in inter-Asian trade, and one that had a remarkable effect on the way textiles were made in Southeast Asia, was the Indian cloth that was traded for all manner of local products in the ports and market places of the region.[64] These trade cloths continued to have a decisive impact on the textile art of the region long after the immediate influences of India had waned.

296,297,
299

It is impossible to establish when Indian trade cloths first began to appear in Southeast Asia. However, we have noted that both the stone and metal statuary of Indic Southeast Asia and the earliest descriptive accounts of foreign visitors suggest that imported textiles were already a prominent feature in the courts of the region well over a thousand years ago. We know from the writings of historians such as van Leur (1955) that Indian textiles were a profoundly important element in early inter-Asian trade during the centuries before European influence became dominant. There is also considerable evidence about the existence of Indian cloth in early indigenous inscriptions and texts. For example, textiles from southern India (*wdihan kling*) are mentioned in tenth-century Javanese inscriptions (Wurjantoro, 1980: 201), while Robson (1981) outlines in some detail the Indian textiles mentioned in fifteenth-century Javanese literature. Such sources provide us with valuable confirmation of the existence of Indian cloth in ancient principalities, and some of the terms gleaned from the inscriptions and texts are familiar, such as fifteenth-century Javanese references (Robson, 1981: 110) to *patawala* (*patola*). However, we have no way of knowing what these Indian textiles actually looked like as the texts provide only general information about colours, materials, techniques and designs. We are not able to determine degrees of similarity or difference between the early trade textiles and the categories of Indian cloth — many of them bearing the same names — that have survived to the present day.[65]

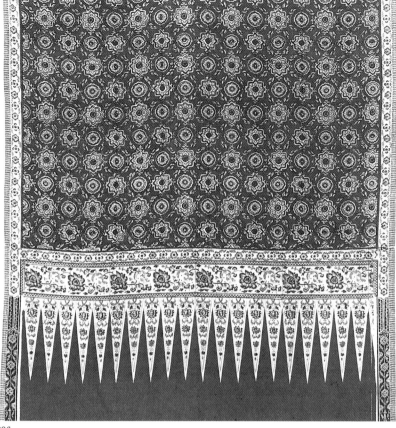

296

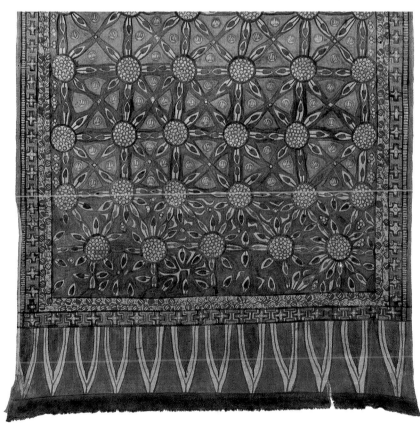

297

297 (detail)
ma'a; mawa
sacred textile
Sa'dan Toraja people, central Sulawesi,
Indonesia
cotton, natural dyes
painting
157.0 x 90.0 cm
Australian National Gallery 1984.608

Imported Indian cottons are sacred
textiles in the Toraja region of
Sulawesi, where they are stored away
in specially knotted baskets to be
opened only for important rituals. Such
is their antiquity and their prestige in
this area that many *ma'a* are believed
to have been woven by ancestral
deities. However, Torajan artisans
have also made their own *ma'a* using
ancient designs taken from other art
forms such as carving or by developing
popular designs found on the sacred
Indian *ma'a*. This Toraja painted
fabric, in brown and beige-green on
commercial cotton cloth, has
transformed the floral rosettes of the
Indian textiles into prominent sun-like
motifs. Similar designs also appear on
architectural woodcarving, where they
are interpreted as depicting a variety
of tree (*pa'bua tina*). The structure of
the Indian trade cloth border has been
retained on this *ma'a*, although the
stark simplicity of the triangles is
closer to the designs found on Toraja
warp ikats. There is also a narrow
surrounding band of crosses known as
doti langi'. Other *ma'a* display designs
similar to those found on some of the
oldest surviving examples of Indian
printed cotton, the fragments
recovered from the Egyptian site of
Fostat which have been dated to the
fifteenth century.

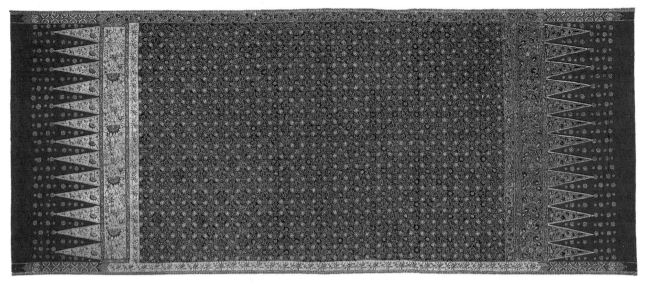

298

298
kain batik
skirtcloth; shouldercloth
Palembang region, south Sumatra,
Indonesia
cotton, natural dyes
batik
252.0 x 104.0 cm
Australian National Gallery 1980.1651

Small rosette patterns are widely used
on textiles throughout Southeast Asia,
and are especially popular designs
along the east coast of Sumatra where
they are evident on both locally made
textiles and those batiks made in Java
for export to that region. This
Sumatran textile is a
nineteenth-century example.

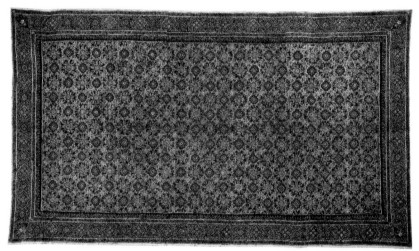

299

299
pha kiao
ceremonial covering cloth
south-east India; central Thailand
handspun cotton, natural dyes and
mordants
mordant painting, batik, painting
197.0 x 113.0 cm
Australian National Gallery 1984.619

This trade cloth displays an unusual
format with four equal borders, and
apparently was used as a covering
cloth for sitting platforms, important
ritual objects, and even elephants. It
contains both figurative and decorative
motifs, and although many of the
designs are now thought of as Thai,
they are the eventual result of a long
and complex interplay between Indian
and Thai textile patterns and design
structures. This was a process that
occurred gradually over many
centuries as the textile trade between
India and the Thai courts was pursued.
This particular central field design is
very similar to a pattern found on
trade cloths located in many other
parts of Southeast Asia. In each of the
four corners is a Thai deity (*deva*) in
prayer pose (*tepanom*).

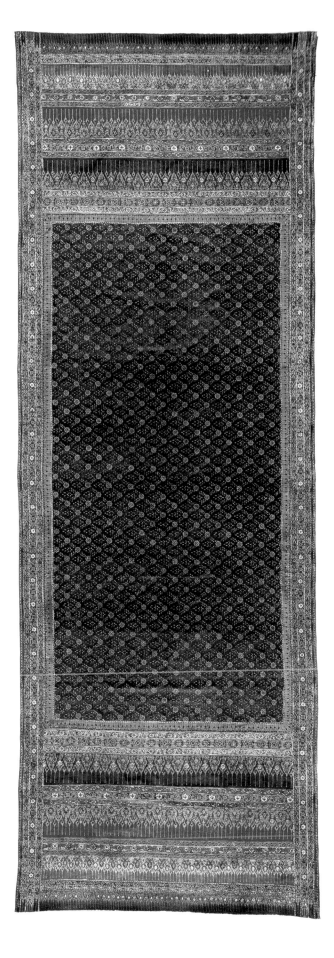

300
pha nung
ceremonial skirtcloth
south-east India; central Thailand
cotton, natural dyes
mordant painting, batik, painting
111.0 x 413.0 cm
Australian National Gallery 1984.621

The diagonal lattice filled with floral motifs was a popular design on many painted and polished cotton textiles made in India for the royal Thai courts. Although the field pattern is similar to some of those found on silk *patola* cloths and mordant-printed cotton fabrics destined for the Indonesian archipelago, these patterns were specifically executed to Thai tastes and were not considered to be foreign designs, being known generally as *pha lai Thai* (Thai-patterned cloth). The broad intricately worked borders at each end of the cloth are embellished with different coloured bands of flame and foliated triangular designs, and are characterized by fine parallel lines. These textiles were worn by both aristocratic men and women as wraps in different styles (*pha nung*, dhoti-style and *pha na nang*, as a wrap-around skirtcloth). They were also used as room-dividers, curtains, and coverings for altars, floors and seats for the nobility. Though decorated on only one side of the fabric, occasionally these skirtcloths are embellished with gold leaf gluework.

Given the rigours of the tropical climate and the demands of ceremonial use, most of the Indian trade cloths found in Southeast Asia today are probably of seventeenth- to early nineteenth-century origins, although some of the oldest extant examples collected may be considerably older.[66] It is possible tentatively to date some of the earliest examples by reference to similar Indian fabrics of known provenance that were traded to Europe and Japan.[67] Cautious though interesting stylistic comparisons are possible with some of the Indian textile fragments retrieved from the Egyptian archaeological site at Fostat (Pfister, 1938). Some of these mordant-painted and resist-dyed cotton fragments have been tentatively dated to the twelfth century (Nabholz-Kartaschoff, 1986: 83, 205), although most of the material recovered from this old trading centre appears to be from the fifteenth century or later (Gittinger, 1982: 30–57). Some examples of Indian trade cloths discovered in Southeast Asia bear makers' stamps in various forms of Indian and Arabic script as well as the unmistakable stamp of the Dutch trading company (VOC) which operated in Southeast Asian territory during the seventeenth and eighteenth centuries. These VOC marks provide definable limits to the age of the textiles on which they appear.

It is significant that few of these types of cloth are now found in India; nor do comparable examples exist in museum collections of domestic Indian textiles. The reasons for this are clear enough: although made in various parts of the subcontinent by Indian hands, the textiles carried to Southeast Asia were produced essentially as foreign trade items. Consequently, it is important to consider whether Southeast Asians were merely passive recipients or whether they played an active part in the process. We know from the accounts of the trade to Europe that European demands on the producers of Indian chintz resulted in significant adaptations to Indian designs to conform with European tastes and fashions (Irwin and Brett, 1970; Gittinger, 1982: 175–91). While we have insufficient knowledge of the earliest Indian trade cloth to Southeast Asia, or the exact nature of the interplay between the Indian prototypes and Southeast Asian interests, there is some evidence that Southeast Asians were also discriminating purchasers and provided significant input to this trade through clear expressions of their requirements, tastes and preferences. Examination of early European trade records from the seventeenth and eighteenth centuries has revealed that Southeast Asian tastes were highly specialized with some regions demanding particular types of cloth. It has even been reported that entire shipments were rendered valueless when cloth did not conform to local preferences (Gittinger, 1982: 137).[68]

While most attention has been focused on the obvious and important impact that trade cloth designs had on Southeast Asian textiles (Bühler, 1959), there is a strong indication that Southeast Asian motifs and designs, including some of those found on indigenous textiles, were reproduced on certain Indian trade cloths intended for the Southeast Asian market. One of the clearest illustrations of this process is provided by those Indian cloths made for the Thai market (*Old Textiles of Thailand*, 1979). These are strikingly 'Thai' in their appearance, and often combine Thai royal motifs and designs. The style of elaborate ornamentation found on these cloths and on many other arts of the Ayutthaya period is known as *lai yang* or *lai Thai* (Thai designs).

300

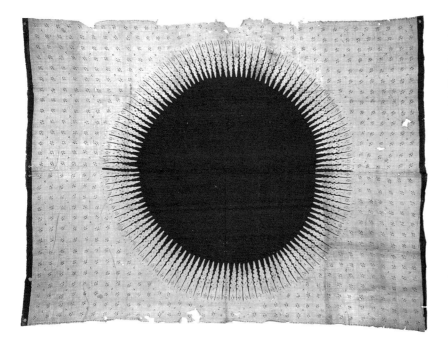

301 (detail)
...........
sacred heirloom textile
Coromandel region, India; south
Sumatra, Indonesia
cotton, natural dyes and mordants
block printing, mordant painting
277.0 x 208.0 cm
Australian National Gallery 1987.1071
Gift of Michael and Mary Abbott,
1987

The rich red colour of this seventeenth- or eighteenth-century Indian cloth has been achieved through mordant painting, while the blue speckled patterning which covers the ground appears to have been rolled or stamped directly on to the cloth. Like Javanese batik, but unlike most Indian cotton trade textiles of the same period, the designs on this cloth have been applied to both sides of the fabric. In fact, trade cloths of this format raise some important questions about the interplay between foreign and local designs in the development of both Southeast Asian textiles and Indian textiles intended for Southeast Asian markets.

This cloth is of similar dimensions to the Javanese *dodot*, the voluminous wrap of the aristocracy, and is composed of two hand-stitched panels. The two-sided pattern makes it an attractive cloth to wrap in the style of a *dodot*, or with a long sweeping train in the manner of the formal court *tapih* skirtcloth of Java and Bali. Although the main pattern is evidently not one of the familiar batik designs, like many *dodot*, the cloth's patterns are arranged across the diagonal corners of a central lozenge. The lozenge is licked by a border of flames, similar to the pattern that appears in this position on certain Javanese textiles (*cemukiran*). It may be that a garment of this type was popular for aristocratic ceremonial wear in southern Sumatra. (Indian textiles with a similar design structure in the collection of the Frankfurt Museum für Volkerkunde (NS3033) and the Museum voor Land- en Volkenkunde, Rotterdam (18158) were collected in the late nineteenth century in south Sumatra.) This is also suggested by the costume worn by some of the figures depicted on certain Lampung *tampan* textiles.

The evidence of indigenous impact on trade cloth design elsewhere in the region is less clear, although, for example, some of the Indian mordant-painted cottons display a design structure similar to that found on certain Javanese *dodot*. Both Indian and Javanese textiles contain a large central lozenge, often edged by tongues of flame, and the similarity is too remarkable to ignore. The diamond-shaped lozenge is also a prominent feature of other Javanese textiles, including those belonging to the ancient category known as *kain kembangan*, which are decorated by the stitch-resist technique known as *tritik*. It is possible, therefore, that the Indian textiles were an attempt to imitate a design format already prominent in Java and in other regions where these Javanese textiles were held in high regard.

While shiploads of plain or simply dyed cotton textiles flooded into Southeast Asia over the centuries, it was the elaborately decorated Indian textiles that were the most highly valued and had, as a result, a lasting effect on local textile design.[69] Many spectacular Indian trade cloths, most now two or three centuries old, have been treasured as heirlooms throughout Southeast Asia into the twentieth century, making only rare appearances at important ceremonies or at times of crisis.

The best documented of the decorative Indian trade cloths are the silk *patola* (singular, *patolu*) from the north-west region of India. These sumptuous textiles are patterned by the double ikat technique, in which both the warp and weft threads are resist-dyed before the fabric is woven. Most examples found in Southeast Asia are sari lengths of over four metres, although smaller pieces of about two metres and of a coarse weave and inferior colour were also made specifically for trade. The details of the technique and most of the known *patola* designs and their variations have been carefully documented by Bühler and Fischer (1979), while attention had been drawn to the role of these prestige silk textiles in Southeast Asian art in an earlier seminal article (Bühler, 1959).

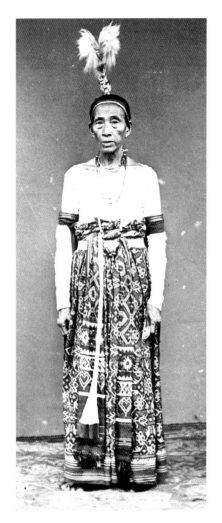

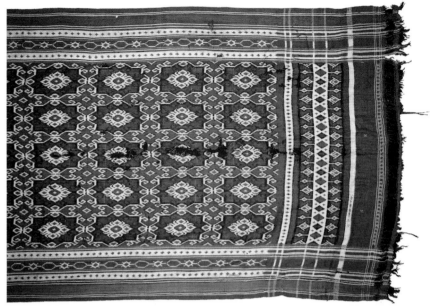

303

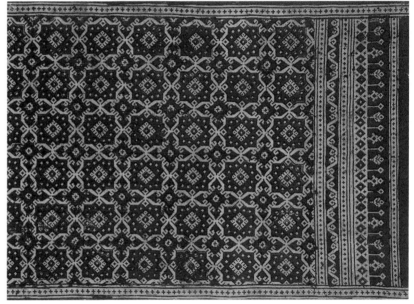

304

302

As costume and as objects assisting in their mediation with the spirit world, imported Indian textiles also became an important part of the sacred regalia of traditional leaders. This early twentieth-century photograph from the Minahasa region of north Sulawesi shows a female (or transvestite?) shaman in a *patola* skirt and sash. In this region, genuine silk *patola*, and both Indian and European imitations displaying the popular star pattern enjoyed sacred value and high prestige.

303 (detail)
patolu
heirloom cloth (in Southeast Asia)
Gujarat region, India; south Sumatra, Indonesia
silk, natural dyes
double ikat
Museum voor Land- en Volkenkunde, Rotterdam 18094

304 (detail)
............
heirloom cloth (in Southeast Asia)
Gujarat, India; Bali, Indonesia
handspun cotton, natural dyes
mordant block printing
242.5 x 86.0 cm
Australian National Gallery 1984.613

This unusual *patolu* was collected in the Palembang region of Sumatra in the nineteenth century. It is not the usual sari-length textile but a shorter version made for the Southeast Asian trade. The design on this *patolu* and its counterpart in Plate 304, a popular red and white mordant block-printed *patola* imitation, were both reproduced in various ways on many Southeast Asian textiles. The cotton version, dating from the eighteenth century, was used in Bali.

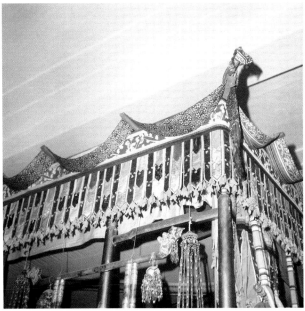

305

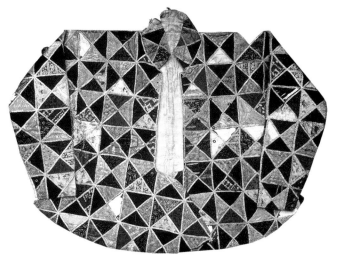

306

Also of great importance in the transformation of Southeast Asian textile traditions, though so far seriously underestimated, are decorative cottons from Gujarat and the Coromandel coast (Gittinger, 1982: 137–65; Nabholz-Kartaschoff, 1986: 100–5). The designs on these cloths were achieved by painting, or in the case of the cruder examples, by the woodblock printing of iron and aluminium mordants on to woven cotton cloth before the application of the red dyestuffs.[70] The brilliance and colourfastness of the red and black patterns thus achieved have made them justly famous throughout the trade world. Additional blue, green and yellow highlights were added by a wax-resist batik process to apply indigo and turmeric staining. The designs on these painted and printed cottons are far more varied than those of the silk *patola* textiles. They include a wide range of repetitive floral, geometric and schematic patterns, and a number of figurative motifs drawn from the natural and mythological world. Some of the printed cotton textiles are crude though striking imitations of popular silk trade *patola* designs.

The prestige trade textiles entered Southeast Asia as items of wealth and exchange, the possessions of local rulers and wealthy traders, the *orang kaya*. Some courts on the west coast of the Malay peninsula, such as Malacca, came to depend entirely for their royal costume on the costly Indian textiles which passed in huge numbers through that entrepôt. In the southern Philippines, seventeenth-century European travellers such as William Dampier reported that the rich and powerful wore imported cloth while the ordinary people wore clothing fashioned from abaca (Blair and Robertson, 1903–9, Vol.39: 24–5). In some parts of the region, imported cotton textiles from India or other parts of Southeast Asia had more appeal for everyday and ceremonial wear, and displaced indigenous fabrics, particularly bark, bast and hard fibre textiles. On the island of Nias off the western coast of Sumatra, appliqué techniques used imported fabric as a source material rather than bark-cloth. By the beginning of the nineteenth century, the making of local textiles in places such as the

24,214
263,277
296,299
300,301

304

302,305

305
In the court of Kutei at Tenggarong on the mighty Mahakam River in east Kalimantan this decorative structure above the royal throne combines the majesty of an Indian heirloom *patola* textile with the protective power of the serpent image. The *patola* cloth as python and its pattern as snake-skin is a common metaphor throughout Indonesia and Malaysia and the use of the silk textiles in royal ceremony is a means of harnessing the potency of the great mythical serpent for the benefit of the ruler.

306
Antakusuma
magical royal jacket
Javanese people, Yogyakarta, Java, Indonesia
Museum voor Land- en Volkenkunde, Rotterdam

Jackets like this nineteenth-century example, known as *Kyahi Antakusuma*, have been part of royal ceremonial dress in central Java since the eleventh century. We are told by the early chronicles that the original *Antakusuma* was made by the one of the first Islamic saints to reach Java, Sunan Kalijaga, and was reserved for the use of the Sultan at state occasions and for wearing into battle (Veldhuisen-Djajasoebrata, 1984: 74). It has also been suggested that the jacket, said to have the power to enable the wearer to fly, was originally the skin of *Ananta*, the great serpent of Indic mythology (Hooykaas, 1956: 313–17).

307
The seated corpse of an east Sumba raja is covered with a fine *patolu*. The cloth not only symbolizes his great earthly status but as a sacred heirloom fulfils a protective function. One important and recurring analogy throughout Southeast Asia likens the patterns of the *patola* textiles to the skin of a great python, often an incarnation of the spirit of ancestor-deities, and this is the case in Sumba (Adams, 1966). Harnessing its symbolism for the benefit of the ruler has also been a factor associated with the display of *patola* motifs on textiles.

Halmaheras and the Minahasa region of north Sulawesi had declined markedly.

The indigenous aristocracy or those families with power and wealth were undoubtedly the first Southeast Asians to adopt elaborate foreign textiles as prestige garments. Nineteenth-century wooden puppets and statues and *wayang kulit* leather puppets depict recognizable Indian trade cloth patterns as well as classical Javanese *dodot* designs on the dress of central Javanese deities and ancestral nobility, while their servants and lesser mortals wear only the familiar Javanese batik patterns and plaids (Forge, 1989). Even today, the attendants at the courts of the Susuhunan of Surakarta and the Sultan of Yogyakarta in central Java still wear a short, narrow sash (*samir*) around the neck to indicate that they are in the service of the ruler (Bondan, 1984: 82–3). Made of *patola*-patterned fabric, this collar is clearly a truncated replica of the *patola* sashes worn in the past as an important part of ceremonial attire.

As a consequence of their beauty and cost, and in some cases their rarity, these imported Indian textiles were gradually absorbed into the existing patterns of textile usage. Across the southern part of Southeast Asia, Indian cloth fitted readily into those networks of display and exchange of wealth on occasions such as births, marriages and funerals, and in certain cultures the ritual value of the trade cloths ultimately surpassed that of the finest local cloths.

Thus Indian trade cloths were eventually used in mortuary ceremonies to cover the bodies of the most esteemed. They became paramount in bride-wealth exchange, and are suitable as ritual payment for house construction and boat-building and may function as a symbolic sail or flag at the launching of a boat and the 'cooling' of a new house. Where symbolic exchange requires the pairing or balancing payment of male and female objects, trade cloths have become the superlative female item, and their rarity and exotic origins are an appropriate and complementary counterpart for elephant tusks and bronze kettledrums (Maxwell, 1981). In the Babar archipelago in eastern Indonesia, however, where local and foreign origins are also opposing categories, the Indian printed and painted trade cottons known as *basta*[71] stand in an ambiguous position: they are both textiles and hence female, foreign objects and therefore male. The most popular basta are the red and black varieties and the red trade cloths in particular are most prized because they embody two important elements — fertility and protection from danger.[72]

Indian cloths have also taken on many of the sacred qualities associated with certain locally made fabrics. Many imported mordant-painted cottons were traded into central Sulawesi and have been accorded the status of sacred *ma'a*. At the cyclical feasts for agricultural increase these textiles form the major symbolic link between Torajanese leaders and the Upper World of the deified ancestors whose blessing and presence are required on such occasions (Crystal, 1979: 58–60). In the courts of central Java, one of the most honoured and venerated *wayang kulit* puppets, the image of *Batara Guru* (Lord Siwa), is covered with a folded red silk *patolu* during the ritual airing of the royal puppets (Bondan, 1984: 82–4). A replica of this magic textile also surrounds the shadow screen (*kelir*) during *wayang kulit* performances at the Yogyakarta palace (Bondan, 1984: 53–5).

Indian trade cloths are also assumed to have the special protective powers that are called upon at times of crisis. Children with

210

307

24,214

diseases that elude conventional cures are wrapped in protective trade cloths in Lembata, and small fragments of a *patolu* are burnt in Bali as a cure for illness, a practice that probably arose from the increasing rarity of perfect examples in which to wrap the afflicted. *Patola* sashes rendered Malay warriors invulnerable to enemy blows, and members of the palace guard at the Thai court were provided with special Indian-made mordant-painted jackets (*su'a senakut*) featuring ferocious fanged monsters to ward off danger on all four sides — at each shoulder, front and back.[73]

307
305

The notion of protection came to be associated in particular with the silk *patola* textiles. These cloths are used as a royal canopy in south Sulawesi, as a curtain for the palanquins carrying Javanese rulers and Balinese deities, and as a shroud for the dead ruler in Sumba or a ritual leader in east Flores. They appear shaped as the *naga* around the throne of the sultan in east Kalimantan, and have been wrapped around vessels of holy water, sick children and royal personages on Sumbawa. In all these cases, the *patola* symbolize many of the inherent qualities of both sacred and secular textiles: they are a protective barrier and a communication link with the deities, and at the same time they triumphantly display wealth and splendour.

306

Ceremonial garments have sometimes been made from scraps of trade cloth, to preserve precious and increasingly rare objects and to retain both their prestige and magical properties. One of the most interesting uses of these fragments of trade fabric was the creation of elaborate ceremonial jackets, although they have also been used as decorative panels on jackets, tunics, skirtcloths and betel-nut bags. In central Java, patchwork garments are considered holy and have been the prerogative of particular individuals or groups. The Sultan of Yogyakarta has worn a special jacket of multicoloured cloths for particular court rituals, members of the elite corps of palace guards at the court of Solo wear patchwork jerkins at certain great ceremonies, and the Tengger priests and priestesses possessed long tunics of patchwork that were worn over batik skirts (Veldhuisen-Djajasoebrata, 1985: 74–9).[74] These garments, 'gifts from heaven', added the prestige of rare objects to the image of the Buddhist mendicants' clothing of rags.

310,311

This use of trade cloth fragments to create garments may have been the inspiration for the intricate *tambal* patchwork batik design.[75] The combination on a single cloth of so many significant designs, and the exclusive and sacred nature of trade cloth may explain why this batik is rarely worn.[76] Although trade cloths may have been a dominant influence on the origins of this batik design, the grid of triangles and squares upon which this pattern is based is a design structure evident on a number of ancient forms of decorative textiles throughout the region, including beadwork from Irian Jaya, bark-cloth from the Pacific and the batik costumes of the Hmong from southern China.

In some parts of Southeast Asia, the arrival of trade cloths added another element to the use of textile design as a way of identifying an individual's place in the social order, as well as membership of kin groups and clans. One striking example can be found among the Lamaholot people of eastern Flores and the small islands nearby. A detailed account of the textiles of one village in this region, the whaling and fishing centre of Lamalera on the south coast of Lembata, has shown that each traditional ritual house contains a *patolu* (Barnes,

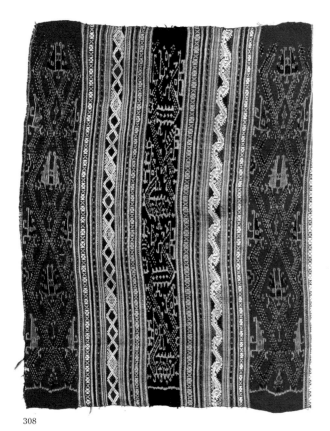

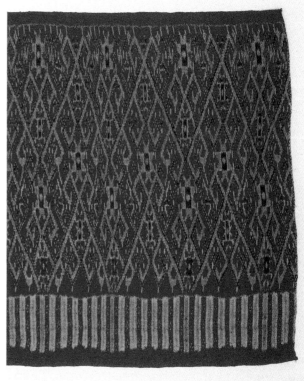

308

309

The Tai cloths that use silk for supplementary weft weaving usually rely closely on the archaic banded form, alternating between cotton bands of indigo ikat and silk bands of red ikat with additional highlights of different colours. In Plate 308 the red bands contain the serpent motif (*nak*) viewed from above with both eyes visible, while the blue-black bands show the same creature in writhing profile. The serpent theme is also suggested in the bright supplementary weft bands. In Plate 309, however, under the influence of trade cloth designs, the red ikat bands of silk have been extended into a full field of intricate patterning. A separate

1989a). Over the centuries, the specific designs of these rare *patola* cloths have come to represent the clans affiliated with each of these ritual houses, and they have been reproduced in the wide central band of each clan's own warp ikat textiles (Barnes, 1989b). Elsewhere in east Flores, there appears to be a very close connection between *patola* designs, the carvings found on wooden clan posts in the ritual house (*korké*) and some of the most important designs on the widest warp ikat band on locally woven textiles.[77]

Like indigenous sacred textiles, sacred Indian cloths fall into two categories. Some are the property of families, and are used in exchange, at individual rites of passage or at times of special need or personal crisis. Other trade cloths are communal heirlooms, the property of a clan or a village which controls their ritual use to ensure the general well-being of the group. These patterns of trade cloth use are not only repeated throughout the Indianized world of Southeast Asia but are even evident in remote parts of the region where, at least until recent decades, the basic social structure and religious beliefs have not dramatically changed since prehistoric times. In these areas, Indian trade textiles found an important place in mythology and customary practice. As we will see, the European manipulation of traditional leadership in Southeast Asia added a further dimension to the use of trade textiles and their importance as symbols of authority.

INDIAN TRADE TEXTILES AND SOUTHEAST ASIAN TEXTILE DESIGN

One of the most significant themes in the historical development of Southeast Asian textiles has been the gradual transformation of elements of motif and design from Indian trade textiles on to cloth

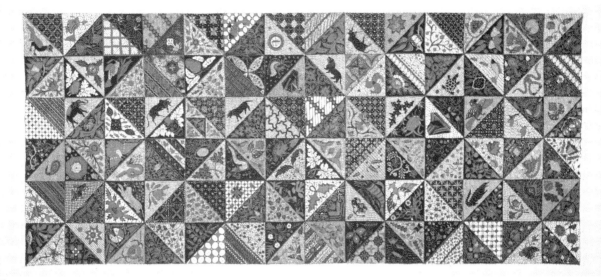

310

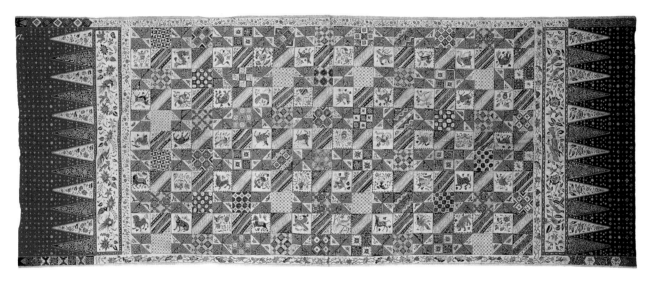

311

supplementary weft band (*tin chok*)
would have been added to complete
these nineteenth-century women's
ceremonial skirts.

310
kain panjang
skirtcloth
Javanese people, Yogyakarta, Java,
Indonesia
cotton, natural dyes
batik
241.0 x 106.0 cm
Australian National Gallery 1984.1220

311
kain panjang
skirtcloth
Peranakan Chinese people, Lasem (?),
Java, Indonesia
cotton, natural dyes
batik
276.0 x 106.7 cm
Australian National Gallery 1983.3693

There are several sources for the
patchwork design structure (*tambal*)
of these two batik skirtcloths.
Triangular grids are found on both
ancient textiles and Indian cotton trade
cloths, and patchwork jackets and
sashes of imported cloth, including
luxurious brocades and velvets, were
used in Javanese court circles as
talismanic costume (Veldhuisen-
Djajasoebrata, 1984: 74–8).

The central Javanese *tambal* design in
Plate 310, a skirtcloth from the 1930s
in characteristic Yogyakarta tones,
combines a number of well-known
animal, plant and schematic patterns
on a triangular grid. Some of these are
based upon trade cloth designs; other
triangles in the grid display some
simple yet ancient patterns (such as
geringsing and *kawung*). In contrast,
the batik in Plate 311 dates from the
nineteenth century and incorporates
into its design a number of Chinese
patterns popular on the north coast of
Java. However, the medium,
hand-drawn batik, is Javanese and the
design structure of the cloth with the
triangular end borders is a typical
Southeast Asian format.

produced by many different peoples throughout the region. The finest trade cloths were remarkably attractive, and artisans obviously delighted in reproducing some of their most popular and beautiful designs. Moreover, the fact that many of these Indian textiles had become an established part of Southeast Asian costume, ritual and ceremony, and had become closely associated with notions of sacred and temporal power, has also been an important influence upon this process.

As the highly valued objects were lost, damaged or consumed by the demands of ritual, there was an urgent need to find substitutes. When the trade cloths themselves could not be replaced, it was possible for Southeast Asians to emulate, on their own cloth, the most powerful and important symbols these Indian textiles displayed. The restrictions as to who might use the prestigious Indian textiles were often transferred to local textiles with similar designs. For example, where imported *patola* had been the exclusive possession of the aristocracy, indigenous textiles with *patola*-inspired motifs were usually also the prerogative of the rulers. Although the study of this phenomenon has tended to concentrate upon the spectacular impact of the silk *patola* cloths (Bühler, 1959), close scrutiny of textiles from many parts of Southeast Asia reveals that Indian painted and resist-dyed cottons were also important in this process.

The vision presented by Indian trade textiles led to a variety of changes on Southeast Asian cloth. Though some of these changes were more subtle than others, several key features of the new style can be identified separately or in combination on many of the region's textiles. These include the structural adaptation of ancient banded textiles to incorporate wider panels of patterning, the enclosure of the central field pattern by rows of large triangular teeth, and the adoption of special motifs and pattern elements that had a particular attraction.

The shift away from bands and stripes in favour of all-over patterns is evident on both warp- and weft-decorated textiles and is directly attributable to trade cloth influence. The expansion of the major decorative elements into a central field of patterning with contrasting borders was a feature found on the *patola* and on many of the painted and printed cottons. On the three-panel banded cloth prominent throughout eastern Indonesia, this change to all-over patterns was often achieved by covering the central panel entirely with a design displaying motifs adapted from the Indian trade cloths. Where ancient motifs and patterns were retained, these were arranged in new ways to satisfy the demand for cloths to show these wider sections of patterning. In ritual exchange in many parts of eastern Indonesia, cloths with wider bands and all-over patterns in a central panel assumed supremacy over the older banded styles.

308,309, 312,313

314,315,316, 317,318,319, 320

Throughout Southeast Asia there has been a tendency for the central field pattern to be tilted into a diagonal lattice. This seems to have been a common feature of prehistoric design and is evident in the striking sloping spiral patterns found on ancient metal objects and pottery.[78] The diagonal grid is also seen on textiles apparently little touched by trade cloth, including some of the banded cotton cloths of eastern Indonesia and the warp ikat weavings of the T'boli and the Toraja. Such a wide distribution suggests that it was already established as a satisfying means of arranging a pattern on cloth. Its popularity was, however, undoubtedly reinforced by the arrival of Indian trade cloths also displaying patterns arranged in a diagonal

321,322

grid. Sometimes elements copied from trade cloths have been adapted to emphasize this desired format, and on occasions an Indian square grid design has been transformed on Southeast Asian cloth into a sloping lattice. In south Sumatra, for example, the addition of gold leaf to Indian painted or printed cloths (*sembagi*) with a square grid pattern transformed the design into a diagonal and familiar pattern.[79]

Where a diagonal grid is a feature of Southeast Asian textiles the complexity of the grid pattern varies. The cotton trade cloths made for the Thai market incorporated Thai-style Buddhist motifs into an elaborate diagonal lattice, and an arabesque mesh is a prominent feature of the Thai gold thread brocades and Khmer silk weft ikat designs popular in the courts of central Thailand. Similar lattices are found on both the ikat and supplementary weave textiles associated with the Malay coastal courts of Kelantan and Terengganu where many patterns closely resemble trade cloth designs. Sometimes local patterns have also been slightly altered and rearranged to suit the design structure of the trade cloth. Elsewhere the diagonal grid is subtly suggested by the arrangement of isolated motifs against a plain-dyed ground. This structure is used on the warp ikat shawls of Endeh where the dark maroon ground is scattered with rosettes in a diagonal arrangement.

While the use of triangular ornamentation can be found on many ancient Southeast Asian artifacts as well as the earliest textile designs, under the influence of trade cloth it became the most popular device for terminating and enclosing the central patterns on textiles of many different materials and decorative techniques. On many of the imported Indian textiles the borders at each end of the cloth that frame a central field display rows of elaborate triangles,[80] and some triangular motifs on Southeast Asian cloths are almost exact replicas of these well-known trade cloth designs. Other triangles are shaped like the architectural structures of the Indic world of Southeast Asia, with stupa and temple motifs. The elaborate flame and the cosmic tree can also be identified in many of these decorative borders. On other textiles the triangular border motifs have been reduced to stripes resembling the fringes on many cloths, and some examples include floral and animal motifs, and even stylized human figures. These triangular borders often bear the names of local objects; amongst the most common terms are the *pucuk rebung* (bamboo shoot) and the *tumpal* (a specific name for a row of triangular shapes).[81]

On certain Southeast Asian textiles, these border patterns based on trade cloth designs have been transformed into a single panel of patterning by moving the border patterns from their position at each end of the cloth and joining them together so that they form two confronting rows of triangles. This is a characteristic design feature of many cylindrical skirtcloths formed with a seam from a single length of fabric, and it is widely known throughout the Malay-speaking regions of Southeast Asia by the terms *kepala* (head or head-panel) or *pantak* (bottom or back-panel).[82]

Not all Southeast Asian cylindrical skirts have adopted this design feature, and Thai and Khmer skirts continue to be woven with the triangular border elements at each end of the fabric. However, this panel has frequently been adopted by the batik-makers of north-coast Java, the Maranao weavers of silk supplementary weft skirts, and the Malay weavers of Terengganu and Kelantan gold brocade.

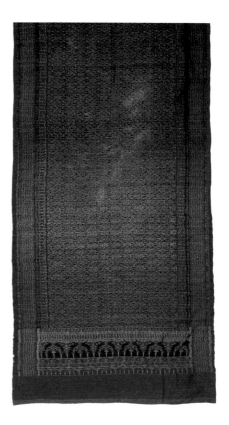

312 (detail)
sampot hol
ceremonial skirtcloth
Khmer people, Cambodia
silk, natural dyes
weft ikat
300.0 x 96.0 cm
Australian National Gallery 1989.2251

This heirloom skirtcloth is an example of the Khmer weft ikat textiles sent to the Thai courts until the mid-nineteenth century. It shows a fine diamond grid similar to the patterning on certain Indian trade textiles. The triangular motifs at each end are in a stylized form suggestive of a stupa, ceremonial head-dress or offering platter.

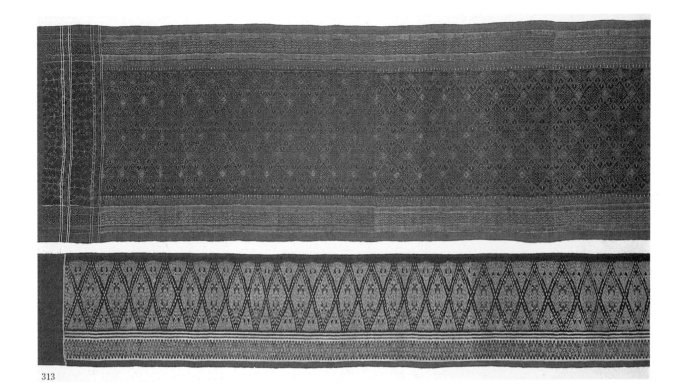

313

313 (details)
pha toi; chong kaben
ceremonial skirtcloths
Tai Lao people, Paksé district, Laos
silk, natural dyes
weft ikat, staining
650.0 x 47.0 cm; 316.0 x 89.0 cm
Australian National Gallery
1987.1583; 1989.2100

These nineteenth-century textiles from
locally produced silk were probably
woven in the Paksé region near the
old southern capital of Champassak, an
area where textile techniques and
designs have been strongly influenced
by Khmer silk traditions. Both textiles
were clearly intended for court use,
and each has a continuous field pattern
of lozenges common throughout
Southeast Asia, particularly where fine
Indian textiles have been much
admired. The weft ikat textile with the
symmetrical design and elaborate end
borders was clearly intended as a large
and impressive ceremonial wrap
(*chong kaben*) similar to the Khmer
silk weft ikats which have been
treasured textiles in the central Thai
kingdoms. The other long
asymmetrical weft ikat fabric still has
remnants of stitching along the inside
selvage, suggesting that it may have
been one of an identical pair originally
sewn together to form a larger
skirtcloth. However, there is no
evidence that cloths were worn in this
way in the courts of Laos, and they
may in fact have been used as shrouds

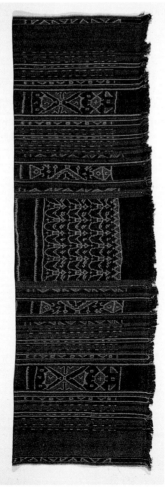

314

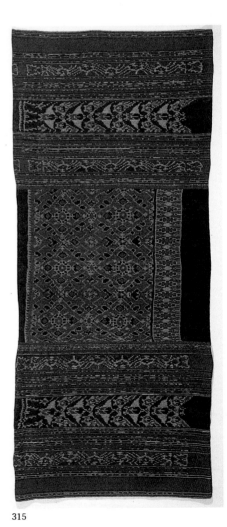

315

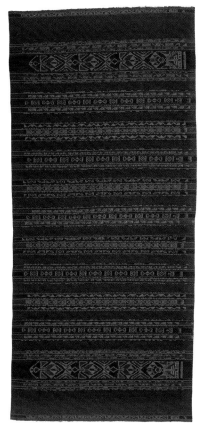

316

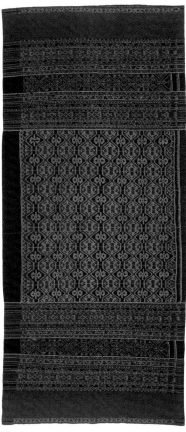

317

316
kewatek méan
woman's skirt
Lamaholot people, Ili Api district,
Lembata, Indonesia
handspun cotton, natural dyes
warp ikat
150.0 x 67.5 cm
Australian National Gallery 1982.2302

317
kewatek méan
woman's skirt
Lamaholot people, Ili Api district,
Lembata, Indonesia
handspun cotton, natural dyes
warp ikat
160.0 x 71.0 cm
Australian National Gallery 1983.3691

Throughout the Lamaholot domains, where the widest warp ikat band on skirts indicates the weavers' clan affiliations, trade cloth design elements are often prominent motifs. These two finely worked nineteenth-century examples are Ili Api cloths of the highest rank (*kewatek méan*; red skirts). One retains the older banded format, while the other displays a wide central field design clearly influenced by imported Indian trade cloth heirlooms. While a wide central field was extensively adopted for bride-wealth skirts in south Lembata, it is found only rarely in the Ili Api region in the northern part of the island. In neighbouring east Flores rare examples of skirts with central field patterning are known as *kewatek tenipa*, the *patola* skirt (Maxwell, 1982).

for members of the Lao nobility. The design is finished across each end with a simple row of triangles. Some yellow staining or spot dyeing is evident, although the dominant colours are red, blue and purple-blue over-dye.

314
petak haren; *kewatek nai telo*
woman's skirt; ceremonial exchange
object
Lamaholot people, south Lembata,
Indonesia
handspun cotton, natural dyes
warp ikat
194.0 x 123.0 cm
Australian National Gallery 1984.1238

315
petak haren; *kewatek nai telo*
woman's skirt; ceremonial exchange
object
Lamaholot people, south Lembata,
Indonesia
handspun cotton, natural dyes
warp ikat
148.3 x 70.0 cm
Australian National Gallery 1984.1219

Although made in south Lembata as cylindrical skirts, with the warp threads uncut these cloths are used primarily as bride-wealth payments. The patterns and design structures displayed on each have been inspired by trade cloth, probably silk *patola* from the treasure of the weaver's clan. The ornamental grid pattern evident in the central panel on Plate 314, an excellent nineteenth-century example, has almost certainly developed out of a *patola* design. Although Indian cloth inspired the patterns for the motifs of these wide bands in south Lembata, sometimes weavers reworked ancient motifs into the central field patterns. On Plate 315, a mid-twentieth-century textile, an ancient human figure motif (*ata diken*) has been transformed into a continuous decorative pattern within such a central field design. Both textiles retain the traditional banded structure in the upper and lower panels, where the giant ray (*mokum*) and boat (*téna*) are displayed. These motifs are an indication of the dominant role of the sea in the social and economic life of this area of Lembata.

The head-panel has been exploited as a new way of arranging a textile's design structure and appears on some of these cloths in a central position dividing the main field into two halves. In the same regions triangular motifs continue to be placed at each end on unsewn rectangular textiles that are intended as wraps, shawls and baby-carriers. *100*

Batik made in centres outside the Javanese principalities of Surakarta and Yogyakarta, particularly textiles made for interregional and domestic trade, display these framing devices of bands, triangles and *310* other variations in border motifs, along with a range of popular patterns that borrow heavily from Indian trade textiles. By contrast, central Javanese batik is one of the rare textile traditions of Southeast Asia to follow the all-over unbordered pattern found on many bolts of Indian cotton cloth. Yet trade cloth patterns have had less obvious *311* influence on the development of the well-known batik patterns associated with the principalities and aristocracy of central Java. Most of the exclusive categories preserved for the use of the Javanese aristocracy are patterns of ancient Javanese heritage, such as the diagonal *parang* (sword), the *kawung* (set of four ovals), and other *197* patterns alluding to Indic mythology such as the *garuda* wings and *16,278,279* cosmic landscape scenes. A few restricted patterns, however, can be linked to trade cloth designs, including the *sembagen huk* design which takes its name from two foreign elements: a bird medallion of Chinese ancestry (*huk*), and the general term used in south Sumatra and Java for multicoloured Indian cotton trade cloths (*sembagi*). While high status trade cloths such as the silk *patola* (known in Java by the term *cindai*) were exclusively reserved for the royal courts of Java, hardly any of the batik designs inspired by *patola* patterns were placed in the restricted group. This includes examples from the design category known as *nitik* (dotted designs inspired by woven cloth), such as the star motif known variously as *cakar ayam* (chicken's footprint), *cakar melik* or *jilamprang*.

In one of the simplest methods used to rework trade cloth elements, patterns or particular motifs were slipped into the ikat bands *318* of woven textiles. In some instances, for example on the feature band on many eastern Indonesian women's skirts, the trade cloth origins are immediately recognizable. On the other hand, the star motifs some cloths display are sometimes not very different from the hooked lozenge also found on older cloth designs and in these areas trade cloth patterns are sometimes difficult to distinguish from ancient designs.

Sometimes a particular trade cloth motif has been 'read' or interpreted in several ways by the women who created the original designs. On the island of Roti, for example, two distinct motifs, one round and one square, were inspired by the same *patola* eight-pointed star pattern (Fox, 1980a: 50). It is also common for trade cloth motifs to be redrafted so that they conform more closely with local artistic style. In parts of central Flores, the elephant motif that appears on several impressive *patola* has been transferred on to locally woven *329,331* warp ikat textiles. However, the elongated and spindly elephants *332,333* depicted on Ngada cloths are stylistically closer to other Ngada motifs such as the horse. On certain Endeh cloths, although the howdah remains, the elephant has been reduced to a schematic repeating pattern and its *patola* origins are scarcely identifiable (Maxwell, 1983). The actual *patola* textiles that inspired these designs are now

extremely rare in these parts of Flores, and despite the fact that these motifs are known as elephants, weavers in Ngada or Endeh no longer associate their own textiles with these trade cloth patterns.[83]

Particular designs and patterns can also be linked directly to certain types of mordant-painted cotton trade cloth. A rare painted *ma'a* with dancing human figures in fluid profile can be traced to a painted and batik-resist Indian cotton depicting the groups of dancers in characteristic Gujarati style so far only found in the Toraja regions of central Sulawesi (Guy, 1989).[84] Batiks with flower and tendril motifs on silk or cotton are closely related to certain floral trade patterns that were drawn or block-printed on to bolts of cloth designed for cutting into short lengths. These floral printed trade cottons, the *basta* of the south Moluccas, also transformed the patterns of some Sangihe supplementary weft textiles, even though the wild banana plant, Musa textilis, continued to provide the fibre from which they were woven.

While the trade cloth origins of some Southeast Asian textile patterns are obvious, in other cases this influence has been masked by the ingenious way the pattern has been reinterpreted in accordance with the prevailing artistic style. This applies in particular to several well-known Javanese batik patterns such as *semèn* and *pisang balik*, and the closely related variations of the *lar* motif which are also found in Sumatra and Malaysia, particularly on the silk weft ikat of Bangka, Palembang and Terengganu. Despite the close identification of such patterns with classical central Javanese art, old Indian trade cloth counterparts exist for many of these patterns. It is worth noting that many of the earliest batik patterns to be recorded and described, textiles from Gresik on the north coast of east Java, are predominantly small geometric patterns remarkably similar to the designs found on many printed Indian cottons, although the designs have everyday Javanese names (de Groot, 1822).

In a small number of cases, a Southeast Asian textile has become almost a replica of the Indian trade cloth in its design and structure, even though such a textile is seldom created with the same raw materials or techniques as the Indian model. The Lio man's shawl clearly resembles the vibrantly coloured, star-patterned silk *patola*, although it is woven from cotton in warm earthy tones obtained from local dyestuffs. Some of the *ma'a* cloths made in central Sulawesi by the Toraja follow very closely the designs of certain Indian imported cottons, and yet the colours are significantly different, and the patterns are blocked and painted more freely.

There are several interesting points of comparison between trade cloths, in particular the silk *patola*, and the *geringsing* textiles woven in the village of Tenganan in east Bali. Both are important textiles widely used in magic, ritual and ceremony throughout Bali, and both are made by the same complicated double ikat technique. In addition to the impact of Indic architecture and sculpture on the iconography of the *geringsing wayang* patterns, other *geringsing* display the clear influence of trade cloth designs (Bühler et al, 1975–6: Figs 44–57).

The exact origins of these Balinese textiles are unknown and any theories on this matter can only be speculative (Ramseyer, 1983: 24–5).[85] Although woven from handspun cotton thread on a simple backstrap loom without the use of a reed, their patterns are entirely dominated by Indic aesthetics of one kind or another. As well as these

22,23

296,297

13,207

282,334

318
lawo mogha mité
woman's skirt
Lio people, Flores, Indonesia
cotton, natural dyes
warp ikat
173.0 x 138.0 cm
Australian National Gallery 1981.1143

319
lawo redu
woman's skirt
Lio people, Flores, Indonesia
cotton, natural dyes
warp ikat
158.0 x 142.0 cm
Australian National Gallery 1984.3186

The spirals and stars which appear in
the warp bands of certain Lio skirts
(Plate 318) seem to have been
inspired by *patola* motifs. The
influence of these trade cloth motifs is
more obvious on those examples
where the central panel of bands has
been converted into a panel of all-over
warp ikat patterning. Plate 319 is a
clear example of this transformation
and cloths of similar design are also
known as *lawo pundi* and *lawo sindé*.
Sindé is the term used for *patola* in
this district of Flores. Lio skirts with
this central panel of all-over patterning
are regarded as textiles of the highest
status and in the past were only worn
by women of the dominant clans.
Nowadays, banded cloth, particularly
with white and blue-black (*mité*) ikat,
is favoured by older women, while
younger women prefer the more
decorative larger patterns. Both skirts
date from the mid-twentieth century.

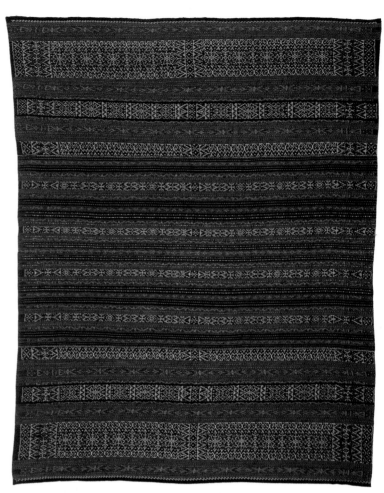

318

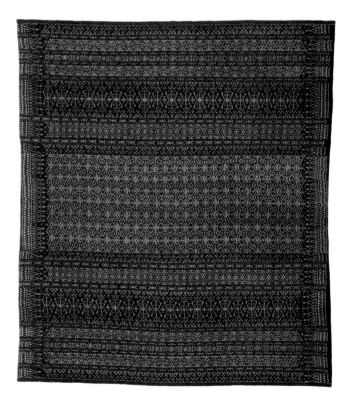

319

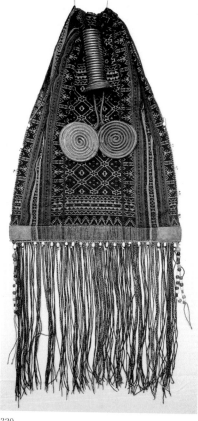

320

320
pundi
ceremonial betel-nut bag
Lio people, Flores, Indonesia
handspun cotton, natural dyes, brass
rings
supplementary warp weave
Tropenmuseum, Amsterdam 1329–1

This ceremonial betel-nut bag (*pundi*),
woven in an ancient supplementary
warp technique, is an exclusive
possession of the Lords of the Earth in
the Lio domain of central Flores. The
motifs on these bags are based on
sacred heirloom trade cloths. Identical
motifs also appear on women's skirts
of the highest rank, which are known
as *lawo pundi* (the skirts with the
pundi pattern). This fine nineteenth-
century example is worked in
handspun cotton and natural dyes.

321
lafa
man's cloth
Rotinese people, Roti, Indonesia
cotton, natural dyes
warp ikat
180.0 x 83.0 cm
Australian National Gallery 1980.1643

322
pou
woman's skirt
Rotinese people, Roti, Indonesia
handspun cotton, natural dyes
warp ikat
155.0 x 57.3 cm
Australian National Gallery 1983.3694

The man's cloth (*lafa*) contains an
ancient snake motif displayed in
narrow warp bands. The Rotinese
associate this pattern with the great
snake figure of oral legend, and the
even number of bands indicates that
the cloth was made on Roti rather
than on the neighbouring island of
N'dao where cloths of this pattern are
also common (Fox, 1980a). On the
woman's skirt (*pou*), the bands of
snake motifs have been amalgamated
into a diagonal grid design. This
results in a pattern that closely
resembles the designs found on highly
valued heirloom trade cloths owned by
the Rotinese aristocracy. Other design
features of the men's cloth are also
repeated in the narrow bands at each
edge of the woman's skirt. The central
section of a Rotinese woman's skirt is
undecorated and folded out of sight
when it is worn. Both textiles are in
indigo-blue, red and white ikat and
date from the mid-twentieth century.

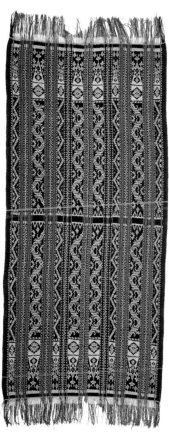

321

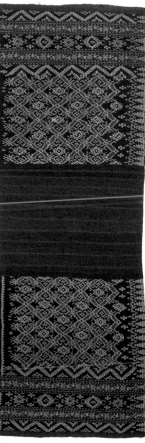

322

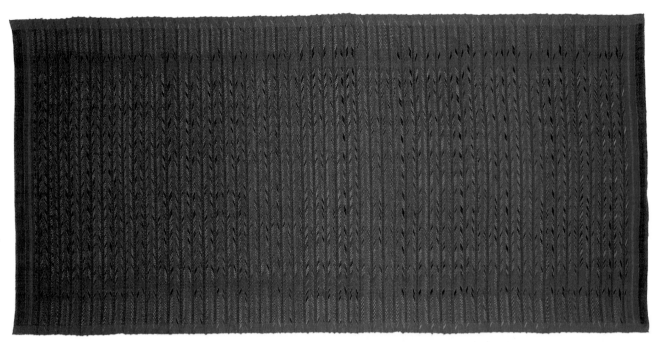

323

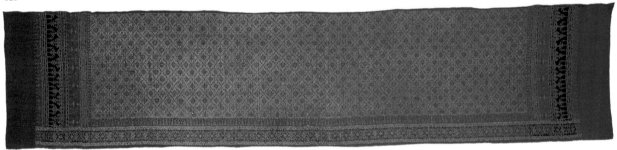

324

323
sampot hol (?); *chong hol* (?)
woman's skirt
Khmer people, Ban Kuow, Surin
district, north-east Thailand
silk, natural dyes
weft ikat
193.0 x 93.4 cm
Australian National Gallery 1986.1243

324 (detail)
sampot hol (Khmer); *pha poom*;
sompak poom (in Thai court)
ceremonial skirtcloth
Khmer people, Cambodia
silk, natural dyes
weft ikat
374.0 x 82.0 cm
Australian National Gallery 1986.1237

The skirtcloth in Plate 323 is woven from silk in bright colours using natural dyes and is decorated with simple weft ikat (*hol*) in a 'tears' or 'step' pattern (*lai pa lai*). While this style uses the ancient structure of narrow bands of patterning, Khmer weft ikat designs vary in width and many cover the whole cloth with an all-over pattern (Plate 324). Khmer textiles displaying the most ornate patterns were highly valued by the Thai aristocracy as an important part of ceremonial costume until at least the mid-nineteenth century, although the extent of Thai influence over their designs is uncertain. The design structure and patterns on these textiles were clearly affected, however, by Indian trade cloth. Unlike the Khmer hangings (*pidan*), which draw directly on the sacred symbols of Buddhism, figurative motifs are rarely evident on these skirtcloths. Both textiles are in red, yellow, green and blue-black; the textile in Plate 323 dates from the mid-twentieth century while Plate 324 dates from the nineteenth century.

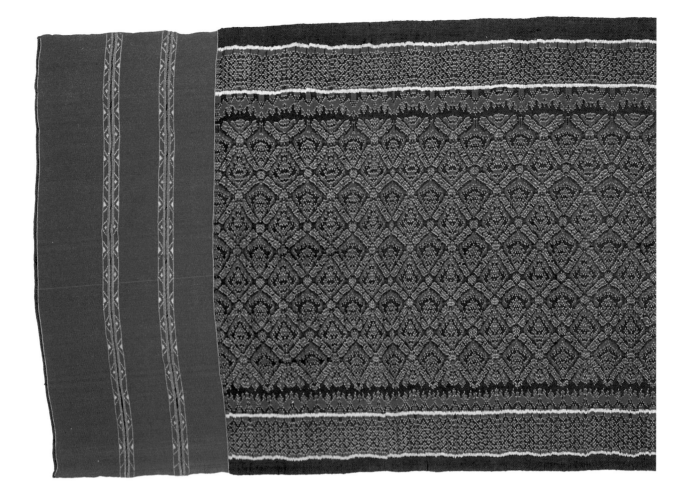

iconographic connections, the actual technique of double ikat may have developed in Bali under the inspiration of the *patola*. While the method could have emerged there independently, it is possible that competent weavers discovered the technique for executing the patterning by carefully examining the coarse type of *patola* often imported to that island. This may have occurred when fragments of the *patola* were cut up and burned for their magical healing powers.

330,335 Other Balinese interpretations of popular *patola* designs, some probably copied from *geringsing* patterns, have also appeared on certain traditional weft ikat textiles such as the *kamben cepuk*. Consequently, these cloths are considered suitable substitutes for *patola* in rituals such as tooth-filing (Nabholz-Kartaschoff, 1989).[86] This is a ritual function that may once have been fulfilled by an ancient form of Balinese sacred warp-decorated cloth.

The presence of trade textiles did not always lead to dramatic changes in the motifs and designs on Southeast Asian cloth. The effect, if any, on some cultures and on some textile styles has been negligible. For example, despite centuries of trade in sandalwood, foreign designs are rarely found on Timorese textiles, and although textiles are treasured possessions, Indian trade cloths have not been noted among royal heirlooms.

Similarly, although large numbers of trade cloths were imported into Borneo over the centuries, only rarely has this influenced the iconography of indigenous textiles in that region. Although Indian

325 (detail)
chong kaben; sompruat
ceremonial skirtcloth
Khmer people, Surin district,
north-east Thailand
silk, natural dyes
weft ikat
190.0 x 96.0 cm
Australian National Gallery 1989.2250

This early twentieth-century example of a silk weft ikat skirtcloth was made in Khmer style by the people of the Surin region of Thailand. The warm rich colours and clear geometric patterns are typical of weft ikat cloths from that region. The influence of Indian textiles on the format of these textiles is obvious in the field and border arrangement. The cloth displays striped ends, rather than triangular border designs, suggesting that it was used by a member of the lesser nobility or as a front-pleated skirtcloth.

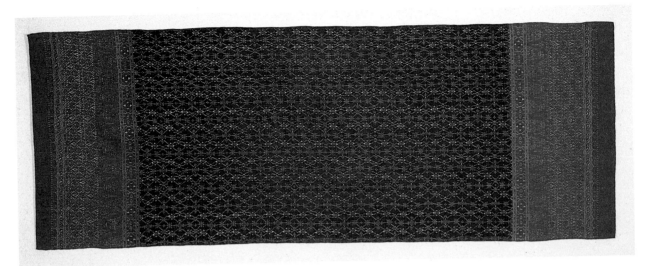

326

326
kain lemar
shouldercloth
Malay people, Kelantan, Malaysia
silk, natural dyes
weft ikat
82.5 x 227.0 cm
Australian National Gallery 1984.582

Double ikat silk *patola* have been worn
as shawls by women in the courts of
the Malay kingdoms, and these are
still evident among the treasured
heirlooms of the royal families. The
weavers of weft ikat (*kain lemar*) in
Kelantan adopted many of the patterns
that they admired on foreign textiles,
including those found on *patola*. The
overall design structure and the
decorative style of the weft ikat end
borders of this cloth display a
remarkable similarity to some of the
silk weft ikats produced by Khmer
weavers in mainland Southeast Asia. In
earlier centuries, the narrow isthmus
across the peninsula to the north of
this Malay kingdom was an important
trade route between the Indian
subcontinent and the ports of powerful
empires in Cambodia and Vietnam.
The northern Malay states such as
Kedah and Kelantan were also part of
the wider Thai sphere of influence
before the arrival of the British on the
peninsula, and it is probable that the
Patani cloths from the Malay region of
southern Thailand, which were popular
for centuries in interregional trade (B.
Watson-Andaya, personal
communication, 1986) also shared
some of the design features of these
Kelantan textiles. In neighbouring
Terengganu, however, textiles are
closer in motif and design to the silk
weft ikats woven in the Palembang and
Bangka regions of south Sumatra.

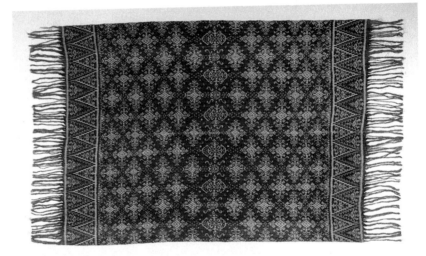

327

327
semba
man's shawl
Endeh people, Flores, Indonesia
cotton, natural dyes
warp ikat
264.0 x 153.0 cm
Australian National Gallery 1984.581

The design and motifs of the shawls
worn by the Lords of the Earth in
central Flores have been inspired by
Indian textiles (*sindé*). This is evident
in the all-over patterns of the central
field and in the triangular bands at
each end. Lio *semba* also display wide
warp bands on each side, but these do
not appear on the Endeh cloths. The
striking difference between the Indian
heirlooms and these Flores textiles is
their colour: the cotton shawls exhibit
the warm red-brown hues derived
from Morinda citrifolia. Nineteenth
century.

328
kain lemar
skirt
Malay people, Terengganu, Malaysia
silk, natural dyes
weft ikat
106.8 x 103.3 cm
Australian National Gallery 1984.1249

The fields on some Malay weft ikat
skirts are decorated entirely in ancient
banded patterns with an ornate
head-panel of bolder design. On the
cylindrical skirt, the head-panel is filled
with a luminous red floral grid
enclosing eight-pointed blossoms. The
foliated trellis is another favourite
Malay pattern, although it usually
appears as a field design.

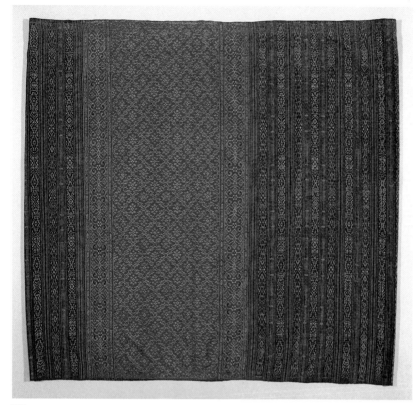

328

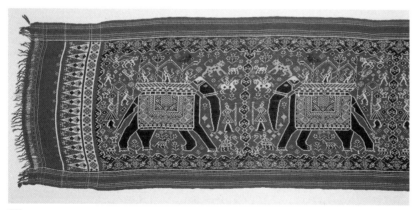

329

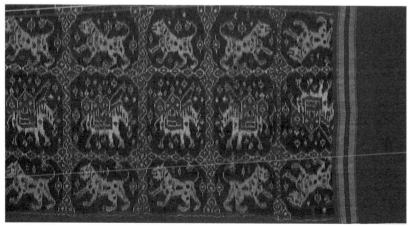

330

329 (detail)
patolu
ceremonial cloth; sacred heirloom in
Indonesia
Gujarat region, India; eastern
Indonesia
silk, natural dyes
double ikat
111.0 x 500.0 cm
Australian National Gallery 1984.3184

Though rarer, those *patola* that depict
animals have been extremely popular
in Southeast Asia, and became an
important source of motifs and
patterns. The dramatic *patolu*
containing a huge elephant motif has
been located with a number of
different background colours, and this
fine example has black elephants
against a red ground. This type of
patolu became an important heirloom
and transformed a number of textile
patterns, particularly in Flores and the
Solor archipelago. It has also been
recorded in south Sumatra and it may
have influenced the way the elephant
motif is depicted on the textiles of that
region. Elephants also appear on other
Indian trade cloths including a *patolu*
with a diamond lattice design that has
also been an attractive arrangement
for Southeast Asian textile artisans.

330 (detail)
kamben endek
ceremonial breastcloth
Balinese people, Karangasem (?), Bali,
Indonesia
silk, dyes
weft ikat
320.0 x 60.0 cm
Australian National Gallery 1989.1860

The field design of this early
twentieth-century breast-wrap is
closely based on the *patola* cloths that
feature royal animals, such as the tiger
and the elephant in a lattice. While
patola were a popular source of design
for the magical *kamben cepuk*
(Nabholz-Kartaschoff, 1989), figurative
motifs such as these are rare. While
the central field is red with bright
patches of ikat, the end sections are
deep purple-pink.

331 (detail)
lawo butu
woman's ceremonial skirt
Ngada people, Flores, Indonesia
handspun cotton, natural dyes, beads,
shells
warp ikat, bead appliqué
187.3 x 78.0 cm
Australian National Gallery 1981.1157

The attenuated white warp ikat
elephant motifs on this dark indigo
Ngada skirt were inspired by one of
the elephant *patola* patterns found in
eastern Indonesia. These beaded
cloths, like the Indian *patola*, are the
exclusive property of the *gae mezé*,
the highest class within Ngada society
(Maxwell, 1983).

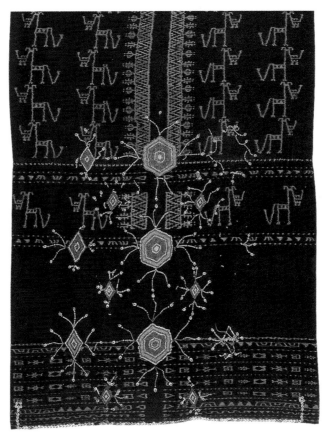

331

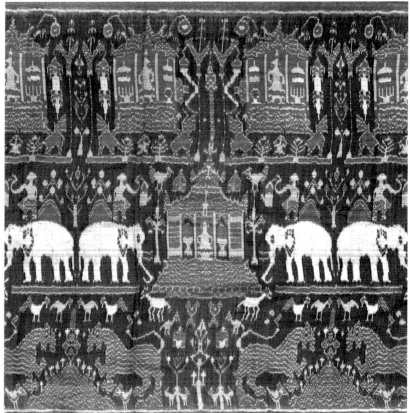

332

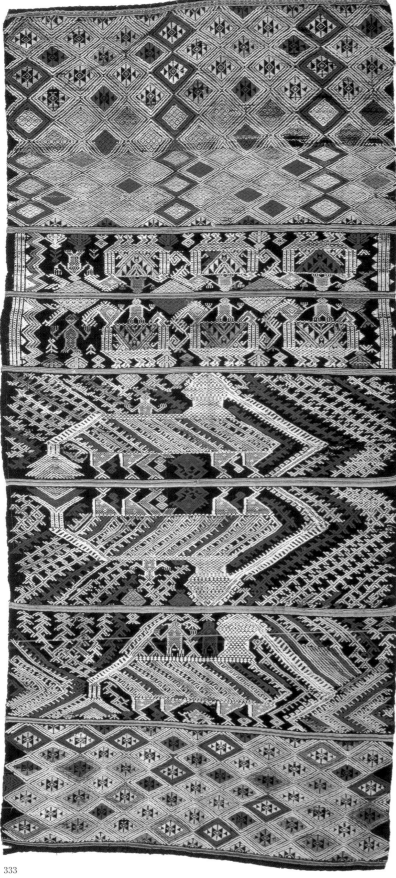

333

332 (detail)
pidan
ceremonial hanging; covering
Khmer people, Takeo province,
Cambodia
silk, natural dyes
weft ikat
85.0 x 191.0 cm
Musée de L'Homme, Paris 978.65.18

333
pha biang
ceremonial shawl
Tai Nuea people, Laos
silk, cotton, dyes
supplementary weft weave
67.0 x 148.5 cm
Australian National Gallery 1987.1825

Both these early twentieth-century
cloths from mainland Southeast Asia
feature elephant motifs. The *pidan*
contains some of the most realistic and
overtly Indic iconography found on any
Southeast Asian textiles. These cloths
are used as wall-hangings and ceiling-
cloths in Buddhist temples and
monasteries, and this particular
example was a canopy covering a
statue of the Buddha. They were
presented to temples and monasteries
to gain merit. *Pidan* are also
prominent in rites of passage, when
they are suspended in the house during
marriage celebrations, and used to
provide comfort and a contemplative
vision of the next world for the dying.
Many nineteenth- and twentieth-
century examples of these textiles
contain clear images of temple or
palace buildings, with cloisters,
curving roofs, balconies and pavilions,
often flanked by elephants. The
elephants flanking the central shrines
are depicted bearing a howdah with
the kneeling mahout clad in a *sampot*.
In the upper frieze a statue of a deity
appears within the shrines and stylized
birds hold lizards and snakes. The
lower band of motifs contains a variety
of animals including large creatures,
possibly tigers, flanking a mountain
shape.
On the Tai Nuea textile two bands
contain clear elephant motifs with
curling trunks and human passengers.
The largest motifs are also suggestive
of elephants although in a more
stylized manner, and human figures
also appear in howdahs on the backs of
these creatures. The figurative central
section of this cloth is bordered by
wide bands of diagonal diamond grids.

334 (detail)
geringsing petang desa cecempakan
ceremonial breastcloth, sacred textile
Balinese people, Tenganan, Bali,
Indonesia
handspun cotton, natural dyes
double ikat
176.0 x 61.0 cm
Australian National Gallery 1980.725

335 (detail)
kain cepuk; kamben cepuk
ceremonial cloth
Balinese people, Karangasem district,
Bali, Indonesia
handspun cotton, natural dyes
weft ikat
241.0 x 83.0 cm
Australian National Gallery 1984.1243

Although it is identified as the
frangipani flower (*cempaka*), this
geringsing design closely follows a
popular Indian trade cloth pattern. The
term, *petang desa*, indicates the width
of the fabric, calculated by the number
of bundles of warp ikat threads
required to be woven with weft ikat
threads. This same pattern
(*cecempaken*) also decorates narrower
geringsing cloths used for different
ceremonial purposes.
The double ikat resist technique is
only found in Southeast Asia in the
village of Tenganan in Bali. The
prestige of the *geringsing* can be
largely attributed to the exclusiveness
of Tenganan's production and the
mystique surrounding the very
complex processes that are entailed.
However, other textile artisans in
south Bali used very similar designs on
their own weft ikat textiles and some
of them appear to be direct copies of
geringsing patterns. In Plate 335, the
cempaka pattern also appears in weft
ikat (*bedbed*) using handspun cotton.
The dyes achieved from Morinda
citrifolia have produced brown tones
rather than the red shades of the
geringsing. This cloth is believed to
have been woven in the Puri Kanginan
of Amlapura (Karangasem).

336
Few Indian cloths have survived as
heirlooms in Borneo, and there is little
information on how those which were
imported into that island were used.
This early twentieth-century
photograph shows an Ot Danum man
at Teluk Julo wearing a loincloth
consisting of an Indian trade cloth (or
a European imitation) with a *patola*
design.

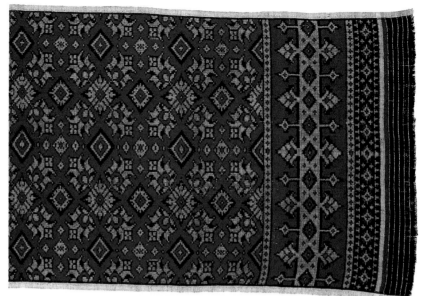

334

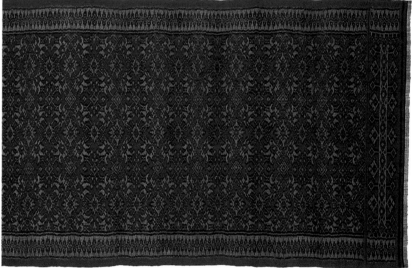

335

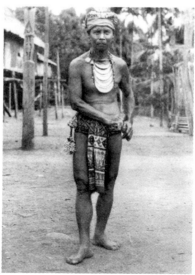

336

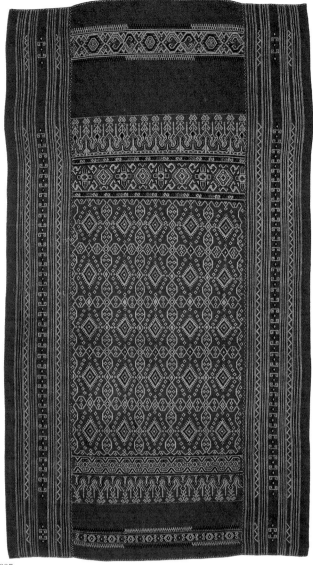

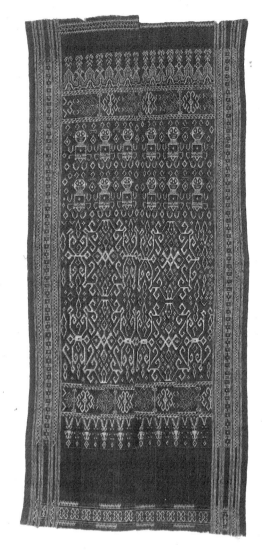

337

338

337
pua sungkit
ceremonial cloth
Iban people, Sarawak, Malaysia
handspun cotton, natural dyes
supplementary weft wrapping
182.0 x 103.0 cm
Australian National Gallery 1981.1100

338
pua sungkit
ceremonial cloth
Iban people, Sarawak, Malaysia
handspun cotton, natural dyes
supplementary weft wrapping
197.0 x 204.0 cm
Australian National Gallery 1982.2304

Instances of direct trade cloth
influence on Iban textiles are unusual,
although the pattern on Plate 337
closely follows a known Indian trade
cloth style. This design, however, is

known to the Iban as the horse mango
(*buah bunut*) surrounded by small
spots that represent the eyes of
worms (*mata ulat*). Trade cloth
influence on the other *pua sungkit*,
Plate 338, is not immediately evident.
The central field of the cloth contains
two bands of grinning spirit figures
(*Bong Midang* or *antu gerasi*)
combined with a broad area of
complex and seemingly confusing non-
figurative designs. However, within
the twists and turns of these hooks
and lozenges, it is possible to
distinguish the eight-pointed star
pattern associated with many trade
cloth designs. The minor motifs in the
border bands of both *pua* are identified
as the ceremonial seat-mats worn by
men (*tikar buret*) and dangerous roots
which protrude from the surface
(*plapak nyingkong*).

textiles were occasionally worn as costume and used in local appliqué, their designs were apparently too alien to become an important source of inspiration. However, trade textiles, along with other valuable heirlooms such as bronze gongs and Chinese porcelain plates and storage jars, have always been associated with prestige and power in many Dayak communities. At least two trade cloth patterns found on *patola* and on imitation *patola* cotton prints widely distributed throughout Southeast Asia have been used as the model for remarkable Iban designs. As far as Iban textiles are concerned, trade cloth influences are only evident on the patterns found on *pua sungkit*, the supplementary weft-wrapped textiles that are always associated with power in Iban ritual.

The finest foreign objects obtained by those Southeast Asians with direct access to the main trade routes did not always reach the remote and distant parts of the region because these goods were often controlled by coastal rulers who dominated trade with the hinterland. Inferior quality goods or locally made substitutes in the general style of the most valued imported commodities were made for inland or interregional trade. This may have been an incentive for the adoption of trade cloth designs on many locally produced textiles, particularly batik from Java's north coast.[87]

INDIAN TRADE TEXTILES AND SOUTHEAST ASIAN TEXTILE TECHNIQUES

Apart from the Indian contributions to materials and weaving already discussed in this chapter, certain other Southeast Asian textile techniques were strongly influenced by the Indian cloth trade. One of the most obvious is cloth-painting with pigments. Although painting on bark-cloth was a well-developed and ancient form of artistic expression, the themes found on Southeast Asian cloth-painting suggest that the influence of Indian iconography was the more important. The most elaborate cloth-paintings in Southeast Asia today are found in Bali, where this technique is still used to create pictorial hangings of various dimensions that are used to decorate temples and shrines. The Balinese do not follow the Indian cloth-painting techniques which make use of mordant dyeing,[88] but instead pigments are applied directly to the prepared surface of the cloth.[89] However, Hindu myths and legends are an important part of the subject matter of these paintings, and various examples of mordant-dyed cotton trade cloths from south India depicting battle scenes from the Ramayana legend have been found in Bali.

This particular type of trade cloth has also been located in central Sulawesi where large numbers of Indian cottons with a wide range of patterns and designs have become prominent among the heirlooms of the Toraja. Some of these inspired Toraja artisans to emulate the trade cloth patterns on their own textiles. The techniques of printing and painting were already practised by the Toraja on fine bark-cloth which they continue to make to the present day and these techniques were readily transferable to imported cotton cloth. Nevertheless, the Toraja painted *ma'a* are one of the few examples of the transition to woodblock printing occurring in Southeast Asia. In the southern Philippines a rare type of hand-painted or hand-drawn cloth has been recorded among the lowland peoples of the Lake Lanao region of

336,339

337,338

273

214

297

339
sapé manik
ceremonial jacket
Maloh people, west Kalimantan,
Indonesia
beads, shells, sequins, cotton
beadwork, appliqué
48.5 x 41.5 cm
Australian National Gallery
1985.1694a

kain manik
woman's ceremonial skirt
Maloh people, west Kalimantan,
Indonesia
beads, shells, sequins, cotton
beadwork, appliqué
58.0 x 42.0 cm
Australian National Gallery
1985.1694b

While it is still possible to distinguish the serpent (*naga*) and the mask (*udo*) patterns in the beadwork on these textiles, these motifs are part of the all-over patterning of decorative spirals. The *naga* and *udo'* motifs have been reduced to an elaborate hook and rhomb design and are no longer immediately apparent.

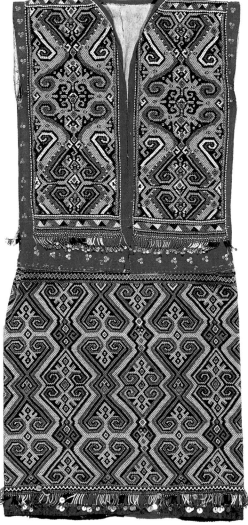

339

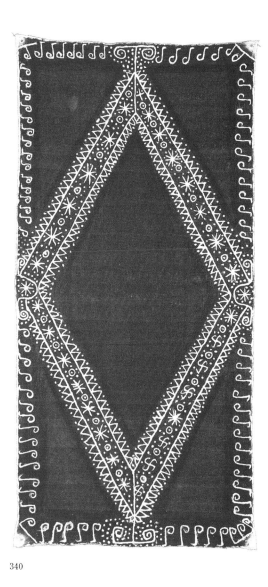

340

Mindanao.[90] These cloths are woven from abaca, the painting is executed in a rich black colour on a natural ground, and the designs appear to have developed directly from trade cloth models.

These remain isolated instances of the technique of painting and printing on cloth. The famed mordant painting and printing techniques of the Indian cottons never became established in Southeast Asia, despite evidence that Indian artisans familiar with the procedure lived in the trading quarters of the coastal centres of Southeast Asia.[91] In the case of batik, however, it is very likely that Indian methods did stimulate the development and expansion of the technique in Java where a simple form of paste-resist batik had already existed.

We know very little about the stages between these early forms of batik and those that we recognize today. In west Java, a paste-resist batik known as *kain simbut tulis*, evidently an ancient textile type, displays some of the characteristics that later developed on some central Javanese court designs (Veldhuisen-Djajasoebrata, 1985: 49–51). The diamond lozenge with a triangular zigzag edge appears on these cloths and may have been a forerunner of the flame-licked *modang* found on royal *dodot* and headcloths, while other stylized

340

16,279

340
kain simbut
ceremonial textile
Sundanese people, Rangkasbitung,
west Java, Indonesia
cotton, natural dyes
batik
Museum voor Land- en Volkenkunde,
Rotterdam 26131

Simple batik using a stiff glutinous rice-paste applied with a stick or finger was made in west Java. The design of these *kain simbut*, incorporating cosmic or magical motifs, was mapped out on the cloth by a group of ritually mature women (Veldhuisen-Djajasoebrata, 1984: 49, 51). The cloth seems to have been used at transition ceremonies, such as tooth-filings, births and circumcisions to protect the person from misfortune. Early twentieth century

This group of women in central Java are engaged in one of the most important stages of the batik process. They are applying molten wax as a resist to the surface of the cotton cloth with the *canting*, a pen-like tool used to draw precise and intricate patterns. The work is inherently time-consuming and high-quality batik requires a sure hand and a thorough knowledge of the traditional patterns. These complex batik techniques appear to have emerged independently in Java, although the origins of batik can be traced to earlier forms of wax- or paste-resist in other parts of Southeast Asia.

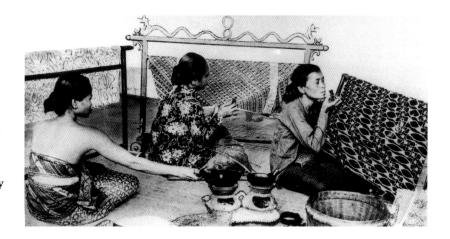

symbols may have developed into schematic batik patterns such as the *kawung* and *truntum*.[92] Some of the most famous designs displayed on central Javanese batik draw upon ancient Southeast Asian patterns which, as we have shown in the last chapter, can be seen on objects thousands of years old. For example, the diagonal interlocking spirals on which the *parang* designs are based, were used to decorate Metal Age bronze vessels and continue to appear on bark-cloth designs in the Pacific region.

Batik in central Java is used side by side with an ancient type of woven cotton cloth known as *lurik*, which is patterned in simple stripes and checks (Yogi, 1980; Geirnaert-Martin, 1983). According to the strict hierarchy of the court circles, certain batik patterns have traditionally been the preserve of the rulers. However, at the most sacred rituals concerned with the appeasement of spirits and the exorcism of evil, the fertility of the kingdom and the individual, and at times of death, it is the simple stitch-resist *kembangan* or woven *lurik* *110* cloth that are required, even when these ceremonies are performed within the court (Geirnaert-Martin, 1983). The divisions of rank and symbols of prestige displayed by central Javanese wax-resist batik, stand apart from these ancient and fundamental concerns of both nobility and peasantry. An apparently early form of wax-resist batik, still practised in Java on woven *lurik* fabric, contains many of the *116* simple dots and stripes that were once executed in rice-paste-resist (Heringa, 1985: 119), and other designs from Tuban on the north coast of Java appear to be derived from matting patterns.

Indian influence on the Javanese technique of batik seems to have been indirect. During the seventeenth and eighteenth centuries, locally produced substitutes for valuable Indian cloth were devised for Javanese use and as a trade commodity throughout the region. With the development of the unique and highly efficient *canting*, a pen with *341* a reservoir to hold the wax,[93] a period of expansion heralded the flowering of one of Southeast Asia's most famous textile traditions. One feature of Javanese batik cloth which gave it an advantage over Indian mordant-printed cotton, was that it was patterned on both surfaces, and it steadily supplanted Indian textiles in the regional textile trade.

The designs on Javanese batik — even those associated with the court circles of central Java's principalities — are a fascinating combination of influences derived from many different sources. The success of certain batik designs appears to have been strengthened by

the links that could be made with Hindu cosmology. However, many patterns were also inspired by the designs on some of the most popular Indian trade cloths. Since the development of hand-drawn batik seems to have been boosted by the presence of these Indian textiles, it is not surprising that trade cloth patterns became an important element in the batik of the north-coast towns which were established as the main production centres of batik cloth intended for trade.

The many sacred qualities of Southeast Asian textiles were not diminished by Indian influences. While in remote communities and at the level of the Southeast Asian village, textiles remained essential in the communication with ancestors and spirits, in the Indianized world of the courts of Southeast Asia their sacred powers and great beauty were also harnessed to enhance the position of the nobility. Although sumptuous gold and silk fabrics were generally not considered sacred, their finery demonstrated to the world the blessing of the gods and the might and wealth of the ruler. In contrast to these beautiful silk and gold textiles produced in the courts of the region, the exotic Indian imported cloths were established as paramount images of sacred and secular power.

The process of Indianization, like the passing on of trade goods, was by no means direct, and was often transmitted through Southeast Asian intermediaries. The indirect spread of Indian culture through regional trade, marriage alliances between Southeast Asian rulers, and the political dominance of certain powerful states over their neighbours contributed to the spread of Indic designs, motifs and patterns, and the display of these symbols in ceremonies. However, even where Hinduism and Buddhism have prevailed as dominant religions, regional styles have been responsible for distinctive artistic achievements. Though the impact of Indian ideas, techniques and materials, and the arrival of Indian trade cloth have been of crucial importance in the history of the region's textiles, Southeast Asians have still produced substantially different textiles from Indian imported cloth by using and adapting these foreign elements to enhance the quality and value of their own work.

The coming of Islam eventually brought to a close the Hindu-Buddhist era in the Malay peninsula and the Indonesian archipelago, although the strength of the traditions that had grown out of contact with Indian culture lived on. Despite the demise of the great Hindu-Buddhist kingdoms in the southern parts of the region, local adaptations of Indic custom and costume still remained visible throughout Southeast Asia. Islamic rulers in the region continued to manipulate these symbols of royal office. Upon their arrival on the Southeast Asian scene the Europeans also encouraged the display of the royal symbols of the great Indic period. Despite the stagnation of local royal authority in nineteenth-century Southeast Asia in the face of an increasingly powerful European colonial presence, the elaborate court ritual and regalia of that period provides a glimpse into an opulent Indianized world of the past.

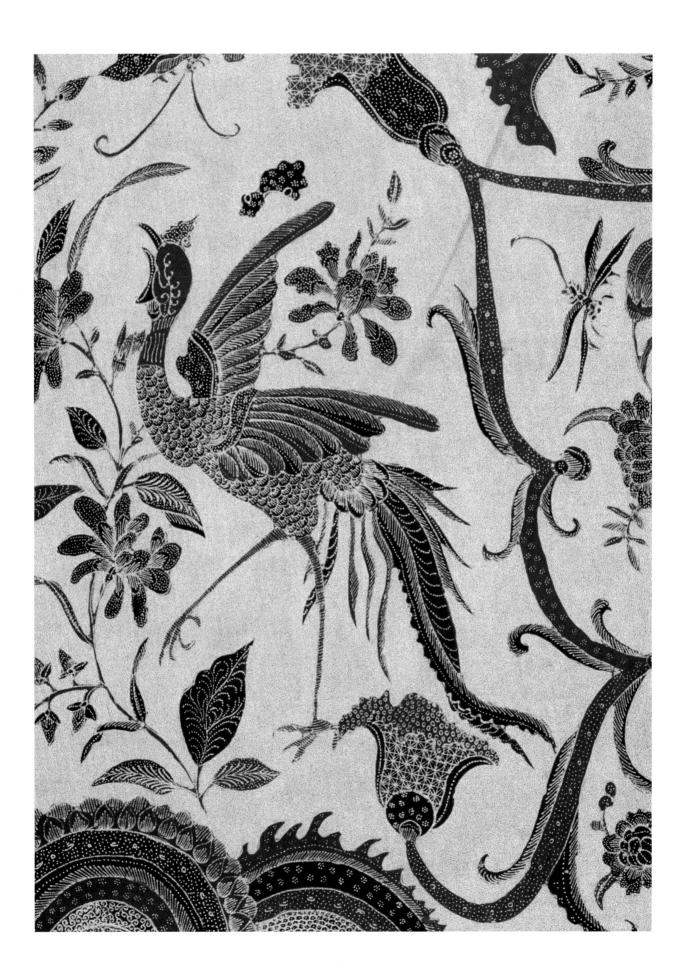

Chapter 4

CHINESE THEMES

The impact of Chinese culture on the art of Southeast Asia has often been underestimated or even ignored. In part, this may be due to the fact that Chinese influence did not result in impressive stone architectural complexes such as the Indianized monuments of Borobodur and Angkor which attracted the attention of archaeologists, epigraphers and Indologists eager to explore and interpret the spread of Indian culture beyond the subcontinent. Also significant are the complex social, economic and political tensions that have arisen from the establishment of Chinese communities throughout the region, especially in the last one hundred and fifty years. These tensions have occasionally flared into open conflicts in recent decades, and this has created an unfavourable climate in which to analyze the Chinese contribution to the shaping of Southeast Asian art and culture. Yet it is impossible to ignore the Chinese historical presence, in particular the extensive borders that southern China shares with much of mainland Southeast Asia, the existence of several ethnic groups inhabiting these border areas, and, in the past, the actual Chinese conquests of Southeast Asian territory.

Ceramics are one form of Chinese artistic expression to be widely acknowledged both within Southeast Asia and elsewhere, and recent research has shown that while indigenous Southeast Asian trade ceramics — the porcelain and stoneware produced in the kilns of Annam, Sukhothai and Sawankhalok — developed in their own specific local styles, they owe a great deal to the Chinese models that were traded into the region over many hundreds of years (Guy, 1986). Although we are gradually building up a picture of the technology and distribution patterns of this durable commodity, the simultaneous trade in Chinese silks to Southeast Asia and the historical dimensions of the Chinese contribution to textiles are subjects that have been almost totally ignored.[1]

A number of significant Chinese themes are central to the development of Southeast Asian textile art. These include the spread of certain aspects of an ancient Bronze Age culture; the historical importance of political and trading contacts between China and Southeast Asia, and the resulting impact of an influx into the region of major commodities, especially silk and ceramics; the indirect effects on Southeast Asia of the great interest in chinoiserie in Europe, Persia

342
The Chinese immigrants to Southeast Asia added another rich dimension to the region's ritual and regalia. This mid-nineteenth-century coloured lithograph of a Chinese priest in ornate robes in the grounds of a temple in Java, was published in W. L. Ritter, *Java: Tooneelen uit het Leven*, The Hague, 1855.

Opposite Detail of Plate 406

and Mughal India during the seventeenth and eighteenth centuries; and the impact of Chinese immigration into the region with the subsequent development of the Chinese communities of the Nanyang ('the Southern Ocean'). It is important to understand that we are not only considering the influences of Chinese culture on Southeast Asian textiles. We are taking into account the Chinese as an ethnic minority in the region and one that has made its own distinctive contribution to Southeast Asia's textile art, both influencing and being influenced by their adopted environment. 342

EARLY TECHNIQUES AND MATERIALS — A SHARED PAST?

The Southeast Asian Metal Age culture, Dong-Son, takes its name from archaeological sites in northern Vietnam, and refers in particular to a style of beautifully decorated bronze objects dating from approximately the seventh century BC.[2] The elements of the Dong-Son art style include many of those that are still prominent in the art of Southeast Asian textiles — rhombs, keys and spirals, and the depiction of human figures in frontal style. Some of these features were considered in Chapter 2. Objects in this style and of this period have been found in many parts of mainland Southeast Asia and the Indonesian archipelago, and as far east as New Guinea. Initially, Dong-Son culture was believed to have been heavily influenced by a Chinese culture of approximately the same period, the somewhat more elaborate Late Zhou style. However, the discoveries of the remarkable bronze culture of the Lake Dian district in the southern Chinese province of Yunnan has confirmed a distinctive artistic style with great affinities to Southeast Asia.

In the past, art historians and archaeologists argued that the spread of Dong-Son culture was the result of large waves of migrations, perhaps originally from Europe but certainly from China into mainland Southeast Asia and from there into the rest of the Southeast Asian region.[3] Recently, archaeologists have been more reserved in their support for this theory.[4] They argue instead that these migrations were limited in scale and that contact between existing cultures was the means of spreading the material objects and techniques associated with Metal Age culture. Moreover, recent archaeological finds in Thailand at Non Nok Tha and Ban Chiang have confirmed the great age of many of the motifs and patterns used to ornament objects including pottery and metal vessels, and the likelihood that these indigenous cultural developments occurred, particularly in mainland Southeast Asia, quite independently of China. The direct and early influence of Chinese styles on the development of Dong-Son and other Metal Age cultures of the region is not a sufficient explanation of the development of Southeast Asian art forms. However, many elements of Dong-Son style persist to the present day and both the Late Zhou period in China and the Dong-Son culture of mainland Southeast Asia may be considered the cultural precursors of many shared aspects of Chinese and Southeast Asian art.

Many of the ethnic groups of mainland Southeast Asia — for example, the Hmong of northern Thailand, the Tai Nuea of Laos and the Shan of northern Burma — share a common ancestry and culture with neighbouring peoples in southern China, in particular the min-

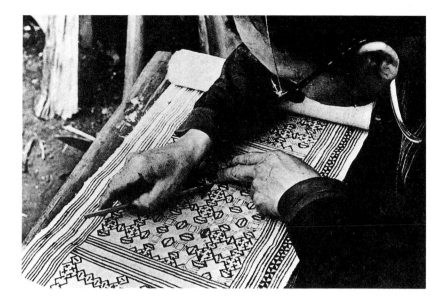

343
This Blue Hmong (Mong Njua) woman is applying wax to a length of hemp cloth. Although these skirts are also woven from cotton, the Hmong prefer to use the hemp yarn obtained from the Cannibas plant as the fabric woven from this bast fibre holds the fine pleats better than cotton cloth.

ority groups of the provinces of Yunnan, Giuzhou and Guangxi.[5] While historical circumstances and political borders now separate peoples with very similar material cultures, extensive migrations of these groups into Southeast Asia occurred until relatively recently (McKinnon, 1983: 328–9).[6]

Many ancient motifs found throughout the region should be seen not as a Chinese influence but as a substrata common to the textiles of Southeast Asia and the art of the Chinese. Some of the most basic Southeast Asian textile techniques and the decorative patterns that resulted were established before migrants moved from southern China in prehistoric times, as these peoples took with them not only a knowledge of agriculture and the domestication of animals but also the skills of weaving with a continuous warp and a backstrap loom. The foot-braced loom, now only found in isolated parts of Southeast Asia, was being used in southern China by non-Chinese (non-Han) peoples in the second century BC, although wooden weaving equipment from that area, like the wooden spindle-whorls of Southeast Asia, eventually disappeared without a trace.[7] This shared heritage may also have included techniques such as batik and supplementary weft weaving[8] both of which have an ancient history in the mountainous interior of mainland Southeast Asia among the Mien, Tai, Shan and Hmong.

Although batik is now clearly identified in Southeast Asia with the cloth of the Indianized world of Java, the technique may share the same ancient origins as those used by the peoples of southern China. The intricate hand-drawn batik of central Java using the *canting* seems to have been a relatively late development, probably in the seventeenth or eighteenth centuries. Less delicate but none the less striking forms of batik-resist dyeing were practised in several parts of Southeast Asia long before this flowering in Java occurred. The patterning on Hmong batik is still achieved by using a bamboo stick to apply the resist, a somewhat similar technique to those of several parts of the Indonesian archipelago until the beginning of the twentieth century. In central Sulawesi the Toraja, like the Hmong, used a wax-resist to create their huge ceremonial banners (van Nouhuys, 1925–6), while in west Java the Sundanese used a paste-

344
tia mong njua
woman's skirt
Mong Njua people, Laos; Thailand
hemp, cotton, silk, indigo, dyes
batik, appliqué, embroidery
140.0 x 80.0 cm
Australian National Gallery 1986.1244

The Hmong (or Miao) moved into
Southeast Asia from southern China
during recent periods of history. Their
costume includes pleated skirts (*tia*),
similar to the pleated aprons that are
part of the court dress of the Han
Chinese. The white batik designs on
their indigo-dyed hemp skirts continue
to display ancient geometric motifs,
which are a part of the shared cultural
heritage of both Chinese and
Southeast Asian peoples. The
technique of rice-paste-resist batik
(*nra cia*) has probably also been used
in the area for thousands of years. The
bold red, black and white diamond and
triangle border appliqué is a prominent
feature of many Southeast Asian
textiles, particularly on ceremonial
hangings. The skirt's border has
additional cross-stitch embroidery in
yellow, pink and white silk thread. The
ornamentation of cross-stitch, appliqué
and batik that are the characteristic
feature of the ceremonial costume of
the Blue or Green Hmong (Mong
Njua) together constitute *pa ndau*,
flowered cloth (M. Clark, personal
communication, 1989). These *pa ndau*
designs are said to distinguish the
living from the spirits (Gazzalo, 1986).

345 (detail)
pio puang; cawat cindako; topu baté
ceremonial banner; headcloth
Toraja people, central Sulawesi,
Indonesia
handspun cotton, natural dyes
batik, tie-dyeing
403.0 x 161.0 cm
Australian National Gallery 1981.1128

Simple wax-resist batik was also
practised in the mountains of Sulawesi
until at least the late nineteenth
century. This striking hanging is
formed from plain-dyed strips of red,
black and white locally woven
handspun cotton cloth interspersed
with simple batik panels. Across each
end is a simple triangular pattern in
tie-dyed spots. The schematic patterns
on this cloth repeat those found on
other Toraja art forms, such as wood
and bamboo carving, woven textiles
and beadwork.

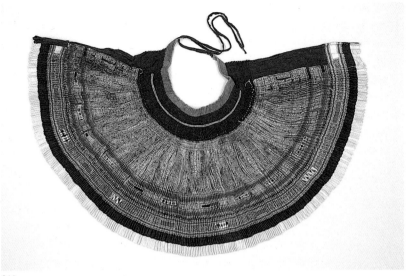

344

resist of rice pap for their *kain simbut*. Both these textiles were a *340*
significant element of ritual and were among the objects required at
rites of passage in these communities. The Manobo of Mindanao are
also said to have made trousers and jackets from abaca cloth pat-
terned by wax-resist.[9] All these early forms of Southeast Asian batik
were applied only to vegetable fibres such as hemp, abaca and cotton.
(In fact, the batik technique has rarely been applied to silk fabric in
Southeast Asia, the major exception being the so-called *lokcan* or
Rembang batiks made along the north coast of Java in the nineteenth
and early twentieth centuries for export to other parts of Southeast
Asia.)

Though it is unclear how the technique spread throughout
Southeast Asia, batik has an ancient history in southern China where
it is known as *laran* (Gittinger, 1985: 163–8). Archaeological finds of
batik in China date back to the Han dynasty (206 BC-AD 220) and
sophisticated batik made by wax-resist techniques had spread to
Japan from China by the eighth century.[10] Simple batik-resist
techniques may have been more widely used across Southeast Asia in
the past but eventually have given way to textiles with woven or
embroidered decoration.

In China and in some parts of Southeast Asia embroidery appears
to have surpassed decorative weaving techniques, particularly weft-
patterned styles, as a way of achieving spectacular display on fabrics.
In particular, the cross-stitch monochrome embroideries still made in
the mountain areas of southern China have an ancient history, and the
origin legends of the Mien tell of the first ancestral embroiderer who *346*
created the landscape with her needle and thread (Nabholz-Kartas-
choff, 1985: 160). Simple cross-stitch embroideries are also made in
neighbouring parts of Southeast Asia. Hmong batik, for instance, is *344,347*
enlivened with striking decorative stitch and patchwork appliqué,
although while bright silk embroidery has been used for centuries to
transform the basic indigo cotton or hemp fabric on skirts, pants and
head-dresses, the actual style of stitchwork applied has changed rela-
tively recently. The much older weaving-stitch has been replaced by
cross-stitch as a dominant technique only in the last fifty years (Lewis

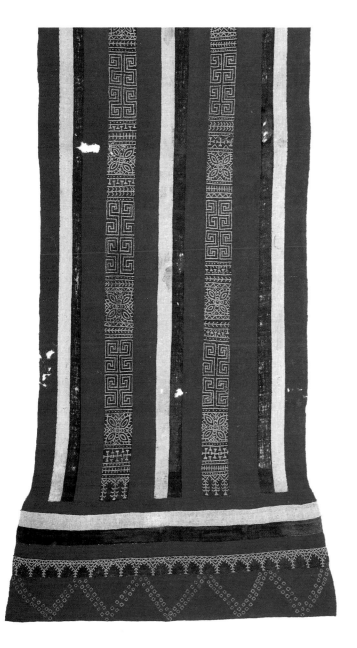

345

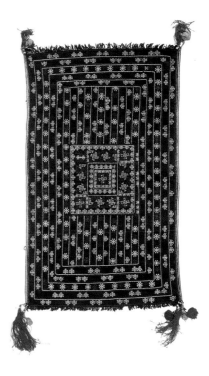

346

Mien women stitch their elaborate patterns into the back of the fabric, while the Hmong stitch on to the front.

One of the most important items on which embroidery appears is the bridal headcloth, which is worn over a large wooden frame (Nabholz-Kartaschoff, 1985: 160–1). As an indication of her female skills, it is traditionally embroidered by the bride herself to a prescribed design structure of linear rectangles filled with small stylized motifs, many of which display the influence of Han Chinese art, particularly through their adoption of Daoist beliefs and rituals. The flowers, fish and butterflies on Mien marriage garments have obvious Chinese origins and are selected for their appropriate symbolism: butterflies associated with joy and pairs of fish with marital happiness (Forsythe, 1984: 81).

Such hangings were displayed during the funerary rites of important leaders of the community, and were also worn as headcloths by prominent warriors. The earliest origins of the banner are suggested by its various names: *cawat cindako* (*cawat*, loincloth; *cindako*, bark-cloth) and *pio puang* (nobleman's loincloth). By the nineteenth century, however, the huge dimensions of this textile were no longer compatible with its use as a man's loincloth, although the particular long, narrow strips of cloth from which the hanging is composed are perhaps an indication of this original function. When it was used in the construction of the great Toraja symbolic tree or ladder to heaven, the *baté*, it was also known as *topu baté* (or *topu sabidan*).

346
............
bride's head-dress
Mien people, Laos; Thailand
handspun cotton, dyes
embroidery
79.0 x 49.0 cm
Australian National Gallery 1986.1245

Although the Hmong use multicoloured cross-stitch embroidery on garments, this technique is probably at its finest and most intricate on the indigo fabrics of the Mien or Yao people, also recent immigrants from southern China into mainland Southeast Asia. One difference in the embroidery technique of these two groups is the direction from which the stitches are applied:

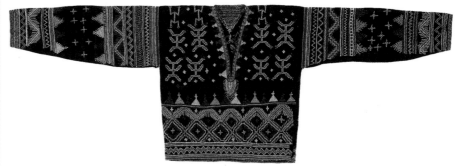

348

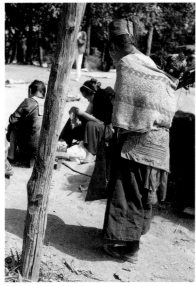

347

347
This group of White Hmong women in a village in north-west Thailand are using cross-stitch embroidery on hemp and cotton fabric to make collars, caps and baby-carriers for everyday wear. The mother with her child in a baby-carrier decorated with cross-stitch has covered its fine embroidered designs with a towel to avoid their being 'stolen' by the photographer, thus diminishing their talismanic powers. Babyhood is fraught with dangers in village Southeast Asia, and particular baby-carriers and other carrying-cloths display motifs or design structures intended to protect the baby from surrounding evil.

and Lewis, 1984: 138). The Bagobo, Kulaman, and Bilaan of the southern Philippines also lavishly cover the surfaces of their plain woven cloth with fine cross-stitch. *348*

CHINESE CONTACTS WITH THE NANYANG: THE SEA SILK ROUTE

Recorded contacts between the Han Chinese and the peoples of Southeast Asia, dating from as early as the beginning of the first millennium AD, reveal something of the nature of the formal cultural exchanges which took place between the imperial Chinese courts and the various principalities of Southeast Asia. Officials, emissaries and scholars were conduits through which gifts and tribute passed, and by the fifth century during the Liu Song dynasty, for instance, thirty-eight official missions were sent to various Southeast Asian principalities (Wang, 1958: 45). These contacts with China cover a period similar to that of Indian influence in the region, although the Chinese presence in Southeast Asia often had direct political and territorial designs. Vietnam, for example, was occupied by China from 111 BC until AD 979. Many other Southeast Asian regions, particularly those areas of the mainland bordering southern China, were directly affected by Chinese intervention, and in the thirteenth century the forces of the Mongol dynasty mounted military expeditions that ventured as far as Java. Throughout most of this period the kingdoms of Southeast Asia acknowledged the suzerainty of the Chinese emperor and emissaries from the rulers of Southeast Asian states brought tribute to the courts of the various Chinese emperors.

This earliest exchange of tribute and gifts was in extravagant luxury goods, 'strange and precious'.[11] Exotic curiosities and special forest and sea products from Southeast Asia included rhinoceros horn, elephant tusks, kingfisher feathers, pearls, scented woods, dyes and perfumes, tortoises, and, it was often recorded, cloth of woven cotton, hemp and other vegetable fibres. In return, the region's rulers *349* received the most desirable objects from China, silk and porcelain. Luxury textiles from China exported into the region for local rulers included silks, satins, and damasks. One prince of the Southeast Asian kingdom known to the Chinese as Ch'ih-t'u is recorded to have received five thousand rolls of the precious fabric (Wang, 1958: 66). Silk was thus a popular item even in the very earliest trade with Southeast Asia and for centuries the Chinese rulers appear to have successfully controlled the secrets of sericulture.[12] The long, overland trail stretching between China and Central Asia that has come to

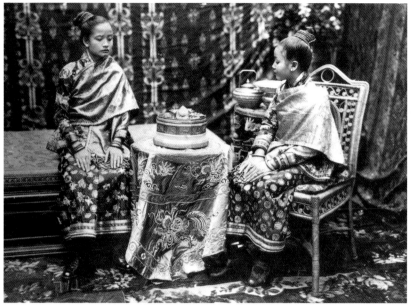

349

be known as the Silk Road, and the sea passage to India and the West
were the major routes by which luxury objects and artistic techniques
and styles were transferred. Early trade along the silk sea route
appears to have been largely in the hands of Persians, Arabs, Indians
and local Southeast Asian traders, such as the Malays. This may
explain the adoption throughout the Indonesian archipelago and the
Malay peninsula of the Indian word *sutra* for silk. *Jusi*, the term that is
widely used for silk in the northern Philippines, is clearly derived from
the Chinese *hu xi* (*hu hsi*).[13] Fourteenth-century Chinese documents
mention *xiyang sipu* (*hsi-yang-ssu pu*), a kind of cloth that was traded
for sandalwood in the south-eastern islands of the Indonesian archi-
pelago (Rockhill, 1915: 257–8).

The trade between China and the Middle East passed through
the ports of Southeast Asia where silk was also a treasured and desir-
able commodity, and one that was used in the region from a very early
period.[14] Chinese involvement in trading had increased substantially
by the beginning of the eleventh century AD, particularly from the
Yuan period (AD 1279–1368) onwards, and there was a significant
growth in the quantities of luxury Chinese trade items such as silk and
ceramics arriving in Southeast Asia. Some of this trade even began to
penetrate to the more remote parts of the region, and Chinese sailors
and merchants, especially from the southern coastal regions of China,
became major figures in the coastal regions of Southeast Asia.

By the arrival of the Europeans in the late fifteenth and early
sixteenth centuries, Chinese silk was already an established trade
commodity within the region. It was a prominent item among the
cargoes found by the Spaniards in their first encounters with Chinese
ships in the Philippines. A Spanish report from 1570 notes silk, both
woven and in skeins, gold thread, pieces of cotton cloth and, of course,
porcelain. The silk was stored with the most valuable goods carried in
the cabins (Lopez, 1976: 22). Throughout the following century silk
thread and silk cloth became important items for the trade to Europe
passing through ports such as Malacca on the Malay peninsula,

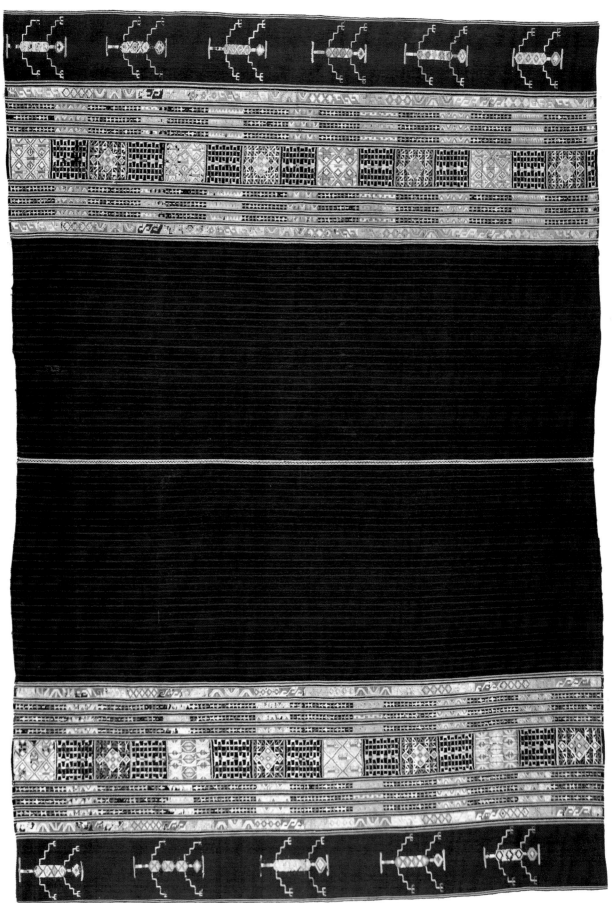

350

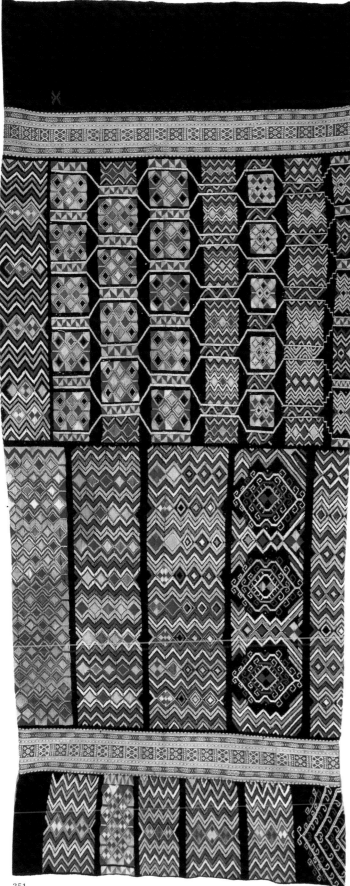

350
tais
woman's ceremonial skirt
Tetum people, south Belu region,
Timor, Indonesia
cotton, silk, dyes
supplementary weft wrapping
172.0 x 117.6 cm
Australian National Gallery 1984.610

351
tais
woman's ceremonial skirt
Tetum people, south Belu region,
Timor, Indonesia
cotton, gold thread, silk, natural dyes
supplementary weft wrapping,
supplementary warp weave
63.0 x 152.0 cm
Australian National Gallery 1984.1104

Even apparently remote islands of the
Indonesian archipelago were visited by
foreign traders and the large island of
Timor was renowned for fragrant
white sandalwood, a commodity that
was highly valued by the Chinese. The
Tetum people of the Belu domain were
especially active in this trade. Silk and
gold thread never became major raw
materials in Timor, even on the
textiles used by traditional rulers.
However, these materials, particularly
silk thread (generally known as *letros*)
were occasionally used on textiles
made by the supplementary weft
wrapping technique (*buna*) to produce
the striking, brightly coloured surface
patterns that are frequently mistaken
for embroidery. Textiles embellished
with this decorative technique were
usually reserved for the families of
local rulers or ritual warriors. Both
these cylindrical ceremonial skirts are
formed from two panels of handspun
cotton stripes with reversible *buna*
patterns in vegetable-dyed wefts. Both
textiles display the stylized
anthropomorphic or reptile motifs and
schematic patterning typical of
Timorese textiles.

351

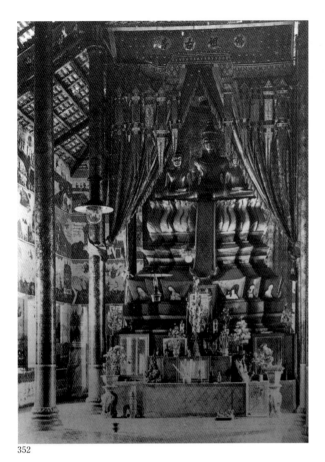

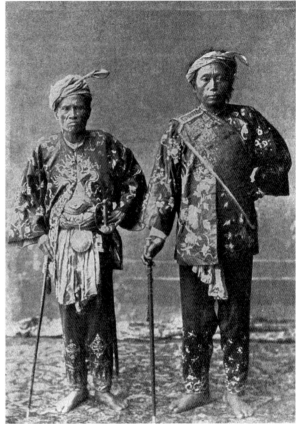

352

353

An early twentieth-century photograph
in a Cambodian temple, Vat Bathay, in
the province of Kompong Cham,
showing textiles being used as flags,
curtains and altar-cloths. The valance,
in fact, displays Chinese characters.

353
The extent to which Chinese fabrics
and designs were admired in the
Islamic principalities of Mindanao and
the Sulu archipelago can be judged by
the lavishly embroidered Chinese
jackets worn by local chieftains. This
photograph was taken in Zamboango,
Mindanao, around the turn of the
century. These two men combine the
jackets with headcloths, sashes and
long trousers embellished with
embroidered cuffs. Similar garments
are also part of formal ceremonial
costume in the Malay courts of
Borneo, Sumatra and the Malay
peninsula.

Banten and Batavia in Java, and Manila in Luzon, and it is probable
that some of those Chinese silks, like the Indian *palampore* mordant-
painted coverings and hangings destined for European markets, also
found their way into the treasure chests of Southeast Asia.

Unlike the Indian trade textiles from this period that have often
survived as local Southeast Asian heirlooms, few old examples of silk
fabrics traded from China still exist in the region. The rarity of extant
examples of Chinese silk is difficult to explain when compared with
the large numbers of spectacular and equally perishable silk *patola*
that have been found. However, as we have already noted, in many
parts of Southeast Asia trade textiles with elaborate patterns or dra-
matic iconography such as the *patola* were not always worn as cloth-
ing but were reserved for use in ceremonies and rituals, and then
carefully stored away. While records indicate that pictorial banners of
Chinese cloth were used in Buddhist ceremonies in Thailand as early
as the fourteenth century (Wray et al, 1972: 131), it seems that most
of the Chinese silk, like the vast bulk of the Indian monochrome or
striped textiles, was used to fashion articles of clothing which steadily
wore out and disappeared.[15]

There are, however, some notable exceptions, and elaborately
embroidered Chinese jackets and coats are evident in many parts of
Southeast Asia where Chinese trade has been significant. The central
motif emblazoned on many of these jackets is a huge dragon, one of
the most spectacular symbols in Chinese textile art. This design also
appealed to Southeast Asians since similar serpentine creatures were
already a prominent part of indigenous myth and legend. At the begin-

ning of the fifteenth century, the emperor of China sent the king of Malacca suits of clothes embroidered with dragons (Winstedt, 1925: 71–2). Another visitor to the Ming court, a ruler of Sulu, was presented with a robe embroidered with golden snakes, another embroidered with dragons and a third decorated with *qilin* dog-lions (Groeneveldt, 1877: 104). In addition, he received five hundred pieces of plain and patterned silk, and two hundred strings of Chinese coinage. The items of apparel became an important part of a ruler's costume in the Sulu archipelago and Mindanao in the southern Philippines. Chinese textiles, porcelain and metal were traded for local Thai products such as sappanwood and pepper for many centuries, and Chinese silks are also evident amongst the many imported heirloom cloths of the Thai court, although surviving examples seem to be relatively recent. During the nineteenth century at least, the pleated breast-sash (*sabai*) and the skirtcloth (*pha nung*) were often made from Chinese patterned silk brocade (Chira Chongkol, 1982: 121–3).

As well as the imported Chinese silks, local Southeast Asian sericulture with the potential to produce large quantities of thread for weaving also became firmly established from early times. On Java, for instance, by the Song dynasty, Chinese travellers noted that people were cultivating and weaving their own silk (Groeneveldt, 1877: 16, 19). In particular, the northern mainland principalities became renowned for textiles woven from locally cultivated silk, and the rulers of Southeast Asian trade centres such as Ayutthaya appear to have preferred imported weft ikat fabrics from Cambodia, and gold and silk brocades from the southern Patani region to silk fabrics from either India or China (*Old Textiles of Thailand*, 1979).

CHINESE TRADE OBJECTS AND SOUTHEAST ASIAN TEXTILES

Although early examples of the Chinese trade in silk are relatively rare in Southeast Asia, other Chinese trade goods have survived to the present day. Among the most important items traded in large quantities over the centuries was Chinese porcelain, and it has become one of the most highly valued heirlooms of Southeast Asian peoples. Shards of glazed earthenware objects have been found in burial sites in insular Southeast Asia dating from as early as the Eastern Han period of AD 25–220 (Guy, 1986: 2). In the form of plates, urns, tiles, pots, dishes, lidded boxes and decorative figurines, porcelain became a principal symbol of wealth, and consequently, an essential feature of funerals, marriage arrangements and other ceremonial occasions. Local Southeast Asian potteries also flourished in a number of locations including Annam, Thailand and even coastal Borneo, some under Chinese tutelage.[16] Like the Indian textiles made specifically for trade, the style and ornamentation of this porcelain were often tailored to meet market demands.[17] However, the surface decoration on some of these porcelain objects also provided Southeast Asian textile artisans with imaginative ideas to use as motifs on their own textiles. Ceramic patterns presented a range of Chinese animal motifs drawn from both the natural and the mythical world, including dragons, birds and fish, that were obviously intrinsically attractive to Southeast Asian weavers. Their appearance on textiles also symbolized wealth and access to prestige trade goods such as ceramics.

354

354

............

mat
Ot Danum people, central Kalimantan,
Indonesia
rattan, natural dyes
interlacing
181.0 x 112.0 cm
Australian National Gallery 1985.1741

This nineteenth-century ceremonial
mat is packed with sacred symbols. A
zigzag water serpent with smaller fish
motifs is found in the centre and small
figures, possibly dogs or tigers, across
one end. The cosmic tree on the
mountain is filled with images of
snakes, scorpions and ceremonial
storage jars and plates. In one corner,
a symbolic tree appears as a pole hung
with skulls, gongs and banners.
Large Chinese storage jars, known as
martavan throughout Southeast Asia,
are especially popular among the
Dayak peoples of Borneo. Chinese
porcelain — especially plates and
storage jars — and precious textiles
are among the very few valuable items
that are carried with great difficulty
when a Dayak community moves to
better hunting or farming lands. These
items are displayed and used during

occasions of ceremony and ritual, and
large jars are often filled with rice
wine as part of the festivities. Many
martavan are decorated with raised
dragon motifs around the vessel's
circumference, and this has almost
certainly contributed to their
popularity since similar creatures
(*nabau* and *naga*) have a prominent
place in Borneo mythology and are
also found on many locally made
ceremonial objects including mats and
textiles.

355
Chinese coins are attached to the
frame used for tying the threads to
produce the pattern for the sacred
double ikat *geringsing* in the village of
Tenganan in Bali. The coins are part
of the offerings made to appease and
repel troublesome spirits who might
otherwise disturb the creation of an
important ritual textile.

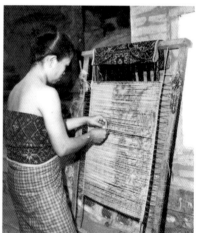

355

Along with porcelain and Chinese silks and embroideries, other non-textile objects were also treasured and these provided an important source of design on textiles and other regional arts. Carved furniture and gold- and silver-work bearing prominent Chinese motifs and designs and made by Chinese artisans, fell into the same category of prestige items. The lacquer-work and carving of south Sumatra and Bali reveal this Chinese influence, while the gold-and silver-work of the Malay courts was often the work of Chinese smiths. At least during the nineteenth century, some of these objects were made in the region by immigrant Chinese artisans.

One unusual but important by-product of Chinese commercial activity in the region was the arrival of surprisingly large numbers of Chinese coins and tokens which continued to circulate freely through Southeast Asian trade. By the Song period the Imperial court was so concerned about the drain of coinage from China through trade that laws were enacted to prohibit the practice (Guy, 1986: 14) and attempts were made to encourage barter trade using other items instead, especially various types of silk. However, these measures failed to halt the flow and quantities of Chinese coinage continued to arrive in Southeast Asia, and were still being imported during the Qing dynasty. While apparently of little intrinsic value, Chinese lead and brass coins with a central square hole (widely known throughout the Indonesian archipelago as *kepeng*),[18] became imbued with magic significance and have been widely used to adorn many sacred objects, including textiles.

Kepeng are especially popular in Bali and Lombok.[19] Painted curtains and hangings have often been suspended from Chinese coins and the Balinese interlace them to create one special form of the shrine and temple-hanging known as *lamak*. *Kepeng* are also used to construct various religious effigies, including anthropomorphic fertility figures (*cili*) and the symbols of material wealth known as *rambut* or *rabut sedana*.[20]

Chinese coins used in Bali and Lombok also have special relevance to textiles and textile-making. Both Balinese and Sasak weavers make offerings of *kepeng*, along with other items such as betel-nut and rice, to seek protection during the weaving of important ritual textiles. Heavy strands of these coins are often threaded on to the long warp fringe of certain Sasak textiles, the magic *kekombong* or *umbaq*, and some examples of these cloths have been found to contain over a thousand coins. The *kepeng* are believed to guard and preserve the supernatural powers of these sacred textiles (Damste, 1923: 176).[21]

While the notion of coins as charms and sacred talismans is implicit in their use in Bali and Lombok, their attachment to the edges of ceremonial jackets and skirts, and to bags and headcloths, as well as their use in ritual in other areas also draws on the protective powers coins are believed to possess. Coins also cover the elaborate headdresses of Akha women and the turbans of the Lahu in mainland Southeast Asia as a form of ostentatious display of wealth. On certain north-coast Javanese batik designs, especially those which are used by the Chinese community, a beribboned coin also appears as one of the Eight Treasures or Eight Ordinary Symbols, an emblem of wealth and prosperity.[22]

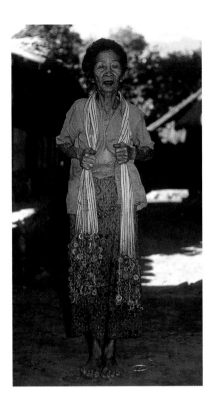

356
On Lombok, the Sasak attach Chinese coins to important cloths as talismans. This elderly woman wears a simple striped *umbaq kombong* around her shoulders, each end weighed down with heavy strands of coins threaded on to the fringe. These simple striped cloths are also important as prophylactics and cures at times of illness or misfortune.

355

356

THE APPEAL OF CHINESE COURT COSTUME: SILK AND GOLD EMBROIDERY

With greater proximity, a shared border and frequent political intervention, China's involvement with much of mainland Southeast Asia has been an especially significant factor in its history, and Chinese cultural influences have been more penetrating there than elsewhere in the region. Consequently, the traditional costume of many ethnic groups in mainland Southeast Asia has been strongly influenced by the form and style of Chinese dress, and there is some evidence in myth and legend that certain types of clothing are attributable to ancient Chinese influence.[23] The shape and decoration of gowns, coats and jackets, moreover, are remarkably similar to that of the formal court costume associated with the officials of the Imperial Chinese court.

The pleated skirts of the Hmong resemble the formal pleated aprons of the Chinese courts. Many jackets of the Mien, Lisu and Lahu, with high collars and distinctive cross-over fastenings on one shoulder, are simple versions of the elaborate embroidered coats worn by Chinese officials, while jackets worn by both Mien and Hmong men and women display decorative squares resembling the badges that were embroidered on the coats of Mandarin officials as an insignia of rank (Adams, 1974a: 58).[24] The paraphernalia used by the Mien priest in Daoist rituals combines both locally made cross-stitch embroideries and Qing gold thread embroidered costumes.

Elsewhere in Southeast Asia, the influence of Chinese court costume found its way into the region through the introduction of Chinese women as concubines and marriage partners for the royal families of Southeast Asian kingdoms and principalities. The emissaries from Southeast Asia who carried tribute and acknowledgements of Chinese suzerainty always returned from their arduous journeys to the Middle Kingdom with reciprocal gifts from the Chinese emperor. On occasions these gifts were apparently accompanied by 'Chinese princesses' sent to please the rulers of the Southeast Asian states,

344

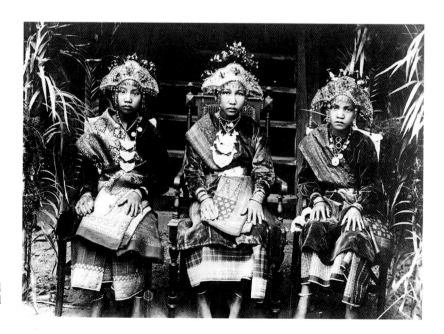

357
Three young dancers from the Komering district south of Palembang in full ceremonial costume — long velvet tunics, richly woven gold thread brocade skirts and shoulder-sashes and gold ornamented head-dresses

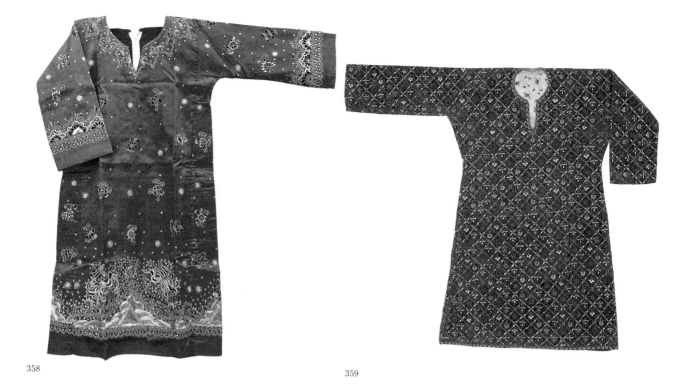

358

359

and many legends and court chronicles record these unions between local rulers and Chinese concubines.[25] In the case of at least one principality, the south Sumatran sultanate of Palembang, these patterns of alliance have continued into recent times. The Palembang royal family has traditionally received female marriage partners from a long established and economically powerful community of Chinese on the island of Bangka,[26] and this has contributed greatly to the Chinese character of many south Sumatran art forms including woodcarving, lacquer-work and costume.

These patterns of intermarriage between Southeast Asian ruling houses and Chinese women introduced various elements of Chinese art and culture into the courts of the region. Of particular relevance to the development of indigenous textile traditions are the silk and gold embroidered coats and tunics, slippers, collars and ceremonial headdresses that were part of Chinese ceremonial dress. Throughout Southeast Asia, formal court costume began to exhibit many of these Chinese influences.

357,358
359
In the Malay courts of coastal Southeast Asia, women began to wear either the *baju kurung*, a long collarless closed shirt with a slit neck-opening, or the *kebaya panjang*, a long gown opening at the front. While supplementary weft gold thread brocade cloth was sometimes used for both these styles, in some Malay areas, such as Palembang, the woman's tunic was also made of richly embroidered velvet. The motifs usually repeated the small grid patterns prominent on woven fabric, but the technique of embroidery and many of the patterns on these tunics were influenced by the embroidered coats that are still worn as wedding attire by the Straits Chinese.

360,361
One of the most prominent features of Southeast Asian aristocratic ceremonial costume, especially the dress of court dancers, is a range of spectacular scalloped collars. These appear to be directly

358
baju kurung
woman's tunic
Minangkabau people, Naras, west Sumatra, Indonesia
satin, silk, gold thread
embroidery, couching

359
baju kurung
woman's ceremonial tunic
Malay people, Palembang region, south Sumatra, Indonesia
velvet, silk, gold thread, sequins
embroidery, couching
133.0 x 95.0 cm
Australian National Gallery 1989.1865

Embroidered Qing court robes have influenced the structure of certain Southeast Asian garments and the motifs they display. The form and decoration of Chinese costumes have been admired in various parts of the archipelago, particularly in Islamic areas, and these elements have been reworked to create local tunics. The rose-pink tunic follows the Chinese design very closely and was worn by brides in coastal west Sumatra in the 1970s. The green velvet tunic worn by court dancers in the Palembang region dates from the nineteenth century. Its design in gold thread and bright silk is a simple grid of flowers, possibly also influenced by Mughal-style fabric. It is lined with European printed cotton from the same period.

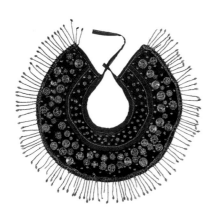

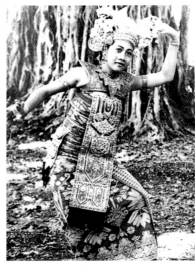

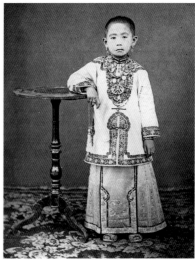

360
lengkung léhér
ceremonial collar
Malay people, south Sumatra,
Indonesia
cloth, cotton, gold alloy ornaments
appliqué
44.0 x 48.0 cm
Australian National Gallery 1984.1992

This ceremonial collar is worn tied
around the neck by Palembang brides
and court dancers. It is composed of a
simple round green ring of felt fringed
with light metal chains. A roughly
sewn red trim appears to have been
added later. Scattered randomly
among the smooth studs and lotus
buds are ornamental gold alloy
roundels containing fish, the crane and
the phoenix, bats, butterflies, stars and
floral shapes. Other metal studs are
shaped like jewels. The ornaments on
these collars were made by immigrant
Chinese artisans and a complete set of
symbols was not always included.
However, selected emblems convey
suitable good wishes on occasions such
as wedding ceremonies. The exact
Chinese origins and meaning of these
symbols are probably not understood
by either the Peranakan Chinese or
Malays who wear such costume. Since
similar items are used in Malacca for
ceremonial costume (Ho, 1984: 87)
and as part of the royal regalia of the
Sultan of Perak (Sheppard, 1972: 23),
these metallic ornaments may have
originated on the Malay peninsula
where it seems likely that collars on
costumes are also a reflection of the
historical presence of the 'Chinese
bride' in the Malay courts.

361
A Balinese dancer wearing an
embroidered and cut leather collar
(*sesimping*), a sash and a boldly
patterned supplementary weft
skirtcloth. An early twentieth-century
photograph from a family album

361

362

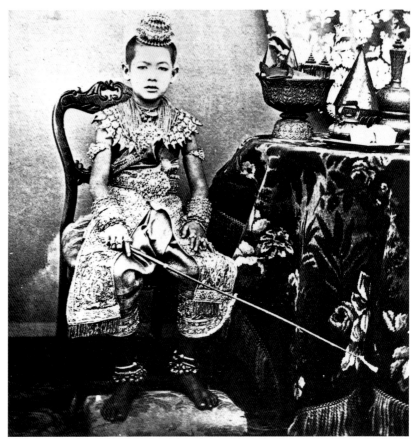

363

362
A child from an immigrant Chinese
family at Probolinggo in east Java in
1913 wearing embroidered garments,
including the scalloped collar (*yün
jian*)

363
A young Thai prince photographed in
1898 in central Thailand wearing an
embroidered collar and sash. The
lobes of the collar, which form peaked
shoulders in Thai royal and theatrical
costume, are suggestive of the
intricate metal bands worn on the
upper arm of courtiers in earlier
times.

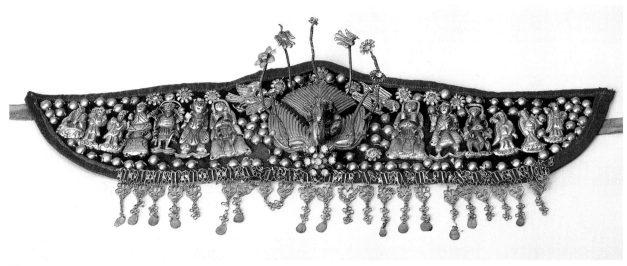

365

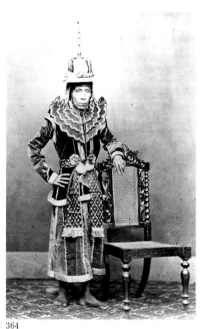

364

364
An elderly Burmese official
photographed in the year 1878
wearing court uniform with a tiered
and peaked cloud collar. The tiered
collars and skirt panels are also
formed into upturned curves, usually
associated with deities and royalty
(Lowry, 1974: Pl. 42).

365
pak sian
head-dress
Malay people, Palembang region, south
Sumatra, Indonesia
cotton, dyes, gold and copper alloy
appliqué
13.0 x 64.0 cm
Australian National Gallery 1984.1993

Head-dresses of this type are used by
court dancers and brides in south
Sumatra and Lampung, and by brides
in the Baba Chinese communities of
Malacca and Singapore. Similar types
of head-dresses were also worn in Java
by boys at circumcision ceremonies.
In most cases the gold alloy trinkets
are arranged around a central bird or
dragon figure, often without a rider.
Pak sian, the name used by the Baba
Chinese of the Malay peninsula and
Singapore for this head-dress, derives
from the gold figures of the Eight
Immortals (*Ba xian*), the legendary
figures of Daoist religion, whose
particular emblems indicate the special
powers or secrets for which they are
revered.
This example comes from the
Palembang region of south Sumatra
and contains a total of thirteen figures
in two distinct styles, the
amalgamation of two incomplete sets
of deities. The focus is on glittering
decoration rather than philosophical
accuracy. One group of six Immortals
are slightly smaller and more finely
wrought; the other group of seven
characters have been rather crudely
fashioned from strips of rolled gold.
The set of six, in Chinese style,
represent from the right, He Xiangu
(the woman with the lotus), Cao Guojiu
(with the castanets), and Lü Dongbin
(bearing a sword behind), and from the
left, Confucius (?) as a seated bearded

sage, Lan Caihe (with a basket of
flowers) and Zhongli Chuan (holding
the fan with which he can revive the
dead).
The other set of larger figures are
difficult to identify as some of their
characteristic emblems are now
missing. The female clothing of the
figure on the far left of this group
suggests it may also be He Xiangu.
Some of the figures in this set have
unusual costume reminiscent of
European pantaloons and cloaks. The
Eight Immortals are often
accompanied, as in this case, by the
God of Longevity depicted as an old
man mounted on a crane. This central
image appears to have been the work
of the same smith who crafted the set
of seven larger Immortals. The crane
has been rendered in a typical
Southeast Asian manner, more like the
familiar fantailed *garuda* or *sari
manok*, and appears with an ornament
dangling in its beak (*muncong itek*).
Other ornaments on this head-dress
include flowers and birds on delicate
springs (*sunting-sunting*) which
respond to the wearer's every
movement. The ornaments are
attached to green felt, and the red
border cloth and intricate chain fringe
appear to have been a later addition.

This funeral bier in Cambodia is completely encircled with a Chinese-style embroidered and couched valance. The sarcophagus itself has pigment-painted scenes around the top. The sculptures at each end confirm that the transition symbols of a horned *naga* or dragon-boat are appropriate at funerals.

related to the *yün jian* cloud collars, a feature of Chinese court dress since the Tang dynasty (Rawson, 1984: 132).[27] In Southeast Asia, these breast and collar pieces are embellished with gold and silver ornaments, embroidery or gold leaf gluework and are often an extension or consolidation of Indianized forms of jewellery.[28]

362,363,364

The gold and silver images that are sewn to these collars, especially in many parts of the Malay peninsula, Sumatra and Java, are the products of Chinese influence and craftsmanship. In keeping with the expanding wealth of the region, there appears to have been an increasing number of Chinese gold- and silversmiths working in these parts of Southeast Asia throughout the nineteenth century. Many of these decorative collars, for instance the south Sumatran examples, are not only embroidered with silk, metallic thread and sequins; some are also covered with silver and gold ornaments. Although usually composed of a cheaper alloy — gilt silver or low-grade gold with a high concentration of copper — many of these ornaments have great charm. In keeping with the desired Chinese style, a red tint has usually been achieved by coating the surface of the ornaments with cinnabar.

14,360

Other items of court costume and royal paraphernalia commonly found in Southeast Asia may also have been the products of Chinese artisans working in the region (Ho, 1984). These include decorative instruments such as silver earpicks and tools for beautification often attached like jewellery to chains and cloth pouches. These pouches were another version of the betel-nut container, and consisted of a square of exotic material (often Indian trade cloth or imported silk). The corners were usually caught together with silver or ivory points or rings to which the toiletry tools were attached. Other metal objects made by Chinese craftsmen include silver betel-nut containers, decorative silver end-plates for cushions and bolsters, silver or gold belt buckles, and various items of jewellery.

357,365

In present-day Southeast Asia sumptuous silk embroideries couched in gold thread are the most notable Chinese fabrics that are still widely used and highly valued.[29] These textiles include elaborate formal costume worn on ceremonial occasions and ornate religious

and ceremonial hangings used in homes, shrines and temples. The Chinese techniques of raised silk and gold thread couching (stumpwork) were at their most elaborate and ostentatious under the Qing emperors during the eighteenth and nineteenth centuries, and during this period large numbers of these Chinese costumes and ceremonial hangings, produced by artisans back in China, were imported into Southeast Asia by wealthy Chinese merchants and immigrants for use by ethnic Chinese throughout the region. Many of these textiles are still evident in Southeast Asia today, especially in the coastal towns of Java, Sumatra, Borneo and the Malay peninsula.

In addition to their use within the circle of the local Chinese communities, it is clear that these Chinese embroideries have had an important impact throughout Southeast Asia upon certain textiles made by the indigenous peoples. Early European travellers to Southeast Asia reported evidence of expertise in embroidery using Chinese gold and silver thread (Marsden, 1783: 148), and present-day weavers and embroiderers in many parts of Southeast Asia can recall that the best quality gold thread was originally imported from China. The influence of this couching and embroidery has been strongest and most enduring in the coastal sultanates of Sumatra and the Malay peninsula where the sumptuousness of the decorative finery for ceremonial occasions indicated each court's prosperity. Embroidered ceremonial objects include decorated boxes used to carry betel-nut, and the embroidered squares used at ceremonies to cover offerings and ritual gifts. At the Malay courts such embroidered cloths are known as *tetampan* and have traditionally covered the raja's bowl and the shoulders of royal attendants (Winstedt, 1925: 71).[30] Two-and three-dimensional embroidery on velvet continues to be associated with the states of Johor, Selangor, Pahang, Negri Sembilan and Perak. (Significantly, the art of embroidery is not as prominent in the renowned weaving centres of Kelantan and Terengganu.) While predominantly used to add lustre to hangings, cushion-ends, mats, and betel-nut boxes in the Malay wedding room, gold thread and silk embroidery has also been used to embellish Malay clothing. The Malay chronicles record instances of legendary heroes wearing 'shirts with thousands of mirrors at the waist and hundreds of mirrors at the edge', and 'bejewelled tunics'.[31]

As we have observed earlier, the use of textiles as ceremonial hangings for festive and religious purposes was evident in Southeast Asia long before the influence of foreign textiles became apparent. Local customs dictated the display of fine textiles in honour of the gods and ancestors and as a way of demonstrating a family's wealth and status. However, the Chinese embroidered and couched textiles in the form of temple- and altar-hangings, banners, and bridal-bed and wall decorations appear to have inspired certain types of elaborate embroidered hangings used for weddings, circumcisions and other ceremonial occasions by the Acehnese, the Minangkabau, and the various Malay communities on both sides of the Straits of Malacca and the Borneo Malay courts of Pontianak and Kutei.[32] Although the decorative styles of the embroidered hangings that make up the ceremonial reception room (*pelaminan*) differ slightly between Malay communities, these textiles share many common features. Stitchwork motifs including vases of flowers, foliage and birds are popular images on these textiles in the Malay peninsula and Sumatra, while an appliqué of mirrors and mica fragments has also been a prominent

366

358,359, 367

368,369, 371

372,373

352,366

20,28,370

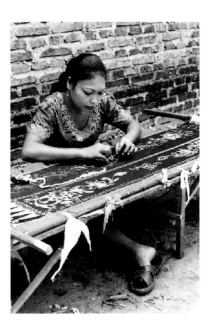

367
Embroidery frames at a coastal village near Naras in west Sumatra are used to create shawls and tunics for ceremonial dress, particularly bridal wear. Gold thread is laid in patterns on the upper surface of the satin fabric and couched down with tiny stitches.

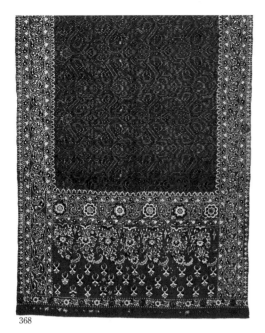

368

368 (detail)
kain limar
ceremonial shouldercloth; sash
Malay people, Palembang region, south
Sumatra, Indonesia
silk, natural dyes, gold thread, sequins
weft ikat, embroidery, appliqué
193.0 x 84.5 cm
Australian National Gallery 1981.1119

369
kain nyulam
ceremonial shouldercloth; sash
Malay people, Palembang region, south
Sumatra, Indonesia
silk, gold thread, sequins
embroidery, stitch-resist dyeing
83.5 x 190.0 cm
Australian National Gallery 1989.1495

Embroidered patterns add richness to
these silk sashes. Like the gold leaf
gluework that is also used to decorate
cloth in south Sumatra, embroidery
(*sulam*) appears to be a quicker and
cheaper way of embellishing a festive
garment than the woven
supplementary gold thread patterns
that usually provide the borders for
kain limar and which require the use
of large numbers of shed-sticks to set
up the complex pattern for weaving.
While not frequently used on weft ikat
and *tritik* cloths, embroidery is a
major form of textile decoration on
other types of cloth in south Sumatra,
including the cuffs of men's ceremonial
trousers, where it appears to be
interchangeable with gold
supplementary weft brocade. A
prominent feature of both of these
embroidered textiles is the tear-shaped
border design.

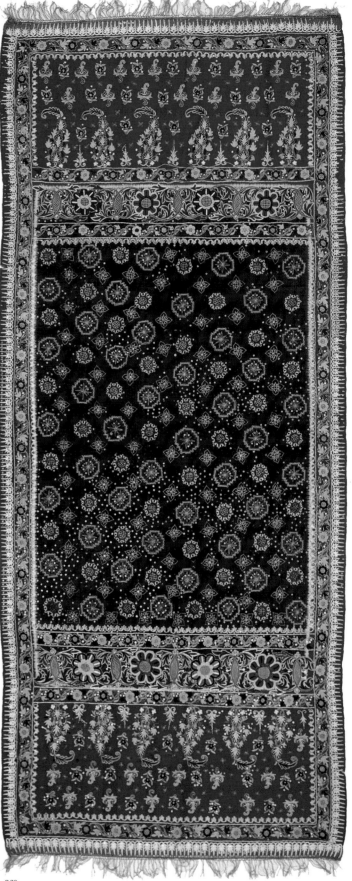

369

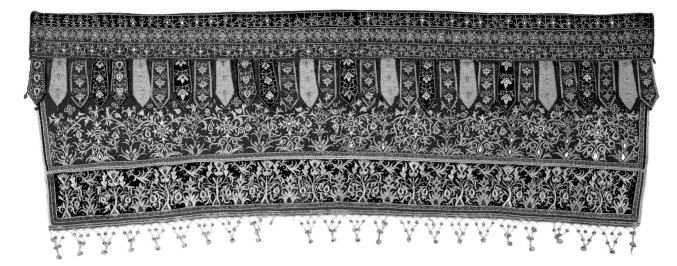

370

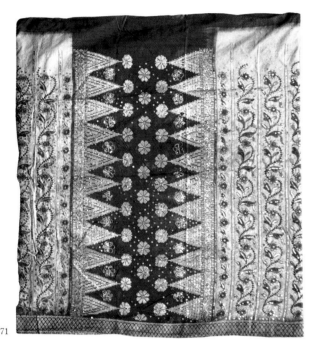

371

371
kain kerlip
ceremonial skirt
Malay people, Pontianak, west
Kalimantan, Indonesia
silk, sequins, gold thread
appliqué, embroidery

Chinese patterned silk skirts decorated
with bright copper sequins and
multicoloured silk are a special feature
of the Malay riverine Sultanate of
Pontianak. The large Chinese
community in west Kalimantan
encouraged a steady import of luxury
Chinese commodities into this part of
Southeast Asia, and Chinese
merchants were involved in peddling
silk, gold thread and sequins (*kerlip*) to
the indigenous inhabitants, the Malays
and Dayaks. The design of the skirt
follows the established structure
familiar on woven silk and gold fabrics
— scattered field patterning with
strikingly elaborate pairs of triangles
forming the head-panel.

370
tirai
part of a set of cloths used as hangings
for festive occasions
Malay people, south Sumatra,
Indonesia
cotton, silk, gold thread, lead-backed
mirror pieces
embroidery, appliqué
79.0 x 210.0 cm
Australian National Gallery 1984.1998

The festive hangings of the Malay
peoples of Sumatra, Borneo and the
Malay peninsula draw inspiration from
many traditions. The size and shape of
these textiles are comparable to many
of the Chinese embroidered and
couched hangings used for important
celebrations such as weddings. While
the actual motifs probably display
more of the influence of Indian and
Middle-Eastern sources, the border
meander pattern is widely used in
Chinese art.

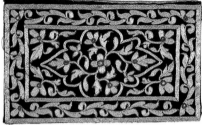

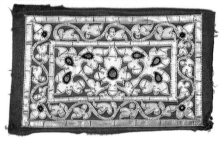

372
bantal peluk
end-panels for a ceremonial bolster
Malay people, Palembang and
Lampung region, Sumatra, Indonesia
silk, commercial cotton cloth, natural
dyes, gold thread, gold paper
embroidery, appliqué

These small decorative panels display
a variety of designs using gold thread
couching and gold paper appliqué and
are typical of those used by Malays in
the Palembang and Lampung regions
of Sumatra and also by Baba Chinese
in the Malacca region of Malaysia to
ornament the ends of a bolster. Other
end-panels for bolsters and pillows are
circular or octagonal and many pillows
are piled up to decorate the bridal-bed
and throne.

feature, reflecting light and colour during marriage and circumcision festivities.[33]

Not only was the technique of embroidery used for some types of ancient ceremonial textiles like the *tampan*, but a few old Southeast Asian beliefs related to the making and using of textiles also became associated with the application of embroidery to ceremonial objects. In fact, some of the beliefs surrounding Chinese textiles were found to be compatible and complementary in a Southeast Asian context. For example, the decorative fringes and tongues of fabric attached to Chinese altar-cloths were intended to repel evil spirits. The idea of warding off evil with sacred textiles has been an important element in many parts of Southeast Asia. Consequently, in addition to glorious and glittering display, the notion of protection also underlies the widespread use of embroidered panels around thrones, beds, platforms and funeral biers in Malay ceremonies. Some of the precautionary rituals that accompanied the making of sacred textiles in ancient traditions have also been applied to the technique of embroidery. In both Malay and Southeast Asian Chinese communities, beautiful embroidery has been a way of displaying appropriate female skills and the familiar division between complementary male and female activities is evident in the Malay proverb: 'let not the axe venture near the embroidery frame' (Winstedt, 1925: 74).

In the previous chapter we examined another Southeast Asian technique used to create rich ceremonial costume in the courts and principalities of the region: the gold patterning achieved from the application of small pieces of gold leaf to the surface of fabric using eggwhite or fish glue. The Chinese have also played a direct part in these developments since the paper-thin gold leaf, like much of the high quality gold thread, was imported in large quantities from China throughout the nineteenth century and the early part of this century. The manner in which gold leaf gluework is executed varies slightly in different parts of the region. As far as the local Chinese communities are concerned, gold leaf is used to embellish their own batik wedding *27* skirtcloths. Where the gold leaf designs appear against a plain cotton ground as in the case of the Javanese *kain kembangan* or on silk stretched over a frame as in Bali, the pattern is first drafted in yellow clay. Then the pattern outline is brushed in with glue before the gold leaf is applied (Jasper and Pirngadie, 1927: 79–80). However, for the Malay gold leaf decorated textiles, known as *kain telepok*, carved *262* wooden blocks are used to apply the glue. Chinese influence on Balinese textiles is not always obvious, yet the floral patterns, particularly the lotus, on the gold leaf gluework (*prada*) of dancers' costumes *259* clearly suggest the emulation of Chinese designs, possibly copied from imported Chinese fabrics.[34]

THE TEXTILE TRADITIONS OF CHINESE COMMUNITIES IN SOUTHEAST ASIA

The Chinese contribution to Southeast Asian textile history has not been confined to bringing Chinese cloth, techniques and raw materials into the region. A crucial factor has been the establishment of permanent communities of Chinese as important ethnic minorities in every country of the region.[35] Chinese quarters for traders, artisans and other immigrants existed for centuries in the port cities of the

Nanyang. The sailors, pedlars and traders who settled in these coastal towns and the indentured labourers who came to work on plantations and in tin mines in more recent times were almost exclusively from peasant and trading backgrounds of the southern regions of China, especially from the Guangdong and Fujian provinces. These Chinese communities have played an important role in the social, economic and political life of Southeast Asia and have also been an important conduit for the dissemination of elements of Chinese culture throughout the region. These Chinese settlers, however, formed a sharp contrast to the court officials, scribes, monks and royal brides of an earlier epoch, since they represented neither the intelligentsia nor the cultured elite of Imperial China. Consequently, the arts and crafts they have introduced have not necessarily been the finest or most elegant examples of Chinese culture in the homeland. Despite this, Chinese migrants have made a considerable and distinctive contribution to Southeast Asian art.

Of particular importance has been the historical development, especially throughout the nineteenth century, of a distinctive brand of Chinese culture in certain parts of the region. There have, in fact, been significant differences in the way Chinese settlers have interacted with their environment, largely reflecting various socio-cultural factors at work in particular parts of Southeast Asia. Nevertheless, two opposing tendencies have generally emerged within the region's Chinese communities.

In some parts of Southeast Asia, at least until towards the end of the nineteenth century, the local Chinese community tended to assimilate over several generations with the indigenous population. This process occurred, though in different ways and for different reasons, in both Thailand and the Philippines. However, for those Chinese communities established in Java, Malacca and various other parts of present-day Indonesia and Malaysia, there have been severe structural impediments to this assimilation process.[36] In these areas, there developed instead a Chinese community that to a large extent had become acculturated. These Chinese, many of whom were the descendants of unions between Chinese men and local women, no longer spoke a Chinese language but used Javanese or a Malay dialect instead. Many other aspects of indigenous culture were adopted and became distinctive features of their lives. However, these communities, the Baba Chinese or Straits Chinese of Malaysia and Singapore and the Peranakan Chinese of Indonesia, despite adapting to their environment, remained unassimilated and identifiably Chinese. Their culture was clearly neither that of the Chinese homeland nor of the inhabitants of their adopted land, but rather an interesting and unusual amalgam. The way these particular Chinese communities influenced and responded to the textiles of the region added an entirely new dimension to Southeast Asian textile traditions.

It became an important feature of the women of the Baba and Peranakan Chinese communities to adopt a Southeast Asian style of dress closely related to that of the indigenous community of their immediate environment, for example, the *kain kebaya* (the Javanese and Malay skirtcloth and blouse). While the form and general appearance of this costume is Malay or Javanese, the Chinese communities developed their own distinctive styles and many Chinese women played an important role in forming a splendid synthesis of Chinese and indigenous textile art in particular parts of the region. This is

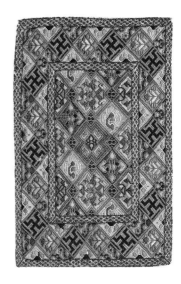

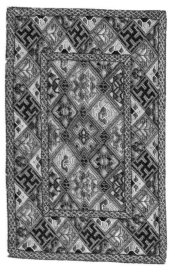

373
bantal peluk
end-panels for a ceremonial bolster
Malay people, Palembang and
Lampung region, Sumatra, Indonesia
silk, commercial cotton cloth, natural
dyes, gold thread
embroidery
21.5 x 14.5 cm; 21.5 x 14.5 cm
Australian National Gallery 1985.385

Although the custom of using such decorative cushion ornaments is unknown in China, on some *bantal peluk*, such as this fine pair, Chinese-style satin-stitch silk embroidery has been used instead of the familiar couching or appliqué techniques.

most clearly evident with some of the batik cloth produced in towns and cities along the north coast of Java, where the influence of Chinese iconography has been dominant.

In the ceremonies of the Baba Chinese communities of Malacca and Singapore many local customs have been absorbed and these require similar paraphernalia. These include both functional and non-functional items of apparel such as the ornamental kerchiefs or kerchief holders (*sapu tangan*), and the couched embroidered shoulder-cloth (*sangkut bahu*), betel-nut sets, fans, backless slippers, belts and many items of jewellery including sets of *kerosang* brooches for fastening the *kebaya*. The decorative pillow (*bantal*) of the Malay ceremonial throne has also become a common part of the bridal room at weddings. There are also a few specifically Chinese embroidered objects used only within the Chinese communities of Southeast Asia. Apart from magnificent Chinese robes these include embroidered silk knee-pads, collars and purses which form part of the Baba bridal couple's attire. Also evident at marriage ceremonies are embroidered chopstick-holders and sheaths used to cover mirrors to repel evil spirits (Eng-Lee, 1987: 110–11, 114).

Many of these objects have been decorated with tiny seed-beads by the mestizo descendants of Chinese immigrants in Malaysia, Indonesia and the Philippines. The technique of embroidered stitched beading is very different from that of the ancient Southeast Asian network of threaded beads. The Baba and Straits Chinese communities have used a multitude of tiny bright seed-beads and have worked on the familiar wooden stretcher-frame (*pidangan*) used by Malay embroiderers. While most objects decorated by this process have been small, hundreds of thousands of Rocaille (or drawn) glass beads were required for the larger marriage-bed panels, especially those from Penang (Ho, 1987: 32, 48). The motifs have been derived from many sources especially Chinese and European cross-stitch embroidery patterns (Ho, 1987). Other items of Baba Chinese costume have been worked in couched gold thread embroidery technique known as *kasot tekek timbol* or *kasot sulam*, and in the tradition of the textile art of the Malays, references to embroidery are common in the Malay *pantun* rhymes which young Baba men and women have customarily exchanged during courting.

While Malays and Baba Chinese have used similar styles of costume and ceremonial objects, they have favoured rather different designs.[37] Malay regalia, under the influence of Islam, has favoured elegant and highly formal floral and foliated arabesques and scrolls. The Chinese counterparts, on the other hand, have incorporated a heterogeneous collection of mythical animals, revered deities, and propitious symbols. The selection of these motifs has often been dependent upon their associations and allusions as much as their aesthetic qualities, and the resulting designs, while charming, sometimes seem visually chaotic and cluttered.

By the late nineteenth century, in different contexts and for different occasions, we find the same Chinese women wearing formal Chinese robes, hand-drawn batik *kain* or *sarong* with lacy *kebaya*, or Western dress, all of the very finest quality and style (Chang, 1981). Members of these Chinese communities wore heavily embroidered Chinese coats on certain formal occasions and at weddings,[38] following the custom instituted during the Manchu period in which the bride and groom were treated as emperor and empress for the day

(Vollmer, 1977a). This custom was repeated in many parts of Southeast Asia where the bride and groom were elevated to the status of king and queen for the day and permitted to wear the rich garments normally regarded as the prerogative of nobility. The wide range of Malay or Javanese traditional garments worn by Chinese Baba or Peranakan women suggests that the women of these communities were often of mixed descent. For example, Baba Chinese brides today may be dressed in long Chinese formal embroideries by the Sang Kheh Umm, experts in ceremonial costumery and ritual. These older women and their assistants wear Malay style *kain kebaya* while carrying out these exacting tasks. The Chinese communities who have become a permanent feature of Southeast Asian society have taken diverging paths, and the costume of the Baba Chinese of Malacca and Singapore, for example, has become closer to that of the Malay Islamic courts than to the *kain kebaya* of the Peranakan community of north-coast Java.

From the end of the nineteenth century until the Second World War a dramatic change occurred in the nature of the Chinese presence in Southeast Asia. The tendencies towards assimilation and acculturation that had been at work within Southeast Asia's Chinese minorities were largely reversed by unprecedented numbers of new migrants from China. During the late nineteenth century thousands of Chinese began to arrive in the European colonies of Southeast Asia, especially the Federated Malay States, Singapore and various parts of the Netherlands East Indies, and for the first time in the history of Chinese migration to the region, significant numbers of women were among the new arrivals. Thus, not only did the weight of numbers have an important effect upon the established communities of Southeast Asian Chinese, but the historical tendency of newly arrived Chinese men to take local marriage partners was arrested. Consequently, Chinese culture and society could now be substantially recreated in an adopted homeland. Chinese language, culture and traditions were reinforced, moreover, by the rise of Chinese language education. As Chinese culture was invigorated, religious and festive hangings and items of clothing were imported from China in large quantities. The making of certain types of Chinese-style textiles — particularly those which featured silk and gold thread embroidery — also seems to have blossomed in Southeast Asia itself.[39]

This influx of large numbers of newcomers had important consequences, at least in the short term, because some members of the acculturated or partly assimilated Chinese communities of the region began to identify with the newcomers and with the purer form of Chinese culture that they represented, becoming in the event 'resinofied'. The Baba Chinese community in Malacca and Singapore in particular was so swamped by the large numbers of newcomers that they became a minority acculturated Chinese community. Among the Chinese in Indonesia there emerged, early in the twentieth century, two distinct streams: the pre-existing Peranakan Chinese and, alongside and apart from them, a new community of Chinese known as *totok* ('pure'), who by language, culture and initially birthplace, identified their heritage with that of China.

However, while these Chinese have formed a separate group, and have been part of a more or less pure Chinese cultural milieu that was richly filled with objects and ritual of Chinese origins, the Second World War saw the end of large-scale immigration from China and

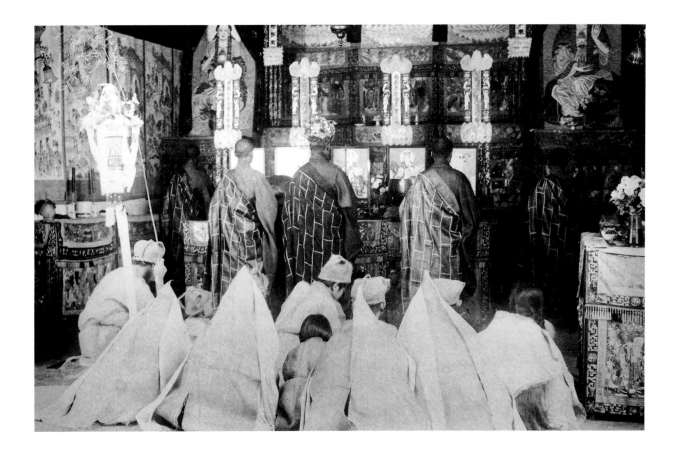

374
In towns and cities throughout
Southeast Asia traditional Chinese
hangings and banners have occupied
prominent positions in Chinese temples
and household shrines. This 1921
photograph from north Sumatra shows
the funeral ceremony for *Majoor*
Tjong A Fie, one of the most
prominent leaders of the Medan
Chinese community (Chang, 1981:
172). The fine embroidered
altar-cloths were clearly imported
from China.

375
tok wi
one of a pair of altar-cloths
Peranakan Chinese people, Java,
Indonesia
cotton, dyes
batik
104.0 x 104.0 cm
Australian National Gallery 1981.1173

This roughly drawn and gaily coloured
batik version of the Chinese altar-cloth
contains figurative images from
Chinese mythology in the lower panel.
Almost certainly a product of one of
the Chinese batik workshops that
sprang up along the north coast of
Java during the nineteenth century,
the designs were probably drawn in

there have been no new arrivals to reinvigorate Chinese culture in
Southeast Asia. Although the process may be slow and difficult, it
seems that ultimately the historical trends of assimilation and accul-
turation will prevail, as the descendants of these communities become
more and more influenced by their Southeast Asian social and cultural
environments. However, in the late twentieth century this is unlikely
to lead to the creation of great textiles as it did in the past.

CHINESE INTERESTS IN BATIK

Of all the incursions by the Chinese minorities into the field of decor-
ative textiles, one of their most enduring and important contributions
has been in the genre of batik, and in certain parts of Java a special
style of batik was developed by the Peranakan Chinese for their own
use and for trade. Chinese and Arab traders had always been active in
the batik commerce of the north coast, particularly in the handling of
white cloth and other raw materials. It was those towns along the
north coast, especially Cirebon, Tegal, Pekalongan and Semarang,
that became renowned throughout Southeast Asia for their own batik
textiles, many of which were produced for trade to other parts of Java,
Bali, Sumatra and the Malay peninsula. Peranakan Chinese families
became involved in the management and marketing of batik through-
out most of Java by the late nineteenth century, and each of these
north-coast batik centres continued to produce distinctive regional
styles, designs and colours. Different Chinese influences upon the
development of regional batik can also be distinguished. Hence, for

example, the Chinese of Cirebon developed a batik style specific to the district, and Cirebon *kanduruan* batik (named after the once exclusively Chinese district of Kanduruan in the centre of Cirebon) is identifiably different from the batik made in Pekalongan for the Peranakan community of that region.

These north-coast centres developed a style of batik incorporating Chinese motifs into the designs. Throughout Java women of Peranakan Chinese descent adopted the *kebaja* or *baju panjang* (two different styles of jacket) and the tubular batik *kain sarong*. The choice of this particular form of dress is, of course, indicative of the influence of indigenous Javanese traditions, but the style of the *sarong* and *kebaya* that ultimately emerged characterizes Peranakan Chinese cultural identity. A batik made by and for this community could never be mistaken for a traditional Javanese textile.

Throughout the eighteenth and nineteenth centuries, batik design was absorbing many foreign influences, and by the beginning of the nineteenth century the design structure of the batik cloths associated with the Chinese and European communities — a wide, elaborate head-panel and field bordered by narrow bands — was clearly established.[40] To the Indian trade patterns and existing local *19,27,377* designs, the Chinese added a range of characteristic motifs which appeared in both the field and head-panel of their batiks. These include strikingly traditional Chinese motifs — dog-lions, swastika grids, dragons and phoenix — and lyrical floral and butterfly patterns.

In addition to their characteristic designs and motifs, the batiks of the Peranakan Chinese have also been noteworthy for a number of significant technical innovations. Unencumbered by the weight of centuries of Javanese tradition, women from the north-coast Peranakan communities were amongst the first to use the new aniline dyes that became available during the late nineteenth century. With the *376* application of these materials, batik-makers were able to achieve the bright colour combinations that had always been a prominent feature of the Chinese silk textile tradition. Peranakan Chinese and Eurasian batik both became famous for their remarkable range of colours, including shades of orange, pink, mauve, green and yellow.

Batik-makers overcame the problem of the larger number of colours on a single batik by a simple technical adaptation to the resist-dyeing technique. Small areas of the cloth were encircled and effectively dammed off by the wax-resist, enabling the batik-makers to *378* apply the rainbow hues by a delicate process of hand-colouring or hand-painting. These technical innovations in no way diminished the quality of hand-drawn batik work. In fact, a number of outstanding batik workshops were established along the north coast of Java where successive generations of Peranakan Chinese batik-makers have been responsible for the creation of some of the finest and most technically elaborate examples in the history of batik. These workshops were renowned for their masterful refinement of the batik technique. The women employed to execute the patterns were trained in intricate and precise application of wax, and an extraordinarily delicate stippling and dotting technique was used, especially with some of the wonderfully ornate floral designs of certain batik producers.

As the patterns and design structures of textiles became increasingly elaborate throughout the nineteenth century, another style of *379* batik emerged — the so-called 'three-district' batiks (*batik tiga negeri*). Especially popular in the Chinese and Arab communities,

375

wax by a Javanese woman quite unfamiliar with Chinese religious imagery. Consequently, the figures on these batik *tok wi* are often hard to identify and do not correlate precisely with the sages and gods found on the embroidered Chinese hangings upon which these batiks were modelled. It is likely that the figures depict the Three Abundances (*San Duo*), representing long life, many sons, riches and prosperity. On the left appears a woman holding a child, symbolizing many children, and accompanied by a servant. In the centre is a mandarin scholar (although not in the usual corpulent condition of such figures) holding a sceptre (*ruyi*), representing riches and success. He is also shown with a servant (bearing an umbrella, the aura-like shape behind the figure's head). On the right is a bearded old man, but without his characteristic gnarled wooden stick or the other symbols frequently used to depict longevity, the stork and the antelope.

If this was made as a household altar-cloth, however, these figures may have been intended to represent certain popular Chinese deities, such as the Kitchen God (often depicted with a flaming aura like the central figure on this cloth), and the God of Long Life who often appears with the Gods of Wealth and Happiness. The upper panel contains a number of beribboned lucky symbols, and such cloths were displayed on occasions when best wishes for material wealth, a large family and long life were appropriate.

376
kain sarong
woman's skirt
Oey Soe Tjoen (1901–75),
Kedungwuni, Java, Indonesia
cotton, dyes
batik, hand painting
108.0 x 99.4 cm
Australian National Gallery 1984.3141

The finest and most technically intricate examples of the batik process have been made on the north coast of Java in workshops operated by Peranakan Chinese and other immigrant communities. Some of the most notable examples of this type of batik have come from the workshop of Oey Soe Tjoen and his wife at Kedungwuni, just outside Pekalongan. This fine cotton cylindrical skirt bearing the characteristic Oey Soe Tjoen signature, demonstrates the superb batik technique that made this workshop famous throughout much of this century. This design combines a version of the classical Javanese *kawung* pattern with a delicately coloured and intricately worked head-panel with a bouquet and butterflies. The composition of the bouquet in the head-panel and the inclusion of bluebells and snowdrops are evidence of the interaction that occurred between the European and Chinese batik workshops in the development of north-coast designs. The exact date of the skirt's execution is uncertain. This head-panel design was reported to have been first made, in the indigo blue and white mourning style of the Peranakan Chinese, by the mother of Oey Soe Tjoen's wife in 1920 (Elliott, 1984: 132). However, since the source of the dyes on this example is uncertain, and analine colours may have been used, it was probably made in the late 1920s or early 1930s.

these cloths were sent to be waxed and dyed in several different locations in Java. The completed batiks display a variety of patterns and colours that would have been impossible to obtain on a batik made in a single district. In particular, they combine the rich red dyes of Lasem with the *soga* brown of Solo. These *tiga negeri* cloths, the finest of them using a two-sided batik process of the highest quality, were often divided diagonally into two distinct designs so that they could be worn upside-down and inside-out to display a completely different design. This style became widely known throughout Java as *pagi soré* ('morning and evening').

At the time of the Japanese occupation of Java during the course of the Second World War, and throughout the subsequent war of independence, the shortage of high quality cotton cloth probably contributed to the popularity of the *pagi soré* bipartite design. Peranakan Chinese batik-makers set out to utilize every part of the surface of the available fabric. Many overtly Japanese motifs such as fans were combined with the birds and flowers already widely used in their patterns, and the batiks produced in this period displayed the brightest *380* possible colours and wide fanciful borders. The resulting style became known as *jawa hokokai*, and continued to influence the batiks of the 1950s and 1960s.

In addition to skirtcloths, baby-carriers and shouldercloths, the Peranakan Chinese have also applied the technique of batik to a range of characteristically Chinese textiles for ceremonial purposes. Although the Chinese community had customarily used silk and gold thread embroideries for the banners, altar-cloths and temple- *375* hangings used for marriage festivities and religious purposes, during

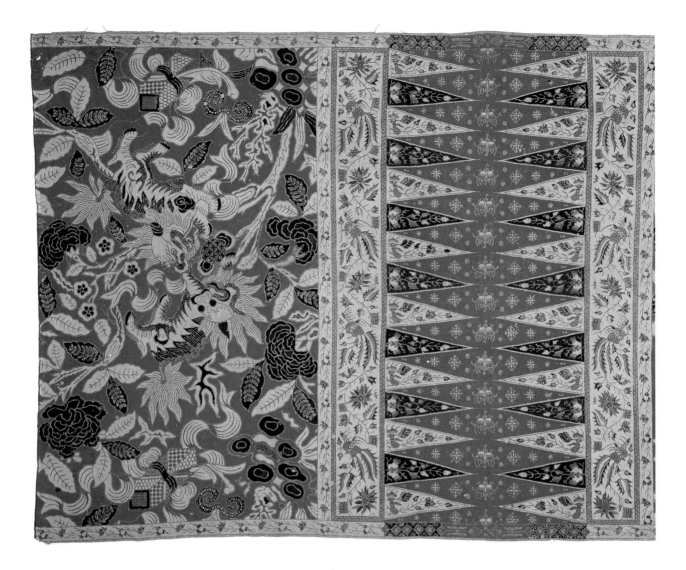

377 (detail)
kain sarong
woman's skirt
Peranakan Chinese people, Cirebon,
Java, Indonesia
cotton, natural dyes
batik
195.3 x 105.2 cm
Australian National Gallery 1984.3153

This nineteenth-century batik
combines a number of features
characteristic of Peranakan Chinese
batik within the design structure
typical of the north-coast Javanese
kain sarong. The playful dog-lions
(*kilin*), the flaming pearl symbol, the
peonies arranged in bold gradations of
colour reminiscent of the Cirebon
cloud formation pattern (*mega
mendung*), and the strong red and blue
dyes indicate the batik-maker's
Chinese origins. Although the overall
design structure of the skirt — the

double rows of triangles in the
head-panel, and the narrow borders
flanking a central field — is typical of
the style that developed out of the
interchange of ideas and fabrics
between India and the region, on the
north coast of Java this also became a
hallmark of the finest Peranakan
Chinese batiks.

378
kain sarong
woman's skirt
Peranakan Chinese people, north-coast
Java, Indonesia
cotton, natural dyes
batik, hand painting
111.5 x 101.0 cm
Australian National Gallery 1987.1063

This striking cloth contains many
motifs inspired by Chinese culture and
traditions and is full of flowering trees,
peony blooms, and colourful fish,
animals and butterflies. The Chinese
influence is particularly evident in the
panels (*papan*) on each side of the
head section (*kepala*) where vases of
peonies, beribboned lucky symbols and
the phoenix are enclosed by a swastika
meander. The textile is a remarkable
example of the technique of hand
painting brilliant small patches of
colour directly on to the surface of the
fabric.

379
kain sarong
woman's skirt
Peranakan Chinese people, Lasem;
Javanese people, Surakarta, Java,
Indonesia
cotton, natural dyes
batik
103.0 x 132.0 cm
Australian National Gallery 1984.3149

In order to exploit the different skills
of the various regional batik centres of
Java a style of batik developed that
was waxed and dyed in two or three
different locations. This example of
batik tiga negeri (three-region batik)
was probably dyed *soga* brown in Solo,
mengkudu red in Lasem, and
indigo-blue in Pekalongan (Djoemena,
1986: 72). The different patterns of
these regions are also evident on this
example which combines the
geometric *kawung* pattern of central
Java with the *buketan* floral motif of
the north coast. In the period when
only natural dyes were available this
system produced unusually colourful
and elaborate batik textiles. The red
floral head-panel is not shown.

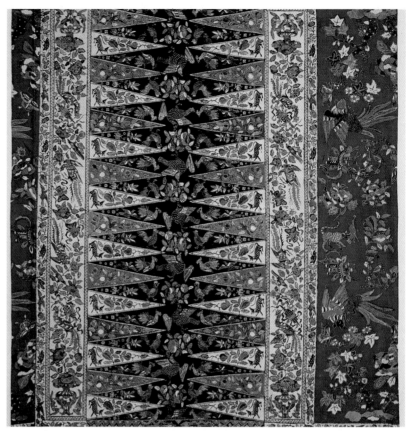

378

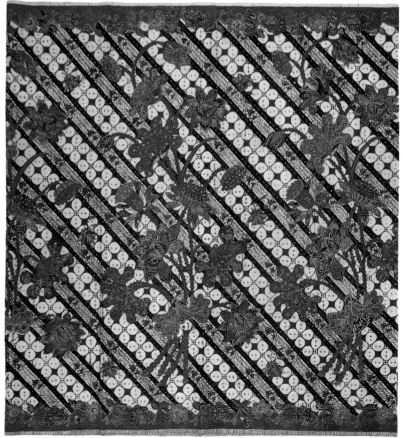

379

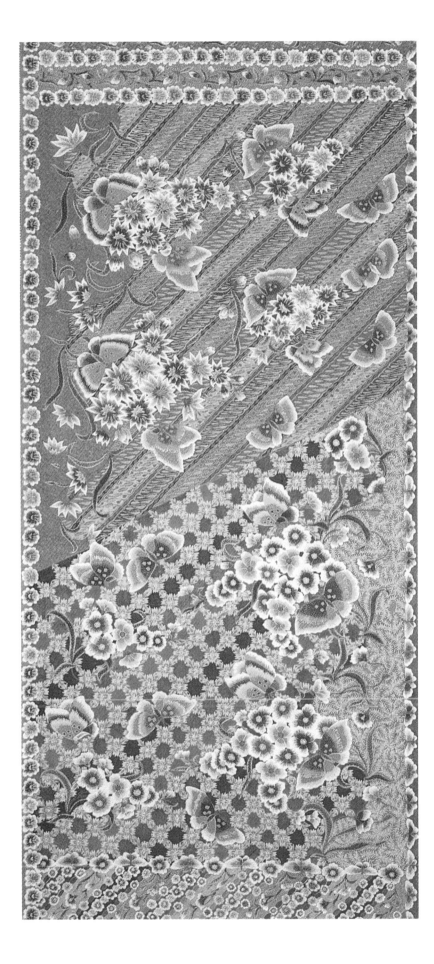

380
kain panjang
woman's skirtcloth
Peranakan Chinese people, north-coast
Java, Indonesia
cotton, dyes
batik
107.5 x 276.0 cm
Australian National Gallery 1984.3140

Gaudy colour and lively patterns crowd
the Peranakan Chinese batiks made
during the 1940s. Usually in *pagi soré*
('morning and evening') structure with
two related but distinct designs in
each half of the fabric, the entire
surface of the cloth is filled with detail
in the central motifs, the background
patterns, and the borders. Known
generally as *jawa hokokai* after their
genesis during the period of the
Japanese occupation of Indonesia, the
designs drew upon the butterflies,
birds and flowers of the pre-war
Chinese and Indo-European styles.
Little is known about the factors that
led to the development of these bright
and sometimes garish examples of
Japonisme. The style may have merely
been a reaction to the atmosphere and
hardships of the war and the
occupation, or it may have been the
result of an apparent interest in Japan
at that time. During the occupation,
schools throughout Java were teaching
Japanese language and culture, and at
a time when the Chinese community in
particular was feeling threatened by
the Japanese presence, Peranakan
batik-makers may have taken the
opportunity to include Japanese motifs
into their designs.

the nineteenth century some sections of the Peranakan community began to replace these imported cloths with locally made hand-drawn batik textiles of similar dimensions and with the same motifs and designs.

The quality of the altar-cloths (*tok wi*) used on family shrines was dictated by factors such as wealth and cultural distance from China. Probably most wealthy families, especially those of *totok* backgrounds, were still using embroidered *tok wi*, while the batik versions were produced for poorer Chinese or those more deeply adapted to Javanese society and culture. The quality of the batik work and the accuracy of the iconography of these batik *tok wi* also varied dramatically, and large numbers of coarsely worked altar-cloths were produced for Chinese families by the batik workshops of the north coast. In many cases the colours were not those we would now perceive as characteristically Chinese: at first the colours were limited by the range of natural dyes used in traditional Javanese batik processes, and later, when the whole range of analine dyestuffs became available, the Chinese prototypes were perhaps forgotten.

The impact of Chinese influence on the development of batik has been an important part of its complex history. While some of the textiles made by this community, such as the distinctive *kanduruan* batiks of Cirebon, have only been worn by women of Chinese ancestry, elsewhere Chinese batik has become a fitting, if not always recognized, part of ceremonial costume, and many Chinese motifs have become absorbed into regional batik styles worn by other communities — Javanese, Sundanese, Malays and European.[41]

CHINESE CONTRIBUTIONS TO SOUTHEAST ASIAN TEXTILE ICONOGRAPHY

Through the valuable imported objects that have become sacred heirlooms all over the region as well as the presence of large numbers of Chinese immigrants who have displayed their cultural symbols in everyday life and on festive occasions, Chinese culture has provided a new source of exciting textile imagery to Southeast Asia. Animals, both real and mythical, flowers, figures and various Chinese emblems can be found on textiles made throughout the region. These motifs and symbols have arisen from many great Chinese traditions — ancient, Buddhist, Daoist, Confucian, and from both the court and folk arts of China. Although their specific origins can be identified, the original cultural and religious significance of many had been lost or forgotten by the time they reached Southeast Asia, and in most cases, these symbols have merely been regarded even by the immigrant Chinese communities as pleasing charms evoking general good fortune and an abundance of happiness, descendants and wealth.[42] However, Chinese sources have sometimes provided indigenous Southeast Asians with new ways of depicting concepts that were already firmly grounded in local mythology. The presence of certain images on sacred heirlooms such as porcelain has confirmed their appropriateness. To the urban communities of the late nineteenth and early twentieth centuries — Chinese, European and mestizo alike — Chinese symbols were also a source of charming decoration for everyday apparel.

Floral patterns in particular have been very appealing, and many of the flower motifs that have been present in Chinese art since at

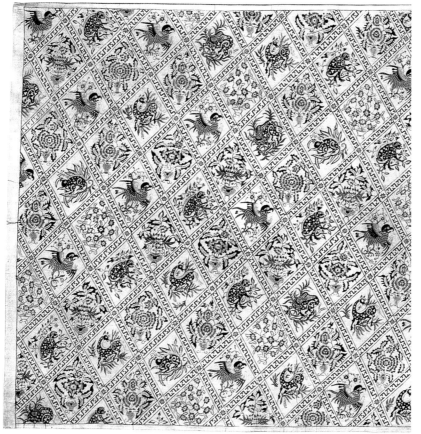

381

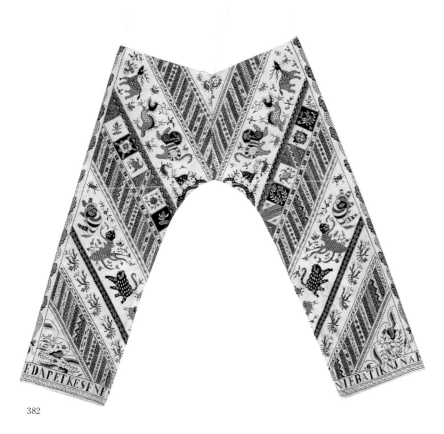

382

381 (detail)
kain panjang
skirtcloth
Peranakan Chinese community,
Cirebon, Java, Indonesia
cotton, natural indigo dyes
batik
276.0 x 107.8 cm
Australian National Gallery 1984,3132

382
celana batik
trousers
Peranakan Chinese community,
Lasem (?), Java, Indonesia
cotton, natural dyes
batik
126.4 x 59.5 cm
Australian National Gallery 1981.1123

Both these examples of hand-drawn batik textiles show a sample of charming animal figures, interspersed among the floral and geometric patterns widely used along the north coast of Java. The patchwork of triangles, the diagonal orientation of the patterns and the lattice grids evident on these batiks also suggest the contributions of other foreign and local sources to these designs.
For the Chinese community of the Cirebon region, the monochrome blue on white design of Plate 381 is typical of the style reserved for mourning or pre-nuptial ceremonies. The popular diagonal grid is formed from an interlocking swastika pattern (*banji*), and each rhomb contains a flower-filled vase or an animal motif. Though stylistically Chinese, the floral designs are also a reflection of the chinoiserie patterns found on many Indian trade cloths. The animals, however, represent a selection of symbols taken from the Chinese twelve-year calendar — monkey, rabbit, rooster, buffalo and horse.
On the trousers, diagonal zigzag bands filled with narrow stripes of north-coast batik patterns are interspersed between bands displaying lively mythical creatures such as the dog-lion (*kilin*), the deer and the tiger. Above the *banji* border a message appears written in the Malay dialect of the Peranakan, *BATIK NJ NA KEDAPET KESENIE*, suggesting that this object should be admired for its artistic merit. (*NJ NA* is possibly intended to be *Njonja*, a polite form of address for Peranakan Chinese married women.)

383
............
ceremonial hanging or banner
Peranakan Chinese community, Lasem,
Java, Indonesia
cotton, natural dyes
batik
84.0 x 205.8 cm
Australian National Gallery 1984.584

This late nineteenth-century
ceremonial hanging depicts a wedding
procession. In the rich red and cream
colours of the north-coast batik district
of Lasem, the hand-drawn scenes are
divided by strong banks of colour
forming the road and the base of the
house. The participants that fill the
intervening spaces carry lanterns and
banners, while the groom (?) is
sheltered by a large fringed canopy. A
sedan-chair is often a feature of these
scenes but on this batik it has been
replaced by a substantial carriage. The
red Morinda citrifolia dyes were
excellently suited to the making of fine
festive hangings for the Chinese
communities of Java, since red is the
dominant colour at Chinese marriage
celebrations. These textiles were often
made in pairs and the partner to this
particular example is in the collection
of the Victoria and Albert Museum,
London (V.A.M. I.S. 143–1984).

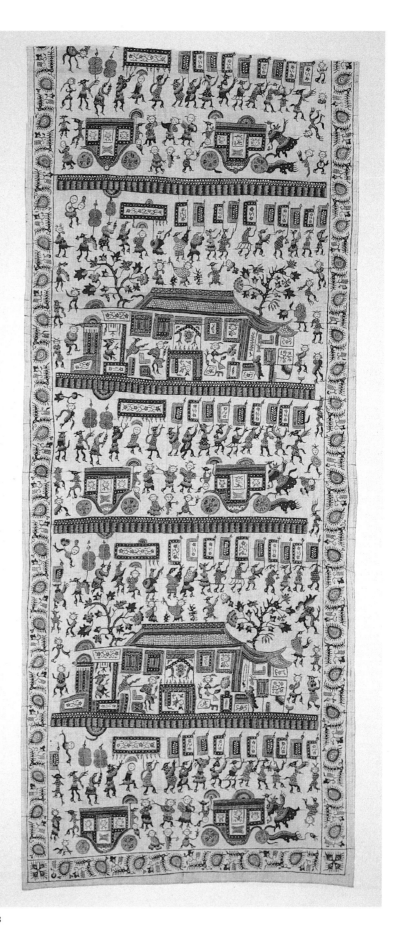

383

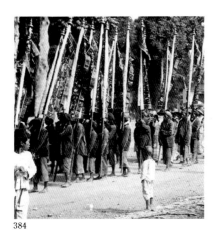

384

384
Participants carry huge banners during
a Chinese wedding procession in
Salatiga, central Java.

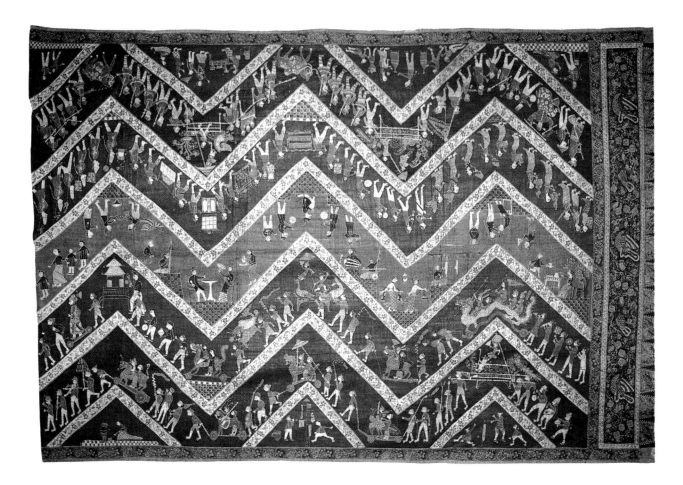

least the eighth century can be found in Southeast Asian textile patterns. They include both highly imaginative and perfectly realistic lotus flowers, chrysanthemums and peonies. The lotus, of course, is also a popular Hindu-Buddhist emblem but the form of this motif in Southeast Asia often draws upon Chinese style.[43] At the same time, the lotus was sometimes interchangeable with another Buddhist symbol, the tree of enlightenment. 'The tree of life', in fact, is transformed into the vase of flowers on Indian trade textiles and also on many Middle-Eastern carpets. However, like many Indic motifs, Chinese motifs are now reproduced in Southeast Asian art, even within the immigrant Chinese communities, for their intrinsic decorative value rather than for their original symbolic meaning.

Nevertheless, if we look carefully at the way some of these Chinese decorative symbols have been applied, we are often able to detect at least the vestiges of some of the philosophical and religious notions that lay behind them. The Flowers for the Four Seasons, a set of symbols dating back to the Song period, associates particular flowers with specific times of the year — bamboo with winter, the peony with spring, the lotus with summer and the chrysanthemum with autumn. In the Peranakan Chinese communities of Java, floral batik patterns have been associated with age and status. The peonies of spring have been appropriate for young girls, the lotus of summer and fullness for young married women, while matrons and older women have worn the chrysanthemums and blossom branches (Veldhuisen-Djajasoebrata, 1984: 70). While the peony has probably been the most popular Chinese floral image to appear on batik, the

377,378

385 (detail)
kain sarong
woman's skirt
Peranakan Chinese people, Semarang, Java, Indonesia
cotton, natural dyes
batik
212.0 x 112.0 cm
Rijksmuseum voor Volkenkunde, Leiden 101–22

This is a wonderful example of Peranakan Chinese batik, displaying a procession design arranged in bold zigzag bands with a simple floral head-panel. A cross-section of life in the Netherlands East Indies is depicted, including festivals with Chinese dragons, domestic scenes with Europeans pouring tea, and court celebrations with a *gamelan* orchestra and dancers. The batik was presented to the Rijksmuseum voor Volkenkunde in Leiden by the Ministry of the Colonies in 1869, and is recorded as having been made in Semarang for the use of itinerant female dancers (*ronggeng*).

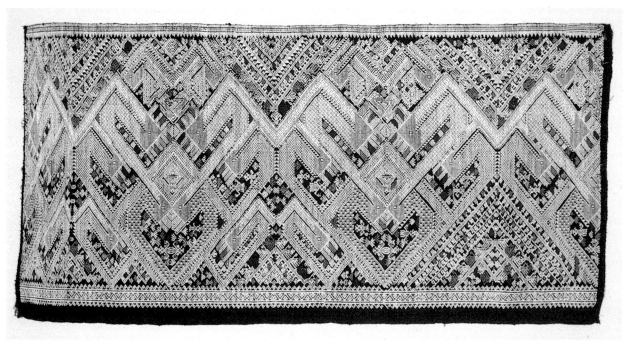

386

386
pha sin
woman's ceremonial skirt
Tai Nuea people, Laos
cotton, silk, natural dyes
supplementary weft weave
67.5 x 136.0 cm
Australian National Gallery 1984.743

387 (detail)
pha sin
woman's skirt
Tai Daeng people, Laos
silk, handspun cotton, natural dyes
supplementary weft weave
150.0 x 66.0 cm
Australian National Gallery 1984.3192

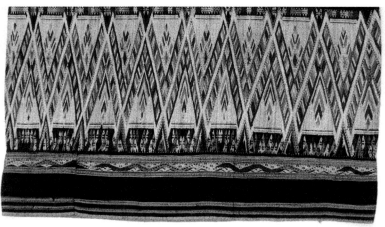

387

The zigzag pattern is worked in luminous coloured silks on these cylindrical skirts, and stands out starkly against the dark blue indigo handspun cotton ground. The design is balanced by a wave-patterned border band. The asymmetrical zigzag design on the Tai Nuea skirt is in fact intended to represent interlocking mythical creatures, and small human figures are still discernible within the apparently schematic filling and elaboration.

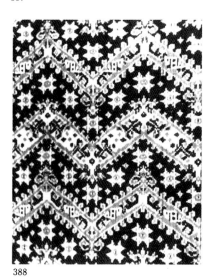

388

388 (detail)
sampot hol
skirtcloth
Khmer people, Cambodia
silk, natural dyes
weft ikat

This skirtcloth displays alternating zigzag patterns worked in silk weft ikat and embellished with the characteristic Southeast Asian hook motifs. Star motifs are interspersed between the bands.

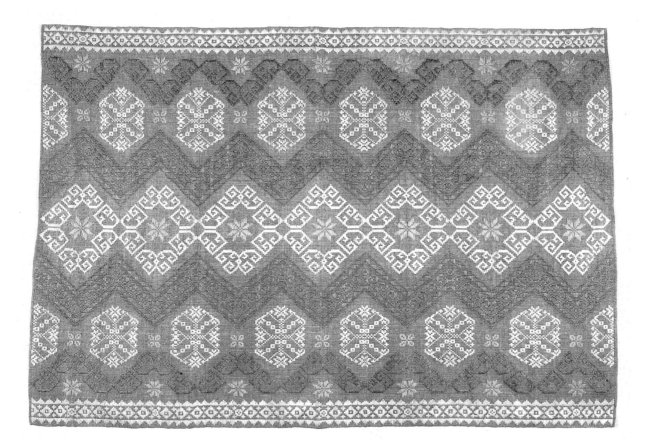

lotus has often been incorporated into embroidered, weft ikat and gold leaf patterns. It is doubtful, however, whether those who have worn textiles displaying either of these flowers have been aware of any particular symbolic meaning attached to them. According to Chinese tradition, the peony, for instance, symbolizes worldly happiness and is an appropriate image for many ceremonial occasions.[44] These floral symbols have also been accompanied by appropriate colours according to the occasion. Blue, green and white have been *381* reserved for those batiks worn by Peranakan Chinese during mourning, and for an important ceremony the night before a wedding when a bride mourns her approaching loss.

376,380 Gaily coloured butterflies appear on many Southeast Asian textiles intended for marriage celebrations. In China, their innocence and lightness represent joy, summer and marital bliss (Myers, 1984: 42), though they seem to have served a more decorative function in both Peranakan Chinese and European circles in Indonesia where butterflies and birds have been very appealing motifs for many textile-makers. However, some other traditional Chinese symbols have apparently not had the same attraction. Bats, for instance, are infrequently used, probably because the Chinese rebus for happiness — a group of five bats indicating the five blessings (old age, health, prosperity, love of virtue, and natural death) — is lost on those Southeast Asian Chinese who do not speak or write Chinese.[45] In fact a whole range of symbols from the late Ming and Qing dynasties that depended on clever puns or plays on Chinese words and characters

389
hoté; tepiké
a length of cloth intended as a room-divider; hanging; mat
Sangihe-Talaud Islands, Indonesia
abaca fibre, natural dyes
supplementary weft weave
68.4 x 104.0 cm
Australian National Gallery 1984.1241

This small piece of fabric was possibly used as a mat. The zigzag pattern found on many of these textiles is a popular decorative device on the fibre cloths of the area, and some early examples also contain supplementary gold and silver thread.

392

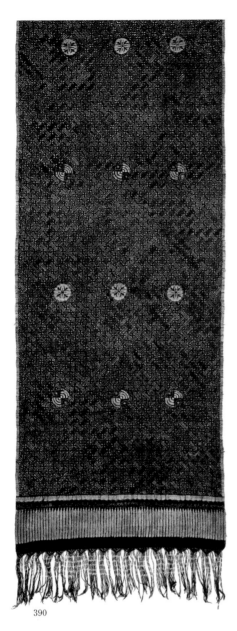

390

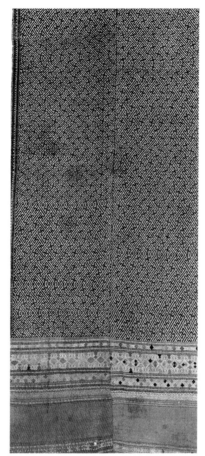

391

390 (detail)
selendang; kemben
carrying-cloth; breastcloth
Javanese people, Tuban, Java,
Indonesia
handspun cotton, natural indigo dyes
batik
310.0 x 58.0 cm
Australian National Gallery 1984.491

391 (detail)
pha hom
ceremonial blanket; shroud
Tai Nuea people, Luang Prabang, Laos
cotton, silk, dyes
supplementary weft weave
186.2 x 69.8 cm
Australian National Gallery 1984.3200

Despite the remarkable similarity
between the basketry-weave pattern of
this village batik from the north-coast
district of Tuban in Java (Plate 390)
and the pattern on ceremonial blankets
of the Tai Nuea (Plate 391) these
textiles probably reflect quite different
forms of Chinese influence. The Tai
continue to use geometric designs
which have their historical roots in the
Dong-Son culture of the region, on
textiles woven from cotton and silk in
the continuous supplementary weft

technique known as *khit*. The patterns
on north-coast Javanese cotton cloth
were probably inspired by a long
history of Chinese contacts through
trade and in pre-European times,
through Chinese immigrants.
Stylistically, both patterns are related
to the Buddhist swastika motif, known
as *banji* in Java and *lai khachai* to the
Lao. The roundels on the Tuban batik
carrying-cloth contain very simple
versions of two Chinese symbols, the
phoenix and the lotus.

392 (detail)
kain panjang
skirtcloth
Cirebon, Java, Indonesia
cotton, natural dyes
batik
98.0 x 220.0 cm
Australian National Gallery 1989.2246

This classical nineteenth-century
Cirebon batik consists of a series of
friezes formed by bands of layered
rocks from which exotic leaves and
flowers grow. Small animals appear
throughout, but the most striking
motifs are the gnarled rock-like
elephant and the shrimp woman.
Known as the *urang ayu* (lovely
woman) design, a play on the double
meaning of *urang* as person and
shrimp (Abdurachman, 1982: 136),
this is an example of the Cirebon batik
genre known as *taman arum* (fragrant
garden) which was strongly influenced
in its development by Indian cotton
palampore. However, the popularity of
layered rock and cloud motifs in
Cirebon can be attributed to the
strong Chinese influence on the
courtly arts of this region.

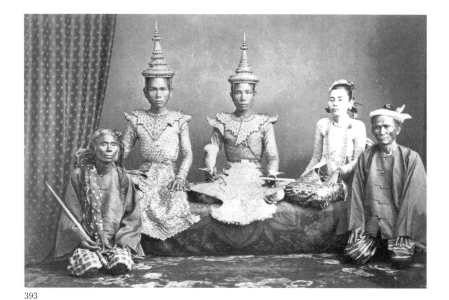

393

393
In the traditional theatre of Southeast Asia, the distinctions between the common people such as servants and clowns, and the nobility whom they served, was made obvious by the lavish costume of the aristocratic characters. The courts of the region were great patrons of the arts, and royal theatrical and dance performance revealed fine textiles. This 1878 photograph shows the Burmese royal dancers, dressed for the roles (from left to right) of clown, minister, prince, princess and servant. The male noble characters wear extravagantly embroidered and besequinned costumes while the princess wears the distinctive silk tapestry weave *lùn-taya acheik* skirtcloth made in the Mandalay and Amarapura districts, Burma. The front flap of the male costume is a reminder of the elaborate floating folds of skirtcloths found on the region's ancient statuary, although it now resembles the rock or cloud layers so popular in Chinese art.

had little impact upon the overseas Chinese communities who were almost entirely from the southern provinces, or who had almost no understanding of the language and culture of the Imperial Chinese court.

A popular mythical creature on Southeast Asian textiles, particularly those made for the Chinese communities, is the dog-lion or *qilin*, also known in Java as *kilin*. This symbol of prosperity has a long history in Southeast Asia. Unlike other animal motifs, it is seldom found on Chinese porcelain, but it has often appeared on imported Chinese textiles. A suit of clothes with the *qilin* motif, for instance, was among the gifts from the emperor of China to the king of Malacca in the early fifteenth century (Winstedt, 1925: 72). Also known as the Buddhist lion or Chinese unicorn, versions of the creature in unmistakably Chinese style appear on nineteenth- and early twentieth-century batik made on the north coast of Java. The dog-lion had already been an established part of the iconography of this region for many centuries and decorates the palace and ancient regalia of the Kasepuhan court of Cirebon. Since the time of Confucius, the *qilin* motif has been a good omen in China, a symbol of fertility and a bringer of children (Cammann, 1953: 211), and its presence on textiles displayed at wedding ceremonies suggests that the Peranakan Chinese batik-makers were aware of this symbolism. It is also a popular motif on Chinese altar-cloths.

Fish are also a common motif on Chinese batik and the Chinese-style carp is often found on batik *selendang* and *kain sarong* of north-coast Java and Palembang. Most have been inspired by decorations on ceramics from China and the Southeast Asian kilns of Thailand and Vietnam where the fish was a popular design. The double fish motif (*yu*) also appears on textiles and gold ornaments and may be a rebus for abundance, appropriate for marriage. The Mien deliberately embroider a pair of fish on marriage capes in the hope of conjugal happiness.

Many other creatures — real and mythical — that appear in Chinese art have been adopted into Southeast Asian textile designs, especially those achieved by embroidery and batik techniques which are less technically constrained by repetition than weaving. The

394

394 (detail)
lùn-taya acheik
skirtcloth
Burmese people, Mandalay or Amarapura region, Burma
silk, natural dyes
tapestry weave
243.0 x 69.0 cm
Art Gallery of South Australia 847A57

The wave patterns, known generally as *joe gee jay* (*jay* meaning hook or link), on many of these Burmese tapestry weave designs suggest the influence of Chinese cloud motifs.

Chinese twelve-year calendar is a source of a dozen of these animals, ranging from exotic or dangerous creatures (the tiger, snake and dragon) through to familiar or domestic ones (the monkey, pig, rooster, goat, dog, buffalo and even the rat). Only the rabbit is perhaps an unfamiliar animal in Southeast Asia. These Chinese motifs and symbols appear on batik in various configurations. They are sometimes found on Javanese design structures such as the *tambal* patchwork, but are also evident in designs based on Chinese sources such as the Ho Lo Boon gambling charts.[46] Batiks displaying processions of animals may have been inspired by such charts although the spiral arrangement is not as well suited to rectangular skirt-cloths.

Many auspicious symbols are colourful and unambiguous, and although a blending of various elements from Buddhism, Daoism and Confucianism is apparent, zodiac animals, figures representing the Buddha, various household gods, ancestors such as Confucius or the Eight Immortals, and the Eight Lucky Symbols have all been popular as motifs on those Southeast Asian textiles made by the region's Chinese minorities. The overtly religious figures have been widely used to evoke notions of blessedness and correct conduct amongst Southeast Asia's Chinese, especially when these figures appear on ritual textiles serving specific religious functions. According to magical Daoist beliefs, the Immortals also possess particular supernatural gifts, and their presence on ceremonial textiles has been intended to invoke those powers. Although primarily decorative, occasionally these figures and auspicious symbols have appeared on garments and ritual objects belonging to other Southeast Asian communities, such as the gold ornaments on the collars and head-dress worn by a royal Palembang bride or dancer.

Along with the playful depiction of various animal figures, the way human figures are represented on certain Southeast Asian textiles also seems to have been strongly influenced by Chinese models. In particular, the batiks of north-coast Java often contain many tiny figures engaged in a variety of activities drawn from everyday life and ceremonial occasions. Similar scenes with figures carrying lanterns, banners and sedan chairs are found on both the brightly coloured silks and the simpler blue and white cotton embroideries of southern China.

It is possible to identify some of the figures on batik altar-cloths and banners, although the confused configuration of the Immortals on many of these textiles is a reminder of the distance between Peranakan batik designers and the Chinese homelands of their forebears.[47] However, these traditional Chinese motifs have provided images that have delighted both Chinese and non-Chinese, and despite their inaccuracies the batik altar-cloths have been widely used by the Peranakan Chinese community of Java. Many Chinese-style figures are also evident on batik produced in Indo-European workshops from the late nineteenth century when it became the fashion to depict figures in a quaint chinoiserie style.

The natural and decorative images derived from Chinese art have had the greatest impact throughout Southeast Asia, although some prominent Buddhist symbols and motifs evident in the region's art and textiles have been influenced as much by Chinese iconography as by Indian art. However, Chinese cosmic diagrams and calligraphy appear to have had little impact in the region compared with the

<div style="text-align: right">

381

311

365

*383,384,
385*

374

</div>

influence of many ancient Indian cosmic symbols that have been absorbed into Southeast Asian cultures along with Indic religions and statecraft.

6,7
386,387 The diagonal or zigzag pattern is a popular decorative device that has ancient origins in Southeast Asian art. Its use as a design format and as a border pattern on cloths in many different techniques and materials across the whole region suggests its strong and fundamen-
388 tal appeal. It appears on Cambodian and Palembang silk weft ikat, tapestry weaves and silver and gold *songket* from Bali, Bima and
389 Burma, Sangihe abaca supplementary weft, and on batiks of various styles. The motifs enclosed within these zigzag designs show considerable variation and it is doubtful if such a schematic pattern can be traced directly to Chinese influences, such as the ancient thunderbolt designs. However, the zigzag pattern is often used as a central design format for certain Chinese-style batiks from the north coast of Java,
385 displaying a ceremonial procession of human figures, animals and carriages. Similar procession scenes are evident on both embroideries from south China and early Indian painted cotton trade textiles.

 Like the zigzag, the swastika is also widely used in Southeast Asian art, appearing on textiles as a striking central field design and as a popular border pattern. Though the swastika has important philosophical significance in Buddhist art as a powerful emblem of eternal change, its appearance on simple wedding decorations is widespread. On these occasions, whether used by Chinese immigrants or by indigenous Southeast Asians, the swastika generally evokes good luck. In fact, the swastika motif is widely known in insular Southeast Asia as *banji* (from the Chinese *ban* meaning ten and *dzi* meaning thousand), a term evoking good luck and plenty (Gittinger, 1979c: 132).[48]

 While the name *banji* indicates Chinese origins, the geometric swastika shape has been adopted and reworked across Southeast Asia in a great variety of techniques including weft ikat, supplementary weft weave, embroidery, batik and gold leaf gluework. In the process, great changes in the form of the motif have occurred. Angular meshed field patterns of swastikas, similar in appearance to palm-leaf matting
390,391 designs, appear on Tai Nuea supplementary weft textiles and on the thick handspun batiks of Tuban and the Hmong. In contrast, the swastika can be identified in the form of serpent-headed star motifs on numerous silk weft ikat fabrics from the region. A fine grid of swastika patterning has been widely adopted as a background for other motifs,
378,381 and a meander of swastikas is especially popular as a border on many types of textiles. (Reduced to their most simple form, these interlocking swastika borders are very similar to the ancient hooks and spirals prominent in Southeast Asian art.) While the swastika's appearance on many of these textiles — particularly on those where it is displayed among peonies and lotuses — suggests Chinese influence, the motif can also be found on objects produced by some of the more strongly Islamic cultures of Southeast Asia. In these instances, the motif is often indistinguishable from a popular Islamic motif, the endless knot.

 Another feature of Chinese art, particularly attractive to Java-
392 nese batik-makers, was the layered cloud or rock motif.[49] This motif is a prominent feature of many Chinese scenes, both mythical and realistic, including those that appear on Chinese textiles. The rendering of cloud and rock shapes in Southeast Asia exhibits considerable variation. Although one striking but schematic cloud-like meander

395

395 (detail)
ider-ider
valance for a temple or pavilion
Balinese people, Bali, Indonesia
silk, dyes, gold thread, sequins, glass
beads
embroidery, couching, appliqué
271.0 x 55.5 cm
Australian National Gallery 1988.1579
Gift of Michael and Mary Abbott, 1988

396 (detail)
sabuk; kamben
waist-sash; breastcloth
Balinese people, Bali, Indonesia
silk, natural dyes
weft ikat, supplementary weft weave
36.0 x 230.0 cm
Australian National Gallery 1984.1242

The dragon motif on Balinese textiles
takes many forms. A highly realistic
creature is displayed on the
embroidered valance (Plate 395), hung
beneath the eaves of a communal
pavilion during ceremonies. It also
appears as a completely schematic
pattern known as *gigi barong* (the
teeth of the mythical lion, the *barong*)
on the weft ikat and gold brocade
(Plate 396). The *barong* is an ancient
image of a monster, a benevolent
spirit, and an important part of Hindu
Balinese legend. However, the form
that this creature has taken in Bali has
been influenced a great deal by
Chinese dragon imagery.

pattern on Burmese silk tapestry weave skirtcloths (*lùn-taya*) is
known as the five-stripe Mount Meru design (Fraser-Lu, 1988: 89), it
is probably an adaptation of the Chinese rock motif which is often
worked in auspicious five-coloured spirals. Rock and mountain for-
mations are rendered in this graduated way in Javanese art where
they are also widely believed to symbolize the sacred mountain of
Indic religion. Chinese influence is quite pronounced on the art of the
Cirebon region of Java, and it is not surprising that the layered rock or
coral (*wadas*) and the spiralling cloud (*mega mendung*) are widely
used patterns in the art of the Cirebon courts. The *wadas* pattern is
especially prominent in many of the fragrant garden (*taman arum*)
frieze designs for which the Cirebon courts are famous. The closely
related *mega mendung* design provides a canopy of graduated bands
of colour forming abstract cloud motifs assembled along diagonal
orientations.[50] Cloud motifs also appear on other textiles from South-
east Asia, for example, in the leafy arabesque 'spreading cloud' image
(*awan larat*) in Malay art (Sheppard, 1972). Closely related to the
cloud is the flame motif and these symbols at times appear to be
almost interchangeable. In Thai art, in particular, the celestial
nymphs appear to float on flame shapes rather than the rounded
clouds apparent on older Chinese scenes, while both clouds and flames
are popular motifs in Balinese art.

THE DRAGON AND THE PHOENIX: IMPERIAL SYMBOLS IN THE NANYANG

Of all the ancient Chinese mythical creatures found on Southeast
Asian textiles, the most powerful and prominent are the dragon and
the phoenix, and each has appeared on Chinese objects imported into
the region for many centuries. The Chinese link the dragon with the
emperor and the phoenix with the empress, so as Chinese rituals and
ceremonies spread to Southeast Asia, especially in the nineteenth
century, and as costume emulating Qing court dress was adopted at
weddings, these images became widely used by people of Chinese
descent throughout the region. As in Southeast Asia, the Chinese
bride was considered an empress for the day, and in both the court and
folk traditions of China, the phoenix appears as her emblem on
wedding finery, especially textiles (Cammann, 1953: 208).

In Chinese art, the dragon (*liong* or *ying lung*) is a benevolent
symbol associated with the sky, clouds and rain, and the great positive
forces of the *yang*. In addition to its connection with the ruler, the
dragon motif also appears in other settings and it is a central figure on
many Chinese altar-cloths used in family shrines and in elaborate
temples established by Chinese communities. The body of the dragon
on these textiles, some of them imported embroideries and others
made in Southeast Asia, is sometimes so truncated that the head
appears as the mask-like monster face, *taotie*, a creature similar to
the mythical Indic *boma* or *makara* head also prominent in the art of
the region.

But the use of the dragon and phoenix images in Southeast Asia
extends far beyond the Chinese immigrant communities, and the
forms which these creatures take show great regional variation and
adaptation. The rainbow skin of the python is a recurring image in
Southeast Asian textiles and legend, and reptile motifs such as the

393,394

392

395,396

397

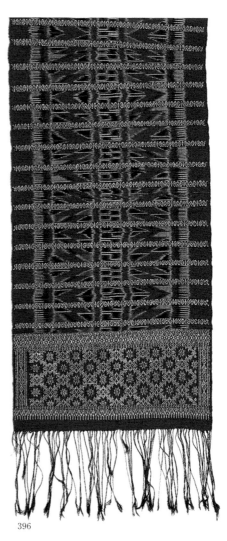

68,350 dragon, the crocodile and the lizard, the water serpent and the *naga* are among the oldest images in Southeast Asian art and mythology. These motifs have appeared and reappeared over the centuries, touched by different traditions but exclusive to none.

Nevertheless, the dragon appears as a prominent motif on the painted glaze and incised relief of Chinese and Annamese porcelain jars, lidded boxes and plates, which have been found all over Southeast Asia. These highly valued ceramics and other imported Chinese objects, including textiles, have given regional artists pleasing and attractive interpretations for their ancient serpent. The reworkings of these ideas by Southeast Asian textile makers has resulted in spectacular differences and striking similarities in the rendering of reptilean motifs throughout the region.

Reptile mythology is an important part of the ancestral origins of the peoples of Borneo. The Iban, for example, believe that the river

179,192 serpent (*nabau*) is the grandfather of Keling the python (*sawa*) who had challenged the son of the crocodile (*baya*) for the hand of Kumang, the goddess of weaving. The river serpent is used as a striking and ritually potent image on Iban *pua kumbu*, and it also appears on the beaded and shell-decorated jackets and skirts worn by the neighbour-

82,191 ing Maloh women on festive occasions. The reptile motif is also found on some Iban *pua sungkit* supplementary weft textiles where it is known as the *naga*. The name may be derived from India but the images upon which it is based are Chinese. Among the treasured heirlooms in both Iban and Maloh longhouses are sacred brass gongs embossed with dragon motifs and huge ceramic jars (*martavan*) which display dragons around the rim.[51] These gongs and *martavan* have provided the Iban and the Maloh with particularly concrete models for the serpent.

The unity of water and serpent in the form of the dragon-boat

398 motif has been popular in festivals and ceremonies in both China and mainland Southeast Asia. According to the traditional Chinese calendar, the festival that marked the summer solstice and the ascendance of the evil elements of the *yin*, incorporated dangerous symbols such as the tiger, the scorpion and the centipede. These were balanced and counteracted by the dominant presence of the benevolent dragon in the form of the dragon-boat. The powers for goodness evoked by the dragon-boat symbol were intended to ward off evil (Cammann, 1953: 221). In northern Thai ceremonies, it is also associated with rain and fertility.

169,244 The blending of the images of the dragon-serpent and ancient
245,400 ship motif is also found on a variety of Southeast Asian textiles, including the woven *pha biang* shawls of Laos and the *tampan* of Sumatra. In fact, on the *tampan* and on other objects used in rites of passage, for example the tooth-blackening receptacle (*sihung*), the dragon and ship apparently became interchangeable elements of the design. The dragon-boat is also an image on a number of central Javanese batik designs and the same motif appears on several other rare museum examples suggesting that this symbol may have once been more widely applied in Southeast Asian art.[52] Although reptile iconography is also apparent on the batik of central Java, the clearest evidence of Chinese influence is to be found on the batik cloths used or worn by Peranakan Chinese families, especially the huge canopy-bedcovers where handsome dragons are prominent among the menagerie of lucky symbols.

396

397
Chinese influence has been considerable on Balinese art. Balinese temple complexes are studded with old Chinese plates and tiles, and Chinese artisans were brought to Bali as wood-carvers during the nineteenth century. The form in which the mythical *barong* dragon-lion and the *boma* monster mask is portrayed, for example in this early twentieth-century photograph of a Balinese cremation tower, resembles the writhing dragon of Chinese processions. Long textiles are suspended from the towers.

398
An early twentieth-century photograph of the royal barge in Bangkok. Shaped in the form of a serpent, it carries the king's offerings to the pagodas during the ceremony of Thot Kathin. This ceremony is based on the ancient custom of offering new robes or lengths of cloth (*kathin*) to the monks, although nowadays other expensive gifts are presented instead. All over Thailand, after a period of penitence, processions with flags and standards accompany the offerings to the monasteries.

397

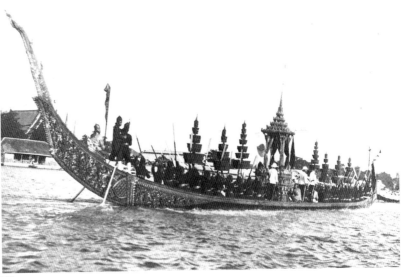
398

In south Sumatra the *naga* is a prominent symbol and appears in various guises, particularly on textiles. On certain *tampan* the *naga* assumes a very Chinese form but on other examples it has been interpreted as a more recognizably local shape. As Islamic influences strengthened in this region, the *naga* became stylized into the S spiral form. It also appears in other Lampung art and is a spectacular feature on the carved wooden *pepadon* seats that form a throne for ceremonies associated with feasts of merit (Gittinger, 1972: 4, 6–7). *399 401*

One of the most striking examples of the serpent motif is the head-dress worn by royal Malay bridegrooms, depicting a realistic *naga*. The Chinese linking of the dragon with the emperor and the phoenix with the empress also finds some expression in the Palembang wedding head-dresses: the groom's in dragon form, the bride's with bird shape centrally positioned. *403,404*

365

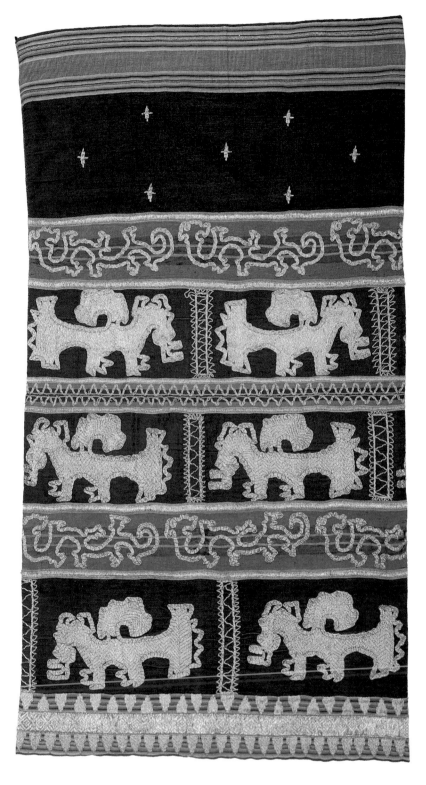

399
tapis
woman's ceremonial skirt
Abung people, Lampung, Sumatra,
Indonesia
cotton, silk, gold thread, natural dyes
couching, embroidery
114.0 x 61.0 cm
Australian National Gallery 1984.570

Monsters with stylized riders or wings
are interspersed with schematic
dragon motifs within the bands of
densely couched gold thread on this
Abung *tapis*. The dragons have been
rendered in outline and almost reduced
to arabesques.

Throughout Southeast Asia, pairs of serpents are used to flank
and encircle a central motif, and the intertwining of serpent bodies
has given rise to a wide range of beautiful Southeast Asian textile
designs. In Bali, for example, the bodies of two serpents form an
'endless knot', possibly representing the red and black male and
female serpents that make up the *basuki* form (Forge, 1978: 18). The
naga or serpent image is also popular in Tai art, where it seems to
combine the benevolence of the Chinese dragon with the dangers and

109,280
308

400
tampan
ceremonial cloth
Paminggir people, Lampung, Sumatra,
Indonesia
handspun cotton, natural dyes
supplementary weft weave
66.0 x 79.0 cm
Australian National Gallery 1984.257

401
tampan
ceremonial cloth
Paminggir people, Lampung, Sumatra,
Indonesia
cotton, natural dyes
supplementary weft weave
48.5 x 52.0 cm
Australian National Gallery 1984.1194

The dragon-serpent has been depicted
in various ways even within a single
textile tradition, and this is readily
apparent on the several styles of
tampan that developed in Lampung.
The textile in Plate 400 displays a
strange yet wonderful combination of
images. Under the apparent influence
of Chinese iconography, the simple
ship motifs have been converted into
writhing dragon-ships in each of the
three bands, flanked by ancient
creatures with the heads of the
hornbill. A figure with grotesque
features and elegant head-dress stands
within a shrine in the centre of each of
the three rows. The dragon-ship
carries centaurs with human heads and
peacock tails, and snarling monsters
with human-headed tails.
While vestiges of the dragon remained
evident, the penetration of Islam
throughout south Sumatra seems to
have led to the abstraction of these
fantasy motifs and the complete
removal of human figures from these
textiles. In Plate 401, a multicoloured
blue, red and golden brown example,
highly stylized dragons set in four
rows form the central element of the
design. On simpler and later *tampan*,
the rows of schematic dragons have
been reduced to ancient S spiral
patterns.

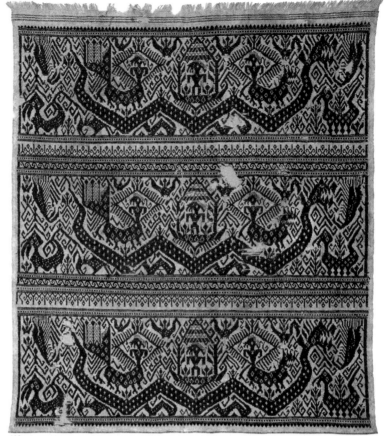

400

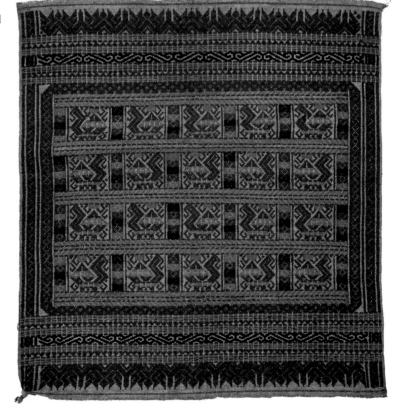

401

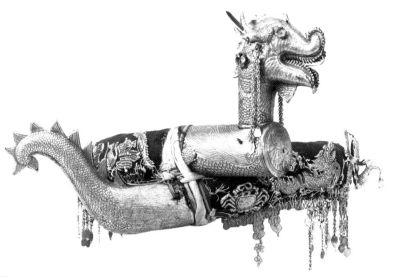

403

402

402 (detail)
sampot hol
skirtcloth
Khmer people, Cambodia
silk, natural dyes
weft ikat
Musée de L'Homme, Paris 70.120.290

On this silk skirtcloth (*sampot*)
decorated with weft ikat (*hol*) dating
from around 1920, the dramatic field
depicts stylized dragons which have
been linked and moulded into the
right-turning Buddhist swastika
symbol. These appear to be
interspersed with crab motifs. On
other Khmer skirtcloths two-headed
serpents are used to create a border
meander around an intricate floral
grid, reminiscent of patterns found on
many Palembang, Terengganu and
Javanese textiles.

403
bebulan semutar (?); *tengkolok sering* (?)
noble bridegroom's head-dress
Malay people, south Sumatra,
Indonesia
gold alloy, woollen cloth, cotton, glass
appliqué
36.0 x 12.0 x 34.0 cm
Australian National Gallery 1984.1994

Head-dresses in the shape of serpents
have been worn by aristocratic
bridegrooms in many parts of
Southeast Asia. On this example the
dragon is clearly depicted with glass
eyes and a tail covered in scales. Small
gold emblems and a fringed metal
chain have been stitched along the
green felt body which is designed to
wrap around the head. Many of these
gold ornaments are clearly of Chinese
origin: small dragons in profile, the
phoenix, butterflies, the God of
Longevity mounted on a crane, and on
the dragon's breast, a double fish
roundel simplified into the Chinese
symbol of cosmic unity, the *yin yang*.
These are all auspicious symbols for a
long and felicitous marriage. Other
symbols include a *bouraq*-like creature
with a Chinese-style lion face, and the
elephant-lion image (*peksinagaliman*)
with a rider depicted in the style of a
wayang puppet. These emblems have
evidently been made by smiths who
have been long-time residents in
Southeast Asia. Even the Chinese
crane has been transformed and
suggests the influence of the *sari
manok* or *garuda* carrying in its beak
a bell-like object. On the Malay
peninsula, rolled head-dresses take
names such as *bebulan semutar* or
tengkolok sering.

404
A young prince from the island of
Madura, Indonesia, dressed in courtly
dance costume in a photograph dating
from the 1870s. His head-dress is a
rolled length of cloth shaped like a
bird-dragon.

405

kain celana batik (?)
trouser material
Perankan Chinese people (?)
north-coast Java, Indonesia
cotton, natural dyes
batik
157.5 x 83.0 cm
Australian National Gallery 1981.1122

The phoenix and the serpent both
appear in the pattern on this
turn-of-the-century length of fabric
designed to be tailored into pants for
Chinese or Europeans. The mythical
phoenix and other minor bird and
floral patterns fill the field while the
entwined serpents have been
positioned so that they will run the
length of the outer leg of the finished
garment. The border meanders include
simple versions of the bird-fish of the
Ganges (*ganggamina*) and a swastika
pattern (*banji*).

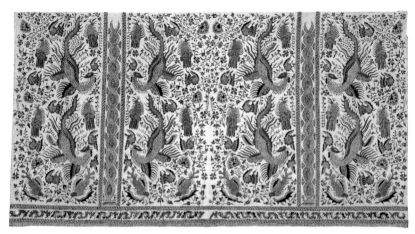

405

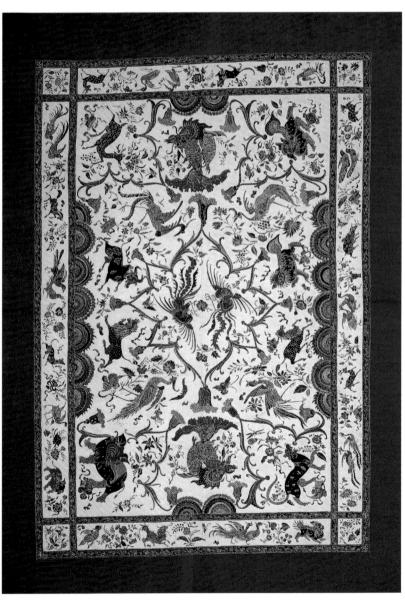

406

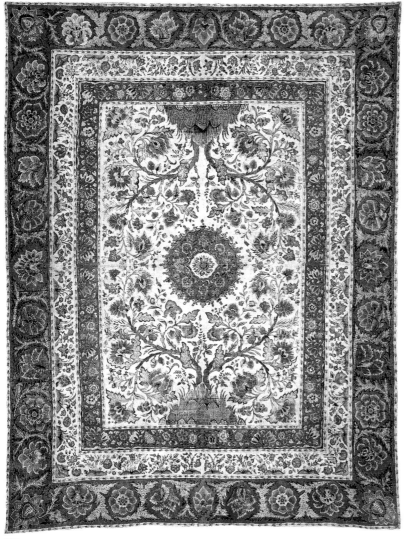
407

uncertainties of ancient Southeast Asian reptiles. It appears in numerous forms and in various textile techniques across the Tai groups. In Thai art the *naga* sprouts from the mouth of another *naga*, an image that appears on the *pha lai Thai* cottons made for the Ayutthaya courts. On Khmer weft ikat textiles some versions of the serpent display Chinese characteristics with clawed feet, writhing bodies and flaming nostrils while other *naga* appear as stylized, interlocking swastika motifs.

The phoenix (*feng huang*) is another Chinese motif that has been a powerful influence upon Southeast Asian iconography. The sources of inspiration have varied, and have included porcelain bowls and lidded boxes, embroideries, and possibly in the past, tapestry silks. Like the 'tree of life' and the *naga*, such mythical birds have a well-established place in Southeast Asian legend and art. Metal Age bronze objects found in Indonesia are decorated with flying birds, and as we have noted in previous chapters, birds — from the domestic chicken to the mighty hornbill — have always been an important part of the region's iconography. Consequently, the phoenix was an attractive symbol for Southeast Asian textile artisans, especially in view of its association with exotic luxury objects.

402

406
lelangit (?)
canopy, cover
Peranakan Chinese people, north-coast Java, Indonesia
cotton, natural dyes
batik
212.0 x 255.0 cm
Australian National Gallery 1984.3093

407
ma'a
sacred heirloom
Coromandel coast, India; Toraja region, central Sulawesi, Indonesia
handspun cotton, natural dyes and mordants
mordant painting, batik
223.0 x 175.0 cm
Australian National Gallery 1987.1074
Gift of Michael and Mary Abbott, 1987

The red, blue and cream batik cloth (Plate 406) was apparently a cover or canopy, used during wedding celebrations by members of the Chinese community somewhere on Java's north coast. By the nineteenth century the Peranakan Chinese had adopted the batik technique to decorate textiles required for ceremonial occasions. Many of the animals and birds that are popular in Chinese art appear within the central field and the narrow border of this huge cloth — phoenix, horses, deer, tigers, kilin, fish, buffaloes, lions, elephants, peacocks, geese and butterflies. Beribboned symbols can be identified near the larger animals. The central floral lobed medallion framing the long-tailed phoenix, and the rigid semicircular rock formations are also Chinese decorative devices.

The types of flowers and the sinuous arabesques formed by the foliage suggest the influence of Indian mordant-painted cotton trade textiles in the form of *palampore*, which often display chinoiserie patterns of similar dimensions to these Peranakan Chinese canopies. While the central lozenge was an ancient Southeast Asian design feature, under the influence of chinoiserie it was transformed into an enclosure for key aspects of the overall design.

The *palampore* (Plate 407) were apparently used as bed-covers and wall-hangings throughout Southeast Asia from as early as the seventeenth century. While most may have been intended for the Europeans who lived in the port cities of the region, many found their way into the collections of indigenous Southeast Asians. Most of the recently collected examples, however, have been located in central Sulawesi or south Sumatra.

Rarely does the phoenix in Southeast Asia retain the identifiably male and female characteristics that it sometimes displays in Chinese iconography, although simple forms of the phoenix in a decorative roundel suggest a stylized *yin yang* motif. This encircled stylized phoenix appears on other textiles as a coin, or even as a very simple lotus form. It is a particularly appropriate motif for use on decorative baby-carriers as it signifies long life and good luck. The phoenix image appears in a number of guises on the batik of Java: it is found on the Chinese community's canopies, the court batiks of central Java and the simple circle motifs on some north-coast handspun cloths. It also appears on one famous batik pattern, *sembagen huk*, according to Javanese legend one of the designs created in the seventeenth century by the powerful ruler of the kingdom of Mataram, Sultan Agung. *Sembagen* is the name given to certain imported Indian painted or printed cotton chintz in Java and in Malay regions, while *huk* is a Javanese term for the phoenix motif contained within a roundel. Thus, the design draws upon two of the major external influences of the period, India and China. In central Java this was one of the designs that could only be used by the Javanese aristocracy associated with court circles.

405,406
407

390

Like the dragon images, the phoenix and other symbolic birds are ambiguous motifs in Southeast Asian art. Even on one particular style of costume featuring bird motifs, considerable variation is apparent. The centrepiece of one type of Malay woman's wedding head-dress illustrates the transitions that occur: examples include the *naga*, an overt dragon shape, and the *sari manok* bird which is probably related to the *garuda*. The Baba Chinese of Malaysia, who use similar gilt ornaments, identify it as the crane with its elderly passenger who together represent longevity (Cheo, 1983: 57).[53] Bird head-dresses, sometimes without the rider, were also worn in Java as part of a bride's costume and by young boys at circumcision ceremonies,[54] and silver-gilt birds made by Chinese craftsmen were worn in Johore as sleeve ornaments by Malay bridegrooms (Ho, 1984: 161).

365

TAPESTRY WEAVE IN SOUTHEAST ASIA: A CHINESE POSTSCRIPT?

The Chinese art of silk tapestry weave brocade, *kesi*, has an ancient history, and the earliest recorded fragments dating from the eighth century show a high level of technical sophistication and complex iconography. Many sixteenth- and seventeenth-century Chinese tapestry weave textiles have been preserved as heirlooms in remote and marginal regions of Asia, in particular the monasteries of Nepal and Tibet, and although no such examples have been located in Southeast Asia, it is possible that the impact of such textiles has survived through the adoption of this technique in those parts of the region where Chinese influence has been an important factor. In fact, one of the earliest records of imported fabric in Southeast Asia, a Sriwijayan inscription, describes 'banners of Chinese cloth' used as temple decoration in a monastery at Nakhon Si Thammarat on the east coast of the Thai peninsula (Guy, 1986: 5).

408

Tapestry weave often appears on textiles only as a minor finishing or framing element. However, where tapestry weave is used as a major decorative technique in Southeast Asia, particularly when it is

applied to silk thread, the method is remarkably similar to that which has been used in China.[55] The Chinese *kesi* is a true tapestry weave in which the wefts of different colours are turned and usually interlocked and woven back and forth to form patterns. In Southeast Asia, tapestry weave has been described by van Nouhuys (1918–19: 33–7) who shows, by diagram, the different linking techniques used in selected tapestry weaves from Bima, Nusa Laut (near Ambon in the Maluku region of eastern Indonesia) and south Sulawesi.[56] The looms used in China for silk weaving (Bussagli, 1980), however, are quite different from those that are used in Southeast Asia for tapestry weaving, and it seems that while the skills required to produce silk thread eventually spread to Southeast Asia, the Chinese loom for weaving that fibre did not. Rather, as we have seen in the previous chapter, the traditional loom was largely retained with modifications to accommodate the fine silk threads. It seems that materials and motifs, rather than weaving technology, were transmitted through trade.

The early Ming period saw a sharp reduction in the availability of Chinese trade goods in Southeast Asia and this has been pinpointed as a reason for the growth of local ceramic sites to supply the region's demand for porcelain (Guy, 1986). It is also possible that a shortage of Chinese silk during the same period provided the stimulus for silk weaving in tapestry style among some of the best known trading groups in the region. A well-established network of inter-island trade carried textiles from Java, Bali, Sulawesi and Sumbawa into ports further east.

409 The spread of this technique closely follows the migrations and cultural contacts of the *orang laut*, the sea-faring peoples of the region.[57] Some of the most spectacular tapestry weaves, largely in silk, are made by the peoples of the Sulu archipelago and the Bajau communities along the fringes of insular Southeast Asia who have from an earlier period of history been influenced by direct Chinese trade. Although further study of this problem is required, there is a strong possibility that this influence led to the development of the art of tapestry weave in these areas and its subsequent spread throughout insular Southeast Asia by means of the migrations of these coastal peoples to other regions, particularly those of the sea-gipsy Bajau communities.

The Sulu archipelago was a target for Chinese trade from at least the thirteenth century and silk regularly appears amongst the listed
353 trade items (Warren, 1981: 5). Photographs and lithographs from the nineteenth century reveal local chiefs wearing ornate Chinese
7,292 embroidered jackets in addition to the characteristic headcloths as-
410,411 sociated with the Islamic world (Marryat, 1848). The Tausug, Yakan and Bajau peoples of the Sulu archipelago are renowned for their brightly coloured silk tapestry weave headcloths and sashes, and the Maranao women on the shores of Lake Lanau in north-eastern Min-
9 danao weave narrow bands using a tapestry weave technique known to them as *langkit*, to join the vibrant silk panels of their tubular skirts.

Neighbouring Bajau groups on Sabah in northern Borneo also use similar decorative weavings for headcloths and skirtcloths,[58] while a
412,414 close inspection of sombre Rungus cotton garments reveals the subtle addition of tapestry woven silk inserts. Off the coast of south-eastern Borneo, simple tapestry weave silk textiles are found on the island of

408
kesi
ceremonial valance and hanging
China
silk, natural dyes, gold thread
tapestry weave
90.0 x 198.0 cm; 205.0 x 203.0 cm
Australian National Gallery
1986.2457; 1986.2458

Like many Indian textiles in Southeast
Asia, this splendid pair of Chinese
tapestries dating from the Ming
period, has survived since the
seventeenth century in the Himalayan
region as part of the treasures of a
Buddhist monastery. The design on
the larger hanging displays many of
the classical Chinese motifs that have
been incorporated into the iconography
of Southeast Asian textiles — cloud
and rock formations, the Eight Lucky
Symbols of Buddhism and various
animal motifs. Many of these symbols
— the endless knot, the sacred
canopy, the lotus, the wheel of
knowledge, and even the dragon itself
— were also prominent in the arts of
other visitors to the Southeast Asian
region. The central dragon and the
encircling smaller versions are worked
in gold thread on a deep indigo ground.
The major images on the valance are
the sun and the golden crane, symbols
of longevity. The field is divided by
two vertical bands of Buddhist
propitious symbols, the rhinoceros
horn, the book, the pearl, the lozenge,
the covered vase and the leaf. Along
the lower section is the insignia of the
Chinese court, two confronting
dragons fighting for a pearl against a
pattern of waves or clouds.

409
kain uté-uté
woman's ceremonial skirt
Kilmuri, south-east Seram, Indonesia
cotton, silk, gold thread, dyes
warp ikat, tapestry weave,
supplementary weft weave
Museum voor Land- en Volkenkunde,
Rotterdam 25603

Over centuries, the eastern Indonesian
island of Seram was a port of call for
adventurers and merchants following
the trade routes. Only a small number
of the textiles from this island have
been recorded. On some of the most
splendid Seram skirts, the meeting of
many textile traditions is evident: in
addition to ancient warp ikat on hand-
spun cotton, they contain sumptuous
brocade and intricate tapestry weave
seams (Niggemeyer, 1952: 3881). The
warm earth colours of the natural dyes
of the foundation weave form a sharp
contrast with the bright, supplemen-

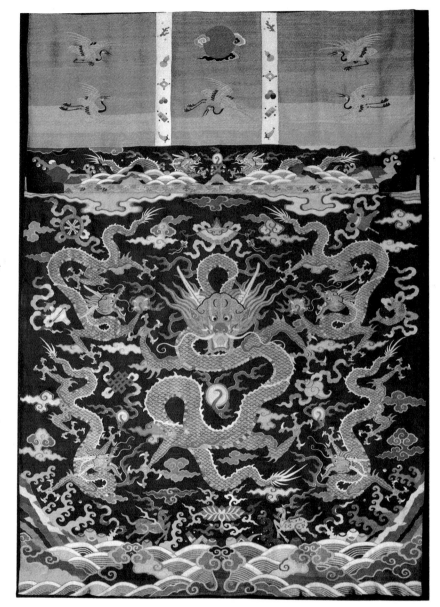

409

tary silk and gold imported threads.
This example dates from the turn of
the century.

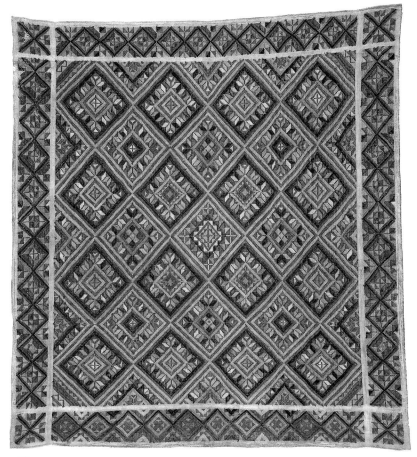

410

410
seputangan
headcloth
Yakan people, Basilan, Philippines
cotton, silk, dyes
tapestry weave
93.0 x 83.2 cm
Australian National Gallery 1984.1213

411
pis siyabit
man's headcloth
Tausug people, Sulu archipelago,
Philippines
silk, dyes
tapestry weave
88.0 x 77.0 cm
Australian National Gallery 1984.1225

The communities of the southern islands of the Philippines played an historic role in international and inter-island trade for many centuries, and silk and textiles from China were an integral part of that exchange. It is therefore probably not a coincidence that, throughout the whole of Southeast Asia, only on these islands has tapestry weave become the major means of textile decoration. These men's headcloths reveal two different ways of executing this weaving technique. The Yakan cloth (Plate 410) combines a basic weave of white cotton with bright blocks of orange, red and yellow silk. The tufted ridges caused by the interlocking of the different wefts is a notable feature. The Tausug textile (Plate 411) has been woven in more muted pastel tones and the intersection of the fine silk wefts results in a smooth silk fabric surface.

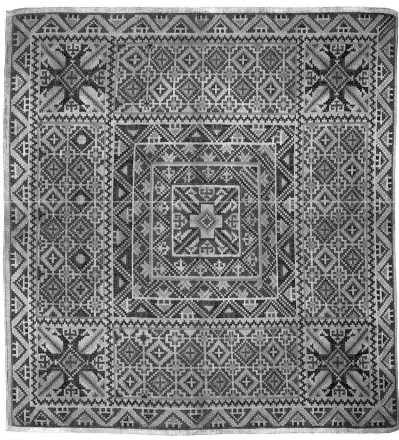

411

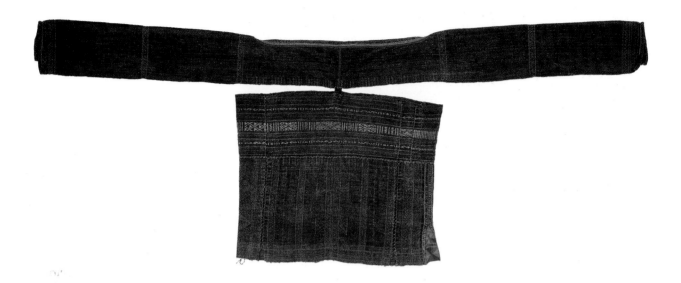

412
............

woman's shirt
Rungus Dusun people, Sabah, Malaysia
cotton, silk, dyes
supplementary warp weave, tapestry
weave
36.0 x 102.0 cm
Australian National Gallery 1984.1105

The basic fabric from which this
unusual woman's shirt is formed is
decorated by the ancient supplemen-
tary warp method in narrow black and
white bands known as *pudang* (or
pudung?). The lower sides of the
bodice, however, are ornamented in
bright silk tapestry weave insets,
probably executed with a needle.
Rungus Dusun women combine these
shirts with short cylindrical skirts,
sometimes decorated with simple
dashes of warp ikat and finished with
valuable brass bells stitched to the
hem.

Pulau Laut. One item of ceremonial costume in the courts of Bima,
Alas and Sumbawa Besar on the island of Sumbawa is the wrap-around
silk or cotton rectangular skirtcloth for men (*salampé* or *pabasa*), *415*
worn over long trousers. The large diamond lozenge in the centre of
these cloths is achieved by tapestry weave, and it is interesting to
note that the people of Bima still refer to themselves as *orang mbojo*,
the Bajo or Bajau people (Hitchcock, 1983).

A simple triangular tapestry pattern is also found along the
borders of certain supplementary weave handspun cotton skirts in *413*
west Flores. While only a minor part of the ornamentation, this tri-
angular tapestry weave border is regarded by the Manggarai as a
highly valued design feature. West Flores was a vassal of the court of
Bima for many years and, in marked contrast to the rest of the island,
Manggarai textiles show greater affinity with those of the neighbour-
ing island, Sumbawa. The textiles of both regions display these
tapestry-woven borders and use supplementary weft weaving as the
major decorative technique. Tapestry borders also appear on the
canopies of the Sasak of Lombok, who were under the control of *166*
Sumbawa and Makassar in the seventeenth century.

Although the silk tapestry weave technique is not often used
elsewhere in Southeast Asia, Chinese influence on Burmese silk tex-
tiles is apparent. In the nineteenth and early twentieth centuries
tapestry weave was closely associated with the Burmese court, and
this technique is still a speciality of the Amarapura district of central *394,416*
Burma. The long silk skirtcloths are patterned with meanders,
zigzags and waves running down the main body of the cloth with one
end of simple checks. The scroll or meander motifs are often based on
ancient double spiral meanders although they also draw inspiration
from Chinese motifs, and the form permitted by the technique casts
the patterns in close comparison with the *kesi* of sixteenth- and
seventeenth-century China. This tapestry weave technique was
obviously much admired by the Tai Lue who moved across the Bur-
mese border into northern Thailand and they have incorporated *418*
narrow bands of bright tapestry weave into their simple banded cylin-
drical skirts.

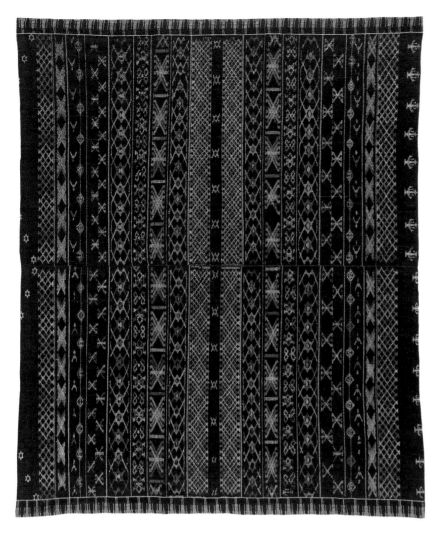

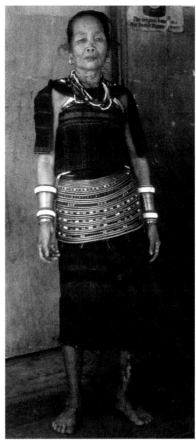

414
A woman wearing the traditional costume of the Rungus Dusun in Sabah

413
lipa songké jok
skirt
Manggarai people, Flores, Indonesia
handspun cotton, commercially-dyed cotton, natural indigo dyes
supplementary weft weave, tapestry weave
129.6 x 109.0 cm
Australian National Gallery 1984.1987

The cylindrical skirts of the Manggarai of west Flores are significantly different from the garments of all the other ethnic communities of this eastern Indonesian island. The use of supplementary weft decoration (*songké*), the clear division of the skirt into a star-scattered field pattern and a densely filled head-panel, and the lack of any distinction between cloths for men or women, indicates the influence upon the Manggarai of the cultures to the west and north, particularly Bima and south Sulawesi where these are also features of traditional textiles. These influences are also suggested by the linguistic terms used. *Lipa* is also the term for a skirtcloth in the weaving areas of Salayer and south Sulawesi and *songké* is obviously derived from the term for metallic supplementary thread weaving. Textile terminology in the other regions of Flores is completely different.

The tapestry weave triangular motifs (*jok*) along the borders of the finest Manggarai textiles are a subtle but highly valued finishing device. The bright supplementary commercial thread designs stand out on the foundation weave of handspun cotton thread and saturated indigo dyes suggestive of the older textile traditions of the region.

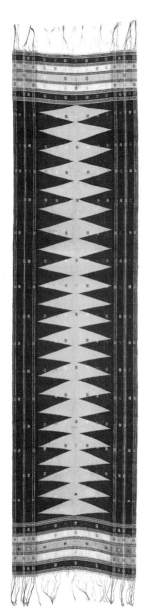

415

415
salampé; pabasa
shouldercloth or man's hipcloth
Semawa or Bimanese people,
Sumbawa, Indonesia
silk, dyes
tapestry weave, supplementary weft
weave
339.0 x 69.0 cm
Australian National Gallery 1984.1253

In both the sultanates of Bima and
Sumbawa, weavers have produced
elaborate metallic thread
supplementary weft and tapestry
weave textiles. On this example there
is limited use of supplementary
metallic thread brocade. The bright
yellow and pink tapestry weave fabric
displays colours similar to those found
on textiles produced by the Islamic
weavers of the southern Philippines.

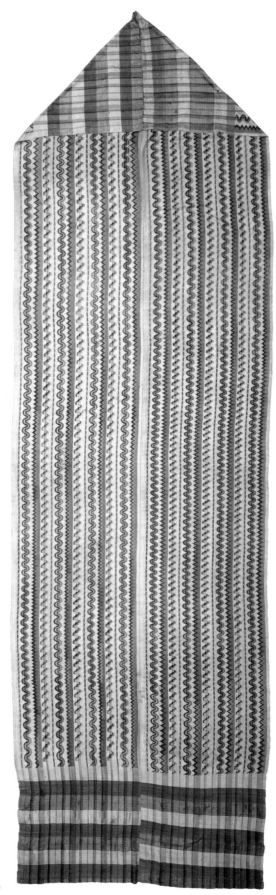

416

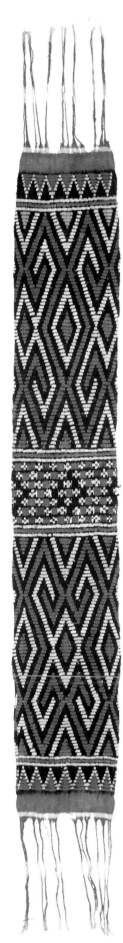

417

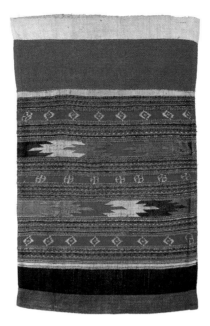

418

This is an especially rare and possibly very ancient form of tapestry weave, found only in Southeast Asia on the textiles of the Toraja of central Sulawesi. The cloth is woven from natural handspun cotton and is transformed by an elaborate tie-dyeing process that simulates ikat in the appearance of the finished patterning but is in fact more closely related to the *plangi* technique. Small sections of the cloth, between the slits in the tapestry weave, are resist-tied and dyed after the weaving has been completed. Other examples of this textile also have tie-dyed spotted border patterns. The inversion of the hooked rhombs at each end of the cloth adds dynamism to this ancient design and is typical of the asymmetric design structure of many *tali tau batu*. This textile belongs to the class of sacred heirlooms known among the Sa'dan Toraja as *ma'a* or *mawa*, and to the communities living further north as *mbesa*. The particular name by which it is known, *tali tau batu* (the sash or tie of the stone person), suggests that it may have been used to dress sculptured figures such as the *tau-tau* funerary puppets. It is also apparently known as *pewo* or *pio* (loincloth).

416
lùn-taya acheik
skirtcloth
Burmese people, Mandalay or
Amarapura region, Burma
silk, natural dyes
tapestry weave
107.0 x 396.0 cm
Australian National Gallery 1986.1252

The Burmese silk tapestry weave cloths are known as *lùn-taya acheik paso* for men, and *lùn-taya acheik htamein* for women. This example displays a typical scroll pattern and the colours are characteristically Burmese — soft pinks, greens and lemon on a cream ground. The pastel-pink dyes may have been imported from China, like the pink dyestuffs used in northern Thailand. The cloth was probably made in one of the traditional centres of Burmese culture, Amarapura or Mandalay, although silk tapestry weave was also a skill of the Shan in the Inlé Lake district. The function of the pouch or hood formed by the folding and joining of the hemmed seam at one checkered end is uncertain. It may have been looped over the arm to form a receptacle.

417
tali tau batu
sacred heirloom
Toraja people, Rongkong district,
central Sulawesi, Indonesia
handspun cotton, natural dyes
slit-tapestry weave, resist-dyeing after
weaving
232.0 x 28.0 cm
Australian National Gallery 1981.1121

418
pha sin
woman's skirt
Tai Lue people, Chiang Kam, Phayao
province, Thailand
silk, cotton, natural dyes
weft ikat, tapestry weave
60.4 x 95.4 cm
Australian National Gallery 1988.1651

Many of the Tai Lue who have migrated in the past from the Sipsong Pan Na region of southern China decorate their cylindrical skirts with simple bands of tapestry weave (*ko*). This decorative band is incorporated into the weft-striped design, and the skirt is seamed on each side to maintain a horizontal design orientation. The Shan of northern Burma have also made skirtcloths with similar narrow bands of tapestry weave combined with weft ikat (Fraser-Lu, 1988: Plate 5).

In other parts of Southeast Asia, the origins of tapestry weave are even more problematic and it seems that in many areas where it is applied to cotton thread it developed independently, perhaps as an elaboration of ancient supplementary weft twining techniques. In such cases a Chinese connection is far less likely. The presence of decorative and colourful slit-tapestry twining on small costume pieces in remote parts of the region attests to its great ceremonial significance and probable antiquity. These include the finery of the *raja* and *méo* warriors throughout the mountains of Timor and the wonderful tapestry weave badges and bands found across the back of Iban jackets, particularly those worn by traditional healers and ritual leaders.

144,185

Balinese weavers create an open weave lace-like cotton fabric, predominantly worn as a breastcloth at temple ceremonies, from the combination of spaced warps and slit-tapestry wefts, and amazing tapestry weave patterns entirely cover some cloths of the small island of Nusa Lembongan, south of Bali (Gittinger, 1979c: 142). Among the Toraja of central Sulawesi a remarkable cloth, the *tali tau batu*, incorporates slit-tapestry weave with a resist-tying technique in which small sections of woven cloth between the slits were bound off in the manner of ikat before dyeing (Jager Gerlings, 1952: 40–2).

6,211

417

As with Indian influence, the impact of Chinese culture on textile technique and iconography has varied in strength across Southeast Asia. Undoubtedly its greatest contribution was the introduction of silk thread and sericulture into the textile traditions of the region. As we have seen in the previous chapter, this led to technological and design changes of the most fundamental type through the shift from warp to weft decoration. In addition to this important raw material, still imported into the region in the twentieth century, Chinese influence remains evident in several aspects of the textile art of both indigenous and immigrant communities. However, unlike Indian influences that have largely diminished with time, the continued presence of a recognizably different Chinese population in most Southeast Asian countries has had certain direct influences on the designs, motifs and functions of the region's textiles.

While the last half of the twentieth century has seen a number of conflicting trends within Southeast Asia's Chinese societies, within the Baba Chinese communities of Singapore and Malacca there has occurred a recent and quite sentimental re-assertion of Baba customs and traditions. It has yet to be seen whether this renewed interest in the Baba blend of Chinese and Malay cultures, particularly of the artifacts that display this synthesis, will encourage an on-going textile tradition in these parts of Southeast Asia.

While Chinese embroideries and tapestry weave textiles have stimulated decorative techniques in certain directions, the imaginative symbols found on Chinese objects, especially textiles, obviously fascinated the textile-makers of Southeast Asia. As a rich source of ornament and style for functional items, Chinese images appealed not only to women of Chinese ancestry. At a symbolic level, certain Chinese motifs found ready acceptance in the region, although it is necessary to distinguish between those textiles that have been made for religious use by members of the overseas Chinese communities, and those textiles where Chinese images have been merely adopted

as an attractive means of representing existing concepts of the universe.

Many motifs, whether of a secular or a sacred nature in Chinese art, were adopted by Southeast Asian textile artisans because of their decorative appeal, and the attraction of chinoiserie led to the creation of some of the most charming decorative textiles to be found in the region. In particular, the natural style in which these appealing images were depicted transformed figurative designs on batik and embroidery.

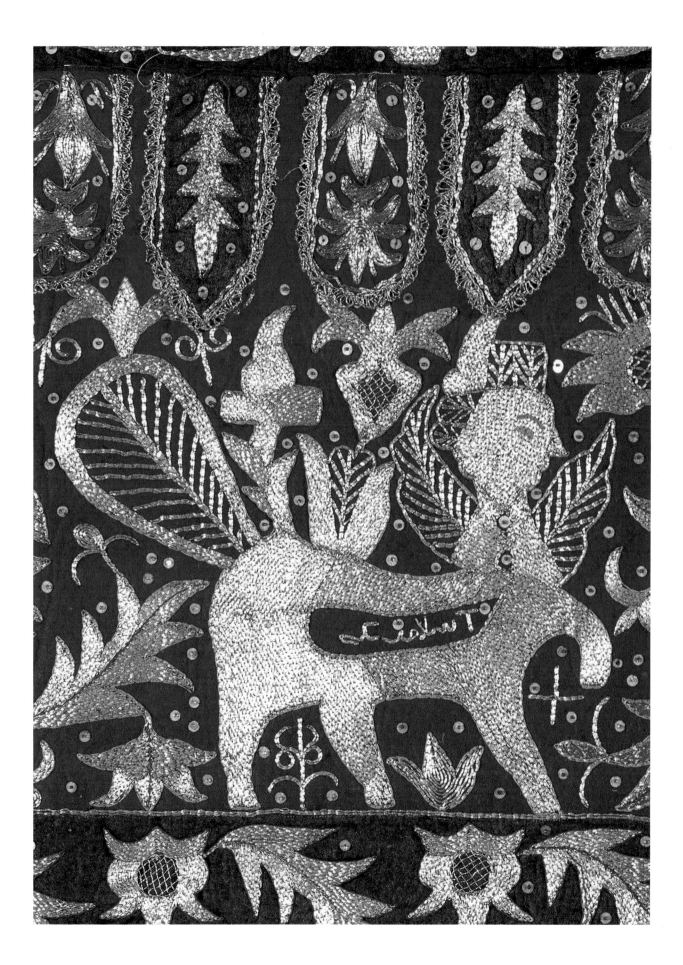

Chapter 5

ISLAMIC CONVERSIONS

The early history of Islam in Southeast Asia is still obscure. From earliest historical times, a growing system of international trade, both land and sea, linked the Middle East and the Mediterranean through Central Asia and the Arabian peninsula with India, Southeast Asia and China.[1] From its founding at Medina in the seventh century AD, Islam had an immediate and increasingly powerful impact on the trading world passing through the Middle East, and it is probable that foreign Muslim traders visited Southeast Asia soon after the conversion of Arab peoples to Islam. However, it is uncertain when Southeast Asians themselves were converted in significant numbers. Marco Polo, on his return by sea from his epic voyage to China in 1292, noted the existence of a Muslim town on the coast of north Sumatra, but it was probably not until the fourteenth and fifteenth centuries that Islam gained many followers in the Indonesian archipelago. The identity of the bearers of Islam to Southeast Asia also remains obscure, although there is evidence that they came from various backgrounds, and included traders from the Arab world, north-west India and southern China.

Apart from coastal Sumatra and particularly Aceh at the tip of that large island, the earliest recorded centres of Islam in Southeast Asia have been Terengganu on the east coast of the Malay peninsula, the north coast of Java, Brunei on the west coast of Borneo and Jolo in the Sulu archipelago (Ricklefs, 1981: 3–6), although it is unclear whether these Islamicized principalities were initially controlled by foreign rulers or by local converts. Southeast Asian merchants and seamen, and the local wives and families of foreign traders were probably among the earliest converts to the new religion, and many coastal and riverine kingdoms and city-states steadily and irrevocably became identified with Islam. The conversion of the major entrepôt centres in international trade, such as Malacca, facilitated the spread of Islam alongside commerce, although the dynamism of the new religion was not entirely restricted to the coastal regions. There is even evidence of conversions occurring within the court of Majapahit in east Java in the late fourteenth century, at a time when that mighty Hindu kingdom was still flourishing.

Despite egalitarian precepts and the lack of a highly specialized hierarchical clergy, it is clear that Islam had a strong attraction even

419
This lithograph of an Arab trader on Java's north coast ably captures the different style of garments worn by members of the Islamic community established in the towns and market centres. Robes are rarely worn in Southeast Asia nowadays, except by pilgrims returning from the hajj to the Holy Land. From W. L. Ritter *Java: Tooneelen uit het Leven*, The Hague, 1855

Opposite Detail of Plate 20

for the rulers of the coastal states of Southeast Asia, and it appears that conversions in many areas may have begun with the leaders at the top rather than with petty traders below. To explain the apparent appeal of what seems to have been a traders' creed, it has been suggested that Sufi teachers, who emphasized the mystical and spiritual aspects of Islam, may have played a key role in its spread throughout the region (Johns, 1961). These learned men would have fitted well with the intellectual milieu of the established courts of Southeast Asia, and their approach to Islam made it possible to integrate many older religious beliefs and social practices with the new religion. This obvious reconciliation of ancient traditions with adherence to Islam has remained a notable feature of Muslim communities throughout Southeast Asia and in particular has distinguished the practice of Islam among many of its followers in Java.

Like the spread of other new ideas, the impact of Islam has inevitably been uneven, with its strongest support becoming established in the archipelagos of western Indonesia and the southern Philippines. Beyond the Malay peninsula, Islam had little direct impact on mainland Southeast Asia.[2] It is in the coastal regions that Islam has continued to exercise the strongest cultural influence, but even within these communities, the strength of Islamic beliefs and the degree to which Islamic religious practices have absorbed older customs and traditions has varied considerably. Apart from the divisions that arose between coast and hinterland, Islam also became a rallying code behind which newly emerging powers aligned themselves. Religious divisions became prominent in the battle for commercial supremacy between the Christian Europeans who arrived in increasing numbers in the region in the sixteenth and seventeenth centuries, and the Islamic rulers of many of the region's trading centres.

The influence of Islam on the art of the region has been as diverse as the sources of Islam itself: some influences came via India through Gujarati and Persian traders and Mughal court fashions; others came through southern Chinese traders, some of whom had also become Muslims; yet other ideas came directly from Middle-Eastern sources with the visits of Turks and the travels of Southeast Asian pilgrims to Mecca. From the Islamicized centres of power and trade on peninsular Malaya and southern Thailand, Sumatra, Borneo, Sulawesi and the smaller adjacent islands, objects of material culture influenced by the Islamic world spread throughout Southeast Asia, even into its remote regions. We have already noted the spread of tapestry weave techniques through Bajau and Buginese seafarers. A number of other textiles and decorative textile techniques widely identified with Islamic culture burgeoned with the spread of the religion. The impact of these elements will be considered throughout the course of this chapter.

One of the most important factors in the spread of Islamic religious teachings and Islamic social and cultural values throughout Southeast Asia has been the role played by the hajj, the pilgrimage made by devout Muslims to the Holy Land and its sacred shrines in and around Mecca. Until recently, the hajj was often a long, arduous and even dangerous journey that took the pilgrim away from his or her native land for many months or even years. It was also an expensive venture and a privilege that only a small number of devout Muslims were able to experience. Consequently, those returning from the hajj have always been honoured and respected figures in the community.

Their first-hand experience of foreign lands, especially the culture and customs of the Islamic countries of the Middle East, and hard-earned wisdom and religious knowledge placed them in an important position in the local community. It has often been the hajji and their families who have been among the strongest critics of the older traditional elements of Southeast Asian culture, condemning any Islamic accommodation of them as dangerous heresy imbued with notions of spirit and ancestor worship. Consequently, in spite of the historical tendency for Islam to accommodate some of the mystical elements and beliefs of Southeast Asia, there has also been an opposing trend to promote a purer form of Islam more in keeping with the legal orthodoxy of the Koran. Since Southeast Asian culture, including traditional textiles, has been closely linked with ceremony and ritual, any reformist trend to promote a purer form of Islam has posed an important challenge to the traditional arts of the region.

CHANGES IN THE FUNCTION OF TEXTILES WITH THE COMING OF ISLAM

Islam has had a profound effect upon indigenous culture and the traditional ritual cycle wherever it has become well established in Southeast Asia. For instance, where Islam has taken root, elaborate funerals and the various associated mortuary rites are no longer so central to ceremonial life, and the focus has tended instead to be directed upon the spectacular celebration of the rites of life, in particular, circumcision, marriage and the installation of important leaders.[3] These cultural changes have had an important effect upon the way traditional textiles are perceived and used. Textiles are still

420 abundantly in evidence on ceremonial occasions, although hangings around bridal beds and circumcision thrones, for example, have been used predominantly as ornamental objects, providing glitter for the occasion and reflecting the wealth and prosperity of the family. The advent of Islam in the region has in no way diminished the pomp and ceremony of the royal houses or their exclusive and hereditary rights to certain symbols. Especially where Islam had to come to terms with the power of Hindu-Buddhist beliefs, many of the ancient Indic customs associated with kingship have been incorporated into the ritual of the courts of Southeast Asian sultans. Since textiles have played a central role in the court ceremonies of these domains, the specialized weaving villages that had flourished near court centres across Southeast Asia continued to provide fine textiles for the royal families who embraced Islam. The splendid model set by the Mughal rulers and their great appreciation and support of the decorative arts has been widely emulated by Southeast Asian rulers. Yet strange incongruities sometimes occurred, as in the Sulu archipelago where the long plain white shroud of Islam is wrapped around tiered umbrellas at the funerals of important members of the nobility (Bruno, 1973: 135).[4]

Whether because of changing social structures, particularly in the urban centres of Southeast Asia, or because strict ceremonial exchanges of rigidly delineated goods had declined in those cultures, the importance of textiles in marriage arrangements is not particularly significant in the Islamic societies of the region. While textiles as clothing and as decoration are an essential part of wedding celebrations, the bride's dowry or trousseau of outfits are an indication

420
In Islamic areas of the Malay world, bridal couples or children about to be circumcised are treated as royalty for the day. These occasions call for the finest textiles to be worn and displayed. At a young boy's circumcision in the Alas district of central north Sumatra, the main decorative technique evident on textiles is embroidery.

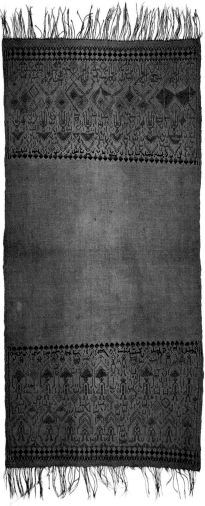

421

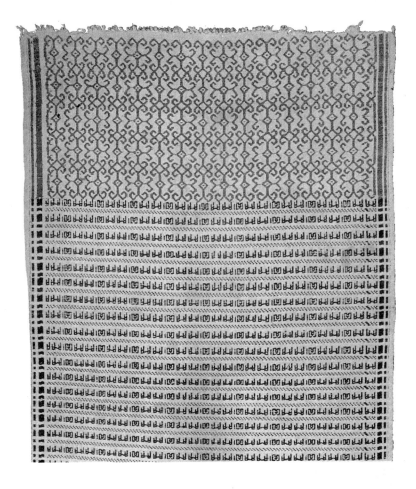

422

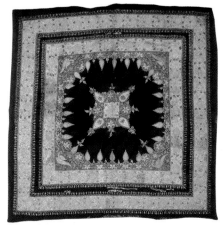

423

421
pesujutan; subahnalé
sacred cloth
Sasak people, Sembalun (?), Lombok,
Indonesia
handspun cotton, natural dyes
supplementary weft weave
82.5 x 39.5 cm
Australian National Gallery 1984.3180

422 (detail)
pesujutan
sacred cloth
Sasak people, Lombok, Indonesia
handspun cotton, natural dyes
supplementary weft weave
Museum voor Land- en Volkenkunde,
Rotterdam 27195

These Sasak ritual cloths, woven in
handspun cotton and displaying natural
dyes, occupy an important position in
both *Waktu Lima* and *Waktu Telu*
mortuary rites. Although, with the
passing of time and the strengthening
of Islamic belief, the designs on Sasak
textiles have become more stylized,
certain elements popular on early
Indianized textiles remain evident as in

Plate 421 — human figures, umbrellas
and buildings that appear to be
shrines. The fragmentary motifs
bordering the central section, and also
scattered throughout the design, are a
decoration based upon Arabic script.
The pattern on Plate 422, however,
displays an unusually clear message in
Islamic calligraphy, an invocation for
protection from God. Such clear
examples of Arabic script are rare on
Lombok, where even palm-leaf
manuscripts are still inscribed in
Sanskritic script.

423
Islamic pilgrims have traditionally
returned home with souvenirs from
their travels to the Holy Lands and
these occasionally included Middle-
Eastern textiles. This huge canopy of
imported cloth, displayed here as a
ceremonial wall-hanging (*dindi*), is an
heirloom of the royal family of Bima
on Sumbawa. It was probably made in
Turkey.

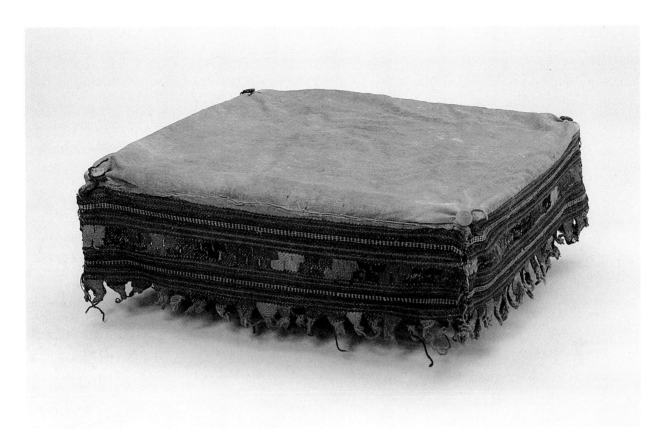

of the wealth of her immediate family, rather than a matter involving ritual exchange between lineages or larger family units.

Traditional theatre continued to thrive into the last century and its recent demise can only partly be attributed to conservative Islamic pressures. The courts of the Malay and Javanese sultans continued to be avid patrons of the arts, in particular, certain forms of classical theatre that had their origins largely in Hindu legends.[5] These dramas, such as the *mayong* on the east coast of peninsular Malaya, maintained the need for classical garments and the opportunity for their rich visual display.

Under the influence of Islam, in particular its reformist branches, many of the magical functions of textiles have diminished in importance. However, even where such changes have occurred, they have often been far from complete and there has usually been a degree of syncretism with pre-Islamic traditions and beliefs. This process can clearly be demonstrated by examining the religious and cultural changes that have taken place in Lombok since the arrival of Islam there in the seventeenth century.[6]

The Sasak people of Lombok themselves acknowledge a distinction within their society between two religious streams: those Sasak who are commonly described as followers of *Waktu Telu* and those who are followers of *Waktu Lima*. Taken literally, these terms are based on the notion that *Waktu Telu* Sasak allegedly acknowledge only three (*telu*) of the mandatory five (*lima*) Islamic precepts.[7] These labels are in fact an attempt to distinguish the devout followers of Islam from those Sasaks who, while nominally Moslem, have retained a strong and active commitment to traditional Sasak religious beliefs and cultural practices. *Waktu Telu* has been applied to the people of the remote villages in north-east Lombok around the

424
lelangit
sacred canopy
Sasak people, Lombok, Indonesia
cotton, Chinese coins, natural dyes
tapestry weave
63.0 x 67.0 x 18.0 cm
Australian National Gallery 1984.614

This Sasak sacred canopy is woven from handspun natural brown cotton. The borders are decorated in brilliant natural hues. Although the dominant colours consist of different shades of indigo, the effect is reminiscent of Central Asian flat-weave carpets (*kilim*). We know very little about the carpets brought back from the Middle East by the earliest Muslim pilgrims from this part of Southeast Asia although a connection is possible, and tapestry weave is also found on the neighbouring islands of Sumbawa and Bali. Canopies over participants in rites of passage have been widely used throughout Islamic Southeast Asia.

425
tudung tandu
canopy
Middle East; Terengganu, Malaysia
silk, natural indigo dye
tabby weave, braiding
201.0 x 205.0 cm
Australian National Gallery 1984.597

This indigo-dyed, plaid silk textile was used in Malay royal ritual as a canopy or cover (*tudung*) for a palanquin (*tandu*) in the court of Terengganu and was almost certainly brought back as a souvenir from the pilgrimage to Mecca. The actual shape of the textile and the finely worked braid are not typical features of Malay silk weaving. Similar cloths have been recorded in the treasuries of other noble families in Southeast Asia, including Aceh, and the Muzium Negara, Kuala Lumpur contains an identical cloth in its collection.

perimeter of the volcano, Mount Rinjani. Excluding the large Balinese communities in the west, orthodox Islam has become dominant in the rest of Lombok, and this is now widely regarded as *Waktu Lima* territory. However, the reality of social and religious change in Lombok is far more complex than this neat distinction suggests. The pace of this change has quickened in the last two decades and Islam has already penetrated the remote mountain villages. Nevertheless it is clear that throughout all of Lombok there remain small groups of people, particularly of the older generation, who still cling to pre-Islamic beliefs.

How has this complex pattern of social and religious change affected the traditional textiles of the Sasak? In those villages where their traditional culture has been most tenacious, certain named cloths are still used for ritual, magic and curative purposes, and these are woven by women using a backstrap loom with a circulating warp. Although in the past this type of weaving was widespread throughout the whole of Lombok, where Islam is now the dominant religion and cultural force, and where women still weave they produce textiles with greater affinity to Balinese secular weaving, using a comb loom and a discontinuous warp to make cloth for apparel.[8] The decorative techniques of gold supplementary thread on silk in a distinctively Sasak style are also evident.

This distinction, however, is really not as clear cut as it first appears. The different ritual functions of particular warp-striped textiles (variously called *kekombong, umbaq* or *lempot*) in *Waktu Telu* areas are well known. However, what has not been made apparent is that these textiles are also still to be found in many areas that are supposedly the stronghold of *Waktu Lima* culture, where they are regarded as valuable and even essential items, especially by the elderly. Another important category of Sasak traditional textile consists of several types of supplementary weft cloths known by various names (*usap, pesujutan* and *subahnalé*). While the textiles are found throughout Lombok, nowadays they are woven only in the remote mountain villages which are most strongly associated with *Waktu Telu* beliefs. Although these textiles have a wide range of functions in those areas, their use elsewhere in Lombok has been somewhat modified by the growing power of orthodox Islam. According to local Islamic practices, a cloth is used to cover the face and genitals during the washing of the corpse before burial.[9] Throughout Lombok, even in areas where a commitment to Islam is now dominant, these unusual supplementary weft textiles continue to be used for such purposes. In the villages of north-east Lombok where supplementary weft cloths are still woven, these textiles are still known as *usap*. It has been argued that the term *usap* may be derived from the Indonesian term *mengusap* (to wipe), as the wiping of the face is a Muslim custom after prayer (Kartiwa, 1986: 76–7). However, the use of the *usap* in *Waktu Telu* ritual goes far beyond that particular function.

Waktu Lima Sasak, however, often refer to such textiles as *pesujutan* (from *sujut*, to prostrate oneself during prayer, a prayer mat) and *subahnalé* or *subhanali* (from *Subhanallah*, the Koranic expression of praise, Most Holy Allah). While a few rare examples of these textiles display Islamic script woven into the design, other *pesujutan* retain ancient designs that include anthropomorphic motifs and Indic-style shrines. The secular ceremonial textiles woven in supplementary weft technique by the *Waktu Lima* Sasak of the cen-

94,356

184,195,246
421,422

422
184,421

tral plains also include figurative motifs — in particular pairs of human figures with pointed profiles, sheltered by umbrellas of rank or riding in dragon-ships — and although these are pre-Islamic and notably Indic designs they are also known by the Islamic title, *subahnalé*.

166,424 Throughout Lombok the body of the deceased continues to be laid out beneath a cloth referred to as a *langit* (ceiling, heaven). Despite the spread of Islam these textiles have retained their old name and take the form of either small locally made tapestry weave cloths or large Indian mordant-painted textiles. Sacred and royal canopies
425 were often converted under Islam to form a decorative backdrop for ceremonial occasions, although sometimes such textiles retained names more appropriate to their original function. In the Sultanate of Bima in eastern Sumbawa, for instance, an aristocratic bridal couple sit in state on a raised platform before an heirloom wall-hanging from
423 the woman's family, which is called the *dindi langi*, the wall of heaven (*dindi*, wall; *langi*, heaven, sky).[10] In the southern Philippines, the T'boli *k'labu* is a canopy formed from appliqué of cloth traded from the coastal areas. The opulence of these T'boli canopies is a direct indication of the wealth and prestige of the family who display them in the area of the T'boli traditional house reserved for the head of the house and distinguished guests. In similar displays, several communities in the southern Philippines, including the non-Islamic T'boli and the Muslim Tausug, strew the reception area of their houses with richly decorated mats, stuffed mattresses and cushions on ceremonial occasions (Bruno, 1973: 10). This use of these objects is also a feature of Sumatran Malay ceremonies.[11]

426 Funerary canopies have continued to be used in many Islamic societies, for decorative, practical and symbolic reasons. So, too, have textiles as flags and offerings that mark the graves at the anniversaries of the dead in the Sulu archipelago (Szanton, 1963: 39). Important batik-making villages in Java are situated near royal cemeteries, and it is the female relatives of the Islamic officeholders who control textile production in these districts (Joseph, 1985). The importance of textiles at grave-sites appears to be a continuation of a much older Javanese custom that dates back to pre-Islamic times when textiles were important as religious art and offerings. In return for maintaining these important sanctuaries, the Javanese who lived in villages located near shrines and grave-sites visited by pilgrims were not required to pay taxes. This has allowed the inhabitants of these villages the time and wealth to develop artistic skills and many batik centres are still located near such sites (Boow, 1986: 67–8).[12]

Warfare, a traditional element of Southeast Asian life, became even further entrenched as foreign forces began to influence the region and as small and large kingdoms strove to establish and maintain their power in the face of rival centres. The Islamic coastal communities, in particular, were regarded as feared pirates and aggressive fighters, and as contacts increased between potential rivals for power and authority in the region, warfare became more evident and imperative. In place of the ritual communal importance warfare has traditionally held, dramatic martial-art styles developed in many societies, especially in the Malay-Islamic world. Refined entertainment and forms of meditation, these were opportunities for men to dress in fine and beautifully decorated traditional costume — shirts, pants, headcloths and waistcloths (Amilbangsa, 1983).

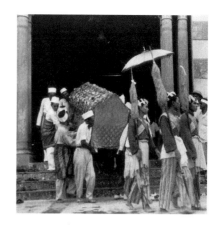

426
A photograph taken during the funeral of an unidentified sultan on the east coast of Sumatra. Malay attendants in headcloths, pants, shirts and waistcloths carry furled umbrellas. The funeral bier is draped with an elaborately worked cloth.

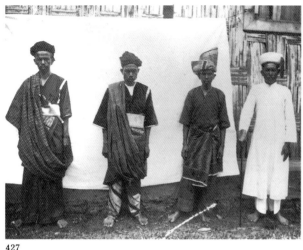

427

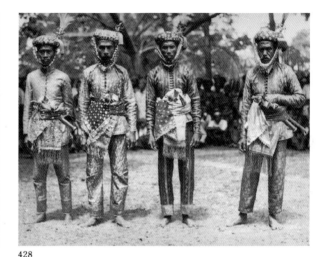

428

GARMENTS FOR THE NEW FAITH

Despite the conversion of many rulers to Islam, the structure of the kingdoms of Southeast Asia did not greatly change.[13] The well-established symbols of state power were maintained, and clothing continued to indicate rank. Islamic notions of appropriate dress, however, steadily began to affect the forms of clothing worn in many parts of the region. While this occurred initially within the Islamic communities, such changes gradually began to influence the textiles of neighbouring peoples. One fundamental change attributable to Islam was the way the human body became substantially covered in public, especially during overtly Islamic ceremonies and observances. In some instances, new garments became appropriate for everyday wear and as costume for Islamic festivals, while older textiles with special significance were retained for more ancient rituals and ceremonies.

427

In contrast to the dictates of ancient custom by which garments were made up of sets of rectangular textiles, the influence of Islamic cultures from the Middle East and elsewhere produced a range of wonderfully decorative garments, including robes, coats, shirts, jackets, trousers and many smaller costume accessories, that demanded expert tailoring skills. While some of these items of clothing — especially shirts, trousers and head-coverings such as caps, veils and wraps — became more apparent, it seems that, wherever possible, Southeast Asians continued to prefer a minimum of cutting and tailoring of cloth. Where cloth was cut to be tailored it was often imported fabric that was used. When locally woven cloth was required, it was mainly the plain woven varieties, with ornamental embroidery added after the garment was made up.

428

A prominent feature of Islamic costume throughout the region is the headcloths of various types for both women and men. As far as women are concerned, while the form of many of these cloths reminds us of the veil of the Middle East, veils as such are rarely worn in Southeast Asia, and the cloths are worn more often draped lightly over a woman's shoulder. It is probable that the origins of the Malay and Javanese *selendang* are a reflection of these influences, though these have remained merely decorative shouldercloths.[14] In many areas, the multipurpose, often plaid, cylindrical cloths are used in a

427
This carefully posed photograph illustrates the variation in costume that the Minangkabau of west Sumatra deem appropriate for different ceremonial occasions. On the left, three men are dressed in full traditional costume suitable for celebrations such as weddings and the installation of ritual leaders. The locally made garments are woven in gold thread and silk. The checkered cylindrical shouldercloths are Buginese from south Sulawesi, and the batik from which the brightly patterned trousers are fashioned comes from Java. The actual composition of the outfit will depend on the particular ceremony and in the case of weddings, the man's relationship to the female participants. The man on the far right is suitably clad for an Islamic observance.

428
A nineteenth-century photograph of court officials on the island of Sumbawa wearing Indian brocade coats and trousers, flat metal embroidery and 'handkerchiefs' (*sapu tangan*) tucked into waist-wraps. On their heads are rolled headcloths with the characteristic chin strap of Bima.

429
In the Lanao district of Mindanao, a Magindinao man and his family wear the versatile cylindrical cloths, which are particularly popular in Islamic Southeast Asia. These tubular textiles, often in checks and stripes, also function as veils, waist-wrappers and carrying cloths for babies, goods and ceremonial objects. Two of the cloths are decorated with warp ikat designs.

429,430

variety of ways — as skirtcloths, shouldercloths, head-coverings and as slings for goods or children.[15]

The Central Asian turban had little appeal for men living in tropical Southeast Asia. Although many forms of headcloths were widely adopted, particularly by coastal peoples,[16] these do not appear to have become common in Southeast Asia until after the height of the great Indic kingdoms.[17] There are many terms for headcloths across the region, and some of them suggest the foreign origins of the garment. For example, *dastar* or *destar* follows the Persian term for turban (Chandra, 1961: 13, 19; Crill, 1985). The tubular head-dress worn at circumcisions, coronations, and by the bridegroom at weddings in parts of Sumatra, Java and the Malay peninsula, often appears to be a remnant of certain older types of turbans. Although some examples have ornaments appliquéd to the surface, among the Minangkabau of west Sumatra and the Buginese of south Sulawesi the turban was transformed into a tubular metal crown. The style of this head-dress, however, is reminiscent of early nineteenth-century lithographs depicting Arab traders or local Islamic pilgrims returning from the hajj. Women's head-dresses from these areas are composed of ornamented cloth, or sometimes are constructed entirely of tooled metal.[18] Another structured form of head-dress, also based originally on a Turkish or Central Asian model, is the Acehnese *kopiah*, a large quilted cap worn by men on formal occasions.

125,126
127,178

431

The headcloth, approximately one metre square, has been widely adopted by men in many parts of Southeast Asia as both formal and everyday wear, and it has been tied in a wide variety of ways, some of which have been used to indicate status or ethnic origin. Among the Malays, devising elegant new forms of tying their particular brocade headcloths (*tengkolok*; *tengkuluk*)[19] became a leisured pastime. On the Malay peninsula, the manner of tying the headcloth worn by nobility has been a way of indicating the royal house to which the person belongs. Each style of folding had its own charming or descriptive title — *dendam ta' sudah* (endless longing), *ayam patah kepak* (the chicken with a broken wing), *mumbang di-belah dua* (a split coconut) or *sa' kelongsong bunga* (a flower in its sheath) — and many were invented for a special occasion or commemorated an historic event (Sheppard, 1972: 110–11). In the Sultanate of Kedah the position of the tips of the headcloth when folded and tied were one sign of a person's social status: left ear for nobility and senior rank, right ear for commoner and if the knot was worn at the back, warrior.

438,439

434,435,436
437

The Sulu archipelago and parts of neighbouring Mindanao were the areas most strongly exposed to Islamic influences in the southern Philippines. The history of this region and its people became identified with the long struggle against the Spanish invaders. There the square headcloth is a characteristic item of costume for the Islamic peoples,[20] although many of their non-Islamic neighbours, such as the T'boli of Mindanao, have also adopted it for men (*olëw*) and women (*kayab*). These have obviously been an integral part of T'boli material culture for centuries and are now an important element in marriage ritual and legend.[21] The traditional costume of the Bagobo, another Mindanao non-Islamic people, also displays a melding of ancient and foreign elements. Short jackets are worn by both sexes, and Bagobo men long ago seem to have adopted the headcloth of their Islamic neighbours although they have continued to apply their distinctive

292,410
411

432,433

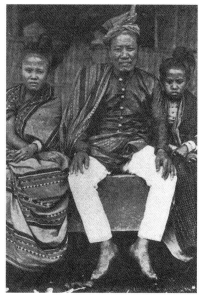

429

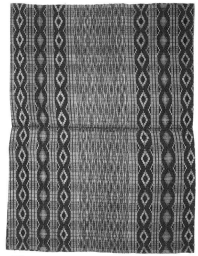

430

430
patadjung
skirt; shouldercloth; baby-carrier; headcloth
Tausug people, Sulu archipelago, Philippines
silk, dyes
tapestry weave
108.0 x 83.0 cm
Australian National Gallery 1984.1222

Cylindrical cloths serve a multitude of functions in everyday life and at ceremonies in the Islamic world of Southeast Asia. This fine example probably dates from the mid-twentieth century and might function as skirt, headcloth or shouldercloth for women in the Sulu archipelago. The colours are predominantly red, green, purple and orange.

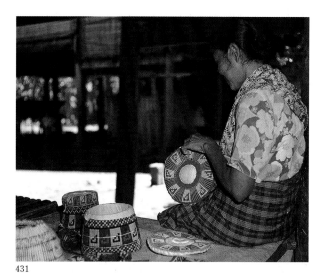

431

432

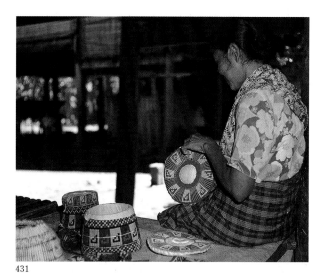

433

431
Apart from headcloths, various forms of caps are worn by Muslim men in Southeast Asia. This women is stitching a *kopiah*, the brightly coloured quilted headgear worn on ceremonial occasions by Acehnese men. A headcloth is sometimes wrapped around the *kopiah*. In the foreground caps in various stages of construction can be seen.

432
This incomplete *tanculu pamudbud* was collected by the anthropologist Laura E.W. Benedict in Talun,

Mindanao, in 1908 to demonstrate the process of tie-dyeing (*binudbud*). According to Benedict's notes at the Museum of Cultural History, New York, the Bagobo women told her it took four to five weeks to stitch and tie the patterns preparatory to dyeing.

433
tanculu pamudbud
warrior's headcloth
Bagobo people, Mindanao, Philippines
cotton, natural dyes, beads, sequins
tie-dyeing, stitch-resist dyeing,
embroidery
86.5 x 77.6 cm
Australian National Gallery 1984.1227

The design of this headcloth (*tanculu*) shows branches (*ponga-ponga*) radiating from a central moon motif. Other shapes are said to be stars and smaller moons. The range of motifs used on tie-dyed Bagobo headcloths was quite restricted and the designs are always worked in neutral cream-white motifs on a deep brown-red ground. The wearing of a headcloth of this type was the traditional mark of a successful warrior in Bagobo society. This headcloth dates from the late nineteenth or early twentieth century.

434

435

436

437

schematic emblems. However, the designs on these headcloths are worked in tie-dyeing techniques and on imported cotton cloth, in sharp contrast to the abaca weave textiles which the Bagobo also continue to use for their other costume.

In the tropical climate of Southeast Asia it seems that jackets were initially restricted to priests and soldier-warriors, and even they appear to have worn them mainly for ceremony, ritual and warfare.[22] In Bali and Lombok, for instance, sacred woven cloth is used for men's ceremonial jackets, although jackets never became a part of everyday apparel on those islands. In Southeast Asia before the coming of Islam, royalty wore skirtcloths distinguished from those of the ordinary people largely by the fineness and opulence of the cloth (Reid, 1988: 85), and neither king nor commoner seem to have covered the upper body with clothing. However, influenced by Middle-Eastern traditions and environment, the Islamic custom of covering the upper body of both men and women, encouraged the use of shirts and jackets throughout the Islamic world and this eventually spread to Southeast Asia. By the beginning of the fifteenth century not only did the men of the great port of Malacca, already converted to Islam, wrap their heads with a square piece of cloth, but short jackets were widely worn (Groeneveldt, 1877: 123).

By at least the eighteenth century, and increasingly in the nineteenth, longer flowing shirts and jackets had become widespread, even in non-Islamic Southeast Asia, as items of daily apparel. Many tailored shirts and jackets cut in Indian style also became popular in Southeast Asian courts where Islam was a dominant influence, and these long shirts and jackets appear to have been inspired by the *jama* coats of the Mughal courts of India (Lal, 1983: 90). This seems to have been the case in the courts of Aceh, and also those of south Sulawesi and Sumbawa,[23] where long Mughal-style coats in Indian brocade became an important part of the regalia of the sultans.[24]

In most cases the Islamic-style shirts were worn short, often over the traditional Southeast Asian skirtcloth. Tunics already in use within the region may have steadily changed shape in response to these influences, for there is widespread similarity in the cut of many upper garments throughout Southeast Asia. While the Minahasa abaca fibre *baju* was gradually replaced by more comfortable cotton fibre during the nineteenth century or earlier, flowing robes of fine

440,441
442,443

428

434, 435, 436 and 437
Just as arranging one's cravat or tie was an important part of men's dress in Europe, the aristocracy of the Malay peninsula made an art out of the tying of the headcloth. Each style had a particular name, some of them poetic, others commemorating a special event or celebration. Each of the Malay sultanates devised unique forms which became identified as symbols of their particular court. This set of photographs of various members of the Malay aristocracy in the mid-1960s illustrates decorative ways of arranging the square headcloth. From left, top row, the Sultan of Pahang, the Yang di Pertuan Besar of Negri Sembilan, and the Sultan of Kelantan and, below, the Sultan of Kedah.

438
A group of Malay and British rulers in colonial Malaya dressed in formal attire. A great variety of headcloth styles is evident. The court attendants in the front row are wearing *kain wali* around their necks, or *kain tetampan* on their shoulders.

439
ikat kepala; tengkuluk
man's headcloth
Malay people, Palembang region, south Sumatra, Indonesia
silk, gold metallic thread, natural dyes
supplementary weft weave, weft ikat
86.0 x 84.0 cm
Australian National Gallery 1980.1631

Throughout coastal Sumatra, men's headcloths were especially decorative. This example combines weft ikat (*limar*) with supple gold thread supplementary weft weaving (*songket*). Because of the outstanding quality of the gold thread it is not easily damaged when the headcloth is folded ready for use.

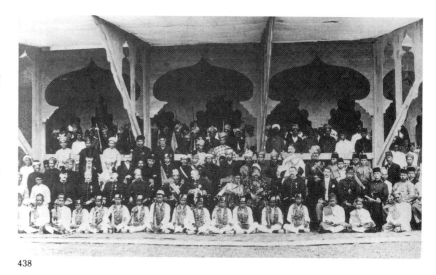

438

abaca fibre continued to be worn as a sign of high birth in the Sangihe and Talaud Islands. Long-sleeved tunics are now widely used by women throughout the Malay world. For formal occasions they are made out of expensive fabric, either woven or embroidered, and the embroidery on long tunics often follows an established weaving pattern. Among the peoples of south Sulawesi, the customary use of textiles to indicate social status was extended to include the flimsy pineapple-fibre woman's blouse, the *baju bodo*. Buginese women of different age and marital status have traditionally worn blouses of particular colours and shades in natural dyes, and certain colours were the prerogative of members of the highest nobility and even the royal wet-nurses (Sapada, 1977).

Only rarely did locals adopt the flowing kaftans of the Middle East, although early lithographs and photographs suggest that these garments were often worn by Arab traders, many of whom settled in port cities and market towns. The wearing of such garments may have distinguished foreign Muslims from Southeast Asians in the past. However, within the religious communities which grew up wherever Islam took root in Southeast Asia, such as the *pesantren* of Java and the *surau* of west Sumatra, the leaders of these communities, usually well-known and highly respected religious scholars and teachers (the Javanese *kiai* and the Minangkabau *ulama*) often adopted the flowing robes associated with Islam and the Middle East as their badge of identity. The names of these garments, such as the *jubah* (after the Arabic *jubbah* or *jaibbah*, robe) and *cadar* (*chadar*, veil) indicate their specific origins and direct identification with Islam. Nowadays this style of costume most readily distinguishes religious leaders and pilgrims recently returned from Mecca from the rest of the population.[25]

Pants and trousers for men were widely adopted wherever Islamic culture spread. In particular, this has included certain forms of short pants, with a wide inset and often loose crutch, sometimes heavily embroidered and elaborately decorated along the cuffs. These include the Acehnese *silueuë*, the Javanese *sruwal*, the Malay *seluar* and the Tausug *sawal*, all terms that are related to the Persian *shalwa* and Turkish *shalvar*. Women in Southeast Asia, however, generally did not respond to either the Middle-Eastern or Chinese custom of wearing trousers, and only in Aceh, east Sumbawa[26] and throughout

444

358,359

445

419

444

116,141
446,447
448

1

439

440
baju telepok
woman's ceremonial jacket
Malay people, Malaysia
cotton, gold leaf
gluework
105.0 x 50.0 cm
Australian National Gallery 1984.596

In certain regions of the Malay
peninsula, locally woven brocade was
not the basis of ceremonial dress.
Some sultanates developed elaborate
costumes from imported Indian
brocades, and in other kingdoms it was
gold leaf gluework (*telepok*) that
provided the sumptuous fabric for
royal ceremony. The glue was applied
with small wooden stamps and the
adherence of the gold leaf was assisted
by polishing the fabric with a shell.
This small collared jacket for a young
girl opens down the front and would
have been fastened with a series of
ornamental brooches. The pattern in
gold leaf emulates gold brocade
designs.

441
baju prada
man's ceremonial jacket
Javanese people, central Java,
Indonesia
cotton, gold leaf
gluework
179.6 x 58.4 cm
Australian National Gallery 1988.1547

Jackets have been part of the formal
dress of the Javanese aristocracy for
centuries. Most nineteenth-century
jackets were made of striped handspun
cotton (*lurik*) or dark imported
European fabric emblazoned with
passementerie. This is a rare example
of a fine festive jacket, tailored from
imported fabric and decorated with
gold leaf gluework (*prada*). The cut of
the garment with a high collar and
long pointed front panels is similar,
however, to those older style jackets
fashioned from *lurik*.

440

441

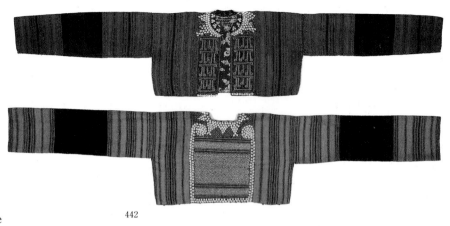

442

............
women's jackets
Kauer people, south Sumatra,
Indonesia
cotton, silk, natural dyes, mirror
pieces, shells, metallic thread
supplementary weft weave,
embroidery, appliqué
153.5 x 33.0 cm; 151.0 x 30.0 cm
Australian National Gallery
1981.1170; 1980.1652

Young women in the Kauer district of
the western highlands of south
Sumatra wear decorative long-sleeved
jackets on ceremonial occasions. There
is little variation in the designs on
these short jackets, and these
examples show the typical intricate
embroidery and supplementary weft
weave with which the front and back
panels are filled.

442

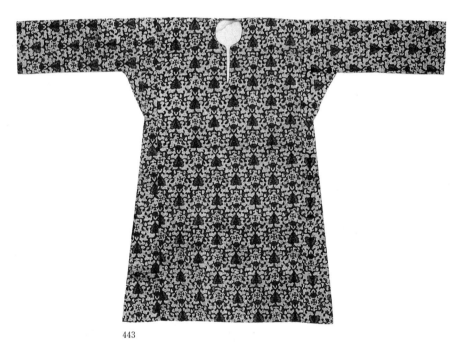

443
baju kurung (?)
woman's tunic
Javanese people, Lasem, Java (?);
Acehnese people, Sumatra, Indonesia
cotton, natural dyes
batik
153.0 x 106.2 cm
Australian National Gallery 1987.1818

This long tunic is fashioned from batik
cloth of a style modelled on a floral
Indian trade cloth design and popular
in Sumatra. The tunic is believed to
have come from Aceh, but it is typical
of the *baju kurung* style used
throughout the Malay world of
Southeast Asia. The batik has the rich
red and cream colours of north-coast
Java, although batik cloth is never
used in Java by any group for woman's
tailored jackets and tunics. The
garment was probably made up
elsewhere.

443

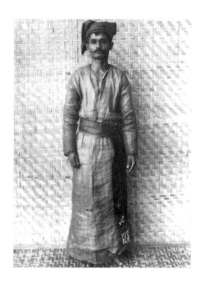

444
On the small islands of the
Sangihe-Talaud group, long robes
modelled on Middle-Eastern garments
became accepted wear for men and
women. This photograph of a man in a
woven fibre robe was taken in the
early twentieth century. Until at least
that period these robes were made
from a fine gauze-like fabric of
vegetable fibres, obtained from the
wild banana plant or from wild
pineapple leaves, and woven on a
simple backstrap tension loom. Such
robes (*jubah*) became widely known
throughout the Indonesian archipelago
after the Arabic term.

the southern archipelagos of the Philippines did they adopt this form of dress. Elsewhere the cylindrical skirt was already well established for women, and in many cultures, also for men.

In the Islamic areas where trousers have been adopted by either sex, a shortened wrap or skirt is usually worn over the trousers on formal occasions so that the tops of the legs are concealed. This has led to a new narrower version of the skirtcloth or the use of shoulder-cloths and short skirt-wraps. Where the legs of the trousers are exposed, decorative silk embroidery or gold brocade borders are often features of these garments.

Trousers are rarely worn by women in mainland Southeast Asia. Further north, Mien women wear loose embroidered pants, but the model for these is clearly Han Chinese as the art and culture of Daoist Mien culture has been strongly influenced by its northern neighbours. Elsewhere in Southeast Asia, however, the adoption by men of short pants or trousers by certain non-Islamic peoples, such as some of the ethnic groups in Mindanao and the Toraja of central Sulawesi, appears to have been strongly influenced by the costume of their coastal Islamic neighbours, for the similarities of cut and style are too obvious to ignore. The terms for trousers even in non-Islamic regions show similar derivations from the Central Asian term *shalwar*.

The colour symbolism of Southeast Asian textiles continued to play a prominent role in Islamic communities. In the coastal Malay sultanates yellow was restricted to royal use, and golden silk outfits of

449

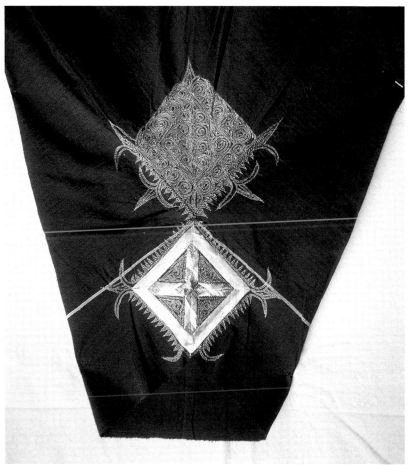

446

445

445
The Buginese and Mandar people of south Sulawesi are well known throughout Southeast Asia as seafarers and traders. Consequently the textiles woven by the women of south Sulawesi have been carried to many parts of the Southeast Asian region, and their clothing styles have influenced other groups, particularly coastal dwellers. This young Mandar woman wears a fine checkered textile coloured with natural dyes. Her blouse is the traditional *baju bodo*, although made from nylon gauze rather than from the traditional but now obsolete woven pineapple fibre. This simple but elegant blouse is formed from a folded rectangular piece of fabric stitched along the selvages, with openings left for armholes and with a hole cut for the neck opening. This form of blouse has now become popular in many parts of eastern Indonesia.

446 (detail)
silueuë lambayong
ceremonial trousers
Acehnese people, Aceh, Sumatra, Indonesia
silk, metallic thread
couching, embroidery
79.0 x 68.0 cm
Rijksmuseum voor Volkenkunde, Leiden 1599–258

Women rarely adopted trousers as ceremonial dress in the Islamic world of Southeast Asia. In Indonesia the exceptions are found in Aceh and Sumbawa. The cut is very wide around the hips and tapering to fit tightly to the leg. The style and placement of the gold-thread embroidery on these Acehnese woman's trousers suggests strong Turkish influence (Johnstone, 1985: 28).

447
sawal
man's trousers
Bagobo people, Mindanao, Philippines
abaca fibre, cotton, dyes
embroidery
47.0 x 51.0 cm
Australian National Gallery 1984.1229

448
seluar
man's ceremonial trousers
Malay people, Terengganu, Malaysia
silk, cotton, gold thread, natural dyes
weft ikat, supplementary weft weave,
needle-weaving
71.0 x 79.0 cm
Australian National Gallery 1984.1095

While there is great diversity of
language throughout the region,
insights into the shared origins of
textile techniques, forms and styles
can sometimes be gleaned from local
terminology or traced from local
names for particular types of textiles.
The term for short trousers varies
little across insular Southeast Asia and
apparently derives from the Persian
word, *shalwa*, meaning tailored
trousers. The length of the leg may
change, but the basic shape remains
standard in those parts of the region
where trousers have been adopted. On
the east coast of the Malay peninsula
trousers are worked in gold and silk
thread (Plate 448), while the Bagobo
of Mindanao continue to use abaca
cloth (Plate 447).

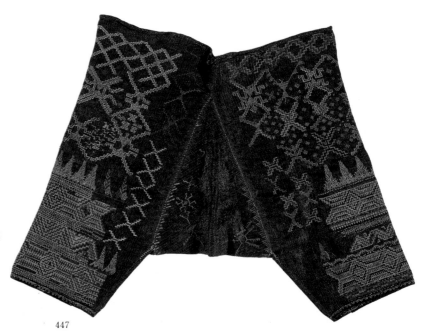

447

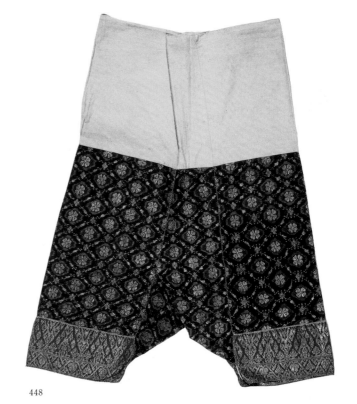

448

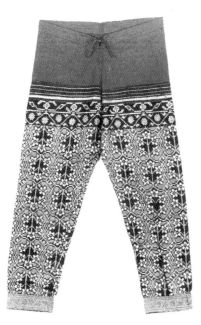

449

449
celana cindé
ceremonial trousers
Gujarat region, India; central Java,
Indonesia
silk, braid, natural dyes
double ikat, band weaving
137.0 x 44.0 cm
Art Gallery of South Australia
747A150

In the courts, ceremonial trousers
were made from rich silk fabrics
decorated, particularly around the
cuffs of the legs, with gold brocade,
braid or fine embroidery. A dazzling
and expensive fabric also used for this
purpose was obtained from the double
ikat *patola* imported from Gujarat. The
high status and wealth of the wearer
were signalled by the particular *patola*

shirts and pants, dyed in turmeric root, have been noted from the tip of Aceh to Mindanao. This colour may have earlier associations with kingship and authority in Southeast Asia, however, for yellow is also the traditional colour of royalty in northern Thailand and Laos among the Buddhist Tai Lue (Prangwatthanakun and Cheesman, 1987). Green on the other hand became the colour of Islam and its religious leaders in many parts of Southeast Asia. Hence the *patola* most favoured by some of Malay rulers display the popular star motif set against a yellow or green ground.

CLOTH OF GOLD: ISLAMIC INFLUENCES ON EMBROIDERY IN THE MALAY WORLD

The importance of Indian and especially Chinese influences upon the spread throughout Southeast Asia of metallic thread and the textile techniques associated with it have been described in the previous chapters. The arrival of Islam and the impact of influences from the Middle East, Turkey and Mughal India upon the region further strengthened these trends. Gold and silver thread is now closely identified in Southeast Asia with the Malay-Islamic world. How long this has been the case is not known and we have no more than a

patterns chosen. This example comes from central Java where *patola* trousers and waist-sashes are an important part of royal costume for ceremonial occasions.

450
............
ceremonial cover or cushion
Malay people, east Sumatra, Indonesia
velvet, gold thread, sequins, mirror pieces
couching, embroidery, appliqué
50.8 x 48.2 cm
Australian National Gallery 1987.1067

451
bantal (?)
ceremonial pillow
Malay people, Palembang region, south Sumatra, Indonesia
kapok, cotton, velvet, silk, gold thread, sequins
embroidery, couching
7.4 x 33.6 x 56.4 cm
Australian National Gallery 1986.2455

Many of the objects used in Malay ritual are covered with protective textiles, displaying images such as birds, animals and foliage. These motifs are unrelated to Malay villagers' direct experience, but are chosen for their exotic qualities. Islamic script is also a popular feature. It varies on these examples, from a simple evocation of Allah to a phrase or verse from religious sources.
A majestic animal with a barbed tail, possibly a lion or a Chinese mythical creature such as a dragon or unicorn, prances along each side of the ceremonial coverlet (Plate 451). The borders are decorated with vases from which flowers curl. The star shape in each corner and in the centre is a simplified version of the star flower-head found on Ottoman decorative covers (*bohça*). Most *bohça* also had a central pattern framed by a wide border filled with floral and arabesque scrolls.
The three-dimensional cushion, probably made for an aristocratic child's first ceremonial hair-cutting, also has features typical of Malay embroidery, including a diagonal grid with floral motifs, and stylized Arabic calligraphy. The cushion has velvet sides and two loose embroidered covers.

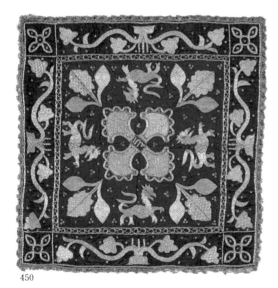
450

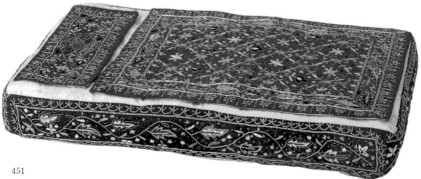
451

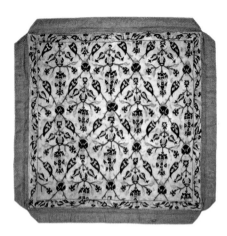

452
bohça
cover
Turkey
linen, silk
embroidery
88.9 x 88.9 cm
Australian National Gallery 1980.4314

This seventeenth-century Ottoman embroidered cover displays a number of design features evident on Southeast Asian textiles: the structural layout of a square central field and a meandering border, the diagonal grid containing vases or posies, and even stylized tulips and carnations. Other examples of Turkish *bohça* from the same period were made of velvet and embroidered in gold thread (Johnstone, 1985: 27; Atil, 1987: 204).

fragmentary picture of the possible influence of those areas of the Islamic world beyond Southeast Asia in these developments. Through commerce and diplomacy the courts of the region maintained contacts with the Sultan of Turkey and the Mughal rulers of India (Reid, 1969). As in the Ottoman and Mughal empires, lavish metallic thread embroidery appears to have flourished in the Islamicized regions of Southeast Asia from at least the seventeenth century, and certain styles of embroidery encountered in Aceh were known in Europe as 'Turkey work' (Leigh, 1982).

By the seventeenth century, the rulers of Aceh and many of the Malay kingdoms were said to have modelled their court dress and royal ceremonies on those of Mughal India (Hall, 1968: 218–19). By this period, Islamic modesty had almost certainly prevailed and the women and men of the Acehnese court had probably already adopted the pants, overskirt and head-covering still worn on ceremonial occasions. Embroidered objects such as square food- or cushion-covers from the courts of Sumatra, Borneo and peninsular Malaya are often *450,451* quite similar in their design structure and arabesque motifs to Turkish gold and silk embroidered *bohça* of the seventeenth and *452* eighteenth centuries. The basis for such embroideries was often wool and velvet cloth and both these fabrics were early imports into Southeast Asia from Persia (Rouffaer and Juynboll, 1914: 437). Embroidered covers and breastcloths were also prominent in the Ayutthaya courts, and while these were worked in Thai style, they were also clearly imported from Mughal India (*Old Textiles of Thailand*, 1979).

Although the importance of Chinese influences upon the spread of the couching technique has already been described, within Southeast Asia couched gold embroidery has achieved its highest standards *453* in the Malay world where Islam has become firmly established as the guiding religious and cultural ethos. It appears that the royal courts on the Malay peninsula became centres of excellence for either weaving or embroidery, but not both, and the Sultanate of Perak, in particular, became famous for the quality of its three-dimensional form of gold thread couched embroidery (*suji timbul*, also known as *tekat*). In the nineteenth century, embroidery was still a noblewoman's occupation, and the wife of the Sultan of Perak was considered one of the finest artists in this decorative technique (Wray, 1908: 237).[27] The decorative technique is also used on many court costumes, particularly those worn by dancers, and on many examples of raised couching, gold thread is combined with silk, mirrors, sequins and metallic tinsel (widely known as *gim*).

The couching technique known as *tekat* uses small card templates which are cut into the shape of the desired motif. These form the base (*dasar*) over which the gold thread is laid back and forth on the surface. At each turn the gold thread is tacked into position with hidden thread, a technique that permits the maximum use of expensive gold thread since none is lost from view on the inside of the object. This suggests that embroidery in Southeast Asia was seen as a faster and more frugal alternative to gold thread supplementary weft weaving. Similar to the use of gold leaf gluework, the ornamentation is sometimes added only to those parts of the costume that are revealed when it is worn.

This couching technique has been used throughout the Malay-Islamic world to embellish a wide variety of ceremonial hangings and

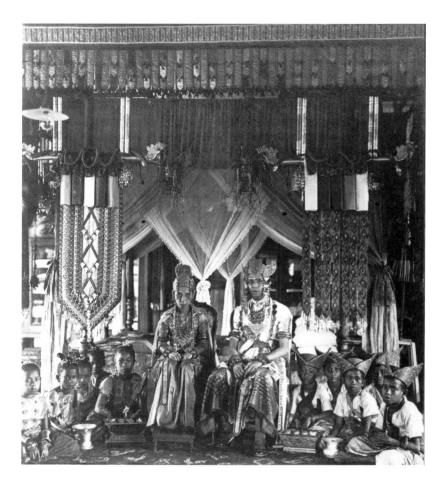

453
In a photograph taken in 1927 at Tenggarong in the Sultanate of Kutei in east Kalimantan, an aristocratic bridal couple wearing gold brocade textiles sits in state above a group of followers. The throne room is decked with embroidered and appliqué hangings, and a carpet lies on the floor.

regalia. The function and size of these objects have been contributing factors in the selection of the various motifs. Some of the larger hangings have traditionally been used to decorate the wedding seat and bridal chamber. In their most elaborate form these hangings *454* create the complete decorated room (*pelaminan* or *kamar lengkap*) and contain many of the most dramatic and striking designs. Simpler forms of decoration adorn a range of accompanying items: food-covers, mosquito-net clasps, pillow-ends, fans, slippers, betel-nut boxes and prayer mats.

The size, shape and structure of these various hangings indicate the variety of foreign influences on them. Long narrow horizontal *20,28,370* hangings, with tongues of embroidered fabric, recall the welcoming Rajastan *toran* (or *torah*) used around doorways. These textiles are known in many parts of the Malay world as *tirai*, a name also given to woven borders that display similar motifs (Ng, 1987). Long rectangu-*455* lar vertical hangings, often with a central tree or vase motif, are reminiscent of the *qanat* hangings of Mughal India. In contrast, the square betasselled hangings, with distinctly different motifs in each of two horizontal panels and sometimes finished with a macramé fringe, reflect the influence of Chinese altar-cloths and hangings discussed in the previous chapter. The motifs these cloths contain, however, have clearly been influenced by Islam and all these variously shaped hangings are prominent at circumcisions as well as weddings.

Certain curvilinear patterns which best suit the *tekat* technique are quite different from the designs that appear on locally woven

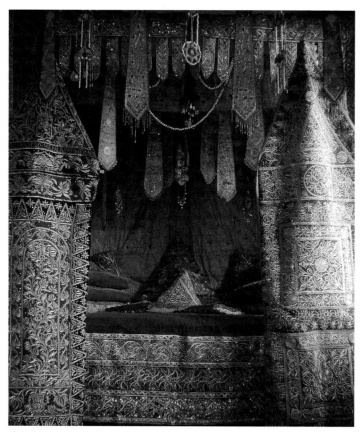

454

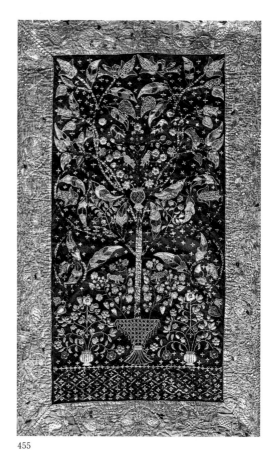

455

454
In a village in the highland Minangkabau area, a bridal chamber is richly decorated with embroidered hangings of many shapes and sizes. The side panels, shaped like the sacred mountain, are dated 1908.

455
............
hanging
Malay people, south Sumatra, Indonesia
velvet, silk, gold thread, tinsel, sequins embroidery, couching, appliqué

The elaborate tree image on this large embroidered hanging developed from the tree-in-niche motif, a popular element in Mughal Indian and Persian art. This motif came directly to Southeast Asia in the form of painted trade cottons, particularly from the Golconda and Coromandel regions of south India. Examples of these have been located in south Sumatra, and probably provided the model for these elaborate embroideries.

brocades. Tendrils and arabesque shapes, often in formal geometric arrangement, are among the most popular with peninsular Malay embroiderers. Throughout coastal Sumatra, a wider range of motifs have included birds of many shapes, potted trees, vases of flowers, and even such mythical creatures as the legendary *bouraq*, Muhammad's steed to heaven.[28]

MINOR DECORATIVE TEXTILE TECHNIQUES OF THE ISLAMIC COURTS

Mirror discs have often been incorporated into silk and metallic thread embroidery to reflect light and add to the sumptuous effect.[29] Although mirror-work often appears on Chinese embroideries, it is also commonly found on the bright needlework of the Muslim cultures of north-west India, Central Asia and the Middle East, and the influence of these textiles upon Southeast Asian technique is suggested by the number of examples that have been located in the region.[30]

It is possible that in some parts of the region, mirror pieces served to replace existing mica appliqué work which was a very old form of textile decoration. However, mirror embroidery ultimately became established as a popular decorative technique in a number of Southeast Asian cultures where Islam has been dominant. Some of the richest and most spectacular examples are found in coastal Malay cultures, where a wide variety of ceremonial objects are so decorated.[31] Mirror-work only rarely appears on garments although it is

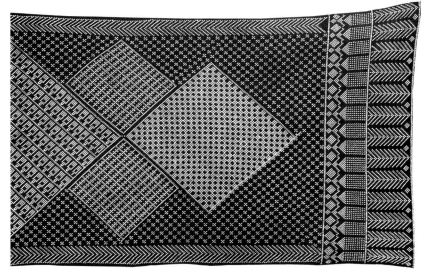

456

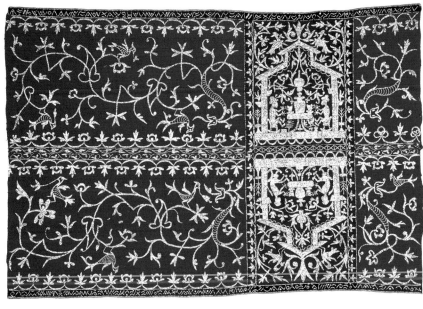

457

456 (detail)
............
bridal veil
Egypt
silk, silver ribbon
netting, embroidery
68.0 x 245.0 cm
Australian National Gallery 1986.1236

This Egyptian veil was probably
obtained as a souvenir during a
nineteenth-century pilgrimage to
Mecca. Flat slivers of silver have been
wrapped into the mesh of the black
silk-netting fabric.

457
kré tahan luji
ceremonial skirtcloth
Semawa people, west Sumbawa,
Indonesia
cotton, silver ribbon, dyes
embroidery
185.0 x 125.0 cm
Australian National Gallery 1987.1097
Gift of Michael and Mary Abbott, 1987

This is an unusual example of a
skirtcloth decorated with flat ribbon
embroidery, and in the past all girls
were expected to learn to embroider
(*ngejet*) in this style. Flat silver ribbon
is known in west Sumbawa as *tahan
luji or galinggang*, and according to
present-day local informants it
originally came from a place they call
Albaka (Arabia?). This technique
appears to have been a nineteenth-
century substitute for the usual
method of embellishing a fabric with
metallic thread, the supplementary
weft weaving technique.
However, this cloth achieves a
completely different visual effect. The
woman who embroidered this cloth has
presented a slice of human experience
with particular vividness. The field is a
simple leaf-and-vine design against a
red ground, but in a style typical of
many textiles from west Sumbawa, it
is the head-panel (*alu*) that is
especially eye-catching. On a black
ground a highly imaginative and
surprisingly realistic 'café' scene is
depicted. The figures are seated at a
table, holding drinks. Above them
hangs a nineteenth-century branched
lamp, and under the table appears the
ubiquitous spittoon.

442 evident on some of the spectacular cylindrical skirts (*tapis*) of the
Abung and Kauer peoples of south Sumatra.

Appliqué hangings and canopies have also been constructed from
brightly coloured strips of plain fabric. From the nineteenth century
this material has often been imported, and usually the colours chosen
to construct these festive decorations have still been confined to red,
black and white, and sometimes yellow or green. In some regions,
notably the southern Philippines, this patchwork and appliqué has
included cutout shapes stitched on to plain grounds.

Other embroidery techniques have been inspired by treasures
from the pilgrimages to Mecca. Fine silk-net veils from the Middle
456 East embroidered with flat silver ribbon are evident in the private

collections of families in those parts of Indonesia, Malaysia and the Philippines where the hajj has been an important element in people's lives.[32] Locally worked examples of flat ribbon embroidery are usually found in the coastal and Islamicized courts. While the Middle-Eastern examples were worked in fine netting,[33] Southeast Asians have adapted this silver ribbon embroidery technique to various sorts of gauze or translucent cloth to create stronger textiles suitable for ceremonial and festive costume. These cloths provide bright accessories — handkerchiefs, small shouldercloths and headcloths — to the main items of courtly dress in the Islamic sultanates of Southeast Asia. The technique was adapted in different ways in Aceh, Sumbawa, and the Malay peninsula and may have been another substitute for time-consuming and costly *songket*.

457

Needle-braiding was an elegant finishing technique applied in the nineteenth century to pants, betel-nut sachets and headcloths of coastal Malay and Acehnese textiles.[34] A silk or gold weft is stitched through the hem or edge of the garment and 'woven' with a needle through the warp threads laid out on the surface. Similar finishing techniques are still used throughout the Arab world. The use of needle-weaving and related tapestry weave to join or finish garments is an outstanding feature of the textiles of many of the Islamic peoples of insular Southeast Asia. Among the most remarkable examples are the skirtcloths of the Maranao women of Mindanao and the Dusun or Kadazan of Sabah.

446,448

9,412

Throughout coastal Southeast Asia, and particularly in areas with historical connections with the sea-faring Buginese of south Sulawesi, ceremonial textiles of finely woven cotton are often calendered to achieve a high surface gloss. The starched surface of the woven fabric is rubbed with a tension-sprung, smooth, spherical cowry shell until it shines like silk. Although this technique is especially popular in the weaving centres of Islamic principalities, such as those in Sulawesi, Sumbawa, Sumatra and the Malay peninsula, this process (known widely throughout the region as *geris*, from the Buginese *garusu*) may have been influenced by the model provided by polished Indian cotton chintz. The technique has been applied to some

458

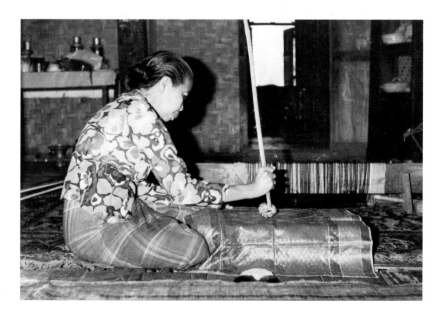

458
A women in Alas, west Sumbawa, is glazing a supplementary silver-thread cotton headcloth with a cowry shell on a sprung bamboo pole.

north-coast batik textiles in Java and certain painted Indian cottons in central Thailand, although the use of this technique on the abaca warp ikat cloth of Mindanao and during the preparation for Balinese pigment painting indicates that the custom of polishing the surface of woven textiles to achieve a high sheen is relatively widespread. Burnishing is an important stage in applying gold leaf gluework patterns to cloth — the *kain prada* or *kain telepok* (or *telepuk*) — and Malays attribute both their knowledge of *kain telepok* and burnishing techniques to Buginese settlers and merchants from Sulawesi.[35]

RAINBOW CLOTHS: TIE-DYEING IN SOUTHEAST ASIA

The tie-dyeing of finely woven cloth, often imported cotton and silk, is a widespread though minor decorative textile technique found largely in the coastal cultures of Southeast Asia — Kelantan, Pontianak, Palembang, Java, Bali and Sumbawa. It is especially popular in those regions associated with Islam. There are two methods of tie-dyeing used in Southeast Asia. Throughout the Malay world, when the resist binding is wrapped around small pockets of cloth, the technique is known as *pelangi* or *plangi*; when the resist lines are formed by tightly gathered stitching it is referred to by the term *tritik*. The tie-dyeing technique is well known in the north-west of the Indian subcontinent and throughout Central Asia where it is a major textile technique known as *bandhana* (Bühler et al., 1980: chapter 4). In these areas also it has been associated with Islam.

While it is clear that certain types of Indian textiles have had a profound influence on Southeast Asian textile art, simple tie-dyeing may well have developed independently in the region over time, and it is used by a number of non-Islamic peoples as a minor decorative technique. In north Sumatra the Karo Batak make headcloths and shouldercloths, with narrow white tie-dye end borders set against a plain indigo black ground. These cloths provide one of the simplest forms of this resist technique. On the other hand, a bold and dramatic example of the tie-dye technique is found among the heirloom textiles of the Toraja of central Sulawesi. Huge, colourful spots and circles decorate these handspun cotton banners which are known as *roto*. The Toraja share many textile techniques with the lowland Buginese and Makassarese people, from whom they also received many imported textiles, and it is possible that they may have developed the idea for these spectacular hangings and banners from cloths obtained from their coastal neighbours.

While the tie-dye technique is simple, distinctive regional styles have developed and it appears that, like batik, this may have been a very early resist-dye technique which was later adapted to a variety of situations and influenced by foreign textiles, many of them from Central Asia and Mughal India. The function of textiles ornamented with tie-dyeing is largely decorative, and the technique is used to decorate sashes, headcloths, shouldercloths and handcloths.

In a number of areas, however, despite the existence of some wonderfully ornate tie-dyed textiles, certain cloths with simple stark designs have maintained a ritual significance. In Cambodia, indigo-dyed cotton cloths with a sparse border of white tie-dyed circles continued to be made alongside the bright flimsy silk rainbow tie-dyed shawls. This has also been the case in the courts of central Java where retainers wear simple spotted skirtcloths in ritual processions, while

440

459,460
461,462

432

463

464

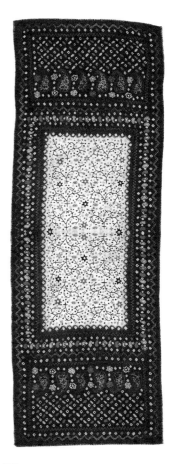

459
pelangi
shouldercloth and shawl
Malay people, Palembang region, south Sumatra, Indonesia
silk, natural dyes
tie-dyeing, painting, stitch-resist dyeing
209.0 x 76.0 cm
Australian National Gallery 1980.1654

Worked on fine imported Chinese silk cloth, the tie-dye designs of the Palembang region of south Sumatra follow an established format. Unless totally undecorated, the central field contains star-shaped patterns often laid out in a rigid manner. The eight-petalled lotus is often reduced to four- or six-pointed stars, and the borders consist of simple spots, meanders and zigzags. The most striking feature of these vivid and diaphanous fabrics is the row of Kashmiri cone motifs invariably found across each end. The cloths are known as *pelangi* (a term that indicates both the particular tie-dye technique and their rainbow-bright colouring). While it was customary to daub additional colours on to the cloth as highlights, this cloth is unusual as a pattern of leafy branches has been drawn in the central field.

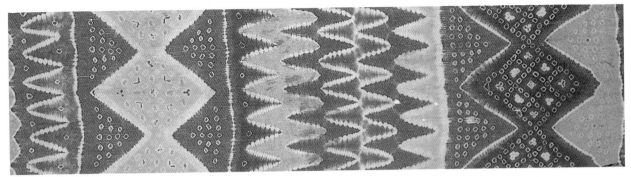

460

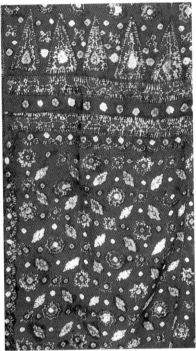

461

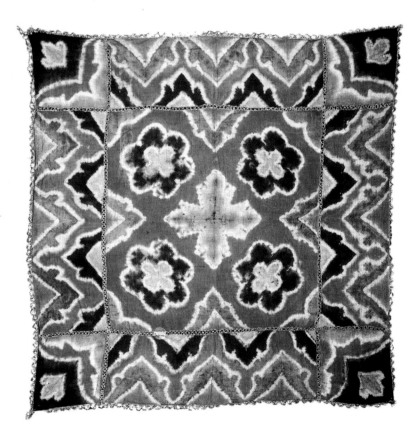

462

460 (detail)
kamben pelangi
breast-wrapper
Balinese people, Lombok, Indonesia
cotton, dyes
stitch-resist dyeing, tie-dyeing
45.0 x 324.0 cm
Australian National Gallery 1988.1566
Gift of Michael and Mary Abbott,
1988

For spectacular display, the Balinese
examples of tie-dyeing are without
competition. Bold asymmetrical
splashes of colour are muted by
pelangi spots. The textiles function as
waistcloths and breastcloths and are
used by the Balinese and Sasak
communities of Lombok.

461 (detail)
kain pelangi
skirtcloth
Malay people, east-coast (?) Malaysia
silk, dyes
stitch-resist dyeing, tie-dyeing
Muzium Negara, Kuala Lumpur

This brightly coloured tie-dyed
skirtcloth uses the same design
structure as those created in weft ikat,
gold brocade and gold leaf gluework.
The head-panel displays a double row
of triangles and the field is filled with
rosettes. Early twentieth century

462
sapuk
handscarf
Sumbawa, Indonesia
cotton, metallic thread, natural dyes
tie-dyeing, lace-work
76.0 x 76.0 cm
Rijksmuseum voor Volkenkunde,
Leiden 1010–3

This gaily coloured kerchief with a
tie-dyed motif in the shape of a cross
is a minor element of ceremonial
costume in Sumbawa. The flimsy
cotton is finished with metallic-thread
lace. Nineteenth century

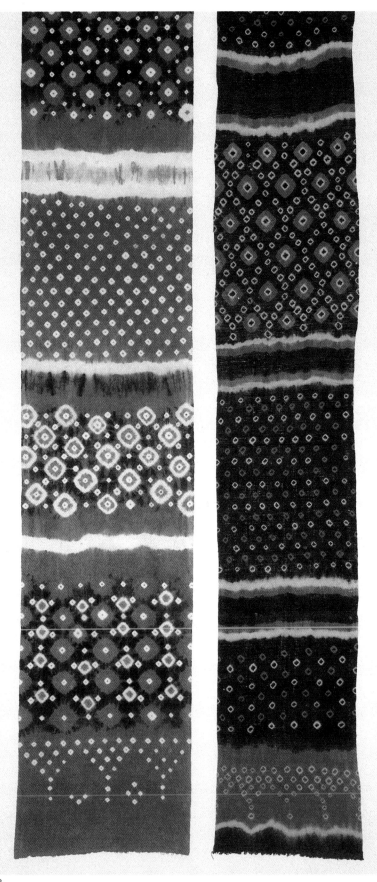

463

463 (details)
roto
ceremonial banners
Toraja people, central Sulawesi,
Indonesia
handspun cotton, natural dyes
stitch-resist dyeing, tie-dyeing
404.7 x 60.5 cm; 422.0 x 49.0 cm
Australian National Gallery
1981.1147; 1982.2306

These long handspun cotton banners
are displayed by the Toraja at
ceremonial events such as feasts of
increase and funerals. Tie-dyeing is
probably an ancient means of
decorating large textiles woven from
supple fibres such as cotton. As a
decorative textile technique it is less
suited to stiffer vegetable fibres such
as abaca, and felted bark-cloth,
although the sunburst patterns of
these *roto* are also painted by the
Toraja on paper-thin bark-cloth skirts.

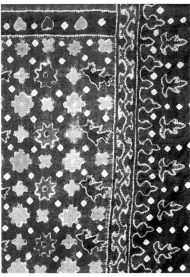

464

464 (detail)
............
ceremonial textile
Khmer people, Cambodia
silk, dyes
stitch-resist dyeing, tie-dyeing
158.0 x 81.0 cm
Musée de L'Homme, Paris 62.22.114

Though usually associated with the
Islamic peoples of Southeast Asia,
bright silk shawls were also made for
festive wear in other parts of the
region. The Khmer examples are
among the most spectacular, both for
their elaborate border designs and for
the bird and animal patterns that
appear in the field. Most tie-dyed
textiles in Southeast Asia contain only
schematic designs.

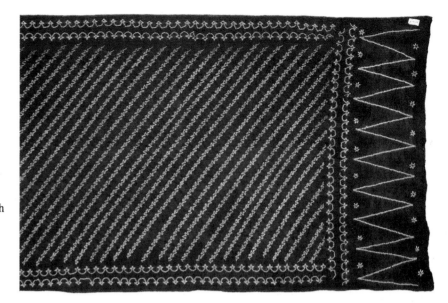

465 (detail)
kain panjang
skirtcloth
Javanese people, Kebumen, Java,
Indonesia
cotton, natural dyes
stitch-resist dyeing
Rijksmuseum voor Volkenkunde,
Leiden 300–1327

This *tritik* skirt follows an ancient
Southeast Asian design format known
in Java as *blabagan*, in which patterns
are arranged along diagonal planes.
Until at least the end of the nineteenth
century, these *tritik* cloths co-existed
with a very similar batik pattern of
interlocking spirals known as *parang
rusak*.
The historical relationship between
both types of textiles is unclear: were
they nothing more than different
Javanese responses to the possibilities
of fine pliable fabric or was one of
these diagonal designs the stimulus for
the other? Both textile techniques
were practised inside and outside the
central Javanese courts. The *parang*
design has been one of the restricted
batik patterns associated with the
central Javanese aristocracy, and it
appears doubtful that a Javanese
outside court circles during the
nineteenth century would have risked
censure by copying such a batik
pattern using the easier *tritik*
technique. Could the jagged *parang*
bands have developed from an older
tritik skirt pattern?

bright silk tie-dyed cloths have only a minor decorative role. Although
a few examples from the nineteenth century have been preserved in
museum collections, the use of the technique of stitch-resist *tritik* to
decorate skirtcloths has not survived in Java. 465

In Southeast Asia, it is only in Mindanao that we find major items
of clothing, and even entire outfits, finely decorated with the tie-dye
technique. Both men and women of the Bagobo people wear shirts,
skirts, pants, shouldercloths and headcloths decorated with this 432,433
technique, known locally as *binudbud*. The Bagobo also produce a
spectacular form of *tritik* ornamentation on a warrior's costume of
pants and jacket, which creates an initial impression of having been 141
worked by the ikat technique.

As the term *pelangi* (rainbow) suggests, the textiles are usually
brilliantly coloured, and the name itself evokes many legendary al-
lusions. In many parts of Southeast Asia the rainbow is believed to
form a bridge or conveyance between heaven and earth, and it is the
road of the gods (Hooykaas, 1956). In textile imagery and in Malay
terminology, the rainbow and the serpent are often interchangeable
concepts. The colouring of the *naga* serpent is widely perceived to be
closely related to the rainbow, and the rainbow to take on a serpent's
shape. The multicoloured rainbow is a propitious sign and multi-
coloured threads are used to protect persons from evil spirits or to
lead a lost soul back to its body. A seven-stranded rainbow thread,
known as a soul-cloth, is used by Malay shamans as a bridge and a
barrier (Endicott, 1970: 136), and the same number of colours are
favoured for the most complicated of Malay weft ikat patterns (*cuai*
or *cual*).

One of the clearest examples of the way some tie-dye techniques
in Southeast Asia have been influenced by foreign models, and es-
pecially those from the Mughal world, can be found in the Palembang
region of south Sumatra. Feather-light shouldercloths of flimsy 459
imported Chinese silk are a feature of ceremonial costume, and
among the elaborate tie-dye designs is the well-known Persian or
Kashmiri cone motif. These cloths and their designs suggest that at
least in Palembang the tie-dye techniques may have been transformed
by north-west Indian models obtained through trade. This is not sur-

prising since Palembang has been strategically placed on the international sea route for centuries, and imported fabrics have been immensely popular in that region of Sumatra.

BATIK BLOSSOMS WITH ISLAM

Batik is not a decorative textile technique readily associated with Islam or the Islamic world of the Middle East or Asia, yet it appears to have developed almost concurrently with Islam on Java. It is uncertain why and how this occurred, but the growth of batik in the form we know it in Java today was directly stimulated by the rise of Islam on Java and the fall of the Hindu kingdom of Majapahit towards the end of the fifteenth century. The fact that the skill of making batik never developed in Bali suggests that batik flourished in Java subsequent to the exodus of many Javanese aristocrats to that island after the collapse of Majapahit and in the face of encroaching Islam. Many Javanese chronicles describe and name clothing and textiles in some detail, yet rarely is there a description that scholars are able to link positively to batik (Robson, 1981). Many of the textile items mentioned in these early chronicles are clearly foreign imports, and it has been suggested that it was during periods of deteriorating relations between the central Javanese courts and the ports on the north coast, when trade was no doubt disrupted, that locally made batik developed as a substitute for the limited supplies of Indian textiles which passed into the central Javanese courts from those northern locations (Hardjonagoro, 1980). Thus the growth of the technique was stimulated by a need or desire to replace the imported textiles on which the Javanese aristocracy had come to depend and which they greatly admired. Whatever its cause, the generation and elaboration of this local Javanese craft had occurred by the eighteenth century and the use of *soga*, the brown dye so distinctively part of central Javanese batik, was already well established. The eighteenth century was in fact a period of Javanese artistic development and of Islamic expansion, and batik was to become a fine symbol of Javanese court culture.

Although the symbolism of this Javanese art can be traced back to earlier periods, batik did not generally absorb the supernatural aspects that are thought to permeate ancient textile types. There is little magic or mystery attached to batik-making and usage. In contrast, however, there is a great deal of majesty and royal prerogative linked to certain batik motifs and cloth styles. The rulers of Java were able to establish and maintain control over certain important designs, many of which are transformations of well-known patterns found on the prestigious foreign textiles that were favoured by the aristocracy.

On the north coast, batik developed as a locally produced, cheaper substitute for Indian trade goods, and many of the popular Indian cloth patterns were reproduced on batik for consumption in Java and for trade to other parts of Southeast Asia. Many of the traders who operated along the north coast of Java were members of the Islamic Peranakan Arab community (*kauman*), the descendants of Islamic Indian and Arab cloth traders who had settled in Southeast Asia and established families with local women. Like the Peranakan Chinese communities, these people adopted local customs and language, including garments such as the skirt (*kain sarong*). While the symbol of the Middle-Eastern Arab world, the long flowing robe,

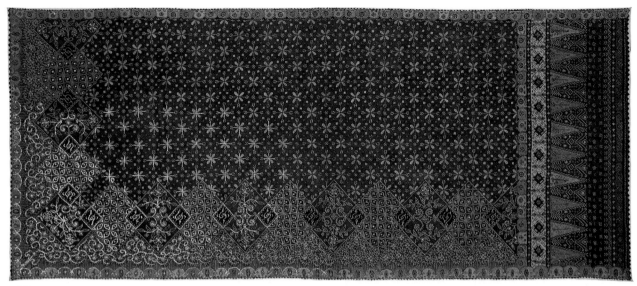

466

466
kain panjang
ceremonial skirtcloth
Peranakan Arab people, Pekalongan,
Java, Indonesia
cotton, dyes, tinsel, sequins
batik, embroidery
106.0 x 254.0 cm
Australian National Gallery1984.3130

467 (detail)
kain pinarada mas
ceremonial skirtcloth
Javanese people, Surakarta (?), Java,
Indonesia
cotton, natural dyes, gold leaf
batik, gluework
104.5 x 249.6 cm
Australian National Gallery 1987.1823

468
kain sarong
ceremonial skirtcloth
Peranakan Arab people, Pekalongan,
Java, Indonesia
cotton, dyes
batik
105.0 x 243.2 cm
Australian National Gallery 1984.3129

467

Designs emulating woven patterns
have been popular in the Islamic
quarters (*kauman*) of the towns and
port cities of the north coast of Java.
From the basic 'weave' the batik
makers have created a wonderful
range of designs, generally known as
nitik because of their dot-like
qualities. The pattern on the skirt in
Plate 468 suggests a banded woven
fabric, and could be used for everyday
wear, while the other examples were
clearly intended for festive occasions
such as weddings and circumcisions.
The batik fabric in Plate 466 has been
embellished with glittering gold tinsel
along the border that would be
exposed when the cloth is worn. This
illuminates the main features of the
batik lattice pattern which is
suggestive of Central Asian *tabriz*
'compartment' carpet designs.
The gold leaf gluework on Plate 467 is
often used as an alternative method of
decoration and the surface of this cloth
has been lavishly embellished,
presenting a glowing contrast to the
subdued brown and indigo of the
central Javanese batik. The
sumptuousness of this example and the
fine batik work indicate that it was
probably worn by a member of the
Javanese aristocracy. The design
follows closely the field pattern of a
costly *patola* silk, in the past also
acknowledged as the prerogative of
the nobility.

continued to be associated with Islamic religious leaders in Southeast Asia, the cloths of other members of Islamic communities were distinguishable more by design than type.

Not only did the families of Arab and Indian traders wear local costume, but they also became prominent in the manufacture of local cloth, including batik.[36] In a conscious attempt to avoid any allusions to earlier Southeast Asian traditions, the patterns favoured by the *kauman* Arab communities follow both the popular floral designs of the trading world and other designs closely related to imported Indian textiles, particularly schematic, non-figurative patterns. In fact, many of the most popular Peranakan Arab batik patterns were not based on the mordant-painted and block-printed cotton textiles but on woven cloth. Those batiks falling within the spotted or dotted design category, *nitik*, were especially prominent, and even plaids and stripes were reworked in batik.

466,468 These *kauman nitik* patterns differ from central Javanese examples in the 'woven' designs and particularly in the colour combinations favoured, since the batiks of the north-coast Arab communities share bright palettes similar to Indo-European and Chinese tastes. However, several patterns based on *patola* designs were pop-*467* ular within both the *kauman* community and the royal courts of central Java.

Eventually many Southeast Asians came to prefer batik to the Indian trade cottons, especially since it was also probably cheaper. However, given the growth of batik at the expense of the Indian imports, it is not surprising that many of the north-coast batik designs are local variants on popular and well-known Indian patterns. While many batik patterns shared by both the central Javanese courts and the coastal towns are derived from Indian trade cloth designs, the styles and colouring of each region are very distinctive. The north-coast commercial batiks became renowned for their rich red and blue dyes and cream ground, in contrast to the browns and blacks of the Javanese courts. Floral and geometric patterns, with rows of intricate triangles at each end or combined into the central *kepala*, became the hallmarks of north-coast batik. These cloths were popular throughout Southeast Asia and have been incorporated into the women's dress of certain groups in Thailand, Cambodia, the Philippines, Malaysia and Burma.

In central and southern Thailand where printed imitation batiks are still popular, the cloth is known as *salong baeb khaek* (Indian-like print 'sarong'). In the Malay peninsula, a shortage of Javanese batik in the twentieth century stimulated the growth of the Malay batik cottage industry on the east coast (Sheares, 1977: 17–18; Peacock, 1977), and certain batik styles there are known by corruptions of place names along Java's north coast, such as *kain kalongan* (Pekalongan cloth) and *kain gersik* (Gresik cloth). All these popular Malay designs are based on blossoms and bouquets of flowers.

While the origins of Sumatran batik can be traced to the north coast of Java from whence immigrant artisans probably came, many patterns gradually became recognizably different from the Javanese source. Jambi batik, in particular, developed certain identifiable characteristics, influenced by mordant-painted and batik-decorated cotton cloths from the Indian region of Negapatnam: dominant blue colours, striped ends to simulate fringes, even borders on four sides, and certain trade cloth patterns and Islamic script as important field motifs.

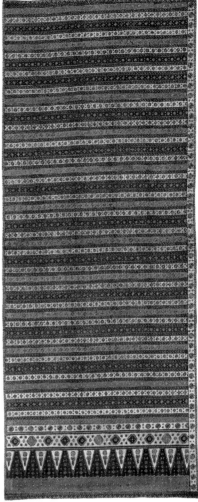

468

THE INFLUENCE OF ISLAM ON MOTIFS AND DESIGN

The representation of living creatures in art has become a central issue in Islamic theology. While there is little guidance in scripture, controversy over this fundamental aspect of artistic expression has had profound effects on the art of many Muslim peoples, and where orthodoxy and true beliefs have become a concern, such representations have usually been avoided.[37] The gradual spread of Islam in Southeast Asia contributed considerably to modifications in motif and patterning throughout the region. In the field of textiles few specifically religious objects were made, but the images on many fabrics intended for secular celebrations did change.

In Southeast Asia, as elsewhere, different strands of Islamic art can be distinguished. The aristocratic and wealthy merchant cultures looked to beautifully decorated luxury objects to enhance their wealth and position. Many of their designs, decorative rather than iconographic, were those of the international Islamic mercantile world, and parallels can be identified, for instance, with the art of the Mughal and Ottoman empires. Such objects often displayed purely ornamental designs, and the image of the pleasure garden or paradise was also popular, sometimes incorporating living creatures, especially birds. However, urban centres were tied to the regional cultures from which they grew. To the ordinary people of Southeast Asia, ancient images from pre-Islamic religions continued to convey magical security in a world still inhabited by spirits and jins, and beliefs and practices concerned with their propitiation remained. Only a fierce and prolonged onslaught by reformist Islamic missionaries has led to large-scale and irreversible change in certain parts of the region.

In such areas, geometric patterning and the depiction of figurative motifs in a highly schematized manner offered more security than the older realistic figurative symbols. While orthodox Islamic beliefs confined some weavers to plaids and stripes, geometric and striped patterning was already widely used in many parts of Southeast Asia and this trend provided a new way of exploring the possibilities of these old designs and elaborating upon them. Despite the constraints imposed by a limited range of natural dyestuffs, wonderful combinations of colours and shades appeared. In regions such as south Sulawesi, where a number of separate principalities have existed, the distinctive plaid skirts (*lipa sabai*) of each domain are easily recognized by the local inhabitants (Sapada, 1977). Particular striped and plaid patterns produced in weaving centres such as Mandar, Samarinda and Sengkang are given special titles and have been passed down from one generation to the next. These skirts, sewn into cylinders, became widely known as *kain sarong* throughout the Malay world, as Buginese seafarers and traders spread their textiles throughout the region. They have been especially popular in west Sumatra, where the Minangkabau eagerly sought these checkered fabrics (known there as *kain bugih*, Buginese cloth). The use of plain-weave plaid skirtcloths as everyday wear for men also spread to mainland Southeast Asia, where such garments are known in the Esarn region as *pha sarong*.[38]

While the spread of plaids may in large part be attributed to Islam and the desire for a lack of ostentation in dress, the prominence of stripes and their interplay in plaids may be seen as another return, under the influence of Islam, to the oldest kinds of textile patterning.

445

469

The impact of the checkered skirtcloth, particularly on the clothing of men in coastal areas throughout insular Southeast Asia, is remarkable. Combined with collarless white shirt and black cap, this was generally regarded as standard Islamic dress, at least for everyday wear, until it was more recently replaced by trousers. Even in non-Islamic mountain regions, the plaid skirtcloth has had a considerable impact. In the past, for example, the skirtcloths of the men of Endeh, Lio and Sikka in central Flores were probably decorated with a similar warp ikat pattern to those found on women's skirts. This is still the case in the neighbouring domains of the Lamaholot and the Ngada. However, the men's cloths of central Flores, both towns and remote villages, are now patterned in stripes and checks, styles spread by the coastal Buginese traders.

Plaids and stripes have not been limited to tabby weave fabrics, but have also been worked in supplementary weaves and even on batik in imitation of woven fabric patterns: the soft natural plaids of Mandar and Samarinda were transformed into very bold linear batik fields in Java; in both east and west Sumatra, the popular Buginese plaids have influenced the designs on the base fabrics for gold thread brocade; and in the Sulu archipelago, the multi-purpose cylindrical *patadjung* is made in checkered tapestry weave.

In spite of Islamic influence, a number of important symbols have endured. The Muslim women of Sumbawa have continued to create cotton and silver thread textiles with imaginative and fanciful images including trees, birds, serpents and human figures. The *naga* serpent remains a symbol of the power of many sultanates throughout insular Southeast Asia, although given its continued popularity, its absence on Malay embroidered hangings is remarkable. However, both the *naga* and bird motifs can often be distinguished in the narrow panels at each end of the floral or geometric central field on the supplementary weft weave textiles from the Palembang region of south Sumatra where animal and human forms are notably absent.

While some figurative textile motifs fell from favour with the spread of Islam, other imaginative creatures began to appear. These have included the lion, symbol of the caliph Ali', sometimes bearing a flag and often depicted beside the double-bladed sword. This sword, the miraculous *Dhu'l-Faqar* given by Muhammad to his warrior son-in-law, is a popular motif for banners and protective charms (Welch, 1979: 76–7). Another popular Islamic creature in Southeast Asia is the *bouraq*, a mythical flying creature with the head of a woman and the body of a horse, and believed to have been ridden by Muhammad. Its popularity in Southeast Asia may also be due to its similarity to the Hindu deities, the *kamadhenu* or the *navagunjara*[39] although its Middle-Eastern origins are probably closer to the Greek centaur. The *bouraq*, Muhammad's mount when he ascended to heaven, is sometimes depicted in Southeast Asian art with wings outstretched. Like textiles displaying Hindu religious figures, these new images were not used on clothing, but have appeared on many ceremonial sails, flags and banners, and on wall-hangings.[40]

The anthropomorphic figures that previously rode upon the backs of mythical monsters have often become unrecognizable where Islam has become the dominant ethos. These motifs and many elements of Indic iconography, such as the lotus or trident, have been reduced to wings or appear schematically as hands, a popular evil-repelling motif in Middle-Eastern art.[41]

469

470

469 (detail)
lipa sungké
skirtcloth
Salayer, Indonesia
cotton, natural dyes
supplementary weft weave
Rijksmuseum voor Volkenkunde,
Leiden 2429-8

Textiles woven on the barren islands
of Salayer and Buton were a major
trade item for the inhabitants of that
region, and in parts of eastern
Indonesia and Irian Jaya fragments of
Buton plaid skirts were circulated as a
popular form of currency. Though the
designs were predominantly checks
and stripes, simple supplementary
weaves provided additional patterns to
many skirtcloths.

470 (detail)
kain panjang
skirtcloth
Javanese people, Tuban, Java,
Indonesia
handspun cotton, dyes
batik
272.5 x 92.5 cm
Australian National Gallery 1984.481

The design on this red batik is created
by applying wax resist batik dots to
handspun *lurik* fabric woven in a black
and white check. The simple pattern,
while attractive in its own right, may
have been an attempt to reproduce in
another medium the small
supplementary rosettes.

Many animal motifs were transformed into birds on textiles used in Islamic ceremonies. The bird, including the domestic fowl, is a familiar and ancient motif found in early Southeast Asian design, and bird motifs continued to be applied to textiles and in the plastic arts of the Malay-Islamic world even when other realistic creatures disappeared. Elements of the bird motifs of old — the hornbill, *garuda* and phoenix — can be found in the form of the *sari manok*, a bird with a chain, a key or a fish dangling from its beak. The appearance and underlying meaning of this image as a symbol of the soul and a link with the heavens, seem to be closely related to its predecessors in Southeast Asian art.[42] Whatever its origins, the bird image spread throughout all parts of the Malay world and is especially prominent on the couched gold thread embroideries of the Malay sultanates. In male art forms in insular Southeast Asia it is evident in metal and wood craft, including brass oil-lamps and carvings.[43] Under the influence of Mughal and Gujarati Islamic traditions, the peacock also became a popular motif in the Islamic art of Southeast Asia, and a prominent element on rich gold thread hangings.

One author (Leigh, 1985) notes an apparent paradox in the iconography of certain Acehnese textiles. Despite the monopoly women hold over the making, ownership and use of the gold thread embroidered textiles that appear in Acehnese celebrations such as weddings, the motifs depicted on these hangings are purely male symbols associated with Father Heaven, as opposed to those associated with Mother Earth. These male Father Heaven symbols include leaves and flowers, birds, and more recently the overtly Muslim star and crescent moon.

Under reformist Islamic influences there appears to have been a deliberate move away from the pictorial representation of scenes, especially those with human actors. Despite the retention of birds and animals and even humans in some parts of Southeast Asia, on peninsular Malay textiles not only have anthropomorphs entirely disappeared, so too have most animals and many bird motifs. In other Islamic areas of Southeast Asia, human and animal forms which were

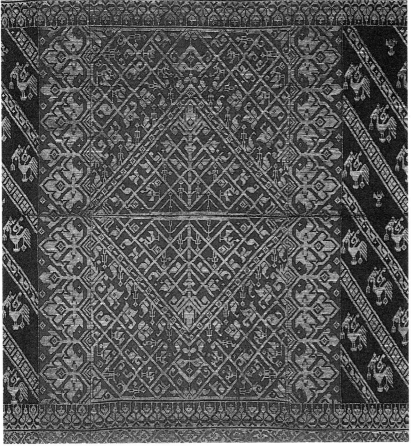

471

471 (detail)
kré alang
skirtcloth
Semawa people, west Sumbawa,
Indonesia
cotton, silver thread, dyes
supplementary weft weave
169.0 x 115.0 cm
Australian National Gallery 1984.3189

472 (detail)
ija sawa
shouldercloth; waistcloth
Acehnese people, Aceh, Sumatra,
Indonesia
silk, gold thread
supplementary weft weave
300.0 x 75.0 cm
Australian National Gallery 1987.1060

Where tree motifs appear in woven
textile designs, the treatment is often
abstract. Woven on backstrap tension
looms, the symmetrical designs on
these brocades are achieved by the
use of large numbers of shed-sticks.
While the Acehnese cloth displays
elegant borders against a rich purple
ground, the motif on the head-panel of
the Sumbawan skirt is a synthesis of
many ancient motifs — the mountain,
the tree and human figures.

473
............
ceremonial flag
Acehnese people, Aceh, Sumatra,
Indonesia
cotton, dyes
appliqué
Volkenkundig Museum Nusantara,
Delft S230–1294

Flags and banners bearing propitious
symbols were an important feature of
Islamic Southeast Asia, flown by
seafaring peoples from the prows of
sailing vessels on ritual occasions such
as weddings, although the occasions on
which this red and white banner was
unfurled are not recorded. It was
collected in 1883, and displays the
two-bladed sword motif, a powerful
talismanic symbol found on many
banners and headcloths throughout
Southeast Asia.

472

473

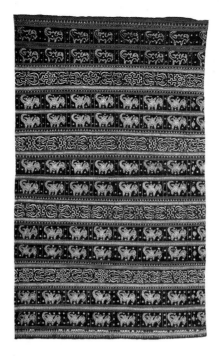
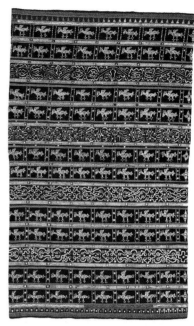

474
tapis
women's ceremonial skirts
Abung people, Lampung, Sumatra,
Indonesia
cotton, natural dyes, silk, gold thread,
sequins, lead-backed mirror pieces,
natural dyes
couching, satin-stitch embroidery,
appliqué
106.0 x 66.7 cm; 101.0 x 62.0 cm
Australian National Gallery
1981.1131; 1981.1132

The equestrian image of a human
figure on various types of real and
mythical creatures was an important
element of south Sumatran art. On
these skirts, however, the creatures
have been reduced to decorative
devices arranged in narrow bands of
gold couching. The 'winged' bird
figures are almost unrecognizable as
the ancient symbol of human riders
with outstretched arms and astride a
buffalo. The motif now resembles a
flame or a hand rising from the back
of a creature, possibly still intended to
depict a buffalo. At ceremonial
occasions, the garments are symbols
of the wealth and prestige of the
wearer's family. In recent times, the
focus has been on marriage
celebrations, but in the past these
elaborately decorated skirts were also
worn throughout the annual
ceremonial cycle with its rituals of life
and death.

once a powerful and explicit element of textile iconography, have
become so stylized that their origins are barely recognizable.
Examples of this abound on Lampung textiles, where creatures with *399,401*
474,475
477
riders have changed into winged birds, human figures have faded into
decorative patterns, and dragons and serpents have turned back into
spirals. On Sulu and Bajau grave-markers the dragon-boat motif is
known as a little horse (*kura-kura*) and flags from this archipelago
display other stylized serpentine shapes concealed within the
arabesque appliqué (Dacanay, 1967: 149, opp.151).

The adoption of Islam has contributed to a series of transforma-
tions in motifs on some Southeast Asian textiles. In south Sumatra the
omnipresent ship motif in bands of silk embroidery became more *479*
schematic on many types of *tapis*. Other skirts which retained the
name *tapis jung sarat* (the laden ship), had their surface entirely
covered with gold thread embroidery, the patterns achieved by the *260*
476
careful arrangement of the couching threads with only pale schematic
patterns visible in the stitches on the glowing surface.

In the Endeh region of Flores subtle changes occurred in the use
of certain women's skirts depicting *patola*-inspired animal designs
such as the elephant and the horse motifs. Their spindly local style
interposed with diamond shapes can not be exclusively attributed to
the influence of Islam as the motif is now equally obscure in neigh-
bouring non-Muslim communities. In Endeh such cloths are still used
by senior women of high status for festive dress, although, despite the
abstraction of the motif, these should be worn upside-down at Islamic
funerals.

The human form has maintained an ambiguous position as a tex-
tile motif in several parts of Islamic Southeast Asia. On the batiks
from the courts of central Java and Cirebon, where Islam has merged
with Hindu Buddhism and older Javanese cultural values, the only
recognizable anthropomorphic images are those two-dimensional fig- *274,275*
ures based upon the *wayang* shadow-puppet characters. The shadow-
puppet play continues to attract enthusiastic audiences in Java and

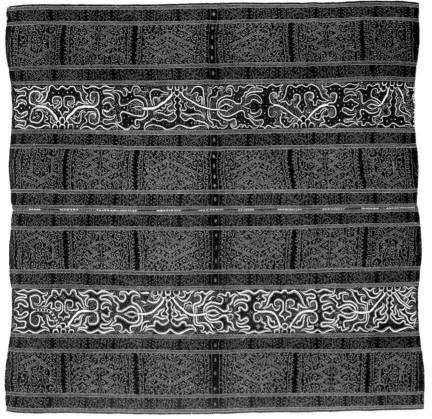

475

475
tapis
woman's ceremonial skirt
Paminggir people, Lampung, Sumatra,
Indonesia
handspun cotton, silk, natural dyes
warp ikat, embroidery
131.0 x 122.0 cm
Australian National Gallery 1982.2301

The ceremonial skirts of southern
Sumatra display a number of quite
different embroidery techniques
including gold thread couching,
needle-weaving and silk embroidery
using satin-stitch. On this example
bands of silk embroidery, in a bold and
rather heavy style, stand out clearly
against the interspersed warp ikat
panels. The embroidered foliated
motifs are elongated versions of the
flowering tree, also a popular image on
couched embroidered objects.

476

476
The striped silk base-cloth used to
create the Abung *tapis* is woven on a
simple backstrap loom. The fabric is
then formed into a cylinder, half the
width of the eventual garment, and
stretched around a triangular couching
frame. The gold thread is then laid on
to the surface of the fabric and
stitched into place. With high quality
gold thread now being impossible to
obtain in Southeast Asia, this fine
embroidery technique has been
steadily disappearing during the last
few decades.

elsewhere in present-day Southeast Asia. Puppets have been popular
elsewhere in the Islamic world (including Turkey and Egypt) and this
may help to explain how the familiar shadow silhouette has survived
as a motif in the art of various Southeast Asian peoples when other
human forms have been discarded. Similarly, on the later types of
tampan found in south Sumatra the so-called *wayang*-style human
figures remain clearly evident while other human figurative forms are
lost in curvilinear ornamentation.

242,243
281

Human and animal forms are sometimes depicted enigmatically
through Arabic script, a tradition which had gained some popularity in
the graphic arts of Persia and the art of Mughal India.[44] The anthro-
pomorphic form, again in shadow-puppet style, sometimes appears
within the intricate calligraphic designs of Javanese art.[45] The most
popular and readily recognized is the rotund figure of Semar, the
Panakawan clown from the Indic epics. In the past, it appears that
cloths containing figurative motifs composed from religious quo-
tations had special talismanic qualities to protect the wearer from
harm, as was the case elsewhere in the Islamic world. The eclectic
application of these images is merely indicative of the syncretic
approach of the Javanese to religious iconography.

The process of redefining existing textile designs in the light of
the new strictures imposed by Islam led not only to the use of new and
adapted patterns from the portfolio of Islamic art. Many reinterpret-
ations drew upon some of the oldest decorative devices in Southeast
Asia — the spirals, hooks and rhombs of the prehistoric era. These
were geometric designs that were safe to use as they were free of the
taint of representation. Thus it is ironic that many of the later *tampan*
designs in Lampung call upon this ancient Southeast Asian style of

246

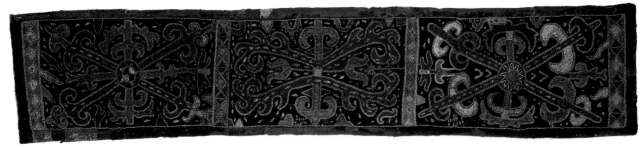

477

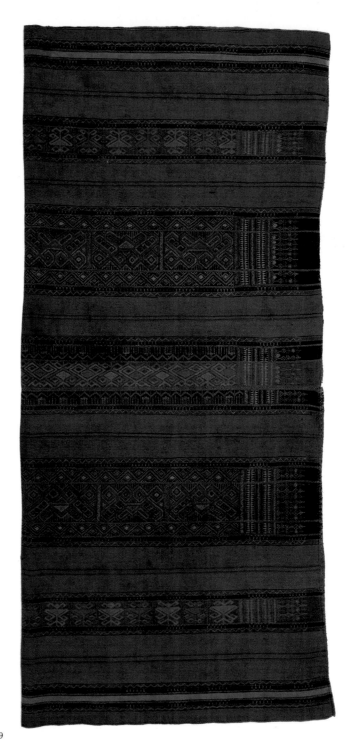

477
selesil; palepai maju (?)
ceremonial hanging
Paminggir people, Branti district,
Lampung, Sumatra, Indonesia
rattan, cotton, beads
appliqué, interlacing, beading
61.0 x 305.0 cm
Australian National Gallery 1983.3690

The beaded mats and wall-hangings
and the woven and embroidered
textiles of south Sumatra display many
important similarities. The motifs on
this beaded example can be compared
with those found on the embroidered
bands of many of the ceremonial skirts
from this particular region. Both have
become less figurative and more
decorative and the design on this huge
beaded mat is dramatically ornamental.

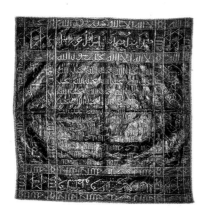

478
sapuk
man's headcloth
Sumbawa, Indonesia
cotton, silver thread
supplementary weft weave,
embroidery (?)
Rijksmuseum voor Volkenkunde,
Leiden

Islamic calligraphy is often displayed
on headcloths worn by men on
ceremonial occasions. Such textiles are
powerful talismans and in the past
were probably worn into battle and on
other dangerous missions.

479

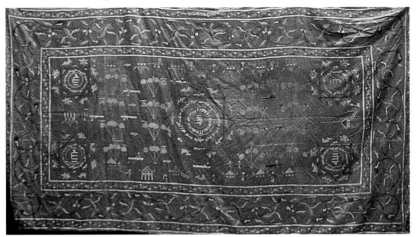

480

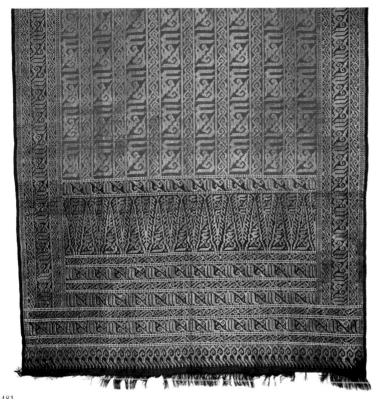

481

ornamentation as these patterns were re-established throughout
south Sumatra under the influence of religious and social change.

THE POWER OF THE WORD: ARABIC CALLIGRAPHY IN TEXTILE DESIGNS

Flowing Arabic calligraphy became a popular artistic device in the
many parts of the Islamic world where figurative images were con-
sidered inferior to written ones. The overwhelming popularity of
calligraphic art can be attributed in part to the concern of Muslims
about the representation of living beings in art. In Southeast Asia,
however, this trend was not nearly as widespread. From mediaeval
times Malay became one of the major languages for Islamic discourse
throughout Southeast Asia, and as a result, Kufic script has been used

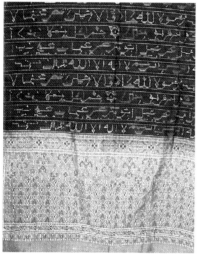

482 and 483 (details)
kain lemar berayat
shouldercloths; shrouds
Malay people, Kelantan, Malaysia
silk, dyes
weft ikat
Muzium Negara, Kuala Lumpur

The Islamic inscriptions on woven
cloths are often less adventurous and
more repetitive than those worked in
more fluid textile techniques. The weft
ikat designs bearing the name of Allah
are found on textiles in the form of the
shouldercloth, but these may also have
functioned as shrouds at Malay
funerals and as canopies at royal
circumcisions. While one example is a
simple pink on purple pattern, the
other is a complex four-colour ikat
which would have required the
changing of the ikat bindings during
the dyeing process.

to record both Arabic and Malay, especially in the Malay areas of the
region. Examples of Islamic texts in Kufic script can be found on
Southeast Asian textiles using a variety of techniques and materials,
in forms varying from precisely written holy phrases to illegible
impressions of Arabic script. While these calligraphic messages are
usually restricted to brief and repetitive invocations to Allah or
Muhammad, there are occasional examples of more elaborate phrases
applied to cloth. A Buginese sword-belt from south Sulawesi repeats 17
the well-known Muslim *Shahadah* (in Southeast Asia, *sahadat*): *la
ilah illa Allah Muhammad rasul Allah*, 'there is no God but Allah
and Muhammad is His Messenger'. In this case, the tablet weaving
permits a very clear depiction of the script, and while further
examples from the region drawing on other weaving techniques are
less well defined, elaborately scripted cloths, including examples with
the same *sahadat* are also evident in the Sulu archipelago.

The symbolism of the written word in Islam incorporates two
closely related properties — sacredness (since Arabic is the medium
for the word of God and each letter of the alphabet begins another
name of the Prophet) and magic (since writing also functions as a
protective talisman).[46] In Southeast Asia, the notion of protection
appears to be especially important. The banners, headcloths and
shawls on which religious quotations appear are often still used in
accordance with the ancient functions of sacred cloths. The motifs
and symbols may have been changed but the essential meaning of
many ostensibly Islamic cloths remains similar to that of numerous
ancient Southeast Asian textiles. In Cirebon, on the north coast of
Java, calligraphy was originally applied to batik banners and flags.
Eventually these designs began to appear on headcloths and shawls
which were used for the same purposes (Abdurachman, 1982: 154).
Even in the form of animal and bird figures, the Kufic script seems
intended to demonstrate piety and ward off evil.[47] The use of Arabic
script on a warrior's costume, such as the Buginese sword-belt, draws
directly upon the belief in the protective qualities of the written word,
and the characters are designed as talismans for warfare where they
will deflect the weapons and blows of the enemy.[48]

The use of talismanic cloths is not restricted to warriors, and
textiles decorated with Arabic lettering are displayed on auspicious *480*
and dangerous ritual occasions and during significant rites of passage.
Islamic exhortations and phrases of praise appear in the silver and
gold brocade designs of Aceh and Sumbawa and in the silk weft ikat *478,481*
patterns on Kelantan shouldercloths,[49] although the decorative *482,483*
techniques used on these textiles largely confine the script patterns
to a repetition of the names of the Prophet. Although the egalitarian
Koranic white shroud has been used widely during Islamic funerals,
cloths decorated with calligraphy are sometimes regarded as the
most appropriate covering for the devout on these occasions. The silk
weft ikat cloths (*kain lemar berayat*) of Kelantan have been used in
this way, and so have the *pesujutan* of Lombok including some dis- *421,422*
playing Arabic inscriptions. The notion of seeking protection against
evil lies behind these customs. In these instances Islamic practices
seem to have been affected by existing mortuary rituals, where cloths
were used as shrouds while the deceased rested in state. Canopies are
suspended over the dead, and in accordance with Malay custom, form
a low tent, while the use of cloths with Islamic messages as shrouds
during funeral processions to the burial ground also draws upon

ancient cloth functions. Islamic messages have also been embroidered on canopies from the Sulu archipelago, possibly used for funeral ceremonies. The luxurious silk and gold thread and fine craftwork on these textiles also affirms the wealth and status of the deceased, even at the moment when all are believed to be equal.

Throughout the Malay world, phrases in various scripts, including Arabic (or Jawi as it is known in the region) have also decorated pieces of weaving apparatus such as the shuttle cases used to throw the weft bobbins through the open warp. In the past these messages may also have been charms to protect the weaver engaged on a demanding and dangerous task. More recently they have been messages of good-will (such as *selamat pakai*, happy using) carved by husbands and suitors.

Embroidery is one of the most popular ways of incorporating calligraphic motifs on to textiles, since this technique permits far greater design flexibility than most weaving. On the Malay and *20* Acehnese embroidered hangings used to decorate ceremonial beds and thrones at weddings and circumcisions, the messages offering best wishes are often in the Malay language. Sometimes calligraphy has been attempted by women who are less pious or, more importantly, less literate in the Arabic language. In the nineteenth century literacy among women was still a rare phenomenon, even within court circles, and in these cases, as Arabic script was elaborated upon, it became an attractive decorative device rather than an accurate and readable statement. Nevertheless, its identification with Islam and its religious sentiment has remained important to the wearers or users of the textiles on which it appears, and exhortations particularly to Allah and Muhammad are immediately recognizable even to the Kufic illiterate, and this may explain their recurring use. Thus even in the Malay courts, where cloth patterns were sometimes worked by women from men's designs, between the drawing or the carving and the weaving or embroidering of the fabric, the accuracy of the calligraphy was often lost. The calligraphic designs on batik, a free-flowing and flexible decorative textile technique, usually feature quite *484* unintelligible and unreadable script-like patterns, known generally as *tulisan Arab* (Arab writing or script).

In addition to its decorative qualities and its association with the notion of protection, Arabic calligraphy draws attention to the Islamic faith of those who use the textiles on which it appears. With very few exceptions, however, these textiles are rarely used or worn on specifically Islamic religious occasions,[50] but appear at those cer-*485* emonies of the life cycle — circumcisions, weddings and funerals — that have always been an essential part of Southeast Asian traditions. On such occasions, though few Southeast Asian Muslims are literate in Arabic, calligraphy is a reassuring symbol of their religious beliefs.[51]

The use of calligraphy on textiles is not restricted to Islamicized communities in Southeast Asia, although only there has it become a major element of textile design. Unlike the Malay language, which *487* was often transcribed using Arabic letters, on Java, Bali and Lombok Sanskritic scripts similar to those used in mainland Southeast Asia continued to be widely used, and on occasions were also incorporated into textile designs. While tattooing disappeared entirely from Islamicized areas of Southeast Asia, as the practice of scarring and marking the body was proscribed by religious officials (Reid, 1988: 77),

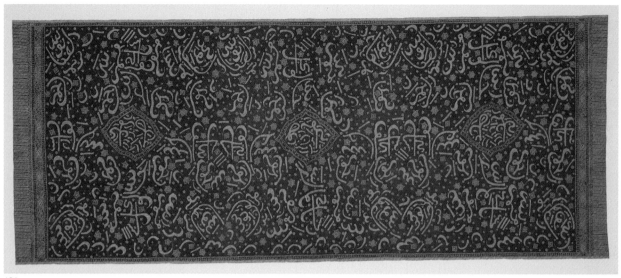

484

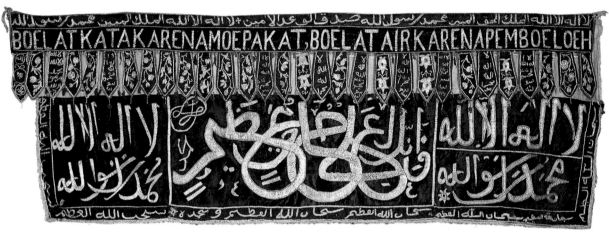

485

484
kain batik tulisan Arab
shouldercloth; shroud (?)
Jambi (?); Aceh, Sumatra, Indonesia
handspun cotton, natural dyes
batik, calendering
220.0 x 87.4 cm
Australian National Gallery 1987.347

This nineteenth-century batik cloth
collected in Aceh displays an Arabic
calligraphy design (*tulisan Arab*;
Arabic script). Some of the calligraphy
has been formed into birds and the
actual words are largely
indecipherable. Although the textile is
of the same dimensions as a skirtcloth,
it seems doubtful that a textile with
Arabic script, however unintelligible,
would have been sat upon. It probably
functioned in Aceh as a shouldercloth
and a ritual textile, and also perhaps
as a shroud.
The striped end-patterns are a
characteristic of Jambi batiks, and this
example has very narrow border

patterns along each side. The
calligraphy stands out in rich honey
tones against an over-dyed aubergine
ground.

485
tirai
festive hanging
Minangkabau people (?), west Sumatra,
Indonesia
cotton, gold thread
couching, bobbin lace, pompom lace
Museum voor Land- en Volkenkunde,
Rotterdam

This ceremonial hanging combines
Roman and Arabic script in both Malay
and Arabic languages. The format,
however, is similar to other more
floral decorative hangings. In addition
to Arabic expressions of praise to
Allah, it displays a Malay message,
'Agreement flows from discussion as
water flows from a pipe' (*Boelat Kata
Karena Moepakat Boelat Air Karena
Pemboeloeh*), suggesting that it was a

particularly suitable hanging for those
occasions when the traditional
Minangkabau community assembled.
The velvet ground is purple with
maroon trimmings and tongues against
a pale green silk support.

calligraphic and magical diagrammatic tattoos in the Buddhist cultures of Thailand have provided essential talismanic protection. In rare instances calligraphy appears on textiles in mainland Southeast Asia, including warriors' garments, funeral canopies, prayer flags, gifts to monasteries and wrappers for sacred texts.

Where cloth designs exhibiting messages in regional languages and scripts occur in Southeast Asia, they are achieved by a variety of decorative techniques including tapestry weave, supplementary weft weaving and embroidery. Examples include south Sumatran *tapis* with traditional *pantun* rhymes in Lampung script couched in gold thread, batiks with Chinese characters, embroidered or painted ceremonial hangings from Bali with inscriptions and labels appearing in Balinese characters, and some Burmese embroidered *kalaga* and tablet-woven manuscript ribbons (Zwalf, 1985: 170) which contain local script announcing the date the textile was made and the name of the family or monastery to which or by whom it is dedicated. With Romanized script replacing Arabic in Indonesia and Malaysia during the colonial period, messages and the signatures of weavers became a prominent feature of cloth design.[52]

486

269,273

271

21,274
275

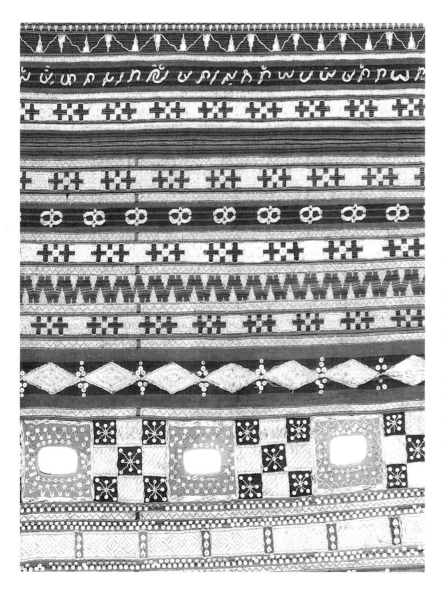

486 (detail)
tapis tua
woman's ceremonial skirt
Abung people, Lampung, Sumatra, Indonesia
cotton, felt, silk, gold thread, mirrors, sequins
couching, embroidery, appliqué

The band of couched embroidery on the upper section of this woman's ceremonial skirt (*tapis*) woven by the Abung people of Lampung demonstrates the use of local script on an important ritual textile. A cryptic couplet is couched in gold thread in the script of the Abung language, and proclaims that 'You are a nobleman, I am a commoner, yet pure gold when smelted continues to shine'. The Abung's conversion to Islam has affected the motifs displayed on ceremonial dress, and geometric patterning in gold thread, mirror-work and sequins is now the most prominent feature of their sumptuous skirts.

487 (detail)
kain selendang, kain gedongan
baby-carrier
Javanese people, Yogyakarta, Java,
Indonesia
cotton, natural dyes
batik
278.0 x 75.0 cm
Australian National Gallery 1987.344

This remarkable textile, a
carrying-cloth for a young child,
combines two potent protective
elements — a powerful batik design
and the magical qualities associated
with calligraphy. Although the
message invokes the name of Allah
and his prophet Muhammad, it is
rendered, not in Arabic, but in the
Javanese-language Kawi script, and
covers both ends of the cloth in
precisely formed hand-drawn batik
characters. It takes the form of a
tembang, a classical Javanese poem
written in *kinanthi* verse form and
was intended to be sung or recited
(S. Supomo, personal communication,
1989). In nine incomplete stanzas, it
consists of a prayer to God and
Muhammad asking for blessings and a
magical incantation designed to protect
a young baby from diseases — in this
case, stomach worms and convulsions.
The *parang rusak* pattern suggests
that this batik was, in all probability,
prepared for a child of high status
associated with the central Javanese
Sultanate of Yogyakarta. This
syncretic approach to religious beliefs
and ancient ancestral practices is a
notable characteristic of Javanese
culture.

ISLAM AND THE ARABESQUE

One of the major features of ornamentation in the art of Southeast
Asia, especially that of the Islamic world, is the flowing arabesque
which appears on various metal, wood, stone and textile objects. It is
often based on foliage where curling tendrils and leafy vines are
attractively arranged, either in decorative bands and borders or form-
ing an overall field pattern. Other arabesque designs incorporate
clouds, formal geometric meanders, and stylized patterns of birds and
serpents. These scrolls appear to be a further development of the
spirals and hooks of early Southeast Asian art, and when creatures
such as the *naga* and the cock are depicted, they are often trans-
formed, amid trees and vines, into multi-petalled finials. In the south-
ern Philippine art of the Lanao region, these curvilinear arabesques
are recognized and named after the famous cock motif, *sari manok*,
said in past golden ages to carry messages from the sultans to their
ladies.[53]

A connection is frequently apparent between the arabesque
designs found on textiles produced by women and their appearance on
carving and metal-work. Among the Maranao of Mindanao, for
example, the arabesque designs on the intricate tapestry weave *lang-
kit* bands which intersect women's silk skirts are generally known as
okir (carving) and present the same curving lines as the timber archi-
tectural decoration and the silver-inlaid betel-nut boxes fashioned by
the male members of the Maranao community. The curling tendrils
and floral designs, sometimes tulip-like in shape, appear on many
textiles from that area, including embroidery and brightly coloured
decorative beadwork attached to accessories.

We have already noted that woven or matting textures are
another source of geometric patterns, universally acceptable in
Islamic art, and these have included many ancient patterns that imi-
tate the weave of plaited mats. Striking examples of this can be found
in the southern Philippines where the tapestry-woven headcloths and
shouldercloths from the Jolo and Tawi-tawi archipelagos closely
resemble the brilliantly patterned rattan matting (*boras*) used on spe-
cial festive occasions, particularly weddings, as floor covering and
wall decorations (Jundam, 1983: 16; Szanton, 1963). In those islands,
the designs of both the silk tapestry-woven textiles and the rattan wall
hangings are said to follow *ukir*, a local word for both designs and
carving. While the designs on the textiles are schematic, twentieth-
century designs on the rattan *boras* are painted by women and incor-
porate architectural designs such as the prayer niche with flowering
tree-in-vase and mosques, creatures such as the sphinx-like flying
horse (*borak* or *akura sambalani*) as well as elaborate arabesque
grids.[54]

Such shared carving and textile patterns suggest a common
source of inspiration. Sinuous meanders appear in the head-panel
borders of north-coast Javanese batik where they are known as the
papan (board or plank) and on the carved lintels and posts around the
doors of traditional Javanese houses. Arabesque scrolls are also found
on the *songket* gold brocades and embroideries of the Sumatran and
Malay courts, where particular designs share the same names as
those that appear in wood and precious metals. Apart from purely
formal descriptions, such as the chain and the diamond pattern, many
textile designs of this type take the names of actual plants, flowers and
leaves. Among the most popular are the jasmine flower (*bunga*

488,489
490

258,328

melati, Malay), the broad taro leaf (*keladi*), the 'flower' on the base of the mangosteen fruit (*kembang manggis*), and exotic species such as the rose and the tulip.

475,477 Designs of dramatic stylized foliage appear on a wide variety of textile types in south Sumatra including the large beaded hangings and the silk embroidered *tapis*. Their occurrence in that region suggests that, under the influence of Islam, the figurative and mythical elements of Paminggir textile art which are usually vividly depicted on the *palepai* and the *tapis*, have been deliberately avoided and that the designs have become purely decorative.

A popular plant image in Southeast Asia is the flowering tree. This is depicted in a variety of styles including an elaborate asymmetrical design with a sinuous twisting trunk and a mass of leaves and flowers. It also appears as a formal repetitive pattern of stylized vases or tree shapes. The former type of tree motif is prominent on north-coast Javanese batik designs and on the gold couched hangings of Sumatra, and these renditions have usually been inspired by a certain
24,407 genre of Indian mordant-painted cotton textiles known as *palampore*. The designs on these Indian hangings also varied: those popular during the seventeenth and eighteenth centuries in Europe as furnishings and bedspreads combined fanciful blooms and imaginative figures clambering over patterned rockeries with garlands and posies, while the more formal symmetrical designs made for Persia and the Mughal
494 courts displayed architectural structures such as the prayer niche surrounding formal shrubs and cypress cones, sometimes joined in a series like Mughal *qanat* tent linings.[55] Indian mordant-painted tree textiles have been located in many parts of the Indonesian archi-
495 pelago, and even printed versions produced in European factories for export during the nineteenth century were favourably received.

Like many other decorative Indian trade textiles, the *palampore* were absorbed into Southeast Asian textile traditions as sacred heirlooms. The peoples of Southeast Asia, both Islamic and non-Islamic, seem to have appreciated any Indian tree-decorated cloth and many of the features of the *palampore* were incorporated into local cloth designs, particularly using those decorative textile techniques that
491,492 permitted the display of fluid curves of Southeast Asian versions of
493 the flowering tree (Maxwell 1990). The *palampore* tree appealed, as so many other foreign motifs had, to ancient perceptions of the universe and of the ordering of the cosmos, for the complex tree form was part of the visual and philosophical world of many cultures in Southeast Asia. These had been reinterpreted and represented in parts of the region in accordance with sacred Hindu-Buddhist symbolism where the cosmic tree became an interchangeable symbol with the world mountain. However, we can only speculate on how much the trade *palampore* and flowering tree motifs' popularity was a result of the symbolic meaning which attached from ancient times to the tree image and how much this was secondary to the splendid visual impact that the trade textiles and the magnificent floral tree motif made.

496 In Sulawesi many types of *palampore* were treasured as *ma'a* and the Toraja have transformed the tree on its rocky mound into wonderful textile patterns. On the north coast of Java, the Cirebon-
25 style batik with its light ground and dark frieze-like scenes was also inspired by the pictorial Indian cloths. However, it was not only in painted or batik form that trees were transformed on to Southeast Asian textiles.

488
lutuan; lotoqan
betel-nut boxes
Maranao people, Mindanao, Philippines
bronze, silver
cast bronze with silver inlay work
12.0 x 6.0 x 5.3 cm; 16.0 x 7.5 x 7.5 cm
Australian National Gallery
1984.1231; 1984.1232

Betel-nut continued to be an important element in ritual activities in the Islamicized societies of Southeast Asia. Although betel-nut ingredients were usually carried in light bags and purses, the containers used on ceremonial occasions such as wedding betrothals were heavier, larger and designed to display the wealth of the household. The inlaid silver and brass boxes of the Maranao men of Mindanao were much admired and traded to other parts of the region. Their flowing arabesque patterns are similar to the motifs woven by Maranao women and are also known as *okir*.

489

489
malong landap
woman's ceremonial skirt
Maranao people, Mindanao, Philippines
silk, dyes
tapestry weave
86.0 x 175.0 cm
Australian National Gallery 1984.1251

This woman's cylindrical skirt is
formed from narrow woven bands of
warp-striped yellow and red silk joined
by decorative strips called *langkit*,
which are woven in tapestry weave on
a backstrap loom. The arabesque
designs of the *langkit* are said to
reflect men's carving patterns (*okir*)
and are also known by the same term
(*okil* or *okir*). Because of the nature of
this particular textile technique, the
motifs are more angular than the
curvilinear motifs appearing on
metal-work and wood. For this reason
it seems male patterns are perceived
in this region as rounded, while female
patterns are thought to be sharper.

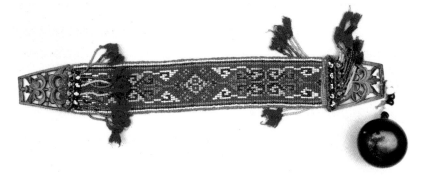

490

490
............
cosmetic container and belt
Maranao people, Mindanao, Philippines
beads, buffalo-horn, cotton, wood
beading, carving
57.0 x 6.6 cm
Australian National Gallery 1986.2117

The multicoloured beaded bands on
cosmetic and betel-nut containers are
probably ornamental rather than
symbolic, and the designs also repeat
the arabesque foliated patterns of the
tapestry weave *langkit* bands and the

491

okir carved patterns found throughout
Maranao art. While the ancient
combination of red, white and black is
dominant, yellow, blue and green
beads have also been included. The
lidded jar which hangs at one end is
carved from buffalo-horn.

491 (detail)
kain batik
shouldercloth
Jambi, Sumatra, Indonesia
cotton, natural dyes
batik
89.4 x 226.2 cm
Australian National Gallery 1987.1061

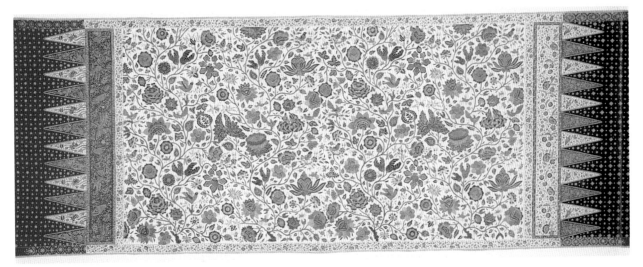

492

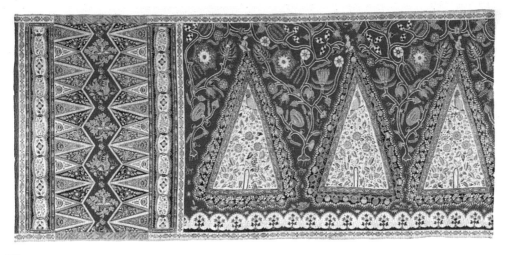

493

492
kain panjang
skirtcloth; shawl
Javanese people, Lasem, Java,
Indonesia
cotton, natural dyes
batik
104.0 x 279.5 cm
Australian National Gallery 1987.1059

493
kain sarong
skirtcloth
Javanese people, Batavia (Jakarta),
Java, Indonesia
cotton, natural dyes
batik
107.4 x 232.0 cm
Australian National Gallery 1981.1135

Very different transformations of the
flowering tree on the rocky mound are
evident on a number of batiks. On
batiks made in Cirebon, the
characteristic features of the
palampore tree have been retained
with birds depicted among many types
of large flowers and dark motifs set
against a light ground. In contrast, the
Jambi batik (Plate 491) is a
wonderfully stylized version of the
palampore on a rich maroon ground.
The meandering limbs of the trees are
thinly clothed in leaves and the flowers
have assumed strange, sometimes gro-
tesque shapes. Each end of the textile
is finished in a tightly striped, mock
fringe pattern characteristic of many
of the batiks made in Jambi, or made
elsewhere for that particular market.
The rich warm red and cream colours
of Lasem transform another decorative
chintz-like design (Plate 492) into the
style of batik much admired in east
Sumatra. The flowers and leaves are
sinuous and robust, but little remains
of the mound from which the
palampore trees sprout. The triangular
end-panels are in contrasting colours,
also a characteristic feature of Lasem
batik for the Palembang market.
The cloth in Plate 493 is believed to
have been made in Batavia, where a
number of batik workshops flourished
from the mid-nineteenth century
deliberately recreating batiks after
regional and communal styles. The
eccentric design is dominated by the
red and blue triangular mountain
shapes. These motifs alternate with
flowering trees and the triangular
mounds are also filled with foliage and
peacocks. While the ambiguous
tree-mountain motif is a familiar one
on Java, other features of this design
suggest that this batik was not
intended to be highly symbolic. These
include the very decorative borders
around each triangle, the quaint human
figures, and the *kain sarong* design
format with an intricate floral and bird
head-panel.

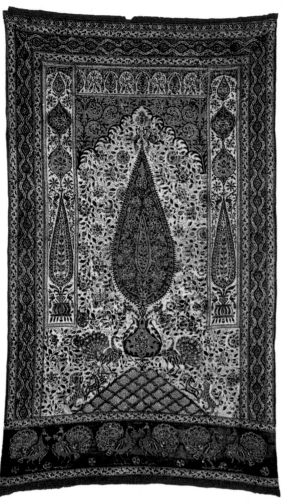

494

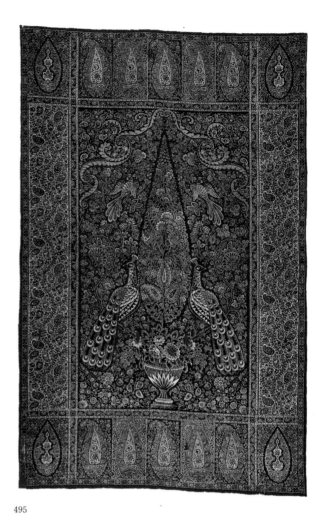

495

494
kain leluhur (?)
ceremonial hanging
India; southern Sumatra, Indonesia
cotton, natural dyes and mordants
mordant block printing
334.0 x 173.0 cm
Australian National Gallery 1987.1075
Gift of Michael and Mary Abbott,
1987

495
kain leluhur (?)
ceremonial hanging
Europe; southern Sumatra, Indonesia
cotton, dyes and mordants
copper roller printing
199.0 x 128.0 cm
Australian National Gallery 1984.2000

Indian textiles displaying prominent
tree motifs were popular in both Asia
and Europe throughout the
seventeenth and eighteenth centuries
when huge quantities of Indian cloth
were shipped by the European trading
companies operating from various
parts of India. While many *palampore*
reveal the strong influence of
European taste on aspects of the
design, such as the bouquets and the
ribboned and garlanded border, other
examples clearly demonstrate an
Islamic aesthetic. These usually
display tree designs (Plate 494) with
creatures such as the peacock and the
tiger at the base of a formal
symmetrically arranged tree or shrub,
often a variety of cypress.
These design structures, both of the
tree on the mound and in the
architectural niche, have influenced
certain Southeast Asian textile
designs. This is particularly evident in
the case of Malay embroidered
hangings used as elaborate wall
decorations during rites of passage.
Plate 495 is, in fact, a nineteenth-
century European version of this
popular Islamic textile, exported to
Asia in an attempt to secure a share of
the market for European manufactured
textiles. Both the Indian cloths and
their imitations entered the realm of
the ancestors (*leluhur*) and the
supernatural and were stored as
village treasures. These tree-patterned
textiles, known outside Southeast Asia
as *palampore*, provided a new source
of inspiration for local textile-makers,
particularly those working in the fluid
media of batik and embroidery.

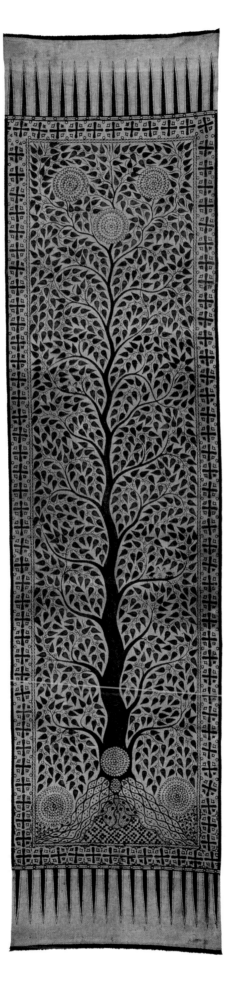

496
ma'a
sacred heirloom
Toraja people, central Sulawesi,
Indonesia
cotton, dyes
painting, drawing, block printing
374.0 x 89.0 cm
Australian National Gallery 1983.3684

The influence of Indian trade textiles
on local technique and design is
evident among the Toraja, who
developed a technique of direct
woodblock printing and painting. Both
of these techniques are rarely applied
to decorative textiles in Southeast
Asia, but the Toraja have adapted
them to produce replacements and
counterparts for their valuable Indian
heirlooms.
In this particular example the sinuous
trunk remains, while the foliage has
been simplified into a canopy of small
leaves. The great blooms of the Indian
palampore are carefully arranged in
two groups of three bold sunbursts at
top and bottom of the cloth. The
mound from which the tree sprouts is
composed of interlocking blocks of
trade cloth patterns. These include
woven designs and a patterned pool
swarming with fish, which, in the style
of Toraja illustrators, break through
the bounds of the enclosure. Small
birds are naively drawn nesting in the
branches.

498

499

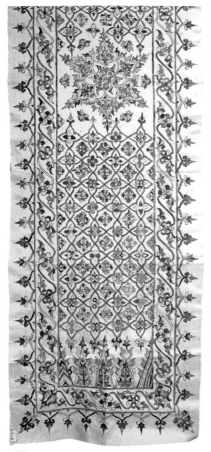

497

497 (detail)
ija plangi (?)
painted textile
Acehnese people (?), Aceh, Sumatra,
Indonesia
silk, pigments, resins
painting
180.0 x 50.0 cm
Rijksmuseum voor Volkenkunde,
Leiden 1599–134

This unusual pigment-painted textile
was collected last century in Aceh.
While its origins are unknown, the
decorative design has similarities to
Sumatra embroidery and gold thread
patterns. According to the museum
records the fabric was painted with
analine colourings and resins.

498
kain songket
skirtcloth
Malay people, Terengganu, Malaysia
silk, gold thread, natural dyes
supplementary weft weave
210.0 x 102.0 cm
Australian National Gallery 1984.1096

This is an opulent Malay brocade with
gold thread supplementary weft
(*songket*) over a red silk ground. The
design structure is typical of Malay

court style, and consists of a densely
worked head-panel edged by rows of
triangular foliated borders and a field
pattern composed of a diagonal grid
filled with trefoil *fleur-de-lis* foliage.
Many of the trade cloths that were
highly prized in Southeast Asia display
a diagonal grid similar to the field
design of this Malay cloth. A
distinctive feature of the
supplementary weft weaving of
Terengganu is the way the
supplementary weft threads are woven
into the foundation weave at regular
intervals. Consequently, strands of
gold thread do not float across the
surface of the silk cloth in the manner
of other Malay *songket*, and although
the patterning is more subdued it
results in a stronger and more pliable
fabric.

499
kain songket lemar
ceremonial skirtcloth
Malay people, Terengganu, Malaysia
silk, gold thread, natural dyes
supplementary weft weave, weft ikat
213.0 x 103.4 cm
Australian National Gallery 1984.596

Motifs arranged in formal lattices are
a popular design feature used to
decorate the fields of Malay
ceremonial skirtcloths. On this
nineteenth-century example, narrow
rows of eight-pointed stars alternate
with bands of small squares. These
gold motifs appear against alternating
ground patterns of subdued green and
purple weft ikat. The section of the
cloth intended to be worn at the rear
(*pantak*) has double rows of highly
decorative triangles, bordered by
scrolling arabesques.

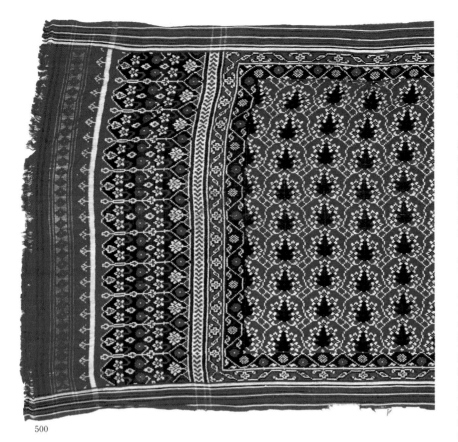

500

501

500 (detail)
patolu
heirloom textile
Gujarat, India
silk, natural dyes, gold thread
double ikat
134.4 x 405.0 cm
Australian National Gallery 1980.1640

501 (detail)
ma'a; mbesa
sacred heirloom
Coromandel coast, India; Toraja
region, central Sulawesi, Indonesia
handspun cotton, natural mordants and
dyes
mordant painting, batik
112.4 x 398.0 cm
Australian National Gallery 1988.1612
Gift of Michael and Mary Abbott, 1988

Certain textile designs favoured by the
Islamic courts of India and Central
Asia and some Indian trade cloth
patterns which followed these designs
were taken up by the textile-makers of
Southeast Asia, and reworked in
accordance with local aesthetic
principles and in local techniques. One
design that found favour in a number
of locations was the diagonal lattice
enclosing a motif of sprigs of flowers
sporting either three or five stalks
(Plate 500). This particular *patola*
design is known as *ful vadi bhat* (floral
field pattern) in Gujarat (Bühler and
Fischer, 1979: 33–67). The same
patterns and design structures are also
found on Indian mordant-painted and
printed cottons traded to Southeast
Asia (Plate 501). This bolt of fine old
Indian fabric in deep reds and blues,
probably dating from the
mid-eighteenth century and stored as
an heirloom in central Sulawesi,
displays a similar patterned grid with a
cartouche enclosing a pot of flowers.
Both the grid and these particular
motifs can be found on many
Southeast Asian textile designs worked
in ikat, supplementary weft,
embroidery and batik. The design is
especially popular in the Malay-Islamic
courts.

It is within the Islamic communities where floral and creeper images are so widely used, that many renditions of the flowering tree are found. The arrangement of the tree on certain Acehnese and Malay embroidered hangings is clearly influenced by the Mughal-Persian architectural design found on prayer mats and also on both painted and printed cottons from India. On the figurative supplementary weft fabrics of Sumbawa and other coastal Malay communities, *471* however, the tree and floral motifs were transformed into potted bushes or vases of flowers in Mughal style. The formal tree with flanking creatures (often royal motifs such as the elephant or *455* peacock) is also found on a number of south Sumatran examples, and similar images are found on the appliquéd hangings of the Sultanate of Sulu. These were used to line the ceiling and walls of each room at the funeral of a prominent figure (Roces, 1985: 2).

The impact of Persian and Mughal taste on trade cloth design cannot be underestimated in the development of floral and leafy patterns and arabesque lattice designs. The textile-producing centres of Golconda in the Coromandel hinterland and Gujarat in north-west India exported such cloths to Islamic markets elsewhere in the world and many of these textiles reached Southeast Asia. Among the most common types to have some impact on Southeast Asian design and pattern were the floral varieties. The three-branched plant, or three-stalked floral arrangement, was widely favoured, and Indian trade cloths in both silk and painted cotton with such grid patterning were *500,501* especially popular in the region. It is also possible that carpets with this popular design were amongst the treasures of the region's sultanates.[56] This is a design structure that was immensely popular throughout Southeast Asia, and not only in Islamic areas. A specific *patola* motif of this type has been reproduced on *kamben cepuk* weft ikats in Hindu Bali and Nusa Penida, on warp ikat men's cloths from Christian Roti and on *kain songket* gold brocades by the Muslim Mal- *498* ays of Terengganu and Palembang.

The popularity of the diagonal lattice design structure probably increased with Islam, and the formal grid design is a favourite means *497* of decorating textiles, particularly for field patterns in coastal Southeast Asia. Within the compartments of the arabesque trellis, stars and flowers frequently appear. On woven textiles, especially the gold supplementary weft *songket* which became the hallmark of the wealthy Islamic coastal kingdoms, figurative patterns are rarely encountered, and then only in a stylized and formal way. *Songket*-weavers in these coastal courts favoured the use of sets of shed-sticks to facilitate repeated patterns, and this tended to schematize the designs into symmetrical shapes — eight-petalled rosettes, eight-pointed stars, *499* diamonds, crosses and lozenges. The tendency, however, was to continue to utilize grids based on the old *mancapat* four-sided figures (with or without the understood fifth point in the centre) and the eight-pointed lotus form rather than the hexagon tesselations so popular in the Islamic arts of Central Asia. As we have already observed, the eight-pointed star or rosette was a well-established motif in the textile art of those parts of Southeast Asia where Indian and Islamic influence was strong (Coffman, 1983a). While the well-known *patola* star motif often became rounded and more identifiably floral, its appeal and its reproduction in a variety of shapes, materials and techniques across Southeast Asia was probably a reflection of the philosophical resonances suggested by such a motif. As we have seen,

schema based on eight directions or points around a ninth central point were part of Indic cosmology. In Java this notion was restated in terms of Allah's nine *wali*, the messengers of God said to have first introduced Islam to Java.

SOCIAL DISTINCTIONS UNDER ISLAM

Neither under Islam nor through the influence of Indian textile crafts, largely produced by men, did textiles in Southeast Asia really waver from being exclusively the art of women. Men usually made the weaving equipment, and as we have seen, the similarities evident between motifs in male and female arts was recognized, and in some instances men were actively involved in design. While this custom was obviously not new, and men had in other cultures been involved in carving the designs for bark-cloth painting or beading, it was more formally recognized in the Islamic regions. We are told that the late Sultan of Terengganu supplied drawings of his cloth designs to the master weavers of the courts who then transposed them into shed patterns for *songket* brocade and silk weaving (Sheppard, 1978). This Malay custom of interaction and co-operation between males and females in the design and execution of new textile patterns is especially necessary in the creation of the *kain telepok*, where wooden blocks carved by men are used by women to apply gluework to their woven cotton fabric. The rulers of central Java have also been credited with the inspiration for certain batik designs made by their concubines.

While the world of textiles in Southeast Asia has remained throughout history a predominantly female sphere, one of the few arenas in which males have played an extended role was in the traditional batik production of Cirebon. Here men have long been involved not only in creating designs but also in the application of the wax. This has been attributed to the traditional and ancient division of skills into male and female specialities — women wove and men painted in the Cirebon area.[57] Since batik on cotton cloth may have grown out of the input of both local painters and immigrant Indian textile artisans long ago, it developed as a male activity. Certainly Cirebon batik has a frieze-like style of patterning on a light ground quite unlike the batik designs of other Southeast Asian regions and more appropriate to mordant painting techniques. It appears that where textile designs are closely identified with male activities such as carving, painting or writing, men may have some input in textile production.

An important consequence of the coming of Islam to the islands and peninsula of Southeast Asia, and one which is reflected in many aspects of culture, including textiles, has been the consolidation of the divisions between mountain and shore. Coastal societies have always been more open to contacts and stimulation from the outside world and these influences have filtered more slowly into the interior mountain regions. The arrival of Islam accentuated existing cultural differences between its coastal adherents and the followers of older religious beliefs. Some inland peoples have maintained an ethic of cultural superiority and have regarded the adoption of the cultural attributes of coastal neighbours, particularly when this has involved embracing a new religious creed, as a retrograde move.[58] This has led

to the creation or strengthening of many minor regional cultural distinctions embodied in dress.

The sharp division between the Buginese and the Toraja peoples in Sulawesi, in spite of their common myths, similar language and shared history, seems to have been exacerbated by the early conversion of the Buginese to Islam. Similarly, the distinctions between the Mandailing and Angkola peoples and their Toba Batak neighbours, between the Aceh lowlanders and the Gayo highlanders in north Sumatra, and between the Endeh and Lio communities in Flores, seem to be based on present or past religious differences, particularly between those categorized either as Muslim and non-Muslim. As we shall see in the next chapter, the coming of the Europeans into Southeast Asia magnified these divisions, and this has led some writers to suggest that the very notion of separate *adat* or customary law, the basis for such divisions, was 'invented' by the colonial powers.

We do not have to look to a wave theory of migrations into Southeast Asia to explain the physical and cultural differences that have developed between the more isolated inland communities and their coastal neighbours whose numbers were swelled by male migrants from India, China, the Middle East and Europe. In fact, it is surprising that the cultures of these coastal communities, much more exposed to rapid change and to foreign influences, have retained so many characteristics that are identifiably Southeast Asian. However, the textile styles and techniques that coastal communities have adopted have not always penetrated to the hinterland, and the resulting differences have become part of the perceptions of cultural identity and superiority.

This division was not associated exclusively with Islam. As far east as Irian Jaya, bark-cloth is always seen as a 'hill product' while the trade cloth on which wealth and ritual exchange is based is a 'coastal product' (Elmberg, 1968: 192). Similarly on the Babar Islands, the male goods in ritual exchange are imported foreign objects, 'products of the sea' including gold and trade cloths, while the female goods, 'products of the land', are locally made textiles (van Dijk and de Jonge, 1990). Both are necessary in ritual but the exotic foreign goods hold a superior position. This has been the prevailing attitude between Islamic coastal societies and their neighbours — one of cultural superiority and religious enlightenment, while recognising the need to maintain essential trade relations. These attitudes of difference and superiority have had a great influence on the spread and aceptance of certain Islamic artistic styles and motifs.

With the adoption of Islam throughout Southeast Asia, two apparently contradictory principles seem to have been at work. On the one hand, motifs, particularly those that depicted realistic scenes with human and animal activities, although the resulting patterns continued to draw upon many ancient forms. Simultaneously, the desire for ornamental textiles, bright and beautiful in their own right and unaffected by other religious elements, led to the dazzling embroideries and gold thread work which are still associated with private and public ceremonies throughout the Malay-Islamic world. The spread of Islam to Southeast Asia coincided with a period of economic prosperity, although control of much of this wealth ultimately passed into the hands of Europeans. Islam provided not only a new focus but also an

alternative Southeast Asian cultural identity in opposition to that brought by the European intruders, and while there were important changes in the central rituals of the life cycle, the pomp and majesty of the nobility, the splendour of court regalia and silk and gold textiles remained undiminished.

Western research has, in the main, failed to explore the Islamic contribution to the arts of the region. The coming of Islam has generally been viewed as heralding the demise of the great Southeast Asian cultures, both those of the Hindu-Buddhist courts and those associated with the ancient practices of the ancestors. The scholars and collectors of the European colonial period focused their attention either on what they regarded as the exotic and the primitive, or on the magnificence of court wealth and splendour. For the British, even the latter had little appeal in their Southeast Asian possession, since the art of Lesser India was eclipsed by the Great Traditions of the Indian subcontinent. Beautiful Malay silks, for instance, were largely treated as handicrafts beside the wonderful textiles of India. In the Philippines, under colonial rule, disdain for the Moros and their way of life, and conversely, great anthropological interest in the traditions and culture of other communities have resulted in few nineteenth-century examples of silk textiles from the southern Philippines surviving in museum collections.

There are many magical events and splendid legends surrounding the coming of Islam to Southeast Asia, a process which began in the thirteenth century, and which had firmly established Islam in many of the region's ports of international trade by the time the Europeans arrived in the early sixteenth century. The mystical bias of Sufism may explain why it is still possible in the nineteenth and twentieth centuries to document some of the more ancient textile rituals and traditions of the region in both the courts and the countryside. However, in general, the conversion of peoples to Islam tended to reduce the sacred and magical importance of textile art, and led to the disappearance of certain types of cloths. But there was no parallel diminution of pomp and ceremony and textiles remained a prominent visual symbol. In particular, the festivals of life and status prompted the display of rich fabrics, frequently embellished with gold and silk threads, while the human body continued to be decorated in fine textiles for, with the coming of Islam, clothing became a more obvious element in people's lives.

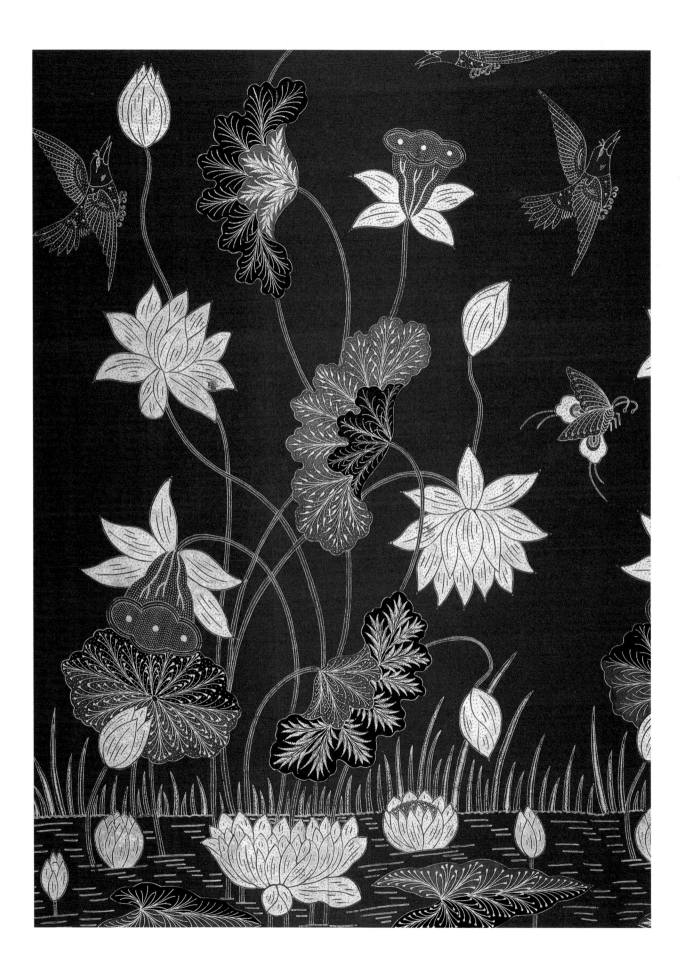

Chapter 6

EUROPEAN INCURSIONS

In the sixteenth century a new group of foreigners joined the melting pot of Asian cultures. The Portuguese and Spanish were the first to arrive, pursued before long by the Dutch, English and French, so that every European maritime power was eventually active somewhere in the region. With the opening of the sea routes from Europe to Asia in the fifteenth century, European adventurers were attracted into Southeast Asia by the desire to exploit the Eastern spice trade which had previously passed through Arab and Indian ports. These Europeans initially jockeyed for positions in trade alongside Asian merchants, but their aim to monopolize this lucrative business soon led to the formation of companies such as the VOC (Vereenigde Oost-Indische Compagnie, United East-India Company of the Netherlands) and the EIC (East India Company of England). These corporate ventures established factories for the collection of produce in the primary-producing areas such as the Spice Islands in eastern Indonesia, and on the Indian subcontinent where they tried to control the flow of Indian trade cloth, a commodity which the Europeans quickly discovered was an essential item in Asian trade.[1]

By seizing existing trading cities and establishing new entrepôt centres in Java, the Malay peninsula, Sumatra, Burma, Thailand and the Philippines the trading companies paved the way for the colonization of most of Southeast Asia in the nineteenth century. European governments steadily intruded into the more remote parts of the region. Between the sixteenth and twentieth centuries, Europeans increasingly vied with each other for control over the internal affairs of Southeast Asian states, which were continually dogged by wars, quarrels about accession to thrones and conflicts over territory. Colonial boundaries emerged that had little to do with ethnic and cultural realities, and which represented a sharp break with the fluid nature of those borders and political allegiances that had characterized life in Southeast Asia for over a millennium. While the Indianized states had developed hierarchical systems of power, prestige and wealth over many centuries, a structure which was little affected by the coming of Islam, the European presence in the region impinged upon the autonomy and sometimes the very existence of many of these traditional principalities.

502

502
A Crown Prince of Yogyakarta in about 1900 dressed in ceremonial attire walks beside the Dutch assistant-resident, also in formal dress. They are followed by a retinue of court retainers carrying the royal regalia. The Dutch colonial government encouraged adherence to court rituals and ceremonial pageant in those parts of the region sympathetic to European rule.

Opposite Detail of Plate 21

............
jacket
Nias people, Nias, Indonesia
cotton, flannel, silver lace, gold paper
appliqué, lace-work
Volkenkundig Museum Nusantara,
Delft S 231–61

The jackets of Nias warriors and
noblemen have been constructed of a
variety of materials including
bark-cloth and animal hides. This
nineteenth-century sleeveless jerkin
with a high collar and a sweeping cut
to a wide lower border, is made of
various European commercial fabrics.
The textile company's gold label,
SUPERFINE COTTON, has been
carefully incorporated into the border
design as a decorative element,
together with fragments of silver lace.
The fluffy fabric gives the appearance
of a short fringe.

The European trading companies, and later the colonial governments, also established and consolidated new aristocracies in regions where political power and authority had traditionally rested upon small family and lineage units. Where Western powers needed support for reasons of trade or security, sympathetic families or lineages were promoted and defended as the rulers of particular areas.[2]

Textile art was already well established before the arrival of the Europeans, and many early travellers were evidently impressed by the grand apparel of their hosts — particularly those of royal blood. The fashions of the West, suited to a very different climate, had relatively little immediate impact on local dress, and apart from their novelty, European textile techniques and materials such as wool had little effect. On the contrary, the opening of the new trade routes heralded the beginning of an era in which Indian and Chinese silks and cottons, and the dyeing techniques applied to them, became as popular in the West as they were in the East.

From the seventeenth century, however, European influence gradually became a dominant factor in the life of Southeast Asia, life in which art played an integral part. Social structures and customs changed, and while relatively few textile developments can be pinpointed as specifically European, the impact on textile usage was dramatic.

FROM VALUABLE CLOTH TO SYMBOL OF AUTHORITY

The earliest intrusion which the Europeans made upon Southeast Asian textile history was through their increasing control and manipu-

lation of the market in Indian trade cloth. Through superior naval and military power, and through the establishment of trading factories (in Southeast Asia and India) and forced deliveries of produce, the Europeans effectively took over the external affairs of many regions. The Dutch VOC was particularly aggressive in the competition against both local and European rivals, and gradually came to dominate the manufacture and supply of Indian textiles to Southeast Asia. The sixteenth, seventeenth and eighteenth centuries saw the peak of this trade — in numbers and in value of goods. It continued into the nineteenth century and prestige cloths such as the *patola* remained in demand into the twentieth century. However, decline and mismanagement were features of both the VOC and the EIC during the eighteenth century.

Rulers loyal to the colonial regime were rewarded, not only by European military support, but by gifts of rare valuables. As a part of this process of indirect rule, the Europeans exploited existing notions of royal symbolism, and associated beliefs and practices.[3] These symbols of status became the sole preserve of the European-backed nobility and the ritual that grew up around them became an integral part of local tradition.

Among the most prominent of the gifts of favour were the double ikat silk *patola* cloths from India. As we have already observed, the significance of this textile as a luxury trade item was already established before the arrival of the Europeans. Now more than ever before, these textiles became part of the special dress of the aristocracy, and a prominent source of aristocratic design throughout Southeast Asia. It is interesting to note that the name of the great and legendary Palembang ruler, the first sultan to be elevated and acknowledged by the VOC after their sacking of that city in 1662, was Cindai Balang ('Multicoloured *Patola*'). Cindai Balang is said to have established the aristocratic social order, arranged tribute and controlled the rich hinterlands which included the Pasemah highlands and parts of Lampung (Collins, 1979: 83–9).

I have already suggested that elaborate Indian cloths or local textiles displaying motifs derived from these Indian trade cloths were ultimately used in some parts of Southeast Asia to create the dress of the rulers and their court while the rest of society wore locally woven cloth. *Patola* cloths were used to fashion trousers for the exclusive

504,505
506,507

22,303
329,500

509

504 and 505 (details)
ma'a
heirloom textile
Gujarat (?), India; Toraja region,
central Sulawesi, Indonesia
cotton, natural dyes and mordants
mordant block printing
80.0 x 798.0 cm
Australian National Gallery 1988.1605
Gift of Michael and Mary Abbott, 1988

While many Indian cloths were complete pieces, finished at each end with elaborate triangular bands and side borders, some textiles were traded as long bolts of fabric intended for cutting into shorter lengths to create particular garments. These cloths influenced the designs on many Southeast Asian textiles, especially those with overall patterns such as batik. This particular trade cotton in red and brown tones is a typical example of the genre, and Indian cloth with such floral designs was also popular in many other parts of the world, including Europe.

The reverse side of one end of the fabric bears a small stamp displaying the letters VOC. This was the official stamp of the Dutch trading company, Vereenigde Oost-Indische Compagnie, which had secured a monopoly over the trade in Indian cloth to the Indonesian archipelago, and indicated through which company factor or port the cloth would be traded (R.Laarhoven, personal communication, 1988). The VOC took this step to distinguish legally traded cloth from smuggled goods. Cloth with such stamps must have been produced no later than the end of the eighteenth century since the VOC ceased operating in 1799 because of financial mismanagement, due, in large part it seems, to VOC officials' private dealings in commodities such as trade cloth.

504

505

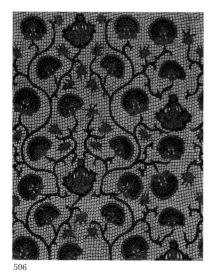

506

506 (detail)
kain panjang
skirtcloth
Javanese people, Surakarta, Java,
Indonesia
cotton, natural dyes
batik
103.2 x 250.0 cm
Australian National Gallery 1984.3084
Purchased from Gallery Shop Funds,
1984

The floral batik pattern sometimes
known as *celuki*, and in this instance
named *geringsing semyok*, was clearly
influenced by the floral designs found
on certain Indian mordant-printed
cottons.

507
tepiké; hoté
ceremonial mat; hanging
Sangihe-Talaud Islands, Indonesia
abaca fibre, natural indigo dyes
supplementary weft weave
147.0 x 182.0 cm
Australian National Gallery 1986.1240

On this example of a Sangihe abaca
textile, the over-all pattern closely
follows a rare floral design found on
Indian cottons. From before the
earliest European involvement in Asian
commerce, trade cloths were brought
in large quantities to that region of the
Indonesian archipelago to purchase the
famous spices that were grown there.
This textile has been assembled from
four separate panels of woven fabric,
and a closer examination reveals two
slightly different designs of flowers
and leaves. Although the blue colour of
the supplementary thread has been
obtained from indigo, this colour is
seldom used with hard fibres such as
abaca, because such materials do not
adequately absorb the dyestuff.

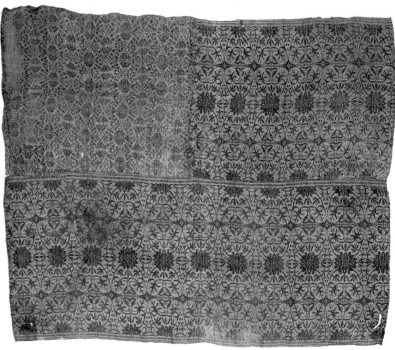

507

use of the Javanese rulers, who also used the Indian double ikat silks 449
as shawls, breastcloths and waistcloths. Trousers fashioned from
exotic Indian fabric, including gold thread brocades and silk *patola*,
were also part of the ceremonial dress of the Malay courts and
elsewhere. The *patola* were prominent as wraps, overskirts, sashes
and even turbans.

The rarity and status of the *patola* and its fragile weave meant
that these double ikat textiles were not often cut. Moreover, tailored
garments were generally not favoured in Southeast Asia except in
those areas where Chinese or Islamic influence had had a decisive
effect upon costume. In most of the principalities and sultanates rec-
tangular textiles, sometimes stitched into a cylinder, remained the
usual form of costume. The *patola* served as an elaborate version of
these existing rectangular garments. In the Sultanates of Sumbawa
and Bima, for example, the double ikat silks were used as ceremonial
baby-carriers by the aristocratic wet-nurse (*ina susu*) of the princes
and princesses. At the circumcisions and marriages of these royal
children, the *patola* was worn by the wet-nurse as a symbolic
shouldercloth.

The very large *patola* silks have been frequently displayed on 508
ceremonial occasions as objects of eye-catching splendour when the
full extent of their glory could be appreciated. They were used by the
rulers as opulent furnishing material to decorate their palaces,
throne-rooms and private chambers, and functioned as cushion- 305
covers, and as standards, drapes and hangings for the royal marriage
beds, ceremonial dais, palanquins and pleasure-garden pavilions. In
the courts of Sumbawa and south Sulawesi *patola* cloths were used as
royal canopies, instead of or in addition to the traditional parasols of
rank. Thus *patola* cloths, a central part of the pomp and pageantry of
these established courts and sultanates, were important symbols of
royal power and authority.

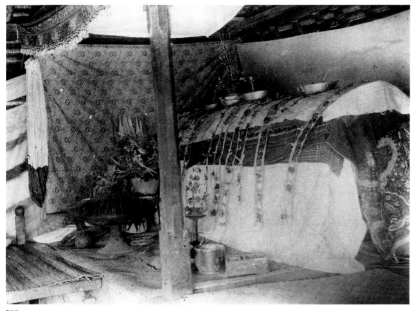

508

508
Throughout Southeast Asia, the fine textiles used to honour the dead and mediate with the spirit world often include Indian trade cloths, or locally woven cloth with designs and motifs derived from these sources. A body lies in state in Singaraja, north Bali, early this century beneath a huge tasselled canopy, covered with royal textiles, including *patola* cloths (or a Balinese weft ikat *kain cepuk*).
The *patola* became one of the most prestigious categories of ceremonial cloth in Bali and on the small off-shore island of Nusa Penida, and royal couples sat upon the silk *patola* at wedding rituals. Not only did the Balinese prefer certain *patola* designs but they also favoured a smaller version of the silk double ikat. The usual four-metre sari-length *patola* were uncomfortably long and awkward for Balinese purposes, and the Indian makers and Dutch merchants were able to supply two-metre versions with their favoured patterns.

These cloths were always one of the most expensive prestige trade textiles imported into Southeast Asia. The limited distribution of those that did reach the region is largely a reflection of the role played by traditional rulers who, aided by their European colonial allies and overlords, tried to restrict their use to their courts where, in some cases, a hierarchy of *patola* patterns emerged. The rarity of these cloths was exacerbated by the gradual decline of the Indian cloth trade during the nineteenth century at a time when rulers, fearful of their loss of real power in colonial Southeast Asia, continued to play out elaborate court rituals which required such powerful and reassuring symbols.

With the disintegration of the Dutch United East-India Company at the end of the eighteenth century, the trade in luxury goods including textiles declined. During the nineteenth century, colonial economic interests increasingly concentrated on the possibilities of commercial cash crop agriculture,[4] and markets for commodities, including textiles, produced in European factories. Fewer Indian cloths were imported into Southeast Asia. As highly valued trade textiles such as the *patola* became scarcer, the motifs and patterns associated with them were transferred on to locally made cloth. These textiles, like the *patola* prototypes from which the designs were obtained, became associated with the traditional aristocracy and ruling elites, and the use of these textiles was also restricted. *Patola*-inspired designs are still widely regarded as the prerogative of royalty, even in areas where the *patola* origins have long been forgotten. *Patola*-derived designs have become sacred symbols, particularly within cultures where royalty is regarded as the protector and custodian of sacred ritual and traces its origins to legendary ancestors.

In eastern Indonesia on the island of Roti where *patola* designs
516,517
have also been sources of motif for local textiles, the exclusiveness associated with Indian trade cloth ensured a royal monopoly on related designs. During the seventeenth and eighteenth centuries *patola* and other symbols of power — muskets and gold and silver

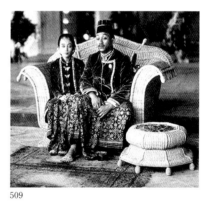

509

509
This photograph of Prince Mangkunagoro VII and his consort was taken in Surakarta in 1920. They both wear velvet jackets, trimmed with gold metallic braid, hers in the long Portuguese style, his jacket displaying an asymmetrical Chinese cut. Her set of *kerongsong* brooches takes the form of butterflies, while the prince wears a formal cap based on Middle-Eastern models. They wear velvet slippers embroidered with gold thread.
Their skirtcloths are splendid examples of imported Indian double ikat *patola*, known in Java as *cindai*. This old symbol of royalty in Southeast Asia was exploited by the Dutch colonial regime, and the *patola* ultimately became the mark of a ruler acknowledged and supported by the colonial powers.

510
ei ledo
woman's skirt
Savunese people, Savu, Indonesia
cotton, natural dyes
warp ikat
120.0 x 178.8 cm
Australian National Gallery 1988.1561
Gift of Michael and Mary Abbott,
1988

511
ei raja
woman's skirt
Savunese people, Savu, Indonesia
cotton, natural dyes
warp ikat, supplementary warp weave
121.0 x 170.0 cm
Australian National Gallery 1988.1563
Gift of Michael and Mary Abbott,
1988

Plate 510 is the skirt worn by
Savunese women of the *Hubi Iki*
(Lesser Blossom) moiety. It is known
as *ei ledo*. Plate 511 is the *Hubi Ae*
(Greater Blossom) skirt known as *ei
raja*. While the format is followed
strictly by all weavers from a
particular moiety, there is some
variation in the patterns in the widest
band (*hebé*), which indicates
membership of the moiety subdivision
(*wini*, seeds). These traditional cloths
are worn on all important ritual
occasions associated with ancient
ancestral traditions when moiety
membership is a significant factor.
Unlike other Savunese textiles, *patola*
influence never appears on these
cloths.

512
The family of the former district chief
(*fettor*) of Mesara in south Savu
retains the right to wear *patola* motifs
on the main ikat bands (*hebé*) of their
ei worapi skirts. A later development,
the *ei worapi* often requires more
elaborate dyeing procedures than the
other Savunese skirts and the *patola*-
inspired band on this woman's cloth
displays an additional stage of opening
and tying ikat.

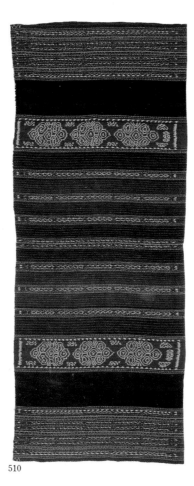

510

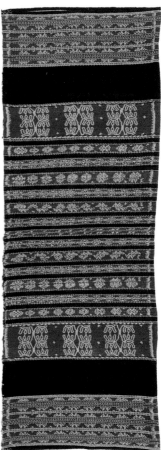

511

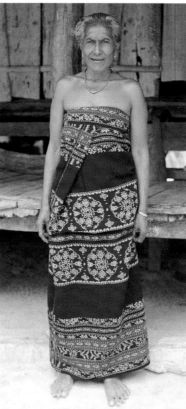

512

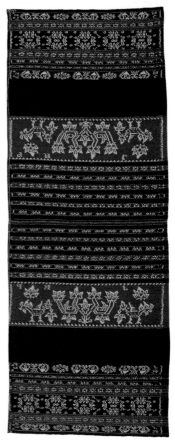

513

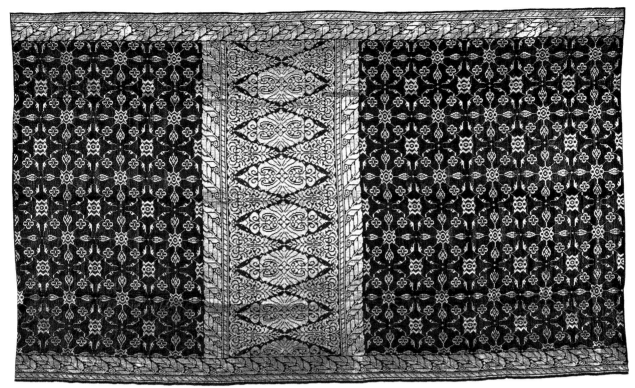

514

515

514
514
kain songket
ceremonial skirtcloth
Malay people, Kelantan, Malaysia
silk, silver thread, natural dyes
supplementary weft weave
166.6 x 97.5 cm
Australian National Gallery 1984.598

515 (detail)
kain lemar
shouldercloth; breastcloth
Malay people, Kelantan, Malaysia
silk, natural dyes
weft ikat
77.0 x 215.0 cm
Australian National Gallery 1984.599

513
ei worapi
woman's skirt
Savunese people, Savu, Indonesia
cotton, natural dyes
warp ikat
161.6 x 62.3 cm
Australian National Gallery 1985.1695
Gift of Jonathan Hope, 1985

This style of *ei worapi* displays
non-traditional and naturalistic motifs
that are generally known to Savunese
weavers as wardrobe (*lemari*)

patterns, a reflection of the influence
on textile designs of the heavily carved
Dutch colonial furniture lavishly
ornamented with scrolls of flowers,
leaves and birds (Verendeel, 1987:
121–2). Some *lemari* designs also
include cupids and urns, and many of
these warp ikat motifs come from
Dutch embroidery pamphlets. The fine
ikat and dye work of this example
suggests an aristocratic maker,
although an *ei worapi* displaying this
pattern can be worn by anyone.

Patola are also found among the
heirloom textile treasures still
controlled by the families of the Malay
sultans, where they have been used as
ceremonial clothing and as ritual
paraphernalia. The royal heirloom
patola were also the source of many
Malay textile patterns, and the striking
example displaying silver thread
against black silk provides a fine
illustration of the way in which royal
designs emulated the prestigious
imported *patola* star.
The influence of *patola* design is also
evident in Plate 515, a rectangular
weft ikat textile which serves as a
breastcloth, dance-sash and stole. The
end patterns of stupa-like flames,
however, are in a style common to
many Southeast Asian silk-weaving
centres.

batons — were regularly supplied to loyal allies in the name of the Dutch Governor-General in Batavia, often after a specific letter of request from a Rotinese ruler (Fox, 1977b: 102). Ultimately, *patola*-inspired motifs became closely associated with the rulers of each small Rotinese princedom and were used on locally woven textiles as conspicuous symbols of noble birth and authority.

Until late in the nineteenth century, there was minimal European influence or involvement in the internal affairs of the neighbouring small island of Savu. Until the eventual supremacy of the chief of Seba, which united the whole island under his own leadership, it was divided into a number of mini-states, each controlled by a traditional ruler. Both leadership and village residence in Savunese society are based on membership of male lineages. However, Savunese society is also divided according to matrilineal descent into two moieties known as *Hubi Ae* (the Greater Blossom) and *Hubi Iki* (the Lesser Blossom). Membership of these moieties has been the dominant factor in determining the design structure and decorative motifs of Savunese warp ikat textiles. For women, the two classical styles of cylindrical skirt are the *ei ledo* for members of *Hubi Iki* and the *ei raja* for members of *Hubi Ae*.[5] The structure and general design of each skirt has been determined according to tradition and the only significant variation appears in the major ikat band where different patterns indicate membership of moiety subdivisions, known as *wini* (seeds). *510,511*

While these textiles are a clear and public indication of moiety membership they have no relationship to rank or status within Savunese society. The Savunese solution to the problem of displaying superior rank, an issue encouraged by the European presence in the region, was to create a new style of women's skirt, known as the *ei worapi*, which incorporated bands of more elaborate warp ikat characterized by over-dyeing of red and blue.[6] This style of ikat was a striking characteristic of the textiles of neighbouring Sumba with whom, by this period, the Savunese were in close and regular contact through the settlements of Savunese migrants along the coast of east Sumba. The development of ikat bands displaying both indigo and red colours, and the application of over-dyeing techniques to achieve purple and brown, typified a general response in eastern Indonesia to the problem of how to reproduce successfully the multicoloured trade cloth patterns on cotton with only a limited range of natural dyestuffs. The application of this layered ikat technique (often known as *lapit*, layering) is largely confined to those designs that display these influences. *512,513*

The design format of the *ei worapi* closely resembles the other two styles of Savunese women's cloths: two panels, each containing narrow warp ikat stripes, one wide undecorated indigo band, and one wide band of warp ikat. However, the motifs in this warp ikat band on the *ei worapi* bear no relationship to *hubi* or *wini* membership. Instead, it is in this band that the symbols of rank and status appear — the well-known *patola* star and the emblem of a silver belt (*pending*) from the royal regalia. Such prestigious motifs are considered the exclusive property of the royal families of Savu and the right to make and use them is guarded fiercely. *512*

Other motifs found on the wide warp ikat bands of the *ei worapi* include a variety of decorative designs known generally to the Savunese as *lemari* (wardrobe patterns), so called because they resemble the ornate carving on colonial furniture. This genre also *513*

includes many floral and bird motifs from tablecloths, lace and embroidery patterns. Although *ei worapi* are often acknowledged in Savu to be the most finely worked garments, revealing the great skills of the dyer, such textiles have no place in traditional Savunese ceremonial life and even the women of the royal family of Savu are buried in the *ei raja* or *ei ledo* of their ancestors.

Throughout the Indonesian archipelago, the symbolic association of royalty with *patola* cloths and *patola*-derived motifs is widespread. We have less information on the exclusiveness of *patola* ownership in other parts of Southeast Asia although there is plenty of evidence that *patola* cloths found their way to many parts of the region. The *patola* were highly valued in the Malay courts, and royal *514,515* weavers adopted certain *patola* motifs on many of their sumptuous *kain lemar* and *songket* textiles. In the southern Philippines, too, the *patola* stars appear on the silk weft ikat skirts (*malong andon*) woven in traditional Maranao royal colours of yellow and purple, and a *pinatola* (*patola*-like) design is still remembered there (Casino, 1980: 181).[7] Patola were also imported into central Thailand and probably Cambodia, although there the association with the aristocracy and the subsequent impact on royal textile design appears less direct.

FOR GOD AND GLORY: CHRISTIAN AND MILITARY MISSIONS IN SOUTHEAST ASIA

The European influence was responsible not only for bringing inspiration to the textile arts of the region. It can be seen also in the destructive effect of colonial rule on many forms of indigenous culture, a process which invariably had negative consequences for the making and using of traditional textiles. Through colonial conquest and war, Europeans were directly responsible for the destruction of certain traditional centres of royal authority and the aristocratic court cultures associated with them. In the early twentieth century, one of the notorious examples of this occurred in south Bali when, in the face of imminent Dutch conquest, the court of the two princes of Badung conducted mass suicide. Other instances were less dramatic but no less devastating. In Aceh, for example, the demise of its fine weaving tradition was largely the result of the prolonged wars against Dutch invaders in the early twentieth century.[8]

Once European authority was established, colonial officials began to introduce rules and regulations designed to manage and control the lives of the indigenous people. In their attempts to organize and 'civilize' the population, many aspects of traditional life and culture were actively discouraged. Villagers were moved from their ancestral lands to positions where it was easier to control and pacify them, and practices such as head-hunting and ritual warfare were outlawed. During the nineteenth and twentieth centuries, colonial authorities issued bans and restrictions on feasts of merit, lavish bride-price agreements, elaborate buffalo sacrifice and conspicuous consumption, especially at ceremonies associated with funerals. These colonial edicts had the side-effect of reducing the need and demand for ceremonial finery, including the decorative textiles used on such occasions.

In the Philippines the Spanish were not confronted by entrenched and elaborate feudal courts such as those facing the Dutch

516
lafa bui nggeo
man's cloth
Rotinese people, Roti, Indonesia
cotton, natural dyes
warp ikat

Rotinese leaders loyal to the Dutch
East India Company and later to the
Governor-General in Batavia were
rewarded with fine objects such as
patola for their exclusive use. From
the structure of the star *patola*
pattern, Rotinese noblewomen have
derived two distinct motifs, the *dula
nggeo* (black motif) and the *dula penis.*
This large man's cloth belongs to one
of the royal families of Roti and was
made last century by the grandmother
of the present *manek* (ruler). It
displays the *dula nggeo* motif across
each end and a plain black centre (*bui
nggeo*), also reserved for the rulers of
the various domains of the island.

517
pou
woman's skirt
Ndao people, Ndao; Rotinese people (?)
Roti, Indonesia
cotton, natural dyes
warp ikat
60.0 x 169.0 cm
Australian National Gallery 1984.1988

The unusual red skirts found on the
island of Roti are often made by the
people of Ndao, a tiny island off the
west coast of Roti. While some Ndao
designs are closely related to Rotinese
textiles, these red cloths are not
common. Some of them were probably
woven and traded from Ndao.
However, each petty kingdom (*nusaf*)
in Roti has an Ndao clan, and these
Ndaonese are permanent members of
Rotinese society. While the status of
the Ndao clans varies across the
island, where they rank high and
provide marriage partners for the
aristocracy the red textile is
considered prestigious (J.J. Fox,
personal communication, 1987). The
high value of this cloth is confirmed by
the central application of a
patola-derived motif, which here takes
the form of a floral lattice. Other
minor motifs such as the triangular
mound may also have been inspired by
these imported silks.

in Java or the French in mainland Southeast Asia. The fragmented
island world consisted of many small societies, too weak, isolated, and
technologically ill-equipped to resist the Spanish, who were easily
able to establish Manila on the island of Luzon as an entrepôt for trade
between China and Europe and Mexico across the Pacific.

As Spanish colonial rule spread throughout the Philippines, some
of the most significant opposition came from the south where largely
Islamic but culturally diverse peoples were collectively dubbed
'Moro' by the Spanish, after the Moors of northern Africa. The inhabi-
tants of the Sulu archipelago and substantial portions of Mindanao had
probably been Islamic for two centuries before the arrival of the
Spanish and the wealthy sultans of this region had played an influential
role in the important inter-island and Chinese trade that passed
through their territory. Their influence spread beyond their immedi-
ate domains, and the Sulu (or Jolo) Sultanate had already established
outstations and was receiving allegiance from coastal ports in Borneo
and the eastern islands of the Indonesian archipelago. Spanish zeal for
conversion to Christianity, and the large missions they established
from the sixteenth century onwards, contributed directly to the
Spanish-Moro conflicts that continued until the end of the nineteenth
century. The apparent unity of this ethnically diverse region probably
derived from a common Islamic-inspired opposition to a foreign
Catholic enemy.

The situation had a direct effect on clothing associated with
warfare. Traditional armour and war jackets had been made from
tough local vegetable fibres and other protective material such as
shell discs, cotton wadding, and thick bark, and were often sup-
plemented by talismans. As a consequence of war with Europeans,
metal or chain-mail jackets and metal helmets were developed by *520,521*
seafaring peoples in both the Sulu archipelago and south Sulawesi,[9]
the form clearly modelled on suits of armour worn by invading
soldiers. Similar developments also occurred in certain parts of east-
ern Indonesia where the Portuguese were active in the sixteenth
century, and heirloom metal helmets are still part of the ceremonial
costume of Banda and the Halmaheras in eastern Indonesia (Douwes
Dekker, n.d.: 172). The protective clothing of other ethnic groups in
Southeast Asia may have been indirectly influenced by the presence
of European soldiers. The Torajanese, mountain neighbours of the
Buginese in Sulawesi, have also worn a warrior's outfit of thick scales
and a sturdy helmet of twined rattan of distinctly European appear-
ance. In Java the costume of Yogyakarta court retainers in Yogya-
karta worn on certain ceremonial occasions includes the knee
breeches and jackets of Europeans soldiers of past centuries. Even
the unique plaited hats of the Rotinese, more flamboyant than pro-
tective, have been attributed to the historical influence of the Por-
tuguese, while the Malay term for jackets or vests, *rompi*, is derived
from that European language.

Portraits of European military officers and senior officials from
the nineteenth century reveal richly embroidered formal jackets and
waistcoats with elaborate gold passementerie on the collars, lapels
and epaulettes. Many of the nineteenth- and early twentieth-century
photographs of the courts of central Java show Javanese aristocrats *509,518*
wearing similar styles of formal dress with heavily couched gold
thread embroidered trim and braid, and the women of the court wear-
ing long velvet jackets (*kebaya panjang*), also with gold embroidery,

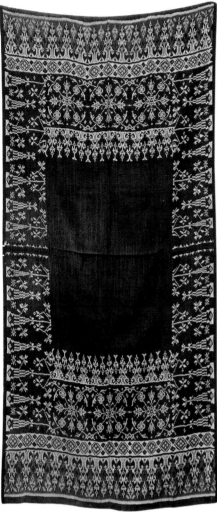

516

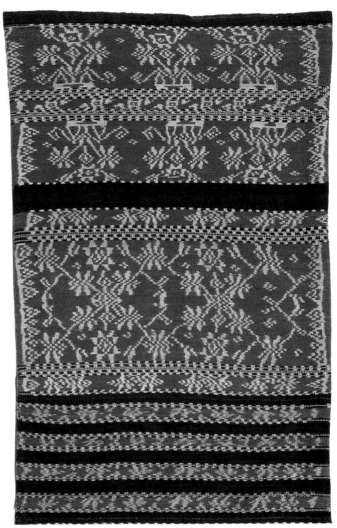

517

over their batik skirtcloths. Costume of this type was also adopted by other rulers: the Sultan of Kutei and his wife wore formal Javanese-style jackets of embroidered velvet over batik, and the voluminous formal brocade coats of the Thai kings were trimmed with gold thread couching. Initially such apparel was used mainly for social interaction with the European world, while within the courts ceremonial wear hardly changed from the styles prevailing before European intrusion. On occasions such as royal weddings, for instance, many noble brides and grooms wore no shirts or jackets at all.

The development of the art of gold couched embroidery on the Malay peninsula since the fall of Malacca to the Portuguese in 1511 suggests that European models may have also been an important influence on that technique in the Malay world, reinforcing the inspirations provided by Indian embroideries, Middle-Eastern decorative stitchwork and Chinese hangings and costumes. In the Philippines, even the rich spectacle of the most elaborate Chinese ceremonial costumes was rivalled by the couched gold thread ecclesiastical garments of the Spanish religious orders.[10] While some of these ornate costumes were made of locally embroidered silk, other materials such as damask, velvet and brocade were brought from Spain for chasubles and religious hangings (Casal and Jose, 1981: 98), and were the

518
Court dress differed according to the occasion. This nineteenth-century photograph shows the princes of Yogyakarta wearing Javanese batik skirtcloths (*kain panjang*) as waistcloths and severely tied headcloths (*iket kepala*) with formal suits, notable for the elaborate gold thread couched embroidery on the jackets and belts. On this occasion stockings and court shoes complete the attire.

518

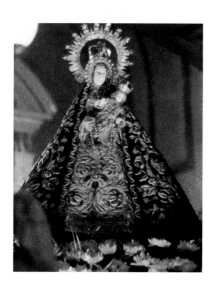

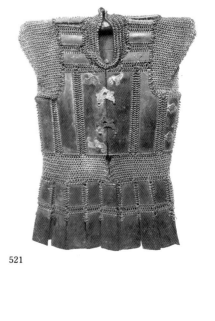

521

519
Throughout the Philippines during rites of veneration of the Madonna, fine images are paraded through the streets cloaked in elaborately embroidered garments.

520 and 521
............
helmet and coat of armour
Islamic people, southern Philippines
brass, cotton, silk (?), metallic thread
American Museum of Natural History,
New York

Suits of armour constructed from chain mail, metal plates and metal helmets were adopted from the Portuguese and Spanish by warriors in coastal areas, such as the Moro of the southern Philippines and the Buginese of Sulawesi. This set of helmet and vest was collected in the southern Philippines. The fine helmet features a stylish tall plume constructed of long sticks decorated with metallic thread lace and silk (?) and gold thread brocade.

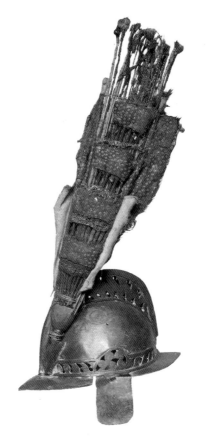

520

522
anting-anting
talismanic shirt
Philippines
handspun cotton, ink
drawing

The written word was also believed to
have protective and healing qualities,
and calligraphic images and religious
graphics on certain manuscripts and
textiles were used as amulets at times
of crisis. In the Philippines, such
objects were known as *anting-anting*
or *agimat*. This example of a
handspun cotton undershirt contains
biblical evocations and Latin
inscriptions. Undershirts like this and
scraps of cloth with similar inscriptions
were especially popular in times of
warfare, as it was believed that, like
other talismans, they could render the
wearer immune to attackers' weapons
(Casal and Jose, 1981: 118).

precursors of the profusely ornamented gowns (*labrado*) made by
many Filipino communities to dress their patron Madonna for religious festivals and processions (Santos, 1982). These embroidery
skills (*burdado*) are still applied to clerical dalmatic in the Philippines
today, although in other Christian areas of Southeast Asia, such as
eastern Indonesia, local textile techniques such as warp ikat decorate
ecclesiastical vestments. The bishop's mitre, the priest's shawl and
the altar-cloth now are often adapted from local textiles.

In areas where ancestral religions have been encroached upon by
Christianity there have sometimes been dramatic changes in ceremonial life and in attitudes towards the place of many ritual objects,
as priests and missionaries have attempted to eradicate practices
deemed pagan. In many instances this task has proved elusive and
traditional beliefs and observances have been reinterpreted to suit
new circumstances. The positioning of a statue of the Madonna and
Child in a chapel alcove lined with a silk *patola* illustrates the efforts of
the Church and its missionaries on the island of Flores to appropriate
important local sacred objects and symbols for Christian use.

In the parts of the Philippines archipelago that experienced the
longest and most intense colonization and religious conversion by the
Spanish, the original indigenous customs and culture are now hard to
determine. However, there are still hints of ancestral ways in the
manipulation of Christian symbols. Talismanic shirts and pieces of
cloth with Latin script have served as protection from evil and enemy
attacks in a similar fashion to the simple stripes of the Balinese and
the Sasak, and the garments and objects on which were inscribed
fragments of Sanskrit or verses from the Koran. These talismanic
applications of the written word are widespread, even among non-
literate sections of Southeast Asian society.

With the increase in Western education in Southeast Asia from
the end of the nineteenth century, messages and personal signatures
in Romanized lettering began to appear on many textiles. In particu-
lar, the practice of signing garments became popular among weavers
in the Christian areas of Indonesia where initials or even full names
appear in warp ikat. Where textiles are intended to convey a message
or greeting, this is sometimes spelt out on the cloth. The most popular
message in the Malay peninsula and the Indonesian archipelago con-
veys good wishes for the use or wearing of the cloth (*selamat pakai*),

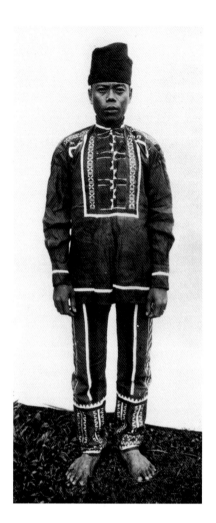

523
In the southern Philippines, the Bukidnon adapted various aspects of Western techniques and materials to develop a unique patchwork tradition. This early twentieth-century photograph shows a Bukidnon man in shirt and trousers with a typical contrasting trim, usually in red, black and white.

while many Batak ceremonial *ulos* gifts are now emblazoned with the greeting *Horas Mahita* or a detailed embroidered account of the occasion and the names of the leading participants.

SEEKING A MARKET IN THE EAST: THE IMPACT OF EUROPEAN TEXTILES AND RAW MATERIALS

Many of the raw materials that had become a fundamental part of Southeast Asian textile art continued to enter the region after Europeans had become a dominant force there. European commercial interests sought to play a direct role in this trade, wherever possible establishing a monopoly over the import of products such as Indian cloth, silk and beads. Even before the Industrial Revolution changed European attitudes towards trade with Southeast Asia, large quantities of certain items were being made with Eastern markets in mind. Beads, for example, were a particularly important commodity and had traditionally been an appliqué material long before Europeans began to export them to the region. Many came from Venice where production was greatest in the sixteenth century, and from factories in Amsterdam from the seventeenth century onwards (van der Sleen, 1967: 108–13).

Few items of clothing were tailored, and when jackets or pants were made, they retained characteristic Southeast Asian attributes, largely the result of earlier foreign influences from China and Central Asia. Pants usually displayed a long undecorated panel at the top which was intended to be folded and rolled in a manner similar to rectangular and cylindrical skirts, as few traditional Southeast Asian garments incorporated the button-and-hole openings of European costume. Even into the twentieth century, women's shirts and jackets continued to be fastened with jewellery in ways peculiar to the region. Elsewhere in Southeast Asia, a fastening device was usually modelled on the Chinese plaited fabric toggle. Although buttons were eventually imported in some quantities into Southeast Asia to use as fasteners, they became more popular as appliqué materials, particularly small white ones made of shell (and later plastic) and were used as a substitute for beads and split nassa shells.

With the growth of factories in Europe during the nineteenth century the potential huge markets of Asia became an attractive target for many of their new products. Finely woven commercial fabric from Europe was used to create Southeast Asian traditional dress just as cloth from China and India had been in previous centuries. European cloth provided the raw material for the foundations or lining material of certain costumes, and was particularly important in the production of high quality Javanese batik. Factory-woven cloth, including flannels, velvet, and fine cottons of various grades, became *503,523* very popular as base fabrics for appliqué hangings and accessories. In central Borneo the practice of using bark-cloth as the base material to create jackets and skirts with stencilled ochre patterns was almost entirely abandoned under the impact of cheap European cloth made available by traders operating out of the markets and coastal towns. The Kenyah-Bahau communities began to reproduce the same *526* designs and patterns on jackets and skirts using an appliqué technique of cut-out silhouettes stitched on to a plain contrasting ground. While the iconography remained faithful to tradition, both the appliqué and the base fabric were of imported commercial cloth.

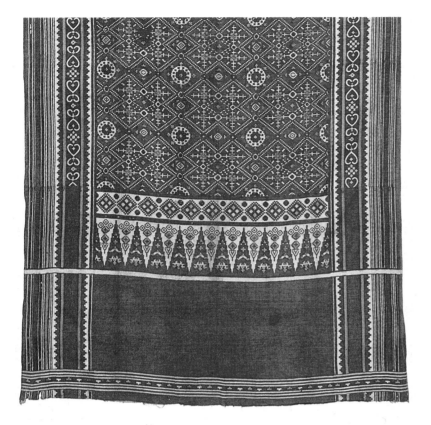

524

525

524 (detail)
............
heirloom
Europe; Indonesia
cotton, dyes
copper roller printing
111.0 x 333.0 cm
Australian National Gallery archival
collection
Gift of Michael and Mary Abbott, 1988

525 (detail)
............
imitation batik textile
Haarlem (?), Netherlands; Sumatra,
Indonesia
cotton, dyes
batik, machine printing
87.0 x 193.5 cm
Australian National Gallery archival
collection
Gift of Michael and Mary Abbott, 1988

In the nineteenth century, European
industrialists set out to supply the
markets of the colonial world with
manufactured cloth from their
factories. Using copper-plate and
copper-roller printed fabrics, attempts
were made to develop colours and
styles to suit the tastes of particular
regions and communities.
The established market in Southeast
Asia for the Gujarati silk *patola* and
for Indian block-printed cotton
imitation *patola* encouraged European
textile manufacturers to produce
factory-printed versions in various
sizes of the best known star and lattice
patterns (Plate 524). While these
imitation Indian cloths appear to have
had considerable appeal in some
regions, the European batiks could not
compete with locally made
block-waxed versions. Plate 525
follows the style of batik popular in the
Jambi district of east Sumatra in the
nineteenth century, with a blue-black
pattern against a maroon ground and a
striped mock fringe.

526
te'eh (?)
skirtcloth
Kenyah people, Kalimantan, Indonesia
cotton, dyes
appliqué

Unlike other peoples of Borneo,
especially the Iban and the Benuaq,
the Kenyah did not possess an
elaborate decorative weaving tradition.
Their ceremonial garments were
originally ornamented with beads or
stencil painting and stitching on
bark-cloth. With the availability of
imported commercial cloth, however,
the Kenyah women applied their
familiar symbols to a new medium,
appliqué. Cut-out motifs appeared both
in positive and silhouette images
against a contrasting base-cloth, also
of imported fabric. Colourful braids
and trims were added to these
wrap-around style skirts.

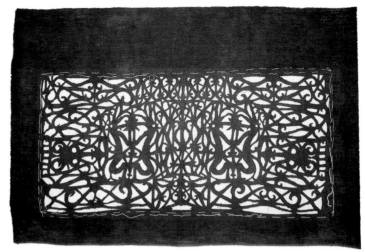
526

527
ma'a
sacred textile
Toraja people, central Sulawesi,
Indonesia
cotton, dyes
painting, block printing
109.0 x 70.0 cm
Australian National Gallery 1980.1666

This painted ceremonial textile,
coloured an unusual green, displays a
Toraja village with houses, animals and
human inhabitants. While such scenes
have been a feature of Southeast Asian
art for thousands of years, the
portrayal of such realistic figures on
Toraja textile art seems to have been
influenced by the Dutch factory-made
sarita, which contained similar images.

528
sarita
sacred heirloom
van Vlissingen and Co., Helmond,
Netherlands; Toraja region, central
Sulawesi, Indonesia
cotton, indigo dyes
paste-resist dyeing
17.6 x 487.0 cm
Australian National Gallery 1980.1653

Although most of the Western
attempts to imitate Indonesian textiles
used copper-plate printing methods,
these narrow cotton textiles were
made in the Netherlands by a
paste-resist dyeing process and
exported to Sulawesi from 1880 to
around 1930 (Nooy-Palm, 1989:
171–2). There they became an
important type of ceremonial textile,
and seem to have inspired the Toraja
to develop their own *sarita* with paste
batik and with carved stamps.

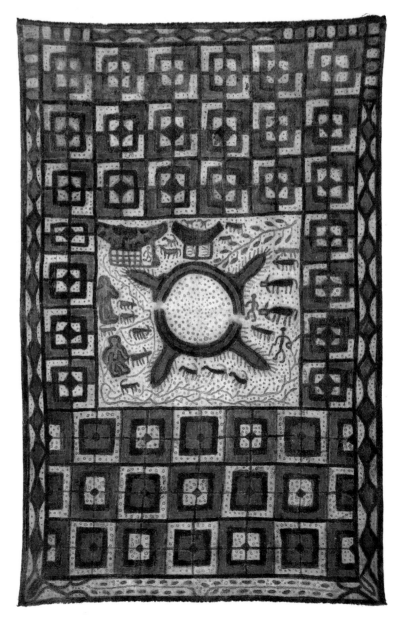
527

European factories also began to produce cotton prints in imitation of both Southeast Asian and Indian textile designs. These included cheap factory copies of certain types of Indian trade cloths that were known to be popular in some parts of the region, and in some cases these cloths secured a place in the market.[11] The Minahasa in north Sulawesi, for example, accorded the European printed imitations of *patola* cloth the high value of the genuine Indian double ikat silks. During the same period, European factories also produced imitation *bhandani* tie-dye cloths in the style of those made in Rajasthan. These textiles were also traded into Southeast Asia, and were absorbed into the heirloom realm in south Sumatra and the Babar archipelago.

Other European factories reproduced Javanese batik designs in an attempt to compete with the local product. Ironically, some of the earliest collections of Javanese batik to be found anywhere in the world were made at the behest of European textile industrialists eager to discover what styles, patterns and designs were popular in Asia. These collections were used by the European entrepreneurs as a source of ideas to create cotton print designs aimed at the huge export markets of Asia and Africa. Although they included designs, some of them elaborate, in brown, maroon and indigo colours somewhat similar to those used on authentic Javanese batik, these printed fabrics had little success in Java.[12] (The invention of the copper stamp waxing tool (*cap*) in Java to hand-produce batik cloth at a faster and cheaper rate was a significant factor in the lack of success of the European imitation batik textiles.) In the twentieth century, local factories throughout mainland Southeast Asia have also produced machine-printed cottons in imitation of Javanese batik, usually in the bright floral and bird-motif styles of the north coast, and this fabric has been popularly accepted by women as cheap skirt material.

In the mountainous centre of Sulawesi, long before European penetration, the Toraja had made huge tricoloured banners (*cawat cindako, pio puang*) using an elementary form of paste-resist batik to effect patterned bands. In the nineteenth century, the batik sections of these banners were copied by a European factory and the resulting long narrow bands were aimed specifically at the Toraja market.[13] Known as *sarita*, they displayed a crisp, tight pattern which became the basis for many twentieth-century Toraja printed and painted (or drawn) textiles. (Another type of *ma'a* textile also emerged in the Toraja region, using the techniques of block printing and freehand painting of pigments on to both locally woven and imported cotton cloth. While some of these textiles contain motifs and design structures influenced by Indian trade cloth, many of the most elaborate of this type of *ma'a* display a central window within a small repetitively patterned field, through which can be seen cameo impressions of Toraja village and agricultural life.) It seems that the later versions of the *sarita* made by the Torajanese were based upon the combined inspiration of many different sources: the ancient stick batik, the Dutch factory *sarita*, the Indian trade cloth patterns and other designs found on both woodcarving and other woven textiles. Just as batik seems to have flourished in Java in the nineteenth century with the availability of huge supplies of European factory-woven cloth, Toraja textile techniques such as batik and particularly cloth-painting and printing may also have been stimulated in new directions when these fabrics became available in the interior of Sulawesi.

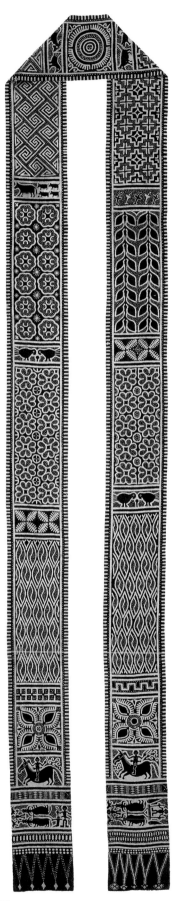

528

The Industrial Revolution in Europe and the competition to find markets for the rapid increase in textile production drew other responses in Southeast Asia. The use of frame looms, both hand and semi-mechanically operated, developed during the colonial period. These included four-heddle looms which enabled weavers across Southeast Asia — in Burma, Luzon and Kelantan for example — to produce the 'Op Art' designs in which arrangements of squares lead the eye to see circles.[14] The replacement of body-tension looms by non-mechanical frame looms was also common and these looms have been widely used to weave both decorative and everyday textiles intended for sale through the market-place. Some widely used looms, which still produce textiles by hand although at a faster and more commercial rate, include the ATBM (*alat tenun bukan mesin*, the non-mechanical loom) of Java, the post-Second World War silk-weaving looms of Bangkok, and the *piña*-weaving looms of Luzon and the Visayas.

Apart from their speed and convenience, a major advantage of these looms is that weavers have been able to produce fabrics in widths not usually possible with a body-tension loom. Hence, skirt-cloths can be made from a single length of fabric rather than the two lengths of cloth with a central join necessary in the past. Since the semi-mechanical and mechanized looms have not been used to produce the sort of textiles used for sacred rituals, they are often operated in wage-paying workshops by men who had previously not participated in the weaving of traditional textiles in Southeast Asia.

The effect of economic change on indigenous textile production under European domination varied in different parts of Southeast Asia. While the demand in the West for Manila hemp (abaca) grown in the Philippines rose dramatically in the nineteenth century (Owen, 1984), the areas where abaca had been traditionally used for fabric, notably Mindanao, were little affected by the trade until after the First World War, and even then the effect on local textile traditions appears to have been minimal. However, with the establishment of new commercial agricultural enterprises in Southeast Asia during the nineteenth century one product stands out in relation to textiles. The forced planting of indigo as a cash crop for European markets ensured that this dyestuff was also available almost everywhere within the region, even in places where it had not been used before.

By the end of the nineteenth century, however, natural dyes were being replaced in Southeast Asia, as they were in many other parts of the world, by new chemical dyes, although these products were more immediately appealing in some regions than in others. The batik-makers of north-coast Java were among the first textile artisans to be attracted to the range of bright hues that aniline dyes offered. Dyeing with red *mengkudu* bark is a laborious process and this traditional dyestuff was one of the first to fall victim to the new, quick, colourful and imported products, both in Java and elsewhere.

EUROPEAN FRILLS: EMBROIDERY AND LACE

Certain European textile techniques, especially lace-making and embroidery, gradually found their way into the region. This was the result, in the main, of the contact between Southeast Asian and European women, particularly in Christian mission schools. These two

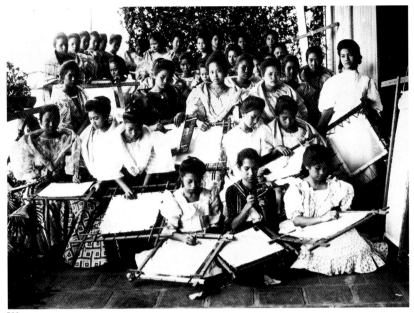

529

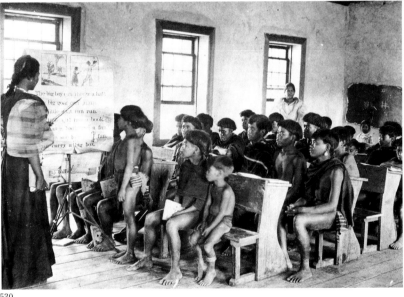

530

529
A group of young women in the northern Philippines early this century pose for a photograph with the new symbol of female textile knowledge, the embroidery frame. The younger girls are wearing typical Edwardian frills and puffed sleeves, while some of the older members of the class have already adopted the characteristic blouse (*camisa*) with its wide shawl neck and stiff, wide butterfly sleeves. During the colonial period the *camisa*, and the lacy scarf (*panuelo*) worn over the blouse, continued to be made of locally woven vegetable fibres, such as *sinamay* and *piña*. Both the names and the style of these garments reveal the strong influence of Spanish culture on urban Luzon.

530
An early twentieth-century photograph of a young female teacher instructing a class of Ifugao youngsters in central Luzon. The contrast between the European-influenced costume of the urban Tagalog and the ancient forms of traditional dress still worn by isolated mountain groups is evident. The woman wears a full *camisa* blouse with wide billowing sleeves over a turn-of-the-century style skirt. Although urban men were already wearing loose shirts (*baro*) of fine local vegetable fibre fabric such as *sinamay* or *piña*, these boys are still wearing the traditional loincloths (*wanoh*) and woven shoulder wraps. A number carry at their waist the distinctive *butong*, the Ifugao triangular supplementary weft bags (Ng, 1977: 18–19).

textile art forms were actively encouraged as useful and appropriate female pursuits and in the late nineteenth century they were widely practised, especially in urban centres, in both Christian and non-Christian regions. Using embroidery frames similar to those used in Central Asia and China, European teachers encouraged cross-stitch and satin-stitch embroidery.

529 European-inspired embroidery became most firmly embedded in the textile traditions of the lowland communities of the northern Philippines, especially Luzon. Using the local *piña* fabric, a gauze-like cloth woven from pineapple fibre, which in its fineness competed successfully with imported European voile, various embroidery and cut-and-drawn thread techniques were applied. These included a striking style of shadow appliqué (*sombrado*) on almost transparent *piña* fabric, and openwork (*calado*), which formed a filigree ground-pattern against which other dense motifs were worked (Roces, 1985).

Traditional-style textiles such as loincloths, headcloths and shawls were decorated with fringes or embroidery, known in Tagalog as *labrado*.

The Spanish colonial government encouraged the use of such embroidery techniques to produce European motifs in Luzon, in an attempt to compete with popular Belgian and French lace (Roces 1985: fn.29). The items of clothing decorated with such embroidery were frequently European in style — shawls, blouses and shirts — although a few traditional garments remained a part of the established regional dress of the Christian coastal communities and subsequently became a part of Filipino 'national dress'. The styles were predominantly European, although the over-skirt (the cloth draped over the billowing skirts of nineteenth-century Christian women in Luzon) continued the style of the striped wrap-around skirts still worn by women in remote mountain communities and took the same name (*tapis*). The favoured fabrics for these over-skirts were *piña* and imported silk. 530

During the eighteenth and nineteenth centuries in particular, Spanish-style shawls embroidered with satin-stitch, stem-stitch and cut-work were made in large numbers in China for trade to Spanish colonies and ultimately, via the Pacific and Atlantic routes, to America and Europe (Gilfoy, 1983: 134–5). This trade, first of all in Spanish and later in American hands, all passed through Manila, which led to the embroidered shawl's distinctive though mistaken name, *mantōnes de Manila* (Manila shawls). Chinese silks had already been traded into the Philippines region for centuries, but the shawls added European and chinoiserie elements to the embroideries done in those islands.[15]

These Manila shawls were large, brightly coloured squares of silk with wide, knotted fringes on four sides. The designs were predominantly chintz-like floral combinations of European roses and Chinese peonies, although quaint chinoiserie-style scenes of human activity also appeared on some examples. The garments found favour among the upper classes of Luzon, where they became a part of fashionable colonial dress (Robinson, 1987). It is possible that the silk satin-stitch embroideries of other Southeast Asian peoples, such as those found on weft ikats in south Sumatra, may have been prompted by the decorative techniques of such popular garments. The macramé tied and fringed shawl, popular in Europe during the Victorian era, also spread to Southeast Asia where local textiles of a wide variety of designs, both traditional and modern, began to appear with knotted silk fringe borders. In west Sumatra this macramé knotting technique is known as *jambul* and the work is performed on a simple frame. 531

In the northern Philippines, while the names of the embroidery techniques and many of the garments to which they have been applied are unmistakably of Spanish origin, the names of the actual designs have developed a local meaning.[16] For example, the field pattern on a Catholic altar-cloth may be described as *apak manok* (a chicken's footprint).[17] Such terms were obviously inspired by the visual impression of the motif after it had been created.

Openwork embroidery techniques are found throughout the Southeast Asian region, especially applied to garments such as shirts and jackets. These items of dress, and the techniques, seem to have developed since the arrival of the Europeans in the region. Garments include men's ceremonial shirts (*baju guntiang cino*, shirts cut in

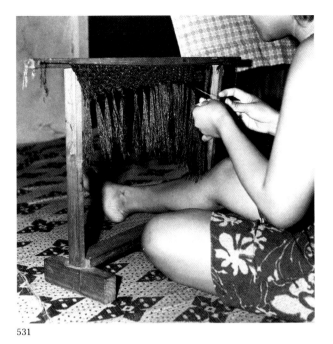

531

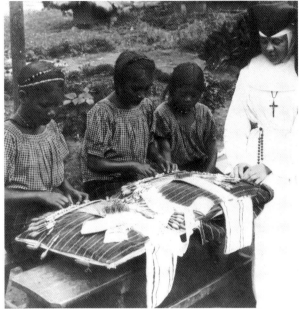

532

Chinese style) and women's shawls in west Sumatra, the elaborate *kebaya* blouses of the European and Chinese women of coastal Java, and various garments in the Minahasa region of northern Sulawesi.

The spread of the sewing-machine during the nineteenth and early twentieth centuries was potentially damaging to embroidery skills all over Southeast Asia. In many cases the effect on local costume was limited to the machine-stitching of narrow panels into cylinders and shirts. However, in some parts of the region where hand embroidery had become an important part of local textile traditions, the introduction of the treadle-machine rapidly displaced hand embroidery using the needle.

256,532 A decorative technique which was directly the result of a European presence in the region, was lace-making. Said to have been introduced into Malacca by the Portuguese (Wray, 1908: 239), locally made crochet and bobbin lace became popular as finishing borders for woven and resist-dyed textiles. While the skill of making lace became more common in the nineteenth century when European women joined their husbands and families in the tropics in larger numbers, it is clear that bobbin lace was already known in Southeast Asia in the seventeenth century. Recent archaeological finds in the wreck of the *Batavia*, lost off the Australian coast in 1629 on a voyage from Holland to Java, include fragments of lace, four lace-bobbins and other lace-making equipment.[18] Certainly, the growing number of European women living in the colonies in the nineteenth and twentieth centuries encouraged the use of the technique among Southeast Asian women, particularly those of elite backgrounds who were able to spend time in the company of Europeans. Bobbin lace-making was not only practised in the Netherlands East Indies, but also in Malaysia and the Philippines where it was taught by Catholic religious teachers.

In some parts of Southeast Asia the use of lace as a decorative trim on textiles was simulated by other techniques. The lower band of

531
A young woman is making macramé at Koto Gadang, west Sumatra. Along with the Minahasa region of north Sulawesi, west Sumatra has been one of the few places in the Indonesian archipelago to develop macramé, cut-thread and lace-making techniques and incorporate them into shawls, handcloths and other garments such as men's shirts.

532
A Catholic nun is teaching young women new textile skills, probably in inland Luzon, in the early twentieth century. The pillow on which the lace bobbins lie seems to have been woven from handspun cotton on a backstrap loom in the traditional manner. The women are negotiating an apparently wide and complex lace pattern.

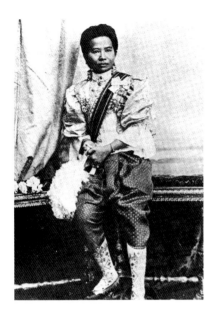

533
A royal princess wears a rich brocade cloth (probably woven in India in accordance with Thai style) in the *chong kaben* manner which was first adopted by aristocratic women during the reign of King Rama IV. The breast-wrap (*sabai*) has been transformed into a decorative shoulder-shawl, and the remaining items of costume are Western — frilly blouses, stockings and high-heel pumps.

534
celana batik
trousers
north-coast Java, Indonesia
cotton, natural dyes
batik
157.5 x 83.0 cm
Australian National Gallery 1981.1123

Unlike their womenfolk, European and Chinese men did not adopt the skirtcloths of the Javanese. Instead, lengths of cool cotton batik cloth were fashioned into trousers and pyjamas for informal wear. The designs were a colourful contrast to the plainness of European dress. Although on the surface the use of a classical central Javanese royal pattern, *parang rusak*, is highly unusual on a pair of trousers, the dominant blue and white colour and the floral meander at each cuff indicate that the fabric was in fact made on Java's north coast. The larger size of many European men was overcome by extending the characteristic wrap of plain material which the Chinese added to the top of batiks of standard dimensions. This band was always concealed by a long jacket or shirt.

warp ikat on Sikka women's cloths in central Flores is often decorated with a motif known as *renda*, which has a lace-like appearance. The term is in fact derived from the Portuguese word for lace. On Indo-European batik of the late nineteenth and early twentieth centuries, both the field and the decorated head-panel of the cloth are often fringed with a batik pattern which imitates the form of lace-work.

FASHION IN THE EAST AFTER THE WEST: NEW TEXTILE FORMS AND USAGE

Lace became an important part of the costume of well-to-do women in urban areas of Southeast Asia during the nineteenth and early twentieth centuries. In the Philippines, the costume of women of such backgrounds exhibited few traditional elements. The *barong Taga-log*, developed by women in Manila and destined to become the basis for the national dress of the Philippines, was an amalgamation of Spanish dress and the Spanish colonial styles worn in Mexico and central America with whom a large amount of trading contact oc- 529 curred. Although their billowing blouses were made of *piña* fibre they were fashioned with huge lacy sleeves and fitted bodices, worn over voluminous European-style skirts and petticoats.

Blouses and shirts became far more widely used throughout all of Southeast Asia during the colonial period. While the influence of Islam had encouraged the use of such garments in the Malay courts, during the nineteenth century they began to appear in the other parts of the region, although the form they took varied greatly. Instead of adopting the mode of dress worn in the large urban centres on Java and Sumatra, women who converted to Christianity in the Netherlands East Indies tended to wear modest cylindrical skirts, often made of checks and plaids from south Sulawesi and Java, and long tunics of European fabric.[19]

During the nineteenth and early twentieth centuries in Indonesia, Singapore and Malaya, well-to-do urban women, especially those of Chinese, Eurasian and European backgrounds, wore costly blouses (*kebaya*) of fine cotton lace over their tubular batik skirts (*kain sarong*). This style of blouse, like the *kebaya* worn by Malays and Javanese, has long sleeves, a rolled neck and an open front fastened with brooches. Lace was the dominant decorative embellishment on these striking blouses and very broad bands of lace were displayed around the cuffs and edges, sometimes dropping to long lacy peaks in the front. While early examples display handmade lace, many of the later *kebaya* used a machine-made trim.[20] *Kain kebaya* (skirt and blouse) of this type are still worn by elderly Peranakan Chinese women in Java and elsewhere in Indonesia.

The courts of central Thailand had always demonstrated an eclectic approach to foreign objects, including textiles, and so it is not surprising that selected items of Western attire were enthusiastically 533 adopted there during the period of Rama V (1868–1910) when modern styles were encouraged. While retaining the *chong kaben* style, often from imported European fabric, royal women began to wear elaborately frilled and lacy Victorian blouses with 'leg-o'-mutton' puffed sleeves and high collars, stockings and court shoes. Thai princes were also photographed in formal Western jackets and sometimes trousers, although the long loose open jackets of Indian brocade or embroidered gauze worn over waistcoats by the Thai aristocracy

was retained for ceremonial occasions. By the twentieth century, however, the women of the central Thai courts had largely abandoned the *chong kaben* style and had adopted a slim cylindrical skirt clearly modelled on their northern Tai neighbours.

In the cosmopolitan cities and the wealthy courts of Southeast Asia, the European notion of changing fashions began to develop. Though change was in itself hardly a new concept in Southeast Asia, the European penetration of the region appears to have encouraged some sections of society, especially those living in large towns and cities where European values and influences were more evident, to consider changes of fashion and dress to be a desirable feature of life. For much of rural Southeast Asia, however, traditions were slower to alter.

During the nineteenth century, the cylindrical *kain sarong* became acceptable wear for all urban women along the north coast of Java. Whalebone corsets and the long voluminous gowns of the Europe of Victoria and Wilhelmina were unsuitable for tropical climates and light cotton batik was favoured for informal wear by women in the Netherlands East Indies. The Dutch colonial wives even adopted the local batik skirts, at least at home, although it was, notably, the more manageable closed form of batik, the *kain sarong*. For European men, Chinese-style batik trousers were acceptable and comfortable as casual wear. Instead of buttoning, the top was folded and drawstring ties were sometimes added. Batik trousers were rarely worn by the indigenous population in Java, although they became part of ceremonial dress in west Sumatra where Minangkabau men include batik trousers (*salawor batik*) in most sets of ceremonial attire (Ng, 1987: 179–85).

While Europeans have customarily stressed the distinction between clothing for men and for women, this often had little effect on the main items of ceremonial costume used in Southeast Asia. In the Thai courts of Ayutthya and Bangkok, and in nineteenth-century Burma, similar skirtcloths were worn by both sexes. In the hinterland of Java where Islam was not as evident, and particularly in the Indianized courts, the wrap-around skirtcloth remained standard wear of both men and women for formal or ceremonial occasions well into the twentieth century. In fact during the rise of the nationalist movement in Java in the first decades of this century, many Javanese men, rather than adopt European-style trousers, continued to wear the *kain panjang* as an overt sign of being Javanese. This style of dress has remained such a symbol to the present day.

On the other hand, in many of the court centres in the Netherlands East Indies where traditional rulers had allied themselves to the Dutch colonial authority, trousers became status symbols necessarily worn on those formal state occasions when contact between the Dutch Governor-General or his representatives occurred. Yet even when trousers were worn, the ancient skirtcloth usually remained evident, often as a finely worked textile draped over the trousers at the hips.

To some extent, Christian missionary activity and religious conversion has aggravated existing differences between neighbouring peoples in the region. Within the Gaddang-Kalinga language group in Luzon, for instance, a distinction in name and identity arose between those peoples who were converted to Christianity (the Gaddang), and those who continued to follow more closely the religion of their

535
534

518

534

535

535
A late ninteenth-century photograph of a young Dutch couple in the Netherlands East Indies in typical informal wear: batik trousers and white collarless shirt for men; short lace-trimmed *kebaya* and floral batik *kain sarong* for women.

ancestors (the Kalinga) and were thus considered 'pagan' (Conklin, 1980: 98). Initially at least, certain distinctions in textiles and dress resulted from these religious differences, and combinations of stripes and colours became associated with each section of the language group. However, the availability of commercial thread and dyes, and the ease of exchange of goods and ideas during the nineteenth and twentieth century, has eventually resulted in the blurring of any differences in textiles in Luzon rather than the accentuation of distinct ethnic dress. Throughout the region, many textiles made by the coastal Ilocano have been to some extent based upon the styles of other ethnic groups, and traded into the hinterland. It is also clear that in Luzon, as in other parts of Southeast Asia, the finest textiles of one culture are also admired and copied by others. The Ifugao and the Kalankay, for example, exchange ikat motifs on their shrouds.

THE ROCOCO STYLE IN NINETEENTH-CENTURY SOUTHEAST ASIA

The combination of the highly ornamental artistic styles of the middle to the late nineteenth century, and the period of peaceful affluence which the colonial governments forced upon the courts and principalities of Southeast Asia, to a large part determined the art style still evident in those royal domains today. For many of these courts, the expense and time spent on interregional warfare in the past was now directed inward towards grand living and ceremonial displays of apparent rather than real power. Similar trends can also be identified in the history of courtly arts during the late Mughal, Persian and Ottoman empires. Chandeliers and gilt furniture were matched by gold embroidery, jewels and sequins. The costume styles associated with this era were those identified with the high Indic period, a legendary time nostagically looked back upon as a Golden Age by Europeans and Southeast Asian aristocrats, and those forms of courtly dress favoured in the colonial nineteenth century are still to be found in the court costumes of the present day.[21]

Throughout the nineteenth century, in particular, the elaborate and baroque design and decoration which was a central feature of European fashion found a ready response in Southeast Asia. Although rich ornamental styles of courtly dress were already well established in pre-colonial times, in many of the region's courts earlier notions of elegant simplicity were overpowered by ornate decoration. Gold was added to batik,[22] embroidery to weft ikat, silver lace to brocade headcloths, and braid to jackets. The nineteenth-century statues of Bali, Burma and Thailand reflect the opulence of court fashion, with layers of brocade and dense metal appliqué and embroidery evident. Frills were added at shoulders, waists and hem, and festive hangings were as glittering and eye-catching as could be devised.

A greater range of materials, foreign textiles and exotic influences were available during this period than ever before in Southeast Asian history, and textile makers were able to draw upon many of the rich traditions and influences outlined thus far. Improved communications provided textile artisans with a wide range of raw materials with which to work. Gold thread, for example, was available from France, China or India. Some raw materials or techniques had already been passed over for more attractive substitutes. However, the urge to produce the finest objects in honour of the family, the lineage or the

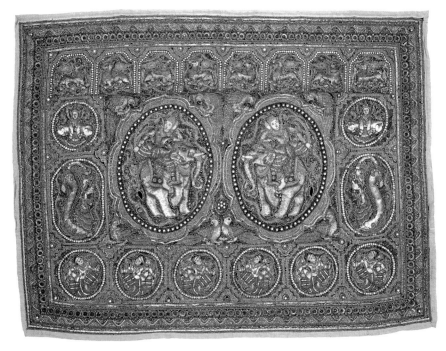

536
kalaga
hanging
Burmese people, Mandalay or Rangoon
region, Burma
cotton, silver sequins, glass and
semi-precious stones, silk
embroidery, appliqué
128.0 x 176.0 cm
Australian National Gallery 1986.1916

As the meaning of its name suggests,
the *kalaga* (foreign curtain), one of the
most spectacular decorative hangings
to evolve in Southeast Asia, may have
been inspired by imported
embroideries from other parts of Asia
(Lowry, 1974: Plate 25). Fine *kalaga*
were commissioned by wealthy
Burmese for festive occasions and
offered as gifts of merit to
monasteries. They were displayed 'in
almost any situation where a
decorative hanging may be
appropriate' indoor or outdoor,
monastery or home (Lowry, 1974:
item 25).

The *kalaga* caught the attention of
early European travellers and seem, in
fact, to have been an Asian form of the
European custom of hanging pictures
on walls. This particular style, in
which the surface is completely
covered in sequinned scales and
glittering jewels using
three-dimensional stumpwork, does
not usually display narrative scenes.
The cameo decorative motifs appear to
be predominantly ornamental. While
the realistic and active poses of the
riders suggest that these *kalaga*
images have been been influenced by
European artistic conventions,
theatrical and royal ceremonial
costume worked in this same
embroidery style were probably
already well developed in the Burmese
court before the Europeans became a
powerful force in the region.

kingdom remained a powerful incentive for women to experiment in
ever more elaborate feats of ikat, embroidery, weaving and batik
work. The great colonial exhibitions held in European capital cities
during the nineteenth century displayed the finest decorative arts of
the East, and virtuoso demonstrations of intricate ornamental style
elicited the highest praise.

During this period, the evolution of ceremonial hangings took
advantage of the great variety of glittering objects and materials, both
local and imported. Perhaps the most extravagant display consists of
536 those Burmese *kalaga* that combine vast quantities of heavy silver
sequins with cut and polished glass and semi-precious stone appliqué,
velvet, gold thread and painting. Along with sacred scenes from the
Jataka legends, these three-dimensional padded ceremonial hangings
display secular fantasies of love, sport and adventure.

REALISTIC MOTIFS, SECULAR THEMES: EUROPEAN
CONTRIBUTIONS TO TEXTILE DESIGN AND MOTIFS

An important element to be considered in determining the complex
ancestry of Southeast Asian textile design is the influence of cloths
originally intended for other markets, which eventually found their
way to Southeast Asia. The familiar *fleur-de-lis* pattern was a design
translated by Indian artisans on to painted and printed cloth intended
498,500 for furnishings and costume in Ottoman Turkey and Mughal India.
501,537 However, some of these cloths also reached Southeast Asia where
538,539 they proved to be popular in certain regions, and Indian textiles with
these patterns continued to be produced specifically for the Southeast
Asian trade. A related design, derived originally from a stylized tulip
in a vase with huge upward and downward curving leaves, was also
adapted from Italian and Ottoman textiles to pattern Indian painted
540,541 and printed cottons. Some of them eventually reached Southeast Asia
542,543 where the design was obviously admired, and influenced local cloth
544 patterns.

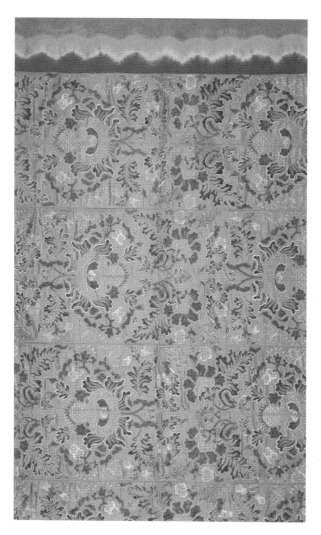

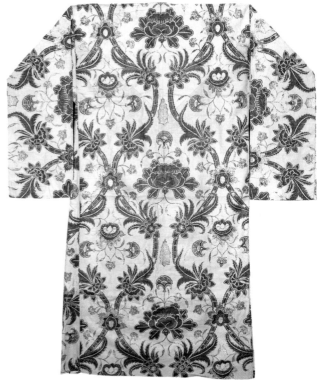

537
kain beber
ceremonial hanging
Europe; Malay people, Palembang
region, south Sumatra, Indonesia
silk, handspun cotton, natural dyes,
pigments, metal rings
damask foundation weave, painting,
stitch-resist dyeing

This painted hanging, one of a pair,
was intended for display on ceremonial
occasions. It was suspended from the
locally tie-dyed cotton section at the
top by a series of brass rings. It
consists of large pale green panels of
eighteenth-century European figured
damask cloth, which has been
hand-painted in south Sumatra with
bright pigments. These painted
designs draw out the main features of
the European floral and leafy
patterned cloth but the use of bright
colours completely changes the
aesthetic.

538
............
ceremonial coat
India; Palembang region, south
Sumatra, Indonesia
handspun cotton, natural dyes and
mordants, gold leaf
mordant painting, gluework
Tropenmuseum, Amsterdam
1772–1414

This wonderful robe is made from
Indian trade cloth, gilded with gold
leaf. The design of the textile and the
sumptuousness of the garment may
have been inspired by the splendid
textiles of the Ottoman empire,
sometimes made of Italian silk velvet,
and it is very likely that sumptuous
Italian and Turkish silks were known
to the courts of Southeast Asia. The
shape of the coat, however, is more
akin to the garments of Japan, where
Dutch trade also flourished. The ports
of Southeast Asia played a key role in
this trade (R. Laarhoven, personal
communication, 1988).

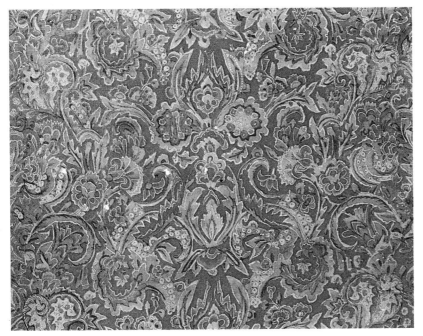

539

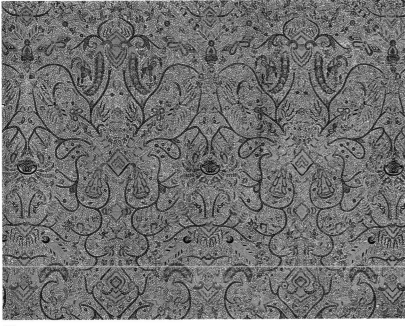

540

539 (detail)
ma'a
sacred heirloom textile
Coromandel coast, India; Toraja region, Indonesia
handspun cotton, natural mordants and dyes
mordant painting, mordant printing, batik
343.0 x 106.0 cm
Australian National Gallery 1987.1073
Gift of Michael and Mary Abbott, 1987

540 (detail)
kain panjang
skirtcloth
Javanese people, Solo, Java, Indonesia
cotton, natural dyes
batik
106.7 x 253.1 cm
Australian National Gallery 1984.3122
Purchased with Gallery Shop Funds

This Indian textile (Plate 539) is a complete length of early eighteenth-century handspun cotton cloth that has been stored as a rare heirloom in the Toraja region of Sulawesi. Many similar Indian painted and block-printed cottons, with repetitive all-over designs like this example, are also used as shouldercloths and sashes in south Sumatra. The all-over patterning is crude but vigorous, and the design of scrolling flowers and leaves is closely related to motifs found on Malay weft ikats and a number of well-known Javanese batik designs, including *sawat* (the double-wing motif), *pisang balik* (inverted banana) and the *semèn* pattern of tendrils and sprouts, of which Plate 540 is a familiar version. It seems that many of the motifs on indigenous cloths were derived from Indian textile designs, although particular trade cloths appear to have been made specifically to accord with familiar Southeast Asian patterns.

By as early as the eighteenth century and steadily throughout the nineteenth, European artistic conventions began to make a stronger impact upon the traditional arts of Southeast Asia. The European characteristic of realistically depicting motifs from the natural world had an especially strong influence upon decorative textiles in many areas. As a result, artisans throughout the region adapted old motifs and created new ones to display a greater realism. However, where such changes did occur, it was usually within the traditional design structures of Southeast Asian cloth, and Europeanized design thus began to appear within motif bands, or on the central field of a textile that remained clearly Southeast Asian in appearance.

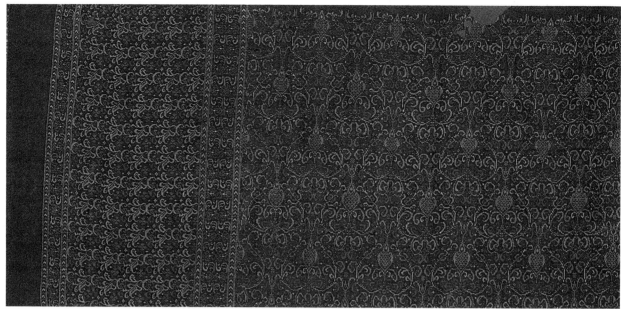

541

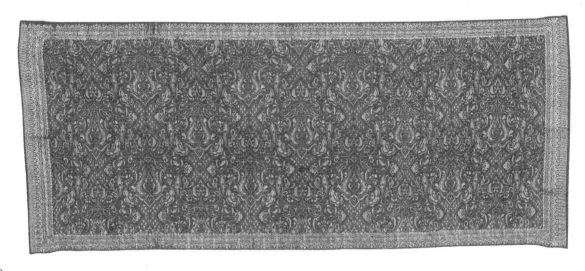

542

541 (detail)
kain lemar
waistcloth; shouldercloth (?)
Malay people, Terengganu, Malaysia
silk, natural dyes
weft ikat
427.0 x 86.0 cm
Australian National Gallery 1984.593

542
kain limar
waistcloth; shouldercloth
Malay people, Palembang region, south
Sumatra, Indonesia
silk, gold thread, natural dyes
weft ikat, supplementary weft weave
95.0 x 228.0 cm
Australian National Gallery 1984.1995

543
kain limar
waistcloth; shouldercloth
Malay people, Palembang region, south
Sumatra, Indonesia
silk, gold and silver thread, natural
dyes
weft ikat, supplementary weft weave
210.0 x 89.0 cm
Australian National Gallery 1984.609

544 (detail)
sampot hol
skirtcloth
Khmer people, Cambodia
silk, natural dyes
weft ikat
Museum voor Land- en Volkenkunde,
Rotterdam 47157

The pattern that appears in Java as
the *garuda* double-wing symbol (*sawat*
and *mirong*) also appears as an
abstract floral design on these Malay
cloths. On some examples (Plate 543),
although it has been absorbed into
other decorative designs, the wing
motif is still apparent. On Plate 542, a
strong cross-shaped motif composed of
five adjoining lozenges is a dominant
element of the pattern and is placed
above or below the stylized wing
motifs. In this case the influence of
another Indian trade cloth design is
apparent. On the Terengganu textile
(Plate 541), the upturned wing has
been developed into a linear foliated
motif with floral finials. The fanned tail
feathers of the *garuda* have been

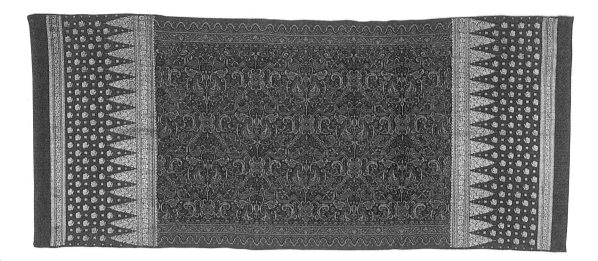

543

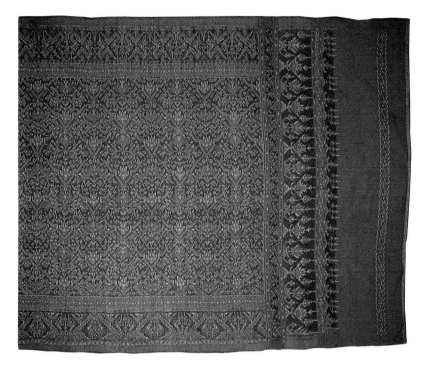

544

depicted as a cross-hatched schematic vase or grid motif. On the Khmer textile, the finials have almost been absorbed into a trellis pattern. On some weft ikat silks from the region, leaves have been transformed into serpents and on others, the pattern blurs into the trident, an Indic symbol of the ancient kingdoms.

The Terengganu silk is believed to have been reserved for royal use. It is unusually long, and delicate weft ikat patterns have also been worked into each end of the cloth. The central field patterning of the Sumatran *kain limar* is usually bordered with gold supplementary weft weave (*songket*), and the typical design structure of these cloths is evident on Plate 543 where wide sections of gold thread patterning decorate each end. The design of Plate 542 featuring the four even borders is more unusual, and with fine stripes at each end it is suggestive of the striped borders and design structure of certain Jambi batik.

3 There are numerous examples of this process from many parts of the region. Iban *pua kumbu* designs, for example, began to include more figures to which outsiders could clearly attribute anthropomorphic meaning, and the bands on some Savu cloths were filled with flowers and birds. Twentieth-century Esarn weft ikat textiles from north-east Thailand display peacocks, bouquets and entwined *naga* serpents that have been transformed into harmless snakes with their ribbon-tails tied into bows. In most cases these new Tai Lao motifs are arranged as a wide decorative border along the lower edge of the skirt. The embroidered fibre-cloths of the lowland Christians of the northern Philippines are one of the most striking examples of the way a traditional fabric has been combined with European designs, embroidery and lace-making techniques, although elaborate embroidery

545
kain sarong
skirt
J. Jans, Pekalongan, Java, Indonesia
cotton, dyes
batik
223.5 x 105.0 cm
Australian National Gallery 1984.3169

Irises in pinks and greens are
stretched diagonally across a delicate
striped ground. While the diagonal
arrangements of both background
patterns and major motifs favoured by
Jans draws also on centuries of local
textile design, the Art Nouveau
decorative art movement in Europe
was an important factor in the
development of this elegant style,
which became the hallmark of batik
cloths produced in this workshop.
Signed on the reverse side of the
cloth, this work dates from the first
decade of this century.

546
kain sarong
skirt
Lien Metzelaar, Pekalongan, Java,
Indonesia
cotton, natural (?) dyes
batik
104.0 x 103.0 cm
Australian National Gallery 1981.1138

Among the many fairy-tales used as
themes for batik designs, Red Riding
Hood (*Roodkapje*) was especially
popular. This elegant European
version of the fairy-tale is signed
L. Metz, Pek. and was made in the
well-known Pekalongan workshop of
Mevrouw Lien Metzelaar, which
operated from 1880 to around 1920
(Veldhuisen, 1980: 27). The clothing
on the characters is European, as are
the trees, and the realism of the scene
is typical of a style favoured by
Indo-European batik-makers. The
colours of aubergine and blue were
certainly not found in any of the other
batik-making communities in Java.
This batik, in fact, seems to have been
a close adaptation of another
Roodkapje batik designed by Eliza van
Zuylen, who ran one of the most
famous workshops in the same
north-coast town. One of her versions
of Red Riding Hood, dating from 1895,
differs only from the Metzelaar
example in the beige brown and red
colours and background details where
she uses a basket-weave pattern
similar to the *nitik* style instead of
Metzelaar's linear chevrons and a
slightly different head-panel design of
butterflies and flowers (Raadt-Apell,
1980). Another later van Zuylen
version of this design (Kahlenberg,
1977: 66) shows the wolf peering

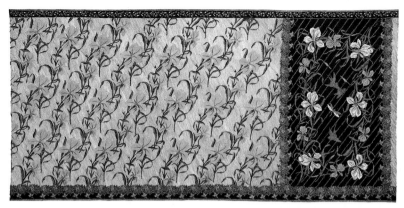

545

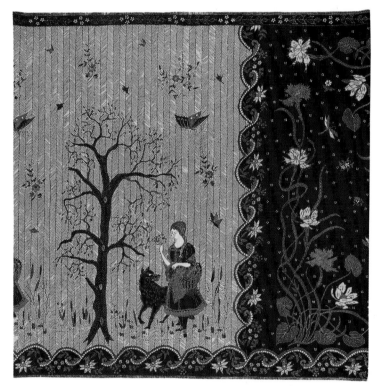

546

was used in many parts of Southeast Asia to depict narrative scenes
and individual motifs with a new and studied realism.

Floral motifs, drawn from European lace and embroidery pat-
terns and samplers, attracted the interest of textile artisans for vari-
ous reasons. Obviously such patterns were seen as new, attractive
and prestigious, but they also provided motifs that were outside the
tight restrictions of the traditional system of designs. Hence they
were a source of patterns which anyone could make and wear without
the fear of mistake or the need for great ceremony. They were par-
ticularly attractive to younger textile-makers who were uncertain of
their role in their own changing societies, and especially where their
ties with the traditional religious beliefs of their ancestors were
weakening. Sometimes these designs were appealing simply because
they represented foreign European ideas.

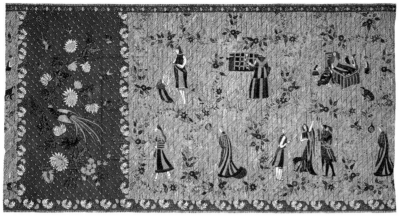

547

Whatever the reasons, the resulting motifs were often executed with the same virtuosity of technique as the older more traditional designs. Foliated tendrils and winged cupids were worked into intricate bands, and the central fields of many textiles were filled with vases of flowers. The characteristic ethnic origins of each cloth style, however, remained unquestionably identifiable, since the style, colours and patterning of the adapted motifs fitted into the existing structure of established types of local cloth. During the nineteenth century, the Minangkabau of west Sumatra, for example, developed floral motifs which were far more figurative and realistic than the patterns of old (Ng, 1987). Among these, the rose motif was especially popular. These new designs were worked with traditional materials and within the conventions of Minangkabau textile structures. Many popular patterns were retained and reinterpreted as floral motifs and the names of many well-known plants, leaves and flowers became linked with ancient and new motifs and designs.

Of all the textiles of Southeast Asia, the influence of Europe can be seen at its most dramatic and direct on certain categories of batik made in Java. The womenfolk of the Javanese trading world were in a peculiar position to influence this aspect of Southeast Asian dress. The local wives of Dutch VOC officials became important and constant arbiters of culture as their sons were sent back to the Netherlands for education, and their daughters remained to become marriage partners for the next generation of Dutch company officers (Taylor, 1983). These mestizo women combined Western and Javanese fashions, including certain forms of the batik *kain sarong*. In the nineteenth and twentieth centuries, with improvements in transportation, the expansion of European colonial control and the establishment of new agricultural enterprises, increasingly more European women joined their men in Southeast Asia. During this period, women of Dutch, Eurasian and Chinese descent adopted the cooler local costume of the batik skirt, at least for informal wear at home. We have already acknowledged the contribution of Peranakan Chinese women to the history of batik. During this particular period, Dutch and Eurasian women also played an innovative role in batik production along the north coast of Java through their choice of patterns and colours as consumers, and their actual involvement in the establishment of batik workshops producing very fine batik for this section of Netherlands Indies society. One of the longest lasting and most famous ateliers, directed by Eliza van Zuylen, operated in Pekalongan from 1890 to 1946 (de Raadt-Apell, 1980).

round from behind Red Riding Hood's skirt, while the tree under which they shelter is now in flower.

547
kain sarong
skirt
S.E. Bouwer, Pekalongan, Java, Indonesia
cotton, natural (?) dyes
batik
215.3 x 106.5 cm
Australian National Gallery 1982.2300

The European fairy-tale, Snow White and the Seven Dwarfs, also appears on Indo-European batiks. This example shows a series of scenes from the tale, including a number with the wicked queen — with the mirror, with the hunters and with an apple at the dwarfs' cottage — and others with Snow White begging the hunter not to kill her, and picking flowers. In another scene the prince arrives to revive her. The sequence, however, is random and there are fewer than seven dwarfs.

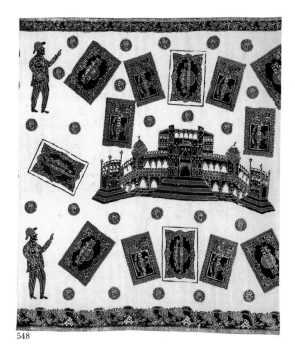

548

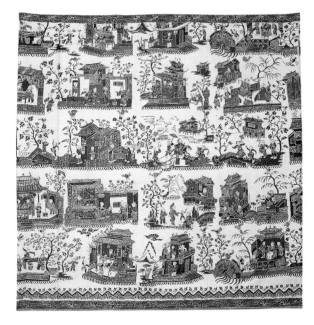

549

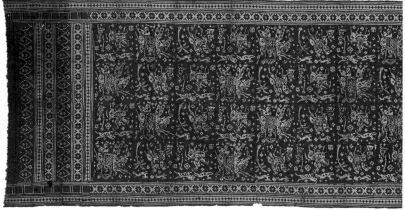

550

548
kain sarong
skirt
north-coast Java, Indonesia
cotton, dyes
batik
267.0 x 106.5 cm
Australian National Gallery 1984.3134

This charming though crudely-worked batik presents a rather comic image of the colonial regime. Batiks of this design genre showing colonial Dutchmen at work became known as *batik kompani* (company batik), named after the Dutch East India Company (VOC), although when this batik was made or by whom is not clear. It may have been the product of an Indo-European batik workshop, but it may also have been the work of a north-coast Javanese batik-maker poking sly fun at the life-style of the Dutch colonials. Perhaps the most likely possibility is that it is a local version of an older established Indo-European design that featured colonial figures and architecture. The main motifs in the field of the cloth are a number of clearly drawn Dutch 25-guilder banknotes and 2-guilder coins and a colonial official of awkward appearance in tropical pith helmet and formal dress. The bank building is imposing, although it resembles a mosque. The head-panel contains the usual floral and bird images.

549
kain sarong
skirt
north-coast Java, Indonesia
cotton, natural dyes
batik
Museum voor Land- en Volkenkunde, Rotterdam 55812

This batik shows scenes of village life reminiscent of the chinoiserie-style willow-pattern designs of temples, bridges, houses and figures that were extremely popular in Europe. It is not known whether this batik, possibly made in Semarang, was the creation of a Peranakan Chinese or Indo-European atelier, as both communities favoured such quaint Chinese-style designs. The head-panel (not shown) has bold triangles of different sizes in red and blue, and a simple bird motif is repeated in the *papan* borders.

550 (detail)
ma'a
sacred heirloom cloth
Gujarat region (?), India; Toraja region, central Sulawesi, Indonesia
cotton, natural mordants and dyes
mordant printing
420.0 x 94.0 cm
Australian National Gallery 1983.3686

This particular Indian trade cloth design contains a parade of elephants, camels and horses with tigers (?), deer, dogs and rabbits (?) running in between. The textile structure is typical of many trade cloth designs with geometric borders and wide, elaborate ends. The actual field pattern uses many of the design features and motifs of the large elephant-patterned silk *patola*. The foot attendants bearing the standard and the ruler seated in state in an

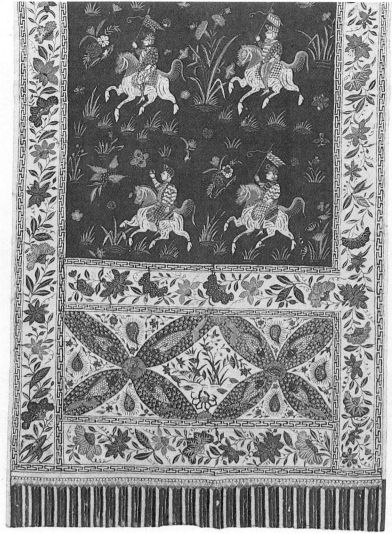

551

The most significant period of innovation under the influence of these women was confined approximately to the sixty-year period between 1860 and 1920. During these years of the colonial period, batik technique reached new heights of colour and fine detail. While the designs of the batik field changed with European cycles of fashion, a design format emerged which remained firmly in place even after Indonesian independence was achieved. The *kain sarong* format developed a head-panel no longer distinguished by rows of triangles but filled instead with floral bouquets and birds. The field was enclosed by narrow borders of floral or lace meanders. These standard features remained in place although the actual designs of the central field varied considerably and included battle-field scenes, whimsical nursery-rhyme stories and European floral arrangements.

The floral and plant designs were especially popular and included a wide range of styles, with all-over floral patterns, bouquets, trails of blossoms and single blooms. The ideas on which these designs were based were drawn from a variety of sources: magazine illustrations, European herbals, and Art Deco wallpaper (Veldhuisen, 1983–4; Kahlenberg, 1980). Among the many foliated patterns found on these batik, the grape-and-vine motif seems to have been popular in

ornate howdah are found on both types of Indian trade cloth. This cotton textile was probably cheaper than the silk *patola*, but it was still a spectacular item. Although this example was located in central Sulawesi, the suggestion of the Middle East with date palms and camels may have been especially appealing for Islamic communities in Southeast Asia.

551 (detail)
kain gendongan; selendang
baby-carrier; shouldercloth
Lasem, Java, Indonesia
cotton, natural dyes
batik
296.0 x 98.5 cm
Australian National Gallery 1984.3151

The main figure on this nineteenth-century batik is believed to depict the Javanese hero *Pangeran* (Prince) Diponegoro, who resisted the Dutch attempt to conquer and annex Java as a colony in the early nineteenth century, and who became a symbol of national resistance to Dutch colonial rule during the twentieth century. While the manner in which Diponegoro is depicted — on horseback and wearing an Islamic-style robe with turban — has some resemblance to his portraits, the equestrian elements of this design and the depiction of turbans on the riders suggest that it was probably based upon an early Indian trade cloth. Diponegoro holds not a sword but a flag, and the Prince's dress has been modified to suggest textiles with the *kawung* and *garis miring* batik patterns. However, striped leggings worn by European soldiers are also evident on Indian trade cloth.

Despite the military image, the cloth's design structure includes a floral meander border which suggests Chinese influence. Its colours indicate that it was probably made in Lasem and a bold 'fringe' of batik stripes completes the design. The size and proportions of the cloth and the thickness of the fabric are those of a baby-carrier rather than a shoulder-cloth. Textiles of these dimensions with striking designs were especially popular as ceremonial baby-carriers within the Peranakan Chinese community.

552 (detail)
ma'a
sacred heirloom textile
Golconda (?) region, India; Toraja
region, central Sulawesi, Indonesia
handspun cotton, natural dyes and
mordants
mordant painting, batik
Rijksmuseum voor Volkenkunde,
Leiden

This is a rare example of a remarkable
type of trade cloth design. The long
parade includes rulers carried by
elephants, dancing women,
sabre-wielding officers riding horses
and camels, and a file of infantry
bearing muskets and leading
horse-drawn cannon. Among the
wonderful details are a drum and flute
band and a standard bearer. The
different types of hats on the figures
suggest that the troops include both
Europeans and Asians.

553
kain sarong
skirt
Semarang, Java, Indonesia
cotton, natural dyes
batik
106.5 x 111.0 cm
Tropenmuseum, Amsterdam 949–1

554
kain sarong
skirt
north-coast Java, Indonesia
cotton, natural dyes
batik
104.0 x 198.0 cm
Australian National Gallery 1984.616

These batik cloths represent versions
of military themes. The field design of
Plate 553, a nineteenth-century
north-coast batik, follows closely the
elaborate processions of foot-soldiers,
standard bearers, musicians and
aristocratic rulers in horse-drawn
carriages that are also found on
certain Indian trade cloths. According
to the museum records, it is a
depiction of the Garebeg ceremony of
the Sultanate of Yogyakarta. The
head-panel (not shown) has a double
row of triangles and geometric
ornamental motifs typical of the *kain
panjang* designs made in Java for the
Sumatran market.
Plate 554, an early twentieth-century
example, depicts a battle scene design
which was identified early this century
with the Lombok wars, a prolonged
series of armed confrontations
between the people of Lombok and the
advancing Dutch colonial forces.
Although there are a number of
versions of this batik, they all include
foot and mounted soldiers in both

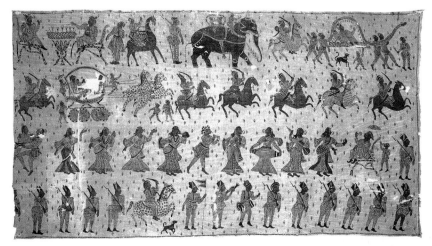

552

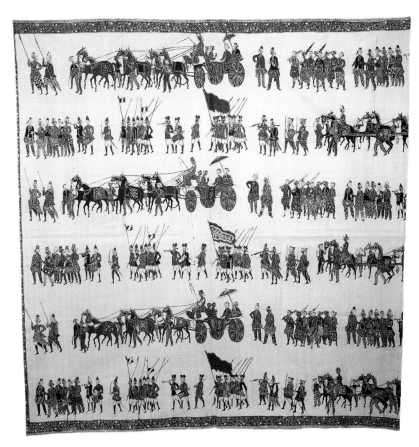

553

nineteenth-century Batavia and was also favoured where mission em-
broidery was encouraged.

European involvement in trade with the East had resulted in
many fascinating curiosities being carried back to Europe. By the
seventeenth and eighteenth centuries, versions of Oriental style —
sometimes accurate but usually highly fanciful — were much admired
in Europe. European artists began to produce a variety of decorative
objects after an exotic 'Chinese' style and this chinoiserie became
enormously popular (Jarry, 1981). This development affected the

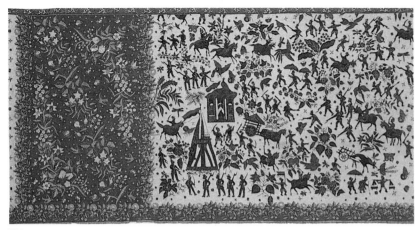

554

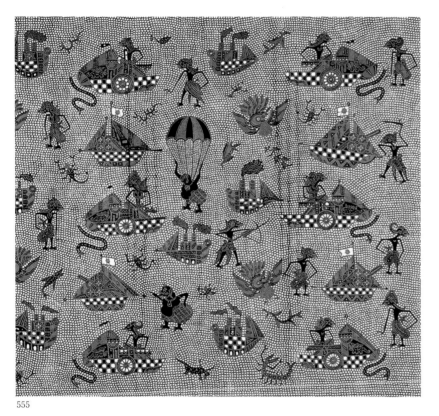

555

European and local uniforms brandishing weapons, and accompanied by horse-drawn artillery or carts. There are also a variety of buildings ranging from what appear to be forts or towers flying flags to substantial colonial residences. In this particular design, the conflict seems to be raging as soldiers mount bayonet attacks and horses rear. The battle scene also includes hawkers carrying their wares on bamboo shoulder-poles, old men hobbling on walking-sticks, and attendants with umbrellas held aloft. Despite the seriousness of the subject, the figures are interspersed with floral bouquets, birds and butterflies. These motifs are repeated in the red head-panel and border.

555 (detail)
kain panjang
skirtcloth
Javanese people, Yogyakarta, Java, Indonesia
cotton, natural dyes
batik
106.4 x 244.0 cm
Australian National Gallery 1984.3110

Although this batik was apparently produced during the Second World War and the Japanese occupation of the Indonesian archipelago, it displays some of the legendary heroes of the Mahabharata epic, including Arjuna, Bima and the Panakawan servant clowns who appear in the popular Javanese theatrical performances of these tales. They are presented here in the flat two-dimensional style associated with the *wayang kulit* shadow-puppet theatre, with elongated physical features and traditional costume. The figures appear against a background composed of the scaly *geringsing* pattern, a design also associated with a fabled, protective cloth for warriors. These modern warriors are depicted driving tanks and armoured cars, apparently battling the Japanese whose flag flutters from opposing vehicles. One charming vignette is the popular and rotund figure of Semar, suspended from a parachute. Although most Indonesian nationalists did not view the Japanese as enemies, the harsh treatment suffered by many Javanese during those years may have inspired the drawing of this batik.

batik artisans of Java in a number of ways. In particular, many of the Indian textiles especially designed for European markets began to display quaint chinoiserie designs, and considerable numbers of these also arrived in the port cities of the region where they influenced local batik design. We have seen how the chintz-style flowering-tree motif, which can be traced to the influence of Indian trade cloth designed for the European and Persian markets, also appeared on floral batiks of the nineteenth century.

In the second half of that century, the growth of the Arts and Crafts movement in Europe led by William Morris and Owen Jones as a reaction to the machine-made products of industrialization, encouraged an interest in fine handmade objects, especially textiles. The popularity of this movement in the Netherlands stimulated an interest

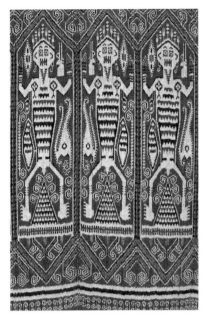

556

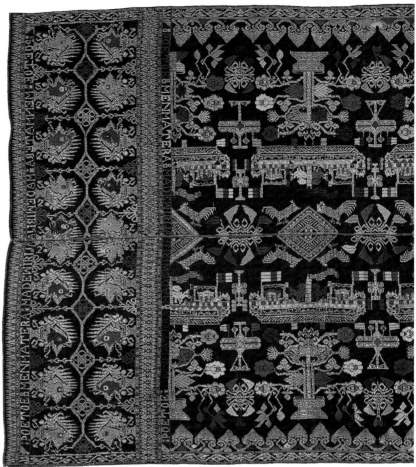

558

557

556 (detail)
pua kumbu
ceremonial cloth
Iban people, Sarawak, Malaysia
cotton, natural dyes
warp ikat
242.0 x 156.5 cm
Australian National Gallery 1981.1113

Throughout the twentieth century the Iban have steadily begun to represent the figurative images on their textiles with a greater degree of realism. While the Iban images of warfare on this *pua kumbu* echo the traditions of their ancestors, the anthropomorphic figures are armed with modern rifles and traditional shields. The cloth is worked within the parameters of traditional design structures and displays natural dyes, although the intensity of the colours and the detail of the ikat are less impressive than those displayed on older Iban textiles.

557
This fine twentieth-century example of *sungkit* technique was woven in an Iban longhouse in the Upper Kapuas region of west Kalimantan, not far from the border with Malaysia. During

the early 1960s this region was embroiled in the regional conflict known as '*Konfrontasi*' as Indonesia opposed the formation of the state of Malaysia. The exact origins of the figure depicted on this cloth are uncertain, but it appears to be a wonderful combination of a British colonial officer and an Iban legendary warrior. The figure's name and title, *Radja B(?)eikunai Tuan Pemesai*, are recorded on the message of greeting worked in Roman lettering along the edge of the *pua sungkit*.

558 (detail)
saput songket; kampuh songket
ceremonial cloth
Poetoe Imen Matera I Made Wirija,
Bali, Indonesia
silk, gold thread
supplementary weft weave
101.5 x 153.8 cm
Australian National Gallery 1989.405

The motifs on this Balinese *songket* are a blend of traditional and European influences. The field includes realistic images of flowering pot-plants, steamers and bi-planes, while the end patterns depict the heads of the

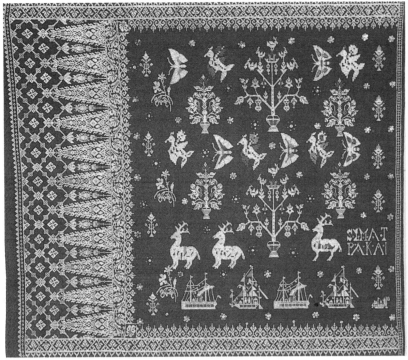

559

560

561

mythical *garuda*. The weaver has taken the unusual step of including her name in Roman script. The textile probably dates from the 1920s.

559
............
one of a pair of ceremonial hangings
Malay people, coastal Kalimantan (?), Indonesia
silk, cotton surround, gold thread, dyes, sequins,
supplementary weft weave
181.0 x 219.0 cm
Australian National Gallery 1981.1172

This is one of a pair of festive hangings which contain a number of motifs depicted in the realistic style adopted from European art. Many of these motifs — butterflies, birds, floral branches, vases of flowers, and ships — have traditionally been part of Southeast Asian textile imagery. In this instance there are two types of ship, a sailing vessel and a steamer. The birds which perch in the tree in the urn appear in the *sari manok* style found on supplementary woven designs and embroidered hangings from other parts of the region.
The exact origin of these textiles is uncertain, although since they are believed to have come from coastal Kalimantan, they may have been woven in Sambas, on the island's west coast, once famous as a centre for fine Malay gold brocade. A line of brocade bordering the edge of each textile

suggests that the two pieces were never intended to be worn as an item of apparel but were made as a pair of hangings. This is also indicated by the carefully attached cotton surround and brass rings and the woven message in Romanized Malay, *Slamat Pakai* (best wishes) which is commonly found on other Malay festive hangings. These textiles were probably used on occasions such as wedding ceremonies when they may have decorated the marriage-bed or the ceremonial throne.

560 (detail)
kain panjang
skirtcloth
Javanese people, Yogyakarta, Java, Indonesia
cotton, natural dyes
batik
263.5 x 109.0 cm
Australian National Gallery 1984.3111

Aquatic birds and ships were both popular as motifs in the Indo-European batik workshops of the late nineteenth and early twentieth centuries. This batik, however, is essentially an ancient central Javanese design with the fish-scale ground pattern known as *geringsing* against which other motifs are superimposed. The long wrap-around style of this *kain panjang* and its natural central Javanese colours of indigo blue and *soga*-brown indicate that despite the introduction of a new European element into the

design in the form of modern steamers flying Dutch flags, this cloth was made by a Javanese batik artisan for Javanese use.

561
In 1977, on the day following his ordination in the church of the nearby town, a young Catholic priest leads his first mass in the Ngada region in Flores. Before the mass began, buffaloes were slaughtered, their blood smeared on the village's ancestor poles, and the rice harvest was blessed. The mass, prepared by a Dutch missionary in the 1930s, was danced to drums and gongs by performers wearing traditional dress. The young priest wears a shawl of Ngada woven fabric and the sacraments are placed between the ancestor poles in the centre of the village square.

562
Although Christian messages or symbols are rarely incorporated into Southeast Asian textile iconography, this Maloh flag at Ukit-Ukit in west Kalimantan combines the mythical *aso* motif with a Christian cross and crossed swords in bold bright appliqué.

563
hinggi kombu
man's cloth
Sumbanese people, east Sumba, Indonesia
cotton, natural dyes
warp ikat, weft twining
271.8 x 114.0 cm
Australian National Gallery 1980.727

This huge cloth is unusual because it has an asymmetrical design structure, with different sets of motifs at each end. The majority of Sumba men's cloths have bands of motifs at each end which are mirror images achieved when the warp ikat patterns are tied simultaneously. This example displays ancient symbols such as the skull tree, and motifs attributable to European influence, including sets of confronting animals. These became popular with Sumba weavers and were adapted from similar images on coins and medallions. On this cloth lions are depicted within a medallion flanked by larger lions. The central band also displays three distinct prestige patterns derived from imported Indian textiles.

in batik as a feature of modern interior decoration (Veldhuisen, 1983-4). Like many artists associated with the Arts and Crafts movement in Europe, the source of inspiration for north-coast Indo-European batik designers was a blend of Eastern and Western elements, and a conscious interplay of designs and techniques developed between the Netherlands and Java. The increased frequency of ships between Europe and the colonies, and the availability of well-illustrated art journals and popular magazines enabled Indo-European artists in Java to keep abreast with the latest fashions in the West, and adapt contemporary fashion ideas to their own products. By the late nineteenth and the early twentieth century, the works of European and Indo-European batik designers on Java's north coast were displaying features of the current art movements of the Western world.

The popularity of movements such as Art Nouveau (*Nieuwe Kunst* in the Netherlands) is particularly evident in the treatment of European flowers such as the iris or the tulip against an asymmetric and delicate ground. Among the finest works in this style were the batiks of J. Jans, also working in Pekalongan. On many of these batiks, the gradation of colour achieved through clever variation in the density of dots and sequential dyeing is visually similar to the graded bands of deepening colour on batik cloths more directly influenced by Chinese art. The keen interest displayed in Japanese art in Europe at this time can also be seen in the treatment on north-coast batik of the familiar themes of storks, waterlilies and bamboo. 545

The influence of Javanese batik on the development of batik-making in the Malay peninsula and the popularity of certain batik patterns there and on printed fabrics in other parts of Southeast Asia has already been noted in chapter 4.[23] The most popular styles in these areas were the colourful floral patterns of the export batik trade rather than the classical designs of central Java, and while many of the earlier products were substitutes for Indian cloth, by the late nineteenth and early twentieth centuries it was the European-style batik patterns that were most popular. Ironically, these floral bouquets and birds have become identified throughout much of Southeast Asia as Javanese batik designs of the most desirable type.

Scenes from European fairytales, especially the Dutch '*sprookjes*', were popular as themes for batik designs from around 1900 until 1920. The stories provided an opportunity for different interpretations and styles, although when these were executed by Javanese or Chinese artisans, variations often reflected a lack of familiarity with such stories as Red Riding Hood, Snow White and the Seven Dwarfs, and Sleeping Beauty. As a result, Red Riding Hood's wolf sometimes appears in a form more like a lion or a pet dog. Other scenes of a more prosaic nature were displayed on batik skirts as Eurasians and Dutch, like their Chinese counterparts, took up familiar objects from the world around them in their quest for new and eye-catching motifs. Cards, fans, umbrellas, bicycles, gramophones, banknotes and coins were worked into the batik fields, while fanciful designs included idyllic scenes, bridges, streams and boats which obviously drew upon the well-known willow pattern designs of European crockery. Figures like those that sometimes appeared on the batiks of the Chinese community were reproduced by the European or Indo-European batik ateliers. These pigtailed figures, chosen for their quaint decorative quality rather than for any particular Chinese significance, joined the cast of engaging characters that were a feature of the Indo-European batiks of this period, another late mani- 546,547 548 549

festation of European chinoiserie. These were immensely popular designs, especially on batik cloth intended as skirtcloths and baby-carriers. Chinoiserie-style designs also dominated the so-called *lok-can* silk batik textiles that were produced in large numbers on the north coast for export to Bali and Sumatra.

550,551 Other narrative scenes were also favoured by the major Indo-European batik workshops and their imitators. Battle scenes associ-552,553 ated originally with the turn-of-the-century colonial wars in Lombok 554 and Aceh displayed soldiers in various uniforms, towers, horses and gun-carriages. The adaptation of such motifs extended far beyond the particular world of north-coast Javanese batik. In central Java, and 555 elsewhere in Southeast Asia, war and revolution have also contributed ideas for textile motifs — parachutes, aeroplanes, helicopters, soldiers with rifles, bombs and guns. The Vietnam War provided the hill-dwelling weavers and embroiderers of mainland Southeast Asia with ample opportunity to reproduce these motifs on their cloths,[24] and some Hmong cross-stitch embroideries portray dramatic scenes of recent conflicts in a realistic style. The Iban have also included examples of such modern weaponry on their textiles: warfare has 556,557 always been a dominant theme in Iban ritual and legend and has already appeared as a traditional textile theme.

In Java and Bali, modern means of transportation — planes, cars 558 and bicycles — were interpreted in classical frieze style on textiles alongside traditional motifs such as *wayang* shadow-puppets (Ramseyer, 1977: 244–5). The popularity of depictions of *wayang* puppet characters among non-Javanese peoples, including colonial Europeans, resulted in the production of textiles with such figures for their ornamental effect rather than for any symbolic significance.

Under European influence many other popular and ancient textile designs and motifs were also depicted with greater realism. The mysterious symbols of the ancestors often gave way to other human forms, and even the weird stylized creatures on Paminggir *tampan* became more readily identifiable. While bird motifs continued to be 21 popular, swans, swallows and storks replaced *garuda* wings and phoenix tails. The images of animals and birds were drawn directly from nature or were reproduced without the embellishments of the weaver's vivid imagination. Twentieth-century Khmer silk weft ikat hangings (*pidan*), in particular, display scenes depicted with great accuracy, with mounted cavalry on prancing horses, ships with full rigging, and figures seated in architectural structures on which details such as roof tiles are meticulously recorded.

Ships and boats, which had been an ancient and recurring image in Southeast Asian art, began to appear in a realistic form on batik of both the north coast and the central Javanese principalities. Modern ships were also a prominent feature of the supplementary weft textiles of Lampung and Sumbawa, cultures which had used the ship symbol on their textiles long before European influence became pervasive. While the transition symbolism of the ship motif may still be evoked, the results are less imaginative and the ancient passengers and other strange creatures have disappeared. European ships first appeared on textiles in the form of elegant sailing vessels and bulky, 558,559 elaborately rigged galleons, but by the twentieth century smoke-560 belching steamers were more often depicted.

Despite the efforts and considerable successes of Christian missions in many parts of Southeast Asia, specifically Christian motifs on regional textiles are surprisingly rare. Symbols such as the cross

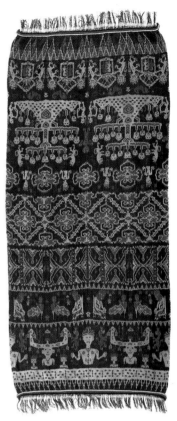

563

A number of other pictorial motifs also appear in a realistic style. The treatment of the figures on this *hinggi* is in marked contrast to the elongated ribbed style of those found on older extant examples of Sumba cloth. Although the image of the Madonna and Child is depicted with Christian crosses around their necks, these motifs are juxtaposed with the skull tree, an indication that the influence of the Catholic mission on Sumba has been limited by the strength of traditional belief.

Royal symbols appear in two forms of ceremonial head-dress — the European crown (symbol of the colonial presence) and the Sumbanese horn-shaped *lamba* hung with gold earrings (*mamuli*). The quality and detail of the work on this cloth and the predominant use of red dyes (*kombu*) indicate that, despite its unusual design, this was probably a nobleman's cloth worn wrapped around the waist, shoulders and head. In the past, red-dyed cloths were used exclusively by royalty whereas blue was the basic colour for everyday garments (Adams, 1971a: 322). This is the type of cloth which has traditionally been used in important ceremonies such as bride-wealth exchanges and at funerals.

564
kain panjang
skirtcloth
Javanese people, Yogyakarta, Java,
Indonesia
cotton, natural dyes
batik
108.0 x 264.0 cm
Australian National Gallery 1984.3120

Medallions and coins also inspired
design arrangements on other textiles.
On this noble central Javanese batik, a
medallion pattern has been positioned
over a bold *parang rusak* (broken
sword) design. The medallions display
crowned lions (?) confronting a central
heart-shaped shield capped with a
large crown. The initial of the
aristocratic owner, W, is emblazoned
on the shield. The background motifs
are a combination of classical *isen-isen*
filling patterns, in particular the
geringsing scales which also decorate
the creatures.

are singularly absent on the ceremonial textiles of most Christian
communities in Southeast Asia. The functions of traditional textiles
did not marry easily with the demands of the missionaries of the new
religion: the two spheres, ancient traditional customs and church-
going Christian activities, were often kept remarkably discrete. In the
Sikka district of Flores, for example, certain ancient motifs depicting
human figures, which appear on women's warp ikat skirts, have been
branded as *jentiu* (gentile, pagan) by Christian members of the Sikka
community. However, there is no evidence that specifically Christian
motifs have replaced these older less acceptable designs. Where
Christian symbols do appear, these have been self-consciously used in
areas where people adopted Christianity under the impact of the
strong missionary influence of the nineteenth and twentieth centu-
ries.

561,562

On the other hand, unmistakably European crowns did replace
traditional items of jewellery as a clear symbol of royalty in some of
the region's court centres and principalities,[25] and these crowns also
appear as minor motifs on many types of Southeast Asian textiles.
Other secular objects that played an important part in the transfor-
mation of motifs included European coins and medallions, especially
those displaying coats-of-arms with confronting heroic beasts such as
lions and gryphons. These medallions and coins were in high demand
in the eastern Indonesian region, as much for the precious metals that
could be melted down or reworked into ornamental jewellery and
ceremonial dress accessories. Like other valued items such as bells
and beads, coins became additional textile decoration and a sign of
opulence. They were also, as we have seen with Chinese coins, talis-
mans against evil, and were attached to the borders of garments such
as jackets, and betel-nut containers, and stitched in central positions
on belts, bands and head-dresses.

On textile designs both the motifs themselves and the arrange-
ment of motifs were affected by the imagery of these medallions.
Many Sumba cloths have bands of bold rampant lions borrowed
directly from medals. However, ancient animal motifs such as prawns,
cocks, deer and snakes (even Chinese-style dragons) have also been
presented on Sumba textiles in confronting medallion style. The

design admirably suits the warp ikat technique since the threads for pairs of motifs are tied simultaneously, then opened and arranged on the loom to form mirror images. Sumba royal cloths, like many others, often present an amalgam of prestigious motifs, both old and new, and images of fine gold heirloom earrings appear in warp ikat patterns beside busts of Dutch queens.[26] On Javanese batik the medallion shape has been used to enclose and isolate a classical pattern against a ground or network of other traditional motifs. The phoenix in roundel and in medallion are sometimes interchangeable interpretations of the circular form.

563

564

The effects of the European presence can still be observed in Southeast Asian textile art. Although Christianity as a religion contributed few new designs to the textile repertoire of the region, the secular aspects of the European presence were pervasive. The imaginary creatures of the past gave way to recognizable scenes and characters from the real world, particularly on textiles with little ceremonial importance. Where textiles continued to be required for ancestral rituals, the form and iconography of the past was more often retained.

Through both the manipulation of the Indian textile trade and their superior military power, Europeans had considerable impact on the courtly traditions of Southeast Asia. Their involvement in the political arena destroyed certain courts and their cultures, and supported and promoted that of others. The royal dynasties that flourished under colonial rule continued to embellish their ceremonies with ostentatious displays of fine textiles, in part supplied and encouraged by their European patrons.

Unlike the fragmentary knowledge of earlier influences on Southeast Asian textile traditions, the combination of European and Asian records provides more information about changes in textile traditions during the colonial period. From the eighteenth and particularly the early nineteenth centuries there are drawings, aquatints and lithographs, and from the mid-nineteenth century when European influence was strongest, photographs began to appear. The costumes depicted in these visual records give some idea of colours, textures and patterns although the accuracy of the designs was often irrelevant to the early European artists who clearly did not understand the specific messages that textiles conveyed in Southeast Asia. Nevertheless, these works on paper provide informative details about how cloths were worn and which designs were favoured. These are supported by nineteenth- and twentieth-century museum collections and the few rare examples of objects in earlier curiosity cabinets. Apart from the important comparative value of textile types collected over a long period, some cloths which survive in museum collections have long ceased to be made or used.

Chapter 7

THE CHANGING ROLE OF TEXTILES IN SOUTHEAST ASIA: CONCLUSIONS

A frustrating aspect of the study of traditional textiles in Southeast Asia is that in comparison with many other art forms, textiles are a relatively impermanent commodity. Sunken ships and excavated burial sites full of dateable porcelain have survived to inform our understanding of the patterns of life and art of particular historical periods, while precise knowledge of the fragile textiles known to have accompanied these durable objects has been lost forever. Yet the very impermanent qualities of cloth have necessitated the continual supply of new types of textiles and fresh designs to replace even the most significant heirlooms. Over the centuries, this refurbishing and renewing of cloth has ensured an active role for textile artisans who have transformed foreign ideas, motifs and techniques in a manner compatible with the needs and demands of their own society.

SHIPS: BEARERS OF CHANGE

Trade and commerce flourished in Southeast Asia from at least the first centuries after Christ. Many of the foreigners to come to the region — whether they were Hindu, Buddhist, Islamic or Christian, Europeans, Chinese, Indians or Arabs — were spurred on by the spirit of trade. Much of our discussion of trade and its influence on the region has focused on maritime trade, and it is interesting that the ship, the vehicle of change since the Metal Age, has continued to be a prominent and recurring image in the art and legend of the region.

The different forms and styles in which the ship motif appears not only reflect differences in textile techniques and changes in the ships Southeast Asians have observed, but also transformations in beliefs. Thus we find a range of images from simple canoes to *567,568* *569,570* Buddhist dragon-boats and European galleons. By the late nineteenth century, as sailing ships were gradually replaced by steamships, the ship motif began to appear with increasing realism on certain textiles such as Javanese batik. However, at around the same period ship motifs steadily became increasingly stylized and obscure on such textiles as the supplementary weft weave *tampan* and *palepai* cloths of south Sumatra.

Opposite Detail of Plate 560

565
An early twentieth-century photograph of two women in the Pasemah district of south Sumatra reveals the rich and diverse array of cloth that makes up ceremonial attire in that region. The textiles include Javanese batik, Palembang weft ikat and tie-dyed fabrics, a plaid skirt (possibly Buginese), European floral printed cloth and a tunic probably made from Indian machine-made brocade. The photograph originally appeared in J.E. Jasper and M. Pirngadie, *De Inlandsche Kunstnijverheid in Nederlandsch Indië* (1927).

Motifs such as the ship, the serpentine figure, the eight-lobed rosette and the tree appear in many shapes and forms on various types of cloth using silk, cotton and bast fibres. The different depictions of these motifs have depended both upon the popularity of particular ways of representing these ancient symbols and upon the conventions and technical constraints imposed by each local artistic tradition. Sometimes these same factors have contributed to similar versions of these motifs appearing in widely separated locations. It is not always possible to determine a precise meaning for designs and motifs and this often varies greatly according to regions, social groups or even individual interpretations. However, where textiles have fulfilled an important symbolic role in social and ceremonial life, a shared understanding is usually apparent. It is the sum of the parts on any Southeast Asian textile — design structure, motifs and materials — which presents an important symbolic message to the informed observer, a message which goes far beyond the identification of particular patterns.

The task of decoding motifs and symbols may initially appear rewarding. But in many instances the historical sources of the motif tell us little or nothing about what such patterns mean for the maker or the user of a particular cloth. In the field of Chinese art, Cammann (1953: 197) has demonstrated how certain symbols which once held deep religious and philosophical meaning were later transformed into lucky charms and have eventually become simply decorative. On the other hand, Gombrich (1979) has noted that elements chosen purely for their ornamental appeal may later assume religious or philosophical meaning and significance compatible with the culture that has adopted them. In Southeast Asian textile art, both trends are apparent. However, in an increasingly secular world meaning has often become linked to everyday objects and items drawn from nature.

The transfer of motifs, techniques, materials and textile usage between the outside world and Southeast Asia has not followed a clear-cut path. We have seen, for example, that *patola* cloths were not only an Indian influence, and an Islamic Indian influence at that, but that the Europeans through their trading monopolies exploited these double ikat silk fabrics as symbols of royal authority throughout Southeast Asia. It seems that Southeast Asian tapestry weave was inspired by several sources including Chinese *kesi* weavings or even Middle-Eastern and Central Asian *kilim* carpets. While the development of Javanese batik was influenced by imported Indian cotton textiles, the designs on these trade cloths were largely achieved by mordant painting and printing rather than by the application of wax-resist which was a secondary and less impressive process in India. Ironically, although batik developed to a refined level in Java, some of the greatest exponents of this technique have been members of the Chinese and European immigrant communities. We have also seen how a technique such as couched gold thread embroidery, at different times and in different ways, was inspired by Indian, Turkish, Chinese or European influences since its capacity for opulent display was admired at some stage in all these areas. Thus, the foundations of Southeast Asian textile art and the various external influences that stimulated its development preclude tidy classification.

INTERREGIONAL TRANSFORMATIONS:
FROM NEAR AND FAR

While the major foreign influences on the artistic styles of Southeast Asian textiles provide the rationale for the ordering of this book, the flow of textiles, motifs and styles within the region over the centuries has been much more complex than that emphasis has been able to suggest. One element of very great significance, but more difficult to document, has been the internal exchange of ideas and techniques between various Southeast Asian cultures within the region. Some of the similarities that can be recognized in the textiles of many different ethnic groups, while sometimes rooted in sources outside the region, are the result of a long and sustained interaction between particular parts of the region.

Even remote societies have not been totally isolated, but have, to some degree, been influenced by a steady trickle of goods and ideas from outside their territory, either those of foreign origin or of neighbouring Southeast Asian cultures. Material objects have moved readily within the region, and metal objects, textiles, carved wood, pottery, beads and shells have at one time or another been valuable trade items. Regional substitutes for highly prized Indian trade textiles also became important trade goods in certain areas and, in time, assumed similar heirloom value to Indian cloth.

Huge quantities of cloth have served as symbols of wealth and power and as currency in the exchange system among the non-weaving Mejprat in the Bird's Head peninsula of Irian Jaya (Elmberg, 1968). These textiles have a variety of origins. Known collectively as *kain timor* (Timorese or eastern cloth), they include Indian cotton prints, European imitations of Indian trade cloths, and woven textiles from Sulawesi, Buton, Flores and Kisar.[1] The Mejprat do not make any distinctions between these cloths according to their origins or their exotic qualities, but judge them instead according to their particular patterns and colours. In fact, many of the cloths valued most by the Mejprat are not highly regarded within their cultures of origin.

Diplomacy, wars, trade, tribute, marriage and migration have all been important factors helping to spread textiles as objects as well as the knowledge of how they have been made and used. While we are not able to consider the details of regional histories, some of the paths of the textile transformations can be traced from known historical contacts, while others are suggested by the fabric designs themselves.[2]

Since textiles in Southeast Asia are almost exclusively the art of women, the strategic marriage alliances forged between the ruling families of different regions were an important avenue of cultural exchange and made a significant contribution to the development of similar styles of dress and adornment throughout the court centres. As royal brides and their entourage of retainers settled into new environments, the elaborate skills of textile-making they brought with them were harnessed to the glory of God and their adopted domain. It has been reported that a bride of the Sultan of Ternate was accompanied by a retinue of weavers from her home in Salayer, an event that led to a major transformation of certain ceremonial textiles in the Ternate court (Abdurachman, n.d.; Visser, 1989). In Java, batik patterns have evolved with classical designs, but subtly tinged with

566
keng (west Alor); *kewatek* (Lembata)
woman's skirt
west Alor; Lamaholot people, Ili Api, Lembata, Indonesia
handspun cotton, silk, natural dyes
warp ikat
195.0 x 68.0 cm
Australian National Gallery 1984.1237

Skirts similar to this example are made by Lamaholot people in the Ili Api district of northern Lembata, and traded to the non-weaving communities in the western region of the neighbouring island of Alor. Although the addition of imported silk is expensive and increases the commercial value of this textile, since the skirt is no longer made entirely of local materials it has no place in the elaborate bride-wealth exchange system of the Lamaholot people of Lembata and east Flores.

567

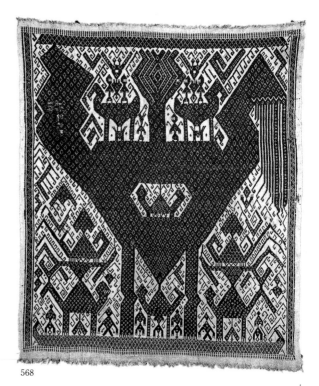

568

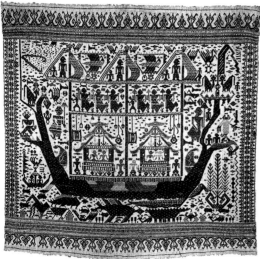

569

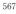

567, 568, 569 and 570
tampan
ceremonial cloths
Paminggir people, Lampung, Sumatra,
Indonesia
handspun cotton, natural dyes
supplementary weft weave
Tropenmuseum, Amsterdam 2125-36;
1979-1; Rijksmuseum voor
Volkenkunde, Leiden 90-32

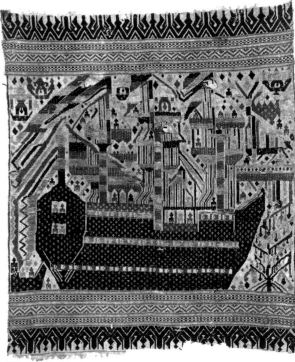

570

A single motif on a particular type of textile can reflect the diverse influences upon a culture and its traditions. This series of *tampan* are all woven using the same floating supplementary weft technique and each cloth displays elaborations of the ship motif which has been a prominent feature of Southeast Asian art for thousands of years. The ship iconography of the *tampan* varies in style from simple boat forms overshadowed by enormous imaginary beasts, to scenes of ships bearing courtiers and crew with royal elephants. The human figures sometimes appear in the refined style associated with the Javanese *wayang*, suggesting the influence of these artistic conventions on Paminggir textile art.

The ship is sometimes transformed into the dragon-boat of Chinese and Southeast Asian art or the fully-masted European galleons flying Dutch tricolour flags. In the final phase of its development, probably in response to the expansion of Islam throughout the south Sumatran region, the ships and passengers displayed on the *tampan* became so stylized as to be barely discernible. On these examples, the decorative aspects of weaving are paramount.

the freer, more colourful north-coast hues, as the daughters of the central Javanese courts married regents along Java's north coast.

To the present day, fine textiles from many parts of Southeast Asia can be identified in the collections of heirloom treasures found throughout the region. In the royal court centres and sultanates, silk and gold fabrics have been especially popular, though their precise origins are often unknown. Fine Balinese supplementary gold thread and weft ikat silks are evident in Thai and Malay court collections, and Palembang silks in Sumbawa. Khmer weft ikats have long been admired by the rulers of central Thailand and Acehnese silks were once part of the formal attire of the Kelantan royal bridegroom.

Further study of particular societies may reveal more about widening ripples of influence on the region's textiles. Textiles and clothing styles of the recent historical period in Bali may furnish important clues about the textiles of mediaeval Java before the fall of Majapahit,[3] while the study of the textiles woven by the Sasak of Lombok may shed further light on the earliest Balinese and Sumbawan textiles. On the other hand, the historical links between different regions may be misleading for an understanding of the course of textile history. For example, although Minangkabau artisans are attributed in folk history with the introduction of many crafts to the Malays who inhabit the mainland peninsula, weaving is not an important art in the Negri Sembilan area of Malaysia despite that region's close ties with Minangkabau culture. The practice of couched embroidery which has been common to both the Minangkabau and the Negri Sembilan Malays may have developed in both regions at similar times.

Outside these court centres, many Southeast Asian textiles have become popular and desirable items away from the regions which actually produced them. For example, sacred *geringsing* from the village of Tenganan are not only treasured by other Balinese but also by their Sasak neighbours on Lombok. During the eighteenth and nineteenth centuries, Javanese batik steadily became a favoured item of costume in many parts of Southeast Asia — throughout the Indonesian archipelago, and in Thailand, Malaysia, the Philippines and Cambodia. In the Tanimbar Islands, textiles from the south-eastern islands of Kisar and Luang gained great currency.

The interplay between certain textile designs from the Endeh region of Flores and those of east Sumba followed a history of slavery, intermarriage and migration. Examples of Sumba textiles are found with parallel rows of motifs in the style of Endeh stick-figure horses (*njara*), while many nineteenth-century Endeh men's shawls display motifs and design structures that were clearly inspired by Sumba *hinggi kombu* (Khan Majlis,1985: 263, 272).

These trends have been accelerated in the twentieth century by improved communications between previously isolated communities. Weavers in eastern Indonesia, with a long experience of developing new designs based upon imported objects, are frequently also interested in the designs of their neighbours. Lio warp ikat patterns appear on Sikka cloths, and Sumba horses fill the bands of Savu women's skirts woven by the immigrant Savunese communities in east Sumba. From at least the nineteenth century, Sumbanese weavers have found inspiration for their textile designs from many foreign sources including coins, flags and Indian textiles, and in the decades since the Second World War, further unusual designs have appeared including the red and white Indonesian national flag, and

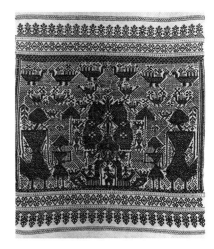

571
'*tampan*'
imitation ceremonial cloth
H. Abdul Kadir Muhammad,
Pekalongan, Java, Indonesia
cotton, dyes
supplementary weft weave
93.5 x 81.0 cm
Australian National Gallery, archival collection

This well-made textile, a deliberate copy of a traditional Paminggir *tampan* was woven in the last decade by a Javanese man in Pekalongan on the north coast of Java. Since 1975, when he was challenged to make a new version of an old *palepai* ship cloth belonging to an elderly acquaintance, Haji Abdul Kadir has produced many such cloths using methods that closely resemble the time-honoured Lampung weaving techniques. The weaver's skills are such that many who eventually purchase these cloths believe that they are genuine rare antiques. The design on this example is copied from the photograph of a fine *tampan* in a famous published collection of Indonesian textiles (Langewis and Wagner, 1954: Figure 70).

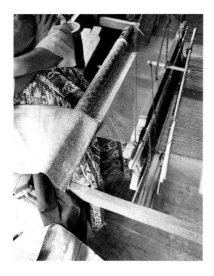

572
Rarely do Southeast Asian textile artisans use patterns or samplers. They do, however, constantly refer to highly valued heirloom cloth to recreate fine textiles in the family's traditions, which are sometimes unavailable today. In this photograph a young Minangkabau woman at Pandai Sikat is weaving a fine gold brocade cloth, following a fragile nineteenth-century example. Unfortunately, given the poor quality of metallic thread today, the textile which she will weave will last only a fraction of the time of the one she is replicating.

quite recently, men's cloths decorated with huge figures from the Hindu Ramayana epic, possibly inspired by the Balinese living in the coastal areas of Sumba.

While foreign influences have made little impression on Toba Batak textile designs, in the last half-century Mandailing, Minangkabau and Palembang supplementary weft textiles have influenced the development of certain textile types in Toba Batak weaving areas. The new, bright textiles that have resulted have become especially popular with younger women, although they have not yet been absorbed into the hierarchy of traditional Toba Batak *ulos* textiles. In a sense this adds to their appeal, for these textiles can be worn as decorative shouldercloths on those important occasions, such as church ceremonies and government functions, unrelated to the traditional exchange system that applies at births, marriages and funerals.

In other regions of Southeast Asia, economic and ritual constraints have led to cloths from one region being used by others, and 565,566 traditional systems of exchange have emerged between weaving and non-weaving areas or communities. In Luzon, as lowland weavers began to market cloths for highland groups such as the Ilocano, Bontoc and Kalinga, the distinctions in stripes and colour combinations of many communities became blurred.

In northern Thailand, the differences between textile styles have also become less apparent with the steady migrations of various Tai peoples within the region continuing into the twentieth century. Tai groups who have settled around Chiang Mai, for example, have been influenced by royal Thai costume and have incorporated gold thread into their supplementary weft skirt borders.[4] In the Esarn region Tai Lao people now make beautiful *chong kaben* in the Khmer style long favoured by the central Thai courts, although these are woven on Lao looms.

Textiles from certain parts of the region are often regarded as exotic outside their place of origin. Sumba *hinggi* are known to have been used to create the characteristic layered skirts of the people of Kulawi in addition to beaten bark-cloth, Indian printed cottons, European *sarita* and Toraja warp ikat fabrics.[5] In Sumba it appears that women admire and wear the supplementary weft woven skirts of the Manggarai in west Flores.

The costumes of certain groups can be a composite of the finest 565 textiles obtainable through trade. The traditional dress of the Minangkabau in west Sumatra, famed as travellers and traders, includes *songket* brocades from south Sumatra and Sambas in west Kalimantan, silk plaids from south Sulawesi and Samarinda in east Kalimantan, and cotton and silk batik from Java. The incorporation of cloths and particular design elements from outside the region into local costume does not appear to have been a random process in these societies. In eastern Indonesia, the non-weaving Sahu people of Halmahera[6] have systematically chosen cloths of many origins for different ritual activities, including batik from Java, supplementary weft (*kain kulincucu*) from Ternate,[7] and plain imported fabrics.

SOCIAL CHANGE AND THE ROLE OF TEXTILES IN THE TWENTIETH CENTURY

Throughout most of Southeast Asia during the nineteenth and the early twentieth centuries, the intrusion of Western colonial authority

substantially reduced the effective power of many Southeast Asian traditional leaders. In some court centres, however, this did not lessen the enthusiasm for the trappings of authority and office and the grand display of the courts and their rulers as cultural leaders.

Much of this changed dramatically with the rise of nationalist movements leading up to the Second World War and the struggle for independence that followed. The indigenous aristocracy maintained its pre-eminent position in Thailand, and certain Malay and Javanese traditional rulers also secured their place in the post-independence nation states, thereby protecting many of their courtly privileges. Elsewhere in Southeast Asia, the social revolutions that accompanied independence movements decimated many aristocratic families and destroyed the artistic milieu which their courts had supported. The virtual disappearance of gold and silk brocade weaving on the east coast of Sumatra was largely the result of the obliteration of most of the Malay aristocracy in that region during the late 1940s after the defeat of the Japanese. The cultural domination of the courts of Burma, Laos and Cambodia also steadily declined in the twentieth century, and the costly silk and gold thread textiles associated with these centres have also disappeared. Where traditional aristocratic rulers still survive, changes in their economic status under the new political and economic systems of the post-war era have prevented them from supporting the artistic pursuits, lavish performances and grand display to the extent that had prevailed during the nineteenth century and earlier. Even where traditional court arts still survive, certain essential raw materials such as fine gold thread are either no longer available or are too expensive. Present-day weavers and 572 embroiderers offer this as an explanation for the inferior quality and durability of the textiles they now produce.

The political and economic structure of Southeast Asia has been dramatically transformed during the last century and this has affected the pace of social change in most textile-producing cultures. Large metropolitan centres have emerged, strengthening the influence of international and cosmopolitan cultural values, while the harbours of many traditional entrepôt centres have now been reduced to silted backwaters. Twentieth-century technology and communications have brought even remote parts of the region into contact with the modern world and the viability of traditional culture and life-style is constantly under threat. Remarkably, however, many aspects of traditional textiles have survived in some form or other.

The most sacred textiles and their associated techniques have been preserved in some traditional exchange systems, perhaps surprisingly given the availability of commercial thread and imported cloth and the facility of synthetic dyes.[8] Handspun cotton, natural dyes, ancient looms and secret rituals are still the hallmarks of textiles where traditional cultural values are still a powerful force in people's lives. Important ancient textiles have not always been discarded merely because they are no longer required for the functions they once fulfilled. Sometimes these cloths reappear in different guises, and men's loincloths, for example, have often been transformed into banners, scarves and sashes for ceremonial occasions.

Despite those aspects of the traditional textile heritage which have survived, the pace of social change places this art form under increasing threat. Throughout the nineteenth and twentieth centuries two fundamental changes have been taking place: there has been a move towards finer, more elegant textiles and there has also

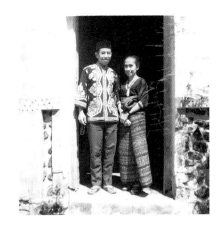

573
A married couple in the Endeh district of central Flores, Indonesia, appear in typical formal attire. She wears a fine, long warp ikat skirt and a blouse cut in the traditional style of the Buginese areas of south Sulawesi, where it is known as a *baju bodo* and from where it has spread throughout many parts of Indonesia. Her husband wears a batik shirt and trousers.

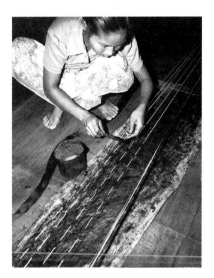

574
Time-saving techniques have been developed in an attempt to produce textiles which simulate older styles. In south Sumatra, a woman is using small spatulas to rub thick dyestuffs on to threads to achieve an ikat-like effect when the threads are woven on a handloom. This technique is known in the Palembang region as *colet*.

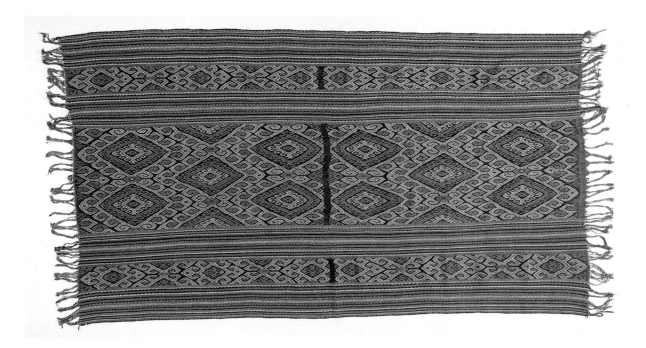

575
mau
man's cloth
Ibu Puai-Selan, Besi Pae, Soé district,
west Timor, Indonesia
handspun cotton, natural dyes
warp ikat
230.0 x 113.0 cm
Australian National Gallery 1987.1065

This fine textile was completed in
1985, and was the winner of a small
regional textile competition, the
culmination of a special aid project
aimed at restoring the importance of
the skills of weaving and dyeing using
traditional materials. In keeping with
the rules of the competition the
weaver, Ibu Puai-Selan, made this *mau*
entirely of handspun cotton and natural
dyes. It also displays the characteristic
arrangement of a wide central pattern
flanked by narrower side sections
repeating the principal theme, a design
structure developed long ago to
accommodate the narrow cloth widths
of the backstrap loom.
The ancient hooked lozenge motif
(*kaif*) used here is still dominant on
various forms of Atoni art including
carving in wood, bamboo, horn, ivory
and stone, and jewellery as well as
textiles. The dominant use of red and
beige ikat for both the large (*kai naek*)
and small *(kai mnutu)* diamond
patterns, indicates that the weaver is
from Amanuban, one of the traditional
domains of the Dawan people who
inhabit most of mountainous west
Timor.

been a growing tendency to simplify designs as textiles (and the
rituals in which they once played an integral part) lose their essential
meaning. Fine machine-spun thread has facilitated the application of
more precise and intricate ikat patterns or batik designs emphasizing
the textile-makers' skills, and in those places where attempts have
been made to encourage weavers to return to traditional ways, includ-
ing the spinning of cotton, they complain of the difficulty of tying elab-
orate ikat designs on to the coarser handspun yarn after a lifetime of
using fine commercial fibres (Maxwell, 1987). On the other hand, the
twentieth century has also seen the reversal of the trend towards
elaboration. Simplified images and patterns are readily apparent in
most weaving areas where the craft survives, and in most parts of the
region there is abundant evidence that the textile skills of the past
were far superior.[9]

Although the threat of European cultural imperialism during the
nineteenth and twentieth centuries encouraged many Southeast
Asians to retain and display their textiles (occasionally to the extent of
exaggerating ethnic and regional differences), the anti-colonial move-
ments and the task of nation-building after independence have often
resulted in the blending of regional cultures, including textiles and
costumes, into one 'national' style. The development of this national
culture as an expression and symbol of identity has usually drawn
heavily upon the cultural attributes of the largest and most powerful
ethnic groups. Consequently, the art and cultural traditions of the
smaller and less politically powerful communities have often been
totally ignored or at best relegated to the category of 'folk crafts'.
Despite recent attempts to redress this imbalance, the material cul-
ture of many of these societies has been poorly documented. Thus the
national dress of Southeast Asia's countries draws heavily on the silk
songket costume of the Malays in Malaysia, the *piña* of the Tagalog-
speaking lowland Christian cultures of the northern Philippines, the
batik of the Javanese in Indonesia, the ikat textiles of the Burmese and
the modern silks of the central Thais.

575

574

573

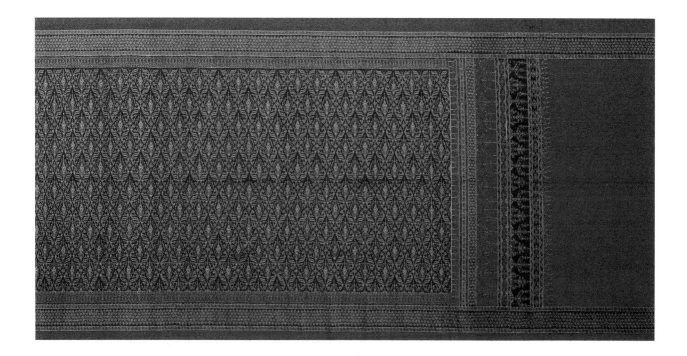

In the twentieth century, and particularly in the post-independence period, a network of modernizing factors has threatened the survival of handmade textiles. These include the emphasis upon industrialization in many Southeast Asian economies and the competition posed by the availability of attractive commercial cloth, as well as the rise of new textile status symbols such as Pierre Cardin shirts and blue denim jeans. Modern Western-style education has been especially important in creating a younger generation alienated from the ways of their ancestors or self-conscious about traditional culture. There have also been many changes in customs and beliefs in those regions where local religions have been affected by either Christian or Islamic missionary activity.

Many of the newly independent national governments have embarked on policies that actively discourage many aspects of traditional life and ceremonial practice. For example, the social structure which stemmed from the longhouse communities of the region has been threatened by government efforts to resettle entire areas, while the extravagant display and lavish consumption of traditional mortuary ceremonies have again been curtailed by new regulations. Political change or instability caused by war and revolution has further disrupted cultural cohesion in several countries. None of these factors is particularly new. However, the increased dimensions of social change in the second half of the twentieth century has dramatically and often irrevocably disrupted the making of traditional cloth by many of the remaining textile-producing peoples of Southeast Asia.

Although still important as markers of ethnic, regional and national identity, and as costume for cultural performances, traditional textiles have achieved a degree of prominence as gifts for senior officials and as tablecloths and wall-hangings, and as garment lengths for domestic and foreign tourists to convert into shirts, dresses and bags. Government departments of information, culture and tourism and national media outlets are often solicitous about the

576 (detail)
chong kaben
festive skirtcloth
Song Khram, Chonnabot, north-east
Thailand
silk, dyes
weft ikat
103.4 x 363.5 cm
Australian National Gallery 1987.1066

This fine weft ikat was designed and woven by Song Khram in 1985 on a hand-operated frame loom. The use of two sets of continuous wefts, one plain-dyed and the other patterned with a weft ikat design, has resulted in a considerably thicker fabric than that of the traditional weft ikats from this region, and the reverse of the cloth appears almost unpatterned. The design structure and pattern is in fact inspired by the Khmer silk weft ikats imported into Thailand for many centuries for court use. Workshops concerned with the revival of traditional Tai textile skills are sometimes directed by men, and the maker of this cloth was male. Song Khram won the first prize for the best design and best weaving awards in the 1988 Khon Kaen Silk Festival, and his winning entry was clearly inspired by a *patola*-derived pattern. His textiles are mainly sold to the well-to-do inhabitants of large towns and cities.

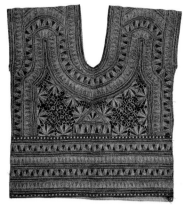

577

577
baju mesirat
woman's blouse
Alas people, Aceh, Sumatra, Indonesia
cotton
embroidery
38.0 x 42.2 cm
Australian National Gallery 1988.1649

578
The hand-embroidered Alas blouse in Plate 577 was made in the nineteenth century, probably by a woman. At one time Alas women wove in a similar way to the neighbouring Karo Batak, although present-day festive clothing is entirely decorated with machine-embroidery. The machine-embroidered blouse and shouldercloth in Plate 578 were made, as is all machine-embroidery in this region, by a local man. The name for this technique and the patterns is *sirat*, to write, and the same term is applied in Batak regions to the twined braid which is also the man's contribution to the finished *ulos* cloth. The colours, have remained black for the base-cloth, and red, yellow and white for the embroidery threads.

survival of material culture, especially decorative items such as textiles which are believed to be marketable. However, traditional textiles do not exist in isolation: they are an integral part of the religious beliefs, social system and cultural identity of the people who make and use them. Inevitably, reducing the role of textiles to that of souvenirs of one kind or another will not motivate people to expend the enormous time and effort required to produce magnificent art objects.[10]

As well as those genuine traditional textiles still being made, there is now a large production of another kind.[11] These are often a pastiche of many regional features cobbled together for tourists, rather than for local celebration or ritual. While handlooms and some traditional decorative textile techniques may be used, time-consuming materials such as handspun cotton or silk and natural dyestuffs are usually avoided. These fabrics are an inevitable development of the region's textile arts in an era of mass tourism, but they are only tenuously connected with the cultural traditions and the authentic traditional textiles produced by Southeast Asians. The driving forces at work here are commercial and these textiles are intended purely as objects for sale to outsiders. It is doubtful if the impact of international tourism will lead to any important new developments in the field of traditional textiles,[12] despite a few recent isolated but nevertheless genuine attempts to revive textile skills.

575

MEN AND MODERNITY

Whether the products of courtly leisure or of peasant hands, textiles have traditionally been women's art, highly valued by societies because of the significance of cloth in ritual, exchange and apparel. As cloth decoration is a female craft, handloom weaving and other forms of textile ornamentation have to some extent escaped the modernizing hand of industry until comparatively recently, and women have continued to uphold traditional customs, including the making and wearing of handmade cloth. It has been the men who have been quicker to abandon traditional clothing for Western-style dress, and as a consequence, some beautiful textiles are no longer required or made.

Where textile processes have been modernized and largely de-skilled, particularly where this has involved machinery, textile production has often shifted into the hands of men. In the nineteenth century the invention of the metal block (*cap*) to speed up the laborious task of applying wax-resist to Javanese batik led to the widespread employment of men in a field which had hitherto, despite its Indian textile links, remained an exclusively female preserve. Women never use the *cap*, while men have rarely been involved in the fine drawing in wax with the *canting* pen. In north Sumatra, sewing by machines replaced hand embroidery and backstrap weaving among the Gayo and Alas peoples, resulting in men also producing ceremonial textiles and accelerating a widespread demystification of textiles used in ritual.[13] Similar changes can be noted elsewhere: men are involved in the large-scale production of commercial batik in west Malaysia and the ikat-tying of thread for sarongs sold in local and tourist markets in Bali and Java. Such a pattern is well established in the Third World and, especially where machinery and large-scale commercial production of a mechanical or semi-mechanical kind is involved, the activity

577,578

tends to be perceived as male work. The textiles produced by these processes have not been included in this study: even where men are actively involved in the making of allegedly 'traditional' textiles, their products are intended principally for the metropolitan and tourist markets. This is clearly the case with the *endek* weft ikat cloth industry of Bali, the imitation 'Sumba ikats' and 'Sumatran ship cloths' produced in Java, and the embroidery of decorative objects in Aceh.[14]

571,579

A few men, however, have become closely concerned with producing very high quality textiles using traditional skills, with designs that draw upon existing local textile traditions. During the twentieth century, in the field of high quality Javanese *batik tulis*, a small number of men have been especially prominent, at least as designers of patterns. These men have an extensive knowledge of Javanese batik and have striven for creative developments of traditional patterns. While the work of Oei Soe Tjoen, Mohamad Hadi, K.R.T. Hardjonagoro, Iwan Tirtaamidjaja, Masina[15] and other male batik designers has a certain historical precedent in those legends which tell of Javanese rulers who prepared batik designs for their wives, it has been largely their entrepreneurial skills and subsequent publicity that have given them national and international prominence ahead of many outstanding contemporary female batik-makers.

There are several significant instances of male artisans maintaining or even reviving traditional textiles in other parts of Southeast Asia. In Sarawak, for instance, Nicholas Entarey has reasserted the use of traditional dyestuffs and has set about teaching this skill to urban women there at a time when many female textile artisans are abandoning traditional techniques in favour of the bright colours of commercially produced threads (Ong, 1986: 37). In north-east Thailand, men have also been actively involved in reviving and developing certain Esarn textile traditions, and their brilliant weft ikat cloths, with designs drawing on traditional Khmer styles, have restored the locally woven *pha nung* to favour with Thai royalty and the national elite in Bangkok.[16] The revival of interest in traditional arts and crafts is by no means limited to men. It is largely an educated urban movement, somewhat akin to the Arts and Crafts movement of nineteenth-century industrial Europe.[17]

576

THE BALANCE BETWEEN LOCAL GENIUS AND FOREIGN INFLUENCE

It may be dangerous to draw too close a comparison between what we can deduce to be the social, cultural and artistic traditions of ancient Southeast Asia, the recent past and today. Yet from the evidence available to us throughout the more remote parts of the region, people continue to follow the ways of their ancestors and this is necessarily reflected in their art. Moreover, the same patterns and motifs are found across the region and reappear on different kinds of textiles and in different materials, sometimes even within the same area. In mapping these patterns, and in placing textiles of different origins, meanings and materials side by side, the Southeast Asian historical experience and the responses of its peoples to new ideas repays scrutiny. Even in those parts of Southeast Asia further removed from the outside world, the impact of these external influences remains apparent.

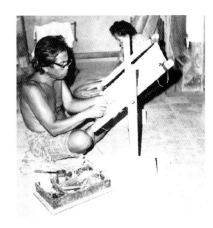

579
A man in east Bali is tying cotton weft threads into weft ikat patterns (*endek*) using plastic raffia. These textiles are largely produced for the tourist market.

580 (detail)
kain panjang
skirtcloth
Javanese people, Yogyakarta, Java,
Indonesia
cotton, natural dyes
batik
267.0 x 106.5 cm
Australian National Gallery 1984.3124

A close examination of this early
twentieth-century hand-drawn batik
cloth from central Java reveals a
synthesis of many different artistic
traditions. The mythological birds of
both India and China — the *garuda*
and the phoenix — have been adapted
to Javanese forms. These stylized bird
motifs alternate with the *parang*
design, derived from the archaic
Southeast Asian diagonal double-spiral
patterns. These motifs are linked by a
diagonal grid of floral tendrils. This is
a restricted design, wearing of which
was originally permitted only by
members of the aristocracy in this part
of central Java, who are, at least
nominally, adherents of Islam. The
batik appears in the characteristic
Yogyakarta colours, *soga* brown and
indigo-blue on a white ground.

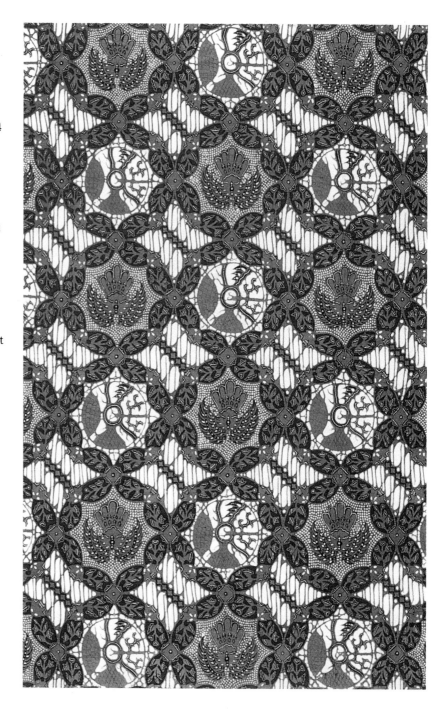

The examination of the changing textile traditions of the region
is one way of illustrating the continuing debate among historians of
Southeast Asia about the balance between the impact of foreign
influences and the resilience of indigenous traditions. By adopting a
comparative approach to the art of many Southeast Asian societies, I
have attempted to redress the overemphasis art historians have
frequently placed on the Indianized art of the region. I have sought to
demonstrate that while the contribution of the Indian connection was
clearly significant, the arts of Southeast Asia were also deeply
affected by other external influences and no part of the region has
entirely escaped their impact.

580

Southeast Asians were active participants in trade and the subsequent exchanges of ideas and materials that have occurred over many centuries. Southeast Asian textile-makers selected from a range of available motifs, designs and techniques the options most attractive to them and the styles which best suited their understandings of the role textiles were expected to fill in their society. Although certain motifs or symbols have been evident since prehistoric times, their form and meaning have been continually reinterpreted as changes have occurred in the ceremonies and rituals for which they were required. While motifs such as reptiles, birds, buffaloes, ships and human figures, depicted in spiral, hooked and rhomb configurations, have been identified among the earliest and most resilient features of Southeast Asian art,[18] new meanings have been added to these ancient forms, and objects and designs have been transformed and reinterpreted to suit local conceptions stretching from the present back into the distant past.

To explain the great resilience of Southeast Asian textile art in the face of powerful foreign influences, and the remarkable ability of the peoples of Southeast Asia to synthesize such foreign inspirations into acceptable local styles and forms, we must look to the functions of art in the region. For in addition to textiles as a human expression of creativity and beauty, I have emphasized throughout this study the importance of seeing textiles as a means of defining and demonstrating social status and power, both sacred and secular.

Throughout Southeast Asia, traditional textiles are a visual expression of the fabric of life. These textiles place the individual symbolically within the social milieu, identifying rank, family, locality and religious affiliations. The textiles are items of wealth and indicators of people's prosperity. For many peoples, cloth provides a link between the human and the spiritual realm, and a vehicle for the display of sacred and secular potency. Certain decorative textiles are believed to embody special transforming powers and sacred mediating qualities, providing protection and evoking life-enriching forces for individuals or social groups. Although historic and traditional textiles of this type still exist to the present day, in the future they will probably be used only as anachronistic costume on ceremonial occasions.

Readers may decide for themselves to what extent the influences of foreign cultures have been a mere 'thin flaking glaze'[19] through which the most ancient aspects of Southeast Asian culture continue to surface, and to what extent each new development and foreign contact has irrevocably changed the face of Southeast Asian textile art. Fortunately, a multitude of textile types have survived to tell their own story, and these splendid textiles are as colourful and complex as Southeast Asia's long history.

NOTES

1 An Introduction

1 For an early study which drew upon his work in Southeast Asia, see Bühler (1943). Other important works by Bühler are listed in the bibliography.

2 For example, apart from Boulbet's study of Ma' textiles (1964), there are only scattered references to the making and meaning of traditional textiles in the historical and anthropological writing on Vietnamese hill-tribes. Among these are Condominas (1977) and Hickey's two volumes (1982a; 1982b). In recent years, however, more intensive study has begun on the textiles of the Tai and Lao groups of Laos and northern Thailand. See for example Cheesman (1988) and Prangwatthanakun and Cheesman (1987).

3 One of the problems implicit in a 'national' approach is illustrated by a number of recent exhibition catalogues of Indonesian textiles which have contained examples made by the Iban people. Invariably, these textiles were collected in Sarawak, a state in the Federation of Malaysia. At least one writer (Fischer, 1979) has acknowledged this problem by entitling his work accordingly.

4 The Field of Ethnological Study approach of J.P.B. de Josselin de Jong (1935) of the Dutch school of Anthropology, for instance, focused attention on the appropriateness of viewing the cultures of the Malay archipelago in a comparative way.

5 Of the Malay peoples of Southeast Asia, apart from peninsular Malaysia, major groups are found in the southern Philippines, southern Thailand and various parts of Indonesia, especially in Sumatra and Kalimantan. Several Dayak groups inhabit territory on both sides of the border between Malaysia and Indonesia on the island of Borneo, and many ethnic groups in mainland Southeast Asia, such as the Tai Lue, are scattered across several countries.

6 For example, on Indonesia, Kahlenberg (1977) and Khan Majlis (1984); on the Philippines, Casal et al. (1981); and on northern Thailand, Lewis and Lewis (1984), Cheesman (1988) and Prangwatthanakun and Cheesman (1987). A recent study of traditional weaving across Southeast Asia (Fraser-Lu, 1988) also divides the material geographically by country.

7 See for example, Bühler (1943); Jasper and Pirngadie (1912b; 1916); Langewis and Wagner (1964); Maxwell and Maxwell (1976); Warming and Gaworski (1981); and a slim volume on Malaysia, Peacock (1977).

8 Within the field of Indonesian textiles, a recent catalogue by Solyom and Solyom (1985) provides useful insights of this type.

9 In other Southeast Asian mainland entrepôt, however, a major impetus for trade during the same period came from Theravada Buddhism.

2 The Foundations

1 There are many factors that affect radio-carbon dating results, and, consequently, there continues to be considerable debate among archaeologists and prehistorians over the timing and length of these prehistoric periods. This does not alter the general thrust of my argument.

2 A study of the techniques, materials and patterns used by Austronesian-speaking peoples in Micronesia and the Pacific to decorate the human body, including textile types such as bark-cloth and unwoven fibres, may also inform us about other methods that were once used by the peoples of insular Southeast Asia, even though these elements have now disappeared or been superseded by other techniques within the region.

3 Illustrations of bark-cloth beaters appear in Bellwood (1985: 151, 156, 216, 226, 232).

4 Van Esterik (1984) explores some of these continuities and transformations in symbols on Thai ceramics.

5 There is also speculation that the small cylindrical pottery rollers found at a prehistoric Ban Chiang burial site may have been used to pattern bark-cloth (Van Esterik and Kress, 1980).

6 There is even the suggestion that the making of bark-cloth had become a priestly function in certain parts of Southeast Asia by the time written records began (Kooijman, 1963: 59–60, 68–9). In early Javanese inscriptions, bark-cloth is recorded as the material for the special garments (singhel) of priests (Wurjantoro, 1980: 200).

7 A. Forge, personal communication, 1987

8 Collins (1979: 233) discusses heirloom bark-cloth manuscripts, known as pusaka in the Pasemah region of south Sumatra. The best known bark-cloth manuscripts are those of the Toba Batak (Guy, 1982: 82–3).

9 One of the most important of these discoveries has been the Niah Caves in Sarawak. A photograph of the rock paintings in this complex is clearly illustrated in Chin (1980: 12).

10 A nineteenth-century example of bark-cloth with a simple pattern from the Malay peninsula is illustrated in Wray (1908). See Roces (1985: 9) for a rare illustration of a Negrito painted bark-cloth from the Philippines. The use of bark-cloth fabric to clothe a scarecrow doll in Luzon is illustrated in Newman (1977: 3). Whether this practice was traditional is unknown, although it is in keeping with the protective function of the fabric.

11 See for example the statues on the Pasemah plateau of south Sumatra which possibly date from late in the first millenium BC (Bellwood, 1979: 227).

12 An uncut narrow geringsing double ikat is worn in this way at the village of Tenganan Pegeringsingan in east Bali. See Bühler et al. (1975-6, plates 49,51,77).

13 William Marsden (1783: 49) commented on the fineness of bark-cloth from Rejang in west Sumatra which he likened to kid leather. Bark-cloth is now chiefly known in Sumatra in a coarse, red-brown form as the support or backing-cloth for other textiles.

14 Bellwood (1979: 153 and 161). These pottery finds possibly date from 3000 BC in mainland Southeast Asia, and from before 1000 BC in insular Southeast Asia.

15 Other decorative textile techniques (such as batik and embroidery) have, of course, been used to achieve the free patterning comparable to painted designs on bark-cloth.

16 One type of flat, round disc discovered at Niah (Chin, 1980: 10) is almost identical to those attached to certain Dayak twined jackets in the nineteenth century. See, for example, Avé and King (1986: 17).

17 Chin (1980: 11). These are also the three colours of the Iban warp ikat pua kumbu.

18 Spun bark was used into the twentieth century as a type of thread in mountain Luzon. Its preparation is described by Lambrecht (1958: 1).

19 Until recently there were only three examples of the beaded textile-mats of south Sumatra in museum collections. The object at the Tropenmuseum in Amsterdam was published in Steinmann (1946: 1885) and Tropenmuseum (1987: 26). The two items at the Museum Nasional in Jakarta have also been published: No. 23299 appears in the Koninklijk Bataviaasch Genootschap van Kunsten en Wetenschappen (1940: 152, 169) and again in Museum Nasional (1980: 280–1) and No. 577(?) in Palm (1965: 65). Another smaller example in a different beading style is illustrated in Gittinger (1979: 74). During the last few years, further examples have appeared and photographs of several of these have been published. However, doubts over the authenticity of some of these items or the radical repairs which they have undergone make useful comparisons difficult and necessarily tentative.

20 Bellwood (1985: 216, 226, 232) discusses the prehistoric routes by which weaving may have entered Southeast Asia from southern China. In part, the evidence is based on the origins of the terms for weaving techniques, apparatus and materials. For instance, some linguists point to the widespread use of variations on the word tenun (to weave with a loom) across the region, as distinct from the quite different terms for interlacing, suggesting a very long weaving tradition stretching back into prehistoric times. The term for thread (benang) is also an Austronesian word. Two recent studies (Barnes, 1989a; Hitchcock, 1983) briefly discuss the probable history of cotton weaving in the eastern Indonesia region.

21 One such sculpture, located until recently in the east Flores region of Indonesia, is illustrated in Solyom and Solyom (1985: 2) and Adams (1977: Pl.1). It appears from evidence such as the presence of a similar bronze maternity figure in Borneo and a Chinese inscription on an early bronze kettledrum found in Indonesia, that many of these prehistoric bronze objects were imported into the region.

22 The notable exception is Taiwan where prehistoric spindle-whorls have been discovered. The earliest clay spindle-whorl finds in insular Southeast Asia have been in burial and cave sites in northern Luzon (1500–0 BC) and the Calamian Islands north of Palawan (1000 BC to AD 500) (Bellwood, 1985: 224; Solheim, 1981: 56).

23 Hemp is also used by the original inhabitants of Taiwan, who share close cultural and linguistic affinities with the peoples of Southeast Asia.

24 Owen (1984) looks at the effects of international trade in abaca on Luzon, and to a lesser extent Mindanao where it continues to be extensively used for traditional fabrics.

25 The textiles of the Benuaq, a small Dayak group, are not very well known, although several examples of the women's skirt have recently appeared in exhibitions (Kahlenberg, 1979: 20; Solyom and Solyom, 1985: 2). Very few of the large ceremonial hangings exist in public collections, although the Rijksmuseum voor Volkenkunde, Leiden has several fine examples. For a rare published reference, see Nieuwenhuis (1914: Fig.13).

26 Plain, sturdy, woven fabric used to make clothing for agricultural work is still produced from Corypha gebanga fibre on the island of Roti (Khan Majlis, 1984: 280).

27 Corypha palm-fibre sails continue to be used in Lamalera, south Lembata. Agel, as Corypha gebanga is known in Java, was also used as sail fabric on the north-coast town of Lasem (Veldhuisen-Djajasoebrata, 1984: 23). The same fibre was woven for sails by the people of Salayer, an important centre of sea trade, until at least the end of the nineteenth century (Engelhard, 1884: 330). Sailing appears to have been a skill in insular Southeast Asia from as early as 2000 BC (Solheim, 1981: 32–3).

28 For an outline of the dyes used by Pacific and Indonesian peoples on bark-cloth, see Leonard and Terrell (1980: 17–18). Many of these dyestuffs are the same as those used on fibre threads.

29 Muds and ochres are also added to dyes as minor ingredients as part of the complex process to attain rich colours.

30 Blue-black dyes are obtainable from a number of plants in Southeast Asia, including the well-known Indigofera tinctoria, as well as Indigofera hirsuta, Marsdenia tinctoria, Polygonum tinctorium, Wrightia tinctoria, Isatis tinctoria and Strobilanthes flaccidifolia. The hill people of northern Burma and Thailand, in particular, make use of many different sources of natural indigo. The cultivation of certain imported varieties to Southeast Asian regions occurred under European influence. A map outlining the early spread of indigo appears in Oei (1985: 16–17).

31 Job's tears were also probably a prehistoric form of decoration in Timor (Glover, 1977).

32 Bellwood (1979: 228–31) discusses the discovery of beads in Southeast Asian Metal Age sites and the role of beads in pre-Indian trade. In the Philippines, beads were a feature of burial sites from at least 700 BC (Solheim, 1981: 44). For a much later period Fox (1976: 765) confirms that beads found in patterns on a child's skeleton in a fourteenth- to early sixteenth-century burial site in south-west Luzon must have been sewn to a cloth skirt.

33 Nooy-Palm (1975: 36) shows a photograph of a man engaged in beadwork.

34 Dance aprons with a diagonal grid of single spirals from the Cenderawasih (Geelvink) Bay area are published in Loebèr (1913: Plate 9) and Wassing-Visser (1984: Fig. 63). A beaded bag with a single human-reptile motif set against a fine, triangular patterned ground appears in Tichelman (1944: Plate XVI).

35 Woodward (1980) uses the term 'meaningful stripes' to refer to these bands in delineating the first of three historical stages of Indonesian textile patterns.

36 In particular, the use of four-heddle looms in parts of Southeast Asia permits the creation of so-called Op Art textiles that exploit the optical perception of rectangular grids as circles. Examples of these optical designs can be found on textiles from various parts of Southeast Asia including Luzon, east-coast Malaysia and Burma. A Tinguian example from Luzon is illustrated in Ellis (1981: 231).

37 Larsen applies the term 'proto-resist' to these garments. The fibres are tied and dyed not painted. Similar proto-resist techniques are applied to unwoven goat hair on armbands in Assam, the north-east Indian border district near Burma (1976: Frontispiece, 18–23).

38 One fragment from this burial site, possibly dating from the fourteenth or fifteenth century and now in the National Museum of the Philippines, Manila, is illustrated in an unconserved state in Solheim (1981: 79). The same example and another fragment from the same site appear in Roces (1985: 9). The ikat stripes on the second fabric appear to include a simple bird or cock motif.

39 While they are not illustrated here, drawings of Shan textiles produced using the weft-wrapping technique can be found in Start (1917).

40 As we shall see in Chapter 3, this three-section design feature developed into a fully patterned central field under the influence of imported cloth design.

41 In Austronesian languages, *ina* and *ana* not only signify mother and child, but also refer to the whole and the part (J.J. Fox, personal communication, 1986). For Bagobo terminology see Casino (1981: 134) and for the Ifugao see Lambrecht (1958: 10).

42 Different interpretations of designs have also been noted within literate communities of Southeast Asia. See, for example, Boow (1986) for an account of different Javanese interpretations of well-known batik patterns in Solo in central Java.

43 Among the northern mountain-dwelling peoples of mainland Southeast Asia, the identity of certain sub-groups takes its terminology from a remarkable feature of their women's clothing, such as the Black Lahu, the Striped Miao or the Yao with the Great Headpiece (Nabholz-Kartaschoff, 1985).

44 Bellwood (1979: 139). The betel-nut palm, *Areca catechu*, was evidently one of the earliest plants to be cultivated in Southeast Asia. In northern Thailand, where significant archaeological evidence has been located in the Spirit Cave, the custom of chewing betel-nut can be traced back to between 10000 and 6000 BC. In the central Philippines it had become a customary practice by at least 2500 BC (Bellwood, 1985: 216; Solheim, 1981: 31).

45 Thierry (1969) provides an overview of the use of betel-nut in various rites of life and death throughout mainland Southeast Asia.

46 A cloth drawstring bag with some supplementary weft decoration from the Man Tien of north Vietnam is illustrated along with many other Southeast Asian examples in Thierry (1969: 275).

47 Ancient beads sometimes also fall within the female sphere of goods. On Sumba, beadwork bands and bags are part of the gifts given by the bride's family to the groom's family during marriage settlements.

48 The Kei Islands in south-east Indonesia is an example of a non-weaving region where these rules still apply.

49 In the past, however, it seems very likely that specific types of *ulos* were associated with certain districts or particular villages within the Toba Batak region. Even today, certain Toba Batak textile designs are closely associated with or exclusively made in one village complex or sub-district. For example, the *ulos ragi hotang* come from around Baligé, the *ulos pinunsaan* from the Porsea district, and types of *ulos ragidup* vary considerably from one Toba Batak area to another.

50 Similar rules apply in European cultures to the buttoning of shirts and jackets. Forth (1985) discusses this issue for east Sumba where it is most common for women to wrap or wind from right to left and men from left to right. However, whether the move to the right denotes a clockwise or an anticlockwise movement varies. For example, on Sumba movement to the right is anticlockwise while on Bali it is understood to be in a clockwise direction. So in Bali the men wrap their skirts from right to left while the women wrap them from left to right (Duff-Cooper, 1984: 5).

51 The wrappings of the corpse and those of the special attendants at funerals are wound to the left (Forth, 1985).

52 Maxwell (1990) discusses Indonesian examples of these metal and textile structures. For the Mien staircase, see Campbell et al. (1978a: 46).

53 Fox (1980a: 39–55) develops the link between legendary reptilean ancestors and textile patterns for the eastern Indonesian island of Roti.

54 Particular circumstances have led to these two colours taking on other forms of symbolic importance. In Savu, for instance, the moeities each identify with red and black, and on Roti the association of indigo with Dutch cultivation led black to become the predominant colour for those textiles worn by the indigenous elite on that island (Fox, 1980a: 42–3).

55 These notions vary from region to region, even when the polarity between red and black is recognized. In Bali, as we will see when discussing the influence of Indian philosophy on ancient Southeast Asian culture, red and black are associated with the directions of sea (*kelod*) and mountain (*kaja*) as well as with Hindu deities and cardinal points. According to Ramseyer (1984), black and red textile offerings are associated with the east and west.

56 The role of the twined tricolour threads in Karo ritual, particularly in traditional funerals, is discussed in Kipp (1979: 62–95).

57 A number of prehistorians, in attempting to reconstruct the culture of prehistoric Southeast Asia, isolate head-hunting as a part of life in Austronesian Southeast Asia. One of the most important contributions to this subject was Heine Geldern's article (1932), which has been the subject of half a century's debate. Archaeological findings in mainland Southeast Asia and southern China suggest that head-hunting may also have been practised there (Bellwood, 1979: 92, 162). The bronze sculptures from Lake Dian in Yunnan that appear to record head-hunting practices, date from 400 BC to 200 AD, and also depict women weaving on continuous circulating warp foot-braced looms (Cultural Relics Publishing House 1983).

58 These also serve as protection from torrential rains. The Maori of New Zealand also made similar twined and tufted raincoats (Ling Roth, 1923: 46–50). The Musée de L'Homme, Paris, holds a photograph (M.H.85.21.20) of a jacket of similar construction from the Malay peninsula.

59 Ng (1978: 14). The weaver (or plaiter) described in this work is a traditional priest.

60 M. Heppell, personal communication, 1987

61 There are many similarities between the terms used in Southeast Asia to describe parts of the traditional house, the boat, and the most basic structural elements of society. Many such similarities date back to very early settlements in the region (Manguin, 1986).

62 M. Fischer, personal communication, 1984

63 As we have seen, men sometimes make beaded objects. There is also evidence that the painting of certain bark-cloth motifs was once a male activity (Hukom and Lilipaly-de Voogt, 1985: 134). This is also usually the case with other traditional forms of pigment painting.

64 Some of the finest examples of these implements are illustrated in books on Southeast Asian sculpture. Hedda Morrison's photographs of Iban carved weaving equipment can be seen in Wright, Morrison and Wong (1972: 76–7).

65 It may also indicate to the keepers of the Other World that she is 'complete', meaning that she has a spouse (A. Forge, personal communication, 1986).

66 In Luzon the finest Kalinga textiles are used as sun shades or crumpled into the tops of jars during negotiations to secure peace after conflicts between factions. Such ostentatious display seems intended to demonstrate cultural superiority and wealth.

67 For examples of such origin myths, see Ellis (1981: 229) on the Ifugao, Niessen (1985a) on the Toba Batak, and Nooy-Palm (1979) on the Toraja.

68 Among the Buginese of south Sulawesi, transvestite priests (*bissu*) play a prominent role in the arrangement and preparation of costume for important ceremonies such as weddings. A photograph of a *bissu* making the braid that is attached to apparel worn by Buginese nobility appears in Harmonic (1977: 42).

69 Graham (1987: Chap. 4) discusses the Iban transformed shaman (*manang bali*).

70 The term *bali*, while used in many Iban areas, is also the word used for identical large warp ikat textiles by the related Dayak groups of west Kalimantan, such as the Kantuk and the Desa.

71 Photographs of a master *manora* dancer (*tua nora*) wearing the beaded jacket appear in Ginsburg (1975: 40, 68). See also Nicolas (1975) for a discussion of the dramas as they are enacted in central Thailand. The beaded jacket is known there as *sab sruang*.

72 Cole (1913: 194–6) offers this explanation for images of humans depicted within the bodies of large animals on Mandaya textiles.

73 Some Southeast Asian peoples, including the Batak of north Sumatra and the Iban of Borneo, also store their most valued textiles in elaborately carved chests.

74 Even deities and spirits may make use of these powerful designs. For example, according to Iban legend the god *Lang Singalang Burong* wears a woven cotton jacket decorated with the pattern of the tiger-spirit roaring at the door of his lair (Sandin, 1977: 146).

75 Gittinger (1975: 20) suggests that these motifs are intended to repel danger.

76 Adams (1974a: 60–2) refers to this motif as the Tiger Maul (perhaps Maw?). It is illustrated in Adams (1974a: 57).

77 For example, among the Kankanay of Luzon, a woman falling pregnant for the first time wears an entirely white costume (Ellis, 1981: 237).

78 These include *jukung penunjal* for a child who steals things (clearly an illness in a village society), *ragi memeng* for a deaf child and *damar muruk* for the socially disturbed.

79 Hose and McDougall (1912) report that certain prized beads were tied to the wrist and bear the same name as a tattoo etched on that part of the body. These charms (*lukut*) were said 'to prevent the escape of the soul and to ward off all disease'.

80 Beyer, H.O. in an unpublished manuscript, Harvard Peabody Museum, 1909, quoted in Ellis (1981: 224), has interpreted the crosses on Ifugao textiles as the roofs of houses.

81 Some animals are immediately recognizable, while others, like the pigs depicted on Ifugao cloth, appear in highly schematic form. Beyer quoted in Ellis (1981: 224).

82 In eastern Indonesia the founding ancestors are sometimes addressed as the sun and moon.

83 Lewis and Lewis (1984: 76) remark briefly upon the association between the warp ikat process and spirit worship among the Karen.

84 This may be related to the high status of Tenganan people and the unpleasant odour of rotting indigo (Maxwell, 1985).

85 A Dusun legend where a stranger warns against the approach of visitors during the preparation of dyestuffs is recounted in Evans (1922).

86 Throughout Southeast Asia careful and respectful behaviour is demanded of men when cleaning an heirloom sword or spear. Fever, sickness or misfortune are widely believed to result if these strictures are not followed.

87 In Mindanao, it is believed that T'boli women returning from collecting raw abaca should not be stopped lest they fall ill (Casal, 1978: 141).

88 See Evans (1922) for an example of a Dusun legend about indigo dyeing in the presence of other colours.

89 Stuart-Fox (1985) notes a number of thirteenth- and fourteenth-century Javanese references to the cutting of the warp by priests.

90 The Rijksmuseum voor Volkenkunde in Leiden has the collection of Siebold and the cloths of Muller, acquired in Indonesia in the early nineteenth century. Unfortunately, only two batik cloths brought back to England by Sir Stamford Raffles after the 1812–15 British interregnum in Indonesia survive in the Museum of Mankind, although there are Javanese wooden puppets decorated in painted cloth patterns from the Raffles period (Forge, 1989). However, an Indian cotton trade textile, preserved as an heirloom in the Toraja region of Indonesia, has recently been tentatively dated to 1635 (Guy, 1989). This suggests the possibility that many fine, highly valued, locally made textiles, stored as heirlooms in Southeast Asia, may also be of considerable age.

3 Indian Impressions

1 The evidence of the first contacts or earliest kingdoms is still sketchy. The first Indianized state in Southeast Asia appears to have been Funan in Indo-China in the first centuries AD. Indianized kingdoms were established in Java from early in the fifth century. For a general overview of the spread of Indian influence see K.R. Hall (1985) and D.G.E. Hall (1968: Part 1).

2 Hall (1968: 35–6). Epigraphical evidence for the western Burmese kingdom of Arakan, however, dates from AD 146.

3 This evidence is summarized in the general histories of Southeast Asia. See for example Hall (1968: Part 1). For a useful introduction to the plastic arts of Indianized Southeast Asia, see Rawson (1967) and Groslier (1966).

4 The effects of the growth of trade on Southeast Asia are summarized by Hall (1985: 136): 'In tribal societies, a reciprocal sharing of economic resources among family, community and religious groups maintained the social unit. The development of entrepreneurial activities brought social imbalances, resulting in the transformation of the indigenous economy and the emergence of political entities based on redistributive exchange.'

5 For a useful summary of this issue as it relates to Indonesia and the arguments for and against competing theories, see Legge (1980: 38–46). Essays such as those edited by Marr and Milner (1986) throw new light on the processes of change in the early Southeast Asian states.

6 The most important architectural sites include Dieng, Prambanan and Borobudur on Java, Candi Bukit Batu Pahat on the Malay peninsula, and the Funan-Zhenla and Angkor sites in Vietnam and Cambodia. These and other monuments are illustrated and discussed in Rawson (1967) and Groslier (1966).

7 A Thai study of clothing depicted on stone and metal sculpture over the last thousand years provides some indication of the changes that have occurred in the dress and adornment of the nobility in that part of Southeast Asia (National Museum, 1968).

8 The legend is recounted in Hall (1968: 25–8). In some versions the woman is described as the queen of the *naga* serpents. Though this tale is used to explain the origins of Khmer women's clothing, the garment it

describes in fact resembles the blouses and shifts worn by women of a number of minority groups in mainland Southeast Asia, including the Karen.

9 Elsewhere in Asia, for example in India and China, styles and forms of dress during this period changed dramatically from dynasty to dynasty, although this was often related to changes in the ethnic and religious identity of the ruling class.

10 The Lopburi period of Khmer influence extended from the height of the Khmer kingdom of Angkor in the eleventh century until the fourteenth century. The central Thai kingdom of Ayutthaya dated from the fifteenth until the late eighteenth century.

11 Some fine examples of this lacquer work are illustrated in Chumbhot (1960).

12 A thorough account of the trade in Indian cloth to both the East and the West is provided by Gittinger (1982).

13 For an overview of the arts of Mughal India, see Skelton (1982).

14 Carnelian beads, apparently from north-west India, have been found during the excavation of grave sites in Southeast Asia dating from as early as 500 BC. The earliest reference of these Indian beads is reported for the Sa-Huynh Culture of south Vietnam (Bellwood, 1979: 228–31). Many of these highly valued red carnelian beads continued to be imported from the Indian subcontinent until European times. See also Lamb (1965).

15 A map accompanying the article by Mook-Andreae (1985: 16–17) charts the early spread of indigo. The spread of certain imported varieties to Southeast Asian regions occurred under European cultivation.

16 A late seventeenth-century traveller reported that in Thailand the Prince and all his retinue wore red for war and hunting (La Loubère, 1693: 26).

17 A number of the terms found in early Balinese inscriptions, and which are derived from the Sanskrit *karpasa*, are discussed by Stuart-Fox (1985).

18 Gossypium hirsutum is often referred to as 'New World' cotton, a misleading term suggesting that this plant was introduced into Asia after the establishment of European sea routes to the Americas.

19 In fact, where cotton was not already a feature of the earliest textile crafts in Southeast Asia, it was from India rather than China that it was probably brought into the region, even for the northern ethnic groups of mainland Southeast Asia. Cotton was not widely used in Japan until after the fifteenth century and was probably also a late arrival to the Han Chinese. The high regard with which the Chinese viewed cotton from Southeast Asia and the Himalayas has been recorded by Schafer (1962: 204–6). He notes that it was already cultivated by non-Chinese ethnic groups in the Yunnan area of southern China in the late Han dynasty.

20 Turmeric is the sacred colour and dye of Wishnu.

21 This term is explained in Bangladesh Rural Advancement Committee (1981: 1). According to Buhler and Fischer (1979: 317), the spinning-wheel for winding thread is also known as *charkho* in Gujarat.

22 Some of these terms may be found in Jasper and Pirngadie (1912b: 320–1, 330). Other terminology has been collected during my own field work.

23 There are of course many variations of the term *sutra* throughout Southeast Asia, as in the Khmer term for silk, *saut* (Stoeckel, 1923: 399).

24 The term *sabai* is used for a woman's silk breast-wrapper in central Thailand, while in coastal Sumatra it describes a shouldercloth. In south Sulawesi the Buginese use this word as a general term for silk cloth.

25 There are certain exceptions in the form of transition-type looms where a circulating warp is inserted in one direction through the comb.

26 A number of fine recent photographs of mainland Southeast Asian looms appear in Lewis and Lewis (1984), including examples of the Hmong (104) and the Akha (207) foot-operated looms.

27 Sheppard (1972: 98, 109). The Kelantan textile collection in the Muzium Negara, Kuala Lumpur, includes a number of warp ikats that were probably

imported from Aceh. Other cloths, while similar to the Acehnese *ija plang rutha* (or *rusa*), are of a different colour and a bolder banded style, suggesting that similar warp ikat cloths were also made on the Malay peninsula. One of these Kelantan warp ikats from the Malaysian national collection is illustrated in Peacock (1977: 26). Although Wray (1902: 153–5) discusses warp ikat in the Sultanate of Perak, his account is imprecise and is illustrated with a weft ikat cloth from the Perak Museum that was probably woven in Kelantan or Patani. His photographs of ikatted silk threads do not permit any conclusion as to whether they are warp or weft threads. He also noted that this type of weaving was introduced to Perak by Malay women from Kelantan.

28 Although Gullick (1952) suggests that the weavers in post-war Kelantan were immigrants from Terengganu, distinct regional styles had been well established in the Malay peninsula for centuries. Kelantan weft ikats show more affinity with those of their northern neighbours, notably the Khmer cloths popular in the Thai courts, while the Terengganu *kain lemar* are similar in design structure, style and colour to the weft ikats of south Sumatra and Bangka.

29 There is a remarkable similarity in the origin myths and legends of the Buginese and the Torajanese. However, the passing of time, warfare and slave-trading, exacerbated by religious differences, have contributed to today's distinct ethnic identities. The Toraja peoples of central Sulawesi continue to make warp ikat cotton fabrics. However, as active sea-going traders, many different sources of inspiration are probable for Buginese ikat weaving, stretching from south Sumatra to the southern Philippines.

30 The handspun cotton weft ikat textiles of Lombok have only recently come to the attention of Southeast Asian textile specialists (Khan Majlis, 1984: 78; Breguet and Martin, 1983: Fig.7.1).

31 Schafer (1962: 206) also reports that during the Tang dynasty, the Chinese were great admirers of the fine cotton wraps worn by the Burmese.

32 Some recent examples combine Musa textilis and gold metallic thread (Abdurachman, n.d.).

33 Hall (1985: 1–25) provides a model for the interaction between those inland societies that were the sources of primary produce and tribute, and the port principalities.

34 Certain small non-functional shouldercloths worn in the Malay courts by bearers of royal regalia take an almost identical name, *tetampan* (Sheppard, 1972: 26).

35 Other textiles also appear in the form of token pillows. Sacred double ikat cloths support the head of the initiate in tooth-filing ceremonies in Bali. Among the Hmong, women mourners from the immediate family of the deceased present special embroidered 'pillows' to rest the head of the deceased. These are small but beautiful token cloths of 30–35 centimetres square. As symbolic maps which guide the dead to the next life, these pillows draw upon ancient notions of the sacred textile as a spiritual medium (Lewis and Lewis, 1984: 128).

36 A rare figurative Lombok textile of this type of *usap* appears in Holmgren and Spertus (1989: 84–5). The authors also reproduce an early twentieth-century photograph of a Shan banner or prayer flag from Burma of similar design format (80).

37 These recent shared historical experiences have contributed to the similarities between the weaving traditions of east and west Sumbawa. However, Bima in east Sumbawa also shares common linguistic characteristics with the people of west Flores and Sumba (Lebar, 1972: 60).

38 This is despite the fact that these textiles might be seen to amalgamate ancient male and female characteristics by combining the elements of gold and cloth.

39 For reference to early Khmer and Javanese temple gifts that include textiles, see Hall (1985: 117, 148–51).

40 Ricklefs (1981: 38, 72–3) provides several instances of Javanese rulers or would-be rulers pursuing the *pusaka* or heirloom regalia as part of their quest for legitimate authority. In fact, the acquisition of royal

heirloom regalia can be viewed as the ultimate legitimation of the ruler.

41 In Bali, for example, the use of silk and gold thread brocade was restricted exclusively to the highest castes, the *Triwangsa*. This continued to be the case until the 1970s and 1980s when under the impact of social change these status symbols began to be worn by anyone able to afford them (Ramseyer, 1987: 4).

42 Hitchcock (1983: 109–10). A description of the making of the metallic thread in Bima appears in Hitchcock (1985: 30, 32).

43 A number of textile designs from south Sumatra have acquired ship-related names such as *tiang condong* (a raking mast) and *jung sarat* (fully-laden junk or ship). Manguin (1986) notes the use of similar terms elsewhere in the region, including references in classical Javanese literature (*songket jong sarat*) and Malay court textiles (*jung sarat*). In each case the term *jung sarat* indicates a textile completely decorated with gold thread.

44 Gold leaf gluework is also practised in many regions of India including Gujarat, although it seems to be largely decorative technique for hangings such as the Deccani *pichhavai* and the Rajasthan *kanat* (Talwar and Krishna, 1979: Cover Plate; Irwin and Hall, 1971: Plates 86–9).

45 Rare examples also exist of Javanese gold leaf gluework applied to ikat textiles including the Indian silk *patola*. Jasper and Pirngadie (1916) have suggested that *prada* is also added to certain exclusive batik patterns. Contrary to the example they give, however, nowadays gold leaf is rarely added to the ancient *parang rusak* batik designs, although it may have been used to embellish such patterns in the eighteenth and early nineteenth centuries (Forge, 1989).

46 In the Esarn region of Thailand, the Tai Lao and Khmer are exceptional in this regard since locally produced silk thread is often used to weave their everyday clothing.

47 Throughout coastal Southeast Asia, courtly romances such as the Panji cycles of the Indonesian archipelago, have appeared alongside the great Indic legends as sources of imagery in the arts. Forge (1978: 12–14) outlines the foreign and indigenous sources of some of the scenes that appear in Balinese paintings.

48 See, for example, Gittinger (1972: Plates 34, 105) and Holmgren and Spertus (1980: 157–98).

49 Cloth and eventually replaced palm-leaf as the foundation for these drawings. For an illustration of a *tumbal rajah* inscribed on lontar palm-leaves, see Ramseyer (1977: 100).

50 These flying *apsara*, 'the essence of the waters', often bear great similarity to the mermaid motifs found on certain Javanese and Sumatran textiles.

51 One nineteenth-century example of a *kalaga* illustrated in Lowry (1974: Plate 25) appears to be related stylistically to certain Indian mordant-painted cotton textiles, in particular a famous pair of early painted cottons from India, one now in the collection of the Victoria and Albert Museum, London, and the other in the Metropolitan Museum of Art, New York, illustrated in Gittinger (1982: 112).

52 The Sanskrit term *naga* is widely used for the serpent throughout Southeast Asia. For discussion of the serpent symbol in India, see Zimmer (1983, vol.1: 48–67; 1972: 37–8, 59).

53 The *garuda* is also used as a symbol of the modern state of Indonesia.

54 For a detailed discussion of these motifs in the context of Javanese cosmology, see Solyom and Solyom (1980a: 248–74); Veldhuisen-Djajasoebrata (1984: 100–9); and Maxwell (1990). Day (1987) has suggested that the decorative depiction of landscape in early Javanese art not only alluded to this cosmic symbolism but was an expression by the artist of the ruler's power over his own landscape, his domain.

55 The arrangement of the scenes and the dramatic size of the motifs on Cirebon batik also suggest that these textiles may originally have functioned as hangings.

56 Sheares (1984: 45–53). Gallotti (1926: 161–8) does not distinguish between hangings (*pidan*) and skirtcloths

(*sampot*). The latter usually have a more formal schematic patterning.

57 The trident is generally recognized in Hindu imagery as the weapon of Siwa (Zimmer, 1983: 27–8; Coomaraswamy, 1955: 25, 197). It also represents the Hindu Trinity of Siwa, Wishnu and Brahma.

58 A number of examples of bold linear tattoos on Karen men are shown in Lewis and Lewis (1984: 94–5).

59 Thai examples of magical diagrams and calligraphy drawn on cloth are illustrated in Bhujjong Chandavij (1982: 118).

60 Museum Tekstil Jakarta (1980: Plate MT.038, 27) shows an example of one type of *kain kembangan* with a *bangun tulak* (to repel evil) design. This cloth is said to have been worn as a head-cover by two rulers, Susuhunan VII and VIII.

61 Veldhuisen-Djajasoebrata (1980: 203–5) points out the pre-Hindu foundations of the Javanese *manca pat* beliefs. It seems that Indic cosmology provided a meaningful way to illustrate and elaborate certain ancient ideas about divisions into colour realms.

62 The Balinese identify these colours with the appropriate deities of the Hindu Trinity.

63 It is equally arguable that these star motifs were attributed these Indic properties after they had been adopted into local textile iconography because of their high value and their attractive decorative appeal. Such an argument is generally proposed by Gombrich (1979), although, as we have set out to show here, many other Southeast Asian textile motifs have great symbolic and social meaning.

64 Many old Indian cloths found in Southeast Asia and now in public and private collections have been documented in the literature on Asian textiles. For example, Yoshioka and Yoshimoto (1980); Gittinger, (1982); and *Old Textiles of Thailand* (1979). Numerous other examples located and photographed in their Southeast Asian setting appear in works such as Barnes (1989a); Maxwell (1980); and Nooy-Palm (1975).

65 Silk skirtcloths (*sampot*) with gold thread brocade are known in Khmer, for example, as *sampot sarabap* (Stoeckel, 1923: 399). *Sarabap* appears to be a term derived from the name of an early type of Indian trade cloth. While the trade cloth term, *serribaff*, is said to have referred to fine muslin (Irwin and Schwartz, 1966: 71), *sarabaf* may well have been derived from Persian and Indian textile words like *zari* (gold thread) and *bafta* (woven) as the Khmer textile most closely resembles the gold brocade fabric known in India as *kinkhab* (Nabholz-Kartaschoff, 1986: 184–5). Certain gold thread brocades in central Thailand are known by similar terms, such as *pha yerabab* and *pha khem khap* (P. Cheesman, personal communication, 1988).

66 One example, illustrated in Guy (1989), has been dated at 1635 and is now in the collection of the Australian National Gallery, Gift of Michael and Mary Abbott, 1989.

67 Indian trade textiles were justly famous over several centuries not only in Southeast Asia, but throughout Europe and other parts of Asia including Japan.

68 It appears that responses to foreign goods varied, with some groups being notably conservative in their demands for trade cloths and rejecting any which fell outside prescribed patterns. Other communities appeared more eclectic, and some expected new and different variations each season and refused last year's fashion.

69 Some of the more modest examples of trade cloth have survived as part of ceremonial garments such as jackets. In most cases, however, these were discarded when worn out, while heirloom hangings have often remained relatively intact through limited use.

70 For a detailed account of the techniques, see Irwin and Schwartz (1966: Part 2), Gittinger (1982: 19–29) and Varadarajan (1982: 51–9, 75–89).

71 *Basta*, the term for certain trade cottons in Babar and throughout the southern Moluccas, is derived from the trade term, *bafta*, a type of Indian cloth, the origins of which are described in Irwin and Schwartz (1966: 59).

72 The continuing importance of Indian cotton cloth in

the ritual and costume of the Babar archipelago is outlined in van Dijk and de Jonge (1990). Red in the Babar archipelago is also the colour of warriors' headscarves.

73 One of these jackets is illustrated in Gittinger (1982: 164). They can also be identified on guardian figure sculptures at the National Museum, Bangkok.

74 A rare, late nineteenth- or early twentieth-century photograph shows these tunics on a group of male and female priests in the mountain district of Tengger in east Java (Gittinger, 1979a: 123; Veldhuisen-Djajasoebrata, 1985: 78). They are flanked by retainers carrying the umbrellas of rank.

75 However, a few rare examples of Indian trade cottons with a patchwork design have appeared in Japan and Indonesia: a Japanese heirloom is illustrated in Yoshioka and Yoshimoto (1980: Cover Plate); a photograph of a similar textile taken in Java in the early twentieth century can be found in the American Museum of Cultural History, New York (36798); and the Victoria and Albert Museum has recently acquired another *dodot*-style Indian textile found in Sumatra with a patchwork design.

76 A photograph of a young woman from the court of the Susuhunan of Surakarta formally dressed in a *tambal*-patterned batik appears in Veldhuisen-Djajasoebrata (1984: 89).

77 The nexus between these elements is tentatively discussed in Maxwell (1981). P. Graham (personal communication, 1987) reports that the painted carvings on one part of the *korké* in east Flores are stylized representations of sacred *patola* designs.

78 Prehistoric objects with this diagonal pattern from Southeast Asia are illustrated in Bellwood (1979: 215, 224).

79 Some gold leaf gluework apparently was applied in the Coromandel region of India (Diebels et al, 1987: 112), though particular regional variations were obviously executed in Southeast Asia (Loebèr, 1914: Figs 1–5).

80 While this is not a striking feature of Indian domestic textiles, it was certainly a popular feature of those made for the Southeast Asian markets, possibly to suit regional demands.

81 This is a common term throughout western Indonesia. The motif is apparently also known as *tumpala* to the Mandaya of the southern Philippines (Roces, 1985: 3).

82 When skirtcloths displaying a head-panel (*kepala*) are wrapped or folded correctly, this part of the design is often displayed at the rear.

83 Ancient symbols continue to be subsumed by or adapted to new ideologies and religious philosophies, and are explained in new or more comprehensible terms. The *patola* star design on Lio shawls is now identified as a crab (or on Javanese batik as the chicken's foot). In the late 1970s in central Flores the pattern on an old Indian cotton print heirloom was identified by Catholic villagers as the obelisk-like shrine (Ka'abah) at Mecca visited by Islamic pilgrims. This was the electioneering symbol of a political party in the 1977 Indonesian general elections.

84 Figures of a comparable style are combined with other patterns on a Toraja painted *ma'a* illustrated in Solyom and Solyom (1985: 39).

85 In contrast to the Balinese *geringsing* textiles, the ancient Javanese batik pattern of the same name appears to have no iconographic connections with trade cloths and is not a restricted pattern. The term *geringsing* is an old Javanese word meaning 'not ill' and the batik cloth or pattern to which this name was applied is believed to be, like the Balinese *geringsing*, a talisman to ward off evil (Ramseyer, 1983: 22–3).

86 A *kamben cepuk* is evident in a photograph of a tooth-filing ceremony in Wassing-Visser (1984: 20).

87 Similar motives no doubt encouraged Southeast Asian potteries to produce Chinese-style vessels with Chinese designs and motifs, and shapes intended for trade.

88 For an account of Indian pigment cloth-painting, see Talwar and Krishna (1979).

89 For a precise description of the painting technique used in Bali, see Forge (1978: 9–11).

90 A few rare examples of these textiles are held in the collections of the Field Museum of Natural History, Chicago and the Museum of Natural History at the Smithsonian Institution, Washington.

91 In Southeast Asia the presence of Indian artisans along with the artifacts did not change the established division of labour in textile work from female to male.

92 Although geometric designs similar to these appear on the skirtcloths of early Javanese sculptural figures, there is no real indication of how such patterns were achieved.

93 Indian batik is also produced by the use of a pen or a stamp. However, the tools and techniques developed in Java were significantly different from those used in India. Batik on Indian trade cloth tended to be a crude, subsidiary decorative technique.

4 Chinese Themes

1 This is in large part due to lack of archaeological finds of silk in Southeast Asia. It may also be related to the treatment of textiles as a minor art form by Western art historians in contrast to their long admiration of Chinese ceramics.

2 For a description of Dong-Son style, see Bellwood (1979: 183–91).

3 One of the most influential proponents of this theory was Heine-Geldern (1932). Wagner (1959) also adopted this approach in his general text on Indonesian art, while other writers have gone as far as to suggest that this represented the spread of 'Chinese' influence (Koenigswald, 1961).

4 Recent research into the issue of prehistoric migrations and the development of a metal culture in Southeast Asia is summarized by Bellwood (1979: 153–232).

5 The costumes of the ethnic minorities of southern China are richly displayed in a volume produced by the China Art Publishing Company (1982). For a specific study linking southern Chinese textiles with the costume of the Hmong of Southeast Asia see Gittinger (1985: 163–8). In the same volume, Nabholz-Kartaschoff (1985: 155–62) looks at the textiles of the Hmong, Akha, Mien, Lisu, Karen, Lawa and Lahu peoples.

6 In this volume, most studies of particular ethnic groups in the mountainous interior of mainland Southeast Asia include brief histories of their migrations into the area from China or neighbouring Southeast Asian countries. In his concluding essay 'Behind and Ahead', McKinnon (1983) points out that these movements of people south from the interior of Asia have been occurring from prehistoric times down to the present day.

7 Vollmer (1979) discusses the discovery of the parts of a metal loom in a Bronze Age tomb in Yunnan, and suggests that these may have been created for ceremonial purposes rather than for everyday use. Several other Metal Age objects depicting weavers have been recorded. These include a cowry-shell container from a Yunnan site, with a group of bronze weavers around the lid (National Gallery of Victoria, 1977: 80), and a bronze weaver found in Flores (Adams, 1977). Adams also outlines the distribution of foot-braced looms in present-day Southeast Asia (92).

8 For illustrations of recent supplementary weft textiles of southern Chinese ethnic minorities see, for example, China Art Publishing Company (1982).

9 Steinmann (1947b: 2101). It is possible, however, that Steinmann was mistaken and incorrectly identified as batik the technique of stitch-resist dyeing used on warriors' outfits.

10 Examples of batik from the eighth century have been preserved in Japan's Shoso-in, the imperial storehouse at Nara. The motifs on the batik show the exchange of designs that occurred along the Silk Road, with Persian influence apparent in the treatment of trees and animals such as rhinoceros and elephants that were not indigenous to China. For a discussion and illustrations of these textiles see Hayashi (1975) and Matsumoto (1984).

11 Objects from Southeast Asia were so described in the Chinese document, *Chi'en Han Shu*, dated AD 80 (Wheatley, 1959: 19).

12 From as early as the Han period the Chinese traded gold and silk, and in fact silks and brocades preceded porcelain as exports to Southeast Asia (Wang, 1958: 53). For a history of the development of the Nanyang (Southern Ocean) trade, see Wang (1958). Groeneveldt (1887) uses Chinese sources to document early Chinese contacts with Southeast Asia, as does Rockhill (1915) for the fourteenth century. Guy (1986: 1–43) discusses the early Chinese trade to Southeast Asia in relation to ceramics.

13 See Wallace (1983: 79). The Romanized Chinese character for silk is *si* or *ssu*. *Yü* appears to have been a Chinese term for a type of satin (Wilson, 1986: 46) and *ju* also appears to mean weaving (Wilson, 1986: 98). Mailey (1971: 18) also mentions *chu-ssu* as a type of Chinese tapestry weave. *Ch'ou* is used generally as a term for silk and *shi* for shantung (Schafer, 1962: 201, 326). *Hsi* probably means thread and *pu* means cloth.

14 Remnants of silk have been discovered at the Ban Chiang prehistoric sites in north-east Thailand, an area where silk weaving remains an important skill to the present day. These archaeological finds indicate that silk textiles were known in this part of Southeast Asia some 3000 years ago (Chira Chongkol, 1982: 124).

15 Unlike Indian textiles, there is little remaining evidence and almost no examples of decorative Chinese textiles in either villages or courts of Southeast Asia (or museum collections). The Bangkok National Museum contains a few relatively recent and simple items.

16 There have been a number of significant studies of Chinese and Southeast Asian ceramics found throughout Southeast Asia. See for example, van Orsoy de Flines (1972); Frasché (1976); Brown (1977), and Guy (1986).

17 For example, the Chinese produced porcelain in Thai style specifically for the Thai market. Like the Indian cotton textiles produced for the Ayutthaya and Bangkok courts, it was also known by the term, *lai thai* (Robinson, 1981: 76–83).

18 According to Rostov and Jia (1983: 128), Chinese coins have taken this form since the Qin dynasty (221–207 BC). Coins were often considered to be lucky charms and talismans, and coin motifs appear as propitious symbols on Chinese textiles and carpets, especially as a border pattern.

19 Chinese coins continued to be used as local currency in Bali until the Second World War.

20 See Ramseyer (1977: 35, 165, plates 217, 223–4, 233). Cambodians also construct money dolls from coins as propitious wedding symbols.

21 Chinese coins are also hidden in the corners or fringes of tapestry-woven canopies and are a prominent part of Sasak bride-wealth payments.

22 For discussion of the meaning of the coin symbol, see Rostov and Jia (1983: 128); Morgan (1972: 101–2); and Hawley (1971: supplement item 114).

23 Folk history attributes the introduction of the men's *sampot* into Funan to the Chinese (Hall, 1968: 28). The garment is not recognizably Han although the silk tradition undoubtedly came from the north.

24 Adams's (1974a) article discusses Mien (Yao) costume. The Hmong are also renowned for embroidered collar squares and badges.

25 The sixteenth-century Javanese hero and first ruler of Demak, Raden Patah, is believed to have been the son of the last ruler of the great kingdom of Majapahit, and a Chinese princess, Putri Cina (Ricklefs, 1981: 34). Similar stories are recounted of a beautiful Chinese woman, sometimes said to be a Chinese princess, marrying the Sultan of Malacca. It is claimed that various Malay royal houses are descended from this alliance (Tan, 1988: 29–31).

26 I am indebted to M. Somers Heidhues (personal communication, 1986) for this information.

27 These cloud collars, which were already in use in eighth-century Japan and China, are based upon an ancient Buddhist lotus design in which the lobes form the petals.

28 Among the Lisu of mainland Southeast Asia,

however, silver stud decorations form a collar shape against the dark fabric of men's jackets.

29 The Chinese are reported to have made gold thread brocade as early as 300 BC although it is unclear whether this was in warp-patterned or weft-patterned weaves. Weft brocade seems to have developed in China in the seventh century AD during the early Tang dynasty. Gold thread appears to have begun in China as flat gold ribbon cut into narrow strips from very thin sheet metal. It was then developed into very thin leaf gold and wrapped around animal membranes, which gave a soft and pliable thread although the gold leaf was easily rubbed off. Other Chinese brocade fabrics are made from gilt leather strips, and later, as in Southeast Asia, gilt paper was used.

30 These embroidered squares carry almost the same name as the supplementary weft cotton ritual textiles (*tampan*) of south Sumatra. Both textiles are of similar dimensions and are a good example of how certain ancient textiles have been transformed by gold and silk thread embroidery into more spectacular ceremonial objects. A photograph of recent versions of the embroidered *tetampan*, worn by Malay courtiers and as a part of the royal regalia, appears in Sheppard (1972: 25).

31 From the *Hikayat Angun Cik Tunggal* quoted in Siti Zainon Ismail (1983: 12).

32 An elaborately carved marriage bed adorned with ornamental textiles also became a central feature of the new year offerings made by the Mien to the protective spirits of the family (Adams, 1974a: 59).

33 Mirror-work is also a prominent decorative element on the textiles of north-west India and some of these textiles also found their way to Southeast Asia. However, the larger numbers of Chinese textiles displaying mirror appliqué have undoubtedly been the more significant factor. Mirrors are sometimes also fixed to items of Southeast Asian ceremonial costume. This technique is evident in the textile work of the Abung and Kauer peoples in Lampung and a number of their skirts are decorated with small mirror discs set within the bands of couched gold thread.

34 On Bali, the gilding of cloth has been predominantly the work of men (Loeber, 1914: 48). The application of gold leaf may be associated with metal-work which, like woodcarving, is part of the male domain in Southeast Asia.

35 For a succinct overview of Southeast Asia's Chinese minorities, see Somers Heidhues (1974: 1–7).

36 For a discussion of the various factors influencing either assimilation or acculturation of the Chinese in various parts of Southeast Asia, see Somers Heidhues (1974: 30–43).

37 Chinese silver- and goldsmiths worked for both Chinese and Malay customers but tailored their designs to the tastes of each community.

38 In nineteenth-century photographs, the local leader (*Kapitan*) of the Chinese communities in towns throughout Sumatra and Java invariably appears wearing full Chinese costume.

39 A similar trend occurred with European-style textiles and textile techniques when European women began to arrive in Southeast Asia in large numbers in the second half of the nineteenth century.

40 Batik textiles of this design format, with rows of bold triangles on the head-panel, are illustrated in the lithographs that appear in Raffles's *History of Java* (1817).

41 The printed cotton cloths worn as everyday wear by Tai Thai and Khmer women are largely modelled on north-coast Javanese batik.

42 In fact many of these Chinese symbols had already shed their original sophisticated and multi-referential meanings in Chinese art by the Qing period (Cammann, 1953: 195–6, 227–8).

43 The depiction of flowers and plants in vases forms an important homonym for Chinese-speakers, as the word for vase sounds the same as the word for peace (Myers, 1984: 39). However, this has had little significance for the non-Chinese-speaking Peranakan communities of Java.

44 These Chinese symbols can convey different

meanings to different people. Although the pomegranate was an early Chinese symbol of fertility, Cammann (1953: 195) points out that to many Chinese it merely suggests the abundance of joy, wealth, children and wisdom. The pomegranate is not a Southeast Asian fruit, but it appears occasionally in batik designs made in Lasem on the north coast of Java, a district that has absorbed many Chinese motifs.

45 The bat motif does, however, appear on the embroideries of the Mien who have far closer cultural affinities with the Han Chinese.

46 Illustrated in Chia (1980: 150). See Solyom and Solyom (1985: 42) for an illustration of this batik pattern. Chinese gambling scenes were a familiar aspect of life in Southeast Asia, and early European lithographs show Chinese card players still wearing the characteristic queue hairstyle, which is sometimes depicted on nineteenth-century batik patterns.

47 On the majestic family altars of the wealthiest Southeast Asian Chinese families, especially those who had regular contact with China and who were influential in economic and political affairs there, the altar-cloths displayed the correct configurations of symbols. With their closer cultural ties, such cloths were probably brought directly from China.

48 Elsewhere in Southeast Asia the swastika motif has been identified as a specific flower, for example the *nra pu* pattern of the Kachin weavers of Burma (Fraser-Lu, 1988: 100).

49 A mountain range motif was already in use during the Han dynasty and this motif is also apparent on early Chinese porcelain.

50 Despite the evident Chinese influence, Abdurachman (1982: 148) points out that these batiks were not created by Peranakan Chinese communities but by members of a mystical Islamic artisans' guild in Trusmi and elsewhere in the Cirebon region. One of the most famous examples of this pattern dating from the mid-nineteenth century was collected by the cultural historian Rouffaer, and appears in Veldhuisen-Djajasoebrata (1984: 54).

51 These are large storage jars often with dragon motifs which take their generic name in Southeast Asia from the Burmese port of Martaban through which part of the ceramic trade passed.

52 A spectacular dragon-ship motif appears in gold leaf and tempura on a splendid Balinese *tritik* and *prada* cloth formerly in the collection of the Prague National Museum. This textile is illustrated in Forman and Forman (1957: 248–9, 264–6). Curiously, a photograph of the same textile appears in a recently published work where it is listed as part of a 'Prague private collection' and erroneously described as batik (Forman, 1988: 116). A beaded mat used as a bridal-seat from Lampung, in the collection of the Museum Nasional Jakarta, also exhibits a powerful dragon-ship motif (Museum Nasional, 1980).

53 The crane, another Chinese symbol, is often confused in flying form with the phoenix although it appears standing distinctively tall on other textiles. A drawing in the Raffles collection at the British Museum also shows a Javanese bride with a head-dress featuring a backward-looking crane (A. Forge, personal communication, 1988).

54 Examples of simply decorated diadem, from Jepara on the north coast of Java, with ornaments depicting the bird and rider and pots of flowers, appear in Jasper and Pirngadie (1927). The head-dress is apparently known there as *oklo*. A photograph taken around 1920 in Pasuruan in east Java, also shows a young boy wearing a head-dress and collar at his circumcision (Veldhuisen-Djajasoebrata,1984: 122).

55 Tapestry-woven fabrics from seventeenth-century colonial Peru reveal the marked influence — in technique and motif — of the Spanish-Chinese trade that passed through the Philippines.

56 For the tapestry weave of the Lesser Sunda islands of Indonesia see Nooteboom (1948). For detailed diagrams on the technique in Borneo and Sulawesi see Jager Gerlings (1952: chapter 2).

57 The presence of tapestry weave textiles on the islands of Seram, Sumbawa, Lombok, northern Borneo and in the southern Philippines also suggests Islamic inspiration, perhaps in the form of flat-woven carpets.

58 See Solyom and Solyom (1973: 27, Plate 9) for a Bajau Darat (Lowland Bajau) cotton headcloth from Sabah. For a detail of a Kadazan woman's skirtcloth with a tapestry weave band similar to the Maranao *langkit*, see Fraser-Lu (1988: Plate 25).

5 Islamic Conversions

1 Isolated objects, including ancient glass beads and coins of Roman manufacture which date from that very early trade period, have been found in Southeast Asia.

2 Although most of Thailand and the inland kingdoms of mainland Southeast Asia did not convert to Islam, the growth and spread of Theravada Buddhism during much the same period stimulated the growth of trade and an appreciation of new ideas and foreign technologies in these areas.

3 Islamic Holy Days and their celebration have become important separate events in the annual ritual calendar, though where Islam has had to accommodate powerful indigenous beliefs, as in Java, a synthesis of ancestral and Islamic celebrations has inevitably occurred. For instance, in central Java, the ancient fertility rite of Garebeg is now enacted on Muhammad's birthday.

4 The number of tiers of the umbrella is in accordance with the rank of the deceased and extends to thirteen for the sultan (Bruno 1973: 136).

5 Islam in Java has been particularly accommodating to pre-Islamic traditions, stories from the courtly romances of the Panji cycle have remained prominent in literature and theatre.

6 During this period of its history, Lombok had fallen under the political suzerainty of Sumbawa and Makassar.

7 The five obligations of Islam are belief in one God and in His Prophet, regular prayer throughout the day, the payment of alms to support the poor, fasting during the month of Ramadan, and the pilgrimage to Mecca.

8 Much of lowland Lombok was colonized by the Balinese in the seventeenth century and Lombok remained under Balinese control until the defeat of the Balinese aristocracy by the Dutch in the early twentieth century. Balinese influence is still strong in the west of Lombok.

9 Water, believed to weaken the boundaries between one spiritual state and another, has an ancient history in the rituals of Southeast Asia, and is especially prominent at marriage and funeral rites, and during the installation of rulers when holy water from sacred springs is often evident. The use of water in rituals has continued under Islam although the meaning and purpose has often shifted towards notions of ritual cleanliness.

10 See Hitchcock (1983: 204) for a different interpretation of this terminology.

11 This custom has its corollary in the Buddhist cushions of merit in Laos and Thailand.

12 The Balinese village of Tenganan appears to be another example of a community that has established its independence and wealth because of its exclusive control over the making of magical cloths for the aristocracy (Ramseyer, 1983: 22).

13 Many of the rulers continued to use Indic terms such as *raja* or *sunan* rather than adopt the Islamic title of *sultan*.

14 The baby-carrier, a length of cloth also widely used throughout Java and Sumatra, may have been a forerunner of the *selendang*, while sashes of office or rank worn in various ways across the shoulder are the male form of this. For example, the T'boli community leaders (*datu*) wear the *angkul* as a 'sign of eminence', a cloth arranged diagonally across the chest and gathered on to a wide band.

15 Amilbangsa (1983: 83–7) outlines the many uses of the *patadjung* of Sulu and Tawi-tawi. These cylindrical cloths include imported batik and ikat cloths from Indonesia and Malaysia, Indian checks and stripes and locally woven fabrics.

16 While turbans never became popular in Southeast Asia, the long lengths of fine imported cloth which were used to construct turbans did find favour in some non-Islamic parts of insular Southeast Asia as material for men's loincloths (Visser, 1989).

17 Figures from that period are rarely recorded wearing headcloths. The absence of references to headcloths during the Hindu Javanese kingdoms is noted by Wurjantoro (1980: 198). However, Hindu Balinese priests (*pedanda*) wear tall head-pieces and some of the earliest Javanese *wayang* puppets include similarly capped figures (Forge, 1989).

18 The women's head-dresses, however, appear to be modelled on more ancient forms — the buffalo-horn crescent shape, or the Indic head-ornaments which still appear on the Javanese *wayang* puppets.

19 The most common name for the Malay headcloth is *tengkolok* but it is also known in different regions by various other terms including *tanjak, setangan, destar, bulanghulu* and *pemuntal*.

20 The headcloths of the Yakan and the Tausug are very similar to those of the Bajau, another sea-going people with a similar cultural history (Solyom and Solyom, 1973: Plate 4; Fraser-Lu, 1988: Plates 26, 27).

21 T'boli legends include an account of an ancestor who removes her headcloth to find that it has been transformed into a shield to forestall an enemy. During T'boli wedding ceremonies, while the bride's abaca covering is symbolically removed before the wedding by her in-laws, so, too, is the groom's headcloth (Casal, 1978: 75).

22 In Hindu Java, jackets were known by the same term as the one which the Iban still use for that item of costume, *kalambi* (Wurjantoro, 1980: 201). A rare early depiction of a jacket appears on an eighth-century bronze figure from Java (Brown, 1985: 125).

23 Hall (1968: 219) notes that Acehnese rulers and through their influence other rulers of the Malay peninsula and the archipelago were said to have adopted the Mughal style of dress.

24 As access to replacement costume became impossible, and as the coats had to accommodate rulers of different sizes, the ways in which these coats were used eventually changed and in many cases they have been worn for at least a century as combination waistcloths and hipcloths.

25 The *dakwah* Islamic missionary movement in recent years has encouraged young Malay women in Malaysia to adopt the full veil.

26 The use of pants constructed of muted indigo handspun striped fabric by the Dou Donggo women of mountainous eastern Sumbawa suggests the possibility that this form of dress may also once have been worn by women throughout the rest of Bima. The Dou Donggo term for pants, *deko*, is also used by the Manggarai people of west Flores (a region once controlled by the Sultanate of Bima) for their men's short trousers. The Bimanese people of Sumbawa now wear the plaid skirtcloths of the Buginese world, with brocaded textile cylinders reserved for ceremonial occasions.

27 The ancestors of present-day Perak embroiderers are said to have migrated from Sumatra. Such migrations and their influence, however, did not only flow in that direction for local histories in the east Sumatran province of Riau attribute the establishment of weaving there to a Terengganu woman who is said to have introduced the skills of *songket*-making to the court of Indrapura in the eighteenth century (Tampubolan, 1978: 8).

28 The *bouraq* replaced other ancient flying creatures depicted in Sumatran art. The carved hornbill on the chariots of Lampung can be compared to the bewinged creature with the head of a *bouraq*, which emblazons the front of the bridal carriage (*pelarakan*) in the Pasemah district of Bengkulu (Jasper and Pirngadie, 1927: 7).

29 The prominence of mirrors on ceremonial objects may relate to the belief that mirrors keep evil spirits at bay. The Samal of the Sulu archipelago apply small mirrors to their grave-markers for this purpose (Szanton 1963: 39). Straits Chinese communities share these beliefs about mirrors frightening evil spirits, although they cover the mirrors in the house during weddings.

30 Evidence of Indian embroideries from north-west India imported into Southeast Asia can be found in nineteenth-century museum collections. For example, a number of Indian embroideries found in Lampung are in

the collection of the Rijksmuseum voor Volkenkunde, Leiden.

31 In the Malay community of Pontianak in west Kalimantan mirrors were replaced earlier this century by silver paper, metal discs and silver ribbons.

32 European museums also include these imported shawls in their collections of Southeast Asian objects. For instance, nineteenth-century examples collected in Aceh can be found in the Rijksmuseum voor Volkenkunde, Leiden. The Muzium Negara in Kuala Lumpur has an example acquired in Terengganu.

33 This technique is known in Iran as *dhus-duzi* (Gluck and Gluck, 1977: 236–7). The technique spread to the far corners of the Islamic world. An Algerian example is published in Champault and Verbrugge (1965: 114–15).

34 Small square cloths were popular as the basis of betel-nut sacks or holders for toiletries. The four corners, sometimes tipped with precious metal, were passed through small decorative rings to form a reticule. Throughout Southeast Asia, and particularly in the Islamic sultanates, this decorative kerchief-sachet became part of formal costume.

35 For other textile techniques that appear to emanate from south Sulawesi, see Visser (1989).

36 The extent of the Arab involvement in batik manufacture in certain regions of Java in the early twentieth century is outlined in Kat Angelino (1930).

37 Grabar (1973) provides a detailed discussion of the attitudes to and the development of art in the early Islamic world.

38 It is clear that many of the less significant Indian trade cloths, particularly the yardage types, also consisted of stripes and checks (R. Laarhoven, personal communication, 1988).

39 The *kamadhenu* has a female head and a cow or horse body. The *navagunjara* is another of the forms of the great god Wishnu. Both the *bouraq* and the *navagunjara* are illustrated on Indian cotton textiles (Fischer, et al. 1982: 106–7).

40 It is clearly inappropriate to sit on certain religious images, and hence textiles containing these motifs are reserved for hangings and other items, and are occasionally used as clothing for the upper body.

41 For an analysis of the use of the hand motif in Middle-Eastern and Central-Asian Islamic art, see Champault and Verbrugge (1965).

42 The bird with a jewel in its beak is also found in Tai and Lao art although it is not a prominent motif. This ancient motif also appears in Chinese art. Hayashi (1975: 128–9) discusses some of these avian motifs, including cranes, falcons, parrots and geese, holding various symbols in their beaks.

43 An Acehnese oil-lamp in the shape of this bird is illustrated in van der Werff and Wassing-Visser (1974: 20).

44 More commonly, the calligraphy includes birds as mystical symbols of humanity (Welch, 1979: 180). For examples of calligraphic animals, see Welch (1979: 181) and Safadi (1978: 136–7).

45 Similar images appear on reverse glass painting and wood panelling from north-coast Java.

46 An immense textile, richly decorated with calligraphy, is draped around the Ka'abah at Mecca during the annual Islamic pilgrimage. After the ceremonies are completed, the textile is divided into fragments which are presented as powerful talismans to important dignitaries participating in the hajj.

47 Like the paper message (known as *wafak*) suspended over the door of Islamic homes, textiles with these images indicate the owners' religious piety and provide protection against evil.

48 Welch (1979) notes the protective application of calligraphy on Turkish coats of mail. Fragments of Koranic phrases also act as charms (*jimat* or *azimat*) throughout Islamic Southeast Asia (as do fragments of sacred Buddhist texts and calligraphic tattoos in mainland Southeast Asia) and small pieces of paper inscribed with holy verses are sewn into neck-pieces and worn for security.

49 Among the textile treasures of the court of Johore on the Malay peninsula, are a number of collarless

tunics with a small slit opening at the throat (in the style of *baju kurung*). Most are fashioned from rich gold and silk brocade imported from India and a few also have Arabic calligraphy bearing pious phrases within the woven patterns.

50 Certain small square textiles serve as Koran wrappers in some Islamic courts and homes.

51 For discussion of the value of calligraphy as symbolic affirmation and protestation of religious affiliation, rather than a direct means of communication, see Ettinghausen (1974).

52 There are also names of owners marked on to cloths at a date after their completion. This occurs particularly where textiles are borrowed between groups for great ceremonies.

53 In this explanation, the article the fish dangles from the beak is a love note (Hartendorp, 1953: 8–9).

54 Unlike most of the mat interlacing in this part of the Philippines which is woman's work, the *boras* mats are made by men and painted by women.

55 Persian art was also much affected by Chinese images including the dragon and the phoenix, and by decorative devices including cloud and thunderbolt swastika-like meanders.

56 While trade records tell of their import and local architectural design favoured their use, carpets appear to have contributed little to Southeast Asian textile development. The continued manufacture of finely plaited mats suggests that these were generally regarded as more suited to the climatic conditions of most of Southeast Asia.

57 Iwan Tirtaamidjaja (personal communication, 1984) suggests that in batik this became tied to the form of design — freehand for men, repetitive patterns for women. This is in fact the opposite to most twentieth-century batik where men produce repetitive patterns with metal stamps and women produce freehand *tulis* designs.

58 In west Kalimantan and Sarawak, this is captured by the phrase *turun ke Melayu* (going down to become Malay), a term synonymous with conversion to Islam.

6 European Incursions

1 On this aspect of the European trade, see, for example, Prakash (1984; 1985) and Arasaratnam (1986).

2 Such a procedure was especially the case in eastern Indonesia where the existing political systems were relatively fluid and were related to control over land and ritual and to the origin of the earliest settlers. In contrast, the Dutch-appointed *raja* were assured of hereditary positions and titles in return for their loyalty to the colonial administration and its monopoly over trade.

3 In fact Daendels, Governor-General of the Netherlands East Indies (1808–11) decreed that the Dutch residents, the colonial officials who were placed in charge of regions, were also to use the golden parasol of rank (Sutherland, 1979: 8)

4 These included textile-related commodities such as Manila hemp (abaca) and indigo.

5 Savunese men's cloths also indicate *hubi* membership. The men of *Hubi Ae* wear the *higi huri worapi* while the men of *Hubi Iki* wear the *higi huri wohepi*.

6 It is impossible to date this change precisely, but it probably occurred during the nineteenth century. The earliest and finest group of textiles from Savu in any museum collection is in the Rijksmuseum voor Volkenkunde, Leiden and dates from early in the nineteenth century. Although there are many beautiful examples of *ei ledo* and *ei raja* and of men's cloths, it is significant that there are no examples of the *ei worapi* form.

7 The use of *patola* by the local rulers in the southern Philippines predates the arrival of the first Spanish travellers in this part of the region, and the finest trade cloths appear to have been a symbol of the *orang kaya* (wealthy families) as well as of the sultanate.

8 This, however, followed a long period of conflict in Aceh between traditional and Islamic leaders.

9 Sheppard (1982: 32–3) illustrates a Buginese set of metal armour from south Sulawesi. The American Museum of Cultural History in New York has a number of examples from the southern Philippines.

10 A number of early examples of these ecclesiastical robes and other textiles are still preserved in Filipino religious institutions such as the San Agustin Museum in Intramuros, Manila.

11 Versions of Thai and Malay brocade made on Jacquard looms on the east coast of India for export to Southeast Asia from around the same period also seem to have been successful.

12 Ironically, these imitation batiks were extremely profitable in West Africa (Kroese, 1976). Many of these industrialists' collections are now housed in European and British museums. Among the earliest are the Bevering collection at the Museum of Mankind, London and the collection at the Musée de l'Impression sur Etoffes, Mulhouse, France. The textile patterns that resulted can be found in a number of textile company swatch books that were produced seasonally. A huge collection of 'Java print' designs from the Haarlemsche Katoen Maatschappij are now in the Vlisco archives at Helmond in the Netherlands.

13 See Nooy Palm (1980; 1989). The designs on these European *sarita* may also have been influenced by other sources including decorated bark-cloths and Toraja architectural carvings.

14 A Tinguian example is illustrated in Casal (1981).

15 Many of the Spanish influences on the textiles of the Philippines came through the colonies in the Americas where a distinctive Spanish colonial style had developed.

16 While embroidery terms in the Tagalog-speaking areas of the Philippines are all derived from Spanish, weaving terms are Tagalog and bear a marked similarity to the terminology used by many other Austronesian language groups. For instance, *hanay*, to set up a warp; and *balila*, the weaving sword (Scott, 1982: 528–9).

17 See Roces (1985). In a similar fashion, the well-known Javanese batik pattern obviously inspired by an Indian trade cloth design also takes the same name (*cakar ayam*, chicken's footprint).

18 These and other items from the *Batavia* are in the collection of the Maritime Museum, Fremantle, Western Australia.

19 There are a number of published photographs of such costumes. Sachse (1907: 80) shows the daughters of a Christian regent on the island of Seram in the Moluccas wearing white knee-length, long-sleeved jackets over what appear to be Salayer plaid skirts with a small supplementary weft pattern.

20 Raadt-Apell (1980: 15–16) illustrates two fine examples, one with machine-made lace, the other hand-made.

21 Southeast Asians are not alone in this regard. It has been argued that the British royal ceremonial traditions were also 'invented' in the nineteenth and early twentieth centuries (Carradine, 1983).

22 Batiks for weddings and festive occasions were made more sumptuous with the addition of gold leaf gluework (*prada*). It seems that the way gold was applied at the Indo-European batik ateliers was closer to the traditional painting practices of Europe. After the batik had been calendered, a mixture of linseed oil, incense and ochre-like clay was brushed on to the fabric in the desired pattern. As in Europe this bole served to heighten the colour of the Chinese gold-dust which was applied after drying the next day (Jasper and Pirngadie, 1916: 79). This process was also intended to render the *prada* more amenable to washing, a criteria usually irrelevant to the heirloom and sacred cloths of other cultures to which gold leaf is added.

23 Javanese batik, particularly those north-coast styles with large floral and bird patterns against a contrasting ground, and derivative regional prints can be traced into many other parts of the Southeast Asian region. They have been found in Cambodia, throughout Thailand, the Philippines and across Indonesia. Fox (1982) shows many photographs of batik cloth in use in Palawan, in the central Philippines. Stoeckel (1923: 400) mentions that batik was imported to Cambodia from Java by Malays.

24 Illustrations of contrasting ancestral and war-inspired motifs in supplementary weft in the same traditional cloth format appear on the covers of Gerald Hickey's two volumes on the ethnohistory of the Vietnamese central highlands (Hickey, 1982a and 1982b). The women say 'We weave what we see around us' (1982b: 249).

25 See Brus (1989) for illustrations of various European-style gold crowns that are part of royal regalia in the sultanates of Malaysia. The same article shows the crowns of the Sultanate of Gowa, in south Sulawesi, which are modelled on European helmets of the Portuguese period.

26 It is likely that the lions that appear on Ilocano blankets (Roces, 1985: 3) were also inspired by Spanish doubloons and medals.

7 Conclusions

1 Despite their generic name, these cloths rarely originated from the island of Timor. A collection of them is located in the Rijksmuseum voor Volkenkunde, Leiden.

2 The existence of fibre textiles and looms similar to those of Indonesia and the Philippines, on the island of Madagascar off the coast of southern Africa, attests to the seaworthiness of some of the earliest ships of Southeast Asia.

3 For instance, the absence of the batik technique on Bali is generally regarded as confirmation of the relatively late development of this technique in central Java.

4 P. Cheesman, personal communication, 1988

5 For a recent photograph of these Sumba cloths in the Toraja area, see Rodgers (1985: 169). In fact these may be mass produced 'Sumba ikat' cloths made in north-coast Java for the international tourist market.

6 The Sahu continued to make beautifully ornamented bark-cloth until the early twentieth century.

7 Kulincucu was the name of the centre of Buton and Salayer weaving from which the princess who brought a retinue of weavers to Ternate came (Abdurachman, n.d.). The cloths used by the Sahu, however, may have been specifically made on Ternate by the descendants of Kulincucu weavers for the Sahu trade (Visser, 1989).

8 Despite the continued importance of textiles in ritual, in the twentieth century some aristocratic women have begun to consider the arduous task of making traditional textiles too demeaning and have chosen to avoid the dirty and time-consuming dyeing processes, particularly those associated with the use of indigo (Maxwell, 1985). This is most likely to occur, however, in areas where the central ceremonial importance of textiles has greatly diminished.

9 While additional colours have sometimes been added as highlights to basic traditional ikat designs before weaving, especially on weft ikat silk cloth, modern textile producers have discovered that printing or painting the patterns is a much faster method than the laborious and painstaking traditional tying and dyeing techniques. A description of how this process was adopted by the Buginese in the late 1930s can be found in Zerner (1983).

10 The simple but often ritually important striped fabrics are also unlikely to survive in the modern world since such items will have little or no appeal to tourists or visitors.

11 The demand for cheap ethnic fabric, particularly for both the foreign and domestic tourist market, has been met by the expansion of machine textile printing in factory conditions throughout Southeast Asia. A variety of patterns and designs are quickly produced in large uniform quantities by printing them either on to finished fabric in imitation of batik or on to the loom threads, for imitation ikat. This is a purely commercial operation and apart from the adaptation of some traditional designs, has nothing to do with traditional textiles or the methods used to create them. This is not an entirely new phenomenon for printed reproductions of imported Javanese batik were made in Thailand and Cambodia earlier this century, and the Thai products were also traded to Burma.

12 As we have seen, much of the early development of batik along the north coast of Java was inspired by market forces. However, the technique, designs and textiles have been long absorbed into regional usage.

13 It is difficult to discover whether the widespread secularization of textiles and the growing insignificance of ceremonial apparel hastened this shift in traditional sex roles. If textiles are no longer of great importance it may be irrelevant who makes them.

14 See Ramseyer (1987) on the *endek* industry in Bali and Sheares (1983) on twentieth-century weft ikat production in Java. Barbara Leigh (personal communication,1985) reports the move into couched embroidery by enterprising men in Aceh. They are apparently very well placed to control major tourist outlets.

15 Masina admittedly works in the Cirebon tradition where males have always had a prominent place in the making of batik textiles. In this region women weave cloth and men paint designs on textiles. This division of artistic labour between weaving and painting can be found elsewhere in Southeast Asia, including Bali and northern Thailand.

16 In many cases, it is the designs that are created by men, while women still wield the waxing pens and the weaving shuttles.

17 As Southeast Asian art follows Western models, painting, works on paper and sculpture have been the prime concern of artists and art historians. Textiles have been viewed as a minor decorative art form.

18 Holt (1967) isolates these features in the first chapter of her book on Indonesian art, where she focuses largely on the continuities and changes of such motifs from Indianized sculpture and dance to modern Indonesian painting.

19 The famous phrase by van Leur (1955: 95) was at the heart of an intense debate among historians about the timing and strength of European intrusions into the region.

abaca A 'hard' fibre obtained from the leaf sheaths of the wild banana plant, Musa textilis.

aniline dyes Aniline is a chemical substance derived from coal-tar. Discovered in 1856, it was the first synthetic dyestuff. The application of a number of dyes produced from aniline changed the world's dye industry (Robinson, 1969: 33–4). It is sometimes used as a general term for *synthetic* or *chemical dyes*.

appliqué The superimposition of areas of accessory fabric on a ground fabric, usually by stitching, for patterning purposes (Emery, 1966: 251). Also the application of any accessory fabric or object to the ground fabric usually with stitches. See also *shadow appliqué*.

backstrap tension loom A two-bar frameless loom with a backstrap, belt or wooden yoke passing around the weaver's back and secured to the *breast-beam*. The weaver controls the tension of the warp yarns by leaning forwards or backwards against the strap, while at the other end of the warp, another beam, known as the *warp-beam*, is held secure (Solyom and Solyom, 1985: 57). It is also known as a *back-tension loom* or a *body-tension loom*. See also *loom*.

back-tension loom See *backstrap tension loom*

bark-cloth Smooth fabric made from a fibrous plant substance, usually inner bark or bast, which is softened, flattened and felted by soaking and beating (Emery, 1980: 20).

base weave See *ground weave*.

basket weave A style of weave in which the pattern has the appearance of *matting* or basketry.

basketry See *matting*.

bast fibre 'Soft' fibre obtained from the stem structure of dicotyledonous plants (Emery, 1980: 5). See also *hemp*.

batik A resist dyeing process in which a substance such as hot wax or rice paste is applied to the surface of fabric as a resist to dyes to form undyed areas of pattern. The resist is removed by boiling, melting or scraping after dyeing. See also *canting, cap, block printing, resist dyeing, stick batik*.

bead weaving The threading of small beads on to the weft yarn before it is inserted into the warp.

beading A general term for the application of bead networks or strips of beads to a ground fabric. See also *netted beadwork*.

beadwork See *beading, netted beadwork*

beater See *sword*. A *bark-cloth* beater is a mallet with a textured stone or wooden head, used to pound the softened bark fibres into a flat fabric.

binding thread The resist fibre (often strips of palm-leaf fibre) tied in patterns around the warp or weft threads. This prevents dye from entering those sections of the threads. After the dye process, the resist bindings are removed before the patterned threads are woven. See also *ikat*.

block printing The use of carved wooden blocks to apply mordants or resist substances such as hot wax to the surface of woven cloth prior to dyeing.

bobbin An article, usually a small rod, around which the weft thread is wound for insertion into the warp during weaving. Also a small pin of wood, with a notch, used in lace-making. See *bobbin lace*.

bobbin lace Interlaced fabric made by manipulating groups of many separate threads by means of attached *bobbins*. The work is usually done on a pillow, hence the alternative term, pillow lace.

body-tension loom See *backstrap tension loom*.

bow An instrument, usually made of bent bamboo and held taut with twine stretched between each end, used to fluff cotton fibre during the carding process. The string of the bow is struck to produce vibrations which loosen any packed cotton fibres. See also *carding*.

braid A general term to describe a flat, decorative, woven or plaited tape or band used particularly to trim borders.

braid weaving The process of producing narrow bands of braid. Some types of braid are woven on narrow looms, while other braid is produced by interlacing elements by *plaiting* or *twining*. See also *needle-weaving, weft twining*.

breast-beam The beam in the *backstrap tension loom* closest to the weaver, around which the woven section of the warp moves or is rolled. It is also known as the cloth-beam. The backstrap of the loom is attached to this beam.

brocade A general term referring to the patterning of woven fabric by means of supplementary threads. It is usually applied to silk fabric richly patterned with gold or silver weft thread (Emery, 1980: 171). See also *supplementary weft (weaving)*.

burnish Make shiny by rubbing with a hard, smooth object.

calender A general term for polishing or *glazing* fabric.

canting The Javanese name for a small batik tool consisting of a wooden handle with a copper reservoir from which a spout or spouts permit the controlled application of the molten wax to the cloth surface. See also *batik*.

cap The Javanese term for a metal stamp, usually constructed of strips of sheet copper, used in the batik process to apply molten wax to the cloth surface. See also *batik*.

card weaving See *tablet weaving*.

carded cotton The fluffy, untangled and loosened cotton fibres prior to *spinning*. See also *carding*.

carding The process of untangling and loosening fibres of dried cotton, usually in Southeast Asia with the application of a *bow*, prior to *spinning*.

chemical dyes. See *aniline dyes, synthetic dyes*.

chintz A mordanted and dyed cotton textile of Indian origin, although in English the term is generally applied to highly glazed, floral, printed cotton. See also *palampore*.

comb A piece of loom apparatus consisting usually in Southeast Asia of fine bamboo slivers standing vertically between two horizontal bars. The comb acts as a warp-spacer and, when weaving, the weaver beats the comb against the newly inserted weft thread with her *sword*. It is also known as the *reed*. See also *comb loom*.

comb loom Any type of loom which includes a *comb* or *reed* for spacing the warps. In most instances this type of loom is characterized by a *discontinuous* warp.

commercial fibres Threads spun by machine. These include natural fibres such as *cotton* and *silk* and *synthetic fibres*.

complementary warp weaving A woven fabric structure in which two sets of yarn elements in the warp are co-equal. In *warp-faced* fabric this weaving method may produce an identical pattern on both sides of the cloth.

compound ikat See *double ikat*.

continuous circulating warp A set of warp threads or partially woven cloth, which make a continuous circle around the *breast-beam* and *warp-beam*. When the completed cloth is removed from the loom, it is also circular.

continuous supplementary weft (weaving) Supplementary weft patterning in which the extra ornamental weft threads are carried back and forth across the full width of the cloth (Emery, 1980: 141). See also *supplementary weft*.

cotton Fibre from the floss of the seed heads of cotton shrubs of the Gossypium family. See also *handspun cotton*.

couching A method of embroidery in which decorative threads are laid on the surface of the cloth and tacked in position with small stitches, which may themselves be arranged or coloured to create a pattern (Gittinger, 1979c: 233; Solyom and Solyom, 1985: 57).

crochet lace Open fabric formed by interlooping threads with a hooked instrument. See also *lace*.

cross-stitch An embroidery style in which two flat stitches of equal length cross the same small area of ground fabric at opposite angles.

cut-and-drawn thread A type of openwork embroidery which depends on the cutting and withdrawing of yarn from a woven ground fabric, and the stitching of the remaining threads and edges into decorative patterns. Also known as drawn threadwork.

damask A general term applied to fabrics patterned by floating weaves dissimilar on each surface, imported into Southeast Asia.

discontinuous fabric A fabric woven in such a manner that it is removed from the loom as a non-circulating, flat rectangle. The manner of *warping* the loom through a *comb* usually results in a discontinuous length of fabric.

discontinuous supplementary weft (weaving) Supplementary weft weaving in which extra weft threads are worked back and forth across limited areas of warp to shape pattern units (Emery, 1980: 141). See also *supplementary weft*.

double ikat The ikat-resist dyeing process applied separately to both warp and weft threads. The fabric is woven to achieve a balanced plain or *tabby weave* so that the patterning of both sets of loom threads emerges. See also *ikat*.

drop-weight spindle A small hand-held rod weighted with a disc (*spindle-whorl*) which is allowed to spin freely from some height, to twist the fibre into thread. See also *spinning*.

dyestuffs Materials used to colour threads or fabric. True dyes penetrate the fabric and bind to the fibres. See also *aniline dyes, natural dyes, vegetable dyes*.

embroidery Accessory stitches used to decorate or embellish a fabric, usually by means of needlework (Emery, 1980: 232). See also *embroidery frame, ribbon embroidery*. For couched embroidery, see also *couching*. For *three-dimensional couched embroidery*, see also *stumpwork*.

embroidery frame A rectangular wooden frame, with tapes of fabric fastened to each side, to which the ground or backing fabric for the embroidery is usually attached by stitching or lacing. Frames are used to keep the ground fabric taut and are especially necessary for couched metal threadwork.

embroidery stretcher See *embroidery frame*.

fabric A generic term for all fibrous constructions (Emery, 1980: xvi).

felt, felting A process of producing a firm fabric from the matting and adherence of a mass of fibres lying indiscriminately in all directions by mechanical processes such as pressure, moisture, pounding. See also *bark-cloth*.

fibres A general term referring to strands of plant or animal tissue, of naturally limited length, used in the construction of fabrics. Twisted fibres refers to the twisting of two or more strands of unspun fibrous material (Emery, 1980: 9). See also *commercial fibres, synthetic fibres, vegetable fibres*.

field The design element on a textile which contains a wide and often repetitive pattern. While usually occupying a central place in a design structure, the field on some Southeast Asian textiles may be divided by a *head-panel*.

flannel Woven woollen fabric imported into Southeast Asia.

flat weave A general term applied to carpets and rugs woven by a *tapestry weave* or *weft wrapping* process rather than a knotting technique which produces a tufted pile surface.

floating threads Warp or weft threads travelling over or under two or more of the opposite elements (Solyom and Solyom, 1985: 57). See also *supplementary weft weave*.

foot-braced loom A two-bar frameless loom, with one bar secured to a backstrap for controlling tension and the other bar braced against the weaver's feet. It is one type of *backstrap tension loom*.

foundation weave The basic woven structure of a fabric over which any supplementary elements float. This is usually a one-over-one-under *tabby weave*. Also known as *ground weave*.

four-heddle loom A simple but versatile *frame loom* with four *heddles* or sets of heddles, used to produce striking geometric patterns from supplementary floating wefts. Also known as the four-shaft loom (Burnham, 1971: 18–19).

frame loom A type of non-mechanical loom in which a wooden frame permits the tension on the warp threads to be regulated by the beams without the need for the backstrap operation of the earlier types of loom. The *heddles* are opened by foot pressure on treadles.

frill An ornamental edging of woven material, of which one edge is gathered and the other left loose, giving a wavy appearance.

fringe An ornamental border of loose or twisted threads, usually the unwoven warp ends remaining at each end of a length of fabric when the textile is removed from the loom and the warp is severed.

gauze A general term applied to light, sheer or open fabrics.

glazing The action of polishing or *burnishing*.

gluework The application of a glue or a viscous substance to the surface of a fabric to enable decorative elements to be attached.

gold thread Thread formed from finely beaten gold ribbon usually wrapped around a core fibre. See *metallic thread*.

ground, ground weave The background weave or foundation of the fabric into which supplementary elements are interlaced.

handloom Loom operated manually and not by a machine. See also *loom*.

handspun cotton Cotton thread made locally using simple non-mechanical apparatus such as a *spindle* or a *spinning-wheel*.

handspun thread Locally grown animal or plant fibres, usually cotton or silk, spun into yarn by hand, using a *spindle* or *spinning-wheel*. See also *spinning*.

head-panel A section of different patterning which divides the field pattern on certain design structures of Southeast Asian textiles.

heddle An essential feature of a loom which produces shed openings, through which the *weft* threads are inserted during the weaving process. In Southeast Asia it usually consists of a wide rod (heddle rod) to which selected sets of *warp* threads are attached by loops of yarn. These loops of yarn are sometimes also known as heddles. See also *shed*, *shed-openers*.

heddle-sticks Additional rods used to select particular warp threads for the purpose of creating the pattern. They are also known as *shed-sticks*. A *supplementary weft* is inserted in the *sheds* they are used to create.

hem To turn in and sew down the edge of a fabric.

hemp Bast fibres obtained from the wild marijuana plant, Cannabis sativa. See also *bast fibre*.

ikat The resist dyeing process in which designs are reserved in warp or weft yarns by tying off small bundles of yarns with palm-leaf strips or similar materials to prevent the penetration of dye. For each colour, additional tying or partial removal of the bindings is required. After the last dyeing, all bindings are removed and the yarns are ready for weaving (Gittinger, 1979c: 233; Solyom and Solyom, 1985: 57). See also *double ikat*, *warp ikat*, *weft ikat*.

ikat-resist See *ikat*.

indigo The blue-black dye derived from plants of the Indigofera and Marsdenia species, by producing an active precipitate from the reaction of the leaves with an alkaline solution.

interlacing A general term for the process of basketry and *matting*, in which fibres are interlaced to form fabric without the use of a loom with heddles, the elements being indistinguishable as warp and weft and all active at different times.

Jacquard loom A loom incorporating the Jacquard punched card apparatus, invented in the early nineteenth century, which mechanically opens the warp sheds in intricate repetitive patterns. Usually the warps are lifted and the shuttles are thrown also by mechanical means.

kesi A Chinese term for weft-faced, often *slit-tapestry weaving*.

kit The term applied to *continuous supplementary weft weaving* in northern Thailand and Laos.

knotting A fabric formed by tying free-hanging sets of threads around adjacent threads, in combinations of structurally identical knots (Emery, 1980: 65). See also *macramé*.

lac The resinous droppings of the lac insect, Coccus lacca, deposited under the bark of certain trees. It is a popular source of red dye in mainland Southeast Asia. Also known as stick lac.

lace A general term for an open, usually finely worked fabric. See also *crochet lace, bobbin lace*.

layered ikat A general term for *ikat-*resist dyeing which involves the repeated opening or tying off of different sections of the threads during the dye process. See also *over-dyeing*.

linked warp The joining and substitution of different coloured threads into the basic warp where a change of pattern colour in the *ground weave* of a *warp-faced* textile is desired.

loom Apparatus on which sets of yarn are interlaced, by shed openings, to produce woven cloth. See also *backstrap tension loom, frame loom*.

machine printing The process of printing designs in dyes or pigments on to a cloth surface by mechanical means, usually employing copper-plates or rollers on to which the patterns are etched or engraved.

machine-spun thread See *commercial fibres*.

macramé A general term for ornamental knotwork. More specifically the term refers to an ornamental fringe of knotted threads (Emery 1980: 65). See also *knotting*.

matting An often somewhat rigid fabric constructed of interlocking fibres which are not woven on a loom with shed openings. Also known as basketry *interlacing*.

metallic thread Worked metals, especially gold and silver, are used to fashion thread either in the form of wire or flat metal ribbon, or wound around a core of other fibre. The metallic thread is used as a weaving and embroidery element.

mica Thin, flexible, transparent and glittering scales of silicate found naturally and used to decorate garments in Southeast Asia. Mica has largely been replaced by *mirror-work*.

mirror-work Rounds cut from thin mirror glass, often lead-backed, or from mica, and sewn on to a base fabric with a framework of stitches.

mordant A chemical which serves to fix a dye in or on thread or fabric by combining with the dyestuff to form an insoluble compound (Gittinger, 1982: 198).

mordant block printing A design in *mordants* applied to cloth by carved wooden blocks. The design remains fixed and the coloured pattern stands out against an undyed ground after the dye process.

mordant painting A design in *mordants* painted on to a prepared cloth with a pen or stylus. The mordants will react with the dyes to produce a colourful pattern against an undyed ground.

Morinda citrifolia A tree grown widely in Southeast Asia, the bark of the roots of which yield red or rust dye. It is known as *mengkudu, kumbu* or a related term.

natural dyes *Dyestuffs* obtained from natural plant, animal and mineral substances.

needle braid A decorative border or join achieved by interweaving threads with a needle. See also *braid weaving, needle-weaving*.

needle-weaving A weaving technique in which the weft elements are inserted with the assistance of a needle. The needle may also be used to open the sheds.

net, netting A general term for an open-textured, net-like fabric.

netted beadwork The threading on to yarn of a large number of different coloured tiny beads in a regular pattern to form a variety of coloured designs in an open net-like fabric. This is then anchored on to a ground fabric with stitches. See also *beading*.

openwork See *cut-and-drawn thread, net*.

over-dyeing *Dyestuffs* of different colours used consecutively to achieve a darker, mixed colour.

padded See *quilting*.

painting The application of mordants, dyestuffs or pigments to an object, usually to the surface of a fabric, or to unwoven threads.

palampore A mordant-painted and sometimes batik resist-dyed Indian cotton fabric which usually features an elaborate flowering tree on a rocky mound. One genre of *chintz*.

panel A section of a textile or a separate length of fabric. Not to be confused with a *head-panel*, a design element on certain Southeast Asian textiles.

paste-resist A resist dyeing process in which a thick paste is applied to the surface of the fabric and allowed to harden before the cloth is dyed. See also *batik, resist dyeing*.

patchwork A decorative fabric assembled by seaming together many relatively small and more or less equivalent pieces of a number of different fabrics (Emery, 1980: 252). See also *appliqué*.

pattern-sticks Sets of *shed-sticks* supplementary to the main *heddles* used to create other *sheds* for the purpose of decorative patterning. Mostly used for *supplementary weft* weaving, they may also be used to create *supplementary warp* patterning.

pigments Colouring agents which stay on the surface of the fabric.

pilih The term applied to *continuous supplementary weft weaving* in Borneo and Kalimantan.

piña Threads obtained from the shredded leaves of the wild pineapple plant. Also the name of the cloth woven from these threads.

plaid A checkered pattern achieved by *tabby weaving* different sets of coloured warp and weft threads in recurring arrangements.

plain weave See *tabby weave*.

plaiting See *interlacing*.

plangi; pelangi A resist dyeing and patterning process in which areas of cloth are reserved from dye by being bound off with dye-resistant fibres before dyestuffs are applied. Patterns are usually built up from small circles.

pokerwork Ornamental work produced by burning designs on to the surface of an object with a hot pointed instrument.

polished cloth See *glazing, burnishing*.

prada A term widely used in Southeast Asia for gold leaf *gluework*, the application of gold leaf or gold dust to the cloth surface (Gittinger, 1979c: 234).

printing See *block printing, machine printing*.

quilting The joining together, by means of evenly distributed lines of stitches, of two or more layers of fabric to afford warmth, protection and decoration.

rattan Fibre from the stems of various climbing palms of the genus Calamus, used for *matting* and basketry.

rayon A term for artificially-made silk thread. See also *synthetic fibre*.

reed See *comb*.

resist dyeing Any process which employs dye-resistant materials to block the penetration of dyes on to or into

selected areas of fabric or threads for the purpose of decorative patterning (Solyom and Solyom, 1985: 58). See also *batik, ikat, plangi, tritik*.

ribbon embroidery An embroidery technique in which narrow flat ribbon thread, usually of beaten silver in Southeast Asia, is interlaced or stitched into a net or gauze-like fabric. See also *embroidery*.

rickrack Narrow zigzag braid used as trimming.

sampler A small piece of fabric bearing examples of patterns for the purpose of recording these (Swift, 1984: 181).

sappanwood The wood of a small tree, Caesalpinia sappan, from which a red dyestuff is obtained.

satin A term used to describe both a simple float weave structure of either warp or weft threads, and a type of woven fabric characterized by a smooth, lustrous silky appearance (Emery, 1980: 108).

satin-stitch A simple, straight, flat stitch, circling through the fabric, which is often used to produce flat, smooth, patterned surfaces by laying a series of fairly long stitches parallel and close together.

selvage The edges of a textile where the wefts encircle the outermost warp threads.

sequins Small, shiny, usually metallic discs with a central hole. Also known as spangles.

sericulture The rearing of silkworms and the production of raw silk. See also *silk*.

shadow appliqué Appliqué embroidery in which the base fabric shows through a pattern cut out of a translucent upper fabric.

shed A temporary opening between two planes of warp threads, selectively separated, for the passage of the weft during the weaving process (Emery, 1980: 75). See also *heddle, shed-opener*.

shed-opener A device used to open a shed through which the weft threads can be inserted during the weaving process. See also *heddle, shed, shed-sticks*.

shed patterns See *heddle-sticks, shed-sticks*.

shed-sticks Rods or sticks used in conjunction with a main heddle to produce other often irregular sheds for supplementary thread patterning. See also *heddle-sticks*.

shuttle A tool by which the weft is passed through the shed opening in the warp during weaving. In many cases in Southeast Asia the weft is wound on to a *bobbin* which is placed inside a *shuttle case* for weaving.

shuttle case An implement in which the bobbin containing the weft threads is inserted for a smoother passage through the warp shed. In insular Southeast Asia this is often a hollow tube, smooth at the closed end. On the northern mainland the shuttle case is a long boat-shaped piece of carved wood. See also *bobbin, shuttle*.

silk Thread composed of filaments secreted by caterpillars. It is obtained from the cocoons of the cultivated mulberry silkworm, Bombyx mori, or other wild silk insect sources.

silver thread Thread formed from finely beaten silver ribbon, sometimes wrapped around a core fibre. See also *metallic thread*.

slit-tapestry weave Tapestry weave in which the adjacent areas of colour are separated by slits in the woven fabric, achieved by repeatedly turning back the discontinuous weft threads around adjacent warps (Emery, 1980: 79). See also *tapestry weave*.

soga A brown dye used in Javanese batik, derived from a combination of bark and wood from several trees (Solyom and Solyom, 1985: 58). A major ingredient is the bark of the *soga* tree, Pelthophorum ferrugineum (Gittinger, 1979c: 234).

songket A widely used term in Southeast Asia for *supplementary weft* patterning usually denoting metallic thread as the major *supplementary weft* element. See also *supplementary weft*.

spindle A tool used for spinning thread. The hand spindle consists of a short rod weighted at the lower end with a disc (*spindle-whorl*). It is either let fall from a height to spin freely or spun with the lower point in a

smooth concave receptacle. See also *spinning, drop-weight spindle*.

spindle-whorl A small disc through which the spindle-rod passes. It provides weight and balance during the spinning process. See also *spindle*.

spinning The process of twisting together and drawing out massed short fibres into a continuous strand (Emery, 1980: 9).

spinning-wheel Apparatus consisting of a wheel turned by hand which rotates, via a belt, a spindle-rod around which the spun thread is twisted. In Southeast Asia this apparatus sits flush with the ground. See also *spinning*.

staining A method of colouring small sections of pattern on fabrics after the weaving is completed, by the staining or daubing of dyes, usually of a fugitive nature.

stem stitch An embroidery stitch which moves forward on the front of the cloth and then part way back on the underside of the cloth to start the next forward stitch on the top surface in a regular fashion. It is used to produce lines or outlines.

stick batik A batik resist dyeing process in which the resist substance is applied with a small stick or rod rather than a pen or block. See also *batik*.

stitch-resist dyeing A resist dyeing and patterning process in which the cloth is stitched, gathered and tucked tightly before dyestuffs are applied so that dye cannot penetrate the reserved areas. Also known as *tritik*.

stitchwork See *embroidery*.

stumpwork Raised couched metal thread embroidery which is worked over padding or a card cut to the shape of the pattern to achieve a three-dimensional effect. See also *couching*.

sungkit A term applied in Borneo and Kalimantan to weft wrapping. Elsewhere in Southeast Asia it is an alternative spelling and pronunciation of *songket*, supplementary weft weaving. See *supplementary weft, weft wrapping*.

supplementary warp (weaving) A decorative weaving technique in which an additional set of warp threads is woven into a textile to create an ornamental pattern additional to the ground weave.

supplementary weft (weaving) A decorative weaving technique in which extra ornamental weft threads are woven into a textile between two regular wefts to create patterns additional to the ground weave.

swatch A sample or specimen of a cloth design.

sword A smooth narrow wooden slat, inserted into newly opened sheds of warp threads and used to beat in each newly inserted weft (Gittinger, 1979c: 229).

synthetic dyes Synthetic chemicals used as dyestuffs. Increasingly available since the first *aniline dyes* were discovered in the mid-nineteenth century.

synthetic fibres A general term for artificially-made fibres. More specifically the term refers to mechanically extruded thread; usually long, fine, structurally continuous filaments obtained by a chemical process from petroleum and coal-tar by-products. (Emery, 1980: 5; Robinson, 1969: 36).

tabby weave The simplest basic interlacing of warp and weft threads in a one-over-one-under plain weave.

tablet weaving A band weaving process in which warps are threaded through holes punched in tablets or cards which are turned to create shed openings for the weft to pass through.

tailor A general term to describe the making of a garment by cutting and sewing.

tapestry weave Weft-faced plain weave, with discontinuous wefts, usually of different colours, woven back and forth within their own pattern areas (Emery, 1980: 78).

thread A simple continuous aggregate of fibres that is suitable for textile construction. The composition of threads varies in Southeast Asia from single strands of fibrous material, untwisted but knotted to achieve

length, to spun yarn which is plied or twined for added strength and thickness.

three-dimensional couched embroidery See *stumpwork*.

throw Each projection or insertion of the weft shuttle and bobbin through the shed opening in the warp threads. See also *shuttle*.

tie-dyeing A general term for resist dyeing processes applied to already woven fabric, in which areas of fabric are reserved from dyes by stitching (*tritik*) or binding with fibre (*plangi*). See also *plangi, stitch-resist dyeing*.

tinsel Coarse decorative thread embellished with rough pieces of gold, silver or imitation metal leaf.

traditional dyes See *natural dyes*.

treadle loom A loom in which the heddles are alternatively opened by use of a foot-operated treadle. Also known as a foot-operated heddle loom.

tritik See *stitch-resist dyeing*.

tuft Short bunches of fibre secured in the basic fabric.

turmeric A fugitive yellow dyestuff obtained from the rhizome of the Curcuma domestica plant.

twill weave Weaving or cloth patterned by a regular diagonal alignment of floating threads.

twining Two or more weft (or warp) elements worked together by spiralling around each other while encircling successive warps (or wefts).

vegetable dyes Dyestuffs obtained from naturally occurring plant material.

vegetable fibres Fibrous plant materials which can be used for the construction of thread and felted fabric. See also *abaca, bark-cloth, cotton, hemp, piña*.

velvet A fabric characterized by a woven pile, imported into Southeast Asia.

voile Thin semi-transparent woven fabric.

warp Parallel threads that run longitudinally on the loom or cloth.

warp beam A board or rod which holds the warp threads in a frameless *backstrap tension loom*. It may be a flat board around which a discontinous warp is rolled, or a bamboo roller for a *continuous circulating warp*.

warp-faced Woven fabric in which the warp threads conceal the weft.

warp ikat The ikat-resist dyeing process applied only to the warp threads so that the warp threads are patterned before weaving. The fabric is woven to achieve a predominantly warp-faced weave. See also *ikat, warp-faced*.

warping To wind or string the warp threads on to a frame or loom by laying out threads of equal length parallel to each other. See also *warp*.

wax-resist See *batik*.

weaving To interlace warp and weft threads in a specific order with the aid of apparatus, usually a loom, which facilitates shed openings.

weft Traverse threads in a fabric that cross and interlace with the warp elements.

weft-faced Woven fabric in which the weft threads conceal the warp.

weft ikat. The ikat-resist dyeing process applied only to the weft threads so that the weft threads are patterned before weaving. The fabric is woven to achieve a predominantly weft-faced weave. See also *ikat, weft-faced*.

weft twining Two sets of threads worked together by spiralling around each other while encircling successive warps (Gilfoy, 1983: 31).

weft wrapping The encircling or wrapping of passive warp elements by weft threads to create a pattern. The weft threads can be either the sole wefts in the fabric or supplementary to regular wefts in a ground weave. The weft threads, usually discontinuous, can be wrapped with the fingers, a pick or a needle. See also *sungkit*.

woven beading See *bead weaving*.

BIBLIOGRAPHY

(The following list of monographs and journal articles is not intended to be a complete bibliography of all references to Southeast Asian textiles. It has been necessarily confined to those works that have been directly used in the preparation of this publication. Specialist works on any particular textile technique, historical period, ethnic group or cultural region will provide more extensive and detailed bibliographies.)

Abdul Halim Nasir (1986), *Ukiran Kayu Melayu Tradisi*, Kuala Lumpur, Dewan Bahasa dan Pustaka.

Abdurachman, P.R. (1977), *Pameran Batik Corak Cina (Batik Exhibition of Chinese Designs)*, Jakarta, Museum Tekstil.

—— (1982), *Cerbon*, Jakarta, Sinar Harapan.

—— (n.d.), 'Spinning A Tale of Yarn', *Garuda Magazine*, Jakarta.

—— (1988), 'Indian Patola and their Transformation from trade good to sacred cloth in Indonesia', in *Cindai: Pengembaraan Kain Patola India*, Jakarta, Wastraprema.

Adams, M.J. (1966), 'Tissus Décorés de l'Ile de Sumba', *Objets et Mondes*, 6.

—— (1969), *System and Meaning in East Sumba Textile Design: A Study in Traditional Indonesian Art*, New Haven, Southeast Asia Studies Cultural Report Series 16, Yale University.

—— (1970), 'Symbolic Scenes in Javanese Batik', *Textile Museum Journal*, 3/1.

—— (1971a), 'Design in Sumba Textiles: Local Meanings and Foreign Influences', *Textile Museum Journal*, 3/2.

—— (1971b), 'Work patterns and symbolic structures', *Southeast Asia*, 1/4.

—— (1974a), 'Dress and Design in Highland Southeast Asia', *Textile Museum Journal*, 4/1.

—— (1974b), 'Symbols of an organized community in East Sumba', *Bijdragen tot de Taal-, Land- en Volkenkunde*, 130.

—— (1977), 'A "Forgotten" Bronze Ship and a Recently Discovered Bronze Weaver from Eastern Indonesia', *Asian Perspectives*, XX/1.

—— (1980), 'Structural Aspects of East Sumbanese Art', in J.J. Fox (ed), *The Flow of Life: Essays on Eastern Indonesia*, Cambridge, Harvard University Press.

—— (1981), *Threads of Life*, New York, Katonah Gallery.

Adriani, N. and Kruyt, A.C. (1912), *De Bare'e-sprekende Toradja's van Midden-Celebes*, Batavia, Landsdrukkerij.

Allen, M. (1981), *The Birth Symbol in Traditional Woman's Art from Eurasia and the Western Pacific*, Toronto, Museum for Textiles.

Alman, E. and Alman, J. (1963), *Handicraft in North Borneo*, Jesselton, Sabah Printing House.

Alman, J.H. (1960), 'Bajau Weaving', *Sarawak Museum Journal*, IX/15–16 (New series).

—— (1962), 'Dusun Weaving', *Sabah Society Journal*, 2.

Amilbangsa, L.F. (1983), *Pangalay: Traditional Dances and Related Folk Artistic Expressions*, Manila, Ayala Museum.

Andaya, B.Watson (1988), 'Textiles in Indonesian History and Culture: A Case Study from Jambi and Palembang, 1600–1800', paper presented to the Asian Studies Association of Australia Seventh National Conference, Canberra, February.

Andaya, B.Watson and Andaya, L.Y. (1982), *A History of Malaysia*, London, Macmillan.

Anderson, B.R.O'G. (1965), *Mythology and the Tolerance of the Javanese*, Ithaca, Cornell University.

Arasaratnam, S. (1986), *Merchants, Companies and Commerce on the Coromandel Coast 1650–1740*, Delhi, Oxford University Press.

Arney, S. (1987), *Malaysian Batik: Creating New Traditions*, Kuala Lumpur, Kraftangan Malaysia.

Atil, E. (1987), *The Age of Sultan Süleyman the Magnificent*, Washington, National Gallery of Art.

Avé, J. (ed) (1988), *The Crafts of Indonesia*, Singapore, Times Editions.

Avé, J.B. and King, V.T. (1986), *Borneo: The People of the Weeping Forest*, Leiden, National Museum of Ethnology.

Baal, J. van (1941), 'Het Alip-Feest te Bajan', *Mededeelingen van de Kirtya Liefrinck-van der Tuuk*, XV, Singaraja.

Baker, M. and Lunt, M. (1978), *Blue and White: the cotton embroideries of rural China*, London, Sidgwick and Jackson.

Bangladesh Rural Advancement Committee (1981), *Jamdani: figured muslins of Dacca*, Dacca.

Barbier, J.P. (1982), *Art of the Archaic Indonesians*, Dallas, Dallas Museum of Fine Arts.

—— (1985), *Art of Nagaland*, Geneva, Musée Barbier-Müller.

Barbier, J.P. and Newton, D. (eds) (1988), *Islands and Ancestors*, New York, Presthell.

Barbosa, D. (1918), *The Book of Duartes Barbosa: An Account of the Countries Bordering on the Indian Ocean and Their Inhabitants, AD 1518*, (trans. M.S. Davies), London, Hakluyt Society.

Barnes, R. (1989a), *The Ikat Textiles of Lamalera: A Study of an Eastern Indonesian Weaving Tradition*, Leiden, Brill.

—— (1989b), 'The Bridewealth Cloth of Lamalera, Lembata', in M. Gittinger (ed), *To Speak with Cloth: Studies in Indonesian Textiles*, Los Angeles, Museum of Cultural History, University of California.

Bastin, J. and Brommer, B. (1979), *Nineteenth Century Prints and Illustrated Books of Indonesia*, Utrecht, Spectrum.

Batenburg, C.J. (1922), *Catalogus van eene Verzameling van Voorwerpen van Kunstnijverheid uit de Hoofdstad Palembang en de Landstreek Pasemah Lebar*, Amsterdam, Zuid-Sumatra Instituut.

Bellwood, P. (1979), *Man's Conquest of the Pacific: The Prehistory of Southeast Asia and Oceania*, New York, Oxford University Press.

—— (1980), 'Plants, Climate and People: The Early Horticultural History of Austronesia', in J.J. Fox (ed), *Indonesia: The Making of a Culture*, Canberra, Australian National University.

—— (1985), *Prehistory of the Indo-Malaysian Archipelago*, Sydney, Academic Press.

Benedict, L.W. (1913), 'Bagobo Myths', *Journal of American Folk Lore*, 26.

—— (1916–17), 'A Study of Bagobo Ceremonial, Magic and Myth', *Annals of the New York Academy of Sciences*, XXV.

Bernet Kempers, A.J. (1959), *Ancient Indonesian Art*, Cambridge, Harvard University Press.

Bezemer, T.J. (1936), *Indonesische Kunstnijverheid*, Amsterdam, Kolonial Instituut.

Bhujjong Chandavij (1982), 'Thai Votive Tablets and Amulets', *Arts of Asia*, November-December, 118.

Bik, J.Th. (1864), 'Aantekening nopens eene reis naar Bima, Timor, de Molucksche eilanden, Menado en Oost Java', *Tijdschrift voor Indische Taal-, Land- en Volkenkunde*, 14.

Blair, E.H. and Robertson, J.A. (1903–9), *The Philippine Islands, 1493–1898*, 55 vols, Cleveland, Arthur M. Clark.

Blussé, L. (1986), *Strange Company: Chinese Settlers, Mestizo Women and the Dutch in VOC Batavia*, Dordrecht, Foris.

Blust, R. (1984), 'Austronesian culture history: some linguistic inferences and their relations to the archaeological record', in P. van de Velde (ed), *Prehistoric Indonesia: A Reader*, Dordrecht, Foris.

Bolland, R. (1956), 'Weaving a Sumba Woman's Skirt', in Th.P. Galestin, L.Langewis and R. Bolland, *Lamak and Malat in Bali and a Sumba Loom*, Amsterdam, Royal Tropical Institute.

—— (1970), 'Three Looms for Tablet Weaving', *Tropical Man*, 3.

—— (1971), 'A Comparison Between the Looms Used in Bali and Lombok for Weaving Sacred Textiles', *Tropical Man*, 4.

—— (1977), 'Weaving the Pinatikan, a Warp-Patterned Kain Bentenan from North Celebes', in V. Gervers (ed), *Studies in Textile History: In Memory of Harold B. Burnham*, Toronto, Royal Ontario Museum.

—— (1980), 'Twill weaving by the Angkola Batak people of north Sumatra', in M.S. Gittinger (ed), *Indonesian Textiles: Irene Emery Roundtable on Museum Textiles, 1979 Proceedings*, Washington, Textile Museum.

Bolland, R. and Polak, A. (1971), 'Manufacture and Use of Some Sacred Woven Fabrics in a North-Lombok Community', *Tropical Man*, 4.

Bondan, M. (1984), *Lordly Shades: Wayang Purwa Indonesia*, Jakarta, Jayakarta Agung.

Boow, J. (1986), 'Mbatik Manah: Symbols and Status in Central Javanese Batik Making', unpublished PhD thesis, University of Western Australia.

—— (1989), *Symbol and Status in Javanese Batik*, Perth, University of Western Australia.

Boulbet, J. (1964), 'Modes et Techniques du Pays Ma'', *Société des Études Indochinoises*, XXXIX/2.

Bowring, J. (1857), *The Kingdom and People of Siam*, 2 vols, Kuala Lumpur, Oxford University Press, reprinted 1977.

Breguet, G. and Martin, J. (1983), *Art Textile Traditionnel D'Indonesia*, Lausanne, Musée des arts décoratifs.

Brown, R.L. (1985), 'The Art of Southeast Asia', *Arts of Asia*, 15/6.

Brown, R.M. (1977), *The Ceramics of Southeast Asia: Their Dating and Identification*, Kuala Lumpur, Oxford University Press.

Bruno, J. (1973), *The Social World of the Tausug*, Manila, Centro Escolar University.

Brus, R. (1989), 'Crowns in Asia', *Arts of Asia*, 19/4.

Bühler, A. (1941), 'Turkey Red Dyeing in South and South East Asia', *Ciba Review*, 39.

—— (1943), 'Materialien zur Kenntnis der Ikattechnik', *Internationales Archiv für Ethnographie*, Supplement 43.

—— (1959), 'Patola Influences in Southeast Asia', *Journal of Indian Textile History*, IV.

—— (1969), *The Art Of Oceania*, Zürich, Museum Rietberg.

—— (1972), *Ikat Batik Plangi*, 3 vols, Basel, Pharos-Verlag Hansrudolf Schwabe.

Bühler, A., Ramseyer, U. and Ramseyer-Gygi, N. (1975–6), *Patola und Geringsing*, Basel, Museum für Völkerkunde und Schweizerisches Museum für Volkskunde.

Bühler, A. and Fischer, E. (1979), *The Art of the Patola*, 2 vols, Basel, Krebs.

Bühler, A., Fischer E. and Nabholz, M-L. (1980), *Indian Tie-Dyed Fabrics*, Ahmedabad, Calico Museum.

Burnham, D.K. (1973), *Cut My Cote*, Toronto, Royal Ontario Museum.

—— (1980), *Warp and Weft: A Textile Terminology*, Toronto, Royal Ontario Museum.

Burnham, H. (1971), *Handweaving in Pioneer Canada*, Toronto, Royal Ontario Museum.

Bussagli, M. (1980), *Seide und Baumwolle im Mandschu-China*, Parma, Weber.

Butler, J. (1970), *Yao Design*, Bangkok, The Siam Society.

Cammann, S. (1953), 'Types of Symbols in Chinese Art', in A.F. Wright (ed), *Studies in Chinese Thought*, Chicago, University of Chicago Press.

Campbell, M., Nakorn Pongnoi and Chusak Voraphitak (1978), *From the Hands of the Hills*, Hong Kong, Media Transasia.

Carradine, D. (1983), 'The Context, Performance and Meaning of Ritual: The British Monarchy and the "Invention of Tradition", c.1820–1977', in E. Hobsbawn and T.O. Ranger (eds), *The Invention of Tradition*, Cambridge, Cambridge University Press.

Casal, G.S. (1978), *T'boli Art in its Socio-Cultural Context*, Manila, Ayala Museum.

Casal, G.S. and Jose, R.T. (1981), 'Colonial Artistic Expressions in the Philippines (1565–1898)', in G.S. Casal, R.T. Jose, E.S. Casino, G.R. Ellis and W.G. Solheim, *The People and Art of the Philippines*, Los Angeles, Museum of Cultural History, University of California.

Casal, G.S., Jose, R.T., Casino, E.S., Ellis, G.R. and Solheim, W.G. (1981) *The People and Art of the Philippines*, Los Angeles, Museum of Cultural History, University of California.

Casino, E. (1981), 'Arts and Peoples of the Southern Philippines', in G.S. Casal, R.T. Jose, E.S. Casino, G.R. Ellis and W.G. Solheim, *The People and Art of the Philippines*, Los Angeles, Museum of Cultural History, University of California.

Cederroth, S. (1981–2), 'The Use of Sacred Cloths in the Wetu Telu Culture of Bayan', *Ethnographical Museum, Stockholm, Annual Report*.

Champault, D. and Verbrugge, A.R. (1965), *La main: Ses figurations au Maghreb et au Levant*, Paris, Muséum National d'Histoire Naturelle.

Chandra, M. (1961), 'Costumes and Textiles in the Sultanate Period', *Journal of Indian Textile History*, VI.

Chang, Q. (1981), *Memoirs of a Nonya*, Singapore, Eastern Universities Press.

Cheesman, P. (1982), 'The Antique Weavings of the Lao Neua', *Arts of Asia*, 12/4.

—— (1984), 'Laos', in *Indigo Textiles: Japan-Laos-Nigeria*, Crafts Australia Supplement, Autumn, 1.

—— (1988), *Lao Textiles: Ancient Symbols — Living Art*, Bangkok, White Lotus.

Chen Chi-Lu (1968), *Material Culture of the Formosan Aborigines*, Taipei, Taiwan Museum.

Ch'en Ching-Ho (1968), *The Chinese Community in the Sixteenth Century Philippines*, Tokyo, Centre for East Asian Cultural Studies.

Cheo Kim Ban (1983), *A Baba Wedding*, Singapore, Eastern Universities Press.

Chia, F. (1980), *The Babas*, Singapore, Times Books International.

—— (1983), *Ala Sayang*, Singapore, Eastern Universities Press.

Chin, L. (1980), *Cultural Heritage of Sarawak*, Kuching, Sarawak Museum.

China Art Publishing Company (ed) (1982), *Costumes of the Minority Peoples of China*, Kyoto, Binobi.

Chira Chongkol (1982), 'Textiles and Costumes in Thailand', *Arts of Asia*, 12/6.

Chumbot, H.R.H. (1960), *The Lacquer Pavilion at Suan Pakkad Palace*, Bangkok, Pikhanes Press.

Chung, Y.Y. (1983), *The Art of Oriental Embroidery: History, Aesthetics and Techniques*, New York, Charles Scribner's Sons.

Coedès, G. (1968), *The Indianized States of Southeast Asia*, Honolulu, East-West Center Press.

Coffman, C. (1983a), 'Three Faces of the Eight Pointed Star Motif', *Shuttle, Spindle and Dyepot*, 55, XIV/3.

—— (1983b), 'Learning the Ropes: Abaca', *Spin Off*, VII/4.

Cole, F.C. (1913), *The Wild Tribes of Davao District, Mindanao*, Chicago, Field Museum.

Colijn, H. (ed) (1912), *Neerlands Indië*, Amsterdam, Elsevier.

Collins, W.A. (1979), 'Besemah Concepts: a Study of the Culture of a People of South Sumatra', unpublished PhD thesis, Berkeley, University of California.

Condominas, G. (1977), *We Have Eaten the Forest*, London, Allen Lane.

Conklin, H.C. (1980), *Ethnographic Atlas of the Ifugao: A Study of Environment, Culture and Society in Northern Luzon*, New Haven, Yale University Press.

Coomaraswamy, A.K. (1955), *History of Indian and Indonesian Art*, New York, Dover.

Crafts Council Centre Gallery (1984), *Arts of the Indonesian Archipelago*, Sydney.

Crawfurd, J.C. (1820), *History of the Indian Archipelago*, 3 vols, Edinburgh, Constable.

—— (1828), *Journal of an embassy to the courts of Siam and Cochin China*, London, Colburn.

Crill, R. (1985), *Hats of India*, London, Victoria and Albert Museum.

Crystal, E. (1979), 'Mountain Ikats and Coastal Silks: Traditional Textiles in South Sulawesi', in J. Fischer (ed), *Threads of Tradition: Textiles of Indonesia and Sarawak*, Berkeley, Lowie Museum of Anthropology.

Cultural Relics Publishing House (1983), *The Chinese Bronzes of Yunnan*, London, Sidgwick and Jackson.

Dacanay, J.E. (1967), 'The Okil in Muslim Art', in A.G. Manuud (ed), *Brown Heritage: Essays on Philippine Cultural Tradition and Literature*, Quezon City, Ateneo de Manila University Press.

Damsté, H.T. (1923), 'Heilige Weefsels op Lombok', *Tijdschrift voor Indische Taal-, Land- en Volkenkunde*, LXIII.

Dao Xin Hua (trans.) (1989), 'Two Lü Songs', *Thai-Yunnan Project Newsletter*, 6, September.

Day, A. (1987), '"Landscape" in Early Javanese Art', unpublished paper presented to Europe and the Orient symposium, Humanities Research Centre, Australian National University, Canberra, 24–7 August.

H.H. Prince Dhaninivat (1975), 'Traditional Dress in Classic Dance of Siam', in Mattani Rutnin (ed), *The Siamese Theatre: a collection of reprints from the Journals of the Siam Society*, Bangkok, Sompong Press.

Diebels, P., Hartkamp-Jonxis, E. and Slikke, J. van der (1987), 'Verklarende Woordenlijst', in E. Hartkamp-Jonxis (ed), *Sits: Oost-West Relaties in Textiel*, Zwolle, Waanders.

Dijk, T. van and Jonge, N. de (1980), *Ship Cloths of the Lampung South Sumatra*, Amsterdam, Galerie Mabuhay.

—— (1990), 'Bastas in Babar: imported Asian textiles in a south-east Moluccan culture', *Ethnologica*, 14, Cologne.

Djoemena, Niam S. (1986), *Ungkapan Sehelai Batik: Its Mystery and Meaning*, Jakarta, Djambatan.

Dodd, E.C. (1969), 'The Image of the Word', *Berytus*, 18.

Dournes, J. (1963), 'Le Vetement Chez Les Jorai', *Objets et Mondes*, III/2.

Douwes Dekker, N.A. (n.d.), *Tanah Air Kita*, Bandung, van Hoeve.

Downs, R.E. (1955), 'Head-hunting in Indonesia', *Bijdragen tot de Taal-, Land- en Volkenkunde*, 111.

Dubin, L.S. (1987), *The History of Beads*, New York, Harry N. Abrams.

Duff-Cooper, A. (1984), *An Essay in Balinese Aesthetics*, Hull, University of Hull.

Dunsmore, S. (1978), *Beads*, Kuching, Sarawak Museum.

Elliott, I. McC. (1984), *Batik: Fabled Cloth of Java*, New York, Clarkson N. Potter.

Ellis, G.R. (1981), 'Art and Peoples of the Northern Philippines', in G.S. Casal, R.T. Jose, E.S. Casino, G.R. Ellis and W.G. Solheim, *The People and Art of the Philippines*, Los Angeles, Museum of Cultural History, University of California.

Elmberg, J-E. (1968), *Balance and Circulation: Aspects of Tradition and Change among the Mejprat of Irian Barat*, Stockholm, Ethnographical Museum.

Elson, V.C. (1979), *Dowries of Kutch*, Los Angeles, Museum of Cultural History, University of California.

Emery, I. (1980), *The Primary Structure of Fabrics*, Washington, Textile Museum.

Endicott, K.M. (1970), *An Analysis of Malay Magic*, Singapore, Oxford in Asia.

Engelhard, H.E.D. (1884), 'Mededeelingen over het Eiland Saleijer', *Bijdragen tot Taal-, Land- en Volkenkunde*, 32.

Eng-Lee, S.C. (1987), 'The Straits Chinese Bridal Chamber', *Arts of Asia*, May-June.

Errington, S. (1983), 'The Place of Regalia in Luwu', in L. Gesick (ed), *Centers, Symbols and Hierarchies: Essays on the Classical States of Southeast Asia*, New Haven, Yale University Southeast Asian Studies Monograph 26.

Ettinghausen, R. (1974), 'Arabic Calligraphy: Communication or Symbolic Affirmation', in D.K. Kouymjian (ed), *Near Eastern Numismatics, Iconography, Epigraphy and History*, Beirut, American University.

Evans, I.H.N. (1922), *Amongst Primitive Peoples in Borneo: a description of lives, habits and customs of the practical head-hunters of north Borneo*, London, Seeley Service.

Feldbauer, S. (ed) (1988), *Bathik: Simboli magici e tradizione femminile a Giava*, Milan, Electa.

Feldman, J. (ed) (1985), *The Eloquent Dead: Ancestral Sculpture of Indonesia and Southeast Asia*, Los Angeles, Museum of Cultural History, University of California.

Femenias, B. (1984), *Two Faces of South Asian Art: Textiles and Painting*, Madison, Elvehijem Museum.

Fischer, E., Jain, J. and Shah, H. (1982), *Tempeltücher für die Muttergöttinnen in Indien*, Zurich, Museum Rietberg.

Fischer, J. (ed) (1979), *Threads of Tradition: Textiles of Indonesia and Sarawak*, Berkeley, Lowie Museum of Anthropology.

Forge, A. (1978), *Balinese Traditional Paintings*, Sydney, Australian Museum.

—— (1989), 'Batik Patterns in the Early Nineteenth Century', in M. Gittinger (ed), *To Speak with Cloth: Studies in Indonesian Textiles*, Los Angeles, Museum of Cultural History, University of California.

Forman, B. (1988), *Indonesian Batik and Ikat*, London, Hamlyn.

Forman, B. and Forman, W. (1957), *Exotic Art*, London, Spring Books.

Forsythe, M.G. (1984), 'Modern Mien Silver, *Arts of Asia*, 14/3.

Forth, G. (1981), *Rindi: An Ethnographic Study of a Traditional Domain in Eastern Sumba*, The Hague, Nijhoff.

—— (1985), 'Right and Left as a Hierarchical Opposition: Reflections on Eastern Sumbanese Hairstyles', in R.H. Barnes, D. De Coppett, and R.J. Parkin (eds), *Contexts and Levels: Anthropological Essays on Hierarchy*, Oxford, JASO.

Fox, J.J. (1977a), 'Savu, Roti and Ndao', in M.H. Kahlenberg (ed), *Textile Traditions of Indonesia*, Los Angeles, County Museum.

—— (1977b), *Harvest of the Palm*, Cambridge, Harvard University Press.

—— (1980a), 'Figure Shark and Pattern Crocodile: The Foundations of the Textile Traditions of Roti and Ndao', in M.S. Gittinger (ed), *Indonesian Textiles: Irene Emery Roundtable on Museum Textiles, 1979 Proceedings*, Washington, Textile Museum.

—— (ed) (1980b), *The Flow of Life: Essays on Eastern Indonesia*, Cambridge, Harvard University Press.

—— (1983), 'Neither Ordered nor Complete: Comments on the Construction of Gender on Roti', paper prepared for the Conference on Cultural Construction of Gender in Insular Southeast Asia, Princeton, 8–11 December.

Fox, R.B. (1970), *The Tabon Caves*, Manila, National Museum.

—— (1976), 'Ancient Beads: Unstringing the History of Old Beads', *Filipino Heritage*, 3.

—— (1982), *Tagbanuwa Religion and Society*, Manila, National Museum.

Frasche, D.F. (1976), *Southeast Asian Ceramics. Ninth through Seventeenth Centuries*, New York, Asia Society.

Fraser-Lu, S. (1982), 'Kalagas: Burmese Wall Hangings and related Embroideries', *Arts of Asia*, 12/4.

—— (1988), *Handwoven Textiles of South-East Asia*, Singapore, Oxford University Press.

Freeman, J.D. (1979), 'Severed Heads that Germinate', in R.H. Hook (ed), *Fantasy and Symbol*, London, Academic Press.

Freeman, J.D. and Freeman, M. (1980), unpublished notes accompanying a collection of Iban textiles in the collection of the Australian National Gallery, Canberra.

Gallotti, J. (1926), 'Les Sampots Cambodgiens', *Art et Decoration: la review de la maison*, Paris, 50.

Gazzolo, M.B. (1986), 'Spirit Paths and Roads of Sickness: a symbolic analysis of Hmong Textile Design', unpublished PhD thesis, Chicago, University of Chicago.

Geertz, C. (1960), *The Religion of Java*, New York, The Free Press.

Geijer, A. (1979), *A History of Textile Art*, London, Sotheby Parke Bernet.

Geirnaert-Martin, D.C. (1983), 'Ask Lurik Why Batik', in J. Oosten and A. de Ruijter (eds), *The Future of Structuralism*, Gottingen, Edition Herodot.

—— (1990), 'The Snake's Skin: traditional ikat in Kodi', *Ethnologica*, 14, Cologne.

Gilfoy, P.S. (1983), *Fabrics in Celebration from the Collection*, Indianapolis, Museum of Art.

Ginsburg, H.D. (1975), 'The Manora Dance-Drama: An Introduction', in Mattani Rutnin (ed), *The Siamese Theatre: a collection of reprints from the Journals of the Siam Society*, Bangkok, Sompong Press.

Gittinger, M.S. (1972), 'A Study of the Ship Cloths of South Sumatra: Their Design and Usage', unpublished PhD thesis, New York, Columbia University.

—— (1974), 'Sumatran Ship Cloths as an Expression of Pan-Indonesian Concepts', *Sumatra Research Bulletin*, IV/1.

—— (1975), 'Selected Batak Textiles: technique and function', *Textile Museum Journal*. 4/1–2.

—— (1976), 'The Ship Cloths of South Sumatra: Function and Design System', *Bijdragen tot de Taal-, Land- en Volkenkunde*, 132.

—— (1979a), 'Conversations with a batik master', *Textile Museum Journal*, 18.

—— (1979b), An Introduction to the Body-Tension Looms and Simple Frame Looms of Southeast Asia', in I.Emery and P. Fiske (eds), *Looms and their Products: Irene Emery Roundtable on Museum Textiles, 1977 Proceedings*, Washington, Textile Museum.

—— (1979c), *Splendid Symbols*, Washington, Textile Museum.

—— (ed) (1980), *Indonesian Textiles: Irene Emery Roundtable on Museum Textiles, 1979 Proceedings*, Washington, Textile Museum.

—— (1982), *Master Dyers to the World*, Washington, Textile Museum.

—— (1985), 'Sier en symbool: De kostuums van de etnische minderheden in Zuid-en Zuidwest-China', in L. Oei (ed), *Indigo: leven in een kleur*, Weesp, Fibula-Van Dishoeck.

—— (1989a), 'A Reassessment of the "Tampan" of South Sumatra', in M. Gittinger (ed), *To Speak with Cloth: Studies in Indonesian Textiles*, Los Angeles, Museum of Cultural History, University of California.

—— (ed) (1989b), *To Speak with Cloth: Studies in Indonesian Textiles*, Los Angeles, Museum of Cultural History, University of California.

Glover, I. (1977), 'Prehistoric plant remains from Southeast Asia, with special reference to rice', *South Asian Archaeology 1977*, Naples, Istituto Universitario Orientale.

Gluck, J. and Gluck, S. (1977), *A Survey of Persian Handicraft*, Tehran, Survey of Persian Art.

Gombrich, E. (1979), *The Sense of Order*, Oxford, Phaidon.

Goris, R. (1936), 'Aanteekeningen over Oost Lombok', *Tijdschrift voor Indische Taal-, Land- en Volkenkunde*, LXXVI.

Grabar, O. (1973), *The Formation of Islamic Art*, New Haven, Yale University Press.

Graburn, N.H.H. (1979), *Ethnic and Tourist Arts: Cultural Expressions from the Fourth World*, Berkeley, University of California Press.

Graham, P. (1987), *Iban Shamanism*, Canberra, Australian National University.

Greub, S. (ed) (1988), *Expressions of Belief: Masterpieces of African, Oceanic and Indonesian art from the Museum voor Volkenkunde*, Rotterdam, New York, Rizzoli.

Groeneveldt, W.P. (1877), 'Notes on the Malay Archipelago and Malacca, compiled from Chinese sources', *Verhandelingen van het Bataviaasch Genootschap van Kunsten en Wetenschappen*, Batavia, W. Bruining.

Groot, C. de (1822), 'Statistiek van Java — Residentie Grissee', manuscript H379, Leiden, Koninklijk Instituut voor Taal-, Land- en Volkenkunde.

Groslier, B.P. (1962), *The Art of Indochina*, New York, Crown.

—— (1966), *Indochina*, New York, World Publishing Co.

Grubauer, A. (1923), *Celebes: Ethnologische Streifzüge in Südost-und Zentral-Celebes*, Hagen, Folkwang-Verlag.

Gullick, J.M. (1952), 'A Survey of the Malay Weavers and Silversmiths in Kelantan in 1951', *Journal of the Malayan Branch of the Royal Asiatic Society*, XXV/1.

Guy, J.S. (1982), *Palm-Leaf and Paper: Illustrated Manuscripts of India and Southeast Asia*, Melbourne, National Gallery of Victoria.

—— (1986), *Oriental Trade Ceramics in South-east Asia Ninth to Sixteenth Century*, Singapore, Oxford in Asia.

—— (1987), 'Commerce, power and mythology: Indian textiles in Indonesia', *Indonesia Circle*, 42.

—— (1989) 'Sarasa and Patola: Indian textiles in Indonesia', *Orientations*, 20/1.

Haake, A. (1984), *Javanische Batik*, Hanover, Schaper.

Haar, J.C.C. (1925), 'De Heilige Weefsels van de "Waktoe-Teloe" op Oost-Lombok', *Tijdschrift voor Indische Taal-, Land-, en Volkenkunde*, 65, Batavia.

Haddon, A.C. and Start, L.E. (1936), *Iban or Sea Dayak Fabrics and their Patterns*, Cambridge, Cambridge University Press.

Hall, D.G.E. (1968), *A History of Southeast Asia*, 3rd edn, Hong Kong, Macmillan.

Hall, K.R. (1985), *Maritime Trade and State Development in Early Southeast Asia*, Sydney, George Allen and Unwin.

Hamonic, G. (1977), 'Les "fausses-femmes" du pays bugis (Célèbes-Sud)', *Objets et Mondes*, 17/1.

Hardjonagoro (1980), 'The Place of Batik in the History and Philosophy of Javanese Textiles: A Personal View', in M.S. Gittinger (ed), *Indonesian Textiles: Irene Emery Roundtable on Museum Textiles, 1979 Proceedings*, Washington, Textile Museum.

Harrison, T. (1950), 'Kelabit, Land Dayak and related beads in Sarawak', *Sarawak Museum Journal*, V.

Hartendorp, A.V.H., (1953), 'The Art of the Lanao Moros', *Philippines Quarterly*, Manila, 2.

Hartkamp-Jonxis, E. (ed) (1987), *Sits: Oost-West Relaties in Textiel*, Zwolle, Waanders.

Hawley, W.M. (1971), *Chinese Folk Designs*, New York, Dover Publications.

Hayashi, R. (1975), *The Silk Road and the Shoso-in*, New York, Weatherhill.

Hayward Gallery (1976), *The Arts of Islam*, London, Arts Council of Great Britain.

Heine Geldern, R. von (1932), 'Urheimat und früheste Wanderungen der Austronesier', *Anthropos*, 27.

—— (1966), 'Some tribal art styles of Southeast Asia: an experiment in art history', in D. Fraser (ed), *The Many Faces of Primitive Art*, Englewood Cliffs, Prentice-Hall.

Heppell, M. and Enyan anak Usin (1986), 'Dress fit for the gods', unpublished manuscript, Melbourne.

Heringa, R. (1985), 'Kain Tuban: Een Oude Javaanse Indigotraditie', in L. Oei (ed), *Indigo: leven in een kleur*, Weesp, Fibula-Van Dishoeck.

—— (1989), 'Dye-Process and LIfe-Sequence: The Coloring of TExtiles in an East Javanese Village', in M: Gittinger (ed) *To Speak with Cloth: Studies in Indonesian Textiles*, Los Angeles, Museum of Cultural History, University of California.

—— (1990), 'Lawai Lawa: Brown Cotton', *Ethnologica*, 14, Cologne.

Hickey, G.C. (1982a), *Sons of the Mountains*, New Haven, Yale University Press.

—— (1982b), *Free in the Forest*, New Haven, Yale University Press.

Hill, A.H. (1949), 'Weaving Industry in Trengganu', *Journal of the Malayan Branch of the Royal Asiatic Society*, 22/3.

Hinton, E.M. (1974), 'The Dress of the Pwo Karen of North Thailand', *Journal of the Siam Society*, 62.

Hitchcock, M.J. (1983), 'Technology and Society in Bima, Sumbawa, with Special Reference to House Building and Textile Manufacture', unpublished PhD thesis, University of Oxford.

—— (1985), *Indonesian Textile Techniques*, Aylesbury, Shire.

Ho Wing Meng (1984), *Straits Chinese Silver*, Singapore, Times Books International.

—— (1987), *Straits Chinese Beadwork and Embroidery*, Singapore, Times Books International.

Holmgren, R.J. and Spertus, A.E. (1980), 'Tampan Pasisir: Pictorial Documents of an Ancient Indonesian Coastal Culture', in M.S. Gittinger (ed), *Indonesian Textiles: Irene Emery Roundtable on Museum Textiles, 1979 Proceedings*, Washington, Textile Museum.

—— (1989), *Early Indonesian Textiles from Three Island Cultures*, New York, Metropolitan Museum of Art.

Holt, C. (1967), *Art in Indonesia: Continuities and Change*, Ithaca, Cornell University Press.

Hoop, A.N.J.Th.a Th. van der (1949), *Indonesian Ornamental Design*, Bandung, Koninklijk Bataviaasch Genootschap van Kunsten en Wetenschappen.

Hooykaas, J. (1956), 'The Rainbow in Ancient Indonesian Religion', *Bijdragen tot de Taal-, Land-en Volkenkunde*, 112.

Hose, C. and McDougall, W. (1912), *The Pagan Tribes of Borneo*, London, Macmillan.

Hoskins, J. (1988), 'Arts and Culture of Sumba', in J.P. Barbier and D. Newton (eds), *Islands and Ancestors*, Presthell, New York.

Hukom, C. and Lilipaly-de Voogt, A. (1985), *Amaone: Moluksse Handvaardigheid in de praktijk*, Hoevelaken, Christelijk Pedagogisch Studiecentrum.

Hutton, J.H. (1928), 'The Significance of Head Hunting in Assam', *Journal of the Royal Anthropological Institute*, 58.

Innes, R.A. (1957), *Costumes of Upper Burma and the Shan States in the Collections of Bankfield Museum*, Halifax, Bankstown Museum.

International Exhibitions Foundation (1981), *Portugal and the East Through Embroidery*, Washington.

Irwin, H.J. (1955), 'Origins of the "Oriental Style" in English Decorative Art', *The Burlington Magazine*, XCVII/625.

Irwin, J. and Brett, K.B. (1970), *Origins of Chintz*, London, HMSO.

Irwin, J. and Hall, M. (1971), *Indian Painted and Printed Fabrics*, Ahmedabad, Calico Museum of Textiles.

—— (1973), *Indian Embroideries*, Ahmedabad, Calico Museum of Textiles.

Irwin, J. and Schwartz, P. (1966), *Studies in Indo-European Textile History*, Ahmedabad, Calico Museum of Textiles.

Jager Gerlings, J.H. (1952), *Sprekende Weefsels*, Amsterdam, Koninklijk Instituut voor de Tropen.

Jarry, M. (1981), *Chinoiserie: Chinese Influence on European Decorative Art 17th and 18th Centuries*, New York, Vendome Press.

Jasper, J.E. and Pirngadie, M. (1912a), *De Inlandsche Kunstnijverheid in Nederlandsch Indië: Volume I, Het Vlechtwerk*, The Hague, Mouton.

—— (1912b), *De Inlandsche Kunstnijverheid in Nederlandsch Indië: Volume II, De Weefkunst*, The Hague, Mouton.

—— (1916), *De Inlandsche Kunstnijverheid in Nederlandsch Indië: Volume III, De Batikkunst*, The Hague, Mouton.

—— (1927), *De Inlandsche Kunstnijverheid in Nederlandsch Indië: Volume IV, De Goud en Zilversmeedkunst*, The Hague, Mouton.

Johns, A.H. (1961), 'Sufism as a category in Indonesian literature and history', *Journal of Southeast Asian History*, 2.

Johnstone, P. (1985), *Turkish Embroidery*, London, Victoria and Albert Museum.

Joseph, R.M. (1985), 'Batik Making and the Royal Javanese Cemetery at Imogiri', *Textile Museum Journal*, 24.

Josselin de Jong, J.P.B. de (1935), 'The Malay Archipelago as a field of ethnological study', reprinted in P.E. de Josselin de Jong (ed), *Structural Anthropology in the Netherlands*, The Hague, Nijhoff, 1977.

Jumsai, Sumet (1988), *Naga: Cultural Origins in Siam and the West Pacific*, Singapore, Oxford University Press.

Jundam, M. Bin-Ghalib (1983), *Sama*, Quezon City, Asian Center, University of the Philippines Press.

Juynboll, H.H. (1928), *Catalogus van s'Rijks Ethnographisch Museum, XX: Philippijnen*, Leiden, Brill.

Kadang, K. (1960), *Ukiran Rumah Toradja*, Jakarta, Balai Pustaka.

Kahlenberg, M.H. (ed) (1977), *Textile Traditions of Indonesia*, Los Angeles, Los Angeles County Museum of Art.

Kahlenberg, M.H. (1979), *Rites of Passage*, San Diego, Mingei International Museum of World Folk Art.

—— (1980), 'The Influence of the European Herbal on Indonesian Batik', in M.S. Gittinger (ed), *Indonesian Textiles: Irene Emery Roundtable on Museum Textiles, 1979 Proceedings*, Washington, Textile Museum.

Kana, N.L. (1983), *Dunia Orang Sawu*, Jakarta, Sinar Harapan.

Kartiwa, Suwati (1980), 'The Kain Songket Minangkabau', in M. Gittinger (ed), *Indonesian Textiles: Irene Emery Roundtable on Museum Textiles, 1979 Proceedings*, Washington, Textile Museum.

—— (1983), *Kain Tenun Donggala*, Palu, Donggala Press.

—— (1986), *Kain Songket Indonesia: Songket Weaving in Indonesia*, Jakarta, Djambatan.

—— (1987), *Tenun Ikat; Indonesian Ikats*, Jakarta, Djambatan.

Kat Angelino, P. de (1930-1), *Batik Rapport*, 3 vols, Weltevreden, Lands Drukkerij.

Kaudern, W. (1944), *Art in Central Celebes*, Göteborg, Elanders Boktryckeri.

Kern, R.A. (1926), 'Tjinden en plangi in Gresik', *Djawa*, 2.

Khan Majlis, B. (1984), *Indonesien Textilien: Wege zu Göttern und Ahnen*, Krefeld, Deutsches Textilmuseum.

King, D. (1982), *Imperial Ottoman Textiles*, London, Colnaghi.

King, V. (1975), 'Stones and the Maloh of Indonesian West Borneo', *Journal of the Malaysian Branch of the Royal Asiatic Society*, 48.

—— (1985), 'Symbols of Social Differentiation: A Comparative Investigation of Signs, the Signified and Symbolic Meanings in Borneo', *Anthropos*, 80.

Kipp, R.S. (1979), 'The Thread of Three Colours: the Ideology of Kinship in Karo Batak Funerals', in E.M. Bruner and J.O. Becker (eds), *Art, Ritual And Society in Indonesia*, Ohio, Ohio University Press.

Kitley, P. (1985), 'Cultural Involution: A Study of the Aesthetic Style of Javanese Batik', unpublished manuscript, Toowoomba.

Knoob-Bödiger, U. (1973), 'Die Bedeutung der Birmanischen Handweberei fur die Nationaltracht', in K. Tauchman (ed), *Festschrift zum 65 funfundsechzigsten: Geburtstag von Helmut Petri*, Cologne, Bohlau.

Koenigswald, G.H.R. von (1961), 'Opmerkingen over Chinese en Indonesische Invloeden op de Kunst van Nieuw-Guinea', *Kultuurpatronen*, 3-4.

Kohl, D.G (1984), *Chinese Architecture in the Straits Settlements and Western Malaya: Temples, Kongsis and Houses*, Kuala Lumpur, Heinemann.

Koninklijk Bataviaasch Genootschap van Kunsten en Wetenschappen (1940), *Jaarboek 1940*, Bandung, Nix.

Kooijman, S. (1958), 'Some Ritual Clothing from Borneo in Dutch Museums', *Sarawak Museum Journal*, VIII/11 (new series).

—— (1959), *The Art of Lake Sentani*, New York, Metropolitan Museum of Art.

—— (1963), *Ornamental Bark-cloth in Indonesia*, Leiden, Brill.

The Koran, (1968) (trans. N.J. Dawood), Harmondsworth, Penguin.

Koubi, J. (1982), *Rambu Solo': "La Fumee Descend"*, Paris, Centre National de la Recherche Scientifique.

Kreemer, J. (1922), *Atjeh*, 2 vols, Leiden, Brill.

Kroese, W.T. (1976), *The Origin of the Wax Block Prints on the Coast of West Africa*, Hengelo, Smit van 1876.

Krom Songsoem Utsahakam (Department of Industrial Promotion) (1986), *Phatho Lai Khit (Khit Textiles)*, Bangkok.

Kruyt, A.C. (1938), *De West-Torajas op Midden Celebes*, 5 vols, Amsterdam, Verhandelingen der Koninklijke Nederlandsche Akademie van Wetenschappen.

La Loubère, S. de (1693), *The Kingdom of Siam*, Kuala Lumpur, Oxford University Press, reprinted 1969.

Lach, D.F. (1965, 1970), *Asia in the Making of Europe*, 2 vols, Chicago, University of Chicago Press.

Lal, K. (1983), 'Islamic Influence on Indian Textiles', in K. Khandalavala (ed), *An Age of Splendour: Islamic Art in India*, Bombay, Marg.

Lamb, A. (1965), 'Some Observations on Stone and Glass Beads in Early South-east Asia', *Journal of the Malayan Branch of the Royal Asiatic Society*, 38/2.

Lambrecht, F. (1958), 'Ifugaw Weaving', *Folklore Studies*, 17.

Land, C. op't (1968-9), 'Een merkwaardige "Tampan pengantar" van Zuid-Sumatra', *Kultuurpatronen*, 10-11.

Landolt-Tüller, A. and Landolt-Tüller, H. (1976-7), 'Qalamkär-Druck in Isfahan', *Verhandlungen der Naturforschenden Gesellschaft in Basel*, 87/88.

Langewis, L. (1956), 'A Woven Balinese Lamak', in Th.P. Galestin, L.Langewis and R. Bolland, *Lamak and Malat in Bali and a Sumba Loom*, Amsterdam, Royal Tropical Institute.

Langewis, L. and Wagner, F. (1964), *Decorative Art in Indonesian Textiles*, Amsterdam, van der Peet.

Larsen, J.L., Bühler, A., Solyom, B. and Solyom, G. (1976), *The Dyer's Art: ikat, batik, plangi*, New York, Van Nostrand Reinhold.

Lebar, F.M. (ed) (1964), *Ethnic Groups of Mainland Southeast Asia*, New Haven, HRAF Press.

—— (1972), *Ethnic Groups of Insular Southeast Asia: Volume 1, Indonesia, Andaman Islands and Madagascar*, New Haven, HRAF Press.

—— (1975), *Ethnic Groups of Insular Southeast Asia: Volume 2, Philippines and Formosa*, New Haven, HRAF Press.

Lee Chor Lin (1987), *Ancestral Ships: Fabric Impressions of Old Lampung Culture*, Singapore, National Museum.

Legge, J.D. (1980), *Indonesia*, New Jersey, Prentice Hall.

Leigh, B. (1982), 'Design Motifs in Aceh: Indian and Islamic Influences', in J.R. Maxwell (ed), *The Malay-Islamic World of Sumatra: studies in politics and culture*, Clayton, Monash University.

—— (1985), 'Village Women in Aceh', unpublished paper prepared for the Women in Asia Conference, Canberra, 8-10 July.

—— (1988), *Tangan-tangan Trampilan: Hands of time: the visual arts of Aceh*, Jakarta, Jambatan.

Leigh-Theisen, H. (1985), *Der SüdÖstasiatische Archipel*, Vienna, Museum für Volkerkunde.

Lemoine, J. (1982), *Yao Ceremonial Painting*, Bangkok, White Lotus.

Leonard, A. and Terrell, J. (1980), *Patterns of Paradise*, Chicago, Field Museum of Natural History.

Leur, J.C. van (1955), *Indonesian Trade and Society*, The Hague, van Hoeve.

Leuzinger, E. (1978), *Kunst der Natur Völker*, Frankfurt, Propyläen.

Lewis, P. and Lewis, E. (1984), *People of the Golden Triangle*, London, Thames and Hudson.

Li, H.L. (1970), 'The Origin of Cultivated Plants in Southeast Asia', *Economic Botany*, 24.

Lin Y. and Zhang, F (1988), *Richly Woven Traditions: Costumes of the Miao of Southwest China and Beyond*, New York, China House Gallery.

Ling Roth, H. (1896), *The Natives of British North Borneo, Volume II*, London, Truslove and Hanson.

—— (1910), *Oriental Silver Work, Malay and Chinese*, London, Truslove and Hanson.

—— (1918), *Studies in Primitive Looms*, Halifax, Bankfield Museum.

—— (1923), *The Maori Mantle*, Halifax, Bankfield Museum.

Loebèr, J.A. (1903), 'Het Weven in Nederlandsch Indië', *Bulletin van het Koloniaal Museum te Haarlem*, 29.

—— (1913), 'Het Schelpen- en Kralenwerk in Nederlandsch-Indië', *Bulletin van het Koloniaal Museum te Haarlem*, 51.

—— (1914), *Textiele Versieringen in Nederlandsch-Indië*, Amsterdam, Koloniaal Instituut.

—— (1916), *Techniek en Sierkunst in den Indische Archipel*, Amsterdam, Koloniaal Instituut.

—— (1926), *Das Batiken*, Oldenburg, Stalling.

Lombard, D. (1969), 'Jardins à Java', *Arts Asiatique*, 20.

Lopez, V.B. (1976), *The Mangyans of Mindoro: An Ethnohistory*, Manila, University of the Philippines Press.

Loveric, B. (1987), 'Rhetoric and Reality: The Hidden Nightmare', unpublished PhD thesis, Sydney, University of Sydney.

Lowry, J. (1974), *Burmese Art*, London, Victoria and Albert Museum.

Lu Pu (1981), *Designs of Chinese Indigo Batik*, New York, Lee Publishers Group.

Lumholtz, C. (1920), *Through Central Borneo*, 2 vols, New York, Charles Scribner.

Mack, J. (1987), 'Weaving, Women, and the Ancestors in Madagascar', *Indonesia Circle*, 42.

McGovern, J.B.M. (1922), *Among the Headhunters of Formosa*, London, T Fisher Unwin.

McKinnon, J. (1983), 'Behind and Ahead', in J. McKinnon and Wanat Bhruksasri (eds), *Highlanders of Thailand*, Kuala Lumpur, Oxford University Press.

McKinnon, J. and Wanat Bhruksasri (eds) (1983), *Highlanders of Thailand*, Kuala Lumpur, Oxford University Press.

McKinnon, S. (1989), 'Flags and half-moons: Tanimbarese textiles in an "engendered" system of valuables', in M. Gittinger (ed), *To Speak with Cloth: Studies in Indonesian Textiles*, Los Angeles, Museum of Cultural History, University of California.

McReynolds, P.J. (1980), 'The Embroidery of Luzon and the Visayas', *Arts of Asia*, 10/1.

—— (1982), 'Sacred Cloth of Plant and Palm', *Arts of Asia*, 12/4.

Madhu Khanna (1979), *Yantra: the Tantric Symbol of Cosmic Unity*, London, Thames and Hudson.

Mailey, J. (1971), *Chinese Silk Tapestry: K'o-ssu*, New York, China Institute in America.

Manguin, P-Y. (1986), 'Shipshape Societies: Boat Symbolism and the Political Systems in Insular Southeast Asia', in D. Marr and A.C. Milner (eds), *Southeast Asia in the 9th to 14th Centuries*, Singapore, Institute of Southeast Asian Studies.

Marr, D. and Milner, A.C. (eds) (1986), *Southeast Asia in the 9th to 14th Centuries*, Singapore, Institute of Southeast Asian Studies.

Marryat, F. (1848), *Borneo and the Indian Archipelago: with drawings of costume and scenery*, London, Longman, Brown, Green and Longmans.

Marsden, W. (1783), *History of Sumatra*, Kuala Lumpur, Oxford University Press, reprinted 1966.

Marshall, M (1975), 'The Vanishing Plumage', *Archipelago*, 2.

Mashman, V. (1986), 'Warriors and Weavers: a Study of Gender Relations Among the Iban of Sarawak', unpublished MA thesis, Canterbury. University of Kent.

Matisoff, J. (1983), 'Linguistic Diversity and Language Contact', in J.McKinnon and Wanat Bhruksasri (eds), *Highlanders of Thailand*, Kuala Lumpur, Oxford University Press.

Matsumoto, K. (1984), *Jodai-Gire: 7th and 8th Century Textiles in Japan from the Shoso-in and Horyu-ji*, Kyoto, Shikosha.

Maxwell, J.R. (1980), 'Textiles of the Kapuas Basin — with Special Reference to Maloh Beadwork', in M.S. Gittinger (ed), *Indonesian Textiles: Irene Emery Roundtable on Museum Textiles, 1979 Proceedings*, Washington, Textile Museum.

Maxwell, J.R. and Maxwell, R.J. (1976), *Textiles of Indonesia: an introductory handbook*, Melbourne, Indonesian Arts Society/National Gallery of Victoria.

—— (1989), 'Political Motives: the batiks of Mohamad Hadi of Solo', in M. Gittinger (ed), *To Speak with Cloth: Studies in Indonesian Textiles*, Los Angeles, Museum of Cultural History, University of California.

Maxwell, R.J. (1980), 'Textiles and Ethnic Configurations in Flores and the Solor Archipelago', in M.S. Gittinger (ed), *Indonesian Textiles: Irene Emery Roundtable on Museum Textiles, 1979 Proceedings*, Washington, Textile Museum.

—— (1981), 'Textiles and Tusks: Some Observations on the Social Dimensions of Weaving in East Flores', in M. Kartomi (ed), *Five Essays on the Indonesian Arts*, Clayton, Monash University.

—— (1983), 'Ceremonial Textiles of the Ngada of Eastern Indonesia', *Connaisance des Arts Tribaux*, 18, Geneva, Musée Barbier-Müller.

—— (1985), 'De rituele weefsels van Oost-Indonesië', in L. Oei (ed), *Indigo: leven in een kleur*. Weesp, Fibula-Van Dishoeck.

—— (1987), *Southeast Asian Textiles: The State of the Art*, Working Paper 42, Centre for Southeast Asian Studies, Clayton, Monash University.

—— (1990), 'The Tree of Life in Indonesian Textiles: ancient iconography or imported chinoiserie?', *Ethnologica*, 14, Cologne.

Meilink-Roeslofsz, M.A.P. (1962), *Asian Trade and European Influence in the Indonesian Archipelago between 1500 and about 1630*, Le Haye, Nijhoff.

Mellot, R. (1983), *Thai Sarasa*, Kyoto, Shibunkaku Art Museum.

Milner, A.C. (1982), *Kerajaan: Malay Political Culture on the Eve of Colonial Rule*, Tuscon, University of Arizona Press.

Mohamad Kassim bin Ali (1984), 'Golden Threads and Silver Needles', *Wings of Gold*, 10/1, Kuala Lumpur, Malaysian Airline System.

Mook-Andreae, H. (1985), 'Het wonder van de Indigo', in L. Oei (ed), *Indigo: leven in een kleur*, Weesp, Fibula-Van Dishoeck.

Morgan, H.T. (1972), *Chinese Symbols and Superstitions*, Detroit, Gale Research Co.

Museum Nasional (1980), *Koleksi Pilihan Museum Nasional: Volume 1*, Jakarta.

—— (1984), *Koleksi Pilihan Museum Nasional: Volume 2*, Jakarta.

Museum Tekstil Jakarta (1980), *Batik: Pameran koleksi terpilih Museum Tekstil Jakarta dan Museum Batik Yogyakarta*, Jakarta, Djaja Pirusa.

Myers, D.K. (1984), *Temple, Household, Horseback: Rugs of the Tibetan Plateau*, Washington, Textile Museum.

Myers, M.A. (1982), 'Sacred Shawls of the Toba Batak: "Adat" in Action,' unpublished PhD thesis, Riverside, University of California.

Nabholz-Kartaschoff, M-L. (1985), 'De bijzondere plaats van een gewone kleur: Blauw in de traditionele kleding van de bergstammen van Birma, Thailand, Laos en Vietnam', in L. Oei (ed), *Indigo: leven in een kleur*, Weesp, Fibula-Van Dishoeck.

—— (1986), *Golden Sprays and Scarlet Flowers: Traditional Indian Textiles*, Kyoto, Shikosha.

—— (1989), 'A Sacred Cloth of Rangda: Kamben Cepuk of Bali and Nusa Penida', in M. Gittinger (ed), *To Speak with Cloth: Studies in Indonesian Textiles*, Los Angeles, Museum of Cultural History, University of California.

National Gallery of Victoria (1977), *The Chinese Exhibition*, Melbourne.

National Museum (1968), *An Illustrated Book of Costumes Based on Historical and Archaeological Evidence*, Bangkok, Fine Arts Department.

Needham, R. (1983), *Sumba and the Slave Trade*, Working Paper 31, Centre for Southeast Asian Studies, Clayton, Monash University.

Newman, T.R. (1977), *Contemporary Southeast Asian Arts and Crafts*, New York, Crown Publishers.

Ng, C. (1984), 'Symbols of Affinity: Ceremonial Costumes in a Minangkabau Village', *Heritage*, 7.

—— (1987), 'The Weaving of Prestige', unpublished PhD thesis, Australian National University, Canberra.

Ng, M. (1977), 'Backstrap Weaving in the Philippines', *Shuttle, Spindle and Dyepot*, IX/1, Issue 33.

—— (1978), *Natido Binwag Weaves the Bango*, Quezon, Council for Living Tradition.

Nicolas, R. (1975), 'Le Lakhon Nora ou Lakhon Chatri et les Origines du Theatre Classique Siamois', in Mattani Rutnin (ed), *The Siamese Theatre: a collection of reprints from the Journals of the Siam Society*, Bangkok, Sompong Press.

Niessen, S.A. (1985a), *Motifs of Life in Toba Batak Texts and Textiles*, Dordrecht, Foris Publications.

—— (1985b), 'Waarom het Garen de Godin der Toba Batak Zwart Was', in L. Oei (ed), *Indigo: leven in een kleur*. Weesp, Fibula-Van Dishoeck.

Nieuwenhuis, A.W. (1914), 'Die Veranlagung der Malaiischen Völker des Ost-Indische Archipels', *Internationales Archiv für Ethnographie*, 22.

Nieuwenhuys, R. (1981), *Baren en oudgasten, Tempo doeloe — een verzonken wereld: fotografische documenten uit het oude Indië 1870–1920*, Amsterdam, Querido.

Niggemeyer, H. (1952), 'Baumwollweberei auf Ceram', *Ciba Review*, 106.

Nona Paknam (1981), *Evolution of Thai Ornament*, Bangkok, Muang Boran.

Noorduyn, J. (1965), 'The Making of Bark Paper in West Java', *Bijdragen tot de Taal-, Land-, en Volkenkunde*, CXXI/4.

Nooteboom, C. (1948), 'Quelques Techniques de Tissage des Petites Iles de la Sonde', *Mededelingen van het Rijksmuseum voor Volkenkunde*, Leiden, 3.

Nooy-Palm, C.H.M. (1969), 'Dress and Adornment of the Sa'dan Toraja (Celebes, Indonesia)', *Tropical Man*, 2.

—— (1975), *De Karbouw en de Kandaure*, Delft, Indonesisch Ethnografisch Museum.

—— (1979), *The Sa'dan Toraja, a study of their social life and religion: Volume 1, Organization, symbols and beliefs*, The Hague, Nijhoff.

—— (1980), 'The Role of the Sacred Cloths in the Mythology and Ritual of the Sa'dan Toraja of Sulawesi, Indonesia,' in M.S. Gittinger (ed), *Indonesian Textiles: Irene Emery Roundtable on Museum Textiles, 1979 Proceedings*, Washington, Textile Museum.

—— (1986), *The Sa'dan Toraja, a study of their social life and religion: Volume 2, Rituals of the East and West*, Dordrecht, Foris.

Nouhuys, J.W. van (1918–19), 'Iets over Indische en Oud-Peruaansche Weeftechniek', *Nederlandsch-Indië Oud en Nieuw*, 3.

—— (1921–2), 'Een Autochthoon Weefgebied in Midden-Celebes', *Nederlandsch-Indië Oud en Nieuw*, 6.

—— (1925–6), 'Was-Batik in Midden-Celebes', *Nederlandsch-Indië Oud en Nieuw*, 10.

—— (1929), 'De Oorsprong van de Toempal-Kapala der Javaansche Batik-Saroeng', *Nederlandsch-Indië Oud en Nieuw*, November.

Obdeyn, V. (1927–8), 'Indragirische Weefkunst', *Tijdschrift voor Indische Taal-, Land- en Volkenkunde*, 68/1–2.

Oei, L. (ed) (1985), *Indigo: leven in een kleur*, Weesp, Fibula-Van Dishoeck.

—— (1979), *Old Textiles of Thailand*, 2 vols, Kyoto, Korinsha.

Ong, E. (1986), *Pua: Iban Weavings of Sarawak*, Kuching, Atelier Sarawak.

Orinbao, S. (Piet Petu) (1969), *Nusa Nipa*, Endeh, Nusa Indah.

Orsoy de Flines, van E.W. (1972), *Guide to the Ceramics Collection of the Museum Pusat*, Jakarta, Museum Pusat.

Owen, N.G. (1984), *Prosperity without Progress: Manila Hemp and Material Life in the Colonial Philippines*, Berkeley, University of California Press.

Palm, C.H.M. (1958), 'Ancient Art of the Minahassa', *Madjalah untuk Ilmu Bahasa, Ilmu Bumi dan Kebudajaan Indonesia*.

—— (1965), 'De Kultuur en Kunst van de Lampung, Sumatra', *Kultuurpatronen*, 7.

Pangemanan, S. (n.d.), *Pelbagai Keradjinan Orang Minahasa*, Jakarta.

Pauw, J. (1923), 'De Kekombong Oemba', *Tijdschrift voor Indische Taal-, Land-, en Volkenkunde*, 63, Batavia.

Peacock, B.A.V. (1977), *Batek, Ikat, Pelangi and other traditional textiles from Malaysia*, Hong Kong, Urban Council.

Peetathawatchai, V. (1973), *Esarn Cloth Design*, Khon Kaen, Faculty of Education, Khon Kaen University.

—— (1976), *Folkcrafts of the South*, Bangkok, Housewives Voluntary Foundation.

Pelras, C. (1962), 'Tissages Balinais', *Objets et Mondes*, 2/4.

—— (1967), 'Lamak et Tissus Sacrés de Bali', *Objets et Mondes*, 7/4.

—— (1972), 'Contribution à la Geographie et à l'Ethnologie du Métier à Tisser en Indonésie', in *Langues et Techniques, Nature et Société: Volume 2*, Paris, Klinsieck.

Penpane Damrongsiri (1985), *The Divine World, Emblems and Motifs*, Bangkok, Amarin.

Pers, A. van (1855), *Nederlandsch Oost-Indische Typen*, The Hague, Koninklijke Steendrukkerj.

Petsopoulos, Y. (ed) (1982), *Tulips, Arabesques and Turbans*, London, Alexandria Press.

Pfister, R. (1938), *Les Toiles Imprimées de Fostat et l'Hindoustan*, Paris, Les Editions d'Art et d'Historie.

Pires, T. (1944), *The Suma Oriental of Tomé Pires: an account of the East from the Red Sea to Japan written in Malacca and India, 1512–1515*, 2 vols (trans. A Cortesao), London, Hakluyt Society.

Polo, Marco (1958), *The Travels of Marco Polo*, (trans. R. Latham), Harmondsworth, Penguin.

Powell, H. (1930), *The Last Paradise*, New York, Jonathan Cape Harrison Smith.

Prakash, Om (1984), *The Dutch Factories in India 1617–1623*, New Delhi, Munshiram Manoharlal.

—— (1985), *The Dutch East India Company and the Economy of Bengal, 1630–1720*, Princeton, Princeton University Press.

Prangwatthanakun, S and Cheesman, P. (1987), *Lan Na Textiles: Yuan, Lue, Lao*, Chiang Mai, Centre for the Promotion of the Arts and Culture, Chiangmai University.

Raadt-Apell, M.J. (1980), *De Batikkerij Van Zuylen te Pekalongan*, Zutphen, Terra.

—— (1980–1), 'Van Zuylen Batik, Pekalongan, Central Java (1890–1946)', *Textile Museum Journal*, 19–20.

Raffles, S.T. (1817), *The History of Java*, 2 vols, Kuala Lumpur, Oxford University Press, reprinted 1982.

Ramseyer, U. (1977), *The Art and Culture of Bali*, Oxford, Oxford University Press.

—— (1983) 'Double Ikat Ceremonial Cloths in Tenganan Pegeringsingan', *Indonesia Circle*, 30.

—— (1984), 'Clothing, Ritual and Society in Tenganan Pegeringsingan (Bali)', *Verhandlungen der Naturforschenden Gesellschaft in Basel*, 95.

—— (1987), 'The traditional textile craft and textile workshops of Sidemen, Bali', *Indonesia Circle*, 42.

Rawson, J. (1984), *Chinese Ornament: The Lotus and the Dragon*, London, British Museum.

Rawson, P. (1967), *The Art of Southeast Asia*, London, Thames and Hudson.

Reid, A. (1969), 'Sixteenth Century Turkish Influences in Western Indonesia', *Journal of Southeast Asian History*, X/3.

—— (1988), *Southeast Asia in the Age of Commerce 1460–1680: Volume One, The Land below the Winds*, New Haven, Yale University Press.

Ricklefs, M.C. (1981), *A History of Modern Indonesia*, London, Macmillan.

Ritter, W.L. (1855), *Java: Tooneelen uit het Leven*, The Hague, Fuhri.

Robbins, C. (1985), *Selections from the Steven G. Alpert Collection of Indonesian Textiles*, Dallas, Dallas Museum of Art.

Robinson, N.V. (1981), 'Indian Influences on Sino-Thai Ceramics', *Arts of Asia*, 11/3.

—— (1987), 'Mantónes de Manila: Their Role in China's Silk Trade', *Arts of Asia*, 17/1.

Robinson, S. (1969), *A History of Dyed Textiles*, Cambridge, MIT Press.

Robson, S.O. (1981), 'Notes on the Cultural Background of the Kidung Literature', in N. Phillips and K. Anwar (eds), *Papers on Indonesian Languages and Literature*, Paris, Association Archipel.

Roces, M.P. (1985) 'Fabrics of Life', in Habi, *The Allure of Philippine Weaves*, Manila, Intramuros Administration.

Rockhill, W.W. (1915), 'Notes on the relations and trade of China with the eastern archipelago and the coast of the Indian Ocean during the fourteenth century', *T'oung Pao*, 16.

Rodgers, S. (1980), 'Blessing Shawls: The Social Meaning of Sipirok Batak Ulos', in M. Gittinger (ed), *Indonesian Textiles: Irene Emery Roundtable on Museum Textiles, 1979 Proceedings*, Washington, Textile Museum.

—— (1985), *Power and Gold: Jewelry from Indonesia, Malaysia, and the Philippines*, Geneva, Barbier Müller Museum.

Rogers, J.M.(1983), *Islamic Art and Design 1500–1700*, London, British Museum.

Rogers, J.M., Hülye Tezcan and Selma Delibas (1986), *The Topkapi Saray Museum: Costumes, Embroideries and Other Textiles*, London, Thames and Hudson.

Rosenthal, F. (1961), 'Significant Uses of Arabic Writing', *Ars Orientalis*, 4.

Rostov, C.I. and Jia Guanyan (1983), *Chinese Carpets*, New York, Harry N. Abrams.

Rouffaer, G.P. and Juynboll, H.H. (1914), *De Batikkunst in Nederlandsch Indië en Haar Geschiedenis*, Utrecht, Oosthoek.

Royal Tropical Institute (1949), *Indonesian Art*, Chicago.

Mattani Rutnin (ed) (1975), *The Siamese Theatre: a collection of reprints from the Journals of the Siam Society*, Bangkok, Sompong Press.

Sabah Museum (n.d.), *Murut Basket-Work Patterns*, Leaflet 9, Kota Kinabalu.

Sachse, F.I.P. (1907), *Seran en Zijne Bewoners*, Leiden, Brill.

Safadi, Y.H. (1978), *Islamic Calligraphy*, London, Thames and Hudson.

Sanasen, Uab (1979), 'Notes on a Weaving Village', *Muang Boran Journal*, 16/1.

Sanday, P. and Suwati Kartiwa (1984), 'Cloth and Custom in West Sumatra', *Expedition*, 26/4.

Sandin, B. (1977), *Gawai Burong: the chants and celebrations of the Iban Bird Festival*, Penang, Universitas Sains Malaysia.

Santos, L.M. (ed) (1982), *The Philippine Rites of Mary*, Manila, National Printing.

Sapada, N. (1977), 'Traditional Textiles of South Sulawesi', paper prepared for Wastraprema, Jakarta.

Schafer, E.H. (1962), *The Golden Peaches of Samarkand*, Berkeley, University of California Press.

Scharer, H. (1963), *Ngaju Religion*, The Hague, Nijhoff.

Schneider, J. (1975), *Textilien: Katalog der Sammlung des Schweizerischen Landesmuseums Zürich*, Zürich, Berichthaus.

Schuster, C. (1965), 'Remarks on the Design of an Early Ikat Textile in Japan', in *Festschrift Alfred Bühler*, Basler Beiträge zur Geographie und Ethnologie, Ethnologische Reihe, 2.

Schwartz, J.A.T. (1908). 'Ethnographica uit der Minahassa', *Internationales Archiv für Ethnographie*, XVIII.

Scott, W.H. (1982), 'Sixteenth-century Tagalog Technology from the *Vocabulario de la Lengua Tagalo* of Pedro de San Buenaventura, O.F.M.', in R. Carle, M. Heinschke, P. Pink, C. Rost and K. Stadlander (eds), *Gava': Studies in Austronesian Languages and Cultures*, Berlin, Dietrich Reimer.

Sellato, B. (1989), *Naga dan Burung Enggang: Hornbill and Dragon*, Jakarta, Elf Aquitaine Indonesia.

Selvanayagam, G. (1981), 'Kain Sungkit Patterns in Peninsular Malaysia', 5 vols, unpublished MA thesis, Kuala Lumpur, University of Malaysia.

Sheares, C.A. (1977), 'The Batik Patterning Technique in Southeast Asia', *Heritage*, 2.

—— (1983), 'The Ikat Technique of Textile-Patterning in Southeast Asia', *Heritage*, 4.

—— (1984), 'Ikat Patterns From Kampuchea: Stylistic Influences', *Heritage*, 7.

Sheppard, M. (1972), *Taman Indera: Malay decorative arts and pastimes*, Singapore, Oxford University Press.

—— (1978), *Living Crafts of Malaysia*, Singapore, Times Books International.

—— (1982), *Tanah Melayu yang Bersejarah*, Petaling Jaya, Eastern Universities Press.

Singer, N. (1988), 'Tattoo Weights from Burma', *Arts of Asia*, 18/2.

Siti Zainon Ismail (1983), 'Seni Tekat', in Baharuddin Zainal et al, *Sirih Pinang*, Kuala Lumpur, Dewan Bahasa dan Pustaka.

—— (1986), *Rekabentuk Kraftangan Melayu Tradisi*, Kuala Lumpur, Dewan Bahasa dan Pustaka.

Skeat, W.W. (1902), 'Silk and Cotton Dyeing by Malays', *Journal of the Straits Branch of the Royal Asiatic Society*, 38.

Skelton, R. (ed) (1982), *The Indian Heritage: Court Life and Arts under Mughal Rule*, London, Victoria and Albert Museum.

Sleen, W.G.N. van der (1967), *A Handbook on Beads*, Liège, Musée du Verre.

Solheim, W.G. (1981), 'Philippine Prehistory', in G.S. Casal, R.T. Jose, E.S. Casino, G.R. Ellis, and W.G. Solheim, *The People and Art of the Philippines*, Los Angeles, Museum of Cultural History, University of California.

Solyom, G. and Solyom, B. (1973), *Textiles of the Indonesian Archipelago*, Honolulu, University of Hawaii Press.

—— (1979), 'Notes and Observations on Indonesian Textiles', in J. Fischer (ed), *Threads of Tradition*, Berkeley, Lowie Museum.

—— (1980a), 'Cosmic Symbolism in Semen and Alas-alasan Patterns in Javanese Textiles', in M.S. Gittinger (ed), *Indonesian Textiles: Irene Emery Roundtable on Museum Textiles, 1979 Proceedings*, Washington, Textile Museum.

—— (1980b), 'A Note on Some Rare Central Javanese Court Textiles', in M.S. Gittinger (ed), *Indonesian Textiles: Irene Emery Roundtable on Museum Textiles, 1979 Proceedings*, Washington, Textile Museum.

—— (1985), *Fabric Traditions of Indonesia*, Pullman, Washington State University Press.

Somers Heidhues, M.F. (1974), *Southeast Asia's Chinese Minorities*, Hawthorn, Longman.

Somprasong Foundation (1975), *The Thai Heritage of Weaving and Embroidery*, Bangkok, Bhirasri Institute of Modern Art.

Stanislaw, M.A. (1987), *Kalagas: The Wall Hangings of Southeast Asia*, Menlo Park, Ainslie's.

Start, L. (1917), *Burmese Textiles From the Shan and Kachin Districts*, Halifax, Bankfield Museum.

Steinmann, A. (1946), 'The Ship of the Dead in Textile Art', *Ciba Review*, 52.

—— (1947a), 'The Art of Batik', *Ciba Review*, 58.

—— (1947b), 'Batik Work, its Origin and Spread', *Ciba Review*, 58.

Stoeckel, P. (1923), 'Etude sur le Tissage au Cambodge', *Arts et Archeologie Khmers*, Paris, 1.

Stuart-Fox, D.J. (1982), *Once a Century: Pura Besakih and the Eka Dasa Rudra Festival*, Jakarta, Sinar Harapan and Citra Indonesia.

—— (1985), 'The Textile Crafts of Ancient Bali', unpublished manuscript, Canberra.

Suchtelen, B.C.C.M.M. van (1921), *Endeh (Flores)*, Weltevreden, Papyrus.

Sutherland, H. (1979), *The Making of a Bureaucratic Elite: The Colonial Transformation of the Javanese Priyayi*, Singapore, Heinemann.

Swift, G. (1984), *The Larousse Encyclopedia of Embroidery Techniques*, New York, Larousse.

Szanton, D. (1963), 'Art in Sulu: a survey', in F. Lynch (ed), *Sulu's People and Their Art*, Quezon City, Ateneo de Manila University Press.

Talwar, K. and Kalyan Krishna (1979), *Indian Pigment Painting on Cloth*, Ahmedabad, Calico Museum of Textiles.

Tampubolon, B. (1978), 'Tenunan Siak Sri Indrapura, Mulanya Cuma di Lingkungan Istana', *Kompas*, 7 March.

Tan Chee Beng (1988), *The Baba of Melaka*, Petaling Jaya, Pelanduk.

Taylor, J.G. (1983), *The Social World of Batavia: European and Eurasian in Dutch Asia*, Madison, University of Wisconsin Press.

Temminck, C.J. (1839–47), *Verhandelingen over de Natuurlijke Geschiedenis der Nederlandsche Overzeesche Bezittingen*, Leiden, La Lau.

Terwiel, B.J. (1983), *A History of Modern Thailand 1767–1942*, St Lucia, University of Queensland Press.

Thierry, S. (1969), *Le Bétel: Volume I, Inde et Asia du Sud-Est*, Paris, Musée de L'Homme.

Thomas, Suman (1984), 'Raingan kanwichai: ru'ang pha lae prapheni kanchai pha Thai (Research report on Thai Textile Traditions)', unpublished dissertation, Bangkok, Thammasat University.

Thomsen, M.(ed) (1980), *Java und Bali*, Mainz am Rhein, Philipp van Zabern.

Tichelman, G.L. (1944), *Nieuwe Guineesche Oerkunst*, Deventer, van Hoeve.

Tirtaamidjaja, N., Anderson, B.R.O'G. and Marzuki, J. (1966), *Batik: Pola dan Tjorak — Pattern and Motif*, Jakarta, Djambatan.

Tourism Authority of Thailand (1983), *Rattanakosin Bicentennial: A Pictorial Celebration of Thailand*, Bangkok.

Tropenmuseum (1987), *Budaya Indonesia: Arts and Crafts in Indonesia*, Amsterdam.

Van Esterik, P. (1980), 'Royal Style in Village Context: Towards a Model of Interaction between Royalty and Commoner', *Contributions to Asian Studies*, 15.

—— (1984), 'Continuities and Transformations in Southeast Asian Symbolism: A Case Study from Thailand', *Bijdragen tot de Taal-, Land- en Volkenkunde*, 140.

Van Esterik, P. and Kress, N. (1980), 'An Interpretation of Ban Chiang Rollers', *Asian Perspectives*, 21/1.

Varadarajan, L. (1982), *South Indian Traditions of Kalamkari*, Bombay, Perennial Press.

—— (1983), *Ajrakh*, Ahmedabad, New Order Book Company.

Veenendeel, J. (1987), 'Seventeenth Century Furniture From V.O.C. Settlements in Asia', *Arts of Asia*, 17/1.

Veldhuisen, H. (1980), *Blauw en Bont*, Delft, Volkenkundig Museum Nusantara.

—— (1983-4), 'Ontwikkelingen in de Batik van Java', *Handwerken Zonder Grenzen*, 1983, 4–5; 1984, 1–4.

Veldhuisen-Djajasoebrata, A. (1980), 'On the Origins and Nature of Larangan: Forbidden Batik Patterns from the Central Javanese Principalities', in M.S. Gittinger (ed), *Indonesian Textiles: Irene Emery Roundtable on Museum Textiles, 1979 Proceedings*, Washington, Textile Museum.

—— (1984), *Bloemen van het Heelal: De kleurrijke wereld van de textiel op Java*, Amsterdam, Sijthoff.

—— (1985), 'De Bangun Tulak van Midden Java', in L. Oei (ed), *Indigo: leven in een kleur*, Weesp, Fibula-Van Dishoeck.

—— (1988), *Weavings of Power and Might: The Glory of Java*, Rotterdam, Museum voor Volkenkunde.

Visser, L.E. (1989), 'The Incorporation of Foreign Textiles in Sahu Culture,' in M.S. Gittinger (ed), *To Speak With Cloth: Studies in Indonesian Textiles*, Los Angeles, Museum of Cultural History, University of California.

Vogelsanger, C. (1980), 'A Sight for the Gods: Notes on the Social and Religious Meaning of Iban Ritual Fabrics', in M.S. Gittinger (ed), *Indonesian Textiles: Irene Emery Roundtable on Museum Textiles, 1979 Proceedings*, Washington, Textile Museum.

Vollmer, J.E. (1977a), *In the Presence of the Dragon Throne*, Toronto, Royal Ontario Museum.

—— (1977b), 'Archaeological and Ethnological Considerations of the Foot-braced Body-tension Loom', in V. Gervers (ed), *Studies in Textile History*, Toronto, Royal Ontario Museum.

—— (1979), 'Archaeological Evidence for Looms from Yunnan', in I. Emery and P. Fiske (eds), *Looms and their Products: Irene Emery Roundtable on Museum Textiles, 1977 Proceedings*, Washington, Textile Museum.

—— (1980), *Five Colours of the Universe: Symbolism in Clothes and Fabrics of the Ch'ing Dynasty (1644–1911)*, Hong Kong, Edmonton Art Gallery.

Vroglage, B.A.G. (1953–6), *Ethnographie der Belu in Zentral-Timor*, 3 vols, Leiden, Brill.

Vuldy, C. (1987), *'Pekalongan: Batik et Islam dans une ville du Nord de Java'*, Paris, EHESS.

Wagner, F. (1959), *Indonesia: The Art of an Island Group*, New York, Crown Books.

Wahyono, M. (1981), *Lurik: Suatu Pengantar*, Jakarta, Wastraprema.

Wallace, L. (1983), 'Pina', *The Weavers' Journal*, VIII/2, Issue 30.

Wang Gang Wu (1958), 'The Nanhai Trade', *Journal of the Malay Branch of the Royal Asiatic Society*, XXXI/2.

Wang Yarong (1987), *Chinese Folk Embroidery*, London, Thames and Hudson.

Warming, W. and Gaworski, M. (1981), *The World of Indonesian Textiles*, Tokyo, Kodansha.

Warren, J.F. (1981), *The Sulu Zone 1768–1898*, Singapore, Singapore University Press.

Wassing-Visser, R. (1983), *Weefsels en Adatkostuums uit Indonesië*, Delft, Volkenkundig Museum Nusantara.

—— (1984), *Sieraden en Lichaamsversiering uit Indonesië*, Delft, Volkenkundig Museum Nusantara.

Wastraprema (1976), *Kain Adat: Traditional Textiles*, Jakarta, Djambatan.

—— (1985), *Pesona Batik Madura*, Jakarta, Himpunan Wastraprema.

Watters, K. (n.d.), 'Sungkit Weaving of the Iban', *Connaisance des Arts Tribaux*, 9, Geneva.

Welch, A. (1977), 'Epigraphs as Icons: The Role of the Written Word in Islamic Art', in J. Gutmann (ed), *The Image and the Word: Confrontations in Judaism, Christianity and Islam*, Missoula, Scholars Press.

—— (1979), *Calligraphy in the Arts of the Muslim World*, Austin, University of Texas Press.

Welch, S.C. (1985), *India: Art and Culture 1300–1900*, New York, Metropolitan Museum of Art.

Werff, J. van der and Wassing-Visser, R. (1974), *Sumatraanse Schoonheid*, Delft, Indonesisch Ethnografisch Museum.

Wessing, R. (n.d.), 'Wearing the Cosmos: symbolism in batik design', unpublished paper, Ithaca, Cornell University.

Wheatley, P. (1959), 'Geographical Notes on Some Commodities Involved in Sung Maritime Trade', *Journal of the Malaysian Branch of the Royal Asiatic Society*, XXXII, Pt 2/186.

—— (1966), *The Golden Khersonese: Historical*

Geography of the Malay Peninsula before A.D. 1500, Kuala Lumpur, University of Malaya Press.

White, J. (1982), *Discovery of a Lost Bronze Age: Ban Chiang*, Philadelphia, University Museum, University of Pennsylvania.

Wibun Lisuwan (ed) (1987), *Pha Thai: phatthanakan thang utsahakam lae sangkhom (Thai Textiles: industrial and social development)*, Bangkok, Bansat Ngoenthun Utsahakam haeng Prathet Thai.

Wilkinson, R.J. (1957), *A Malay-English Dictionary*, London, Macmillan.

Williams, C.A.S. (1976), *Outlines of Chinese Symbolism and Art Motives*, New York, Dover.

Willis, E.B. (1987), 'The Textile Arts of India's North-east Borderlands', *Arts of Asia*, 17/1.

Wilson, V. (1986), *Chinese Dress*, London, Victoria and Albert Museum.

Winstedt, R.O. (1925), *Malay Industries: Part I. Arts and Crafts*, Kuala Lumpur, FMS Government Press.

Wolters, O.W. (1967), *Early Indonesian Commerce*, Ithaca, Cornell University Press.

Woodward, H. (1977), 'A Chinese Silk Depicted at Candi Sewu', in K.L. Hutterer (ed), *Economic Exchange and Social Interaction in Southeast Asia: Perspectives from Prehistory, History and Ethnography*, Ann Arbor, University of Michigan.

—— (1980), 'Indonesian Textile Patterns from an Historical Viewpoint', in M.S. Gittinger (ed), *Indonesian Textiles: Irene Emery Roundtable on Museum Textiles, 1979 Proceedings*, Washington, Textile Museum.

Worsley, P. (1986), 'Narrative Bas-Reliefs at Candi Surawana', in D.G. Marr and A.C. Milner (eds), *Southeast Asia in the 9th to 14th Centuries*, Singapore, Institute of Southeast Asian Studies.

Wouden, F.A.E. van (1968), *Types of Social Structure in Eastern Indonesia*, The Hague, Martinus Nijhoff.

Wray, E., Rosenfield, C., Bailey, D. and Wray, J.D. (1972), *Ten Lives of the Buddha: Siamese Temple Paintings and Jataka Tales*, New York, Weatherhill.

Wray, L. (1902), 'Notes on Dyeing and Weaving as Practised at Sitiawan in Perak', *Journal of the Anthropological Institute of Great Britain and Ireland*, 32.

—— (1908), 'Native Arts and Handicrafts', in A. Wright and H.A. Cartwright (eds), *Twentieth Century Impressions of British Malaya*, London, Lloyd.

Wright, L., Morrison, H. and Wong, K.F. (1972), *Vanishing World: the Ibans of Borneo*, New York, Weatherhill.

Wurjantoro, E. (1980), 'Wdihan Dalam Masyarakat Jawa Kuna Abad IX-X M', *Pertemuan Ilmiah Arkeologi, Volume IV*, Jakarta, Pusat Penilitian Arkeologi Nasional.

Yogi, O. (1980), 'Lurik, a Traditional Textile in Central Java', in M.S. Gittinger (ed), *Indonesian Textiles: Irene Emery Roundtable on Museum Textiles, 1979 Proceedings*, Washington, Textile Museum.

Yoshimoto, Shinobu (1977), *Indonesia Senshoku Taikei*, 2 vols, Kyoto, Shikosha.

—— (1988), *Kain Perada: The Gold-printed Textiles of Indonesia: Hirayama Collection*, Tokyo, Kodansha.

Yoshioka, Tsuneo and Yoshimoto, Shinobu (1980), *Sarasa of the World*, Kyoto, Kyoto Shoin.

Zerner, C. (1982), 'Silks from southern Sulawesi', *Orientations*, 12/2.

—— (1983), 'Animate Architecture of the Toraja', *Arts of Asia*, 13/5.

Zimmer, H. (1972), *Myths and Symbols in Indian Art and Civilization*, Princeton, Princeton University Press.

—— (1983), *The Art of Indian Asia*, 2 vols, Princeton, Princeton University Press.

Zwalf, W. (ed) (1985), *Buddhism: Art and Faith*, London, British Museum.

INDEX

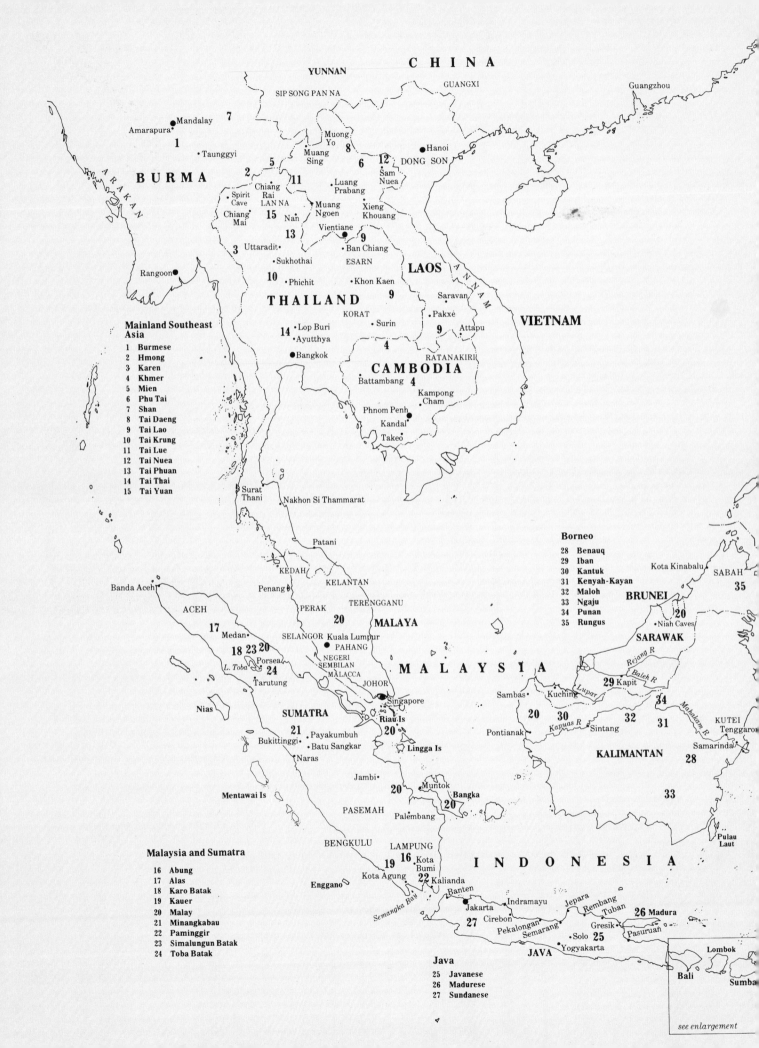

C H I N A

YUNNAN
GUANGXI
Guangzhou

SIP SONG PAN NA

Amarapura • Mandalay 7
1
• Taunggyi

Muong
Yo
Muang 8
Sing
Muang 6 12 • Hanoi
5 DONG SON
2 11 • Luang Sam
 Prabang Nuea

BURMA Chiang
 Spirit Rai
 Cave LAN NA
Chiang • Muang Xieng
Mai 15 Nan Ngoen Khouang
 13 Vientiane
3 Uttaradit • 9
 • Ban Chiang
 • Sukhothai ESARN LAOS
10 VIETNAM
 • Phichit • Khon Kaen
THAILAND 9 Saravan
 KORAT Pakxé
14 • Lop Buri • Surin
 • Ayutthya 9 Attapu
 • Bangkok RATANAKIRI
 4
 CAMBODIA
 Battambang 4
 Kampong
 Phnom Penh Cham
 Kandal •
 Takeo

**Mainland Southeast
Asia**

1 Burmese
2 Hmong
3 Karen
4 Khmer
5 Mien
6 Phu Tai
7 Shan
8 Tai Daeng
9 Tai Lao
10 Tai Krung
11 Tai Lue
12 Tai Nuea
13 Tai Phuan
14 Tai Thai
15 Tai Yuan

Surat
Thani
 Nakhon Si Thammarat

Patani

KEDAH
Penang • KELANTAN
 PERAK TERENGGANU
 20
 MALAYA
Banda Aceh •
ACEH
17 Medan • SELANGOR Kuala Lumpur
18 23 20 PAHANG
 Porsea • NEGERI
L. Toba 24 SEMBILAN
 Tarutung • MALACCA
 JOHOR M A L A Y S I A
Nias Singapore
 SUMATRA Riau Is
 20
 21 • Payakumbuh
Bukittinggi • • Batu Sangkar Lingga Is
 Naras
Mentawai Is Jambi • 20
 Muntok
 PASEMAH Bangka
 20
 Palembang

Malaysia and Sumatra

16 Abung
17 Alas
18 Karo Batak BENGKULU LAMPUNG
19 Kauer 19 16 Kota
20 Malay Bumi
21 Minangkabau Enggano Kota Agung 22 Kalianda
22 Paminggir Banten
23 Simalungun Batak
24 Toba Batak

Borneo

28 Benauq
29 Iban
30 Kantuk Kota Kinabalu SABAH
31 Kenyah-Kayan 35
32 Maloh BRUNEI
33 Ngaju 20
34 Punan • Niah Caves
35 Rungus SARAWAK
 Rejang R
 Baleh R
 29 Kapit
 Sambas • Kuching Lupar 34
 32 31 KUTEI
 Pontianak • Kapuas R Tenggarong
 Sintang 28 Samarinda •
 KALIMANTAN
 28
 33

 Pulau
 Laut

I N D O N E S I A

Jakarta • Indramayu Jepara Rembang Tuban
 Cirebon Semarang Gresik 26 Madura
27 Pekalongan 25 Pasuruan
Semangka Bay Solo
 Yogyakarta
J A V A Lombok

Java

25 Javanese Bali Sumba
26 Madurese
27 Sundanese

see enlargement

International Federation of Library Associations and Institutions
Fédération Internationale des Associations de Bibliothécaires et des Bibliothèques
Internationaler Verband der bibliothekarischen Vereine und Institutionen
Международная Федерация Библиотечных Ассоциаций и Учреждений

IFLA Publications 41

Preservation of Library Materials

Conference held at the
National Library of Austria
Vienna, April 7–10, 1986

Sponsored by the Conference of
Directors of National Libraries
in Cooperation with IFLA and Unesco

Volume 2

Edited by Merrily A. Smith

K·G·Saur

München · London · New York · Paris 1987

IFLA Publications
edited by Willem R. H. Koops

Recommended catalog entry:
Preservation of library materials — conference held at the
National Library of Austria, Vienna, April 7—10, 1986 /
Edited by Merrily A. Smith
Volume 2
München, New York, London, Paris: K. G. Saur, 1987
VI, 155 p., 21 cm. —
(IFLA Publications; 41)
ISBN 3-598-21771-4

CIP-Kurztitelaufnahme der Deutschen Bibliothek

Preservation of library materials : conference held
at the National Library of Austria, Vienna, Austria,
April 7 — 10, 1986 / Internat. Fed. of Library Assoc.
and Inst. Sponsored by the Conference of Directors
of National Libraries in cooperation with IFLA and
UNESCO. Ed. by Merrily A. Smith. — München ;
London ; New York ; Paris : Saur

NE: Smith, Merrily A. [Hrsg.]

Vol. 2 (1987).
(IFLA publications ; 41)
ISBN 3-598-21771-4

NE: International Federation of Library Associations
and Institutions: IFLA publications

ISBN 3-598-21771-4
ISSN 0344-6891 (IFLA Publications)

TABLE OF CONTENTS

Volume 1

Volume 2

Technical Presentations

Policy and Training

Reproduction

Storage and Handling

Treatment and Environment

Conclusion of the Conference

TECHNICAL PRESENTATIONS

Policy and Training

Financial Support for Preservation Activities,
 Charles Kecskeméti

Approaches to Training in Preservation and Conservation,
 Jeanne-Marie Dureau

Reproduction

Organizing and Implementing a Preservation Microfilming Program,
 Mya Thanda Poe

Copyright Aspects of Reproduction,
 Henry Olsson

Storage and Handling

Care and Handling of Bound Materials,
 Merrily A. Smith

Storage and Handling of Photographic Materials,
 Klaus B. Hendriks

Storage and Handling of Audio and Magnetic Materials,
 Harald Heckmann

Treatment and Environment

Conservation Treatment of Rare Books,
 Helmut Bansa

Conservation Treatment of Paper,
 Ove K. Nordstrand

Mechanization of Restoration Work,
 Wolfgang Wächter

Tour of the Conservation Laboratory, National Library of Austria,
 Otto Wächter

Coping with Disaster,
 Anna Lenzuni

Integrated Pest Management for Libraries,
 Thomas A. Parker

Climate Control in Libraries and Archives,
 Timothy Padfield

FINANCIAL SUPPORT FOR PRESERVATION ACTIVITIES

Charles Kecskeméti
Executive Secretary
International Council on Archives
France

ABSTRACT

A strategy for increasing the resources available for preserving archives and library materials is proposed based on the double hypothesis that (1) resources do exist and need only be identified; and (2) current preservation policy to raise the awareness of the public and decision-makers is misdirected and should be revised. Institutions seeking aid should know the procedural rules of funding agencies and develop funding requests that exploit them. National preservation programs that contribute to the development of a country by including industrial initiatives, scientific research, and personnel training will be viewed more favorably by many agencies than those that can only demonstrate "usefulness." Preservation policy should have cooperative sharing as its cornerstone and should seek to eliminate psychological, administrative, and financial barriers between cooperating parties. Partnership ventures between developed and developing countries have great potential benefit for both parties. Areas in which IFLA and ICA could give important cooperative leadership are: the formation of a worldwide training institute that begins with training trainers from all countries in preservation and conservation practices; independent testing of processes, supplies, and equipment, the information to be shared with developing countries; and the formation of guidelines on care and treatments, printed and circulated widely on an international basis.

A paper with such a title should contain the addresses of those national and international bodies that eventually may grant financial support to preservation programs and the description of the procedures to follow for raising funds. A paper of that type would probably be meaningless, however, since both addresses and procedures are either sufficiently well known or readily available. I prefer to consider the subject from another angle and to speak about the unique matter worth discussing in an international meeting regarding financial support, namely, how to increase the global volume of resources available for preserving the library and archival heritage.

The Problem

For the last 40 years, document restoration has made impressive progress: Deacidification, the use of synthetic materials and paper pulp, computer programs for the reconstitution of texts, and so forth. In addition, a number of new techniques, some of them described in papers submitted at this conference, have been developed. It seems, however, that, at the world level, the problems faced by archives and libraries continue to increase. The quality of traditional media (paper, ink) became independent of durability considerations long ago. In developing new media, particularly films and tapes, more attention was given to the fidelity of the image or sound to be preserved than to the capability of the document to resist the ravages of time. Air pollution reached an alarming level in almost all urban centers and often in wider areas than the towns themselves. Holdings that had already survived century after century suddenly started deteriorating as a result of devastating chemical processes.

The annual production of books, newspapers, periodicals, and records is climbing to extraordinary figures, hardly affected, if at all, by the production of nonconventional, audiovisual, or machine-readable documents. Figures are available in the *Statistical*

Yearbook for UNESCO (for books) (1) and the *Proceedings of the 22nd International Archival Round Table Conference* held in Bratislava in 1983 (for records) (2). Even with a ruthless disposal policy, the mass of materials to be preserved is increasing more rapidly than the funds allocated to preservation purposes and the capacity of the binding and restoration workshops.

Preservation and restoration require considerable financial means for buildings, equipment, energy, and manpower. It is therefore not surprising that the ordinary resources libraries and archives have earmarked for preventing decay or for restoring damaged items stay far behind the needs at the global level. Even more worrying, according to the information available, the gap, instead of narrowing, thanks to scientific and technical progress, is widening and thus, unless new resources are granted for preserving the library and archival heritage, and unless the use of the available resources is thoroughly revised, the heritage will continue to weather.

The Working Hypothesis

The subject of this paper has been chosen on the basis of a double hypothesis:
1. The resources that would permit reversal of the trend do exist; it behooves the professional communities, their parent authorities, and the international bodies concerned to identify them and to take initiatives with a view to ensuring that they be allocated to the preservation of the heritage.
2. Although continuous efforts are needed to convince the public and the decision-makers that the preservation of books and records is worthy of financial sacrifices, the main effort should be intellectual; to tap new resources, preservation policy should be revised.

I intend to outline some aspects of this new strategy. Small-scale individual projects such as the purchase of a piece of equipment, training of a technician, or repair of a prestigious manuscript abroad will be purposely overlooked. As mentioned previously, the resources currently available are adequate for coping with such problems and the procedures to be followed for securing them are well known.

The development of a new strategy requires the disposal of some illusions. Archivists and librarians are convinced that the preservation of the heritage for which they are responsible is considered as important by everyone as it is by them. As illusory as it may be, such a conviction does not necessarily have harmful consequences, beyond the deception to which it leads. Another widespread illusion is much more pernicious. It makes believe that because of their exceptional value, libraries and archives are entitled to benefit from exceptional international aids granted according to exceptional procedures. It must be stated again and again: *This assumption is false!* Only resources earmarked for the country by an international body or by a national development agency may be allocated to the libraries and archives of a country. "Out-of-envelope," "over-the-ceiling" aid does not exist except in the event of a disaster (flood, earthquake, war, and so forth).

Procedural Matters

Because of their financial responsibilities, assistance and cooperation agencies must follow rules that may seem overly cautious to uninitiated observers. Requests for information on possible aid and on procedures to be followed for obtaining financial support are usually considered with mistrust. The general position of an agency is that of caution, to avoid being "conned" by shrewd operators or simply wasting money. Whatever field happens to be involved, an applicant for information or actual support

will hear at the outset two objections: "Times are hard and now is certainly not the right moment for requesting financial support" (heard in the 1960's before the oil crisis, as well as 10 or 20 years later, whether the project concerns land irrigation, handicraft, or a mobile library); and "Our agency would certainly be willing to consider your problem, but the project does not fall under its terms of reference." Should mention be made of archives or libraries during such a conversation, the first comment would automatically be, "But it is a project for UNESCO" – in spite of UNESCO's present-day difficulties, which can't be ignored anymore. Encountering such marks of reluctance should not be discouraging. They result neither from a personal hostility towards the applicant nor from indifference to his problems. They represent a kind of compulsory rite, developed as an all-directions defense technique. This technique will not discourage everybody, obviously, but will certainly reduce the number of files to be processed.

Every agency of international or bilateral cooperation observes procedural rules that archives or libraries cannot ignore or by-pass. Applications are considered only if submitted by the appropriate body (e.g., National Commission for UNESCO, Resident Representative of UNDP, Embassy, Ministry of Foreign Affairs, Mixed Commission); the proposed project should be compatible with the terms of reference of the cooperation agency, or in case of bilateral aid, covered by a clause of the agreement of cooperation between the two countries. In all cases, three basic conditions must be observed for obtaining support from any public body, whether a state or intergovernmental agency: The funds must be earmarked for the applicant country (this is the clause of the "envelope"); the project description must be formulated and submitted by a specific, accredited body; and the project must be consistent with the terms of reference of the donor agency.

This last condition permits some flexibility in that the same library project may be submitted to various agencies with various justifications compatible with the terms of reference of the agency approached, and all justifications perfectly true. A public library serves at the same time in literacy programs, promotion of cultural life, guidance to youth, and so forth. Cooperation agencies normally follow the rule of co-financing. They cover only a given percentage of the cost of a project, the rest being borne by the applicant country, or by another public or private donor organization to be approached by the applicant country. Finally, for statistical or administrative reasons, certain agencies require that the projects be submitted with a priority label. In such cases, mention of "first priority" is essential, or the project will automatically be disregarded.

Development Programs

Agencies that are in a position to support ambitious projects are all moved by the same spirit, which is that the money they grant should contribute to the development of the country they want to help. They are not satisfied with a mere usefulness argument because everybody agrees that libraries and archives are useful; rather, the expenditures made must generate direct economic, scientific, or technical progress. The preservation of the library and archival heritage requires precisely programs of this type, including industrial initiatives; the development of scientific, especially chemical and biological, research; and the training of qualified manpower.

A national program for the preservation of books and documents will be credible, and may expect support from cooperation agencies only if it comprises, beyond its central cultural content, industrial (manufacturing of tissue paper, deacidified boxes, shelvings), scientific (microbiology, testing of disinfectants, control of atmospheric

pollution), and educational (training of bookbinders, conservators, engineers, scientists) components. The more the program is job-generating – outside, of course, the walls of the planned conservation workshop – the more it will be appreciated by the agencies approached. For developing such programs, libraries and archives have to consult all potential partners, industrialists, scientists, and administrators on their possible input and the expected economic side effects.

Nevertheless, it would be totally absurd to consider investing money in conservation programs without first guaranteeing the long-term preservation of the rehabilitated documents, even if a generous donor would be willing to subsidize a Danaide-type project. Without a building that would provide adequate protection for preserving the physical integrity of the holdings in the given climatic conditions, it would be pointless to undertake a conservation program. Since cooperation agencies cannot and do not make grants for capital investments, this part of the expenditure should be covered by public authorities of the country concerned. When financing the construction or the adaptation of the premises which will accommodate the technical units responsible for the implementation of the program as well as the documents that will be rehabilitated, these authorities also fulfill the co-funding requirements.

Removal of Barriers

A new preservation and conservation policy passes by the removal of compartmentalization, the lifting of the sluice gates that still exist. A striking example is offered by the contrast between the conservation program and facilities of the Library of Congress and the National Archives of the United States of America, located in walking distance from one another.

Less spectacular barriers often characterize relations between institutions of the same country, between specialized international bodies, and between countries. Where they survive, these barriers constitute no small brake on progress. The lack of dynamism for sharing achievements and combing know-how apparently derives from the conjunction of a variety of factors that are *psychological* (rivalry, mistrust), *administrative* (rigidity of budget regulations, too heavy concertation machinery), and *financial* (dispersion of the resources, inadequate funds).

Even though the immediate causes might be varied and numerous, the barriers we encounter ultimately result from a kind of historical inertia. The happy isolation routine of the time of traditional manual repair continues, although it is no longer compatible with the scientific and technical requirement of our *fin de siècle*. The old routines must be terminated, and the fact accepted that the preservation of the heritage depends, at least partly, upon the quality and intensiveness of international cooperation. Well-conceived international cooperation is possible, and only such cooperation can channel new resources toward the preservation of the documentary heritage.

Partnership

Direct cooperation between institutions of two countries operating in the same field is certainly one of the most efficient means for advancing knowledge. It ensures progress and, above all, it permits the achievement of safer results by gathering experience and checking results in two different environments.

With respect to research on the pathology of documentary media and the development of new restoration techniques, partnership between laboratories and workshops in the "north" and the "south" could probably offer the most efficient

machinery, since it would support development in the Third World while making direct contribution to the research itself. Additional expenditures imposed by such machinery on the "northern" partner are justified by the scientific advantages secured this way, *i.e.*, the possibility of testing processes, products, and equipment in hard climatic conditions. A priori, it is not impossible that a wealthy and financially autonomous institution would be in a position to cover the expenditures of a partnership scheme, including the setting up or the modernization of restoration facilities in the partner country and the carrying through of a conservation program lengthy enough to achieve solid results. Very few such institutions, if any, exist in the world. Partnership ventures therefore require the raising of special resources. These resources do exist, since bilateral cooperation agencies appreciate precisely these types of projects. They contribute to scientific and technical progress, and they create useful and durable links between the specialists of the two countries. An idea that is attractive on paper is not necessarily realistic. Unexpected obstacles are often more powerful than hopes based on mere logic. Nevertheless, the idea of partnership schemes is worth testing. It might be successful.

Training

All specialists agree that no significant improvement can be achieved in the physical preservation of the heritage without revolutionizing, both in the quantity and quality, the training of conservators. The progress achieved over the past 30 years is something of a miracle. Without structures, schools, and spectacular investments, dozens of scientists, engineers, and technicians succeeded in changing the theory and practice of conservation. The time has probably come for opening a new stage: Organizing the training, and first of all the training of trainers. The libraries and archives of the world need at least one institute for specialized training in the conservation of paper and other documentary media. Such an institute could be built up progressively, step by step. At the beginning it could offer short-term (2-3 months) intensive courses, and arrive, within a reasonable delay, at the point of establishing a regular training program covering a full academic year. The institute could receive trainers from all over the world. Back home, those trained in the institute could train "on-the-job" conservators for the archives and libraries of their country.

The creation of an institute of that type would probably cost a considerable amount, but the expenditure would be a reasonable one. The world problem of the training of conservators could be solved before the end of the 20th century. Should the Vienna Conference endorse the idea, the International Federation of Library Associations and Institutions (IFLA) and the International Council on Archives (ICA) would certainly be willing to join efforts for securing the funds required for implementing the project.

Future Cooperation

In spite of the remaining barriers and obstacles mentioned earlier, information circulates more and more rapidly. Those who specialize in paper pathology and conservation know each other either personally or at least by reading. The professional and technical literature is vigorous enough, as shown in the bibliographies. However, something is lacking. There is no international forum or machinery vested with the responsibility of testing processes, supplies, and equipment and that could consequently recommend or warn against using them depending upon

the climatic conditions of the country concerned, the agents of deterioration, and the damages to repair.

Industrialized countries manage to live with this vacuum, because they are in a position to carry out testing and thus choose between the existing techniques. The situation in developing countries is totally different. Their option will often depend on random information from an article, a catalogue, or a contact. One or more light and inexpensive schemes should urgently be conceived and introduced for making possible well-founded and economically viable options instead of haphazard decisions.

By combining the experience and knowledge of libraries and archives, the compilation and circulation of guidelines intended to prevent false diagnosis and the use of wrong therapies would be possible. The problem does not exist in describing the various restoration processes (they are available), but in specifying the conditions under which they are applicable. Thus, as a simple example, encapsulation may certainly be recommended for saving valuable manuscripts that became brittle, but certainly not for mass conservation, since it multiplies by 10 the volume of the document. Such texts could be developed jointly by specialists from libraries and archives and published jointly by IFLA and ICA.

Beyond its practical importance, the development of guidelines would render invaluable service to the research. It would reveal gaps, doubts, and controversial methods and thus identify current priorities; and it would lift the barriers between the conservation programs of archives and libraries and thus multiply the chances of developing mass conservation techniques. Such a standardization exercise would first require a project description and a financial estimate, to be developed jointly by the competent ICA and IFLA bodies. Raising the necessary resources for a project so obviously useful should not be beyond the reach of the international organizations concerned.

Conclusion

This paper advocates a new international strategy. Whatever resources may be made available, the physical status of the documentary heritage will decay without a radical revision of the approaches, the routine, and the "idées reçues" with respect to the limits of what is possible. Joint reflection by the two professional communities is in itself most encouraging. Such cooperation will certainly help convince funding agencies, since it would double the value of the new resources that could be obtained for preserving the documentary heritage of mankind. But to dare to hope does not mean that one has to forget basic realities. In all countries, permanent conservation activities have to be financed under the national budget. Extraordinary private or foreign funds may help in initiating or completing programs; they cannot replace the annual budget appropriations. This is fair enough, since a national community must secure for itself its own continuity and must itself preserve its own memory.

References and Notes

1. UNESCO. Statistical Yearbook. Paris: UNESCO.
2. Twenty-Second International Archival Round Table Conference: Bratislava, 1983. *The Archivist and the Inflation of Contemporary Records*; proceedings of the 22d Conference, 1983. [S.l.: International Council on Archives], 1985, 204 p.

ZUSAMMENFASSUNG – Eine Strategie, um die finanziellen Mittel zu erhöhen, die zur Erhaltung von Archiv- und Bibliotheksmaterial zur Verfügung stehen wird, basierend auf der zweifachen Hypothese, dass 1. Ressourcen in der Tat vorhanden sind und nur gefunden werden müssen und 2. dass die derzeitige Konservierungspolitik, die versucht, die Kenntnis über diese Problematik bei der Oeffentlichkeit und den Entscheidungsträger zu vertiefen in die falsche Richtung gelenkt wird und revidiert werden muss, wird vorgeschlagen. Einrichtungen, die Unterstützung suchen, sollten die Verfahrensweisen der Stellen, die finanzielle Mittel bereitstellen, kennen und sollten solche Bitten um finanzielle Unterstützung entwickeln, die sich diese Verfahrensweisen zu Nutze machen. Nationale Konservierungsprogramme, die zur Entwicklung eines Landes beitragen, indem sie industrielle Initiativen, wissenschaftliche Forschung und Ausbildung von Personal einbeziehen, werden von vielen Stellen positiver betrachtet, als solche, die nur die "Nützlichkeit" hervorheben. Der gegenseitige Informationsaustausch sollte der Grundstein der Konservierungspolitik sein und Konservierungspolitik sollte versuchen, psychologische, verwaltungsbezogene und finanzielle Barrieren zwischen den zusammenarbeitenden Parteien abzubauen. Partnerschaftliche Unternehmen zwischen Industrienationen und Entwicklungsländern weisen grosse potentielle Vorteile für beide Seiten auf. Die Gebiete, auf denen IFLA und ICA eine wichtige gemeinsame Führungsrolle übernehmen könnten, sind: die Errichtung eines weltweiten Ausbildungsinstituts, das mit der Ausbildung von Ausbildern aus aller Welt im Bereich der Erhaltungs- und Konservierungstechniken beginnt; das unabhängige Ueberprüfen von Verfahren, Material und Geräten; der Informationsaustausch mit Entwicklungsländern und das Aufstellen von Richtlinien auf dem Gebiet der Pflege und Behandlung, die veröffentlicht und international verbreitet werden sollen.

RESUME – On propose une stratégie visant à accroître les moyens mis à la disposition de la préservation des archives et des matériaux de bibliothèque. Cette stratégie se fonde sur la double hypothèse suivante: 1. les moyens existent et il suffit de les définir; et 2. l'action actuelle en matière de préservation pour sensibiliser le public et les responsables est mal orientée et il convient donc de la réexaminer. Il faut que les institutions demandant une aide connaissent les règles de procédure des agences bailleuses de fonds pour formuler à leur intention des demandes de financement qui exploitent ces règles. Nombre d'agences considéreront de manière plus favorable les programmes nationaux de préservation qui contribuent au développement d'un pays en y incluant des initiatives industrielles, des recherches scientifiques et la formation du personnel, par rapport aux demandes ne pouvant faire preuve que de la seule "utilité." Il convient que l'action en matière de préservation ait comme pierre angulaire l'échange coopératif, tout en s'efforçant d'éliminer les barrières financières, administratives et psychologiques entre les parties coopérantes. Les tentatives d'association entre les pays développés et les pays en voie de développement comportent de nombreux avantages potentiels pour les deux parties. Parmi les domaines dans lesquels l'IFLA et l'ICA pourraient fournir des directives importantes en matière de direction coopérative on compte les suivants: la création d'un institut mondial de formation, commençant par la formation du personnel enseignant de tous les pays, dans la conservation et la préservation: essais indépendants des processus, des matériaux et de l'équipement, comprenant un échange d'informations avec les pays en voie de développement; et la formulation des directives concernant les précautions à prendre et les traitements à employer. Il faudra prévoir une impression et un tirage importants de ces directives sur le plan international.

APPROACHES TO TRAINING
IN PRESERVATION AND CONSERVATION

Jeanne-Marie Dureau
Ecole Nationale Supérieure des Bibliothèques
France

ABSTRACT

A growing interest in preservation has led a number of library schools to create study programs that incorporate issues of library preservation and conservation. Difficulties in addressing the needs of library school students in this area arise from the difference of meaning that the terms preservation, conservation, and restoration have for French, British, and American educators. Preservation and conservation training is offered in the United States by a number of library schools in a single 50-hour course. The Columbia University School of Library Service offers a lengthy program that has two components: a 3-year program to train conservators, and a 2-year program to train preservation administrators. The Ratcliffe Report summarizes preservation and conservation training in Great Britain. There, practical instruction is given in schools for binders and conservators, and library schools emphasize administration and management. The argument is made in England that all library schools should incorporate preservation and conservation into their curricula, since these matters relate to all materials, new or old. French library schools are in a period of re-evaluation and reform. Of the two schools that produce librarians, the Ecole des Chartres students receive the most historic background on which to build preservation policy. Regardless of the school, the proposal for reform includes the suggestion that preservation be among the required courses for all librarians.

Introduction

What information should be given to librarians in the field of preservation and conservation? I became very familiar with this question during the 10 years I have been responsible for instruction at the Ecole Nationale Supérieure des Bibliothèques (ENSB). I posed it to myself again when I was asked to suggest a possible curriculum for conservation training by the Ministère de l'Education Nationale. This project is part of preliminary discussions of a reform plan for training librarians at and prior to the university level, a plan which is still under study. It surfaced again in other contexts. With the assistance of a Fulbright grant, I visited several library schools in the United States, which permitted me to explore the points of view of our colleagues across the Atlantic (1). Subsequently, I took part in a 1-day workshop sponsored by the Library Association in England, and this experience gave me an understanding of the positions of my British colleagues. I do not pretend to respond perfectly to the above question. I would like, nevertheless, to present my thoughts and conclusions on the subject based on my observations of the fundamentals of training of librarians in preservation and conservation as it is carried out in France, the United States, and Great Britain.

The conservation of cultural artifacts in general, and more particularly of documents housed by libraries, has undergone important developments in the past 20 years, which can be measured in part by the growth of bibliographies dealing with the subject. This development has also led to the establishment by the International Federation of Library Associations and Institutions (IFLA) of a Core Programme on Preservation and Conservation (PAC) (2), which was officially launched at this Vienna conference.

The growing interest in preservation has also induced library science schools to create study programs that incorporate information on this aspect of the profession. Immediately following the Vienna conference, in fact, a conference will be held to discuss these very types of programs (3). Our British colleagues are also having seminars on the subject (4) following a general report on conservation in English libraries (5).

Definitions

Before examining more closely the existing proposals on training in preservation and conservation, it is prudent to first define the terms "preservation" and "conservation." The term preservation is rarely used by French librarians. The word "sauvegarde" is more common for us, it seems. On the other hand, the words preservation and conservation serve, often in an interchangeable way, our Anglo-Saxon colleagues. They always endeavor to distinguish their use, and I will try to observe the distinction that they propose. The definition of these terms opens the new edition of IFLA's recently published Conservation Principles (6). There preservation "includes all the managerial and financial considerations, including storage and accommodation provisions, staffing levels, policies, techniques and methods involved in preserving library and archive materials and the information contained in them." Conservation "denotes those specific policies and practices involved in protecting library and archive materials from deterioration, damage and decay, including the methods and techniques devised by technical staff." The term "restoration" is also used, and "denotes those techniques and judgements [sic] used by technical staff engaged in the making good of library and archive materials damaged by time, use or other factors."

The differences between these words are clear and their meaning is not ambiguous. In preservation, it seems, the general organizational measures and the administration are put to work in a preventive manner for the preservation of collections and their content. Nothing is said about the part of the technical staff, but precisely because their role is not mentioned, preservation appears more to be the matter of the administrator of the collections. Conservation focuses more on precise techniques, perfected by the technical staff in the struggle against the degradation of collections. From this definition unfolds a collaboration in conservation between the technical staff and the administrative staff. The text cannot be more precise on the respective role of each one, because the sharing of the responsibilities is different according to the country involved and the size of the library.

When we come to the designation of the different staffs and to understanding the actions implied by the three substantives defined above, the problems of language become apparent. This problem must be stressed before comparing the contents of the training programs. The French have difficulty with the English word "conservator." From the different sense of the word in English and in French there follows a different conception of the role of the librarian versus the conservator, which is difficult for the French to perceive. The French word "conservateur" relates not to the technical staff, but to the administrative staff responsible for the collections. Besides, there does not exist for us any equivalent to the word conservator, who functions as technical staff in charge of restoration on one hand, but who also assumes a role in the prevention of damage on the other. The technical staff in France concerns itself mainly with the repair of damage. Only the librarian is responsible for preservation.

To avoid these traps, I propose to use a medical vocabulary and to say that the technical staff takes responsibility for treatments, or therapy, in all countries. According to the country and to the importance of collections, the technical staff can

take all or part of the responsibility for the prophylaxy of damage. In all countries administrative staff for the collections assure the preservation of the collections and their content by general measures of organization, administrative management, and finance. Logically, one could in consequence expect to see scientific training more heavily emphasized for the technical personnel in the Anglo-Saxon world and one could expect the administrative staff of French collections to include in its professional training management, prevention, and a high level of technical knowledge. In fact, it is difficult to form a training program that clearly reflects reality.

Current Status of Existing Training Programs

As indicated above, the following examination of library training programs relies on findings gathered from France, Great Britain, and the United States. Other countries have probably endeavored to establish programs of the same type, but those in the three countries mentioned are different enough to give a good overall view.

Training of Librarians in the United States

The drive to evaluate conservation and preservation training across the Atlantic has resulted in a well-compiled book (7), which is in its 5th edition. This volume in its several editions allows a general view of the present as well as a look at the evolution of training. It indicates a growth in the number of schools that offer training in conservation, and the creation of a long and specialized training course in conservation at the oldest library school in North America. It is very appropriate that Susan Swartzburg, who compiled this book, set apart the lengthy training of specialists given at the Columbia University School of Library Service from the more rapid training given in a 50-hour course by half of the library science schools in North America. Besides these two types of training, one also finds a third type in which conservation is included in a course on Administration and Management of Collections.

Swartzburg (7) briefly mentions the contents of some courses, which can be divided into the following sub-headings: Nature of documents; causes of destruction; and techniques of conservation and, more rarely, restoration. In some schools, details are given on the type of documents implied, which show that maps, photos, and audio-visual formats can be lumped with books; and that micrography may also be included in some cases.

In addition to these technical aspects, which are clearly in the realm of conservation in the Anglo-Saxon sense, preservation is taught under the following designations: Conservation policy at the local, regional, and national level; and preparation of a disaster plan. More rarely mentioned as parts of the field are: Communication history, rare books, introduction to the archives, and history of the book and printing. Thus, in most cases, our colleagues seem to be guided by the technical aspects in teaching conservation, rejecting the preservation aspects in the general courses and rarely reviewing the history of the book and other supports in conservation and preservation.

Columbia University Library School. – The Columbia University Library Training Program requires either 2 or 3 years to train the limited number of students they admit (8). In the 3-year program students who already have a degree in chemistry receive instruction in book history and a real mastership of conservation treatments added to manual skill. These are the conservators. In the 2-year program, the skills of a librarian already oriented toward preservation of patrimony are expanded with knowledge about technical conservation treatments. The student gathers competence in administration and collection management and knowledge of the history of the

book and its conservation. The mixture allows administrators to build conservation policies.

This more specialized training confirms the necessity of three combined skills: Knowledge of libraries and their management, techniques and history of the book, and conservation techniques. These three aspects were already mentioned in the programs of other North American library schools, but they were not always systematically gathered and presented at the same time. At Columbia, a graduate librarian may escape the first training year, but is required to study book history if he or she has not already done so.

Training of Librarians in Great Britain

The Ratcliffe Report (5) is a good source for summarizing the thoughts of our English colleagues about training in conservation. This report was based on answers to several questionnaires, one of them on conservation training (Figure 1). The list of questions evaluates the training of administrators as well as that of the technical staff, and includes three parts: a practical part, bookbinding and conservation, clearly designed for conservators; a theoretical part; and an administrative/management part designed for administrators. These last two parts doubtlessly cover preservation and policy and management points met in American programs. The theoretical part of the questionnaire includes conservation necessity; environment; and history/bibliography (material). In so doing, it takes in again, it seems to me, the technical considerations (causes of destruction, conservation techniques) met in the American programs, but very clearly adds to them the contribution of history and bibliography.

The responses to the questionnaire, incorporated into the report, show that practical instruction is given in schools for binders and conservators, whereas library science schools emphasize administration and management. As for our main concern, the training of librarians, the content of the instruction is judged insufficient. The report states:

In most of the library school courses the scientific content varies from negligible to non-existent. After management and administration, they touch collectively on such issues as the need for conservation, environmental considerations, conservation techniques, special collection management, rare book librarianship, archival repairs, physical bibliography and such like. Most of the respondents agree that their attention to conservation is at a basic introductory level. As one commented: this field is an obvious candidate for inclusion in curriculum development in the near future.

Two published proposals are attached to the Ratcliffe Report, one by Barry Bloomfield and the other by John Feather. Bloomfield gives a precise list of existing instruction (p. 109) and formulates a program of accelerated training in 3 months for librarians, including 1 month of theory, 1 month of laboratory, 2 weeks of internship, 1 week of administration, and 1 week of examination. In this framework, the technical aspects of conservation are obviously emphasized. Preservation and its possible fundamentals cannot be taught in the alloted time or are considered as already possessed by the librarian. John Feather rightly distinguishes the sensitivity necessary for all librarians to the problem of preservation of collections from the training of specialists. For that reason, he emphasizes the necessity of conservation training in compulsory courses for all students in library schools. The preservation of the cultural patrimony of libraries must certainly not be limited to the case of rare and old books, as it touches all libraries in their diversity. Consequently, all library science schools should give attention to these problems in the required courses. The most appropriate place to include them, according to Feather, would be in the management of staff and

**CAMBRIDGE UNIVERSITY LIBRARY
CONSERVATION PROJECT**

Training Course Questionnaire

1. Name and address of Institution: _____

2. Name of Principal of Institution: _____

 Yes No

3. Do you offer courses of any kind in Conservation/
Conservation awareness? ☐ ☐

 If so (a) Does it form part of another course? ☐ ☐

 (b) Constitute a course in itself: ☐ ☐

4. Is this course(s) aimed at educating

 (a) Professional librarians ☐

 (b) Binders

 (c) Conservation technicians ☐ ☐

 (d) Other?

5. Name of person in charge of conservation course(s): _____

6. Type of course: Full-time ☐ day release ☐ undergraduate ☐

 part-time ☐ evening ☐ postgraduate ☐

7. Duration of course: _____

8. Normal entrance requirements: _____

9. Maximum number of students admitted per course: _____

10. Brief description of course(s): _____

11. Please indicate the percentage of the course devoted to the following:

 i. Management/Administration ☐

 ii. Practical (benchwork): (a) binding ☐

 (b) archival repair ☐

 iii. Theory: (a) Need for conservation ☐

 (b) environmental considerations ☐

 (c) conservation techniques ☐

 (d) history/bibliography ☐

 (e) other ☐

 iv. Scientific content: _____

 v. Lectures by visiting specialists

 (a) Librarians ☐ (c) Scientists ☐

 (b) Archivists ☐ (d) Binders/con- ☐
 servators

 (e) Other: _____

12. Is any practical project or dissertation required? _____

13. Are students exposed to original materials? _____

14. Final qualification awarded: _____

 Is it granted on the basis of assessment ☐ examination ☐ or both ☐

15. Pass rate for course in 1982: _____

16. Number of teaching staff for this course(s): _____

17. Please state the specific training objectives of your course(s): _____

18. What other courses would you like to see available? _____

19. Comments:

Signed: _____

Position in organisation: _____

(Please use additional sheets if necessary)

80

Fig. 1. Questionnaire used in a survey of conservation training courses in British library schools, results of which are included in the Ratcliffe Report. (Courtesy of Ratcliffe)

- 2 -

PROJET DE PROGRAMME DE L'E.N.S.S.I.B.

Option
PATRIMOINE
==========

On définira le patrimoine comme étant tout ce qui témoigne de la pensée ou du goût d'une époque. L'objectif de cette option est de former des personnes capables de conserver, de constituer, d'enrichir des collections patrimoniales, de les faire connaître et d'en permettre la consultation.
(Ce programme suppose que l'histoire du livre et de la presse a déjà été enseignée dans le tronc commun dans l'information et son support, 1re année, de même que la conservation dans coopération, 2e année).

Les principaux éléments du programme sont :

I - LES DIVERS ELEMENTS DU PATRIMOINE (Cours 37 h)

Les grands jalons dans l'histoire de l'art et de la pensée en fonction des différents médias, aussi bien en ce qui concerne le contenu que la forme (ex : esthétique du livre).

▶ Histoire et évolution des différents supports de communication et de leur contenu

- Histoire de la presse (5 heures)
- Histoire de l'image : estampe, affiche, photographie (10 heures)
- Histoire des médias récents : cinéma, médias sonores, radio, vidéo (10 heures)

▶ L'esthétique du livre

- Histoire de la reliure précieuse (6 heures)
- Le livre illustré moderne (5 heures)
- Caractères et mise en page (2 heures)

II - LES COLLECTIONS DANS LE MONDE ET EN FRANCE (Cours 13 h)

▶ Histoire des bibliothèques dans le monde (8 heures)

▶ Approche générale de la situation française (5 heures)

- Le patrimoine ancien conservé par les bibliothèques françaises : types de documents (manuscrits, livres, estampes, objets) ; provenance (confiscation révolutionnaire, dons, achats) ; nombre ; état matériel ; état de l'inventaire ; valeur marchande et intérêt.

- Autres organismes publics et privés (musées et archives) conservant le même type de document.

.../...

- Le patrimoine des 19e et 20e siècles :
. archives et documents photographiques, cinématographiques et sonores ; organisation de la collecte et de la conservation en France ;
. la presse ancienne, la presse des 19e et 20e siècles ; organisation de la collecte, du recensement et de la conservation.

- Le patrimoine local : fonds locaux et régionaux

III - ENSEIGNEMENT PRATIQUE (TD 60 h, TP 30 h)

● Conservation, acquisition et restauration (20 h)

● Mise en valeur : catalogage, indexation, analyse du contenu, utilisation, exposition (60 h)

● Initiation à la recherche (10 h)

▶ Conservation et accroissements

- Conservation et restauration : étude de cas (10 h)
- Les réserves (3 h)
- L'apport des techniques modernes à la conservation et modalités pratiques de leur utilisation : informatique, photographie et microfilm, vidéodisque (5 h)
- Les acquisitions

▶ Mise en valeur des collections (catalogage, indexation, analyse du contenu, acquisitions)

- Manuscrits médiévaux : typologie des manuscrits ; grands catalogues et instruments de travail spécifiques
- Estampes,
- Photographies,
- Reliures,
- Livres imprimés (30 h)
- Traitement des manuscrits modernes,
- Expositions.

▶ Initiation à la recherche : à aménager selon les orientations de la recherche ; on trouvera, ci-dessous, un EXEMPLE de choix :

- Edition et critique des textes :
. méthodes de la codicologie (5 h)
. apport et méthodes de la bibliographie matérielle (5 h)

- Le point sur la recherche en histoire du livre (3 b)

- Initiation à l'utilisation des archives : histoire des maisons d'édition (3 h)

- La recherche de données chiffrées pour l'histoire du livre et de la lecture (2 h).

IV - PROJET DE FIN D'ETUDES : 80 heures

Fig. 2. Proposed syllabus for a conservation training course in French library schools. (This document is written by the author and is only a proposal. It has not yet been discussed or approved.)

budgets. It should be understood that these courses include a minimum amount of conservation technique.

The formula adopted by the Columbia University School of Library Service for the training of the two types of specialists appears not to be adapted to England – and I think the same is true of France – which offers a narrow market for librarians specialized in conservation. The training of conservators, the 3-year program at Columbia, does not appear suited to library schools. It is toward a specialized option, therefore, which will increase training in preservation and conservation for some students, that library schools should tend. On the other hand, the affirmation that comes from Feather that conservation is as much a problem of management as an amalgam of scientific competency with technical and artistic competencies appears to me a fruitful summary of the different points that would cover conservation and preservation training. To accumulate these skills in a single person is not always possible; it is nevertheless certain that the librarian, aside from his training in administration, must have a familiarity with these points of view and with the historic point of view.

Training of Librarians in France

Some reforms are being studied in France at present to remodel entirely the training of librarians. Among other changes, reform of conservation education is under study. For the moment, however, the education of French librarians in this aspect of their profession is relatively succinct. One must distinguish the librarians who have received preliminary instruction from the Ecole des Chartres, and are then specialized for libraries from those who, at graduate or undergraduate level, are coming from the Ecole Nationale Supérieure des Bibliothèques. The historic training, which the students from the Ecole des Chartres have received, is a positive basis on which to build a preservation policy.

The librarians coming out of the ENSB have a less homogeneous background and must be given the idea of the evolution of communication supports and their content (in such courses as the History of the Book, and Printing from the Middle Ages to Our Day). This training would permit them to learn the important landmarks of the history of thought that documents represent. Personally, I think that only this type of course permits the student to perceive the interest of conserving documents in their original form and also to estimate the relative value of a particular document or type of document. Unfortunately, only the printed book can be approached and there is no time to study the evolution of other media such as prints, manuscripts, films, tapes, and so forth. Technical conservation courses of the type given in the United States are also part of the present training.

The study of a new training program for French library school students has led me to write a proposal for a new curriculum for preservation and conservation. After asking, as Feather did, that the required courses for all students include preservation, so that every librarian may sense the importance of the problem, I have proposed a scheme for a training for conservation in optional courses (Figure 2). The time schedule remains restrained, unfortunately, but it will eventually be longer than it is now. It seems useful to me to articulate the training on three questions: What is patrimony, where is it conserved, and what treatment does it receive and what usage is made of it?

The first two parts are theoretical and endeavor to make students understand the two main aspects of documents – historic or aesthetic – for the oldest as well as for the most recent, then to indicate the institutions that take care of them in France and

in the world. A final practical part plans to show the use of these documents and the attitude of the librarians towards them, which should induce them to conserve or increase existing collections and to make them open and usable. The first two parts help to determine on what criteria one can build a preservation policy. The third includes the material conservation of collections and also their use and access by type of document.

Conclusions

The prospective reform, the examination of our two types of French training, the examination of the different contents proposed by the library science schools in the USA or projects studied by our British colleagues, leads me to formulate the following remarks that may be useful to other countries. We are all agreed that training in preservation and conservation must concern all the administrators of collections and not just a handful of specialists of old collections.

In this frame, with a certain unanimity, one proposes to associate in the training a scientific and technical knowledge of the physical and material problems relating to the physical conservation of documents, in the narrow sense of the Anglo-Saxon expression; and a training in preservation, included in instruction on management, impressing upon the student the responsibility of the librarian with respect to the mission of preserving patrimony. This part must lead to the elaboration of policy, and the building of programs in the local, regional, and national echelon.

On the other hand, the importance of the historic and aesthetic aspect of documents and their interest for present and future research occur less clearly and less often. Often this historic culture exists in the instruction already dispensed, but does not seem to be taken into account as an important element of conservation training. Finally, the total outlook could be less negative for a number of library schools, if they realized that they are already undertaking preservation and conservation training, without knowing it, when they give a course in the technology and history of the book. This aspect must be presented and examined in varying degrees, however, according to whether one forms a more specialized staff or whether one chooses or wishes to put forth a decided sensitivity in the general instruction.

The task of learning to preserve a patrimony of libraries outside of a historic context is impossible, I believe. Perceiving the document as a historic object that is a witness to the thought and taste of a civilization is essential. This view leads equally to the awareness that the patrimony to conserve is the legacy of the past, but also of the present that surrounds us and of which the most common traces are disappearing before our eyes. It is the responsibility of the librarian to act and halt the very rapid destruction of supports and materials that are now becoming more and more fragile.

Familiarity with the gaps that face the historian in his quest for evidence of the past is an excellent way to be attentive to the preservation of the present. This dimension, often absent in many of the courses, is vital. Obviously, if the librarian has to make choices, he must be able to discern the essential from the non-essential (financial considerations lead inevitably to a focus on what deserves most preservation efforts). The action of preservation, beyond the technical work of conservation, can only be conducted with reference to historic fundamentals of thought and its content.

Daniel Boorstin, an American historian and the Librarian of Congress, evoked at the opening of the 1977 conference of IFLA in Brussels, this long symbiosis of the librarian and the historian in his allocution, *A Historian to the Librarians* (10):

Ever since there have been historians, the Library has been the historian's natural habitat. Librarians have kept house for us, you have nourished us.

Although we have been sometimes impatient with you, you have been wonderfully patient with us. You have helped us ask the unasked question and have helped us try to answer the unanswerable. We – historians and librarians – have lived so long and so intimately together that it would be superfluous, if not embarrassing (and out of tune with the spirit of the age) at this late date to try to regularize the relationship with a formal marriage. It remains to be seen to what degree one will lead the historic culture of the librarian responsible for patrimony. Will he content himself to be a technician to the *ecoute* of the historian? It would be, in my judgment, a loss for the historic studies themselves to restrain his role. The symbiosis described by Boorstin should continue, and the dialogue between the librarian and his privileged interlocutor should be pursued to enrich historical studies with the global points of view the librarian has acquired from his familiarity with the media of all times and civilizations, the manifold media of human experience.

References and Notes

1. Dureau, J. M. Elements sur la conservation aux Etats-Unis. *Bulletin des Bibliothèques de France.* 1985, *30* (1), 72-78.
2. International Federation of Library Associations and Institutions. *Draft Medium Term Programme 1981-1985.* The Hague: IFLA, 1982, 12.
3. Teaching of Conservation and Preservation: IFLA, FID, ICA Joint Seminar. Vienna, April 11-13, 1986.
4. Education for conservation: Five seminar papers (Introduced by Sir Harry Hookway). *Journal of Librarianship,* 1985, *17*(2), 73-118.
5. Ratcliffe, F. W. *Preservation policies and conservation in British libraries.* London: The British Library, 1984.
6. Dureau, J. M. and Clements, D. W. G. *Principles for the preservation and conservation of library materials.* The Hague: International Federation of Library Associations and Institutions, 1986.
7. Swartzburg, S. G. *Preservation Education Directory.* (5th edition) American Library Association, 1985.
8. Banks, P. N. The Columbia University Program in Library and Archives Conservation. In: *The History and Future Directions of Conservation Training in North America.* Washington: National Institute for the Conservation of Cultural Property, 1985, 48-53.
9. *Le Patrimoine des Bibliothèques*, rapport à Monsieur le Directeur de livre et de la lecture. Louis Desgraves président, J. L. Gauthier rapporteur. Paris: Ministère de la Culture, 1982. Annexes no. 279 à 189: La formation des personnels.
10. Boorstin, D. *A historian to the librarians.* Speech presented at the conference of the International Federation of Library Associations and Institutions, Brussels, September 5, 1977.

ZUSAMMENFASSUNG – Ein wachsendes Interesse an Konservierung hat eine Anzahl von Ausbildungsstätten für das Bibliothekswesen dazu veranlasst, ein Studienprogramm zu schaffen, das Themen der Bibliothekserhaltung und Konservierung beinhaltet. Die Schwierigkeiten, die vorhanden sind, auf die Bedürfnisse der Studenten auf diesem Gebiet an den Ausbildungsorten einzugehen, entstehen auf Grund des Bedeutungsunterschiedes der Begriffe Erhaltung, Konservierung und Restaurierung für französische, britische und amerikanische Ausbilder. Ausbildung auf dem Gebiet der Erhaltung und Konservierung wird in den Vereinigten Staaten von einer Anzahl von Ausbildungsstätten für das Bibliothekswesen in einem einzigen Kurs, der 50 Stun-

den umfasst, angeboten. Die Columbia University School of Library Service (Ausbildungsstätte für das Bibliothekswesen an der Columbia Universität) bietet ein langes Programm, das aus zwei Teilen besteht: ein 3jähriges Programm, um Konservatoren auszubilden und ein 2jähriges Programm, um Verwalter auszubilden. Der Ratcliffe-Bericht fasst die Ausbildung zur Erhaltung und Konservierung in Grossbritannien zusammen. Dort wird in Ausbildungsstätten für das Bibliothekswesen praktische Ausbildung für Buchbinder und Konservatoren angeboten und Schulen betonen Verwaltung und Leitung. In England wird das Argument hervorgebracht, dass alle Ausbildungsstätten für Bibliothekswesen Erhaltung und Konservierung in ihre Curricula einbeziehen sollten, da sich diese Gebiete auf alle Materialien, sowohl neue als auch alte beziehen. Französische Ausbildungsstätten für das Bibliothekswesen befinden sich in einer Periode der Neueinschätzung und Reform. Von den beiden Schulen, in denen Bibliothekare ausgebildet werden, erhalten die Studenten der Ecole des Chartres die meiste Kenntnis über den historischen Hintergrund, auf dem die Konservierungsmethoden aufzubauen sind. Der Reformvorschlag enthält ungeachtet der Schule die Empfehlung, Konservierung zu einem obligatorischen Kurs für alle Bibliothekare zu machen.

RESUME – L'intérêt croissant porté à la préservation a conduit bon nombre d'écoles de bibliothèques à créer des programmes d'études comportant des questions de préservation et de conservation dans les bibliothèques. Il est difficile de faire face aux besoins des étudiants des écoles de bibliothèques dans ce domaine car il existe une différence de sens qu'attachent les universitaires français, britanniques et américains aux termes "préservation, conservation et restauration". Un certain nombre d'écoles de bibliothèques aux Etats-Unis offre une formation en matière de préservation et de conservation dans le cadre d'un seul cours de 50 heures. La Columbia University School of Library Service offre un programme de longue durée comportant deux volets: un programme de 3 ans visant à former les conservateurs, et un programme de 2 ans visant à former les administrateurs de la préservation. Le Rapport Ratcliffe résume la formation en préservation et en conservation en Grande-Bretagne, où l'on dispense une instruction pratique dans les écoles à l'intention des relieurs et des conservateurs. De plus, les écoles de bibliothèques mettent l'accent sur l'administration et la gestion. En Angleterre on estime que toutes les écoles de bibliothèques doivent incorporer la préservation et la conservation à leurs programmes d'études puisque ces questions concernent tous les matériaux, nouveaux ou anciens. Les écoles françaises traversent actuellement une période de réévaluation et de réforme. Sur les deux écoles qui forment les bibliothécaires, les étudiants de l'Ecole des Chartrés apprennent le plus grand nombre de détails historiques sur lesquels renforcer l'action en matière de préservation. Quelle que soit l'école, la proposition de réforme comporte la suggestion que la préservation fait partie des cours obligatoires pour tous les bibliothécaires.

ORGANIZING AND IMPLEMENTING
A PRESERVATION MICROFILMING PROGRAM

Mya Thanda Poe
Deputy Field Director
Library of Congress Office, New Delhi
India

ABSTRACT

The production of the microfilming program in the Microform Division of the New Delhi office of the Library of Congress has grown from the filming of 14 newspapers in 1962, when it was founded, to its present filming output of 341 newspapers, serials, and government gazettes from 21 countries in South Asia, Southeast Asia, and the Near East. In the microfiche program, viewed as a preservation measure (in contrast to the storage-solving purposes of the microfilm program), the office processes publications of research value from India and other South Asia countries. In India alone permission has been granted to microfiche the publications of 22 state and union territories, 19 legislative bodies, and over 135 academic and research institutions. In addition, efforts are being made to microfiche important documentation pertaining to the former princely states of India. The office has also undertaken cooperative projects with libraries of the region, as, for example, the filming of the *Suriya*, a historically important Burmese language newspaper, of which only one copy is known. These microfilm and microfiche projects, administrated by the New Delhi office and approved by the Library of Congress, are carried out by a staff of eight Indian nationals in a controlled-environment facility; equipment includes two microfilm cameras, two microfiche cameras, a microfiche reader for quality control, and a microfiche duplicator. In 1985 the office produced a total of 115,000 feet of negative microfilm and 49,961 fiches. The office adheres to the standards set forth by the Library of Congress Photoduplication Service and the American National Standards Institute. All materials selected for microfilming are approved by the Library of Congress, and research materials for microfiching are selected in accordance with the guidelines set forth in the Library's Acquisitions Policy Statements.

Historical Background

The New Delhi office of the Library of Congress was established in 1962 for the purpose of acquiring and processing current Indian publications of research value for the Library of Congress and several other United States research libraries. Participation, geographic coverage, and program responsibilities have increased greatly over the past 24 years. At present, the New Delhi office administers acquisitions and cataloging programs with coverage of Bangladesh, Bhutan, Burma, Maldives, Nepal, Sri Lanka, Thailand, and India, the largest with 31 participating libraries and institutions.

In 1964 the Library of Congress received a grant from the Rockefeller Foundation to be applied toward the cost of establishing a microfilming facility in New Delhi. A microfilm unit was established in 1965 with the installation of one large-format camera, and the microfilming of newspapers began in 1966. In 1967 the office was microfilming 112 newspapers from India, Nepal, Pakistan, and Sri Lanka. Microfilming on this scale saved valuable space for participating libraries by relieving them of the need to maintain large back files of bound newspapers. It also allowed them to limit their receipts of the papers to titles required for current use.

In 1967 a small-format camera was acquired, and the office began to microfilm official gazettes and selected small-format serials from India, Pakistan, Nepal, Ceylon, and the United Arab Republic. Since 1967 the microfilming program has grown

dramatically. The New Delhi office now films 143 newspapers, 145 periodicals, and 53 government gazettes from 21 countries in South Asia, Southeast Asia, and the Near East.

With the success of the microfilming program, it was decided to expand the operation to include microfiching. Although the microfilm program was aimed primarily at solving storage problems associated with materials such as· newspapers, gazettes, and serials, the New Delhi microfiche program was, and is, viewed as a preservation tool. In 1977 a Fuji microfiche camera processor was purchased and installed. The microfiche program began as a means to augment the acquisition of Indonesian publications, where insufficient copies were available for participating libraries. This program continues to expand as copyright clearances are obtained from various institutions and governments. In 1983 a second microfiche camera processor was acquired to handle the extra workload. The New Delhi microfiche program now includes the preservation of materials from South Asia, Southeast Asia, and the Near East.

The New Delhi office has also assumed primary responsibility for the filming and· fiching of materials acquired by other Library of Congress overseas offices. In addition, the office films and fiches materials for various custodial divisions within the Library. The New Delhi office and its microform unit are separated from its parent organization by 10,000 miles, and its organization and operation should be viewed in light of this fact.

Development and Planning

Equipment and Supplies

One of the first decisions to be made in establishing a microform program is the selection and purchase of equipment. Many factors must be considered when purchasing expensive microphotographic equipment. These include price, product quality and reliability, local power, and climatic conditions, as well as availability of maintenance service and spare parts. In many developing countries, spare parts and service for foreign equipment are often limited or simply not available because of import restrictions. When deciding what to buy, a survey of in-country availability in terms of service and parts is a prerequisite.

The Microform Division in New Delhi has two Kodak Recordak microfilm cameras and two Fuji microfiche camera processors. The MRC-4 Recordak camera is a large-format camera used in the filming of newspapers. The Model D small-format camera can accommodate government gazettes and small-format serial publications. Both cameras are high-resolution planetary cameras with a maximum reduction ratio of 30:1. Minor service and repairs are performed by local staff, and parts requiring major repairs are sent to the Photoduplication Service in the Library of Congress, Washington. The Recordak cameras produce an exposed, undeveloped roll film negative which is then shipped to the Photoduplication Service for processing. The film used for microfilming is a permanent record-type archival-quality safety film approved by the Library.

The Fuji microfiche camera processors are models S-105B and S-105C. As the name implies, these cameras produce a processed negative microfiche from which silver halide or diazo prints can be made. The Fujis yield an 11- by 15-cm sheet film consisting of 98 single frames or 48 double frames.

In addition to its camera equipment, the division has a microfiche reader that enables the staff to perform quality checks on each frame of every microfiche

produced in New Delhi. The division has recently acquired a diazo printer that produces very inexpensive negative copies from negatives. Other auxiliary equipment includes such devices as a microscope and density meters for checking equipment and film perfection.

Space and Environment

The microform operations in the New Delhi office differ somewhat from those of normal library-related micrographics organizations. These differences, in turn, affect space and environmental needs.

Because microforms produced by the New Delhi office are not retained there, but shipped instead to the Library of Congress, a long-term storage facility to house a microform collection is not needed. New Delhi does not develop the negative microfilm it produces, which further reduces space needs. When space requirements for the New Delhi microform operation are considered, the primary need is for a production facility, and for some storage space for materials to be filmed or fiched, or for filmed material awaiting clearance from Washington.

The New Delhi office must rely on an agency other than its parent body for space to house its microform operation, however. In such a situation space is at a premium, and priority is consequently given to other units within that agency. This effectively reduces the possibilities for further expansion.

Within an area of 1,386 ft², the New Delhi Microform Division operates two microfilm cameras, two microfiche cameras, a microfiche reader for quality control, and a microfiche duplicator. This space also houses a small dark room for storage of chemicals and for testing of film, a storage area, files, and office space for pre- and post-filming processing. The storage area is used for keeping hard copy before and after filming. Once the negative films have been processed and approved by the Library of Congress, the hard copy materials are discarded. We estimate that with the current operation, 1,500-2,000 ft² would be ideal. In addition to floor space, ceiling clearance should be sufficient to accommodate camera booms. Table 1 provides a breakdown of space utilization.

A controlled environment is essential to any microform operation. Temperature ranges are not to exceed 60°-80° F, and relative humidity is maintained between 40 and 50 percent. These temperature and humidity ranges are applicable for all phases of the operation, including the storage of raw and exposed film, the storage and use of chemicals, and the operation of the camera equipment. The microfiche camera processors require access to a relatively pure fresh-water supply, which is then filtered before reaching the camera.

Raw and exposed microfilm is shipped and stored in acid-free boxes. Raw microfiche stock is stored in light-tight acid-free containers. Processed microfiche negatives are inserted into acid-free envelopes and packed in boxes for shipment. Printed matter to be filmed should be kept in a dust-free environment. In New Delhi this material is stored in plastic bags at temperatures of 75°-80° F.

TABLE 1: Space Utilization in New Delhi Microform Division (Square feet)

Camera Rooms (three)	282
Dark Room	47
Office Space	957
Store Room	100
Total Area	1,386

A stable power supply for optimum camera operation is imperative. In India the primary power supply is 220 volts alternating current. The equipment used in the Microform Division operates on standard American current of 110 volts. The use of step-down voltage stabilizers is therefore necessary to convert and "clean-up" the power supply.

Staffing

In 1965 the Library of Congress was fortunate in finding an Indian national in the United States who had considerable training and experience in microphotography, both in libraries and in private industry abroad. Following a 4-month period of training in the practices and procedures of the Photoduplication Service in Washington, he joined the New Delhi office in January 1966 and assumed the position of Film Engineer in the Microfilm Section. His service to the present day has provided much needed continuity to the microform program. When the first microfiche camera processor was purchased, he was sent to Tokyo for orientation and training with Fuji Ltd. Since that time, he has had to assume responsibility for most of the maintenance on the microfiche cameras.

From the original staff of two, the Microform Division now employs eight full-time Indian nationals. Of these, five have been with the office in various capacities for at least 20 years. The present staff consists of two supervisor/technicians, four camera operators, one clerk-typist, and one serial recorder. The continued presence of one highly skilled professional has made it possible for the office to train technical staff in-house. This on-the-job training has helped to reduce the costs of expanding the program. Technical staff, who have been trained to participate in all aspects of the division's work, are interchangeable in their multifarious duties.

Specifications and Standards

The New Delhi office adheres to the standards set forth by the Photoduplication Service of the Library of Congress in its *Specifications for the Microfilming of Newspapers in the Library of Congress*, and *Specifications for the Microfilming of Books and Pamphlets in the Library of Congress*. These publications include standards for materials preparation, reduction ratio, resolution, film inspection, packaging, processing, and other related matters.

In 1981 the American National Standards Institute published its *Standards for Information on Microfiche Headings*. The New Delhi office uses a slightly modified version of this standard. The microfiche header is that area above the image area of the microfiche that is reserved for identifying the information contained in the microfiche. Because it is legible without magnification, the identification and retrieval of individual titles on microfiche is greatly simplified.

The Library of Congress has developed an in-house computer-compatible microfiche identification numbering system. This number appears in the left-hand portion of the header and uniquely identifies each microfiche title. The microfiche number is used both as a filing device and for ordering positive prints.

Over the years the New Delhi office has evolved productivity rates for its microform operation. These are used for determining costs. At full capacity, actual camera time averages 6 3/4 hours in an 8-hour work day. The remaining 1 hour and 15 minutes is used in setting up, closing down, and for maintenance and cleaning of cameras. This time includes employee breaks. To make maximum use of photographic chemicals, microfiche cameras operate 6 days a week.

Productivity levels vary with each camera. The average filming rate per hour on the large-format microfilm camera is 300 pages, or 150 exposures. Production rates on the

small-format microfilm camera are more than double this amount (approximately 710 pages, or 355 exposures per hour) because the materials are easier to handle. During FY1985 the New Delhi office produced a daily average of 417.19 ft of negative microfilm, equivalent to four 100-ft reels (Table 2). Microfiche production per camera averages approximately 5.25 fiche per hour (Table 3). Productivity levels decline somewhat when filming brittle materials because they require special handling.

Microform Production

The microfilm and microfiche projects administered by the New Delhi office constitute two distinct programs. They differ in terms of how materials are selected for microformatting and in how they are processed. The New Delhi office is not totally independent in making decisions about what is to be microfilmed. Because microfilming newspapers and serials requires an on-going financial commitment, each title added to the microfilm program must be approved by the Library of Congress. Materials selected for microfilming are received, recorded, collated, and then stored alphabetically by country until time to film. All efforts are made to obtain missing issues and missing pages and to replace damaged pages before filming. If replacement copies are not available from the original source, we attempt to borrow or photocopy original copies to fill gaps. Our good relations within the library community in India make this possible.

TABLE 2: Microfilm Production Expressed in Film Footage and Number of Exposures - FY 1981-FY 1985 (Newspapers, Gazettes, Remakes, Step Tests, Daily Routine Check, and so forth)

Year	Total Production (feet)	Number of Exposures	Average Production Per Day (feet)
FY1981	72,000	550,372	292
FY1982	73,900	544,697	307
FY1983	83,000	619,828	342
FY1984	92,200	696,530	379.31
FY1985	115,000	872,878	417.19

TABLE 3: Microfiche Production Expressed in Number of Titles, Number of Pieces, and Number of Fiches – FY1981-FY1985 (SA - current and retrospective; SEA - current and retrospective; Africa - current and retrospective; South America - current)

Year	Number of Titles	Number of Pieces	Number of Fiches
MONOGRAPHS (TOTAL)	7,042	10,684	21,818
FY1981	1,301	2,062	4,546
FY1982	1,072	1,591	2,932
FY1983	1,365	1,858	3,225
FY1984	1,912	2,899	6,203
FY1985	1,392	2,274	4,912
SERIALS (TOTAL)	2,903	17,487	28,143
FY1981	240	1,574	2,729
FY1982	537	1,719	3,304
FY1983	755	2,867	5,075
FY1984	663	2,901	4,597
FY1985	708	8,426	12,438

Gazettes are filmed on a quarterly basis. Periodicals are filmed only when the volumes are completed. We have no uniform periodicity for filming newspapers, and filming cycles are determined by standards established in *Specifications for Microfilming Newspapers in the Library of Congress*. All negative microfilm is shipped to the Photoduplication Service of the Library of Congress for developing and inspection. Print copy is not discarded until New Delhi is notified that the microfilms have been accepted and that no refilming is necessary.

Based on policies established by the Collections Development Office in the Library of Congress, titles are selected for inclusion in the microfiche program at Selection Committee meetings held regularly by the New Delhi staff. The New Delhi office acquires materials of research value to be added to the collections of the Library of Congress in accordance with guidelines set forth in the Library's Acquisitions Policy Statements. Materials selected for libraries participating in overseas programs, but not selected for the Library of Congress, are not included in the microfiche program. The general rule is: If the Library of Congress does not want it, do not fiche it. Titles acquired for microfiching are given preliminary cataloging in accordance with the *Anglo-American Cataloguing Rules*, 2nd edition (AACR2). A printed preliminary catalog card in romanized script is produced for each title. Each title is assigned a microfiche identification number from a block of numbers allotted for current and retrospective materials from each country. The microfiche number appears on the printed preliminary catalog card and in the header area of each microfiche.

Microform Division staff collate and perfection-check every page of print copy, and efforts are made to replace any defective copies prior to fiching. A layout sheet is prepared for each title. The layout sheet consists of a blank area at the top for header information. The header contains the microfiche identification number, a bibliographic description of the title, and sequential information. The remaining portion of the layout sheet consists of seven rows of 14 blocks, representing the 98 frames contained on a single sheet of microfiche film. The layout is used to determine the precise number of fiche for each title. This information appears in the sequential area of the header as 1 of 2, 2 of 2, and so forth. The reduction ratio used in microfiching is also given in the sequential area. For multipart monographs, the sequential area also indicates which part or volume of the title is contained on the microfiche. For serials, volume, issue number, month, and year of publication appear in the bibliographic description area of the header.

The preparation of headers has been rationalized so that, instead of preparing headers on the layout sheet, cataloging staff underline relevant information in the preliminary catalog record using color coding to highlight different elements in the header. The header is typed onto an ivory-white card, which is mounted on the camera and fiched before the filming of the first frame of the fiche. The first frame of the first fiche of each title contains a legend identifying the set to which the microfiche title belongs, the publisher of the fiche, the year in which the title was filmed, and terms of availability. The preliminary catalog card is filmed in the second frame of the first fiche of each title, followed by the complete text of the work (Appendix 1).

Each frame of every microfiche produced by the New Delhi office is checked for quality by the Microform Division staff. Negative copies are then made and distributed to institutions that have granted permission to microfiche their publications. The master negatives are deposited with the Photoduplication Service of the Library of Congress. Master negatives of microfilm and microfiche produced by the New Delhi office are registered with the National Register of Microform Masters. In addition, titles selected for microformatting are listed in the various accessions lists

published by the New Delhi office, and other overseas offices of the Library of Congress. Positive film prints are made available to libraries by the Photoduplication Service.

The Microfilm Program

The microfilm program was established in response to the needs of. participating libraries to economize on valuable storage space. The initial effort began with the filming of 14 newspapers. Today, the program has expanded to include 341 newspapers, serials, and government gazettes from 21 countries in South Asia, Southeast Asia, and the Near East. During that time the New Delhi office has assumed responsibility for filming materials acquired by other overseas offices of the Library of Congress. Current print subscriptions to newspapers and periodicals are still offered, but participating libraries have the option of discarding print copy in favor of microfilm for permanent retention in their collections. Government gazettes are offered only in microfilm. Storage space for such material is at a premium. In addition, gazettes are usually printed on poor-quality paper, and sufficient copies are sometimes. not available to meet program needs. The New Delhi office has a mandate not to compete with local micropublishing activities. If a title is available on microfilm within India, the office will purchase the film copy if it meets the standards of the Photoduplication Service of the Library of Congress. One example is the microfilm version of the *Times of India* Bombay. edition.

Although priority is given to filming current program materials, the office has been assigned the task of microfilming retrospective arrearages in South Asian and Southeast Asian languages from the Library of Congress. We are in the process of filming 6 million pages of Indian State gazettes held by the Library of Congress Law Library.

The office has undertaken cooperative projects with libraries in the region. In 1981 a project was begun to film *Suriya*, a historically important Burmese language newspaper, held by the Universities' Central Library (UCL) in Rangoon, Burma, and the only known extant copy. The project involved the meticulous work of mending and collating the newspaper, which had deteriorated badly over the years. The original print copy was returned to UCL along with a copy of the film. Filming of the *Suriya* was completed in 1985, and copies are available from the Photoduplication Service to scholars worldwide.

The Microfiche Program

The New Delhi office acquires and processes publications of research value from India, Bangladesh, Bhutan, Burma, Nepal, Sri Lanka, and Thailand. A great many of these publications are printed or mimeographed on poor-quality paper, or are unavailable in sufficient quantities to meet the needs of participating research libraries. The microfiche program was begun in 1977 in an attempt to cope with this growing problem. An on-going effort to obtain copyright clearance from various research institutions and state and central governments was initiated throughout the region. In India alone, we have received permission to microfiche the publications of 22 state and union territories and 19 legislative bodies. In addition, permission has been received from over 135 academic and research institutions in India. In return for permission to microfiche their publications, the New Delhi office provides a negative copy of each microfiche title to the respective government or institution.

Positive silver halide copies of materials from Indonesia, Malaysia, Sarawak, and Brunei are deposited with the National Library or with a suitable depository library.

The cost is borne by the Jakarta Office. These microfiche are available on standing order from the Photoduplication Service. At present, nine American participants and three foreign libraries are subscribers. Subscribers receive a copy of the preliminary catalog card prepared by the Jakarta Office.

During the past several years, a concerted effort has been made to seek out and acquire for microfiching important documentation pertaining to the former princely states of India, including administration reports, land settlement reports, and annual reports of various government agencies. In 1984 a plan was evolved to visit the libraries that contain the personal collections of eminent scholars, authors, and citizens of India. One such visit resulted in the microfiching of the library of the late Jagdish Singh Gehlot of Jodhpur, a collection rich in princely state documentation and materials on castes and communities. In Unwash, Bihar, a village 180 miles from Patna, we located and were given permission to borrow the serials collection of the library of Padma Bhushan Shivapunjab Sanja. This collection contains many important Hindi serials for the period 1920-62. These titles differ in content and focus and range from literary and cultural themes to history and politics. Edited by such established litterateurs as Munshi Premchand, Ganesh Shankar Vidyarthi, and Banarsidass Chaturvedi, they include the contributions of Jayashankar Prasad, Suryakant Tripathi, Viyogi Hari, and others. The office hopes to continue to explore other sources in an attempt to preserve this rich heritage.

ZUSAMMENFASSUNG – Die Produktion des Mikrofilmprogrammes in der Mikroformabteilung der Neu-Delhi-Geschäftsstelle der Kongressbibliothek ist von der ursprünglichen Verfilmung von 14 Zeitungen im Jahre 1962, dem Jahr der Gründung, auf die heutige Verfilmung von 341 Zeitungen, periodisch erscheinenden Zeitschriften und Regierungsanzeigern aus 21 Ländern Südasiens, Südostasiens und dem Nahen Osten angewachsen. Im Mikroficheprogramm, das als eine Erhaltungsmassnahme (im Gegensatz zum Mikrofilmprogramm, dessen Zweck die Lösung des Problems der Aufbewahrung ist) angesehen wird, werden in der Geschäftstelle Publikationen von wissenschaftlichem Wert aus Indien und anderen südasiatischen Ländern bearbeitet. Allein in Indien wurde die Erlaubnis erteilt, die Publikationen von 22 Staaten und Unionsgebieten, 19 gesetzgebenden Körperschaften und über 135 akademischen und wissenschaftlichen Einrichtungen auf Mikrofiche zu transferieren. Ausserdem werden Bemühungen unternommen, wichtige Dokumente, die die früheren indischen Fürstenstaaten betreffen, auf Mikrofiche aufzunehmen. Die Geschäftsstelle hat ebenfalls gemeinsame Projekte, wie z.B. das Filmen der *Suriya*, einer historisch wichtigen Zeitung in burmenischer Sprache, von der nur ein Exemplar existiert, zusammen mit Bibliotheken der Region durchgeführt. Diese Mikrofilm- und Mikroficheprojekte, die von der Geschäftsstelle in Neu-Delhi verwaltet und von der Kongressbibliothek genehmigt sind, werden von einem Mitarbeiterstab aus acht indischen Staatsangehörigen in einer umweltgeschützten Einrichtung durchgeführt; vorhandene Geräte sind u.a. zwei Mikrofilmkameras, zwei Mikrofichekameras, ein Mikroficheleser für die Qualitätskontrolle und ein Mikrofichevervielfältigungsgerät. 1985 produzierte die Geschäftsstelle 115.000 Fuss Negativmikrofilm und 49.961 Mikrofiches. Die Geschäftsstelle hält sich an die Normen, die vom Photokopierservice der Kongressbibliothek und dem American National Standards Institute (dem amerikanischen Normeninstitut) erstellt werden. Alle Materialien, die für das Uebertragen auf Mikrofilm verwendet werden, sind von der Kongressbibliothek genehmigt worden, und das Forschungsmaterial für die Uebertragung auf Mikrofiche wird in Einklang mit den Richtlinien, die in den Erklärungen zu den Erwerbsrichtlinien der Bibliothek festgesetzt sind, ausgewählt.

RESUME – L'éstablissement du programme d'enregistrement sur microfilms, au Service Microforme du Bureau de New Delhi de la Bibliothèque du Congrès, est passé de l'enregistrement sur film de 14 journaux en 1962, lors de sa création, à une production cinématographique de 341 journaux, séries et gazettes gouvernementales de 21 pays de l'Asie du sud, de l'Asie du sud-est et du Proche Orient. Dans le cadre du programme microfiche, en tant que moyen de conservation plutôt que d'archivage, le Bureau enregistre des documents à valeur de recherche, de l'Inde et d'autres pays d'Asie du sud. Pour l'Inde seule, des autorisations ont été données pour l'enregistrement sur microfiche de documents publiés par 22 états et unions territoriales, 19 corps législatifs et plus de 135 institutions universitaires et de recherche. De plus, des efforts sont engagés pour enregistrer sur microfiche des informations concernant les ex-principautés d'Inde. Le Bureau a également entrepris des projets de coopération avec les bibliothèques du continent pour, par exemple, l'enregistrement sur film du *Suriya*, un journal important en birman, dont on ne connaît qu'un seul exemplaire. Ces projets de microfilm et de microfiche, administrés par le Bureau de New Delhi, approuvés par la Bibliothèque du Congrès, sont mis à exécution par une équipe de huit collaborateurs indiens, en milieu ambiant contrôlé. Le matériel comprend deux caméras de microfilm, deux de microfiche, un lecteur de microfiche pour le contrôle de la qualité et un duplicateur de microfiche. En 1985, le Bureau a produit un total de 115.000 pieds de négatif de microfilm et 49.961 microfiches. Le Bureau suit les normes définies par la Bibliothèque du Congrès, le Service de Photoduplicata et l'Institut National Américain des Normes. Tous les documents sélectionnés pour enregistrement sur microfilm sont approuvés par la Bibliothèque du Congrès. Les documents de recherche sélectionnés pour enregistrement sur microfiche sont sélectionnés suivant les directives définies dans les déclarations d'acquisition de la Bibliothèque du Congrès.

APPENDIX 1

	VADAMALAIPURAM / V.B. ATHREYA, MIDS WORKING PAPER /	1 OF 2
85/	MADRAS INSTITUTE OF DEVELOPMENT STUDIES; NO. 50.	27X
60143	1984.	
	VADAMALAIPURAM / V.B. ATHREYA, MIDS WORKING PAPER /	2 OF 2
85/	MADRAS INSTITUTE OF DEVELOPMENT STUDIES; NO. 50.	27X
60143	1984.	

Sample Header Cards

1 of 2
27X

85/60143

Vertical column header strips (read bottom-to-top): VADAMALAI / MADRAS 1984 / PURAM INSTITUTE / V.e.AT / THREYAL MINDS / DEVELOPMENT OF / STUDIES WORKING / PAPER NO.50.

10	23	MAP	47	61	74	88
9	22	MAP	46	60	73	87
8	21	MAP	45	59	72	86
7	20	MAP	44	58	71	85
6	Chart	33	43	57	70	84
5	Chart	32	42	56	69	83
4	18	31	41	55	68	82
3	17	30	40	54	67	81
2	16	29	39	53	66	80
1	15	28	38	52	65	79
Title page	14	27	37	51	64	78
X	13	26	36	50	63	77
Prelim card	12	25	35	49	Blocking	76
credit Sgn card / Prelim	11	24	34	48	62	75

Fiche Layout

2 of 2
27 X

85/60143

			102	101	100	99	98	97	96	95	94	93	92	91	90	89
			116	115	114	113	112	111	110	109	108	107	106	105	104	103
											End.	X	119	118	117	

Fiche Layout (continued)

COPYRIGHT ASPECTS OF REPRODUCTION

Henry Olsson
Director, Ministry of Justice
Sweden

ABSTRACT

Much of the cultural heritage for which librarians are responsible falls under the provisions of copyright law. Librarians must, therefore, have a basic knowledge of the rationale, philosophy, mechanisms, and various implications of this branch of the law. The basic content of copyright law is that authors and other beneficiaries are granted certain time-limited, exclusive rights to control certain uses of their works and contributions. Copyright law is a positive element in the scholarly world because, like libraries, its purpose is to stimulate creativity and increase the production of information. In addition to the social and cultural impact, copyright law may also have an important economic impact for a country. Copyright laws grant both economic and moral exclusive rights to authors of works. Since exclusive rights cannot possibly be recognized in all circumstances, a balance is struck between the interests of the author and the users through placing certain limitations on authors' rights. The two worldwide conventions providing for protection of copyright are the Berne Convention, to which the European Economic Community, many socialist and developing countries, and Australia, Japan, and Canada belong; and the Universal Copyright Convention, to which most of the Berne Convention countries, the U.S.A. and U.S.S.R., and some developing countries belong. An author has the exclusive right to prohibit or authorize reproduction of his work, but international copyright conventions allow national legislators to make national laws that enable exceptions to the enjoyment of exclusive rights. Both general and specific provisions grant libraries reproduction rights under certain circumstances.

Introduction

The general main aim of the activities of libraries is to preserve and make available for the public various kinds of expressions of culture and information. This material can consist of books or other written material, but it can also consist of other types of material supports on which such expressions are stored.

Much of the material thus stored is not of a recent date and might well be outside all kinds of copyright protection. To a large extent, however, the material is covered by the law on copyright and similar rights. This legislation has far-reaching implications on the use that the libraries can make of their material. Copyright law serves certain specific purposes in the overall legislative framework of a country. The people responsible for library activities should be aware of the rationale, the general philosophy, the mechanisms, and the various implications of this branch of law. Librarians must know what limits are set by copyright law for the use of the material stored in the library. They must also know about the specific rules in national copyright law that are applicable to libraries and archives. This knowledge is important because librarians are, in a way, the guardians of the national and international cultural output and of immense amounts of information. They have, therefore, a certain responsibility to ensure that the interests of authors and other contributors are safeguarded, or at least not disrespected.

General Philosophy and Mechanisms of Copyright Law

Basic Rationale for Copyright Law

The basic content of copyright law is that authors and other beneficiaries are granted certain time-limited exclusive rights to control certain uses of their works and contributions.

Copyright law in the modern sense developed in the 18th century in Europe with the abolishment of the system of printing privileges granted by the King to certain publishers. From this point of departure, copyright developed along two lines. One is the essentially commercial, Anglo-Saxon approach intended to prevent unauthorized copying by others ("copyright" in the true sense of the word). The other approach is the basically individualistic continental European approach, which sees copyright as a kind of human right with strong links between the author and his work ("droit d'auteur").

Whichever approach is chosen, the basic rationale for the establishment of a system of copyright protection can be summarized in the following way. The copyright system aims at stimulating intellectual creativity by supporting the creators and their profession, thereby contributing to the social, economic, and cultural development of the community and of nations. It aims at safeguarding the investments necessary for the production of cultural goods (books, records, films, and so forth), investments which otherwise would be practically impossible because of the unhampered copying of the works. The copyright system also promotes and encourages the dissemination and divulgence of culture and information. By granting certain rights to authors, they are encouraged to publish their works for the benefit of both themselves and of society as a whole.

This basic rationale can be more or less important, depending on the social and economic structure of the country. The emphasis might be different, *e.g.*, in market economy countries compared with countries with a planned economy, and in industrialized countries compared with developing countries. Basically, however, the idea of a copyright law is accepted in countries having different kinds of political systems. In fact, copyright law exists in some form in nearly all countries. It is sometimes said that as soon as a country rises above the purely agrarian level, an intellectual property law system is needed. At present, more than 100 countries in the world are members of the international conventions in the copyright field and even more have national copyright laws.

Economic Importance of Copyright Law

In addition to the cultural and social arguments for copyright law, the economic importance of copyright protection must also be noted. The economic importance of copyright varies, of course, depending on the stage of a country's development and on a number of special national factors.

Studies in certain industrialized countries concerning the impact of copyright law in the national economy have tried to assess the amount of the so-called Gross National Product (GNP) that could be attributed to material protected by copyright law. Such studies have been made in recent years, first in Sweden, then in the United States of America and in the United Kingdom. The studies are not directly comparable, because the scope of the so-called "copyright industries" is variously defined in the different countries. Even if the results have to be taken with some care, they show in surprisingly high figures the importance of copyright law in economic terms. The reason, of course, is the advent of the "information age" with its growing output in the

media and information field as well as in the field of computer software, which is considered in the industrialized countries to be protected under copyright law. The studies will not be dealt with in detail here. It shall only be mentioned that, according to these studies, the percentage of the GNP that could be attributed to copyright-protected material was 6.6 percent in Sweden in 1978; 2.6 percent of the Gross Domestic Product (essentially the equal of the GNP, but without the value earned abroad) in the United Kingdom in 1982; 2.8 percent in the United States in 1977; and 4.6 percent in the United States in 1982.

Basic Concepts of Copyright Law

As mentioned above, the basic intention of copyright law is to grant to writers, composers, artists, and other creators of works of the mind, certain time-limited exclusive rights with respect to the utilization of their works. This applies, with some nuances, regardless of the approach (the Anglo-Saxon or the continental European) that is chosen.

The subject matter for protection is covered by the concept "works," usually referred to as "literary and artistic works" (sometimes "scientific" is added also). Examples of works include books and other writings, lectures, and addresses; dramatic, musical, choreographic, and cinematographic works; works of drawing or painting; maps; photographic works; and so forth. These materials are only examples of what can be considered as works under copyright law. What is essential in principle are the following: (a) Works are considered the authors' individual creations, regardless of the form of their expression; (b) to be considered as a "work," the creation has to be "original" or "unique" in the sense that it is the result of an individual creative effort; (c) the protection applies to the form that the creator has given to his ideas; the ideas as such are not protected, nor are the facts or the information elements contained in a work protected, nor does the protection extend to the manner or the techniques used; and (d) the purpose or the quality of the work is irrelevant for the question of protection; even very bad works or typically utilitarian works, such as computer programs, can enjoy copyright protection.

The idea of copyright law, as mentioned earlier, is to grant to authors certain rights in relation to the utilization of their works. These rights are of two kinds, i.e., so-called economic rights and so-called moral rights. The economic rights can be described in somewhat different ways in various national laws. Basically, however, these rights comprise the right to reproduce the work; the right to communicate the work to the public by means of, e.g., public performance or broadcasting; and the right to make translations, adaptations, or other derivations of the work. The concept "work" relates to something immaterial. This immaterial object can, however, be embodied in a physical object. A literary work can thus be embodied in a book, a photocopy, or a data base. To reproduce a work means that copies are made of it either directly (e.g., photocopies) or indirectly (e.g., when a record is played in a broadcast program and recorded on a tape by the listener).

The moral rights are recognized in statutory law in most countries, e.g., in European continental law, and in case law in other countries, e.g., in those where the Anglo-Saxon approach applies. Basically the moral rights are of two types. These are the right of the author to have his name mentioned in connection with the work ("droit de paternité"); and the right of the author to object to distortion, mutilation, or other actions in relation to his work that are prejudicial to his honor or reputation as an author.

Economic and moral rights are exclusive. This means that the owner of the right can prevent everybody else from undertaking an act that is covered by the right in question. The point of departure is, for example, that nobody is entitled to make any copies of a protected work without the permission of the holder of the copyright. In practice, however, such exclusive rights cannot possibly be recognized in all circumstances. All copyright laws have to strike a balance between the interests of the copyright owners and the interests of the users and of the community as a whole. In national laws this balance is usually achieved by placing certain limitations on the economic rights.

Such limitations can be of various kinds and international copyright conventions give the national legislators a certain freedom in establishing them. For example, the so-called Berne Convention gives the contracting states an opportunity to limit the reproduction right, provided that such free reproduction does not conflict with a normal exploitation of the work and does not unreasonably prejudice the legitimate interests of the author. The Universal Copyright Convention describes the freedom to make limitations in another way, but this convention, too, contains clear limits on the ability of states to provide for limitations on exclusive rights.

National laws have made use of limitations in various ways. For example, the laws in the Anglo-Saxon approach frame limitations in a broad way by stating that a use falls outside the author's exclusive right if it could be considered as "fair use" or "fair dealing." Other legislation, particularly that in the continental European approach, describes limitations more specifically, frequently in much detail, in the copyright statutes. One such limitation is the possibility that a number of national laws grant to public libraries the right to make, under certain conditions, reproductions of the works in their collections. In general, the moral rights of the author shall be respected when a work is used under the limitations provided for in national law.

The rights under copyright law are limited in time. The period for which the countries that are party to the Berne Convention must provide is the lifetime of the author, plus 50 years after his or her death. The corresponding period for the countries that are members of the Universal Copyright Convention is lifetime of the author plus 25 years. Some countries even provide for protection above the minimum level of the conventions. The period of protection in the Federal Republic of Germany, for example, is lifetime plus 70 years, and in Spain lifetime plus 80 years. In certain countries the moral rights are not limited in time.

The purpose of copyright law is to protect intellectual creativity. Consequently, it is natural that the rights under copyright law vest first of all in the creator of the work. This general principle applies both in countries following the Anglo-Saxon approach and in countries following the continental European approach. Particular problems arise, however, in the case of works created for private or public bodies in the course of an employment contract and in the case of works that have been commissioned from the author by others ("works made for hire" according to the Anglo-Saxon terminology). According to the continental European approach the rights in these cases also belong to the author unless otherwise provided for in, or following from, the employment contract or the commission contract, respectively. Under the Anglo-Saxon approach the situation is, in general, the opposite. Unless otherwise agreed, the rights are deemed to be transferred to the employer or the person commissioning the work, at least to the extent necessary for his customary activities.

Violations of the rights under copyright law (infringement of copyright) usually entail various kinds of sanctions under national law. These laws contain a wide variety of such measures, such as penal sanctions (fines or imprisonment or both), liability for

damages, injunctions by courts (obligation to terminate such activities), and seizure of infringing copies, of revenues arising from infringing acts, and so forth.

In most countries copyright protection is automatic and applies regardless of registration or other formalities. In certain countries, although registration systems exist, registration is hardly a condition for protection anywhere. In the United States, for example, registration in the Copyright Office is not a condition for protection, but gives, rather, a presumption of such protection. In certain countries formalities are required. For example, published foreign works enjoy protection in the United States only if the so-called copyright notice is applied to all the copies of the work. This notice consists of a "C" within a circle and the name of right-owner and the year of the first publication.

In addition to the protection of intellectual creativity a number of countries have a protection also for certain other beneficiaries who are not creators, but who make other contributions in this field. Such categories are the so-called performing artists (actors, musicians), producers on phonograms, broadcasting organizations, and so forth. This special protection is similar to copyright and includes the right to control the reproduction of the contributions. The details of this protection will not be discussed here.

The International Protection of Copyright

At the outset copyright protection was entirely based on national legislation, and protection was given only to works from the country in question. As a result piracy (unauthorized reprint of books on a commercial scale) became widespread. The prevalence of piracy necessitated the creation of an international system for the protection of works. Some bilateral treaties were established in Europe in the middle of the 19th century, and the first of the multilateral conventions in this field was created in 1886. After this start on a relatively modest scale, the international system for protection of copyright law has developed greatly, both in geographical scope and in the substance of the protection.

The two worldwide conventions providing for protection of copyright are the Berne Convention for the Protection of Literary and Artistic Works, established in 1886; and the Universal Copyright Convention, established in 1952. Both conventions have between 75 and 80 member states. Many states are members of both conventions. To the Berne Convention belong all European market-economy countries; a number of socialist countries in Eastern Europe; a number of developing countries; and Australia, Canada, and Japan. The Universal Copyright Convention includes most of the countries of the Berne Convention, plus the United States of America, the Soviet Union, and certain developing countries that have not joined the Berne Convention.

The mechanism for protection is basically the same under both conventions and is based on the following elements. The conventions provide protection to works according to certain so-called "points of attachment." This means that a work must, in order to be protected, meet certain requirements, that is, that the author be a national or have his habitual residence in a country bound by the convention, or, if this criterion is not met, that the work be published first in a country of the convention. If a work thus enjoys protection under the convention, it shall be given protection in the countries of the convention, and these countries shall provide in their national legislation for protection of these works. They shall also have an obligation in the framing of such legislation to apply the principles of national treatment, minimum protection, independence of protection, and formalities as a condition of protection.

The principle of national treatment implies that authors whose works are protected under the conventions shall in all countries of the convention, except the country of origin, enjoy the same protection as nationals do under national law. In practice, this means that foreign works shall enjoy the same protection as national ones. On the other hand, the convention applies only to foreign works. The conventions do not oblige countries to protect their own authors. It goes without saying, however, that a country hardly protects foreigners better than its own nationals.

The principle of minimum protection means that the protection that contracting states are obliged to grant to works from other contracting states must not go below a certain level. This level is fairly high in the Berne Convention, but is somewhat lower in the Universal Copyright Convention. Thus, as mentioned above, the minimum period of protection is lifetime plus 50 years in the Berne Convention, but only lifetime plus 25 years in the Universal Copyright Convention. Another kind of minimum protection concerns the nature of the protection to be given. Both conventions oblige the states to provide for certain specific minimum economic rights. One such right that shall be guaranteed is the right to control the reproduction of the work.

The principle of independence of protection means that the protection in one contracting state is independent from the existence of or the scope of protection granted in other countries, including the country of origin. Thus, a work may well be without protection in one country, but enjoys protection in another one.

According to the Berne Convention, copyright protection shall be automatic and granted without formalities. According to the Universal Copyright Convention, certain formalities are allowed. Thus it is allowed for the countries of the Universal Copyright Convention to have registration systems, for example. In relation to foreign works the maximum formality allowed is the so-called copyright notice.

A complex issue concerns the relations between the two conventions. One may of course ask why there are two worldwide conventions covering one and the same field. The answer is related to the origins of the two conventions. The Berne Convention was based at the outset on continental European legal thinking. It provides for a high level of protection and rules out formalities as a condition for protection. After World War II a number of countries, including newly independent ones, wanted to adhere to the international copyright system. Some of these countries could not meet the level of protection under the Berne Convention. Others had a system of formalities that they wanted to preserve. The Universal Copyright Convention was created essentially to make it possible for such countries to become party to the international system and to solve problems concerning the relations to the Berne Convention countries.

As mentioned, a number of countries are members of both conventions. The principle is that the relations between countries that belong to both conventions are governed only by the Berne Convention. If a country is party only to the Universal Copyright Convention, as is the case with the United States and the Soviet Union, its international copyright relations are governed only by that convention and relate only to other countries that are bound by the same convention.

The international system for protection of copyright is somewhat complex. At the same time, it is immensely important from both an economic and a cultural point of view. If that system had not existed, works would be free for use outside their country of origin, which would – particularly in today's internationalized world – have made the production of much cultural, information, and media material virtually impossible.

From a practical point of view, the obligations under the international copyright conventions are reflected in national copyright law. This law takes the form of a

provision to the effect that works originating in other countries that are members of the conventions shall be protected in the same way as the works from the country itself. This provision is particularly important because, with respect to libraries and archives, it implies that the copyright provisions apply equally to national material and to foreign material.

The Reproduction Right

The Nature of the Reproduction Right

The reproduction right refers to the exclusive right of the author to authorize or prohibit the making of copies of his work. This reproduction right is one of the minimum rights provided for in the international copyright conventions. For example, the Berne Convention states in its article 9(1) that "Authors of literary and artistic works protected by this Convention shall have the exclusive right of authorizing the reproduction of these works, in any manner or form." Provisions to the same effect are included in the latest version of the Universal Copyright Convention.

The right of reproduction shall be thus guaranteed to all authors of works protected under the conventions. The right is exclusive, which means that the right belongs only to the person or persons enjoying it. It is a right to authorize (which is something more than just a right to prohibit) the use in question. Furthermore, the right refers to reproduction in any manner or form. Thus the concept of reproduction covers all means of fixing the work in a material form, *e.g.*, by printing processes, photocopying, storage on discs or tapes, or storage in a computer memory. In all these cases there exist copies of the work, although in different forms and on different material supports.

Limitations on the Reproduction Right

The international copyright conventions and national copyright laws grant authors a strong right to control all kinds of reproduction of their works. To have a situation in which it would always be necessary to obtain an authorization before any copy is made of a work would hardly be possible in today's society. For this reason, the international copyright conventions allow national legislators to make certain exceptions in national laws to the enjoyment of exclusive rights. Such exceptions can be based on various considerations, primarily the need to satisfy certain particular interests, such as information, public discussion, education, and so forth. What the conventions offer is a possibility, not an obligation, for states to provide for such limitations. If, and to what extent, states make use of these possibilities is a matter for the legislators themselves to decide.

Although the international copyright conventions provide for the possibility of exceptions, limits are placed on the scope of the exceptions at the same time. The limitations on the right of reproduction are differently framed in the two copyright conventions. The Berne Convention contains provisions on certain specific limitations, such as quotations, illustrations for teaching, discussion on political or religious matters, and reporting of current events. It also contains a more general limitation, which is contained in its article 9(2) and says:

> It shall be a matter for legislation in the countries of the Union [*i.e.*, the member countries of the Convention] to permit the reproduction of such works in certain special cases, provided that such reproduction does not conflict with a normal exploitation of the work and does not unreasonably prejudice the legitimate interests of the author.

This provision gives the member states the power and the possibility to limit the exclusive right "in certain special cases," which means that limitations of a general nature are not permitted. Among the special cases that are frequently mentioned as possible in this context are reproduction for private purposes and the reproduction of protected works carried out for the specific needs in libraries and archives. The possibility given to states under the provision mentioned is, however, subject to two qualifications, which are the non-conflict with normal exploitation, and the absence of prejudice to the interests of the authors.

The Universal Copyright Convention also contains a possibility for its member states to provide for limitations on exclusive rights, including the right of reproduction. Article IVbis(2) of the Convention says:

> However, any Contracting State may, by its domestic legislation, make exceptions, that do not conflict with the spirit and the provisions of this Convention, to the rights mentioned in paragraph 1 of this Article. Any State whose legislation so provides, shall accord a reasonable degree of effective protection to each of these rights to which exception has been made.

Consequently, the Universal Copyright Convention also gives its member states an opportunity to limit the exclusive right of reproduction in certain cases, but with the safeguards mentioned. As in the case of the Berne Convention, the provision can form the basis for special provisions in national laws concerning reproduction in libraries and archives. Thus, the international copyright conventions, to which most of the countries of the world adhere, allow states to provide for certain special provisions for the benefit of copying in libraries and archives.

Reproduction for Library Purposes

General

The possibility admitted under the copyright conventions of establishing special provisions for the benefit of copying in libraries has been used in various ways in various countries. In general, such provisions fall either in the category of provisions of a general scope, or in the category of special, detailed provisions. General provisions include those that appear in copyright laws in countries that follow the Anglo-Saxon tradition and use the concept of "fair use" or "fair dealing." This concept basically means that certain uses (reproductions) are admissible when the use can be considered as fair in view of both the authors' interests and in view of the opposing interest of a public character, for example. In most cases, however, such provisions are not applicable to copying in libraries.

Specifically framed provisions for the benefit of libraries are more common. For example, a provision in the so-called Tunis Model Law is a set of legislative provisions intended to serve as a model for developing countries and was established in 1976 by UNESCO and WIPO (the World Intellectual Property Organization, a specialized United Nations Agency, in Geneva). Section 7(v) of that Model Law contains a provision on library reproduction which implies that such reproduction is allowed in case of

> the reproduction, by photographic or similar process, by public libraries, non-commercial documentation centers, scientific institutions and educational establishments, of literary, artistic, or scientific works which have already been lawfully made available to the public, provided that such reproduction and the number of copies made are limited to the needs of their activities, do not conflict with the normal exploitation of the work and do not unreasonably prejudice the legitimate interests of the author.

The provision of the Tunis Model Law illustrates well the considerations that have to be taken into account in drafting provisions on library copying. On the one hand, it is very important that certain copying is allowed, because it is indispensable for the proper operation of the library. On the other hand, control over the copies is something very important for the authors. Compared to the ownership of physical objects, where the possession of the object in a way guarantees the right, the possibility to enforce and exercise rights in immaterial objects such as works is much more difficult. This is the reason why it is so important for authors to be able to control the copies made of their works. If they do not have such control, they lose in a way the possibility of exercising their rights.

If one tries to synthesize the factors that are particularly relevant to copying in libraries, the following aspects seem to be important. Generally speaking, the availability to make copies is limited to works that are published. This means that the work in question must have been made available to the public with the consent of the author, as in the case of ordinary books. Copying of works that are not published, for example, collections of private letters, is usually not allowed. Several situations exist in which copying for library purposes is, generally speaking, allowed. Copying is allowed when the copies are needed for preservation and security purposes, or when materials are unique and should for that reason not be available for lending to the public. In the latter case, at least certain legislations permit the making of a limited number of copies for lending purposes. Copying is also allowed when the work that the customer wants is only part of a more comprehensive work, *e.g.*, an article from an encyclopedia or a newspaper. In such cases, at least some legislations permit the making of a copy of the work in question to be delivered to the customer instead of lending him the whole collection. Finally, copying is allowed when a work is no longer available on the market (not available at the publisher, out of stock, and so forth); in such cases certain legislations also permit the making of a restricted number of copies for preservation in libraries.

The above remarks apply primarily to photocopying of literary works in libraries. Another kind of copying concerns certain particular cases, *e.g.*, when handicapped persons have difficulties reading books. In such cases certain legislations permit making copies of the work (films, transparencies, and so forth) so it can be read by means of special devices. Another kind of copying is when books are read and recorded on a tape for the benefit of blind or visually handicapped persons. These cases, however, concern a wider field than just library copying and relate to the more general problem of access by handicapped persons to protected works.

Examples of Provisions in National Laws for Reproduction in Libraries

A large number of national copyright laws contain special provisions on copying for library purposes. The presentation here of a detailed survey of the provisions in the national laws is neither possible nor desirable. Examples of certain provisions in certain national legislations could be useful, however, and several follow. In general, such library copying is allowed without payment.

Algeria. – Public libraries, non-commercial documentation centers, scientific institutions, and educational establishments may be authorized by the Ministry for Information and Culture to reproduce works by photography or an analogous process in the quantity that is required for their activities (Art 28 of the Copyright Act).

Australia. – Copyright is not infringed upon when a librarian takes copies for the use of a library, for the supply of material to research students, for study, or for

performing certain duties of a public character (provisions within the scope of Sections 40-73 of the Copyright Act).

Austria. – Certain public non-profit delivery of published works is allowed under specified conditions (Art 50 of the Copyright Act).

Bulgaria. – The reproduction and publication for informatory purposes by any organization engaged in scientific information, documentation, or bibliography, of summaries, references, and so forth relating to written works is allowed (Art 6 of the Copyright Act).

Congo. – It is allowed to reproduce a work by photographic or similar technique by public libraries, documentation centers, or similar establishments of a non-commercial nature, provided that the reproduction is within the limits of the needs of their activities and does not conflict with the exploitation of the work or does not unreasonably prejudice the legitimate interests of the author (Art 33 of the Copyright Act).

Cuba. – Reproduction is allowed without payment by means of photography or analogous process in a library, documentation center, or scientific or teaching institution, provided that the reproduction is for non-profit purposes and the number of copies is strictly limited to the requirements of the specific activity (Art 38 of the Copyright Act).

Denmark. – Archives, libraries, and museums may make photographic copies of works for use in their activities, under the conditions stated in a Royal Decree of July 21, 1962 (Art 12 of the Copyright Act).

France. – As a special feature could be mentioned that recordings of broadcast works may be preserved in official archives on account of their national interest or because of their documentary character (Art 45 of the Copyright Act).

India. – It is allowed for a librarian in a public library to make a limited number of copies of any work in the library for use in the library (Sec 52 of the Copyright Act).

Italy. – The photocopying of works existing in a library is free when made for personal use or for the services of the library (Art 68 of the Copyright Act).

Japan. – The reproduction for use of a library by the librarian is permitted, also if it is made for supply to research students for private study or in examinations (Art 31 of the Copyright Act).

Pakistan. – Making of a limited number of copies of any work in a public library by the librarian is allowed, or the reproduction for the purposes of research or private study of any unpublished work kept in a public library, museum, or other institution to which the public has access, if it is made more than 50 years after the death of the author (Art 57 of the Copyright Act).

Philippines. – It is allowed for libraries, archives, and museums to take photographic copies of works for lending or for purposes of research or private study or for preservation (Sec 13 of the Copyright Act).

Portugal. – Public entities, libraries, and so forth are allowed to reproduce excerpts from works for their own use or for private use by the persons so requesting (Art 63 of the Copyright Act).

Soviet Union. – Reprographic reproduction on a non-profit-making basis of printed works is allowed for scientific, educational, and instructional purposes (Art 103.7 of the Fundamentals of Civil Legislation of the Soviet Union).

Sri Lanka. – Reproduction, under specified conditions, by public libraries, non-commercial documentation centers, scientific institutions, and educational establishments is allowed (Sec 13 of the Code on Intellectual Property).

United Kingdom. – It is not an infringement of copyright to make a limited number of copies of passages from books and so forth kept in libraries or archives, or to publish old manuscripts in libraries or archives, subject to certain regulations issued by the Department of Trade (Sec 7 of the Copyright Act).

United States of America. – Reproduction by libraries and archives is allowed under certain specified conditions (Sec 108 of the Copyright Act).

The above references are made only to show how legislators in different parts of the world have tackled the problem of copying in libraries. The reason all laws are not mentioned is that, in some cases, there are no specific provisions or the legislation is not available or is similar to the legislation in other neighboring countries. The survey shows, however, that, with some nuances, the legislators have approached the problem in basically the same manner but in greater or lesser detail. Some of the provisions are quite general in their wording, whereas others, such as the provisions of Sec 108 of the Copyright Act of the United States, contain very detailed provisions and conditions for library copying. Certain laws provide for the right to publish unpublished works when 50 years have elapsed from the death of the author. In this situation, the period of protection under copyright law is terminated. Some of the provisions regulate not only copying for the activities of the libraries themselves, but also allow the possibility of the librarian making copies for the customers' private needs.

Reproduction for Other Purposes

The above discussion applies primarily to such reproduction of protected works as is considered necessary for the proper operation of the library. Such copying is frequently necessary for preservation and other purposes that are closely linked to library activities in the strict sense of the word. In addition, other kinds of reproduction may be necessary or desirable. Libraries contain large amounts of works that are frequently unavailable on the market or, for other reasons, are inaccessible. Consequently, students, researchers, scientists, or the general public often request that they be able to make copies of these works. This situation causes certain special problems. One such problem concerns if and to what extent librarians are entitled or obliged, or both, to make copies for customers who so request. In these cases, the copies are not made for library activities, but as a sort of service to the public. The question then arises what responsibility the librarian has for the reproduction that he carries out for the customers.

As indicated, certain national laws mention this situation specifically in stating that it is not a copyright infringement if a librarian, upon request, makes copies from his material either for special groups of persons (researchers and so forth) or for persons who want copies for their private use. Most copyright laws, however, do not mention this situation. The question, then, is what copyright liability the librarian does have for the copies made. Under most national legislations, liability would lie with the person who commissions the copying. He is the person who orders the copy to be made and has to see to it that the copy is a legal one and that the use made of the copy is in accordance with the law. Generally speaking, the librarian only provides a service and has basically no duty to check if the reproduction ordered is legal or not. This does not, however, prevent him from being liable for copyright infringement in certain special situations, *e.g.*, in relation to material where it is quite clear that no copying is permitted or when the number of copies is very high or other special circumstances make it clear or dubious if the copying is legal. The question of the librarian's responsibility – as well as the liability of other persons who contribute to such copying

– is a question for national law. It is not possible to indicate any solutions here, but only to point out certain considerations that could be valid in this context.

Some Final Remarks

Librarians have a special responsibility for the preservation and safeguarding of the cultural heritage in all its forms and regardless of age. Much of this heritage is of such a recent date that copyright law applies. It is consequently very important to have at least some basic knowledge about copyright law, its rationale and its mechanisms. Basically, copyright law serves the same purpose as the libraries, *i.e.*, to stimulate creativity and increase the output of expressions of culture, information, and entertainment. Consequently, copyright law must be seen as a positive element because it serves the development of the community as a whole and tries to take into account the special needs of the library sector by means of special provisions in this respect.

ZUSAMMENFASSUNG – Ein Grossteil des kulturellen Erbes, für das Bibliothekare verantwortlich sind, fällt unter die Bestimmungen des Urheberrechts. Deshalb müssen Bibliothekare Grundkenntnisse über das Grundprinzip, die Philosophie, den Mechanismus und verschiedene Auswirkungen dieses Teils des Rechts besitzen. Grundsätzlich beinhaltet das Urheberrecht, dass Autoren und anderen Nutzniessern bestimmte zeitlich begrenzte Exklusivrechte gewährt werden, um bestimmte Verwendungen ihrer Werke und Beiträge zu kontrollieren. Das Urheberrecht ist ein positives Element in der wissenschaftlichen Welt, da es, wie auch die Bibliotheken, dazu da ist, Kreativität zu förden und die Informationsproduktion zu erhöhen. Ausser dem sozialen und kulturellen Einfluss hat das Urheberrecht wohl auch einen bedeutenden wirtschaftlichen Einfluss auf ein Land. Urheberrechte gewähren den Autoren von Arbeiten sowohl wirtschaftliche als auch moralische Exklusivrechte. Da es unmöglich ist, Exklusivrechte unter allen Umständen anzuerkennen, wird ein Gleichgewicht zwischen den Interessen des Autors und denen des Benutzers hergestellt, indem den Rechten des Autors bestimmte Beschränkungen auferlegt werden. Die beiden weltweiten Konventionen, die den Schutz des Urheberrechts vorsehen, sind die Berner Konvention, der die Europäische Gemeinschaft, viele sozialistische Länder und Entwicklungsländer, Australien, Japan und Kanada angehören, und das Welturheberrechtsabkommen, dem die meisten Länder der Berner Konvention, die Vereinigten Staaten von Amerika, die UdSSR und einige Entwicklungsländer angehören. Ein Autor besitzt das Exklusivrecht, Reproduktionen seiner Arbeit zu verbieten oder zu autorisieren, jedoch erlauben internationale Urheberrechtskonventionen nationalen Gesetzgebern, nationale Gesetze zu erlasssen, die Ausnahmen für den Genuss von Exklusivrechten vorsehen. Sowohl allgemeine als auch spezifische Bestimmungen gewähren Bibliotheken unter bestimmten Umständen das Recht zur Reproduktion von Material.

RESUME – La plus grande partie de l'héritage culturel dont les bibliothécaires sont responsables tombe sous le coup des lois de propriété littéraire. Les bibliothécaires doivent donc posséder des connaissances fondamentales de la logique, de la théorie, des mécanismes et des diverses ramifications de ce corps de loi. Les fondements de ces lois sont que les auteurs et autres bénéficiaires ont droit à certains droits d'exclusivité, limités dans le temps, en vue de contrôler certaines utilisations faites de leurs oeuvres et contributions. Le droit de propriété littéraire est un élément positif du monde de l'érudition car, tout comme les bibliothèques, son but est de stimuler la créativité et d'accroître le champ de l'information. Au-delà de son effet social et culturel, il peut également avoir un effet économique important pour un pays tout

entier. Les lois de la propriété littéraire garantissent un droit moral et économique d'exclusivité aux auteurs d'oeuvres. Puisque ces droits d'exclusivité ne peuvent, en toute raison, être reconnus en toutes circonstances, un équilibre doit s'établir entre les intérêts de l'auteur et ceux des utilisateurs, d'où une certaine limitation des droits de l'auteur. Les deux conventions mondialement reconnues sur les droits de propriété littéraire sont la Convention de Berne, dont font partie tous les pays de la Communauté Economique Européenne, de nombreux pays socialistes et en voie de développement, l'Australie, le Japon et le Canada. La deuxième étant la Convention Universelle du Copyright à laquelle ont adhéré la plupart des pays signataires de la Convention de Berne, les Etats-Unis, l'U.R.S.S. et quelques pays en voie de développement. Un auteur a le droit exclusif d'interdire ou d'autoriser la reproduction de son oeuvre, mais les conventions internationales sur la propriété littéraire donnent une certaine latitude aux législateurs nationaux d'établir des lois nationales permettant des exceptions à la jouissance des droits d'exclusivité. Des clauses générales et particulières donnent aux bibliothèques des droits de reproduction sous conditions de certaines circonstances.

CARE AND HANDLING OF BOUND MATERIALS

Merrily A. Smith
National Preservation Program Specialist
Library of Congress
U.S.A.

ABSTRACT

Proper care and handling can do much to preserve a library's bound materials. Smooth solid shelves, keeping books in comfortable upright position, avoidance of stacking in piles, proper removal and reshelving of materials, careful opening of volumes, care in photocopying, and avoiding the excessive use of enclosures in books are all imperative good care measures. Oversize volumes should be handled with special precautions. All procedures applicable to general collections have even greater importance when dealing with old and rare books, which present particular problems of fragility and deterioration. Protective enclosures, such as slip cases, phase boxes, or double-tray boxes, may be desirable to protect valuable items from adverse environmental conditions. Of prime importance is maintaining proper non-destructive levels of light, temperature, and relative humidity in the library environment. Additional care should be exerted when placing volumes in cases for exhibition purposes. The observance of these basic rules of proper handling and storage, in addition to instituting organized stack-maintenance programs, will prolong the life of a library's entire collection.

The preservation of library and archival materials has become a much discussed topic in recent years. Considerable time, effort, and money are being invested by many libraries and archives in protective housing, rebinding, conservation, and preservation microfilming programs. These activities are expensive and can only become more so as time passes. It makes fiscal sense to delay the need for these costly activities by making an effort to preserve library materials in good condition as long as possible.

Everyone who works in a library or who uses library materials can contribute much toward such an effort. The dream that those of us interested in preservation all share is that every staff member in the library and every reader who uses the library's resources will have a genuine concern for the physical survival of library materials and will handle them accordingly. As is often the case with dreams, this one is not based in reality. Many of our colleagues and readers are, at best, oblivious to the impact that poor handling and storage practices have on books, and, at worst, don't care.

Our challenge, then, is to stimulate their interest, raise their awareness of preservation issues, and change their day-to-day practices of handling books. This is a tall order, but one within our grasp through a variety of avenues. Consciousness-raising can be accomplished by including preservation information in staff orientation programs, by mounting exhibitions about preservation or conservation, by including articles on preservation in staff and student newspapers, or by preparing slide-tape programs about preservation in the library, to name a few. Handling practices *per se* can be improved through demonstrations and seminars, through instruction manuals and handouts, and through the use of strategically placed posters and signs.

All these approaches presuppose that we ourselves are fully conscious of the hazards to which books are exposed in routine handling. The purpose of this presentation, then, is to point out some handling hazards and briefly review good handling, housekeeping, and storage practices.

Books in General Collections

Books form such an integral part of our daily lives that, until they fall apart in our hands, we rarely think of them as perishable commodities. Yet libraries spend thousands of dollars each year in the repair, rebinding, and replacement of damaged volumes in their general collections. The care with which a book is handled by readers and library staff members directly affects its longevity; proper handling and storage can prolong the life of a library's collection. The following information suggests appropriate handling and shelving practices for ordinary books in general collections. It describes the correct methods for taking books off shelves and putting them back safely; how to open and use them without damage; and how best to photocopy them.

Books are constructed from organic materials that vary in chemical and physical stability. They resist physical wear and tear to different degrees. Pages and bindings are easily damaged if handled roughly. The majority of bindings are most vulnerable at the joint, where the cover is hinged to the text. Additionally, many modern papers are chemically unstable and become brittle in a relatively short time. Extreme care must be exercised in handling brittle paper.

Proper shelving and storage are important factors in extending the life of all books. The safest storage for them is on smooth, solid, shelves. Avoid shelves that are runged. Also avoid shelving that has protruding screws or jagged edges. Since they spend so much time on the shelves, good posture for books promotes physical well being. Ordinary-sized volumes should be stored upright on shelves, resting on the their base. Avoid stacking them on top of each other or on top of upright volumes. Books placed on their fore edges or spines or allowed to lean will gradually be pulled out of shape by the effects of gravity.

Always use bookends on shelves that are not full. They keep the books from falling over and support the outside board on the end volume. It is important that the bookend be large enough and strong enough to fulfill both of these functions successfully. Some metal bookends are very narrow, and care must be taken to avoid pushing the text over a thin bookend when a volume is reshelved. On full shelves, a happy medium must be struck between loose and tight packing of the volumes. Loose packing is inefficient and encourages the books to lean. Tight packing leads to damage resulting from the force that must be exerted to remove or replace books. Friction and stress created by forcing a book in and out of a shelf space that is too narrow for it will break the book cloth along the joint. Once this happens, the book has lost a portion of its protective covering. Other sorts of breakdown may then occur, such as loosening of the cover from the text or the total detachment of cover boards.

It is never good practice to stand or pile books on the floor. Unexpected water leaks, routine janitorial maintenance, book trucks, and feet will damage them needlessly. A good rule of thumb to follow is that all library materials should be shelved a minimum of 4 inches above the floor.

Careless handling in the process of circulation is a major cause of physical breakdown in books. A particularly vulnerable time for most books is when they are being removed from and replaced on the shelf. The easiest, but most damaging, way to remove a book from its shelf is to hook the index finger over the end cap and pull. End caps are not a strong feature in most bindings. Repeated use of the end cap as a handle leads to a torn or broken spine piece. A better technique is to ease the books back on either side of the desired volume, then grasp the exposed book by the sides with the whole hand, and readjust the shelf space. In reshelving, move the bookend to loosen the whole row of books on the shelf so that ample space at the appropriate

position can be created in which to insert the book. Once it is in place, readjust the row and reset the bookend.

Oversize books – inordinately tall, wide, or thick – frequently have bindings that are weak in proportion to their size and weight. They cannot be stored safely on ordinary vertical shelving. They should be stored flat on broad, fixed shelves or roller shelves, with not more than three or four volumes resting on top of each other. A common hazard in oversize shelving is that volumes may protrude into the aisles because the shelves are too shallow. This situation makes them vulnerable to damage from passing individuals and book trucks. It can be alleviated somewhat by using double-width shelves. The temptation with horizontally shelved oversize volumes is to lift the stack with one hand and slide the desired volume out with the other. As a result, the book can be dropped easily. A safer method is to have intermittent free shelves in the stacks so that upper volumes can be transferred to one of them. Both hands are free to grasp and support the volume firmly as it is removed. If shelf space is limited, a nearby table or book truck would suffice. If oversize books are stored vertically, move adjacent volumes completely away on one side so that, again, both hands can be used to handle the volume.

Dropping a book even a short distance can cause severe damage. Do not carry more than you can handle. When in doubt, use a book truck. Choose a truck that is easily maneuverable, has wide shelves or protective rails to secure the items in transit, and has rubber bumpers on all four corners to minimize damage from inadvertent collisions. Place the books on the truck as they would be shelved in the stacks. Don't pile them on top of each other, and take care that they don't hang over the edges. Load the truck so the books won't jostle off the shelves in transit. For maximum stability keep the center of gravity low.

Books are too often treated casually and handled incorrectly or inappropriately in the course of daily use. Clean hands, and the avoidance of food, drink, or smoking materials in close proximity to books are minimal requirements for proper handling.

The binding structure of a book will survive longer if the boards are always supported when the book is open. Many volumes do not open easily and refuse to rest open to a given page. Forcing these books to open further, and exerting strong pressure on them so they will remain open, puts great stress on both spine and joints.

Excessive use of enclosures in books can distort and eventually break the binding because their presence strains the structure. The damage is particularly severe if the book is used like a filing cabinet or if a thick wad of materials is inserted in one place. When the temporary insertion of enclosures in a book cannot be avoided, minimize strain on the binding by placing them in the middle of the volume, rather than in the joint just under the cover. Remove them as soon as possible. If an enclosure must remain in the volume for an extended period, make sure it is made of an acid-free, non-damaging material. Acidic enclosures pose a chemical threat to the paper because certain materials in them may migrate into adjacent leaves, causing them to deteriorate and discolor. Avoid paper clips. If they are left in the text, they crimp the pages and may eventually damage them with rust.

Photocopying machines are standard equipment in most libraries. Unfortunately, most of the wide variety of machines available are not designed to insure photocopying of books without damage. The very act of forcing a tightly bound book flat on the surface of a copying machine subjects the spine and sewing to more stress than they are designed to withstand. Also, as open books are flipped over for copying pages, all portions of the binding come under great strain. Weak, brittle paper may be bent or broken. Several options are available for minimizing these hazards. The most

practical is to support the covers and pages of a book in the process of photocopying, and to avoid forcing the volume flat on the machine. Learn to recognize, and do not attempt to copy, books whose size or structure prevent them from copying easily or well. This would include volumes with tight bindings and narrow gutter margins. Materials that are too brittle to photocopy should be microfilmed. Patrons requesting copies can either be offered print-outs or copies of the film itself.

These storage and handling practices may not seem significant when considered in connection with one use-cycle of one book. Damage to books is cumulative, however. Repeated poor handling can quickly transform a new book into a worn book, and a worn book into an unusable book that requires costly repair or replacement. Proper use of books by each individual prolongs the life of a library's entire collection.

Books in Rare Collections

The shelving and handling practices that are outlined in the previous section are appropriate for *all* books. No mention is made, however, of some of the extra precautions that need to be taken – particularly by readers – when handling large and rare books.

Readers generally demand too much of the book. The two parts of a volume most affected by use are the spine and the joints (or hinges). Strain on hinges in the course of use can be reduced by not forcing a tight or stiff joint to open flat. Even if the joint is very flexible, the hinge can be damaged if the cover is unsupported and is allowed to open too far. Books will most often work better if they are set up with *both* covers open at equal angles relative to the text block. In some cases, when the book is large and the joints still flexible, both covers can lie flat on the table. However, supporting the covers at an angle is usually best. Both the hinges and the spine are protected as the book is kept from opening too far. On older books, the spine is often in a condition where pressure exerted on the pages to make them open flat will literally crack the binding in half. A good rule of thumb to follow is that, regardless of the strength or flexibility of a hinge, no book should be opened beyond the distance required to read it comfortably.

In the Rare Book Reading Room at the Library of Congress, we use very simple supports for books with weak or delicate hinges. Pieces of high-density foam, under a soft felt, support the open covers like a cradle. They are easy to construct in various sizes, and with a small stock on hand most books and angles can be accommodated. In addition, readers are provided with bean-filled velvet "snakes" that can be draped across the pages of books that resist remaining open to a given page.

The Rare Book Reading Room has also adopted a policy of prohibiting the use of pens of any type when taking notes. This is a very important rule, and one which would be well to adopt in any reading room where rare materials are served.

The issue of enclosures in books, discussed earlier with reference to general collections, is even more important with rare materials, many of which are old and fragile. Although most bindings will withstand one or two enclosures without serious damage, any added thickness put into a book is undoubtedly not good for it. This precaution is especially important with leather-bound volumes, which are generally constructed so the covers fit very snugly around the book. We recognize that many enclosures are pertinent and important to the history and identity of the book, but we would like to see them housed outside of the book itself. This material might better be placed in an acid-free envelope, which can be stored next to the book or in a special file designated for this purpose. Temporary slips should be removed promptly before the books are returned to the stacks.

A procedure not practical in all library situations, but one that is followed habitually at the Library of Congress is the housing of every book that receives full conservation treatment in a box with a portfolio. The portfolio is included to carry any ephemera that go along with the book.

Protective Enclosures

The primary housing for a book is its binding. For most books, a good binding is sufficient to protect and preserve the text. For many books, however – particularly rare books – some additional protective housing may be desirable to protect them on the shelf (from abrasion, dust, dirt, light) or during handling. Numerous examples can be cited where extra protection is called for, such as fragile or vulnerable bindings of paper or cloth; deteriorating or damaged bindings; unusual covering material, or features that pose problems in shelving (chains, bosses); very valuable bindings, *e.g.*, elaborate gold tooling; bindings that are particularly vulnerable to adverse environmental conditions (vellum); or large, heavy books with bindings of odd shapes or sizes.

The criteria for a good protective enclosure are: It must perform its assigned function (protection); it must not damage the material it contains (made from stable materials); it must allow easy removal of the item; and it must be without any design features that could lead to inadvertent damage.

The most familiar protective housing is probably the slip case. This design has its drawbacks, however; the spine of the book is exposed, and the cover can abrade. Many other protective boxes can be devised that vary in design and complexity. Some are simple and relatively easy to construct; others require greater ingenuity and skill. Unusual shapes and strange ephemera will require special boxes. Two more common designs are the phase box and the double-tray box. The phase box is a simple folding box made from light-weight board and is suitable for most books. It is particularly good for books covered with vellum or that have vellum text blocks because it provides pressure needed to prevent warping. The double-tray box (clam shell) is a common design that has been used by bookbinders for decades. It is a simple and efficient design suitable for small books with paper text blocks and with leather, cloth, or paper covers. The box consists of two trays, one that fits into the other, with a case (or cover) wrapped around the outside. Variations on this basic design can accommodate most needs.

Stack Maintenance

One of the most cost-effective ways to preserve bound library materials is through an active and efficient stack-maintenance program. Such a program is a crucial element in any cohesive preservation program, not only in libraries that have an in-house conservation facility, but especially in libraries that do not.

An example of a stack-maintenance project is one that was carried out at the Library of Congress between 1979 and 1981 on the Law Library's collection of 15,000 rare American and British law books. Although this project was initiated as a leather-binding maintenance program, it expanded rapidly to include preventive conservation and stack maintenance. All procedures were carried out immediately adjacent to the books, so a work station was set up in the stack area. A team of three persons did the work. The stacks presented them with a wide range of maintenance problems: The shelf area was dirty and dusty; books were often in pieces with covers missing, separated, badly damaged, or loosely attached; numerous loose pamphlets were inside

deteriorating folders, envelopes and pamphlet binders; and many books had been damaged by previous repair efforts.

The initial step in the project was to dust each book and shelf. At the same time (since many books had never been catalogued) a shelf listing system was devised, not only to maintain shelf order, but also to facilitate the preparation of a retrievable record of the treatment that each book had received. As the project progressed, several categories of treatment evolved.

1. Cleaning and oiling of leather bindings. – This aspect of the program was to have been a major feature of the project, but rapidly assumed a minor place because many of the leather-bound books in the collection could not be treated, because (a) the leather was cracked, broken, or powdery (suffering from red rot); (b) they had been over-oiled in the past; (c) they had been previously coated with an impervious material, such as polyvinylacetate emulsion adhesive or shellac; (d) they were bound in vellum or alum-tawed leather (neither of which should be treated); or (e) they simply were not leather (only looked like leather). Recognizing these difficulties required considerable training, sophistication, and alertness on the part of the maintenance team.

If no treatment could be given to the binding, the following treatments were carried out, where necessary:

2. Wrapping in polyester jackets. – If the boards of the book were still attached, but the leather was powdery or loosely attached, a polyester book jacket was made. This solution works best with small and medium-sized books of regular shape. The book jacket minimizes wear on fragile covers, and limits the spread of red rot dust.

3. Boxing in phase boxes. – When the book was badly warped, such as a vellum-covered book, or in several parts because of broken sewing or cover detachment or spine deterioration, or if for any other reason it needed better physical protection than a jacket could give it, a phase box was made for it.

4. Placing in alkaline-buffered envelopes. – All envelopes that were found on the shelf were replaced with alkaline-buffered envelopes, with an acid-free folder going around the item inside the envelope. Unbound material discovered on the shelves was also placed in alkaline-buffered envelopes. All brittle or damaged pamphlet binders were replaced with envelopes, even if the item was sewed in. At some later time these items can be conserved, if necessary, and placed in archival pamphlet binders.

5. Miscellaneous procedures. – Enclosures, paper clips, and bookmarks were removed. Loose, badly damaged pages at the front and back of coverless books were put into a polyester folio or envelope before the book was boxed. Loose pages still in good condition were sometimes tipped in with paste. Bent, misshapen corners on books for which a jacket was planned were sometimes straightened and reinforced with adhesive.

In addition to these procedures, alkaline-buffered corrugated cardboard was placed under the books and in the ends of the shelves to protect them from rough surfaces and protruding bolts.

At the conclusion of the project, the entire stack area was clean and neat, and all the books were in a much better state of repair. Much had been learned about the design and management of a stack-maintenance project.

Environmental Control and Monitoring

Library materials are organic in nature, and all organic materials change with time. Some books, because of the materials from which they are made and the manner of their manufacture, have a greater potential for change – and a shorter life expectancy – than others. The only power that we have over this natural process is the power to control the *rate* at which change takes place.

The chemical reactions associated with the breakdown of organic materials need a certain amount of energy in order to occur. The more energy is introduced into a system, the faster the reactions proceed. Heat is an energy source. It is an accepted maxim in chemistry that for every 10° C increase in temperature, the rate of a chemical reaction doubles. Actually, for paper, the rate of deterioration more nearly doubles for every 10° F. Thus, the paper in books stored at 80° F will deteriorate twice as fast as in books stored at 70° F. Water is known to facilitate some chemical reactions. For example, in the presence of moisture some metals rust. Moisture also assists the breakdown of alum into sulfuric acid to make acid paper. Prolonged exposure to high humidity can lead to the growth of mold. Light is a source of energy also. Especially in the shorter wavelength regions of the spectrum, it can alter the chemical make-up of certain materials such as dyes, lignin, and other organic substances. It follows, then, that one way in which the rate of deterioration of library materials can be slowed is through control of the levels of heat, light, and humidity in the environment in which they are stored.

What is the ideal temperature for storing library materials? A non-fluctuating temperature of 70° F, or less, is usually recommended. (If it weren't for people in the environment, a lower temperature would probably be recommended.) What is the ideal relative humidity for storing library materials? Recommended humidity levels vary, depending on the materials in question. In general, for bound materials, recommended values range from 40 to 50 percent, with fluctuations not more than 2 percent. And what is the ideal level of light for storing library materials? Darkness, except when light is needed – which is why there are dozens of light switches throughout the stack areas of many libraries.

Another question must be posed, namely: When is the "ideal" necessary? The answer to this question depends on the nature of the collections (circulating public library collection; research collection; rare book collection); and on what the preservation goals for these collections are (in terms of life expectancy). Certainly, for optimum preservation, one would aim for environmental ideals. However, the building structure, budget, and use patterns of the library may not allow them to be attained. Wishes may have to be balanced with realities, and a moderate environment be maintained that isn't too hot, isn't so humid that mold grows and insects thrive, and whose temperature and relative humidity don't fluctuate to extremes. In addition, collections should be kept out of direct sunlight and light levels and length of exposure to light should be kept as low and short as practical.

Several instruments are available with which environmental conditions can be monitored. Among them are the sling psychrometer, which gives a precise on-the-spot reading of temperature and relative humidity; the recording hygrothermograph, which produces a continuous chart that shows fluctuations in temperature and relative humidity from one day to a month or more; and a light meter, which gives light readings in foot-candles in any given location.

Exhibition of Bound Materials

I have never visited a library that had not enhanced the ambience of at least one room, hallway, or reception area with an interesting display of some of its materials. The subject of preservation in the exhibition of books is a large one; here I will discuss only a few of the major concerns to be dealt with when mounting a display.

First, when books are selected for exhibition, consider the condition of each volume. Can it withstand the strain of display? If it is damaged or badly deteriorated, schedule conservation treatment prior to display. If this is impossible, perhaps another book in better condition should be substituted. Second, make a note of its physical condition before putting it in the case: Is the cover faded? Are any pages bent or discolored? Then, keep an eye on it during its display. Examine the book again subsequent to exhibition. By monitoring the book in this way, any negative aspects of the exhibit set-up, which previously went unnoticed, will become apparent, and corrective measures can be taken when mounting the next display.

The placement and design of exhibit cases should be considered. Most library exhibit cases are either upright or flat-topped rectangular modular units. They are usually set up where the public has easy access to them – in entry halls, passageways, or a reading room. Is there anything about their design or location that makes the materials in them easy targets for thieves or vandals?

Exhibit cases usually consist of glass-walled spaces in which the rate of air exchange is generally slow. For this reason, the micro-environment within them, although similar to the overall library environment, is uniquely characteristic of small enclosed spaces. In many ways the case acts like a greenhouse. During the day, lights burning within it or shining on it at close distances from the outside heat the air so the temperature inside the case can be much higher than that of the surrounding room. As the temperature goes up, the relative humidity drops. At night, when the lights are out, the temperature falls and the relative humidity increases. Under certain conditions, these changes can be extreme, with the air in a case going through a temperature change of 30°-40° in a 24-hour period. Extremes of this sort can be very destructive to books, and every attempt should be made to minimize them. For example, cases should not be placed in front of radiators, or in direct sunlight. They should be lit from the outside only, so heat is not actually generated inside them.

In addition to generating heat, light can cause fading of dyes and discoloration of paper if exposure is intense or prolonged. Sunlight brings these changes about most rapidly, because it contains invisible ultraviolet (i.e., high energy) light rays. Fluorescent lights also contain some ultraviolet light; incandescent lights contain little or no ultraviolet light. Every effort should be made to remove ultraviolet rays from exhibition areas through the use of window shades, filtering materials, or non-ultraviolet-containing illumination. Light in the visible spectrum can be as damaging to some materials as ultraviolet light if it is bright enough and if the exposure time is long enough. Unfortunately, we don't know a great deal about the rate at which objects are affected by light. Presently, the recommended level of illumination for long-term display of light-sensitive materials is 5-10 foot-candles.

As with the general environment in the library, existing conditions must be monitored before any steps to control them can be taken. Temperature and relative humidity in an exhibit case can be determined with a dial hygrometer. Left inside the case, readings will be precise but not necessarily accurate, because calibration drifts with time. The instrument must be recalibrated occasionally. Cobalt indicator strips within the case will change color in response to changes in relative humidity; blue indicates drier ranges and pink indicates wetter ranges. This method is not as precise

as the dial instrument, but is fairly accurate. Light can be measured with a light meter, which gives readings in foot-candles. An ultraviolet light meter will determine if the light source needs a filter to remove ultraviolet rays. Blue wool standard cards are helpful in estimating if any fading has occurred, and to what extent.

In display, as in handling, book bindings should never be forced into positions they cannot accommodate easily, should not be opened wider than is natural, and should not be restrained in any position with heavy weights. Similarly, covers should be supported to keep the joints free from strain. In addition, when books are displayed open, the text block should be supported along the bottom so it doesn't sag. All these things can be accomplished by displaying the books in custom-made cradles, made from Plexiglas or from 4-ply board. The latter can be prepared easily in-house. They are made from permanent and durable materials, are inexpensive, and can be constructed in a small work area with limited tools and materials, and with only a little practice. The pages of a cradled book can be held open to a given place with narrow bands of polyethylene taped together at the back of the book.

Conclusion

Proper care and handling can do much to preserve library materials. The maintenance of a moderate environment in the library, in which temperature, relative humidity, and light levels are not too high, can slow the rate at which chemical changes occur. Good shelving, combined with careful handling by staff and readers, can limit physical wear and tear. Organized stack-maintenance programs that incorporate cleaning of shelves and books and rehousing of vulnerable or damaged materials can aid the preservation effort, as can proper exhibition. Taken together, these practices will help prolong the life of a library's entire collection.

ZUSAMMENFASSUNG – Sorgfältige Pflege und richtige Handhabung können im grossen Masse dazu beitragen, das gebundene Material einer Bibliothek zu erhalten. Glatte, massive Regale, das Aufbewahren der Bücher in stützender, aufrechter Stellung, Bücher nicht flachliegend stapeln, sie sorgfältig vom Regal nehmen und wieder zurückstellen, sorgfältiges Oeffnen eines Bandes, Sorgfalt beim Photokopieren und das Vermeiden des übermässigen Gebrauchs von Einlagen in Büchern sind alles notwendige und gute Pflegemassnahmen. Uebergrosse Bände sollten mit besonderer Vorsicht behandelt werden. Alle Verfahren, die auf allgemeine Sammlungen anwendbar sind, haben eine noch grössere Bedeutung, wenn mit alten und seltenen Büchern umgegangen wird, da diese besondere Probleme der Brüchigkeit und des Zerfalls aufweisen. Schutzbehälter, wie z.B. Bücherkassetten, Phasenbehälter oder Behälter mit Doppeleinsatz sind zum Schutz wertvoller Gegenstände vor ungütigen Umweltbedingungen wünschenswert. Es ist äusserst wichtig, ein angemessenes, nicht zerstörend wirkendes Mass an Licht, die richtige Temperatur und relative Luftfeuchtigkeit im Bibliotheksumfeld zu erhalten. Büchern sollte zusätzliche Pflege zukommen, wenn sie zu Ausstellungszwecken in Glasschränke gelegt oder gestellt werden. Das Einhalten dieser Richtlinien für eine sorgsame Behandlung und Aufbewahrung zusammen mit der Einführung eines systematischen Wartungsprogrammes für die Magazine wird die Lebensdauer der ganzen Sammlung einer Bibliothek verlängern.

RÉSUMÉ – Une manipulation et des soins adéquats sont essentiels à la conservation de documents reliés d'une bibliothèque, dont, impérativement, les mesures nommées ci-après: étagères d'un seul tenant sans aspérités, livres posés bien droit, élimination de livres empilés horizontalement, retrait et remise en place soigneux des documents,

ouverture en souplesse des livres, soin apporté à la manipulation en cas de photocopie, ultilisation judicieuse des garde-pages. Les livres de taille plus importante devraient être manipulés avec un soin tout particulier. Tous les soins qui s'appliquent aux collections d'ordre général seront tout particulièrement recommandés quant à la manipulation de livres rares et anciens qui sont vecteurs de problèmes particuliers de fragilité et de détérioration. Les couvertures de protection, telles que couvre-livres, fausses reliures simples ou doubles, peuvent être recommandables en vue de protéger des documents de valeur contre des conditions atmosphériques inadéquates. Il est tout particulièrement important de maintenir des niveaux appropriés et non-destructeurs de lumière, de température et d'humidité relative dans la bibliothèque. Il est recommandé de prendre des précautions spéciales pour la mise en vitrine d'exposition des documents. L'application de ces règles fondamentales de manipulation et d'entreposage, venant s'ajouter à des programmes officiels d'entretien, prolongera d'autant la durée de vie de la collection de documents d'une bibliothèque.

STORAGE AND HANDLING OF PHOTOGRAPHIC MATERIALS

Klaus B. Hendriks
The Public Archives of Canada

ABSTRACT

Less than 20 years after the invention of photography the two predominant agents responsible for the deterioration of black-and-white photographs had been identified: chemical reagents, such as sodium thiosulfate (a processing chemical) or hydrogen sulfide; and moisture in the form of relative humidity. As photographic technology progressed the detrimental effects on photographic materials of elevated temperatures and high relative humidity were demonstrated in the laboratory. Fading in color photographs, which occurs even when they are stored in the dark, takes place at a much slower rate at low storage temperatures. Thus dark areas where temperature and relative humidity are low and constant, and where the atmosphere is free of gaseous pollutants and particulate matter, are recommended for the long-term storage of photographic records. A consistently low level of relative humidity (30-35 percent) is recommended for all types of library and archival materials. Additional factors to be borne in mind when storing and handling photographic materials are: the quality of the storage envelope and all other storage containers; specific procedures for handling them; clean dust-free environment; monitoring processing standards, both in-house and by outside firms; and adequate provisions for photographic materials in disaster plans.

Processed photographic materials, in the form of historical negatives and prints in black-and-white or color, whether microfilms or motion picture films, are distinguished from other paper-based records in libraries and archives by the presence of two distinct layers: a support and an image-bearing layer. A glance at a cross section of a photograph through the microscope allows us to recognize clearly the characteristic layer structure of photographs. The support may consist of paper, glass, or plastic film, onto which is coated the second layer. The latter is a binding medium for the image-forming substance, which in all black-and-white photographic records discussed in this presentation is finely divided particles of elemental silver. In photographs of the 19th century, this second layer, with a thickness in the order of magnitude of one-hundredth of a millimeter (1/100 mm), consisted largely of collodion (on glass plate negatives made by the wet collodion process), or of albumen (egg white) on paper prints. The resulting albumen prints were the most important print material of the 19th century. For the past 100 years the image-bearing layer has consisted almost exclusively of gelatin. The presence of these two different layers characterizes photographic materials and determines their properties to a large degree. This can be demonstrated in a model experiment. If two photographs, a silver gelatin print and an albumen print, are placed in a chamber with low relative humidity (RH), they will curl up more or less tightly. If the relative humidity is raised in the chamber (by changing a tray with a certain saturated salt solution), both prints will flatten of their own accord within a short time. Because both photographs carry a proteinous layer (one gelatin, one albumen), which under dry conditions contracts at a different rate from the paper support, the prints roll up. In a high relative humidity situation the two layers absorb moisture from the atmosphere, causing them to relax and uncurl.

Not all photographs have a distinct layer structure. The principal types of negative, *i.e.*, original camera records, are shown in Table 1. (In negatives the geometry of the original scene as well as the tones are reversed. For example, a microfilm negative of a

printed book page shows white letters on a black background.) The daguerreotype, for example, made by one of the earliest photographic processes, does not have a recognizable layer structure. Similarly, the earliest photographic prints on paper, so-called salted paper prints, do not have a distinct binding medium. The silver particles that form the image rest partially on the surface of the paper and are partially absorbed into the paper fibers. Salted paper prints form an important class of photographic prints in the group of printing-out papers (Table 2). The negatives listed in Table 1 are arranged in an approximate chronological order. Of these, silver gelatin materials on a plastic film base are by far the most numerous in libraries and archives. After these, wet collodion glass plate negatives and silver gelatin dry plates are likely to be the most common.

To determine optimum storage conditions for processed photographic materials it is useful to examine the effect on their permanence of various environmental factors. We have just described an experiment that showed how relative humidity affects some physical properties of photographic prints. The action of moisture was among the earliest observations made by photographers and keepers of photographs regarding the resistance of photographs to various environmental conditions. In 1855 a "Committee Appointed to Take into Consideration the Question of the Fading of Positive Photographic Pictures upon Paper," by the Royal Photographic Society (RPS) in London, England, published its findings. The committee had studied the effects of certain chemicals and environmental factors on the stability of photographic paper prints (1). They presented evidence that certain aggressive chemicals, notably "the presence of hyposulphite of soda" (a residual processing chemical, called today sodium thiosulfate, or "hypo") and "the continued action of sulphuretted hydrogen and water" (called today hydrogen sulfide), can cause discoloration and fading of black-and-white paper prints. The committee noted that "there are traces of this gas (i.e., hydrogen sulfide) at all time [sic] present in the atmosphere," and lamented that "pictures will not remain unaltered under the continued action of moisture and the atmosphere in London." Conversely, the committee members observed and noted that pictures may be exposed to *dry* hydrogen sulfide gas for some time with comparatively little alteration. Thus, less than 20 years after the invention of photography the two predominant agents responsible for the deterioration of photographs had been correctly identified: chemical reagents capable of reacting with the black elementary silver particles in a photograph to form yellowed or discolored pictures, and moisture in the form of relative humidity that catalyzes such reactions. Well-processed contemporary silver gelatin negatives and fiber-base prints are essentially stable to dry heat and to light. The combination of reactive chemicals with high temperature or relative humidity presents the most damaging condition.

Empirical evidence of these factors has been reported in the literature throughout the history of photography. In 1892, Gladstone reported on what he termed the fugacity of bromide prints, made on a common photographic enlarging paper (2). The disappearance of images on bromide prints observed in India by the author was traced to "the instigation by humidity of a chemical action in the material of the paper, which converts the silver into a compound that diffuses and disappears in the support." Another photographer, N. C. Deck, discussed in 1923 the effect of tropical climates, *i.e.*, persistently high relative humidity, on the permanence of photographic prints (3). Reporting from the Solomon Islands, *i.e.*, "from a climate of the warmth and dampness of that of the South Pacific Islands," Deck described humid conditions as a very good test as to the permanence of photographic prints. The "fading to a sickly yellow in a

TABLE 1: Principal Groups of Black-and-White Photographic Negatives

1.	Daguerreotypes
2.	Paper negatives
	Waxed paper negatives
3.	Albumen-on-glass
4.	Wet collodion glass plates
	(including ambrotypes and tintypes)
5.	Silver gelatin materials
	(i) Dry plates (on glass)
	(ii) On film base
6.	Negatives containing chromogenically developed dyes
	(Ilford XP1 and Agfa-Gevaert Vario-XL)

TABLE 2: Principal Groups of Black-and-White Photographic Prints

1.	Printing-out papers (P.O.P.)
2.	Developing-out papers (D.O.P.)
3.	Resin-coated papers (D.O.P.)
4.	Papers using non-silver metals, or metal salts (P.O.P.)
5.	Papers using non-silver pigments

Note: Not included are individually sensitized prints physically developed with gallic acid; developed printing-out papers; solar prints; and contemporary rapidly processed prints, e.g., stabilization prints, 3M dry silver prints, Polaroid instant B/W prints, and others.

TABLE 3: Contemporary Materials: Subtractive Color Processes

1.	Chromogenic development	
	a)	Kodachrome principle (1935): External dye coupler
	b)	Agfacolor principle (1936): Incorporated non-diffusing dye couplers
	c)	Ektachrome principle (1940): Incorporated protected dye couplers
2.	Dye imbibition processes	
	a)	Technicolor motion picture film
	b)	Kodak dye transfer print
	c)	Fuji dye color print
3.	Silver dye bleach process Cibachrome	
4.	Dye diffusion transfer processes (one-step photography)	
	a)	Polacolor; Polacolor 2; Polaroid SX-70
	b)	Kodak PR-10
	c)	Fuji instant color film
5.	Pigment printing processes Tricolor Carbro, Fresson Quadrichromie, Gum Bichromate	

TABLE 4: Guidelines for Environmental Conditions in Archives and Libraries*

1.	Stability of all materials is increased as the temperature is decreased.
2.	Stability of all materials is increased as the relative humidity is decreased.
3.	Maintain the temperature and relative humidity as constant as possible, because (i) Cycling of temperature and relative humidity increases the rate of degradation of paper; and (ii) A change in temperature also changes the relative humidity.
4.	Stability is adversely affected by atmospheric pollutants. The action of sulfur dioxide is well documented. Other pollutants are suspect, but their effects are not so well documented.
5.	Stability is adversely affected by light. Damage is an inverse function of the wavelength of light.

* Wilson and Wessel (1984)

TABLE 5: Recommendations for Counteracting Harmful Conditions in Archives and Libraries*

1.	Maintain the temperature at the lowest practicable level, and as constant as possible.
2.	Maintain the relative humidity at the lowest practicable level except for the storage of parchment, and as constant as possible.
3.	Keep air pollution at the lowest practicable level.
4.	Avoid light shorter than 460 nm in wavelength.
5.	Keep the relative humidity below 70 percent, so mold growth is not likely to occur.

* Wilson and Wessel (1984)

TABLE 6: Recommended Air Quality Criteria for Archival Storage: Categories of Storage*

CATEGORY 1.	Storage facilities for unrestricted public access
CATEGORY 2.	Storage facilities with access restricted to authorized personnel only, but in which documents must be removed and replaced frequently
CATEGORY 3.	Storage facilities with highly restricted access, and in which documents will be removed and replaced infrequently

* NBSIR 83-2795

TABLE 7: Recommended Air Quality Criteria for Archival Storage: Temperature and Relative Humidity*

	Category of Storage		
	1	2	3
Public access	Yes	No	No
Duration of storage	Short/Long	Short/Long	Long
Dry-bulb temperature range	18-24°C (65-75°F)	10-13°C (50-55°F)	-29°C (-20°F)
Temperature control	±1°C (±2°F)	±0.5°C (±1°F)	±1°C (±2°F)
Relative humidity	40-45%	35%	2%

* NBSIR 83-2795

year or so" of bromide prints was ascribed "to retained sulphur or sulphur compounds in the print, which in the presence of moist heat reacts on the silver image."

Such empirical observations made in the humid atmosphere of either London or some place in India, or even in the South Sea Islands, can also be verified in the laboratory and so can be made more precise and objective. In accelerated aging tests photographic materials are subjected under controlled laboratory conditions to elevated temperatures and high relative humidity. The photographic manufacturing industry has used such conditions for several decades to evaluate the resistance of their products to unfavorable environments. Their findings were published for the first time about 60 years ago (4,5). Today many of the details of these early testing conditions are part of published standards specifications, thus allowing institutional consumers to do such experiments themselves. Examples are several recommendations published by the American National Standards Institute (ANSI), (cf. references 6, 7, 8, and 9). At least one major manufacturer maintained a research station in a tropical country to study the effect of high relative humidity on the permanence of photographic materials. Henn and Olivares, of the Eastman Kodak Company, identified the occurrence of fungus growth on photographic negatives that are stored under warm, humid conditions (i.e., above 65 percent RH) as one of the predominant threats to their longevity (10). They recommended the use of specific filing enclosures and the treatment of these enclosures with fungicides or by interleaving with fungicide-treated paper when more than one negative is enclosed.

Contemporary color photographs, the majority of which are made by the so-called chromogenic development process, i.e., the dyes in them are synthesized in the photograph during processing, are the first known colored medium that fades in the dark. The terms "dark fading" and "dark storage stability" originate in the photographic manufacturing industry. Tests indicate that the storage temperature determines the rate of fading in the absence of light. The phenomenon of dark fading of color photographs precipitated the concept of cold storage, which was first proposed for color photographs about 20 years ago. Cold storage, the opposite of accelerated aging, has been shown to increase the dye stability of processed color photographs by several orders of magnitude, the exact additional degree of longevity being determined by the temperature level (11, 12). Relative humidity must be strictly controlled in cold storage areas. Today several archives and libraries have cold storage facilities. Storage temperatures below 0° C, the freezing point of water, are part of standard recommendations for the long-term storage of color photographic records.

The principal groups of color photographs are summarized in Table 3. With the exception of photographs made by pigment printing processes, all color photographs contain organic dyes, the permanence of which is considerably improved when kept at low temperatures in the dark.

We have discussed the structure of photographs, and the principal factors that affect their permanence, and we have reviewed the difference between black-and-white and color materials. We now turn our attention to recommended storage conditions. Two important reports have become available during the last 2 years that make recommendations on the basis of scientific evidence. In the first of these reports, Wilson and Wessel described the effect of environmental factors on the longevity of materials (including paper records) in archives and libraries (13). Their findings about the effects of temperature, relative humidity, gaseous polllutants, and light on the permanence of archival records are summarized in Table 4. The authors also give specific recommendations to counteract harmful conditions (Table 5).

The second recent study that provides recommendations was published by the U. S. National Bureau of Standards (NBS) in November 1983 (14). It introduces the concept of different categories of storage (Table 6). The authors of the NBS study made recommendations for suitable storage conditions of archival materials in general with respect to temperature and relative humidity for three categories of storage (Table 7), as well as for storage conditions with regard to gaseous pollutants and particulate matter (Table 8). Although these recommendations are for all types of materials in libraries and archives, the consistently low level of relative humidity at 30-35 percent is noteworthy. Only a few years ago, maintaining a relative humidity of around 55 percent was an accepted practice. The singular importance of relative humidity in affecting the permanence of archival records is now beyond question.

Four storage recommendations have been written by ANSI specifically for the storage of photographic materials. Specifications for the storage of photographic plates are summarized in Table 9. Table 10 shows ANSI's recommendations for the storage of photographic paper prints (15, 16).

Storage temperature for both plates and prints may range from 15° C to 25° C, but must never exceed 30° C. In fact, a temperature below 20° C is preferable. Daily fluctuations of more than 4° C must be avoided. An acceptable relative humidity is between 20 and 50 percent, but preferably below 40 percent. Current theory suggests, in line with recommendations published in the NBS study, that 30-35 percent RH is optimum. It should never exceed 60 percent. Fluctuating relative humidity must also be avoided.

Detailed recommendations exist for processed safety photographic film, which includes microfilm, motion picture film, x-ray film sheets, and aerial film, as well as historical still photographic negatives (17). These recommendations are summarized in Table 11. This particular standard, ANSI PH1.43-1983, differentiates for the first time between short-term storage – up to 10 years – and long-term archival storage. For the latter purpose, low temperature is advocated somewhat timidly, for it is well established now that cold storage conditions will definitely provide additional protection. The recommendations for relative humidity levels are rather detailed, depending upon the product type. A close examination reveals that the relative humidity level varies with the nature of the material. Silver or dye gelatin images on a cellulose ester base; silver or dye gelatin images on a polyester base; or non-silver, non-dye, non-gelatin images on either support all require different relative humidity levels. The figures in Table 11 also substantiate our earlier suggestion that a relative humidity of 30 (±5) percent constitutes the most beneficial level for all materials.

Photographic materials, while in storage, are in close contact with the sleeve, or envelope, in which they are placed. Experience has shown that certain components in envelopes – such as the adhesive in the seams, or the poor quality of some papers – can cause the discoloration of negatives or prints. Thus, filing enclosures must be chosen with care. The American National Standards Institute has published a useful guide to filing enclosures to help select a suitable material. It is entitled "Requirements for Photographic Filing Enclosures for Storing Processed Photographic Films, Plates and Papers" (18). According to this standard, materials used in the manufacture of filing enclosures must be free of acid and peroxides and must be chemically stable; adhesives in seams must be free of sulfur, iron, and copper; and printing inks must not bleed, spread, or transfer. Paper envelopes, in particular, must have a high alpha-cellulose content (minimum of 87 percent); be free of highly lignified fibers (ground wood); have an alkaline reserve of 2 percent; contain a minimum of sizing chemicals; and should be free of waxes and plasticizers which may transfer to the photographic

TABLE 8: Recommended Air Quality Criteria for Archival Storage: Gaseous Pollutants and Particulate Matter*

	Category of Storage		
	1	2	3
SO_2	$\leq 1\ \mu g/m^3$	$\leq 1\ \mu g/m^3$	$\leq 1\ \mu g/m^3$
NO_x	$\leq 5\ \mu g/m^3$	$\leq 5\ \mu g/m^3$	$\leq 1\ \mu g/m^3$
O_3	$\leq 25\ \mu g/m^3$	$\leq 25\ \mu g/m^3$	$\leq 25\ \mu g/m^3$
CO_2	$\leq 4.5\ g/m^3$	$\leq 4.5\ g/m^3$	$\leq 4.5\ g/m^3$
HCl — Acetic Acid — HCHO —	Use best control technology		
Fine Particles (Total Suspended Particulate)	$\leq 75\ \mu g/m^3$	$\leq 75\ \mu g/m^3$	$\leq 75\ \mu g/m^3$
Metallic Fumes	Use best control technology		

* NBSIR 83-2795

TABLE 9: Practice for Storage of Processed Photographic Plates*

	Storage Temperature	Relative Humidity
Recommended:	15-25°C (59-77°F)	20-50%
Preferably:	< 20°C (68°F)	< 40%

* ANSI PH1.45-1981

TABLE 10: Practice for Storage of Black-and-White Photographic Paper Prints*

	Storage Temperature	Relative Humidity
Acceptable	15-25°C (59-77°F)	30-50%
Never:	>30°C (86°F) Avoid daily cycling of >4°C (7°F)	>60%

* ANSI PH1.48-1982

TABLE 11: Practice for Storage of Processed Safety Photographic Film*

I. Short-Term Storage			
Storage Temperature	Relative Humidity		
Preferably < 21°C (70°F)	< 60%		
If possible not > 24°C (75°F)	For polyester film base: not < 30%		
Peak temp. not > 32°C (90°F)			

II. Archival Storage			
Storage Temperature	Relative Humidity		
Preferably not > 21°C (70°F)	(The optimum storage relative humidity varies with the product type)		
Low-temperature storage may provide added protection	Sensitive layer	Base type	Recommended relative humidity range (percent)
For color film: Preferably 2°C (35°F)	Microfilm:		
	Silver-gelatin	Cellulose ester	15-40
	Silver-gelatin	Polyester	30-40
	General:		
	Silver-gelatin	Cellulose ester	15-50
	Silver-gelatin	Polyester	30-50
	Color	Cellulose ester	15-30
	Color	Polyester	25-30
	Diazo	Cellulose ester, Polyester	15-30
	Vesicular	Polyester	15-50

* ANSI PH1.43-1983

record during storage. These recommendations are accompanied by references to specific test procedures that can be used to evaluate the envelope material in terms of the specifications, making it a useful document.

A prominent example of the harmful effects of certain storage containers on photographic records was discovered about 20 years ago and widely discussed in the technical literature. This particular kind of deterioration of the image silver was observed in processed microfilms. Aging cardboard boxes containing ground wood emit peroxides, gaseous compounds which can be envisaged as reactive forms of oxygen and capable of chemically attacking silver grains in processed microfilm. The resulting redox blemishes – microscopically small, circular spots of orange-red color – caused intensive studies of the susceptibility of image silver in photographic records to oxidizing agents (19, 20, 21). As a result of such studies it is recommended that processed microfilm rolls be stored in either metal cases or in boxes of rigid polypropylene (similar to the boxes in which the unprocessed raw stock is purchased), which are supplied by photographic manufacturers.

Stored photographs are threatened by floods, fires, and the effects of fire extinguishers. Therefore we must consider those threats when discussing optimum storage conditions. Contingency plans for dealing with natural disasters are often prepared in major libraries and archives. They should include provisions for photograph collections. We have published recently the results of an extensive study

on the recovery of water-soaked photographic records (22). We found that water-soaked photographs are ideally air-dried without prior freezing. Since space is not always available to spread out and air-dry photographs, however, most photographic materials, including all contemporary silver gelatin and dye gelatin photographs, can be frozen after they have been soaked in water to await later treatment. Freezing slows down dramatically any further degradation and provides time for gradual recovery. When or as the situation permits, frozen photographs should be thawed and air-dried. A third option is freeze-drying photographs in a vacuum chamber, which virtually leaves photographs unharmed. Freezing followed by thawing and vacuum-drying at 4° C, as done with books, is not recommended, however, because of blocking or sticking of gelatin layers. Emphasis is placed on the observation that glass plate negatives made by the wet collodion process, including the collodion positives known as ambrotypes and tintypes, are the materials most susceptible to water damage. They should neither be frozen nor freeze-dried once they have been immersed in water. Other exceptions to the recommendations given above are daguerreotypes and color lantern slides made by pre-1935 additive color processes (such as Lumière Autochrome Transparency Plates, Agfacolor Plates, and so forth). Samples of these photographs were not included in our experiments on disaster recovery.

From the foregoing it has become clear that photographs are delicate objects that require some attention and care if they are to be kept for the long term. Correct handling of processed photographic materials is, for the most part, a matter of common sense. Since negatives and prints are liable to be damaged physically through fingerprints or scratches, unsleeved negatives and prints should be handled only with protective lintless cotton or nylon gloves. This is general practice in major photographic collections. For optimum protection, negatives and prints should be placed first in sleeves of uncoated polyester or cellulose triacetate (both commercially available), and then in paper envelopes on which is written all necessary documentation. They can be viewed without removing them from the transparent sleeve.

Ideally, photographs are handled in a clean, dust-free environment. No food or drinks should be tolerated in their vicinity. They should not be left lying around unattended or unprotected. Large-format negatives or prints must neither be folded nor rolled. Care must be taken not to damage the corners and edges of a photographic print while examining it. This can be prevented if prints are mounted before handling (23). Paper prints should not be stapled or attached to other documents with paper clips. Inscriptions in ink are liable to fade when photographs are on display and will invariably bleed or become illegible if accidentally immersed in water. If something must be written on the back of photographs to identify them, a soft lead pencil is the preferred medium.

The stability of photographic records is determined by the following principal factors.
1. The inherent properties of a negative or print material that are built into the product by the manufacturer. Some materials are inherently more stable than others. Contemporary safety films on either cellulose triacetate or polyester are more stable then cellulose nitrate film base; or black-and-white fiber-base prints are more stable on display than color prints.
2. The processing methods used with photographic materials. (The potentially harmful effect of certain residual processing chemicals has been briefly alluded to earlier. Details are not within the scope of this paper.) This adds a new responsibility to the user, one which is inherent to photographic records, as it

does not exist for any other material in libraries. Whether film and print processing is done in-house, or contracted to an outside firm, regular controls should be installed to ensure that the processing meets well-specified standards (7, 8).

3. The subsequent conditions for storage and handling of photographic materials, the subject of this presentation. They, too, are the custodian's responsibility. The three factors have equal weight and therefore deserve equal consideration and attention. It is contingent upon keepers and users of photographic collections in libraries and archives to ensure that the processing of photographic materials as well as their storage meet recognized specifications.

Concerning the manufacture of photographic films and papers, contemporary color materials are inherently less stable than contemporary black-and-white records. Color instability can be countered somewhat by minimizing exposure to light and by keeping such records in cold storage. Modern black-and-white film bases used in the manufacture of microfilm, motion picture film, aerial film, and still photographic negatives are made to such rigid specifications and have been tested extensively enough to merit their official recognition as permanent record materials (24). Moreover, they remain the only non-paper records in libraries and archives having that status. They are human-readable, and their permanence under a given set of conditions is well established. Modern safety film is clearly superior to any other non-paper, non-parchment record material in common use, or under consideration for use, in libraries and archives.

References and Notes

1. Delamotte, P. H., et al. First report of the committee appointed to take into consideration the question of the fading of positive photographic pictures upon paper. *The Journal of the Photographic Society*, 21 November 1955, no. 36, 251-252.

2. Gladstone, J. S. Fugacity of bromide prints. *The British Journal of Photography*, 29 July 1892, p. 484.

3. Deck, N. C. The permanence of photographic prints as tested by tropical climates. *The British Journal of Photography*, 1923, *LXX*(3284), 222-223.

4. Kieser, K. Wärmetest lichtempfindlicher Materialien [The heat test on light-sensitive materials]. *Die Photographische Industrie*, 1926, 303-304.

5. Emmerman, C. Die Brutschrankprüfung lichtempfindlicher Materialien [The incubator test on light-sensitive materials]. *Die Photographische Industrie*, 1926, 384-386.

6. American National Standards Institute. *Specifications for safety photographic film.* ANSI PH1.25-1983. New York: American National Standards Institute, 1983.

7. American National Standards Institute. *Specifications for photographic film for archival records, silver-gelatin type, on cellulose ester base.* ANSI PH1.28-1984. New York: American National Standards Institute, 1984.

8. American National Standards Institute. *Specifications for photographic film for archival records, silver-gelatin type, on polyester base.* ANSI PH1.41-1984. New York: American National Standards Institute, 1984.

9. American National Standards Institute. *Method for evaluating the processing of black-and-white photographic papers with respect to the stability of the resultant image.* ANSI PH4.32-1980. New York: American National Standards Institute, 1980.

10. Henn, R. W. and Olivares, I. A. Tropical storage of processed negatives. *Photographic Science and Engineering*, 1960, *4*(4), 229-233.

11. Tuite, R. J. Image stability in color photography. *Journal of Applied Photographic Engineering*, 1979, *5*(4), 200-207.

12. Bard, C. C., et al. Predicting long-term dark storage dye stability characteristics of color photographic products from short-term tests. *Journal of Applied Photographic Engineering*, 1980, 6(2), 42-45.

13. Wilson, W. K. and Wessel, C. J. *Guidelines for environmental conditions in archives and libraries*. Technical Report, Review of Existing Literature, with Draft Standard from National Archives and Records Service to the National Institute for Conservation. February 1, 1984.
 Appendices 3, 4, 5, and 6 to this report are the following documents:
 3.) Wessel, C. J. Environmental factors affecting the permanence of library materials. *The Library Quarterly*, 1970, 40(1), 39-84.
 4.) Wessel, C. J. Deterioration of library materials. *Encyclopedia of Library Science*, 7, New York: Marcel Dekker, 1972, 69-120.
 5.) Wilson, W. K. and Parks, E. J. An analysis of the aging of paper: possible reactions and their effects on measurable properties. *Restaurator*, 1979, 3(1/2), 37-61.
 6.) Feller, R. L. Contrôle des effets détériorants de la lumière sur les objets de musée [Control of the deteriorating effects of light upon museum objects]. *Museum*, 1964, *XVII*, 57-98.

14. Mathey, R. G., Faison, T. K., and Silberstein, S. *Air quality criteria for storage of paper-based archival records*. NBSIR 83-2795. Washington: National Bureau of Standards, 1983.

15. American National Standards ·Institute. *Practice for storage of processed photographic plates*. ANSI PH1.45-1981. New York: American National Standards Institute, 1981.

16. American National Standards Institute. *Practice for storage of black-and-white photographic paper prints*. ANSI PH1.48-1982. New York: American National Standards Institute, 1982.

17. American National Standards Institute. *Practice for Storage of processed safety photographic film*. ANSI PH1.43-1983. New York: American National Standards Institute, 1983.

18. American National Standards Institute. *Requirements for photographic filing enclosures for storing processed photographic films, plates and papers*. ANSI PH1.53-1984. New York: American National Standards Institute, 1984.

19. Henn, R. W. and Wiest, D. G. Microscopic spots in processed microfilm: their nature and prevention. *Photographic Science and Engineering*, 1965, 9(3), 167-173.

20. McCamy, C. S. *Inspection of processed photographic record films for aging blemishes*. (National Bureau of Standards Handbook 96). Washington: National Bureau of Standards, 1964.

21. McCamy, C. S., Wiley, J. R., and Speckman, J. A. A survey of blemishes on processed microfilm. *Journal of Research of the National Bureau of Standards*, 1969, 73A(1), 79-99.

22. Hendriks, K. B. and Lesser, B. Disaster preparedness and recovery: photographic materials. The *American Archivist*, 1983, 46(1), 52-68.

23. Smith, M. A. *Matting and hinging works of art on paper*. Washington, D. C.: Library of Congress, 1981.

24. Adelstein, P. Z. and Rhoads, J. B. Archival and permanent. *Journal of Micrographics*, 1976, 9(4), 194.

ZUSAMMENFASSUNG – Innerhalb der ersten 20 Jahre nach der Erfindung der Photographie wurden die zwei hauptsächlichen Ursachen der Zerstörung von Schwarzweissphotographien erkannt: chemisch aktive Reagenzien wie das Natriumthiosulfat (eine im Fixierbad vorhandene chemische Verbindung) oder der Schwefelwasserstoff, und Feuchtigkeit in der Form relativer Luftfeuchtigkeit. Im Laufe der Entwicklung der photographischen Technik konnten die schädigenden Auswirkungen von Wärme und hoher relativer Luftfeuchtigkeit im Labor nachgewiesen werden. Das Verbleichen von Farbphotographien, das sogar dann auftritt, wenn diese unter Lichtausschluss aufbewahrt werden, läuft bei niedrigen Aufbewahrungstemperaturen wesentlicher langsamer ab. Aus diesem Grund wird Lagerung im Dunklen, wo die Temperatur und relative Luftfeuchtigkeit niedrig und konstant sind und wo die Luft frei von gasförmigen Schadstoffen und Partikeln ist, für die langfristige Aufbewahrung von photographischen Dokumenten empfohlen. Eine gleichmässige relative Luftfeuchtigkeit (30-35 Prozent) wird für alle Arten von Bibliotheksmaterial und Archivdokumenten empfohlen. Weiterhin sollten folgende Faktoren berücksichtigt werden, wenn photographisches Material aufbewahrt und gehandhabt wird: die Qualität der Aufbewahrungskülle und aller anderen Lagerungsbehälter; detaillierte Vorschriften für die Handhabung; eine saubere und staubfreie Umgebung; Einhalten der Verarbeitungsnormen, sowohl in den Bibliotheken selbst als auch bei auswärtigen Firmen; und gut ausgearbeitete Vorschriften für die Behandlung von photographischem Material im Katastrophenfall.

RESUME – Moins de 20 ans après l'invention de la photographie, les deux principaux agents responsables de la détérioration des photographies en noir et blanc furent identifiés: premièrement des réàgents chimiques, tels que le thiosulfate de sodium (agent résiduel du traitement), ou le sulfure d'hydrogène et, deuxièmement, l'humidité sous forme d'humidité relative. Au fur et à mesure de l'avancement technologique de la photographie, les effets nuisibles causés sur les matériaux photographiques par de températures élevées et une forte humidité relative, furent démontrés en laboratoire. La décoloration des photographies en couleur, même si celles-ci sont gardées dans l'obscurité totale, est beaucoup plus lente à basse température d'entreposage. Ainsi, des endroits obscurs à température et à humidité relative basses et stables, une atmosphère libre de polluants gazeux et de particules solides sont recommandés pour l'entreposage à long terme de documents photographiques. Une humidité relative variant entre 30% et 35% est recommandée pour l'entreposage de tous les documents de bibliothèques ou d'archives. De plus, il faut également considérer les facteurs suivants lors de l'entreposage et de la manipulation de documents photographiques: la qualité des enveloppes ou des autres matériaux d'emballage, des procédés bien précis au moment de la manipulation, un milieu ambiant propre et sans poussière, une vérification par un service interne et externe des normes de traitement et finalement, une préparation adéquate des documents photographiques en cas de désastre.

STORAGE AND HANDLING OF AUDIO AND MAGNETIC MATERIALS

Harald Heckmann
Deutsches Rundfunkarchiv
Federal Republic of Germany

ABSTRACT

Sound and video carriers are beginning to take their place among books in the world's libraries, which are discovering in these materials new challenges for preservation. Gramophone records are subject to damage from wear, which deforms the grooves, but this is inescapable because the records must be played. For best preservation, records should be systematically transferred to tape. Records should be stored upright, in a moderate non-fluctuating environment. For storage, a temperature of 20° C and relative humidity of 40 ±5 percent are recommended. Magnetic tapes are less sensitive to wear than records, though abrasion from guide rollers, sound-scanning heads, and rapid rewind can occur. Mechanical strain can also result in a loss of magnetization. Storage conditions for tapes are the same as for records. High temperatures must be avoided, as they aggravate the print-through effect. Magnetic tapes can be ruined if exposed to magnetic fields, but metal shelves will not harm them. Records and tapes may be lost for other than physical reasons: The equipment on which many formats are played is rapidly becoming obsolete. Without it, the information on these media will effectively be lost. In view of the lack of standardization in the production of sound and video products, perhaps it would be much wiser to abandon the notion that retention of the original is essential; speedy transformation of the material into a more recent recording medium might be more appropriate.

Be assured that as it is today so it will be in the future. Libraries may legitimately adhere to their denomination. The book itself will not be replaced by any other medium of information transfer. Yet the book must face competition that is already underway. Together with books, sound and video carriers enter the libraries and confront them with new fields of operation regarding handling and preservation. Recognition of this recent development may be why I was asked to speak about the storage and handling of audio and magnetic materials at a conference on the preservation of library materials. The remarks that follow will be restricted primarily to the predominant media capable of storing acoustical signals: the record (audio disk or gramophone record) and the magnetic tape. The numerous other variations of acoustical media such as Edison cylinders, piano rolls, wires, and the complete audiovisual scope of film and video storage will be dealt with only briefly. The field of digital recording as used for the manufacturing of both the compact disc and the video disc will be touched upon, but on the fringe of my deliberations. In the course of this survey I shall follow a review by the chairman of the Technical Committee of the International Association of Sound Archives, Dietrich Schüller (1). This article, which covers all relevant publications and combines their findings with personal experience, represents a model of lucidity and clearness.

Records

Gramophone records containing analog recordings of acoustical signals, *i.e.*, records of the kind still dominating today's market, date back roughly 100 years. Their invention followed that of the so-called Edison cylinders and applied the same physical principles. One property that Edison cylinders and the shellac record that followed share is that they are extremely sensitive to mechanical damage and are easily

breakable. Although the successor of the shellac record, known as the long-play record, qualifies as almost unbreakable, it is subject to the same drawback as its predecessor in that it deteriorates through wear caused by the very use for which it is made: by playing.

The record is liable to wear from playing because of friction contact between the signal-bearing grooves and the stylus. The friction contact is needed to reproduce the signal, but it is also harmful because it causes gradual deformation of the grooves. The result is a progressive distortion that builds up from one play-back to the next. The degree of distortion depends on a number of factors, such as composition and condition of the carrier substance; signal frequency; position of the grooves on the record; shape, condition, and adjustment of the pick-up needle; stylus pressure; and so forth. Since these factors can hardly be influenced, all mechanically reproducible sound carriers such as cylinders or records should be duplicated once onto magnetic tape to prevent repeated reproduction of the carrier itself. By so doing, the welcome side-effect is achieved of preventing destruction by breakage, mold, or any possible environmental pollutants, the effects of which, owing to the relatively short history of the record, we do not fully understand at present, but which should be taken into account for the future.

Before copying, the carrier should be cleaned in a supersonic water bath enriched by an appropriate solution additive and followed by subsequent thorough dehydration in a jet stream. Repositories of big collections of records that cannot be transferred to tape in a systematic and continuous routine should follow a pattern of making tape copies whenever a record is wanted for replay. This approach would allow the step-by-step transfer of as much of the information stock as possible from the highly sensitive carrier (the record) to the less sensitive carrier (the magnetic tape).

Appropriate storage is very important to the preservation of records (2, 3, 4, 5). Whenever possible, records must have a dust-tight jacket and should be kept standing or suspended in an upright position. Storage rooms must be largely free of dust and must have temperature and humidity levels controlled by an air-conditioning system. Shellac records are known to be extremely sensitive to humidity, which, in conjunction with high temperatures, can lead to the destruction of the carrier through the development of mold. This danger, which also affects record covers, is found less in central European climates. Extreme dryness can lead to the formation of static charge that will affect reproduction by a crackling sound, but is temporary in most cases.

A generally accepted average level of humidity in which to store all types of sound carriers is 40 percent RH. A deviation of plus or minus 5 percent RH could be tolerated since it is not harmful. Shellac and polyvinylchloride (PVC) records must be stored in temperatures that do not exceed 50° C. Two facts concerning temperature and relative humidity should be observed. First, a clear interdependence exists between temperature and humidity. Second, staggering temperatures may be harmful to sound carriers because they can cause deformation as well as condensations of humidity on the record. Consequently, temperatures must not be allowed to approach or reach limiting ranges, but should remain in the medium ranges. Moderate temperatures will allow both long-term storage and handling of sound carriers under the normal climate conditions of a work room.

If sound carriers are required to leave an optimal storeroom climate for such purposes as cataloging or copying, the deviation of temperature should be kept as small as possible. Assuming a storage temperature of 20° C, a deviation of 3° C higher or lower should be regarded as of practical benefit and therefore considered advisable. Lower temperatures may prove useful for long-term storage in which the carriers

would leave storerooms very rarely if at all, or in which a provision for gentle acclimatization was made in case of a need for them to change rooms. Frequent or sudden change of climate will result in a much greater harm to the carriers than would come to them if they did not enjoy optimal low temperatures. For example, after transportation in a chilly container (as in the freight compartment of a plane), water may condense from the air as soon as the carriers are brought back into a damp and warm location. Measures would have to be taken that would dry the carriers prior to their replacement in final storage. The danger of deformation to records from sources of heat deserves special attention. Room heating devices or sunlight streaming in through glass panes can be particularly damaging.

Magnetic Tapes

Magnetic tapes are much less endangered by handling and mechanical wear, but certain general factors should be considered in their use and storage (6, 7, 8, 9, 10). While in the case of records the friction contact between the grooves and the stylus has to be accepted as a necessary prerequisite for reproducing the recorded signal, a much less severe friction contact occurs between the magnetic tape and the guide rollers or the sound scanning (reproducing) heads and is viewed merely as a cumbersome inconvenience. Nevertheless, some abrasion does occur, which affects older tapes more than newer tapes. As experience has shown, the latter can suffer hundreds of replays without any loss of signal property. An even stronger abrasion than that caused by playbacks for reproduction occurs when rewinding tapes at extremely high speed. For this reason, the rewinding speed applied should not be allowed to exceed 1 meter per second. In addition, the extent of abrasion can be reduced by keeping friction areas clean and well groomed. Damaged parts should be replaced promptly.

In addition to abrasion, mechanical strain produces a loss of magnetization that varies depending on the composition of the tape material. Tapes made of cobalt-doped ferric oxide suffer a continuous loss of magnetization at every replay, whereas tapes made on a base of chromium dioxide or gamma ferric oxide are subject to a loss of magnetization that is stabilized at a somewhat lowered level after only a few playbacks. Magnetization of both guide rollers and sound scanning heads may enhance the background noise and distort the signals; in some cases, even a partial erasing effect may be found. Maintenance, therefore, should regularly include de-magnetization of guide rollers, reproducing heads, and any tools needed to operate equipment and magnetic tapes, including scissors. An even more serious danger exists: that of unintentional erasure through operating errors. This danger can only be eliminated with certainty if, for playback purposes, equipment is used that has had its recording and wiping devices removed.

Statements about ideal room temperatures for the storage of records can, in principle, be repeated as a recommendation for the storage of magnetic tapes. It is especially important to refrain from exposing tapes to a defined upper limit of temperature, as the so-called "print-through" effect may turn out to be harmful to the technical condition of the tape. Magnetic tapes are less sensitive to humidity than shellac records. Nevertheless, a strict control of both humidity and temperature is essential since excessive humidity may have a bad effect on the oxide binder. Older tapes of the acetate-cellulose type, however, tend to develop a sensitivity to dryness and will become brittle or may even break. Duplication of any of the older carrier tapes onto modern tape materials is therefore recommended.

Tapes may be soiled by residues of adhesives used for splices. Surgical spirits or a similar substance will help to remove these residues. Avoidance of splices altogether would be the best way to escape from any such inconvenience.

Since tape material is unstable and may be subject to damage from temperature, humidity, tractive powers on a running tape, or dryness leading to shrinkage, special attention must be given to the process of proper spooling and to the condition of the center piece or bobbin used for the winding of tapes. Tests involving computer tapes made of polyester or similar material resulted in a recommendation to re-spool every tape after an interval of 3 1/2 years to preserve an ideal minimal tension of the tape.

A reasonable way of storing tapes is to keep them in an upright position, like records. A plea for wood or aluminum shelves for tapes may be found in older literature because these materials are not affected by magnetization. Yet such a need has not been confirmed by the experience gained from the utilization of steel racks. So-called "compact" structures are considered harmless as long as the dispersion field of the engines is reliably screened off. Magnetic tapes are specifically endangered and, in severe cases, subject to erasure if they are exposed to magnetic fields disseminated by loud-speakers, earphones, tape recorders, and power transformers of all sorts of electrical equipment (11). Even magnetic door locks may be harmful. No general advice can be offered with regard to necessary distance from any such trouble source. Individual measurements are thought to be inevitable. To give a rule of thumb, loud-speakers should be positioned approximately 150 mm away from tapes, and from earphones and microphones 70 mm and 30 mm respectively.

A topical question of recent time pertains to the introduction of metal detectors used as part of safety measures at airports: May magnetic tapes be exposed to them? As no reliable data are at hand, insistence on visual inspection instead of detector control is advised as a matter of precaution. X-rays, however, as clearly proven in the case of computer tapes, do not affect tapes in any way that brings them in line with radar, microwave, laser, or gamma beams. I am unable to state whether experience with computer tapes is easily transferable to the situation of magnetic tapes, as the latter do not enjoy the same safeguard against damage by redundant keeping that computer tapes do.

A phenomenon called print-through effect deserves special attention because it is detrimental to the signal recorded on a tape (12). By way of technical explanation: The print-through effect occurs when some of the magnet particles of the tape coating come into contact with a neighboring layer of the spooled tape, provoking reciprocal reaction. The effect is heard as a pre- or post-echo. The intensity of the print-through effect is influenced by various factors, among the most important of which are time, temperature, and thickness and pigmentations.

The print-through effect is logarithmically built up in a gradually flattening curve as soon as a contact between both of the tape particles has been established. After separation of the tape layers this characteristic reverses in the same mode. In other words, the increase of print-through effect during the 1st hour after a contact of particles is equal to any further increase from the 1st to the 10th hour, while this factor itself is equal to the increase occurring from the 10th to the 100th hour, and so forth. The same applies to the reversal of the effect after separation. An increase in temperature will lead to an increase of the print-through effect. The same applies to a regular fluctuation of temperatures. Unlike the time factor, an increase of temperature will bring about irreversible symptoms of print-through effect. The tendency of a magnetic tape to print-through effects decreases as the thickness of the

tape increases. A tendency toward reinforced print-through effect is equally fostered by pigments for noise reduction or modulation support.

Taking note of these factors in addition to some others of minor importance, appropriate measures to prevent damage should be considered. These include selecting a standard type of tape of sufficient thickness (52 μ/m) and a pigmentation of low print property; trying to ensure ideal, *i.e.*, rather low, uniform temperatures; and organizing a regular re-spooling of tapes to reduce any existing print-through effects. If badly affected, the copying of a tape's signal onto another tape will be of little help, since copying necessarily includes the slave signal which will behave like a master signal on the new tape. If this occurs, the print-through can never be reduced any more. Reduction of the print-through effect is only possible on the original tape where it first appeared.

While being aware of the various specific dangers that may threaten sound carriers, one should not overlook dangers of a more general nature that could be hazardous to their existence such as theft, vandalism, fire (13), or water. As a safeguard against possible loss or destruction of this kind, it may be advisable to think about having technically identical duplicates of the original recordings made and then to store them in a remote safe place along with copies of the complete documentation related to them. The necessary funding for such an operation will not be easy to find. If only a consciousness could be established that would acknowledge the equal value of sound or information carriers and written or printed materials, it would be an enormous step forward. Perhaps the results of the Vienna conference will help promote these aims.

Equipment

Before closing, I would like to draw attention to a phenomenon that tends to be overlooked in view of the acute hazards associated with improper handling, technical impairment, and so forth. Any information stored in classic library and archives materials will remain "readable" as long as both the information carrier is undestroyed and a skilled person is available to decode the code – that is, as long as the living generation is able to read any used language.

In the case of so-called audiovisual information, decoding is no longer the task of human beings, but rather of complicated machines. The machines, however, are subject to obsolescence and in fact die out without passing on their skills to the next generation. Clearly, this means that certain current standard technologies, such as the realm of video, will be replaced by others. Experience shows that such switch-overs occur every 10 years. The radio stations, for example, are just now confronted with the fact that the production of 2-inch magnet-video machines was discontinued 4 years ago. Supply of spare parts for repairs is guaranteed no longer than 10 years after the stoppage of production, so these machines cannot be operated beyond the end of 1992. As a consequence, all 2-inch magnet recordings in the custody of radio archives that have been identified as having lasting program value and that have therefore been selected to be kept indefinitely would have to be copied onto carriers of recent standard. Without copying this stock of information would have to be regarded as lost or non-existent due to inability to read it. A general inquiry held in 1982 revealed that the German radio would have to deal with a quantity of 12,000 reels of black-and-white recording material containing 527,000 minutes' duration, and 75,000 reels of color recording material with 3.314 million minutes' duration, all of which are thought to be absolutely necessary for copying. To complete this vast operation, 5 years would be needed, and the sum of DM 50 million would have to be raised to pay for it. The only alternative to this colossal expense is a cautious and well-justified reduction of

materials. The actuality of this problem, which has now become obvious in the video sector, will soon crop up in the audio sector as well, judging from the recent development in the digital technology.

Conclusion

It may well be that we are forced to make up our mind about whether, concerning the audiovisual media, it is any longer suitable for us to regard as essential the difference between an original and its copy. Would it not be recommendable to consider a speedy transformation of the material into a more recent recording medium, rather than to prolong by high investments the service life of the original for only a limited space of time?

I am unable to state whether this prevailing situation in radios can in any way be compared with that of libraries. A considerable part of our contemporary history is reflected in other than written or printed records, however. It seems well founded, therefore, to give timely attention to the protection and preservation of audiovisual sources before it is too late.

References and Notes

1. Schüller, D. Behandlung, Lagerung und Konservierung von Schallträgern. *Das Schallarchiv*, April 1983, *13*, 29-56.
2. Pickett, A. G., and Lemcoe, M. M. *Preservation and storage of sound recordings.* Washington: Library of Congress, 1959.
3. Lotichius, D. Sicherheit zuerst – auch für Tonträger. *Phonographic Bulletin*, August 1972, *4*, 10-19.
4. McWilliams, J. *The Preservation and restoration of sound recordings.* Nashville: American Association for State and Local History, 1979.
5. Lotichius, D. Measures for the preservation and for the protection of archived program property on sound carriers. *Photographic Bulletin*, November 1981, *31*, 37-39.
6. European Broadcasting Union, Technical Centre. *Study of the storage of sound programmes recorded on magnetic tape.* Brussels, 1971.
7. DIN 45 519, Teil 1, Magnetbänder für Schallaufzeichnung, Bestimmung der Kopierdämpfung, February 1976.
8. Knight, G. A. Factors relating to long term storage of magnetic tape. *Phonographic Bulletin*, July 1977, *18*, 16-46.
9. Bertram, N., and Eschel. *Recording media archival attributes (magnetic).* New York, 1980.
10. Fontaine, J.-M. *Conservation des enregistrements sonores sur bandes magnetiques.* Paris, 1981.
11. Aschinger, E. Report on measurements of magnetic stray fields in sound archives. *Phonographic Bulletin*, July 1980, *27*, 13-20.
12. Bertram, N., Stafford, M., and Mills, D. The Print-through phenomenon. *Journal of the Audio Engineering Society*, 1980, *28*(10).
13. Schüller, D. Preliminary recommendations for fire precautions and fire extinguishing methods in sound archives. *Phonographic Bulletin*, March 1983, *35*, 21-23.

ZUSAMMENFASSUNG – Ton- und Videoträger beginnen ihren Platz in den Bibliotheken der Welt, die durch diese Materialien neue Herausforderungen an die Konservierung gestellt sehen, einzunehmen. Schallplatten kommen durch Abnutzung zu Schaden. Ihre Rillen werden verformt, was jedoch unvermeidbar ist, da Schallplatten dazu da sind, abgespielt zu werden. Der beste Weg, sie zu erhalten, ist, Schallplatten systematisch auf Bänder zu übertragen. Schallplatten sollten aufrecht, in einer angemessenen, sich nicht verändernden Umgebung aufbewahrt werden. Für die Aufbewahrung wird eine Temperatur von 20°C und relative Luftfeuchtigkeit von 40 ± 5 Prozent empfohlen. Magnetbänder werden weniger abgenützt als Schallplatten, obwohl Abrasion durch Umlenkroller, Tonköpfe und schnelles Rückspulen auftreten kann. Mechanische Belastung kann ebenfalls zum Verlust der Magnetisierung führen. Die Aufbewahrungsbedingungen für Bänder sind die gleichen wie für Schallplatten. Hohe Temperaturen müssen vermieden werden, da sie den Kopiereffekt steifern. Magnetbänder können zerstört werden, wenn sie Magnetfeldern ausgesetzt sind, jedoch Metallregale schaden ihnen nicht. Schallplatten und Bänder können aus anderen als physischen Gründen verlorengehen: die Geräte, auf denen viele Formate abgespielt werden, werden rasch obsolet. Ohne diese Geräte wird die Information auf diesen Medien für immer verlorengehen. In Anbetracht dessen, dass es keine Normung bei der Produktion von Ton- und Videoprodukten gibt, wäre es vielleicht sinnvoller, von der Ansicht, dass das Aufbewahren von Originalen von wesentlicher Bedeutung ist, abzugehen. Die prompte Uebertragung von Material auf einen neueren Datenträger scheint eher angemessen.

RESUME – Les documents de type audio- et vidéo commencent à s'installer parmi les livres qui composent les bibliothèques du monde, d'où un nouveau défi à la conservation. Les disques audio conventionnels sont sujets à endommagement par usure amenant la déformation des sillons. Ceci ne peut être évité, il faut bien utiliser ces disques. Pour une meilleure conservation, il est recommandé de faire une copie, automatique, de ces disques sur bande magnétique. Les disques seront entreposés verticalement, en milieu ambiant stable. Pour leur entreposage, l'on recommande une température de 20°C accompagnée d'une humidité relative de 40 ± 5 pour cent. Les bandes magnétiques sont moins susceptibles à l'usure que les disques, bien que les têtes de lecture, de guidage et de rembobinage soient un facteur d'abrasion. La pression d'éléments mécaniques peut conduire à une perte de magnétisation. Les conditions d'entreposage des bandes magnétiques seront les mêmes que pour les disques. Il faut éviter les hautes températures ayant un effet de sur-impression. Un dommage irréparable peut intervenir en cas d'exposition des bandes à des champs magnétiques, mais des étagères métalliques n'auront aucun effet négatif sur ces dernières. Les bandes magnétiques et les disques peuvent être détruits pour d'autres raisons que celles purement physiques: le matériel sur lequel il est possible de passer des documents audio sous plusieurs formats devient rapidement obsolète. Une fois qu'il aura définitivement disparu, les informations portées sur ces média seront réellement perdu. En vue de la normalisation des produits audio et vidéo, il serait sans doute raisonnable d'abandonner le concept de rétention obligatoire de l'original. Il sera sans doute plus raisonnable de le transférer sur un médium moderne.

CONSERVATION TREATMENT OF RARE BOOKS

Helmut Bansa
Bayerische Staatsbibliothek
Federal Republic of Germany

ABSTRACT

Rare books are threatened by heat, light, handling, and pests. These threats can be effectively countered with a variety of precautionary measures. More important in a library are efforts at restoration and conservation, applied in conjunction with each other. Conservation aims at treating an item so it is less susceptible to attack from various chemical reactions. Washing and deacidification of paper can effectively protect it from chemical attack by neutralizing acids in the paper and introducing a substance that acts as a buffer against the effects of future oxidation and hydrolysis. The best approach is to wash out soluble decomposition products with water that has a high concentration of carbonate, then introduce a buffer through the application of a non-aqueous deacidification solution. Mold can be treated in rare books by fumigation, but this approach should not be applied routinely to all books. Leather bindings can also be given conservation treatment although controversy exists concerning which of the variety of methods available is best, and the chosen method can easily lead to damage if carried out by insufficiently trained personnel.

Conference Context

For two reasons I did not find it easy to prepare the paper that I have been asked to give for the First International Conference on Preservation of Library Materials: first because the topic that I have been given is either too general or too specialized; second because I have to compete with more than 40 other speakers who have similar topics.

In order to avoid undue repetition and to contribute to continuity of ideas, I tried to imagine what the other speakers would report regarding the special aspects of the topics that have been allocated to them. There are lectures during this conference on acquisition: what kind of materials must be collected in libraries to preserve our cultural heritage for the future. In the context of rare books we can reduce all relevant ideas to a very simple principle: a librarian must collect any rare book pertaining to a special field of his library. The subject field of his library is a question of general library policy. It may exclude the topic of this conference and, for libraries serving the general public, preservation may be reduced to careful handling. There are lectures during this conference on general aspects of preventive care: nobody can doubt that a librarian must protect any rare book he has collected against decay and disaster. Another group of lectures is discussing preservation in original format or format conversion: in the context of rare books these two are not alternatives, but supplements. To make possible preservation in original format the librarian responsible for rare books will use any conversion format, such as microfilm or microfiche, reprint and facsimile. Adapting the first part of this pair of notions to rare books, any measure, any precaution, any activity that makes possible preservation in original format is used: starting from proper storage under suitable climatic conditions, including careful handling, and ending with preservation treatments of the paper in those books, treatments that change the chemical composition so that the paper will be less exposed to decay.

Topic Wording

Another method to prevent undue repetition of ideas and words that will be presented by others, during this conference and elsewhere, is to take the special topic that has been allocated to me in its narrowest sense. *Conservation.* Not restoration and not "preservation," a word which has no equivalent in other languages except English, and even in this no clear distinction from "conservation" (1). Conservation *treatment.* Not precaution and measures for protection. Conservation treatment, this is a concrete measure applied to a particular object by human beings using their hands or tools in order to have the object remain the way it is or at least appear that is has remained so. In our energy-filled world, everything pushes for change, every order for its own dissolution, and effort is required to soften and avoid this process.

The third concept of my topic: rare book. One can have an easy time with defining it, for the idea which everybody associates with it is pretty much the same in all minds, even through not clear. A rare book is a thing which is considered valuable. Why? Often only because it is rare. It is rare only in the sum total of its peculiarities: there are any number of objects with similar peculiarities in a different combination, each with other peculiarities and none with all of them. One peculiarity acquires particular meaning, namely antiquity. This peculiarity is often the one which is the basic reason for rarity. Only very few books acquired by a library in the period of their production are actually rare, but nearly any book is potentially so. I will not extend my special topic in this direction; I will restrict it to those books that everybody agrees are rare. Those books are in a preeminent way an object of conservation: everything about them should remain the way it is. Above all everything about each book should remain old and antique; each book has its special character. It is the treatment that is difficult to solve: what can one do to guarantee a book remains the way it is?

Treatment

The logical answer would be: nothing. Everything that one now does as new is naturally not old. This resigned notion takes a turn to the positive, thanks to the condition that was placed above on the definition of the word "treatment": if not everything can remain as it is, at least it should appear that it has remained that way. In the much larger context concerned with working to maintain rare books, namely working on those individual parts which are no longer the way they were and should be, that is, in the area of restoration, this latter limited goal can be pursued only with great difficulty, not to mention the unlimited one. The effort that one must expend will increase in exponential proportion to the result desired. This has led theoreticians of restoration to change the basic statement around: one must be able to see everything that is done to a rare book. In the case of conservation treatment, such a goal would not be attainable. This conflict over basic theory to which I am alluding is still far from over, but it is not part of my topic. Continuing with the topic leads us to the question: what kind of treatment can one carry out, apart from protective measures, so that the various forms of destructive energy that surround and threaten the rare book can be softened and thereby lessened in their effect? These are forms of destructive energy from warmth, light, from strength in the hands of readers or in the teeth of small creatures, from secretions and enzymes and whatever.

Before I attempt to treat these matters in the general way that is required for library managers, the profession this conference is organized by and for, I must make one more digression. I must point out that in actual practice involving libraries and their laboratories, these treatment procedures play a secondary role. Far more

important are precautionary protective measures: temperature and humidity control, boxes and other arrangements for isolation, directions for limiting use, and providing substitute copies. If we restrict ourselves to the word treatment we must say: far more important are efforts at restoration. In practice, conservation treatment takes place only along with these latter lines.

Deacidification

The area of effectiveness of deacidification is indeed quite limited. It embraces only the limited possibilities of modifying the composition of material with complex construction – in the case of the rare book: paper, leather, coloring and ink – so as to offer lesser access to destructive energy. This concerns above all access to chemical reactions: oxidation, hydrolysis, crosslinking, or, to use other words as one finds in the mouths of researchers and in the technical literature: decomposition, keratinization, hardening, yellowing, fading, photolysis and many others. The way by which these reactions take place is nowadays understood in the basic characteristics, as well as what can be done theoretically to prevent them. Research is seeking out the best and quickest practice: mechanization and bulk treatment. In the matter of rare books, those results are adopted which chemical imagination and practical experience indicate to be most effective in the desired direction and to avoid mostly undesired side effects. These results are modified and integrated into the overall tasks involving the material of the rare book. This modification takes into account that for rare books the aspect of aesthetic quality has the highest range. Let us consider the deacidification of paper, by far the most important of the treatments that modify the composition of a book material, in this case paper, so as to make it more permanent and durable. More precisely, deacidification is the introduction of a substance, *e.g.*, magnesium carbonate, which works as an alkaline buffer against acid-catalyzed hydrolysis and also works as a catalytic blocking agent against oxidation. It is purely a matter of conservation treatment. This procedure is an unquestioned part of rare book restoration in a number of laboratories, for example, the one from which I come (2), even if it is true that just the paper of rare books has less need for a relevant treatment than the paper of other books, for the simple reason that rare books are mainly old books, which means handmade paper, that is, generally speaking, more permanent and durable than most modern machine made paper. Nonetheless, if the condition of paper in a book that must be restored arouses only a remotest suspicion that the paper is exposed to oxidation and hydrolysis (including, therefore, all paper which was not manufactured with the above-mentioned blocking agent), the paper is deacidified. Depending on greater or lesser previous efforts at preservation, the eye and the sensitive hand of the restorer are for the most part able to detect paper in which oxidation *and* hydrolysis have already taken place, without the restorer needing to measure the pH factor or carry out chemical analyses.

The decomposition products of oxidation and hydrolysis promote further decomposition and so it is important first of all to remove them completely. Like deacidification, washing is an unquestioned part of old book restoration and likewise a conservation treatment technique. It is often suited for the paper of a rare book on aesthetic grounds and is often preliminary to other procedures, for example, leafcasting. More about washing later. Washing and aqueous deacidification can in part be mechanized. In some places, ingeniously constructed plants are available for this purpose (3). Where one can use them, it seems that the additional expense is relatively small if the rare book has already been taken apart for other reasons, namely so that it can be restored. Aqueous deacidification of paper, provided that the ink and

color and other elements can sustain it, is the only treatment of paper which can qualify as basically positive. I know that this thesis, which I am not now presenting for the first time, has aroused opposition. I will gladly debate this thesis, provided the discussion is well-argued and not based on empty phrases. Sometimes aqueous deacidification is not possible, on account of the ink and the color, particularly in the case of a rare book. The fact that there can be no doubt about the positive effect of the material brought into the paper in the process of aqueous deacidification has led to the result that non-aqueous methods, which introduce the same material into the paper, have likewise been included in the repertory for conservation treatment of rare books. The non-aqueous methods were developed for the bulk treatment of modern books. One of them has already been employed for this purpose on a large scale (4). For the rare book, they form a substitute when aqueous procedures are not possible. In the case of one of these methods (5), the very one employed for large scale bulk handling, it is possible to introduce into the paper more of the material which works with a positive effect than with any other method, including the aqueous (6), and in this sense it is superior to all others. Nonetheless, one has reservations against it concerning the paper of rare books. These reservations may be based more on feeling than on reason. Through experience with rare books one cannot completely avoid the inclination to allow feeling to win out over reason. For me personally as well as others, aqueous deacidification of paper is preferable to non-aqueous deacidification. In seeking reasons for this preference, one might say: with the non-aqueous procedures, the products of the decomposition which has taken place remain in the paper and promote further decomposition. They are "neutralized." Completely? Permanently? In any case, it is better to wash them out and that is possible only with water. As a second reason, one could introduce the consideration that water would wash out the decomposition products of cellulose which have been affected by the decomposition. Through the washing and through the removal of these decomposition products, the water would activate interfibrillary hydrogen bonding and thereby strengthen the paper. One can add that crosslinking would be avoided through washing out the decomposition products. This occurs because molecular decomposition residue contains reactive groups which are able to form connecting bonds between hydroxyl groups in the cellulose chain. Previously these hydroxyl groups lay freely side by side and promoted the flexibility of the paper. The discussion whether these ideas of my chemical imagination correspond to reality would best be discussed at a meeting of cellulose chemists, at which conservators and restorers and the managers of both these library activities would have a purely receptive role. Such meetings have already taken place (7).

To return to our topic of the conservation treatment of rare book paper, one might say in conclusion that a combination of aqueous and non-aqueous procedures would be the ideal practice. By means of water, perhaps with high carbonate concentration and therefore with deacidifying effect (8), the harmful decomposition products are washed away; then by means of subsequent, non-aqueous deacidification according to the above-mentioned method of Richard D. Smith (5), a maximum of helpful material is introduced into the paper.

Preventive Disinfection

We leave chemistry behind and look to biology: to the conservation treatment of rare book paper against biological, that is microbiological attack, concretely, against mold. In the technical literature on conservation, one can find a whole list of pertinent recommendations and procedures (9); I do not know whether and to what extent they

have been taken beyond research effort and put into actual practice, at least as preventive conservation measures. When the paper of a rare book has suffered damage from fungi, when it has been weakened by mold to the point of becoming physically endangered and has been discolored to the point of becoming aesthetically disfigured, one must adopt restorative treatment: one must wash it, bleach it, resize, split, leafcast it. These are all aqueous procedures, for which it is suggested that one add a fungicide to the water as a preventive measure against future harm. This might be done here and there; it is not generally accepted the way deacidification is. There are good reasons for this. For one, we can never say for certain that a biologically disruptive agent will leave an organic substance like paper unharmed. Experiments in artificial aging with the use of otherwise recommended chemical agents have rather shown the opposite in the laboratory I am from. Secondly, the defense against biological attack, against the dangers for rare books coming from rats and mice, worms and book lice, microbes but – most of all – from fungi; the defense against all this is a problem of library building and involves obvious cleanliness plus well-ordered housekeeping (10). In certain parts of the world and in certain libraries, the defense may also involve climatic control; but only under very extraordinary conditions will it be a problem of chemical or physical conservation treatment. If library building and library cleanliness are ordered with respect to preservation any preventive treatment appears superfluous. It may even appear as inappropriate. All paper in all books is subject to microbiological attack, the older good paper, namely the kind that is mildly alkaline and has been sized with animal glue is even more liable to biological attack than modern paper which contains filler and has been sized with rosin.

To give preventive treatment to all paper in all rare books, especially those in good condition, is a sheer impossibility. On account of the circumstances involved in providing the treatment, it would also be sheer foolishness. To treat the paper of a book that arrives in the laboratory more or less by chance, namely because it is being restored and has to be taken apart, and not to treat all the remaining books merely distracts from the unavoidable necessity of building and outfitting library book stacks where no mold can grow. In the laboratory that I am from, paper receives preventive impregnation against the growth of mold when it already shows signs of such growth and when the mycelium cannot be fully destroyed on account of the condition of the ink or the color or for whatever other reason. In such a situation, we let ourselves be guided by our understanding that a mycelium living in the book needs less moisture and warmth for new growth than the spores, which are everywhere, need for their sprouting before beginning growth. The mycelium can grow when an inhibitor is present, e.g., in the case when the mycelium is dormant rather than fully destroyed, this situation makes storage practical within the wider temperature/moisture limits that prevent spore growth, but could allow the growth of the mycelium.

Active Infestation

The topic "conservation treatment of rare books against biological attack" may also cover possible methods to disinfect the stockrooms for rare books and the rare books themselves if there is an active infestation. What is the best treatment in such a case: poisoning, fumigation, or freezing? What poisons or fumes or gases are most harmful for the animals and fungi and least harmful for men and rare books? Such technical questions are best determined by technical experts. Library managers should take part in these determinations and must emphasize what the specific character of rare books is and what these books require in exacting treatments to insure mere technical

aspects are not over emphasized. For this purpose they must be, to some extent, familiar with relevant technology.

Leather Treatment

As a final aspect of conservation treatment of rare books the treatment of their bindings should be considered, most particularly, their leather bindings. I would not know what else to mention. Leather treatment, that is, impregnating the leather of the bindings with a fatty substance, or, using the technical term of the English language, dressing the leather, is the most frequent kind of conservation effort carried out in libraries with old volumes. Dressing bookbindings is burdened with high expectations even though its effects cannot be described exactly. It is the ideal starting point for a variety of methods and prescriptions as well as for bitter arguments about which are the best dressings or which is the only correct one (11). This argument leaves its mark on the pertinent technical literature. It is not wrong to say that in principle, assuming correct use as prescribed by the producer occurs, nearly any dressing suggested in the technical literature is good for the leather, at least from the aesthetic point of view. But what is even more true is that if dressing only is practiced and all the other and more important aspects of conservation are neglected, no leather-bound book will be preserved.

Finally, it can be reported: The obvious final step in working on a leather binding in either the restoration or the repair laboratory is treating leather with oil, wax and water as the basic elements, and with various additives which achieve a biological and chemical balance, applied either in one or in more mixtures used successively. Moreover, such a treatment is occasionally carried out on a large scale with all the leather-bound volumes in a library collection. Reservations against such a general procedure are appropriate. Such actions are almost always measures to create work. The dressings are applied by workers who have not been trained for the task and who have been only partially instructed for it. They are not able to distinguish properly among the various types and conditions of leather. Mistakes occur: The most frequent one where water and oily material are not applied in the right proportion, *e.g.*, too much oil is applied and too little polishing is done so that after treatment the book becomes a sticky dust catcher. Actions of this kind are most suited to pacify in a deceptive way the conscience of the responsible librarians. Conservation, however, is not a matter of isolated actions: it is a matter of constant striving that must pervade the entire work day and staff of the library (12).

Consequence

This last section may be best begun by a general statement regarding the conservation of, mainly but not only, rare books: What must or should be done to preserve rare and other books is well known. What we need to do is to carry out conservation work. Doing conservation is not so much a problem of funds. An international conference of librarians is not the place to struggle for funds. Even though these conferences are often used as a platform to cry for better funds, this is the wrong way to approach conservation. By crying loudly enough, the librarian responsible for conservation gets a feeling of having accomplished something, that is, of having transferred this responsibility for conservation which really is his own and not, absolutely not, transferable!

Funding requests must be presented to the representative and the sponsor of the library. To present them in an irrefutable way the librarian needs good arguments. He

himself must be convinced of these arguments. They must be based on certain knowledge and a clear consciousness. The librarian must understand the course of the chemical, biological, and mechanical processes of damage and decay just as thoroughly as he must understand the course of the chemical, biological, and mechanical solutions to resolve these problems. Although he must have a general understanding of the methods used to carry out the different conservation techniques, he must even more have a well-rounded grasp of what can be achieved using these methods and techniques and what cannot be resolved by using them. He must combine this general technical and scientific understanding with his professional knowledge in the field of librarianship. From this combination, he must develop conservation policies; a theoretical policy for the whole profession and a practical policy for the role of his very own library within this profession.

Some of the principal questions are: what part of the immense stacks of printed and written paper in the libraries of the world, of his own country, of his own library must be treated? In what way must this treatment be carried out? The top of the treatment hierarchy that can be done is the careful and costly work to preserve and restore not only the original format, but the original appearance of a book as if it were an object in a museum or an antiquity; the end of the hierarchy is neglect, that is, no treatment at all. Not every book in any library is deserving everlasting life. Knowledge and understanding of what this means and, as a result, a real and realistic conservation consciousness must penetrate throughout the entire professional life of the librarian. His entire professional work should be oriented towards conservation. This is what our profession needs. If all activity and processes in daily library work are oriented towards conservation, then the funds that society can provide for library conservation will be used much more effectively than they are used now. Those funds are limited in any event. Librarians cannot bring about a social and cultural situation where the preservation of books is comparable to the last phase of the Egyptian Pharaoh culture. A major part of the national product cannot be invested either into the cult of the dead or into old books. However, librarians can insure the funds that can be invested.

Range within Policy

Conservation is an important library activity, a task of high importance, in national libraries possibly of highest importance. In any event, its importance in the national library has a higher rank than the comfort of a reader. In a national library and in other libraries having rare and unique collections a reader must wait when a book endangered by decay and loss is being microfiched, before it can be made available. If the reader only needs the information stored in the book, he must be satisfied with the microfiche. The microfiche makes it possible to separate a book that is endangered by decay and loss, to wrap it and to wait for the day the book can be restored – if one day the book seems to deserve restoration. This separating and wrapping is a very important measure of conservation, even though not a conservation treatment and therefore not the topic of this paper.

In a national library the reader must accept the expense of a costly print from the microfiche instead of the cheap, direct photocopy. He must even accept an additional charge for the copy he gets and to contribute in this way to build up a microfiche collection of rare books in the national library or in another library with unique collections. For our rarest books, that is for manuscripts, this is just the usual condition of library management, and it is necessary to extend it to printed books. Printed books do not enjoy the deep respect that manuscripts do, but often books are just as rare and mostly they are more endangered by damage and loss. Sending books around for

exhibitions and for inter-library lending is quite the opposite to conserving books. National libraries should protect their books by not taking part in inter-library lending actively, only passively. Perhaps as a compensation to lending libraries, borrowing libraries should take over the duty to microfiche any book that they borrow, providing two copies of a quality comparable to the master that allows both duplication of the microfiche and photocopies of single pages. One copy should be supplied to the national library, and the other for the lending library. In this way, the next demand for this very book (that seems to be a rare one only from the fact that it is not present in the national library) can be satisfied by a conversion format; and the original can be further protected by any suitable means of preventive care, of conservation or even restoration treatment.

References and Notes

1. Dureau, J. M. and Clements, D. W. G. *Principles for the preservation and conservation of library materials.* The Hague: International Federation of Library Associations and Institutions, 1986.
2. Bansa, H. Das Restaurieren von Papier, 1.: Nachleimen und Neutralisieren. *Bibliotheksforum Bayern,* 1984, *12,* 60.
3. Müller, G. Zur Massenrestaurierung von zerfallsbedrohtem wertvollem Schriftgut. *Zeitschrift für Bibliothekswesen,* 1980, *94,* 226-236.
 Wächter, W. Über Möglichkeiten der Mechanisierung restauratorischer Tätigkeiten. *IFLA General Conference Munich 1983. Paper 52-Con-3.*
 Petersen, D. A. Die Wolfenbütteler Papier- Wasch- und Trockengeräte. *Einbandkunst '85, Ausstellungskatalog Buchmesse Frankfurt 1985.*
4. Banks, J. Mass deacidification at the National Library of Canada. *Conservation Administration News,* January 1985, *20*(27), 14-15.
5. Smith, R. D. Mass deacidification: the Wei T'o way. *College and Research Libraries News,* December 1984, *45,* 588-593.
 U. S. Patent 3,939,091, Febr. 17, 1976 (Kelly, Jr.).
6. Santucci, M. L. Paper deacidification procedures and their effects. In Colloques international sur les techniques de laboratoire dans l'étude des manuscrits, Paris, 1972. *Les techniques de laboratoire dans le étude des manuscrits.* Paris: Centre national de la recherche scientifique, 1974, 207.
7. Williams, J. C. (Ed.). *Preservation of paper and textiles of historic and artistic value.* Washington, D. C.: American Chemical Society, 1977.
 Williams, J. C. (Ed.). *Preservation of paper and textiles of historic and artistic value II.* Washington, D. C.: American Chemical Society, 1981.
8. Tang, L. Washing and deacidifying paper in the same operation. In J. C. Williams (Ed.), *Preservation of paper and textiles of historic and artistic value II.* Washington: American Chemical Society, 1981, 63-86.
9. Kowalik, R. Microbiodeterioration of library materials. Decomposition of paper by microorganisms. *Restaurator,* 1980, *4* (3-4), 171-200.
 Strzelczyk, A. B. & Rozanski, J. The effect of disinfection with quaternary ammonium salt solution on paper. *Restaurator,* 1986, 7, 3-13.
10. Baynes-Cope, A. D. *Caring for books and documents.* London: British Museum Publications, 1981, 28. (Deutsche Ausgabe, 94).
11. Bansa, H. & Maier, H., Bemerkungen und Beobachtugen zur Lederpflege. *Maltechnik Restauro,* 1981, *87*(2), 111.
12. Bansa, H. The awareness of conservation. *Restaurator,* 1986, 7(1), 44.

ZUSAMMENFASSUNG – Seltene Bücher sind von Hitze, Licht, Gebrauch und Schädlingen bedroht. Diesen Bedrohungen kann mit einer Vielzahl von Vorbeugemassnahmen wirkungsvoll entgegengewirkt werden. Wesentlich wichtiger freilich sind Restaurierungsmassnahmen bzw. eine Verbindung miteinander. Konservierungsbemühungen zielen daraufhin ab, einen Gegenstand so zu behandeln, dass dieser gegen Angriffe verschiedener chemischer Reaktionen weniger anfällig ist. Waschen und Entsäuern von Papier kann dieses effektiv vor chemischen Angriffen schützen, indem Säuren im Papier neutralisiert werden und eine Substanz, die als Puffer gegen die Effekte zukünftiger Oxydation und Hydrolyse wirkt, eingeführt. Die beste Vorgehensweise ist, lösliche Zerfallprodukte mit Wasser, das eine hohe Konzentration von Karbonat aufweist, auszuwaschen und dann einen Puffer, durch Anwendung einer nichtwässrigen Entsäuerungslösung einzuführen. Schimmel kann bei seltenen Büchern durch Begasung behandelt werden, jedoch sollte dieses Verfahren nicht routinemässig. Konservierungsmassnahmen können auch bei Ledereinbänden durchgeführt werden, obwohl eine Kontroverse darüber besteht, welche der zahlreich zur Verfügung stehenden Methoden die beste ist, und das gewählte Verfahren kann leicht Schaden anrichten, wenn es von nicht ausgebildetem Personal durchgeführt wird.

RESUME – Les livres rares sont à la merci de la chaleur, da la lumière, des manipulations et des parasites. Ces menaces peuvent être efficacement contrecarrées par diverses mesures de précaution. Les efforts de restauration et de conservation atteignent leur plein effet lorsqu'ils sont appliqués conjointement. La conservation vise au traitement d'un article afin qu'il soit moins sensible aux attaques de diverses réactions chimiques. Un lavage et une désacidification du papier peuvent le protéger, efficacement, d'attaques chimiques par la neutralisation d'acides du papier et l'introduction d'une substance agissant comme tampon contre les effets futurs d'une hydrolyse et d'une oxydation. La meilleure politique est d'éliminer les produits de décomposition solubles avec de l'eau à haute concentration de carbonate, puis d'introduire un tampon par le truchement d'une application de solution de désacidification non-aqueuse. Les moisissures, dans les livres anciens, peuvent se traiter par fumigation, mais ce procédé ne pourra être appliqué communément à tous les livres. Les reliures en cuir peuvent également être traitées pour conservation bien qu'une controverse se soit instaurée sur le choix de la meilleure des méthodes. Ensuite, la méthode sélectionnée peut s'avérer nuisible si elle est exécutée par un personnel insuffisamment formé.

CONSERVATION TREATMENT OF PAPER

Ove K. Nordstrand
Principal Conservator
The Royal Library
Denmark

ABSTRACT

The deterioration of collections can be slowed by the skillful application of suitable conservation treatments coupled with storage in an appropriate environment. In conservation treatment the integrity of the item must always be respected, the procedures utilized must be reversible, and the treatments given and materials used must be well documented in the conservation record. Paper conservation treatment often includes disinfection, mechanical cleaning, solvent cleaning, washing, neutralization, stabilization (sizing), restoration, and reinforcement. Three types of materials that the paper conservator treats are manuscripts, maps, and works of art on paper. Manuscripts vary considerably and present diverse treatment problems. Consequently, each item must be considered and dealt with individually. The treatment problems of newer manuscripts are often more complex and problematic than those of older manuscripts. Acid deterioration from iron gall ink is a particular problem. Maps fall into the categories of globes and flat maps, with the former involving a number of special problems. Experience has shown that the paper gores of a globe are best treated *in situ*. Works of art on paper are the most demanding because they are made with a broad range of techniques (sometimes combined in one item), and treatment must not affect the aesthetic perception, and thus the monetary value, of the piece. Iron gall ink and water-soluble colors offer particular challenges. When treated, art works should be hinged with Japanese paper into passe-partout mats made from high-quality acid-free materials.

One of the hard-to-swallow realities of the library and archive world is the fact that all paper items in our collections are in the process of deteriorating – relentlessly. The process ordinarily proceeds at an extremely slow rate, but negative influences from the environment may accelerate it. Our prime professional duty, therefore, is to create as sound and positive an environment for our collections as is technically and economically possible. Prevention is better than treatment. The process of deterioration, however, may not only be accelerated. It may be decelerated, too, by skillful application of suitable conservation treatments, particularly if they are coupled with suitable changes of the environment in which the collections are housed. Ethically considered, therefore, the preservation of paper in our collections becomes the common objective of librarian, conservator, manager, and technician. The chief aim of the paper conservator is to prolong by skillful application of the technical means at his or her disposal the useful lifetime of any paper item that is brought into the laboratory for treatment.

A range of procedures is at the disposal of the conservator. However, the actual treatment to be utilized in an individual case depends, and definitely must depend, on the specific demands of the individual item. It also depends on some fundamentally significant principles that must be respected in any case. The integrity of the individual item must always be strictly respected. All procedures utilized must be reversible, and all procedures and materials used in the conservation treatment must be well documented in the conservation record. Last, but not least, the principle of "the-less-done-the-better" should be respected. These principles should be considered central parts of the ethics of paper conservation.

The conservation treatment of paper should proceed as a planned, but flexible, process. Decisions of what to do, and sometimes what *not* to do, are usually made

between the librarian responsible for the item and the conservator responsible for the treatment. Prior to any decision the item should be carefully investigated by the conservator, using a range of technical procedures, to establish a detailed assessment of its structure and condition of preservation. All observations made during this initial investigation, as well as those made subsequently during the conservation process, must be carefully noted and, if necessary, illustrated in the conservation record.

The actual conservation treatment falls into a number of phases. If the item has been attacked by microorganisms, the first phase is a disinfection, which is carried out by gassing the item at reduced pressure with either ethylene oxide or methyl bromide. If disinfection is unnecessary, the first phase of treatment will be cleaning to remove dust and grime that has accumulated on the surface of the paper. The cleaning proceeds in stages. The first stage involves mechanical cleaning with hand-held and rotating brushes and, if necessary, scalpels and needles. The next stage would be a solvent cleaning, if necessary. Fatty spots and other stains are removed with a suitable organic solvent. Finally, the paper is washed in tap water. If a detergent is added to the water, washing should end with at least a 20-minute rinse in running tap water. Research results from the Library of Congress proved some years ago that distilled water should never be used for the washing of paper.

During the conservator's initial investigation of an item the acidity of the paper is measured, usually with an electronic instrument called a pH meter. The level of acidity or alkalinity is expressed in terms of pH as a number on a logarithmic scale that ranges from 1 to 14. The value 1 is the most acidic, the value 7 is neutral, and the value 14 is the most alkaline. If the pH of a paper item is less than 6, neutralization is usually undertaken. Neutralization of paper may be done by various procedures, all of which should shift the pH value of the paper into the alkaline range. The procedure most widely used is the Barrow procedure, which first neutralizes the paper in a 20-minute bath of 0.15 percent calcium hydroxide, then introduces an alkaline buffer into the paper in another 20-minute bath of 0.20 percent calcium bicarbonate. The calcium carbonate buffer protects the paper against further attacks of acid. Another procedure that is widely used in the United States is the Wei T'o procedure, which neutralizes the paper with magnesium methoxide in a mixture of methanol and Freon. In the near future a mass-neutralization procedure will be put into use by the Library of Congress. This procedure uses diethyl zinc in the vapor phase in a vacuum chamber. In this process the acid in the paper is neutralized, and buffers of zinc oxide and some zinc carbonate remain in the paper. The next step in the conservation treatment process is stabilization of the paper, which may be carried out by various means, ranging from the classical gelatin planing to the modern treatment with cellulose derivatives. Of the latter, sodium carboxymethyl-cellulose and hydroxypropyl cellulose have proven particularly useful. Both materials have the common advantage that they will swell in a mixture of water and ethyl alcohol; thus, cockling of the paper, when wetted, may be reduced. Soluble nylon, formerly hailed in Western Europe and the United States, and polyester impregnation, similarly once hailed in Eastern Europe, have both been proven by practical experience to be unsuitable for paper conservation purposes.

The task of the paper conservator is to restore to full usability any paper item brought to the laboratory for treatment. The conservation treatment, therefore, will usually also include some elements of restoration. Thus, rifts and tears in the edges will be closed and reinforced with narrow, torn strips of Japanese tissue. The tissue strips may be adhered with paste or used in the heat-seal manner. Holes may be filled by pasting patches of Japanese paper, torn to the size of the hole, on both sides; or by leaf-casting with paper pulp either manually or with a machine. When the paper is

either very weak or brittle, some kind of physical reinforcement may prove necessary. If the paper has writing on one side only, this reinforcement may be accomplished by backing the paper with a sheet of suitable-strength Japanese paper. If the paper has writing on both sides, reinforcement may involve pasting the paper between sheets of Japanese tissue, followed by a hard pressing. Still another widely used procedure, which is particularly popular in the United States, is encapsulation between sheets of polyester film that are sealed along all four edges. It should be emphasized, however, that this procedure is unsuitable for pencil and charcoal drawings and for pastels, because the film surface tends to generate static electricity.

Lamination of paper by sandwiching it with a reinforcement of Japanese tissue between sheets of thin cellulose acetate or polyethylene film, then pressing it together between heated plates or rollers, must be considered only as a last resort. The technique should be used to add some years to the physical existence of documents that cannot be successfully treated in any other way and that would otherwise be expected to perish over a short period of time.

The collections of any large, old library may hold a fair selection of items representing the wide variety of purposes for which paper was utilized as a carrier for written, printed, and drawn presentations, and will exhibit various stages of disrepair into which these items may have fallen in the course of time. In principle, the selection of items sent to the paper conservation laboratories for treatment should reflect this state of affairs, but seldom does. Understandably, librarians who are in charge of collections tend to give a higher priority to their most valuable items (in terms of money) and lower priority to other items. This tendency clashes with the ethical rule of conservators not to discriminate between items based on their monetary value. As it is, the problem arises from the deplorable fact that almost everywhere the available resources are too limited. Viable ways to solve the problem must be found, however, and doubtless can be found if librarians and conservators could enter into unbiased discussions on the subject.

The range of problems that are put before paper conservators for solution is very wide. Since the problems pertaining to rare printed books is the subject of another session at this conference, I will confine myself to discussion of problems related to the treatment of manuscripts, maps, and works of art on paper. The category of paper manuscripts is large and varies widely, ranging from scraps of 3rd century paper manuscripts excavated from dilapidated watchtowers on the outskirts of the Middle Kingdom of China to items that have proven to be either historically significant or are in other ways worthy of preservation (the more-or-less casual notes of contemporary politicians, for example). Very few of these manuscripts were ever intended to have lasting value, but once they are recognized and particularly once they are in a public collection, they must be preserved; and their preservation is the headache of the paper conservators of the respective institutions.

In conservation treatment each paper manuscript must be dealt with individually, with due consideration paid to the particular nature and properties of the materials of each item. The full spectrum of treatments so far described (plus a few) will usually have to be applied. Paradoxically, the conservation problems of newer manuscripts are frequently more complex and problematic than those of older ones and may call for considerable inventiveness on the part of the conservator. Paper manuscripts are quite often rather acidic, with the amount of acid present stemming from the ink. Frequently the acid ink has corroded the paper to such an extent that it is extensively perforated. In such cases conservation, particularly neutralization, and subsequent

restoration are very time-consuming processes that require considerable dexterity on the part of the conservator.

The category of maps should be divided into two subcategories: flat maps and globes. The conservation problems of flat maps are essentially the same as those of works of art on paper. The conservation of globes, however, involves a number of special problems, some related to the globe itself and some related to the gores on which the globe image was drawn or printed. The latter are of concern to us. Globes have been varnished, as a rule, and the dust and grime adhering to the surface of the globe will therefore be removed simultaneously with the removal of the varnish. For the removal of the varnish a traditional alcoholic varnish stripper is used.

All practical experiences have demonstrated that conservation treatments of the paper gores carrying the globe image should be carried out with the gores *in situ* on the globe body, whenever possible. Were the gores dismounted from the globe body and exposed to conservation treatments in the ordinary way, the situation might become uncontrollable because the paper will swell on wetting and shrink on drying and the paper gores, therefore, would not fit exactly together when remounted on the globe body. If the gores are treated *in situ* these problems will not occur. Damaged areas of the paper may be filled by pasting in patches of Japanese paper torn to the size of the damaged area. This paper is later toned down with water coloring. The surface of the globe body consists of a smooth layer of gesso. When the paper is treated *in situ* it may locally loosen from the gesso and form a blister. This problem may be solved by the injection of a cellulose paste, preferably hydroxypropyl cellulose in water and alcohol. The paper is then worked gently down, then covered with a piece of release paper and a thick swab of cotton wool, which are weighted down during the drying. The paper may also have loosened at the seams. In that case, starch paste is brushed under the loosened paper, which is then worked down with the bone folder and weighted during drying. When treatment is complete, the globe is revarnished, usually with a traditional mastix varnish.

The category of works of art on paper is doubtlessly the most demanding for the paper conservator. A broad range of techniques was used in the creation of these items. At times, a combination of greatly differing techniques was used for the same item, which greatly complicates treatment. Works of art on paper are artistic creations and as such often have considerable monetary value. Therefore, conservation and restoration treatments must not influence the aesthetic appearance of an item in any way that may detract from its monetary value, a requirement that the conservator must keep constantly in mind. For this reason, some conservation procedures must be more or less modified when works of art on paper are to be treated. Neutralization of acid thus only rarely may be done by bathing. Instead, a floating procedure must be used in which the sheet is placed with its back floating on the surface of the neutralization bath. During the floating it may be necessary to support the sheet with an open-meshed nylon or polyester web. When this procedure is used, repeated treatment is necessary, and between the treatments the sheet should be fully dried.

Pen drawings made with iron gall ink may present the particular problem of ink corrosion, which has already been touched upon in the area of manuscripts. Iron gall ink consists of an infusion of sulphate of iron with gallo-tannic acid. If these ingredients are unbalanced, sulphuric acid is formed which penetrates the paper from the ink of the pen strokes and corrodes the fibers. Items attacked in this way cannot be treated with any aqueous procedure, or at least can only be treated with difficulty and great care. In these cases, procedures such as that based on magnesium methoxide in methanol will be mandatory. After neutralization physical strengthening will also be

necessary. Strengthening is done by dry-laminating a sheet of Japanese tissue impregnated with polyvinyl alcohol to the back of the drawing by using moderate heat and pressure.

Old engraved hand-colored maps may present a problem if part, or all, of the coloring is sensitive to water. In such cases, if wet treatments are necessary, the sensitive areas must be protected, which may be done with thick cellulose paste. In this connection, copper-plate engravings must not be pressed too hard, since the impressions of the plate edges into the paper should be preserved. Works of art on paper are the only items treated by the paper conservator where retouching is permissible. However, retouching should always be executed in such a way that it is clearly recognizable on scrutiny, but unobtrusive with ordinary observation. Also, retouching should always be done with water colors that may be removed easily, if necessary.

The final stage in the conservator's treatment of a work of art on paper is the mounting of the item in a passe-partout. The passe-partout is meant to give the item future protection against negative influences, mechanical and chemical, from the environment. Therefore, it should be made from good, stout, acid-free board that is as free from metal impurities as technically possible. The components of the mount should be prepared so they fit together exactly. The item should be fastened to the mat with hinges of Japanese paper. The frame should touch the item as little as possible and be thick enough to keep the front protection out of contact with the item.

This presentation is only a rather perfunctory description of some aspects of the multitude of challenging problems that face paper conservators during their daily work. Nevertheless, I hope that I have conveyed at least an outline of the nature of the problems facing us, of the procedures at our disposal, and, above all, of the responsibilities resting on us.

ZUSAMMENFASSUNG – Der Zerfall von Sammlungen kann durch geschickte Anwendung angemessener Konservierungsmethoden zusammen mit der Aufbewahrung in einer angemessenen Umgebung verlangsamt werden. Bei der Konservierungsbehandlung muss immer auf die Unverfälschtheit des Gegenstandes Rücksicht genommen werden; die Verfahren, die angewendet werden, müssen reversibel sein und die Behandlung, die durchgeführt, und das Material, das dabei verwendet wird, müssen in den Aufzeichnungen über die Konservierung gut dokumentiert werden. Die Konservierungsbehandlung von Papier umfasst oft Desinfizierung, mechanische Reinigung, Lösungsmittelreinigung, Waschen, Neutralisierung, Stabilisierung (Leimung), Restaurierung und Verstärkung. Drei Materialarten, die von einem Papierkonservator behandelt werden, sind Manuskripte, Karten und Kunstwerke auf Papier. Die einzelnen Manuskripte sind sehr verschieden und stellen unterschiedliche Behandlungsprobleme dar. Folglich muss jeder Gegenstand individuell betrachtet und individuell behandelt werden. Oft sind die Behandlungsmethoden neuerer Manuskripte komplexer und problematischer als die älterer Manuskripte. Säurezerstörung von Eisengallustinte ist ein besonderes Problem. Landkarten werden in Globen und flache Karten eingeteilt, wobei die erstgenannten eine Anzahl von Sonderproblemen darstellen. Erfahrung hat gezeigt, dass der Papiereinsatz eines Globus am besten *in situ* behandelt wird. Kunstwerke auf Papier stellen die grössten Anforderungen dar, da sie mit einer Vielzahl von Techniken geschaffen werden (manchmal sind alle Verfahren auf einen Gegenstand angewandt), und die Behandlung darf den ästhetischen Eindruck des Gegenstandes und somit den finanziellen Wert nicht beeinflussen. Eisengallustinte und wasserlösliche Farben stellen besondere Herausforderungen dar. Nach

der Behandlung sollten Kunstwerke mit Japanpapier in einen Wechselrahmen, der aus hochwertigem säurefreien Material hergestellt ist, gehängt werden.

RESUME – La détérioration de collections de documents peut être freinée grâce à l'application compétente de traitements pertinents de conservation combinés à un entreposage en milieu approprié. L'intégrité de l'article, lors du traitement de conservation, doit toujours être respectée. Les procédés utilisés ne doivent pas être irréversibles, et leur processus et matériaux enregistrés soigneusement. Les traitements de conservation du papier comprennent souvent une désinfection, un nettoyage mécanique et/ou chimique, un lavage, une neutralisation, une stabilisation (prise), une restauration et un renforcement. Les trois types de documents traités sont les manuscrits, les cartes et les oeuvres d'art sur papier. Les manuscrits sont de types variés et présentent un large éventail de problèmes, donc chaque article doit être pris et traité séparément. Les problèmes de traitement de manuscrits moins anciens sont souvent plus complexes et difficiles que ceux présentés par les manuscrits plus anciens. La détérioration acide d'encre ferreuse est un problème tout particulier. Les cartes se répartissent en catégories de mappemondes, rondes ou plates, ces dernières présentant des problèmes différents. L'on sait d'expérience qu'il vaut mieux traiter les mappemondes *in situ*. Les oeuvres d'art sur papier sont les plus difficiles à traiter car elles ont été exécutées grâce à de nombreuses techniques, quelquefois même combinées, et leur traitement ne doit nuire à la perception esthétique, donc à leur valeur commerciale. Les encres ferreuses et les peintures à l'eau présentent des défis particuliers. Les oeuvres d'art, lors de leur traitement, devraient être imbriquées sur du papier Japon, en nattes passe-partout à partir de matériaux de haute qualité, non acide.

MECHANIZATION OF RESTORATION WORK

Wolfgang Wächter
Deutsche Bücherei
German Democratic Republic

ABSTRACT

A restoration workshop was established at the Deutsche Bücherei in 1964 and has expanded into a 200-m² facility with a staff of eight people. Experience has demonstrated that the only way to improve the cost-benefit ratio of restoration operations is to deal with these activities on a large scale, which inevitably leads to the mechanization of restoration work. Projects underway at the Deutsche Bücherei are oriented toward the stabilization of heavily damaged stocks, and work is in progress on the development of a machine that will supersede manual paper-splitting techniques. The integration of mechanized wet treatment with mechanized stabilization meets all criteria of economy, aesthetics, quality, and quantity. The Deutsche Bücherei is also a regional center in the IFLA Core Programme on Preservation and Conservation, and in this context is offering training opportunities in the form of seminars and internships to students from all over the world.

The first steps were taken to establish a restoration workshop at the Deutsche Bücherei in Leipzig at the end of 1964. From modest beginnings this workshop has grown over the last 20 years into an efficient facility that covers 200 m² of floor space and employs a staff of eight. The policy governing its development has always been to translate research findings into the practice of preservation and restoration and to improve the cost-benefit ratio for these operations. We have found in our own experience that the latter can be done only by dealing with the problem of large-scale restoration, which inevitably involves the mechanization of restoration work.

Our workshop was made a consulting center for training restorers in the German Democratic Republic (GDR) in 1978, and the first mechanized equipment for the wet treatment of material started operating in 1979. The period from 1980 to 1984 saw the development of optimal restoration techniques for wood pulp paper. At the same time, a technical book treating the subject was published and was well received by international experts, as was reflected in the favorable reviews it received. In 1985 the Deutsche Bücherei assumed the function of a regional center for preservation on behalf of the International Federation of Library Associations and Institutions (IFLA), a commitment that is an honor as well as a challenge to become even more efficient in the improvement of preservation and restoration techniques in the future.

In pursuit of our new function, we set about providing the necessary facilities by completing the related planning and building work for a new restoration department in 1985. As a result, we now have excellent areas for individual and group work as well as meeting and common rooms, social facilities, a darkroom and photo laboratory, and a room for wood- and metalworking. In addition, most of the furniture and equipment has been replaced, creating an aesthetic and functional environment and an extremely good atmosphere in which to work.

As well as this capital investment for the safeguarding of library materials, we made organizational changes and created an Office for the Care of Stocks. The office oversees the activities of the restoration workshop, the in-house book bindery and the

bindings department. This new structure will improve the availability of our stocks and help keep them in better condition.

Having described our facilities and organization, let me now say something about the content of our work as a regional center.

In September 1985 two seminars on paper splitting were held in Leipzig under the auspices of the International Working Group of Restorers of Archive and Library Materials and Prints. These two events were indicative of the demand that exists for specialist meetings. In recognition of this widespread interest we plan to hold similar seminars each September, again as part of our work as a regional center of IFLA. We are presently drawing up a list of subjects that might be eligible and would appreciate your contributions in the form of concepts, requests, and expertise.

Outside this framework, there is now ample opportunity for individual projects because we are now in a position to provide, on a permanent basis, 10 work places for students or trainees from any part of the world. As a national advisory and consulting center, we would also be glad to give assistance with specific technical problems.

Another area in which we will continue our efforts is the mechanization of restoration work. Now that we have had first results from the wet treatment technique, which embodies most current research findings, we find ourselves under pressure to search for efficient stabilization procedures. The reason for this pressure is the condition of many of our wood-pulp-containing materials. We are quite impressed with the large-scale nature and technical perfection of the project for deacidification being undertaken by the Library of Congress. Although this project represents a necessary and important step toward solving the problem as a whole, it is at the same time limited to the aspect of preservation.

Our own projects are concerned with rational approaches to stabilizing heavily damaged stocks. All libraries have large quantities of these, and preserving the original is often the most important consideration. For some libraries, microfilm or microfiche may be a feasible solution, but this approach will not resolve all aspects of the problem.

We have tried to supersede manual paper splitting with a mechanized technique for some time now and are at present finalizing the design work for a machine. The documentation will be available in July 1986. We have also successfully completed the model experiments for all the functions of the unit and have tested the auxiliary materials involved. Construction of the unit is expected to start in the second half of 1986, so practical testing can begin in 1987.

The benefits we foresee from mechanized paper splitting include a tenfold increase over the manual method in the quantity handled; better quality through the elimination of subjective errors; and a major cost saving through matching the capacity of wet treatment with that of mechanized stabilization. To generalize, one could say that, if we are now handling hundreds of sheets per day, the number will rise to thousands per day in the future, with better quality and lower costs.

Although we are still working to complete the second major mechanization project at the Deutsche Bücherei, we already have plans for more ambitious undertakings. In pursuing these, however, we are fast approaching the confines imposed on us by the limited capacity of an individual establishment or country. A realistic concept of current possibilities in the large-scale restoration and preservation of paper in terms of economy, aesthetics, quality, and quantity might take the following form: All requirements can be met by integrating mechanized wet treatment with the mechanized reconstruction of lost substance and the mechanized stabilization of whole pages. The wet treatment plant in Leipzig, the casting machine from Copenhagen, and

the splitting machine now being made (also in Leipzig) form the beginnings of a system for the industrialized restoration of paper. For users such as libraries and archives this combination has the advantage of being extremely flexible. The complete arrangement could deal with the most serious cases of paper damage; the individual units would take care of less damaged materials. Within the limitations of what we know today, this system is the best available to fulfill the chemical, physical, and aesthetic demands that can be made on efficient paper restoration.

We have concrete evidence to support this statement, which may appear a little absolute to some. In the last few months, the restoration workshop of the Deutsche Bücherei has treated manuscripts showing extreme damage. In the case of these documents, international cooperation was embodied in that the sheets went through mechanized wet treatment in the Federal Republic of Germany, lost substance was reconstructed using Per Lauersen's casting machine in Copenhagen, and the whole sheet was then stabilized by splitting in Leipzig. The results speak for themselves and indicate that this is a realistic approach to the preservation of library stocks and is desirable for all users. Considerable effort is needed, however, to turn these first beginnings into an accepted standard.

Under an active and vigorous policy of preservation, which should also make good use of the related effects, we have a real chance of drastically improving the condition of the stocks that are now in our libraries and archives.

ZUSAMMENFASSUNG – 1964 wurde ein Restaurierungsworkshop an der Deutschen Bücherei eingerichtet, der sich mittlerweile auf eine Einrichtung mit 200 m² Fläche und einen Mitarbeiterstab von acht Personen ausgeweitet hat. Erfahrung hat gezeigt, dass der einzige Weg, das Kosten-Nutzen-Verhältnis zu verbessern, der ist, diese Tätigkeiten in grossem Umfang anzugehen, was unweigerlich zur Mechanisierung der Restaurierungsarbeit führt. Projekte, die momentan an der Deutschen Bücherei durchgeführt werden, sind auf die Stabilisierung von stark beschädigtem Bestand ausgerichtet, und es wird an der Entwicklung einer Maschine gearbeitet, die die manuellen Papierspaltverfahren ersetzen soll. Die Einbeziehung einer mechanisierten Nassbehandlung mit mechanisierter Stabilisierung erfüllt alle Kriterien der Wirtschaftlichkeit, Aesthetik, Qualität und Quantität. Ausserdem ist die Deutsche Bücherei ein Regionalzentrum des IFLA-Schwerpunkteprogramms zur Erhaltung und Konservierung und bietet in diesem Zusammenhang Ausbildungsmöglichkeiten in der Form von Seminaren und Praktika für Studenten aus allen Teilen der Welt an.

RESUME – Un atelier de restauration a été créé à la Deutsche Bücherei en 1964 devenu aujourd'hui un établissement de 200m² qui emploie huit personnes. L'expérience démontre que la seule manière d'améliorer le ratio coûts-avantages des opérations de restauration est d'exécuter ces tâches sur une grande échelle, ce qui, invévitablement, conduit à la mécanisation des travaux de restauration. Les projets en cours à la Deutsche Bücherei portent sur la stabilisation de documents fortement endommagés et des travaux sont engagés pour la mise en place d'une machine qui remplacerait les opérations manuelles de division du papier. L'intégration d'un traitement d'humidification mécanisé avec stabilisation mécanisée satisfait à tous les critères d'économie, d'esthétique, de qualité et de quantité. La Deutsche Bücherei est programme fondamental de l'IFLA pour la Protection et la Conservation. C'est dans ce contexte qu'elle offre des possibilités de formation sous forme de séminaires et de bourses pour des étudiants du monde entier.

TOUR OF THE CONSERVATION LABORATORY, NATIONAL LIBRARY OF AUSTRIA

Otto Wächter
Head, Institute for Conservation
National Library of Austria
Austria

ABSTRACT

The Conservation Department of the National Library of Austria, founded after World War II, was the first to use the now generally common celluloses for strengthening old brittle paper and parchment size for strengthening age-weakened parchment. In the 1950's processes were devised for strengthening flaking illuminated manuscripts; leaf-casting machines were used for applying fibers; and various gelatins were used to buffer acids in paper and ink. More recently, technological advances have been made in the reduction of lignin in wood pulp papers; the diagnosis of the disintegrating effects of verdigris; and the inhibition of the destructive effects of copper acetates. Presently the large-scale restoration of newspapers is the most pressing problem. Various conservation activities in the laboratory include the treatment of rare books, such as the *Dioskurides*, the *Tabula Peutingeriana*, the *Imperii ac Sacerdoti Ornatus*, and the Flemish Prayer Book of 1470, threatened by blackened parchment; the use of the leaf-casting machine to close up tears and fill missing places in paper; the quality improvement of wood pulp paper by delignification; and mass newspaper preservation by deacidification and increasing the endurance of the newsprint through vacuum impregnation, rapid freezing, and freeze-drying. Large-scale fumigation is carried out by ethylene oxide treatment. Conservators are trained at the Vienna art schools or in secondary schools with required technical training programs. Practical training of Austrian library and archives conservators is obtained in-house in the Conservation Laboratory, where large numbers of foreign conservators, principally from the Federal Republic of Germany and Switzerland, have also received their training.

The Conservation Laboratory in the National Library of Austria, like many restoration institutions in European libraries, came into being after World War II. Its founding did not result from damage done directly by the war which, for German libraries, was usually the decisive impetus, or even from indirect war damage, which was minimal and manifested itself most frequently in mildew that developed through storage in inadequate locations. Instead, its founding arose from the growing recognition that book repair as it had been practiced by bookbinders was no longer adequate. Increasing damage, not only to the materials within books (paper, parchment, inks, printing dyes, book art, and book illustrations) but also to maps, art on paper, old globes, and the overall library holdings, required the conservator's touch. But we didn't yet have conservators who could perform such work.

At this time there were some efforts at library conservation in Rome, Paris, and London, but these, too, were oriented predominantly toward bookbinding. We studied with interest the techniques of these three conservation institutions, but then followed our own course. We were the first to use the now generally common celluloses for strengthening old brittle paper, and parchment size for strengthening parchment weakened with age. As early as the 1950's we were involved with the strengthening of flaking illuminated manuscripts; we were the first to convert a leaf-casting machine into a machine for applying fibers; and we discovered that different sorts of gelatin can buffer the acids in paper and ink. At first we took the homeopathic route. But we don't want to lose ourselves in the history of library restoration, so will confine our remarks to present technologies.

In the area of technology, our biggest successes were achieved in cooperation with chemists in the treatment of wood pulp papers through the reduction of lignin (in the case of graphic materials); the diagnosis of the disintegrating effects of verdigris in the coloring of manuscripts, books, and maps; and the inhibition of the destructive effects of copper acetates. A research project to clarify the problem of corrosion and to develop possible methods of treatment is presently being conducted on a cooperative basis by several institutions in Vienna with funding from the German Volkswagenwerk Foundation.

Perhaps the question arises regarding how so many different projects and operations can be performed in such a small laboratory with such limited manpower. Naturally, with a team of a dozen conservators we are very small by comparison with the conservation laboratories of other national libraries, which can often employ a hundred or more conservators. But we are a small nation, our cultural budget is limited, and we must always manage economically. This is one side of the picture. On the other side, a laboratory or an institute must be planned and equipped in accordance with the demands of the work to be done. In the period following World War II we conservators were chiefly called upon to restore old and rare books – therefore we required qualified personnel. Large-scale restoration was not yet of immediate interest. Damaged 19th and 20th century books were usually sent to bookbinders, both within and outside of the institution, who performed the customary "repairs." We were not and still are not as alarmed by the damage to our book holdings from the last two centuries as other libraries are. Although the interim report of the Committee on Preservation and Access stated in July 1985 in Washington that in various United States libraries every fourth book was already at risk, that is, so brittle that it would soon be useless, we were able to ascertain that the degradation in our libraries was not so advanced; perhaps every twentieth or fiftieth book is in danger. In any case, our problems with large-scale restoration are pressing chiefly with regard to our newspaper holdings.

Of the various conservation activities of the laboratory, I should like to select and illustrate a few that may be of interest and also offer something novel.

Rare Book Conservation

The *Dioskurides*

This book, completed in 512 A.D., is an herbal that was written and illuminated on behalf of the Byzantine princess Anicia Juliana. Among completely intact scientific works, it is probably the most valuable in the world, and because of its elaborate illustrations it is held to be the chief work among late-ancient illuminated manuscripts. Its condition was bad, not only because of its great age, but also because this codex was for many centuries in constant use as a health and herb manual by Greek, Arab, and Jewish doctors. Twenty-five years ago, when we began the restoration of this manuscript, the chief problems were the brittleness of the nearly 1,500-year-old parchment and the flaking illuminations. In both cases we were helped by parchment size, an extract of new parchment, in one case with, in the other without, the addition of vinegar. Vinegar is capable of softening even ancient, horny parchment and of activating it in such a way as to lend even brittle parchment an elastic consistency and strength. One's first reaction might be shock at the thought of using vinegar and acid. The latter mentioned in the context of library holdings now evokes visions of horror. In the case of parchment and parchment size, however, this is in no way the case; alkaline animal-derived sizes and gelatins are able to absorb a certain amount of acid

and thus serve as a natural buffer. After only a few weeks the introduced vinegar acid cannot be traced. We have made use of this finding in order to apply a gentle therapy even to acid-damaged and ink-corroded paper, particularly where the damage is less severe. For the same reason, in the Vatican nylon japan that is affected by ink corrosion is treated by applying gelatin to the damaged leaves. In the case of more virulent acid damage, a chemical buffer must be applied. For the strengthening of illuminations, parchment size without vinegar was used because of the possibility of reactions among different pigments, and we don't yet have sufficient knowledge about the pigments used in the oldest paintings.

Tabula Peutingeriana

With the 11 parts of the *Tabula Peutingeriana*, the copy of a Roman street map from the 12th century (the original, no longer extant, has been dated to the 4th century B.C.), the problem was strong deterioration from verdigris. The colorist had used verdigris freely in marking rivers, lakes, and oceans. During research into the causes of the deterioration, it was ascertained that various copper compounds become unstable as a result of atmospheric factors and in the course of centuries could destroy both themselves and their surroundings. The progression of this destruction can be clearly seen on the left and right edges of the sheets, where the pieces of parchment were glued on top of one another. These original glued areas were not detached until 1863. Whereas the greens that had undergone 800 years of exposure to oxygen and humidity in the atmosphere were largely destroyed and browned, the verdigris that was exposed 120 years ago is still the original blue-green and exhibits no traces of deterioration. According to the latest finding, the progress of deterioration can be brought to a standstill through the use of magnesium salts. Missing places were filled in with parchment. They were also recolored to make the connection clear to the eye. The color, however, is intentionally applied in such a manner that the old color can be clearly differentiated from the new.

Imperii ac Sacerdoti Ornatus

This clothing manual, dating from 1578, richly illustrated and colored with different destructive and nondestructive green copper colors, was the key to our research into verdigris green. The green background on which the figures are placed was uniformly broken up and had to be totally replaced.

The Black Prayer Book

The pinnacle of Flemish book art, created in Bruges in 1470, this richly illuminated codex is one of the few holdings of our library that is in a "lethal" stage. Before being written and drawn on, the parchment pages had been blackened with an ink-like dye. The pages are between panes of glass and seemingly still in good condition. When the glass plates are opened, however, and the parchment is touched, it can completely disintegrate. Moist neutralization can no longer be employed because, upon moistening, a mass that is similar to black chewing gum and that will not dry out and sticks to everything is formed from the black parchment. The approach to this problem will have to be gaseous neutralization followed by the embedding of each individual leaf in glass containers filled with nitrogen or helium, in the manner of the mounting of the Declaration of Independence in Washington. At this point we have postponed the decision until we have made more progress with our ink-corrosion research project, and more exact results are available.

Fiber-Applying Machine

We were the first to convert a leaf-casting machine used by the paper industry into a fiber-applying machine for use in conservation work. Our first efforts began 20 years ago. To date, a total of five apparatuses have been built. The most recent is rectangular, whereas the previous ones were made in the less economical cylindrical form. Using this device, one can precisely close up tears and missing places in paper. We can handle leaves of every kind of paper. When a leaf-casting machine with draining frames (hydrostatic principle) is used, only leaves with limited formats can be handled.

Delignification

During the recent visit of an American conservator in Vienna we heard the astonished question: "You can extract wood pulp from wood pulp paper?" We have been doing this with individual leaves of particular value for quite some time. In 1952, the American John Gettens announced his process for bleaching graphic materials with chlorine dioxide. It was evident from this work that the cellulose portion of the paper was being bleached, but that this process could very well be further developed to extract the wood content. Above all, if the chlorine dioxide is applied in a gaseous form it reacts with the lignin, that is, with its chromophoric groups. Subsequent to alkaline rinsing and additional bleaching with hydrogen peroxide, the paper appears clarified and free of lignin, i.e., no traces of lignin remain in the paper. The paper no longer yellows or browns, and its pH no longer drops. This "quality improvement" to the paper has remained stable for 20 years. It is not yet clear, however, what kind of transformation processes may have taken place in the paper. It is still the job of the chemist to determine this.

Mass Newspaper Preservation

We have seen that it is possible to reduce the harmful wood pulp content of valuable items of art on paper. With a large-scale process or with the treatment of newsprint, which consists of a large percentage of wood pulp, delignification is not possible. It would be too expensive, and extraction of 80 percent of the wood pulp would lead to the collapse of the structure. Now we are attempting to neutralize the numerous acids that come from the lignin and to make the paper water repellent through additional sizing. This treatment decisively raises the endurance of newsprint. In addition, newspapers in bound volumes are, of course, protected from daylight. Photochemical browning, acid formation, and embrittlement (depolymerization of the fiber molecules), all of which are triggered by daylight, can take place only in a limited way in a bound volume. A work of art on wood pulp paper hanging on the wall is in much greater danger, and here delignification is more urgent – and also possible.

In newspaper conservation in Vienna we attempted for the first time to employ a large-scale process, since the traditional paper conservation processes would, in this case, constitute a pronounced Sisyphean labor and require large numbers of personnel. In this procedure entire blocks of newspapers are impregnated in a vacuum with strengthening and buffering solutions followed by freeze-drying of the wet blocks to prevent the sheets from sticking together.

The three chief stages of this technology – vacuum impregnation, rapid freezing, and freeze-drying – are done by machine. The intermediary stages, particularly cleaning with a vacuum cleaner, the removal of the old boards from the bound

volumes, the repairing of tears and holes in the newspaper leaves, and the rehanging in the old boards, are carried out manually. The manpower needs are small.

Fumigation

Our ethylene oxide plant is located in the Museum of Anthropology, directly next to the National Library. In Vienna expensive conservation equipment is frequently acquired on a pool basis and then made available to several institutions. This equipment is, among other things, intended for large-scale treatment of books that are suspected of having suffered mildew or insect damage, and, of course, of books in which damage has actually occurred. Depending on their format, several thousand volumes can be put into the apparatus for gas treatment. At first we were not certain if the gas would be able to penetrate a closed large-format book. We therefore placed open volumes into the gas chamber. In the meantime we have ascertained that the gas penetrated completely, although twice the amount of gas must be used. Library items and museum items therefore must be treated separately. Originally we had thought that, depending on the demand and the available space, both types of objects could be treated at the same time.

The installation of such equipment is sensitively expensive nowadays, primarily because the environmental requirements are so great. In the new central workshop of the Vienna Archive, presently under construction, an ethylene oxide chamber of the same size is being built. In this chamber provision is made for burning off the already detoxified ethylene oxide that is removed through a suction chamber. This additional incinerator alone costs over a million schillings. The technical details can be explained by the chief chemist of the Conservation Laboratory of the Museum of Anthropology, Dr. Baumär.

When mildew or insect damage is suspected on individual books, manuscripts, globes, and so forth, the objects are treated with hexachlorcyclohexane (HCCH). This compound has proved itself as a successor to DDT; insects have not yet demonstrated an immunity to this preparation. To ensure penetration of the gas into the text block, we carry out this extermination work in the vacuum chamber of our newspaper conservation equipment.

Training of Conservators in the Conservation Laboratory

The Conservation Laboratory personnel is made up of conservators in different fields. We have academic conservators (conservators who have completed the conservation courses of both the Vienna art schools); a large number of mid-level conservators (those who have completed an academic secondary school and have the required technical training); and, as a third group, bookbinders with additional training as conservators. Personnel at all three levels can pass a technical examination that permits them to attain a higher job classification and increased pay. The theoretical subjects – historical development of book binding, history of early printing, library history, and the study of book plates – are studied together with librarians. Paper and art conservation, printing technology, and chemistry for conservators are provided by lectures at the Master School for Conservation and Technology of the Academy of Fine Arts.

Austrian library and archives conservators receive their practical training in the Conservation Laboratory of the Austrian National Library. A large number of foreign conservators, primarily from the Federal Republic of Germany and from Switzerland,

have also received their training at the Conservation Laboratory. Neither of these countries has yet set up similar conservation training programs.

ZUSAMMENFASSUNG – Die Konservierungsabteilung der österreichischen Nationalbibliothek, die nach dem Zweiten Weltkrieg gegründet wurde, war die erste, die die jetzt allgemein verbreitete Zellulose zur Stärkung von altem, brüchigem Papier und Pergamentleim zur Stärkung von durch Alter geschwächtem Pergament benutzte. In den 50er Jahren wurden Verfahren entwickelt, abblätternde kolorierte Manuskripte zu stärken; Anfasergeräte wurden benutzt, um Fasern aufzutragen und verschiedene Gele wurden verwendet, um Säuren in Papier und Tinte abzupuffern. Vor nicht allzu langer Zeit wurden Fortschritte bei der Reduzierung von Lignin in Zellstoffpapier erzielt, die auflösenden Effekte von Grünspan diagnostiziert und technische Fortschritte bei der Hemmung der zerstörenden Effekte von Kupferazetat erzielt. Momentan ist das dringlichste Problem die umfangreiche Restaurierung von Zeitungen. Verschiedene Konservierungstätigkeiten im Labor sind u.a.: die Behandlung seltener Bücher, wie z.B. des *Dioskurides*, der *Tabula Peutingeriana*, des *Imperii ac Sacerdoti Ornatus* und des Flämischen Gebetbuches aus dem Jahre 1470, die durch geschwärztes Pergament bedroht sind; der Gebrauch der Anfasermaschine, um Risse und fehlende Teile im Papier zu schliessen; Qualitätsverbesserung von Zellstoffpapier durch Ligninzerstörung; Zeitungskonservierung in grossem Umfang durch Entsäuerung und Verlängerung der Haltbarkeitsdauer von Zeitungspapier durch Vakuumtränkung, schnelles Gefrieren und Gefriertrocknen. Die Begasung in grossem Umfang wird mit einer Aethylenbehandlung durchgeführt. Konservatoren werden an Wiener Kunstschulen oder in weiterführenden Schulen mit obligatorischem technischen Ausbildungsprogramm ausgebildet. Praktisches Training für Konservatoren österreichischer Bibliotheken und Archive wird im Konservierungslabor selbst durchgeführt, wo auch eine grosse Anzahl ausländischer Konservatoren, vor allem aus der Bundesrepublik Deutschland und der Schweiz, ihre Ausbildung erhalten haben.

RESUME – Le Service de Conservation de la Bibliothèque Nationale d'Autriche, créé après la Seconde Guerre mondiale, a été le premier à utiliser la cellulose, d'utilisation commune aujourd'hui, pour renforcer le papier friable et le parchemin cassant du fait de l'âge. Dans les années 50, de nouveaux procédés ont été appliqués pour renforcer les manuscrits enluminés écaillés: des machines pose-feuilles ont été appliquées comme buvards d'acides du papier et de l'encre. Plus récemment, l'on a effectué des percées technologiques pour réduire la lignine des pâtes de bois, le diagnostic des effets de désintégration du vert-de-gris et l'inhibition des effets destructeurs de l'acétate de cuivre. Le problème le plus pressant de l'heure actuelle est la restauration, à grande échelle, des journaux. Diverses actions ont été entreprises par notre laboratoire pour le traitement de livres rares tels que le *Dioskurides*, la *Tabula Peutingeriana*, l'*Imperii ac Sacerdoti Ornatus* et le Livre de Prières flamand de 1470 menacé par le noircissement du parchemin; l'utilisation de machines de pose de feuilles pour couvrir les déchirures et les fragments manquants; amélioration de la pâte de bois grâce à la délignification et conservation de masse de journaux par désacidification, amélioration de résistance des caractères imprimés par imprégnation sous vide, congélation instantanée et lyophilisation. La fumigation sur grande échelle est exécutée par traitement à l'oxyde d'éthylène. Les techniciens da la conservation sont formés dans les écoles des Arts de Vienne ou dans les écoles secondaires proposant des programmes de formation spécifiques. Leur formation pratique, pour la conservation de documents de bibliothèque et d'archives, se fait au Laboratoire de Conservation même, formation à laquelle ont également participé de nombreux techniciens étrangers, de Suisse et d'Allemange Fédérale principalement.

COPING WITH DISASTER

Anna Lenzuni
Director
Biblioteca Nazionale Centrale
Italy

ABSTRACT

The flooding of the Arno River in Florence, Italy, damaged the precious and specialized collections in many public and private libraries. Thousands of bibliographical materials, periodicals, newspapers, prints, and maps in the National Library were affected, as was the building and its contents. Volunteers selflessly offered their services to retrieve materials from flooded areas. A number of library technicians came from all corners of Europe and America to assist with the salvage. The materials were dried as fast as possible. They were muddy, stained with oil, and brittle from glue that had dissolved and rehardened in the paper. Colors in leather and dyes had bled into the paper. A restoration workshop was set up for treating the dried books and was organized into three sections: modern books, old books, and prints. Special washing sinks were constructed and used to clean the paper. New binding techniques were developed. The work continues, and current problems include how and where to store the restored newspapers and books. The next major task is to evaluate the treatment records so statistics can be compiled and conclusions drawn from the experience.

In November 1986 it will be 20 years since disaster fell on Florence, Italy, with the flooding of the Arno River. This flood destroyed many public and private libraries with very specialized and very precious collections. Never has Italy or any other country known such a calamity. For this reason, no one was prepared or had any miraculous solutions for the salvage of thousands of books and documents, not only in the National Library, but also in the Archives, the University Library, and other libraries. We realized from the beginning that the engineering of salvage must be set up before calamity strikes, not afterward when everyone involved is under great pressure. Financial appropriations must be made, and specialized crews must be trained in advance. Most important, disaster plans must be tested to ensure their transition from theory to reality. Our institution has been a pioneer in the field of disaster recovery.

The National Library materials damaged by the flood included about 1,200,000 bibliographical items; about 300 oversized rare books; 20,000 newspapers; 10,000 periodicals, representing 60,000 volumes; 4,000-5,000 fascicles from the Michelin collection, which were lost; a collection of French and German texts; a collection of "Manifestoes," which were very precious; and maps and prints from the cartography collection. No manuscripts were damaged, as they were stored on the upper levels of the building. In addition to damaged books, there were damaged catalogs – a serious problem; damaged furniture, bookcases, tables, chairs, desks for the employees and the public, typewriters, the heating apparatus, and the electric network. The sub-basement, the basement, and the ground floor (up to a certain level) were full of water, mud, and oil.

After the first shock we tried to think of what could be done. In those hours of anguish and uncertainty no one had a plan. But, to save the books and documents belonging to the library and the institutes, thousands of young people, students and nonstudents, Italian and foreigners, came to our rescue by offering their services to all of our cultural institutions, which showed extraordinary civic conscience. Without their help we could never have pulled books and documents from the mud fast enough. Boys and girls created human chains to retrieve from flooded areas books and bundles of

documents that looked like solid blocks of mud. These were immediately loaded onto trucks and sent to storage places all over Tuscany and even as far away as Rome.

In addition to the young people, who unfortunately had no special training and no knowledge of books or libraries, a number of library technicians soon arrived in Florence from all corners of Europe and America. The cooperation we received, both inside and outside the country, was incredible. First came the Central Institute of Rome, which specialized in book pathology; then came a committee that provided the necessary material to disinfect books; and then an American committee that sent us funds. Vienna requested 1,000 books for restoration, and the British Museum also did some restoration. English technicians sent by the committees decided to extend their stay and to pursue the relief operations beyond the initial stage.

At the central railway station, the only site in Florence where hot and cold water were abundant, books were washed and dried. We were fighting time, as the mud, the naphtha, and the oil were doing their job much too well. Decisions had to be taken rapidly. Finally, all the books were sent for drying and then returned to the library. Drying was chosen instead of refrigeration (freezing) because the technicians could not comment on the refrigeration process. Also, it was impossible to find immediately refrigeration facilities for thousands of volumes. No one knew whether immediate drying was the right step, but without it our books would not look as they do today; instead, they would be a culture of fungus and mildew.

The young people eventually returned to their homes, and we were left facing mountains of books, disinfected and dry, but still full of mud – awaiting a miracle! The time had come for the librarians to go to work. With the help of a cooperative, the government contracted 110 persons as library workers. You can easily imagine the management problems involved in dealing with workers who had never handled books, at least not books in such poor condition. Thanks to the foreign technicians, though, we were finally ready to set up a plan and to organize our work.

Before describing the restoration of the books I will describe the state they were in after the damage from the flood and after the inexperienced handling they received. The flood had left the books moldy. The mud had transformed them into dry mud bricks in which the leaves were stuck together in a homogeneous mass that was almost impossible to separate without causing further damage. Black stains from the heating-system oil masked the text and illustrations. Fortunately, very few books were damaged by naphtha, since traces of this chemical are practically impossible to remove, and the long and difficult treatment operations are not to be recommended. The glue had dissolved and rehardened in the leaves of books, making them brittle. The tannin from the leather bindings left very dark stains on pages of text and on adjacent books.

Modern books, particularly those from the second half of the 19th century, with color plates containing aniline dyes, presented another problem because the colors stained the water with the result that more pages were damaged; some books were completely dyed. We decided not to touch those books, but to wait for other copies. Limp vellum and paper bindings resisted damage to a greater extent than leather bindings. Of course, some damage existed prior to the disaster as the result of poor-quality bindings, bad materials, time (age stains), and so forth.

One great mistake was made, to which I would like to draw your attention. We received many books that were still damp, and we started interleaving the pages using blotting paper, which is very useful and presents no dangerous effect. However, the volunteers were very inexperienced, were not aware of the problems involved, and

were full of enthusiasm. The result was that many books were damaged, and the whole operation had to be stopped abruptly.

Following the advice of an English technician, we set up a restoration workshop, the first in Italian library history. Today we have six workshops specializing in restoration. We began treating the books, first by opening the volume, then separating the leaves, and washing the pages. A restored book has obviously lost its "original" character, but we had to do what had to be done. As we went along we studied the old sewing methods, noted the materials used, and identified techniques that were subsequently used on the restored books.

Special sinks were designed for the washing operations, and drying methods were also studied. At the central railway terminal wet book leaves were hung on lines in such a manner that it would be easy to reassemble them quickly in their original order. Priorities had to be set because the public was requesting books, and we had to decide without regard to value which was more important: speed or need. We concluded that since we are the depository library for the nation, our books not only have intrinsic value, but also have value because they belong to a certain collection and a certain library. Therefore, regardless of age, each book would have to receive the same treatment, and the time element would have to be disregarded.

This approach was criticized by some who thought certain books should be discarded and simply replaced with new copies, which would have been possible since book shops were ready to donate books. We firmly believed, however, that the copy given to the library was a *part* of the library and could not be disregarded. Perhaps, inside the book, there were marginal notations, perhaps the book belonged to a special collection. We came to the conclusion that all the books must be kept.

Three treatment sections were created in the workshop: one for prints, one for ancient books, and one for modern books. I insisted that modern books receive as much attention as old books and that each book must be treated as the sole copy. The books were sometimes difficult to identify since, too often, no trace of the call number had survived, and a book without its call number is useless in a library. One had to look inside the book or go through catalogues. A special bureau was put in charge of this research, and a card was designed for each book following the recommendations of the workshop.

We thought that everybody should work together, that the people working in the workshop should remain in constant contact with the librarians and the curators, and that all should feel free to express their opinions. May I remind you that I am not talking of today, but of 20 years ago. I apologize for underlining this concept, but my colleagues have reminded me of it, because it is only in 1970 that IFLA published its "Recommendations for Preservation." I must add that we found in this report many of the principles that our National Library had initiated and adopted.

Well-trained personnel are needed who will rely on specialized technicians and keep in touch with people working directly on books. These personnel must have knowledge of book structure and must believe that it is important to restore books, not only for the sake of the book itself, but also because the binding is often contemporaneous with the book and one must have great respect for it. You will find that the same statements were made by Mr. Crochetti at the International Conference on Cooperation. Our workshop is still following those principles.

Other problems had to be solved, *e.g.*, the need for material. Because of the enormous quantity of damaged books, the need for materials and the corresponding cost was great. The Pesche Company gave us paper made exclusively for us. It is acid-free and bears a watermark that identifies the library, includes four undulating lines

that represent the mud, and also has the astrological sign of Sagittarius, which represents the month of November. Another problem was how to fix the colors on the paper, as they do not withstand the products recommended by the Institute of Pathology of the Book, so other methods had to be considered. We are currently using drops of formalin (formaldehyde) to make a jelly, but formalin is dangerous. The staff of the workshop have also developed two or three new binding methods.

Another hurdle was how to store newspapers. All the newspapers have now been cleaned and sorted out, and I believe that within a year our collections will be in order. But what should be done with them? The workshop is microfilming the latest newspapers, and we now give only microfilms to our readers. We cannot destroy these newspapers, however, so for the time being we leave them as they are and do not bind them. We are studying the design of special storage boxes, but because of the size of the newspapers much space would be required, and space is our daily fight! Newspapers that have been sorted out are stored in the old Reading Room. We have not yet decided what to do with these original copies. After the flood we were not allowed to put books back on the lower levels. After restoration, therefore, books are sent to a storage room that was built recently for the Reading Room. However, so much work has been done to dam up the Arno River that I cannot believe that another flood will threaten us today or tomorrow.

Another aspect of the restoration operation that is very important and very interesting is the card file containing information about the restored books. These cards must be examined and compared so statistics can be established and conclusions drawn. This is a project I am planning to start this year. We must not focus our minds simply on the effects of the disastrous flooding of the Arno River, but must turn the event into a positive experience, a vow for the future.

ZUSAMMENFASSUNG – Das Hochwasser des Arno in Florenz, Italien, beschädigte kostbare Sammlungen in vielen öffentlichen und privaten Bibliotheken. Eine grosse Anzahl von bibliographischem Material, Zeitschriften, Zeitungen, Drucken und Karten in der Nationalbibliothek waren betroffen, ebenso wie das Gebäude und dessen Inhalt. Freiwillige boten selbstlos ihre Dienste an, um Material aus den überschwemmten Gebieten zu bergen. Eine Reihe von Bibliothekstechnikern kamen aus allen Teilen Europas und Amerikas, um bei der Bergung behilflich zu sein. Das Material wurde so schnell wie möglich getrocknet. Es war mit Schlamm bedeckt, hatte Oelflecke und war brüchig vom Leim, der sich gelöst und im Papier wieder verhärtet hatte. Die Farben in Leder und Färbstoffe liefen in das Papier aus. Ein Restaurierungsworkshop wurde für die Behandlung der getrockneten Bücher eingerichtet und in drei Abteilungen geteilt: zeitgenössische Bücher, alte Bücher und Drucke. Spezialwaschbecken wurden konstruiert und dazu benutzt, das Papier zu säubern. Neue Einbindungstechniken wurden entwickelt. Die Arbeit wird fortgesetzt, und momentane Probleme sind unter anderem, wie und wo die restaurierten Zeitschriften und Bücher gelagert werden sollen. Die nächste Hauptaufgabe ist, die Aufzeichnungen der Behandlung auszuwerten, so dass Statistiken erstellt und Schlüsse aus der Erfahrung gezogen werden können.

RESUME – Le débordement de l'Arno à Florence en Italie a endommagé de nombreuses collections précieuses et spécialisées dans des bibliothèques publiques, des périodiques, des journaux, des imprimés et des cartes de la Bibliothèque nationale ont été touchés, tout comme le bâtiment en lui-même et son contenu. Des bénévoles, sans relâche, se sont mis à disposition pour évacuer les documents des zones inondées.

Un certain nombre de techniciens de bibliothèque sont venus de partout, Europe, Etats-Unis, pour nous aider dans cette mission de sauvetage. Les documents ont été séchés aussi rapidement que possible. Ils étaient boueux, tâchés d'huile et friables à cause de la colle dissoute qui s'était répandue sur le papier, avant de s'y infiltrer en séchant. La teinture du cuir et les couleurs sur papier avaient bavé sur le papier. Un atelier a été mis en place pour le traitement des livres déssechés et ce, en trois sections: livres modernes, livres anciens et imprimés. Des éviers de lavage spéciaux ont été construits pour le nettoyage du papier. De nouvelles techniques de reliure ont été inventées. Les travaux continuent et le dernier problème apparu est celui de l'entreposage (où et comment) des livres et journaux restaurés. Viendra ensuite l'évaluation des résultats de ces procédés de restauration afin de pouvoir en tirer des conclusions et de compiler des statistiques.

INTEGRATED PEST MANAGEMENT FOR LIBRARIES

Thomas A. Parker (1)
President
Pest Control Services, Inc.
U.S.A.

ABSTRACT

A library is, in effect, a concentration of foodstuffs for the common pests – insects, rodents, and mold – that attack the collections. The best control of pests is furnished by an integrated pest management program, *i.e.*, the use of a combination of control techniques. Insect damage to library materials is caused primarily by cockroaches (mainly the American, Oriental, and Australian cockroaches); silverfish (13 species are known in the United States); carpet beetles (the larvae of several species are damaging); cigarette beetles (the most common pest of herbarium collections); the drugstore beetle (sometimes called a "bookworm"); and psocids, or book lice. The common rodent found in libraries is the house mouse. Mold and mildew are large problems in libraries, particularly in subtropical and tropical climates. All of these infestations can be dealt with by the concerted use of various techniques, including external precautions to buildings, insect traps, the use of insecticides and other chemicals, control of moisture, cleanliness measures, limited heat treatment of infested materials, and continual inspection for evidence of infestations. Fumigation of library materials may be warranted in some instances, but is rarely necessary. A continual awareness of potential problems and immediate treatment are essential.

Man has come to realize that no one approach to pest prevention and control will suffice. Instead a combination of techniques is usually required to maximize the effectiveness of any pest control program. The term "integrated pest management" (IPM) has been coined to embody this concept: That all pest control programs must rely on several approaches working in concert to effect the desired result. An IPM approach must be considered when addressing the problems of pests in libraries.

A library, where books, printed materials, manuscripts, maps, prints, photographs, and archival materials are stored, perused, and exhibited is not unlike the setting in agriculture where huge quantities of foodstuffs are stored for long periods of time. The library is a concentration of foodstuffs, including starches, cellulose, and proteins, which forms a banquet for insects, rodents, and mold. In addition, the environment in which these foodstuffs are stored is indoors, protected from extremes of harsh climates. Populations of insects specific to this micro-environment can easily explode and cause serious damage if IPM approaches are not utilized fully to prevent such an occurrence.

In the course of 15 years of working with museums, libraries, collections, and historic properties in setting up IPM programs and addressing pest problems found in these situations, I have found damage to collections and structures inflicted by pests ranging from wood-destroying insects to woodpeckers. In such a short presentation, it is impossible to cover such a wide range of actual and potential pest problems. Even though it is not uncommon to find ethnographic and cultural material, decorative arts, religious material, artifacts, historical pieces, and works of art stored and exhibited in libraries, in this discussion of IPM approaches for libraries, the topics covered will be confined to the more traditional materials found in the libraries of the world.

The most common pests encountered in libraries are insects, rodents, and mold. Each of these pest problems will be reviewed, and the IPM approaches necessary for their control and prevention will be outlined.

Insects

Damage to library materials from insects is primarily caused by cockroaches, silverfish, various beetles, and book lice. Damage to these materials results when insects use them as a food source. Both immature and adult stages of cockroaches, silverfish, and book lice cause feeding damage on library materials. In the case of beetles, it is primarily the larval stage that is responsible for the feeding damage. The larvae chew their way through a book, ingest the material, and leave a tunnel filled with powdered excrement. Once the larvae have completed their development, they pupate, and the adult beetles emerge by chewing their way out. Small round exit holes are left in the book.

Cockroaches

Substantial damage to library materials can be attributed to various large species of cockroaches. These problems are more prevalent in the subtropical and tropical areas of the world, but damage can also be found in temperate climates.

Three cockroaches in particular are notable for the damage they do to library materials. They are the American cockroach, *Periplaneta americana* (Linn.); the Oriental cockroach, *Blatta orientalis* (Linn.); and the Australian cockroach, *Periplaneta australasiae* (Fabr.). These cockroaches have large, strong, chewing mouth parts, prefer starchy materials, and can easily destroy paper, paper products, bindings, and other coverings on books and pamphlets. Chewing damage is generally recognized by smears of fecal material in association with the damage and a ragged appearance to the areas that have been fed upon. These areas generally appear around the edges of the piece where small bits of paper have been removed and eaten. Sometimes pelletized droppings are also found in association with the feeding, particularly with the American cockroach.

The **American cockroach** (Figure 1) tends to hide in dark shaftways, basements, and false ceilings during the daytime, emerging at night to roam the library and feed on library materials. These cockroaches also regurgitate a brown liquid called attar, which is often smeared on the library materials. Attar acts as a chemical attractant for other American cockroaches. This cockroach is fully an inch and a half long with reddish brown wings and light markings on its thorax. It is cosmopolitan and prefers to live in warm moist places during the daytime. Favorite buildings of this cockroach are those that are heated with a steam heating system with boiler rooms and steam tunnels. It is also commonly found in sewer systems and will invade buildings through holes in manhole covers and sump pumps.

The female of this species forms an egg capsule which will be dropped or sometimes glued to surfaces. In time, nymphal cockroaches will emerge from the egg capsule. The young cockroaches will then go through a series of molts until reaching adulthood. This developmental process takes well over a year. Nymphal cockroaches are similar to the adults except they lack wings and sexual maturity. The life span of this species of cockroach from egg to death can last well over 2 years.

The **Oriental cockroach** (Figure 2) is a dark brown to black cockroach. The male's wings do not reach beyond the tip of the abdomen; the female is essentially wingless. The damage to library materials is similar to that of the American cockroach except that the Oriental cockroach does not produce pelletized excrement. This cockroach prefers to live in cool, moist places such as sewers, basements, around air-conditioning systems, and associated with water pipes and piping. Whereas the American cockroach will be found roaming on many floors of a building, the Oriental cockroach will generally be found on lower floors and horizontal surfaces because it lacks sticky pads

on its feet. The claws on the feet of all cockroaches, however, enable them to climb rough surfaces. Like the American cockroach, the Oriental cockroach is also notably gregarious. It is commonly known as the "water bug."

The life cycle of the Oriental cockroach is similar to that of the American cockroach with many molts from the time the nymphs hatch until adulthood. The life span is extremely long, well over 1 year, sometimes 2, and may even approach 3 years. The American cockroach female produces five times as many egg capsules as an Oriental cockroach female. The Oriental cockroach female does not glue her egg capsules, but drops them randomly.

The **Australian cockroach** (Figure 3) closely resembles the American cockroach, but can be distinguished from it by its slightly smaller size, the yellow margin on the thorax, and the light yellow streaks on the sides at the base of the wing covers. Older nymphal individuals of this species possess distinct bright yellow spots along the margins of their abdomen. Although this species is commonly found in more tropical regions of the world, it can be found indoors in heated buildings as far north as Canada. I have seen colonies in buildings in Pennsylvania and Idaho. It is common in greenhouses in various parts of North America.

Like the other two species, the Australian cockroach takes a long time to develop from egg to adult, generally, over 1 year. The female produces some 20-30 egg cases in her lifetime, with an average of 24 eggs per capsule. Like the American cockroach, it tends to prefer warm, moist environments.

Smaller cockroaches, such as the German cockroach, *Blattella germanica* (Linn.), and the Brown-Banded cockroach, *Supella longipalpa* (Serville), do not feed on library materials as a rule. They may, however, leave droppings resembling ground pepper on the materials. These droppings can usually be vacuumed up with a soft brush attachment and do not stain the materials.

The large species of cockroaches can be controlled by the following IPM measures.

1. Installation of a gravel 6-foot barrier around the perimeter of the library to prevent ingress from outdoors.
2. Elimination of all vines and ivy from the building.
3. Installation of proper screening on all windows and doors.
4. Installation of exterior lights away from the building so they will shine on the building from a distance rather than fastening them to the building so that insects are attracted to the exterior walls during the night.
5. Removal of all debris, leaves, and twigs around the exterior of the library as well as cleaning out debris from gutters on the roof of the building.
6. Elimination of cockroach harborages and entries by caulking and sealing.
7. Installation of sticky glueboards that will trap insects on their nightly forays around the library. These insect traps can be installed in false ceilings, basements, elevator shaftways, and closets so they intercept insects as they travel looking for food.
8. Whenever insect infestations are found, a common attempt at their control is by insecticidal treatments with an aerosol or fog. Insecticidal fogs or aerosols should never be used in any collection. Such formulations are normally oil-based. During application, small droplets of the oil/insecticide mixture are dispensed into the air, eventually settling on the entire collection. This kind of treatment irreversibly damages the collection.
9. The use of insect baits, such as 2 percent Baygon Cockroach Bait, applied sparingly to quiet zones of the interior of the library. This bait, which looks like

Fig. 1. The American cockroach, *Periplaneta americana* (Linn.). (Courtesy of Mallis *et al.*)

Fig. 2. The Oriental cockroach, *Blatta orientalis* (Linn.). The male is on the left and female on the right. Note the absence of developed wings in the female. (Courtesy of Mallis *et al.*)

Fig. 3. The Australian cockroach, *Periplaneta australasiae* (Fabr.). The bright yellow "shoulders" on this species set it apart from the American cockroach. (Courtesy of Mallis *et al.*)

Fig. 4. A silverfish, *Lepisma saccharina* L. This species is one of the most common indoor pests of library materials. (Courtesy of Kingsolver and Pest Control in Museums.)

sawdust, is bran mixed with molasses and contains 2 percent Baygon. This bait is a favorite of large cockroaches and will easily bring populations into control.

10. Perimeter fan spraying with residual insecticides, paying particular attention to those areas adjacent to pipe chases, elevator shafts, storage areas, and mechanical rooms.

11. In the case of the American and Australian cockroaches, perimeter, exterior power-spraying of the walls and overhangs may be required.

12. Installation of thresholds and rubber flaps on exterior doors to prevent ingress by cockroaches from the exterior, particularly at night.

13. The use of steel wool in holes and openings leading from drainage and sewer systems to prevent cockroach ingress.

Silverfish

Silverfish (Figure 4) are one of the most common pests of libraries. All have weak, chewing-type mouth parts and tend to feed on products high in carbohydrates (starch) and proteins. Such materials as paper, paper sizing, prints, glue and paste, wallpaper, and drywall are favorites of silverfish. Damage from the feeding of silverfish can be recognized by certain areas that have been eaten all the way through and other areas that have only partially been eaten through. Silverfish tend to rasp their way slowly through a piece of paper, and it is this damage that is seen on library materials and prints. Silverfish will roam widely in search of foods, but once they have found a satisfactory source, they remain close to it.

There are many species of silverfish in the world; thirteen are known from the United States. Some prefer cool, moist environments, others warm and moist environments. They are small, tapered, wingless insects with long antennae and three long bristles protruding from their posterior end. They are nocturnal, resting in cracks and crevices during the daytime. When exposed to light, they move quickly to avoid it.

Silverfish are particularly fond of paper with a glaze on it. Often sizing, which may consist of starch, dextrin, casein, gum, and glue, is particularly attacked. Certain dyes are attractive to silverfish. Studies have shown that papers consisting of pure chemical pulp are more likely to be attacked than those consisting in part of mechanical pulp. In general, papers and books in regular use are not damaged by silverfish. Silverfish are also particularly fond of rayon and cellophane.

In temperate climates, silverfish tend to migrate vertically depending on the season of the year. In the hot months of summer, silverfish will migrate down into the cooler, more moist portions of the building, and in the fall and winter they will tend to migrate to attics and higher levels. Drying out a building with heat in the winter time will help to reduce silverfish populations. The heat also eliminates the microscopic mold that grows on plaster walls and drywall providing a food source for silverfish. In cool, moist basements, and commonly in poured-concrete buildings, silverfish are a year-round problem.

It is impossible to eliminate bringing silverfish into a library. Silverfish are a very common problem in cardboard box and drywall manufacturing facilities. Silverfish lay eggs in the corrugations of cardboard boxes, one of their favorite areas for egg deposition. With every cardboard box coming into a library, a new load of silverfish and their eggs is bound to arrive. Upon hatching, silverfish go through many molts throughout their lifetime and have a long life span.

Control and prevention of silverfish damage to library materials can be effected in a variety of ways.

1. Thorough vacuuming of the perimeters of rooms where silverfish like to hide underneath the toe moldings and baseboards during the daytime.

2. The use of insect sticky traps or glueboards in those areas where silverfish seem to be a problem. Each night, when silverfish are active, they will be trapped on the glueboards.

3. In cabinet storage situations, the use of silica gel in a finely powdered form in the void space beneath the bottom shelf or drawer of a cabinet. Sometimes the use of a 1/4-inch drill is necessary to gain access to apply this dust into the voids beneath the cabinets. Silica gel is a desiccant and kills silverfish by drying them out. By placing silica gel powder (sometimes in combination with pyrethrum insecticide) beneath the cabinets, there is virtually no way a silverfish can crawl up into the cabinet without encountering the silica gel thus being repelled or killed.

4. In some instances, particularly in manuscript, rare book, and print collections, the use of insecticide resin strips may be used in enclosed spaces. Insecticide resin strips contain the insecticide Vapona (DDVP). This material volatilizes from the resin strip and fills a confined space with molecules of insecticide. It is a mild fumigant and in time will kill all stages of insects within the enclosed space. The normal rate of application of these strips is one strip per thousand cubic feet of enclosed space (2). This type of chemical application is for enclosed spaces only, such as cabinets, vaults, and small storage rooms, and is not designed to be used in open, public spaces or where ventilation would carry the fumes out of the space.

5. Application of residual, liquid insecticidal sprays to perimeters of rooms and at the base of all stack shelving areas, paying particular attention to that crevice where the floor meets the wall, baseboards, and shelving.

6. The application of insecticidal dusts, such as a silica gel/pyrethrum combination, to voids where pipes enter walls and penetrate floors and in wall voids. In warmer parts of the world, construction engineers sometimes inject powdered silica gel in wall voids during construction of a building. This practice eliminates insect harborages.

7. Crack and crevice injection of small spot applications of liquid insecticides to the backs of cabinets where they are attached to walls.

8. The control and elimination of moisture such as leaky plumbing, around laundry areas, in bathrooms, and workrooms where a silverfish population can thrive because of the high moisture situation.

9. Reduction of potential sites of harborage by the use of caulking compounds and patching plasters.

Carpet Beetles

Carpet beetles belong to the family Dermestidae, which includes several species whose larvae damage library materials in storage. Except for one species known as the Odd Beetle, most of these beetles are small, round to oval, tiny beetles which are attracted to light (Figure 5). They may be found in light fixtures and on window sills. The primary source of food in libraries for the larvae of these beetles is dead insects. The larvae prefer materials high in protein, and carcasses of insects provide the total nutritional needs for many of these species. Once the larvae conclude their feeding on a dead insect or rodent, they pupate and emerge as adult flying beetles. The beetles seek out other proteinaceous materials on which to lay eggs.

Among traditional materials housed in libraries, probably the only places an adult beetle has to lay eggs in addition to carcasses, are tapestries, woolen goods, and the felt lining of storage boxes for rare books. If a library has an herbarium collection,

some species of carpet beetles will infest these collections. Rarely do the larvae of these insects attack leather-bound books. Thick, tanned leather does not appear to be attractive to them for feeding. Obviously, these beetles are a serious problem of museums and libraries where other animal-based, proteinaceous items are housed in addition to the traditional library materials.

Control of carpet beetles is not difficult provided the staff is involved in the IPM program. The following control measures can be employed.

1. Thorough vacuuming on a regular basis of all library areas, paying particular attention to the edges of the room where adults find dead insects on which to deposit their eggs. Annual inspection and vacuuming of false ceilings, attics, closets, maintenance areas, mechanical rooms, and elevator shaft pits are necessary to eliminate reservoirs of food sources and carpet beetle larvae.

2. Placement of sticky traps to intercept insects as they crawl into the library helps to keep carcasses of insects at a minimum. Keep in mind, however, that carpet beetles can fly into a sticky trap, lay eggs on a dead insect, and fly out of the trap without being trapped themselves. The larvae can proceed to devour the carcass of the insect on the sticky trap, pupate, emerge as an adult beetle, and fly out of the trap without being mired in the glue of the trap. This situation necessitates the removal of traps that have an accumulation of insects on a regular basis and replacement with a fresh trap.

3. Screening of all windows and doors to prevent ingress of adult beetles from the exterior of the building. Plantings of shrubbery around the building should not include plants whose flowers are white or blue and whose flowers contain high amounts of pollen. Crepe Myrtle and Spiraea are very attractive to adult carpet beetles, where they feed on pollen.

4. Elimination of all bird nests on and around the building. Carpet beetles become entrenched in such nests, feeding on dead birds, feathers, and other debris found in the nests.

5. The elimination of rodents and rodent nests for the reasons given above.

6. The use of residual sprays may help to some extent for carpet beetle control, but is usually of little value, particularly in warm, humid climates.

7. The use of Vapona resin strips in vaults, closets, and enclosed storage spaces is a valuable technique for eliminating all stages of carpet beetles within these spaces.

Cigarette Beetle

The **Cigarette Beetle**, *Lasioderma serricorne* (F.) (Figure 6) is a small, round, cinnamon-colored flying beetle whose larvae infest dried leafy materials, such as tobacco and tobacco products, spices, corn husk dolls, dried flowers, and books. This beetle, whose head is tucked under at a right angle to its body, is found throughout the world. It is the most common pest of herbarium collections and is often called the "Herbarium Beetle."

The female of this beetle lays approximately 30 eggs over a period of 3 weeks. The larvae are small and grublike and complete their development in from 5 to 10 weeks. The entire life span is from 70 to 90 days with five to six overlapping generations per year in warm localities, but only one generation in more temperate regions. The adult beetles are strong flyers in subdued light.

This beetle is one of two commonly known as the bookworm. Eggs are laid on the spine of the book and along the edges of the cover. Upon hatching, the larvae tunnel immediately beneath the covering of the book to eat the glue on the spine and under the cover. After feeding on the glue for a period of time and tunneling for

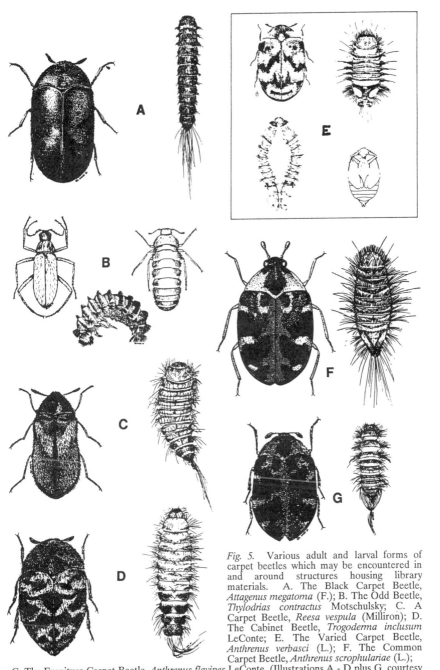

Fig. 5. Various adult and larval forms of carpet beetles which may be encountered in and around structures housing library materials. A. The Black Carpet Beetle, *Attagenus megatoma* (F.); B. The Odd Beetle, *Thylodrias contractus* Motschulsky; C. A Carpet Beetle, *Reesa vespula* (Milliron); D. The Cabinet Beetle, *Trogoderma inclusum* LeConte; E. The Varied Carpet Beetle, *Anthrenus verbasci* (L.); F. The Common Carpet Beetle, *Anthrenus scrophulariae* (L.); G. The Furniture Carpet Beetle, *Anthrenus flavipes* LeConte. (Illustrations A - D plus G, courtesy of Kingsolver and Pest Control in Museums. Illustrations E and F, courtesy of Mallis *et al*.)

Fig. 6. The Cigarette Beetle, *Lasioderma serricorne* (F.). Note how the head of the adult beetle is tucked down at a right angle to the axis of the body. (Courtesy of Mallis *et al.*)

Fig. 7. The Drugstore Beetle, *Stegobium paniceum* (L.). The striations on the wing covers are a distinguishing feature of this species. (Courtesy of Mallis, *et al.*)

Fig. 8. A Book Louse, the Larger Pale Trogiid, *Trogium pulsatorium* (L.). (Courtesy of Kingsolver and Pest Control in Museums.)

approximately 3-4 inches, the larvae will pupate and emerge as an adult beetle, leaving a round hole upon exiting. Generally, fine powder is found in association with the holes, the powder being the color of the book cover in which the feeding has occurred. These piles of colored powder are easily detectable by inspecting the shelving with a flashlight.

The control of cigarette beetles in a library can be effected with a combination of approaches.

1. Screen all entries from the exterior to prevent beetles from flying into the building.

2. Do not allow dried flower arrangements to be in the open in the library. Often eggs and larvae are imported into the library on dried flower arrangements. The larvae will consume the dried vegetable matter of the arrangement as well as the glue that generally holds the flower arrangement together.

3. Do not allow the storage of spices or other leafy vegetable matter in the library. Cigarette beetles are particularly fond of red spices, such as cayenne, paprika, and chili powder.

4. Do not encourage the storage or display of botanical collections in the library. If a collection is to be stored or exhibited within a library, it should be disinfected with heat to kill all stages of cigarette beetles in the sheaves of botanical specimens. By heating the collection to 130° F for 3 hours, all stages of insects will be killed. After this treatment, stored collections should be housed in cabinetry with Vapona resin strips to prevent possible reinfestations. Botanical specimens should be displayed within Plexiglas enclosures to keep insects out.

5. To disinfest an entire structure of insects, heating the space with commercial gas burners has been successful in the past. By using electric fans to distribute the heat throughout the building, all insect stages can be killed by maintaining a temperature of 140° F (60°-63° C) for 6 hours. It is helpful to loosen the books and materials to allow the air to circulate around them. This technique not only controls cigarette beetles in books, but all stages of insects in the entire structure (3).

6. By using plants that are preferred by gravid female cigarette beetles, infestations can be controlled. These bug traps, such as whole leaf tobacco, can be placed in strategic locations in the library. As the plant traps become infested with eggs and larvae, they can be removed and burned, before the larvae have a chance to pupate and emerge as adult beetles (4).

7. If a localized, limited infestation is found in a library, isolate the infected books and subject them to a heat treatment. By placing the books in a standard oven at the lowest temperature possible (130° for 3 hours), and placing wet newspaper or a pan of water in the bottom of the oven to maintain humidity inside the oven chamber, all stages of this insect, and in fact any insect, will be killed. This technique is commonly used in herbarium collections in various parts of the world. It is much easier to kill all stages of insects with heat than it is by freezing. By supplying a source of humidity in the chamber, the books should not dry out during this treatment. Only active infestations should be treated in this manner. Dark exit holes, showing no powder associated with them, indicate that the infestation has long since died out and does not require treatment.

8. If a library has an active bindery, sometimes it is possible to mix a pesticide with the glue as the damaged books are bound. In some parts of the world, the insecticide dieldrin is used for this purpose. A cigarette beetle larva consuming

some of the glue would then be killed before it has a chance to develop and emerge as an adult beetle.

Drugstore Beetle

The **Drugstore Beetle**, *Stegobium paniceum* (L.) (Figure 7) may infest books and manuscripts and is sometimes called a "bookworm." Where the cigarette beetle tends to confine its larval feeding to the spine and glue that holds the book together, the drugstore beetle larvae often tunnel through the pages of the book, as well as emerging through the cover and spine. This type of infestation may be found in storage areas of libraries that tend to be moist. Active infestations are a real threat to books and should be dealt with quickly. Again, only those books showing small, round exit holes, associated with powder drifting onto the books and shelving, should be treated. Small, round, dark exit holes from older books, particularly pre-19th century books, that show no powder associated with the holes are not active infestations and nothing need be done to them.

Eggs of the drugstore beetle are laid singly on the books, instead of in a mass. The larval period ranges from 4 to 5 months. Generally 7 months are required to complete the life cycle from egg to adult in a temperate climate. In warmer climates four broods per year are possible.

In addition to the IPM measures listed for the cigarette beetle, the following IPM approaches can be used to control the drugstore beetle.
1. Screen all windows and doors to prevent ingress from the exterior.
2. Caulk around all windows to prevent ingress into the building.
3. Eliminate pigeons' nests from the building. In one instance, drugstore beetles were emerging from pigeon nest debris and gaining access to a library through loose-fitting windows. The larvae of the drugstore beetles were feeding on undigested grain and other food products found in the manure layers of the pigeon nests.
4. Books infested with drugstore beetles can be disinfested by the use of humidified heat at 130° F for a period of 3 hours as explained more fully in the section dealing with the cigarette beetle.
5. The incorporation of an insecticide in the glue at a bindery may have a limited effect on controlling infestations of drugstore beetles in books. When cigarette beetles infest books, their primary diet is the glue of the binding, hence they may be controlled by incorporating insecticide in the glue. Drugstore beetle larvae, however, tunnel directly into the interior of the book, feeding on pages. Because they ingest such small amounts of glue in their feeding activities, the larvae and adults of the drugstore beetle will generally not be killed by the incorporation of an insecticide in the glue.
6. The use of fans to keep air circulating in the stacks and to keep the books dried out is an aid in controlling infestations. Attempt to keep the relative humidity between 50 and 60 percent at all times.
7. Regular inspection of the stacks with a flashlight will enable the librarian to pinpoint areas of infestation by locating the piles of fine powder drifting from the books onto the shelving.

Psocids

Psocids (Figure 8), or book lice as they are commonly known, are small, wingless, soft-bodied insects that are very hard to see with the naked eye. Psocids are a common pest of paper materials, where they feed on microscopic mold growing on the pages. Except for the spot they may leave when crushed in a book, they do no damage to the book

itself. Several species are found in libraries across the world. Psocids are not a threat to collections, but are an indicator of high humidity and moist conditions.

Book lice are parthenogenetic, that is, females can reproduce without the sperm from a male. After the eggs hatch, there are generally four molts until the small nymph reaches adulthood. The life cycle averages 110 days. In warmer regions of the world, life cycles are speeded up to as many as 15 generations per year. During cold weather the adults die, leaving eggs to hatch in the spring.

Psocids prefer damp, warm, undisturbed situations. In temperate climates they become most numerous during the spring and summer. Heated buildings in temperate climates reduce the dampness and fungi upon which book lice feed. In addition to mold, book lice have been known to feed on cereals and materials of a starchy nature. Book lice are of prime concern in newly constructed buildings. Insulation, hollow walls, and wrapping around pipes and electrical fixtures incorporate moisture that is not readily evaporated and which promotes mold growth on which book lice feed.

Control of book lice is difficult. Several approaches must be considered.

1. In enclosed spaces, psocids may be controlled with the use of Vapona resin strips.
2. Lowering the moisture in materials and in the room will help control psocids by preventing mold growth. The use of fans and climatic controls to keep the relative humidities within a range of 50-60 percent and temperatures from 68° to 72° F will aid in reducing psocid populations.
3. For archival materials in "dead storage," placing the material in a large polyethylene plastic bag with several cups of dried, powdered silica gel wrapped in muslin or cheese cloth will help lower the moisture within the bag to the point where mold will not grow and psocids will be eliminated.
4. With heavily infested, moldy books, paradichlorobenzene (PDB) may be used as a fumigant to control book lice. A very tightly confined space must be used, such as a weather-stripped cabinet or closet or a heavy-duty polyethylene bag and sufficient quantities of PDB crystals to obtain air concentrations that will effectively kill the insects. A rate of 1 pound of crystals per 100 cubic feet of space for a period of at least 2 weeks is the minimum necessary for a complete kill. Paradichlorobenzene used in this manner will also kill surface mold and spores on the materials. After the fumigation, the materials should be aired thoroughly.

Rodents

The most common rodent found in libraries is the **House Mouse**, *Mus musculus* (Figure 9). This species seems to be able to invade practically any structure man has made. Damage to library materials comes from mice destroying materials for nesting purposes, and urinating and defecating on library materials. Populations of mice can build up very quickly, and when they die, their carcasses act as a source of food for carpet beetles. In addition to damaging collections directly, mice may chew the insulation off electrical wires, causing them to short and start a fire.

House mice are secretive and are generally active at night. They live in a territory with a small home range. The average distance that a mouse travels in its activities is 12 feet. Male mice are highly territorial, and for this reason control measures must be designed for specific areas where mouse droppings are found. Glueboards and traps should be set in these areas. House mice live outdoors year around, but will invade buildings, particularly in the fall of the year in temperate climates.

Mice are sexually mature in 35 days. The average litter size is about six. A female can have another litter approximately every 50 days. Community nests of mice, where several females may share the nest with their accumulated brood, are not uncommon.

Fig. 9. The House Mouse, *Mus musculus* (Linn.). (Courtesy of Mallis *et al.*)

They breed throughout the year indoors. Mice living outdoors are seasonal breeders, peaking in the spring and the fall.

Mice feed on a variety of foods provided by man. They also feed on dead insects found indoors. Mice have been found to be cannibalistic. They apparently do not need free water to drink, but will consume it if it is available. Mice feeding on high protein diets must supplement their diets with free liquid.

During their nocturnal activity, mice leave fecal droppings wherever they have been active. Other signs of mouse infestation are gnaw marks; small, stained holes in floors and walls, and beneath doors; and a pungent odor from their urine.

Mouse control in a library is important and should be dealt with in the following ways.

1. Seal the building on the exterior as tightly as possible with steel wool and caulking compounds.
2. Never use a toxic baiting program for mice on the interior of a library. The mice will die in the walls, floors, and ceilings, and provide food for carpet beetles.
3. Use mechanical control techniques for mouse control. Snap traps baited with cotton balls or peanut butter can be used to trap mice. Multiple-catch live traps are available on the market, such as the "Ketch-all" trap. These are capable of catching more than one mouse at a time without the use of bait, relying on the innate curiosity of the mouse. Glueboards can also be used to trap mice. Soon after they are trapped they will die, and the trap or glue board can be discarded.
4. A thorough inspection of the building with a flashlight on a periodic basis is important to identify those areas where mice activity is present. The presence of droppings is a clear indication that control measures should be undertaken in that exact spot. Two or three weeks after a control program has been instituted, remove all droppings so the progress of the trapping program can be determined.
5. In temperate regions, in late summer and early fall, trapping programs should be instituted so they will be in place when the mice naturally tend to invade structures.
6. Sonic devices aimed at rodent elimination are of questionable value in most library mouse control programs.

Mold and Mildew

One large problem in libraries, particularly in subtropical and tropical climates, is the presence of mold on library materials. Mold results from spores landing on a substrate that has the correct temperature and surrounding humidity to initiate germination of the spores. When the spores germinate, they put out fine strands of mycelia, which invade the substrate, utilizing it as a food source. The mold mycelia exude liquids that dissolve the substrate, and this food is then used in the production of more mycelia and eventually millions of spores.

In order for this scenario to take place on paper products, books, and other library materials, prolonged periods of high humidity are required for mold growth. If the environment of a library is held at a temperature of from 68° F to 72° F and a relative humidity of 50 percent to 60 percent, mold will not be seen. This is not to say that some spores will not germinate. It simply means that after germinating, the mycelia will not have conditions suitable for growth and will die before being visible to the naked eye.

When the relative humidity of the environment remains in the 60 percent to 70 percent range, certain kinds of mold spores will germinate, but most will be unable to maintain mycelial growth and will collapse. This higher humidity range is not as "safe" for paper products, because there will tend to be micro-environments in the library where humidities will peak higher than the overall relative humidity for the entire structure and may create conditions conducive to localized mold growth. Of course, higher temperatures under these higher humidities will also enhance the possibility of localized mold growth on library materials.

When the relative humidity· of a library exceeds 75 percent and remains in this range for a period of time, serious mold problems will result on library materials. Even if temperatures are low, the effects of the high humidity will stimulate spores to germinate en masse. Not only will spores germinate, but growth of the resultant mycelia will be quick and unabated. In as short a time as 36 hours, mycelial mats will begin to appear on the materials and spread outward. Soon the center of the mat will begin to appear dark, generating millions of spores. The key to long-term mold control, then, is to manage the moisture in the air of the library and stacks in a manner that will minimize periods of high humidity.

Each cubic foot of air contains thousands of mold spores which land on surfaces and objects in the library every day. Attempts to control mold on library materials by using various chemicals therefore are usually ineffective. Chemicals such as thymol, ortho phenylphenol (OPP), alcohol, and diluted bleach solutions kill some of the mold spores on the surface as well as some of the mycelia. As soon as these chemicals have volatilized from the surface, the object is vulnerable to new mold spores landing on the surface. If the conditions are correct, germination and production of more mold will result. These types of chemicals do not impart residual control for mold or the mold spores.

Similarly, fumigation with poisonous gases in a chamber does not impart any residual mold control effects. Much of the fumigation that is done in libraries is not warranted. Changing the environment that produced the conditions suitable for mold growth in the first place is the only truly effective means of retarding and eliminating mold growth. If a spore lands on a substrate that is not suitable for growth, in time the spore will desiccate and die. As long as the conditions of the substrate and surrounding micro-environment are not suitable for spore germination, the spores will not germinate and mold will never appear.

Some considerations in handling mold and mildew in libraries follow.

1. An air handling system should be installed that will lower the humidity in the air and then reheat the air to desired levels. This system should be designed to handle incoming outside air as well as recirculated air. Such systems must be carefully thought out and must be large enough to accept incoming loads with humidity levels of the exterior air as well as the amount of moisture contained in the interior air. The aim is to maintain an interior environment in the library of from 50 to 60 percent relative humidity and 68° to 72° F at all times.

2. If such air handling systems are not available or cannot be installed, fans can be used to keep the air moving, particularly near outside walls and close to floor levels, in an attempt to lower moisture content of library materials.

3. Waterproofing basements and walls below grade on the exterior to prevent moisture from wicking through the walls and into the interior will aid in keeping humidity levels down inside the building.

4. Earthen floors in basements and sub-basements should be sealed with concrete to prevent moisture from wicking up into the building. At the very least, earthen floors should be covered with 4-6 mil polyethylene film to lessen the amount of moisture being volatilized into the interior air.

5. Water-sealant paints can be applied to floors and walls to prevent ingress of moisture into the interior of the building.

6. Attic vents and fans can be installed to pull air through buildings that have no air handling systems and where tropical climates require windows to be opened throughout the year. With such installations air can at least be kept moving throughout the building.

7. Open trenches and drains in mechanical rooms and areas adjacent to stack areas should be covered to prevent evaporation of liquid into the interior space.

8. Except for drinking fountains, interior fountains or waterfalls should not be permitted in a library.

9. Do not allow indoor planted areas in a library. Keep ornamental and hanging plants to a minimum to reduce the amount of water released into the interior air.

10. Heavy mold infestations resulting from flooding, water damage, leaks, and fires is an entirely separate topic and cannot be dealt with within the scope of this paper.

11. Regular inspection of the collections with a flashlight to pinpoint trouble areas is a necessity. Localized infestations of mold can be temporarily arrested with topical applications of chemicals until other modifications can be made.

12. Thymol is commonly used as a temporary mold-control chemical on books, paper, and other library materials. The use of thymol, either as a mist or spray, or as a fumigant volatilized by heat, does not impart residual mold control to the library materials. Thymol will kill some species of mold spores and mycelia upon contact. Taking the materials out of the atmosphere of thymol will leave them vulnerable to mold spore deposition and possible germination.

In the United States, thymol is not registered as a mold-control chemical with the Environmental Protection Agency. It is often used, however, by library technicians and museum conservators. A wet mist can be applied by dissolving thymol crystals in ethyl alcohol (ethanol). A 1 percent finished dilution is normally used. The technician should wear a respirator approved for organic chemicals as well as goggles when using thymol. To protect from dermal irritation, the technician should also wear rubber gloves.

Some institutions have designed small chambers for the use of thymol for fumigation. Thymol crystals are placed on a metal tray and heated with several light

bulbs. The space within the enclosed chamber becomes saturated with thymol molecules, fumigating the materials in this space. The same precautions apply for the operator as previously discussed. Goods fumigated in such a way should be aerated thoroughly in a fume hood or outdoors to volatilize any remaining thymol before the materials can be safely handled. As stated previously, after the materials have been aerated, there will be no thymol left on the materials to provide protection against subsequent mold development.

Paradichlorobenzene (PDB) can be used in an enclosed space as a mild fumigant for mold control. Where a thymol fumigation takes no more than 24 hours for the application phase, a PDB fumigation would take up to 3 weeks unless the crystals were volatilized by heat. As before, PDB does not give residual mold control to the library materials.

Ortho phenylphenol (OPP) is another phenolic chemical that has been used for non-residual mold control on library materials. This chemical is not registered for use for mold control in libraries in the United States, but has been used in the past for extensive mold infestations brought about by flooding and fires. Repeated applications of the diluted material in alcohol are made by spraying or fogging this solution onto the library materials. Repeated applications are made over a series of days. These types of applications are usually performed by professional pest control operators or those who are thoroughly trained in the use of this chemical.

Alcohol and dilute bleach solutions have been used by technicians for spot applications to library materials, shelving, walls, and floors. Any strong oxidizing agent will kill mold spores, but most will not impart residual chemical control.

Fumigation

Fumigation of library materials with extremely toxic chemicals is rarely necessary. It may be warranted when dealing with bookworms, but fumigation is generally not warranted when dealing with mold and mildew problems. Historically, the library community has used ethylene oxide in fumigation chambers for mold and mildew control on incoming library materials. As was stressed in the section on mold, fumigation will not control mold and mildew if the library materials are placed back into the same conditions from which they came. In most instances library materials that have been fumigated are then stored in areas which do not have an environment conducive to mold growth. The success of the fumigation is given as a reason for the control of the mold and mildew, when, in fact, the new area in which the materials are stored is the governing factor in the mold and mildew control.

Ethylene oxide, either in combination with Freon or carbon dioxide, has been found to be a carcinogenic material. In the United States a chamber may have no more than 1 part per million (ppm) of ethylene oxide left after the aeration and before the materials can be removed safely. One of the major problems with ethylene oxide is that very few chambers in the world meet this requirement. Any fumigation chamber relying on an air wash system to aerate the goods after a fumigation has been completed usually will not reach levels of 1 ppm or below at the end of the air wash cycles.

An air wash cycle is a term coined by the manufacturers of chambers to mean one complete cycle of "air washing" of the goods inside the chamber after exposure to a toxic gas. At the end of the exposure phase, the chamber is under vacuum. The operator, either manually or electronically, allows fresh air to come into the chamber. Another vacuum is then drawn, removing some of the toxic air by expelling it to the atmosphere. After a vacuum has been drawn, fresh air once again is allowed to rush

into the chamber. Then another vacuum is drawn and this contaminated air is once again expelled into the atmosphere. This series of alternating between pulling a vacuum and allowing fresh air to rush into the chamber is termed an air wash cycle. Most chambers are set up in such a manner as to allow for up to five total air washes before the electronics must be reset.

After such a limited number of air wash cycles, it is rare to find a chamber that meets the current standard of 1 ppm. Studies have shown that in some chambers, after 75 air wash cycles, 4 ppm ethylene oxide still remained in the chamber. In designing, modifying, and testing chambers, I find it difficult, if not impossible, to reach such low levels without a flow-through ventilation system. Even with such a system, depending on the materials being fumigated, 1 ppm or below is difficult to obtain with ethylene oxide.

Ethylene oxide is soluble in oils, fats, and lipids, making leather-bound books retain ethylene oxide for long periods of time after fumigation. After bringing books out of a chamber, they will volatilize ethylene oxide into the air for varying periods of time up to and exceeding 3 months. It is therefore critical that the managers of major libraries test in-house chambers and study fumigation policies and procedures to determine if they are meeting current requirements. Most will find that fumigation chamber modifications and procedural changes are required to meet current standards.

Other fumigants, such as methyl bromide, hydrogen sulfide, and some of the liquid fumigants, are not generally acceptable for library materials for several reasons. Methyl bromide sometimes chemically reacts with materials high in sulfur. If this chemical reaction were to take place, mercaptans would be formed and would create an irreversible, foul-smelling odor. Hydrogen sulfide is explosive and dangerous to use. Some of the liquid fumigants have been found to be carcinogenic.

Recently in the United States, Vikane (sulfuryl fluoride), manufactured by Dow Chemical Company, has been registered for use in chambers as a fumigant. As with all fumigants, this material does not impart any residual control, but can effectively penetrate dense materials, such as library materials, and will kill all stages of insects. One problem with Vikane is that it is a poor ovicide, and therefore dosages must be increased in order to penetrate the eggs of certain species of insects. To date, this material has been found to be very nonreactive with materials and is commonly used as a structural fumigant in wood-destroying insect control. Its use to control mold spores and mycelia remains in debate.

Conclusion

As is true with all museum materials, one cannot delay treatment until insects, rodents, and mold have turned the library collections into a food source. We must be keenly aware of what is happening in our collections and structures. We must anticipate the types of problems unique to libraries and provide an integrated pest management plan to deal immediately with those problems present and to prevent others from arising. In this way, we will establish the most common sense approaches to pest prevention and control with the least impact on our environment and ourselves from toxic chemicals.

References and Notes

1. Dr. Parker, an entomologist, is a consultant to museums, historic properties and libraries, specializing in IPM approaches. He is President of Pest Control Services, Inc., 14 East Stratford Avenue, Lansdowne, Pennsylvania, USA, 19050. Telephone (215) 284-6249.

2. The No-Pest Strip is the only dry strip available on the market today. It is available through Kenco Chemical Company, P. O. Box 6246, Jacksonville, Florida, U.S.A., 32236. Telephone (800) 523-3685.
3. Cressman, A. W. Control of an infestation of the cigarette beetle in a library by the use of heat. *Journal of Economic Entomology*, 1935, *26*, 294-295.
4. Merrill, E. D. On the control of destructive insects in the herbarium. *Journal of the Arnold Arboretum*, 1948, *29*, 103-110.

Additional References

Anonymous. The carpet beetles. *National Pest Control Association Technical Release 7-75*. Dunn-Loring, Virginia: 1975. (4 pp.)
Anonymous. Varied carpet beetle: *Anthrenus verbasci* (L.). *Pest Management*, 1982, *1*(4), 17-18.
Back, E. A. Psocids in dwellings. *Journal of Economic Entomology*, 1939, *32*, 419-423.
Becker, P. C., & Brockman, W. Library pests. *Pest Control*, 1982, *50*(12), 43.
Block, S. S. Experiments in mildew prevention. *Modern Sanitation*, 1951, *3*, 61-67.
Protection of paper and textile products from insect damage. *Industrial Engineering Chemistry*, 1951, *43*, 1558-1563.
Humidity requirements for mould growth. *Applied Microbiology*, 1953, *1*, 287-293.
Czerwinska, E., & Sadurska, J. Actinomycetes damaging old manuscripts and documents. (In Polish with English summary), *Acta Microbiology Polonica*, 1953, *2*, 160-164.
Czerwinska, E., & Kowalik, R. Penicillia destroying archival papers. *Acta Microbiology Polonica*, 1956, *5*, 299-302.
Evans, D. M. Cockroaches and bookbinding. *Penrose's Annual*, 1960, *54*, 118-120.
Edwards, S. R., Bell, B. M., & King, M. E. *Pest control in museums: a status report.* Lawrence, Kansas: Association of Systematics Collections, University of Kansas, 1980.
Gallo, F. *Biological factors in the deterioration of library and archive materials.* Rome: ICCROM, (In press).
Gallo, F., & Gallo, P. Bücherfeindliche Insekten und Microorganismen. *Papier Geschichte*, 1966, *16*(3/4), 7-28.
Gould, G. E., & Deay, H. O. The biology of the American cockroach. *Annals of the Entomological Society of America*, 1938, *31*(4), 489-498.
The biology of six species of cockroaches which inhabit buildings. *Purdue University Agricultural Experiment Station Bulletin*, no. 451. West Lafayette, Ind.: Purdue University Agricultural Experiment Station, 1940.
Hueck, J. J. Textile pests and their control. In J. E. Leene (Ed.), *Textile Conservation*, Washington?: Smithsonian Institution Press, 1972, 76-97.
Kowalik, R., & Sadurska, I. The disinfection of infected storerooms in archives, libraries, and museums. *Acta Microbiology Polonica*, 1966, *15*, 193-197.
Laibach, E. Warum wird Kunstseide von Silberfischchen (*Lepisma saccharina* L.) gefressen? *Melliand Textsser*, 1948, *29*, 397-401.
Lepisma saccharina, das Silberfischchen. *Zeitschrift für hygienische Zoologie und Schädlingsbekämpfung*, 1952, *40*, 321-370.
Langwell, W. H. *The conservation of books and documents.* London: I. Pitman, 1957.
Lasker, R. Silverfish, a paper-eating insect. *Scientific Monthly*, 1957, *84*(3), 123-127.
Mallis, A., *et al.*, *Handbook of pest control* (6th ed.). K. O. Story (Ed.). Cleveland: Franzak & Foster, Co., 1982. (1101 pp.)
Marsh, R. E., and Howard, W. E. House mouse control manual. Part one. *Pest Control*, 1976, *44*(8), 23, 24, 26, 30, 33, 62, 64.
Plenderleith, H. J. *The conservation of antiquities and works of art* (2nd ed.). Oxford: London University Press, 1962.

Story, K. O. *Approaches to pest management in museums.* Suitland, Maryland: Conservation Analytical Lab, Smithsonian Institution, 1985. (165 pp.)

Sweetman, H. L. Responses of the silverfish, *Lepisma saccharina* L. to its physical environment. *Journal of Economic Entomology,* 1939, *32,* 698-700.

Sweetman, H. L., Morse, F. E., & Wall, Jr., W. J. The influence of color and finish on the attractiveness of papers to Thysanurans. *Pests,* 1944, *12*(10), 16-18.

Truman, L. C., Bennett, G. W., & Butts, W. L. *Scientific guide to pest control operations.* Cleveland: Purdue University/Harvest Publishing Co., 1976. (276 pp.)

Walchli, O. Papierschädlinge in Bibliotheken und Archiven. *Textil-rundschau,* 1962, *17,* 63-76.

Westrate, D. F. Warning: your collection may be bugged. *American Philatelist,* 1984, *98*(9), 929-932.

Ziegler, T. W. Silverfish control in buildings. *Pest Control,* 1955, *23*(6), 9-12.

ZUSAMMENFASSUNG – Eine Bibliothek ist in der Tat eine Konzentrierung von allgemein auftretenden Schädlingen – Insekten, Nagetieren und Schimmel – die die Sammlungen angreifen. Ein integriertes Schädlingsbekämpfungs- und Vorbeuge-programm, *i.e.* der Einsatz einer Kombination verschiedener Techniken, bietet die beste Eindämmung für Schädlinge. Insektenschaden an Bibliotheksmaterial wird hauptsächlich durch Schaben (vor allem amerikanische, orientalische und australische Schaben), Silberfische (von denen 13 Arten in den Vereinigten Staaten bekannt sind), Teppichkäfer (deren Larven verschiedener Arten zerstörend wirken), Zigarettenkäfer (den am häufigsten auftretenden Schädlingen in Herbariumsammlungen), den Kabinettkäfer (manchmal auch "Bücherwurm" genannt) und Psokopteren oder Bücherläuse hervorgerufen. Das gemeine Nagetier, das in Bibliotheken vorzufinden ist, ist die Hausmaus. Schimmel und Mehltau stellen grosse Probleme in Bibliotheken, vor allem in subtropischen und tropischen Klimaten dar. Durch den konzertierten Einsatz verschiedener Techniken kann mit den verschiedenen Arten des Befalls umgegangen werden. Zu diesen Techniken gehören externe Vorbeugemassnahmen an Gebäuden, Insektenfallen, der Gebrauch von Schädlingsbekämpfungsmitteln und anderen Chemikalien, Feuchtigkeitskontrolle, Reinigungsmassnahmen, begrenzte Wärmebehandlung von befallenem Material und ständige Kontrolle bei Nachweis von Befall. Die Begasung von Bibliotheksmaterial kann in einigen Fällen berechtigt sein, ist aber selten notwendig. Ständiges Bewusstsein dessen, dass potentielle Probleme vorhanden und Sofortmassnahmen notwendig sind, muss vorhanden sein.

RESUME – Une bibliothèque est, de fait, un centre d'alimentation pour les parasites de type commun nuisant aux documents rassemblés: insectes, rongeurs, moisissure. Le meilleur moyen de lutter contre ces parasites consiste dans des programmes intégrés de lutte, dont l'utilisation combinée de différentes techniques. Les dommages d'insectes aux documents de bibliothèque sont provoqués tout d'abord par les cafards (par ordre de gravité: américain, oriental, australien); mille-pattes argenté (espèces connues aux Etats-Unis); cafards de tapis (leurs larves sont particulièrement dangereuses); cafards cigarette (l'insecte trouvé le plus fréquemment); le cafard simplex (aussi appelé ver de bibliothèque) et le psocide ou pou du livre. Le rongeur le plus souvent trouvé dans les bibliothèques est la souris domestique. Les moisissures et le mildiou représentent des problèmes importants en bibliothèque, tout particulièrement dans des climats tropicaux ou sous-tropicaux. Toutes ces infestations peuvent être traitées par l'application combinée de diverses techniques dont la protection extérieure des bâtiments, les pièges à insectes, l'utilisation d'insecticides et autres produits chimiques, des moyens de contrôle de l'humidité, des mesures d'hygiène, traitement restreint des documents touchés et inspections continues pour

dépister d'éventuelles infestations. La fumigation de documents pourra être autorisée dans quelques cas mais elle est rarement nécessaire. Une prise de conscience constante des problèmes éventuels ainsi qu'un traitement immédiat, le cas échéant, sont deux éléments d'importance cruciale.

CLIMATE CONTROL IN LIBRARIES AND ARCHIVES

Timothy Padfield
Conservation Analytical Laboratory
Smithsonian Institution
U.S.A.

ABSTRACT

The climate maintained within a library is the result of a compromise between the climatic needs of the readers and the staff, the climatic needs of the structure of the building, the need to minimize the deterioration rate of the collection, and the maintenance demands and running costs of mechanical air-conditioning. Passive climate control by careful design of storage containers and by slowing down the heat and moisture transfer through walls allows simpler air-handling systems that are less troublesome, less costly to run, and less dangerous if they fail. Orthodox air-conditioning systems can produce air at a dew point of about 5° C, allowing the building to be held at 18° C and about 42 percent relative humidity (RH). A lower temperature can only be obtained by allowing the relative humidity to rise, or vice versa. A lower dew point can be obtained by drying the air with a silica gel desiccant system after the initial dehydration with a cooling coil. Bound books are liable to physical damage below about 35 percent RH, however, and people feel cold below about 18° C. Therefore, colder or dryer conditions are only suitable for carefully insulated storage vaults, in which only a minimum amount of air need be circulated. The relative humidity in vaults should be maintained slightly below that in the reading room so the moisture content of the book does not change when it is warmed for the reader. A stable relative humidity is desirable, but the value can be chosen, within the limits of 40-62 percent, to take account of peculiarities of the local climate and of the building. Buildings which are humidified in winter may be damaged by condensation and freezing of water in the walls. Sudden changes of relative humidity can be entirely prevented by enclosing books in close-fitting, nearly airtight containers, which are safe if there is no permanent temperature gradient from one side to the other and no sudden temperature drop around them. The small danger of locally generated air pollution can be minimized by sealing interior wooden surfaces and by incorporating alkaline buffered paper into boxes and shelf liners.

Introduction

Cool air of moderate and stable relative humidity is good for books. This happy state is attained by a combination of a congenial local climate, a suitably constructed building envelope, good internal layout, mechanical air-conditioning, and passive climate control through well-designed containers for the books and documents. This article is an attempt to bring together the concerns of the architect, the air-conditioning engineer, the paper chemist, the conservator, and the librarian so that each can understand the difficulties facing the others as they try to achieve a good climate for conservation. I will not try to define the ideal climate for storage of documents. Tight specifications, laid down without regard for the problems of a particular building, in a particular climate, and with particular limitations in local skills, are a major cause of eventual dissatisfaction with the results.

This article begins with a description of mechanical control systems for indoor climate; continues with a description of the needs of the collection and how the characteristics of equipment and of the building structure set limits to the climate that can be imposed; and concludes with an account of the role of passive climate control.

Relative Humidity and Dew Point

One of the difficulties that people have with discussions on climate control is understanding the concept of relative humidity and why it is, for preservation people, the significant measure of atmospheric moisture (1). For air-conditioning engineers the important parameter is the dew point of the air, because this sets limits on the climate that can be attained with orthodox methods (2).

Given a room full of air, at a comfortable 20° C, with a piece of paper in it, we can add water vapor to the air and watch what happens to the paper. Without any water vapor the paper will be rather stiff and brittle. As the amount of water vapor increases, the paper becomes softer and larger. Eventually we find that we can add no more water vapor to the air: It immediately condenses out on the walls if we try. Turning to the paper, we see that it has become very flabby. If we measure the water content of the air at this time, we find that the most we can add is 0.015 grams per gram of dry air. This quantity is 2.4 percent of water vapor by volume. The typical water content of air at this temperature (20° C) in everyday, outdoor life is about two-thirds of this value. Rather than quote the absolute value of the water content, we say that the relative humidity is 67 percent. The relative humidity (RH) expresses the atmospheric water content as a percentage of the maximum possible water content at that temperature. It is a ratio, not a concentration.

The convenience of using, and thinking in terms of, relative humidity only becomes apparent when we consider the situation at a different temperature. At a room temperature of 10° C, for example, the maximum amount of water vapor in the air will be 1.2 percent, just half the amount that could be accepted by the air at 20° C. If we now turn to the paper, however, we find that it is just as limp as it was at the higher temperature, with the higher value of atmospheric water vapor. The paper would, however, be quite crisp in air at 20° C with 1.2 percent of water vapor. Thus the paper responds mainly to the value of the relative humidity rather than to the value of the moisture content. Actually, this is not surprising: The paper is responding to the potential for action of the water rather than to its absolute amount (3). To put it another way, the wateriness of the air depends on how close it is to saturation rather than on how much water it contains.

After saying this, I must now point out that the moisture content of paper, and therefore its stiffness and dimensions, is not exactly dependent on the relative humidity alone. There is a small temperature dependence which can usually be neglected in buildings held at a normal comfortable temperature. This effect needs to be considered in studies of the influence on paper of cold storage and of heat sterilization processes.

The 1.2 percent of water vapor that only half saturates the air at 20° C completely saturates the air at 10° C. This particular batch of air, whatever its actual temperature, has a "dew point" temperature of 10° C. If it is cooled below 10° C, water will condense out.

The Technology of Climate Control

The simplest way to control the climate in a building is to distribute air from a central conditioning plant through ducts to the individual rooms. An air-distribution system allows control of dust, pollution, and humidity as well as temperature regulation, all within the same system.

Let us build up a typical air-conditioning system (Figure 1) piece by piece (4). A fan blows air through a duct into the room. Upstream from the fan there is a heating coil

Fig. 1. Diagram of an air-conditioning system

1. Outside air inlet
2. Damper
3. Coarse filter
4. Pre-heat coil
5. Recycled air entry
6. Cooling coil
7. Re-heat coil
8. Steam humidifier
9. Medium filter
10. Fan
11. Pollutant filter
12. Fine filter
13. Damper
14. Re-heat coil
15. Steam humidifier
16. Return air duct
17. Return air fan
18. Exhaust

to give winter warmth. In summer the air will need to be cooled. The same coil could be used, circulating a refrigerant through it. For reasons that will become clear, it is customary to provide a separate cooling coil upstream from the heating coil. These two coils provide for the temperature control of the room. A temperature sensor in the room sends signals to the control system, which adjusts the flow rate of hot water or of coolant to the coils. Humidity is controlled by spraying water or steam into the air stream, or by allowing air to pass through a wet mesh. This procedure allows us to increase the relative humidity of the room air, up to a point. To dry the incoming air we can use the cooling coil to condense water from the air, which may then need to be reheated. Thus separate coils are used for heating and for cooling: Sometimes both are in operation at the same time. Dust filters are usually put in the air stream to protect the equipment as well as the room. Filters for gaseous pollutants are better placed downstream of the equipment to catch pollutants given off by the humidification equipment. The air pumped through this series of devices is a mixture of recycled room air with some outside air. The outside air serves three purposes: It pressurizes the building, it keeps the oxygen and carbon dioxide and odor contents within comfortable limits, and it sometimes contributes to fuel economy.

Such a simple system is excellent for a single room with a naturally uniform internal climate. A dimly lit, unoccupied book stack deep within a building, and with no unusual sources of heat in adjacent rooms, could be very accurately controlled by such an arrangement. The air would be distributed throughout the room by branch ducts so that every part would be flushed by air of uniform temperature and relative humidity.

Most buildings are more difficult to control because of the uneven distribution of sources of heat in different rooms. These heat sources may also vary from time to time. Sun shines through the windows intermittently, and cooking is mostly a daytime activity. A system that delivers uniform air to all these rooms will fail to provide adequate comfort to the occupants or safe conditions for the collections. This situation can be dealt with in several ways. I will describe one solution which could be applied to control the climate in a particular research library or archive. This is only an example; it must be emphasized that each building should be treated as an entire system and should not be governed by a set of arbitrarily imposed standards and methods.

Buildings lose heat only from their perimeters. They gain heat throughout the interior, from lights and from the activities of people, their computers and their coffee pots. A perimeter heating system, using hot water circulating through radiators, will cope with the winter heat loss through walls and windows. The interior of the building will then only need cooling. The cooling needs of the various rooms will differ, but none will need heating, except on starting up the system. A library needs continuous air-conditioning, so restarts will only result from occasional mishaps.

The air-conditioning ducts therefore carry an air stream that is always cooler than the required room temperature. Each room has a valve in its branch duct that lets into the room just enough of this air to maintain the room at the correct temperature. The air temperature in the duct is held at a value that will just serve to cool the room with the greatest cooling need. Other rooms take less air. Uniformity of temperature in a room demands a moderate air circulation so it is necessary to have some minimum air input. A small heating coil in the duct near the air inlet will allow a flow of air without over-cooling the room. This is wasteful of energy, but some waste is inevitable in close control of building climate.

The relative humidity is controlled by holding the moisture content of the air in the duct at a value that gives the correct relative humidity when the air has warmed to the correct room temperature. The relative humidity is therefore not independently

controlled from room to room as is the temperature. Each room is merely flooded with air of the correct moisture content. The moisture content of the air can be boosted by putting a small steam injector in the local duct. This addition allows very close control of relative humidity but brings some hazards, which will be mentioned later.

Putting dryer air into the room cannot compensate for sources of humidity such as people and boiling kettles. A dehumidifier in the local duct would make a rather complicated system. A free-standing dehumidifier within the room is preferable. A consequence of this characteristic of air-conditioning systems is that it is important to prevent leakage of outside air into the building. The system will cope with the heat gain or loss caused by leakage, but it is less efficient at preventing changes of relative humidity. For this reason, and to avoid drawing in dust and pollutants, it is customary to design air-conditioning systems so that the interior is at a slightly higher pressure than that outside. This brings other troubles which will be discussed later.

The climate in a room can be controlled in many other ways. All use the same basic devices. One commonly used system does not vary the air volume pumped into the room, but has a heating coil in each branch duct to bring the air to a suitable temperature. A variant on this is to have a parallel duct carrying warmer air, which is mixed in varying proportion with the cold air to supply each room. These methods are rather wasteful of fuel.

Air Pollution

Filtration to remove particles is relatively easy and noncontroversial. For libraries one should aim for nearly total removal of dust. Several filters are needed. The first is a coarse filter to remove large lumps. The last is a very fine filter capable of removing nearly all dust over 1 micron in size. This filter presents a considerable resistance to air flow, and a correspondingly powerful pump is needed to drive the air through it. An alternative filtration method is the electrostatic precipitator, which removes dust particles by first charging them by passage through a strong electric field and then catching them on oppositely charged plates. Electrostatic precipitators tend to produce large agglomerations of particles, which eventually get caught up in the air stream. A conventional fiber filter is therefore put downstream to intercept these large particles. These devices have been criticized for generating ozone, but the rate of production of this dangerous pollutant seems to depend very much on the design of the device. This gas can also be removed, however, by a pollutant absorber downstream of the precipitator.

Gaseous pollutants are not customarily removed by air-conditioning equipment except in specialized buildings. For libraries the best choice seems to be active carbon filters. This material is inflammable, and an alternative is active alumina impregnated with potassium permanganate. This impregnant is needed to ensure complete removal of the very damaging pollutant sulphur dioxide (6, 10). The air is passed over granular beds of the absorbent. There seems to be some uncertainty over the performance in real life of pollutant absorbers, particularly for oxides of nitrogen.

Some pollutants are generated by the air-conditioning equipment. Chemicals are used in the humid parts of the equipment, such as drain pans for humidifiers, to prevent algal growth. Steam humidifiers are free of this problem, but chemicals are customarily added to the steam pipes to inhibit corrosion. The best solution at present seems to be to use high pressure steam to generate steam from purified water brought through plastic tubes to stainless steel heat exchangers. Electrical boiling of pure water is an expensive alternative.

Monitoring of pollutant concentrations demands more elaborate equipment than that needed for measuring temperature and humidity. Indeed, the efficiency of pollutant absorption by freshly installed active carbon can lead to such small concentrations in the air that only the most costly equipment and skilled operators can produce reliable data.

Controls and Calibration

There is a decisive move towards electronic sensing of the climate. A computer program decides what action is needed to keep each room at a constant climate and to minimize fuel consumption. The various valves and shutters are usually operated pneumatically.

Inaccurate sensors spoil the entire operation. Temperature sensors are quite reliable. They are usually devices whose electrical resistance varies with temperature. Relative humidity sensors are less reliable because their calibration drifts slowly, and all types are affected by contamination from airborne dust and pollutants (5). Recently, a dew point sensor has become available for air-conditioning applications. This device is a small metal mirror, which is automatically cooled to a temperature that just causes condensation. This humidity sensor is the most accurate available. The cold moist surface is even more prone to contamination than are the other types of sensor. It is, however, easy to clean.

A record of the interior climate can be obtained from the sensors used to control the system, but it is much better to use an independent network of sensors placed well away from the system sensors. If a bubbling coffee warmer is placed right under the system sensor, the climate in the rest of that room will become cool and dry as the system responds to the incorrect climatic data.

The clockwork hygrothermograph is still the best monitoring system for small institutions with less than 10 air-conditioned spaces. Above this size electronic systems are cheaper, and their data can be presented and recorded in a more informative way.

It is also vital to have intermittent checks on the system with hand-operated, calibrated sensors. Accurate electronic thermometers are available, which are quicker to respond than liquid-in-glass thermometers. Some have alternate sensor heads to allow measurement of surface temperatures as well as air temperatures. The psychrometer, or wet and dry bulb thermometer, is still the best hand-operated device for measuring relative humidity. Other electronic relative humidity indicators use sensors that are not so easily cleaned, and they are not to be relied upon for checking the system performance.

Climate for Books and Their Readers

After this very brief account of air-conditioning systems, I will turn to the climatic needs of the collections and describe how the choice of equipment and its mode of operation can best be adapted to the needs of a library. Several values are recommended for the climate that should be imposed in libraries (7). These are based on some reliable research on the rate of aging of paper. We can say with considerable confidence that the durability of a single sheet of paper is vastly improved if it is kept cool and dry. The degree of coolness and dryness that can be imposed to the benefit of the document apparently has no limits. On the other hand, readers don't like being cold, and a low relative humidity makes paper brittle and warps laminated materials. Therefore, no absolutely best condition for paper can be obtained in the everyday world. The building climate which is specified, and may be attained, will be a

compromise based on the interplay of numerous factors whose relative importance will vary from library to library.

Temperature

Coolness greatly extends the life of paper (8). The ability of people to endure a cool reading room is limited, however. This limit seems to be about 21° C in the United States, but apparently Europeans are hardier, and temperatures down to 18° C are acceptable. In tropical climates people may find 21° C rather cool for sitting and reading. For good conservation, one should strive for the lowest possible air temperature. A moderately high relative humidity and still air allow the lowest comfortable air temperature. Discreet use of radiant heaters allows a further reduction in air temperature, but books also absorb the radiant heat, and so there will be some local lowering of the relative humidity. There is a natural limit to the temperature that can be imposed in a building by orthodox air-conditioning. This limit is set by the lowest dew point that can be obtained. The minimum value is around freezing, because below this the cooling coil will become obstructed by ice. If a relative humidity of 50 percent is specified, for example, the minimum room temperature will be about 10° C.

Air of lower dew point can be obtained by adding an absorption dehumidification stage to the air-conditioning system. Two methods are available. One method, which uses a lithium chloride solution to absorb water vapor, is not recommended because failure can be catastrophic. If the air stream becomes contaminated with lithium chloride for any reason, the salt will deposit as a liquid film on the collection. This deposit can be removed only by washing each document in water. The other method is to pass the air through granular silica gel, which takes up water by physical adsorption. The exhausted silica gel is regenerated by warming it in an air stream of low relative humidity. This method is reliable. The only danger comes from the tendency of silica gel to disintegrate into dust as it repeatedly wets and dries, particularly if the water absorption stage is allowed to go too far by a malfunction of the control system. More durable silica gel is becoming available, but it is advisable to have a dust filter downstream of the dehumidifier.

The latter system is, of course, more expensive and more complicated than the usual air-conditioning for peoples' comfort, but it can work reliably and allows storage at low temperature. There is again a natural temperature break, which is set by the temperature at which water will condense from the warm air of the inhabited parts of the building as it cools against the walls of the cold area. Let us assume that the office and reading areas are at 20° C and 50 percent relative humidity. This air has a dew point of 9° C. A cool storage vault that is below this temperature will have to have airtight insulation to prevent condensation, a construction that requires refrigerator technology and is quite expensive on a large scale. The other solution is to have a building that is a system of boxes within boxes, each one cooler than the one outside it. Such a building design is quite practical, and indeed a system of concentric zones for different purposes is sometimes the only solution to condensation problems which can afflict the outer wall of the building, as we shall see later.

It seems that cooling paper below freezing causes no physical disruption by ice formation if the paper was at equilibrium with a moderate relative humidity at normal room temperature. The evidence comes from experiments on the nature of water in wood fibers rather than from empirical experiments on repeated freezing and thawing of paper (12).

The technology of cold storage differs considerably from normal air-conditioning practice. Usually much less outside air is drawn in, because people do not work within. For museum use, a free-standing pollution absorber is needed within the enclosure.

The retrieval and re-storing of documents that are normally kept rather cold demands an inconvenient ritual. Thermal equilibration must be achieved without significant migration of water through the paper. The book must therefore be put into an airtight container before removal from cold storage and allowed to equilibrate to the higher temperature of the reading room before it is removed from the container, a process that takes about an hour. The danger is greater during re-entry into the cold chamber. Water may distill from the warm book and condense on the cold sides of the airtight container. This water can then dribble down and migrate into the paper, causing staining. The temporary transfer container should therefore have a water absorbent lining, and cooling must be gradual.

Relative Humidity

We have reliable evidence that a low relative humidity retards the deterioration of paper (8). A low relative humidity also makes paper brittle. This brittle state is not harmful if the paper is not handled in this condition and the stiffening effect is completely reversible. Embrittlement of an irreversible kind is characteristic of chemical degradation of paper by oxidation or hydrolysis. Because the two effects are similar to the hand, the two phenomena are confused, and people talk about desiccated paper when they are in fact talking about decayed paper of near normal water content.

There is really not much scope for aiding the preservation of paper by imposing a low relative humidity. A sheet of paper may be dried without catastrophic effect, but books react differently. They are made of different materials laminated together. As the relative humidity is lowered, these materials change their physical properties in different ways. Paper and leather will shrink and stiffen. Paper will shrink differently in different directions. Cloth, on the other hand, will expand in area as the relative humidity diminishes. Glue becomes extremely hard and brittle as it dries. These materials working against one another cause book covers to warp. These effects are not yet documented by reliable published data. Apparently a relative humidity below about 35 percent is rather risky. The upper limit for good conservation is set by the danger of mold growth at about 70 percent RH. Within this range the deterioration rate of paper seems to vary by a factor of between 2 and 4. The damage done by handling dry and stiff, rather than damp and pliable, paper is very difficult to quantify. At high relative humidity the various materials continue to expand at different rates, but they are much more forgiving to each other and will creep and deform to reduce the stresses caused by movement. I believe that within the limits of 40-60 percent relative humidity the choice should be controlled by the local climate and by the nature of the outer wall of the building, as I will explain later. It is better to have a constant relative humidity within this range than to strive towards an ideal relative humidity which can only be obtained in some seasons of the year.

Different parts of the building can have different levels of relative humidity. Buildings that are vulnerable to winter condensation should have offices around the perimeter in which a low relative humidity, down to 25 percent perhaps, is maintained in winter, with the collection confined to an inner region with higher relative humidity. It is not advisable to move books from air at one relative humidity to another environment that is more than 5 percent different in relative humidity because changing the equilibrium moisture content of a book is a very slow affair indeed. It

takes weeks, rather than the hours needed for temperature equilibrium. If books have to be subjected to sudden changes of relative humidity because of the way the library operates, it is much better to have a rather high general level, around 60 percent, because climate changes at high relative humidity are much less traumatic for the book.

I strongly recommend a uniform relative humidity throughout the stack and reading area. The natural tendency of the air-conditioning system, as of the outside world from hour to hour, is to operate at a constant dew point. This means that in a single duct system every room must be at the same temperature to be at the same relative humidity, unless special provision is made by installing a secondary humidifier in the branch duct leading to a room. This allows a room to be at a higher temperature. Such local humidifiers are often inserted because the specification calls for very tight limits on relative humidity variation. These devices, so close to the room, can cause rapid oscillation of relative humidity about the set value, which is surely as harmful as an occasional slower wandering from the specified value. Such a local humidifier can cause trouble in another way: If the room humidistat calls for more humidity, the steam injector in the duct will add moisture. The dew point of the room air will increase and may exceed the temperature of the duct, which is carrying cool air. Condensation on the outer surface of the duct will drip into the room.

It is important that the curator understand the consequences of setting close tolerances on the climatic variation allowed. A less onerous specification, combined with some of the passive climate control methods discussed later, may well give a more reliable total system.

As a postscript to these separate discussions on the effects of temperature and of relative humidity, a comparison of the preservative effects of low temperature on the one hand and of low relative humidity on the other is of interest. The dew point attainable in a building is dependent on the technology of the device used to cool the air. Once a design dew point has been defined, one has a certain freedom in the choice of temperature, or of relative humidity, but not of both independently. For example, air at a temperature of 22° C and 33 percent RH has the same 5° C dew point as air at 12° C and 62 percent RH. The damage done by the high temperature of the first set of conditions is offset by the preservative effect of the low relative humidity. It seems from the slender evidence available that the low temperature-high relative humidity alternative gives better preservation (8).

People have a great tolerance for low relative humidity with little tolerance for low temperature, while books have a great tolerance for low temperature with little tolerance for low relative humidity. For a design dew point of 5° C a good compromise would be a room temperature of 18° C with a relative humidity near 42 percent. Cold storage vaults in the same building should be held slightly below 42 percent RH, depending on the temperature, so the moisture content of the paper does not change when a book is withdrawn and warmed up to the reading room temperature.

Effect of the Indoor Climate on the Building Envelope

Let us turn now to the extremely important but rather neglected subject of the influence of atmospheric moisture on the building (9). The problem can be simply stated, but not so easily solved. If the air inside the building has a higher dew point than the outside temperature, and if it diffuses or flows through the wall, then somewhere within the wall condensation will occur. The process is exactly the same as condensation on windows, but since it is invisible, it is presumed not to happen, or at least not to matter. In fact, the window condensation is sometimes the less harmful

event. Moisture in walls, and in roofs, can cause serious damage very quickly. Old buildings are vulnerable because they have no provision for preventing the diffusion of air through walls. New buildings are vulnerable because they are well insulated so that the interior surface of the outer skin of the wall is close to the outside temperature. The results of condensation can be increased corrosion of metal fastenings within the wall; movement of soluble salts, whose recrystallization physically disrupts the masonry; and frost damage from the expansion of ice lenses within the wall. In continental climates, these conditions pose a serious threat to buildings.

Vapor barriers are customarily installed to prevent diffusion of water vapor through the wall. They seldom work as intended, because they are rarely installed carefully enough. The barrier must be airtight. If it is not, it will allow some air through to deposit dew in the wall, and then it will inhibit the free air circulation that would, in warmer weather, evaporate the water.

Old buildings are generally not worth making airtight. A thorough survey can give reason for optimism, however. Thick, porous, salt-free masonry walls are not unduly vulnerable if they do not have iron cramps within them. Some old buildings faced with porous stone have an impermeable backing to the stones, originally put there to prevent salt migration from brick work. I am not suggesting, therefore, that old buildings can never be humidified to counter the desiccating effect of warmed winter air, but it must be done cautiously, and after a thorough structural survey.

One welcome side effect of running a building cool is that this danger of condensation in the walls is much reduced. Not only is the dew point lower, but the amount of water vapor carried by a given volume of air diminishes sharply with temperature so that the damage done by cool humid air diffusing out to a very cold outside wall surface is very much less than the damage done by warmer air diffusing out to a surface that is an equal number of degrees below its dew point.

As I mentioned before, air-conditioned buildings are customarily operated at a slightly raised pressure so that any leakage will be of conditioned air outwards rather than of raw outside air inwards. This pressure difference is designed into the system; it is seldom imposed by active measurement and control, although there is no reason why this cannot be done. It is advantageous to run a building which is in a cold climate and is humidified to more than 35 percent in the winter at, or slightly below, atmospheric pressure. This procedure will not solve the condensation problem entirely, because it is quite possible for air to be entering the building from outside in one place, but for another part of the wall to be exposed to inside air. This phenomenon is very common in buildings with high open interior spaces such as domes. The warm, moist air within the building is less dense than the cold dry outside air and so it tends to rise, escaping from the roof while outside air enters down below.

Another phenomenon operates in buildings with cavity walls. The general air flow may be inwards, but the air entering the wall will move sideways in the cavity towards fissures in the inner wall. Water vapor diffuses through the pores in the inner wall and crosses this cavity air stream diagonally to condense on the outer leaf of the wall.

In summer a danger is the condensation of moist, warm outside air near the inner surface of the wall. This air may be moister than you might suppose from the local weather report because an additional burden of water vapor can be coming from evaporation of water that has condensed during the winter. The evaporation rate increases dramatically at the high temperature reached within a sunny wall or roof on a warm day. This spring re-activation of water accumulated over the winter can produce spectacular flows of condensate.

A building that is not airtight and is in a place with cold winters and hot summers should be operated at a positive pressure during the summer and at a negative pressure during the winter. This seasonal change in operating pressure of air-conditioning systems is never deliberately used, as far as I know, but it is undoubtedly helpful to the preservation of the building. I discovered this when modifications to the air-conditioning system of a museum building unexpectedly altered the direction of air flow and dramatically reduced the winter condensation within the walls.

The relative humidity and temperature limits are thus set by the method of construction of the building and by its local climate. There is no easy way to predict the performance of an individual building, nor is it easy to measure the direction and vigor of air movement within the walls and roof.

Buildings that are vulnerable to damage by condensation should have sensors buried in the walls and roof to record the state of the climate within the structure. Only a few studies have been published on this subject (5, 9), but the growing practice of humidifying museums and libraries, and modern trends in insulation for energy saving, no doubt combine to cause damage to buildings in cold climates.

In continental climates the best argument for maintaining a low winter relative humidity is the preservation of the building rather than the preservation of the paper within it, although one must not forget the damage done by low relative humidity to furniture and panelling. In humid summer weather the burden of maintaining this constant low relative humidity becomes very expensive. It seems reasonable, therefore, to allow the relative humidity to change slowly through the seasons between limits that should not exceed 35-62 percent. Books take a very long time to re-equilibrate to a different relative humidity and the stresses imposed by the transient uneven moisture content are not beneficial, so a very slow seasonal change should be imposed.

Passive Climate Control

We have no doubt that books should, if possible, be kept in a constant climate. Much can be done, however, to safeguard collections without the benefit of the mechanical and electronic systems that I have described. Fortunately, books and documents are rather easy to care for in less than ideal climates. The first basic principle is to put them in a set of nearly airtight and close-fitting enclosures. The second principle is to prevent rapid temperature change around the collection.

The effect of enclosure, apart from its obvious role in excluding dust, needs some explanation. The physical properties of paper, such as its dimensions and its stiffness, depend on the moisture content, which is usually around 6 percent. This water is loosely bound and will be lost to surrounding air of low relative humidity. More water will be absorbed if the surrounding air has a high relative humidity. If the air surrounding the book is isolated from the rest of the atmosphere and if this air volume is kept small compared with the volume of the book, then this exchange of water will be very small, because, although the relative humidity of an isolated volume of air will change with temperature, the amount of water that has to move from book to air, or the other way, to maintain the equilibrium is entirely negligible. The book regulates the moisture in the air trapped around it (11). Some complicated movements of water can occur on a small scale if a temperature gradient exists across the enclosure. Good thermal buffering is important and can be achieved by insulation, by close stacking of the books, by massive construction of the building, and by keeping the book stacks away from outside walls, or the walls of furnace rooms.

A slow change in air temperature that causes no steep temperature gradients around a book does no harm. A sudden upward temperature change is not too

damaging either. If a book in a container is suddenly cooled, condensation will occur when the walls of the container drop below the dew point of the air within. The book will release to the air more water vapor to compensate for that lost, and a rather large amount of water will condense and drip on the book or flood the bottom of the enclosure. From there it will re-evaporate, setting up a cyclic process that will stain the book. This effect is well demonstrated by the glass-fronted boxes fixed to the walls of restaurants. If the menu is not changed frequently in winter, the passing gourmet will soon notice a stain creeping upward past the dessert list.

A very similar affliction can damage books in cases against uninsulated outer walls. The cold of a winter night can cool the back of the case, while the books remain warm because the glass front readily transmits the heat of the room. The books maintain the relative humidity of the air in the container. This condition is normally a virtue, but now it becomes a source of danger, as the condensed water dribbles invisibly down the back of the bookcase. Less dramatically, but more often, the relative humidity close to the cold back will only rise to some value above 70 percent, which allows dormant fungal spores and filaments to become active.

It is dangerous to allow the temperature of any part of a book stack to fall much below the temperature of the main body of air in the room because a roomful of air quickly achieves a uniform moisture content by convective mixing. If the temperature differs from place to place, the relative humidity must vary also. Cold walls have a boundary layer of cold air close to them which does not so readily mix into the general air circulation in the room. If water is rising in the wall, or penetrating through a porous wall, the moisture content of the air may locally be high. The two independent effects combine to give a dangerously high local relative humidity. The intermediate technology solution to this situation is to scour away the boundary layer with a draft from a fan. The permanent solution is to put insulation on the wall and cover this with an impermeable membrane.

If the average climate outside the library is within the limits set for good conservation, that is, less than 25° C and between 40 percent and 65 percent RH, then no great harm will come to collections that are not air-conditioned. Some seasons of the year, however, may be beyond these limits. The buffering capacity of the passive climate control measures described above may be exceeded, and the climate within the containers will drift towards a dangerous condition (1). Air-conditioning, even of a simple kind, then becomes essential. It may be that small free-standing humidifiers or dehumidifiers will cope with these brief seasonal periods of danger.

Much can also be done by adjusting the environment near the building. Pale paint reduces heat gain in the sun. Trees will do the same, eventually. Grass surroundings will reflect less solar energy onto the façade than will a marble concourse. The adjustment of the microenvironment, which is one of the more enjoyable fantasies of the ecological movement, can tip the balance for buildings that are not in extreme climates.

For libraries not yet built, we can rethink the whole concept of library design. On the whole, the custom of building massive, prestigious shrines to learning has served the cause of conservation well. Their natural temperature stability leads to good relative humidity stability because the daily fluctuation in atmospheric relative humidity is mainly caused by the daily temperature cycle. The moisture content of the air changes less often since it is controlled mainly by the direction of origin of the air mass that covers the region. More radical solutions are available, however, such as partial, or nearly complete, burial of the building. Existing buildings can be adjusted, for example, by installing a ventilated attic space to reduce heat conduction through

the roof and to prevent roof condensation in a humidified building. Finally, in this varied collection of measures to modify the indoor climate, one should not neglect the pleasure that can be obtained from air-conditioning devices. An ornamental fountain in the lobby can be used to humidify, or to dehumidify the air, according to the water temperature.

Air Pollution Originating Within the Building

Much has been written lately on the subject of air pollution generated indoors (10). In libraries the important pollutants are formaldehyde, formic acid, and acetic acid emitted by wood, particularly plywood and particle board. Some humidifiers release gases into the air, such as diethylaminoethanol, which are used to inhibit the corrosion of steam pipes. This chemical is a hygroscopic alkaline vapor which probably reacts with the acid pollutants in air to form nonvolatile salts, which precipitate as a slimy film on surfaces. One unusual hazard in libraries is the oxides of nitrogen released by the pyroxylin cloth used to cover books.

Damaging chemicals are also released within books, but climate control cannot cure this problem because the molecule will react long before it can diffuse out from the book. We are concerned, therefore, about chemicals that emerge from the container and from the outside surface of the books. Wood should really not be used in libraries, but, of course, it will continue to be used and to survive, so the collection must be protected against its outgassing. Various techniques can be used, depending on the circumstances. Fierce ventilation is the traditional, but not now popular, method. Some research is in progress on the efficiency of various surface coatings. Until results of these studies are released, a layer of aluminum foil is recommended as an impermeable barrier, or a layer of paper impregnated with calcium carbonate, which will react with the mainly acid gases emitted from wood. This paper should also catalyze the transformation of formaldehyde into formic acid and then react with the product, but research has not yet demonstrated that this reaction actually takes place.

If the container is lined with foil or alkaline paper in this way, it seems that tight containment of books presents less danger than exposing them to the room air. It certainly ensures a constant climate. For those who are not convinced by these arguments, even a permeable container such as an ordinary envelope slows down fluctuations in relative humidity, reacts with pollutants, and gives useful protection to the contents.

Conclusion

The influences on paper storage of climate, building methods, air-conditioning technology, pollution chemistry, and reader comfort are varied and intertwined. In such a complicated environment reliance on an arbitrary set of standards can lead to great expense and ultimate failure if the standards prove impossible to realize in a particular geographical and social environment. Each institution must be regarded as a unique system for which a unique compromise must be developed by intelligent study. A knowledge of the principles which underline the standards and codes of practice that have been developed over the years is essential.

References and Notes

1. A good general text on the effects of climate on historic materials is: Thomson, G. *The museum environment.* London: Butterworth, 1986.

2. The standard reference text for air-conditioning design in North America is the series of handbooks produced by the American Society of Heating, Ventilating and Air Conditioning Engineers, of Atlanta, Georgia, U.S.A. In particular the *Handbook of fundamentals* covers many of the subjects discussed in this article.

3. A standard work on the interaction of cellulosic material and water is: Hearle, J. W. S., & Peters, R. H. *Moisture in textiles.* New York: Textile Book Publishers, 1960.

4. A useful introduction to air-conditioning technology is: Shuttleworth, R. *Mechanical and electrical systems for construction.* New York: McGraw-Hill, 1983.

5. Relative humidity measurement is reviewed in: *Moisture and humidity 1985.* Research Triangle Park, North Carolina: Instrument Society of America, 1985.

6. Methods of pollution control are discussed in: Mathey, R. G., Faison, T. K., and Silberstein, S.. *Air quality criteria for storage of paper-based archival records.* NBSIR-83-2795. Washington: National Bureau of Standards, 1983.

7. The N. B. S. report, reference 6, proposes three grades of storage: 18°-24° C and 40-45 percent RH for immediately accessible books, 10°-13° C and 35 percent RH for less frequently used materials, and -29° C for cold storage. An American National Standard, Z39.54-198X, is currently being prepared. A committee of the U. S. National Academy of Sciences is also deliberating on the subject. There is a British Standard, BS 5454:1977, Recommendations for the Storage and Exhibition of Archival Documents.

8. Graminski, E. L., Parks, E. J., and Toth, E. H. The effects of temperature and moisture on the accelerated aging of paper. In *Durability of macromolecular materials.* Washington, D. C.: American Chemical Society, 1979, 341-355. (ACS Symposium series no. 95)

9. See the ASHRAE *Handbook of fundamentals* (reference 2) and also Lieff, M., and Trechsel, H. R. *Moisture migration in buildings.* American Society for Testing and Materials, 1982. (Special Publication 779)

10. Padfield, T., Erhardt, D., and Hopwood, W. Trouble in store. In International Institute for Conservation of Historic and Artistic Works. *Science and Technology in the Service of Conservation, Preprints of the Contributions to the Washington Congress, 3-9 September 1982.* London: International Institute for Conservation of Historic and Artistic Works, c1982, 24-27.
Indoor pollutants. Washington, D. C.: National Academy Press, 1981.

11. Padfield, T., Burke, M., and Erhardt, D. A cooled display case for George Washington's Commission. In International Council of Museums, 7th Triennial Meeting, Copenhagen, 10-14 September, 1984. *Preprints.* France: ICOM, 1984.

12. Nanassy, A. J. Temperature dependence of NMR measurement on moisture in wood. *Wood Science,* October 1978, *11*(86).

ZUSAMMENFASSUNG – Das Klima, das in einer Bibliothek aufrechterhalten wird, ist das Ergebnis eines Kompromisses zwischen den klimatischen Bedürfnissen der Leser und der Mitarbeiter, den klimatischen Bedingungen der Gebäudestruktur, der Notwendigkeit, die Zerfallsrate der Sammlung minimal zu halten, und den Wartungs-erfordernissen und Betriebskosten einer mechanischen Klimaanlage. Passive Klima-steuerung mit Hilfe eines gut durchdachten Entwurfs eines Aufbewahrungsbehälters und durch Verlangsamung des Hitze- und Feuchtigkeitstransfers durch Wände, erlaubt einfachere Klimasysteme, die problemloser sind, deren Betriebskosten niedri-ger liegen und die weniger gefährlich sind, wenn sie ausfallen. Herkömmliche Klima-anlagen können Luft mit einem Taupunkt von ungefähr 5°C erzeugen, was ermöglicht, dass im Gebäude eine Temperatur von 18°C und ungefähr 42 Prozent relative Luft-feuchtigkeit(RL) aufrechterhalten werden können. Eine niedrigere Temperatur kann

nur dann erreicht werden, wenn die relative Luftfeuchtigkeit erhöht wird oder umgekehrt. Ein niedrigerer Taupunkt kann erzielt werden, wenn die Luft mit einem Silikageltrocknungsmittelsystem nach anfänglichen Wasserentzug mit einer Kühlschlange getrocknet wird. Jedoch sind gebundene Bücher physischem Schaden ausgesetzt, wenn die RL unter etwa 35 Prozent liegt, und den Personen ist es zu kalt, wenn die Temperatur weniger als 18°C beträgt. Deshalb sind kältere oder trockenere Bedingungen nur für sorgfältig isolierte Lagergewölbe geeignet, in denen nur wenig Luft zirkulieren muss. Die relative Luftfeuchtigkeit in Gewölben sollte ein wenig unter der im Lesesaal liegen, so dass der Feuchtigkeitsgehalt des Buches sich nicht ändert, wenn dieses für den Leser erwärmt wird. Eine stabile relative Luftfeuchtigkeit ist wünschenswert, jedoch kann der Wert innerhalb der Begrenzung von 40 bis 62 Prozent gewählt werden, um die Eigenheiten des Klimas vor Ort und des Gebäudes in Betracht zu ziehen. Gebäude, die im Winter befeuchtet werden, können durch Kondensation und gefrorenes Wasser in den Wänden beschädigt werden. Plötzliche Veränderungen der relativen Luftfeuchtigkeit können vollständig verhindert werden, indem Bücher in enganliegende, fast luftdichte Behälter eingelegt werden, die sicher sind, falls es kein ständiges Temperaturgefälle von einer Seite zur anderen gibt, und die Temperatur im Umfeld nicht plötzlich absinkt. Die geringe Gefahr von lokal erzeugter Luftverschmutzung kann verringert werden, indem innere Holzoberflächen versiegelt werden und alkalisch gepuffertes Papier in die Kästen und Regaleinlagen eingelegt wird.

RESUME – Les conditions climatiques maintenues dans une bibliothèque sont le résultat d'un compromis entre les besoins climatiques du lecteur et aux du personnel, les besoins climatiques du bâtiment, le besoin de réduire le taux de détérioration des documents, les obligations d'entretien et les frais de fonctionnement de la climatisation mécanique. Un contrôle climatique passif par le choix de containers conçus à cet effet, par la diminution du transfert de la chaleur et de l'humidité au travers des murs, tout ceci permet un système de l'utilisation de l'air plus simple, moins problématique, moins cher et moins risqué en cas de défaillance. Les systèmes conventionnels de climatisation peuvent produire un point de rosée d'environ 5°C, ce qui permet une température stable dans le bâtiment de 18°C et 42 pour cent d'humidité relative. L'on peut obtenir une température plus basse en élevant l'humidité relative ou vice-versa. Un plus bas niveau d'humidité peut être obtenu en asséchant l'air par un procédé de dessication au gel de silice après une déshydratation initiale grâce à une spirale réfrigérante. Cependant, en dessous de 35% d'humidité relative, les livres reliés peuvent être endommagés et les êtres humains ressentent le froid en dessous de 18°C. Ainsi donc, des conditions climatiques plus froides ou plus sèches ne peuvent être pertinentes que dans des coffres d'entreposage soigneusement isolés, dans lesquels seul un minimum d'air ne circulera. L'humidité relative des coffres devra être maintenue un peu en dessous de celle de la salle de lecture afin que le niveau d'humidité du livre ne change pas lors de son réchauffement pour le lecteur. Une humidité relative stable est souhaitable, mais ses paramètres peuvent être choisis, dans les limites de 40-62 pour cent, pour prendre en ligne de compte les particularités du climat local et celui du bâtiment. Les bâtiments humidifiés en hiver peuvent être endommagés par la condensation de l'eau et le gel à l'intérieur des murs. Un changement subit de l'humidité relative peut être totalement prévenu par le dépôt des livres en containers de taille adéquate, étanches, qui sont sûrs si les changements de température ne sont pas extrêmes ni permanents. Le danger, bénin, de pollution locale, peut être réduit en scellant les surfaces intérieures en bois et en incorporant du papier de type alcalin dans les boîtes et le revêtement des étagères.

CONCLUSION OF THE CONFERENCE

Recommendations of the Conference,
 Adam Wysocki

Closing Remarks,
 Rutherford D. Rogers

RECOMMENDATIONS OF THE CONFERENCE

Presented by
Adam Wysocki
Chairman, Programme Management Committee, IFLA
The Netherlands

Introduction

The recommendations highlight conservation problems and refer to the need expressed by the library community for international action in this area. They note the efforts already made, endorse the steps taken, and welcome the initiatives of some institutions involved in the establishment of the IFLA Core Programme organization and structure. The second part of the draft is addressed to the international library community and seeks its participation in solving preservation problems; to member associations, which are urged to take concrete steps at the national level in the field of conservation policies and plans; and, finally, to IFLA for action intended to improve the preservation and conservation of library materials. In their final part the recommendations call on competent international organizations for their participation in and financial support of preservation and conservation efforts.

The Recommendations

Having been made aware of the enormous scale of the needs for urgent conservation measures to protect library materials, a need confirmed by the participants of the Conference, including those from the developing countries;

Having noted the views expressed by the representatives of national libraries and other professional groups that the needs for preservation and conservation of library materials, both retrospective and prospective, can only be solved through a combination of national and international efforts;

Being mindful of the unanimous support given to the recommendation on the conservation of library and archival materials by the delegates of all nations of the Cultural Forum in Budapest;

Having reviewed the IFLA International Core Programme for Preservation and Conservation (PAC), its objectives, orientation, and plan of action;

Recalling the successful results of the ongoing IFLA International Core Programmes on Universal Bibliographic Control (UBC), Universal Availability of Publications (UAP), and International MARC (IMP);

The International Conference on the *Preservation of Library Materials* held in Vienna, April 7-10, 1986

1. Endorses the steps already taken by IFLA to establish its International Core Programme on Preservation and Conservation;
2. Welcomes the initiatives of the Library of Congress (U.S.A.), the Bibliothèque Nationale (France), and the Deutsche Bücherei (German Democratic Republic) in establishing an international and two regional centers for preservation and conservation in the framework of the Core Programme;
3. Proposes that IFLA, as a means to mobilizing further interest and support, consider designating, as soon as possible, an IFLA Year on Preservation and Conservation, and

4. Recommends that the international library community bring to the attention of the broad public in every country the importance and urgency of preserving library materials, which form an essential part of the intellectual heritage of all nations – and stress the irreversible consequences for future generations of continued failure to undertake massive preservation and conservation measures;

5. Recommends that IFLA encourage member associations (a) to urge national policy-making bodies to establish guiding principles for formulating and implementing national programmes for preservation and conservation of library materials; (b) to appeal to governments for the supplementary funds certainly required to implement well-conceived national preservation programmes;

6. Invites member associations of IFLA to play an active role in persuading appropriate institutions to host additional regional centers in other parts of the world;

7. Recommends that IFLA contribute to the harmonization of international action in this field by working out internationally applicable guidelines, by issuing directories of available facilities and other required publications, and by organizing training courses, pilot projects, and other activities intended to improve the preservation and conservation of library materials;

8. Urges UNESCO and other competent international intergovernmental organizations (a) to increase the attention given in their programmes to promoting the undertaking of preservation and conservation measures by publishers, printers, and paper manufacturers, as well as by librarians, archivists, and other information personnel, and (b) to augment their financial support for activities leading to improved knowledge of the problems involved in preservation and conservation and to the solutions of both retrospective and prospective needs in this field; and

9. Recommends that IFLA continue its efforts to associate other competent nongovernmental organizations with its endeavor to establish an effective international programme in preservation and conservation.

CLOSING REMARKS

Rutherford D. Rogers
Yale University Librarian, Retired
U.S.A.

The satisfactory compression and summary of the 30 hours of discussion and lectures that have been presented at the Vienna Conference into less than one-half hour seems a fundamentally impossible task. Each person present would perform this task differently, especially the process of determining what to select and what to exclude. I will present my version under the principal headings: (1) The magnitude of the problem; (2) specific advice on care and conversion of collections; and (3) organizing preservation programs.

The Magnitude of the Problem

Speakers from different countries place the number of books now at risk at roughly 25 percent of their research collections, although in specific countries or libraries the conditions may depart from this norm. In more concrete terms, the Bibliothèque Nationale gauges its problem, based on 1979 figures, at 800,000 volumes. The humanities and social science collections of the British Library (BL) fall into the 25 percent endangered category. Although other BL collections have a lower percentage of risk, still one-half million additional books will need 400 camera-years for rescue. A selective program of preservation restricted to brittle books in the United States is provisionally estimated to cost $400 million. Even these massive figures fail to measure the problem of preserving archival and other non-book materials. Furthermore, many developing countries face environmental problems, often because of tropical climates, with which they are financially unequipped to cope. In our international planning we must consider the special need such nations have for assistance in preserving their publications. Finally, our gathering in Vienna from all parts of the world to address the issues of preservation is the best evidence of the enormity of the problem.

Specific Advice on Care and Conversion of Collections

Methods of dealing with deteriorating library collections fall into four categories: proper storage and handling, repair and deacidification of original volumes, text conversion, and disasters.

Storage and Handling

Some less affluent libraries must rely solely on proper handling and storage of materials because funds are unavailable for more sophisticated measures. It would be a mistake, however, to think that these steps are unimportant in any library. Staff as well as readers misuse books, and a continuing program of staff training in the care and handling of books should be a part of every library's repertoire. Can any of us be unaware of what one speaker described as "Xerox corpses," books badly damaged by readers using photocopying machines?

We know in general the ideal ambience for storing library materials, even if we are not always able to afford optimum conditions. The following guidelines have been enumerated at this conference.

1. Temperature should be maintained at the lowest practicable level and as constant as possible. Daily fluctuations of more than 4° C must be avoided.
2. An acceptable relative humidity falls in the range of 20-50 percent, but preferably below 40 percent and never over 60 percent. The optimum range, however, appears to be 30-35 percent, although one speaker said that books are liable to damage below 35 percent RH. Changes of more than 5 percent should be avoided in moving books to a different environment.
3. Photographic materials are best stored at 15°-25° C, but never above 30° C; below 20° C is preferable. Several libraries use cold storage facilities below 0° C for color film.
4. People have a great tolerance for a low relative humidity and little tolerance for low temperatures, but books have a great tolerance for low temperatures and little tolerance for low relative humidity. A good compromise for people, books, and phonograph records is 18° C and 40 percent RH.
5. Fungus growth is a hazard above 22° C and 65 percent RH.
6. Color photographs may fade even in the absence of light, if the storage temperature is high.
7. The most common pests in libraries are insects, rodents, and mold, and the worst insects are cockroaches, silverfish, beetles, and book lice. Preventive measures include avoiding interior fountains and plantings of shrubs or flowers; fixing exterior lights on supports away from, rather than on, library buildings; eliminating ivy and other vines from structures; and keeping leaves, twigs, and other debris away from foundations.
8. Insecticidal fogs and aerosols should never be used in collections because they leave an oily residue.
9. Magnetic tapes may be damaged by magnetic fields generated by loud-speakers, earphones, tape recorders, magnetic door locks, electrical transformers, and so forth.
10. Audiovisual and magnetically recorded data are only accessible through playback equipment. Maintaining such machines is essential, but will become increasingly difficult as manufacturers discontinue models and no longer provide spare parts.

Repair and Deacidification

Turning specifically to the preservation of original materials as opposed to text conversion, we are reminded of certain procedures that are acceptable or unacceptable.
1. Soluble nylon is unsuitable for paper conservation.
2. Distilled water should never be used for washing paper.
3. Encapsulation between sheets of polyester film is unsuitable for pencil, charcoal, or pastel drawings because of static electricity on film surfaces.
4. Cartographic globes are best treated with the gores in place rather than dismounted.
5. Water-soaked photographs are ideally air-dried without prior freezing, but freeze-drying in a vacuum chamber leaves photographs virtually unharmed. Freezing, followed by thawing and vacuum drying (as is done with books), is not recommended for photographs. Glass plate negatives, made by the wet collodion process, however, should never be frozen or freeze-dried once immersed in water.

The training of people in conservation techniques is a major concern of those countries attempting to accelerate conservation programs. This is particularly true in Latin America and other countries where even standard texts in the vernacular are

lacking. The Deutsche Bücherei in Leipzig has assumed regional leadership for training. The Austrian National Library trains conservators, and Britain and France have training programs, but these need upgrading. Library preservation is taught only cursorily in most Australian library schools. In the United States, noticeable strides in training are barely a decade old.

Deacidification appears to be the most significant procedure for saving the great mass of paper in libraries. Canada, Austria, France, and the United States are among the countries reporting major efforts in this field.

1. Canada currently can deacidify 40,000 volumes annually with its Wei T'o nonaqueous system and hopes to raise the capacity to 300,000 volumes at a cost of $3.50-$4.50 (Can $) each.
2. The Library of Congress expects to be able to deacidify at least 500,000 volumes annually at a cost of $1 for handling and $3.50 for actual deacidification using a diethyl zinc process. They hope to attain a million-volume level at $2.00 each.
3. Mass deacidification in France is expected to be operational by June 1986. The Deutsche Bücherei in Leipzig has a process for deacidifying and strengthening paper.
4. The British Library is experimenting with a combination of monomers and gamma irradiation to deacidify and strengthen paper.
5. The Austrian National Library can treat several thousand volumes with ethylene oxide gas and has had success in treating text blocks of newspapers by putting them in a vacuum chamber, impregnating the blocks with celluloses in polyvinylacetate, after which the block is quickly frozen at -30° to -40° C and freeze-dried for 2 days. The Library has also successfully subjected art on paper to delignification and groundwood removal, but at a high price.
6. Helmut Bansa believes aqueous deacidification of rare book papers is the preferred treatment.

Text Conversion

Currently, microforms are the most permanent, but the least convenient and compact, means for secondary preservation. Magnetic media are the least permanent, but more compact and flexible. Optical digital disks are the most compact (storing 10,000-15,000 images on one side of a disk) and may become as permanent as microforms and as flexible as magnetic media, but cost of the optical disk technology is not yet established.

The Library of Congress filming program in India offers valuable experience for large-scale filming efforts.

1. They presently film 143 newspapers, 145 periodicals, and 53 government gazettes from 21 countries.
2. They have found that full capacity of a camera in an 8-hour day is 6 3/4 hours of actual operation and that productivity per camera is 150 exposures per hour for large formats, 355 exposures per hour for small formats, and 5.25 fiche per hour for microfiche.
3. Sixty-seven Canadian libraries participate in a national preservation program.
4. Britain has many large-scale microform projects, and the work of the Public Record Office is probably most widely known and is of direct benefit to great numbers of scholars.
5. As an example of non-governmental programs, the Research Libraries Group now has underway two major filming projects, one for United States imprints for the period 1870-1920 and Chinese language materials for 1880-1949.

Librarians are obliged to consider the copyright protection of works they may want to copy. One hundred countries are members of international copyright conventions. The most common term of copyright is life of the author plus 50 years. A work may be without copyright in one country, but protected in another. The right to reproduce a work is exclusive and applies to fixing it in any form including film, disk, or computer memory. Copying for library purposes, however, may most often be allowed for purposes of preservation; or if the material is unique and the original work should not be handled by readers; or if a reader wants only part of a comprehensive work copied; or if the work is no longer available in the market.

Disasters

Disasters can be precipitated by vandalism, fires, leaking roofs, broken pipes, and overflowing rivers. Fires are most often caused by careless workmen on library premises, but the most frequent and extensive damage comes from water. Every library should have a disaster plan, and a model plan should include prevention, protection of materials, and efficient and prompt salvage of damaged material.

Organization of Preservation Programs

Adam Wysocki has articulated a series of steps that may very well become momentous in our worldwide efforts, and we are indebted to UNESCO, IFLA, and CDNL for their foresight in bringing global notice to preservation. The task of preserving the world's intellectual heritage is clearly so vast that cooperative action is the only possible solution. If one accepts this principle, then it follows that bibliographic control is an indispensable requirement of large-scale preservation programs so that institutions may know what has been, or is being, preserved, thereby enabling them to avoid unnecessary duplication of effort, at the same time serving the needs of readers seeking specific sources. The creation of a central record of this kind, first nationally and then internationally, is of such immense importance to our efforts that it should be a topic for priority action and therefore one of the most important conclusions that could come from our deliberations.

"It is unlikely," says Jan Lyall of Australia, "that any national preservation program will ever succeed unless a mechanism is established for its central control and management." Marie-Louise Bossuat, Alexander Wilson, and others have expressed similar sentiments. Warren Haas has laid down five elements for defining and shaping a national program:

1. Understanding fully the nature of the problem by exploring the number of items at risk, the storage conditions available, paper quality and the dangers of insects and fungus, the adequacy of the bibliographic record, and the need for standards for film and paper.
2. Establishing leadership for the program.
3. Building understanding in order to marshall the financial support and cooperation of librarians, publishers, and funding sources.
4. Planning to avoid unnecessary duplication, to train a corps of experts to undertake the work, to provide for access to information about preserved items, and to determine the optimum technology.
5. Action: "The result of national planning is the accumulated product of the preservation work of many institutions."

Several principles enunciated by William Welsh should be in the forefront of our planning:

1. International standards are a *sine qua non* of cooperation.

2. Each national library should undertake the preservation of indigenous imprints.
3. Where possible, national libraries should assist less affluent countries with their preservation problems. In this connection it is a relevant fact that the greatest research libraries develop collections without regard to national boundaries. It follows that many important collections of the world reside in libraries located outside the nations where these publications originated.

Richard McCoy of the Research Libraries Group defined for us the steps for launching a specific large-scale microform program:

1. Design and selection of an achievable goal.
2. Establishing and documenting standards by which the work will proceed.
3. Establishing a procedure for identifying the collections to be treated and the participating institutions.
4. Raising the necessary funds.

The final thought with which I close is embodied implicitly or explicitly in many papers, but is perhaps most eloquently expressed by Jean-Marie Arnoult of the Bibliothèque Nationale. The overwhelming source of our problem is paper. Permanent/durable paper is available, if only it would be used by printers and publishers. Should we not, above everything else, renew and intensify our efforts worldwide to persuade publishers to use the proper paper, despite the obstacles to be surmounted, as described by Klaus Saur? The century and a half of production that is already decaying on our shelves is more than enough to engage our attention without indefinitely augmenting our holdings of perishable paper. In this connection, one of the most encouraging and significant messages to issue from this conference is Lewis Brown's news about the increasing production of permanent paper brought about by manufacturing methods that have less adverse environmental impact.

Since Adam Wysocki has presented so forcefully the rationale, program, and recommendations for international cooperation in this field, and since the audience has been so supportive of the envisaged action, I will not burden you with repetition of the obvious, but I would compliment IFLA, the Library of Congress, the Bibliothèque Nationale, and the Deutsche Bücherei in Leipzig for the important responsibilities they have agreed to undertake.

Finally, I salute the Conference of Directors of National Libraries, IFLA, and UNESCO for sponsoring this conference, and we are all in the debt of the Austrian National Library for their splendid hospitality, which has contributed so much to the success of our deliberations.

INDEX

IFLA ANNUAL 1986

Proceedings of the 52nd General Conference
Tokyo 1986 Annual Report

Actes de la 52 Session de la Conference Générale
Tokyo 1986 Rapports Annuels

Edited by Willem R.H. Koops and Carol Henry

1987. 234 pages. Paperback. DM 68.00
ISBN 3-598-20667-4

With this publication the Federation of Library Associations
and Institutions present their report of activities during 1986.
Also included is an account of the procceedings at the Annual
Conference in Tokyo.

K·G·Saur München·London·New York·Paris

K·G·Saur Verlag · Postfach 71 10 09 · 8000 München 71 · Tel. (0 89) 7 91 04-0
K·G·Saur · Shropshire House · 2-10 Capper Street · London WC 1E6JA · Tel. 01-637-1571
K·G·Saur · 175 Fifth Avenue · New York, N.Y. 10010 · Tel. (212) 982-1302
K·G·Saur, Editeur · 6, rue de la Sorbonne · 75005 Paris · Téléphone 43.54.47.57

saur

AUTOMATED SYSTEMS FOR ACCESS TO
MULTILINGUAL AND MULTISCRIPT
LIBRARY MATERIALS

Problems and Solutions

Papers from the Pre-Conference held at Nihon Daigaku
Kaikan Tokyo, Japan, August 21-22, 1986

Edited for the Section on Library Services
to Multicultural Populations and the Sections
on Information Technology
by Christine Boßmeyer and Stephen W.Massil

(IFLA Publications Vol. 38)

1987. 227 pages. Hard cover. DM 68.00
ISBN 3-598-21768-4

These conference reports present and discuss problematic
issues relating to bibliographical work by computer in the
sphere of materials in a foreign language, with particular refer-
ence to Asian countries.

K·G·Saur München·London·New York·Paris

K·G·Saur Verlag · Postfach 71 10 09 · 8000 München 71 · Tel. (0 89) 7 91 04-0
K·G·Saur · Shropshire House · 2-10 Capper Street · London WC 1E 6JA · Tel. 01-637-1571
K·G·Saur · 175 Fifth Avenue · New York, N.Y. 10010 · Tel. (212) 982-1302
K·G·Saur, Editeur · 6, rue de la Sorbonne · 75005 Paris · Téléphone 43.54.47.57

saur

INTERNATIONAL BIBLIOGRAPHY
OF ART LIBRARIANSHIP

An annotated compilation

Edited by the International Federation
of Library Associations and Institutions

1987. V, 94 pages.
Hard cover. DM 40.00
ISBN 3-598-21767-6

(IFLA-Publications Vol. 37)

This bibliography is an extensive compilation of literature, selected for its pedagogical relevance to the theme of art librarianship. It provides valuable international perspectives on the period 1908 to 1985. The entries are ordered systematically and are accompanied by short descriptions, while easy access is ensured by an author index.

K·G·Saur München·London·New York·Paris

K·G·Saur Verlag · Postfach 71 10 09 · 8000 München 71 · Tel. (0 89) 7 91 04-0
K·G·Saur · Shropshire House · 2-10 Capper Street · London WC 1E6JA · Tel. 01-637-1571
K·G·Saur · 175 Fifth Avenue · New York, N.Y. 10010 · Tel. (212) 982-1302
K·G·Saur, Editeur · 6, rue de la Sorbonne · 75005 Paris · Téléphone 43.54.47.57